ISSN 1052-1712

VOLUME 2

MODERN ARTS CRITICISM

A Biographical and Critical Guide to
Painters, Sculptors, Photographers, and Architects
from the Beginning of the Modern Era to the Present

Joann Prosyniuk
Editor

David Kmenta
Jelena O. Krstović
Marie Lazzari
Zoran Minderović
David Segal
Bridget Travers
Sandra Williamson
Associate Editors

012505

 Gale Research Inc. · *DETROIT · NEW YORK · LONDON*

STAFF

Joann Prosyniuk, *Editor*

David Kmenta, Jelena O. Krstovic, Marie Lazzari, Zoran Minderovic, David Segal, Bridget Travers, Sandra Williamson, *Associate Editors*

Tina Grant, Alan Hedblad, Grace Jeromski, Andrew M. Kalasky, Linda M. Ross, Mark Swartz, Debra A. Wells, Janet M. Witalec, *Assistant Editors*

Jeanne A. Gough, *Permissions & Production Manager*

Linda M. Pugliese, *Production Supervisor*

Maureen Puhl, Jennifer VanSickle, *Editorial Associates*

Donna Craft, Paul Lewon, Lorna Mabunda, Camille Robinson, Sheila Walencewicz, *Editorial Assistants*

Maureen Richards, *Research Supervisor*

Paula Cutcher-Jackson, Heidi Fields, Judy L. Gale, Robin Lupa, Mary Beth McElmeel, *Editorial Associates*

Jennifer Brostrom, *Editorial Assistant*

Sandra C. Davis, *Permissions Supervisor (Text)*

Maria L. Franklin, Josephine M. Keene, Denise M. Singleton, Kimberly F. Smilay, *Permissions Associates*

Rebecca A. Hartford, Michele Lonoconus, Shalice Shah, Nancy K. Sheridan, *Permissions Assistants*

Shelly Rakoczy, *Student Co-op Assistant*

Margaret A. Chamberlain, *Permissions Supervisor (Pictures)*

Pamela A. Hayes, *Permissions Associate*

Keith Reed, *Permissions Assistant*

Mary Beth Trimper, *Production Manager*

Mary Winterhalter, *Production Assistant*

Arthur Chartow, *Art Director*

C. J. Jonik, *Keyliner*

The paper used in this publication meets the minimum requirements of American National Standard for Information Sciences—Permanence Paper for Printed Library Materials, ANSI Z39.48-1984.

Contents

Preface vii

Acknowledgments ix

Berenice Abbott (1898-)1
American photographer

Ivan Albright (1897-1983).....................16
American painter

Charles Burchfield (1893-1967)30
American painter

Alexander Calder (1898-1976)56
American sculptor

Henri Cartier-Bresson (1908-).............83
French photographer

Marc Chagall (1887-1985)....................109
Russian-born French painter

Giorgio de Chirico (1888-1978)...........142
Italian painter

Joseph Cornell (1903-1972)..................166
American multimedia artist

Otto Dix (1891-1969)188
German painter

Lee Friedlander (1934-)....................210
American photographer

Naum Gabo (1890-1977).....................231
Russian-born sculptor

Barbara Hepworth (1903-1975)253
English sculptor

Edward Hopper (1882-1967)................277
American painter

Wassily Kandinsky (1886-1944)310
Russian painter

Man Ray (1890-1976)...........................337
American photographer

Diego Rivera (1886-1957)368
Mexican painter

Eero Saarinen (1910-1961)...................401
American architect

Minor White (1908-1976).....................432
American photographer

Modern Arts Criticism Cumulative Artist Index 455

Modern Arts Criticism Cumulative Medium Index 457

Modern Arts Criticism Cumulative Title Index 459

Preface

Modern Arts Criticism has been created in response to the need for a comprehensive, convenient source of biographical, critical, and bibliographical information on world artists. Although a vast amount of such information exists, no other reference source compiles and organizes all of the diverse types of materials presented in this series.

Scope of the Series

Modern Arts Criticism is designed as an introduction to major painters, sculptors, photographers, architects, and multimedia artists of the modern period. Commentators most often identify the advent of photography as the first of the many formative influences in the development of modern art; this series therefore includes artists active after the emergence of that medium as a form of artistic expression, which occurred in the mid-nineteenth century. Because the number of such artists is extremely large, *Modern Arts Criticism* focuses only on those whose works have been the subject of significant commentary.

In presenting discussions of major artists by leading commentators and art historians, *Modern Arts Criticism* helps students develop valuable insight into art history and sparks ideas for papers and other assignments. In addition, by including a wide spectrum of critical opinion, the series fosters an awareness of the dynamism and diversity of the visual arts and their impact on modern life.

Highlights of Each Entry

An entry in *Modern Arts Criticism* consists of the following elements: artist heading; biographical and critical introduction; excerpts of criticism (each preceded by explanatory notes and followed by a bibliographic citation); illustrations; and a bibliography of further reading.

- The *artist heading* consists of the name by which the artist is most commonly known, followed by the birth date and, where applicable, death date. If an artist consistently used a pseudonym, the pseudonym will be listed in the artist heading and the real name will appear in the first line of the introduction, as will any other important variations of an artist's name.

- The *biographical introduction* outlines the artist's life and career, as well as critical response to the works.

- Whenever possible, *criticism of three types* has been included in entries: artists' statements concerning their works or aesthetic ideas, introductory overviews, and criticism of more specific issues or phases in an artist's career arranged in chronological order to convey a sense of the development of critical opinion.

 All titles of works featured in the criticism are printed in boldface type to enable the user to easily locate discussion of particular works. Also for purposes of easier identification, the critic's name and the publication date of the essay are given at the beginning of each piece of criticism. Unsigned criticism is preceded by the name of the journal in which it appeared.

 Some of the excerpts in *Modern Arts Criticism* also contain translated material. Unless otherwise noted, translations in brackets are by the editors; translations in parentheses or continuous with the text are by the critic. Publication information (such as publisher names and book prices) and parenthetical numerical references (such as footnotes or page references) have been deleted at the editors' discretion to provide smoother reading of the text.

- Critical excerpts are prefaced by *annotations* providing the reader with information about both the critic and the criticism that follows. Included are the critic's reputation, approach to art criticism, and particular expertise. Also noted are the relative importance of a work of criticism, the scope of the excerpt, and the growth of critical controversy or changes in critical trends regarding an artist. In some cases, these annotations cross-reference excerpts by critics who discuss each other's commentary.

- A complete *bibliographic citation* designed to facilitate location of the original essay or book follows each piece of criticism.

- Whenever possible, two types of *illustrations* have been included in artist entries. These include *artist portraits* and *reproductions of selected works* discussed in the text.

- An annotated list of *further reading* appears at the end of each entry. Included are writings by the artist, interviews, bibliographies (both primary and secondary), biographies, critical studies and reviews, and sources of reproductions of the artist's works. These categories of primary and secondary readings are clearly labeled to facilitate location of specific types of material.

Cumulative Indexes

Each volume of *Modern Arts Criticism* will include *a cumulative medium index* listing artists who have appeared in the series arranged according to the primary medium with which they are identified. The *cumulative title index* will list the titles of all works that have been discussed in the series. Beginning with the second in the series, each volume also includes a *cumulative index of artists.*

A Note to the Reader

When writing papers, students who quote directly from any volume in the *Modern Arts Criticism* series may use the following general forms to footnote reprinted criticism. The first example pertains to material drawn from periodicals, the second to material reprinted from books:

[1] R. Gordon Taylor, "Ansel Adams 1902-1984," *The British Journal of Photography* 131 (September 28, 1984), 1014-16; excerpted and reprinted in *Modern Arts Criticism,* Vol. 1, ed. Joann Prosyniuk (Detroit: Gale Research, 1991), pp. 11-13.

[2] Lionello Venturi, *Impressionists and Symbolists* (Charles Scribner's Sons, 1950); excerpted and reprinted in *Modern Arts Criticism,* Vol. 1, ed. Joann Prosyniuk (Detroit): Gale Research, 1991), pp. 255-72.

Suggestions Are Welcome

Readers who wish to suggest artists to appear in future volumes, or who have other suggestions, are cordially invited to write the editors.

Acknowledgments

The editors wish to thank the copyright holders of the excerpted criticism included in this volume, the permissions managers of many book and magazine publishing companies for assisting us in securing reprint rights, and Anthony Bogucki for assistance with copyright research. We are also grateful to the staffs of the Detroit Public Library, the University of Detroit Library, the Library of Congress, the Wayne State University Purdy/Kresge Library Complex, and the University of Michigan Libraries for making their resources available to us. Following is a list of the copyright holders who have granted us permission to reprint material in this volume of *MAC*. Every effort has been made to trace copyright, but if omissions have been made, please let us know.

COPYRIGHTED EXCERPTS IN *MAC*, VOLUME 2, WERE REPRINTED FROM THE FOLLOWING PERIODICALS:

Afterimage, v. 10, October, 1982 for "Grist for the Mills" by Steve Cagan. Copyright © by the author 1982. Reprinted by permission of the author.—*AIA Journal*, v. 70, November, 1981. © 1981 by The American Institute of Architects./ v. 67, November, 1978 for "The Arch: An Appreciation" by George McCue. © 1978 by the American Institute of Architects. Reprinted by permission of the author.—*American Artist*, v. 30, January, 1966. Copyright © 1966 by Billboard Publications, Inc. Reprinted by permission./ v. 20, January, 1956. Copyright © 1956, renewed 1983 by Billboard Publications, Inc. Reprinted by permission of the publisher.—*American Photographer* (currently American Photo), v. XII, March, 1984. Copyright © 1984. All rights reserved. Reprinted by permission of the publisher, Hachette Magazine Inc.—*Américas*, v. 24, November-December, 1972. © 1972 *Américas*. Reprinted by permission of the publisher.—*The Antioch Review*, v. XX, Spring, 1960. Copyright © 1960, renewed 1988 by the Antioch Review Inc. Reprinted by permission of the Editors.—*Aperture*, n. 85, 1981. Copyright © 1981 by Aperture Foundation Inc. Reprinted by permission of the publisher.—*Apollo*, n.s. v. LXXIX, May, 1964. © Apollo Magazine Ltd. 1964. Reprinted by permission of the publisher.—*Architectural Forum*, v. 134, June, 1971. © 1971 BPI Communications, Inc. Used with permission of the publisher./ v. 70, February, 1939. Copyright 1939, renewed 1966 BPI Communications, Inc. Used with permission of the publisher.—*Art and Artists*, v. 12, May, 1977. © copyright Hansom Books, 1977.—*Art & Artists*, v. 13, December, 1978 for a review of "Kriegsfolge" by Gertrud Mander. © 1978 by the Foundation for the Community of Artists, Inc. All rights reserved. Reprinted by permission of the author.—*The Art Digest*, v. 19, April 1, 1945. Copyright 1945 by The Art Digest, Inc. All rights reserved.—*Art in America*, v. 50, 1962 for "Chicago: Ivan Le Lorraine Albright" by Doris Lane Butler. Copyright 1962 by Art in America, Inc./ v. 64, November-December, 1976 for an interview with Berenice Abbott by Alice C. Steinbach. Copyright © 1976 by Art in America, Inc. Reprinted by permission of Alice C. Steinbach./ v. 69, September, 1981 for "Return to Order" by Linda Nochlin. Copyright © 1981 by Art in America, Inc. Reprinted by permission of the publisher and the author./ v. 63, May-June, 1975; v. 71, Summer, 1983. Copyright © 1975, 1983 by Art in America, Inc. Both reprinted by permission of the publisher.—*Art Journal*, v. XXIII, Spring, 1964 for "Man Ray and New York Dada" by Carl Belz. Copyright 1964, College Art Association of America, Inc. All rights reserved. Reprinted by permission of the publisher and the author.—*Art International*, v. XXII, February, 1979. Reprinted by permission of the publisher.—*Artforum*, v. XI, March, 1973. © 1973 Artforum International Magazine, Inc./ v. X, September, 1971 for "Kinetic Solutions to Pictorial Problems: The Films of Man Ray and Moholy-Nagy" by Barbara Rose; v. XII, November, 1973 for "The Rivera Frescoes of Modern Industry at the Detroit Institute of Arts: Proletarian Art Under Capitalist Patronage" by Max Kozloff; v. XIII, April, 1975 for "Lee Friedlander's Guarded Strategies" by Martha Rosler; v. XIV, April, 1976 for a review of "Changing New York" by Ann-Sargent Wooster; v. XXV, November, 1986 for "Sun Rising in Calder" by Lisa Liebmann. © 1971, 1973, 1975, 1976, 1986 Artforum International Magazine, Inc. All reprinted by permission of the respective authors./ v. 26, October, 1987 for "Mystery in a Hat" by Charles Hagen. © 1987 Artforum International Magazine, Inc. Reprinted by permission of the publisher and the author./ v. XV, May, 1977. Copyright © 1977 by Artforum International Magazine, Inc. Reprinted by permission of the publisher.—*ARTnews*, v. 63, October, 1964; v. 66, Summer, 1967; v. 68, October, 1969; v. 69, May, 1970; v. 74, May, 1975; v. 75, December, 1976; v. 76, January, 1977. © 1964, 1967, 1969, 1970, 1975, 1976, 1977 ARTnews Associates. All reprinted by permission of the publisher./ v. XLIX, March, 1950. Copyright 1950, renewed 1978 ARTnews Associates. Reprinted by permission of the publisher.—*Arts & Architecture*, v. 74, July, 1957.—*Arts Magazine*, v. 41, May, 1967. © 1967 by The Arts Digest Inc./ v. 53, October, 1978 for "Alexander Calder: Cosmic Imagery and the Use of Scientific Instruments" by Joan M. Marter. © 1978 by the Arts Digest Co. Reprinted by permission of the author./ v. 39, September-October, 1965 for "Arcadia Enclosed: The Boxes of Joseph Cornell" by Ellen H. Johnson; v. 54, February, 1980 for "Charles Burchfield: The Last Pantheist?" by John I. H. Baur; v. 57, September, 1982 for "The Metaphysical de Chirico, and Otherwise" by James Beck. © 1965, 1980, 1982 by the Arts Digest Co. All reprinted by permission of the publisher and the respective authors.—

COPYRIGHTED EXCERPTS IN *MAC,* VOLUME 2, WERE REPRINTED FROM THE FOLLOWING BOOKS:

PHOTOGRAPHS AND ILLUSTRATIONS APPEARING IN MAC, VOLUME 2, WERE RECEIVED FROM THE FOLLOWING SOURCES:

Berenice Abbott

1898-

American photographer.

One [...]
tieth [...]
pho [...]
An [...]
to r [...]
thr [...]
her style as "forthright, sharp, and penetrating" and
notes: "Abbott's photography cast an unflinching eye on
the textures, details, paradoxes, incongruities, and monot-
onies of life—and found them exquisite."

Abbott was born in Springfield, Ohio, and raised, after her
parents' separation, by her mother. She attended Ohio
State University before transferring to the Columbia Uni-
versity School of Journalism, and it was while attending
Columbia and living in Greenwich Village that she be-
came interested in art. In 1921 she went to Paris to study
sculpture. However, after working as an assistant to the
photographer Man Ray, she became fascinated with that
medium. She later noted: "I took to photography right
from the start—then I never wanted to do anything else."

In 1925 Abbott opened a portrait studio with financial
help from Peggy Guggenheim, an heiress and patron of
the arts, and for the next four years she photographed
members of the avant-garde art community and other no-
table figures, including James Joyce, Djuna Barnes, and
Guggenheim herself. While living in Paris, Abbott also be-
came acquainted with Eugène Atget, a Parisian photogra-
pher who had spent much of his life documenting the rap-
idly changing appearance of the city. Atget's work was at
that time unknown, and at his death in 1927 Abbott pur-
chased his photographic plates as well as his entire output
of prints and negatives, thereby preserving the work of a
man who is now recognized as one of the most significant
photographers of the twentieth century.

Returning to the United States in 1929, Abbott settled
again in New York, where she resolved to create a photo-
graphic portrait of the city in all its remarkable diversity.
She began photographing New York in 1930, supporting
herself by teaching classes in photography at the New
School for Social Research, and in 1935 she was granted
funding for her project by the Works Progress Adminis-
tration. Interested in particular in presenting the startling
contrasts of the urban landscape, Abbott maneuvered her
cumbersome equipment to achieve unusual perspectives
and juxtapositions of the old and the new, the Gothic and
the ultra-modern. She later remarked of this period: "I
was at the height of happiness because someone was pay-
ing me to do what I wanted." However, Abbott's New
York photographs, published as *Changing New York* in
1939 and later reissued as *New York in the Thirties,* at-
tracted little attention when they were shown in museums
around the city.

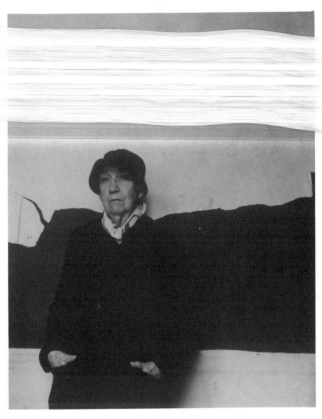

(c) Arnold Newman

After completing the New York series, Abbott became in-
terested in photographing such scientific phenomena as
the effects of magnetism and various forms of motion,
finding that existing techniques and equipment produced
blurry and uninteresting images of visually fascinating
subjects. In order to capture the minute complexities of
such phenomena, she adapted equipment and devised a
variety of new photographic strategies, in some cases
using light-sensitive paper to capture images without the
use of a camera, a technique borrowed from Man Ray. For
a number of years she was unsuccessful in persuading sci-
entists of the need for photographic documentation for
their work, and her prints were repeatedly rejected by art
journals. However, after science education became a gov-
ernment priority in the late 1950s, Abbott was invited to
join the Physical Science Study Committee at the Massa-
chusetts Institute of Technology, and her scientific photo-
graphs gained attention for their educational and docu-
mentary value. During the 1960s and 1970s, renewed in-
terest in documentary photography also resulted in a reap-
praisal of Abbott's earlier works, which were featured in
major exhibitions throughout the country. Abbott's last
major project was a series of photographs taken along U.S.

Route 1, which follows the East Coast from Florida to Maine.

Although her work was all but ignored for several decades, Abbott is today acknowledged as one of the most talented photographers of this century. Described by Berman as "revelatory in its accuracy and unsurpassed in its breadth," her record of New York City at a time of unprecedented change is prized as an invaluable contribution to documentary photography, while her portraits of well-known figures are praised for their unusually candid depictions. In addition, Abbott's realistic techniques have provided inspiration and guidance to a younger generation of photographers who have carried the documentary tradition into the mainstream of contemporary art.

ARTIST'S STATEMENTS

Berenice Abbott (essay date 1951)

[*In the following excerpt, Abbott delineates her views on pictorialism and realism in photography.*]

The greatest influence obscuring the entire field of photography has, in my opinion, been pictorialism. But first let me define it: pictorialism means chiefly the making of pleasant, pretty, artificial pictures in the superficial spirit of certain minor painters. What is more, the imitators of these superficial qualities are not aware of the true values for which painting strives. Photography can never grow up if it imitates some other medium. It has to walk alone; it has to be itself.

If a medium is representational by nature of the realistic image formed by a lens, I see no reason why we should stand on our heads to distort that function. On the contrary, we should take hold of that very quality, make use of it, and explore it to the fullest. It is possible that the subject matter best suited to that characteristic quality be the one dictated by it. After the early pioneer days of photography, which were very creative and healthy, a wave of rank pictorialism set in and flourished. This type of work was usually very sentimental. Its settings were staged; and the system was to flatter everything. These limitations of painting, catering to the worst Victorian standards, are familiar to most of us. The man most responsible for the whole movement was Henry Peach Robinson, an Englishman who was very successful financially and who exported the mania to this country where it was gobbled up by Americans. The word 'salon' descended from Robinson, and the 'salon' print is still rampant in American clubs.

But there are always two sides to the question, and perhaps there always will be. In those days there was, fortunately, another side of the picture. Men like Mathew Brady, William H. Jackson, Sullivan, Gardner, and others, were making magnificent realistic pictures of their world and of their time.

At the beginning of the century serious photographers were rightfully disdainful of Robinson and his followers. They graduated to a more refined or elevated grade; they became the fellow travelers of the more modern painters. They were interested in proving that photography was art with a capital 'A', and they were quite touchy about it. Their work was spiked with mystical and subjective overtones. Terms like 'equivalents', 'hand of God', etc., were used to bewilder the layman. Art was by the few, for the few, and cultural America was represented by the back end of a horse to people who did not know that they were being insulted.

These photographers raised the craft, as such, to a higher technical level with their reverence for glorified technique. The United States was wedded to technology and was favorably inclined toward a technological art. In the case of Stieglitz, who was an institution within himself, and who was God to many, and to many others not at all, he did make, when he ventured outside himself, a few great pictures. In Stieglitz' time what was unquestionably an advance in pictorialism, is not an advance in 1950.

These latter-day pictorialists did not know that they were pictorialists. They were what I can only call, for lack of a better word, the advanced or super-pictorial school. The individual picture, like a painting, was the thing. Above all, the perfect print. Subjectivity predominated. About this same period another man was working quietly unknown, unappreciated, but with a profound love of life. With concentrated energy and mature discernment, this man came to photography in the second half of his life. His name was Eugene Atget. He gave the world hundreds of great photographs. He was very busy and excited in discovering photography and what it meant. He didn't talk much; his time was spent penetrating and recording his immediate and wonderful world. His work is purely and entirely photographic, and it is still comparatively little known today.

While not of the same stature or range, another photographer on this side of the ocean showed remarkable photographic acumen in the early half of this century. I believe the true photographer is a curiously odd type of species, not easy to define, but his photographic gift is a highly charged and trained vision. This vision is focused, by the nature of the medium, on the here and now. Realist par excellence, inescapably contemporary, Lewis Hine had this photographic gift. He responded to the world around him, armed with a camera and his penetrating eagle-like, agile, but disciplined eye. Stieglitz and his disciples looked down their noses at Lewis Hine and fell in line with the coterie of Katherine Dreier's gallery. It was about that time (1918) that the abstractions of cracked paint began.

At the risk of over-simplification I propose that there is a third fling of pictorialism—the abstract school—the imitators of abstract painting, the photographers of the pure design, the cracked window pane, or the cracked paint. I think this represents the end.

Now they would be like the great painter Mondrian. Recently I have even seen would-be Jackson Pollocks. But instead of spattering paint at a canvas, in desperation they

might yet resort to ripping the emulsion off the paper or spattering a print with hypo. Anything goes.

Why do I concern myself with these problems? Because it affects me, and other photographers, if, due to a preponderant amount of this type of work, it holds back sorely needed improvements of the instruments we need to work with. This is why I must take issue with the pictorialists. They are the ones who choose the subjects which are so easily expressed within the primitive limitations of present-day, backward equipment.

This brings me to the vast amateur field, and finally to the serious photographer. On the positive side, the amateur market presents the possibility for the development of a great democratic medium—photography by the many and for the many. It is also a potential source for the development of professional photographers. This vast potential is rich, uncultivated soil, but it can erode away if it is flooded by pictorialism. The amateurs imitate the pictorialists because this is the line of least resistance, and they delight the manufacturers with their prodigal use of film, paper, and cheap cameras. The result is a mass production type of photography, limited in subject material, hackneyed in approach.

But the serious photographer is a forgotten man. He is sorely in need of far reaching improvements in all directions and over the entire field. He is living in a dynamic time and place, working with Model T cameras and outmoded sensitive materials. Photography does not stand by itself in a vacuum; it is linked on the one side to manufacturers of materials and on the other side to the distributors of the product, that is, to publishers, editors, business leaders, museum directors, and to the public. Unless they do their share of growing up to their responsibilities the photographer can languish or take up knitting. What we need of equipment is this: let it possess a good as structure as the real-life content that surrounds us. We need more simplifications to free us for seeing. And we need editors and publishers who will try to understand photography and who will live up to their responsibility to raise the general cultural level of our country which we, who love America, believe in for its great potential. We need a creative attitude on the part of the manufacturer, the distributor, and the consumer.

I should like to give a quotation from Goethe, who was discussing a poet. Said Goethe: 'He was a decided talent, without doubt, but he has the general sickness of the present day—subjectivity—and of that I would fain heal him.' Does not the very word 'creative' mean to build, to initiate, to give out, to act—rather than to be acted upon, to be subjective? Living photography builds up, does not tear down. It proclaims the dignity of man. Living photography is positive in its approach: it sings a song of life—not death. (pp. 56-7)

Berenice Abbott, in "Photographers on Photography," edited by Nathan Lyons, in Camera, *Vol. 46, No. 1, January, 1967, pp. 56-7.*

Berenice Abbott with Alice C. Steinbach (interview date 1976)

[*In the following interview, Abbott discusses her career, including her association with Atget and the philosophy of realism behind her work.*]

[Steinbach]: *Some 25 years ago you wrote that "the greatest influence obscuring the entire field of photography has, in my opinion, been pictorialism." Would you define "pictorialism" for me and elaborate a little?*

[Abbott]: Well, pictorialism means chiefly the making of pleasant, pretty, artificial photographs in the superficial spirit of certain minor painters. And with little or no knowledge of the true values that painters strive for. At the beginning stages of photography, there was bound to be a kind of imitation of painting for a while—a kind of artiness that was probably inevitable—but it's certainly not the function of the realistic image. Realistic image, realistic life. You know, if a medium is representational by nature of the realistic image formed by a lens, I see no reason why we should stand on our heads to distort that function. On the contrary, I think you should take hold of that very quality, make use of it and explore it to the fullest. After the early, pioneer days of photography, which were very healthy and creative, a wave of rank pictorialism set in and flourished. It was usually very sentimental work. The settings were staged and the photograph was set up to flatter everything. These imitations of paintings, which catered to the worst Victorian standards, are familiar to most of us. Henry Peach Robinson, the man most responsible for the whole movement, was a financially successful Englishman who exported this mania to the U.S., where it was gobbled up by Americans. The worst disaster of all, though, was an influential book he wrote in 1869 called *Pictorial Photography.* His system was to flatter everything. He sought to correct what the camera saw. And, you see, by doing that he denied the essential dignity of the human subject. Fortunately, though, there was another side of the situation. Men like Mathew Brady, William H. Jackson, Alexander Gardner, Timothy O'Sullivan and some others were making wonderful realistic pictures of their world and their time.

In the same article you continued: "Photography can never grow up if it imitates some other medium. It has to walk alone; it has to be itself." Has photography grown up?

I think it's growing up. It's inevitable . . . it can't help but grow up. And it's time, too. It's a rather strange period now, though—confused, eclectic, anything goes. And there's still what I call the "final fling" of pictorialism going on—the abstract school, the imitation of abstract painting. That's impossible in photography, of course. And there's a terrible urge today to try to be original at all costs. This, I think, is downright stupid. The world today has been conditioned to visualize. In some ways the picture has almost replaced the word as a means of communication. We're surrounded by movies, television, documentary films. The picture has become one of the principal mediums of interpretation, and its importance continues to grow. History is pushing us more and more to the brink of a realistic age. I believe there is no more creative

medium than photography to recreate the living world of our time.

"To chart a course, one must have direction. In reality, the eye is no better than the philosophy behind it." You said that some years ago. How would you sum up your major philosophical concern as a photographer?

Well, it's almost impossible to answer that. The problem of selectivity, of course, comes in, and selectivity is the result of your philosophy. A photographer explores and discovers and reacts to the world he lives in. There's also the matter of discernment—the way you interpret things, see things and relate them; the way you bring your subjects together. That is, I suppose you might say, a philosophical problem. Subject matter itself has no limits. But to extract something or not, to relate it to history, to think of it as something very beautiful or something very derogatory or sordid—that's all a part of reality and you have to choose. The challenge for me is to see things as they are. I have tried to be, in other words, objective. What I mean by objectivity is the objectivity not of a machine but of a sensible human being, with the mystery of personal selection at the heart of it. The second challenge has been to impose order on the things seen and to supply the visual context and the intellectual framework. That to me is the art of photography.

Is there an "American" tradition in photography?

Well, I think we can boast of a sound American tradition. Americans, you know, took to the new medium right away. Robert Taft wrote an extremely interesting study of photography in the U.S.—an important book for everyone to read—*Photography and the American Scene.* He integrates the growth of photography with the social and economic growth of our country. Portraits flourished here in the early days as in no other country. The Civil War created a demand for millions of "likenesses" of young men marching off to the front. The newness of our country provided another stimulus to the growth of the medium, with many people sending pictures of themselves to relatives left behind in the westward movement or to prospective brides and husbands in the "old country." Photographers also played their part in the conquest of the frontier, going along with U.S. Geologic Survey expeditions after the Civil War. A magnificent example of that is William H. Jackson. These practical uses for photography produced thousands of straightforward, competent operators, whereas in England there were comparatively few—in England, apparently, a monopoly of all patents tied up the photographic process and prevented the spread of interest in and use of the new invention. But in the U.S., it was virtually impossible to make such a monopoly stick.

Let's go back to the beginning—you attended college, Ohio State I believe, and then in 1918 went to New York to study sculpture. What happened then?

Well, I didn't go to New York to study sculpture. I didn't know at the time I wanted to do sculpture. You know, you're finding yourself as you go along when you're young. You often enter a field that isn't right for you. I wanted to study journalism when I came to New York. I

think I would have made a very poor journalist . . . it's a good thing I didn't go on with it. Instead, I found sculpture.

During those early years in New York, were you at all aware of what was happening in photography? Of Stieglitz and his group, for instance?

Not a bit. In fact, Stieglitz never had any influence on me whatsoever . . . at *any* time. I was a friend of Man Ray's and I thought his pictures were very nice, though it never occurred to me to be a photographer. But I *never* had any rapport with the Stieglitz group—I thought they were overrated.

Did you ever meet Stieglitz?

Yes.

What was your impression of him?

A crotchety old man. It's sort of sacrilegious to say that—you're not supposed to say that because he was God—but this is the way it struck me. He had a tremendous ego—just a stupendous ego—that, more than anything else, struck me, if you want to know the truth. But he produced a powerful cult. I don't go along with cults of any sort.

I read somewhere that you said Stieglitz "did make, when he ventured outside himself, a few great pictures."

A handful.

I'm curious about which photographs you think are "the few great pictures."

Well, the horse with the streetcar, the *Steerage,* his girl-friend in Berlin, one picture made down on the waterfront, oh and maybe another one—I don't remember at the moment.

What about his celebrated photographs of Georgia O'Keeffe?

Well, they're all right, but they don't touch me in any way. I don't respond to them—let's put it that way. Maybe there's a blank in me. They just never moved me at all.

Let's get back to your career. In 1921 you left New York, when you were just 23 years old, and went to Europe to study, again sculpture, in Paris and Berlin. Just how and when did you make the transition to photography?

Well, I had to earn a living, and I wasn't very practical or knowledgeable in that sense. I heard Man Ray needed an assistant and I needed a job. So I became his apprentice in 1923 in Paris.

Were you interested in photography at that time or was it just a job to you?

At the beginning it was just a job, but immediately I became interested.

What was it like working in Man Ray's studio?

Oh, I found it very interesting. I loved the job and was very happy.

Did you know anything about photography when you took the job?

No, nothing. He wanted somebody who didn't know anything, so I thought I might do.

How did you learn?

I started with darkroom work. I found that fascinating.

Did Man Ray teach you?

Yes. I took to it very readily, very quickly, immediately. That surprised me. Surprised him, too!

Tell me about the first time you saw Atget's photographs. It was at Man Ray's studio, wasn't it?

Yes. It was toward the end of my time with Man Ray. I had begun to photograph on my own by then.

How did Atget's photographs come to your attention?

Man Ray had a few in his studio one day.

What was your response—do you remember?

Immediate. Immediate. I thought they were wonderful. I wanted to go to his place right away and buy some.

And you did.

Yes!

You bought Atget's photographs from André Calmette in 1928 and cared for them for 40 years before you finally sold them to the Museum of Modern Art. Have you ever felt that your own work, your own reputation, suffered because of the Atget connection? Did you ever resent it at all?

Well, I certainly never resented *him* because I cared very much for his work and tried to promote it. I thought people would become interested in his photographs much sooner than they did. But for a very long time, they weren't interested so I had no choice but to be responsible for it. It did interfere with my work to some extent. You can see why—it's like dealing with two photographers instead of one. People become confused.

Yes. And it seems as though sometimes you dealt with him first and yourself second.

Yes, that's true. And I'm not a self-sacrificing type of woman at all, so this was rather difficult. But I always stuck right with him because, of course, I had to.

Of all the celebrities you photographed in Paris in the '20s, who impressed you the most? Do you have a favorite photograph from that time?

No, I don't think I have a favorite. Of course, James Joyce pops into my mind. I admired him very much.

What was it like photographing Joyce?

Very pleasant. Very nice. I photographed him twice. In his home the first time, the second time in my studio. He was very charming . . . he was a beautiful person.

Imogen Cunningham said that "portraiture is not the easiest way of making a living if you know what people are like." Did you like portrait work?

Oh, at that time I liked it. It seems I had a flair for it and it absorbed me. Each person was extremely important to me. I wasn't trying to make a still life of them, but a person. It's kind of an exchange between people—it has to be—and I enjoyed it.

You were eminently successful in Paris—what made you decide to come back to the U.S. in 1929?

Oh, I became interested in the States from a distance. Sometimes, when you live abroad, you become fascinated with your own country. I had been sort of disgusted with it when I left, and I rebelled against it, really. There are many things in it to rebel against—especially for an artist. It hasn't been very friendly to its artists—maybe it is a little more now, but it certainly wasn't then—that's why so many left. But I found myself interested again and a certain nostalgia crept up on me over the years.

When you came back, did you intend to stay?

No.

What made you decide to stay?

When I came back on a visit, I was fascinated by New York City and the changes in it. I was really very much excited about it. So I decided to either stay in Paris for good or to come back here and start over again.

So, in 1929, you rediscovered America, came back and on your own initiative began to document New York City with your camera—a project which became the basis for your book **Changing New York.** *When these photographs were first shown in the mid-'30s at the Museum of the City of New York, what was the public's reaction?*

Nothing special. People rather liked it but were casual about it. It was too familiar, you see. To see the present, understand it, be part of it—that's much more difficult than understanding something that's in the past or imagining the future. New York is very familiar to people who live in New York, so they'd rather see pictures of Mexico or some other exotic place. In the same way that New Yorkers didn't particularly want to see New York, the French, I think, didn't care so much about Atget, because they were so familiar with what he photographed.

Do the French care about Atget now?

They haven't.

Not even today?

Some. But I went over there in 1966 trying to interest the French government in Atget. I thought they should have a first chance at his work. But they were not interested. I went to the top—I went to André Malraux and it didn't amount to anything. The French didn't appreciate photography. But I've heard that since then, they're beginning to. They thought it was a game, a sport, sort of an amusement.

Getting back to your New York pictures—I understand that more than half the places you photographed on this project have since been demolished. Have you any desire to go back and photograph the changes in New York now?

Oh yes. That could be a constant job. It should be done. I wanted the City of New York to hire me permanently to photograph New York as it changes every day, but there's no program for that—nothing like that going on. This needs to be a permanent thing, but it needs to have a very serious photographer to do it.

Have you ever involved yourself with a group or a cause in photography?

No. I've been labeled, though—but it's stupid.

What have you been labeled?

Documentary.

I want to ask you about that. What, if any, are the differences between so-called "documentary" and "creative" photography?

There aren't any! All photography is documentary by nature. Good photographs are documentary—they can't escape it. There's a great misunderstanding there. This word "documentary" has been bandied about out of all proportion and meaning. It's a foolish cliché if it's used to imply the commonplace and drab or the opposite of "creative." Webster's definition of "documentary" is: "truth, evidence, conveying information, authentic judgment." The photograph may be presented as finely and artistically as possible, but to merit serious consideration, it must be directly connected with the world we live in. Ultimately, you see, the photograph is a document of the now. And documentary pictures include every subject in the world—good, bad and indifferent.

Are there any photographers today whose work you especially enjoy?

Lisette Model. Lisette Model is a great photographer.

How do you feel about the late Diane Arbus' work?

Good photographer. It's strong, good photography. She chose the pathological subject. That's all right, too . . . it should be done. To make a trend or fashion out of it, though, is a little silly. Or to use it for shock appeal. I don't think hers is shock appeal, though. It was real, you see. Her subjects were shocking in a sense, but they were real.

One question concerning women as photographers. Anne Tucker, in her book The Woman's Eye [1973], *wrote that "knowing a photographer's sex influences our judgment of the photographic content and even its value." What do you say to that?*

I think that's worse than ridiculous! I don't think one's sex has anything to do with it. I just don't see any difference whatsoever.

Tucker also writes, when she is commenting on your work along with the work of Bourke-White, Frances Johnston and Diane Arbus, that "the photographs made by these four women are those the public is most likely to assume were made by men."

That's ridiculous, too. I think it's just silly. What does it mean? That women have to be emotional and sentimental? Are women only supposed to photograph babies? The best baby photographers I know happen to be men.

Do you feel that there have been any distinctions made against you in your profession because you are a woman?

Certainly.

What were they?

Oh, I don't know—there have been too many. There were just obstacles that were rather nameless—subtle, complicated, unconscious. They exist. You try to ignore them, but they exist.

What are your feelings about the women's movement? It seems to me that you were "liberated" long before the term was coined.

Yes, I was. I think it's a very healthy thing, but it's late in coming. I believe in it very strongly, very strongly. In the long run, I think it will be better for both men and women. I think most women are not aware of the degree of their oppression. And it is definitely oppression. But it's so profound that I think a lot of women don't even know it.

I'd like to ask you about your scientific photographs. What made you turn to science as a subject?

Well, the circumstances of photographing New York were very complicated and difficult, and after a few years I began to lose interest and wanted another subject. I thought science was a very vital subject.

I've read that some of those photographs are among the most pleasing to you. Is that so?

Well, I was very much interested in doing it. The odds were great—too much so, really. But the experience of trying to work out the problem of explaining science in a simple way to the layman—like myself—was challenging. Of course, I never had the means to work with. It was all rather primitive. I had to work with very amateurish equipment. I really think, though, the essence of creativity today is in science. It seems to me science is *it*.

What do you feel is the esthetic value of your scientific photographs?

Well, there's no reason why they couldn't be of the greatest esthetic value. I don't say that *mine* were. There's no reason in the world why we shouldn't have splendid photographs of science instead of mean and stupid ones that only scientists can understand, and with a caption. They should be vivid and visual as much as possible. It isn't always possible, of course. We're really being manipulated by science today, so we ought to try to understand it. It's important.

Do you feel there's anyone writing on photography today who's doing a good job?

I think there's a lot of very bad criticism of photography going on today. It's not understood by most. I think Hilton Kramer writes very well about photography. Elizabeth McCausland, who is dead now, wrote extremely well on photography.

Yes, I recall she wrote of your work: "The clue to the character of Berenice Abbott's work is a desire to take myriad unrelated elements in life and make order from them." Do you agree with that?

Yes, I think it's a pretty good statement, don't you? It's important to have order in a work, whether it's a photograph or a short story or a ballet. There has to be a certain order. You have to work within the limitations of that particular medium. In a photograph, you have a rectangle and you have to organize it.

Some writers on photography have said your work is too detached and objective—that you have withheld yourself from your work and kept your subject matter at a safe distance. Any comment on that?

I think that isn't true at all. I don't think they've understood my work. Every photographer has a picture of himself in his photograph. I don't know what they mean when they say that. To me it's ridiculous. Pictures are taken because the subject matter hits you hard with its impact and excites your imagination to the extent that you are forced to take it. I took to photography right from the start—then I never wanted to do anything else. My excitement about the subject has never waned. It has always been there to provide the push needed to carry me through the drudgery necessary to produce the final photograph.

You've said that you had to improvise with your equipment. What is the state of photography equipment today?

It's very primitive. Backward. The serious photographer is forgotten. We are desperately in need of far-reaching improvements in all directions and over the entire field. Here we are, living in a dynamic time and place but working with Model-T cameras and outmoded sensitive materials. Not too long ago, I went out to buy a new camera but after looking them over decided not to bother, just to use my old ones. We need more simplifications to free us for seeing. It's high time industry paid some attention to the expert opinions of experienced photographers, and to the needs of the professional worker as well. But they'll tell you—Eastman will tell you—they can't bother with a few professionals. Cameras are designed for the amateur by engineers who don't photograph. A good photographer cannot fulfill the potential of contemporary photography if he is handicapped with equipment and materials made for amateurs only. The camera and all the other picture-taking necessities must be vastly better machines if they are to free the photographer creatively instead of dominating his thinking. What we need is a more creative attitude on the part of the manufacturer and the consumer. This is not to condemn the industry as a whole but only certain segments of it, for their fixed outlook and lack of proper perspective. Photography gains much of its strength from the vast participation of the amateur, and of course this is the market where mass production thrives.

What are you working on now?

Traffic photographs. Our mad traffic conditions are, I think, really quite . . . well, mad. Getting stuck in traffic is one of the most terrible things. It's difficult work, though—selecting the right movement, the right angle, when things are moving so quickly. It's not easy.

It seems to have taken the establishment so long to have finally come to grips with the force of your work. Do you wish it had happened sooner?

I think so. Oh, I don't know—I'm not sure on that. There's a sculptor in Maine—a very important man—and he made a remark one day which I think is very interesting. He said, "Early success is very dangerous." And I believe it can be. I think he's right.

In what way?

Well, for one thing, maybe you try a little less hard. But more than that, it's hard to stay up there all those years, isn't it? (pp. 77-81)

Berenice Abbott and Alice C. Steinbach, in an interview in Art in America, *Vol. 64, No. 6, November-December, 1976, pp. 76-81.*

SURVEY OF CRITICISM

Elizabeth McCausland (essay date 1934)

[*McCausland was considered by Abbott to be one of the most insightful photography critics in America. In the following excerpt, she discusses Abbott's early photographs of New York, noting in particular their classical mood and keenly sensitive awareness of life.*]

Pictures of the changing world, thus may the subject matter of Berenice Abbott's photographs be described. To use this phrase and to write this sentence at once suggests the direction of her creative endeavor; for two things are immediately implied, that, first, it is a world in flux which fascinates her as an artist and that, second, the emphasis of her esthetic labors is on her theme, not on her ego or on some jealously held theory. To say this is to suggest further that her art cannot by the very definition of its terms be a precious or cloistered art. Having said this, it is necessary in the interests of complete intellectual integrity to add that this point of view, this approach to art, does not seem to be the only possible point of view and approach or inevitably the most admirable (since in matters of art comparisons are futile and absurd), but that it is a point of view and an approach which provide an antecedent condition for the production of splendid work, as another point of view and another approach with an artist of another temperament and tradition will also produce splendid work, of another sort. In Miss Abbott's case, this point of view, tenaciously maintained, has already produced splendid work, witness her photographs of New York City and the portraits done in Paris and New York. Furthermore such an approach, preserved with great conscientiousness and fidelity to the artist's ultimate objectives, unquestionably should in her lifetime produce an impressive body of work truly classical in mood.

Classical in this context is meant to convey a sense of the intellectual coolness and detachment of the photographer's approach to her theme. This does not mean that the approach is lacking in sympathetic warmth and understanding; on the contrary, one of the most appealing qualities of Berenice Abbott's work, whether her New York City scenes or her Paris portraits, is the tenderness with which she regards her subject. This tenderness would seem to be not a sentimental softness but a deeply sincere effort to present the essential truth of her subject, whether the subject is the Chrysler Building or James Joyce. There is here no psychical montage by which the personality of the artist is superimposed on the personality of her subject. Perhaps, however, one may be permitted to think of the subject as having been filtered through the personality of the artist and thereby having taken on added value and significance because some subtle apperception of the artist has caught (as moving pictures catch the passage of d.c. electricity traveling over a copper wire at the incredible speed of light, 186,000 miles a second) what a less sensitive mind and eye could not. Put these two qualities together and the germinal energy of this artist's work can be appreciated. Add to this a profoundly passionate search for significance in a wider human sense than is possible under the reign of cults or schools or romantic individualism, and it is clear why Berenice Abbott's photographs impress one not only by their honesty and modesty but also by the vigor and breadth of their scale.

That is, Berenice Abbott is not content merely to execute tours de force, elegant and balanced compositions of fragments of life. Her ambition and her hunger is to possess life, through the lens, on an epic scale. Unlike those very typical (and also splendid) American creative workers who have inherited the Emersonian tradition of "the poet in utter solitude," she finds her imagination captured by the crowded city, the changing world. Nature (that 19th century deity whom American artists have worshipped in the past and today still legitimately worship and will continue to worship as long as man has a deep need to be united with the earth from which life comes and to which life goes back) has never had her franchise. It is the complex and hurrying tempo of great cities which thrills her and obsesses her creative thought. Thus fine and sensitive in a simple and direct way as are the portraits done in Paris from 1923 to 1929, yet it is in the New York City photographs that Berenice Abbott reveals herself as a mature worker, sure of what her function is and not content with achieving less than the major task she has set herself. And precisely because she is not satisfied with these prints, in themselves as fine and honest work (if not finer and more honest) as is being done in America today by any of the younger generation of American photographers, one may confidently look forward to work of even more profound reach and intent,—especially if the artist can realize her desire to photograph America's great cities as a record for the future.

The work of Berenice Abbott is particularly significant for the American creative worker of this period because it represents an esthetic formulation of experiences which have been the common lot of Americans who came of age in the war years or just after. Born in Springfield, Ohio, in 1898,

Berenice Abbott early felt the impact of the stifling national pressure for conformity. She took the avenue which many talented young Americans took in those inflated early post-war years, turned her back on America, and looked to Europe for the freedom to achieve esthetic integration and fulfilment which she could not find at home. After studying art in Paris and Berlin, she became interested in photography, worked in Man Ray's laboratory for a while, and began to do portraits on her own, of such men and women as Joyce, Atget, Gide, Cocteau, Barbusse, Paul Morand, Siegfried, Marie Laurencin, Margaret Anderson, Princesse Eugene Murat, George Antheil, Jules Romains, Tardieu. From 1923 to 1929 her photographic evolution was in this milieu, and with what was probably a somewhat artificial European esthetic imposed on her natural sturdiness and integrity. Returning to this country early in 1929, before the crash and deflated dollars drove back to these shores the expatriates who were belatedly to re-discover America, she fell in love with her native land. This love for America, which she speaks of as a "fantastic passion," so far has expressed itself chiefly in terms of the metropolis, of towering skyscrapers, of titanic canyons between steel frame cliffs, of excavations for Rockefeller Center, of thundering Els, of wharves and docks, of vestigial structures of an older New York which miraculously have survived the march of time,—and the steam shovel.

But New York is by no means all of America Berenice Abbott loves. Its cities challenge her as an artist, or so it would seem when one talks with her. The changing world, the profound and terrible social transformation this nation may expect to undergo in the next half century,—this vision tantalizes her. There are myriad aspects of America, fantastic, quaint, archaic, even in a provincial sense baroque and rococo, incredible naivetes and vulgarities, a people in the process of forging its soul or (if this word is not the word she would use) its national character. Before this is all changed, by the inevitable rationale of contemporary history, she would photograph the changing world of today, imprison with the lens and the shutter this fantastic and unbelievable yet somehow lovely mirage. A glimpse of this fantastic and lovely world she caught last summer when she worked rather briefly in Boston, Baltimore, Charleston, Philadelphia and other cities, making the photographs for Henry-Russell Hitchcock, Jr.'s architectural exhibition, "The Urban Vernacular of the Thirties, Forties and Fifties." These photographs were straightforward documents, in which the photographer's sole purpose was to present the architectural fact of the period under survey. But having seen this much of America, besides the beloved metropolis, she is more than ever hungry to set down in the imperishable fabric of the photographic print that ultimate truth which is art's contribution to the history, the artist's perception of the moment translated into terms which definitively capture the spirit of his age and which by this very quality of being supremely topical achieve timelessness.

Therefore it is to the future she looks as an artist, feeling that her lifework is before her rather than behind. This is as it should be for a woman in the prime of her powers, equipped with sure technical proficiency and with a ma-

ture knowledge of her own creative intention. Nevertheless, it would be less than just, critically, by saying that Berenice Abbott's best work is yet to be done to seem to ignore the sincere, honest work she has already accomplished, for the quality of this work is the best indemnity for her future work. Perhaps, however, it is fair to concentrate on her New York series, in the sense that the work she has done in the past five years, photographing (as much as circumstances permitted) the dual personality of a great city in which the past lives side by side with the incredible present, represents a real coming of age on the artist's part. That is, in photographing New York, its skyscrapers and its little old harness shops, its city lights at night, its noisy and antiquated means of transportation like the elevated, its busy shipping and its out-of-date housing, she has been arriving at a more precise understanding of her own function and more precisely formulating a point of view which probably has been integral in her character from the start, but which is only now beginning to emerge into an articulated and self-conscious conception. Thus the Rockefeller Center photographs, done from the summer of 1932 to the summer of 1933, apparently developed spontaneously and unself-consciously from her life. They have, nevertheless, the effect of a terrific indictment of the unreality of the thing created at tremendous cost in human labor and intelligence. If a time should come when man's skill and technical apparatus are put to the service of decent and humane purposes, such photographs will surely constitute that undying record for the future which Berenice Abbott longs more than anything else to create. A small point like this, the tiny workman dwarfed by the inhuman steel girder so that he can barely be seen in the photograph, is in itself a devastating criticism of the thing observed and noted down by the artist. And from such photographs the future should be able to read what sort of changing world it was Berenice Abbott saw and sought to record.

"Fantastic" is Berenice Abbott's word for the world she sees and seeks to capture in art. Probably it is the right word, too, for it is fantastic that the Chrysler Building, the Daily News Building, Rockefeller Center, the Stock Exchange, and any other of a hundred similar displays of ostentatious and vulgar wealth should exist side by side with those Central Park shanties of the unemployed which she has also photographed. One would not argue too strenuously that these contrasts and paradoxes have sprung from a deliberate and willed campaign on the photographer's part; in fact, one would prefer to believe that they are the result of a much more direct and desirable sort of observation of life; in fact, the artist's observation of life rather than the propagandist's. However, a keen eye, with a sensitive heart and an alert mind, are of as much use to the social muse as a set of dogmas. And one feels that this is the particular gift Berenice Abbott has brought to her work, this sympathetic and yet somehow burning awareness of life, whether life is a workman on a steel girder or old women sitting on the front steps of a Cherry-street house.

Because the sum total of the impact of her photographs

on the beholder has this quality, it is difficult to speak of single prints. Beginning with the notes on New York she made with a little camera in 1929 and 1930, she has worked through to elaborate compositions (it is dangerous to use such a word with a worker who has what is almost an exaggerated fear of preciousness) like *West Street: 1932* in which a thousand conflicting elements of design, rhythm and value are brought together in a complex and rich pattern. Again in *Coentie's Slip: 1933* and *Pennsylvania Station: 1931* difficult problems of integration confronted the photographer, in the first print that of getting the desired perspective when the physical limitations of the waterfront site made it impossible to get more than a given distance away from the thing to be photographed and in the second print that of reconciling the scale of the railroad station with the grasp of the lens. In the latter print the elaborate tracery of the arches and windows are brought together in organic relation with the tiny figures of people buying railroad tickets. The two tempos, that of the building and of the bustling human life going on within the building, are united in that living unity which art, when it succeeds in its endeavor, is able to impose on the disunity of life.

In many ways this is the clue to the character of Berenice Abbott's work, this desire to take myriad unrelated elements in life and make order from them. This is true of such a picture as *South Street: 1931,* where a hydrant, a lamp post, a street cleaner, an old house and a sign "Jesus Saves," become more than a collection of items, become in fact an evocation of the life they derive from. Taking these complicated and often disintegrated scenes, (for example, *Barclay Street Ferry: 1933,* with its crowded life of the docks, railroad cars, a ferryboat, tugs, ocean liners, smoke drifting from smokestacks), the photographer fuses the diverse elements into an exciting whole. Equally complex, though different in mood, is *Trinity Church and Churchyard: 1933,* tombstones and people sitting on benches, a flash back to the American past. *West Broadway: 1932,* the framework of elevated structures, the tension of moving city traffic; *Pawtucket Pier, South Street: 1931; Water Street and Maiden Lane: 1930,* with incinerator smokestacks dominating the skyline; the *Barclay Street Elevated Station: 1932,* with automobiles moving under the elevated, light shifting through the tracks and a skyscraper in the background; the Hudson River suspension bridge, trolleys, huts in Central Park, men walking the railroad—these show the life of a great American city in the fourth decade of the 20th century. As do also the various skyscraper pictures, the Rockefeller Center series from the moment excavating, drilling and blasting on the basic rock of Manhattan Island begins till the thing is done, through the elaborate and highly integrated stages of steel-frame construction, girders rising, a skeleton of steel thrusting up from its foundations, workmen at their jobs, and the final flimsy facade finished. This is a modern saga, the saga of construction. And it is not the artist's fault that the theme is less worthy and enduring than the artist's own sincerity and integrity of purpose deserve. This is true, also, of other skyscraper pictures, the *Squibbs Building: 1930,* in which the white mass of the building is silhouetted dramatically against the monumental black mass of a nearby building. The drama here, one feels, is

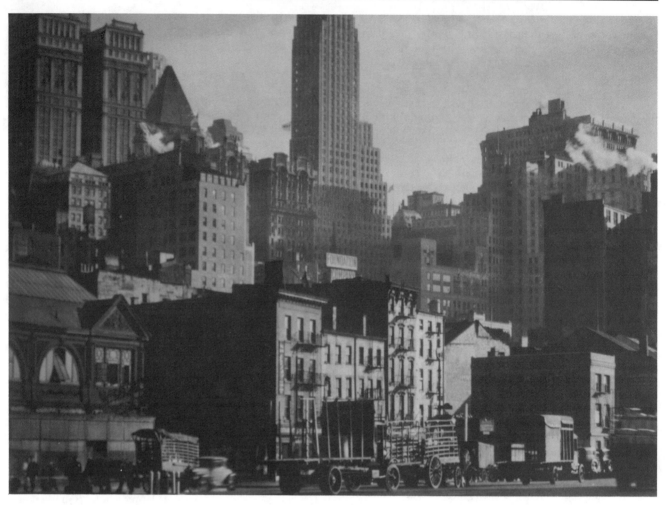

West Street: 1932.

an implicit criticism of the object rather than revelatory of any fatally romantic flaw in the photographer's thinking. So, too, with the flat facade of the *News Building: 1930* and the view from the Chrysler Building of the *Chanin Building: 1931,* in which the oblique angle of vision succeeds in creating the emotional effect of a world about to fall over from its own sheer lack of balance. On the other hand, in a poetic mood the photographer has captured that sense of romance, nostalgic yet natural and human, which emanates from all great cities at night, in her print *Midtown Night View,* in which the movement of the lights is like music.

If this seems to suggest that Berenice Abbott's emphasis is too sociological, it must be added at once that her art is not lacking in humor and in a spontaneous pleasure in the human comedy. *Horse Fountain, Lincoln Square: 1929, Cigar Store, Third Avenue: 1929, Statuary Shop, Water Street: 1930* with a galaxy of plaster saints coyly peering from the window, *Harness Shop, East 24th Street: 1931,* the interior and exterior of *Old Drug Store, Market Street: 1931, Former Shop for Nautical Instruments: 1930, Union Square: 1932* with the statue of Lincoln lying prostrate on the ground, the Stock Exchange

with a leg of George Washington very large in the foreground, lower East Side scenes, push-carts, curbstone markets, old Murray Hill, Hester Street,—these show another side of her range of interest and observation. It is a range into which a tender and creative love enters. These things are amusing and quaint and significant in an historical way; they can also be loved for themselves, for their materials and shapes and textures and uses or for their sheer lack of meaning and their grotesquerie. As, say, *Cherry Street: 1931* is loved for its dormer windows against the sunset sky, or for the placard "For Rent" in the window, or even for the litter blowing about the streets.

This analysis may convey something of the character of Berenice Abbott's work. Certainly it is sound, sensitive, honest work. Already standing squarely and sturdily on its own feet, this approach, together with an indisputable technical skill, cannot help but produce even finer work in the future. (pp. 15-18, 21)

Elizabeth McCausland, "The Photography of Berenice Abbott," in Trend, *Vol. III, No. 1, March-April, 1934, pp. 15-21.*

Muriel Rukeyser (essay date 1970)

[Rukeyser was an American poet whose work is highly regarded for its insightful exploration of political issues. In the following excerpt from her foreword to Abbott's Photographs, *she praises the expressive power of Abbott's work.]*

These faces look out at us with the clarity of extremes. They are human faces, yes; but they are also human bodies looking out at us, with their pride, their deep gifts, their magnetic strangeness asking for response. They are also buildings, streets, shopwindows, a cart and a clock, all seen by this photographer as human faces, with their expressive power entire. They are also a penicillin mould and a bouncing metal ball, watched with the attentiveness and grave joy that let them speak to us.

What makes the distinctness and excitement here? What kind of artist has given us these?

Berenice Abbott is one of those extraordinary master-artists who is an inventor, too. In the notebooks—not yet published—we find a woman who is as practical as Ben Franklin, working out the steps and adjuncts of her art and the daily life connected with it: cameras, fixtures, clothes, while she discovered ways of showing the human being and the human city. She presented us with Atget, the very character of Paris in his years; we see him in this gallery of persons, wearing the new overcoat of suffering. We see Joyce in the elegance of his great fertility, and again Joyce, and his wife, and his daughter Lucia not yet in the sanatorium. All these people, faces like magnets, Gide, Cocteau, Margaret Anderson, Leadbelly in his bronze loud tones, the Princess Murat looking out at us in a kind of roaring—the qualities in these complex looks, people who show us the moments of their perception because Berenice Abbott perceives them.

She does not have to be introduced to the young, who take these photographs directly, in excitement receiving.

But there are those who lived through the period when the pictures were made and never recognized what had happened. I think of the magazine editor before whose office I waited until Berenice Abbott came down with the series of big "science" pictures still under her arm. . . . She came out with her clown look, the pure child in grief. "He turned them down. But he said they had very little grain," she told me in wry despair; another picture editor who could not see. Look at that penicillin until it opens you, brilliant and round, producing its droplets. Also, the picture has *no* grain. It is made with an invention of Berenice Abbott's.

"We need a light as good as the sun," she said. "Greater than the sun."

She made a picture of a clock-face. "A most human face," she said.

These have been called marvelously objective pictures. I myself do not know what this means. They are extreme works of art, carrying the artist and the object and our-

selves to us, carrying poetry and the big concepts she has always undertaken: a road down the length of the Atlantic coast, the cycle of the year in one spot in Maine, pictures of things seen with such concentration that they can be called "science" pictures; New York; and always portraits. The last three groups are represented in [*Photographs*]; we see the human face when all those people were young and in Paris, and after that Berenice Abbott's concern beyond "all those people" to focus on everyone whose face and body speak—to focus on a burnt-out man facing 1000 magazines all false. Studies of Sloan and Hopper in their studios, yes; but also the ferry pier; also rock-face with holes drilled for dynamite, all overlaid with ice, a foundation; also the strong magic of the chicken sign, the hardware store; the "fiery parcels" of New York, evening advancing; the narrow vertical Exchange Place, and the people of those years crossing their streets in the lost sunlight.

There is a pride and sadness each time, in a moment of entire and silent declaration. How is it possible that this book was not with us years ago? It is that the time has finally come around to this artist, explorer, discoverer, and these forms pour through her self to us.

The [scientific series], these *things* and forces—ripples of water, shallow-edge waves; surface of bubbles, very physical; the prism declaring its effect on life like Cocteau; light bent, motion of a bouncing ball in a perspective of vanishing arches. These orbits; and a final movement-forward, seen as a locomotive and the span of a bouncing ball. Magnets here like faces. Actually, forces like faces.

I think that the witnesses of this art, coming to it for the first time, will see that Berenice Abbott has given us the vision of a world in which all things look at us, declaring themselves with a power we recognize. A power that is related to something in the human face. (pp. 9-11)

Muriel Rukeyser, in a foreword to Photographs *by Berenice Abbott, Horizon Press, 1970, 175 p.*

Abbott on her work:

I think my work is very American. In the first place, I am American and deeply so. I lived away from this country for a while, which gave me a perspective, then I came back with a kind of nostalgic boom. In broad terms the work I have done here is really the American scene, which I think is very important to photograph because the United States is such a changing country and is still young. Photography can only represent the present. Once photographed, the subject becomes part of the past.

From Recollections: Ten Women of Photography, *by Margaretta K. Mitchell.*

Douglas Davis (essay date 1976)

[*In the following review of an exhibition at the Marlborough Gallery in New York, Davis discusses Abbott's New York series and her photographs of rural America.*]

There is an extraordinary image lurking among the 189 photographs by Berenice Abbott now on view at the Marlborough Gallery in New York City. It is that of an old West Virginia grandmother staring with undisguised hostility across a fence at the photographer. Taken in 1935, the picture seems to have nothing in common with the dramatic cityscapes of New York or the portraits of the artistic-intellectual elite for which Abbott has long been celebrated. But the old Appalachian woman is no less "important": like the skyscrapers and the portraits of the famous, she has been "trapped" by one of the subtlest eyes in documentary photography.

Berenice Abbott is now 77 years old and enjoying the fruition of lifelong goals, both in her own work and on behalf of her master, the late Eugène Atget, whom she met in Paris when she was in her 20s. Atget was poor and unknown then; now he is recognized as one of the major photographic forces of the century, thanks largely to the efforts of Abbott, who purchased and disseminated his pictures after his death in 1927. More important, Atget's dedication to pure photography, pictures taken without frills or sensationalism, obviously influenced her well before anyone else understood him. "He was a historian," she says. "He wanted to photograph the real Paris, not just decorative scenes."

She did exactly the same for New York when she returned in 1929. "I was wildly excited by the city," she recalls. "It was so different from Paris. The colors were brighter. I couldn't go back. Even the dull scenes in New York excited me." The heart of Abbott's New York pictures is at Marlborough, the images that made her work—if not her name—famous. There is the view of Manhattan Bridge, the camera positioned exactly at the hub of long trisecting lines of steel; the spectacular top-down views of parking lots, pedestrian crossings, skyscrapers verging into each other; and the startling, concisely composed pictures of billboards and street signs.

But in these photographs—and in her portraits of artists and writers like Cocteau, Max Ernst and James Joyce—Abbott's professionalism almost undoes her. She is a fanatic believer in craft and composition: "Nothing is really photographed unless it is photographed in the best way possible," she insists. Because of her concern for "perfection," she often produces imagery bordering on slickness—even though she always refused to work "for the magazines."

There is none of this in her overlooked photographs of rural America, which she in fact loves. "I am from the Middle West, I am a part of it," she says. Besides the West Virginia woman, there are vivid images of miners and Southern sharecroppers, rivaling the best of Walker Evans or Dorothea Lange. The portrait of an old, decaying house in rural Staten Island is very nearly a classic. It is a house but more than a house—a gray, decaying and forgotten metaphor, left alone (but for this picture) to die.

Speaking about the recent rise to popularity of photography-as-art, she says: "There is something very mysterious about reality." In the best of her work, Berenice Abbott establishes precisely that feeling—bringing "documentary" photography to the edge of surrealism. (pp. 82-3)

Douglas Davis, "Abbott's Eye," in Newsweek, *Vol. LXXXVII, No. 3, January 19, 1976, pp. 82-3.*

Ann-Sargent Wooster (essay date 1976)

[*In the excerpt below, Wooster discusses the direct and unpretentious qualities of Abbott's portraits and photographs.*]

Berenice Abbott was originally known in the '20s for her unadorned portraits of such famous people as James Joyce, Djuna Barnes and Marcel Duchamp. They were shorn of fantasy embellishments or formality, qualities thought to be necessary accoutrements of portrait photography at the time. One feels Abbott was completely comfortable with her sitters; occasionally, though, she allowed people to present themselves as dramatic personages. Accessories or props, like the attributes of saints in medieval art, were sometimes used successfully. In an attempt to show his inner, turbulent nature, Max Ernst is depicted as almost fusing with an elaborate high-backed chair in which he is seated. The wild points of his hair echo the carving of the chair. In a series of photographs, Cocteau is shown as a fey *poseur* with several mannequins. These theatrical props seem in keeping with the sitter's character.

Some of Abbott's photographs are in the tradition of Jacob Riis, but her interests did not lie in the reform of social conditions. Instead, she sought to document the abstract graphic qualities of the urban environment. She often approached her street scenes straight on, paralleling a building facade with the picture plane. In her many scenes of shops, the newspapers, tools, or other items displayed become geometric modules filling the entire photograph with a particlelike field. Often dramatic shots of New York were the result of extreme camera angles, many produced by means of her acrobatic feats on perilous ledges and flagpoles. Her series of the staggered ziggurats of the skyscrapers and the dark canyons between them went romantically beyond mere record making to shape our view of the modern city.

Abbott's sense of the present juxtaposed extreme modernity with the past. In a single photograph, the dark Gothic spires of Trinity Church are outlined against the stark rectangular masses of office buildings. More characteristically, she divided the various facets of city life into separate series. Simultaneously she would photograph the streetscapes of Lower Manhattan with its pushcarts and three-story buildings, the rooflike masses of the El, the zooming diagonals of the bridges, and the verticals of the skyscrapers. Her principal photographing of New York City took place from 1935 to 1939, when she supervised a document for the Federal Arts Project resulting in a book, **Changing**

New York, with photographs by Abbott and a text by the critic Elizabeth McCausland (1939).

In an essay she wrote about Eugene Atget, Abbott said: "The photographer's punctilio is his recognition of the *now*—to see it so clearly that he looks through the past and senses the future. This is a big order and demands wisdom as well as an understanding of one's time. Thus the photographer is the contemporary being par excellence; through his eyes the now becomes the past." These words are equally true of Abbott. We do not look at her photographs merely for reasons of nostalgia. Rather, they act as a crucible, fusing a way of life that has vanished, the city as it still is, and a potential future. (pp. 72-3)

> *Ann-Sargent Wooster, in a review of "Changing New York," in* Artforum, *Vol. XIV, No. 8, April, 1976, pp. 72-3.*

Stewart Scotney (essay date 1977)

[*In the excerpt below, Scotney finds Abbott's view of New York disturbing but admires her straightforward presentation.*]

Berenice Abbott is very much interested in Goethe's views of "the truth of reality" and she says that she believes "that the affinity of photography to writing is strong" though I am unsure just what this statement means. . . . [Looking at her] works, and depending on how you regard cities, Abbott's views of New York can be either claustrophobic or nightmarish. So each work becomes a chapter in an endless book, which is one way, rather subjective but interesting, of looking at New York. But, whilst seeing that Abbott follows through her link with writing by telling photographic stories we don't see anything particularly novel about it (sorry for the pun). Abbott decided to live in New York almost on a whim. It was evidently the skyscrapers and the massive urban rape that excited her. She reflects this feeling with the startling contrasts of her (in the main) cosy interiors and her dead-pan exterior shots ranging from an early cinema, heavily advertising Charlie Chaplin films, to the brutal serenity of inconographic looking tall buildings in her *View from the Commodore Hotel.* Looking at Abbott's New York you can get the feeling that there never was a golden age, that it was always destined to be a race of concrete to the sky. But such a race, in such a city, must have been exciting in itself. Her views of people are usually in crowds or not fully featured, apart from one noteable exception of a group in an 'El' station interior, are designed in such a way that 'the city' becomes all. The interiors, in that context, assume a lesser importance, somehow. The richness of her work, on first impression, approaches gothic proportions occasionally. Her images take on a knitted appearance as skyscrapers are set against, and so into, the 'El' rail lines and bridging; as fishing boat masts and rigging interlace with the complex ironwork of the Queensboro Bridge. But later, one realises, it's New York that is gothic. Abbott, with wonderful simplicity, has thus expressed her visions of Goethe's "Truth of reality" with convincing integrity. (pp. 23, 25)

> *Stewart Scotney, "Smile Please," in* Art and Artists, *Vol. 12, No. 2, May, 1977, pp. 23-7.*

Kay Larson (essay date 1981)

[*In the following excerpt, Larson assesses Abbott's achievements, comparing her work with that of Atget.*]

Priestess of the city, archivist of New York, the Carl Sandburg of Bowery restaurants and bridges—Berenice Abbott is as much a figurehead as a photographer. How and why she became a phenomenon is not quite clear—countless other photographers in this century possess more dramatic imagination and pictorial brilliance. But Abbott is now identified with a "truth-telling" tradition that also included her prophet and predecessor Eugène Atget, the old man whose pictures of Paris she rescued from oblivion in the twenties, who taught her to look at city streets with an unblinking reverence for documentary evidence.

Abbott's best photographs date from a single decade, the 1930s, when she set about recording "changing New York," the title of the book that followed. . . A sizable hunk of her appeal no doubt is due to her perceptive plunge into New York City as it slipped from a nineteenth-century town in which elegant wooden houses still had lawns to a skyscraper megalopolis that channeled people into asphalt rivulets between concrete cliffs.

Atget, her mentor, taught her only the documentarian's point of view; his own concerns were the vanishing natural vistas of French fields, small towns, and Paris street scenes, in the moment before war and technology altered them forever.

Abbott's New York photographs cultivate a gaze so thoroughly at one with the subject that it seems not photographed but witnessed. Truth telling respects life's mundane facade; the photographer becomes a visionary of the real, anchoring the present in a near-religious act of self-abnegation.

Abbott's observations of New York carry a subtle emotional load, from her visions of Trinity Church precariously stuck between enormous skyscrapers to the picture in which the steel webbing of the Brooklyn Bridge hovers like an industrialized angel of change over a mute, boarded-up nineteenth-century brick warehouse. She never again was this good. The stop-action science photographs from the forties and fifties run aground on objective observation; the pictures made after she moved to Maine don't sear the mind with information.

Abbott left the United States in 1921 to study sculpture abroad; she first picked up a camera when another émigré, Man Ray, coaxed her into it. Her casual appraisal of the people who came through Man Ray's portrait studio—and later her own studio—lacks the intensity she would focus on New York. From James Joyce to Cocteau to the nobodies, she knew how to make them relax. If judged just on these astute and reflective observations, however, she would merit no more than a line or two in the textbooks. The portraits are more significant for what they leave out. Life in Paris was awash in Surrealists and literati; their influence should have sent her into giddy experimentation. Instead, she drifted to Atget.

But Atget's factualness is infiltrated with romance. Fields, village streets, or Parisian storefronts, in Atget's vision, built themselves slowly around human beings, like second skins. His work attempts to halt the moment in which humans are still the measure of the things they live with. Through hundreds of photographs, that vision remains constant as the things it photographs disintegrate. Atget's pictures are remarkable for the quality of life conveyed by architecture. Like Proust's hawthorn trees and lilac bushes, church spires and garden gates, the multiplicity of detail comes massed with impressions—groups of different impressions among which "fancy strays alone in ecstasy." Proust's zones of melancholy and luminosity mark out Atget's cobblestone pavements and geranium-studded windows. It's a long way to Abbott's city, the clanging battleground.

Truth-telling photographs, of course, choose which truths they wish to consider. Abbott's familiar pronouncements about the legitimate role of photography (which naturally coincide with the role she adopted) are just that—pronouncements. Anyone who has handled a camera knows that the lens is indifferent to the perspective of the human eye. The value of Abbott's work, and Atget's, and documentary photography in general, rests on a perception of transience. Time is the hidden elucidator in all meetings with "the real." Each picture's momentum increases as time separates us further and further from the recorded instant. The difference between Abbott and Atget is that her understanding of time seems a calculated gesture, not to be repeated; his was as natural and deeply rooted as breathing. Abbott changed as fast as the city she photographed; Atget could no more change than could the apple trees and whitewashed walls he loved so much. (pp. 150-51)

Kay Larson, "Abbott and Atget," in New York Magazine, *Vol. 14, No. 48, December 7, 1981, pp. 150-51.*

FURTHER READING

I. Writings by Abbott

"My Favorite Picture." *Popular Photography* 6, No. 2 (February 1940): 19.

> Brief essay in which Abbott discusses her photomontage *New York*.

"What the Camera and I See." *ARTnews* 50, No. 5 (September 1951): 36-7, 52.

> Explores the theory of realism in photography.

"The Image of Science." *Art in America* 47, No. 4 (Winter 1959): 76-9.

> Abbott discusses the objectives of her scientific photographs.

"Berenice Abbott." In *Photographers on Photography*, edited by Nathan Lyons, pp. 15-22. Englewood Cliffs, N.J.: Prentice-Hall, 1966.

> Reprints Abbott's essays, "It Has to Walk Alone" and "Photography at the Crossroads".

II. Critical Studies and Reviews

Andre, Michael. ". . . And Three Disciples: Abbott, Brandt, Brassai." *ARTnews* 75, No. 1 (January 1976): 116-17.

> Review of the 1976 exhibition of Abbott's work at the Marlborough Gallery.

Berman, Avis. "The Unflinching Eye of Berenice Abbott." *ARTnews* 80, No. 1 (January 1981): 86-93.

> Biographical and critical overview of Abbott's life and career.

Henry, Gerritt. "Berenice Abbott." *ARTnews* 72, No. 8 (October 1973): 74.

> Positive review of a 1973 exhibition of Abbott's works at the Witkin Gallery.

Kasmin, Paul. "Berenice Abbott and Atget." *British Journal of Photography* 126, No. 6207 (13 July 1979): 665.

> Brief overview of Abbott's career with an emphasis on her association with Atget.

Levine, Helen. "Berenice Abbott: The Beauty of Physics." *Women Artists News* 12, No. 3 (Summer 1987): 29.

> Review of a 1987 exhibition of Abbott's scientific photographs.

Martinez, R. E. "Berenice Abbott." *Camera* 43, No. 4 (April 1964): 3-18.

> Critical commentary on Abbott's works. This article also includes numerous photographs from the artist's New York and scientific collections.

Tannenbaum, Judith. Review of an exhibit at the Witkin Gallery. *Arts Magazine* 48, No. 2 (November 1973): 66-7.

> Praises the directness and honesty of Abbott's works.

Zwingle, Erla. "A Life of Her Own." *American Photographer* XVI, No. 4 (April 1986): 54-67.

> Biographical and critical overview containing anecdotes from Abbott's friends and acquaintances as well as quotes from the photographer herself.

III. Selected Sources of Reproductions

Abbott, Berenice. *Changing New York*. E. P. Dutton, 1939, 175 p.

> Abbott's best-known work. This book was republished in 1973 as *New York In the Thirties*.

——*Greenwich Village Today and Yesterday*. New York: Harper Brothers, 1949, 155 p.

> Contains photographs by Abbott and text by Henry Wysham Lanier.

——*Photographs*. New York: Horizon Press, 1970, 175 p.

> Contains photos from each phase of Abbott's career. The volume also includes the essay by Muriel Rukeyser reprinted above and an introductory overview by David Vestal.

O'Neal, Hank. *Berenice Abbott, American Photographer.*
New York: McGraw-Hill, 1982, 255 p.
 Contains commentary by O'Neal, photographs by Abbott, and an introduction by photography critic John Canaday.

Ivan Albright

1897-1983

(Full name Ivan Le Lorraine Albright) American painter, sculptor, and graphic artist.

Considered a remarkable painter for his painstaking technique and highly intricate compositions, Albright depicted physical and material decay in all his works. He is best remembered for *That Which I Should Have Done I Did Not Do* (1941), an ominous painting of a battered, closed door, and *Poor Room—There Is No Time, No End, No Today, No Yesterday, No Tomorrow, Only the Forever, and Forever and Forever Without End* (1962), a chaotic still life viewed through a dilapidated window. Independent of prevailing trends towards abstraction, Albright scrutinized objects and human models in microscopic detail, developing a painting style that Harriet and Sidney Janis termed "a fantastic and unorthodox realism."

The son of a well-known genre painter, Adam Emory Albright, Albright often posed for portraits when he was growing up in Chicago, as did his twin brother, Malvin Marr Albright. Both brothers showed an early interest in drawing, and both planned careers in architecture before deciding to pursue painting. A member of the American Expeditionary Forces in Paris during World War I, Albright served as a medical draftsman, and critics believe that his experience creating watercolor depictions of wounds instilled in him a fascination for damaged flesh, as well as a reverence for the minute complexities of nature, evident in his later work. He began his formal art education in France at the École des Beaux-Arts and continued at the Art Institute of Chicago, where he studied from 1919 to 1923. In 1927, Albright, his brother, and his father purchased an abandoned Methodist church in Warrenville, Illinois, and converted it into a studio.

In his early paintings, Albright relied on the amplification of observed detail to convey his moody, pessimistic worldview. For example, when he depicted a haggard figure standing in blue and brown shadows in *Among Those Left* (1929, also known as *The Blacksmith* and *The Wheelwright*), the subject's face is rendered as "corrugated mush"—the artist's expression for the appearance of flesh in his work. *Into The World There Came A Soul Called Ida* (1930), a portrait of an aging prostitute gazing sadly into a mirror, features a meticulously rendered dresser on which some of the woman's meager possessions, including a comb and a vase of dry flowers, are placed. Albright's first major still life, *Wherefore, Now Ariseth the Illusion of a Third Dimension* (1931), simultaneously presents objects viewed from various angles, thereby distorting logical perspective.

Albright devoted the years between 1931 and 1941 to an eight-foot-tall canvas that he called *The Door*, later giving it the more literary title *That Which I Should Have Done I Did Not Do.* The picture of a weak hand reaching toward a scarred, coffin-like door hung with a wreath of flowers

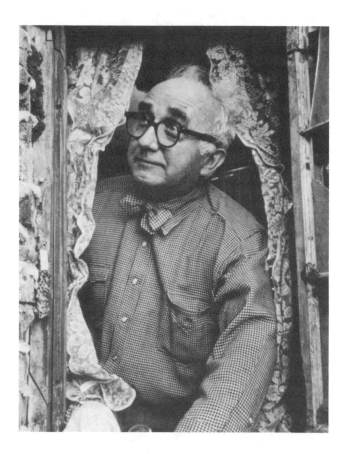

was immediately hailed as Albright's masterpiece. In preparation for his next project, *The Poor Room,* Albright constructed a window framed by a brick wall and spent years collecting what he called the "philosophical toys" that were to be portrayed, including jewelry, bottles, an oil lamp, a key, picture frames, and spider webs. Albright began the painting in 1941, and besides two prolonged interruptions during which he created the grotesque portrait commissioned by MGM Studios for the film *The Picture of Dorian Gray* and another work entitled *Portrait of Mary Block,* he concentrated on it exclusively until its completion in 1962. In 1966, Albright moved to Woodstock, Vermont to begin another major work, initially calling it *The Vermonter* and later renaming it *If Life Were Life—There Would Be No Death;* the portrait was completed in 1977. A series of self-portraits begun in 1981 was his last endeavor. He died from complications following a stroke in 1983.

Albright was widely educated in literature and philosophy and considered his paintings to be the product of profound thought, declaring, "I haven't painted pictures per se, I make statements, ask questions, search for principles." Most critics, however, disregard his philosophic aspirations—along with his ambitious titles—in favor of an ap-

preciation of Albright as a master on a purely technical level. His knowledge of anatomy and his skillful, patient application of color are considered unparalleled in modern art, and the melancholy, macabre emotion that pervades the works is recognized as a powerful illustration of the spiritual malaise of the twentieth century.

ARTIST'S STATEMENTS

Ivan Albright (essay date 1964)

[*In the following essay, Albright discloses some of the existential concerns that motivate his work.*]

The simplest things confound us. We look for the explanation but never find it. There is no limit to the division of things; there is no limit to the size of things. The answer is not in the eye, nor in reason. They make of the real the abstract and the mind gropes in the sub-conscious for an unanswerable answer.

Put everything in total darkness and you see nothing; put everything in full, powerful, brilliant light and you see nothing. For example, look at the sun, what do you see? If a room were lighted with a light as bright as the sun, you would see no more than if it were in total darkness. We are workers, see-ers in a twilight world of shadow.

In painting what do I have to work with? Darkness and light fused into twilight and shadow, movement and the motionless. In a room if I move, all things move with me. If I stir, they stir. If I stand arrested, all things become motionless. But on canvas—a single plane—I cannot paint motion, so all the things around me are deadly still, so still they hurt the eye. Still and flat and only the light from the sun that half-enters, turns and wheels them about bringing to them new facets and forms, new shadows. The sun becomes the mover, the disrupter of the deadlines of the quiet.

I have tried in a small way to enter the principle that is implied in motion on my flat area pictures. Motion is merely the change of position, of size, of angle causing in its change a change of color, a change of light with resultant change of shadow. These effects I achieve in my canvas by walking around my objects and painting them from numerous angles. Sometimes my canvas is upside down and the object then rendered when the canvas is righted becomes an object of contention with its neighbor. You place fifty objects like this and you have a picture battle whether you are painting a saint or sinner.

I walk about and put things in different positions to break up the deadness of their eternal death. I like to see dust move and crawl over an object like a film. I like to see the objects scream and work against their positions, against their size. Our world of sight is built around a world of very slow motion. If everything whirled around a room, you would see nothing, just as a fly-wheel becomes a mass of light, formless and light. For a moment before it reached high speed you would discern objects through this speeding light, then on faster motion nothing but light. We live in a land of shadow and sorrow and blinding light. So too, our happiness is in a shadow world; it reaches no greater depth than our eyes see in the visual world. Our sorrows are shaded shrouds of immobility, our ideas shaded, muted, toned down to dry-bone gray. Our efforts are as weak as our shadows; we exist in a clouded sphere of doubt, of uncertainty; through this haze no clear thoughts, no clear perceptions can penetrate far.

In this eternal smog-land of ours, if the real truth appeared, it would blind us, it would incinerate us as the sun would blind and incinerate us on close approach. We are shadows of the real but not the real; we live by half-truths and half facts. We live in a two dimensional world with the perception of space granted to each individual according to the distance set between his eyes, his space consciousness no matter who tells you is no more or no less than the width of the bridge of his nose. Each man carries his own space with him. This sight sense we use in our shadowy, slow-moving, half-feeling world in which we gropingly strive. Mortally we cannot get out; knowledgeably we do not know how we got in. We expect the part we haven't seen—the soul—to get us out, but did the soul have a part in getting us in?

Here on this planet we laugh-look at baseball, listen to jazz, drink, count dollars, overly breed, attempt to buy world friends so our enemies can't buy them, pray to the same God in churches of different denominations, hope our individual soul will reach heaven and have the best ringside seat. We are captured, tormented victims in a world of shadow, motionless and dead. Reason is based on falsehoods, is a limb of tree a million miles long. We have not one sure thing to hang reason on and, knowing nothing, realize not that we know nothing. Yes, we are subject to pain but how much pain can man take? Too much and he blacks out. Hunger? He can fill his stomach like you fill a pail of sand.

Virtue? How much can man take? Given overly and he is either nuts or a saint. We are a weak machine made to do weak things in a weak way. The body is our tomb. Shake the dust from our soul and maybe there lies the answer for without this planetary body, without eyes the light would not hurt, without flesh the pain would not hurt, without legs our motion might accelerate, without endless restrictions our freedom greater, our slavery less, without examples all around us our originality might be different. Without a body we might be men. (pp. 16-17)

> *Ivan Albright, "Reflections by the Artist," in* Ivan Albright: A Retrospective Exhibition Organized by The Art Institute of Chicago in Collaboration with The Whitney Museum of American Art, *The Art Institute of Chicago, 1964, pp. 16-17.*

Ivan Albright with Paul Cummings (interview date 1972)

[*In the following interview, Albright discusses his choice*

of subjects and his approach to rendering them in his paintings.]

[Cummings]: *Why did you start viewing subjects from different angles?*

[Albright]: Because I was fascinated. I thought: Why am I standing still? This apple or whatever it is has a viewpoint on the other side. Why do I confine myself to just one part of it? Why don't I explain it more? We had all this talk about Cézanne and other artists getting space, but I couldn't see where the hell the space was.

In **The Door** [**That Which I Should Have Done I Did Not Do**], I kept changing things around. All you have to work with is light falling on an object. So on the molding I had the light falling on one thing. I thought: Why couldn't the light fall on the other side? Why do I always work the whole thing as if the light—heck. I'm just dealing with a fantasy, anyhow, or a vision. So I made certain sections with the light falling on the opposite side. And you get a reverse.

I made a brick wall for **The Window** [**Poor Room—There Is No Time, No End, No Today, No Yesterday, No Tomorrow, Only the Forever, and Forever and Forever Without End**] and spent three days picking out the brick. Some of the bricks were burned where they had got too near fire, and there was a beautiful glaze like lava—yellow and green running down the sides. I picked out about five hundred or six hundred or maybe eight hundred bricks. For "The Window," I looked around for the sill or frame. I couldn't find anything I wanted, so I made one. I got old parts and put them together, trying to make up a portion a little bit narrower than usual, so it would have a little character outside of mine. For background, I got a not very good rug for the floor and an old bureau and I put a lamp on it and so forth.

How did you decide to use a window as the main . . . ?

I had painted **The Door** and had painted wood for ten years, and I didn't want to see any more wood as long as I lived. Before that I had painted a strong laborer. I called the painting **Room 203** [**And God Created Man in His Own Image**]. He posed for me for thirteen months. Well, after painting that guy for thirteen months, I didn't want to see any flesh. So I painted **The Door.** So why did I paint brick? I wanted to get away from wood. And when I got through with brick, I didn't want to ever see a brick again.

Do you collect the objects in a painting with a particular reason in mind?

Well, yes—so they fit in. I use this old thing here, for instance. I don't want to have a new Tiffany pitcher, for God's sake (I don't like that new polished stuff anyhow).

Do you know what starts an idea for a painting?

Well, when I'm through with one and if I want to start another serious painting, if I need a model, the first thing I'd have to think about is if I can get a model and then, will the model stay with me. I don't want to get one that will die or become incapacitated or won't pose or is too fussy. If I want to make a figure piece, say, that would be the first thing to consider. Of course, if I want to make a still life,

I'm on my own and they can't stop me. Then I try to run some subject through my head that might be of value to somebody philosophically, some conception other than painting. Something like a Childe Hassam—a fish and a bowl of grapes, for God's sake—to try to have something that will pertain to a phase of life that might have a little more meaning if possible. Then I go on from that.

And then you start to accumulate the objects that you use?

Once I know what I want. With **The Door** I kept collecting things. For instance, the doorstep was a tombstone. I got it in Naperville [Illinois] for thirty-five cents. My study of architecture came in handy here. I knew I'd have to have a threshold. I went down to the junkyard and finally found a nice brass thing that looked paintable, old, battered, not true. Then I thought a girl's hand would give it a little human interest. If you get a human being into a thing you have something closer. A piece of wood is not your roommate or your bedmate. I think it's better if you can tie it up somewhat with a person. So I got a girl with a small hand and posed the hand leaning. Symbolism. It could be a funeral wreath—anything. My mother had a very fine handkerchief of allover lace that probably belonged to her grandmother. It was very silly in size, unusable. It was white and I dyed it blue; I don't know why, except that I didn't want to paint a white handkerchief. I suppose I thought white would stand out too much, that it would be too important. The brass key was from the door of my old studio, which I had built. I found an old door at a junkyard in Chicago. I didn't want to have an ordinary outside stock door three by seven feet made of white pine. I looked around until I found an old door that looked drab, like a Charles Addams or from a ghost house. One that would have a little character in itself, that had been painted and had started to fade. You want to pick something that looks as if it's lived its life. The funeral wreath. I got a cheap one so it wouldn't look like a gangster's funeral or a rich person's. I had to replace the calla lillies three or four times. The wires last only so long. You see, they're made for you to die and then be buried, not to have someone look at them for ten years. When I sent the painting to the Carnegie Institute I made a frame for it. It was terribly hard work. I wanted to line it with casket lining. I had to get a permit from the undertaker in Naperville to go to the casket company to buy it. At the company I bought that drab black cloth. When I asked how to put it onto a frame, the man said, "Well, what we use is library paste. They only want it for two or three weeks anyhow."

How did the long titles that you use come about?

My dad and all the artists of that early period—from 1903 up through 1912 to 14—used titles such as *Boy with Sunflower, Sunbonnet, Man Standing by River*. And I thought: My Lord, I would have loved to have been able to write. When I was a student at Northwestern University I tried to write. I got kicked out. I thought that there I not only had a chance to paint, but if I made the titles long enough I could write. In those days I was writing poetry. Do you want to hear a poem?

Sure. Do you still do it?

No, I haven't done it for many years. I have about three hundred poems.

When did you stop writing them?

More or less after I got married. I used to write a lot in Hollywood, under the piano, when I got drunk. There was Albert Lewin there. We were in Santa Monica on producers' row. Every Saturday and Sunday they had these big cocktail parties. They never had writers there. They never had actors. You know, if they had had actors, they might try to get a job. For instance, once George Sanders went there and tried to get a job; he made an ass of himself. So it was mostly Jean Renoir, Anita Loos, people of that type. Al Lewin was a little guy, my size or smaller. And he could talk. He was professor of English at Harvard at one time. He had a good sense of amusement. He'd get up on a chair and tell story after story. Maybe there'd be about thirty people present. And Herb Staud was there. He was a musical chap; he had seventeen hits on Broadway. He'd get at the piano. Well, after, say, the nth drink I used to think: What the hell can *I* do? So I only had to take my paper and pencil and crawl under the piano and come up with a piece of poetry all in forty seconds or half a minute or a minute. Al Lewin would look at my poem and say, "Damn it! It's pretty good, anyhow." So, here's a poem I wrote, oh, many years ago:

> A painter am I of all things
> An artist who sees a door and chair
> And sees them smooth things a flaw there
> And sees them round things a hollow there
> And colors are to him but the form within
> He knows not but that the world is colored and
> strong
> With light and shadow and forms that inter-
> twine
> And the sky is not blue to him as it runs over the
> meadows and trees
> And the river is not held within its banks
> As the colors swim over the land
> And the tree is not a tree to him
> But a song of beauty in the sky
> And color is not just colors to him
> But each a dream and a fantasy that makes unre-
> al this world of yours to him to this painter
> man.

Can you work on several paintings simultaneously?

This is the one I'm working on now. If you have two you would be running from one to the other; at least, I would. I tried that with *The Door.* I had that and I had *Showcase Doll,* or something, started. I worked on one in the morning and one in the afternoon. I had these two setups. For *Showcase Doll,* I had a case made as if it were in a store, with the doll and lace and different stuff all around. And I found that I was running back and forth from one to the other. The light would get good over one—say, *The Door*—and I'd run over and work on it. Then I'd run back to the other one. Finally I said to myself, "For gosh sakes, Albright, make up your mind. It's got to be one or the other. Now which one?" Having no one else to decide for me, I chose *The Door.* I worked on it for ten years.

The idea—the philosophy behind your pictures suggests an interest in philosophy in general. Are you interested?

No. The philosophy I use more or less goes with space and nature. Another man's philosophy wouldn't do me any good, but probably did the other man a lot of good. But if I can turn an object and make it go up and down, then I can create a feeling of motion, and with that feeling the object will take on a new dimension.

Do you feel that the objects in your paintings have symbolic meanings?

No. I know when I painted *The Door* I had it in Hollywood, and Sidney Janis came along and said, "You've got a whole lot of symbolism in it." "What do you mean?" I said, "I never tried to put any symbolism into anything." Maybe you're bound to get some, but I don't look for it, and I don't try to put any in. I think there's enough symbolism in making things move around, without my trying to put in a few clever little symbolisms. I don't think it's necessary.

You don't overpaint, do you?

No, never. Not on this stuff. To start a new painting, first I think of what I want to make. That may take a number of weeks. When I painted *Ida* [*Into the World There Came a Soul Called Ida,* 1929-30], I had her there for three weeks before I started to paint. I'd have her do everything: when I said "Pose," I didn't look at her; when I said "Rest," I'd look at her. I never hire professional models. I've never had one yet. The models I use are all amateurs, and they can't take these five-dollar-an-hour or fifteen-dollar-an-hour poses. They don't know them. They take natural poses. You can make them sleepy and tired, and they'll slump in a certain position that you know is more or less natural. If you wait until they get tired, the hands will drop down in a certain way. Then I study the light on them here and there. I don't make a sketch and try to have them fit the sketch. I work with the model and with light. Generally, in the studios I've had before this one, I've been able to pull every curtain up or down and control the light. Then when I find something I like, I mark the position on the floor with Scotch tape, the hour of day, how the clouds were, and about where the sun was. Then I monkey around, and if I find a better light I'll mark down the time, the clouds, and everything. Naturally, I know that it's just the law of averages if I get that lighting. Then I make a note of the clothes and so forth—so much open and so much closed and this and that. And I write down the poses. I don't try to make sketches. They don't amount to anything because I'm going to make a picture.

You mentioned off the tape that you wanted to continue talking about **The Window?**

In the first place, the setup covered an area of about fifteen by twenty feet in back of the window. Then I stood in front of the window. Now I have about fifteen major movements in the picture—swing this way and then foil against it; then minor things like the lamp, a flask, a bowl with flowers, like the chair with the three movements—and possibly forty to fifty minor movements controlled by the major movements.

What's a major movement?

A major movement would be swinging a big area in one

direction, like a big arc; the whole window frame would swing one way. Then, to counteract it on the other side, I might have part of it swing one way and then swing back to have a force there. I make forces and then try to stabilize them so they won't be too violent. For instance, I have three beer bottles in one area. Each one, though fighting each other, is made from three different viewpoints, so they're contained. I'm trying to have it so you feel that you're walking in back of it and all through it, not just looking at it. I'm trying to put the observer in the picture, not outside of it. Though he *is* outside of it, I make him wander around through that room seeing the things from their different positions, as if he were in there. I'm composing with motion instead of with area, though naturally it becomes an area of flat paint.

What started you looking at things from different points of view?

It was gradual. The first pictures had a little of it. I had one, *Flesh* [1928]. It was just a glass bowl with water and the flowers upside down. It could go either way. We're taught about hollows. But who can tell which way it's hollow? It can be convex or concave. And later, with *The Door,* I made the flowers from different heights, because I had to get them higher and from different angles. I found it had more volume and more space that way. Instead of trying to pretend there's space, I used the exact realism from a different direction, and I made one flower from one direction and the other from the other direction. I looked two ways in that picture.

Did that start by chance or by coincidence?

Well, no. As I told you, when I studied at the Chicago Art Institute, their color was mixed up with form, and color was mixed up with light. Hawthorne was always just color; he didn't understand when I said I wanted form. I was probably one of the first to go for form. From the form, I was trying to get more space than form. I was trying to get around the object. Trying to model it more than what you see. I'd walk from one position to another to try to reach around it to make it more sculpturesque, as it were. From the sculpturesque it turned into more motion. I'd walk further around, and I found that it gave more of an extending of the figure out toward you. I'm not trying to use distortion. I'm not distorting anything. If anything, I'm making the object more realistic by walking around it. An object has a million different viewpoints, and I'm taking a certain one. Now, say I'm going to paint a banana or a grapefruit or an orange or an apple on a table. That object doesn't have any size; it has all sizes. If you stand off fifteen feet, it's smaller. If you stand off far enough, it'll disappear. As it's disappearing, the color will become more and more neutral, until finally you'll have just a black spot. I'll walk about the same distance around it, so it will keep relatively the one shape. Say the object is three inches high; it'll keep that roughly. But I'll be painting the back of it and the front of it and trying to relate the two, but not too violently, because it won't work. But I *am* getting around the object. Well then, the object will have a tendency to try to get out of that shape. There's where the action happens when the observer looks at it. A lot of the objects I paint are trying to get back to their original

shapes and that's where the force lies. And the job of the artist is to compose with these shapes and do what he wants with them. Naturally, that's where the artistic effort would be displayed.

Would you discuss your interest in the quality of light?

Ah, the quality of the light. Not working from sketches. I work moving a model around for, say, three weeks, or moving a still life around in a hundred positions. I use the skylight—top light. And then I like to concentrate. The more you make it smaller and smaller, the more you'll have a sharper light and more shadows, and it brings out more form. Here in Vermont, the light is fairly good. But it's better in Canada. I find that the farther north I go, the stronger and the whiter the light. I've painted in California a few times, and that is simply ghastly. It gets kind of an orange glow. It's impossible. I don't like it. I like a cold light, what some people might call a cruel light, the kind of light that no actress would want. I like a powerful white light on the head; this is the light that shows form the most. A steady light with white clouds reflecting down is, I think, the best light you can have.

In **The Vermonter,** *for instance, there is the luminosity of his hands and his face.*

I can't see that. But when I went to Chicago and looked at my pictures, I thought there was a little luminosity. I think that may be caused by getting close values. In painting a hand (and, incidentally, most artists paint terrible hands, including Rembrandt—horrible), you should make the fingers so they can move.

Do you look at the hands the same way you do an object?

Yes. It doesn't matter whether it's the head or the hand or a button or a piece of wood or the background or a brick or whatever. I try to make it have more feeling. In the painting *Room 203,* I tried to put force in his eyes. I almost had to put it in myself, because people generally have a look of receding in their eyes, or they're hiding all their emotions back of them and trying to be secretive. You have to pull the emotions out of them.

In painting or anything, you cannot have hate. If you have hate, you destroy the picture and yourself. It doesn't work. You can have hunger, you can have thirst, you can have great feeling for texture, you can be sensitive to touch, you can be sensitive to color, but for the head you've got to be sensitive to love. Otherwise it will not work. I think that's the only thing. Now, that love won't change the shape, but it will add something. And you won't get that through feeling. You're going to have to just look and see the difference because it's extended out. Because, after all, when I'm painting you I'm not touching you; I'm off a ways. And this radiates out from a person. So it's in the air between myself and the object I'm looking at.

Don't you use a magnifying glass when you paint?

Well, I use it, yes. I paint under it. I'm a realist in that I want to paint that way. I'm an abstractionist in that I'm trying to have motion. But if I'm going to make a thing move, I'm not going to make a distortion. I don't want to

move a distortion. I'm not interested in distortion. It's fun to play with, but it's just like a dream.

What would distortion be?

If I wanted to distort, I could make a coat this big or a sleeve. Like a Dali. I'm not trying to make a fantasy or a dream. I follow construction. I'm not trying to make a wonderful pattern like surrealism.

In a way, it's more real than real.

Yes. The reality is more than what a man can dream up. A man who makes a fantasy of surrealism thinks he can beat nature. And he can't. Because he's part of nature, and he's a small part. I'm just trying to follow nature and let nature come out. Which is a whole lot stronger, I think. I'm just the instrument of making it. In other words, I'm not an artist. No, it's true. I'm an observer. But I'm making people observe the way I want them to look.

But still, you don't use trompe l'oeil.

No. That would be like Hieronymus Bosch or something. That would be fun, too. But I would much rather do this and see how far I can go with it. (pp. 53-63)

> Ivan Albright and Paul Cummings, in an interview in Artists in Their Own Words by Paul Cummings, St. Martin's Press, 1979, pp. 49-63.

SURVEY OF CRITICISM

Daniel Catton Rich (essay date 1943)

[*Rich was an American art historian who served as director of the Art Institute of Chicago from 1945 to 1958. In the following essay, he follows the progression of Albright's career, deeming him a skillful, intense, obsessive artist.*]

Claude would have disowned his namesake. The wanderer through tranquil groves and the haunted realist of Illinois share but one thing—"Le Lorraine," the name fastened on Ivan by his painter-father in 1897.

Adam, the first Albright, was and still is, a fancy painter of childhood. By the hour Ivan posed with his twin brother in ragged breeches, dabbling his toes in silvery brooks or fishing with string and bent pin. Barefoot boy with cheek of umber. This gave him a disrespect for art and a passion for drawing.

He planned to become an architect, but in 1917 the Army discovered that he could record torn and bleeding flesh with an uncanny precision, and made him a medical draughtsman. Sometimes too much has been inferred from this experience. At the Art Institute of Chicago, and later in Philadelphia, Ivan learned more from advanced students than from men like Hawthorne and Seyffert. An exception was Henry McCarter. He "upset" Ivan, and

Ivan "upset" him by laying a still life arrangement on the floor and painting it from a chandelier angle. It took him forty-two days to conquer the technical problems involved.

With his brother Malvin, who renounced architecture for sculpture, Albright built a studio at Warrenville, near Chicago. For the first ten years there issued from its doors a procession of obsessed figures. He chose rugged models from the neighborhood, a lineman or a blacksmith. Posed in harsh, unfeeling light which falls devouringly on leather, hair or skin, these figures are somber in browns, dead tans and faded blues. At the beginning, Ivan tried to give back an external world, heightened with externalities. But already in *The Blacksmith* (1928) his vision of the model is so intense that it puckers the folds of coat and apron into a wavering, abstract rhythm and corrugates the head with extreme sculptural shadow. The realism becomes more terrifying. *Flesh* (1928) and especially *Woman* (1928), with its dead purple and black surfaces picked out in chalky whites, suggested that he was doing in paint something akin to what Mid-western writers like Edgar Lee Masters and Dreiser had done with words. His work had the despair of *Spoon River Anthology* and the compulsive detail of *Sister Carrie*. In these scabrous faces and wrinkled, puffy hands, may be read the whole backwash of pioneer optimism.

But in his next two paintings, *Into the World There Came a Soul Called Ida* (1928-1929) and *And God Created Man In His Own Image* (1930-1931) Albright outstripped the "corn-fed" realists. Ida—a modern *Vanitas*—was posed in the same black-walled studio under a trap-door of light which pitilessly searches out every crease and vein. Nevertheless the nightmare mood gives off a kind of disenchanted loveliness and the effect grows phantasmagoric. Every inch of *And God Created Man . . .* is rendered with a fastidious delight in the tints and textures of sagging flesh, worn clothing, cheap wooden bed and wall paper. By this time Albright's knowledge approached the graphic control of a Dürer or Cranach. Illusionism is pushed so far that it becomes abstract. If one needs a contemporary parallel in letters it would have to be William Faulkner.

Over ten years ago the artist considered painting a tawdry doll in a glass case shaped like a coffin. Two desires possessed him: first, to bring the elements of his art into more dynamic interplay and second, (never confessed) to paint the theme of death. So far most of his figures had been static, or at least the large blocks of his design had the immobility of still life. Within the forms there was a lively play, but often it had been a play of surfaces. In a still life, *Wherefore, Now Ariseth the Illusion of the Third Dimension* (1931) he bent and wrenched space to suit his feeling. Apples in a dish are designed from varying perspectives; a glass of wine is seen from still another angle. The technique becomes even more explicit. Each filigree of lace or spot on an apple is heightened to a point where the whole picture takes on the feeling of psychic tension. Here Albright seems to be staring through matter into a world of his own obsessions.

These explorations were to continue in a tall canvas of a door, hung with a funeral wreath. The theme took prece-

dence over the painting of the doll, which exists today only as a charcoal lay-in with one or two touches of color. For the next ten years he worked on the door. He finally called it *That Which I Should Have Done I Did Not Do,* (1931-41). Examining the canvas touch by touch, one wonders what further the artist *could* have done. It is the most carefully painted picture of our day, perhaps of almost any day.

Great and careful were the preparations. An actual door was found and set up on a sill made from a discarded tombstone. A wreath of artificial flowers (it faded) was placed on its scarred surface. Diagrams were made of the flowers, some to be painted one foot above the ordinary line of vision, others from three feet below. The door itself was "shot" from contrasting angles. Realizing the flatness of the object, Albright saw that movement into space must be created through reversals and combinations of perspective. Originally a model was called in to pose for the hand. She grew weary and a plaster cast of her hand was taken and wired into position. Albright was delighted. The false hand was more spectral than the live one. Season after season the charcoal preparation was filled in, every mar, scratch or blemish recorded. The full and empty spaces were welded together with new lines of force. After a decade it was finished, Albright's masterpiece.

Here his extraordinary vision at last finds a commensurate theme and technique. Death's corruption has never been exposed with more unfailing insight. The very pigment seems dead, made up of cobwebs, dried spittle and dust. Color is smoked on rather than painted. The twisting moldings and distorted wreath are sharply cut by a metallic, cold light. Vapor drifts from the shadow. At key points the form dissolves into an ectoplasmic mist. The canvas dulls or glows with a charnel luminosity. The tall warping format is made to symbolize a casket.

That Which I Should Have Done . . . poses the whole question of Albright's significance. No one can fail to admit his technical mastery; few so far have been more than shocked or repulsed by his subject matter. This failure to understand the themes of his painting is a fault of our time. Through undue emphasis on form we have become such materialists that we are in danger of ignoring all meaning which resides in a work of art.

Though Albright—who is usually remarkably clear on his processes—insists that "it doesn't matter in the least what you paint," I state that it matters extraordinarily to him what model he chooses or what idea he broods over. His world is a world of midnight. One of his pictures even carries that title; they might all have it. Against black or sooty backgrounds these over lifesize figures loom out of shadow, nakedly exposed to the glare of light which the artist pours over them. It is a light cruel in revealing the least trace of corruption or indulgence. With his excited eye Albright probes his characters as they stand bared before him. "I like faults and quirks in people," he admits. "I believe a man grows to look more and more like the person he really is."

It is flesh, itself the title of another of his pictures, that Albright analyzes—a rabid, delicate autopsy on skin and tissue. This corruptible he paints with amazing relish; it loosens, rots and decays yet holds a strange fascination. What is his purpose? Does this vision spring from a cosmic bitterness, a personal cynicism or an uncontrollable aggression against his fellow-men? I believe not. Rather it is the result of strong moral indignation, concealed (perhaps even from himself) under the guise of disgust. These maps of faces on which every sorrow or depravity is charted are named, *Into the World There Came a Soul Called Ida* and *God Created Man in His Own Image.* The "soul" of Ida is overwhelmed with the opacity of flesh; the "image of God" is forever caught in a lava flow of matter. In an intense desire to portray a drama of corruption the painter spent ten years of his art in creating this cast of characters, and ten years more in designing a coffin in which they shall inevitably lie. Ivan Albright is like a page from *Jeremiah.* (pp. 49-51)

Daniel Catton Rich, "Ivan Le Lorraine Albright: Our Own Jeremiah," in Magazine of Art, *Vol. 36, No. 2, February, 1943, pp. 48-51.*

Harriet and Sidney Janis (essay date 1946)

[*Sidney Janis was a gallery-owner who helped popularize Abstract Expressionism in America. With Harriet, his wife, he collaborated on two volumes of art criticism,* Abstract and Surrealist Art in America *and* Picasso: The Recent Years, 1939-1946. *In the following exhibition review, the Janises comment on stylistic elements of Albright's paintings.*]

Today the work of Ivan Le Lorraine Albright, in spite of a more general recognition than it has ever had before, still baffles a vast audience. His paintings have played a part in contemporary art in this country since 1924 when his first picture, quite academic in style, was exhibited at the Pennsylvania Academy in Philadelphia. During the years that followed, they have appeared singly or in groups at many exhibitions, welcomed alike to the fold of the most conservative and to the ranks of the advance guard. Becoming progressively more dessicated and livid, his portraits and still lifes have aroused cries of awe and dismay from the public and the press. At the same time they have calmly taken possession of a staggering number of medals, prizes and awards. Finally, conforming fully to the tradition of the American success myth, one of his pictures, the brilliantly appropriate portrait of the aged Dorian for *The Picture of Dorian Gray,* "made the movies."

At the Associated American Artists' gallery in New York . . . was to be seen the first large scale showing of Ivan Albright's paintings. This was part of a joint exhibit shared with his twin brother Malvin, the sculptor-painter known as Zsissly, a name he chose so that the painting identities of the twins might be as widely separated as possible in the catalog listings of the exhibits in which they participated. The group of Ivan's pictures displayed consisted of twenty-eight examples in all, and they were interspersed with those of his brother, who had an equal number on view. Included were some of Ivan's most important achievements, among which was the famous door with wreath titled *That Which I Should Have Done I Did Not*

Do, one of the outstanding contributions to contemporary American art. Others of his major works in the exhibit were *And God Created Man in His Own Image, Into the World There Came a Soul Called Ida,* and *Three Love Birds,* an unfinished work with large exploratory areas of paint, revealing the method by which Ivan works.

Though well represented, this was still not an individual showing, and one must continue to look forward to the experience of seeing Ivan's paintings when the full impact and force of his work, the scope of his talent, can be isolated. Nevertheless, here can be found the gamut from early academism through the evolution of the macabre phase, and, with occasional recent throwbacks to the academic, here also are the seeds of a new creative direction.

Ivan's public, though considerably augmented in recent years, has had to go a long way with him in accepting his challenging art. A public innured to the distortion so expressive a part of almost all contemporary painting, even of much middle-of-the-road painting today, is alternately fascinated and repelled by his pictures which are characterized by a disturbing subjective distortion. Intrigued on the one hand by the labyrinth of endlessly painstaking minutiae and the obsessive technical persistence by which it is achieved, this public has had to accept, on the other, the convulsive atmosphere of putrescence, the strong visual irritation of the senses of touch and smell aroused by his pictures. It has taken virtually a surrealist conditioning on the part of the observer to bring Ivan's esthetic—a fantastic and unorthodox realism which may be termed a Victorian new-objectivity—into focus for understanding.

From whatever psychological causes, such as those attendant upon his being a twin (the twins are now 48 years old), upon a childhood interminably idealized in sentimental paintings by his father, upon the esoteric experiences of a sensitive adolescence, and the traumatic experience of instantaneously recording soldiers' wounds in a war front hospital during the first world war; from these and other contributing psychological causes, a death pallor creeps increasingly over his portrayals through the years. *The Showcase Doll That Was Never Painted,* a charcoal drawing in which Ivan has begun to paint areas of color and flesh, is a death fantasy, made in 1930, the figure being laid out in a glass coffin. The following year he started the painting of the door with wreath, which took ten years to complete, and which, though portraying the threshold of presumably natural death, has ended with grim and desolatingly supernatural overtones.

In the macabre tradition of Ambrose Bierce, Edgar Allan Poe and Henry James, Ivan's *Dorian Gray* is perhaps as shockingly violent a portrait of horror as has ever been devised. Intensifying the virulent decay—if such a thing is possible—are literally dozens of unconscious paranoiac images which continually shift and merge until the brain of the observer swims with the delusion that these are his own aberrations. Almost beyond human ability to conceive and execute is this hideously depraved and demoniac characterization of Oscar Wilde's Faustian victim. One must look deep into the processes of nature itself to find its equal; one can visualize the equivalent taking place in the depths of the earth and over a period of thousands of years, with chemistry slowly, patiently working over dark dank matter until it has reached a state of the most revolting putrefaction. Somewhere before that point has been reached, recrudescence unexpectedly and mysteriously occurs and precious new crystals begin to form. Just as nature reconstructs in the midst of the last stages of decomposition, there are passages in *Dorian Gray,* such as in the table base and the chair, which seem to represent the first stage of crystallization of a new pictorial vision.

With the processes of death and disintegration accomplished and the indications of a new hallucinatory exaltation appearing, it was reassuring to come upon his painting *Manifestation* in the New York exhibit. This picture, small in size and perhaps overlooked by many, is not to be compared as an overall achievement with the other paintings mentioned here. Nevertheless it is extremely important as a first complete example of the new direction of a rarely gifted American painter. It has a mystic, occult quality, a magnetic aura. . . . About it, Ivan writes: "It is in a new vein of color experimentation through which I am now traveling. I have tried to pick out colors somewhat astral—untied either to values or forms." When one recalls that the ominous implications in such paintings as the door with wreath, Ivan attributes to a device he terms simply "top-lighting," then one must accept this statement of a fresh intention not only as indicative of new sensory testimony but, even more important, as prefiguring an abandonment of the tortured hyperrealism for a new inner vision. (pp. 43, 48-9)

Harriet Janis and Sidney Janis, "The Painting of Ivan Albright," in Art in America, *Vol. 34, No. 1, January, 1946, pp. 43-9.*

Albright on art:

A picture is like a house wherein all things are to be found; it is a place wherein, side by side, rest decay and the sublime; and children's laughter brushes the inner prayer. A painting is life and a painting is death. It is essential that we give of the whole and not of the part, for the picture is our legacy left by tomorrow's dead for tomorrow's living.

From Art in America, *1962.*

Jean Dubuffet (essay date 1964)

[*Dubuffet was an influential French painter whose works reflect his anti-art aesthetics in their childlike simplicity and use of nontraditional materials. In the following essay, he expresses emotional and philosophical awe at Albright's painting.*]

I do not believe that I have ever encountered a painting which gave me immediately such a strong sense of commotion as the one by Ivan Albright portraying a door; I found it at the Art Institute during my brief stay in Chicago in 1951. It is an unforgettable painting, and it seems to me, a striking example of a work that it is worth going to

the ends of the earth to see. Later, I had the privilege of meeting Mr. Albright and of being a guest at his studio.

I saw through magnifying glasses his nests of wasps and mice, his cut-glass flasks, oxydized and encrusted with filth, his old hats and gloves, his collection of dust and spider webs. I saw with stupefaction in his studio on a turntable, the dramatic ground floor of a devastated shack which he had placed there after having numbered all the bricks so that he could reconstruct it with his own hands and position behind it, with an application truly demoniacal, so as to make appear in the interior of a room seen through a shattered window, the most alarming disorder of singular objects that can be imagined. I shall never forget that. I have never seen anything as frightening.

There are few pictures as alarming as those of Albright. Because what they represent to us belongs not to our accustomed world. Or rather, and this is what baffles so utterly, we see in them objects that we easily discern to be those which surround us but which are nevertheless unknowable. Never have we suspected that these objects could be clothed with such an aspect. In this strange aspect, it is so impressive, with such convincing authority, that no possibility is left to us of doubting the fixed reality. It is the reality of our customary views of things that we are as soon called upon to question.

We feel strongly, in front of these paintings, that we live in a mirage, that our eyes, that all our vision deceives us, that all the notions on which we have until now based our standards of appreciation of all things—are erroneous. That the keys to the world—and those of our lives and being—are quite different keys from ours: extremely foreign to ours.

I am sure that never have paintings had such strong powers of *revelation*. They upset with one blow the ramparts of our tastes, our affectivity, our aversions. The *hostile* is manifest in them that which we felt before as hostile, and which despite that appears to us suddenly, endowed with a fascinating irresistible attraction. A crumbling, rotting, grinding world of excrescences is offered to us in place of the one in which we had believed we lived. His striking and peremptory character is imposing. Abolished here totally are what were our canons of beauty. Swept away, in the marvelously proliferating universe, in the pullulating anarchy that Albright offers us are all the criteria of order and the archetypes of our former ideas of beauty; nothing remains. For them is substituted a howling tumult, polycentric of many forms—a Gehenna of forms entirely delivered to delirium; to all beings a suddenly rendered liberty. A liberty, one must say, of the most disquieting kind. Each of the painted objects perpetrates its flowering without, it seems, the slightest thought of its surroundings. The center of the picture is everywhere at once; all being is center. And it is from this which doubtless comes the feeling of fear that the painting of Albright gives to many people.

It is uncomfortable to see revealed that our world is constituted of objects thrown into a terrifying isolation, which are neighbors without slightly knowing each other, each one obviously occupied with the expansion of its own being without the shadow of regard for the things of which

it is the neighbor, and not even to those of which it is a component part. There results an impression of profound and irremediable solitude, which without doubt frightens one. As also frightens in this world which Albright reveals to us, the unchained disorder in which these objects so freely conflict, and the apparent total absence of any lightening or moderating intervention which would come to put order into the open range of their appetites. It is this open range which makes one afraid. It is the frightening liberty which all the objects seem to enjoy—an abandoned world, from which all authority has retired.

Rarely, it seems to me, perhaps never, has the platonic and humanistic spirit been opposed with the weight and authority of so devastating a wind. Never has an assault of such force been given to the rationalistic order, to the secular esthetics which rule in our midst and to the metaphysics from which they proceed (or which gave them birth). An artistic creation is worth but the measure to which it conveys. I wish to say to the measure of the views of the spirit to which it can transport, of the myths and the mystiques from which it delivers. The work of Albright—each of the works of Albright—carries (and everyone feels this very strongly at the first glance) a strong charge and is dangerously inflammable.

Must these paintings be burned? Yes, without any doubt, if fear of mental adventure prevails, if the desire—to bind the eyes—not to endanger our traditional conceptions, to preserve the walled gardens that have been for thousands of years the entrenched camp of our tranquillity.

But if the ancient walls by which these gardens are enclosed begin to crack, if the precariousness of this specious refuge begins to make itself felt, if the tranquillity obtained by means of blindness ceases to suffice, if we opt for navigation in the great deeps and not in tide-water harbors, then let us not burn Albright and his abominable propositions and let us salute in this very great artist the *ailé pilote* ["winged pilot"] of new seas. (pp. 7-8)

> *Jean Dubuffet, in a commentary, translated by Josephine Patterson Albright, in* Ivan Albright: A Retrospective Exhibition Organized by The Art Institute of Chicago in Collaboration with The Whitney Museum of American Art, *The Art Institute of Chicago, 1964, pp. 7-8.*

Robert M. Coates (essay date 1965)

[*Coates was an American novelist, short story writer, and critic who, with other expatriates including Ernest Hemingway and Gertrude Stein, lived and worked in Paris in the 1920s. His* The Eater of Darkness *(1926) is often considered the first Dadaist novel written in English. Later, Coates returned to America, where he published short stories and criticism in the* New Yorker *for thirty years. In the following excerpt, Coates praises Albright's compositional skill as it is seen in his drawing and sculpture, but objects to what he views as the "unsympathetic" character of his paintings.*]

Ivan Albright, to give him his present appellation (he was christened Ivan Le Lorraine Albright, but he dropped his

middle name when he learned that his namesake, the early French painter Claude Le Lorrain, spelled it without the final "e"), has always been an oddity and a curiously controversial figure in modern art. It's impossible just to take him or leave him alone. Even back thirty or forty years ago, when the only place he could show his paintings was the come-one-come-all-style annual exhibitions of the Society of Independent Artists, and when he was pretty much of a loner, he was more talked about than his position warranted. The prices he put on his canvases were considered outrageous. As I recall, five thousand dollars was the minimum, and this was at a time when five thousand dollars *meant* something. (Most other Independent exhibitors priced their works at one or two hundred dollars, and that was definitely an asking figure.) But his prices were not the only subject of controversy. He was either praised (it is true that it was at times in a slightly condescending manner) or shuddered at, even hated; and I have a feeling—unsubstantiatable at the moment, for this is his first major New York exhibition in twenty years, and critical and public reaction to him has been minimum—that something of this mixture of attitudes surrounds his work to this day. I imagine, though, that anybody who paid the outlandish five thousand dollars for one of the older pictures has had no reason to regret his purchase. Albright, in a quiet way, has been winning prizes (the latest a Canadian one for, neatly enough, five thousand dollars) and receiving other important honors, and he has now reached what to most artists is a true culmination, a retrospective at the Whitney—a show that, by the way, was organized by the Art Institute of Chicago and began its career there.

It's a small show, and I'm glad that it is, for too much Albright can be overpowering. But then, I must confess that I am not a "fan" of his; I'm a middle-of-the-roader. I don't hate him, though he does occasionally make me shudder a little. On the other hand, I don't love him, either. But I think I shall abandon my effort to disentangle my emotions about him until I have described the showing. I have said that it is a small one, and it is unusually small for the period it covers—forty-three paintings, plus sixteen drawings and other works, dated from 1927 to the present. Yet it is a remarkably cogent and competent collection, and it certainly throws a great deal of new light on Albright's range as an artist. The major part of the affair is quite properly based on his mercilessly microscopic, supranaturalistic (and, I think, inherently sadistic) analyses of the human body at its most varicosed, ulcerous, and purulent. This is the most typical and most characteristic part of his production. But there are other items that reveal quite different aspects of his talent. Did you know that Albright did sculpture? He did, and does, at least dabblingly, and a couple of the pieces in the show—notably a portrait head of Adam Emory Albright, his father—suggest a thoroughly respectable confidence and competence in the medium. There is a set of drawings, too, some of which, among them the elaborate studies for such later oils as the portrait *Captain Joseph Medill Patterson* and the still-life called *Showcase Doll,* testify to the almost finicking attention to detail with which he approaches his compositions. There are, as well, throughout the collection, pictures—of which *Black Cliffs, Schoodic Point, Maine, I Slept with the*

Starlight in My Face (The Rosicrucian), and *Shore Sentinels* are samples—that I can think of only, and no doubt unfairly, as aberrations, since they depart so drastically from the general line of his work. The *Rosicrucian,* a head of a young acolyte seen in profile, is almost pure Pre-Raphaelite; the Maine landscape is a thoroughly naturalistic view of a river racing through high banks and over a falls; *Shore Sentinels,* an outlook through a serried group of pine trees onto a coastal inlet, is, I'm afraid, pure corn. And there are others, such as the small, miniaturistic still-life of musical instruments, *This Ichnolite of Mine,* and the rather Surrealist (Surrealistically titled, anyway) study of Southwestern canyon country called *I Found Myself in the Bottom of the Sea, an Ancient, a Dry Sea,* that indicate other diversions. (It may be needless to point out that the spectacular rock outcrops of the Southwest are probably the result of prehistoric marine erosion.)

The main line of Albright's output, though, is, as I have said, contained in the series of studies of men or women, usually seen individually and portrayed at their lowest point of existence, morally and physically. These are typified by such pieces as the early (1928) torso of a woman called *Flesh* and an equally deliquescent full-length nude, *Three Love Birds,* as well as by *The Farmer's Kitchen,* with its insistence on the hairy sproutings on the chin of the poor farmer's wife, and the rather grandiosely titled study of a broken-down prostitute called *Into the World There Came a Soul Called Ida.* Upon reflection, I feel that my main objection to them is that the attitude, despite the feelingful titles Albright often indulges in, is far from being compassionate or understanding; instead, it is generally a bit prissy, distant (even his close attention to detail argues a certain clinical detachment), and totally unsympathetic. Anyone who used to get around Third Avenue and its now vanishing old-time bars must remember a photograph—used to advertise some brand of beer or ale—of a cheerfully unregenerate, stubble-chinned barfly and boozer happily hoisting a stein of beer to his lips. The photograph, it seems to me now, had more true art, in the sense of understanding and sympathy, than such chill studies of Albright's as the pompously titled portrait of another such bum called *And God Created Man in His Own Image.* (pp. 128-30)

> Robert M. Coates, "Chaos," in The New Yorker, *Vol. XL, No. 52, February 13, 1965, pp. 128ff.*

Margarita Walker Dulac　(essay date 1966)

[*In the following excerpt, Dulac traces the development of Albright's style from 1927.*]

Starting with the *Lineman* (1927), [Albright's] style has developed from one of broadly brushed realism into increasingly minute investigation of detail. At all times, his style is uniquely his own. The content of his paintings reminds one of Faulkner, or Edgar Allan Poe. His paintings show an inverted, hawk-eyed, self-inspecting, tortured mind. He has a nightmare power in him.

From the very first, he has kept his own vision, gone his own hard way in an age when frenzied artists try to electri-

fy the public with all kinds of trapeze stunts and plastic acrobatics. The change in his style has been in an ever-increasing passion for elaborately designed surfaces and an extensive distortion of space and perspective to express objects in conflict with each other in space—proof of his extremely complex mind and personality.

In the *Lineman; Flesh; Woman; Into the World Came a Soul Called Ida; Among Those Left; Heavy the Oar to Him Who is Tired, Heavy the Boat, Heavy the Sea; God Created Man in His Own Image;* and *I Walk To and Fro through Civilization and I Talk as I Walk (Follow Me),* all very large paintings, Albright has created a series of psychological portraits, a *Comedie Humaine* which would do credit to a Balzac. His style, with its extremes of light and dark, his powerful sense of form that molds the figures as if cast in bronze, is well suited to convey the psychological tension, the terror, and the insolubility of the problems of the *Age of Anxiety.*

In spite of the long list of huge, monumentally conceived portraits, it is, perhaps, in his still life paintings he comes closest to what he wants to express. "Whenever possible," he told Katharine Kuh, "I like to create a feeling of the unknown."

The sense of mystery first appears in the still life, *Wherefore, Now Ariseth the Illusion of the Third Dimension* (1931). Here, in a topside view of fruit in a compote, and other objects seen from every viewpoint, time-point, and motion-point, there is an ever-increasing preoccupation with the terrifying isolation of objects in space, a desire to see these withered lemons, apples, and other things struggle against their allotted space. The colors in this still life, with their vibrant yellows, morbid purplish-reds, resonant blues, the delicate spray of lace on the table, stress the musical arrangement of objects on the table.

A deeper, bassoon-like note of dread is sounded in the *Door,* later to be enigmatically entitled *That Which I Should Have Done I Did Not Do.* This is one of the most carefully painted and designed paintings in the history of American art. In January, 1942, the *Door* won the Temple Gold Medal at the Pennsylvania Academy, and in December, 1942 it was awarded the first medal for the best picture in the exhibition at the Artists for Victory Exhibition in the Metropolitan Museum of Art. The center of the design is a funeral wreath of calla lilies, roses, and lilies-of-the-valley, delicately painted, whose circular form tempers the severity of the tall rectangle of the door. Distorted, the lines of the door curve inward to make the door look taller, more awesome. The gray-blue-green color scheme, lit here and there with faded pinks and reds, shades of the patina of bronze, as well as the innumerable grafitti, knife-marks, patches of peeling paint, give a feeling of finality and doom to the picture. A woman's hand, cuffed in the lace of the early 1900's, holding a lace handkerchief and a spray of lilies-of-the-valley, suggests vanished tenderness. It is a threnody, celebrating death and mortality.

The next still life, *Poor Room,—There Is No Time, No End, No Today, No Yesterday, No Tomorrow, Only the Forever, and Forever, and Forever Without End* is Al-

bright's plastic equivalent of James Joyce's *Ulysses,* or the distillation of a lifetime in twenty-four hours of a painter's day. Better than words, its plastic symbols convey the tragic sense of frustrated life. Seen through the ground-floor window of a dismal shack, its casement infested with wasps' nests, a mouse's nest, termite-eaten, crackling with dry-rot, is a room in the most fantastic disorder. A Victorian chair lunges forward head-on into a Regency chest whose drawers spill out old clothes. An oil lamp, the psychological crux of the composition, is about to fall and ignite the chaos within. In the background, coruscatingly dry, is an ancient feminine hat hanging nonchalantly on a Victorian still life. On the floor are a woman's girdle, three coke bottles (the extreme of careless indifference), a withered bouquet, a broken teapot. A woman's hand, with wounds in it (intravenous feeding?), swathed delicately in pearls and lace, rests on the window sill—a final benediction. The whole, painted in Albright's most minute desiccated style, looks, in reproduction, as detailed as a Dürer engraving.

Here we see the artist's style pushed to its logical conclusion: a deep opening in space wrenched open like a psychic wound, and objects which have some deep meaning for the artist whirled around in a sort of personal inferno.

The artist is no mere realist, but a moralist and mystic, all the more conscious, like John Donne, of life because of its fragility and the shadowplay of death behind the scene. He has brought supernatural life to objects we have always seen, but never understood. He has symphonized a planetary system of his own, which we can view or not, just as we choose. He is a metaphysical painter. He reminds me of a passage from the letters of William Blake: "Nothing can withstand the fury of my course among the Sons of God." (pp. 73-6)

Margarita Walker Dulac, "Ivan Albright: Mystic-Realist," in American Artist, Vol. 30, No. 1, January, 1966, pp. 32-7ff.

Katharine Kuh (essay date 1967)

[Kuh is an American curator, lecturer, and critic. In the following essay, originally published in the Saturday Review *in 1967, she recalls a visit to Albright in Vermont and discusses his artistic principles.]*

Nodding, joking, rushing, jerking, Ivan Albright piloted me through his new house in Woodstock, Vermont, or more correctly his two houses, one for children, grandchildren, and guests, the other chiefly for his wife and himself. In contrast to Chicago's Near North Side, where until recently the Albrights lived, this romantic and elegant colonial setting gives the lie to any further theory that the painter is a Midwestern-oriented artist. For years I thought so, but I was wrong. Nothing in his work has changed. The same pulverized, uncompromising images emerge from Vermont as came out of Chicago. A serene New England landscape threaded by the lovely Ottauquechee River affects him no more than did the bleak sprawl of an industrialized city.

Curiously, this man, who is obsessively immersed in his

own painting and who apparently is uninfluenced by any contemporary movements, does not include even one of his works in either house, though both are filled with art from all periods. To see what he is doing, one must go to the studio, an authentic Albright landmark meticulously tailored to his specific needs. And his needs are not simple. For this painter who appears the very incarnation of nervous tension is perhaps the most patient, painstaking artist alive today. In his work nothing happens by chance. Each detail is planned, studied, and researched in depth. Even that tireless prober Edwin Dickinson has never devoted twenty-four years to one composition, as Albright did with *The Window.*

And speaking of windows, in the new studio there are several which were specially designed so that, inch by inch, separate glass sections can be regulated to control the light. Albright dislikes bright light or, for that matter, any kind of cheerful, flat sunlight. He prefers cloudy, gray skies that allow brooding shadows to define form and yet suggest the unknown.

Despite his mercilessly detailed technique, one must not suppose that Albright is interested in the object per se. True, he stages elaborate setups for his compositions, going as far as to reproduce a drab wall, brick by brick, or to tear and resew a worn velveteen sleeve until each wrinkle has the desired consistency. But these visual facts are merely the raw material he manipulates and transforms. He is, paradoxically, an abstract artist who deals

Ivan Le Lorraine Albright, American, 1897-1983, Poor Room, *oil on canvas, 1931-43, 121.9 × 94 cm, Gift of Ivan Albright, 1977.35*

with reality only to destroy it by bending all images to his unique metaphysical bias. Projecting his own kind of ambiguous space, his own labyrinthine perspective, his own irrational light, he creates a jungle of insecurity.

Albright's methods, which at first glance appear literal, are in fact the reverse. He paints solely what he thinks, sometimes what he wants, but never what he sees. What he sees acts only as his point of departure. Attracted by the perversities of life, he infuses the commonplace with deceptive allusions. He once observed, "I like to see dust move and crawl over an object like a film" [see Artist's Statements]. And, to be sure, his paintings have the touch of dusty death. But he is not concerned alone with dissolution. "Let's say I'm equally interested in growth and death. How can you divide them?"

Albright looks on the human body as man's tomb. "Without eyes the light would not hurt; without flesh the pain would not hurt; without legs our motion might accelerate. Without a body we might be men," he says. At best, he transcends human limitations by imperiously disregarding the laws of nature. He shows us human flesh, no matter how young, and inanimate objects, no matter how new, in a relentless journey toward extinction. He claims that when the artist moves, all things move with him. "If I stir, they stir. If I stand arrested, they become motionless." In short, he is the total impresario—to such an extreme that he prefers smooth board to canvas. Not wishing to fight the texture of woven cloth, he wants to weave his own painting. In an interview several years ago, Albright confessed, "I hope to control the observer, to make him move and think the way I want him to. . . . I want to jar the observer into thinking—I want to make him uncomfortable."

Working intensively for some three hours each day, he stops as soon as the painting "begins to look good." At that point he finds his critical faculties becoming blunted. More than any other artist I recall, he can appraise his own work with unflinching objectivity. He knows his strengths; he knows his weaknesses. For him, his two top paintings are *The Door* and *The Window.* He spent long years on both, planning them in excruciating detail with endless preliminary drawings, notes, written directions, and three-dimensional setups. Conflict and turmoil distinguish every inch of the two compositions. Warring forces tip, tilt, slant, invert, twist, and foreshorten each object until the eye reels and the object, ceasing to be itself, takes on hallucinatory overtones. At the same time, the compositions, like tangled quagmires, dispense with ordinary boundaries. Sometimes it is virtually impossible to separate top from bottom or inside from outside in an Albright painting.

And that is precisely what he wants—to confuse and shock, to force re-evaluations. In a notebook of working directions for *The Window* he wrote, "Make the painting more accurate and more accurate and more accurate." But his idea of accuracy was less a realistic than a compulsive one. *The Window* for him was an experience to be seen simultaneously from outside and inside. He tells himself to "make a view of the window as if a man is walking by it." Then, in the next sentence, he demands that each ob-

ject be seen from the inside in multiple combined positions. For only thus does Albright believe that simulated motion can be achieved—not as a finite action but as a creative transmutation. With unorthodox freedom, he defines motion as the third dimension. Relying on physical findings for purely psychic effects, he has developed a kind of simultaneous vision that is a far remove from the structural emphasis of Cubism.

Albright claims that art concepts like motion, space, color, and form are all invented by man, and that without man they cease to exist. Though a door is not curved, if the mind envisions it that way, it is curved. Hence, he painted his famous *Door* as a slightly convex door-coffin combination. With the same speculative drive he questions the role of color, asking himself, "What is the nature of color anyway? Does it build up—does it add strength—does it add softness—what does it do? Why does a certain object have a definite color? Take all the color away from it—then put it back. What is the significance of its color?" The answer "is not in the eye, nor in reason." He implies that it comes only from one's own sensibility, one's cumulative experience. Just as the real transforms itself into the abstract for him, so dark and light merge. "Put everything in total darkness and you see nothing. Put everything in brilliant light and you see nothing." If Albright has a leitmotif it stems from his conviction that no single fact is as it seems.

In his youth, this artist, who was born in 1897, headed toward architecture but shifted to art after two years as a medical draftsman in World War I. The early surgical watercolors and drawings done rapidly on the spot in French base hospitals may seem antipathetic to Albright's subsequent mature style, partly because of the spontaneity with which they were executed, partly because they turned brutal wounds into the equivalents of growing plants. Instead of the dusty, almost dead plum color that characterizes so much of the later work ("maybe because I'm gloomy") we find here a veritable rainbow of iridescent hues. And yet there is continuity, for already the artist was rearranging nature to fit his needs. As later he was to invest the healthy with encroaching decay, so now in a world of death he made death live. These sketches remain an unforgettable indictment of war, both as documents and as exotic comments on the profligate destruction of the young.

One of my reasons for going to Vermont was to see a new painting Albright had started the previous fall. Already a year old, it would, he felt, require at least another five or six years to complete. Realizing that time can subvert the best-laid plans, he never names a work until it is finished. The new one is temporarily called *The Vermonter.* Except for two portraits (of his late father-in-law, Captain Joseph Medill Patterson, and of Mary Block) this is the artist's first figure painting in thirty-five years. The subject is a man in his middle seventies who comes regularly to the studio for long hours each week. Between visits, a dummy carefully constructed by Albright suffices, but for head, hands, and body articulation the sitter is indispensable. According to Albright he chose a model "who has lived and who feels as tired as I do." Could it be the artist paints himself as well as his sitter?

Tacked up on the studio wall is a crude chart with meaning for no one but the painter. Words and brief lines, both frequently crossed out or altered, act as directives. By the time the painting is finished, it is unlikely that any of the guideposts will remain as originally conceived. Nearby on an easel stands a "static drawing"—at least so Albright describes it. For me, it was neither a drawing nor static, but a superb charcoal, white chalk, and black pastel portrait on canvas. Albright considers it static only because it is closer to nature, to what one sees, than to the secret turbulence he feels invests all life. The background is naturalistic, the figure direct, three-dimensional, and harmonious.

And this is exactly what Albright does not want in the final composition. Relentlessly priming and questioning himself in his notebook, he suggests "moving model so light falls strongest on shoulder—then moving it back so light is stronger on face." Thus he makes his own arbitrary light. Next he directs himself to "put stubble of beard on pulsating flesh" and "have end of nose literally wriggle." Now he wants the cap to turn sharply in one direction, the head to turn in the opposite direction, as if the figure were caught in conflicting forces.

Even a modest silverpoint drawing of a bridge becomes the occasion for an entire book of sketches and notes. "Have bridge angle more than it does. Force more interesting rocks into view. Change their position and arrange them in stream so they make flow of water more rapid." The word is always "more," for Albright does not hold with the modern philosophy that less makes more. He deliberately exaggerates the multiplicity of life. Turner, it is said, was less interested in imitating nature than improving on it. Albright, I would guess, feels otherwise. He, too, changes nature, not to improve it, but to energize it with new meaning.

Except for Paul Klee, no modern artist has so frankly employed titles to underline the meaning of his work. What could be more evocative of guilt than the real name of *The Door: That Which I Should Have Done I Did Not Do?* Whether we see here a closed coffin lid, a closed door, or both, the same finality is implied. And, of course, *The Window* eventually became *Poor Room—There Is No Time, No End, No Today, No Yesterday, No Tomorrow, Only the Forever, and Forever, and Forever, Without End,* a title that might seem corny if it accompanied any other painting. A half-nude man in a bowler viewed against shabby furniture under a naked light bulb is called *And God Created Man in His Own Image (Room 203).* The title echoes the compassion implicit in the picture. In most of Albright's work, compassion plays a central role. The artist sympathizes with the human predicament he lays bare.

If the titles have poetic overtones, this is hardly surprising, for Albright has long written verse as "a rest or reaction from painting," and, also, perhaps, as a way of exploring his attitudes toward art. In a poem about a painter, he observes, "And the sky is not blue to him. . . . And the river is not held within its banks. . . . And the tree is not a tree to him. . . . And colors are not just colors to him. . . . " (pp. 3-10)

Katharine Kuh, "Ivan Albright," in her The Open Eye: In Pursuit of Art, Harper & Row, Publishers, 1971, pp. 3-10.

FURTHER READING

I. Interviews

Kuh, Katharine. "Ivan Albright." In her *The Artist's Voice: Talks with Seventeen Artists,* pp. 23-37. New York: Harper and Row, 1960.

> Conversation with Albright covering his philosophy and methods. Asked if he only paints from models, Albright replies, "Yes . . . because even when you don't, you're still depending on recollected models whether you know it or not."

II. Critical Studies and Reviews

Barker, Virgil. "An Imagery of Ultimates." In his *From Realism to Reality in Recent American Painting,* pp. 70-7. Lincoln: University of Nebraska Press, 1959.

> Attributes the fascination of Albright's paintings to "the fact that the painter's intense emotion seems buried so deep below the surface of his litany of the doom of being a human being."

Bonesteel, Michael. "In a Museum of Mirrors." *Art in America* 72, No. 11 (December 1984): 142-47.

> Discusses a series of self-portraits done by Albright shortly before his death.

Calvocoressi, Richard. "The Vanity of It All." *The Times Literary Supplement,* No. 4104 (27 November 1981): 1389.

> Review of Michael Croydon's monograph of Albright (cited below), acknowledging the painstaking technique of Albright's paintings but viewing them as unnecessarily exaggerated and moralizing.

"Among Those Left." Carnegie Magazine XXIV, No. 6 (June 1950): 384-85.

> Commemorates Carnegie Institute's acquisition of *Among Those Left* (also titled *The Blacksmith* and *The Wheelwright*).

Frankenstein, Alfred. "A Modern Moralist." *Art News* 78, No. 2 (February 1979): 32.

> Review of Michael Croydon's monograph on Albright, noting an ironic contrast in "an immensely rich man whose major work has to do with degradation, misery and decay, and whose still lifes are as macabre as his studies of the bruised, varicosed flesh of the human derelict in his picture entitled *And God Created Man in His Own Image*."

Kind, Joshua. "Albright: Humanist of Decay." *Art News* 63, No. 7 (November 1964): 43-5, 68-70.

> Asserts that Albright's paintings have a moral relevance to their age, stating, "The strength of this Midwest expression no doubt lies in its acceptance of the human condition, its unflinching vision of humanity's inevitable despair."

Lyon, Christopher. " 'Synthetic Realism': Albright, Golub, Paschke." *Art Journal* 45, No. 4 (Winter 1985): 330-34.

> Categorizes Albright, with two other Chicago painters, Leon Golub and Ed Paschke, as believers "in the 'legibility' . . . of an essentially two dimensional surface reality."

Pearson, Ralph M. "Ivan Le Lorraine Albright." In his *The Modern Renaissance in American Art,* pp. 235-41. New York: Harper, 1954.

> Enthusiastic assessment of Albright's painting: "Here is a painter performing a super-representation of surface with consummate skill, yet he attains a realism that can almost be called the opposite of naturalism. His exploited surface seems to reveal character down, in, and through."

Pollack, Peter. "The Lithographs of Ivan Albright." *The American Art Journal* 8, No. 1 (May 1976): 99-104.

> Compares Albright's lithographs to his paintings.

Robb, Marilyn. "Ivan Le Lorraine Albright Paints a Picture." *Art News* 49, No. 4 (June 1950): 44-7.

> Focuses on the preparation for and creation of *Poor Room—There Is No Time, No End, No Today, No Yesterday, No Tomorrow, Only the Forever, and Forever and Forever Without End.*

Sill, Gertrude Grace. "The Face in the Mirror." *Connoisseur* 216 (July 1986): 50-7.

> Brief study of *Self-Portrait at 55 East Division Street.*

Teller, Susan Pirpiris. "The Prints of Ivan Albright." *Print Review* 10 (1979): 21-35.

> Describes Albright's twenty-one prints, commenting on their composition and themes.

"Not Nice, but Unique." *Time* LXIV, No. 6 (9 August 1954): 56-7.

> Profiles Albright and quotes him as saying, "I just can't seem to paint nice things. . . . I've tried, but it doesn't work. Once I designed a Christmas card and got a prize for it but no royalties. I think the only copies sold were those I bought myself. It was a stained glass window—very dirty and dusty. Looked like a funeral. Say, do you think I'm crazy?"

Van Der Marck, Jan. "Ivan Albright: More Than Meets the Eye." *Art in America* 65, No. 6 (November-December 1977): 92-9.

> Profiles Albright and discusses his paintings, comparing his methods to the artists Albrecht Dürer and Paul Cézanne and his themes to Chicago writers such as Studs Terkel and Saul Bellow.

III. Selected Sources of Reproductions

Croydon, Michael. *Ivan Albright.* New York: Abbeville Press, 1978, 308 p.

> Most comprehensive monograph. Includes numerous large-format color reproductions.

Charles Burchfield
1893-1967

American painter and graphic artist.

Burchfield was an American painter known for his highly individualized approach to art and his conscious rejection of Modernist aesthetics. His works, primarily in watercolor, indicate three distinct phases in his career: the imaginative fantasy paintings of nature and rural scenery produced during his early years; the more realistic cityscapes of the 1920s and 1930s; and his later paintings, which combine aspects of each of his earlier styles and culminate in a series of vivid expressionist landscapes which many critics consider his best work. Although Burchfield successfully employed varying styles, his works are unified by their consistent expression of what Edward Hopper referred to as "nature's unlimited physical moods and changes."

Burchfield was born in Ashtabula, Ohio. After his father's death in 1898, his family moved to Salem, Ohio, where his eldest brother supported them in a small house purchased by two of their uncles. Sensitive and introverted, Burchfield found solace in the delights of nature, and spent much of his time, when not reading or drawing, studying plants and animals in the woods around his home. Burchfield graduated from high school as class valedictorian in 1911, winning a $120 scholarship. He entered the Cleve-

land School of Art the following year, with plans to become an illustrator. Upon graduation in 1916 he received a scholarship to attend the National Academy of Design in New York City, but, after attending one class there, decided further training would be of little benefit to him. He remained in New York for several weeks while his paintings were exhibited in a local bookstore, proceeds from the sale of his works there earning him train fare home. Returning to a former employer, Burchfield accepted a position as an accountant, sketching and painting prolifically in his spare time. His works produced during the next eighteen months are highly regarded. Consisting largely of landscapes based on childhood memories and fantasies, these paintings use simplified shapes and linear distortion to convey Burchfield's perception of the sounds and moods of nature, as well as the emotions of joy and terror which they evoke in the mind of a child. Burchfield later described 1917 as "the golden year" of his career.

After serving in the army from July 1918 to January 1919 Burchfield again returned to Salem. Initial attempts to resume his nature studies frustrated him, and he suffered a brief period of depression. Later in 1919 Burchfield was given a copy of Sherwood Anderson's *Winesburg, Ohio*. Impressed with Anderson's forthright depiction of the

human condition and his careful descriptions of mood and setting, especially with regard to commonplace subjects, Burchfield began painting familiar scenery in and around his hometown. In 1921, Burchfield lost his job when his employers experienced financial difficulties. He obtained a job designing wallpaper for a firm in Buffalo that same year, and was married the following spring. By 1925 the Burchfields had moved into a home in the Buffalo suburb of Gardenville. The streets and buildings of Buffalo and its suburbs now became the focus of Burchfield's art; initially somewhat fanciful and comically satirical, his urban paintings became increasingly more sober as his art reflected the gravity of the early years of the Great Depression. Later describing his grim cityscapes, Burchfield wrote: "If I presented them in all their garish and crude primitiveness and unlovely decay, it was merely through a desire to be honest about them." Matthew Baigell, however, has noted the romantic sentiment permeating these works: "If these scenes speak of a great sorrow on the land, they also allude to the resilience of the people who lived on it. . . . They seem symbolic of the indestructibility of man, a revelation of his dignity."

The onset of World War II marked the beginning of a shift in Burchfield's style and subject matter. Unwilling to paint scenes of war (which he described as "songs of hate and pessimism"), yet no longer able to find satisfaction studying local scenery during a time of international strife, he turned his attention once again to nature and fantasy, for which he had become increasingly nostalgic. Reworking or completing several of his early paintings in 1943, Burchfield concluded the following year: "To me now, the 1920-1940 period (roughly speaking) has been a digression, a necessary one, but not truly in the main stream that I feel I am destined to travel. . . . During that middle period I was searching for an appreciation of form and solidity and a painting quality that the 1917 things lacked. Now, it seems to me, I am in danger of painting too realistically, and must try to recapture the first imaginative and romantic outlook, and even go beyond the scope of that period."

Initial critical response to Burchfield's sudden shift away from urban realism was negative, and sales of his paintings slumped badly in the years immediately following the end of the war. But Burchfield persisted, and critics are now virtually unanimous in declaring the works of his later years to be his finest. One of his best works of this later period, *Sun and Rocks* (1950), is described by John I. H. Baur as "one of the most original romantic paintings of our day." Baur continues: "It is painted with all the solidity and vigor so patiently acquired in those long middle years, now perfectly fused with the fervor, the poetry and fantasy of Burchfield's youth." Burchfield's paintings grew increasingly more fanciful in these last years and profited greatly from the refinements in his technique that resulted from the more disciplined realism of his cityscapes. These later fantasies were thus considered mystical rather than whimsical in their depiction of landscape, evoking the passion and ecstasy of the natural world in all of its variety. Exemplifying the perpetual freshness of his vision, Burchfield's *Orion in Winter* (1962) and *Dandelion*

Seed Heads and the Moon (1961-65), completed in the last years of his life, are considered two of his finest paintings.

Burchfield is widely considered a forerunner of the American Scene movement, which sought to define a nationalist American art through naturalistic depiction of American life and landscape. He is also often linked to the Regionalist painters Thomas Hart Benton, Grant Wood, and John Steuart Curry, who celebrated rural America in a style of modified realism. However, Burchfield denied any affiliation with the objectives or achievements of these groups. Instead, his paintings merely reflect his personal responses to the scenery portrayed: "While I feel strongly the personality of a given scene, its genius loci, as it were, my chief aim in painting is the expression of a completely personal mood." The vivid eloquence with which Burchfield has achieved this aim led Baur to conclude that "it is as a profoundly Romantic celebrant of nature that Burchfield must finally be judged."

ARTIST'S STATEMENTS

Charles Burchfield (essay date 1965)

[*In the following excerpt, Burchfield discusses his approach to drawing and describes his method of composition.*]

One of the greatest joys of an artist's working life is producing drawings, probably because he enjoys greater freedom in drawing than he does in what he considers his major work. For painting a picture is not an experience of unalloyed joy. There is pleasure indeed in reveling in the dream or vision the artist has before hand, then the good feeling of accomplishment if he can bring the vision to fruition—that is, if he has said what he had to say in a seemingly unlabored and workmanlike manner. But in between these pleasures, a continuous battle is going on, wherein short advances are followed by regressions, and work seems to be progressing in the manner of a sailboat tacking against the wind. There are periods of complete frustration when work comes to a standstill and the artist becomes a slave to his undertaking, from which there seems to be no escape.

Henry Keller once said to me that once you have launched a picture you have to go through with it, no matter how much you have come to despise what you are doing or to wish that you had never started it. You simply cannot endure the dishonor of giving up.

With drawings, however, it is entirely different. Not too much is at stake. If you make a bad or indifferent drawing, it is tossed aside, and you proceed to do another one. Literally thousands of drawings may accumulate through the years, and it goes without saying that most of these are too trivial to be called works of art. But there is no feeling of wasted time or effort connected with the drawings, and therefore the artist has much more freedom in doing them.

Sometimes, quite unexpectedly, a good drawing comes into being.

I have sometimes thought of drawings as the equivalent of chamber music in the work of a composer, because they seem to reveal a more intimate insight into the artist's inner life, just as chamber music is said to do for a composer. Perhaps the analogy is not very apt after all, for a composer has to put as much thought and labor into a string quartet as he has to put into a symphony. It would be better to compare an artist in the act of drawing to a composer sitting at the piano and playing whatever unpremeditated musical thoughts come to mind. What I am trying to say, though not too well, I am afraid, is that the best drawing is nearly always a by-product, not a direct intention. If an artist sets out to make a drawing as an "art" product, dryness and self-consciousness are the result, at least as far as I am concerned. Better for him to let the pencil take the lead while he thinks.

There are many ways that a drawing can come into being. For example, I may be working on a picture that has difficult compositional problems. So I begin making drawings of all the variations or improvements I can think of. This may go on all day, sometimes even into the night, forcing me to get out of bed to put down thoughts that otherwise would be gone forever by morning. In this process of trying to solve the problem, a whole set of drawings may be the result, some of them good enough to stand alone as works of art and altogether different from the finished painting.

Jotting down ideas for a painting—"idea notes," as I label them—is another fruitful source for drawings. This is a happy exercise, for there is little at stake. One drawing after another is made, and it does not matter whether the results amount to anything. The artist keeps on making drawings until he has temporarily exhausted the idea. They are then put away in portfolios to "season," to be taken out later and savored somewhat in the way new wine is savored that has been put away for the same reason—because it is too raw to be palatable.

Another fruitful source for drawings occurs when an artist is looking simply for information about things he may need in a picture: how a branch joins a tree trunk; the form the foliage of various trees takes; how fields fit into groves or woods; or the various forms of clouds. All of these must be drawn beforehand so that the artist will have a complete knowledge of them before a painting is begun. Before he realizes it, his interest grows, and in the end the artist has expanded his information-seeking into finished drawings.

When I am doing a painting out of doors, I usually jot down on sketch paper the idea, or trial composition, to avoid too many changes in the course of the painting. Even these drawings, though fragmentary, may have an independent value as minor works of art.

Not all drawings, it must be admitted, have a utilitarian origin. For example, another series of drawings might originate from the completion of a painting that has been a long and difficult struggle. This form of origin is fraught with the greatest happiness. The artist is emotionally ex-

hausted; he cannot begin a new work, so how can he fill the aching void? Or, to put it another way, how can he continue his creative life? For me, the most satisfying way is to make studies of some form of plant life or other objects, an exercise in which the sole purpose is to draw for drawing's sake—drawing for pure pleasure. No erasures or corrections are permitted either during or after the performance. One must hold the instrument for drawing—whether crayon, pencil, or charcoal—as lightly yet as firmly as one can, sometimes with the least possible pressure, or again, bearing down as hard as possible, perhaps both during the execution of one line.

In a drawing session of this sort, there must be a warming-up period. The first few drawings may be halting or stilted, not getting into the heart of the subject. All at once, everything begins to click, and one drawing after another may come about as if under its own power. I must confess, I love this kind of drawing in the same way as I did some of my paintings, which also seemed to have originated spontaneously. While I am engaged in producing drawings of this sort, a wonderful sense of well-being and contentment comes over me, the feeling that no other activity could possibly be as fulfilling as my reason for being alive.

Sometimes, when I study a picture in progress, the need for changes becomes apparent, but I do not feel completely sure of the need or perhaps do not feel capable of making the correction at the time. So drawings are made as reminders for later consideration.

Again, it is amusing to make a drawing or drawings of a finished picture. This might be called the post-mortem of an event, or a checking out. Such a drawing might turn out to have a value in its own right, or such a procedure might lead to a series of variations on the painting theme.

I have already mentioned "idea notes." These are the most casual and fragmentary of drawings. They may be merely motifs, such as the song of a bird, heat, wind, or cold, even the adaptation of a doodle as an abstract motif. I have hundreds of such notes filed away under seasonal headings, with subheadings such as mood, wind, fantasy, and weather.

Finally, it occurs to me that even doodles may be referred to as drawings of a sort. In my case, doodling is a free exercise in abstraction, unpremeditated, and not a conscious expression, since it is done at the time of some other activity. It seems to me I have doodled all my life. I recall doodling on my mother's Sunday tablecloth before I was of grade-school age. Perhaps I was born with a doodle pencil in my hand, the left one, in the same manner that a fortunate person is said to be born with a silver spoon in his mouth. Even while making a serious drawing it is almost impossible for me to avoid doodling on the drawing at intervals.

It should not be assumed that doodling has no value. True, most doodles are trivial and meaningless, or, worst of all, boringly repetitive. Nevertheless, doodling is a form of subconscious thinking expressed visually, and some of my most useful abstract motifs come from such seemingly idle diversions. In another sense, doodling also serves as a

means of keeping the hands and fingers limber for more serious work.

So it can be seen that, with one notable exception, I seldom set out to do a drawing as a drawing; rather it is a by-product of some other purpose. A good drawing should be a spontaneous creation, not a carefully planned and studied exercise. (pp. 7-8)

Charles Burchfield, in The Drawings of Charles Burchfield, *edited by Edith H. Jones, Frederick A. Praeger, Publishers, 1968, 110 p.*

INTRODUCTORY OVERVIEW

Joseph S. Trovato (essay date 1970)

[*In the following excerpt, Trovato presents an overview of Burchfield's works.*]

While Charles Burchfield was still living I considered him to be one of America's great artists of the twentieth century working in the tradition of Homer and Eakins—a tradition characterized by the highly individual nature of their work. The work of Homer and Eakins is as unique in relation to their nineteenth-century contemporaries as Burchfield's is in relation to the artists of his time. My attitude toward his importance has been strengthened as the full range of his abundant production unfolds.

Just as Homer has given us an authentic visual record of the feel and mood of the sea, and Eakins a truthful analysis of human character, Burchfield has given us an equally authentic and highly personal record of another aspect of nature—its varying light and moods, the effects of the seasons on woods and fields, all of which call attention to its wonders. Like Homer and Eakins, Burchfield drew his subjects from his observations and reactions to the things immediately about him. These artists sought neither the exotic nor the impressive, but were content—and compelled—to express the endless possibilities of their chosen aspects of nature.

Burchfield's development as an artist in twentieth-century America is fascinating. Instead of the usual pattern of influences and interests that have shaped most of the American artists of our time, for Burchfield it was:

> The expression of ideas such as the visualization of sounds and recollections of childhood rather than the practice of the then current stylistic innovations of modern art.
>
> Chinese painting rather than the School of Paris.
>
> Aubrey Beardsley rather than the Impressionists.
>
> Salem, Ohio, rather than Pompeii.
>
> Sinclair Lewis's *Main Street* and Willa Cather's *My Antonia.*

> Tolstoy and Gorky.
>
> Beethoven and Sibelius and the elemental landscape.

Burchfield valued his childhood impressions—he called them "childhood moods"—which are recorded in notebooks and in paintings such as ***Childhood's Garden,*** 1917 and ***The Night Wind,*** 1918. The artist said, "Most adults spurn the things of their childhood and consider the yearning for such things in a grown man as a weakness. Perhaps it is, but it is still my belief that it is of such stuff that real art is made. As an artist grows older he has to fight disillusionment, and learn to establish the same relation to nature as an adult as he had when a child—it will not be like it, but the ratio of emotion will be the same."

Burchfield's early pictures convey an openly joyous, unrestrained reaction to nature which is childlike in its freshness of outlook and spontaneous execution. He managed to sustain this freshness of outlook, gained through his youthful rambles in and recordings of Post's Woods and Salem, impressions that enabled him to grow and develop to the very last. This capacity is the source of his originality. The portrayal of childhood emotions as seen in his interpretations of the nature of the world are indicative of the nature of the man.

Burchfield's early pictures and writings reveal clearly that the painting concepts which engrossed him in his last years were basically the same as those of his youth. While still a student at the Cleveland School of Art he outlined for himself the pictorial ideas with which he would be concerned for the rest of his life. He set out to develop graphic symbols of nature—light, wind, insect sounds, clouds and trees—which he abstracted from his constant observations. (This continuing discipline culminated in his remarkable ability to translate the complex ideas of his late work into visual statements of great power and beauty.)

Because his ideas crystallized early he kept on working in his own way. While thus occupied he was not affected by the developments in Europe introduced to America by the Armory Show, which influenced so many of his contemporaries. Even when he went to study at the National Academy of Design he was seemingly untouched by the contemporary New York art scene. Indeed, he was so homesick for the sights of Salem, Ohio, his childhood home, that he returned there after only two months in New York.

It was during his Salem days that he was most productive. From 1915 to 1920 he did almost half of his total number of paintings—the best of which are among the most original achievements in American art. Many of these early pictures, for all their originality of expression and sparkling color, are in the nature of sketches, done rapidly on week-end excursions, in the evenings, and even during lunch hours. However, the full realization of the ideas contained in these early works had to await his maturity.

Writers on Burchfield, as well as the artist himself, have divided his work into three periods: the early romantic phase from 1915 to 1920; the middle realist period of the 20's and 30's; and the late period combining the motives and styles of the preceding two. The works of the 1920's

Burchfield, Charles. The Night Wind. *1918. Watercolor and Gouache on paper, 21 ½ × 21 ⅞". Collection, The Museum of Modern Art, New York. Gift of A. Conger Goodyear.*

and 1930's are characterized by a greater interest in realism—an interest which, according to the artist, had already begun to show itself in earlier work. Burchfield said, "I think my first period would be said to end in 1918—tho of course there is not a clear-cut division. But it was early in 1918 I started painting houses, stores, railroads, etc. There were throw-backs, that year to the earlier mood, but there always will be." Such works as **Black Houses,** 1918, **Freight Cars,** 1919, and **February Thaw,** 1920, are outstanding examples of this new subject matter. Fuller exploration of such subjects was continued when in 1921 he moved to Buffalo, where he discovered exciting material in the city streets, harbor, railroad yards, and surrounding countryside.

If the 20's heralded a new direction in his painting, it also marked the beginning of a new life: in Buffalo he began a new job, married, and started raising a family. This was a period of adjustment not only in his personal life, but in his painting as well. Speaking of his influences of that time, the artist said,

> It was then that I fell under the charm of the realistic American Scene writers of that era, Willa Cather, Zona Gale, and Sinclair Lewis. Their

group purpose seemed to be to show the pettiness of American Midwestern life. It was an exaggerated point of view, but Willa Cather best expressed the epic grandeur of post-pioneer life. My own viewpoint was somewhat different. . . . I was aiming at realism to be sure, but I painted the old buildings, the towns, the houses for their romantic picturesque qualities. For example, the false fronts fascinated me as being uniquely American.

What could be more typical of midwestern towns than **Noonday Heat,** 1921, with its false front buildings, or **Promenade,** 1928, a double portrait, as romantically nostalgic as a daguerreotype, of Victorian houses that characterize upstate New York cities and towns of that era. On the basis of such paintings Burchfield, by the late 1920's, achieved notable recognition. (pp. 7-9)

The realist's approach was but an interlude, perhaps a necessary one, in his persistent striving for excellence—for the realization of his felt emotions in the presence of nature. The pictures of the 20's and early 30's reveal a deliberate effort on the part of the artist to come to grips with the handling of three-dimensional form and mass—for a

richer pictorial effect—a quality not present in the early pictures, for all their freshness of execution and beauty of flat design. He was maturing and more conscious of the tradition of Western painting. He was, at the same time, aware of his growing fame and perhaps self-conscious about the consequent responsibility that this brings. But Burchfield was not satisfied with his realist approach of this period—he felt he was relying too heavily upon studio work instead of fresh impressions of nature. (pp. 9-10)

Burchfield's pictures of the 1930's follow the realist vein that characterizes his work of the 1920's, which is noted for its observation of factual data. *Rainy Night,* 1930, is an exceptionally fine example of this phase—a striking portrayal of buildings on a Buffalo street corner with lighted windows extending their radiance into the pavement below, as is *Pussy Willows,* 1936, a superb study in tonal relations of indoor and outdoor reflected light.

These pictures of the 1920's and 1930's linked him with the Regionalist movement of the period, a tie which Burchfield considered a dubious honor. Writing to Mr. and Mrs. [Edward] Root in 1932, the artist said:

> What do you think of the so-called American Wave? People like yourselves who have always believed in American painting, must feel like chuckling over the sudden discovery that there are artists in America, a little patronage wouldn't come amiss to many worthwhile artists, tho personally I couldn't have complained before the 'wave'—Just so they don't overdo it and I wish they would quit talking about the American Scene. The American scene is no better or worse than other [sic] scene, and the worthwhile artist doesn't care about a subject for its national character. I have been spoken of as one of the exponents of 'American Scenism' which I consider a libel. The scene itself has never been main motive that impelled me to paint.

In the early 1930's he went through a period of self-examination—appraising his work from what he called the "happy days of 1916" to that time. He came to the conclusion that he should produce a great many pictures from which a few good ones would result: "Some artists," he said, "produce their good things slowly and methodically. Mine are best when unpremeditated, almost subconscious. In my productive years, 1916, 1917, 1918 and 1920, I worked in that manner. Much of what I did was chaff, yet the things that clicked I think were better for it, they have a vividness and spontaneity that the more careful learned things of my recent years lack."

Early in 1934, Burchfield began to sense a change coming about in his work. He said, "I am I believe entering fully now upon a third period, I don't know how to describe it; the intense realism of my second period no longer satisfies me, and probably I have done certain subjects for the last time." At this time, he began again to think in terms of his early ideas, but another decade of thought and work would elapse before he could express his early motives enriched by the discipline of the 20's and 30's. For example, such works as *Ice Glare,* 1931-33, *Freight Cars under a Bridge,* 1933, *Six O'Clock,* 1936, have some of the same

clarity and sparkle as his early pictures, but with more robust and richer pictorial qualities—a greater distillation of ideas in terse pictorial terms.

In the early 1940's the artist returned to those early watercolors which he felt were not full realizations of the ideas he wanted to express. *The Song of the Peterbird,* 1918, was a picture which he picked up again for fuller development in 1944 and which became *Sun and Rocks,* completed in 1950. Even while this painting was in process, he began working on a variation inspired by the same subject. Over a period of years, he made many preparatory sketches for it and finally completed it in 1963 as *Solitude.* A comparison of the initial idea contained in *The Song of the Peterbird* with *Sun and Rocks* and *Solitude* illustrates Burchfield's increased power of expression. *The Song of the Peterbird* emphasizes the subject, whereas *Sun and Rocks* and *Solitude* emphasize expression of ideas. In the early picture, the natural formations of rocks, trees and sky are depicted objectively; in the late pictures, although the natural symbolism which to Burchfield was of paramount importance is retained, a lifetime of experience has transformed these elements into pictorial equivalents of great originality and power that are symbolic of natural forces.

Burchfield was a man of many moods ranging from the lighthearted to the despairing which found parallels in the many moods of nature. His translation of mood into painting was an orderly process of controlled thought by an intelligence that strove to encompass, as he stated it, ". . . the secrets of life, nature and the world of the spirit."

In his late works the artist gave free and exuberant rein to the expression of his innermost feelings. Light and mood and movement, the fundamental motives of all his work, link him inexorably with the world about us and at the same time personify the nature of the artist himself. In such paintings as *The Coming of Spring,* 1943, *East Wind and Winter Sun,* 1951, *Dandelion Seed Heads and the Moon,* 1961-1965, we are led to see the unseeable—we are led to sharpen our sensibilities to objects and events in nature that ordinarily go unnoticed—the sense of growing things, patterns of heat waves in July, the intricate wonder of a dandelion seed ball, light entering the woods, minute creatures that inhabit the earth. In such paintings we are made to see and feel those things as he saw and felt them.

The subjects of his pictures are of the commonest sort, but what he made of them is quite something else—whether depicting a lofty pine or a lowly dandelion, in each he emphasized the look and feel of reality rather than the surface appearance. It is this very look and feel of reality about his pictures that is the measure of their power and importance as works of art. These pictures are based on observable facts of nature that are clear to everyone at a glance. But what is not so obvious are the insights revealed and the superb artistry that lie beneath their surface. His best pictures are extraordinary for their sound pictorial construction, use of the watercolor medium, and inventive patterns and shapes. For example, we can all identify with *Midsummer Caprice,* 1945. It is a familiar summer land-

scape—a field with trees and wildflowers under a cloud-studded summer sky. But how it teems with life—the butterfly and the cicada gayly disporting themselves in the hot summer air. Patterns of heat waves drench the scene and we feel the flutter of butterfly wings as well as hear the song of the cicada. Looking at this landscape we feel that if we moved a stone or branch, insects would scurry in all directions. Burchfield conveys a vivid impression, not only of a place, a season, a time of day, but also of the emotions that led him to paint it. And he does this through sheer imaginative choice and translation of natural elements into graphic equivalents of line, shape, form and color. The cicada, butterfly, and thistle are magnified many times their natural size and become the main actors in the scene.

The same sort of deviation in the size of things occurs frequently in his work. In *White Violets and Coal Mine,* 1918, the violets are shown larger than their natural size—and for expressive reasons. In this connection, the artist's sister, Louise, tells of their childhood romps in Salem's Post's Woods looking for spring flowers. The delight of coming upon the white violets gave them a special importance in the mind's eye, which is why he painted them so big.

Burchfield relied heavily upon his contact with a subject before commencing to paint. And sometimes there was quite a long interval between the conception and execution of a work. For example, the actual painting of *Cicada,* 1944, had to await the alighting of a cicada on his shirt front while going to his studio. The idea for the picture had been brewing in his head for quite some time, but it required this fortuitous incident to enable the artist to go out the next day and to paint this picture.

In the following note to Mr. Harold Olmsted, the artist gives further evidence of his reliance on firsthand impressions of nature for the painting of *Oncoming Spring*— a major example of his mature style. It is a realization of his lifelong concern with the motive of changing seasons.

Oncoming Spring (1954)

The idea of expressing the transition of the seasons is one that has occupied me all my life. As far back as 1915 when I was still in Art School, inspired by Chinese scroll paintings, I made many studies of the transition of weather as well as seasons, day to night and vice versa, etc., to be executed much in the manner of the scrolls. Curiously enough none of these were ever carried out—and following the rapid changes we make when young, I soon turned to other ideas and making pictures in the conventional shapes (if not conventional subject matter!)

Recently the idea of transition again cropped up in my mind, only now it was more mature. I concieved [sic] the notion of encompassing two wholly dissimilar themes in one picture—to reduce each of them to abstract motifs (albeit based on natural forms and experiences) and show them interlocking or striving for the mastery. It was an idea not easy to arrive at, and there was a period of five or six years between the first pencil note and the finished picture

which you now own. I did not even choose the time when it should happen. External conditions had to be right of course, and the idea had to be completely germinated in my mind, ready to burst forth. You may recall last year at the end of March, the big snowstorm we had, and then the glorious thaw that followed—At nearly the end of it I went out painting to a woods on the Gowanda-Zoar Valley Rd. which I call the Big Woods (where I have painted most of my wood interiors). All at once everything seemed to crystallize, and I said 'I'm going to paint the 'winter to Spring Transition' today. Hardly had I set up my easel when a thunderstorm came up. I decided nothing was going to stop my painting, and hurriedly got my huge beach umbrella, & my rain-coat. I protected my legs with a portfolio (the wind holding it in place). And so I painted with my nose almost on the paper with thunder crashing, boughs breaking and rain falling in torrents—A glorious few hours when I seemed to become part of the elements. When I was done at late afternoon, the picture was complete—It seemed as if it has [sic] materialized under its own power—Very little touching up was done later, and that only to eliminate the marks left by the clips that held the board to the easel.

To me the most glorious 'transition' of all is 'Spring-to-Winter' [sic]—So full of hope and promise, like the gates of Paradise opening up after the winter of life.

(pp. 10-13)

Joseph S. Trovato, in Charles Burchfield: Catalogue of Paintings in Public and Private Collections, *Munson-Williams-Proctor Institute, 1970, 367 p.*

SURVEY OF CRITICISM

William B. M'Cormick (essay date 1925)

[*In the following excerpt, M'Cormick examines elements of realism and romanticism in Burchfield's early works.*]

That truth is one of the least understood things in this world as well as one of the least common in daily intercourse is a fact borne out by many sententious sayings and epigrams in the pages of our literature. An atmosphere of much reading might be cast over this article about a young American painter through some superficial references to aphorisms concerning truth hunted up for the occasion. But I will content myself with pointing out that when Pilate asked of Christ, "What is truth?" he demonstrated that it was a moot question nineteen hundred years ago; and the tale of an ambassador, in an almost contemporary novel, who made a remarkable success in his profession by always telling the truth is cynical testimony to its rarity nowadays.

It is this very rarity of truth which puzzles most of us when we are faced with it. And because the pictures of Charles Burchfield are chiefly concerned with showing the truth about a certain ugly little Ohio town named Salem, when he first began exhibiting them the work disturbed those who saw it so much that many of them were incapable of forming a reasonable opinion as to what it was all about. Indeed one art writer conceived the idea that Burchfield painted the pictures he exhibited because he "hates Salem, Ohio, and told the world about it in pictures" that "were remorseless in their scathing irony and quite overpoweringly convincing as works of art." This particular writer has since been informed, on the best possible authority, that Burchfield does not hate Salem. But he holds fast to the idea, nevertheless, mainly for the reason that truth is always regarded as being a trifle old-fashioned by the world's sophisticates. (p. 466)

[Burchfield] presents himself as a man so wholly concerned with truth in one phase of his work as to be a realist of disconcerting frankness, while in his second form of expression he is almost classically romantic. Through the watercolors . . . called **Noonday Heat** and **The False Front,** . . . [typical] of his representations of streets in Salem, it is plain to see how brutal Burchfield may seem to be in recording the facts composing those two scenes. In the first are the hideous store-fronts in the harsh brilliancy of the summer sunlight, the idlers on the steps of one of the stores too lazy to seek the shade, the ill-nourished horses at the hitching-rail, the ramshackle wagon. These effects are repeated in **The False Front,** a picture now in the permanent collection of the Metropolitan Museum of Art, only if anything they appear to be set down even more relentlessly, owing to the introduction of the pathetic attempt to make the store building more impressive in height, the mirey road and the depressing feeling of biting cold.

Whether Burchfield means to be a moralist or not in his art I have no means of knowing. But the disintegrating spiritual effect of unsuccess in life's business is nowhere more completely summed up than in these two pictures, particularly in those store-fronts with the rotted clapboards, the blistered corrugated iron, the warped frames, the weathered paint. All that is noted here in failure as represented through village life is reflected in the world of the farm in the watercolor Burchfield calls **Watering Time.** The too-ambitious barns, ineradicable habit of the American farmer, with their pathetic attempts at conventional ornamentation are hideous in themselves or when regarded as symbols of failure. And their structural unsoundness finds myriad economic echoes in the dreadful barnyard with its ill-conditioned horses. In this picture, as in **Noonday Heat,** Burchfield uses color as unsparingly as he does human facts. In fact his color seems to be even more relentless, no tone or shadow escaping his eyes, his palette contributing quite as much as his passion for truth to the success of his painting.

Even in so drab a place as Salem evening comes in all its tender melancholy beauty and winter spreads its white coat over road and farm. Burchfield can see these things and paint them; but only as different accessory facts to his concern with Salem's houses and stables. Not even the word-painting of Dickens' in his picture of Tom All Alone's or Balzac's of that *pension* where dwelt Père Goriot presents human sordidness in more utter degradation than in the life suggested by the groups of houses on the outskirts of the town in **November Evening** or lining a street-end in the **Winter Solstice.** Yet here again the spectator standing before one of these pictures is so moved by the beauty of Burchfield's truth, as well as by his talents as a painter, as to almost forget all this sordidness and ugliness in the communicated spirit of his art, its clear intensity, its shining passion.

If Burchfield were given solely to this one form of expression he might be counted on to depress visitors to his exhibitions or owners of his paintings, particularly visitors and owners of the cast of mind who cannot see beauty in melancholy. His inclination toward the classically romantic is satisfied by giving almost sculpturesque treatment to those sorry nags of his Salem streets and setting them at play in so fanciful a land as appears in his gorgeous canvas called **October.** Facts concern him here only in his tree trunks, the modeling of his horses' heads, their gaits and postures. Elsewhere in compositions of this type the romantic is the pervading note as in this background of a cloud-filled world. It is interesting to note that in these romantic pictures human beings are seldom portrayed. Men take no part in the joyousness which Burchfield's galloping horses, and even his trees and clouds, seem to feel. Men, according to this painter, belong only in towns.

There is to be noted in his work falling within the romantic classification a joyousness of spirit that is a thing quite apart from that twin-spirit which evokes those versions of Salem's mean streets. His galloping horses are joyousness itself in their realization of the sense of freedom from man's control. His screen of trees serves as a graceful link between the worlds of fact and faery. And in that land of fancy there dwells a vision, to those who may have the grace to see it, of the Burchfield who suffered and endured the vistas of Salem that he might, in the end, move and have his being in the world of art where if the noonday heat is often present there are Octobers just around the corner of the seasons for a reward. (pp. 468-70)

William B. M'Cormick, "A Small Town in Paint," in International Studio, *Vol. LXXX, No. 334, March, 1925, pp. 466-70.*

Edward Hopper (essay date 1928)

[*Hopper is regarded as one of the greatest twentieth-century American representational artists. While he is renowned for realistic paintings depicting particular aspects of modern American life, his works, in the words of Gail Levin, "aspire to the universal" by simplifying visual elements to form timeless, evocative portraits of familiar and sometimes even mundane scenes. In the following excerpt, he presents an appreciative overview of Burchfield's realistic works of the early 1920s.*]

The work of Charles Burchfield is most decidedly founded, not on art, but on life, and the life that he knows and loves best. From what is to the mediocre artist and un-

seeing layman the boredom of everyday existence in a provincial community, he has extracted a quality that we may call poetic, romantic, lyric, or what you will. By sympathy with the particular he has made it epic and universal. No mood has been so mean as to seem unworthy of interpretation; the look of an asphalt road as it lies in the broiling sun at noon, cars and locomotives lying in God-forsaken railway yards, the steaming summer rain that can fill us with such hopeless boredom, the blank concrete walls and steel constructions of modern industry, mid-summer streets with the acid green of close-cut lawns, the dusty Fords and gilded movies—all the sweltering, tawdry life of the American small town, and behind all, the sad desolation of our suburban landscape. He derives daily stimulus from these, that others flee from or pass with indifference.

Through many of these transcriptions are woven humorous anecdotes, which seem to be so firmly kneaded into the picture's plastic qualities that they play only a minor role in one's enjoyment of the intense reality.

Our native architecture with its hideous beauty, its fantastic roofs, pseudo-Gothic, French Mansard, Colonial, mongrel or what not, with eye-searing color or delicate harmonies of faded paint, shouldering one another along interminable streets that taper off into swamps or dump heaps—these appear again and again, as they should in any honest delineation of the American scene. The great realists of European painting have never been too fastidious to depict the architecture of their native lands in their pictures.

Burchfield is one of those who, in each generation, naturally and honestly liberate their subjects from the taboos of their time. This seems to be a recurrent necessity. From the primitives to the post-impressionists, the natural lethargy and vanity of human nature has driven painters to use the material that the original artist has brought to life. From Rembrandt to Degas, the battle is never won, and probably never will be. Burchfield is free and uninhibited in his selection of subjects at all times.

His *November Dawn* is not an artist's dawn, but a real, honest-to-God sunrise. One looks out of the window and sees the black plain of the land against the red of the sky. A straight road and a lawn in the foreground, and on the other side of the road a pond or creek reflecting the sky. All the scene so familiar to the eye, changed to wonder by the early morning, stated with such simple honesty and effacement of the mechanics of art as to give almost the shock of the reality itself.

March is an attempt to reconstruct the intimate sensations of childhood, an effort to make concrete those intense, formless, inconsistent souvenirs of early youth whose memory has usually long since faded by the time the power to express them has arrived, so close to dreams that they disappear when the hand tries to fix their changing forms. Here the vast dream world of the sky stretches over a real and solid earth, with menacing, twisted stumps of trees. A bonfire, that element of glory and excitement in a boy's life, crackles in the distance against the cold half light of Spring. The boy himself stands in the flesh in the foreground. A very tangible expression of youthful memory.

There is no fear in any of this of painting literature, or of making art that is not great art, or of offending good taste. Through all of it runs the courage to do that which the painter has most at heart, a lack of self-consciousness, and an obstinate disregard of that deadly discrimination that blights so often the works of the knowing and well-read.

Is it not the province of work such as Burchfield's to render to us the sensations that form, color, and design refuse to reveal when used too exclusively as an aim in themselves, and which words fail to encompass?

A train rushes on straight and shining rails across our vision, past closed gates, raises clouds of suffocating dust, and rumbles into vague stretches that imagination tries to construct.

Can words express this to the full? We believe they cannot.

Can graphic art? Perhaps—if unrestricted.

Is it the legitimate province of painting? What difference does that make?

There is no too cold detachment here. The thing was seen. Time was arrested. And we re-live again the thrill, transposed by mind into the parallel of art.

As far back as we know the work of the man, there have been no digressions—or few. A simple writing down of that which most moves him. No time wasted on useless representation. No slavery to values, to color or to design as ends in themselves.

This writing has called for a simplification that has taken precedence over any academic appreciation of the value of simplification.

He, too, can retain inflexibly to the end his original conception. No adjunct graces, complication of moods, nor technical difficulties can swerve him from his aim.

Pattern is in evidence here, but he unites pattern and form with such ease that form, design, and color are only the stones with which the emotional structure is built. Even a certain baroque treatment of perimeters, acquired very early, fails to intrude itself upon the emotional content, as in a lesser artist it surely would.

October Moonset shows Burchfield's peculiar power to take the so-called picture postcard subject, give it vitality, and make us see it as it was before it became worn and flat through much use. A crescent moon is falling to the horizon in early evening, with cold sunset clouds, against the sun's afterglow, with pale reflecting water in the foreground. Here are all the elements of the most sentimental buckeye, but seen with so fresh a vision as to return to the scene all its pristine meaning, sombre and moving.

Railroad Gauntry has great beauty of color. A railroad running under a signal bridge and the bright colored lenses of the signals outshining the day give, as all of his things do, a sense of vast expanse beyond the limits of the picture, a feeling that in the doing of them, there must have been impatience with the section of fact before him, and that

that which was there must not become too fixed or it would destroy a more inclusive and more fugitive beauty beyond. He seems always to envisage a wider field than the mere limits of the picture can surround.

In the **Country Blacksmith Shop,** he has attempted, and succeeded with, the difficult problem of giving the sensation for which so few try, of the interior and exterior of a building seen simultaneously. A common visual sensation. He has fixed with tremendous reality the exact mood of the scene and the typically forlorn landscape surrounding the building.

Old Inn at Gardenville renders also with great exactitude a simple, but subtle mood of nature with dappled autumn sky, a group of frame houses, and a little tree all yellow against the pale harmonies of the rest. This is in a gentler and more traditional vein than some of the others, but not the less moving and real.

House by a Railroad seems to be pure emotion, but of a solid and convincing reality. A railroad crossing with its paraphernalia of warning signals and telegraph poles, a horse at one side. The sudden wind before a summer rain is bending grass and trees. A little sapling, seen with great feeling, slaps its leaves violently against the side of the house. The distant foliage is lost in the mystery of the storm and wind. A simple unity of expression that the artist has not surpassed, and that Hiroshigi or Hokusai might not have been ashamed to have done.

Gouache, the medium that is used in most of these pictures, has been so long the pet medium of commercial art, and so long scorned by the purists in water color, that it has been almost dismissed as a means of æsthetic expression. Burchfield has used it with such frankness and daring that he has overturned all our old notions of it. Oil he finds a cumbersome method, and uses it seldom.

Good painting (so-called), that degenerate legacy to us from the late Renaissance, has no place in this writing down of life; the concentration is too intense to allow the hand to flourish playfully about.

He has a remarkable faculty for the subordination of elements that are of secondary importance to the main issue, especially so in the color of these elements. His color is vigorous but subtle, and never gives that colored quality of those who try too strenuously for color for its own sake.

We feel that he must always approach his prospective work with trepidation and excitement and not with the calm cocksureness of the modern arranger of nature. The excitement, at least, must be patent to all. (pp. 6-10)

[Burchfield] has never been to Europe. He has spent most of his life away from the groups of ultra-sophisticates and tongue-in-the-cheek *cognoscenti* who are found in our great cities. This isolation has been partly self-imposed. He has lost nothing by it.

If there is any influence of contemporary movements, it must have been very insidious and not consciously recognized by him. It is difficult to disentangle the threads of influence that go to make an art. Even an artist's own testimony is not always sure evidence, so confused is the trail

usually. Perhaps in the free and stylized design there is some superficial evidence of post-impressionist tendencies. The modern influence is more likely, though, to have been active on the appreciative side, that is, through the more liberal attitude of the intelligent public, and the corresponding courage and freedom it has given the original artist to be himself.

We approach Burchfield's satire, an element in the work that seems to be very important to most critics, and which they have made much of. We think it has been given undue prominence by them, except perhaps in the earlier works. The artist himself admits to some special hates in these, due to a rather unhappy period in his career.

We believe that the lyric quality which has always been present, more or less, will gradually dominate the satiric. This ironic attitude has also been changing to a more gentle humor; as in **Promenade,** the picture of the street with the enormous dogs following the little dog led by his mistress in seven-league arctics. In this, it is fun of a refreshing, unforced simplicity, and very American withal.

Satire crops out again in *Civic Improvement,* another street scene with men cutting down shade trees, whose dismembered limbs fall in agonized gestures in the road. The rather mild venom in this has not blinded his response to the beauty to be found in the thing.

Burchfield has been said to be one hundred percent American. He is all that and more, in the best meaning of the term, entirely devoid of the ridicule that it can imply. His is an art firmly rooted in our land, and will be much imitated by many American painters who, in their intellectual life at least, are most assuredly not so rooted.

He seems to be the latest of the line of our painters who have been race-conscious: Inness, Eakins, Homer, Luks, Sloan, Kent, and Bellows, to name the most typical examples. The diversion from European influence seems in this line of descent to be growing more marked, and the character progressively more native. It is only the vaguest speculation, however, to say whether it will so continue. Precedent seems to say yes.

After all, the main thing is the natural development of a personality; racial character takes care of itself to a great extent, if there is honesty behind it. The danger, of course, is in trying to superimpose a culture that is not truly congenial to it.

As we look at Burchfield's work in its relation to the young and thoughtful in American painting today, it is at once evident that he is ploughing a different furrow than most of the others. He makes it plainly known that so emotional an art as his will not relinquish easily its prerogative, to express nature's unlimited physical moods and changes, and finds no satisfying substitute in the eternal aspect of nature, or in a highly stylized expression of it.

His art fits into no pigeon-hole. Such an isolated and vigorous originality seems so simple and natural a phenomenon that one ponders why such a one does not happen more often.

It makes many of his successful contemporaries seem like

very learned professors of painting. It clears the air and brings us back to good sense, which always prevails in the end.

It has no fear of standing on its own simplicity. It does not strive to be cosmopolitan, or for sophistication that it may not be thought provincial.

By the real and pressing need to make known its message, and by its natural good sense, it avoids the pitfalls that a less original talent might fall into.

It follows no fashions, but is destined to be always new by its originality and truth. And above all, it reaffirms the sovereignty of natural endowment, emotional and interpretive. (pp. 10-12)

> Edward Hopper, "Charles Burchfield: American," in The Arts, *New York, Vol. 14, No. 1, July, 1928, pp. 5-12.*

Burchfield explains his preference for watercolor:

My preference for watercolor is a natural one. To paint in watercolor is as natural to me as using a pencil, and presents no more difficulties than a pencil; whereas I always feel self-conscious when I use oil. I have to stop and think how I am going to apply the paint to canvas, which is a detriment to complete freedom of expression. It is like a speaker pausing in his talk to get just the right word. To me watercolor is so much more pliable, and quick. For instance, you decide that a whole passage is undesirable; you take a sponge and wipe it out in just a few seconds.

From Art Digest, *April 1, 1995*

Alfred H. Barr, Jr. (essay date 1930)

[*A highly influential American art historian and educator, Barr was the first director of the Museum of Modern Art in New York City and has been credited with shaping the museum's multidisciplinary program. He was also the author of numerous studies of modern artists and significant art movements. In the following excerpt, he discusses Burchfield's early watercolors and suggests some possible influences.*]

In his recent work which has placed him among the most interesting American artists Burchfield has examined critically the mid-western town: its houses, its railroad yards and eating places, its false fronted stores, Garfield Gothic churches, and telegraph poles confronting their reflections in main street puddles. Satire in which hate and wit are mingled is combined with the discovery of picturesque ugliness. In these gray, silver and black watercolors that authentically native movement which might be christened American-Scenism is seen at its pictorial best.

In his earlier work we find an astonishingly different spirit. Frequently the same objects appear—small town, post-Civil War buildings—but they are not so much satirized as eagerly accepted as material for romantic composition. A more essential similarity between his familiar later work

and these early inventions lies in the very fact that in both Burchfield was thoroughly interested in subject matter at a time when interest in subject matter was generally discredited.

During this early Romantic Period Burchfield concentrated upon the expression of moods and emotions on the one hand, and on the other upon specific forces and even sounds and movements of nature. His method was neither vague nor spontaneous as is frequent in expressionistic painting, but deliberate and precise. Of the *Night Wind* Burchfield writes: "To the child sitting cozily in his home the roar of the wind outside fills his mind full of strange visions and phantoms flying over the land." In the painting the patterns which surround the house are of two kinds—the torn black silhouette suggests the terrific force of the wind blowing from left to right, while the white wave beyond tosses monstrous half-organic arms which threaten to overwhelm the child's home. These two abstract motives of force and fear were studied and restudied in a long series of drawings before they reached completion in the finished picture. Similar and equally successful is the uncanny *Church Bells Ringing.* In the sky are the same menacing waves. The church tower assumes a face like an African mask and sways with the swinging spiral motion and sound of the bells. Spiral and wave inflect the eaves and windows of the house. The whole scene rocks and quails before the horrid clangour. Again invisible sound and the resulting emotion are realized in visual forms.

More elegiac in mood is the *Garden of Memories* in which an aged woman sits in the tired moonlight while colossal lunar flowers surge and droop about her. The *August North* is similar in mood but more direct in statement. In striking contrast is the *Song of the Katydids* in which the vibrations of heat, the monotonous vibrations of insects, are diagrammed. Houses and trees quiver beneath the hot feet of summer's noon.

Many of the watercolors are less dependent upon expressionistic devices. The haunted gloom of the swamp pervades *First Hepaticas* and the *Fallen Tree.* In the *Rogues' Gallery* and *The Conference* we find a delightful feeling for the grotesquely humorous. *Summer Rain* and *Hot Morning Sunlight* which come early in the series are frankly decorative, more purely aesthetic in their interest.

It is impossible to discover any important external influence upon Burchfield's art. [His early] watercolors were painted in Salem, Ohio, between 1916 and the early months of 1918. In the previous four years he had attended the Cleveland Art School where Henry G. Keller had encouraged him to use his imagination rather than to follow the conventional Impressionist methods of the period. He was almost completely ignorant of what had happened in Europe. He does not remember having seen a Cézanne before 1920. He saw his first van Gogh in 1929. He believes that Japanese prints may have had some influence upon his design but cannot remember any conscious admiration for Oriental art before 1918. One can only conclude that we have in this period of Burchfield's development one of the most isolated and original phenomena in American Art.

Several analogies of course suggest themselves. The patterns of **Night Wind** remind one of van Gogh's cloud structures. The vibrations which radiate from the sun in **Cat-Tails** and from the trees in **Song of the Katydids** also suggest van Gogh's drawings as does the muscular activity of the **Beech Trees.** But Burchfield's invention of abstract motives as direct visual symbols for invisible forces bring him close to the technical methods of Chinese and Japanese painting in which clouds, waves, and flames are transformed into linear formulae. It is but a short step psychologically from the wind monster with its saucer eyes to the more highly developed Dragon of water and air which appears half submerged in the torrential waterfalls of the Sung painters.

In several instances our closest analogies are to be found in German and English romantic art of the early 19th century. Samuel Palmer might have admired the **Garden of Memories;** Caspar David Friedrich the **First Hepaticas.** In Burchfield's art the "Gothick" moods of melancholy and terror are re-born a century later. And curiously enough in such pictures as **Wheat Field with Tower, Church Bells Ringing** and most strikingly in **Sunday Morning** one feels the influence of the silhouettes, the textures, the Spencerian flourishes, the very wall-papers and stained glass of the mid-19th century, assimilated (but not consciously admired as they were to be twelve years later in 1930).

Very curious too is Burchfield's attempt in his early twenties to re-create the sensations and emotions of his childhood: "The child stands alone in the garden—[**The Insect Chorus**]"; "The church bell is ringing and it terrifies me (the child)—[**Church Bells Ringing—Rainy Winter Night**]"; "The child sits listening—[**A Memory from Childhood**]." Much of 1917 was devoted to this problem.

The surrender to mood, the attempt to present sound and energy in terms of vision, the love of the "rustic," the "picturesque," the "melancholy" and the "terrible," the nostalgia for childhood, the use of "literary" titles, are all romantic qualities or vices—but there is also in Burchfield's art discipline, strength of design and a clarity of purpose which raises these youthful watercolors to a high level of original achievement even as formal inventions. (pp. 5-7)

> *Alfred H. Barr, Jr., in an introduction in*
> Three American Romantic Painters: Charles
> Burchfield, Florine Stettheimer, and Franklin
> C. Watkins, *Arno Press, 1969, pp. 1-7.*

Thomas Craven (essay date 1935)

[*An American art critic, Craven was best known as an enthusiastic champion of American Regional art. In the following excerpt, he commends Burchfield's rejection of Modernism.*]

Burchfield is one of those grim, gifted, independent Americans who take nothing for granted, essentially a Middle Westerner with the melancholy, sharp-seeing interest in hard facts that distinguishes the novelists of the central valleys. He was brought up in a rustic background; in drab down-at-the-heels towns and monotonous farm lands that

no one loved. But the life of the midlands made a profound impression on him. Footloose, in the good American fashion, he wandered through town and country, observing the habits of men and women, the wretched architecture, the freight trains, the fields and forlorn vistas of unoccupied earth, the stern farmers and their sad, patient wives, and the social life of the shabby settlements.

In his youth Burchfield frequented an art school in Cleveland, and managed to survive it. Had he been made of the usual plastic stuff, he would have submitted to the Franco-American system of preparing young students for a postgraduate course in Parisian fads; but he had no need of Continental inspiration or training and would allow no one to tell him what or how to paint. In his late twenties he exhibited in New York a collection of water-colors of astonishing originality. At that inauspicious moment American artists were grovelling before Matisse, Picasso, and the cracked-fiddle painters, and the importance of Burchfield's pictures was not generally recognized. But the few artists and critics who were not dizzy with imported distortions and theories saluted the arrival of an authentic American artist.

This young man brought painting down to earth. He was never taken in by the flummery of Cubism, and he avoided New York and the contagion of cults. He painted the country that was in his blood, the Mid-Western environment that had matured his conception of America—and he did not romanticize it. He chose scenes and subjects that had been proscribed because they were supposed to be insular or intrinsically ugly; and his pictures outraged both the modernists and conservatives trained to paint nature in the rosy colors of Impressionism. His experiences had taught him that life was neither charming nor classical; he found it rich in bleakness, and beneath its loneliness and shabby monotony he had found nobility of effort and a naked, haunting grandeur. He painted villages in winter, the coming of spring, the seasons of harvests, and fall-plowing; he painted the countryside with a row of false-front stores straggling on one side of the highway, farmers in Model-T Fords, little towns on a Saturday afternoon; and he made special studies of local architecture from the dilapidated cottages by the railroad to the jigsaw Gothic of the quality folks. And he managed to surround these subjects with a tragic atmosphere, the tragedy of barren living, cheap taste, and starved ideals; to make them personal expressions of his own poetic view of common things.

Burchfield faced life, and extracted from it an art that may be justly called his own. His art is not without flaws; he is a man of a single mood and his technical knowledge is limited. He is more brilliant than powerful, and his work tends to slide into mere illustration; that is, instead of building up well-knit structures, he produces descriptive sketches, and beautiful, suggestive bits of American life. Of late years, living in a new environment near Buffalo, he has endeavored to correct his faults, and his work in oils is more substantial and more poetic, but at times, fantastic and unreal. But I do not wish to underestimate his importance; he is still a young man and his best work, for all I know, may lie before him. On the strength of things

Rainy Night *(1930).*

accomplished he must be called one of our best artists. He was the first of the modern group to throw off the incubus of European imitation, and his example changed the direction of American painting. (pp. 307-09)

> *Thomas Craven, "Our Art Becomes American," in* Harper's Monthly Magazine, *Vol. 171, September, 1935, p. 433.*

Herbert Furst (essay date 1944)

[In the following excerpt, Furst praises Burchfield's paintings as works of realism which nevertheless adeptly convey the artist's feelings toward his subjects.]

In the ordinary course of my business I received for review an illustrated catalogue of Charles Burchfield's "Retrospective Exhibition of Water-colours and Oils . . . 1916-1943, held at the Albright Art Gallery, Buffalo," a few months ago. The operative word in the foregoing sentence is *illustrated.* Had the illustrations not so deeply impressed me—and this despite the fact that they are mere half-tone reproductions in black and white—I should probably have confined myself to a short bibliographical notice; and left it at that. There is, as a rule, no object in discussing exhibi-

tions which neither the writer nor the reader has seen or is ever likely to see. However, in this case I have, at least, seen reproductions and have, to boot, an ulterior motive. So an attempt to convey something of the quality of Burchfield's art has to be made.

Before reading a word of the text of this catalogue, which has a full introduction by the Director of the Gallery, Andrew C. Ritchie, I glanced through the fifty-four illustrations. Then I went through them a second time more carefully, and then once again. It was clear Burchfield has something to say. With the exception of one figure-subject the illustrations are all reproductions of landscapes. The figure-subject is *Portrait of My Aunt Emily,* and the landscape which first made me feel that there was more in the artist than in the common run of water-colourists was *Freight Cars under Bridge* with the detailed information: "Location: Under Clinton Street Viaduct, Gardenville, N.Y." Why should a complete stranger like myself be interested in the artist's *Aunt Emily,* or in *Freight Cars,* in this case a view of one and a half goods waggons? *Aunt Emily* looks like an elderly, perhaps rather careworn, lady. The freight cars look like millions of others, and the viaduct—at least so far as the picture reveals it—is of no architectural or other interest. We turn to another illustra-

tion called *The Parade.* Most of this picture consists vertically of two and one-third railway arches and a foreground of horizontals of cobbled road with tramlines, a gully and a side walk; the human interest is confined to a diminutive procession of men glimpsed through the arches, through which one likewise glimpses a vista of a road. Under the arches are two members of what appear to be mounted police. At first glance not one of these pictures has the slightest interest to outsiders either in respect of subject matter or of abstract design, so that one wonders why on earth the artist should have troubled to paint them. And then the spell begins to work. Burchfield paints *experiences,* where others paint what the eye sees or what the intellect prompts them to do. *My Aunt Emily,* for example, is the sum and substance of the artist's experience of this relative, not as she appeared at a given moment in a given place, but as she lives in his mind. *Freight Cars under Bridge* is not only things seen from a given place, but the prompting of the mind as it happened to notice those goods waggons under a viaduct. I believe, though of course I have no warranty for it, that the urge to paint this subject arose when a freight train came suddenly, clanging, to a standstill before his eyes, conjuring up the palimpsest of thoughts and feelings, echoes of ten thousand such experiences with their overtones and undertones. And *The Parade.* That, too, is the picture of an *experience* involving not only the eye but the responses of the mind to the problems of labour and its troubles. Now we take up at random other subjects. The first and earliest one called *Rogues' Gallery,* an incredible scene of wilting sunflowers against dark gables, which somehow contrives to suggest a child's fancy of a collection of disreputable characters; and *Dandelion Seed Balls and Trees* of the next year, 1917. This last-named, a sheer joy, the mood of a child, excited by the spirit of summer, is followed by *The Mysterious Bird,* the mood of a child frightened by the spirit of winter. All these three pictures are done in quite a different, a broader and more decorative style than those mentioned before. We turn, still at random, to such a picture as *February Thaw* of 1920—an incredible view of an incredible street with incredible buildings casting their incredible reflections on the water of the thawing snow. It shows trees echoing the stalks of the sunflowers, and the side walk is peopled by a few passers-by traipsing through the mush. This is a picture filled with queer exuberant humour: it makes fun of a town. In *Winter, East Liverpool, Ohio* of 1927, another snow scene looking down a deserted street of mean wooden buildings, with, in the background, snow-capped hills, in the foreground, a shop front, on its pane the inscription "Enoch Moon—Lunch," and sheltering in its entrance a decrepit street vendor; in this picture the humour has become grim indeed. It links up, somehow, with the mood of *The Parade.*

These few examples must suffice. The fifty-four illustrations have fifty-four different "stories" to tell; not two of them alike even where the characteristic buildings are in the same style of architecture—a queer style that I have never before encountered, never having visited Ohio—I suppose. (pp. 124-25)

From the introduction in the catalogue it is clear that the artist is "untouched by any obvious pictorial influences,

either at home or abroad," and further that his early pictures give "an insight into the magical world of the child's imagination which rival in originality and individuality, although not in source of inspiration, the work of such a natural primitive as Rousseau, and for qualities, emotional force and explosive dynamic design approach the line established by such a ranking foreign expressionist painter as van Gogh." I rather resent the dragging in of these two *foreigners* which seems to have the purpose of giving Burchfield a kind of foreign hall-mark. He does not need one. He is *sui generis* and has virtues which they have not.

The writer of the introduction invites us, if we "would understand Burchfield's background better," to compare his pictures with the writings of a fellow Ohioan, Sherwood Anderson, and in particular with that author's *Winesburg.* "Each artist," we are told, "reveals the ugliness of the Middle Border where men and women and children were crucified, they knew not how, either by the poverty of the soil or a strident industrial expansion which swept over and about them. Under these circumstances, sensitive young people of small towns like Winesburg were caught in a web of loneliness and nostalgia, Chekovian in its haunting bitterness and futility."

That sense of bitterness and futility was for me, without the knowledge of this background, softened by Burchfield's obvious sense of grim or ironic humour. What occupied my mind as an outsider was the extraordinary sense of intense intimacy; of actuality; a kind of *realism* which has nothing to do with meticulous rendering of *facts,* but, on the contrary, expresses itself, in broad brushing for the most part, with inimitable authenticity, so powerful that the spectator seems to be standing by the painter's side. Moreover, some of the artist's later paintings are neither grim nor have they the child's joy or fear which characterized his early work; they are adult, composed, and concerned with serener views of his environment.

Mr. Ritchie makes one stimulating observation: he says of the artist: "With Hopper he is a pioneer in his socially conscious, yet still epic, feeling for the American scene. Now that we have seen a whole school of regionalist painters springing up in the last ten years, it is well to remember that many of the roots of this movement are in Burchfield, and that almost single-handed he has led, and still continues to lead, the way." (p. 125)

Herbert Furst, "Burchfield," in Apollo, *Vol. XL, No. 236, October, 1944, pp. 124-25.*

John I. H. Baur (essay date 1956)

[*Baur was a curator, an administrator, and finally director of New York's Whitney Museum of American Art who wrote several monographs on artists whose works were exhibited there. His numerous publications also include* Revolution and Tradition in Modern Art *and* New Art in America: Fifty Painters of the Twentieth Century, *for which he served as co-editor. In the following excerpt, Baur traces the development of Burchfield's technique.*]

　　. . . some fabulous Northland unlike any place
　　on earth—a land of deep waterfilled gashes in

the earth; old lichen-covered cliffs and mesas, with black spruce forests reflected in the pools, against which white swans gleam miraculously. This romantic land of the imagination, the mysterious North that has haunted me since I was a boy—it does not really exist, but how did it come into being?

—*Journal* 1954.

There are three Burchfields. . . . (p. 11)

The first is a young clerk at the W. H. Mullins Company in Salem, Ohio. He has just returned from four years at the Cleveland School of Art and is painting small watercolors during his lunch hours, his evenings and on weekends. They are fantastic watercolors that visualize the song of insects and recreate childhood moods, like fear of the dark; in them, flowers have faces, trees gesticulate and cornstalks dance. At the Mullins Company he never mentions them, for he has no intimate friends at the plant and few outside it. To most of Salem, he is a painfully shy, inarticulate young man who disappears on weekends into Post's Woods and is sometimes seen in the distance by picnickers at The Dutchman's as he fords the Little Beaver Creek and disappears into Trotter's Swamp. The year is 1917.

The second Burchfield is forty-two, married, the father of five children, living in a modest frame house in Gardenville on the outskirts of Buffalo. Six years ago he left his job at the wall paper factory to paint full time, and has managed to support his family, though there have been precarious moments. Already he has made a national reputation with his big watercolors of the industrial scene around him—the shipping in the harbor, the bridges, the railroad yards, the dirty snow clinging to brown, weathered houses. These are entirely different from the fanciful Salem pictures, for they are painted on a larger scale with broad realism, though full of the romantic moods which he senses in the city. He is still a lonely man who makes friends with difficulty and often repels acquaintances by his apparent distance. One day he is sketching on a downtown street. Two boys pass, and one comes nearer to watch him. "You'd better stay away from that guy," says the other. "He's liable to clout you over the head." Do I look so fierce, the artist wonders? It is 1935. (pp. 11-12)

[The third Burchfield] broke suddenly with the realism of his middle period and abandoned the industrial scene. Now he paints the one subject that has always been closest to his heart—the changing moods and aspects of nature. He paints these in a new style that is a fusion of his early fantastic manner and the great technical resources of his more realist work. It is a style born of the vivid, romantic imagination that has always burned beneath the quietly conventional exterior, a style that transforms even the backyard of suburban Gardenville into images of God's presence in nature. A deeply religious sense of wonder at the miracle of the seasons, of sun and rain, of birth and death in the natural world, has grown in Burchfield through the years. Sketching east of the Bowen Road one day, he left his easel to explore a brook. "I thought, as I squatted on my heels and gazed into the warm amber-colored water with its teeming life, that if one could but read it aright this little watery world would hold the whole

secret of the universe. At least I had the feeling I was gazing into infinity."

Oddly, it is the second Burchfield who has been most honored and is still best known, perhaps because his paintings of industrial Buffalo seemed to play a pioneering role in the regional movement which swept American art in the early 1930's and were thus more easily classified and more easily understood. There is scarcely a critic who has not compared his work with the writing of a fellow Ohioan, Sherwood Anderson, generally with the latter's *Winesburg, Ohio.* Burchfield read this book soon after it was published in 1919 and has acknowledged that it made a deep impression on him. There is also no doubt that his work, during these middle years, had at least as much regional flavor as Edward Hopper's paintings, let us say, of New York. (Someone once remarked that Burchfield was only Hopper on a rainy day.) But like Hopper, Burchfield never thought of himself as a regionalist and . . . strongly rejected the more militant regional doctrines. Furthermore, he eventually came to feel that the whole realist-industrial phase of his work was a digression, though a fruitful one, from the true direction that he was destined to follow. This direction was the romantic interpretation of nature which drew him instinctively while he was still in art school and which has re-emerged as the dominant aim in his art since 1943. As both his paintings and his journals show, it never entirely disappeared, even in his middle period. It is the durable strand that binds all three Burchfields into one.

Any true understanding of Burchfield and his art must be based on a realization of the intensity of his response to nature. Many academic painters devote themselves to the same theme and produce, at best, only pleasant landscapes and relaxed moods. For Burchfield, nature has always been a mystical experience full of wonders, terrors and true miracles. Every season, every time of day, every change of weather, every flower and insect, even every direction of the compass has its special meaning for him. His feeling for North, though only a single thread in this complex fabric of relationships, may serve to illustrate the consistency and the special quality of his romanticism.

"The old childhood sensation of North," he wrote in his journal in 1917. How it was born he never knew, but from the beginning it was the dark, terrifying, mysterious direction—the heart of the thunderstorm and the blackness of night. It was always to the north that lay those "strange phantom lands" which loomed suddenly in his mind's eye when he was still in art school and had visions of "enormous moonlit cliffs with water roaring at their bases." The crow, for obvious reasons, and August because of its velvety nights and towering thunderheads, were both closely associated with North. So he soon came to think of "the old 'crow-north' feeling," and one of his early watercolors, a garden at night, was called *August North.* All through the middle years, even when he was deeply involved in his paintings of the city, the North feeling would recur without warning. "Over the rim of the earth—to the North—lies the land of the unknown—it is windy, the ground is frozen, hard, barren—there is no snow—white wind clouds scud over a vast gray sky." The mood grew in

scope, adding Druidic, primitive, prehistoric associations, but it remained essentially mysterious. Watching the northern lights one night, "I felt as never before the true mysterious nature of 'North'—and knew why it is that the north attracts me, more than any other direction." In Gardenville, for a few unhappy years, he was obsessed with the idea that he had lost all sense of direction, "and with it the elemental side of nature. North—East—South—West do not seem to have their true character." He had a recurring dream of a wooded cave somewhere to the north.

After 1943, when Burchfield returned to painting the moods of nature, North reasserted itself strongly in both his imagination and his art. He had visions like the one quoted at the beginning of this [essay], and once more he tried to introduce the feeling of North in his paintings. Sometimes this was quite unpremeditated; working on his *Song of the Telegraph,* he suddenly found himself creating a new motif, "which just seemed to grow of its own accord . . . a vast cloud in the form of a cawing crow, soaring above the woods to the left and heading due north. It symbolized for me the old yearning of boyhood for the Northlands, beyond the Covered Bridge, evoked by the elemental calls of crows." North entered equally into other pictures like *Sun and Rocks* and *Moonflowers at Dusk,* the latter a new version of his early *August North.* In one way, the mood became more generalized, a feeling for all that was elemental and enduring in nature. But it never entirely lost the undertones of emotion that went back to childhood. Exploring once in wild new territory, the artist was suddenly aware of "the feeling of coming into a Northwoods at twilight. It recalled some vague elusive memory of my boyhood, or was it a dream . . . ? I wish I could grasp the feeling better. . . . Did I experience it, or is it the lifelong desire for a dreamwoods?" It still haunts him.

The deep strain of romantic mysticism in Burchfield, of which this is only one instance, has never adequately been recognized. This is due to a number of factors. His reputation as a regional realist and even as a social satirist has tended to obscure his greater body of work in different directions. The fine, moody city-scapes of his middle years deserve, without question, a high rank in his total work, but their many admirers are generally unsympathetic to his more romantic nature painting. On the other hand, there are those critics who feel that his early fantasies of 1916-18 are better than anything he has done since. To them, Burchfield is a kind of child genius who has not lived up to his promise, and the fantasies themselves, while extraordinary, are after all fantasies—a word that suggests lively imagination but neither profound nor mature emotion. They are indifferent to his realist phase and dislike the later fantasies that he did after 1943, finding them overblown in scale and less spontaneous than those of his youth. So the artist has fallen, critically speaking, between two stools—those who prefer the middle period and those who prefer the early work. No strong voice has yet been raised for the late paintings of his maturity.

In some ways, this is explainable. For a brief period after 1943, Burchfield tried to turn the clock back too literally and to resume the fantastic style and spirit of 1917 as though the middle years had ceased to exist. Almost at once he ran into esthetic difficulties . . . which did indeed mar some of the largest and most publicized work in his new direction. Since then he has abandoned all attempts to be a child again and has used his full technical equipment to embody, in a very personal kind of expressionism, his mature romantic outlook. The romantic spirit, by its nature, is a young one, and in this sense Burchfield has always kept his liaison with youth, as his persistent feeling for North can testify. But just as that concept broadened and deepened in meaning, so his art has acquired, in the last decade, a more profound and elemental romanticism. It is no longer fantasy in the 1917 sense but a powerful evocation of the mystery and beauty of God's creation. Some of the greatest pictures of his career—among them, *Sun and Rocks, An April Mood* and *Night of the Equinox*—have been painted in only the last six years and are still not widely known. Yet they mark the crowning achievement, so far, of a painter who has done more than any other in our day to revitalize the long American tradition of an intimate and fruitful relation between the artist and the natural world. (pp. 12-16)

> *John I. H. Baur, in his* Charles Burchfield,
> *The Macmillan Company, 1956, 86 p.*

John Canaday (essay date 1962)

[*Canaday was an American art historian noted for challenging the validity of Abstract Expressionism during the 1960s. In the following excerpt he commends Burchfield's return to the fantasy style of his early works.*]

A lot has happened to American art during the near half-century of Charles Burchfield's career. This year he is 68, but his new paintings are very close to the Burchfields dated 1916, when he was a sprouting 23 and was given his first exhibition.

Say that about most painters and you would be describing a man who, having found a successful formula, has devoted himself to repeating it, commercializing it and desiccating it. Not Mr. Burchfield.

The new paintings are fantasies, and so were those of 1916. But they are a return to fantasy, without equivocation, after years of preoccupation with the American scene in its industrial, urban and semi-rural aspects of a man-botched countryside, and more years during which Burchfield has been working his way back to fantasy, often with discouraging indications that he might be losing his way. Now that he has come full circle, it is apparent that he knew where he was going and has learned a lot during the trip.

The sun, the moon and the turn of the seasons in a world of nature where joyousness and violence are never far apart are the theme of Burchfield's newest paintings. These are not exactly landscapes; they are no closer to topography than they are to weather reports. Although they use the forms of nature—everything from flowers to planets—as points of departure, they are mystical explorations of a world essentially primeval. The existence of man is

not recognized in them, except as a spirit whose observation of the annual cycle of growth, rest and rebirth gives meaning to phenomena.

Actually, the phenomena of nature have been the persistent meaningful factor in all of Burchfield's work, even when he seemed to depart furthest from the natural world into the man-made one. The Fine Arts Gallery of San Diego owns a Burchfield, **Rainy Night,** of 1930, which is all pavement, brick and metal. There is not a plant or a spot of earth visible in this cityscape of two intersecting streets and their ugly buildings backed up by water tanks. But the undefeatable sky and the rain that falls everywhere transforming dirty asphalt into a reflector like a lake, are what the picture is really about. Pictures of this kind established Burchfield as a major American painter, a position that is certainly deserved, but half of the time these pictures were only half understood by the people who admired them.

Burchfield is always thought of as two painters, first the poet of the early fantasies and then the "socially conscious" painter connected with regionalism and the rediscovery of the American scene. This is a mistaken idea, for he has consistently been a poet and a very personal kind of poet, even though his two kinds of poetry are not compatible and have resulted in some bad garbles when he has tried to mesh them in a single picture.

With social consciousness and realism in bad favor with painters and critics today, Burchfield's return to pure fantasy will be welcomed as a return to the right road by a painter who had the misfortune of getting misled onto a detour. The return is welcomed by this critic also, but for a somewhat different reason having nothing to do with objections to the vaguely regionalist work. Actually, there is a good chance that when all the sifting and shaking down has been done, Charles Burchfield's place in American art may rest most firmly on the pictures in which he recorded the American scene with a special perception of its character.

Much American (as opposed to New York-International American) painting of the thirties can be remembered only with embarrassment for its obviousness and jingoism. The beauty of Burchfield's Americanism of that period (like Edward Hopper's, in a different way) is that Burchfield as a Midwesterner (like Hopper as an Easterner) assumed no stance but painted honestly and expressively in a way that was possible only to a painter of his temperament and his variety of American experience. The resultant paintings were, and remain, fifty times as American as any doctrinaire work by Wood, Benton or Curry, the doggedly American regionalist trinity.

Burchfield never propagandized for the idea that the soil imparts its virtues to cultivators, and his occasional mild satires, another aspect of regionalism, are his least successful pictures. What Burchfield showed us, while other painters were busy retouching the surfaces of the American scene, was the indomitable life of nature beneath the scrubby overlay created by a generation of Americans who had forgotten how to live with nature but had not yet learned how to live away from it.

Whether or not Burchfield was conscious of this American dilemma in the semi-urbanized United States I do not know, but he certainly expressed it. He was thus a regionalist in a much deeper way than those men who hunted out the picturesque superficies of a locale and grafted onto them a set of preconceived notions as to what its character should be—a character that had died with Tom Sawyer's adolescence. In America's trying awkward age—from the depression to Pearl Harbor—Burchfield knew what kind of place he was painting.

The thesis behind these paintings—a thesis that Burchfield did not formulate, but which he understood better than did the painters who tried to formulate it and failed—is not valid today. It had to do with a kind of American provincialism that disappeared with the war, to be replaced perhaps by another kind of provincialism, but which disappeared nevertheless. The Burchfields of latest date in the Whitney retrospective five years ago were efforts to synthesize the fantasy of earlier works with the poetic realism of the vanished thirties and early forties, and they just didn't come off. One of our best painters seemed to be left standing nowhere.

For that reason it is good to find Burchfield the nature fantasist back in his timeless world. He is less specifically an American painter than he was, unless we insist upon believing that Americans have a special sensitivity to the swamps, woods, hills and skies of the wilderness. But he is expressing fully and powerfully the mystical love of nature that infused more delicately his earliest fantasies and more subtly his American scene. As a fantasist he has come back home, and his joy at returning is good to see. (pp. 129-33)

John Canaday, "Round Trip: Charles Burchfield's Journey of Exploration," in his Embattled Critic: Views on Modern Art, *Farrar, Straus and Company, 1962, pp. 129-33.*

President Lyndon B. Johnson, in a tribute to Burchfield:

Charles Burchfield loved the soil of his native land. From childhood, he found romance in the commonplace creatures of nature.

In his paintings of the American scene, his brush endowed the ordinary with universal greatness.

During a period of urbanization and industrialization, he focused our vision on the eternal greatness of living things.

He was artist to America.

From Charles Burchfield: Catalogue of Paintings in Public and Private Collections, *1970.*

Rackstraw Downes (essay date 1970)

[*In the following review of the Burchfield memorial exhibition at the Munson-Williams-Proctor Institute,*

Downes assesses Burchfield's achievements, commending his individuality.]

By all canons of current esthetics Charles Burchfield's watercolors look shamelessly idiosyncratic and *outré*. His reputation itself is a puzzle; for although he was generously honored by provincial museums and a Whitney retrospective before his death in 1967, still, artists of the most catholic taste and literate bent are amazed at an enthusiasm for his work and even confess to rather a nebulous idea of what it looks like. The truth is that Burchfield has not been *seen* in a considered way. (p. 54)

Criticism has been bemused for the best part of a century with the idea of the vanguard, modernism, the tradition of the new, in which art is pictured as a grand chronology of styles locked in a quasi-Hegelian dialectic; changeovers from style to style are effected by a chronic series of momentous revolutions in which the victor is represented as the champion of liberty, the vanquished as torpid, entrenched, authoritarian, obsolete; if this is a caricature, still it colors almost all thinking about art. It is a concept which demands a developmental meaning, a sense of "advance" from everything we look at, and so confers preeminent powers on history as the filter which makes one artist more visible than another, as though a successful search for antecedents and followers were the ultimate touchstone of quality. The phrase "modern art" has become virtually an elision of "modern art history." But although the vanguard is presumed to march in the name of freedom and originality, to some artists its revolutions tend to look distinctly like the palace variety, with built-in exclusions as rigid as those of the academic whipping-boy it presupposes; and the whole progressive idea with its distasteful parallels, both political and consumerist, resembles a threat, not a liberation—a veiled orthodoxy irrelevant to artists' concerns. Burchfield is such a painter, the nonparticipant par excellence. Even his individualistic contemporaries Georgia O'Keeffe and Edward Hopper, who likewise chose to ignore the "message" of the Armory Show (though Hopper was in it) are better known, for assiduous critics have found *some* parallels in their work to vanguard esthetics; in one case by a "proto-Minimal" precisionism of handling, in the other by a deceptively formal interest in light and an elusive attitude to pre-Pop banalities. Burchfield, raised in rural Ohio and spending the remaining 45 years of his life in suburban Buffalo, developed his art in isolation, apparently convinced that close familiarity with tradition, or the art world, could not enrich but only alter the complexion of his art. He took more interest in music and literature than in the great schools of painting. The beauty of his career is that the more independent its direction, the better the work.

His art offends virtually all the predilections of modern taste. No Pirandellian preoccupations with the act of making art, no Cubist collage announcing the reality of the picture; from a watercolorist not even any splashy bravura washes or virtuoso dry-brush rendering; for Burchfield the medium serves the story-telling: it is what he has to tell that makes his use of it so original. One older artist seeing his early work remarked "If this is watercolor painting I have wasted a lifetime studying methods and techniques." Burchfield commented, "No doubt he had, for by that re-

mark he revealed that he was a true pedant; and a pedant cannot become an artist . . . because he puts form ahead of content and suffers over any deviation from what is 'proper'." Like Hopper, for whom light was not a sensuous revelation of color but an index of mood, Burchfield concentrates on "what is really there," as he put it. When he paints the woods, it has nothing to do with the tradition of Western landscape art, based as it chiefly is on the picturesque eye of the gentleman traveler passing through a cultivated countryside; nor even with the explorer's sensibility that comes into 19th-century American landscape with its taste for spectacular prospects of untamed nature. Burchfield's vision is that of the naturalist joined with the romantic poet; it is a vision that *reads* nature, for whom a wildflower is not a spot of color but a sign. One of his earliest ideas came to him, he wrote, after seeing an exhibition of Chinese painting at the Cleveland Museum and it preoccupied him right up to his last completed painting; it was to make "all-day" pictures describing changes in weather, light and vegetation from season to season. Thus he was led to include heat hazes, the hum of insects and the force of the wind because only these would reveal the processes of nature he wished to describe. The strange dislocations of space and scale required to combine such disparate things in his pictures gives them their hallucinatory quality.

He once described himself as "96 per cent introvert," and the tone of his imagination is peculiar to the solitary. It revels in the pathetic fallacy, animating the natural world, coloring it—especially in his early works—in a deliberate attempt to recapture childhood moods, fearful, nostalgic, wistful. They are moods which are generally found embarrassing by the sophisticated, haunted since Baudelaire by more tortuous emotions. But as with the Celtic tales and plays of Yeats or the novels of Knut Hamsen, both favorites of the artist, this is a serious attempt to break with the artificial, to evoke life on a simpler, more elemental plane. At worst Burchfield enters the cloying fairyland of Tolkien; at best his work is like a courageous interlinear account of the taboos on modern sensibility.

T. S. Eliot once referred to Blake's philosophy as the work of "an ingenious Robinson Crusoe"; it is the quality of Burchfield's early watercolors. Encouraged by a teacher who responded to his unusual direction, telling him that his "inability to see form amounted almost to genius," he attempted to develop a language in which everything is symbol, realized in pattern. Employed full-time at a sheet-metal works, he drew often from memory; lack of time and absence from the motif suggested to him the use of stylized abbreviations to depict natural forms. This system allowed him to introduce without absurdity those conventions for phenomena not strictly visual that look like some ersatz musical notation. He knew *Art Nouveau* and Japanese prints and used them; but his remarkably abundant group of small watercolors painted in 1916-18, the product of a temperament so personal, look thoroughly original, *sui generis*. When they were first widely seen at the Museum of Modern Art (in 1930), they astonished collectors; Alfred Barr compared, in kind, the wind of a Burchfield to the dragon of air and water in a Sung waterfall [see excerpt dated 1930].

About 1918 Burchfield turned his attention to small-town life. The pictures of backyards and shabby Victorian rooming houses, especially in the rain or snow, have a sympathetically dreary ambience, and a touching identification with the underdog characteristic of the artist—who once proposed the skunk cabbage for the emblem of New York State. Burchfield's streets and industrial subjects are unmistakably his own; but they lack the originality of his earlier work. Approaching traditional illustration, he left out the stronger aspects of his own vision. They were, of course, his most popular years. The pictures of factory workers trudging home from work, or a view from outdoors into their brightly lit kitchens, titled **Six O'Clock,** contain, as Dr. Johnson said of Gray's *Elegy,* "images which find a mirror in every mind, and sentiments to which every bosom returns an echo." No doubt their popularity will persist; for as documents of an industrial age that now looks picturesque they can only gain in nostalgic aura.

In the middle 1940s, Burchfield, feeling that his work had digressed, turned to nature for his themes again: he even reworked some of his earliest pictures. Shortly before his death he said that he needed a quarter century more to finish what he had to say; while most artists would like to have this thought of them, and many persuade at least themselves that it is true, the exhibition at Utica shows that Burchfield did not exaggerate. Wherever they hang his late works dominate the show, and while there are striking ones from the '40s and '50s, it is in the '60s at the very end, that his art, still growing, reaches its noblest intensity. As watercolors their scale is unprecedented, running as large as 70 inches, pieced together out of several sheets of paper, partly because rag papers are not made in such sizes, and often because so many changes took place during their realization: some were worked on over five years or more. During this phase Burchfield drew with puritan exactitude thistles, sunflowers, dandelions, salsify, moths and spider webs—although his imagination often invades these studies too: his conté crayon seems caught in the same wind that sends a cecropia moth hiding under oak leaves.

In the best of these last watercolors (and they are uneven; there are some garish, theatrical monsters among them), whatever seemed quaint and contrived about the early ones is overcome; the curlicue becomes a loping arc made with a fat brushstroke; the harshly brilliant color grows luminous; little symbols vanish into a bold metaphorical design. In **Sparrowhawk Weather** the bird is nowhere to be seen; his swoop is in the cloud rhythms and his beating wings in the limbs of a dead tree. The "all-day" subjects are compressed into a single image, the second season appearing as a glimpse between the trees. The conceptions are grander and wilder: mushrooms of mist rise from a valley, pale yellow in the early morning; dark trees spotted with fireflies break up a sky white with the glare of sheet lightning; a panoramic plain is suddenly blotted by an enormous cloud shadow; the dream of a pioneer evening shows a cabin and pond illumined by the orange blaze and flying sparks of a huge bonfire. **Summer Solstice,** subtitled **In Memory of the American Chestnut Tree,** recalls the visionary Samuel Palmer and the epic scale of Frederick

Church. In a field glowing with wildflowers a hieratic chestnut stands with four luxurious tiers of shimmering foliage, turned white and yellow by perpendicular rays of light. Everything is suffused with the heat of the pausing sun, the sky by turns is oppressively bright then heavy and grey. The surface of this picture is as rich as a tapestry; the image swells with pure romantic feeling. To remember that it was painted in the middle 1960s is to realize the pitiful myopia of standard art history. (pp. 54-7, 83-4)

Rackstraw Downes, "Watercolorist for All Seasons," in ARTnews, *Vol. 69, No. 3, May, 1970, pp. 54-7, 83-4.*

Matthew Baigell (essay date 1976)

[*Baigell is an American educator and art critic who has written extensively on American art. In the following excerpt from his* Charles Burchfield, *he examines Burchfield's later paintings.*]

In 1943, [Burchfield] returned to the world of fantasy once again and began to rummage through nature's moods and seasonal variations as well as to hear the sounds of insects and wildflowers growing. The style he developed did not so much reflect the combination of his first and second periods as it revived his early phase, particularly the works of 1917, modified by the later manner.

The change, when it did come, was sudden and well-nigh complete. Within a year, in 1944, he would talk of the preceding twenty-three or twenty-four years of his career as a thing apart from his present work. In renegotiating the terrain of his youth after such a lengthy digression, as he called it, he felt as one reborn. The world was new to him again.

As if to honor his new-found youthful spirit, for the remaining twenty-four years of his life he painted some of the finest celebrations of landscape moods ever done by an American artist. They depended on no particular tradition or style, old or new, and they neither reflected nor activated any mythic images of American art or life. They marked, instead, one of the unique adventures in American art by an artist who, in burrowing deeper into his own soul, brought forth images that repeatedly strike chords of common recognition. He became a fantasist for the public, creating entirely personal pictures, but ones readily understandable and identifiable.

Burchfield used the most direct method possible to revive the fantasies of his youth. He began to complete old studies or to elaborate those already finished by literally adding sections of watercolor paper to them. When possible, he left the early paintings untouched, adding new elements around their peripheries in a similar style. In this way, the old style actually became part of the new, serving as an everpresent source of inspiration and remembrance of the dreams, sounds, and smells he had once visualized and was trying to visualize again. (p. 169)

The first elaborations of the early papers created a problem of scale. The youthful works were usually small in size, and when he enlarged them Burchfield added detail of the same size. On a small sheet, the scale of the detail

proved adequate for the overall dimensions, but with additional sheets, the scale became too small. As the details multiplied, paintings ran the risk of appearing too busy and too confusing.

The inadequacy of scale led directly to another problem: the sheer physical presence of so much detail might possibly hinder the evanescent suggestions of fantasy, precisely the quality Burchfield wanted to achieve.

He selected two ways to handle this problem. First, he turned once again to the use of conventions to express moods, but this time he purposely blurred their precise forms and meanings. When loops, spirals, and saddlebacks now appeared, they signified the presence of the artist rather than a specific code by which to read the paintings.

The second way Burchfield ensured the dominance of fantasy over detail was to develop further the brushy techniques that had begun to reappear in the late 1930s. Myriad small strokes, although visible, did not always identify particular objects, but only partially revealed them. Equally important, they gave, in more purely pictorial form, an overall pulsating quality to the paintings. With pigment and brushstroke rather than with identifying detail, Burchfield sought the forces of nature as they coursed through all things. With few distractions, he let the sky, the plants, and the earth throb with equal intensity.

Using this technique, Burchfield painted atmosphere as if it had physical density. Depending on tones and colors, he could suggest the look and feeling of a hot, humid day or the frenzied moments of a snowstorm. He could also keep butterflies and other insects in constant motion, as if they were intoxicated, he once said, "by the sheer ecstacy of existence."

But even if Burchfield wanted to add considerable detail, he was able to manipulate it to good effect, for it did not necessarily have to describe objects entirely of this world. It might also record a series of multi-experiences. Soon after the change of 1943, he began to double and triple the activities occuring within a given area of a painting. Not content with indicating a tree or the sound of insects with short calligraphic strokes, he might superimpose a moth's movements on some leaves, or intermingle clouds with a bush, or soften the edges of trees to suggest the movements of insects.

Such exploitation of detail prevented his paintings from lapsing into static compositions, but instead allowed them to expand in continuous movement. The vital forces of nature surged through his forms, sometimes with seemingly reckless abandon, as if growth and movement were parts of their beings.

Although these paintings are obviously derived from nature, they strike a particularly contemporary note. By intensifying the activities of nature and by showing a variety of them at the same moment, Burchfield suggested a type of time sequence usually associated with modern European and New York–school paintings. It may be called "cinematic time."

In Cubism, for example, a form is observed from different points over a period of time and then reassembled in a series of planes on the picture surface. Or, as in Jackson Pollock's drip paintings, the artist works at them over and over again from four different sides. In both cases, the result is a record of a time flow as if the events had happened in a single instant. Simultaneously, time appears to be stretched out and intensified as one observes the various activities represented.

Burchfield provides a naturalists's version of cinematic time. Instead of a few objects viewed from different perspectives at different times and then superimposed, he brings together a variety of objects and intimations of sounds seen and heard at one moment as well as over a period of time and then superimposes them on the picture surface. One sees trees, insects, and birds; feels the wind; and hears the forest sounds. Each of these elements is isolated, experienced for a few moments, and then mixed with the other elements. The time sequences for each are then stretched out and simultaneously intensified and presented as if they all occurred as Burchfield was able to respond to them at a single instant.

The basis for this extraordinary manipulation of time, very likely unique in modern Western art, lies clearly in observation rather than in theory. Precisely for this reason, these paintings, and similar ones of the 1950s and 1960s, reveal to a remarkable degree the synthesis of traditional American concerns with realism and the landscape with one of the major aspects of modern art.

Indeed, as one looks over the great flowering of Burchfield's art after 1943, comparisons with contemporary idioms, particularly Abstract Expressionism, become inevitable—not to provide him with a backdoor relevancy, but to test his worth against the most vital art movement coincident with his later years.

Certainly, many of his paintings show surfaces of remarkable activity and fanciful improvization. Certainly, there are passages of lyrical intensity, spontaneous directness, and profound personal engagement. Burchfield, no less than his younger contemporaries, made that long journey of self-discovery to the center of their own beings, using their art as a naked intermediary between themselves and the world.

But Burchfield's voyage was not based nearly as much on his mind interacting with itself as on a transcendental faith in the operations of nature. To become one with himself, he did not provoke dialog with his unconscious as much as try to let the spirit and moods of nature pass through him. Instead of existential anguish, which takes place in one's mind, Burchfield flung his body on the ground, literally, the better to feel nature's pulse. It was not self-understanding Burchfield was after, but a sense of participation in and reception to the forces that generate from the earth and the heavens.

When Burchfield wrote "The artist must come to nature not with a readymade formula, but in humble reverence, to learn" and "The work of an artist is superior to the surface appearance of nature, but not its basic laws," he was talking about more than finding a sense of structure in na-

ture. He was expressing the conviction that this structure could be recognized in nature's essential life-giving forces.

Of these late works, which share some stylistic features with Abstract Expressionism but are derived from antithetical premises, one is tempted to say that Burchfield took realistic American painting as far as it could go without overtly adopting modern European attitudes, devices, or motivations.

In the late 1940s Burchfield became dissatisfied with the amount of detail his paintings contained. He wanted to increase even further the degree of fantasy and reduce the amount of realism by transforming the detail into what he considered pure art forms, or at least by finding an appropriate blend of realism and abstraction.

Around 1950, therefore, he began to enrich his stylistic vocabulary by lacing in great swirls of color, thick lines, indeterminate shapes, and free rather than compulsively regular caligraphic strokes. Any pretense of capturing atmospheric effects disappeared completely.

To enhance the greater freedom he now felt and required in nature's presence, he searched for new ways to perceive forms. In 1951, for instance, he wrote that he would stare at the sun for a few moments and then paint the effects this had on the images he saw. At times, he might lie down on the ground, then jump up quickly to see the earth quivering in a trembling white light. He was then fifty-eight years old!

While he was indulging himself in these near cabalistic communions, he revived the theme of the apocalyptic landscape. In its new incarnation, grass, bushes, weeds flowers, hills, and visible rays of sunlight, which often touched the earth, trembled as if in the throes of first creation. Compared with earlier versions, with their localized hillsides, the later works are celebrations of Burchfield's soul externalized. No landscapes like these ever existed except in the fancy of a lover. With the exceptions of horizon lines and occasional floral references, these works are largely nonfigurative, holding the promise of reaching object definition, but never achieving it. They invoke landscape as if it is seen in a joyous delirium. Certainly, not in the twentieth century and never before in the history of American art has an artist felt the need to project such an ecstatic vision of nature.

In these works, Burchfield does not look over a scene in the traditional manner of landscape painters, distancing

Charles Burchfield Sun and Rocks, *1918-50 gouache and watercolor on paper 40 × 56" Albright-Knox Art Gallery Buffalo, New York Room of Contemporary Art Fund, 1953*

himself from it. Instead, he is one with the flowers and the sun's rays. He is the wind or a petal or even a color. He is a part of the scene. In making these works, the physical and emotional toll must have been tremendous: all that passion concentrated in the end of a slender watercolor brush!

During the same years that these glorious works of affirmation were being painted, Burchfield also sifted through his feelings about the north. Continued readings in Scandanavian literature very likely helped revive his old fascination with the deep and mysterious forests he associated with that direction. In 1954, as in earlier years, he wrote of its enigmatic sway over him. He invented for it deep, water-filled gashes and lichen-covered cliffs in the landscapes of his mind.

When realized on paper, they had dark and, because of their spiky forms, gothic overtones. Ultimately derived from the barren treescapes of his youth, these paintings of the north were not landscapes to wander through in enjoyment. Usually, they were winter views, and the thick, dark, leafless trees offered no hint of springtime warmth. Unlike the apocalyptic paintings, these contained deep spaces. But they were equally impenetrable because of the forbidding aspect of the trees.

The paintings may have served a purpose other than revealing Burchfield's fascination with the north. There appear throughout his career, views of bleak and desolate scenes. In his early works, such scenes are often populated with leafless trees presented in starkly contrasting tones. Through the middle years, factory scenes and forlorn townscapes convey a similar range of feeling. By 1950, however, Burchfield said that he had grown tired of painting rows of weatherbeaten houses, but evidently he had not lost his desire to show unpleasant weather conditions or melancholic scenes. It was the "northern" paintings that provided him with the vehicle to release those feelings associated with the earlier works. Among his late paintings, they are the only ones to suggest a hostile environment.

A qualification is necessary here. Burchfield often painted rainshowers and snowstorms, but he usually projected through them a celebration of nature's energies. One can speak of his "grand storms." But the "northern" paintings seize nature in a more purely belligerent aspect, when it offers not spectacle but enmity. Despite his overwhelming love for the landscape, Burchfield, as any forest rambler knows, also found nature an adversary worthy of respect and occasional fear.

It is this combination of celebration and respect that makes *An April Mood* one of his richest and most allusive paintings. Begun in 1946 and reflecting the brushy textures of that period, when completed in 1955 it joined feelings suggested by the apocalyptic and the "northern" landscapes. Burchfield wanted it to express God's anger, and a "northern" scene might have sufficed if he had not wanted to suggest as well a Good Friday mood. This obviously required hints of resurrection, if not precisely in an Easter setting—a difficult task for a landscape painter. To convey the twin moods of anger and rebirth, an April

storm became the appropriate backdrop. We see God's anger; we know that resurrection will follow. (pp. 170-95)

[One] might say that there is more childhood fantasy in some works of the 1960s than in the paintings of 1915 and 1916.

Children first see and depict things individually, without regard for logical contexts. A door may appear on its side or on a roof. In a landscape, disparate forms may appear equal in size and have color intensities that obey no traditional means of suggesting depth. Flowers may loom over trees; moons may jostle suns.

In a child's way, Burchfield painted forms that grew from his inner fantasies, isolating and identifying the objects that spurred them into existence. Enormous butterflies become large leaves on a tree; a bird seems to reach up and touch the moon. Moths, flying at moonlight, grow to huge sizes; flowers and boughs defy gravity. As an old man, he understood more clearly the elements of which fantasies are made, and that from a dandelion or a cloud a whole cosmos can be invented.

He looked more acutely at his earliest paintings to help him find once again the kinds of objects he should use and the patterns they should reveal. In 1965, he said that he found himself returning often to the works of 1915, a "rhapsodic, visionary year," for inspiration. In his fiftieth year as an artist, he was literally going back to the beginning to pry further into the secrets of the human spirit.

In *Dandelion Seed Heads and the Moon*, one of Burchfield's absolute masterpieces, the cutout patterns of 1915 act as a retrospective mortar for one of his favorite themes. In this version, the moon seems to exert a force on the dandelions, magically stirring them as if they were an ocean tide. The chimerical creatures, caught between the two forces, glide without effort as if suspended on moonbeams.

The insects and birds of Burchfield's earlier fancies symbolized sounds or the artist's feelings. The creatures that populate the late paintings do not seem to represent actions of this world, but of some other universe. It is as if he no longer cared to objectify his feelings in ways easily understood by others, but wanted to enter ever deeper into the world of spiritual forces. Charged with a magic light, the late paintings are the most purely imaginative he ever painted. They most clearly reflect the workings of the spirit world Burchfield sought to explore fifty years earlier. (pp. 197-201)

> *Matthew Baigell, in his* Charles Burchfield, *Watson-Guptill Publications, 1976, 208 p.*

John I. H. Baur (essay date 1980)

[*In the following excerpt, Baur places Burchfield in the tradition of American Transcendentalism*]

It would be difficult to name an artist living today who experiences nature with the same intensity that Charles Burchfield did. His position in American art begins to seem a terminal one; he may well be the last true pantheist in a tradition that stretches from the early nineteenth cen-

tury to the time of his death in 1967—a span of roughly 150 years.

The cult of nature in American art and letters scarcely existed in the eighteenth century. There was little room for it in the prevailing Deist philosophy with its pragmatism and common sense. But as Deism waned and Transcendentalism grew in the early 1800s, the climate of thought and feeling changed, and the visible universe became for many the transcendent proof and symbol of God's handiwork. "In the woods is perpetual youth," Emerson wrote. "Within these plantations of God, a decorum and sanctity reign. . . . In the woods we return to reason and faith."

A strong moral and religious feeling informed much of the early nature writing. "Standing on the bare ground," Emerson continued, ". . . all mean egotism vanishes. I become a transparent eye-ball; I am nothing; I see all; the currents of the Universal Being circulate through me; I am part or parcel of God."

But the beauty that Emerson sensed at such moments had to be defined. Like Lucretius, he understood that things have their intrinsic poetry or beauty, independent of the symbolism man finds in them. In his essay on beauty he stated his premise: "Such is the constitution of all things, or such the plastic power of the human eye, that the primary forms, as the sky, the mountain, the tree, the animal, give us a delight *in* and *for themselves*." (The italics are his.) But Emerson was not content with this. Beauty required a more elevated justification, and this he found in two concepts—God and reason.

> The presence of a higher, namely of the spiritual element is essential to its [beauty's] perfection. . . . Beauty is the mark God sets upon virtue.
>
> There is still another aspect under which the beauty of the world may be viewed, namely as it becomes an object of theintellect. Beside the relation of things to virtue, they have a relation to thought.

In these few sentences Emerson built the philosophical foundation for Americans' relation to nature which lasted so many years. He prepared the way for artists and for scientists alike, all of whom would have agreed with his conclusion: "A work of art is an abstract or epitome of the world. It is the result or expression of nature, in miniature."

Thoreau, though close to Emerson, recast the thought in a less lofty, more pungent way. "I see, smell, taste, hear, feel, that everlasting Something to which we are allied, at once our maker, our abode, our destiny, our very Selves; the one historic truth, the most remarkable fact which can become the distinct and uninvited subject of our thought, the actual glory of the universe; the only fact which a human being cannot avoid recognizing, or in some way forget or dispense with." He added, "In my Pantheon, Pan still reigns in his pristine glory," and he defined nature as "a greater and more perfect art, the art of God."

Even with artists—and much more so with the naturalists—the sense of God's presence in nature did not necessarily coincide with an acceptance of orthodox Christiani-

ty. Audubon, for instance, could write, "My soul was struck by the idea of the Almighty and his Power, at the sight of the sunrise, a burst of glory from the bosom of the waters," and at almost the same time, "confess I never think of churches without feeling sick at heart at the sham and show of their professors."

This anti-clericalism—if the word is not too strong—is manifest in much of John Burroughs' work. In 1857, when only seventeen, he had absorbed enough pantheism to reflect, "Nature when rightly seen is but a representation of spirit; its face is radiant with celestial smiles," but writing of his father in 1884, after the latter's death, he thought, "The delight he had in his Bible . . . I have . . . in Nature. His was related in his thought to his soul's salvation hereafter, mine to my soul's salvation here." Burroughs' attitude toward Thoreau makes the distinction between naturalist and pantheist clear. "I really see very little of Thoreau in myself," he wrote. "There is a whiff of him, now and then in a few of my pieces. . . . [But] Thoreau preaches and teaches always. I never preach or teach. I simply see and describe. I must have a pure result. I paint the bird for its own sake, and for the pleasure it affords me." Two sentences in his journal summed up his philosophy: "Nature is the only fact, after all. This is the ocean from which all the streams start, and to which they return."

Basically the naturalists agreed with the pantheists in seeing nature as the outward manifestation of ultimate reality. An extension of this concept, with obvious consequences for art, was the widely held belief that nature had moods which echoed those of man and brought solace. The opening lines of William Cullen Bryant's *Thanatopsis* state this thesis:

> To him who in the love of Nature holds
> Communion with her visible forms, she speaks
> A various language; for his gayer hours
> She has a voice of gladness, and a smile
> And eloquence of beauty, and she glides
> Into his darker musings, with a mild
> And healing sympathy, that steals away
> Their sharpness ere he is aware . . .

All the painters of the Hudson River School subscribed to this philosophy and, to varying extents, rearranged nature to emphasize certain of its aspects. In doing so, they put the stamp of their individual temperaments and preferences on their art so that grandiloquent mountains became as characteristic of Albert Bierstadt as gentle wood interiors of Asher B. Durand. By contrast, the mid-century Luminists, Fitz Hugh Lane and Martin J. Heade, were more impersonal in their direct apprehension of nature, although they, too, took some lesser liberties with it for expressive reasons.

As the nineteenth century drew to a close, there was a radical change in taste. The Barbizon School with its misty, intimate, and poetic view of nature influenced George Inness and many other landscape painters, while a younger generation—including Theodore Robinson, Childe Hassam, and John H. Twachtman—turned to French Impressionism for inspiration. Even among American painters deeply rooted in an earlier tradition, such as Winslow

Homer, there was a new freedom of handling, a delight in the suggestive power of paint, a kind of native-born impressionism.

But these were stylistic changes more than a basic shift of attitude toward nature. The old Emersonian concepts of nature and beauty remained remarkably intact. "A spiritual or moral content of human experience is plainly embodied in Inness' view of nature," his biographer, Elizabeth McCausland, wrote. "Nature stands and will suffice, his work proclaims." While Inness himself wrote his daughter in 1877, ". . . we say the sun rises, and the sun sets, but this is not true except as an appearance, and so it is with every fact of the natural world. The truth is the Lord Himself, Who creates and controls all which is thereby made to appear to us." Appropriately, Inness died watching a sunset: "Just as the big red ball went down below the horizon," his son reported, "he threw his hands into the air and exclaimed, 'My God! oh, how beautiful!' and fell stricken to the ground."

Winslow Homer was less demonstrative. "The sun will not rise, or set, without my notice and thanks," was about the limit of his verbal tribute to nature, but no one looking at the powerful seascapes of his late years can doubt his total involvement with the drama of storm, rocks, and sea. Comparing him with Inness, Lloyd Goodrich points out that "his purpose was more objective. . . . There was less overt emotion than physical sensation in his attitude towards nature. . . . His art captured some of nature's own energy and eternal freshness, so that nature herself seems to speak through it. It attained a genuine poetry, harsh and invigorating. . . . " In its objectivity it is thus akin to the art of the Luminists and, like theirs, recalls Emerson's premise that the large forms of nature have a primary aesthetic value of their own.

With the modernist revolution of the twentieth century, it appeared for a time that formal considerations had virtually replaced any meaningful relation between American artists and nature. To be sure, landscape played a part in the work of certain abstract and expressionist painters, such as Stuart Davis, Hans Hofmann, Mark Tobey, Morris Graves, William Baziotes—even Jackson Pollock and Willem de Kooning. It played an even more pronounced role in the painting of Arthur G. Dove, Marsden Hartley, Georgia O'Keeffe, Lyonel Feininger, and Joseph Stella. But the character of the relationship had changed. Nature, for these artists, was a source of forms, colors, and forces (or, in O'Keeffe's case, of personal symbolism) rather than a transcendent experience in itself. The sense of God in nature had gone, taking with it the ecstatic or reflective response of the nineteenth century. John Marin, with his passion for the Maine coast, was perhaps an exception, being close to Homer in his concern for the drama of sunlight, wave and rock, though vastly different in style. But he and Burchfield were alone. No realist painter of the century—not the American Scene men of the 1930s, not even Edward Hopper or Andrew Wyeth—got as near to nature or found in it so profound a source of inspiration.

The same condition held in twentieth-century American poetry, where the mystery of man's psyche (also a dominant concern of Abstract-Expressionist painting) tended

to replace the mystery of nature. Robert Frost's poems of rural life may seem an exception, although he was always more concerned with man than with his surroundings, with morals than with nature. Perhaps the one important poet who can stand with Marin and Burchfield as a true pantheist is Robinson Jeffers:

> —to feel
> Greatly, and express greatly, the natural
> Beauty, is the sole business of poetry,
> The rest's diversion. . . .
> —from *The Beauty of Things,* 1951

Or again:

> —and the island rocks and immense ocean beyond,
> and Lobos
> Darkening above the bay: they are beautiful?
> That is their quality: not mercy, not mind, not goodness,
> but the beauty of God.
> —from *Birds and Fishes,* 1963

Burchfield's place in this long, now waning, tradition is clear. Both his art and his thought coincide with the main aspects of American pantheism. He was a true Emersonian in every important respect. Like Emerson he found an ultimately inexplicable beauty in things "in and for themselves." The agony of spring, the unpaintable beauty of hepaticas, the recurrent pull toward realism as a mirror of nature are witness to this part of his belief. But, like Emerson also, he found a spirit in nature which he identified with God. He rejected the term "pantheism" because he came eventually to feel that God was both in nature and separate from it, but this seems to have been chiefly a way of reconciling his Lutheran faith, always shaky, with his more deeply held convictions about the spiritual essence of the universe. His early agnosticism, his long distrust of organized religion (so like that of Audubon and Burroughs), the profound solace that he found in nature, which shines out constantly in his journals and in his art, are all proof that God and the unspoiled world were, for Burchfield, virtually inseparable. And finally, like Emerson, he found beauty in the facts of nature—in its logic, its structure, its appeal to reason. The botanical drawings that he did as a child in Salem, the temptation that pursued him, even into art school, of becoming a naturalist instead of a painter, and his pleasure through all his life in identifying new flowers or birds were important aspects of his thought and even of his art. A Burchfield tree is seldom simply a tree; it is a locust, an elm, a maple, an oak, recognizable as such in even his most abstract paintings. Reading Audubon's journals he thought, "I find myself again and again in his accounts." And he echoed almost verbatim Burroughs statement: "I cannot write about the birds till they have entered into my life. I cannot write of anything well till I have lived it." Declining an invitation to paint near Detroit, Burchfield explained to Lawrence Fleischman: "I never take sketching trips away from my own locale. . . . I have to *live* for some time in a place before I can begin producing genuine expressions of my reaction to the place."

But to say that Burchfield was part of a long tradition in

American art and letters should not be taken to imply that he was very conscious of it or much influenced by preceding painters in the same line. He had read Thoreau, Audubon and Burroughs, but there is no evidence in the journals or elsewhere that he knew the paintings of the Hudson River School, of Inness or Homer or the American Impressionists (except Twachtman, whose name he misspelled) until he reached middle age. Nor does his art show their influence.

Indeed it seems fair to say that Burchfield contributed more to American pantheism than he took from it. Nature acted on him like a catalyst, stimulating his imagination, memory and emotions, and releasing a vein of fantasy quite unique in our art. He started by humanizing nature (giving violets faces, making cornstalks ghosts), by inventing conventions for its sounds and forces (such as cricket songs and wind) and others for the emotions it inspired (fear, morbidness, brooding), and weaving these all together in superbly decorative patterns. He ended with a hymn to nature on a more exalted level—a hymn that he orchestrated like a fugue in the big expressionist paintings of his last twenty years. That the freshness of these did not flag is testimony to Burchfield's ability to keep intact the awe that nature always stirred in him. "I believe that if one were to live a million years," he wrote a friend in 1959, "he could not exhaust the possibilities for expression that Nature affords and yet think of the tragedy of hundreds of artists who seem never to look at Man or Nature."

He sensed his lonely position, but never doubted its necessity. Perhaps he remembered Burroughs' words: "The great artist is identified with his subject; it is *his* subject; he does not merely write about it; he *is* it; it fuses and blends with his personality. The lesser poets search for a subject; to the great poet the subject comes; he stands in his place and it finds him." (pp. 174-76)

> *John I. H. Baur, "Charles Burchfield: The Last Pantheist?" in Arts Magazine, Vol. 54, No. 6, February, 1980, pp. 174-76.*

FURTHER READING

I. Writings by Burchfield

"Burchfield's Intimate Diaries." *Artnews* 54, No. 9 (January 1956): 26-7, 65-6.
> Selections from Burchfield's unpublished diaries. Excerpts are chosen and arranged by John I. H. Baur to "illuminate the three main phases of [Burchfield's] career."

"Sun and Rocks by Charles E. Burchfield." *The Buffalo Fine Arts Academy Gallery Notes* XVIII, No. 2 (January 1954): 24-5.
> Burchfield describes the inspiration and method for his watercolor *Sun and Rocks.*

II. Catalogs Raisonné

Museum of Art, Munson-Williams-Proctor Institute. *Charles Burchfield: Catalogue of Paintings in Public and Private Collections.* New York: Munson-Williams-Proctor Institute, 1970, 367 p.

Includes an introductory overview, photographs, a chronological list of exhibitions, and a comprehensive bibliography citing more than 300 references. Several color plates are included among numerous black-and-white reproductions, and biographical notes precede each year's listing of paintings.

III. Critical Studies and Reviews

"Charles Burchfield: 1942." *American Artist* 6, No. 5 (May 1942): 5-11.
> Surveys Burchfield's early works and describes his artistic method.

"Burchfield's Buffalo: A Comparison Between the Artist's and the Camera's Eye." *Art News* XLIII, No. 6 (1-14 May 1944): 12-13.
> Compares several of Burchfield's paintings with photographs of the sites they depict. Accompanying captions present Burchfield's own impressions of each scene.

Baur, John I. H. *The Inlander: Life and Work of Charles Burchfield, 1893-1967.* Newark, N.J.: University of Delaware Press, 1982, 280 p.
> Monograph. Describing Burchfield as a "romantic painter of passion and intensity," Baur writes: "It is as a profoundly romantic celebrant of nature that [he] must finally be judged."

Breuning, Margaret. Review of an exhibition at the Rehn Gallery. *Arts* 35, No. 4 (January 1961): 50-1.
> Favorable review of Burchfield's later works, which are described by Breuning as "alluring," "mystical," and "explosive."

Broadd, Harry A. "Charles Burchfield: Painter of Mood." *Arts & Activities* 88, No. 1 (September 1980): 44-7, 58-9.
> Overview of the salient features of Burchfield's work.

"Charles Burchfield." *Carnegie Magazine* XI, No. 10 (March 1938): 309-12.
> Discussion of the artist's life and works occasioned by an exhibition of his paintings at the Carnegie Institute.

Clark, Eliot. "New York Commentary." *Studio* 151, No. 759 (June 1956): 184-87.
> Review of the 1956 retrospective of Burchfield's works at the Whitney Museum. Describing Burchfield's paintings, Clark writes: "Two moods dominate his theme: the dramatic materialisation of the natural world which characterises the middle period of his work, and the phantasy of brooding imagination imbued with the dreams of youth."

Coates, Robert M. "The Three Burchfields." *The New Yorker* XXXI, No. 50 (28 January 1956): 63-5.
> Assesses the strengths and weaknesses of Burchfield's varying artistic styles.

DuPont, J. J. "Charles Burchfield's Buffalo." *The Conservationist* 34, No. 5 (March-April 1980): 24-8.
> Brief critical biography which includes several reproductions of Burchfield's "Buffalo" paintings.

George, Laverne. "Charles Burchfield." *Arts* 30, No. 4 (January 1956): 26-31.
> Biographical anecdotes based on an interview with Burchfield at his home in Gardenville, New York.

"Burchfield, Painter of Familiar Scenes." *Graphic Survey* XLI, No. 3 (1 November 1928): 159.

> Brief sketch of Burchfield's early paintings praising his "fresh vision." The critic writes: "Suddenly we are cured of our astigmatism and can see the rich colors of the everyday world."

Krasne, Belle. "A Charles Burchfield Profile." *Art Digest* 27, No. 6 (15 December 1952): 9, 21-2.

> Includes Burchfield's own reflections on his career.

"A Note on Burchfield." *Magazine of Art* 30, No. 6 (June 1937): 352.

> Brief commentary on Burchfield's career in which the critic concludes: "To be a realist in the sense that Burchfield is, is to be a poet as well."

Richardson, E. P. "Charles Burchfield." *Magazine of Art* 37, No. 6 (October 1944): 208-12.

> Positive review occasioned by an early retrospective of Burchfield's works.

Robertson, Bruce. "Charles Burchfield: *Sun Breaking through Winter Mists.*" *Yale University Art Gallery Bulletin* 37, No. 3 (Spring 1980): 22-4.

> Notes that Burchfield's "mixture of realistic observation and poetic appreciation of nature characterizes much of his work."

Stretch, Bonnie Barrett. "The Last Pantheist." *ARTnews* 83, No. 5 (May 1984): 119-23.

> Traces Burchfield's artistic development.

Tannenbaum, Judith. "Charles Burchfield at Kennedy." *Arts Magazine* 48, No. 8 (May 1974): 72-3.

> Brief overview of Burchfield's art.

IV. Selected Sources of Reproductions

Baigell, Matthew. *Charles Burchfield.* New York: Watson-Guptill Publications, 1976, 208 p.

> Monograph including forty-six color plates among numerous black-and-white reproductions and text by Baigell.

Baur, John I. H. *Charles Burchfield.* New York: The Macmillan Company, 1956, 86 p. + 54 plates.

> Includes extracts from Burchfield's private journal and autobiographical notes.

The Drawing Society. *The Drawings of Charles Burchfield,* edited by Edith H. Jones. New York: Frederick A. Praeger, 1968, unpaged.

> Illuminating quotes from the artist accompany each drawing.

Alexander Calder

1898-1976

American sculptor, painter, and graphic artist.

Calder is regarded as the preeminent American sculptor of the twentieth century. Distinguished by his innovative approach, he produced works in a variety of genres but is best known for his development of the form known as the mobile and for his large metal sculptures, called stabiles. Calder's style, in which biomorphic and abstract forms are mingled, is often described as childlike due to its simplicity and frequent whimsicality. This interpretation is substantiated by Calder's own statement of his aims: "Above all, I feel art should be happy and not lugubrious."

The son and grandson of professional sculptors, Calder was born in Lawnton, Pennsylvania, near Philadelphia. He manifested a talent for art at a very early age and was provided with his own studio space, where he fashioned toys, jewelry, and various miniature objects. However, he initially resisted his father's suggestion that he become a sculptor, planning instead to become a mechanical engineer. From 1915 to 1919, he studied at the Stevens Institute of Technology in Hoboken, New Jersey. After graduating, he held a variety of jobs which failed to maintain his interest, and in 1923 he decided to return to school to study art.

Calder entered the Art Students League in New York City in the fall of 1923 and soon after began working as a free-lance cartoonist for the *National Police Gazette*. Three years later he moved to Paris, where he began creating wire sculptures based on the principle of the single-line drawing, a technique he had mastered while working for the *Gazette*. In one of his best-known series of wire sculptures, depicting the renowned cabaret dancer Josephine Baker, Calder captured Baker's undulating motions through the use of spiral formations. While in Paris, Calder also created a miniature circus composed of bits of wire, string, cloth, yarn, and wood, hoping to market it through a toy manufacturer. In order to earn money, he began giving "performances" of the circus, in which he served as ringmaster and guided the various figures through their acts. Calder's circus became a huge success among members of the Parisian avant-garde, who filled his small apartment each evening and often commissioned special performances. During this period Calder also began carving wood sculptures, focusing in particular on animal subjects, and in the late 1920s he mounted exhibitions of his wood and wire figures in Paris and New York.

After 1930, Calder began to focus more intently on introducing motion into his works and to experiment with abstract forms. He later explained that during a visit to the studio of noted abstract artist Piet Mondrian he became fascinated with the idea of setting Mondrian's pleasing, colorful shapes into motion. Calder's first kinetic sculptures, exhibited in Paris in February of 1932, were powered by motors. However, Calder quickly became dissatis-

fied with the predictability of motion in these works and with the unreliability of the motors that drove them, and he soon afterward developed the idea of pendant, balanced structures that could be propelled by currents of air. Calder's innovation was immediately hailed as a major advance in the development of modern art, and Waverley Root wrote that "Calder's mobiles may well be the beginning of four-dimensional sculpture." Although abstract in appearance, Calder's mobiles frequently suggest biological or astronomical subject matter, as demonstrated in such titles as *Lobster Trap and Fish Tail* (1939) and *Constellation with Mobile* (1946).

As early as 1932, Calder also began creating stationary sculptures notable for their Cubist-influenced, geometric treatment of biomorphic forms; these were named stabiles by Calder's friend and fellow sculptor Jean Arp. Calder's early stabiles were not unusually large, standing from three to six feet high in most cases. However, after 1958 Calder began producing extremely large stabiles and accepted commissions for the public pieces that remain his most visible contribution to modern art. In 1962, he designed *Teodelapio* for the city of Spoleto, Italy, and five years later he produced *Man* for the World's Fair in Mon-

treal. In 1974 he created what commentators consider one of his most successful public works, the fifty-three-foot-high *Flamingo,* which stands in Federal Center Plaza in Chicago, complementing an adjacent skyscraper by Mies van der Rohe and, according to critics, "humanizing" the urban landscape by inviting pedestrians to pause and linger. During the last decade of his life, Calder also became known as an outspoken opponent of the war in Vietnam and as the supporter of various liberal concerns, including the nascent environmentalist movement. In October of 1976 he was honored with a comprehensive retrospective exhibit at the Whitney Museum of American Art in New York City, and at his death, later that year, he was hailed as one of the most popular artists of the century.

For several years following his death, Calder's stature as the popular icon of Modernism inhibited serious considerations of his work; however, recent evaluations have established the importance of his sculpture to the development of modern art. While tracing the origin of Calder's innovations to the kinetic theories of such early Modernists as the Futurists, Constructivists, and Cubists, critics emphasize the originality of Calder's realization of the aesthetic goals of such groups and suggest that his work helped inspire the freedom and mulitiplicity of forms that distinguishes art in the late twentieth century.

ARTIST'S STATEMENTS

Alexander Calder (essay date 1937)

[*In the following essay, Calder describes the development of his technique.*]

When an artist explains what he is doing he usually has to do one of two things: either scrap what he has explained, or make his subsequent work fit in with the explanation. Theories may be all very well for the artist himself, but they shouldn't be broadcast to other people. All that I shall say here will be about what I have already done, not about what I am going to do.

I began by studying engineering. But after four years I decided that engineering did not allow enough play of ingenuity on my part. When I was working in a logging camp I first started painting. I went to New York, and then to Paris, where I started making wire toys—caricatures of people and animals, some of them articulated. Then I made things in wood, taking a lump of wood and making very little alteration in its shape—just enough to turn it into something different. Then I made a circus with elephants, horses, a lion, Roman chariots and so on: basically of wire, but with cork and wood and bright colours added. Most of these objects also were articulated, so that they made characteristic gestures. The material for this was based on my observation at the circus, and on drawings of it. I was always interested in circuses.

My father was a sculptor and my mother a painter, but it

was quite accidentally that I became mixed up with modern art. Through a neighbour who knew about modern art—he had read the books, and so on—I went to see Mondrian. I was very much moved by Mondrian's studio, large, beautiful and irregular in shape as it was, with the walls painted white and divided by black lines and rectangles of bright colour, like his paintings. It was very lovely, with a cross-light (there were windows on both sides), and I thought at the time how fine it would be if everything there *moved;* though Mondrian himself did not approve of this idea at all. I went home and tried to paint. But wire, or something to twist, or tear, or bend, is an easier medium for me to think in. I started with a few simple forms. My first show was at the Galerie Percier, of simple things ranged on a plank against a wall. In a way, some of those things were as plastic as anything I have done. They did not move, but they had plastic qualities. Then I made one or two things that moved in a slight degree. I had the idea of making one or two objects at a time find actual relationships in space.

I did a setting for Satie's *Socrate* in Hertford, U.S.A., which I will describe, as it serves as an indication of a good deal of my subsequent work.

There is no dancing in it. It is sung by two people—a man and a woman. The singing is the main thing in it. The proscenium opening was 12 feet by 30 feet. There were three elements in the setting. As seen from the audience, there was a red disc about 30 inches across, left centre. Near the left edge there was a vertical rectangle, 3 feet by 10 feet, standing on the floor. Towards the right, there were two 7 foot steel hoops at right angles on a horizontal spindle, with a hook one end and a pulley the other, so that it could be rotated in either direction, and raised and lowered. The whole dialogue was divided into three parts: 9, 9, and 18 minutes long. During the first part the red disc moved continuously to the extreme right, then to the extreme left (on cords) and then returned to its original position, the whole operation taking 9 minutes. In the second section there was a minute at the beginning with no movement at all, then the steel hoops started to rotate toward the audience, and after about three more minutes they were lowered towards the floor. Then they stopped, and started to rotate again in the opposite direction. Then in the original direction. Then they moved upwards again. That completed the second section. In the third, the vertical white rectangle tilted gently over to the right until it rested on the ground, on its long edge. Then there was a pause. Then it fell over slowly away from the audience, face on the floor. Then it came up again with the other face towards the audience; and that face was black. Then it rose into a vertical position again, still black, and moved away towards the right. Then, just at the end, the red disc moved off to the left. The whole thing was very gentle, and subservient to the music and the words.

For a couple of years in Paris I had a small ballet-object, built on a table with pulleys at the top of a frame. It was possible to move coloured discs across the rectangle, or fluttering pennants, or cones; to make them dance, or even have battles between them. Some of them had large, simple, majestic movements; others were small and agitated.

I tried it also in the open air, swung between trees on ropes, and later Martha Graham and I projected a ballet on these lines. For me, increase in size—working full-scale in this way—is very interesting. I once saw a movie made in a marble quarry, and the delicacy of movement of the great masses of marble, imposed of necessity by their great weight, was very handsome. My idea with the mechanical ballet was to do it independently of dancers, or without them altogether, and I devised a graphic method of registering the ballet movements, with the trajectories marked with different coloured chalks or crayons.

I have made a number of things for the open air: all of them react to the wind, and are like a sailing vessel in that they react best to one kind of breeze. It is impossible to make a thing work with every kind of wind. I also used to drive some of my mobiles with small electric motors, and though I have abandoned this to some extent now, I still like the idea, because you can produce a *positive* instead of a fitful movement—though on occasions I like that too. With a mechanical drive, you can control the thing like the choreography in a ballet and superimpose various movements: a great number, even, by means of cams and other mechanical devices. To combine one or two simple movements with different periods, however, really gives the finest effect, because while simple, they are capable of infinite combinations. (pp. 63-7)

> *Alexander Calder, "Mobiles," in* The Paint-er's Object, *edited by Myfanwy Evans, Gerald Howe Ltd., 1937, pp. 63-8.*

Alexander Calder (essay date 1951)

[*In the following essay, Calder briefly explains the theory behind his mobiles and sculptures.*]

My entrance into the field of abstract art came about as the result of a visit to the studio of Piet Mondrian in Paris in 1930.

I was particularly impressed by some rectangles of color he had tacked on his wall in a pattern after his nature.

I told him I would like to make them oscillate—he objected. I went home and tried to paint abstractly—but in two weeks I was back again among plastic materials.

I think that at that time and practically ever since, the underlying sense of form in my work has been the system of the Universe, or part thereof. For that is a rather large model to work from.

What I mean is that the idea of detached bodies floating in space, of different sizes and densities, perhaps of different colors and temperatures, and surrounded and interlarded with wisps of gaseous condition, and some at rest, while others move in peculiar manners, seems to me the ideal source of form.

I would have them deployed, some nearer together and some at immense distances.

And great disparity among all the qualities of these bodies, and their motions as well.

A very exciting moment for me was at the planetarium—

when the machine was run fast for the purpose of explaining its operation: a planet moved along a straight line, then suddenly made a complete loop of 360° off to one side, and then went off in a straight line in its original direction.

I have chiefly limited myself to the use of black and white as being the most disparate colors. Red is the color most opposed to both of these—and then, finally, the other primaries. The secondary colors and intermediate shades serve only to confuse and muddle the distinctness and clarity.

When I have used spheres and discs, I have intended that they should represent more than what they just are. More or less as the earth is a sphere, but also has some miles of gas about it, volcanoes upon it, and the moon making circles around it, and as the sun is a sphere—but also is a source of intense heat, the effect of which is felt at great distances. A ball of wood or a disc of metal is rather a dull object without this sense of something emanating from it.

When I use two circles of wire intersecting at right angles, this to me is a sphere—and when I use two or more sheets of metal cut into shapes and mounted at angles to each other, I feel that there is a solid form, perhaps concave, perhaps convex, filling in the dihedral angles between them. I do not have a definite idea of what this would be like, I merely sense it and occupy myself with the shapes one actually sees.

Then there is the idea of an object floating—not supported—the use of a very long thread, or a long arm in cantilever as a means of support seems to best approximate this freedom from the earth.

Thus what I produce is not precisely what I have in mind—but a sort of sketch, a man-made approximation.

That others grasp what I have in mind seems unessential, at least as long as they have something else in theirs. (p. 8)

> *Alexander Calder, in an excerpt in* The Museum of Modern Art Bulletin, *Vol. XVIII, No. 3, Spring, 1951, pp. 8-9.*

Alexander Calder with Katharine Kuh (interview date 1960)

[*In the following interview, Calder discusses the intention of his works.*]

[Kuh]: *Does your work satirize the modern machine?*

[Calder]: No, it doesn't. That's funny, because I once intended making a bird that would open its beak, spread its wings and squeak if you turned a crank, but I didn't because I was slow on the uptake and I found that Klee had done it earlier with his *Twittering Machine* and probably better than I could. In about 1929, I did make two or three fish bowls with fish that swam when you turned a crank. And then, of course, you know about the *Circus.* I've just made a film of it in France with Carlos Vilardebo.

Which has influenced you more, nature or modern machinery?

Nature. I haven't really touched machinery except for a few elementary mechanisms like levers and balances. You see nature and then you try to emulate it. But, of course, when I met Mondrian I went home and tried to paint. The basis of everything for me is the universe. The simplest forms in the universe are the sphere and the circle. I represent them by disks and then I vary them. My whole theory about art is the disparity that exists between form, masses and movement. Even my triangles are spheres, but they are spheres of a different shape.

How do you get that subtle balance in your work?

You put a disk here and then you put another disk that is a triangle at the other end and then you balance them on your finger and keep on adding. I don't use rectangles—they stop. You can use them; I have at times but only when I want to block, to constipate movement.

Is it true that Marcel Duchamp invented the name "mobile" for your work?

Yes, Duchamp named the mobiles and Arp the stabiles. Arp said, "What did you call those things you exhibited last year? Stabiles?"

*Were the mobiles influenced by your **Circus?***

I don't think the **Circus** was really important in the making of the mobiles. In 1926 I met a Yugoslav in Paris and he said that if I could make mechanical toys I could make a living, so I went home and thought about it awhile and made some toys, but by the time I got them finished my Yugoslav had disappeared. I always loved the circus—I used to go in New York when I worked on the *Police Gazette*. I got a pass and went every day for two weeks, so I decided to make a circus just for the fun of it.

How did the mobiles start?

The mobiles started when I went to see Mondrian. I was impressed by several colored rectangles he had on the wall. Shortly after that I made some mobiles; Mondrian claimed his paintings were faster than my mobiles.

What role does color play in your sculpture?

Well, it's really secondary. I want things to be differentiated. Black and white are first—then red is next—and then I get sort of vague. It's really just for differentiation, but I love red so much that I almost want to paint everything red. I often wish that I'd been a *fauve* in 1905.

Do you think that your early training as an engineer has affected your work?

It's made things simple for me that seem to confound other people, like the mechanics of the mobiles. I know this, because I've had contact with one or two engineers who understood my methods. I don't think the engineering really has much to do with my work; it's merely the means of attaining an aesthetic end.

Do you make preliminary sketches?

I've made so many mobiles that I pretty well know what I want to do, at least where the smaller ones are concerned, but when I'm seeking a new form, then I draw and make little models out of sheet metal. Actually the one at

Idlewild (in the International Arrival Building) is forty-five feet long and was made from a model only seventeen inches long. For the very big ones I don't have machinery large enough, so I go to a shop and become the workman's helper.

How do you feel about commissions?

They give me a chance to undertake something of considerable size. I don't mind planning a work for a given place. I find that everything I do, if it is made for a particular spot, is more successful. A little thing, like this one on the table, is made for a spot on a table.

Do you prefer making the large ones?

Yes—it's more exhilarating—and then one can think he's a big shot.

How do your mobiles differ from your stabiles in intention?

Well, the mobile has actual movement in itself, while the stabile is back at the old painting idea of implied movement. You have to walk around a stabile or through it—a mobile dances in front of you. You can walk through my stabile in the Basle museum. It's a bunch of triangles leaning against each other with several large arches flying from the mass of triangles.

Why walk through it?

Just for fun. I'd like people to climb over it but it isn't big enough. I've never been to the Statue of Liberty but I understand it's quite wonderful to go into it, to walk through.

Léger once called you a realist. How do you feel about this?

Yes, I think I am a realist.

Why?

Because I make what I see. It's only the problem of seeing it. If you can imagine a thing, conjure it up in space—then you can make it, and *tout de suite* you're a realist. The universe is real but you can't see it. You have to imagine it. Once you imagine it, you can be realistic about reproducing it.

So it's not the obvious mechanized modern world you're concerned with?

Oh, you mean cellophane and all that crap.

How did you begin to use sound in your work?

It was accidental at first. Then I made a sculpture called **Dogwood** with three heavy plates that gave off quite a clangor. Here was just another variation. You see, you have weight, form, size, color, motion and then you have noise.

How do you feel about your motorized mobiles?

The motorized ones are too painful—too many mechanical bugaboos. Even the best are apt to be mechanically repetitious. There's one thirty feet high in front of Stockholm's modern museum made after a model of mine. It has four elements, each operating on a separate motor.

How did you happen to make collapsible mobiles?

When I had the show in Paris during 1946 at Louis Carré's gallery, the plans called for small sculptures that could be sent by mail. The size limit for things sent that way was $18 \times 10 \times 2$ inches, so I made mobiles that would fold up. Rods, plates, everything was made in two or three pieces and could be taken apart and folded in a little package. I sent drawings along showing how to reassemble the pieces.

You don't use much glass any more, do you?

I haven't used it much lately. A few years ago I took all sorts of colored glass I'd collected and smashed it against the stone wall of the barn. There's still a mass of glass buried there. In my early mobiles I often used it.

Are there any specific works that you prefer and would like to have reproduced?

What I like best is the acoustic ceiling in Caracas in the auditorium of the university. It's made from great panels of plywood—some thirty feet long—more or less horizontal and tilted to reflect sound. I also like the work I did for UNESCO in Paris and the mobile called ***Little Blue under Red*** that belongs to the Fogg. That one develops hypocycloidal and epicycloidal curves. The main problem there was to keep all the parts light enough to work.

Do you consider your work particularly American?

I got the first impulse for doing things my way in Paris, so I really can't say.

Have American cities influenced you?

I like Chicago on the Michigan Avenue Bridge on a cold wintry night. There used to be no color but the traffic lights, occasional red lights among the white lights. I don't think that looking at American cities has really affected me. We went to India and I made some mobiles there; they look just like the others.

*What's happened to that large sculpture, **The City**?*

The City was purchased by the Museo de Bellas Artes in Caracas through the kind offices of my good friend, the architect Carlos Raul Villanueva.

I found it great. What do you think of it?

I'm slowly becoming convinced. I made the model for it out of scraps that were left over from a big mobile. I just happened to have these bits, so I stood them up and tried them here and there and then made a strap to hook them together—a little like *objets trouvés*. ["Found objects" usually refers to articles in nature and daily life, like shells, stones, leaves, torn paper, etc., which the artist recognizes and accepts as art. Ed.] I decided on the final size by considering the dimensions of the room in the Perls Galleries where the work was to be shown.

What artists do you most admire?

Goya, Miró, Matisse, Bosch and Klee. (pp. 39-50)

> *Alexander Calder and Katharine Kuh, in an interview in* The Artist's Voice: Talks with Seventeen Artists, *by Katharine Kuh, Harper & Row, 1962, pp. 39-51.*

INTRODUCTORY OVERVIEW

Bernice Rose (essay date 1969)

[*In the following excerpt, Rose provides an overview of Calder's career.*]

Throughout his long career as one of the pioneering sculptors of the twentieth century, Alexander Calder has been unusually reticent, making very few statements about his work and theorizing as little as possible when he could be persuaded to speak. "When an artist explains what he is doing," he wrote in 1937, "he usually has to do one of two things: either scrap what he has explained, or make subsequent work fit in with the explanation. Theories may be all very well for the artist himself, but they shouldn't be broadcast to other people" [see Artist's Statements].

Calder remains reticent to this day. But, while he has left to others to theorize about his sculpture, the sculpture itself has generated its own definitions. In the Addenda Section of the Second Edition of Webster's New International Dictionary published in 1954 there are two definitions that had not appeared in earlier editions:

> **mobile** *n. Art.* A delicately balanced construction or sculpture of a type developed by Alexander Calder since 1930, usually with movable parts, which can be set in motion by currents of air or mechanically propelled.
>
> **stabile** *n. Art.* An abstract sculpture or construction typically made of sheet metal, wire, and wood. Cf. MOBILE

In subsequent editions the definitions no longer make direct reference to Calder, indicating that his work had generated a whole new genre of objects, so integrated that they were classified as part of the general vocabulary. These are definitions that can be applied only to sculpture made in the twentieth century and only to sculpture set within a fairly specific context, and with certain definite roots. The roots most meaningful here are Constructivism, an art movement based on the analytic structure of Picasso's Cubist collages; Futurist ideas that demanded that art portray space through dynamic movement and use industrial materials appropriate to an age of speed; and Malevich's rejection of the portrayal of objects as necessary to art.

Calder was, perhaps, peculiarly qualified to realize the ideas of the Constructivists and at the same time synthesize them with Surrealism. Son and grandson of sculptors, he himself had been trained as a mechanical engineer. He was thus familiar with both technology and art when he arrived in Paris in the late twenties, and was on the scene during a major revival of interest in nonobjective art, Constructivism, and Dada.

Calder's first fame came from his performance of his miniature circus before the avant-garde. The impact the circus had on these intellectual and social circles is perhaps best indicated by the circumstance that years later Thomas Wolfe, in his novel *You Can't Go Home Again*, would use a performance of the circus as a focus for his stinging com-

ment on a social milieu that used art and artists as a diversion.

> Yes, Mr. Piggy Logan was the rage that year. He was the creator of a puppet circus of wire dolls, and the applause with which this curious entertainment had been greeted was astonishing. Not to be able to discuss him and his little dolls intelligently was, in smart circles, akin to never having heard of Jean Cocteau or Surrealism; it was like being completely at a loss when such names as Picasso and Brancusi and Utrillo and Gertrude Stein were mentioned. Mr. Piggy Logan and his art were spoken of with the same animated reverence that the knowing used when they spoke of one of these. . . .

> The highest intelligences of the time—the very subtlest of the chosen few—were bored by many things. . . . They were bored with living, they were bored with dying, but—they were *not* bored that year with Mr. Piggy Logan and his circus of wire dolls. . . .

> . . . There were miniature circus rings made of rounded strips of tin or copper which fitted neatly together. There were trapezes and flying swings. And there was an astonishing variety of figures made of wire to represent all the animals and performers. There were clowns and trapeze artists, acrobats and tumblers, horses and bareback lady riders. There was almost everything that one could think of to make a circus complete, and all of it was constructed of wire. . . .

> It started, as all circuses should, with a grand procession of the performers and the animals in the menagerie. Mr. Logan accomplished this by taking each wire figure in his thick hand and walking it around the ring and then solemnly out again. . . .

> Then came an exhibition of bareback riders. Mr. Logan galloped his wire horses into the ring and round and round with movements of his hand. Then he put the riders on top of the wire horses, and, holding them firmly in place, he galloped these around too. Then there was an interlude of clowns, and he made the wire figures tumble about by manipulating them with his hands. After this came a procession of wire elephants. . . .

These performances provided Calder not only with money to eat but with introductions to the most advanced artists of the time. In Paris he met Miró (although he did not immediately assimilate the significance of Miró's work), and ultimately Arp, Léger, and other members of Abstraction-Création, the exhibiting group of the Neo-Plasticists and Constructivists in Paris. Gradually he turned the emphasis away from the circus and began to construct and exhibit large wire figures. Josephine Baker was the first subject to be treated in this large format. Though many of the wire sculptures are caricatures, they are—the portraits in particular—the first sculptures in which Calder makes use of multiple views, constructs a sculpture in which all sides can be seen at once, and modulates space as if it were a palpable volume.

It cannot be claimed that Calder was pursuing any radically new, original course in sculpture at this time. Open-form sculpture was under constant discussion during these years; with the collaboration of Gonzalez, Picasso was also working with wire. But, whereas he was soldering and using wire as a stiff, sticklike element, Calder, who has always preferred mechanical constructions, was creating in the manner that has remained characteristic for him. He has always found it easier to think with his hands, to think in terms of specific materials. He bends and twists wire to outline planes and volume and follow features as if wire were a fluid line drawn in space. The flexibility of these wire figures shows that from the first Calder displayed a propensity for moving form. He had become so facile with wire representations that he could make a piece like *Sow* on demand in fifteen minutes. But, by 1930, he was ready for new challenges. An earlier piece of 1928, *Elephant Chair with Lamp,* already shows elements of much later standing mobiles: a fixed organic form for a base, a wire arm extended from the apex, with mobile elements suspended from it. Calder quickly began to move into new areas.

It is at this time that Constructivist ideas seem to have provided him with a new context for open-form sculpture. Constructivism had originated in Russia during the Revo-

Josephine Baker *(1929).*

lution with the brothers Naum Gabo and Antoine Pevsner, who spread its ideas first to Germany and then to Paris during the twenties. In both countries it had significant effects, becoming a focus for plastic innovations. In 1920 Gabo had written the Realistic Manifesto in which he announced the Constructivist break with the plastic tradition that had dominated Western art for "1000 years." Among his pronouncements are several that seem appropriate to Calder:

"The realization of our perceptions of the world in the forms of space and time is the only aim of our pictorial and plastic art. . . . we construct our work as the universe constructs its own, as the engineer constructs his bridges, as the mathematician his formula of the orbits. . . . everything has its own essential image. . . . all [are] entire worlds with their own rhythms, their own orbits." Denouncing descriptive line and volume, Gabo continued: ". . . we bring back to sculpture the line as a direction and in it we affirm depth as the one form of space. We renounce the thousand-year-old delusion in art that held the static rhythms as the only elements of the plastic and pictorial arts. We affirm in these arts a new element of the kinetic rhythms as the basic forms of our perception of real time." Later he expanded his ideas to deal directly with the materials of sculpture: "In sculpture, as well as in technics, every material is good and worthy and useful, because every material has its own aesthetical value. In sculpture, as well as in technics, the method of working is set by the material itself."

In 1930 Calder was invited to join the Abstraction-Création group. In the same year, Mondrian came to see his circus; Calder returned the visit, precipitating the first major change in his style.

"I was very much moved by Mondrian's studio," he wrote,

> large, beautiful and irregular in shape as it was, with the walls painted white and divided by black lines and rectangles of bright color like his paintings. It was very lovely, with a cross-light (there were windows on both sides), and I thought at the time how fine it would be if everything there *moved;* though Mondrian himself did not approve of this idea at all. I went home and tried to paint. But wire, or something to twist, or tear, or bend, is an easier medium for me to think in.

He went back to wood and wire because he "liked manipulating pieces."

Calder is that rare individual who is able intuitively to integrate theory and concept with manual dexterity to create a "mechanical" representation of a visual idea. From Mondrian he learned the essentials of Neo-Plasticism, excerpting what he found useful: flat planes; the use of primary colors in opposition to black and white; equilibrium of space and surface through proportion of line, plane, and color; and non-symmetrical balance: "the balanced relation is the purest representation of universality."

Calder immediately translated this experience into a series of wood-and-wire constructions, which were exhibited at the Galerie Percier in 1931. One of these constructions was the prototype for the motorized mobile *A Universe.* Calder was now making a sharp distinction between these wire-and-wood non-objective constructions of 1931 and the earlier wire portraits, which the gallery owner insisted he show along with them. Calder's recent remark that he didn't consider the *Cow* a very elegant form is revealing: he had begun to think primarily in terms of forms rather than representations, hence the distinction.

The Mondrians that had initiated the change in Calder's formal approach were rectangular, but as soon as Calder turned to three dimensions he thought in terms of round shapes. "Two hoops of wire intersecting form a sphere . . . a sphere is one of the most elementary shapes . . . like drops of water." Calder has connected the idea of spheres and elementary shapes with the idea of the universality of form and the universe itself in a very pragmatic interpretation of Gabo's statements. Plastic art was universal art, and the idea of the universe, itself a moving system, led him into movement. In a statement of 1951 [see Artist's Statements] he wrote: ". . . the underlying sense of form in my work has been the system of the Universe, or part thereof. For that is a rather large model to work from. What I mean is the idea of detached bodies floating in space, of different sizes and densities, perhaps of different colors and temperatures, surrounded and interlarded with wisps of gaseous condition, and some at rest, while others move in peculiar manners, seems to me the ideal source of form."

Calder's transition into mechanical movement in the series of manual and motorized mobiles shown in Paris at the Galerie Vignon in 1933 should be seen in terms of his multi-faceted background. Perhaps first is his training as a mechanical engineer, which has grown rather than diminished in importance. "I was studying a lot of theory and didn't see what use it would be," he has remarked, "but it comes out." The mechanical engineering is not just practically important, for building motors, for example; it is conceptually important. A mechanical engineer studies machines from the point of view of efficient motion; he is technically concerned with kinetic theories, including the movement of liquids and gases. Perhaps as important were Gabo's ideas about a kinetic art. Although Calder did not meet Gabo during the Abstraction-Création years, there can be no doubt that his ideas for the creation of a kinetic art in four dimensions—the fourth dimension being the time interval inherent in any movement sequence—were a major factor in Calder's work, even at second hand. He may even have heard about Gabo's one kinetic construction of 1920. Although Calder did not meet Duchamp until after he made his first mechanized constructions, he knew Picabia, and through Picabia he may have heard of Duchamp's earlier mechanized constructions. While Picabia's own Dada machine portraits are collages, not kinetic constructions, it is also probable that their Dada irony (and even the collage technique) had a strong effect on such pieces as *The Motorized Mobile That Duchamp Liked* and the other motorized pieces of the next few years which move in somehow playful, apparently accidental or irrational patterns.

One catalyst that may have helped to integrate these experiences was Calder's fortuitous viewing in 1928 of an exhibition of automata taking place in the same building where an exhibition of his own was being held, although he probably knew automata before this time. The circus, while not mechanized, is mechanical and, in one sense, a collection of automata. It was a re-creation of a whole world; although, as has been pointed out, its awkwardness, lack of verisimilitude, and the occasional failure of a piece to perform permits it to be art, thus taking it out of the range of automata which aim at verisimilitude and perfect mechanical performance. The circus is in fact a parody of mechanical toys, a combination of "natural" and mechanical movement.

It is, then, not illogical that at the same time that Calder explored mechanized movement he began to make air-driven mobiles. Within the next few years the general cult of faith in the machine as a panacea was to break down under the assaults of Dada and the Surrealists. As the machine cult broke down, Calder became more and more sympathetic to Arp, whom he knew from Abstraction-Création, and Miró, and gradually introduced biomorphic forms, which he added to his geometric shapes. These Surrealist affinities are evident in the work of the late thirties and early forties and account for his inclusion in the *Exposition Internationale du Surréalisme* held in Paris in the summer of 1947. At one point Calder even used found objects for his mobiles but abandoned that because it "was a concession to other people's ideas." Pieces like ***Gibraltar, Morning Star,*** and the series of Constellations are among his most overtly Surrealist constructions.

The mobile, Calder's first major mode, represents a major breakthrough for modern sculpture. While the Futurists theorized, and Gabo, after one attempt, abandoned kinetic, motor-driven sculptures as too primitive, Calder began seriously to explore the possibilities of kinetic sculpture. Between 1931 and 1938, as Jack Burnham, citing George Rickey, in his *Beyond Modern Sculpture* writes:

> Calder in all seriousness explored a considerable area of present Kinetic activity before settling on the hanging mobiles. . . . It may be helpful to name . . . the devices . . . Calder used in principle: in Kinetics some of these are sticklike and unstable objects hung in front of a panel producing random shadow effects (***Swizzle Sticks***), sculptures propelled by pumped liquids, belt and wheel systems as an integral part of a sculpture, constructions in which elements are interchangeable by hand, the use of hand-driven cams and crank trains plus motorized animation of coiled springs.

While Calder has continued to make motor-driven sculpture occasionally since his major machine period of the thirties, it is the air-driven mobile that has dominated his kinetic work. One reason he concentrated on natural movement was that he found motors "too much bother—they always needed fixing," but now he feels that he might have continued if he hadn't had to make his own gear-reduction mechanisms, a process that was too boring and time-consuming. He does not feel, as do some other kinetic sculptors, that motors do not permit varied enough

movements; he still believes, as he did in 1937, that with a motor one can produce a "positive instead of a fitful movement," and that the combination of different elements and movements, although simple, if varied enough in period, can give enough variety so as to be quite interesting.

With the air mobiles he found metal a more flexible material for shapes than wood; but more obviously, if air currents are to produce movement, the resistance of a flat surface is more efficient than that of a sphere. The pieces are arranged so that they operate on the same principle as sails: when pushed by the air a vertical piece moves horizontally, a horizontal piece rises. The opposition of horizontal and vertical pieces will produce varying movements, and a series of either, or both kinds, will increase the complexity and duration of the movement. However, a vertical and horizontal cannot be combined on the same arm because they would work too much against each other: each works best with one kind of wind. Yet the manner in which they are hung, and the combinations, make them capable of more complex movement. As Rickey points out, these can be: linear movement, up, down, and across (horizontal), and rotations around these three centers; Calder's mobiles do not move around centers lying outside of themselves. (Color is an integral part of Calder's plastic images and, far from being incidental, adds still another variable to the motion sequence.)

Another example of Calder's engineering training is his use of torsion: a slight twist to the opposite direction in a piece of wire interrupts the equilibrium of a straight piece and makes it more susceptible to movement. Calder uses this principle in wire bases and also in the reverse twist that forms the loop in the wire arms on which groups of elements are suspended. His pieces are constructed on the principle of non-symmetrical equilibrium, depending on the wind to disrupt balance and overcome inertia. At that point the elements of the mobile will follow a chain of cause and effect in a series of connected trajectories until they have completed the series and come to rest. For Calder the balancing process has become largely intuitive, but is quite exact: his monumental mobiles are made by mathematical enlargement from the model and usually work right the first time. It is in his use of the principle of equilibrium (as stated by Mondrian) that Calder holds to his idea of the universal model.

The first air mobiles were hung from the ceiling, but Calder quickly invented several standing varieties. One of these types, ***Sandy's Butterfly,*** has been called a mobile-stabile. Calder objects strongly to this term because he feels that "anything that moves is a mobile. There are two ways to make something move—suspend it from the ceiling or balance it on a point." Again, ". . . there is the idea of an object floating unsupported—the use of a very long thread—or a long arm in cantilever as a means of support seems to best approximate this freedom from the earth."

It is interesting to note that at rest many of the hanging mobiles, the early ones, in particular, can be lined up in one plane. Constructivists projected depth by arrangements of planes, but Calder relies on controlled chance to arrange his planes in space. Many of the standing pieces

are constructed more deliberately in three dimensions (and this has been carried into the later mobiles) but always of elements hung either vertically or horizontally.

It is clear that the problem of support for moving sculpture led Calder into a direct attack on the formal base which had always supported sculpture and which had proved a problem for the Constructivists. Gabo had rejected ceiling-hung sculpture; Calder accepts it without reservation, and he has even suspended mobiles from the wall. In the large standing mobiles Calder has integrated the base with the sculpture; the base takes on the attributes of sculpture but remains, at the same time, a base. The earliest versions of the standing base are in wire, or pipe, with the mobile elements cantilevered from a central spoke. Pole-supported mobiles such as *Man-Eater* are perhaps the closest Calder has come to a virtually base-less standing mobile.

A later, more monumental version of the standing-mobile base is a sheet-steel pyramid of either open or closed construction with the mobile arms cantilevered from the apex (*Sandy's Butterfly*). The base works not just as support but as foil to the moving elements, not competing with them but providing a dynamic tension between stability and mobility, massive form and open form, lightness and weightiness. This type of base is very clearly distinguishable from a stabile. While the stabile establishes as few contact points with the ground as possible, the base of the standing mobile rests flat to the ground plane; the suggestion of freedom from the earth is concentrated up toward the apex where the mass diminishes abruptly and the movement takes place. In another direction, Calder seems to have used certain formal elements of the stabiles as bases for standing mobiles. It is in these mobiles that base and sculpture are most completely integrated and that the standing mobiles look most like organisms. In fact, the names are frequently animal or, like *Myxomatosis*, are connected with animals.

The stabile—as dictionaries now define it—is the second major mode of Calder's oeuvre. It is difficult to determine the origins of the stabile. Although Calder has adopted the term for all his stable sculpture, the open-form wire constructions shown at the Galerie Percier, to which Arp later gave the name "stabiles"—in contrast to Duchamp's name "mobiles" for the motorized constructions—are quite different; but the stabile appears to have its genesis in certain elements of the hanging mobile.

In 1934 Calder had moved away from strictly geometric shapes and was using "quasi-organic" forms in three dimensions, hanging them from mobiles. The elements themselves seem logical extensions of some of Arp's Surrealist constructions, or three-dimensional renderings of some of Miró's forms. No doubt, floor-standing metal sculpture of Picasso and Gonzalez lurks somewhere in the background. The organic character of these forms seems to have dictated that they be constructed in three dimensions. The *Whale* of 1937, the first of the large stabiles, seems to have come from the idea of placing one of these organic elements on the ground. It is as if the organic quality of the object was so suggestive of an object in nature that it had to find a resting place: the ground plane. How-

ever, *Whale* balances rather precariously on two points; Calder wants the sculpture to appear to rest as lightly as possible on the ground, to appear to rise from the ground or to be capable of instantaneous motion. *Whale* seems to undulate as it rises. In *Whale,* Calder had not yet quite achieved a perfect balance of heavy mass on the ground plane with the fewest possible contact points as support, and the log takes the place of traditional base supplying additional support. The large stabiles, then, provide other kinds of experience in movement and space: arrested movement, different kinds of space as the spectator moves around the object, sudden angles and planes that cut and divide the space which create differently shaped forms.

Calder had been experimenting with ideas for environmental and over life-scale sculpture for several years before he made the first large-scale outdoor stabiles, *Whale,* and *Black Beast* of 1940. His first experience with large- or over life-scale had been in 1935 when he designed theater decor for Eric Satie's *Socrate* and Martha Graham's dance company. He recalls being interested in a mechanical ballet, without dancers, full-scale, using moving objects, for which he built a small model in Paris in 1936. Thus, the earliest models for large-scale sculpture, which date 1936-38, are motorized constructions, and somewhat theatrical. Each element stands separately, like an actor or dancer, somehow recalling Oskar Schlemmer's *Triadic Ballet.* The only one of these early works to be realized at the time was a "ballet" for the 1939 New York World's Fair which used programmed jets of water. (In 1962 one of the motor-driven pieces, *Four Elements,* was built in Stockholm.) The difficulty of realizing these works at the time was both technical and financial.

The same is true of the first large stabiles. The original versions of *Whale* and *Black Beast* were in light-gauge metal (*Whale* was aluminum; *Beast,* steel), bolted so that they could be taken apart easily and moved for exhibition. It is possible to cut lightweight material directly, manually or with a hand-held power tool, then bend and bolt it or make manual staples to hold the pieces together. Calder does not solder and does not approve of soldering. Possibly he considers it a non-mechanical technique; in any case, he has, by preference, always constructed mechanically. However, in a large-scale work the result is structural instability; there is a tendency toward buckling and spreading at the seams and joints which distorts the appearance and offends the good workman in Calder. Calder wants the stabiles to be "as massive as possible," which would seem to make their appearance of resting lightly on the earth a contradiction—a triumph of art over matter. His first opportunity to make a large-scale work in heavy material came in 1957 when the architect Eliot Noyes commissioned a copy of *Black Beast:* "Noyes's interest encouraged me to have it done in heavy material, that is, one-quarter-inch iron plate. This, furthermore, encouraged me to do other things as well in heavy material and also supplied some funds with which to do so." Calder went to a foundry and, using the original *Black Beast* as a model, had a new one fabricated by skilled workmen under his supervision and with his participation.

This has been his working method ever since, and while

parts of the structure of the monumental stabiles are still bolted, they are partially welded for greater stability. This method of working from a "matrix" may in some ways be compared to bronze-casting from a matrix in a foundry under the sculptor's supervision and with his ultimate finish. An important difference in Calder's work, however, is that he makes only one piece from any given model, not a series. Another difference is scale (and here Calder relates himself to stone-carving techniques): Calder's stabiles, and the large mobiles, are mathematically enlarged from the model. Possibly memories of his father, a somewhat academic sculptor of stone, enlarging with a pointing machine from a smaller model, first suggested that this might be a practical technique. The question of whether a work fabricated from a model by a technician is truly an original does not bother Calder. He feels that skilled workmen should do jobs requiring technical proficiency or involving mechanical means beyond those ordinarily available to the artist. In any case, Duchamp's challenge to what constitutes an original work of art (his Bicycle Wheel) and Arp's working method (he made a plaster model from which a marble was made by a skilled stonecutter) were part of history by the time Calder began to work in this way. The question simply has no validity for him; but he does point out that he likes to keep his hand in by supervising.

The first large stabiles were made at foundries near his home in Connecticut. At that time he first made a small model and then cut full-scale paper patterns. Today Calder works in Etablissement Biémont, a steel fabricator in Tours, close to his home in France, where several skilled workmen and technicians customarily work with him and have become accustomed to his needs. At Biémont there is a mechanical department, and the men are now trained to the point where they can mathematically enlarge from the model to make a template themselves.

Teodelapio, which straddles the crossroad entrance to Spoleto, was the first of the series of truly monumental stabiles. Built by an Italian ship builder, it is an adaptation of an earlier model. The unprecedented scale created some unexpected problems, requiring additional bracing at the last moment. Ever since, there has usually been an intermediate step—a scale model to check stability.

Since 1962 a good part of the large stabiles and mobiles which have increasingly occupied Calder's time have been made in Biémont. Sometimes Calder draws directly on metal and the men machine-cut initial pieces for him to bend, fold, and alter. There are machines for crimping and grinding and large machines with rollers for curving heavy sheets of steel. The men are now experienced enough to be able to gauge by themselves not just the technical aspect of how many pieces each part will need on enlargement but even where the bracing—which is important aesthetically—should go. The working relationship between Calder and the four or five men who usually work with him is close enough now to make it unnecessary for Calder to be present at all times, but he comes in to check and see how things are progressing, bringing back part of a model he has taken home to think about, or to decide on color. Calder respects and admires the men for their skill and

they return his respect. They have accepted the man and his work.

Calder's work has been widely accepted—particularly his kinetic constructions—despite a general resistance to nonobjective art. Calder has said, "When you see a thing move you know what it will do," which possibly accounts for the popularity of his mobiles. But it is also possible that since the movement gives the sculpture a life of its own, one responds to it as one responds to another living thing—directly, bypassing the difficulties of its content as a highly sophisticated work of art, taking delight in its humor. The stabiles have also been accepted, although with difficulty at times, perhaps because the spirit of play is very strong in everything that Calder does, but more probably because their strongly organic presence creates yet another direct, physical experience and response.

Fernand Léger once called Calder a realist; Calder's reply is: "If you can't imagine things, you can't make them, and anything you imagine is real." (pp. 4-24)

Bernice Rose, in an introduction to A Salute to Alexander Calder, The Museum of Modern Art, 1969, pp. 4-24.

SURVEY OF CRITICISM

James Johnson Sweeney (essay date 1939)

[Sweeney was a renowned American art historian who served as director of the Solomon R. Guggenheim Museum and contributed criticism to various journals, including the New York Times, Partisan Review, and the New Republic. In the following excerpt, he stresses the importance of Calder's use of natural motion as a tonic to the Modernists' fascination with the machine.]

The basis of graphic representation is a kinetic pleasure—the rhythmic gesture. The finger or pointed stick first recorded it in the sand, as chalk records the child's gesture on city pavements today. But our satisfaction at having achieved such a record soon crowds out all conscious recollection of the pleasurable sensation which underlies it. We quickly come to feel that our pleasure in regarding such a graph derives from some quality inherent in the linear organization itself rather than from kinetic experience of which it unconsciously reminds us.

Calder in introducing actual movement into his plastic organizations has given a new emphasis to the basic rhythmic gesture. This has had the fundamental value of a primitive appeal. And, it comes with Calder's work, at a movement when plastic expression is ripe for such a physical realization of movement.

Since the close of the Renaissance the trend in plastic design has been away from the suggestion of fixity to one of mobility. The closed, symmetrical form has given way to an open asymmetrical one. The mathematical conventions

of a strict perspective-approach have yielded slowly to a free, harmonic ordering of the picture-surface primarily dependent on the individual artist's sensibility. The single fixed viewpoint dominating the geometrical landscaping of a Leontre was seen gradually to have resolved itself through Langley, Brown and Repton to a multiplicity of viewpoints that grew out of the wandering paths of late continental versions of "English" and "Chinese" gardens. While in architecture, as early as Schinkel and Nash, the formalistic stage-set character of the Baroque was turning to a free organic development of the building from within, on the basis of living requirements and in keeping with the demands of the natural surroundings in which the building was set. In short, the trend from the close of the Renaissance to the present day has been one of a growing interest in free natural rhythms and their adaptation to plastic expression.

It was only a step further for Calder to bring back actual movement in place of the suggestions of it. And the immediacy of this stimulus carried with it a primitive strength of rhythmic evocation that is perhaps Calder's most striking contribution. But a still more personal and perhaps more important one lies in his recognition of another feature of natural movements—their unpredictable character and the esthetic possibilities of the unexpected.

The Industrial period, which was ushered in almost contemporaneously with the Romantic Revival, provided a wealth of new materials and plastic possibilities through the development of the machine. But two factors militated against a full use of the opportunities presented. On one hand the complacency of the Victorian world led it to feel it could improve on preindustrial period expressions with the tools and the materials of the Industrial Age. The result was an ugly parody which caused a sensitive revulsion from the machine to a pre-Raphaelite escapism. But such a retreat into the past naturally called up a protest. And shortly after the opening of the present century we had a sentimentalization of the machine.

New materials, new forms, unlimited possibilities opened up toward a new plastic idiom were clearly recognized; but the romantic adulation of the machine which was felt necessary to offset the hostility of the previous generation made an honest plastic approach, for the time, next to impossible.

It was here that Calder's recognition of the potentialities of the surprise-factor in free rhythms and his ingenious, yet unaffected use of it served at once as a tonic and purge. The critics of the Romantic movement had been attracted to the unpredictable features of nature and had rediscovered through them the esthetic of the unexpected. Calder in adapting the natural rhythms also recognized the dramatic value of the surprise element. And his extremely personal use of it has probably done more than anything else toward combatting the fustian seriousness and lack of sense of humor that grew out of the sentimentalization of the machine, and toward laying a sound foundation for a new machine age idiom.

And in Calder's work these are by no means recent developments. Throughout, we see both these features con-

stantly present: on one hand, the movement-through-space, as clearly represented by his tiny Aesop illustrations as by the skywriting of an airplane; on the other, a readiness to accept a hint from the nature of the material itself toward an unexpected rhythm or effect, now a tree root that becomes a curiously distorted representation of a cow, now a figure drawing that takes on an unfamiliarity from his use of an unbroken line. In his wire caricatures we see a similar approach to that of the Aesop illustrations. And in the later mobiles the unexpected rhythmic turn may again be derived directly from nature in a puff of wind that tosses the arms of the object, or from a mechanical rhythm produced by some twist in a wire or idiosyncrasy of the material.

In Calder's mobiles we have the tonic which clears away the sentimental approach to the machine, and lays a new stress on the rhythmic fundament of design through a physical representation of movement. (pp. 25-8)

> *James Johnson Sweeney, "Alexander Calder: Movement as a Plastic Element," in* Architectural Forum, *Vol. 70, No. 2, February, 1939, pp. 25-8.*

James Johnson Sweeney (essay date 1957)

[*In the following excerpt, Sweeney discusses Calder's playful approach to art.*]

Brancusi at eighty years of age is accustomed to say to visitors who talk with him about his work: "To keep one's art young one must imitate young animals. What do they do? They play."

And this is the basis of Alexander Calder's sculpture as it is of Brancusi's: a love of play.

Calder has always played his art as he plays his life. But play with Calder is never frivolous. It is serious, but never solemn. Play is a necessity for Calder which he has to respect, to treat seriously; for if he thwarts it his art suffers, loses that quality of the incalculable which is the source of so much of its richness: it soon begins to look contrived—at best ingenious, but fundamentally self-conscious. Calder in a lumberjack's shirt, wearing a necktie he has embroidered for his own pleasure, and in baggy trousers, is comfortable, alive; Calder in a dinner jacket is stilted, limited, confined. Calder's undress has all the seriousness of the dress of a dandy, with all the dandy's playfulness and fantasy; the solemnity of the conventional constricts him personally and spiritually. And this holds for his art as well.

Another axiom Brancusi has never tired of respecting over the years is: "Once you are no longer a child you are already dead." And if we ask ourselves what are the dominant characteristics of a child's attitude to the world about it, we realize the answer comes at once, "curiosity" and "sympathy"—in the sense of identification with the phenomena it encounters.

These are evidently the qualities of the child which Brancusi admires and which he feels are essential to the artist.

Should they become blunted in an artist the artist "is already dead."

And these are characteristics which we recognize as particularly assertive in the sculpture and drawing of Calder, just as it is eminently apparent in Brancusi's work. Brancusi may give a piece of marble polished bare of detail all the movement he has felt in a seal stretching for a fish tossed to it through the air, or the huddling movement of a group of penguins; but no contemporary artist has succeeded in conveying the animal essentials in such a vital shorthand manner as Calder has in his early wire sculptures and toys, or in transmuting the movements he has felt in nature into funds of rhythmic pattern such as Calder has done in the mobiles of his mature development.

This curiosity and sympathy that are the child's heritage and which constantly feed Calder's arts new freshnesses of concept are perhaps most evident in his early circus figures, his wire sculptures of the late twenties and his toys. Here every movement of a waddling duck, an oriental dancer, or a trotting horse is translated into a mechanical movement which is strictly a simplification without any loss of the natural vitality, or a translation of movement into a suggestive linear vibrancy of wire. And his later work is not merely an abstraction of the essentials of these "essentials" spread to a broader scale, but in each successful venture the growth of a fresh observation of nature, the calculation of the potentialities of his material and a sympathetic marriage of the two. Imitation of the surface character of an animal, plant or human form has little place in Calder's work save as a point of departure, surviv-

Calder, Alexander. Lobster Trap and Fish Tail. *(1939) Hanging mobile: painted steel wire and sheet aluminum, about 8'6" high × 9'6" diameter. Collection, The Museum of Modern Art, New York. Commissioned by the Advisory Committee for the stairwell of the Museum.*

ing usually only as a witty hint or a light caricatural recall. What Calder uncovers through his observation of a form is its constituent rhythms and these he translates into a form composed by static suggestions of movement and the movement of subordinate forms through space. His mobiles are always composed (intuitively no doubt) to present an aesthetic contrast between the static form they offer and the conceptual volumes their movements describe. At the same time there is always a relationship conscientiously observed between the shapes of mobile elements employed and the spirit of their movement. The careful balance he achieves through the parts dictates their relative scale, and the natural flowing movements exact shapes that keep the harmony, both through their size and character.

Calder's genius, in other words, is his ability to feel himself into his expression physically and to compose his work in response to this experience. He has kept his sensibilities in this area fresh by consciously avoiding preconceived solutions. His happiest solutions, like those of many of the greatest artists in other fields, have often been the result of allowing his materials and his "playing with them," or exploration of them to point the way. But his strength as an artist, as in the case of his friend Joan Miro, is his ability to recognize the moment his play—or chance—has disclosed a fresh possibility, then to put play aside and finish the work in a craftsmanly and carefully artisan awareness. This is the fundamental difference between the work of artists such as Calder and Miro and that of children; the true artist has the gift of remaining the child of fresh curiosity and sympathy up to a point; but he also has the ability to break with the child visionary in him at the moment of fullest intensity and to finish off his expression with aesthetic objectivity and workmanship. (pp. 9-12)

James Johnson Sweeney, "Alexander Calder . . . Work and Play," in Art in America, *Vol. 44, No. 4, Winter, 1956-57, pp. 8-13.*

Carola Giedion-Welcker (essay date 1960)

[*In the following excerpt, Giedion-Welcker applauds the poetic quality of Calder's mobiles.*]

The progenitors of Calder's art are those airy constructions that revolve on roofs and church spires. Their movement is borrowed from the wind, their existence airy and playful. Calder's "mobiles", as children of their time, are made of plain sheet iron and tin, mounted on thin wires and rods. They belong to a mechanical age and a technological country, but both mechanics and technology are overcome by their human sensitivity and poetry. A master of delicate craftsmanship, Calder uses the simplest of elements, outlining, balancing, and combining them with the utmost precision in a spreading play of forms. The vivacity of this unprecedented fusion of the organic and the mechanical is revealed when these black or colored discs rise along their stems of wire, cutting into space like a knife and combining in ever-new constellations. A "fish", a metal oval, swims irrationally in air inside a flexible system of coordinates of points and lines; a black "morning star" quivers in the wind among the grass, set in a poised

interplay of balls and lines. Calder's extremely sensitive art developed out of the humorous wire and wood toys with which he began. "Homo ludens" plays just as great a part in his work as it does in the poetic burlesques of William Saroyan. Against the background of the rationalized and overorganized life of our day, his art stands out in joyous detachment. It is just as true to the physical laws of its constructive principle (and hence to the industrial mind of America) as it is to capricious spontaneity. A kinetic energy is released in Calder's early work by mechanical means (motor power), and later by cosmic currents, by the faintest breath of wind. It is a dance of abstract forms in their simple, dynamic interrelationships in time and space.

> *Carola Giedion-Welcker, in an excerpt from her* Contemporary Sculpture: An Evolution in Volume and Space, *revised edition, George Wittenborn, Inc., 1960, p. 204.*

Barbara Rose (essay date 1965)

[*Rose is an American critic and the author of several works on twentieth-century art. In the following excerpt from a review of the 1965 Calder retrospective at the Solomon R. Guggenheim Museum, she identifies Calder as one of the most successful Modernist sculptors and suggests that his stabiles are his most significant works.*]

In our time it is easy to have the feeling that sculpture has not fulfilled itself as painting has. Late cubist and surrealist painting found its logical fruition in post-war abstraction, but the enormous potential implicit in cubist sculpture seems to have not, except in significantly exceptional cases, been as fully realized. One such exception is surely . . . Alexander Calder. . . . Calder's copious production, extending from the miniature wire circus of the late Twenties to the monumental stabiles of the Fifties and Sixties, stands as a monument to the highest kind of creative endeavour, a testimony of affirmation during a period when an optimistic stance grows increasingly difficult to sustain.

Paradoxically, although Calder's is the most ambitious kind of art in terms of its content (it seeks to touch the mythic springs of human emotion and experience), its forms, at least in the beginning, were more received than invented. I mean this in no way to derogate the work of a great master; I am observing that many of Calder's shapes are borrowed from Miró, and to a lesser extent from Arp, merely to make the point that originality is conceivably not the *sine qua non* of artistic achievement or ambition that recent criticism might have us believe. Calder's inventiveness then does not lie so much in the newness of his forms as in the extraordinary use to which he puts them. Although the uniqueness of his use of motion in the mobiles and of architectonic balance in the stabiles should not be minimized, one ought still to be able to see that the greatness of the work resides elsewhere—in its universality and profundity of expressive statement.

This statement essentially is the one the surrealists, influenced by what they knew of Jung's discussions of the collective unconscious, and the forces of nature as experienced and interpreted by the human psyche in its evolu-

tion, sought to make. But the surrealists by and large failed in this respect; their art was mainly literary. Too much intelligence and cerebration obtruded and blocked any real expression of spontaneous emotion. Only Miró and Arp of the group allied with the surrealists seem to have escaped this excessive cerebration, and to have made art that was universal in the sense implied in the surrealist programs. Their creation of a vocabulary of forms based ultimately on the organic shapes found in nature provided the basis for Gorky's art, as well as for that of many artists still working today. In addition, Miró's cosmic imagery, with its references to the sun and the moon, to celestial and chthonic forces, was adaptable to reinforce yet another level of meaning. Many artists benefitted from these formulations and Calder was among them.

Viewing an *oeuvre* as exciting and large in scope as Calder's spread out in retrospective form is pleasurable, but to the extent that it reminds us that most of the work produced today does not approach Calder, either in forcefulness, significance, or ambition, it is chastening as well. On the one hand, we appreciate the measure of Calder's genius, and on the other we sense by contrast the poverty of invention of a large part of the work currently being served up to us. Genius is rare, of course; but it seems more a case of the disappearance of a whole kind of sensibility, and with it the ability to generalize and to infuse inanimate created forms with the pulsating dynamism of the life force. Such a gift is still Calder's, however, and we may be thankful for it. In fact, the coherence of Calder's vision is such that it allows him to transform the humblest gadget or toy into a monumental work of art. The jewellery, toys assembled of odds and ends, and tapestries . . . reveal how Calder is able to infuse the most modest creation with the same joyous verve and formal inventiveness he gives to his sculpture. In many ways, Calder is like Picasso: whatever he touches comes alive, the same mischievous antic spirit animating a child's bauble as animates a colossal public monument.

Both Calder and Picasso chose the circus as a major theme. But they chose it not to show its lurid or sensational aspects, nor even its spectacle and glitter, but because they found it a microcosm of the human comedy. In the circus clowns and fools risk their lives, and the courage of daredevil trapeze artists and circus riders may serve as a metaphor for the artist's courage. But, though some of Calder's works has tragic or ominous overtones, his is essentially a comic (if heroic-comic rather than farcical) view of the human condition. Like Picasso, Calder is the eternal child, the *naïf* whose vision never goes stale, who brings to each new experience the ingenuousness of the innocent eye. Again, Calder's world is like Miró's preChristian garden of flowers and stars and butterflies, where free, natural creatures move without a sense of original sin. Along with Matisse, Miró, Picasso, and a few others, Calder is one of the last of the pagans. Calder's world is the world before the Fall. (pp. 31-3)

To follow the process of the step by step evolution of one of the outstanding achievements of twentieth-century sculpture is in itself fascinating; although the earlier works offer rich experiences in their own right, for me they are

but the preparation for the enormous late stabiles. These in many ways are Calder's most original work, in which he finally abandons surrealist imagery (perhaps under the stimulus of Matisse's cut-outs) and uses shapes that, while they express the same optimism and strength in their soaring pinnacles and cathedral-like arches, are ultimately more abstract than referential. . . . Bolting together these huge, flat, painted shapes (the largest stabile, in Spoleto, is big enough for trucks to pass under), Calder creates art that is modern in the truest sense in its rigour, clarity, and reduction; his scale is heroic, and thus adequate to express the dynamic impulses of his time and civilization. The grandeur of such an achievement is measurable by the scant number of Calder's peers. My own feeling is that only David Smith is working today on the same level in a contemporary idiom. I also feel strongly that it is in Calder's and Smith's resolution, in their most recent polychromed metal constructions, of the implications of cubist sculpture that the best new sculpture will find its inspiration. (p. 33)

> *Barbara Rose, "Joy, Excitement Keynote Calder's Work," in* Canadian Art, *Vol. XXII, No. 3, May-June, 1965, pp. 30-3.*

Gilbert Lascault (essay date 1972)

[*In the following essay, Lascault discusses the element of humor in Calder's works.*]

Calder's world is very odd! If the birds are red, it is because they are crows (gouache, 1967). The fishes in it are defined by temporal formula which we shall never know is a designation of their existence, the moment of their appearance or when they are eaten: *The Eight O'Clock Fish* (mobile, 1965). When a cactus ceases to be a plant and is turned into metal, it is inevitably described as provisional (*Provisional Cactus,* stabile, 1968). The car with the body of a snake meets a red elephant with three black heads in his world; they are neither more nor less monstrous than the strange, hybrid colors (red, black, white) or the forms (disk, crescent, triangle, an arrow head).

Calder's humor is the bringing together of incompatibles. He also stresses the instability of situations. Things with him never quite fit in with their definitions: *A Not Altogether Horizontal Mobile* (1963), *Almost a Triangle* (1965), *Almost Horizontal Red* (1965), *Extreme Overhang III* (1969). But this instability, overhang and absence of plumb lines are not disquieting, they impress and disturb without making us uneasy. Even Sartre, who is always so near to the anguish of existence, made no mistake. His first description of a Calderian object [see essay dated 1946] sees it as a cunning trap, but the menacing associations end in gaiety: "They are resonators and traps, hanging on the end of a string like a spider on the end of its thread, or subsiding onto a base, sullen, withdrawn into themselves, deceptively asleep; a stray breath of air will tangle them, stir them into life, canalize and give them a fugitive form; and a mobile is born. A mobile: a holiday thing . . . " The trap only works to give pleasure and if a capricious wind meddles with them, it produces an ephemeral form, which changes constantly.

Calder's *Arrows,* exhibited at the Galerie Maeght, Paris, in 1968, are more strangely paradoxical than any other of his works. The mobiles confuted faith in the inevitably immobility of sculpture; they reconciled beauty with lines in motion. When they invaded the field of sculpture, they immediately provoked their apparent contraries, stabiles. These are different both from traditional sculpture and the mobiles. But the *Arrows,* which appeared quite early in Calder's work without bearing this name, broke the distinction between movement and stability. They are at the same time rooted in the earth and very mobile. The wind, or a hand can easily make them quiver, the disks turn and the rods move, while the base, which is sometimes heavy, is firmly fixed in the ground. Far from being reconciled, the settled and the nomadic are closely locked in the conflict of their opposing qualities, and their differences are accentuated. The mobile parts of the *Arrows* are like a sort of playful use of the laws of equilibrium; they play with the weight of things and what is called their reality; they make subtle use of the laws of equilibrium to create positions that are both unexpected and instable. The harmony achieved is gay, surprising and threatening. Their forms surprise us at a moment when their surprising relationships are a condition for the survival of sculpture. Calder's logic comprises aberrations. The equilibriums he constructs are both precarious and definitive; they imply the ruptures that break them and the manner in which they are reconstituted. Continuing existence requires that an order be established each instant, which is destroyed and changed the following instant into a new order, which is unforeseeable and calculated.

These oscillations and vacillations possess an emblematic character. They are connected with two antinomies in Calder's work: the relationship of the Calderian object with the world; and its relationship with its creator.

The mobiles, stabiles, arrows and gouaches of Calder are constantly cut off from the world of our daily life and, si-

Flamingo (1974).

multaneously, evoke it. Every comment made on them is both justified and questionable. In 1946, Sartre observed, "Calder suggests nothing; he takes real, living movements and fashions them. His mobiles signify nothing and bear no reference except to themselves: they are, that is all; they are absolutes." But this metaphor, which only refers to the works themselves, necessitates analogies that its absolute character criticizes. Sartre himself, alluding to these mobiles that bear no reference to anything except to themselves, associates with them a bird, the petals of a sensitive plant, a hot-jazz tune, the sky, the morning, the sea "always beginning, all over again", a spider and so on. The works are and are not plants and "lilies" of iron, conceived by a Monet turned blacksmith. They are members of a circus: the clown, the dumbbell lifter, juggler, a seal balancing balls on its snout. His works as a whole continue the entertainment he imagined and produced from 1926 to 1932, which Le Corbusier, Mondrian, Théo Van Doesburg, Léger and Edgar Varèse enjoyed so much. They are also trees and planets. They reveal and increase the winds and the movements of the universe; they make visible the invisible forces among which we live and which link us in subtle ways with the rhythms of the world, and are less altered than other aspects of the earth by civilization.

Calder's sculptures are perfect works, a mixture of delight and gravity, humor and construction; they offer us yet another profound and happy antinomy. On the one hand, they are absolute, finished, complete objects; they are self-sufficient and create a space of incomparable joy around themselves; each one is what Sartre calls "a little holiday thing". On the other hand, these creatures who have become endowed with an independent life of their own and an unforeseeable spontaneity, make us turn, fascinated, to their creator. Each mobile makes us forget Calder and reminds us of him. Calder is never effaced by his works. He never wears a mask. Fernand Léger described him as "an element of nature, which smiles as it sways and is full of curiosity", or "a walking tree trunk". He never ceases to interfere with his creatures. The films on Calder and the photos showing him at work show us a miraculous picture of a kindly Titan, or a happy Vulcan, a meticulous craftsman, cunningly manipulating his materials and, at the same time, an all-powerful demigod. One photo shows him as a handyman, facing a treasury of heteroclite shapes, which he only has to change slightly to construct the kind of myths contained in the *Arrows,* ambiguous, silent, rich myths of our modernity in its relationships with nature. Another photo pictures him as the blacksmith of the minute, a Herculean goldsmith. Mythological comparisons inevitably come to mind when one thinks of Calder, who is both a creator of new myths and the hero of old myths. A mythical mythologist.

One film impressed me particularly in which he laughed. It made me think of that other natural force, Orson Welles. It was the same laugh, but in quite different contexts. The attitudes towards existence behind each laugh were divergent and the experiences of life dissimilar. In the film Reichenbach made on Welles in 1968, he burst out laughing when he confessed, "It is probably time to find a battle-ground where the chances of losing are no greater than the chances of winning." Welles laughs in a world of

failures. Calder has transformed his earth into a playground of delight and success.

Our culture too often gives a pre-eminent place to seriousness and austerity, what Georges Bataille calls "the tight-shut mouth, beautiful as a safe". Calder's works and personality help us to reject this asceticism. His forms in movement are an illustration of a passage from Nietzsche's *Zarathustra*: "Raise your hearts, nimble dancers, higher and yet higher! And don't forget to laugh heartily! . . . I have canonized laughter. Superior men, learn to laugh then!" Calder's sculptures are an image of "gay knowledge", which is another phrase from Nietzsche, and this is very similar to dancing. (pp. 39-46)

> *Gilbert Lascault, "Calder's Contradictions and Laughter," in* Homage to Calder, *edited by G. di San Lazzaro and Angela Delmont, translated by Bettina Wadia, Tudor Publishing Company, 1972, pp. 39-48.*

Daniel Lelong (essay date 1972)

[*In the following excerpt, Lelong examines the factors that unify Calder's varied works of art.*]

The distinction between his motionless sculptures and those in movement matters little to Calder.

The credit for inventing the names "mobiles" and "stabiles", which are now famous, does not anyway belong to Calder, since Duchamp thought of the first, and Arp the second. When he has to refer to them himself, he prefers to call them "objects", probably to avoid any arbitrary classification. In spite of appearances, no one could be less methodical than Calder in his work and, although it is true, for example, that most of his recent works are monumental in size, they also include, besides countless gouaches, birds made out of preserving cans, wire portraits, and the series of Totems, Arrows and Animobiles. Similarly, although the stabiles now account for a large proportion of his work, it should not be forgotten that the first of them, the **Black Beast** was made in 1940 and, that, before the first mobile sculpture appeared in 1933, works in wood and wire already existed beside motorized sculptures. Calder has always changed his means of expression as the humor took him, which one might expect from the impression made by the man himself, or as circumstances and his inner compulsion dictated.

As the son of a traditional sculptor without preconceived ideas, the young Calder was able to train as an engineer, attend drawing classes and travel. Line fascinated him very early on and, without lifting his pencil, he turned from drawing faces on paper to tracing them in space with wire. Then he reduced space to its essential structures as his drawings of 1930 show, which juxtapose the disk of a star and the curved line of the horizon. His visit to Mondrian's studio in 1932 acted like a detonator. "Making Mondrians that move": this ingenious, curious man, who was gifted with an inexhaustible fund of humor, had just taken possession of his tools. The event released his power to understand the universe through its most elementary and direct principles, his love of simple forms, the play of

pure colors and the relations of various forces in equilibrium, which infuse his art with an astonishing vitality.

Calder certainly likes to amuse himself while working but it is not from a sense of play that he turns from metal to paper, from a toy to architecture, or from movement to its contrary. The situations of his different studios, the time at his disposal, the need to be alone or an inclination to join the teamwork of a factory are all factors that decide what he will do without any long term program or preconceived idea. He experiments in his studios and the time he spends there every day is a forcing ground for new problems and their solution. So, as experiment is a natural activity for him, it is not surprising that Calder has never tried to explain it; his mocking "why not" is the only answer to the "why" of his questioners.

Yet, if we turn to the *Autobiography* [see Further Reading, section I], which he recently dictated to his son-in-law Jean Davidson, quite often with ironical amusement, its account of the principal events of his artistic life shows clearly how all his work has been the product of the simplicity and gravity of the man.

It is direct work in which a completely mastered technique only appears as an accessory. It is work based entirely on the immediate appropriation of the material and its conversion into elementary forms, then on the relations of these forms between themselves and, inevitably, with space. As the material is only a means, it is preferable to use whatever lies near at hand, which will not take up too much space when there is none to spare, ordinary materials, in fact. When, for example, Calder was a child and made jewels for his sister's doll, he naturally chose bits of wire that he found in the garden. Later on, he used preserving cans to make various objects and his first motors were do-it-yourself contraptions made from archaic components. Again in 1941, when there was no aluminum at Roxbury, wood and little bits of wire were used for assemblages that eventually became the important Constellations series. Calder, in consequence, turned quite naturally to the typical materials of his age: iron, steel, copper, brass, etc., at a time when they suddenly became common in an industrial society. They became an inseparable part of the sculptor who rejected traditional techniques for pliers, files and a shearing machine, as he created the parageometric forms of elongated triangles, perforated disks, boomerangs and ovals, all those forms that Calder is particularly fond of and has made the elements of a sculptor's idiom. They are brought together in an assemblage of contraries, united or separated by color, and will inevitably be related to the world around them, that is, space, through lines of force. All Calder's work seems to have grown out of this dialectic in which the intermediary is none other than a persistent good humor.

This is the process when he applies the principles of "poetic mechanics" to movement and takes the experiment almost to breaking-point on an axis. Infinite transformations are produced in the sculptural space, which is cut and displaced, and the contents radically varied in consequence, beneath our eyes. The situation is no different in his immobile sculptures; the structures established with the same discipline stand in opposition with the same strength, the space remains cut, and the disequilibrium between flying-buttress planes and verticals is equally marked; but the axes have been replaced by reinforcements and gussets, which prevent the elements from approaching breaking-point. This time, we have to make the displacement ourselves. "Each in turn", Calder would say, but the nature of the object, created in space, remains always the same.

Writing in 1946, Sartre compared this relationship to "a little holiday thing"; or, defined by its movement alone as "a pure game of movement just as there are pure games of light". Calder's sculpture then only occupied a limited, generally enclosed space; it was intended for intimate surroundings and the slightest gesture was sufficient to set the subtle mechanisms in motion. It was tempting to compare these light structures to the mobility of foliage, the ephemeral brilliance of a butterfly in summer, and to treat Calder's work fundamentally with the preconceptions of a naturalist. "I eat nature", he once said with his formidable laugh, as if he wanted to keep his distance. He knew then that he had not yet given his full measure, which would produce the great city monuments of today. Calder was aware of all the energy pent up in these studio works and he passionately wanted to free them, add to their size and make them fitting images of their material. It is a social product, which he had amputated of its proper aggressiveness in the factory and now it had returned naturally to the life of the community, reassuring and gay, and charged with fresh vitality.

As they stand against the anonymous, steel and concrete buildings, where man is now housed, these great red and black monuments have become symbols. Sculptures, like the **Man** at Montreal and the **Red Sun** in front of the Aztec Stadium at Mexico City, are intended, beneath their apparent docility, to give a holiday to a whole people. (pp. 79-86)

Daniel Lelong, "Constructions for a Holiday," in Homage to Calder, *edited by G. di San Lazzaro and Angela Delmont and translated by Bettina Wadia, Tudor Publishing Company, 1972, pp. 79-88.*

Janet Hobhouse (essay date 1976)

[*Hobhouse is an American critic and contributor to various art journals. In the following excerpt, she emphasizes the childlike qualities of Calder's art.*]

What is most appealing about [Calder] . . . is his total engagement in [a] make-believe world. Calder's absorption requires the elaborate pretense of a child that stick-legs are real legs, that a piece of cloth adequately conveys the whole costume, that sound effects don't approximate but are real voices. This child's abstraction of things that can stand for other things is characteristic of Calder's art: a makeshift shorthand rather than a sweeping intellectual condensation of the whole into its essence. . . . Achieving the point where the piece in question adequately conveys the intention of its maker is clearly more important to Calder than its final look. The priority is to make something come alive—a circus, a drawing, a mobile, an animal

CALDER

MODERN ARTS CRITICISM, Vol. 2

shape—and not necessarily to make something finished. (p. 38)

Calder's imagery, as well as his method, derive from the experience of the child—not the primitive, naive, or Rousseauian child, but the serious, upright, information-gathering kind, who spends his weekends with books and telescopes, inside museums and homemade chemistry labs, taking machines and animals apart to see how they work. Calder's abstractions—even those of the Mondrian-influenced period of the '30s—are rooted in this childhood imagery. Though it derives from nature it is not from nature directly observed, but rather as it is originally presented to children in natural history museums and planetariums. So, many of Calder's mobiles look like displays of dinosaur or fish skeletons; his stabiles like huge prehistoric animals in display-case poses, his motorized sculpture like planetary maquettes from the children's wing of a science museum.

The busy, dour-faced child that made jewelry for his sister's dolls grew to make circus miniatures, wooden toys, fish anatomies and coffee-can birds (Calder's art seems the product of a lifelong rainy afternoon). His household inventions—the kitchenware, lamp covers, latches and so on—have been praised for their grown-up "Yankee ingenuity." But these are not inventions that improve on the originals: try using and cleaning afterwards a Calder cooking utensil, or avoiding spills and burns with a Calder (metal spring) coffee cup holder. In conception Calder inventions are antithetical to those gleaming contemporary streamlined houseware designs. They are as useful as the miniature brooms or pie pans a child makes to mimic its mother's; they parody more than they serve and the joy of their making clearly overrides considerations of their future usefulness. The same is true of the Calder jewelry, much of which must surely stab and prod its wearers; certainly by now some of it must have corroded and snapped or finally been confined to nonhuman exhibition space.

The mimicry of the grown-up world of real objects, real postures, runs through Calder's work and provides it with much of its wit. It was clearly significant to Calder that his father and grandfather had engaged their lives in the pursuit of "high art." The images of that world—muscle-thighed Indians astride muscle-finned fish, barebreasted maidens clashing cymbals, city-dominating monuments to William Penn and George Washington—were clearly as much an influence on Calder's art as the experiments in modernism he witnessed in Paris in the '20s and '30s. The relationship between Calder's art and that of his father and grandfather is maintained by its distance and its occasional hint of parody. Even Calder's own city-dominating monuments, the great stabiles such as the dinosaur-backed *Teodelapio* in Spoleto, *La Grande Vitesse,* which mocks its site in Grand Rapids, Michigan, *Le Guichet,* which calls attention to the commercial rather than spiritual intent of its site at Lincoln Center, make fun while complying with the finer intentions of the architects whose buildings they enliven. But perhaps in this respect Calder is as much used by architects as they by him: monolithic contemporary building may need this humor to relate it to its human users. Hence the Dubuffets, the Oldenburgs,

the King Kongs of contemporary industrial plazas; subtle propaganda that corporate ambition has a sense of proportion, a sense of humor of its own.

What else can it mean to come from a family of monumental sculptors, to set up as an artist in Paris in the '20s, to mix with Pascin, Miró, Arp, Léger, and then to produce one's first sculpture in the form of wire caricatures, to make sculpture an arm of the "low art" of drawing, and not just drawing but single-line cartooning in which there is room for every childish joke from pun to dangling genital? Even the more "serious" work, under the sobering influence of Mondrian, appears to mock its source of inspiration. . . . (pp. 38-9)

Calder's most famous creations are as anti-monumental as his early wire sculpture, his cartoons, his wooden toys. A Calder mobile intends literally to make light of abstract sculpture, to deny its gravity. The intention is clearly to wed the sketch, the quick invention, to the permanent. Thus permanent shapes are made mobile and Calder surrenders to chance (to the chance movements of air) the relationships between parts that the artist has traditionally sought to render permanent. Calder is the first to renounce the claims of the traditional, laurel-bound, even frontier-pushing, artists of his grandfather's time and his own, and the last to take seriously such claims and poses in other artists: His attitude to his own work, though hardly diffident, is always unassuming: for years he carried his oeuvre to exhibitions in a bale of wire, or stuffed into trunks (in the case of the circus), or posted it to galleries in manila envelopes (in the case of the smaller mobiles). He preferred gouaches to oils when he branched out into painting because gouaches were "fast," and though as a toy-maker, welding-overseer, mobile-constructor he could spend hours engrossed in the making of the object, once it was made nothing could induce him to provide any form of pedestal for it. . . .

To the extent that Calder alters the definition of whatever category of object he touches (so much so that who among the flying-nervous would willingly board a Calder Braniff) so he has managed to induce delight in a palace of high-seriousness. (p. 40)

Janet Hobhouse, "The Witty, Inventive, Anti-Monumental 'Universe' of Alexander Calder," in ARTnews, *Vol. 75, No. 10, December, 1976, pp. 38-41.*

Franz Schulze (essay date 1977)

[*Schulze is an American critic and the author of works on Chicago architecture and Mies van der Rohe. In the following excerpt, he assesses Calder's works, suggesting that many of his early pieces are overrated. Schulze identifies Calder's mobiles and stabiles as his most important contribution to art.*]

Let us pay Alexander Calder the sincerest tribute by refraining from eulogizing him unconditionally. He was a very excellent artist, and we are all the better for the best of his efforts. But if we do not take the trouble to distin-

guish the best from the less good, how much value is there in all our praise?

There has been a ton of undifferentiated veneration—or what sounds like it—and a good deal of that came well before his death. The dithyrambs seem to have followed several central themes: Calder was an artist with a great wit that was somehow the product of a warm and splendidly ursine personality; he also invented the mobile. Occasionally one hears, too, that he was very American in his "pragmatism" and that that was a good thing.

There is no point in denying any of this, but one wonders first, if it is the stuff of the greatness widely claimed for Calder, and second, if it is the most we can say for him. The fact is, his character illuminates his art hardly at all. And as to the intrinsic wit of that art, it is no doubt integral to his merits, but not, in this writer's mind, the chief reason for remembering him with the admiration and respect that are his due.

Some of the time the wit was overrated. Calder had grown so famous toward the end of his life that cocktail table books about him began materializing in swarms, and they chuckled devoutly at every one of his jokes, including some pretty lame ones. The famous *Circus* is an inherently quite ordinary little creation—if not to say by now rather creaky and dated—that would not have attracted or at least sustained serious attention if it had not been done by someone with his connections in the Paris art world of the '20s, not to mention his later renown. Nearly all of his early toy animals are only modestly droll, and they are seldom done with any noteworthy finesse. A few are cute enough—one thinks of the zany old birds made of the Medaglia d'Oro coffee can cuttings—but they do not convey any singular sculptural talent or even any great gift for the making of playthings. How many forgotten Nurembergers have done at least as well? Yet page after page of the books are given over to these objects, as if they were regarded by the authors as far more important than just precursors of the mobiles.

Calder's merits as a draftsman and painter are more nearly worthy of a good and earnest fight. I am not much persuaded by his efforts in these media, either, though he kept producing them with such unswerving dedication and hardfisted conviction, that the sheer weight of the output is, well, at least corporately impressive.

Still, what some viewers apparently find bold, elemental and high-spirited, in his line drawings and primary-colors-plus-black gouaches and prints strikes some of the rest of us as clumsy and bumptious and little more. Calder's graphics look good in a nursery. I was present at one of his most relentlessly hyped late endeavors, the unveiling in Dallas-Fort Worth of *Flying Colors,* the aircraft which Calder gaudily decorated for Braniff airlines. It was a piece of artistic foolishness, a PR gimmick, less the manifestation of an irrepressible creative soul than a mere daubed airplane. While one is willing to excuse a great artist his goofs, one need not swoon before them. Not only did the media swoon, so did many of his more sophisticated celebrants, who have offered *Flying Colors* up to us in their homages as if it were on a par with his mobiles.

The mobiles are, in fact, a qualitatively different order of experience, and mention of them suggests a near-complete turnabout of critical response. They are marvelous; inventive, dexterous, buoyant, exquisite—just about everything of an expressive and formal nature that his paintings, drawings and assorted aforementioned divertissements are not. Again one feels called upon to differentiate the best from the worst, but so many of the mobiles are beautiful in so many ways that it virtually requires a catalogue to name the good ones alone. It may be enough to recall what is on view in the permanent collections of the museums in New York—the Whitney, the Modern, the Metropolitan, the Guggenheim. There one is conscious of a wellspring of imagination that produced the richest permutations of line, precise and delectable shapes without a trace of ungainliness plus of course, the sure, clear paths and counterpaths of movement which these various forms constantly traverse. When one at last thinks of all these—and only then—he is prepared to accept the romantic American notion that Calder was a steadfast old putterer who gradually and with a minimum of esthetic posturing put together one of the most elegantly original bodies of work of the 20th century.

But there is something more, and, to my way of thinking, something better still. Toward the end of his life Calder was inundated with requests for public sculptures. Most of the pieces he executed were stationary objects—stabiles, he called them—and almost invariably they were very large. We have one of the bigger ones in Chicago—*Flamingo,* a vermilion-painted construction that stands in the plaza of Mies van der Rohe's masterly Federal Center—and if it is not among the most commanding works he ever produced (it may be), it is certainly the most successful recent public artwork to go up in a city that prides itself on its Picasso, its Moore, its Chagall, its Bertoia, its di Suvero and several other ambitious contemporary monuments. *Flamingo* is charged with force and vitality rather than with wit, characteristics which related appropriately to its setting both as an echo of Mies magisterial forms and as a foil to his sobriety. The other major stabiles of Calder's later years warrant similar descriptions: they are powerful works, not just delightful, and indeed at times they are grave rather than delightful. Grand Rapids' *La Grande Vitesse* and Paris' *La Défense* are the products of great and serious modern artist, not bearishly lovable, winking old grandpa. They even surpass many of Calder mobiles, and that seems to me grounds for authentic veneration.

Franz Schulze, "A Refrain for Alexander Calder (1898-1976)," in ARTnews, *Vol. 76, No. 1, January, 1977, p. 48.*

Joan M. Marter (essay date 1978)

[*Marter is an American critic, educator, and author. In the following excerpt, she examines the origins of Calder's use of abstract forms, noting in particular the influence of astronomy in his artistic development.*]

When Alexander Calder produced his first abstract constructions in 1930, it was a significant departure from his

previous figurative sculpture in wire and wood. Within two years the American artist had exhibited his nonobjective works in Paris and in New York, and had created the mobile and the stabile as his personal contributions to twentieth-century sculpture. The American expatriate was also among the first to develop a sculptural idiom of solid components freely arranged in space with little suggestion of a center of focus. Relations between contiguous surfaces of a solitary object were replaced by an interest in the relation among dislocated pieces in a spatial configuration. These new sculptural constellations could be compared to atomic particles or to the planetary bodies obeying the injunctions of the electromagnetic system.

Calder often acknowledged that his first impulse to work in the abstract resulted from a visit to Mondrian's studio in the fall of 1930. Contact with members of Abstraction-Création, which Calder joined in 1931, and his friendship with Joan Miró, Jean Arp, and Marcel Duchamp among others, undoubtedly provided the catalyst for his experimentation with an abstract idiom. But there are other factors to be considered in the analysis of Calder's preference for cosmic imagery and his rapid development of a mature aesthetic based on the utilization of static and kinetic elements.

After 1930, images of the cosmos dominated Calder's artistic production and were repeatedly mentioned in the artist's statements about his work:

> From the beginning of my abstract work, even when it might not have seemed so, I felt there was no better model for me to choose than the Universe. . . . Spheres of different sizes, densities, colors, and volumes, floating in space, traversing clouds, sprays of water, currents of air, viscosities and odors—of the greatest variety and disparity.

In an interview Calder recalled seeing a wooden globe in 1932 which he claimed had inspired him to produce his own model of the solar system. But Calder's obsession with the cosmos and his frequent references to planetary bodies extend far beyond the single antecedent mentioned. As early as 1931 cosmic imagery appears in a remarkable series of drawings. The first constructions based on concepts of the universe were made in the fall of 1930, and comprise a significant portion of his first exhibition of abstract works at the Galerie Percier in April, 1931.

Major astronomical discoveries of the early 1930s and Calder's visit to a planetarium must have revived his childhood fascination with the universe. His interest in heavenly bodies can be documented as early as 1906 when Calder and his family attempted to locate the constellations and planets on a cool desert night in Oracle, Arizona. In his autobiography Calder also mentioned an experience on a sea voyage at the age of twenty-four:

> It was early one morning on a calm sea, off Guatamala, when over my couch—a coil of rope—I saw the beginning of a fiery red sunrise on one side, and the moon looking like a silver coin on the other. Of the whole trip this impressed me most of all; it left me with a lasting sensation of the solar system.

Calder's renewed interest in the cosmos in the early 1930s parallels contemporary developments in the scientific community as a series of new discoveries about the solar system dramatically undermined established theories about its origin and nature. When Calder chose to produce plastic models of the universe, he examined existing astronomical instruments as a basis for his personal conception but also acknowledged recent scientific speculations.

Several weeks after his visit to the atelier of Piet Mondrian in the fall of 1930, Calder made his first abstract constructions. In Mondrian's studio the American saw a white wall with cardboard rectangles of varying colors tacked upon it. This wall impressed him more than the Dutch artist's paintings, and Calder proposed that the rectangles could be made "to oscillate in different directions, and at different amplitudes."

Calder's concept of abstract forms in motion was fully realized within a year of his visit to Mondrian with the creation of the mobile, but even his initial constructions manifest a radical change in his work. The witty wire caricatures of animals and the acrobats of previous years were abandoned for spheres, arcs, and constellations accompanied by analytical descriptions that confirmed the scientific orientation of his vision, for Calder combined his interest in cosmic imagery with the technical mastery of physical principles which resulted from his training as a mechanical engineer.

For the first number of *Abstraction-Création, Art Non-Figuratif,* Calder prepared a statement to accompany a reproduction of **Little Universe:**

> How does art come into being? Out of volumes, motion, spaces carved out within the surrounding space, the universe. Out of different masses, tight, heavy, middling, achieved by variations of size or color. Out of directional lines—vectors representing motion, velocity, acceleration, energy, etc.—lines which form significant angles and directions, making up one or several totalities. Spaces or volumes, created by the slightest opposition to their masses, or penetrated by vectors, traversed by momentum. None of this is fixed. Each element can move, shift, or sway back and forth in a changing relation to each of the other elements in the universe. Thus, they reveal not only isolated moments, but a physical law or variation among the elements of life. Not extractions, but abstractions. Abstractions which resemble no living things except by their manner of reacting.

At the urging of Jean Hélion, Calder had joined Abstraction-Création, a group dedicated to the promotion of nonfigurative art through exhibitions and the publication of a yearly almanac. His friendships with vanguard artists in the group also resulted in Calder's first one-man exhibition of his abstract devices at the Galerie Percier. When the show opened on April 27, 1931, the printed catalogue listed such titles as *Sphérique I, Arc III, Circulation, Densité V,* and *Gémissement Oblique.* Calder's earlier wire portraits were relegated to a position high on the wall where they would not distract attention from the constructions ranged around the room.

Though none are visible in the installation view, reviews of the show indicate that Calder also included drawings. Specific examples cannot be determined, but Calder may have shown some of his earliest sketches to demonstrate his interest in planetary bodies. These studies and others join with early spherical constructions manifest the artist's serious involvement with cosmic imagery in the early 1930s.

It is not surprising to learn of Calder's preoccupation with the solar system when contemporaneous astronomical discoveries were making newspaper headlines around the world. In these years Calder probably shared in the general excitement which followed the identification of a new planet in the solar system, the sighting of numerous asteroids, and the discussion of extragalactic island universes. On March 14, 1930, Lowell Observatory in Arizona announced the discovery of a ninth planet far beyond Neptune. Hailed as the major astronomical find of the century, the new planet was soon being identified and photographed by observatories around the world. For months after the discovery, newspaper and magazine articles appeared which reported on the proposed names for the ninth planet and documented evidence for its orbit and speed. By May 25, 1930, the name Pluto had been selected for the new discovery, but revised theories about the solar system continued to stir worldwide speculation. Identification of a heavenly body beyond the limits of the known planetary system clearly demonstrated the limitations of human knowledge about the cosmos. Scientists advanced various theories concerning the origin of the planets and considered the possibilities of extraterrestrial life, but it was generally conceded that there was much yet to be learned. By the fall of 1931, scientists were speculating that possibly a dozen additional planets would be discovered outside the known solar system.

As Calder made final preparations for his first exhibition of abstract constructions, public attention shifted from Pluto to the reports on the new determinations about the galaxies. In February, 1931, Albert Einstein announced that the secret of the universe was directly related to the red shift of distant nebulae. The red shift, or the speed of distant island universes (galaxies) receding from the earth, had been analyzed by Edwin Hubble, and caused Einstein to abandon his previous model of the universe.

During the early 1930s, a group of minor planets also made headlines as the interested public sought additional information about the solar system. These asteroids (or planetoids) varied in size, the smallest being no more than chunks of rock. Most of them moved in orbits lying between those of Mars and Jupiter. Some moved outside this range and a few came quite close to the earth. For example, on January 30, 1931, the asteroid Eros came within sixteen million miles of the earth, closer than any other planet ever comes. From a scientific viewpoint Eros was most important because, coming so near the earth, its distance could be measured precisely. Thus the distance of the sun as well as the dimensions of the whole solar system could be determined with greater accuracy than by any other method.

The dramatic astronomical discoveries and hypotheses of

1930 and 1931 are remarkably reflected in a series of drawings and abstract constructions created by Calder in the same years. While scientists continued to provoke the interest of an international audience with their theories about the universe, Calder's imagination stirred with images of planetary bodies in motion.

Many is among the first of a series of drawings which indicates the artist's fascination with heavenly bodies in space. Perhaps in this drawing he makes reference to the planets and asteroids orbiting around the sun. An ink and gouache study of the following year may be Calder's attempt to represent an asteroid, a body which was known to have light and dark areas on its surface. Calder's other drawings of planetary bodies floating in space correspond to a statement he prepared to answer a query posed by The Museum of Modern Art [see Artist's Statements dated 1951] concerning the meaning of abstraction in his work:

> I think at the time [1930] and practically ever since, the underlying sense of form in my work has been the system of the Universe, or part thereof. For that is a rather large model to work from. What I mean is that the idea of detached bodies floating in space, of different sizes and densities, perhaps of different colors and temperatures, and surrounded and interlarded with wisps of gaseous condition, and some at rest, while others move in peculiar manners, seems to me the ideal source of form. I would have them deployed, some nearer together and some at immense distances. And great disparity among all the qualities of these bodies, and their motions as well. A very exciting moment for me was at the planetarium—when the machine was run fast for the purpose of explaining its operation: a planet moved along a straight line, then suddenly made a complete loop of 360° off to one side, and then went off in a straight line in its original direction.

Curiously, most of the drawings of the cosmos include a ribbonlike element which twirls around the planets. This curving form may be an attempt to represent "wisps of gaseous condition" which Calder mentioned in his statement. There is also the possibility that Calder visualized the epicyclic motion of a planet. The artist referred to the demonstration of this kind of motion in his description of the planetarium projector. When he observed that the planet "moved along a straight line, then suddenly made a complete loop of 360° off to one side," he was witnessing the epicyclic motion, or apparent motion of a planet as viewed from the earth.

Little Universe is one of Calder's first attempts to realize his concept of the cosmos in three-dimensional form. Two circles of wire intersect at right angles to form a sphere. The plastic form, which probably represents the universe, supports smaller solid spheres which could be planetary bodies or asteroids. In this work and other constructions of 1931 and 1932, Calder tried to visualize his personal musings about the shape and nature of the cosmos. With the discovery of a ninth planet and thousands of asteroids, existing scientific models of the universe became obsolete. Nevertheless, Calder was obviously familiar with astro-

nomical instruments which had been utilized to demonstrate the planetary system throughout the ages.

Antecedents for Calder's attempt to render his personal, three-dimensional model of the universe can be found among such standard astronomical devices as the armillary sphere and the orrery. The armillary sphere is one of the oldest known instruments from the astronomy of antiquity. It became more complicated as knowledge about the solar system advanced: supplementary concentric and movable rings were added to show the supposed orbits of the moon, sun, and planets. In this example of a Copernican armillary sphere, the sun is represented by a small sphere made of boxwood which is carried by a brass rod passing through the poles; the earth and moon are carried on a subsidiary arm from the same rod. This kind of device may have inspired some of Calder's early universes, for he often pierces the open sphere with a wire rod supporting small wooden spheres which represent the sun or planetary bodies.

But Calder's constructions are simplified versions of the armillary sphere, including only a meridien and an equator. Wooden spheres contained within the open sphere of wire or attached to the circumference of the wire sphere suggest Calder's acknowledgment of recent scientific discoveries that demonstrated man's limited knowledge of the full range and scope of the solar system. Not attempting scientific accuracy, Calder explored fantastic renderings of the cosmos while utilizing obsolete astronomical models as sources.

An antecedent for Calder's early motorized constructions is the orrery, the mechanized model of the planetary system which described the velocity and orbits of the heavenly bodies. In an interview, Calder acknowledged his fascination with "eighteenth century toys" which were models of the universe. Undoubtedly he referred to the orreries which were often handsomely crafted objects made in the 1700s for wealthy patrons. (pp. 108-10)

These mechanical models of the heliocentric system may have inspired Calder's earliest motorized and wind-driven mobiles which he began producing in 1931. Wooden spheres of different colors, sizes, and densities were attached to wires and allowed to move through space. Generally, Calder's wind-driven mobiles appear to be more random in movement, which may allude to the concurrent devaluation of established theories about the universe, or may be an imaginative visualization of the interdependence of heavenly bodies in a complex cosmic system.

However, his motorized devices, which include a full cycle of predictable movements, are closely related to the mechanized orreries. *A Universe,* for example, is the culmination of a series of works in which Calder demonstrated his obsession with cosmic imagery and attempted imaginative models reflecting the concurrent revisionism among astronomical theorists. Calder constructed a large piece of machinery that occupies a separate base alongside *A Universe,* and serves to activate two small spheres to traverse the curving paths created for them within the open sphere. The red sphere and the larger white sphere move at contrasting rates of speed, and suggest a binary star system:

Installation view showing Calderberry Bush *(1932; far left) and* Universe *(1934; right).*

the consideration of the motion of two bodies in relationship to one another. In Newtonian physics, the study of moving bodies is the basis for understanding the relationship of all bodies in motion to one another. Binary stars are orbiting bodies of comparable size which mutually revolve to complete a full circuit, consuming only a few hours or as long as one hundred days. Here Calder's red and white spheres, which follow different but related itineraries, also complete a full cycle to demonstrate the range of his interest in heavenly bodies in space: from the planetary system to stellar orbits.

In February of 1931, Calder's first exhibition of mobiles was held at the Galerie Vignon in Paris. For his earliest motorized and wind-driven devices, Calder combined his serious involvement with the cosmos as a source for his imagery with the mechanical expertise he developed at the Stevens Institute of Technology. Despite the generally accepted importance of Calder's training as an engineer, the full range of his knowledge and experimentation with scientific principles in the creation of his mobiles has never been explored. When Calder exhibited his motorized constructions in 1933, he prepared the following statement:

> The sense of motion in painting and sculpture has long been considered as one of the primary elements of the composition. The Futurists prescribed for its rendition. Marcel Duchamp's *Nude Descending the Stairs* is the result of the desire for motion. This avoids the connotation of ideas which would interfere with the success

of the main issue—the sense of movement. Fernand Léger's film, *Ballet Mecanique,* is the result of the desire for a picture in motion. Therefore, why not plastic forms in motion? Not a simple translatory or rotary motion but several motions of different types, speeds, and amplitudes composing to make a resultant whole. Just as one can compose colors, or forms, so one can compose motions.

In addition to the artistic antecedents mentioned, which provided Calder with the motivation for plastic forms in motion, the artist is clearly indebted to his training as an engineer for the concept of composing motions of "different types, speeds, and amplitudes." He attended the Stevens Institute of Technology from 1915 to 1919, and earned a degree in mechanical engineering. A college catalogue from that period indicates that the general engineering curriculum was required of all students at Stevens, and the program of study was predetermined for all four years. Therefore it is possible to determine the courses in which Calder was enrolled. College records also indicate that the artist excelled in mechanical drawing, descriptive geometry, mechanical engineering laboratory, and applied kinetics. Description of the latter course parallels the experiments in "composing motions" found in Calder's early kinetic works:

> KINETICS. Discussion of the laws governing the plane motions of particles and of the mass-centers of rigid bodies, with aplications to the motion of projectiles, vibrating masses, systems of connected translating bodies, constrained motions, and pendulums. Discussion of the laws governing the plane motions of rigid bodies, with applications to machines, compound and torsion pendulums, translating and rotating bodies.

The laboratory demonstrations for various physical principles also provided Calder with some useful antecedents for abstract constructions. From Calder's required college textbooks it is possible to determine the nature of the laboratory presentations to be included in his courses. From a catalogue of the major supplier of equipment for science laboratories at that time, E. L. Knott Company, the range of devices utilized can be ascertained.

For example, in Calder's first year at Stevens, the physics course included the study of vibrations, longitudinal and transverse waves, sympathetic vibrations and resonances. In addition to such standard laboratory equipment as levers, pendulums, and scales, Calder may have seen the thirty-rod wave apparatus, which demonstrated the formation of waves. His *Object with Red Discs* may be derived from this device and his studies of longitudinal and transverse waves. In the laboratory instrument, metal rods are attached at regular intervals to a steel ribbon and metal balls are attached to the rods. The balls on either side of the steel ribbon are painted different colors. When a longitudinal or transverse motion is applied to the crosshead, it is communicated to the other crossheads until a wave pattern is produced. Calder's object achieves the same effect as that produced by the double row of metal balls by using a counterweight to balance the series of five discs attached to rods. The precise equivalent of the observable

propagation of a wave pattern found in the scientific apparatus is not achieved in Calder's work because he limits the number of elements, but the artist has used a similar concept. When one of the red discs is moved, the others are set into motion. The result is an observable propagation of movement. Calder has varied the velocity of each of the discs by using wire of different lengths. A more random movement of elements is the result.

When Calder determined to compose motions of different types, speeds, and amplitudes, he could easily draw upon his college instruction in applied kinetics. Translatory, periodic, and rotary motion were fully described in the second volume of *Textbook of Mechanics,* a six-volume series which was required reading for Stevens students. The book was written by Louis A. Martin, a professor at the college. Such devices as the pendulum and the helix would have been used in the laboratory to explain motions of different types and speeds.

The large motorized *White Frame* of 1934 can be considered a basic demonstration piece for various types of motion. In a stroboscopic photograph, Calder's idea of "composing motions" became more evident. The black helix exhibits simple rotary motion. Blue and yellow wooden balls suspended from coils are simple harmonic oscillators. The open wire circle also demonstrates rotary motion when it spins. The large red disc is a pendulum which swings back and forth, and therefore can be characterized as a periodic oscillator. Thus, within the boundaries of a white wooden frame, Calder has fashioned a composition which includes the primary colors, varying shapes, and a demonstration of the basic types of motion.

An unpublished sketch from the late artist's studio is a preparatory study for a similar motorized device. Again the pendulum is used and other types of motion are incorporated. All of the elements are carefully measured and their planes of oscillation are precisely determined.

Black Ball, White Ball suggests the farcical qualities of a Dada or Surrealist invention with its humorous action and incorporation of an amusing range of sounds. When the piece is set into motion by a forceful push, the two balls twirl around and dip periodically to strike the sides of an array of metal plates of varying dimensions. Sound was consciously included as a compositional element in this work. The frequency of the sound that results is based on the sizes of the plates: the smaller the diameter, the higher the frequency. The quality and resonance of the sound depends on the force and position of impact.

Here Calder has derived his construction from knowledge of the pendulum apparatus which demonstrates variations in the velocities and duration of the movements of elements based on changes in the lengths of wires to which the elements are attached. The motion of *Black Ball, White Ball* is apparently random, unlike the Foucault pendulum, a standard device for demonstrating the conservation of the plane of oscillation. Calder's pendular device swings around and appears to have no predictable pattern because one element is not fixed to a stationary source but to a fulcrum which supports another pendulum. In addition, when the two balls strike the plates, the

impact further modifies the force and direction of movement. Clearly the piece also demonstrates the conservation of angular momentum: the method of suspension limits the angular momentum and eventually makes the mobile stop. (pp. 110-12)

By 1933, Calder's use of biomorphic imagery began to appear more frequently in his work. Organic forms of folded sheet metal and an array of *objects trouvés* often replaced the discs, colored spheres, and helixes of previous years. Some of Calder's wind-driven devices continued to suggest planetary bodies moving through space, but often his kinetic constructions alluded to phenomena of nature—the rustle of leaves, the flight of birds, lily pads on a rippling surface—rather than the incessant and fixed orbit of the cosmos.

However, when Calder constructed his large-scale mobiles in the 1930s, he still prepared such sketches as the unpublished preliminary study for **Steel Fish.** The drawing indicates that the artist carefully measured all elements to be included and precisely determined the fulcrum for the principal objects to be balanced.

Obviously, Calder did not rely totally on his knowledge of engineering principles in order to create his first kinetic works. The artist was undoubtedly encouraged by Marcel Duchamp, the example of Paul Klee's drawings of kinetic devices, and other members of the Parisian vanguard who were involved with mechanical gadgetry in the same period. He was probably aware of Bauhaus constructions by Lazlo Moholy-Nagy, including the *Space-Light Modulator* which was exhibited in Paris in 1930 and subsequently reproduced in the first number of *Abstraction-Création, Art Non-Figuratif.*

Nevertheless, Calder's statements from these early years and the works produced attest to an overwhelming involvement with the cosmos and a mastery of the principles of applied kinetics. His explanations of aesthetic concerns employed the terminology of an engineer. The transition from static forms to kinetic sculpture could be said to correspond to the first two years of his study of mechanics and the change from concentration on "Statics" to the study of "Kinematics and Kinetics." In 1934, Calder wrote a letter to Albert Eugene Gallatin in which he attempted to explain his work. Regarding **Little Universe,** he wrote:

> It was based on a concept of nuclei in space of various intensities, distributions, etc. I finally decided that the spatial relationship to be general, should not be fixed—and later added to that the thought of composing motions just as one composes volumes, spaces, colors. This I consider a rather natural turn for me, for I was once an engineer and am a graduate of Stevens Institute of Technology.

In 1937, when Calder made the **Mercury Fountain** for the Spanish Pavilion of the Paris Exposition, he wrote a lengthy explanation of the technical problems involved in producing the work for the *Stevens Indicator,* his alumni magazine. Apparently Calder sought to be recognized by his college and classmates for his skillful solution of the mechanical problems in the construction of the work.

Calder did acknowledge the importance of his engineering background on various occasions, but made no specific elaborations of antecedents appropriated for his abstract constructions. In decades subsequent to the 1930s, Calder generally became more reticent in discussing his artistic sources. By the final decade of his life, only the intuitive aspects of his creative process were ever mentioned. The early preparatory sketches lay forgotten in the artist's studio. The careful preparations that were deemed necessary for his early abstract constructions were forgotten in the realization of the mature artist who used the principles of physics necessary for his mobiles with effortless skill. Nevertheless, the unpublished drawings of the early years document the precise calculations made by the artist to assure the variations of speed and direction of all of the elements in his mobiles. Despite the seemingly intuitive approach to the creation of his abstract constructions from the beginning, Calder's training in mechanics and his fascination with astronomical instruments account for the cosmic imagery and the successful utilization of static and kinetic elements in the early 1930s. (pp. 112-13)

> Joan M. Marter, "Alexander Calder: Cosmic Imagery and the Use of Scientific Instruments," in Arts Magazine, Vol. 53, No. 2, October, 1978, pp. 108-13.

Lisa Liebmann (essay date 1986)

[In the following excerpt, Liebmann assesses Calder's achievements and influence.]

For quite a long time it seemed as though it were nearly impossible to look closely at a Calder, never mind see one. A Calder, whether standing still and stopping traffic or looping around in some institutional daylight, had become just that, "a Calder," and the artist himself had become Our Calder of the red and black mobiles, an official greeter to visitors of cities, museums, and corporate headquarters, ultimate pavilion man in a world with a better tomorrow. Calders might have been just the things to soothe community boards, chief executive officers, acculturating urbanites, and, of course, his many true believers, but to just about anyone in the thick of what had been going on in art since the late '60s they had become worse than passé, being both irrelevant and very, very nice. It is odd, then, that right now, in what is rarely described as a liberal moment or a particularly nice one, not only can the sight of a Calder be taken in again, but Calderisms, or subliminal traces of his presence, are themselves on the verge of being ubiquitous.

As recently as three years ago, the idea seemed improbable that Alexander Calder, who died in 1976 and must have gone straight to culture-pasha heaven to join Henri Matisse, Edward G. Robinson, and Arturo Toscanini, might be a lodestar to a new generation of young artists then busy picking their way through the century's more expressionistic rubble to some yet unknown destination. What got this writer started was a flash connection of Calder to Marc Chagall (the figures and suspensions) and to Philip Guston (the galumphers and pregnant "bubbles"), two artists whose work has also been reconsidered and applied

in recent painting. And then there was the sight of Calder's 1938 *Apple Monster* tucked into the midst of the Museum of Modern Art's 1984 " 'Primitivism' " show. A not very big, spindly, ramshackle, wood-and-wire construction whose evocative shape might have been derived from a beagle, or, more quirkily but as easily from a giraffe, *Apple Monster* was among the few Western objects on the premises that seemed actively involved with the aleatory elements of spirit and play, perhaps most closely embodying the commonest, readiest, most universal "tribal" impulse of all: simply to make something out of available stuff, that expresses the maker and engages someone else. It was the only object classified as a Modern work of art that made me think of my two-dollar whittled birds from Oaxaca. *Apple Monster* is not the kind of Calder we've come to take for granted, yet the economy that resides at its core integral to virtually every object that Calder ever made. Harmony in movement was his essential subject—literally in the mobiles, almost as literally in the stabiles, by direct implication in the countless acrobat, dancer, and animal figures he made, by flat in the hammocks, automobiles, and airplanes he decorated—and harmony or balance of movement is governed by the laws of physical economy, the laws of the tinkerer and the inventor.

Calder was a lucky artist. His luck began at birth, and there is nothing more lucky than that. Like the 19th-century Peales—Charles and his inspirationally named sons, Raphaelle and Rembrandt—or the more topical, *Dynasty*-like Wyeths, the Calders are a family of artists. In being reminded that both of Calder's parents were artists, that his father and grandfather were in fact well-known sculptors, that his wife, Louisa James Calder, is a grandniece of Henry, William, and Alice, and that his daughter, Sandra, is also an artist, a whole chain of associations slithers by concerning American cultural history and its family names—Adams, Lowell, Beecher among them—that refer to mind and not just money. Luck with Calder is an especially important link, since the body of his work somehow suggests the state of being fortunate.

The sun itself was Calder's *madeleine*. A story goes that in 1922, working on a passenger ship sailing off the coast of Guatemala, he saw the sun rise, fiery red, while the moon was setting like a silver coin dropping, and from that moment knew he wanted to make art that in some way reflected these mechanics of the universe, that would be at once engineered and organic, orchestrated and subject to change, made up of parts simultaneously individual and interdependent. About ten years later this led to his abstract "constellations," and of course to the mobiles, but consistent and benevolent motion and harmony, as well as planetary allusions and the color red, are adamant givens in Calder's work. Typically, they are stylized as emblems of gregarious and pacific radiance. Many quintessential Calderian motifs—anthropomorphic suns, moon masks, amoebic ovoids, irregular cometlike vectors, off-kilter spirals—could almost be categorized as "Grecian Mod," for it is as if Minoan memories of the universe as seen by an earthling, and some presentiment of Keith Haring's cartoon-cosmic radials, had somehow collided in whatever lane overhead permits such traffic.

At the time of the 1913 New York Armory Show Calder was 15 and in California, where his father, Alexander Stirling Calder, had been appointed chief of sculpture for the Panama Pacific Exposition, to be held in San Francisco in 1915. Though several artists who would later be his teachers were included in the Armory Show, his father was not, and pictures of the latter's extravagant, beaux arts—traditional *Fountain of Energy* at the San Francisco world's fair suggest why Calder's grandfather, Alexander Milne Calder, is best remembered through his monument to William Penn on top of Philadelphia's City Hall, and through his statue of George Washington on the Washington Arch in Greenwich Village. With both senior Calders firmly embedded in the 19th century, in the ceremonial bog of academic American sculpture of that time, our Calder was thus doubly lucky in that the frontiers of art in the 20th century were for him untrammeled by any prior family claims, and the role of prodigal son as yet unfilled.

He graduated from New Jersey's Stevens Institute of Technology in 1919, with a degree in mechanical engineering, and for the next three years drifted productively through a variety of technical jobs, including the one in the boiler room of the passenger ship that provided the occasion for his epiphany of the red sun. In 1923 he studied painting for the first time, at the Art Students League in New York, with John Sloan and George Luks of the Eight and other disciples of Robert Henri—advanced in their thinking about art, for the most part conservative in their own art. Like many of his teachers and contemporaries, he worked commercially as an illustrator, for the *National Police Gazette*. Even there, he was not on the beat of trouble. Athletes, acrobats, and animals were his subjects, and in 1925 he made the first of the small wire figures that would evolve into *Circus,* now enshrined at the Whitney Museum of American Art, New York. In 1926 he went to Europe, continued developing his movable wood-and-wire figures, and filled his workbooks with fast, canny calligraphic sketches, most notably of animals. For Calder—as is also the case with Picasso, and with most of the great Falstaffian appetites and transformers in art—animals are ideal material, being at once familiar, "other," and perfect living incarnations of motion. Wings, webbed feet, claws, cocks' combs, antennae, hoofs, horns, udders, and snouts, all filled with metaphor, provide an elaborate, poetic, and often mysterious costume, perhaps especially to the fundamentally abstract artist.

Calder's first show in Paris was at the Salon des Humoristes in 1927, where he exhibited *Circus*-related figures and wire sculptures, or "drawings in the air," including some of his famous, wittily spontaneous portraits of Josephine Baker. It is at moments tempting to recast Calder in the mold say, of a Rube Goldberg: as a visual humorist and fantasist, an American "whimsical" like James Thurber or Saul Steinberg—in short, as a *New Yorker* artist who happened to work on a larger scale. Unlike Ad Reinhardt, who was 15 years younger and who kept his cartoons as separate footnotes to his more austere pursuits, Calder was a great integrationist and assimilator who poured all of his ideas, materials, and sources into one big, serpentine channel. He was a natural tinkerer and made toys and jewelry for his family and friends as a child and

would continue to do so all his life. During the late '20s and '30s, traveling between Paris and New York (later on between Roxbury, Connecticut, and the town of Saché, in central France), he also designed toys for the Gould Manufacturing Company of Oshkosh, Wisconsin, made sets for Martha Graham at Bennington College, and started to hold up his end of the family's civic tradition by participating in the Paris World's Fair of 1937 and the one in New York two years later. The vocabulary of abstract forms that developed concurrently in Calder's work can be seen as both a natural byproduct of his lifelong tinkering and as the willed result of his desire for a "universal" model. Unlike many of his European contemporaries, and the slightly later generation of abstract painters and sculptors in this country, Calder was no Modernist idealogue, and he evinced no tragic impulse. Tragedy comes attached to the idea of stasis, most pointedly death, but movement, Calder's element is the element of comedy, of pleasure. While it is hard to think of any abstract work of art that bears a clearer "signature" than a Calder, the mobiles and stabiles, as well as a great deal of his work in two dimensions, began as distillations—a poet engineer's dream of setting the classic forms of Jean Arp, Joan Miró, and Piet Mondrian into motion. By all evidence, that is how the dream appeared to the young American artist in Paris around 1930, who liked to entertain people by playing ringmaster with a miniature circus, and who was already well aware of the fact that he had a "knack" for getting a lot of action out of an unbroken line.

Calder's first "contacts" in Paris are revealing in that they can be said, coincidentally or not, to represent the two poles of his temperament—the universal, monumental playground, and the intimate improvisation. Calder was introduced to Arp, Miró, Mondrian, Marcel Duchamp, and Fernand Léger, among others, by Stanley Hayter, the master printmaker and connoisseur of the line, and by the sculptor José de Creeft, like Calder's father a sophisticated traditionalist, and responsible for the *Alice in Wonderland* group, 1960, in Central Park. The influence on Calder of seminal Modernist European art is a peculiar mixture of the obvious and the elusive. Though his initial visit to Mondrian's studio constituted a second epiphany, in which the possibilities of abstraction were brilliantly, if somewhat belatedly, revealed to him, Calder, unlike many more doctrinaire American disciples of Mondrian, did not join the academy of the pure. His impatience, or desire, was that things *move,* and the combined impact of his European colleagues had the effect of propelling his merry-go-round to a higher-flying plane.

Calder's earliest abstract sculptures (1930-38) embody all available influences without quite reflecting any single one. Oddly, many of these pieces seem to resemble or prefigure certain painting and sculpture, highly idiosyncratic itself, of the more recent past. *Une Boule Noire, Une Boule Blanche (A Black Sphere, A White Sphere,* 1930,) with its awkwardly suspended pendulums and eccentric rhythm, may obliquely suggest Miró, but its affinities—thematic and dynamic—to '80s work by Rebecca Horn, or Shigeko Kubota, are even more apparent. Early abstract drawings such as *Starfish and Hemisphere,* 1932, and *Volcano in Red and Black,* 1933, look more like work

by Gary Stephan, or, from a different approach, Jedd Garet, than like anything by the Surrealists—Yves Tanguy, for instance, with whom Calder has occasionally been associated. I do not mean to load Calder with psychic prescience, or even with any overweaning influence on contemporary art. For so major a figure, in fact, he has rarely been credited with direct influence. Yet a number of salient aspects to his work, and his working process, give it a sudden relevance.

Calder mainly "borrowed" archetypes from art that affected him, which means that he didn't really borrow much at all. He had a "knack" as well for common denominators, for summary lines, shapes, and gestures. Along with Miró, and Paul Klee, he may have developed the poetic polka dot—or was it Georges Seurat, or an 18th-century woman with her *mouche,* or was it Giovanni di Paolo, whose *Creation of the World,* ca. 1440, includes what appears to be a small Kenneth Noland target? The point is, a circle or dot can't be claimed for long by anyone, and Francis Picabia, Larry Poons, Sigmar Polke, and David Salle have all punctuated its more recent career, at a peak this past summer whether on canvases or clothes. Then there are Calder's biomorphic shapes, which postdate Arp, and the Breugels, but precede the entire kidney-shaped world of '50s design—neoplastic paintings by artists such as César Domela, Auguste Herbin, and Mario Nigro—and its current revival. There is also Calder's connection to what might be called today's vacuum-cleaner or Hoover syndrome, through which found objects as well as borrowed styles are sucked in and promiscuously displayed. Clearly he had an aversion to material wastefulness, and, more to the point . . . , a devotion to manual production.

When Calder "altered" objects or made sculptures out of scraps, his manual and visual compulsion to use matter both prompted and ultimately outstripped any theoretical premise with which he concurred or coincided. His *Gothic Construction from Scraps,* ca. 1936, for instance, may suggest structural similarities to Duchamp's *Nude Descending a Staircase,* 1912, and the mention of "scraps" in its title, unusually self-conscious for Calder, may be an oblique acknowledgment of the found object, but the work remains "primitive" and formal rather than analytic, more like Louise Bourgeois' *Blind Leading the Blind,* ca. 1947-49. By no means a naif or an antiintellectual, he had to have been aware of Jasper Johns when he used coffee tins in some of his constructions during the '60s and '70s, but Calder's tins—which he had been using since the '50s, in whatever brand available—are neither diaristic nor pop. They stand only for ingeniousness and effect. To propose formal and spiritual connections between Calder and such junk-users as Jean Tinguely, John Chamberlain, Bill Woodrow, and Rebecca Howland is entirely germane, yet the work of each of these artists can be provided with more elaborate romantic or political metaphors than Calder's. Perhaps only certain of the late cutouts of Matisse are as blank, as open, as etherized as a Calder mobile. This all-encompassing euphoric blankness of Calder's abstract work functions subliminally as a conduit to so many immediately contemporary ideas. Consider, for instance the possibility that Calder, as seen through the eyes of the 21st

century, might appear to be a summary figure or common denominator for all of Modernism. The thought obviously can't be meant as more than a fancy, but with this moment's infinite patterns of association in art to which his work pertains—a moment which itself lays claims on Modern summary—it becomes conceivable.

Calder's themes were the dominant themes in mid-century American Modernism: motion and ecumenism, whether in '50s action painting or streamlined cars, or in the "instant" and repeatable imagery of '60s Pop. The "1960 look"—as represented architecturally in New York by the 1964-65 World's Fair, and its vestigial globe; by Shea Stadium, before it was stripped of its blue-and-orange Paco Rabanne-ish coat of armor; by so many Idlewild (now Kennedy International) Airport terminals; by the "666" building on Fifth Avenue; by Lincoln Center—until recently was generally considered a low point in design: silly, cheap, and destined to be kitsch. Lately, however, after close to a decade of figurative and often feverish imagery, of palimpsests of layered detail and multiple, ambiguous meanings, the unabashed, now poignant optimism of these buildings (and in many cases of their Calders) is what we see. (pp. 123-27)

When the Museum of Modern Art moved to its present location, in 1939, it commissioned a large Calder mobile for its new stairwell, and in 1943 it presented the first major exhibition of his work. But the Calder-we-came-to-take-for-granted—the consummate public artist—is a postwar and media creation. UNESCO commissions Calder, Calder becomes Mr. Family of Man. Grand Rapids feels good about itself because of its Calder, becomes the city of *La Grande Vitesse,* 1969, on Calder Plaza. In the early '50s Calder began to gather the kinds of large outdoor and indoor commissions and institutional prizes with which he was to become practically synonymous: first prize for sculpture at the 1952 Venice Biennale, and first prize at the Carnegie International in 1958; commissions for a much acclaimed acoustic ceiling for University City in Caracas, Venezuela (1952); for the 1958 Brussels World's Fair, and for Expo 67 in Montreal for the City of Spoleto (1962), for Lincoln Center for the Performing Arts in New York (1963; *Le Guichet,* which means ticket office, a dark, surly piece that looks as though it may have been inaccurately gauged for scale), for a sidewalk in Manhattan, on Madison Avenue and 78th Street (1970), for BMW (1975, to decorate a car) and for Braniff Airlines (1973 and 1975, to decorate airplanes in a let's-hear-it-for-friendly-tech style); and for what would appear to be every major corporation and institution in the third quarter of this century.

During the '60s, Calder became a public individual as well. In 1966, he and his wife took a full page in the *New York Times* to protest the war in Vietnam, and in May of 1972, protesting the Cambodia bombings, helped sponsor another page taken in the *Times* by the National Committee for Impeachment—a quixotic gesture given that the page was published at the time of President Richard Nixon's first visit to the People's Republic of China, a peak of popularity for him. For these reasons, and because of the universalism implicit in his work, Calder came to

be a symbol of enlightened liberal sentiment, a generic and ambassadorial presence representing Modernist good cheer and hope from our shores to the world. But during the 20 or so years of his really pandemic acclaim, somewhere in a sea of generalized significance, his art for a while lost its life.

Calder was a true and innate classicist, not a stylistic one. His genius was his ability to articulate "universals," to make vivid so platonic a concept as "joy." It is a genius that some might interpret as a failing: the absence of particular incident and of tragic insight in the work. Still, Calder, with his beatific sculptures, more exactly fulfilled Le Corbusier's vision of ecumenical sunshine than the architect did himself. With Calder, joy is not simply an emotion, but transport: a motion. (pp. 127-28)

<div align="right">

Lisa Liebmann, "Sun Rising in Calder," in Artforum, *Vol. XXV, No. 3, November, 1986, pp. 122-28.*

</div>

FURTHER READING

I. Writings by Calder

Calder: An Autobiography with Pictures. New York: Pantheon/Random House, 1966, 285 p.
 Calder's life as dictated to his son-in-law, Jean Davidson.

II. Interviews

Osborn, Robert. "Calder's International Monuments." *Art in America* 57, No. 2 (March-April 1969): 32-49.
 Calder discusses the conception and execution of his large stabiles.

Rodman, Selden. "Alexander Calder." In his *Conversations with Artists,* pp. 136-42. New York: Devin-Adair, 1957.
 Calder discusses Modernism and his own aesthetic aims, noting: "I feel that there's a greater scope for the imagination in work that can't be pinpointed to any specific emotion. That is the limitation of representational sculpture."

III. Biographies

Bourdon, David. *Calder: Mobilist/Ringmaster/Innovator.* New York: Macmillan Publishing Co., 1980, 149 p.
 Brief critical biography.

Hayes, Margaret Calder. *Three Alexander Calders: A Family Memoir.* Middlebury, Vt.: Paul S. Eriksson, 1977, 300 p.
 Biography written by Calder's sister. Although Hayes includes information about Calder's father and grandfather, Calder is the focus of the book.

IV. Critical Studies and Reviews

"Mobiles and Objects in the Abstract Language." *Art News* XXXIV, No. 21 (22 February 1936): 8.
 Negative review of an exhibit of Calder's mobiles at the

Pierre Matisse Gallery. The reviewer judges the work "esoteric in the extreme."

Davidson, Jean. "Four Calders." *Art in America* 50, No. 4 (1962): 68-73.
Provides biographical and background information on Calder, his grandfather, father, and daughter.

Frost, Rosamund. "Calder Grown Up: A Museum-Size Show." *Art News* XLII, No. 12 (1-14 November 1943): 11.
Positive review of the Calder retrospective at the Museum of Modern Art.

Gibson, Michael. *Calder.* New York: Universe Books, 1988, 109 p.
Biographical and critical overview with numerous small-format reproductions.

Goitein, Lionel. "Animistic Phase in Art Thinking." In his *Art and the Unconscious,* unpaged. New York: United Book Guild, 1948.
Includes a discussion of Calder's mobile *Lobster Trap and Fish Tail* (1939), which Goitein praises as "kaleidoscopic in its possibilities."

Grafly, Dorothy. "Calder: Creator of Moving Forms in Space." *American Artist* 15, No. 8 (October 1951): 37-9, 69-70.
Brief biographical essay focusing on Calder's early development.

Gray, Cleve. "Calder's Circus." *Art in America* 52, No. 5 (1964): 22-48.
Based on a discussion with Calder, Gray examines a series of circus drawings the artist created during the 1930s. Includes numerous reproductions of the drawings under discussion.

"Calder: He Gave Pleasure." *Horizon* XIX, No. 3 (May 1977): 20-3.
Obituary tribute to Calder in which the critic notes that "for all its exuberant simplicity, Calder's art represents a complex fusion of many elements."

Karshan, Donald H. "Alexander Calder." *Art in America* 58, No. 3 (May-June 1970): 48-51.
Discusses Calder's graphic works and presents a lithograph entitled *Spirals* (1970).

Marter, Joan M. "Alexander Calder: Ambitious Young Sculptor of the 1930s." *Archives of American Art Journal* 16, No. 1 (1976): 2-8.
Examines Calder's correspondence of the 1930s in an attempt to trace the conscious shaping of his career and reputation.

————. "Alexander Calder's Stabiles: Monumental Public Sculpture in America." *American Art Journal* XI, No. 3 (July 1979): 75-85.
Discusses the design of Calder's public sculptures, as well as their architectural and social functions.

Mitgang, Herbert. "Alexander Calder at 75: Adventures of a Free Man." *Art News* 72, No. 6 (Summer 1973): 54-8.
Traces the development of Calder's career.

Pincus-Witten, Robert. "Entries: Childe Sandy in Italy." *Arts Magazine* 58, No. 4 (December 1983): 70-3.
Examines the Constructivist roots of Calder's work.

Ratcliff, Carter. "New York Letter." *Art International* XIV, No. 2 (February 1970): 77.
Review of an exhibit at the Museum of Modern Art. Ratcliff praises Calder's mobiles and sculptures but describes his graphic works as "tentative" expressions of the talent more fully displayed in the three-dimensional works.

Sweeney, James Johnson. "The Position of Alexander Calder." *Magazine of Art* 37, No. 5 (May 1944): 180-83.
Explores the sources of Calder's international appeal.

————. *Alexander Calder.* New York: Museum of Modern Art, 1951, 80 p.
Biographical overview and critical analysis accompanied by numerous reproductions of Calder's works. This volume is a revision of the catalog prepared by Sweeney for the Calder retrospective at the Museum of Modern Art in 1943.

Tuchman, Phyllis. "Alexander Calder's *Almadén Mercury Fountain.*" *Marsyas* XVI (1972-73): 97-106.
Discusses the creation of the *Mercury Fountain* (1937).

V. Selected Sources of Reproductions

Bruzeau, Maurice. *Calder.* Translated by I. Mark Paris. New York: Harry N. Abrams, 1979, 171 p.
Large-format reproductions with text by Bruzeau.

Lipman, Jean. *Calder's Universe.* Philadelphia: Running Press, 1976, 351 p.
Comprehensive catalog of Calder's works with numerous large-format color reproductions.

Lipman, Jean and Conrads, Margi. *Calder Creatures Great and Small.* New York: E. P. Dutton, 1985, 80 p.
Reproductions of Calder's animal sculptures from various periods in his career.

Marchesseau, Daniel. *The Intimate World of Alexander Calder.* Translated by Eleanor Levieux and Barbara Shuey. New York: Harry N. Abrams, 1989, 399 p.
Focuses on Calder's smaller creations, including toys, jewelry, animals, and household objects.

Mulas, Ugo, and Arnason, H. Harvard. *Calder.* New York: Viking Press, 1971, 216 p.
Large-format reproductions of works from various periods with an introduction by Arnason and commentary on the works by Calder.

Henri Cartier-Bresson

1908-

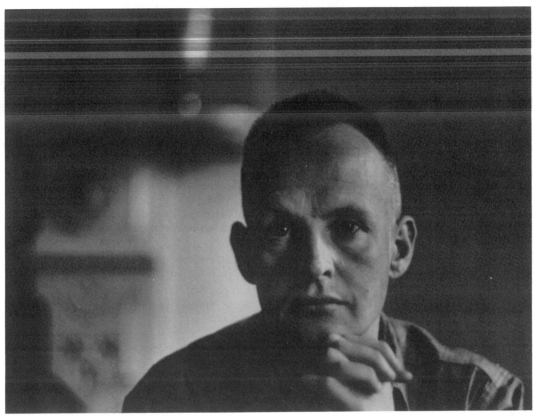

French photographer, graphic artist, and filmmaker.

Regarded as the founder of modern photojournalism and one of the most influential photographers of the twentieth century, Cartier-Bresson is renowned for his candid and spontaneous black-and-white compositions capturing the emotional essence of the diverse individuals he encountered during his extensive travels. While Cartier-Bresson's attraction to the principles of Surrealism is reflected in the highly stylized photographs of his early career, critics generally agree that his finest work results from his interest in human actions and expressions in various social contexts.

Born to affluent parents who operated a textile business in Chanteloup, France, Cartier-Bresson attended private schools in Paris where, encouraged by his family to develop his artistic talents, he spent much of his free time sketching and painting. Although he did not receive a high school diploma, he continued to study art from 1927 to 1928 with the noted Cubist painter André Lhote. He also spent eight months at Cambridge University studying literature, particularly the verse of the French Symbolist poet Arthur Rimbaud and the fiction of the Irish novelist James Joyce, whose emphasis on art as a stimulus for subjective, emotional response he admired. In 1931 Cartier-

Bresson traveled to Africa, where he worked as a wild-game hunter until he contracted malaria on the Ivory Coast. Returning to France to convalesce, he became interested in photography as an art form and purchased a Leica camera, known for its lightness, speed, and simplicity.

Critics note that Cartier-Bresson's early photographs, taken from 1932 to 1934 in France, Spain, and Mexico, illustrate his interest in the imaginative and dreamlike qualities of Surrealist art. Focusing on the actions of both friends and strangers, these photographs also suggest humorous and often erotic aspects of his subjects. In one of these photographs, three Mexican prostitutes wearing bloomers and high heels repose on a tile floor amid ornate decoration. In another, a female friend of Cartier-Bresson stares at the camera through a piece of tightly wrapped nylon hosiery. These highly stylized photographs, among others, comprised Cartier-Bresson's first exhibitions in 1933 and 1934 in New York, Madrid, and Mexico City.

In 1935, during a trip to the United States, Cartier-Bresson became interested in filmmaking and studied with the American photographer and cinematographer Paul Strand. The following year he worked in France as an assistant to the director Jean Renoir, and in 1937 he directed

his own documentary, *Return to Life*. Cartier-Bresson decided, however, that he had "no imagination . . . for plays, for stories—[no] theatrical or narrative ability," and he discontinued his filmmaking career. Describing photography as enjoyable for its similarity to hunting, he remarked that "What I like, you see, is the stalking. . . . To push the shutter release—ping!—that is a great joy." As a corporal in the Film and Photography Unit of the French army at the onset of World War II, Cartier-Bresson was captured by the Germans in 1940 and sent to a prisoner-of-war camp from which he escaped three years later. Upon attaining freedom, he returned to Paris and resumed his career as a photographer, creating portraits of such artists as Henri Matisse and Pierre Bonnard and contributing pictures documenting postwar conditions to the French press.

This interest in "photo-reportage," an area which, according to one critic, Cartier-Bresson "gradually backed into," resulted in his cofounding of Magnum Photos, a marketing agency for photographers. Established in 1946, Magnum provided Cartier-Bresson with the opportunity to work independently and to travel extensively, photographing people and events in India, China, the Soviet Union, and the United States for European and American magazines. His association with Magnum continued for three decades and produced the photographs for which he is best known. Traveling in India in 1948, Cartier-Bresson was able to record the nation's reaction to the death of Mohandas Gandhi. In 1949 he photographed the aftermath of civil war in China and the inception of the People's Republic. Visiting the United States, he documented life among the middle and lower classes in urban and rural areas. He also provided the western world with some of the first published pictures of conditions in Moscow after Joseph Stalin's death in 1954. Capturing the expressions of common people in public settings, Cartier-Bresson's photographs are highly regarded for their content and style. Some critics champion the often satiric pictorial commentary on economic and political conditions as Cartier-Bresson's greatest contribution to the medium of photography. Others emphasize the combination of precision and spontaneity that constitute his highly influential style.

In 1973, Cartier-Bresson gave up photography to devote his time to sketching and painting. Critics note that of the drawings and paintings he has exhibited in Paris and New York, the best works seem hurriedly sketched, sharing the spontaneity and uncomplicated technique that popularized his photographs. According to Cartier-Bresson, speed and simplicity enable an artist to capture the "decisive moment" in a situation, a moment that encompasses "the significance of an event as well as of a precise organization of forms which give that event its proper expression." Through his discovery and mastery of the decisive moment, Cartier-Bresson has influenced the development of modern photography and has produced some of the most memorable photographs of the twentieth century.

ARTIST'S STATEMENTS

Henri Cartier-Bresson (essay date 1952)

[*In the following essay, Cartier-Bresson discusses his photographic technique.*]

I, like many another boy, burst into the world of photography with a Box Brownie, which I used for taking holiday snapshots. Even as a child, I had a passion for painting, which I "did" on Thursdays and Sundays, the days when French school children don't have to go to school. Gradually, I set myself to try to discover the various ways in which I could play with a camera. From the moment that I began to use the camera and to think about it, however, there was an end to holiday snaps and silly pictures of my friends. I became serious. I was on the scent of something, and I was busy smelling it out.

Then there were the movies. From some of the great films, I learned to look, and to see. "Mysteries of New York," with Pearl White; the great films of D. W. Griffith— "Broken Blossoms"; the first films of Stroheim—"Greed"; Eisenstein's "Potemkin"; and Dreyer's "Jeanne d'Arc"— these were some of the things that impressed me deeply.

Later I met photographers who had some of Atget's prints. These I considered remarkable and, accordingly, I bought myself a tripod, a black cloth and a polished walnut camera three by four inches. The camera was fitted with—instead of a shutter—a lens-cap, which one took off and then put on to make the exposure. This last detail, of course, confined my challenge to the static world. Other photographic subjects seemed to me to be too complicated, or else to be "amateur stuff." And by this time I fancied that by disregarding them, I was dedicating myself to Art with a capital "A."

Next I took to developing this Art of mine in my washbasin. I found the business of being a photographic Jack-of-All-Trades quite entertaining. I knew nothing about printing, and had no inkling that certain kinds of paper produced soft prints and certain others highly contrasted ones. I didn't bother much about such things, though I invariably got mad when the images didn't come out right on the paper.

In 1931, when I was twenty-two, I went to Africa. On the Ivory Coast I bought a miniature camera of a kind I have never seen before or since, made by the French firm Krauss. It used film of a size that 35 mm would be without the sprocket holes. For a year I took pictures with it. On my return to France I had my pictures developed—it was not possible before, for I lived in the bush, isolated, during most of that year—and I discovered that the damp had got into the camera and that all my photographs were embellished with the superimposed patterns of giant ferns.

I had had blackwater fever in Africa, and was now obliged to convalesce. I went to Marseille. A small allowance enabled me to get along, and I worked with enjoyment. I had just discovered the Leica. It became the extension of my eye, and I have never been separated from it since I found it. I prowled the streets all day, feeling very strung-up and ready to pounce, determined to "trap" life—to preserve

life in the act of living. Above all, I craved to seize the whole essence, in the confines of one single photograph, of some situation that was in the process of unrolling itself before my eyes.

The idea of making a photographic reportage, that is to say, of telling a story in a sequence of pictures, was something which never entered my head at that time. I began to understand more about it later, as a result of looking at the work of my colleagues and at the illustrated magazines. In fact, it was only in the process of working for them that I eventually learned—bit by bit—how to make a reportage with a camera, how to make a picture-story.

I have travelled a good deal, though I don't really know how to travel. I like to take my time about it, leaving between one country and the next an interval in which to digest what I've seen. Once I have arrived in a new country, I have an almost desire to settle down there, so as to live on proper terms with the country. I could never be a globe-trotter.

In 1947, five free-lance photographers, of whom I was one, founded our co-operative enterprise called "Magnum Photos."

This co-operative enterprise distributes our picture-stories to magazines in various countries.

Twenty-five years have passed since I started to look through my view-finder. But I regard myself still as an amateur, though I am no longer a dilettante.

.

What actually *is* a photographic reportage, a picture-story? Sometimes there is one unique picture whose composition possesses such vigor and richness, and whose content so radiates outward from it, that this single picture is a whole story in itself. But this rarely happens. The elements which, together, can strike sparks out of a subject, are often scattered—either in terms of space or time—and bringing them together by force is "stage management," and, I feel, cheating. But if it is possible to make pictures of the "core" as well as the struck-off sparks of the subject, this is a picture-story; and the page serves to reunite the complementary elements which are dispersed throughout several photographs.

The picture-story involves a joint operation of the brain, the eye and the heart. The objective of this joint operation is to depict the content of some event which is in the process of unfolding, and to communicate impressions. Sometimes a single event can be so rich in itself and its facets that it is necessary to move all around it in your search for the solution to the problems it poses—for the world is movement, and you cannot be stationary in your attitude toward something that is moving. Sometimes you light upon the picture in seconds; it might also require hours or days. But there is no standard plan, no pattern from which to work. You must be on the alert with the brain, the eye, the heart; and have a suppleness of body.

Things-As-They-Are offer such an abundance of material that a photographer must guard against the temptation of trying to do everything. It is essential to cut from the raw material of life—to cut and cut, but to cut with discrimination. While he is actually working, a photographer must reach a precise awareness of what he is trying to do. Sometimes you have the feeling that you have already taken the strongest possible picture of a particular situation or scene; nevertheless, you find yourself compulsively shooting, because you cannot be sure in advance exactly how the situation, the scene, is going to unfold. You must stay with the scene, just in case the elements of the situation shoot off from the core again. At the same time, it's essential to avoid shooting like a machine-gunner and burdening yourself with useless recordings which clutter your memory and spoil the exactness of the reportage as a whole.

Memory is very important, particularly in respect to the recollection of every picture you've taken while you've been galloping at the speed of the scene itself. The photographer must make sure, while he is still in the presence of the unfolding scene, that he hasn't left any gaps, that he has really given expression to the meaning of the scene in its entirety, for afterward it is too late. He is never able to wind the scene backward in order to photograph it all over again.

For photographers, there are two kinds of selection to be made, and either of them can lead to eventual regrets. There is the selection we make when we look through the view-finder at the subject; and there is the one we make after the films have been developed and printed. After developing and printing, you must go about separating the pictures which, though they are all right, aren't the strongest. When it's too late, then you know with a terrible clarity exactly where you failed; and at this point you often recall the telltale feeling you had while you were actually making the pictures. Was it a feeling of hesitation due to uncertainty? Was it because of some physical gulf between yourself and the unfolding event? Was it simply that you did not take into account a certain detail in relation to the whole setup? Or was it (and this is most frequent) that your glance became vague, your eye wandered off?

In the case of each of us it is from our own eye that space begins and slants off, enlarging itself progressively toward infinity. Space, in the present, strikes us with greater or lesser intensity, and then leaves us, visually, to be closed in our memory and to modify itself there. Of all the means of expression, photography is the only one that fixes forever the precise and transitory instant. We photographers deal in things which are continually vanishing, and when they have vanished, there is no contrivance on earth which can make them come back again. We cannot develop and print a memory. The writer has time to reflect. He can accept and reject, accept again; and before committing his thoughts to paper he is able to tie the several relevant elements together. There is also a period when his brain "forgets," and his subconscious works on classifying his thoughts. But for photographers, what has gone, has gone forever. From that fact stem the anxieties and strength of our profession. We cannot do our story over again, once we've got back to the hotel. Our task is to perceive reality, almost simultaneously recording it in the sketchbook which is our camera. We must neither try to manipulate

reality while we are shooting, nor must we manipulate the results in a darkroom. These tricks are patently discernible to those who have eyes to see.

In shooting a picture-story we must count the points and the rounds, rather like a boxing referee. In whatever picture-story we try to do, we are bound to arrive as intruders. It is essential, therefore, to approach the subject on tiptoe—even if the subject is still-life. A velvet hand, a hawk's eye—these we should all have. It's no good jostling or elbowing. And no photographs taken with the aid of flash light either, if only out of respect for the actual light—even when there isn't any of it. Unless a photographer observes such conditions as these, he may become an intolerably aggressive character.

The profession depends so much upon the relations the photographer establishes with the people he's photographing, that a false relationship, a wrong word or attitude, can ruin everything. When the subject is in any way uneasy, the personality goes away where the camera can't reach it. There are no systems, for each case is individual and demands that we be unobtrusive, though we must be at close range. Reactions of people differ much from country to country, and from one social group to another. Throughout the whole of the Orient, for example, an impatient photographer—or one who is simply pressed for time—is subject to ridicule. If you have made yourself obvious, even just by getting your light-meter out, the only thing to do is to forget about photography for the moment, and accommodatingly allow the children who come rushing at you to cling to your knees like burrs.

.

There is subject in all that takes place in the world, as well as in our personal universe. We cannot negate subject. It is everywhere. So we must be lucid toward what is going on in the world, and honest about what we feel.

Subject does not consist of a collection of facts, for facts in themselves offer little interest. Through facts, however, we can reach an understanding of the laws that govern them, and be better able to select the essential ones which communicate reality.

In photography, the smallest thing can be a great subject. The little, human detail can become a leitmotiv. We see and show the world around us, but it is an event itself which provokes the organic rhythm of forms.

There are thousands of ways to distill the essence of something that captivates us, let's not catalogue them. We will, instead, leave it in all its freshness . . .

There is a whole territory which is no longer exploited by painting. Some say it is because of the discovery of photography. However it came about, photography has taken over a part of this territory in the form of illustration.

One kind of subject matter greatly derided by present-day painters is the portrait. The frock coat, the soldier's cap, the horse—now repel even the most academic of painters. They feel suffocated by all the gaiter buttons of the Victorian portrait makers. For photographers—perhaps because we are reaching for something much less lasting in

value than the painters—this is not so much irritating as amusing, because we accept life in all its reality.

People have an urge to perpetuate themselves by means of a portrait, and they put their best profiles forward for posterity. Mingled with this urge, though, is a certain fear of black magic; a feeling that by sitting for a camera portrait they are exposing themselves to the workings of witchcraft of a sort.

One of the fascinating things about portraits is the way they enable us to trace the sameness of man. Man's continuity somehow comes through all the external things which constitute him—even if it is only to the extent of someone's mistaking Uncle for Little Nephew in the family album. If the photographer is to have a chance of achieving a true reflection of a person's world—which is as much outside him as inside him—it is necessary that the subject of the portrait should be in a situation normal to him. We must respect the atmosphere which surrounds the human being, and integrate into the portrait the individual's habitat—for man, no less than animals, has his habitat. Above all, the sitter must be made to forget about the camera and the man who is handling it. Complicated equipment and light reflectors and various other items of hardware are enough, to my mind, to prevent the birdie from coming out.

What is there more fugitive and transitory than the expression on a human face? The first impression given by a particular face is often the right one; but the photographer should try always to substantiate the first impression by "living" with the person concerned. The decisive moment and psychology, no less than camera position, are the principal factors in the making of a good portrait. It seems to me it would be pretty difficult to be a portrait photographer for customers who order and pay since, apart from a Maecenas or two, they want to be flattered, and the result is no longer real. The sitter is suspicious of the objectivity of the camera, while what the photographer is after is an acute psychological study of the sitter.

It is true, too, that a certain identity is manifest in all the portraits taken by one photographer. The photographer is searching for identity of his sitter, and also trying to fulfill an expression of himself. The true portrait emphasizes neither the suave nor the grotesque, but reflects the personality.

I infinitely prefer, to contrived portraits, those little identity-card photos which are pasted side by side, row after row, in the windows of passport photographers. At least there is on these faces something that raises a question, a simple factual testimony—this in place of the poetic identification we look for.

.

If a photograph is to communicate its subject in all its intensity, the relationship of form must be rigorously established. Photography implies the recognition of a rhythm in the world of real things. What the eye does is to find and focus on the particular subject within the mass of reality; what the camera does is simply to register upon film the decision made by the eye. We look at and perceive a

photograph, as a painting, in its entirety and all in one glance. In a photograph, composition is the result of a simultaneous coalition, the organic co-ordination of elements seen by the eye. One does not add composition as though it were an afterthought superimposed on the basic subject material, since it is impossible to separate content from form. Composition must have its own inevitability about it.

In photography there is a new kind of plasticity, product of the instantaneous lines made by movements of the subject. We work in unison with movement as though it were a presentiment of the way in which life itself unfolds. But inside movement there is one moment at which the elements in motion are in balance. Photography must seize upon this moment and hold immobile the equilibrium of it.

The photographer's eye is perpetually evaluating. A photographer can bring coincidence of line simply by moving his head a fraction of a millimeter. He can modify perspectives by a slight bending of the knees. By placing the camera closer to or farther from the subject, he draws a detail—and it can be subordinated, or he can be tyrannized by it. But he composes a picture in very nearly the same amount of time it takes to click the shutter, at the speed of a reflex action.

Sometimes it happens that you stall, delay, wait for something to happen. Sometimes you have the feeling that here are all the makings of a picture—except for just one thing that seems to be missing. But what one thing? Perhaps someone suddenly walks into your range of view. You follow his progress through the view-finder. You wait and wait, and then finally you press the button—and you depart with the feeling (though you don't know why) that you've really got something. Later, to substantiate this, you can take a print of this picture, trace on it the geometric figures which come up under analysis, and you'll observe that, if the shutter was released at the decisive moment, you have instinctively fixed a geometric pattern without which the photograph would have been both formless and lifeless.

Composition must be one of our constant preoccupations, but at the moment of shooting it can stem only from our intuition, for we are out to capture the fugitive moment, and all the interrelationships involved are on the move. In applying the Golden Rule, the only pair of compasses at the photographer's disposal is his own pair of eyes. Any geometrical analysis, any reducing of the picture to a schema, can be done only (because of its very nature) after the photograph has been taken, developed and printed—and then it can be used only for a post-mortem examination of the picture. I hope we will never see the day when photo shops sell little schema grills to clamp onto our view-finders; and that the Golden Rule will never be found etched on our ground glass.

If you start cutting or cropping a good photograph, it means death to the geometrically correct interplay of proportions. Besides, it very rarely happens that a photograph which was feebly composed can be saved by reconstruction of its composition under the darkroom's enlarger; the

integrity of vision is no longer there. There is a lot of talk about camera angles; but the only valid angles in existence are the angles of the geometry of composition and not the ones fabricated by the photographer who falls flat on his stomach or performs other antics to procure his effects.

· · · · ·

In talking about composition we have been so far thinking only in terms of that symbolic color called black. Black and white photography is a deformation, that is to say, an abstraction. In it, all the values are transposed; and this leaves the possibility of choice.

Color photography brings with it a number of problems which are hard to resolve today, and some of which are difficult even to foresee, owing to its complexity and its relative immaturity. At present, color film emulsions are still very slow. Consequently, photographers using color have a tendency to confine themselves to static subjects; or else to use ferociously strong artificial lights. The slow speed of color film reduces the depth of focus in the field of vision in relatively close shots; and this cramping often makes for dull composition. On top of that, blurred backgrounds in color photographs are distinctly displeasing.

Color photographs in the form of transparencies seem quite pleasing sometimes. But then the engraver takes over; and a complete understanding with the engraver would appear to be as desirable in this business as it is in lithography. Finally, there are the inks and the paper, both of which are capable of acting capriciously. A color photograph reproduced in a magazine or semi-luxury edition sometimes gives the impression of an anatomical dissection which has been badly bungled.

It is true that color reproductions of pictures and documents have already achieved a certain fidelity to the original; but when the color proceeds to take on real life, it's another matter. We are only in the infancy of color photography. But all this is not to say we should take no further interest in the question, or sit by waiting for the perfect color film—packaged with the talent necessary to use it—to drop into our laps. We must continue to try to feel our way.

Though it is difficult to foresee exactly how color photography is going to grow in photo-reporting, it seems certain that it requires a new attitude of mind, an approach different than that which is appropriate for black and white. Personally, I am half afraid that this complex new element may tend to prejudice the achievement of the life and movement which is often caught by black and white.

To really be able to create in the field of color photography, we should transform and modulate colors, and thus achieve liberty of expression within the framework of the laws which were codified by the Impressionists and from which even a photographer cannot shy away. (The law, for instance, of simultaneous contrast: the law that every color tends to tinge the space next to it with its complementary color; that if two tones contain a color which is common to them both, that common color is attenuated by placing the two tones side by side; that two complementary colors placed side by side emphasize both, but mixed

together they annihilate each other; and so on.) The operation of bringing the color of nature in space to a printed surface poses a series of problems extremely complex. Certain colors absorb light; certain others diffuse it. Therefore, certain colors advance, certain others recede. So we would have to be able to adjust the relations of the colors one to the other, for colors which place themselves in nature in the depth of space, claim a different placing on a plane surface—whether it is the flat surface of a painting or a photograph.

The difficulties involved in snapshooting are precisely that we cannot control the movement of the subject; and in color-photography reporting, the real difficulty is that we are unable to control the interrelation of colors within the subject. It wouldn't be hard to add to the list of difficulties involved, but it is quite certain that the development of photography is tied up with the development of its technique.

.

Constant new discoveries in chemistry and optics are widening considerably our field of action. It is up to us to apply them to our technique, to improve ourselves, but there is a whole group of fetishes which have developed on the subject of technique.

Technique is important only insofar as you must master it in order to communicate what you see. Your own personal technique has to be created and adapted solely in order to make your vision effective on film. But only the results count, and the conclusive evidence is the finished photographic print; otherwise there would be no end to the number of tales photographers would tell about pictures which they ever-so-nearly got—but which are merely a memory in the eye of the nostalgia.

Our trade of photo-reporting has been in existence only about thirty years. It came to maturity due to the development of easily handled cameras, faster lenses and fast fine-grain films produced for the movie industry. The camera is for us a tool, not a pretty mechanical toy. In the precise functioning of the mechanical object perhaps there is an unconscious compensation for the anxieties and uncertainties of daily endeavor. In any case, people think far too much about techniques and not enough about seeing.

It is enough if a photographer feels at ease with his camera, and if it is appropriate to the job which he wants it to do. The actual handling of the camera, its stops, its exposure-speeds and all the rest of it, are things which should be as automatic as the changing of gears in an automobile. It is no part of my business to go into the details or refinements of any of these operations, even the most complicated ones, for they are all set forth with military precision in the manuals which the manufacturers provide along with the camera and the nice, orange calf-skin case. If the camera is a beautiful gadget, we should progress beyond that stage at least in conversation. The same applies to the hows and whys of making pretty prints in the dark-room.

During the process of enlarging, it is essential to re-create the values and mood of the time the picture was taken; or even to modify the print so as to bring it into line with the intentions of the photographer at the moment he shot it. It is necessary also to re-establish the balance which the eye is continually establishing between light and shadow. And it is for these reasons that the final act of creating in photography takes place in the darkroom.

I am constantly amused by the notion that some people have about photographic technique—a notion which reveals itself in an insatiable craving for sharpness of images. Is this the passion of an obsession? Or do these people hope, by this "trompe l'œil" technique, to get to closer grips with reality? In either case, they are just as far away from the real problem as those of that other generation which used to endow all its photographic anecdotes with an intentional unsharpness such as was deemed to be "artistic."

.

The camera enables us to keep a sort of visual chronicle. For me, it is my diary. We photo-reporters are people who supply information to a world in a hurry, a world weighted down with preoccupations, prone to cacophony, and full of beings with a hunger for information, and needing the companionship of images. We photographers, in the course of taking pictures, inevitably make a judgement on what we see, and that implies a great responsibility. We are, however, dependent on printing, since it is to the illustrated magazines that we, as artisans, deliver raw material.

It was indeed an emotional experience for me when I sold my first photograph (to the French magazine "*Vu*"). That was the start of a long alliance with magazines. It is the magazines that produce for us a public, and introduce us to that public; and they know how to get picture-stories across in the way the photographer intended. But sometimes, unhappily, they distort them. The magazine can publish exactly what the photographer wanted to show; but the photographer runs the risk of letting himself be molded by the taste or the requirements of the magazine.

In a picture-story, the captions should invest the pictures with a verbal context, and should illuminate whatever relevant thing it may have been beyond the power of camera to reach. Unfortunately, in the sub-editor's room, mistakes sometimes slip in which are not just simple misspellings or malapropisms. For these mistakes the reader often holds the photographer responsible. Such things do happen.

The pictures pass through the hands of the editor and the layout man. The editor has to make his choice from the thirty or so pictures of which the average picture-story consists. (It is rather as though he had to cut a text article to pieces in order to end up with a series of quotations!) For a picture-story, as for a novel, there are certain set forms. The pictures of the editor's choice have to be laid out within the space of two, three or four pages, according to the amount of interest he thinks they are likely to arouse, or according to the current state of paper shortage.

The great art of the layout man lies in his knowing how to pick from this pile of pictures the particular one which deserves a full-page or a double-page spread; in his know-

ing where to insert the small picture which must serve as an indispensable link in the story. (The photographer, when he is actually taking the pictures for his story, should give a thought to the ways in which it will be possible to lay out those pictures to the most advantage.) The layout man will often have to crop one picture so as to leave only the most important section of it—since, for him, it is the unity of the whole page or of the whole spread that counts above all else. A photographer can scarcely be too appreciative of the layout man who gives his work a beautiful presentation of a kind which keeps the full import of the story; a display in which the pictures have spacially correct margins and stand out as they should; and in which each page possesses its own architecture and rhythm.

There is a third anguish for a photographer—when he looks for his story in a magazine.

There are other ways of communicating our photographs than through publication in magazines. Exhibitions, for instance; and the book form, which is almost a form of permanent exhibition.

I have talked at some length, but of only one kind of photography. There are many kinds. Certainly the fading snapshot carried in the back of a wallet, the glossy advertising catalogue, and the great range of things in between—are photography. I don't attempt to define it for everyone. I only attempt to define it to myself:

To me, photography is the simultaneous recognition, in a fraction of a second, of the significance of an event as well as of a precise organization of forms which give that event its proper expression.

I believe that, through the act of living, the discovery of oneself is made concurrently with the discovery of the world around us which can mold us, but which can also be affected by us. A balance must be established between these two worlds—the one inside us and the one outside us. As the result of a constant reciprocal process, both these worlds come to form a single one. And it is this world that we must communicate.

But this takes care only of the content of the picture. For me, content cannot be separated from form. By form, I mean a rigorous organization of the interplay of surfaces, lines, and values. It is in this organization alone that our conceptions and emotions become concrete and communicable. In photography, visual organization can stem only from a developed instinct. (pp. iii-xvi)

> *Henri Cartier-Bresson, in an introduction to his* The Decisive Moment, *Simon and Schuster, 1952, pp. iii-xvi.*

Henri Cartier-Bresson (essay date 1957)

[In the following excerpt, Cartier-Bresson discusses photography as an art form.]

In addition to the plastic aspects which are close to my concern with painting, photography is for me a way of keeping a diary. I keep a photographic diary of what I see and may take pictures at any time. I'm just a witness of things which attract my eye. I'm not preoccupied with the thought that I am working for a certain magazine. If there's a story, I'm excited about that story, and I simply record what I am witness to. People may ask me, "Which of your pictures do you like best?" I'm not interested in that—I'm interested in my next picture or the next place I'm going to be. And for myself, each new project must be approached as a new experience. Former achievements don't count in the least and everything must once more be put in question. Only in this way can one keep freshness in his work.

.

Though you must have an understanding of your subject in its various aspects, you must not prejudge it. You must do completely what you have to do. I never look at other photographs of anything I'm going to do; I want to keep my impressions fresh. But by talking to people, listening to people, putting questions, one tries to understand the situation. When you come to a place you mustn't be prejudiced, you mustn't try to find justifications for your preconceptions. You must stick to the facts, know how to *analyze* the facts, modifying your first impressions by what you have observed instead of fortifying your preconceptions. After all, there's no point to be proved, you're not trying to prove anything. If there is one point, it's humanity, it's life, the richness of life. The thing is simply to be sensitive.

For me the great myth is the Greek myth of Antaeus who had to touch earth to regain his strength. I know I must always keep in contact with the concrete, the concrete reality, the little incident and the little, specific truth which might have large reverberations.

.

For the photographer geometry is the abstraction, the structure which is provided, and realism is the flesh and blood that brings it to life. Still, the picture must never be contrived. You must recognize both these elements intuitively. The picture projects the photographer's personality. That's why there is no competition in our work. The only competition may be in the market. Competition doesn't exist because people see the same things so differently, each expressing his own personality (which is part of the total reality and therefore makes the photographer both a witness and a participant). (p. 130)

.

I don't see myself working, of course, any more than I can really hear my own voice but friends of mine tell me it's very funny to see me at work: on the jump, tip-toeing, creeping up to people or shying away. People are not aware sometimes, other times they're aware and then you must wait and look elsewhere and hope they'll come back to their element. It's as if you have thrown a stone in the water. You sometimes have to wait until all the waves are gone before the fishes come back again. But very often your only opportunity is the first time. That's how it was in China—there was no second chance because they see you from miles away, you can't even take a light meter out. If you do, you've spoiled the picture. You have to

have some psychological understanding, you have to know the people and you must work in a way acceptable to them. There you must smile—never laugh, because that's making fun. Smile, take your time, and never come bursting in with your own personality. You have to efface yourself. Of course, you can push and perhaps make a stronger statement but it's like blowing a horn. No, you have to come up on tip-toes.

You must be like a sensitive emulsion, a sensitive plate. Approach gently, tenderly and never intrude, never push. Otherwise, if you use your elbows, it will work against you. Above all, be human!

.

So long as human beings are alive and there are problems which are true, vital, important—and someone wishes to express them with simplicity, with sincerity, or with fun and humor—there will be a place for photographers just as there will be for poets and novelists. (p. 132)

Henri Cartier-Bresson, in a conversation with Byron Dobell, in Popular Photography, *Vol. 41, No. 3, September, 1957, pp. 130-32.*

SURVEY OF CRITICISM

Beaumont Newhall (essay date 1947)

[*Newhall is an American photographer and art critic. In the following excerpt, he discusses Cartier-Bresson's photographic technique.*]

Henri Cartier-Bresson will tell you, if you press him, that photography is for him a kind of sketchbook, journal, or diary; a means of recording what he sees. This oversimplification reminds one of the painter Cézanne's remark about his contemporary Monet: "He is only an eye,—but good Lord what an eye!"

Cartier's eye has highly individual, penetrating, and stimulating vision. A vision never superficial; rather a vision directed by emotion. "One must photograph with the eye and heart," he often says. "One must be aware of the significance of what he photographs. Particularly in photographing people, there must be a relationship between the subject and the photographer, the *I* and the *you,* if the result is to be more than a superficial resemblance."

To capture this extraordinary vision, Cartier has developed a technique which is swift and sure. He not only has trained himself in the mechanics of the photographic process, but also has disciplined himself in the often baffling problems of plastic organization. He paints, not for the public, but for his own education. His acquaintance with many of the masters of modern painting, particularly with Braque, Matisse, and Rouall, gives him the opportunity of having frequent criticisms of his painting. He points out that in France most of the good photographers paint or

draw, if for no other reason than to develop within themselves the sense of what makes a picture. They have an interest in exhibitions of paintings and a lively appreciation of what can be learned from the old masters. As a result of Cartier's plastic interest, each of his pictures is not only a moment, rich with significance, arrested; it is also a moment seen in such a powerful way, with such a strong sense of purely formal organization, that the transitory is made permanent.

He uses the miniature camera exclusively. He has a Contax, a Leica, and a battery of lenses. His favorite rig at the moment is a hybrid—a Contax f 1.5 lens mounted on a Leica body. He prefers the 35 mm camera to the miniature reflex type because the optical eye-level finder is a more direct way of approaching the subject than the mirror-ground-glass image. His way of working demands that he be able to see the subject right up to the very instant of exposure. When he finds a subject which arouses in him the emotion to make a photograph, he seeks a viewpoint, dancing about like a boxer on tiptoe. When lighting, formal organization, and emotion all fit in together, he makes the exposure. Cartier likes to speak of his way of working in metaphors: this split-second peak of emotional tension culminating in the release of the shutter is "like a fencer making a lunge."

The picture is made at this moment of exposure; it is then that the composition is determined. If, when enlarging, Cartier finds it necessary to crop the print, or to alter the image by trimming, he considers the picture as only partly realized. Almost all of the photographs at his forthcoming one-man exhibition at The Museum of Modern Art are made from the full negative. Areas which are essential to the composition extend to the extreme edge of the frame.

So strong is Cartier's sense of formal organization that our eye is at once arrested by the force of the image. It is remarkable that even 11x14 enlargements from the 35 mm frames do not seem to be grainy or to lack definition. We do not have that feeling which is so common when viewing enlargements of many diameters: if only the photographer had used a larger camera! Cartier does not ask the Leica or the Contax to be the universal camera; he does not stretch the technique to rival effects which can only be obtained by the view camera. He limits his approach to what can be most satisfactorily rendered by his medium.

The relationship between vision and technique is perhaps the most critical aspect of the photographic process. Cartier's technique has been created in order to realize his vision. He does not discover through the camera. On the contrary, his camera records what his vision discovers. Seeing comes before photographing. For this reason he dislikes direct flashlight, which is either very flat or largely unpredictable. In those cases where he finds that photography is possible only by playing auxiliary light upon the subject, he prefers a floodlamp, so that he can *see* what he is doing. He never arranges a scene, nor does he pose or direct the subjects. He is the unobtrusive witness who recognizes pictorial possibilities as they present themselves to his eye. His approach is rooted in reality.

The work of Cartier-Bresson may be divided into three pe-

riods. In the first, covering his years of wandering in Africa, Spain, the Mediterranean, the United States, and Mexico, his concern was with the formal recognition of plastic elements. Objects seem to compose themselves as if by magic for him. In one of the accompanying pictures, the children playing in the ruins of a Spanish town seem to be puppets placed in perfect relationship by an invisible pair of hands. In this period the sureness of composition already is evident.

The second period is one of satire, of caricature with the camera. When he was sent by a French newspaper to photograph the coronation procession of King George VI in 1937, he chose to photograph, not the pomp and pageantry of the parade, but the spectators and their reaction. The third and most recent period is dominated by an interest in portraiture, of an intimate and revealing type, with the subjects seen informally in their natural surroundings.

During the war Cartier was a prisoner of the Germans for thirty-five months. He had been captured while he was serving as a corporal in a French army film and photo unit. Two times he escaped, only to be recaptured. On a third attempt, he gained his freedom and came back to Paris to work in his own surroundings. To the public eye he was making photographs of artists for the publishing house of Braun; to the initiated he was an active member of the underground. Braun operated a post office or clearinghouse for the underground, one of the most dangerous of all the secret activities because it involved so many contacts. Cartier and his friends organized still photographers to document the liberation of Paris and the entry of the Allied troops. He was so busy in this work that, to our loss, he himself did not photograph the stirring events of the liberation.

In speaking about his work and his particular point of view, Cartier asked me specifically to point out that he has no dogma. He does not claim that his approach to photography is the only one. On the contrary, he feels that every photographer should seek out his own technique or rather *style.* We speak too much, he feels, of "technique." Photographers have overlooked style in their technical myopia. Style is the sum of emotion and visualization and technique. It is through style that a personal way of photographing can be developed. Cartier prefers photographs which are precise, sharp and *aigu,* or acute. Sharpness to him is not a matter of optical definition. Sharpness is a sureness and precision of approach. The ability of the camera to render parts of the field out of focus he recognizes as a functional control. He is much concerned with the problem of relating sharp with out-of-focus elements. Much experience is needed, particularly when a groundglass is not used, to judge this effect. A sixth sense is developed, so that one can predict how the background will be rendered when focusing on a subject at, for example, a distance of ten feet at aperture f 4.

He has definite ideas about the tonal scale. He is fond of the rich gradation of middle grays which are rendered with such delicacy by the photographic emulsion. Gray tones prevail; black and white are used as accents. He avoids harsh contrasts and excessive low-key effects. He likes semi-matte paper and rich, full development of the image. But the print is for him largely a means to an end. He feels that photography's most important function is to serve as a means of communication, and that this end can best be accomplished through the publication of photographs in magazines, newspapers, and books, where they will be seen by thousands of readers.

Photography means much more to him than picture-making of the passing scene. One must, he feels, approach the subject humbly but with an active and an open mind, prepared to evaluate and distill its meaning and its relationship to the problems and philosophy of the world today. The poetry of natural phenomena can be expressed with the camera, but only by continual contact with reality. To retire within an ivory tower, or to allow an esthetic approach to dominate over appreciation of human values, is to deny photography as a means of communication. One must have something to say, something concrete, definite, and constructive to share with others. This is the driving force: technique and formal organization are the means by which to fulfill the function of photography as a method of communication.

To the special problems of the picture story he has given much thought. He regrets that in recent years there has come into the picture story a detrimental shift of emphasis from the photographer to the writer. He deplores a tendency to decide beforehand what and how a man is to see. The photographer, he quite rightly asserts, should be the one to discover the pictorial and emotional possibilities in a subject, and the editor should create from these pictures, by appropriate presentation and by necessary captions, the unified whole. (pp. 56-7, 134, 136, 138)

The rise and fall of the miniature camera's extreme popularity has been a phenomenon of the past twenty years. Perhaps the decline of the miniature can be traced to the excessive demands which were placed upon it by those who expected to find in it the universal camera which could at once rival the all-over detail of the view camera and yet be operated in the hand under highly unfavorable lighting conditions. Perhaps the fall was due to its widespread and superficial use as a "candid camera." The "candid" shot is a gag: like all gags its life is of the moment and is not lasting. Cartier-Bresson's work is a vindication of the miniature camera. He has demonstrated that, used knowingly, it can produce results which no other camera can capture.

But to explain the magic beauty of the photographs of Henri Cartier-Bresson by mechanics is an error. They move us because of his remarkable vision. They have lasting quality because they have been made by one who knows how to *see.* When Stieglitz was asked "How does a photographer learn?," he replied, "By looking." By looking at the world with a fine balance of emotion and intellect, by seeking to appraise the social background, by developing an awareness of what makes a picture lasting. To all of us who seek to use our cameras as instruments for something more than the production of photographic records, Cartier's work is an object lesson. (p. 138)

Beaumont Newhall, "Vision Plus the Camera," in Popular Photography, *Vol. 20, No. 1, January, 1947, pp. 56-7, 134, 136, 138.*

James Thrall Soby (essay date 1947)

[Soby was an influential critic, editor, and curator. He is noted in particular for his long association with the Museum of Modern Art in New York City and for his numerous, highly regarded critical studies. In the following excerpt, he discusses Cartier-Bresson's career and contribution to photography as an art form.]

In 1933 a very young French photographer, Henri Cartier-Bresson, held a one-man exhibition in New York. His photographs were taken with a miniature camera; they were crude in technique, but overwhelmingly personal in what they had to say. Today Cartier-Bresson's work is being shown in a retrospective exhibition which will travel to many museums throughout the country. Wherever it appears, it will carry the excitement of a new, valid, and strong contribution to photography and, indeed, to the visual arts in general.

The contribution was first made at a rather crucial time. In 1933 there were, broadly speaking, two dominant esthetics in professional as distinct from commercial and from amateur photography. There was the view-camera esthetic-photography's basic classicism—whose core was respect for medium, with attendant emphasis on technical proficiency. Even in modern times, when alternative equipment has been highly developed, a majority of the outstanding professionals have preferred to work with a large view camera on a tripod, if not exclusively, then to achieve the main body of their work. Atget, Stieglitz, Strand, Weston, Evans—these and numerous other leading photographers have customarily made contact prints from big negatives, and have utilized the view-camera controls which result in sharpness of detail and accurate alignment of planes. Long exposures are required as a rule so that the subjects chosen have almost always been motionless.

Among younger view-camera enthusiasts, known as the "documentary" photographers, the need for objective purity of expression was felt partly as a reaction against the abuses of artistic snapshot photography, the rival esthetic. Though there were leading professionals, like Moholy-Nagy and Man Ray, who were contemptuous of medium and used small cameras brilliantly, a subjective approach to photography had led usually to staleness and repetition when it aspired to be serious and original. It had nevertheless become more and more popular. Its aspects were many. One of the most persistent was known as "odd angle" photography, announced in a German book of 1929, "Es Kommt der Neue Fotograf," and for nearly ten years thereafter the scourge of the more advanced photographic annuals. The "odd angle" trend owed much to modern experiments in painting, but derived technically from a chief limitation of the small camera held in the hand—that everything not parallel to its film, if uncorrected, will appear distorted in the final print. But of course distortion was what the "odd angle" photographers wanted, and they pointed their cameras up at buildings or down at murky water or obliquely at nude models, who often looked apprehensive, having a personal stake in whether photography did or did not prove to be an art. The same photographers often stood very near their sub-

jects to stress foreshortening or to exaggerate texture. And if in the best hands this sort of photography became a valuable implement of visual research, it led preponderantly to dead formulas, bringing about the reaction of the "documentary" group.

At this point Cartier-Bresson arrived on the scene, with only one year's professional experience behind him. To a few artists, photographers, and interested laymen, it was apparent that he had discovered a new approach to snapshot photography, utilizing to the full the miniature camera's virtues—its inconspicuousness and extreme portability, its rapidity, its ability to function in poor light and with minimum attention to problems of focus. Of course many other photographers were aware of these virtues, and exploited them in what was soon known as "candid" photography. But Cartier-Bresson's camera was not candid; it was enchanted. He had found and proved that, while *photographic* distortions are limited and tedious, the distortions and tensions of reality itself are endlessly varied and evocative, and may be "stopped" by a supersensitive artist using the miniature camera's shutter in split-second synchronization with his own alert eye. Walking the streets with a tiny Leica camera, he had learned to click the shutter with fantastically acute timing, when scenes which interested him reached their psychological climax.

At the time of his first exhibition in 1933, Cartier-Bresson's photography was called "anti-graphic"—a dubious phrase in an era of muddy labels. What this phrase was intended to mean was that Cartier-Bresson's prints disregarded formal composition and technical display in favor of a spontaneous, unposed recording of reality's persistent and sometimes haunting disorder. Thus if he photographed a child running along a wall in a game of pelota, he did not release the shutter at the instant of most gracious balance, but at the precise second when the child's straining effort and imaginative absorption were so intense as to have an uncanny emotive power, as if this harmless scene were as momentous as Jacques Louis David's image of the martyred Revolutionary child, Bara, dying on the street.

Because of Cartier-Bresson's emphasis on psychological rather than traditional pictorial values, there is a tendency to speak of his photography as anti-esthetic. The truth is, however, that his art is a continuation, though altogether inventive in application, of a visual system inaugurated by Degas out of an interest in the asymmetric patterns of Japanese prints and of instantaneous photographs. Degas referred to his esthetic as depending on "unbalance and surprise"; he preferred tension to static order, spontaneity and telling awkwardness to premediated composure; he substituted for the earlier Baroque standards of tactile asymmetry a new basis of reference—the harsh strains and oppositions of a reality photographically revealed. And in our own time the surrealists, by whom Cartier-Bresson was certainly affected, have contributed an appreciation of the occasional irreality of the real, an exploitation of those rare moments when nature itself furnishes poetic accidents, to be recorded quickly or lost.

If Cartier-Bresson did not invent the esthetic of which he

is so striking a master, he has speeded up its responses to an extraordinary degree, so that often it is difficult to understand how he could have seen, recognized, and recorded an event which only for a fraction of a second was ignited with particular meaning. His timing is perhaps most conspicuously evident in those photographs wherein he captures a bizarre or enigmatic action. Yet he is also a man of profoundly humanitarian conscience, for whom fantasy is only a relieving interest. His satire is almost never cruel; it is tolerant, kindly, almost prayerful at times. One of his recurrent themes is the lyric transfiguration of children at play; another is the ecstasies of adult faith. To the former category belong some of his greatest prints, photographs which penetrate the world of childhood imagining with remarkable acumen. To the second category belong many of his superb photographs of 1938: the coronation parade of England's George VI; figures listening raptly to a Hyde Park soap-box orator; a trembling French youth kissing the ring of Cardinal Pacelli in Montmartre. This was a year when faiths were desperately embraced, and Cartier-Bresson has shown their transforming effects, though himself probably disapproving their sources. In the end we get from these images a moving commentary on human dignity, whether this dignity is misguided or not. And his sense of observation is miraculous. His photography of a coronation crowd could not have been more illuminating in its use of British types if it had been arranged by the most experienced and profligate casting director. But Cartier-Bresson can be bitter when occasion demands. There is no more powerful document of the war's hard aftermath than his photograph of a French informer being accused by one of her fellow-prisoners.

In terms of direct good to photographers, there seemed until recently to be one limitation to Cartier-Bresson's art—no one else could practise it successfully. Lately, however, other younger photographers have followed a parallel track, some of them frankly inspired by him, some developing independently. . . . In general the new vision in photography can be said to have achieved already a worthy counterpart to the great view-camera photography of the earlier century. The new vision's master, we must not forget, is Henri Cartier-Bresson. (pp. 32-4)

James Thrall Soby, "A New Vision in Photography," in The Saturday Review of Literature, *Vol. XXX, No. 14, April 5, 1947, pp. 32-4.*

Lincoln Kirstein (essay date 1947)

[*Kirstein is an American critic best known as the co-founder of the New York City Ballet Company and for his esteemed studies of performance and visual arts. In the following excerpt, he defines Cartier-Bresson as a "documentary humanist," praising the deliberate aesthetic and societal concerns in his photographs.*]

A number of contemporary photographers are united towards formulating a new approach to deliberate photography. Perhaps the leading European exponent of this direction is Henri Cartier-Bresson, who, by his denial of the academic "artistic" or salon taste of modern art-

photography has taken sequences of pictures which in their freshness, elegance and truth remain works of art within their own radical esthetic.

Since the discovery of photography, over a century ago, there has been recurrent confusion as to its function and effect. At first there was the giddy sense, amounting almost to fright, that the camera-lens had spoiled any future for representational painting, making any further realistic rendering by the hand and brush useless. (p. 7)

Afterwards, when it was realized that easel-painters had nothing to fear and even much to gain from the camera, and that the prestige of the painter could remain intact, a school of salon-photographers attempted to imitate or rival painterly compositions. . . . The pictures they posed, however, except possibly for strictly documentary portraits of people or places, did not long satisfy as independent works of art. . . . Photographs were at once post cards and simulacra of paint. Bad taste accompanied the more ambitious, and soon photography as a popular craft was expressed in the promiscuous anonymity of journalism. But in the masses of journalistic shots, every so often a few wonderful human images emerged, and, if this was usually accidental, the pictures were none the less effective for their unconscious appeal. (pp. 7-8)

Then certain artists, primarily interested in the use of the camera, who had been made aware of the naïve, or at least half-consciously formulated journalistic approach, began to use the frank attitude of the reporter-photographer, but now with deliberate design. They began to school the non-selective primitive eye, with all its piquant mishaps, to their own sophisticated program. It is also noteworthy that several of our best documentary humanists were also trained as painters. Cartier-Bresson and the American Walker Evans (who has quite a different style) have both painted, and were considerably influenced by the folk-cultures of Africa, the Caribbean and Polynesia. The photographer Brassaï is a talented draughtsman. These photographers, and others of their school, are as familiar with the creative impulse as painters. They work with a different medium and a more mechanical process.

The decisive part of Cartier-Bresson's particular process takes place not in the mechanism in his hand but in the vision in his head; in that right eye which (he says) looks out onto the exterior world, and that left eye which looks inside to his personal world. The vision fuses on what he sees, where and when, and how he feels about it. His pictures are closer to the newsphoto of a daily crime or a sporting event than to the naïve perfection of the still-life groups of the great chronicler of Paris in the early 1900s, Eugène Atget. But while a news-photo is brutal, factual and public or official, and the great human interest in Atget is more by implication from inanimate objects, Cartier-Bresson, with means as modest, gives us an intense and questioning image, not stripped of light and air, but close to the figures involved, to their private identities, their social origin and habits and the local site. And, while news-photographers specialize in catastrophe, the photo-finish or some aspect of shock, Cartier-Bresson's pictures are seized in the middle norm of a run of action, a specimen-slice or symbolic fragment, snapped from a series.

His early shot of children playing in ruins of plaster walls whose holes seem torn out of the paper on which they are printed was prophecy of an imminent decade of disaster. No image since has provided such a powerful report of fused innocence and destruction, of fun and fright.

Cartier-Bresson feels that an insistence on the direct and indirect documentation of human behavior by the camera offers an unlimited field of investigation for individual photographers, and of infinite differences of personal comment. There is no reason for anyone else to ape his particular eye or to attempt to recapture his set of lyric values, individually developed over a long time to suit his temperament; it would be possible only as dilution. There was only one Atget, despite the apparent anonymity of his plates, and his countless subsequent and careless imitators. The very real differences between Cartier-Bresson and the other documentary humanists—Brassaï, Bill Brandt, Doisneau, Walker Evans, Helen Levitt, Ben Shahn (as photographer, not painter), and Weegee, for example—show how many strongly personal styles may be developed within their program.

Cartier-Bresson's particular personality is Parisian and Norman. From Paris he gains his easy internationalism, his ability to pass in or out of any milieu however exotic, dangerous or boring, without wasting his time. He went off for a year in West Africa with no more equipment than a pair of his father's old pants, a new sun-helmet and a thousand-franc note. He embarked for Mexico without troubling to find out on whose responsibility or authority his vague expedition was based and, of course, it blew up. But he got to know Africa and Mexico as no well-outfitted tourist ever could. He never loses himself in mere nostalgic strangeness; the contrasts of new people and far places do not overwhelm him. He accepts whatever part of the exotic is essential in its integrity as another equally interesting phenomenon, but quite without travelogue romance or soft-focus brooding.

From Normandy comes his frugal elegance and peasant shrewdness, an independent chill or candor, and also a transparent dignity and pride in his own brand of technique, which is less a matter of taking pictures than of talking to people and getting along well with them so they will not shrink from him, or "pose" for him. He has an antagonism to gadgetry in his medium; the instruments are for use like a plane or a square, and his craftsmanship is less specialized than specific for his needs. He does not have much of a feeling for the dark room. Here he supervises the technician for, after all, what he has seen is already implicit in what appears in the negative and on the print. He has taken a sequence of trial shots, dancing about his subject on tip toe, like a boxer or fencer, until he chooses the ultimate frame and instance; then traps it in time. He considers his own assignments and the exploitation of his practical talents (which are considerable) as an ordinary workman does his labor. Should he be occupied with pictorial journalism, very well then, there are the usual conditions of his editors to be satisfied. He is not hampered by them. Peacetime is different from war, but not necessarily easier. The war in Spain is different from the war in France. The parlor of a wine-master of the

Loire certainly differs from those of Bonnard or Rouault, and wherever he happens to work he spends the time as an agreeable and almost invisible guest.

There is a discreet Parisian lightness as well as a Norman rigor in his personality which he transfers to his prints. His cheeriness, his dispassionate curiosity, his stubborn attention and self-effacement: how unlike the usual conscientious or case-hardened reporter. He is sympathetic towards his sitters or assignments in the way of a good nurse with a fractious patient. Without allowing them to be aware of it—which might somehow remind them of their condition, or their habitual defenses—he puts them at ease, makes them quite comfortable, allays their vanities, involves them deeply in their own currents of action, takes his pictures, continues the conversation as if nothing had happened, with his follow-through in the entire process never cutting the ordinary flow of atmosphere by a self-conscious or unconscious flirtation with the camera on the part of the sitter or subject.

Sometimes and somehow, almost out of a superior craftsman's good manners, he seems able to leave his lens out of the picture. His portrait subjects are not shot; they get themselves taken at tactful intervals, by eavesdropping or absorption. His pictures are not generally cropped down

Behind the Saint-Lazare Station, Paris, 1932.

after printing. He does not have to try to save a composition by eliminating a band or an edge, here or there. His finest shots are discovered rather than contrived, and he does not go in for the systematic disruption or rearrangement of an interior, for example, to render it more "picturesque" or "characteristic." That is why his recent series of eminent French writers and painters is so valuable. By avoiding any factitious formal effects, even those recently developed in the mode of the "candid" camera, by having an almost tacit understanding between himself and his sitters that they will, together, defeat the clichés of photography, by not attempting the maximum the camera can do with light and lens, by rejecting most of what usually counts for sensitive arrangement and clever illumination, by coming humbly to his subject with the preoccupied intensity of a fisherman playing to land a big catch or a boxer landing a knockout, he achieves his pure biographical accuracy. Perhaps no illustrious group has ever been portrayed with so much penetration and psychological illumination, unless it was by Nadar. Perhaps it is this very intensity, this spasm at the instant of clicking that exhausts his energy and renders Cartier-Bresson relatively indifferent to the subsequent processes necessary for the public to see his pictures. Up to the click, there has been nothing really mechanical; notch by notch the various accidents and incidents group themselves in space and time for the focal second when he springs his trap. Afterwards, the developing, the printing and the promulgation require a different sort of energy, and one which he dutifully if indifferently spends.

The series on the painter Bonnard is suffused with that intimate sunny light of French domestic life, that constant reference to the family symbols of the white cloth, the brown loaf and red wine which have made Bonnard so representative of a national habit of life. The face of Paul Claudel, flanked by the peasant's black and silver hearse, is a unique synthetic image of the poet whose incomparable diction has fused medieval homily and baroque splendor into the language of a lively faith. Here too, with equal simplicity and sense, we have the faintly sinister intellectual surliness of Jean-Paul Sartre, the puckered old clown's wisdom of Rouault, and the bold elaboration of Matisse's domestic décor, a combination of an aviary and an oriental restaurant.

What could be more British than the absurd dignity and shabby tribal complacency of his Coronation series? Cartier-Bresson turns his back on the majesty of the processions, the brilliance of colonial deputations, the ancient London streets, however appealing and pictorial, to devote himself to the fierce loyalties of the rapt mass. Looking at those traditional faces we are all the more conscious of the truth in John Strachey's *mot:* "Remember, gentlemen, when the time comes, it will be *His Majesty's* Communist Government."

Instead of developing an interest in the rendition of surface or tonal values as such, which in some photographers leads them to present human skin as oiled leather, with every pore a pit and every hair a stroke of engraved penmanship, Cartier-Bresson has rather preferred to whet his historical and moral perceptions. With a kind of bland abnegation he manages to avoid the intrusion of idiosyncrasy, of his own accidental personality, of his individual background. But the more he effaces himself, the more he ignores his particular Frenchness or contemporaneity, the more he becomes the crystal eye, the more his pictures sign themselves. For his sight, divested of superficial prejudice or preference, focussing itself on what is most essential in his subject also reflects what is most essential in himself. (pp. 8-11)

The camera is still a seductive and ambiguous instrument. If today it seldom suffers from soft-focus sentimentality it has the even worse disease of being capitalized upon for a kind of false realism, in staged "true-story" treatments, in prearranged publicity stunt shots, in rearrangements towards the purveyance of an artificial truth. It has taken us too long a time to discover that the most impressive and lasting achievements of the camera are in pictures, snapped from impartial history, which could not have been realized in any other medium. Cartier-Bresson's best shots could not have been drawn or painted, but only photographed. Some of these are among the most memorable documentation of our epoch. And in looking over the range of his fifteen years of work, we realize the great service of photography, in hands as responsible as his, and the discoveries from which even painters have profited, new discoveries in the realm of space, the nostalgia of distance, the pathos of empty enclosures prophesied by de Chirico, and which have had re-echoes of influence in many easel-painters. In an age of predominantly decorative or plastic values in painting, it has been the camera, supervised by such eyes as Cartier-Bresson's, which has kept the fascination of independent reality alive for the re-investigation of the new humanism whose first indications are already felt. (p. 11)

> *Lincoln Kirstein, "Henri Cartier-Bresson: Documentary Humanist," in* The Photographs of Henri Cartier-Bresson, *by Lincoln Kirstein and Beaumont Newhall, The Museum of Modern Art, New York, 1947, pp. 7-11.*

Arthur Goldsmith (essay date 1956)

[*Goldsmith is an American editor and writer on photography. In the following excerpt, he offers an appreciative review of the photographs collected in* The Europeans.]

"In every photographer, there is something of the stroller. If he were endowed with a mechanical mind, he could easily reduce the world to the contents of a card file." So writes Henri Cartier-Bresson in the introduction to his recently published **The Europeans.**

The book . . . is the result of Cartier-Bresson's own strolling about Europe and the British Isles during the years 1950 to 1955. From the thousands of 35-mm negatives he exposed on his travels 144 were chosen for reproduction. The result is less impressive than his monumental **The Decisive Moment,** with which the newer book inevitably, if somewhat unfairly, invites comparison. Even so, **The Europeans** is a treat for lovers of good photography in general and admirers of Cartier-Bresson in particular.

His most recent pictures continue to show the qualities which made him famous: the scalpel-sharp vision, the hair-trigger timing, the mathematically precise sense of design. But there's the hint of a new quality, too—an increased emotional warmth. Although just as fascinated as ever by the abstract relationships of forms in space, Cartier-Bresson seems more concerned with human values than before.

Two Dublin children playing in the street, a grizzled old shepherd in Castille, a girl selling lemons at the Hamburg fish market, an Italian peasant family caught by a sudden rain storm, a grinning French boy with two wine bottles—these are a few of the vivid images which come to mind. You sense that the photographer likes these people and is personally involved with them—even while standing a little aloof in that state of detached alertness which any photojournalist must maintain if he is to do a good job.

However, Cartier-Bresson also can be bitingly satirical. He demolishes sham, reveals cruelty, and points out the ridiculous as adroitly with his Leica as Voltaire or Moliere with words. A stern-jawed horse buyer with a flower clenched between his teeth . . . , a repulsive, reptilian face seen at a New Year's party in Hamburg, a complacent Frenchman and his dog at a sidewalk cafe—these are among the subjects which Cartier-Bresson has impaled with a sharp visual comment.

Cartier-Bresson is no escapist: he sees the realities of his time and place with an unflinching eye and, like the good reporter he is, puts them on film. Here is Europe today, after 10 years of uneasy peace. The scar-tissues left by the war appear only rarely in these pictures: a one-legged man silhouetted against a ruined building or a mountain of rubble rising behind a shiny new shop front. Perhaps the bitterest picture in the book is a double-page spread of a German youth leaning dejectedly against a wall. On his chest he wears a crude sign which reads: "I am looking for work—any kind." Another picture sums up the relationship of man and machine in an unforgettable image: a lone factory worker peeping over the top of a loom and surrounded by a vast, menacing desert of machinery which recedes into a nightmare distance.

A social philosophy is implicit in Cartier-Bresson's photography: his most sympathetic pictures are usually of the underdog—peasants, workers, or street urchins—while the wealthy and the bourgeoisie tend to receive less gentle treatment. This is not to say that the pictures are propaganda, even in a broad sense, but only that the photographer has a personal point of view which is reflected in his work.

Cartier-Bresson's technique for recording what he sees and feels remains essentially unchanged. He still prefers the speed, unobtrusiveness, and flexibility of a 35-mm camera, and continues to exploit the narrow rectangle of the 35-mm format when composing his tightly-organized pictures. Several interesting examples of a long-focal-length lens used to compress space are included among the landscapes and city scenes.

If *The Europeans* indicates any change in Cartier-Bresson it is not in technique but in a deepening maturity which enables him to regard life with a less hurried, more contemplative eye. He has found a new meaning to "the decisive moment . . . that lightning instant of give and take."

"The value of this batting-of-the-eyelash lies in the freshness of the impression which it conveys. But is this to say that experience and study are out of place here?" he asks a little wistfully, like a man who secretly fears his reflexes may be slowing down and his trigger finger growing a trifle stiff. Then he answers the question himself, a few lines later.

"Life takes time and roots grow slowly. Thus, the instant can be the end product of long experience as well as that of immediate surprise."

Judging by the over-all quality of the pictures in *The Europeans,* his new interpretation of the decisive moment is a point well taken. (pp. 76, 118)

Arthur Goldsmith, in a review of "The Europeans in Popular Photography, *Vol. 38, No. 4, April, 1956, pp. 76-9, 118.*

Peggy Sealfon (essay date 1979)

[*In the following excerpt, Sealfon summarizes successful elements of Cartier-Bresson's photographs.*]

Out of a core of social commentary, Bresson's photographs convey the essence of a situation with the evocative strength and immediacy of a haiku poem. With strict economy of line, geometry, poetry, visual wit, tension, balance, and surprise, his pictures revel in a constant admiration for the order found in the universe. These documents of reality transcend being mere facts by converging relationships that border on the surreal.

As Bresson once noted, "Truth in itself doesn't exist. It's always a relationship." In his work, it is a relationship between man and his environment—man and and his destiny. It is the relationship between the eye, heart, and mind as well as the external juxtapositions of forms in reality. (p. 19)

Peggy Sealfon, "The Eye of Cartier-Bresson," in Horizon: The Magazine of the Arts, *Vol. XXII, No. 11, November, 1979, pp. 16-23.*

Yves Bonnefoy (essay date 1979)

[*A prolific and highly esteemed French poet and critic, Bonnefoy focuses on philosophical issues surrounding art and literature. In the following essay, he examines Cartier-Bresson's artistic intentions and theory of composition as represented in his photographs.*]

In some of his photographs—*La Place de l'Europe in the Rain,* for instance—I find something miraculous. How did he catch so quickly the analogy between the running man and the poster? How, from so many fugitive elements, could he compose a scene as perfect in its details as it is mysterious in its essence? How can one know before seeing and decide before knowing? When Henri Cartier-Bresson is complimented for such things he has a way of answering modestly, obliquely, "It's simply that I'm nervous, and

that I love painting." And he adds: "About photography I know nothing"—certainly a surprising statement.

Actually, this statement, like the photograph I mentioned, demonstrates a striking capacity for instantaneous expression, without insistence, without spoiling the fact by too many words. Cartier-Bresson could have been a great writer, I think, somewhere between Mallarmé and Jules Renard or Flaubert. So I feel I must comment on his words, even at the risk of betraying the spirit of brevity which is so much a part of both the man and his works.

To know nothing about photography . . . this means, for one thing, not to bother about developing and printing; Cartier-Bresson leaves these to a specialist, because the subtleties of the developing tank seem to him to lead to narrow experimentation. It is a mistake to take effects of light on foliage or on brick walls for captured truth and mystery revealed. True, all intuition can fit into the infinity of a single touch of the paintbrush or the charcoal stick; that is why Cézanne was content with three apples and we are content with a few touches of color on his canvas. But the grays and blacks which are accentuated or blurred in the developing tank form too much of a structure; they are too closely tied to an irreversible primary situation to allow for creative freedom. Indeed, they inspire a narrow aspiration to taste, to the fashionable mannerisms that are the direct opposite of creativity. We must understand from the start that Cartier-Bresson considers that the photographer's technique, bound as it is to the processing to which it is submitted, is only a *means,* and it must not assert itself at the expense of the object. For it is in the direct apprehension of the object that the movement of the mind that alone ensures the quality of the work takes place, and it happens in an instant. What is the use of faster or slower lenses, of a more or less sensitive film? It is to seize aspects of our experience: simultaneities, fleeting gestures and expressions—momentary events, in short, and also minute details and infinite pluralities—in a way that no other instrument of armed awareness can. And these aspects are the essentials for Cartier-Bresson because of the meaning which he brings to or recognizes in them.

This leads me to pose another question, which causes Cartier-Bresson to formulate another reservation. The meaning inherent in the object but discovered by the photographer is itself affected by its restitution as an image, and, however faithful this image may be, by a sort of metaphysical index of refraction. It is an oversimplification to see in the photographer's gesture only an interrogation of things and events which, in contrast to his subjectivity, remain within the realm of the real and bear witness to it. For as soon as we look at an image the object tends to detach itself from the context of reality in which the artist found it and to relocate in another, unknown world, perhaps delivered from some of the laws of our own. An image produces the imaginary; it lends itself to our dreams. And a photograph, which is also an image, is less a reproduction of the world than it is the point where this world effaces itself before another world, the crossroad where we may decide to prefer our "self," with its myths, its poverties, its ghosts. And it is clear, from the very first photographs by Cartier-Bresson—not to mention from

the man himself—that he is fundamentally opposed to this practice, whether it tends toward vulgar egocentricity or toward loftier creations. He instinctively draws away as far from himself and his reveries as possible, turning to contact with others, to the most varied places and things, in search of the surprise that breaks our habits, the wonder that will free our minds. When he takes a picture we are in China, in India, we are with Ezra Pound or Henri Matisse, and the index of refraction by the imaginary is at a minimum. Cartier-Bresson does not give us what I have called an "image"; that is another demonstration of his "knowing nothing about photography," I suppose, in a society which uses photography on such a large scale to sell dreams and escape.

Fortunately cameras are lightweight, inconspicuous, and very fast. Ever since the first Leica (a contemporary of Cartier-Bresson) the camera has helped us to be ready to seize the content—or shall we say, the very face—of the moment of astonishment. That is, it can do so if we are able to mobilize ourselves instantly, to perceive without analyzing, and jump, like a wild animal, on that which is in the process of being born but also of dying. Here light is shed on the first part of Cartier-Bresson's statement: "I'm nervous." The word, of course, is far too modest. It points to an innate temperament, but it does not do justice to the mastery of self and of the interior, spiritual conversation to which Cartier-Bresson's photographs bear witness. Mere nervousness leads nowhere. If a violinist is nervous, he will play badly. And since Cartier-Bresson is the unfailing predator (to continue the analogy), we must attribute to him, rather than nervousness, a great calm, a power of concentration totally detached from all that is cumbersome and slow in the preoccupation with self; this concentration recalls the moment of void and "selflessness" before the animal's decision to leap. He has in him the immediacy of natural life and the primitive, and yet, as these photographs show us, a wealth of language and values. This contradiction exists in him, and at the same time a peace of mind which seems the proof that it is resolved.

There is a parallel and a name which fit the underlying discipline and experimentation: Years ago, in Provence, probably on the summer day when he brought off the astonishing photograph of the covered square at Simiane, I saw Cartier-Bresson whip out his Leica and shoot—without interrupting a conversation and with a rapid, apparently absent-minded glance which did not even take in the camera, as if it were one with his eyes and his whole being. Instinctively I thought of a book which he later quoted to me, as if it had a special significance for him, Herrigel's *L'Artdutir àl'are* (*Zen in the Art of Archery*). This essay, one of the best on Zen Buddhism, reveals that anyone studying this art under the direction of a true master will be taught no technique and, indeed, will stumble on apparently insoluble contradictions and receive no help. How, for instance, can he simultaneously release the cord and hold back the arrow? But one day he will *know*—without finding the words to describe it or understand what he has done; from then on with his whole body, with the ends of the thousand antennas we ordinarily retract, he will know that which will enable him to close his eyes,

like his silent master, and hit the target, the target which is actually the road within himself to deliverance. The intuition, the serene rapidity, the peace drawn from ceaseless tension—all these gifts of Cartier-Bresson are extraordinarily close to the spiritual readiness of a Zen monk. Like the Japanese duelist, who must be one with his adversary and with the world, he seems to have learned to overcome his apprehension of death. He takes his photographs not from a particular point in space but from the acknowledgment of mortality that makes him the contemporary of all lives and the neighbor of all things. And how much his works confirm a deep kinship between his openness, his response to light, and their equivalents in the East! Those children who pass by, intent on the hoop that leads them on (there are many children in the world of Cartier-Bresson), aren't they the same as those who run, laughing, behind Bashô's horse and then disappear around a curve in *The Narrow Path to the Deep North?* And that dirt road in Ireland, with the grazing horse and the dreaming dog, isn't it close to the vision the Zen master wishes the disciple to have before the cypress in the courtyard of the famous *ko'an?* This simplicity, which rises above anecdote and repetition, has been called, for lack of words in our western tradition, the "classicism" of Cartier-Bresson. (But Mallarmé, another master of the evidence of things, also once declared himself an unconscious Buddhist.) What strikes me in these perceptions of the passing moment—or, rather, in these seconds that deliver us—is that within every gesture, movement, or sound that emerges from the running step or the sounding voice is the same silence as in the *haiku* or the *ukiyo-e,* those poems and prints which speak of the universal cloud. And in it is this silence that reveals to us what words differentiate to prompt action, or to arouse sensations: awareness, dizziness, fear—all that is only a shadow, the scale of the creature, with nothing of the whole trout's quicksilver.

The immediate consequence of this experience, intrinsically inward in spite of its push outward, toward the elsewhere, the unexpected, is that we must guard against interpreting Henri Cartier-Bresson's photographs on the basis of something which, in their excess of riches, we may also see in them: the testimony of an aware, clear-thinking man to a sociological, or historical, reality. They do, indeed, reveal that, thanks to the veil of invisibility that allows him to be present everywhere. All his life Cartier-Bresson has been at the heart of the most significant events of his time: in Germany at the liberation of concentration camps, in China at the end of the Kuomintang and the advent of Mao, in India with Gandhi a few minutes before his death, at the first sit-ins in Alabama. But it would be a gross misunderstanding to think that he prized these moments for their historical value, like a news photographer. For his lesson is also that an old woman at her door has fundamentally the same importance as an army on the march or the death of a sage; and that is not because she is wrapped in the stars and stripes and is to be taken for an image of America, since the meaning of the flag fades in this equivalence of everything with everything that Cartier-Bresson brings out in his probings. There may be an event in the photographs, but it is somehow displaced; a few metaphysical millimeters deprive it of its primacy over life. And if sometimes we perceive in his works a personal

reaction that may suggest a psychological or moral point of view—as in the sense of irony aroused by the racegoer in Ireland, or the aversion provoked by the Virginia ladies, sadly decked out in afternoon finery—it is all on the surface. Underneath it we still hear the murmur "yes, yes, yes," of a spirit which sees beyond, which accepts, which loves again.

But why, if Henri Cartier-Bresson's main characteristic is to say "yes," to react all at once to the sudden manifestation of an overwhelming reality, why does he speak so often of "composition," and indeed, of "geometry"? Moreover, his photographs bear witness to the sharpness and accuracy of his perception and ordering of forms, and this might lead us to think that he cares for these aspects particularly, detaching them from the scene as a whole and bending them to an independent development which would make them an end to themselves, a creation of the mind in its typically western pursuit of absolute accomplishment. Such accomplishment would throw doubt on the assent which is so perceptible in his work; the concern for pure beauty would thus deeply contradict his desire to welcome the flux of things which are born and pass. In his passionate adherence to reality is there not thus the danger of moving toward abstraction?

We have here a problem, essential, to my mind, in regard to Cartier-Bresson, but perhaps also in regard to others, and to art and poetry as such. The example of Cartier-Bresson provides a propitious occasion for inquiring into it more thoroughly. First of all, I must emphasize that if Cartier-Bresson "composes," as he has said and demonstrated he does, it is only in the brief instant between the surprise and the clicking of the shutter, when his intuition simultaneously takes form and expends itself, without the least reworking afterward of what is born in the first operation. He has stated this quite clearly. For instance, he has never tried to re-work the values in the chemical solutions of the laboratory. This is a job he has left, admiringly, to the technicians. He has followed the rule, except upon one negligible occasion, to make no improvements upon the negative, not to reframe, not to darken or lighten. The shot is to be judged successful or unsuccessful according to what was understood and resolved on the spot, in the immediate response to the object.

This brings to mind the tale of the great Buddhist or Taoist painter who had promised the emperor to create for him within a year the finest crab in the world. The painter spent the year pacing up and down the beach, making no work. But when the year had passed and the emperor received him, he traced with a single stroke the harmonious but vibrant, precise but frail, outline of a crab such as had never been drawn before.

Why did the painter of the crab work in this way? Because he had absorbed the odor of seaweed, the sound of waves, the leap of fish, the flapping wings of seagulls and the mysterious gait of crabs, and was now so familiar with all these lives that he no longer had to observe them from the outside, to imitate them bit by bit, but could give them a second birth in his drawing, as if from the very womb of nature. That is, provided that he did not, in a moment of weakness, let rational analysis triumph over immediate in-

tuition and instinctive participation. Bare as the shape he produced was from the western viewpoint of *mimesis,* which seeks truth in a proto-photographic representation, it was not an abstraction but reality itself in one of its essential modes, which is form, or rhythm, one of the cadences of the universe perceived as concretely as our earthly eye can perceive matter. As for the interior harmony and musicality which contribute to the picture's beauty, these too are emanations of the world through the painter; they are the One, the Absolute, which breathes through the All and makes itself present and active in every part. Did the painter "compose"? No; he learned, rather, how not to "decompose," something to which our science, our fear of the moment and of death, continually incites us.

Thus I come back to Cartier-Bresson with a hypothesis which, I think, gathers together in their fullest sense his attitude of affirmation—of "yes"—and his love of form. The unexpected strikes him and he perceives, at the threshold of an instant, a possible photograph; is it not because—thanks to an unforeseen conjunction of the place, the light, the event—he feels a unity which can be seized by the lens in the formal structure that is only one of its aspects, but an aspect inseparable from the others? The day he looked back from his moving car and saw the Greek child in stony solitude, walking out of sheer joy on his hands, what made him seize his camera was not only the little shepherd, but the sky, the earth, the shape of the road, a whole consonance which the boy's dance itself pierced and reflected. To compose, to search intensively for the right relationship between two spots of shadow, was simply to perceive a suddenly readable key to being and to make this flash of lightning the target of the shot. For Cartier-Bresson, "composition" is an instinctive reaction, a quick and sure reflex, which gives reality that fullness that it occasionally reveals to us but which so few of us are capable of grasping. Like the unhesitating stroke of the oriental painter, it is a current which suddenly passes between two poles, repatriating exteriorized awareness to the immediacy of universal life.

It is not easy to state all this with precision. I shall try to make it clearer by calling up two or three examples of Cartier-Bresson's composition. First, the very moving photograph of the two Athenian matrons, white-haired and dressed in black, seen in profile as they pass corpulently under a vast balcony with two great caryatids, viewed face on, young and naked. Here is a juxtaposition of old age and youth, deformity and beauty, everyday life and dream, which immediately conveys that organic relationship between every thing and every other of which Cartier-Bresson is the poet. But how is this relationship shown? By the quite formal tension which has for a second united the principal signifiers, the statues and the women beneath; form thus plays the role of the syntax that makes a sentence readable. And where is the "geometry"? In the photographer's awareness that the two old women were about to pass under the caryatids, in the watchfulness for the exact moment of the conjunction which is also rapidly perceived—an assent given by the mind to a sudden fulfillment. As Cartier-Bresson, with his usual clear-sightedness and concision, puts it: "To take a photograph is to recog-

nize a fact in a split second, and to organize with rigor visually perceived forms which express and signify it. It means lining up brain, eye, and heart for the purpose of taking aim at the target." He quotes Victor Hugo: " 'Form,' that is, the formal structure of a work of art, that which went into its 'composition,' is the base brought to the surface."

Another example, which gives me an opportunity to express my admiration for Cartier-Bresson as a portraitist, is the photograph of the aged Colette with her nurse-companion. The image of Colette is superb as a portrait, catching her with her writer's hand close to her mouth, and her eyes, at once meditative and staring, focused obliquely on some invisible object. But the quality of the work is augmented by the opaque presence of the other woman, who stands behind in profile. Here a whole network of tensions and contrasts appears: distance and intimacy, sense and nonsense, a watchful spirit and indifference. Our attention is suddenly turned inside out, like a glove, and we think of night and solitude, of the mystery of our presence in the world. Metaphysical awareness prevails over psychological interpretation. But how, we may ask, was this second meaning produced? By the juxtaposition of the two heads, of course, one lit up and in the foreground, the other above, behind and in the shadow; by a relationship which reveals a truth, just as the conjunction of two stars discloses a law of astronomy; but above all by the strange fact—pure chance or mysterious sign?—that the women's dresses are of similar material, whose white-dot pattern seems to sweep them away into the same nocturnal abyss. The "geometry," here, was to detect, perhaps unconsciously, this extra marker in the game of "visually perceived forms," and to follow it from the still-potential all the way to the point of revelation that this perfect photograph manages to capture—to capture through pure "vacancy," shall we say, or through the utmost precision?

But the most eloquent work, from the point of view of the dialectic between form and presence, between head and heart is the rightly famous photograph of the funeral of a Japanese Kabuki actor. We may be surprised, at first glance, by the perfect relationship between the light of the faces and handkerchiefs, and the dark of the clothing and the indistinct background. We almost wonder whether Cartier-Bresson did not coldly survey the various movements of the bodies and the variation of values in order to achieve a geometry which is almost abstract in relationship to the drama binding the human figures together. And yet we feel a deeper emotion flowing from us toward them because of the way the photograph is made, and then we know that this photograph is an act of true participation.

What, then, goes on in this highly complex composition? We are told, for once almost explicitly, at the exact center of the picture. For in the fine, clear characters of the inscription on the streamer, doubtless an expression of mourning, are rhythms standing for the rhythms of nature. In this light, the juxtaposition of the heads also makes for a rhythm with the same meaning, and thus the form is revealed to be in its essence a dance, a dance the

unseen witness dances with the mourners. Here there is no calculation based on outward appearances; the mourners have resurged from inside, in the photographer's consciousness, which Cartier-Bresson kept silent and open as an empty room. This work, with its fine gradations of black, is the most beautiful example of calligraphy that the photography of the West has ever presented in tribute to eastern painting.

And in the light of this reconciliation of the two arts, of a rediscovered unity, I might cite many other works of Cartier-Bresson: the child dancing, with his eyes closed, in front of the peeling wall of Valencia, whose spots recall those of the Zen garden walls of Kyoto; the Bowery drunk asleep on the sidewalk, amid spilled beer which signifies not so much wasted powers and a lost life as the reabsorption of that defeated existence into the great pattern of universal forms, now dark, now resplendent, here a sunlit river, there rain tapping at the window.

But words must now give way to consideration of the works. I shall say in conclusion only that I hope I have clarified another seemingly obscure point in Cartier-Bresson's statement: the love of painting and its value to a photographer. It took intuition to attain this kind of rich and rapid vision, but also a long-lasting acquaintance with other great discoverers of the syntax of being. A young man of the 1930s could not look too much to the limited history of photography, even if he claims that a photo-

graph by Munkacsi of three black children disporting themselves in the waves awakened him to his vocation, and even if he credits Kertész with being his chief "poetical source." He could learn more easily from the great ages of painting, which calls for training the eye; and he could learn even more directly from drawing, a more spiritual tradition in both East and West. When Cartier-Bresson speaks of or practices drawing it is not—in spite of his sometimes apparently provocative fervor—in order to separate himself from his search as a photographer. He is simply freeing the object from the tissue of prejudices and preconceptions enveloping it and making it into a pure presence, as the Zen painter, or Theophanes the Greek, or Degas or Giacometti did before him. Following these masters, but in his own way, he has pursued the same goal as a photographer.

On the one hand there are the weaknesses, the distractions, the inconsequences of our daily vision. On the other, thanks to this "drawing" which pierces mere appearances, there is the fullness which art teaches us to find in every thing or being. When I look at a photograph by Cartier-Bresson I feel astonishment at moments so rich in meaning, of forms so charged with life. At first sight I conclude that here is something more than the reality which surrounds us. But at almost the same moment I realize that Cartier-Bresson's epiphany shines on a horizon that is

Funeral of a Kabuki Actor, Japan, 1965.

common to us all. I am encouraged, and led, which is surely the greatest gift a man's work can give us. (pp. 5-10)

Yves Bonnefoy, in a foreword to Henri Cartier-Bresson: Photographer, *translated by Frances Frenaye New York Graphic Society, Boston, 1979, pp. 5-10.*

Ferdinando Scianna (essay date 1983)

[*Scianna is a Sicilian-born journalist, photographer, and critic. In the following excerpt, he discusses Cartier-Bresson's method of portrait photography.*]

Being a great photographer does not necessarily imply that one is a great portraitist. In fact, the great photographers in the history of photography who *have* also been great portraitists (and, conversely, the great portraitists who have also been great reporters or landscape photographers) are few in number. Cartier-Bresson is one of the few. (p. 57)

Brought up on Proust, Saint-Simon and Stendhal, Henri Cartier-Bresson is fascinated by people. His relationship with the portrait has always been particularly intense. That, perhaps, is why he wished [*Portraits*] to be dedicated to a part of his work as a photographer which is so important to him, even if less widely known.

Henri Cartier-Bresson had already written a very illuminating page on his way of conceiving the portrait, in the very famous text his great friend and publisher Tériade persuaded him to write in 1952 as a preface to *Images à la sauvette,* which has been standard reading, *pro* or *contra,* for three generations of photographers now. For this book, however, he wished to add other remarks, other ideas developed over the decades, which have tempered his original views and revealed new, fascinating and often surprising aspects. To do this, he chose the method he prefers—that of a conversation between friends. A conversation, not an interview. It is, in fact, impossible to interview Cartier-Bresson. Statements between inverted commas seem monstrous to him. They prevent one, he says, from contradicting oneself. And contradiction is what Cartier-Bresson is all about. Not because he says contradictory things. But because his very nature is contradictory, impossible to grasp, like mercury, a liquid metal.

When you want to seize hold of it, it breaks up into a thousand droplets, immediately reforming into a compact mass. Henri Cartier-Bresson talks in volleys, accumulates details, turns back, refines an idea, a definition, perpetually on the move. One minute he is kneeling down, the next, up like a shot again, taking hold of a book, quoting a verse by Char, a sentence by Ponge, a definition by Victor Hugo, pursuing his thoughts like an elegant intellectual dance.

One is struck by his speckled blue eyes, like hard stone, which are never still for a moment. His youthfulness, his nervousness are remarkable, almost frightening. This seventy-five year old would wear out a youth.

Here comes the first surprise. The portrait, says Cartier-Bresson, is the opposite of the picture taken *à la sauvette,* in a flash, surreptitiously. To do a portrait, you have to ask for an audience, and obtain it. Then you have to achieve an understanding with the person being photographed, to the point of connivance. A good portrait is the fruit of mutual availability.

Many of his portraits have been taken for publication in books or magazines. I have never had anything, says Cartier-Bresson, against working to order. Some photographers nowadays seem anxious to revive the romantic myth, a little late, of the artist who cannot accept any professional assignment without compromising his freedom. He does not agree. The great artists of the past were perfectly capable of expressing the greatest freedom despite working exclusively to order, if not actually in someone's service. The freedom of the artist, says Cartier-Bresson, is something else. It is a rigorous frame of reference, within which all manner of variations are possible.

In contrast, he has never done portraits directly for customers. Back in 1952, he spoke of what he saw as the dangers of taking portraits directly to order. Apart from a few benefactors, everyone wants to be flattered and then none of the truth is left. In fact, customers are wary of the objectivity of the camera while the photographer is looking for psychological acuteness. Taking a portrait of a customer, he now confirms, means exposing oneself to the inevitable dissatisfaction caused by comparing the portrait with the picture everyone carries around inside their head of how they look. 'Haven't I come out badly', generally means, 'How different I look from the way I think I am and would like to be'. On the other hand, says Cartier-Bresson, I have always enjoyed photographing friends, which is probably, he adds, the hardest task of all.

Why the hardest? Surely it should be easier to achieve the necessary 'mutual availability' with a friend?

Not always, says Cartier-Bresson. In fact—and here is another clue to the way he sees the portrait—the first impression one has of a face is very often the right one, and if it is enriched when we see more of a person, it also becomes harder to express the nature of that person when we get to know them more intimately. He has been convinced of this for thirty years now. When you know a person better, he tells me, you no longer know them well enough.

Does this mean that one can take better portraits of people one does not know at all?

Absolutely not, says Cartier-Bresson. I have always tried to find out as much as possible about the people I have to do portraits of—if they were artists, to read their books, see their pictures, listen to their music, get to know their work, their life history, at any rate.

A fair amount of cultural and intellectual background knowledge is indispensable. Then you must forget it immediately, he adds hastily, just as it is essential to forget yourself in the presence of the person to be photographed and, above all, to get them to forget you and the camera.

How does a portrait session with Henri Cartier-Bresson go? Quite simply. He usually goes to the person's house, or to their place of work, or a place congenial to them. This is very important. If the photographer captures both the internal and external reflections of a world, as he wrote

in his preface to **Images à la sauvette,** this happens because people are *in situ.* He must respect the environment, integrate the habitat which defines the social context and, above all, avoid artificiality, which kills human truth. This is why Cartier-Bresson's portraits are never close-ups, nor do they have too much background either, in which the person could get lost. The people are seen at a classic distance, allowing one to converse with the subject and view them through a 'normal' 50mm lens, which also includes their surroundings.

You must try, says Cartier-Bresson, to place yourself immediately in the most favourable position as far as lighting is concerned. In fact, it has never been possible for him to tell someone to move afterwards because the light is wrong. This would be tantamount to killing the human truth of the meeting. But beware! Truth does not mean 'spontaneity' with which it is so often confused and which is in fact mere superficiality. Down with spontaneity, says Cartier-Bresson cheerfully. Long live fulmination. The stroke of lightning which is so specific to photography and so basic to the work of this great photographer.

The difficulty, continues Cartier-Bresson, lies in the fact that you must talk, listen and—while keeping your eye glued to the camera—continue looking, or rather, seeing. What is more fugitive than an expression, than that mysterious harmony in the dissymmetry of every face, a 'decisive moment' like none other, which if you know how to capture it, becomes a portrait? The thing that strikes him is the ability the viewfinder of a camera seems to have to undress people, to X-ray them and reveal the arrogant, the narcissistic, the shy and so on. It is up to the photographer, as an amateur psychologist, to adapt his behaviour to the nature of the subject. With shy people, the technique Cartier-Bresson has sometimes used—with Bonnard, for example—is to say that he has finished after a few shots, that the portrait has been taken, and to go on chatting until the object of the meeting has been forgotten, trust returns and the sitting can be resumed as if by chance.

Cartier-Bresson usually arrives at an appointment with his camera loaded with fresh film. If after the 36 exposures have been used up he still hasn't got his portrait, he says there is no point in continuing. It won't happen. The mere operation of reloading the camera would only reinforce the barrier separating the photographer from his subject, making it even harder to achieve the essential availability. Therefore it is better to desist.

How long does it take to do a portrait? Simone de Beauvoir once asked Cartier-Bresson the same question—a sign of the mutual embarrassment between two people meeting each other a quarter of a century after the photographer had taken a first portrait of the authoress. A little longer than at the dentist's and a little less than at the psychoanalyst's was his answer, because there is no answer, no hard-and-fast rule, just as there is no answer to the classic question his subjects ask: What must I do? Nothing, one could perhaps say, or: be yourself. A tall order.

Naturally, says Cartier-Bresson, the portrait is not a systematic pose. What I might call rules are purely my rules, the instruments I use to make my work enjoyable. And to enjoy his work, it is absolutely essential with Cartier-Bresson for everything to take place without any 'violence' whatsoever.

He is fully aware that the subject is to some extent the victim of the photographer at a sitting. The click of the shutter, he says, is like an insect sting. You have to reach the subject 'between his shirt and skin', in a moment of inner silence, as lightly as possible, so that he can scarcely feel it, so that the sting is as painless as possible. But you cannot persist for too long without transforming the dialogue into torture. Does the photographer know instinctively when he has taken a good portrait? Yes, says Cartier-Bresson. But, he adds, the miracle can happen in the first instant of the meeting or after a long development process.

With the Joliot-Curies, Cartier-Bresson recalls, it was all over in a flash. I opened the door and saw them there, together, exactly as they should be. I shot the photograph immediately, even before greeting them, like a stroke of lightning. It was all over. If I stayed, pretending to continue my work, it was only out of politeness.

With Ezra Pound, the exact opposite occurred. We stayed there for more than an hour-and-a-half. I was crouched in front of him and we looked each other in the eye without saying a word, without any impatience on either side. He stroked his hands. It was another rhythm, another way of seeking harmony. Every now and then I took a photograph. Very few. I must have taken about eight in all.

Henri Cartier-Bresson has taken photographs of many famous people. Tériade, his friend, says that there is a certain ambiguity in his portraits of celebrities, due to the relationship which is inevitably established between the image of their face and the public image created by what they have done. But Cartier-Bresson's portraits do not include any politicians (with the possible exception of André Malraux). Perhaps, he says, because they are all basically the same to me, in their unaccountable relationship with power. Not that the poet or artist wields no power, but theirs is undoubtedly a lot less dangerous than the power exercised by politicians. However, Cartier-Bresson has taken and still takes many portraits of people untouched by celebrity, but no less dear to him for that—country people, in particular, with whom he has longstanding ties, whom he knows and who know him, and who therefore feel at ease together.

There are other famous and less famous pictures by Cartier-Bresson which could be regarded as portraits, but which according to him are documentary photos, because a portrait, he says, can only be of a person one knows. A very significant exclusion, like the other one of the famous photograph of Matisse surrounded by doves, which he does not regard as a portrait—wrongly, no doubt—because in a portrait, he maintains, the subject must 'give', must not be occupied with other things.

Cartier-Bresson goes on accumulating details which little by little become more than a definition of his approach to portraiture. They define his whole conception of photography as a way of life, a way of involving himself in life,

endlessly asking questions and receiving immediate, astounding, answers.

The portrait is the particular way the photographer has of looking for immediate answers in a person's facial expression, and the rigorous organization of shapes which express and constitute the truth about that person and his relationship with the world and with life as the photographer sees it.

I note that, in this conversation without inverted commas, which I have had the privilege of trying to reconstruct, Cartier-Bresson goes on multiplying the rules and prohibitions, continually narrowing down the frame of reference within which he exercises his prodigious capacity for variation and creation. These rules, he insists, are not general ones, but purely for his own enjoyment and, I might add, for ours. It seems to me that these rules also define a system of ethics as well as aesthetics: the ethics of intelligence, of attention, of respect for others; the art of putting the eye, the heart and the mind in the same line of sight. They also speak of his passion, continued in his drawing, for working 'from life'.

This is why all his portraits have a familiar air about them, because his understanding of people is bound up with his own psychological make-up. In all Cartier-Bresson's portraits, we therefore also recognize his self-portrait, and our own—a miracle which only true artists know how to achieve. (pp. 57-60)

Ferdinando Scianna, "Conversation without Inverted Commas with H. C-B.," in Henri Cartier-Bresson: Portraits, *by Andre Pieyre de Mandiargues and Ferdinando Scianna, Collins, 1983, pp. 57-60.*

Cartier-Bresson on photography:

"Manufactured" or staged photography does not concern me. And if I make a judgment, it can only be on a psychological or sociological level. There are those who take photographs arranged beforehand and those who go out to discover the image and seize it. For me, the camera is a sketch book, an instrument of intuition and spontaneity, the master of the instant which—in visual terms—questions and decides simultaneously. In order to "give a meaning" to the world, one has to feel oneself involved in what he frames through the viewfinder. This attitude requires concentration, a discipline of mind, sensitivity, and a sense of geometry. It is by great economy of means that one arrives at simplicity of expression. One must always take photos with the greatest respect for the subject and for oneself.

Henri Cartier-Bresson, in Henri Cartier-Bresson, Aperture, *1976.*

Charles Hagen (essay date 1987)

[*In the following excerpt, Hagen praises the elusive quality of Cartier-Bresson's early works.*]

A central purpose behind the vast majority of photo-graphs—particularly in such mass-distribution forms as advertising and newspaper photography—is to define a communal perception of reality. This process is both reassuring and coercive, with the photographs implicitly urging that we accept the version of reality they propose and therefore explicitly delineating the boundaries of what is "normal." Photography as it is usually practiced is reassuring (and oppressive) in another way as well—it repeats and seems to certify unchanging verities of narrative, of the nature of the world, of the varieties of human character and incident.

It is from their unrelenting, sometimes subtle and sometimes blunt contradiction of this web of expectation and purpose that the early photographs of Henri Cartier-Bresson—presented this fall at the Museum of Modern Art, New York, in a significant exhibition curated by Peter Galassi—draw their force. This work shifts the familiar image of Cartier-Bresson as a great photojournalist, an image based on his work since 1936. . . . In the early pictures, Cartier-Bresson exploited the ease of operation of the handheld camera, responding quickly, with little premeditation, to the scenes in front of him. This radical shift in technique—which other photographers, including André Kertész, Brassai, and Martin Munkacsi, were exploring at the same time—allowed him to break through formulas of composition and pictorial narrative. The best of his pictures from these years are so startling in the feeling of the rightness of the correspondences they reveal, while so apparently inevitable in their formal beauty, that they seem to offer physical evidence that through the camera the eye can be linked to the world with an uncanny immediacy, allowing profound recognitions to occur. Instead of reassuring the viewer, these photographs point to the existence of unfathomable mysteries beneath the placid surface of the everyday. (p. 119)

Galassi demonstrates the central role that Surrealist themes and techniques play in Cartier-Bresson's work from this period. Instead of constructing his images in the studio, though, as most of the photographers associated with Surrealism did, he discovered his subjects in the street, thus gaining an uncanny authority for his pictures. Included in the exhibition are a sprinkling of photographs that he took of friends and companions—the writer André Pieyre de Mandiargues, the painter Léonor Fini, and others. In one such image, of Fini with her face distorted through the mesh of a stocking, he rehearsed the investigation of social masks and costumes that forms the main theme of his photographs from this period and that he would soon photograph in the street. Other pictures refer directly to well-known Surrealist images. For example, a photograph of a man holding a shrouded figure, presumably a woman, suggests René Magritte's enshrouded kissing couple in *Les Amants* (The Lovers, 1928); this and other photographs of objects or people hidden beneath blankets or cloth also recall Man Ray's seminal *Enigme d'Isidore Ducasse,* 1920.

When Cartier-Bresson pursued Surrealist themes explicitly, he gave them his own twist through his masterly use of photography. For example, a photograph of a horsehide outside a slaughterhouse may have been directly inspired

by a similar photograph by Eli Lotar, published in 1929 in the Surrealist journal *Documents* (and reproduced in the catalogue to *"L'Amour Fou"*). But Cartier-Bresson has photographed the skin in a raking light, from a slightly raised angle; as a result it floats, glistening seductively, in the ambiguous space of the picture. Even in this atypical image Cartier-Bresson's central concerns from this period are apparent. Over and over he photographs what might be seen as images of the self, or parallel selves, or false selves—the masks, the poses, that people construct for themselves. In this light the limp horsehide, with the shape of the flayed horse still apparent in its crumpled folds, can be seen as a bloody costume for the missing carcass of the horse, much as the human body can be seen as a costume for the spirit; it recalls the sagging human skin, abandoned by the departed soul, that Saint Bartholomew holds in Michelangelo's *Last Judgment*.

Cartier-Bresson has a particularly sharp eye for the props and costumes of social class. Men in these pictures are often dressed up in uniforms of some kind, whether the crisply declamatory uniforms of policemen, the bowler hats and dark suits of bourgeois gentlemen, or the rumpled cloth caps of workers. (The sheer diversity of hats here, each succinctly summarizing the social position of its wearer, is amazing.) But Cartier-Bresson is not making a catalogue of social types, the way August Sander did. Instead, he is usually deploying his characters in a romantic, absurdist form of social theater. Like Sergei Eisenstein, Cartier-Bresson is a master of photographic caricature, using the camera and unposed street incidents to give added force to his biting, sardonic lampoons. In some pictures he punctures the pretensions to grandiosity and to immortality of authority figures by contrasting the pomposity of their uniforms with the banality of their expressions. In other pictures he photographs people next to advertising posters or graffiti that in some way echo their expressions. In doing so he throws into relief the question of personal identity and authenticity, implicitly asking what the relationship is between the individual and the image that parallels the individual. He peels away successive layers of the social construction of identity—representation, costume, pose, gesture.

In his recognition of the levels of significance that posters and graffiti can carry, Cartier-Bresson was following a path—pioneered by Eugène Atget—that other photographers, notably Brassai and Kertész, were exploring at roughly the same time. Both Atget and Brassai photographed prostitutes, too, as Cartier-Bresson did most strikingly in Mexico. But he brought a vicious wit and a Surrealist sense of the mysterious to his photographs, giving them a particular pungency. Brassai's pictures of Parisian prostitutes depict the Parisian demimonde in a relatively straightforward, reportorial manner, but the women in Cartier-Bresson's photographs of prostitutes are transformed into performers in an intensely erotic, disruptive drama. In several pictures he shows them, their faces masked by thick, cartoonish makeup, confronting the camera with piercing stares as they squeeze forward through the little display windows that were prescribed for them by law. In other pictures women are given more lyrical roles. In one, a peasant woman is shown under a

boxlike structure of some sort, slumped in sleep, that privileged state in which people can escape the bonds of consciousness, and to which the Surrealists attached such importance; her face is bathed in light, giving her an almost beatific expression. Children, too, are seen in traditionally romantic terms in these pictures: they appear as freer, more expressive, more "natural" than adults. But they are never depicted as innocent or sweet, as a sentimental adult might wish to see them; instead, Cartier-Bresson presents them as essentially amoral. In a pair of photographs from 1933 he photographed a mob of poorly clothed boys playing in the empty shell of a partially destroyed building in Seville. In one picture they gleefully chase each other over the piles of rubble—even one boy on crutches, who hobbles along, grinning; in the other the boys have stopped to stare at the camera, as if challenging its intrusion into their games. In neither image do they show any concern about, or even awareness of, the social and historical circumstances of their situation—how they came to be poor, say, or why the building was gutted. (Ironically, these images are often thought to show the destruction caused by the Spanish Civil War, but in fact they were made three years before the war began.) Instead, unconcerned with the calculations of right and wrong that form the basis of conventional adult morality, the boys seem to occupy a world apart, a timeless world. Perhaps because he was an outsider to the scenes he photographed, Cartier-Bresson was free to cast the people in his scenes in particularly subjective ways, to work outside the constraints of familiarity or even of plausibility, and to indulge his fantasies, whether conscious or unconscious.

He also used the formal rhetoric of photography to heighten the emotional impact of his images. His famous concept of the "decisive moment" refers, as he wrote in 1952, to "the simultaneous recognition, in a fraction of a second," not only of "the significance of an event" but also of "a precise organization of forms which give that event its proper expression." Occasionally his photographs can become intricate compositions of essentially lifeless forms. In a 1933 photograph of the delicate patterns formed by the wrought-iron furniture of a café, a figure bending over in the background is used simply as another element in the design. But more often he applies his formal virtuosity to the central issues in his work, as he did in a backlit scene of children playing among anchors and ropes on a white beach. Seen in silhouette, the children become calligraphic, their quick forms echoing and contrasting with the heavy anchors dug into the white sand.

What finally lies behind the layers of masks Cartier-Bresson so diligently peels away? We can never see. The people in his photographs remain ciphers, their mysteries hidden from our gaze. Cartier-Bresson does not force a false intimacy on them, or attempt to strip them of their masks to make them bare their souls for the camera. By the same token, he doesn't pretend that he has in fact somehow captured the essence of the people he photographs; if anything, he denies that it would be possible to do so. He regards them as if from a great distance, as if separated from them by a series of impenetrable boundaries—of class, of age, of nationality, of sex; finally and most basically, the boundary between one person and an-

other. Although he borrows their images for his photographs, he implicitly acknowledges that they retain a separate existence beyond whatever images are imposed on them—or that they impose on themselves.

The act of finding and photographing these scenes gives the pictures the implicit quality of evidence that all photographs, but especially street photographs, convey. In trying to understand any photograph it's important to consider the terms on which it was made—what was happening when the shutter was pressed, just what the photographer's role was. This is why the stock question asked of photographs—how was it done?—matters. We need to understand the terms on which it was made in order to know whether to treat it as the knowing invention of the photographer or the recording of an event in the world. Usually in Cartier-Bresson's work we are given a variety of clues to indicate that the photograph could never have been faked. But in some cases this question of the origin of the image is complicated, the boundaries between recording and invention becoming blurred. In any event, these are photographs about what cannot be shown in photographs—about the impossibility of capturing someone's personality, in its full complexity and depth, in the camera's analytic eye.

Many of Cartier-Bresson's best-known pictures are from the years covered by this show, and these continue to be included in the surveys and monographs of his work that have appeared with regularity. But the prime thrust of his work since then has changed, as has the public perception of him. In the years between 1936 and World War II he turned increasingly to social reportage. In the same period he worked on two propaganda films, first with Jean Renoir and then for Frontier Films, and became a staff photographer for *Ce Soir*, the communist daily edited by Louis Aragon. Among the other photographers with Cartier-Bresson on *Ce Soir* were Robert Capa and David Seymour ("Chim"); after the war these three were among the founding members of the photojournalists' cooperative agency Magnum.

In the years since, Cartier-Bresson has continued to travel widely. Both through his own work and through Magnum he has exercised an enormous influence on photojournalism, defining a style of photography that makes use of the medium's potential for formal meaning while taking an ethical stance in relation to the world. Instead of concentrating on the usual photographs of great men and women performing events sanctioned as historically important, Cartier-Bresson and other photojournalists working in a similar manner have depicted the everyday life of other societies, finding in it a source of profound historical and cultural significance. Some of these later pictures have the same quality of surprise, the same sense of the revelation of precisely delineated enigmas, that his early work does. Over the years he has undoubtedly made many other such photographs. His work has always blended two seemingly contradictory impulses—one outward-looking and social, the other focusing on inner questioning and continuous testing of the nebulous boundary between self and the world. Such an apparent split is in fact inherent in being alive, an individual and part of a society.

While there is no denying the influence of Cartier-Bresson's later work, both for its ethical stance and its fresh approach to questions of photoreportage, it is difficult to assess it fully. Many of his most widely reproduced pictures from the period since 1936 are anecdotal, depicting heartwarming scenes that seem to accept and reinforce social stereotypes rather than challenging them. What has tended to be shown is his more strictly "photojournalistic" work—often selected by editors who try to anticipate and palliate the tastes of a mass audience. As a result it includes some of his tamest, most sentimental images. This exemplifies photojournalism's dilemma. No matter how skillful a photographer may be at discovering telling moments—decisive moments—about events in the world, the pictures remain subject to the taste of editors who are themselves attempting to anticipate the unspoken desires of an anonymous, formless, faceless audience. In doing so they tend to rely on the safety of the familiar, the already known and understood, the predigested. This process occurs in any mass medium. The larger the audience, it seems, the less one is allowed to say. But every photograph is really a question about the nature of the world—or, more precisely, about the relationship between fact and desire: how the world is, and how we would like it to be. The most important thing is to recognize this question and to accept the possibility it offers for discovery, both formal and psychological. Fear of this possibility is the real enemy of both photojournalism and art. (pp. 120-24)

> *Charles Hagen, "Mystery in a Hat," in* Art-forum, *Vol. 26, No. 2, October, 1987, pp. 119-24.*

Arthur C. Danto (essay date 1987)

[*Danto is an American art critic and writer on philosophy. In the following excerpt, he examines Surrealist elements in Cartier-Bresson's photographs.*]

The mystery of Henri Cartier-Bresson's art as a photographer is not just that his images are dazzling and deep at once but that these polarities coincide in so remarkable a way that one feels they must be internally connected, that he could not be so powerful if he were not also brilliant. So, while his subject must in part be the singular authority of the photographic act, the other part of his subject—that to which we respond in the fullness of our humanity—must somehow connect with this, as if meaning and attack were made for one another.

As a young, fiercely romantic adventurer, Cartier-Bresson passed a year in Africa as a night hunter, using an acetylene lamp to immobilize his prey while he took his killing aim; and the hunter's exact reflexes, the perfect instantaneity of eye, mind and finger for which the high-speed rifle or the high-speed camera are metaphors, carry over in his work as a photographer. Each of his famous pictures refers internally to the act of shooting it, and each, for all its laconic title (***Madrid, 1933; Marseilles, 1932; Mexico, 1934***), is eloquent with the implied narrative of the successful kill. Each encapsulates the speed, the deadly accuracy, the total self-assurance and the patience, endurance and will of the huntsman as artist. I owe to Peter Galassi,

curator of "Cartier-Bresson: The Early Years" and author of the illuminating catalogue that accompanies the show, the insight that the hand-held camera with the high-speed shutter transformed the condition and thence the content of photography (much, I suppose, as the invention of the escapement action transformed performance on the piano-forte and redefined the conditions of composition for that instrument). The old photographers, with their unwieldy equipment, their need for sustained illumination and a total immobility in their motifs, addressed a world of willed stasis, which the best of them—Atget, say—transformed into a kind of frozen poetry, cleaned of time and change. World and artist stood still for one another, the double immobility vesting the plate with an uncanny, platonic stillness. The hand-held camera liberated both parties to this transaction, allowing the world to be itself. Where the older photographers addressed immovable grandiosities—mountains, palaces, enthroned monarchs—the swift, unburdened sharp-shooter of the modern instrument could take on the ephemeral, the transitory, the weightless.

The unmistakable evidence of an advance in the technological side of an art—the unmistakable evidence that technology counts for something in that art—is that, initially, it becomes the subject of the art it revolutionizes. The discovery of perspective meant that its first users were enthusiasts who made each painting an occasion for demonstrating command over the new technology of distal recession, and they chose subjects that best enabled the demonstration to be made. The subject of the first moving pictures was movement itself: rushing streams, speeding trains, the stirring of boughs in the Bois de Boulogne. I sometimes wonder if the exhibition of gore in film today really testifies to an appetite for gruesomeness on the part of an audience, and not instead to the display of craft in the special-effects department, which, like the enthusiasm for distance as distance, movement as movement, will sooner or later cloy. In any case, the fast-action camera initially addressed fast action as such, the image calling attention to the virtues of the new technologies. A certain number of Cartier-Bresson's first works are simply about the arresting of a motion that could not be held, as in the famous shot of a man leaping a puddle behind the Gare St. Lazare. (I could not help smiling at the two torn posters in the background, advertising a concert by the piano virtuoso Alexander Brailowsky, playing Chopin, exactly the composer to enable his brilliance to come forward.) Had Cartier-Bresson remained obsessed with such tours de force, he would have gone down in history as a master of speed and light, but not the deep artist to whom we respond today. For this he needed a content that transcended and yet incorporated the sensitivity of the instrument. And what we have are not just so many examples of arrested motion but examples rather of transcribed revelations, as if the world itself opened, like a shutter, affording a fleeting glimpse, a flash, of otherwise hidden meanings.

It is in fact as though beneath the visual appearances of the familiar world there were another system of reality altogether, covert and disguised, but which stands to the surface world as the unconscious stands to conscious mental processes. Certain juxtapositions, certain startling as-

sociations of ordinary thing with ordinary thing, open up the deeper reality to the observation of an instant, after which the fissures close and we are restored to the commonplace. Cartier-Bresson, who after all had ingested the theory of a double layer of meaning and reality from the Surrealists, who in turn derived their theory and program from the thought of Freud, functioned, as a photographer, on two interpenetrating levels of appearance. Freud famously saw in dreams, jokes and free association the aperture into the primary processes of the unconscious system, which the Surrealists of course treated as the creative substratum of the mind. Cartier-Bresson's work is filled with the power and menace of such associations and puns.

Consider one of his masterpieces, *Madrid, 1933,* which shows a group of men beneath the wall of a mysterious building. The wall is punctuated by windows of various sizes, small in proportion to the wall itself, and seemingly distributed randomly across its surface; it is impossible to infer the internal architecture of the building from the evidence of these openings. Indeed, the wall looks like a rampart of some sort, its original purpose subverted by squatters on the other side who punched holes here and there, opening it to the flat expanse that is the foreground of the picture. The array of square windows conveys the sense of meaning, much in the way in which, though the analogy is forced and anachronistic, the holes in a punch card imply that with the right device the card could yield a piece of information. Or the squares dance across the surface as if in a ready-made counterpart to "Broadway Boogie-Woogie." Or the tiny squares look like the square notes in Gregorian notation, as if someone had composed a chant in the medium of windows. I have often wondered what the building was and whether it still stands, and though only an eye driven by certain beliefs and attitudes could have been sensitive to its overtones, it could have been the motif of a still photograph made by a heavy camera, requiring a tripod. But at the bottom of the picture is the crowd of men and boys—I count fourteen—whose bodies are sheered off, in many cases, by the bottom edge of the picture so that we are conscious, mainly, of the rhythm of their heads, which echoes the rhythm of the windows, like the accompaniment, in another clef, of treble harmonies. Or it is like two voices in an intricate fugue of heads and windows. Or it is as if heads and windows were different forms of the same thing, or metaphors for one another—and in at least two cases one has to look carefully to see whether a certain dark shape is head or window. Yet this is not some formal exercise; the heads and windows are too insistently in resonance with one another for us not to seek a meaning our rational self denies can be there. The image is clotted with magical possibilities, and it seems to force an opening into the mind of the artist if not the mind of the world—one can barely tear oneself away from the riddles it poses. The entire exhibition is a set of traps for the interpretive resources of the eye, but *Madrid, 1933* has the power of a great musical questioning.

André Breton, the relentless theoretician and dogmatist of Surrealism, once said that "Automatic writing is a true photography of thought." By that, I believe he meant that the absurd illogic of automatic writing replicates a corre-

sponding rhythm of thought, recording the creative pulses of the subrational mind. If the real—or better, the surreal—world has the same dislogic the Surrealists attributed to the mind, then a true photography of it would record the magic to which rationality is blind. There can be no doubt that the Surrealists characteristically used photography to insinuate this, using the premises of optical exactitude to demonstrate the fantastic exterior of the after-all-not-so-ordinary world. But often they achieved this by flagrant manipulations and montages, or by using as motifs things they found rich with their own silly meanings. Cartier-Bresson's photographs do not, characteristically, look surrealistic, in part, I think, because he sought the surreal in natural conjunctions that have to be seen as connoting the kinds of things the Surrealists instead built into their own vocabularies. The consequence is that he managed to break through the crusts of habitual perception with images so astonishingly fresh that one's response to them, however familiar they have become, is composed in part of a sense of one's own visual pedestrianism. We feel that between our eyes and the world out there, cataracts of habit have formed, and our own vision is dirty, clouded, oblique. So the surrealism is invisible. What we have instead is the sense of restoration to our true powers and the objective wonder of a world we have taken too much for granted. The photographs of Cartier-Bresson come to us in the form of marvelous gifts; one feels cleansed and empowered by them, and enlarged. (pp. 346-48)

> *Arthur C. Danto, "Henri Cartier-Bresson," in* The Nation, *New York, Vol. 245, No. 10, October 3, 1987, pp. 346-48.*

FURTHER READING

I. Interviews

"Henri Cartier-Bresson: Draughtsman and Photographer." *Art International* 1, No. 1 (Autumn 1987): 69-75.
> Records a conversation in which Cartier-Bresson discusses his decision to concentrate on drawing and painting rather than photography.

Baby, Yvonne. "Henri Cartier-Bresson on the Art of Photography." *Harper's Magazine* 223, No. 1,338 (November 1961): 73-8.
> Cartier-Bresson discusses his artistic goals, themes, and techniques. Includes photographs chosen by the artist as representative of his work.

Seed, Sheila Turner. "Henri Cartier-Bresson." *Popular Photography* 74, No. 5 (May 1974): 108-17.
> Discussion of Cartier-Bresson's life and work. Includes several reproductions of photographs taken in the U.S.S.R.

Weiss, Margaret R. "Encore at the Louvre: Henri Cartier-Bresson." *Saturday Review* XLIX, No. 48 (26 November 1966): 23-8.
> Records a conversation with the artist during a preview of his exhibit at the Louvre.

II. Critical Studies and Reviews

Clark, Roger. "The Sad Fate of Henri Cartier-Bresson." *British Journal of Photography* 127, No. 6,253 (30 May 1980): 514-15.
> Contends that the critics commissioned to compose introductory essays for collections of Cartier-Bresson's work have misrepresented the artist's intentions.

Dalí, Salvador. "Cartier-Bresson: Moralities." *ARTnews* 58, No. 10 (February 1960): 38-9.
> Concise interpretations of four of Cartier-Bresson's photographs by the Spanish surrealist painter.

Davis, Douglas. "A Way of Seeing." *Newsweek* XCIV, No. 23 (3 December 1979): 108 ff.
> Reviews Cartier-Bresson's retrospective at the International Center of Photography in New York, praising the photographs as "brilliant, pioneering pictures."

Esterow, Milton. "Cartier-Bresson's Real Thing." *ARTnews* 88, No. 6 (Summer 1989): 132-35.
> Biographical and critical article on the artist's career as a painter.

Genêt. "Letter from Paris." *The New Yorker* XXXI, No. 40 (19 November 1955): 145-49.
> Includes a favorable review of Cartier-Bresson's photographs taken in Moscow and in Europe.

Goldsmith, Arthur. "Henri Cartier-Bresson: A New Look at an Old Master." *Popular Photography* 85, No. 5 (November 1979): 100-07.
> Characterizes Cartier-Bresson as an artist "whose photographs and personality abound in paradoxes and ambiguities which tend to be obscured or taken for granted by familiarity."

Hofstadter, Dan. "Stealing a March on the World: Parts I and II." *The New Yorker* LXV, Nos. 36 and 37 (23 October 1989; 30 October 1989): 59 ff. and 49 ff.
> Essay on Cartier-Bresson's life and career.

Keating, Peter. "Snap-Shots in Affirmation." *The Times Literary Supplement* (28 March 1980): 344.
> Praises the spontaneity in Cartier-Bresson's works, in a favorable review of *Henri Cartier-Bresson: Photographer.*

Kirstein, Lincoln. "Metaphors of Motion." *The Nation* 212, No. 11 (15 March 1971): 345-46.
> Focuses on the unique effects achieved by the photographer in his pictorial representation of France.

Kozloff, Max. "Mercurial Quietude: Cartier-Bresson and Lartigue." *Art in America* 60, No. 1 (January 1972): 68-79.
> Contrasts the photographs and text in *Cartier-Bresson's France* and J.-H. Lartigue's *Diary of a Century* in substantiation of his claim that "photos in books acquaint us with how much is left out, how arbitrary and inconclusive are the images of those things they represent."

Norman, Dorothy. "Stieglitz and Cartier-Bresson." *Saturday Review* XLV, No. 38 (22 September 1962): 52-6.
> Compares the career and works of Henri Cartier-Bresson and Alfred Stieglitz, characterizing the two artists as innovators in modern art.

Perl, Jed. "Photography and Beyond." *The New Criterion* 6, No. 4 (December 1987): 51-6.

> Argues that Cartier-Bresson's works reflect "a search for quirky variations on the old formulas of landscape art."

Weiss, Margaret R. *"Cartier-Bresson's France." Saturday Review* LIV, No. 7 (13 February 1971): 46-7.

> Praises the emotionally evocative nature of Cartier-Bresson's work, in a favorable review of the artist's collection of photographs of France.

Whelan, Richard. "Cartier-Bresson: 'For Me, Photography is a Physical Pleasure'." *ARTnews* 78, No. 9 (November 1979): 120 ff.

> Discussion of the artist's life and works.

Woodward, Richard B. "Henri Cartier-Bresson." *ARTnews* 86, No. 9 (November 1987): 200, 202.

> Appreciative review of the exhibit of Cartier-Bresson's early photographs at the Museum of Modern Art.

III. Selected Sources of Reproductions

Cartier-Bresson, Henri. *Cartier-Bresson's France.* New York: Viking Press, 1970, 287 p.

> Extensive pictorial representation of French culture.

———. "Coup d'oeil Americain." *Camera* 55, No. 7 (July 1976): 3-46.

> Special issue devoted to photographs of the United States, shot, selected, and arranged by Cartier-Bresson.

———. *The Decisive Moment.* New York: Simon and Schuster, 1952, unpaged.

> An extensive collection of prints and a seminal essay by Cartier-Bresson on his artistic intentions.

———. *The Europeans.* New York: Simon and Schuster, 1955, unpaged.

> Chronicles Cartier-Bresson's travels in Europe in the early 1950s.

———. *Henri Cartier-Bresson in India.* London: Thames and Hudson, 1987, 128 p.

> Includes 105 plates and an introduction to India and Hinduism by Yves Vequaud.

———. *Henri Cartier-Bresson: Photographer.* Boston: New York Graphic Society, 1979, 160 p.

> Retrospective collection of prints. Includes an introduction by Yves Bonnefoy (excerpted above).

———. *Line by Line: The Drawings of Henri Cartier-Bresson.* London: Thames and Hudson, 1989, 97 p.

> Comprises sixty-five reproductions representing Cartier-Bresson's later career as a graphic artist and painter.

Museum of Modern Art. *The Photographs of Henri Cartier-Bresson.* New York: Museum of Modern Art, 1947, 56 p.

> Early representative collection of prints. Contains introductions by Beaumont Newhall and Lincoln Kirstein (excerpted above).

Marc Chagall

1887-1985

Russian-born French painter, graphic and multimedia artist.

Chagall is one of the best-known artists of the twentieth century and is frequently cited, along with Pablo Picasso and Henri Matisse, as a preeminent figure among the artists of the avant-garde situated in Paris from the turn of the century until World War II. Although Chagall's work has been associated with Cubism, Surrealism, and Expressionism, his style is noted for its individuality, depicting images derived from his youth in rural Russia in dreamlike, nonveristic configurations. Chagall is especially praised for his masterful use of color and for his ability to create an atmosphere of fantasy, humor, and sensuality.

The son of Jewish working-class parents, Chagall was born in the town of Vitebsk in northwestern Russia. He attended a local Jewish primary school and public secondary school, after which he studied painting and worked as a retoucher for a photographer. Through the support of a patron, Chagall moved to St. Petersburg, now Leningrad, in 1907, where he received a scholarship and enrolled in an art institute founded by the Imperial Society for the Protection of the Arts. He later studied at the Svanseva School, working under Russian painter Léon Bakst until 1910. During this time Chagall created his first significant paintings, the most notable being *The Dead Man* (1908) and *The Wedding* (1910), which depict people and scenery from his native village and are marked by the formal influence of the painters Paul Gauguin and Vincent van Gogh.

A four-year stipend from his art patron in St. Petersburg allowed Chagall to move to Paris in 1910, where he studied at several academies and made the acquaintance of avant-garde artists and authors, including poets Blaise Cendrars and Guillaume Apollinaire. Chagall's work during this period is considered a reflection of prevailing Modernist theories in art, most particularly the formalist techniques of Cubism, a movement which, despite Chagall's denials, critics cite as an important influence on his work. Marked by rich, modulated tones, Chagall's paintings created in Paris from 1910 to 1914 are regarded as his masterpieces. Among them, works such as *I and the Village* (1911) and *To Russia, Asses, and Others* (1911-12) portray dissected, floating, or upside-down figures and introduce images that permeate Chagall's subsequent works, including farm animals, rural buildings, Jewish musicians and rabbis, and whimsical self-caricatures. His early Parisian paintings also feature brighter, more vibrant colors; Louis Lozowick observes of Chagall's paintings from this time on, "Greater attention is paid to the relation of hue, tone, and color among themselves than to their correspondence to nature, making thus possible an infinite enrichment in the quality of the medium."

In 1914 Chagall traveled to Berlin to attend his first major solo exhibition at Der Sturm gallery, which was critically well received, after which he returned to Russia to visit his future wife, Bella Rosenfeld. The outbreak of World War I, however, curtailed travel and he was forced to remain in Russia throughout the war, residing first in Vitebsk and later moving to St. Petersburg. He supported the Russian Revolution in 1917, and in the following year he was appointed commissioner for fine arts for the province of Vitebsk. There Chagall founded and directed the Free Academy of Art, but due to personal conflicts with other artists and a growing antimodernist trend in the new government's policies, he resigned in 1919. Chagall subsequently moved to Moscow to create stage sets and murals for the Kamerny State Jewish Theater, returning to Paris in 1923.

Critics cite Chagall's return to Paris as initiating the second stage of his career, during which he produced works that are generally less well regarded than those executed earlier. Clement Greenberg, for example, notes that in his paintings created in post-World War I Paris, Chagall "polished, softened and refined his art; at the same time, he sentimentalized and prettified it." In the paintings of this period Chagall repeated the images and structures of his previous works, while he added such new images as

lovers, circus performers, and biblical figures, which he painted in softer lines and colors. Chagall is generally lauded, however, for his ventures into numerous other media from 1923 until the end of his career. In the 1920s, for instance, he initiated several series of graphic artworks, many designed to illustrate Nikolai Gogol's *Dead Souls,* Jean La Fontaine's *Fables,* and the Bible. Chagall completed his autobiography *Ma vie (My Life; 1960)* in 1922, for which he created numerous illustrations; these were initially published divorced from the text, but the entire project appeared in French in 1931. Overall, Chagall's graphic works, both black-and-white and in color, are the most universally acclaimed creations of his later career; Greenberg judges Chagall "altogether great in his etchings and drypoints, a master for the ages in the way he places his drawings on the page and distributes his darks and lights."

During the 1930s Chagall undertook numerous trips abroad, visiting, among other places, Palestine and the Mediterranean countries. He emigrated to the United States in 1941, following the Nazi occupation of France, and in New York City he designed sets and costumes for productions of the ballets *Aleko* and *The Firebird.* In 1946 the Museum of Modern Art held the first major Chagall retrospective, which was jointly organized with the Chicago Institute of Art, and its critical success solidified the artist's reputation as a major international figure in twentieth-century art. Following the death of his first wife, Chagall returned to France in 1948. He settled in the southern village of Vence in 1950, where he later met and married Valentine Brodsky, known as "Vava," who also was featured in and inspired several of his works. Throughout the 1950s and early 1960s Chagall produced numerous large paintings devoted to biblical subjects, while he also created ceramic works and murals and engaged in a number of stained glass projects, including those for the cathedral of Reims, the Metz Cathedral, and his most highly regarded windows, for the Hadassah-Hebrew University Medical Center synagogue, *The Jerusalem Windows* (1961). Featuring a window approximately eleven by eight feet devoted to each of the twelve tribes of Israel, the Jerusalem works follow orthodox Jewish tenets in avoiding the portrayal of human figures, depicting instead birds, animals, pastoral landscapes, and images from Judeo-Roman mosaics in radiant colors. Writing in 1989 critic Andrew Kagan deemed Chagall a "unique success as a designer of monumental windows in stained glass," with *The Jerusalem Windows* representing his "final triumph."

Throughout the next two decades Chagall received numerous commissions for large-scale public art projects. His friend, author André Malraux, then minister of culture in France, contracted Chagall to paint the ceiling of the Paris Opera in 1963. In the United States, the New York Metropolitan Opera commissioned two murals, which Chagall completed in 1967, the National Bank of Chicago requested a concrete parallelipiped mosaic, and the Art Institute of Chicago commissioned the stained glass works *The America Windows* (1979). These monumental projects have earned disparate critical assessments. While commentators such as Kagan highly praise the commissioned artworks, other critics concur with Hilton Kramer's assessment that the later monumental works are "unmitigated aesthetic disasters" marked by a popular sentimentality through which the artist served as "a kind of mascot of government agencies, cultural bureaucrats, and religious publicists the world over." Chagall continued to paint throughout his nineties. He died in 1985, concluding one of the most prolific and diverse careers in modern art. Although Chagall's oeuvre has been rebuked for an uneven level of quality and his style is dismissed by some as nostalgic or anecdotal, his early paintings are considered masterpieces of twentieth-century art, and he retains immense popularity as both a Jewish and an international artist.

ARTIST'S STATEMENTS

Marc Chagall with James Johnson Sweeney (interview date 1944)

[In the following interview, Chagall elaborates on his aesthetic concerns, noting his relation to early twentieth-century artists and art movements.]

[Chagall]: A painter should never come between the work of art and the spectator. An intermediary may explain the artist's work without any harm to it. But the artist's explanation of it can only limit it. Better the understanding that grows from familiarity and the perspective that will come after the artist's death. After all, it is better to judge a painter by his pictures. His words, I am afraid, do nothing but veil the vision.

[Sweeney]: *But your work is well known to the art-public in this country. It has enjoyed an extremely wide appeal. You are regarded as one of the leading fantastic illustrators of the present century—a reactionary from cubism and abstract art, a sympathizer with the emotional emphases of German expressionism and a forerunner of surrealism in its irrationality and dream-character. Thanks to the exhibition of major work such as* **Moi et le village** *[I and the Village] and* **Paris par la fenêtre** *[Paris through the Window], and to large retrospective exhibitions in New York, your name brings to mind at once certain images. The constant recurrence of these images had both fixed them in the public mind and whetted its curiosity. In them it sees a suggestion of nostalgia for the surroundings of your childhood, a fairy-tale atmosphere or the illustration of some folk legends of your native Vitebsk. It sees them as private symbols—using the term symbols to signify an image used as an analogy for an abstract idea,—a dove, for example, to represent peace. Your friend and admirer, Raissa Maritain, apparently also sees them in a similar light in her recent appreciation of your work. Yet the critic Florent Fels in Propos d'artistes once quoted you as stating very flatly: "In my composition there is nothing of the fantastic, nor of the symbolic."*

That was many years ago, 1925, still it is just as true as ever. There is nothing anecdotal in my pictures—no fairy tales—no literature in the sense of folk-legend associations. Maurice Denis described the paintings of the Synthetists in France about 1889 as plane surfaces "covered with colours arranged in a certain order." To the cubists a painting was a plane surface covered with form-elements in a certain order. For me a picture is a plane surface covered with representations of objects—beasts, birds, or humans—in a certain order in which anecdotal illustrational logic has no importance. The visual effectiveness of the painted composition comes first. Every extra-structural consideration is secondary.

Just as before the war of 1914, I constantly had the word literature, or "literary painting" thrown at me, now I am constantly said to be a maker of fairy-tales and of fantasies. As a matter of fact, my first aim is to construct my picture architecturally, just as in their day the impressionists did, and cubists did—along the same formal paths. The impressionists filled their canvases with spots of light and shadow. The cubists with cubic, triangular, and round shapes. I try to fill my canvases in some fashion with objects and figures employed as forms—sonorous forms like noises—passion-forms which should give a supplementary dimension impossible to achieve through the bare geometry of the cubists' lines or with the spots of the impressionists.

I am against the terms "fantasy" and "symbolism" in themselves. All our interior world is reality—and that perhaps more so than our apparent world. To call everything that appears illogical, "fantasy," fairy-tale, or chimera—would be practically to admit not understanding nature.

Impressionism and cubism were relatively easy to understand, because they only proposed a single aspect of an object to our consideration—its relations of light and shade, or its geometrical relationships. But one aspect of an object is not enough to constitute the entire subject matter of art. An object's aspects are multifarious.

I am not a reactionary from cubism. I have admired the great cubists and have profited from cubism. But I have argued the limitations of such a view even with my friend Apollinaire, the man who really gave cubism its place. To me cubism seemed to limit pictorial expression unduly. To persist in that I felt was to impoverish one's vocabulary. If the employment of forms not as bare of associations as those the cubists used was to produce "literary painting," I was ready to accept the blame for doing so. I felt painting needed a greater freedom than cubism permitted. I felt somewhat justified, later, when I saw a swing toward expressionism in Germany and still more so when I saw the birth of surrealism in the early twenties. But I have always been against the idea of schools and only an admirer of the leaders of schools. Cubism was an emphasis on one aspect only of reality—a single point of view—the architectural point of view of Picasso—and of Braque in his great years. And let me say in passing, Picasso's gray cubist pictures and his *papiers collés* are in my opinion his masterpieces.

But please defend me against people who speak of "anecdote" and "fairy tales" in my work. A cow and woman to me are the same—in a picture both are merely elements of a composition. In painting, the images of a woman or of a cow have different values of plasticity,—but not different poetic values. As far as literature goes, I feel myself more "abstract" than Mondrian or Kandinsky in my use of pictorial elements. "Abstract" not in the sense that my painting does not recall reality. Such abstract painting in my opinion is more ornamental and decorative, and always restricted in its range. What I mean by "abstract" is something which comes to life spontaneously through a gamut of contrasts, plastic at the same time as psychic, and pervades both the picture and the eye of the spectator with conceptions of new and unfamiliar elements. In the case of the decapitated woman with the milk pails, I was first led to separating her head from her body merely because I happened to need an empty space there. In the large cow's head in *Moi et le village* I made a small cow and woman milking visible through its muzzle because I needed that sort of form, there, for my composition. Whatever else may have grown out of these compositional arrangements is secondary.

The fact that I made use of cows, milkmaids, roosters and provincial Russian architecture as my source forms is because they are part of the environment from which I spring and which undoubtedly left the deepest impression on my visual memory of any experiences I have known. Every painter is born somewhere. And even though he may later respond to the influences of other atmospheres, a certain essence—a certain "aroma" of his birthplace clings to his work. But do not misunderstand me: the important thing here is not "subject" in the sense pictorial "subjects" were painted by the old academicians. The vital mark these early influences leave is, as it were, on the handwriting of the artist. This is clear to us in the character of the trees and card players of a Cézanne, born in France,—in the curled sinuosities of the horizons and figures of a van Gogh, born in Holland,—in the almost Arab ornamentation of a Picasso, born in Spain,—or in the quattrocento linear feeling of a Modigliani, born in Italy. This is the manner in which I hope I have preserved the influences of my childhood, not merely in subject matter.

I know you have frequently stated "art is international, but the artist ought to be national." Nevertheless, on your return from Russia in 1922 after an eight years' sojourn there you came to the realization that your native land—the Soviet no more than Imperial Russia—had no need of you. You stated "To them I am incomprehensible, a foreigner." Does this mean that you regard racism as more important than nationalism and that you, as a Jew, were a foreigner even in Vitebsk?

Race? Not at all. As a native of Vitebsk I was still as close to Russia and to the soil as the day I left. But as an artist I felt myself just as much a stranger to the official, aesthetic ideology of the new government as I had been to the provincial art ideals of the Russia I left in 1910. At that time I decided I needed Paris. The root-soil of my art was Vitebsk, but like a tree, my art needed Paris like water, otherwise it would wither and die. Russia had two native traditions of art, the popular and the religious. I wanted an art of the soil, not one uniquely of the head. I had the

good luck to spring from the people. But popular art—which I always love for that matter—did not satisfy me. It is too exclusive. It excludes the refinements of civilization. I have always had a pronounced taste for refined expression, for culture. The refined art of my native land was a religious art, I saw the quality of a few great productions of the ikon tradition—Rublev's work, for example. But this was fundamentally a religious art and I am not, and never have been, religious. Moreover, I felt religion meant little in the world that I knew, even as it seems to mean little today. For me Christ was a great poet, the teaching of whose poetry has been forgotten by the modern world. To achieve the combination of refined expression with an art of the earth, I felt I had to seek the vitalizing waters of Paris.

I would like to say that my moves from country to country have always been dictated by artistic considerations. Son of a laborer, I had organically no other grounds for leaving my native land, to which I think in spite of everything I have remained loyal in my art. As painter and man of the people—and the people I consider the class of society most sensitively responsive—I felt that plastic refinement of the highest order existed only in France. Here is perhaps the source of my dualism and my climatic maladjustments through all these years. Still I would not say that I have been less able to acclimatize myself in Paris than other foreign artists.

Neither Vitebsk nor St. Petersburg offered me what I felt I needed as a young painter setting out on his career in 1910. Similarly, after an eight-year sojourn in Russia between 1914 and 1922, I found the ideology of the Soviet provided no better place for my ideals of what an art expression should be. The revolution had not replaced the atmosphere which had proved so unsatisfactory to me in my early years in Russia with a more congenial one. The ideal it proposed to its artists was to become illustrators—to transport the ideology of the revolution onto the canvas. Its aim was a pictorial photography, not a poetry of forms with logic of associations relegated to a secondary level. My ideal was still a picture above all—without subject, without "literature," as always.

But again do not misunderstand me: there has never been a true art but that has not been addressed solely to an elite; and equally there has never been an art truly great which has not been addressed solely to the masses. The fact is, an elite which is truly elite keeps in mind its bonds with and roots in the masses. In the past the proprietor classes possessed not only the great works of art of their period but also possessed the faculty of immediately comprehending them. The masses held themselves apart. This is one answer to the question your Dr. Coomaraswamy of the Boston Museum puts forward as a title to an essay, "Why Exhibit Works of Art?" The artist has lost his old public. The new public has not yet found the artist. While it may be contended that artists of earlier days were more fortunate in having in sight the specific function in a church house or communal building for which their work was destined, today it must be admitted that exhibitions in their real aspect serve an important end for art in educating a new public.

The year 1922 saw me back to the well-spring in Paris. And I can freely say today that I owe all I have succeeded in achieving to Paris, to France, of which the air, the men, nature were for me the true school of my life and of my art—the waters which fed the soil in which my art had its roots. In this way I found the international language in Paris and have scrupulously striven to maintain the strength of my root soil in Vitebsk.

On your first visit to Paris Guillaume Apollinaire the poet-critic from whom the term "surrealism" has been reputedly adopted, already pointed out a surnaturel *character in your work; do you feel this movement an important factor in recent art development and do you feel your work has had any relation to the surrealist point of view?*

Surrealism was the latest awakening of a desire to lead art out of the beaten paths of traditional expression. If it had been a little more reliable, a little more profound in its interior and exterior expression, it would have crystallized into an important movement after the example of those of the periods immediately preceding it. You ask me if I make use of the surrealist approach. I began to paint in 1907 and in my work from the beginning one can see these very surrealist elements whose character was definitely underlined in 1912 by Guillaume Apollinaïre.

Again in Russia during the First World War, far from the Salons, exhibitions and cafes of Paris, I began to ask myself: doesn't the outbreak of such a war call for a certain auditing of accounts? The recent forms of the so-called realist schools, which for me embraced both impressionism and cubism, seemed to have lost their vitality. It was then that that characteristic which so many had treated disdainfully and lazily as "literature" began to come to the surface.

On my return to Paris in 1922, I was agreeably surprised to find a new artistic group of young men, the surrealists, rehabilitating to some degree that term of abuse in the period before the war, "literary painting." What had previously been regarded as a weakness was now encouraged. Some did go to the extreme of giving their work a frankly symbolic character, others adopted a baldly literary approach. But the regrettable part was that the art of this period offered so much less evidence of natural talent and technical mastery than the heroic period before 1914.

As I was not yet fully acquainted with surrealist art in 1922, I had the impression of rediscovering in it what I myself had felt at once darkly and concretely between the years 1908 and 1914. But why, thought I, is it necessary to proclaim this would-be automatism? Fantastic or illogical as the construction of my pictures may seem, I would be alarmed to think I had conceived them through an admixture of automatism. If I put Death in the street and the violinist on the roof in my 1908 picture [*The Dead Man*], or if, in another painting of 1911, *Moi et le village,* I had placed a little cow with a milk-maid in the head of a big cow, I did not do it by "automatism."

Even if by automatism one has succeeded in composing some good pictures or in writing some good poems, that does not justify us in setting it up as a method. Every thing in art ought to reply to every movement in our blood, to

all our being, even our unconscious. But every one who has painted trees with blue shadows cannot be called an impressionist. For my part, I have slept well without Freud. I confess I have not read a single one of his books; I surely will not do it now. I am afraid that as conscious method, automatism engenders automatism. And if I am correct in feeling that the technical mastery of the "realist period" is now on the decline, then surely the automatism of surrealism is being stripped rather naked. (pp. 88-93)

Marc Chagall and James Johnson Sweeney, in an interview in Partisan Review, *Vol. XI, No. 1, Winter, 1944, pp. 88-93.*

SURVEY OF CRITICISM

Louis Lozowick (essay date 1924)

[*Lozowick was a Russian-born artist, educator, and critic, whose works in numerous artistic media, including painting and wood engraving, are distinguished by their pictorial realism. In the following essay, he assesses the technique and significance of Chagall's paintings to 1924.*]

Two factors were decisive in the formation of Chagall's peculiar artistic physiognomy: his life in Vitebsk and his training in Paris. Vitebsk circumscribed the scope of his talent and served as the source of its themes; Paris gave it direction and determined its amplitude. Born in Vitebsk some thirty years ago, Chagall passed his childhood and youth in the very thick of its ghetto, and his early impressions of that Russian provincial city have never been effaced from his memory. "Here were church, fences, store, synagog . . . as simple, monosyllabic, eternal as the structures in the frescoes of Giotto," says he in his autobiographic notes. The city teemed with Jews; merchants, peddlers, beggars, barbers, storekeepers; children going to *Cheder* [Jewish primary school], old men going to synagog, women coming from the market. "I painted them because I loved them." And his love has never faltered since. His first works (***Wedding, The Family, Sabbath***) show him groping, seeking tentatively a definite style. He transforms reality imaginatively as he narrates the quiet tragedies and comedies of provincial existence. He exaggerates both in form and color, but still cleaves to nature with fair fidelity.

His work changes character radically in Paris (1910-1914). He strikes a grotesque and fantastic vein. Flaming reds, blues, greens take the place of the former subdued browns, grays, blacks. Houses are placed on end, demolished; men and animals are dissected, quartered, turned into monsters, given fantastic image and impossible position and sent flying in all directions. Chagall abolishes all physical laws and treats every object as property over which he is absolute lord. (***The Village and I,*** [***The Poet; or, Half-Past Three***], ***The Cattle Dealer, Interior, The Drunken Soldier.***) The significant thing to note is that,

though objective versimilitude is almost entirely renounced, the subject matter, in the measure that one may still recognize it despite distortions, is clearly reminiscent of Vitebsk.

The impulse towards this freedom—or extravagance, if one wishes—had been, doubtless, latent in the artist's subconsciousness before his arrival in Paris. One certainly notices signs of it in his earlier works. It was merely made more articulate and its full expression sanctioned by the state of art then prevalent in Paris. The work of an artist may be better appreciated if the school he comes to replace is understood. Chagall reached Paris as Impressionism was on the wane and Cubism gaining ground. Impressionism, the last step in naturalistic painting, was, paradoxically enough, the first step in abstract painting. What the artists of this school attempted to do was to catch the momentary aspect of things; to paint, in other words, not impressions in general, but *first* impressions. First impressions, being in their very nature fleeting, could not be recorded except by posterior reconstruction. This process absorbed the artist completely. Literary content was disregarded. Even the object represented lost interest and receded into the background as the manner of representing it came to the fore. Attention, from truth to nature, however, was then shifted to artistic effect. This was, precisely, the Cubist's point of departure. Chagall simply went farther in the same direction. The Impressionist sought his artistic effects in the spatial relation among visual forms of nature. He reproduced these relations by dissolving all objects in light and air, though still retaining their recognizable shape. The Cubist found his artistic effects in the spatial relations among juxtaposed pictorial forms on the canvas itself, which relations he created by distorting and decomposing natural objects often beyond recognition.

Chagall learned much from the Cubists (and not a little from the Impressionists). To have adopted all of the modernist precepts would have been to rediscover a continent long well explored. Chagall spared himself this superfluous task. He never became a whole-hearted Cubist. He merely assimilated those aspects of the modernist doctrine which suited his particular needs, as, for example, the tendency towards the dissociation of phenomena and the emphasis on form, keeping at the same time to the path chosen by himself. To limit one's sphere of activity may be the shortest road to greatness. Chagall limited his vision to the life about him and brought it to the attention of the wide world. He distorted and decomposed natural phenomena, not to arrive, like the Cubists, at complete abstraction, but on the contrary to reach even greater concreteness, to single out definite objects or parts of them for special attention, to emphasize the narrative. For Chagall still holds the mirror up to nature, although, to be sure, the angle of reflection produces incongruities bordering on the bizarre.

Chagall's gifts were soon recognized and he was invited to exhibit in various cities of Europe. In 1914, while most of his works were on the way to Berlin and Amsterdam, he took a short trip to Russia. The great war prevented his return, however, and he remained in Russia until 1922. Without direct contact with Western Europe, where the paintings he had left were gaining him ever wider fame,

he worked assiduously, producing during those eight years a great body of new and original work.

The works of this period show a slight deviation from the Paris method. The frenzy which shattered the visible world into bits subsides; color becomes subdued. Human, animal, and natural forms approach reality, at times quite closely, especially in the landscapes of which he has some fine examples (the most impressionistic things he has done). Typical of this period are: **The Green Jew,** a green face with yellow beard; **The Jew at Prayer,** excellent both as a piece of realism and as a harmony in black, white, and flesh color; **Above Vitebsk,** an old Jew with a sack on his shoulders flying above the roofs, both he and the city painted realistically except for the disproportion in their sizes, and **The Promenade,** lovers soaring in the skies, with Vitebsk almost all in purple lying far beneath them. His decorations for the Jewish Kamerny Theatre come nearest in their turbulence and eccentricity to his Paris period. Otherwise all his works show a combination of the reverent attitude revealed in the first period and the skill of workmanship acquired in the second.

The aggregate of Chagall's work is charged with the artist's personal reactions and saturated with the spirit of his milieu. So true is this that, in his decoration to a play of Synge [*The Playboy of the Western World*], Hebrew lettering appears. Although his visions are fantastic, they have the quality of genre painting—there is so much local color

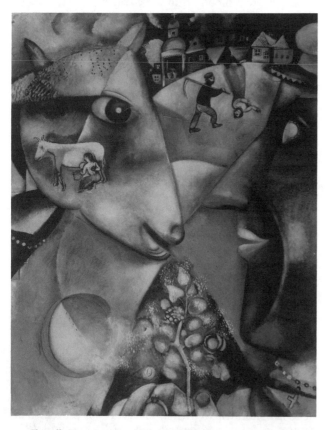

Chagall, Marc. I and the Village, *1911. Oil on canvas, 6'3 ⅝" × 59 ⅝". Collection, The Museum of Modern Art, New York. Mrs. Simon Guggenheim Fund.*

in them, so much of himself, his wife, his neighbors. Like the tales of Poe, his grotesque visions are clothed with striking reality and are always anecdotal. They always tell a story, though one can not always see the point. Nevertheless, one is always interested; one inevitably wonders what lies hidden behind some symbolic statement whose significance is not clear.

Although Chagall's vision is always literary, it is just as unfailingly pictorial. Color and form are equally fantastic, color being used not as an aid in the representation of form, but rather as a means in the evocation of its charm. Greater attention is paid to the relation of hue, tone, and color among themselves than to their correspondence to nature, making thus possible an infinite enrichment in the quality of the medium.

Chagall's weird imagery and whimsical color give the impression that his art is timeless, without tradition or precedent. Nevertheless it is historically as well as biographically conditioned. Chagall descends collaterally if not in direct line from many distinguished forbears. The Egyptian statue of Sebekothep and his midget wife Mimas shows no less disproportion than the two figures in Chagall's picture **Lulov und Essrog.** One finds striking parallels in Byzantine, Proto-Renaissance, Gothic art; in Grünewald, Bosch, Breughel; in Lycothenes' *Book of Monsters.* Under the stress of similar circumstances and the impulse of similar instincts men will react and express themselves in similar ways. The Imp of the Perverse appears in art in all ages to which the term dark may be applied. Our age is certainly dark (apocalyptic perhaps) and ghostridden. It is the age of Spiritualism and Theosophy, the age of Bergson and Spengler. If *L'Evolution créatrice* posits the impotence of intellect to grasp life, *Der Untergang des Abendlandes* prophesies the collapse of modern civilization. Reason is discredited; moral standards are nullified. Everything is possible; everything is permitted. The artist as the most sensitive among human beings feels most keenly the bloody strife that shatters the world about us and the spiritual struggle that rends the soul within us. Chagall is one of a host of artists who interpret in various ways the tortured existence of our day. Modern artists are indeed extremely eloquent orators. A pity that they rarely have an audience! (pp. 343-46)

Louis Lozowick, "Marc Chagall," in The Menorah Journal, *Vol. X, No. 4, August-September, 1924, pp. 343-46.*

Clement Greenberg (essay date 1946)

[*Greenberg is considered one of the most important American art critics of the twentieth century and is renowned in particular for his eloquent arguments in favor of abstract art. The following review of the retrospective held at the Museum of Modern Art was originally published as a journal article in 1946. Here, Greenberg evaluates the status of Chagall's work in the context of European art of the first half of the twentieth century.*]

The large retrospective exhibition of Marc Chagall's art at the Museum of Modern Art (Spring 1946) makes it clear that his natural endowment, if not his actual accom-

plishment, enrolls him among the very great artists of our time. Some become painters by controlling or deflecting their gifts—and even attain greatness—but Chagall was born into paint, into the canvas, into the picture, with his clumsiness and all.

The earliest paintings in the show, executed before 1910—under the influence, it seems to me, of German Expressionism and Munich—establish what remains narrowly and distinctively Chagall's color. The first picture to establish his style, however, is *The Wedding* (1910)—one of the best works in the entire exhibition, for all its maladroitness—which already reveals the dominating influence of Cubism, then hardly born. Henceforth, Chagall's development is synchronized with that of the School of Paris. Cubism gives him his style, his plastic conception, his aesthetic discipline, and the effects of Cubism remain even when all visible sign of it seems to have disappeared. Matisse, in the course of time, teaches him how to unify his color. But Chagall clings to the dark-and-light modeling of Cubism even when his color is purest, flattest and most immediate; rectilinear in his earlier and best pictures, this modeling changes later into soft undulations of warm and cool color along the axes of volumes and planes. And in his most recent paintings there still linger ghostly traces of those patterns of right-angled, open triangles, cutting across volumes and space, that more conspicuously governed his design in the beginning. Chagall is original in his plastic conceptions as well as his iconography, but he is unthinkable without Cubism.

He understands Picasso and Matisse much better than do all the other non-Latin emulators of the School of Paris contemporary with him. Together with Mondrian, Chagall furnishes the best evidence of the School of Paris' capacity to assimilate foreign strains of no matter what provenance, and enrich and realize them.

Chagall's strongest work and his greatest frequency of success came between 1910 and 1920, the period in which Matisse, Picasso, Braque and Gris were also at their peak. A new conception of reality and a new accumulation of creative energy, opened up and progressively organized since 1900, had on the eve of the First World War ripened into a great historic style that decisively reversed the direction of Western pictorial art. The premise of illusion and representation was canceled out, and it was asserted that the genesis and process of the work of art were what was to be most prominently offered to the spectator's attention.

Since this aesthetic repudiated finish, polish, surface grace, Chagall's initial clumsiness became in this period a factor to be capitalized upon. And indeed the frank and unconcerned exposure of his *gaucherie* was an element indispensable to the power of the paintings of his best period. Coarse surfaces, caked paint, crude design in crisscrosses and diamonds, glaring contrasts of harsh and silky, of black or earth tones with complementary primaries—all these added up to virtue, just as a similar if lesser clumsiness in the same time and place added up to the grace of Juan Gris.

Chagall's clumsiness was in part a function of his situa-

tion, balanced as he was between the culture that had formed him as an individual and that which was shaping his art. Ease and facility are attained either by growing up inside the dominant culture or, if you are an immigrant to it, by surrendering and denying yourself without reserve. If you are an East European in Paris, and if you remain one no matter what sort of art you practice, then you are committed to errors of taste—good and bad errors alike. Chagall abounds in both. His "surnaturalism," with its dislocation of gravity, anatomy and opacity, is, like the early coarseness of his *métier,* an error all to the good, though it might have struck the first observers as excessively declamatory and theatrical. But Chagall was also capable of knocking off post-card views and snapshots of romantic couples under the illusion, apparently, that these constituted lyric poetry in the approved Western manner. And the provincial and gifted quaintness of these post cards—whose spirit is so surprisingly in harmony with the commercial ones of that period—only reinforces their bad taste.

In the 1920s, Chagall set himself to assimilating French cuisine and suavity with the obsessiveness of a clumsy and sentimental man learning to dance. He overcame the provincial harshness that had once been such an asset. He polished, softened and refined his art; and at the same time, he sentimentalized and prettified it—relatively. By this time he was sophisticated enough to avoid bad taste. And yet in spite of the many beautiful paintings in royal blue, red, green, pink and white—the still lifes that a sweeter Matisse could have painted, and the bridal couples hovering in luscious bouquets—Chagall has never recompensed himself with anything nearly as valuable as the roughness he sacrificed. His painting ceased to be an adventure in the sense that Picasso's and even Matisse's still are; it settled down to a routine on the order of Segonzac's, Vlaminck's, Derain's, Utrillo's.

However, it must be pointed out in partial excuse for Chagall that he was also the victim of a general tendency that overtook many other masters of the School of Paris after 1925 or so. At that moment Picasso too became softer and somewhat disoriented; Braque began to repeat himself with increasing "sweetness"; Matisse, as his influence spread, took to recapitulating his past; even Gris, before he died in 1927, had toned down his initial vigor; and Léger, becoming more and more eclectic, was departing from the high standard he had set in such canvases as *La ville* and *Le grand déjeuner.* (Bonnard, Mondrian and Miró, however, continued to progress.) The heroic age of modern art was over; its heroes had come to terms with the pessimistic hedonism then reigning in society itself, and the younger aspirants of the School of Paris had turned to Surrealism and Neo-Romanticism. Chagall was simply part of the general phenomenon. But like Chirico in those same years, he went in for "paint quality" in addition to poetry.

The large *White Crucifixion* (1939) and *The Cello Player* (1939) are strong pictures—particularly the latter—and the more recent *Revolution* (not in this 1946 show) demonstrates an amazing unity. But the bulk of Chagall's later production suffers chronically from the lack of concentra-

tion and pressure. We are given painterly qualities, but not whole works of art, not intense unities that start from *an* experience rather than from experience in general and subordinate all general qualities to the total particular impression.

In the last analysis Chagall's accomplishment is incommensurate with his truly enormous gifts. Even in his earlier and best phase he failed to deliver himself of rounded, final, conclusive statements. His masterpieces, unlike many of Matisse's, Picasso's and Gris's of the same period, leave something still to be said in their own terms; either they lack ultimate and inevitable unity, or else they achieve it only by a relaxation of level, by academic softening.

Chagall's early maladroitness, at the same time that it signified power, represented something impure—he went too far in emphasizing the uniqueness of his personality and he did not know at what point to humble himself and modify and discipline his expression so that it might become eligible to take its place in the social order called beauty. After a time the artist has to stop saying: "Take me as I am." But even in his "sweet" period Chagall could not stop saying it—could not stop asking us to take sheer unorganized quality as works of art.

So much for his painting. His work in black and white is another story. Chagall is altogether great in his etchings and drypoints, a master for the ages in the way he places his drawings on the page and distributes his darks and lights. Here his unpurged academicism stands him in good stead; nor is awkwardness any longer a necessary concomitant of the force of his personality. Here his work emerges fresh, pure—and humble. It's passionate severity, its willingness to accept discipline have no parallel in his oils. It may be in part because the black-and-white medium depends on a tradition which Chagall understands more instinctively than he does the tradition of Western painting—of the latter he has in general too operatic a notion.

It must not be forgotten that when Chagall first came to Paris he had to assimilate the past and present of Western painting simultaneously, whereas he was already familiar with the past of graphic art through reproductions. And also, black and white has, since Impressionism, always remained somewhat behind painting and therefore more responsive to academic tendencies. The revolution of post-Impressionism was necessary to enable Chagall to publish his genius as a *Maler* ["painter"], but no revolution at all was needed to prepare his way as a draftsman in black and white.

In any case and in spite of all reservations, Chagall's art remains a feat, in oil as well as in black and white. That a man from the Jewish enclave in the provinces of Eastern Europe should have so quickly and so genuinely absorbed and transformed Parisian painting into an art all his own—and one that retains the mark of the historically remote culture from which he stems—that is an heroic feat which belongs to the heroic age of modern art. (pp. 91-5)

Clement Greenberg, "Marc Chagall," in his Art and Culture: Critical Essays, *Beacon Press, 1961, pp. 91-5.*

Chagall on art:

[The Cubists] did not bother me. I looked at them out of the corner of my eye and I thought:

"Let them eat their fill of their square pears on their triangular tables!"

Undoubtedly my early trends were a little strange to the French. And I looked at them with so much love! It was painful.

But my art, I thought, is perhaps a wild art, a blazing quicksilver, a blue soul flashing on my canvases.

And I thought: Down with naturalism, impressionism and realistic cubism!

They make me sad and they cramp me.

All questions—volume, perspective, Cézanne, African sculpture—are brought on the carpet.

Where are we going? What is this era that sings hymns to technical art, that makes a god of formalism?

May our folly be welcomed!

An expiatory bath. A revolution of fundamentals, not only of the surface.

Don't call me temperamental! On the contrary, I'm a realist. I love the earth. . . .

.

Personally I do not think a scientific bent is a good thing for art.

Impressionism and Cubism are foreign to me.

Art seems to me to be above all a state of soul.

All souls are sacred, the soul of all the bipeds in every quarter of the globe.

Only the upright heart that has its own logic and its own reason is free.

The soul that has reached by itself that level which men call literature, the illogic, is the purest.

I am not speaking of the old realism, nor of the symbolism-romanticism that has contributed very little; nor of mythology either, nor of any sort of fantasy, but of what, my God?

You will say, those schools are merely formal trappings.

Primitive art already possessed the technical perfection towards which present generations strive, juggling and even falling into stylization.

I compared these formal trappings with the Pope of Rome, sumptuously garbed, compared to the naked Christ, or the ornate church, to prayer in the open fields.

From My Life.

Meyer Schapiro (essay date 1956)

[Schapiro was a respected artist, art historian, and critic who is acknowledged as a major influence on the development of modernist theory and practice. In the following excerpt from an essay originally published in a French journal in 1956, Schapiro discusses Chagall's illustrations for the Bible.]

In undertaking to illustrate the Bible, Marc Chagall was moving against the stream of modern art. Most painters today do not take to a set theme; they prefer the spontaneous, the immediately felt, and often discover their subjects on the canvas while at work. Besides, the Bible belongs to a realm of ordained belief, a superpersonal world of ritual and laws, which would limit the freedom that is the indispensable condition of the artist today. (It is clear that this freedom entails for many artists certain strict taboos of subject and form.) Yet our culture is strongly attached by the Bible—never has it been studied so much as in our time. Not only as poetry and myth, but as a revelation of essential humanity; its episodes and avowals have become a permanent part of our thought.

It should be said, too, that, apart from its poetic value, the Old Testament is a living book because of our open interest in the moral, the social, and the historical, whatever our beliefs. The Old Testament, in spite of its mixture of legend and fact, is history in a noble sense. It traces the formation of a community and its highest values, and recounts its fortunes and misfortunes, its great moments. The Old Testament includes also the *consciousness* of history, in referring back so often to the founding occasions and in the prophetic visions of the future, the setting of ideal goals. A striving toward right in purity of spirit, a feeling of commitment and fulfillment, pervade the book. (pp. 121)

And how does Chagall envision the Old Testament? Let us look first at his themes. In his choice Chagall is attached to a few great figures. He represents the patriarchs: Noah, Abraham, Isaac, Jacob and Joseph; the story of Moses and the exodus from Egypt; Joshua, who led the Jews into Canaan; Samson, David, Solomon; then follow the prophets Elijah, Isaiah, Jeremiah, and Ezekiel. Much that is picturesque, delightful, and touching in the Old Testament and that is a familiar part of Jewish imagination has been ignored. Chagall does not tell the story of Adam and Eve, which had interested him early in his career; Cain's crime, the Tower of Babel, the earlier episodes of the Flood, are not here. The novelistic books of Ruth and Esther are omitted; absent, too, are Daniel, Jonah, Job, the Psalms, the Song of Solomon, the so-called Wisdom books, and the apocryphal Judith, Tobit and Maccabees.

Is this choice a random one, without a basic order? Anyone accustomed to study the great cycles of medieval imagery will recognize that Chagall, too, has created according to a plan. I do not mean to say that he followed an already established theological design in selecting the subjects for his plates. But his choices, with all their singular personal elements, fall into three significant groups: a) the great ancestors who founded the Jewish community and received from God a covenant and law; b) the achievement of nationhood with Joshua, Samson, David, and Solomon; and c) the prophets, in their integrity and solitude, their vision of God and prophecies of the misfortunes and consolations of Israel.

These together form a characteristic unity of Jewish awareness, with its strong ethical and communal content and longing for Zion. But in Chagall's Bible the worlds of the patriarchal, the heroic, and the prophetic, which seem to imply an austere imagery of solemn, grandiose figures, also include numerous scenes of the festive, the erotic, the joyous, the intimate familial, the miraculous and fantastic. Very little that has appeared in Chagall's painting fails to turn up somewhere in his images of the Old Testament. But there are in these etchings many things that could occur only in the context of the Bible.

I have said that in this choice Chagall expresses a specifically Jewish vision of the Old Testament. But it is a personal choice and not the carrying out of an already existing systematic program. He has not followed an older set of pictures, though certain of his scenes may be found in medieval illustrated Hebrew manuscripts. Much here is new, and, even in the rendering of the traditional subjects, it is clear that Chagall has read the text for himself. Certain of his themes are highly original and arresting; it is hard to recall other Jewish or Christian representations like these. We recognize here a fresh approach to the Bible and the response of Chagall's poetic heart and fertile imagination.

It is interesting at this point to consider his etchings of themes from the prophets. He begins with the remarkable story from I Kings of the unnamed prophet who is killed by a lion after having violated his promise to God. Gustave Doré had chosen this rarely illustrated episode, and it is instructive to compare his version with Chagall's, which breathes an incomparably deeper poetry as well as sentiment of form. The latter's is a scene in which the fatality of the prophet's calling and the uncanny watchfulness of God are beautifully rendered.

The scenes of Elijah's mission follow, a series that shows the prophet in action, his wandering, the miraculous force that works through his faith, his prayer on the mountaintop, and his ascension to heaven. Something of Jewish folklore clings to these images of the homeless prophet of the desert who has left no book but is known through his action alone. Several of these scenes have been represented in the synagogue of Dura, though not the wonderful episodes of the prophet in the cave hearing the still small voice and alone on Mount Carmel.

Turning to the author-prophets, Chagall has selected from their extensive writings a few verses that distinguish them as individual minds and compose together a rounded view of the prophetic books. Isaiah is for him the prophet who has been purified by the burning coal placed on his lips by an angel; he speaks of God's love for sorrowing Israel and of the future consolations of peace and the restored Zion. Jeremiah is the prophet of Israel's doom and suffering, and he himself suffers imprisonment for his words. Ezekiel is the visionary of God's numinous glory in the fantastic image of the four living creatures at the heavenly throne.

Chagall evokes, too, the Jewish dedication to the sacred word in the scene of the roll given to Ezekiel to eat—a powerful image of magical absorption and inspiration.

One etching from Isaiah is an astonishing choice which is unknown to me in other Biblical cycles. It is the etching of God's mercy proclaimed to Jerusalem and renders the following verses—a most unlikely text for illustration:

> For the Lord hath called thee as a woman forsaken and grieved in spirit, and a wife of youth, when thou wast refused, saith thy God. For a small moment have I forsaken thee; but with great mercies will I gather thee. In a little wrath I hid my face from thee for a moment; but with everlasting kindness will I have mercy on thee, saith the Lord thy redeemer.

It is a haunting image of God as an angel veiling himself behind his robe, which is vaguely like a woman in his arms. The metaphor and its object have been condensed in a single figure. A grandiose Blakean rapture fills this page.

Another imposing etching is Jeremiah's prophecy of Jerusalem's doom. God's wrath is pictured through the tremendous angel with the brand over the burning city and its fleeing people.

Although Chagall illustrates what he has read and knows by heart, his rendering is sometimes touched by memories of older works.

The **Sacrifice of Manoah** recalls Rembrandt's painting in the Louvre of the *Angel Leaving Tobias;* and the **David Playing before Saul** seems to be a reversal of Rembrandt's great painting of this scene. The image of Solomon on his throne, with the medieval scepter and globe—attributes of royal power—is perhaps based on a Carolingian or later conception of the ruler.

A more striking example of Chagall's use of a Christian detail is the horned Moses—a curious borrowing on which I may be allowed to digress. The odd rendering of the patriarch, familiar to everyone through Michelangelo's statue, is common in medieval art. It has been supposed that in the medieval mystery plays horns were attached to the head of Moses to represent the rays that shone from his face (Exodus 34:29), and that the artists copied these horns from the theater in their paintings and sculptures. But the horned Moses had been represented in art long before the time of the first mystery plays. It is known that the horns of Moses come from Saint Jerome's mistranslation of the Hebrew word for ray—the same root k-r-n stood for ray and horn; the similarity to the Latin *cornu* and the existence of horned divinities in the ancient pagan world perhaps contributed to the error. Chagall has read the Hebrew text and also knows, no doubt, the Jewish legend that Moses' face shone already before his second descent from Mount Sinai—Moses wiped his forehead with the divine ink after writing the Torah on the mountain, and from this ink came the rays of light. In Chagall's pictures the rays are a permanent attribute of Moses; they appear before the revelation on Sinai in the scene of the Burning Bush, although they are sometimes replaced by the horns, as in the **Plague of Darkness,** or assimilated to

them in their form. Both attributes, the one heavenly, the other demonic, are expressively right. They give to the patriarch a superhuman aspect, a quality of the portentous and charismatic.

We discover in certain scenes the effect of the more recent historical approach to the Bible, but this is a matter of detail, an enjoyment of cultural perspectives and local color which never displaces the free play of the imagination. Chagall has travelled in the Near East, and like the artists of the last century has represented various figures in the costumes of the modern Bedouins, who were believed to retain the aspect and customs of the nomads of the Old Testament. He has set them in the original landscapes of Palestine and Egypt and he has recaptured the fragrance of the Near East, as in the **Tomb of Rachel** and the charming scene of the **Finding of the Infant Moses.** In some etchings, too, there is a hint of the archaeological remains of the Biblical period not only in material aspects of the figures, but also in their expression—the massive profile forms of God and the Just Man recall the gigantic basreliefs of the Assyrian and Babylonian temples.

But more often Chagall pictures the text with the same freedom, unsophisticated by knowledge of history and ethnography, as the artists of the Middle Ages, to whom it did not occur to distinguish sharply between their own world and the long past world of the Bible. It is in this spirit that he draws the recent Jewish emblem of the Star of David in the scenes of the Old Testament, and decorates the Ark of Covenant with the heraldic lions and the crown and star of the Torah shrines of the East European synagogues he had known in his youth.

What gives the strongest note of actuality and the air of authentic spiritual life to his images of the Old Testament is the wonderful veracity of the faces and bodies, taken from the ghettos of eastern Europe.

The faces are profoundly, unmistakably Jewish and render with a convincing accent the physiognomic of Chagall's people, their piety, concern, and contemplativeness, all without idealization. He had no need to idealize—the real persons he knew, who impressed his memory indelibly, were so compelling and complete in their individual existence.

He has endowed these faces with bodies of a congruent nature—lumpy, imperfect bodies of men who sit long at work, or live in prayer and selfless thought; bodies of a clumsy articulation, the shoulders hunched, the hands often clasped, without grace or firmness, the opposite of the bland Greek and Renaissance figures which are so well-muscled and balanced, so lithe and supple.

They possess a unique power of gesture; the whole body is itself a gesture, like the prostrate Noah before God—a prayerful, humble heap—or Elijah on Mount Carmel. Awkward but never rigid, these figures captivate us by the homely naturalness and sincerity of their movements. If we had to relate these types to one of the great historic styles, we could say that they are Jewish Gothic; they recall to us the ties of their Yiddish speech to the German Middle Ages.

The figures of physical prowess—Samson, Jacob wrestling with the angel—are no less awkward in their strength. They are rustic strong men, massive and bovine rather than athletic, grasping or striking with inapt hands; it is amazing how clumsily they hold a sword or weight. David's struggle with the lion is a dance, a duet, not a combat. Samson barely grapples with the lion; when he touches the pillars to bring down the palace, he seems to exert a magical more than a natural force, and the effect of the tumbling pillars is a little droll. But what grandiose force in the prophets and patriarchs! Not a force of the muscles, but of the moral person, who is often sheathed in a timeless robe which bounds an unarticulated bulk. A marvelous figure is Elijah on the mountaintop who "cast himself down upon the earth, and put his face between his knees." (I Kings 18:42). Faithful to the text, Chagall has drawn the prophet as a rounded mass in the most intense self-immersion, a human boulder within which the great head and hands alone can speak.

It is not from repudiation of the flesh in a spirit of shame or ascetic constraint that Chagall has produced these ungainly forms. Where the text requires it, as in the episodes of Noah's nakedness or Lot's daughters—the latter a scene of legitimate, rational incest, treated as a natural fact—he represents the naked body with innocent admiration as voluptuous and strong. But it is never the regular classic frame with its smooth, pre-established harmony, as we know it in Greek and Renaissance art; it retains always some fresh accent of the felt and imagined fresh—a still unanalyzed and unmeasured force. The young figures—Joseph, Rebecca, and David, bearers of a Biblical sentiment of pastoral beauty—have a plebeian or tribal grace; they are hardly elegant in the traditional Western sense and betray at some point a touching disproportion, a stress that singularizes the posture, prolonging an axis or weighting a limb.

In all his scenes, Chagall is deeply attentive to the momentary moods of his characters. Their faces change radically with their moral state, like Noah sober and drunk, David inspired and sensual, Joshua as warrior, teacher, and judge. How different is the mild animal face of the naked Noah, a Jewish satyr, from the patriarch with his family and beasts in the Ark or in the scene of the Covenant! And the fierce barbaric Joshua girded for battle from his later manifestations! The action determines also the body's proportions and weight: Jacob wrestling with the angel becomes a more powerful figure; the aspect of Moses is transformed remarkably from scene to scene with the content of his role. The personality is the action and must be grasped freshly at each stage; it is never a stereotype as in older art. This flexibility of conception applies, too, in Chagall's rendering of the angels and God.

Chagall feels awe before the divinity. How can he render God, who has forbidden all images? He has given the answer in the **Creation of Man.** God's name is inscribed here in Hebrew letters in a luminous circle in the dark sky. A bearded angel—a figure strange to eyes accustomed to Christian art—holds the still inert body of the first man; his arm merges with Adam's arm and breast; looking back, he flies and is suspended at the same time. Note, too,

that the angel is clothed and the beardless Adam nude—a reversed projection of the human upon the divine. By this ambiguity and tact of the imagination Chagall evokes the secret affinities of the human and divine. Adam's body seems in part a prolongation of his creator or his creator's angelic agent. He exists unconscious in the heavenly space before being cast into the terrestrial void. There is in this magnificent first image of the Bible a dreamlike atmosphere of the mysterious primordial and supernatural; man seems to come into being in darkness and abandonment but also in celestial hands.

The angelic and divine, I have said, appear throughout in everchanging forms. In Chagall's Bible there is no set convention for the superhuman world. In some scenes, great circles of light and the inscribed name betoken the divine, and in the parallel scenes of Moses receiving the law and Ezekiel's vision of the book, the hands of God are depicted. But most often God is represented by mediating angelic beings of many faces and postures. With their rustic wings, they fly, rise, descend, float, approach, and recede, sometimes in dramatic fore-shortenings; their bodies have a supernatural flexibility—they twist and lose their human contours in their prodigious motion; they are like pinwheels and stars, whirling and luminous phantoms. Chagall's lifelong command of the flying figure reaches here a climax of invention.

The perpetual dialogue between God or angel and man determines a dominant vertical in the vague depth of the picture. Many scenes are without a horizon; man lives in a space of ascent and descent. And even where God is not present, the ground is often steep or tilted. Man walks with effort in a world of good and evil, ever conscious of what is above him.

I have spoken of these wonderful etchings so far mainly as images; they are no less fascinating as works of the hand.

These small pictures of great themes invite a close view not only of the details of the story, but also of the barely interpretable details of the artist's touch. They are etchings done from the standpoint of a painter who delights in color and the stroke of the brush, although they offer, too, a delicacy of drawing and other intimate qualities possible in etching alone. Chagall's engraved marks are a loving ornament of the page. In their minuteness they reveal the artist even more than the nature of the objects they combine to represent, as if the ultimate particles of this imagined world were a personal substance secreted by the artist's hand. The needle weaves an infinitely fine web of tiny points, hatchings, lines, grains of black—a shimmering veil, dense and soft, created with joy, filled with light and movement, often playful, sometimes grave, always captivating through its texture and tones. Its unit is the free stroke that has made etching since Rembrandt a modern art and was renewed in the later nineteenth century by Jongkind's fantastic scribbles of the clouded sky. Chagall's figures (and his larger fields) owe to this rich microscopic tissue of black their attractive warmth, their hairy, feathery forms, the hidden pulse of life which a strict outline could never bring. The broken touches build up scenes of monumental breadth and weight of contrast, or they

evoke in their sparseness the softer notes of a lyrical theme.

In the composition of the scenes and interpretation of the text, Chagall seems to me to belong to the class of artists who may be called objective minds. This may seem strange to say of a painter distinguished above all by his daring fantasy. But we are considering here a trait that pertains to the imagination and can be found in realists and idealists alike. In general, there are among painters two approaches to the variety of their subjects. Some will give to the varied subjects, whatever their sense, a common tone of feeling, whether of high excitement or passivity or some other state. El Greco and Piero della Francesca are clear examples. Others, like Giotto, Raphael, and Poussin, are more attentive to the quality of each episode in itself and seek for each a distinct order with a corresponding mood—to such a degree that they seem to have different styles for different kinds of themes. One imposes on all subjects the constant rhythm or tension of his own spirit; the other strives to express the theme as an objective fact, discovering through sympathetic imagination the necessary patterns for its basic sense. Chagall here is of this second type, and yet he is all feeling. But the same emotion does not dominate every episode alike. Confronted by the text, he is able to allow free play to his great receptiveness and understanding without loss of his essential qualities— his buoyant fantasy and warm, caressing touch.

The resulting range of the pictures is amazingly rich. . . . Chagall's capacity to create the sorrowful and gay, the grave and the charming, scenes of the most ingratiating lightness and the awesome apparitions of God. I believe that in this series his greatest achievement is in the images of the patriarchs and prophets, which possess the strongest contrasts, the densest areas of black and gray. In these plates he has responded most deeply perhaps to the major qualities of the text.

If you wish to see how astute and subtle is Chagall in discovering the expressive framework of an action, study in particular the scene of **Abraham's Sacrifice,** where the knife is adjusted to the faggots on the altar and makes with Abraham's right arm a form like the parted wings of the angel above—a pattern of analogy and contrast which serves at the same time to express the impending action and to tie its elements into a firmer whole. Yet this is only a detail in the fuller, incalculable harmony of the work— so grandly simple and strong—which depends also on the massing of the tones with their rich nuances of dark and light. Throughout the book Chagall is especially inventive in composing the angelic and the human through the correspondences of wings and limbs. The **Creation of Man** and **Joshua as a Warrior** are two examples. The parted wings on a dark ground may serve as the emblem of the whole.

After the grandeur of early Christian and medieval art, after Rembrandt, the illustration of the Bible seemed a finished task. It is remarkable that in an age like ours an artist should risk this enterprise again.

Chagall is the chosen master for this task. The result owes much to the happy conjunction of his Jewish culture—to which painting was alien—and modern art—to which the Bible has been a closed book. Chagall was prepared for this achievement by his permanent receptivity of mind. He is a rare modern painter whose art has been accessible to the full range of his emotions and thoughts. This is less uncommon in poetry; but the painters in their enthusiasm for new and revolutionary possibilities of form and in their desire for an autonomous personal realm have come to exclude large regions of experience from their work. In the very beginning of Chagall's career, he pictured beside love and sorrow, the festive and the visionary, the extremities and high points of social life: birth, marriage, and death.

In accomplishing this work, he has surmounted, then, what seem to be the limits of his own and perhaps of all modern art.

He has represented themes of an older tradition not in a spirit of curiosity or artifice, but with a noble devotion. The work is wholly free from self-conscious striving; what is beautiful in it does not spring from a will to novel forms. Although these etchings are marvels of patient, scrupulous craftsmanship, there is no assertion here of skill or technical research, but an immersion in a subject which the artist convinces us often equals or transcends in value the work of art. The style seems natural and is submitted sincerely to the text, which comes to life in perfectly legible scenes, through Chagall's secure power of inventing expressive forms. In almost every image we experience the precise note of his emotion, his awe or sadness or joy, which is voiced in the melody of shapes and the tonal scale peculiar to each conception.

If we had nothing of Chagall but his Bible, he would be for us a great modern artist, but also a surprising anomaly in the art of an age which otherwise seems so remote from the content and attitude of this work. It is a sign that modern artists have greater resources than modernity allows them to disclose—resources which are often unsuspected by the artists themselves, who would welcome, we may venture to suppose, the prospect of great walls to cover or monuments to erect, and would not be at a loss for subjects worthy of this scale, if their art were open to all that they felt or loved. (pp. 124-34)

> *Meyer Schapiro, "Chagall's 'Illustrations for the Bible'," in his* Modern Art: 19th & 20th Centuries, Selected Papers, *George Braziller, 1982, pp. 121-34.*

Erich Neumann (essay date 1959)

[*In the following essay, Neumann relates Chagall's work to Judaism and the tradition of Jewish prophecy.*]

Marc Chagall. The strange painter from Vitebsk is generally regarded as a Romantic, a painter of folklore. Some stress his "childlike" or primitive quality, others the idyllic aspect of his youth in a small town, or his Jewish milieu. But all these interpretations miss the essential.

He is not a great painter of the kind whose gradual growth takes in greater and greater areas of the outward or inner world. Nor is he a painter of upheaval like van Gogh, who passionately experienced the nascent modern world in

every cypress tree of Provence. But he is unique in the depth of feeling that carried him through the surface manifestations of his personalistic existence to the fundamental symbols of the world, the foundation underlying all personal existence.

His pictures have been called poems, they have been called dream images, implying that the intention of his painting extended to a plane removed from all painting—even that of our day. Perhaps only the Surrealists, who for this reason called Chagall the first Surrealist, shared his intention, which might in a certain sense be called a lack of intention. But—and this is the very crux of the matter—Chagall is no Surrealist working with the blind unconsciousness of Freudian free association. A profound, but by no means unformed, reality makes itself felt in his work. The dream law of his paintings flows from a unity of feeling, reflected not only in the intrinsic color development but also in the relationship between the symbols that order themselves round the symbolic center of the picture. These symbolic centers of Chagall's pictures are unquestionably spontaneous products of his unconscious, and not constructions of his ego. The consciousness that executes his painting follows the mood and inspiration of the unconscious. The unity and force of conviction in his pictures are an expression of the obedience with which he accepts the intention of his unconscious. Like a medium, undisturbed by the impressions and influences of the world around him, he follows the inner voice that speaks to him in symbols.

Here we touch on a central Jewish paradox in Chagall: a prophecy in which the godhead does not, as from time immemorial, speak in words, but in mystery and image—an unmistakable sign of the upheaval that has taken place in the Jewish soul.

Language, and the language of prophetic religion more than any other, is indeed rooted in the unconscious, with its stream of images; but Judaism and Jewish prophecy were formed by the ethical accent of a consciousness which derived its own central force from its analogy with the central power of the One God. The imperative guidance of this prophetic will so sharpened the intention of the unconscious forces that stood behind, heated it to so white a glow, that the images lost their colors; the variegated flowers of psychic life were turned to ashes.

But in Chagall for the first time something originating in the very same psychic stratum from which Jewish prophecy drew its power speaks in images and colors. In the new historical situation of a Jewish people transformed through the central depth of its unconscious, prophecy speaks a new language and utters new contents—the beginning of a new Jewish message to the world. The soul of Jewry, compressed by necessity into the shell of isolation, makes itself free, sinks its roots deep into the earth, and manifests itself in a first new flower.

At first glance there seems to be nothing very impressive about Chagall's Jewish provincialism. Folklore, the village idyll, the Jewish small town with its petty bourgeoisie, childhood memories—childhood memories over and over again. Who cares about this Jewish town, about all these relatives and bridal couples, these eccentrics and fiddlers,

these festivals and customs, sabbath candles and cows, these scrolls of the Torah and village fences? Childhood—that is the milieu from which Chagall never escaped and to which he returns over and over again, regardless of Paris and Europe, of world wars and revolutions. All this may be lovable and touching, unless one prefers to call it sickly and sentimental. Is this all? one is justified in asking. What is all the fuss about? Is all this not a mere variant of modern primitivism, only a kind of colorful, romantic popular art? Chagall would give no answer, probably he would know no answer; he would only smile and keep on painting his colorful world, the same little houses, the same childhood memories, the same colored fragments of his early world: cows and fiddles, Jews and donkeys, candelabra and brides. But in the midst of it there are angels and moons, blazing fires, and the eye of God in the village. For what is childhood but the time of great events; the time in which the great figures are close at hand and look out from behind the corner of the house next door; the time in which the deepest symbols of the soul are everyday realities, and the world is still radiant with its innermost depth? This childhood reaches back to the earliest prehistory and embraces Abraham's angels as tenderly as the neighbor's ass; it experiences the wedding and the meeting between bride and bridegroom with the same joy and the same radiant color as the spring and the moonlit nights of first love. In this childhood there is as yet no separation between personal and supra-personal, near and far, inward soul and outward world; the life stream flows undivided, joining godhead and man, animal and world, in the glow and color of the nearby. This simultaneity of inside and outside, which perceives the world in the soul and the soul in the world; this simultaneity of past and future, which experiences the promise of the future in the remote past and the guilt of the ages in the anguish of the present—this is the reality of Chagall's childhood, and the eternal presence of the primordial images lives in his memory of Vitebsk.

For this reason there is no above and below in his paintings, no rigid, inanimate thing, nor any dividing line between man and animal, the human and the divine. In the ecstasy of love man still wears the ass's head of his animal nature and the angel's countenance shines amid calamity and doom. All Chagall's pictures are permeated by the soulful divine light—unbroken by the prism of the understanding—which in childhood fills the whole world; all reality becomes a symbol; every bit of the world is transformed into a divine mystery.

Presumably Chagall "knows" nothing of what befalls him in his pictures, but the pictures themselves know and bear witness to their knowledge. There is the beloved, over and over again, in endless transformations, as soul, as angel, and as the inspiring power of the feminine. In one painting the artist—assuredly without knowledge of the ass Lucius, the unregenerate lower man in Apuleius' romance [*The Golden Ass*]—bears an ass's head as he stands at his easel and the feminine soul figure guides his eyes upward; in another picture it is the angel himself who holds his palette, or else the figure of the anima, the soul, may peer out of the easel. In every case he expresses the unconscious knowledge that his hand is guided and that an earthly

creature is receiving inspiration and guidance from an unearthly, suprapersonal force. In all these visions the masculine is dull, bestial, earth-bound, while the feminine blooms in all the colors of a transfigured, unearthly radiance.

This emphasis on the feminine reflects something essentially new in the outlook of Jewish mankind, which hitherto with its ethic and spirit seemed so fundamentally patriarchal that the feminine, repressed and almost despised, could speak to it only through subterranean channels. In Chagall it is not only the compensating contrary aspect that breaks through, as in the mystical undercurrents of Jewish cultural history; rather, he is the prophet of a nascent new reality, of an upheaval from out of the depths. It is this alone that justifies us in speaking of Chagall's prophetic mission.

The feminine soul figure that fills Chagall's world reaches out beyond his own personal sphere and indeed exceeds the limits of any purely Jewish contemporary constellation; for the circle whose center it forms is the primordial circle of archetypal symbols, such symbols as night or moon, bride or angel, loving one or mother. But it is striking, and characteristic for the situation of the modern man and the Jew, that the mother with child seldom occupies the center of these pictures. The Madonnalike mother with child who appears in Chagall's paintings has always played a significant role in Jewish life as the collectively regenerating emotional force of the feminine. But she has always remained a symbol of collective forces, and has never become truly incarnated as an individual feminine power in life, or as a feminine force deep within the psyche of the Jewish man. But the essential is the individual incarnation of the soulful and feminine in man, and this is how the feminine appears in Chagall and dominates his pictures: as a configuration of the magical and fascinating, inspiring and ecstatic soul that transforms the world with the star-fall of its colors.

For this reason the center of his work is the relation of the masculine to this type of the feminine; and for this reason it is in the lovers that the secret reality of the world flowers mysteriously over and over again. Chagall's Vitebsk and likewise his Paris are full of this bride and bridegroom, whom he never wearies of painting; in them live the darkness of nocturnal drives and the golden light of the soul's ecstasy. The ass of the body may stagger, it may rise on wings to higher realms; in the form of a gigantic, glowing red angel it may hold the chalice with the sacred wine of drunkenness; and yet again the moon may stand so close to the lovers that the distant bridge, like the rim of reality, marks the limit of the transfiguration in which lovers, angels, and flowers hold out their hands to one another, in which the interweaving of drive and soul, the human and the divine, of color and light, is always the one encounter, which lives behind all the rest, the meeting of the bridegroom with the bride. But this is the encounter of the transcendent God with his feminine immanence; it is the encounter of *keter* and *Shekinah,* of God and soul, of man and world, which takes place in the inner reality of every living couple.

Here the cabalistic and Hasidic symbolism of Jewish mysticism become the reality of a man drunk with love, whose rich palette bears witness that creative man is made in God's image, and in whose pictures of human life in the world the creation begins forever anew.

The lovers are God's seal on the world, the seal in which his bond with the reality of man is confirmed like a new rainbow of promise. For despite all the terror, despite all the pogroms and crucifixions, despite all the fires and wars, this earthly life is the consolation of the godhead itself, if it is taken as the symbol that it is.

The white cow lying beside the Jew wrapped in the tallith of his loneliness [in *Solitude*] is the appeasement of the maternal world; and in the nocturnal village whose poor little houses stand low and crooked between the fields and fences, there gleams the gigantic, wide-open eye of God. It watches us always, always it sees the world and us in it and itself; and everywhere it is the center of reality that becomes visible in the stillness as God's presence. Perhaps the woman milking the blue cow beneath the moon sees this eye less than she sees the chickens and the houses; but nonetheless it dominates the nighttime world and opens wherever the creature comes to himself.

But it is chiefly at night and under the moon, when the inwardness speaks and the world of the secret is unsealed, that the world comes to itself. And that is why the night is the time of ecstasy, when the soul's firebird in the form of a flaming rooster abducts the feminine and the music of lovers refashions the world in the perfect original unity from which it sprang in the beginning.

Yet this glowing interior world of Chagall—in which things occupy not their earthly place but the place they hold in the soul, the place assigned them by the creation that is even now in progress—this world is by no means an airy figment. Nor is it the world of miracles and magic spells, in which the Jewish mankind that draws Messianic time down to earth in prayer flies in ecstatic concentration over the historical time of reality. Rather, it is an earthly, real world of the soul, whose nocturnal roots reach deeper than the roots of a merely earthly life, down to the primordial stream of the images, which waters every living existence.

In Chagall's symbol world, the Jewish and the Christian, the individual and collective, primitive paganism and complex modernism, are fused into an indissoluble unity. The persecuted, massacred Jew with the phylacteries hangs as Christ on the Cross of suffering, and the cart, filled with all those terrified fugitives whose home is going up in flames, drives past the figure of the crucified one, who joins their suffering with his; for sacrifice and suffering are everywhere, and crucified mankind hangs everywhere from the Cross of the son of God. But side by side with this there is the pagan vitality of the animals; ram and ass become Panlike figures of the primordial pagan era, in which the angelic cuts across the divine. For nature is life with all its direct fullness of color and all its tragic depth, manifested in drives and instincts and in the wild drunkenness of ecstasy. Drunken knowledge pours from the red luminous wine and from the woman's white body no less than from the crucifix and the scroll of the Torah, and the

desperate mixture of higher and lower in human nature becomes a mysterious coincidence of opposites in the one center of life.

Here past and future, higher and lower, fuse into a dream-like reality; as in Chagall's enchanted forest, outside and inside appear as mirror worlds, reflecting a third world that hides its true reality behind them and in them.

This reality is just as much alive in the Jew at prayer and the rabbi as in the miserable servant girl and the drunkard, the rooster and the weary little horse. The transfiguration of sensuality in the nude lovers is the blazing fiery rooster, whose ecstatic arc cuts through the night; and the lovers in the boat or under the bridge glow like the sabbath candles or the red sun of the wedding.

All these planes of God's hidden world become visible in Chagall's pictures; they appear in the natural, that is, divine, intermixture that determines the world of the soul: natural thing and symbol; specter and reality; harlequinade of life and lovers' magic; naked drive and religious ecstasy; pillaging soldiers and the silver, fish-tailed dancer of the soul; trumpets of judgment and the endless train of mothers with child, of Marys on the flight to Egypt; the apocalyptic end of the world and the October Revolution; scrolls of the Torah, crucifixes, candelabra, cackling hens, ecstatic asses, and radiant violins whose music hovers between heaven and earth. And over and over again the moon.

The godhead speaks in colors and symbols. They are the core of the world of feeling and truth, a truth of the heart, the subterranean dream reality which, like a net of colored veins, runs through existence. For the "real world" is only a feeble illusion that forces itself on the sober; only the drunken eye of the creative man can see the authentic world of images. One of Chagall's paintings bears the motto that for him embodies the secret of all authentic life or knowledge of God: *Devenir flamme rouge et chaude* ["to become a flame, red and hot"]. Only the flame, the passionate devotion that summons up the profound powers of the psychic in man and makes them flow, can reveal the secret of the world and its divine heart.

But all this should not be taken in a pantheistic sense; it is not a universal statement about the presence of the godhead. Close as Chagall's work is to Jewish mysticism and to symbols such as *hitlahavut* (passionate devotion) and *dveikut* (adhesion to the divine), it must not be reduced to these narrow limits. The depth and scope of a revelation correspond to the depth and scope of the psychic intention for which it is revealed, for which the world as a whole is first manifested as a creative secret. And we find similar intentions and unconscious insights throughout modern painting and modern art in general, and in modern man wherever he attains to the heart of actuality. For the reaction against the mechanized and soulless forces, in man as well as the machine, against the soulless mechanization that threatens to stifle the world, is the rebellion of the soul and the inward plunge of modern mankind.

The irruption and descent of the soul into Jewish mankind—this event with which Chagall is possessed and which he proclaims—was long in preparation. Millennia were needed before the godhead could descend from the hard grandeur of the all-governing law, from the steep summit of Sinai, before it could make its way through the luminous spirit worlds of the cabalistic spheres and transcendent divine secrets to the warm earthly fervor of Hasidic mysticism.

With the Diaspora the fenced-in Jewish community opened to the world, and this descent into the world, begun in exile, is at the same time—this, in any case, is the secret hope of Jewish destiny—the rise of the Jew's new psychic reality. This strange people, with its mixture of youth and age, primitivism and differentiation, prophetic fervor and worldly, world-building ethos, of extreme materialism and timeless spirituality—and Chagall is eminently an expression of all these traits—is engaged in a transformation. Regathered in the face of impending doom, the Jews are sowing once more the seeds assembled in centuries of exile. It is an age of degeneration and rot; the primordial world rises to the surface, the angels fall; but in all this the soul is reborn. Yet like all birth, this birth of the human soul occurs "inter urinas et faeces" ["between urine and feces"]. The supreme values collapse, the candelabra totter, vainly the angels blow the shofar of judgment, and bearded Jews unroll the parchment scrolls of the Torah. Everything is carried downward by the fall of a world, and this catastrophe, this crucifixion, is enacted in a sea of blood, violence, pain, and tears. The crematoriums of the concentration camps and the mountains of corpses of the world wars are the stations in this catastrophe and this transformation. For the catastrophe is a rebirth.

The fate of Jewish mankind is also the fate of Europe, the fall of Vitebsk is also that of Paris, and the wandering Jew is the wandering of countless millions of uprooted men, of Christians and Jews, Nazis and Communists, Europeans and Chinese, of orphans and murderers. A migration of individuals, an endless flight from the extreme limits of Asia through Europe to America, an endless stream of transformation, whose depths are unfathomable and whose aim and direction seem impossible to determine. But from this chaos and catastrophe, the eternal rises up in unsuspected glory, the eternal that is age-old and then again utterly new. Not from outside but from inside and below shines the mysterious light of nature, the divine gloriole of the Shekinah, consoling and healing—the feminine secret of transformation.

Chagall's aloofness from the events of the world is anything but indifference to the happenings of his time. Perhaps the pain-drenched colors of the dying villages and homeless fugitives in Chagall's pictures mourn and suffer more profoundly than Picasso's famous *Guernica*. Chagall lacks monumentality because any rigid, monumental form is bound to dissolve in such a swirling stream of emotion, because the pain is too great and its immediacy hollows out all circumscribed form from within. It is the dissolution of a world out of joint, a world whose whole soil is shot through with volcanic crevices; the norms collapse, floods of lava destroy the existing order, but geysers of creativity spurt from the tortured soil. For in this very dissolution a deeper plane of reality is disclosed, yielding its se-

cret to those who, torn like the world itself, experience its primordial psychic source, which is also their own. The divine and the human travel the same road, the world and man are not a duality of one confronting the other; they are an inseparable unity. The moon rises in the soul of every individual, and the house in whose forehead the eye of the godhead opens is you yourself.

Chagall's aloofness is that of the lover who looks toward the one unknown that gives him the certainty of his own being-alive. It is the age-old covenant of Jew and man with the God who, shorn of all limits, not only offers his succor, but sacrifices himself to every nation and every individual. In each man Sinai burns, each man is crucified; but each man is also the whole of creation and the son of God.

Like the break-through of the soul in modern man in general, Chagall's break-through is not so much an act as a suffering of the naked truth concerning the man to whom our epoch does something that it does to every man who truly lives in it. Nothing human remains except for what is divine. Chagall's aloofness is the experience of a man to whom the divine-human world has opened, because the earthly-human is so drenched in the horror and suffering of transformation that his feeling can only remain alive if he keeps a perpetual hold on the heart of existence. (pp. 135-48)

> *Erich Neumann, "A Note on Marc Chagall," in his* Art and the Creative Unconscious: Four Essays, *translated by Ralph Manheim, Bollingen Series LXI, 1959. Reprint by Princeton University Press, 1971, pp. 135-48.*

Franz Meyer (essay date 1964)

[*In the following excerpt from his seminal study* Marc Chagall, *Meyer closely analyzes the form and themes of Chagall's first large masterpieces, created at his La Ruche studio in Paris between 1911 and 1912.*]

In his new studio in the "Ruche" Chagall had space enough to paint large pictures, for which there was no room in his old one. Inwardly, too, he was ready just then to tackle large compositions. He had concluded the first phase of his encounter with Parisian avant-garde art and had found on this new basis his own entirely personal idiom. Several new ideas, first fixed in gouaches, had been added to his previous motifs. He had already elaborated these spontaneous sketches into genuine pictorial compositions before leaving the Impasse du Maine—*e.g.,* **The Drunkard, The Yellow Room.** Others still waited to be "constructively" transmuted and intensified.

The period of the pictures dated *1911* is that in which the constructive element received the greatest emphasis. This applies equally to the formal disposition and to the symbolic statement. In both respects Chagall brought plasticity to the fore, thus making the large works the grand, lofty metaphors we so admire. But it was these very works that caused the greatest offense to the artistic feelings of the majority of his contemporaries, who considered them abstruse and morbid. So Chagall was forced to ask himself, "But perhaps is my art a wild art, a blazing quicksilver,

a blue soul flashing on my canvases?" [*My Life*; See Further Reading, section I]. He was well aware, however, how untrue that was. He did not paint in a trance, at least no more than other artists. Whatever he did was the outcome of a definite artistic will. His aim was to oppose "a revolution of fundamentals" to "Naturalism, Impressionism and realistic Cubism," which in his eyes belonged to the past. [Meyer observes in a footnote that "Chagall's rejection of Cubism was never so absolute as this phrase might make us believe. He greatly appreciated the work of Roger de La Fresnaye and later that of Juan Gris and admired Duchamp-Villon's sculptures, which he found 'mysterious and powerful'."] His means to that end was a "construction" of a totally novel kind, which reveals, however, an affinity with the constructive spirit of the age and was probably inspired by the geometrical articulation in the pictures of his Cubist contemporaries. From now on the composition of his works, both large and small, shows an increasing emphasis on geometrical pattern. This is typical of Chagall's "method" in the creative period 1911/12— the last months in Montparnasse and the first in the "Ruche." In many cases, successive elaborations of a single motif enable us to see how he "composed" at various times. Thus, the cycle of works centered on the painting **Rain** gives an insight into the evolution of his style.

One motif of the picture, the long barn with the cow (which, however, still lies out in the snow), first occurs in a peculiarly charming red and yellow brush drawing reminiscent of Russia. Other motifs—the house, the man with the umbrella, the man in the outdoor privy, the man following the goat—stem from a watercolor which is related to the nocturnal scenes. Here, however, Chagall has continued the rhythm of the man's movement in the geometrical elements of the sky. In the definitive composition he has used the tree as the central accent. By the clear disposition of the motifs he has created poles of tension, "decomposed" the man with the umbrella into two figures, condensed the scene in the sky, and so achieved a rich, natural rhythm. This picture is attuned to the "large compositions of 1911." The later version, which corresponds to the stylistic phase of 1912/13, has still greater unity and gives the movement still greater irreality.

One of the first pictures Chagall painted in his new studio in the "Ruche" was **Dedicated to My Fiancée** after the gouache he had done in the Impasse du Maine. The handling matches the subject in its unbridled violence. There is no neatly painted surface to mask the spontaneity of the first nervous brushstrokes. The whole vibrates with febrile excitement. The artist calls it "a sort of bacchanal, like those by Rubens, only more abstract." Yet not sensual, but rather "somewhat mystical." This is one of the few pictures—another is **Interior II**—which Chagall painted in one go. He tells us that it was done in a single night, whereas most pictures took about a week. He adds that he did not even light the lamp (either because he had started by daylight or because the lamp went out while he was at work) in order not to check the flow of creative inspiration, and finished with no light at all, "entirely by touch."

The color composition is complex, but less fragmentary and cell-like than in **The Wedding** or **The Drunkard.** The

picture radiates a red light, as from a pool of molten metal. The coat of the man with the bull's head burns a bright vermilion. But the woman's legs cut into this coat in a wine red at once cooler and more mysterious than the bright glow. This creates tension in the fire zone, activated by traces of contrasting green. Yellow areas surround the red center like a field of radiation; a blue tinge on the man's shin penetrates the glow from beneath like a cool note, while a smoky black acts as a closure above. As he already had done in *The Wedding,* Chagall also employs gold, which, at once alien and yet comprised in all the color combinations, fills the triangular area of the sofa alongside the lamp. It is also worth mentioning the flat wooden frame, painted black and yellow, which Chagall made for this picture to fence in the wild glow and explosive movement.

Not one of the next works has a frame of that kind. For now Chagall with each successive picture reinforces, side by side with the increasing movement, the mysterious bond that links all the parts. Thus the picture area gains in autonomy and so an external enclosure is no longer needed. This stronger bond consists chiefly in a more geometrical composition, which is the decisive feature of the next group of works. These include *To Russia, Asses, and Others, Russian Village, from the Moon, Hommage à Apollinaire,* and *The Holy Carter,* to which were added some time later *I and the Village* and *The Poet; or, Half-Past Three.*

To Russia, Asses, and Others was preceded, to judge from the subject, by a small gouache belonging to the series of fantastic nocturnal scenes. The modifications are interesting—the hill with the haystack is replaced by houses and a domed church, and the cow, which previously suckled a manikin and a calf, now stands on the peak of a roof, its greedy eyes fixed on a tub. The peasant girl, whose head sails along detached from her body, floats in the sky above the church cross; instead of broad stripes, her dress is adorned with big peacocks' eyes. Instead of childish stars, curving lights distributed in rhythmical divisions now fill the dark background. The construction is based on the diagonals and other lines that pass through the center and through a point on the median vertical somewhat lower than the upper quarter (the tip of the girl's little finger). The drawing has important points on this network and even intermittently follows its lines (the edge of the roof, the cow's front hoof, the triangle in the sky to the left).

It is extremely interesting to see how the greater "density" of the composition intensifies the statement both in its formal and symbolic aspects. The idea on which the sketch is based may be compared with a meteor shooting across the nocturnal sky along a trajectory. Whereas in the first small version in gouache, this idea dominates the picture almost alone, in the definitive version in oils, motif and form are closely correlated and balanced. the support provided by the form, over and above the momentary excitement and surprise, makes the idea more impressive. On the other hand, the inner movement conditioned by the idea is linked more firmly with the form and lends it, both in the single details and in the whole picture, a new stressful vitality.

The use of a geometrical basic network may have been inspired by Gleizes and Metzinger. The latter, in particular, was just then employing that geometrical method in an attempt to achieve measure and order in his pictures. But even if the idea was not his own, Chagall assimilated the "foreign" element immediately and completely into his own personality.

This can also be inferred from the fact that *To Russia, Asses, and Others* is the only picture of his whose composition is based so emphatically on a geometrical network. And in this picture alone, in which Chagall grappled so directly with geometry, can it still be seen—though in truth only after a searching analysis. The significance of such a geometrical basis at that particular time was the following: till then the dialectic of form and image had been instinctive; now Chagall endeavored to work it up in a more conscious and evident manner. To do so he had to elaborate the geometrical element in its contrast to the motif more stringently than before. Later on, this emphasis proved less and less necessary and so gradually disappeared. It might even be said that Chagall nullified it by overplaying it, by making it equivocal as a compulsory order and thus including it in the incessant movement of the picture structure. He succeeded more and more in incorporating the constructive trend in the elements themselves; this in turn made it gradually unnecessary to stress the constructive basis.

The entire picture is built up of formal and symbolic elements and must be read both formally and symbolically. Heinz Demisch suggests one possible symbolistic interpretation [in his *Vision und Mythos in der modernen Kunst* (1959)]. He links the individual motifs with more ancient symbols and interprets the whole as the juxtaposition of heavenward aspiration and heaven-sent food. For him it represents the relation of man to the forces of the "higher" regions. It may also be viewed as a counterpart to *Dedicated to My Fiancée.* Within the compass of the cosmic-psychic universe the former renders an astral, the latter a telluric-chthonic aspect. (pp. 149-50, 153)

To Russia, Asses, and Others was probably followed by *Russian Village, from the Moon.* In this picture the nocturnal atmosphere of an earlier gouache (*Full Moon*) is transposed into a strange, fairy-tale day. Some of the motifs—the moon, the man with the goat, the tavern door—have been kept, while the dormer has become a little house. But what makes the greatest change in the whole picture is the introduction of a great many geometrical elements.

Yet in spite of that, geometry has rather lost in importance as the basis of the composition. Once more the point of departure is the diagonal division of the canvas. This still fixes certain intersections in the structure of the individual geometrical forms, but the over-all order derives more from the natural, dynamically apprehended interplay of these individual forms than from their relation to a surface network. Although, on the whole, the partitioned ground plan has been maintained, yet what is characteristic in each section attains freer expression. Compared with the earlier work, the whole is at once more compact and more open, firmer and more fluid.

The plastic motifs contribute no less than the geometrical forms to the curiously vivid and yet unreal atmosphere. In this picture they have a peculiarly pointed character, as they render the singular excitement already expressed by the motifs in the gouache *Full Moon.* This excitement appears in the smoke that curls up from the chimney of the little house, in the goat's nervous leap, in the man's ecstatic gesture. It is in this sense, and not anecdotally or truly symbolically, that the man's exhibition of his privy parts to the world must be understood. The offense against reason and modesty aims at upsetting the spectator's conventional equanimity and making him receptive to the lunatic excitement the whole picture is meant to convey.

All Chagall's previous paintings are far surpassed by *Hommage à Apollinaire.* The title, which I prefer not to translate, was inspired by the enthusiasm he felt on first meeting the poet. We may assume that when Apollinaire visited Chagall's studio in 1913 he particularly admired this work executed in 1911/12, and that to thank him the painter inscribed on the picture the dedication, which was not indeed addressed to Apollinaire alone but also to Cendrars and Canudo, with whom Chagall had long been on friendly terms, and to Walden, whom he met through Apollinaire. Their four names are arranged in a square at the lower left-hand corner of the picture round a heart pierced by an arrow.

The curious central motif of *Hommage à Apollinaire*—a couple fused up to the hips in a single body and separated only from there up—first appears in two small gouaches. The Bible story of the creation of Eve may offer a clue to its interpretation. God drew Eve from the flank of Adam, thus creating the two sexes [Genesis I:26-28]. This dual-natured being stands under the Tree of Knowledge with apples in its hands; nearby, the serpent rears its head. Thus, Chagall linked the Biblical motif of the division of the sexes with the Fall of Man.

In the definitive version of *Hommage à Apollinaire* every vestige of the earthly paradise has disappeared. In its stead geometrical forms fill the space that surrounds the dual-natured being. A preliminary sketch shows how these geometrical forms came about. The center of the figure coincides with the intersection of the diagonals and the figure itself is enclosed in an upright rectangular box. In addition, a right-hand spiral starts in the middle and, after four spires, ends in a peripheral circle. In the final version in oils, Chagall has maintained this design but has strengthened its dynamism with two compositional modifications. He has shifted the center in which the major axes intersect slightly toward the upper right and increased the radius of the spiral at each passage through the right-hand half of the picture. Moreover, the spiral is broken more than once and hardly deserves to be considered a structural form any more. The outer circle, in part doubled to make a ring, is far more in evidence. Other geometrical forms, derived from the horizontal, vertical, and diagonal division, articulate the great wheel and strengthen or inhibit its movement. And the figures are no longer enclosed in a rigid, rectangular box, but in a trapezoid form whose sides tend to curve outward and upward and which relates the figures to the movement of the whole. Its shape recalls

the medieval structural schemata for the human form (Villard de Honnecourt), which derive, in turn, from antique archetypes. At the same time Chagall has simplified the movement of the arms and thus overcome the difficulty of representing the two bodies side by side. He has also succeeded, by the concentration on *single* apple, the gestures of the hands, and the facial expressions, in rendering more evident the motif of the Fall in comparison with the earlier versions.

The digits and characters at the top and on the left deserve special attention. In their use Chagall has followed the example set by the Cubists. Words in typographical characters had appeared in pictures by Braque and Picasso since 1911 (for the first time in Braque's *The Portuguese,* painted in spring, 1911)—especially newspaper titles and occasional letters on packing cases; only exceptionally, in Picasso, collage-like scraps of newsprint. Though those words should be viewed chiefly as "objects" and consequently count as still-life motifs, yet they also represent the abstract stratum of significance. For that reason the Cubists used letters not only to emphasize the topical objectivity of their still lifes, but also to break through the limits of their reality and so become free to create the new reality of the picture.

For Chagall, however, this Cubist practice merely provided a stimulus. In his pictures the letters have no connection with still-life items and possess the value of statements in the literal sense. In this context Chagall's own name has a special significance. In *Hommage à Apollinaire* he has placed it at the top of the picture, once entire, once without the vowels, and next to it his first name, part in Latin and part in Hebrew characters. Thus, he plays with words as he does with forms and pictorial ideas. That Chagall gives his own name such importance as an emphatic signature is revealing, particularly compared with the unsigned pictures Braque and Picasso exhibited at that very time. The Cubists, in fact—and this makes the comparison still more striking—aimed at achieving extreme objectivity to the exclusion of any personal statement. For Chagall, instead, genuine objectivity can only be achieved through the subjective, as its intensification.

The four digits—a 9, a 0, and two 1s—on the left of the outer circle have a meaning of their own more closely linked with the central motif. A comparison with the drawings, in which these details are indeed only vaguely hinted at, shows that Chagall started out from the three corresponding numbers on a clock face and therefore that they stand for the hours 9, 10, and 11. That makes the entire circle a clock. It might be interpreted as follows: Time began with the Fall of Man and the separation of the sexes; it proceeds from eternity to eternity and man, half one and half two, stands like a gigantic hand in the center of this cosmic clock. The link between the cosmological circle and the concept of the passage of time is extremely ancient, as we can see from antique and medieval representations of the zodiac. But the whole singularity of Chagall's picture consists in the linking of this cosmic idea with the human figure. There, man and the universe, the microcosm, and the macrocosm, are measured on each other.

The circle as paramount motif is also related, both formal-

ly and symbolically, to the themes of the other works of 1911. The circular order that already determined the vorticose movement of *Dedicated to My Fiancée* and underlies the mosaic of forms in *Russian Village, from the Moon,* appears with radiant clarity in *Hommage à Apollinaire.* The circle is symbolic of the whole and becomes on a new level the symbol of the unity of soul and psyche, of conscious and unconscious, of immobility and activity, as reflecting the link between man and beast. The totality experienced in the circle is found in religious art of all epochs, as a sign of perfection framing representations of the godhead. In Byzantine art, for instance, it occurs in representations of Christ's Transfiguration, from which Chagall may have unconsciously drawn his inspiration.

However, it is not God who stands in the center of the circle, but a being that is half the dual-sexed first man and half the first human couple. This symbol leads us deep into the essence of Chagall's art. Even before he left Russia Chagall had painted pairs of lovers in tense proximity. But in the picture we are considering, Adam and Eve are quite different: there is nothing anecdotal about them. The "unity in duality" they represent is the basis of all the pictures of couples Chagall painted later, for they are all concerned with the reunion of the parted, the victory of love over separation. This symbol can be interpreted at various levels. One door to its mystic background is opened by the theosophical doctrine of the cabala in the Zohar circle. For the cabalists, "the mystery of the sexes . . . in human life is a symbol of the love relation between God's divine 'I' and the divine 'Thou,'" and of Creation in its mystic unity, which was shattered by the Fall. The purpose of all religious life is the restoration of that unity. But the love relation between human beings, too, is important for the process of salvation because "the 'sacred union' . . . of the heavenly bridegroom and the heavenly bride" is also fulfilled in the mystery of the union of the sexes.

Chagall's symbolism, however, is by no means based on his conscious or unconscious adoption of any previously formulated views. His connection with such views is at once deeper, more natural, and more free. The waters of Jewish mysticism had always nourished the roots of his forebears' spiritual world, and thus the sources of his art. Hasidism gave a new psychological interpretation to the "theosophical" doctrines of the cabala. The believer casts off his creature-like nature and finally destroys it in order to discover, without taking so much as a step toward the so-called higher worlds, that God is "all in all," and "nothing is outside of him." Divinity is accessible directly by the soaring of the soul. The lost unity of the fundamental forces in the Divine Being, after which the believer aspires, is now to be found again in the "circumstances" of the world, which is both inner and outer; and this world, wrought by God, is affirmed more and more as the place of salvation. Chagall's œuvre often seems a distant reflection of these spiritual processes. The mystery of sex—unity in duality—becomes the emblem of all reality. That is how the artist formulates it as a symbol in *Hommage à Apollinaire.* It is now a polarity akin to that of Yang and Yin, but linked with the "event" of the Fall of Man, which first brought about the separation, and supported by the hope of annulling the separation and restoring the unity.

But all that refers back again to the artistic creation; thus *Hommage à Apollinaire* is also an emblem of the unity in the work of art. If a picture aims at reproducing reality, its polar basic structure must bring that to the fore. All contrasts must be stressed, in motif and design, in form and color, in inward and outward direction. The unity of the work of art stems from the serious consideration of those contrasts and the full appreciation of their vitality. Thus, *Hommage à Apollinaire* reflects not only the ambivalence of man framed by the cosmos, but also this sudden, mysterious metamorphosis.

The color scheme must be interpreted both symbolically and formally. On the one hand, the sacred, luminous gold of man's unity and duality grows through the zones of silvery night and colorful day, rooted in the first and branching out in the second. On the other hand, the colors fit most precisely in the formal order—the red on the left balances with its mighty spread the thrust of the spiral movement to the right; the green attenuates the circular movement; and the blue, enclosing the circle from below and penetrating it at various points, dematerializes the structure of the whole.

Hommage à Apollinaire is one of Chagall's finest and most mysterious pictures. Never before had the rhythms of his forms and the radiance of his colors combined in such a wondrous, soaring unity. It blossoms before our eyes like a luminous rose—a radiant miracle and a delicate mystery.

The Holy Carter rushes headlong toward us. This composition, too, is based on horizontal, vertical, and diagonal division and arranged circularly round the center. The importance of this reference to the center, not merely up and down in the tectonic sense, but in all directions, is demonstrated by the fact that the picture is no longer oriented as it was originally. Walden, at the Berlin exhibition in 1914, was the first to hang it so that the youngster flies head-down through the landscape. Before that, it represented a man sitting on a chair with a written paper in his hand and bending his head back and downward. In those days Chagall was in the habit of working on his pictures from all sides, "as shoemakers do," he is wont to say. This procedure strengthens the centripetal trend and emphasizes the indifference of top and bottom. Both permitted the inversion which found favor with Chagall at that time and has since become generally accepted.

Any way we look at it, this Carter is an odd, mysterious figure. If we consider it a seated figure, as Chagall painted it, the green body is tensed in a bow from which the landscape seems to shoot like an arrow. If we prefer the present-day orientation, this curious, dashing coachman drives along at breakneck pace: a messenger from far away, illuminated by the glare of the wintry steppe and the glittering splendor of an alien world.

That *I and the Village* is at once the term and peak of Chagall's "geometrical" series, is significant not only in respect of "form." In this picture, for the first time, the individual form transcends itself and so creates the picture space that contains the symbolic motifs in a new manner. That makes *I and the Village,* from the symbolic view-

point, too, one of the richest and most impressive formulations of that period. Its importance for Chagall himself can be gauged from the fact that between 1924 and 1926 he did several small replicas in which he again took up the old themes in order to bring them to fruition in a new sense.

As in the other pictures of the "geometrical" series, the composition is based on diagonals and circular forms. The whitish head of the cow to the left and the green head of the youth to the right, which fix each other with a glassy stare, are positioned more or less in a diagonal cross. A magic little branch of blossom in the youth's hand fills the lower triangle formed by this cross and from there illuminates the entire picture like a strange candle. A curious milking scene is superimposed on the cow's head in the same scale as the peasants before the row of houses and the church on the snowy hill in the background. One notes that the peasant girl is standing on her head and two of the houses on their roof tops.

In *To Russia, Asses, and Others* the composition is based on the geometrical division of the ground. This picture is the starting point of the "geometrical" series. But with every new work he did Chagall deviated further from the close tie between the composition—which remained geometrical—and the initial geometrical articulation of the picture plane. *I and the Village* is the terminal point of this development. The composition has freed itself completely from the bonds of this abstract surface arrangement. One gets the impression that it is no longer the "composition" as such that determines in advance the disposition of all forms and objects but that, though still the basis of the general layout, it grows in detail from the interplay of forms and objects and constitutes the resultant of their expressive dynamism. This, needless to say, modifies the order of the whole.

In all Chagall's previous pictures each "form" stood out against a "ground." Virtually every form was clearly defined as primary or secondary, positive or negative. In *I and the Village* this difference tends to disappear. Now virtually every form has become a "figure" and lines up without a gap alongside the others, which have a similarly active character. This is made possible by the dissolution of the basic network. However, the whole structure of forms, one next to the other—each actually becoming a form thanks only to the others—refers to the picture plane as a whole. This naturally does not affect its claim as a basis of organization. But that is no longer satisfied by the rigid adherence to a certain plan, but by the realization of the basic rhythm in the very life of the forms themselves.

This "activation" of virtually all the forms also modifies the essence of the picture space. In fact, every "figure" that stands before a "ground" determines the space in a naturalistic fashion. If, in a nonrepresentational picture, every form succeeds in becoming a possible "figure," the evidence of the naturalistic scaffolding is destroyed and the space linked with it disappears. Needless to say, Chagall's forms do not possess a "nonrepresentational" spatial indifference. But in *I and the Village* he renders the difference between purely active and purely passive forms so relative that a natural disposition of the objects in space

is only partly feasible. What we now have is a "local," naturalistic determination of space that fits into a nonnaturalistic total space. This total space results from the relative position of all the forms in the picture. It is nonnaturalistic insofar as the spectator can neither distinguish clearly between front and rear nor compare it with the spatiality of the outer world. Some forms, but not all, can be read as both "figure" and "ground" and thus advance or recede. Typical of this is the position of the milking scene in the cow's head, which thus achieves both objective (in the sense of representational) and spatial character (as part of the picture area).

The relation of form to motif also seems closer than before. The constructive, geometrical form not only helps to intensify the motif, but possesses in its own right the same value as the motif. Thus, it is just as "symbolic" as the motif is "constructive." The diagonal cross, the circle, and the other forms that emphasize objectivity and unity play no less a part in the "symbolic" statement than the symbols for "male" and "female," "human" and "animal."

In this way, virtually every element has a dual function. And details like the thread stretched from eye to eye, which is analogous to the stream of spittle in *Dedicated to My Fiancée,* or the topsy-turviness of the peasant girl and the houses in the upper quarter of the picture must be considered in the context of the symbolic expression and in that of the constructive rhythm of the picture. (pp. 153-65)

Franz Meyer, in his Marc Chagall, *translated by Robert Allen, Harry N. Abrams, Inc., 1964, 775 p.*

Roy McMullen (essay date 1968)

[*McMullen was an American-born art historian, translator, and journalist, best remembered for his* Art, Affluence and Alienation: The Fine Arts Today *(1968) and for his biographies of J. M. Whistler and Edgar Degas. In the following excerpt from his* World of Marc Chagall, *McMullen examines Chagall's use of color in his paintings.*]

During a recent conversation at his French Riviera home, with sunlit lawns and tropical flowers forming a frame of reference, Chagall issued what was apparently meant as a general warning to critics. "Remember," he said, "that my painting is not really European. It is partly Oriental. Color and substance are what count for me. I am not interested in the formal aspects of pictures."

The warning need not be taken literally: Chagall exercises a poetic license in his talk as well as in his painting, and he definitely is concerned with "the formal aspects of pictures" in his own way. But color and substance are certainly among the most important elements in his work, and they have been since the beginning of his career. Referring to the academic art that flourished under the czars and was officially adopted, after an interlude of modernism, by the Soviet regime, he has said: "I left Russia in 1910 because of the dead color of Russian painting, and I left again in 1922 for the same reason."

He has frequently insisted that he is an "abstract" colorist, and by this he means much more than the mere fact that he has always been willing to make a sky yellow, a face blue, and a tree red. A glance at . . . [the *Swan Lake* section of the Paris Opera ceiling] can make his attitude clear: the vast pool of color, which in the complete work is combined with other pools, has its own—admittedly indefinable—significance. It could illustrate a symphonic movement, or even Rimbaud's vision in *Le bateau ivre* of "the yellow and blue awakening of singing phosphorescences."

All this is not to say that Chagall's delineated elements should be ignored. A picture like **The Green Horse,** for instance, will repay careful and informed study of its figurative meanings. The mother and child, the young man with the flowers, the rooster, the earless horse, and the view of Vitebsk with the human violin on the sidewalk can all be assigned to significant places in Chagall's world. The creamlike cloud that covers most of the canvas can be interpreted as the remembered snow of Russia: it is definitely snow in some earlier and more detailed pictures in which the woman, the rooster, the Vitebsk street, and the same horse and sledge appear.

A representation of snow, however, is not likely to be uppermost in the mind of somebody seeing this picture for the first time. The creamlike cloud, long before it suggests any figurative reality, makes a vigorous sensuous appeal as sheer paint and as the substance in which are embedded the blue, purple, orange-red, and green motifs. It also functions as an abstract picture space, a nowhere irradiated partly by the warm colors in the center and partly by a cool light that, in one of the painter's favorite phrases, "comes from behind the canvas." And finally it functions as a strictly mental space, furnished with both wintry and springlike memories.

In sum, Chagall tries to persuade us to see and feel his world—first of all as iridescent matter infused with mind and spirit, and only later as a collection of images and a possible subject for literary paraphrase. Sometimes he begins a painting without any drawing at all, with simply a few zones of color spread over the entire surface in varying degrees of transparency. Even when this procedure is not followed, the effect is usually the same; one rarely has an impression of preexisting forms filled in with color, and nearly always an impression of color that is at once spatial and substantial, that is saturated with light and yet is solid enough to serve as the matter from which the forms are carved.

Remarkably, as the gouache **For Vava** shows, this spatial and substantial effect is not limited to works having the advantage of oil painting's range from transparency to opacity. Nor is it limited to any particular mood. In **Jacob's Dream** it is as apparent in the bright disk that reveals Jacob wrestling with the angel, as it is in the relatively dark tones of the sleeping earth. In **Clowns at Night** it lends an almost tragic resonance to the familiar theme of the sadness of the professionally gay. The strolling musicians are simply denser portions of the blue-green blackness of the night itself, through which winds an arabesque of broken patches of yellow, lavender, red, green, blue, and dead white.

The elements that go into the making of a colorist, particularly as fine a one as this, are mysterious. Chagall himself gives a great deal of the credit for the development of his talent to the influence of the light and color of Paris and the French countryside. "My Russian pictures," he has written, "were without light. In Russia everything is somber, brown, gray. When I arrived in France I was struck by the shimmer of the color, the play of the light, and I found what I had been blindly seeking—a refinement of matter and of wild color. My familiar sources remained the same: I did not become a Parisian, but now the light came from the outside." There is some exaggeration here; the early Russian pictures are by no means entirely gloomy, and in 1906, four years before the journey to Paris, Chagall was already considered an eccentric by his teacher in Vitebsk because of a habit of painting in violet: "It seemed so daring that from then on I attended his school free of charge. . . . " But it is true that his palette became brighter shortly after his arrival in France. Léon Bakst, his teacher in St. Petersburg, came to Paris in 1911 with Diaghilev's ballet company and noticed the brightness immediately: "Now," he said, "your colors sing." Three years later the poet Guillaume Apollinaire wrote of Chagall as "a gifted colorist who yields to every suggestion of his mystic, heathen fantasy."

In the decades since then Chagall has traveled widely, and has been stimulated by the extremely un-Russian light and color of such places as Palestine, Mexico, Spain, Italy, and the Greek islands. The exact effect, however, of geography and climate on his color has become increasingly hard to define, partly because he seldom paints directly from nature and partly because of what might be called his delayed-response creative process: he stores colors as well as forms in his imagination, allows them to be metamorphosed by memory and new emotional experience, and then, one day, suddenly puts them on canvas in contexts quite different from their original ones. The forms can often be identified almost immediately; the little house, for instance, in the upper right corner of **Clowns at Night** must surely have entered the world of the painter one evening in Russia some time before 1922, when he left his homeland for good. But we cannot say that the lavender of the crescent moon in the same picture is a memory of an evening in Mexico in 1942. The principal exception to this sort of difficulty is the influence of the French Riviera since Chagall settled there in 1950; some of the recent paintings reflect, for me at least, exactly the density and radiance of the trees and flowers of Vence. Others, of course, do not; some, like **Jacob's Dream,** have a density and radiance that one can only assume to be pure products of the artist's imagination.

Chagall has acknowledged, with enthusiasm, that the awakening of his color sense in France before 1914 was due not only to the natural scene but also to what he found in museums and galleries. He was confronted by the reality of a modern pictorial chromaticism of which he had only dreamed in Vitebsk, with the help of poor reproductions:

> . . . this circular motion of the colors which, as
> Cézanne wanted, mingle at once spontaneously
> and consciously in a ripple of lines, or rule freely,

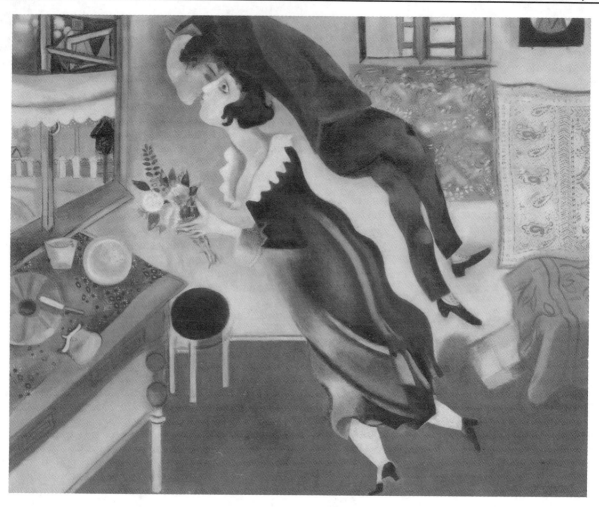

The Birthday *(1923).*

as Matisse shows. One couldn't see that in my town. At that time the sun of art shone in Paris alone, and even today it seems to me that there is no greater revolution of the eye than the one I came across on arriving in Paris in 1910. The landscapes, the figures of Cézanne, Manet, Seurat, Renoir, van Gogh, the Fauvism of Matisse, and so many other things astonished me. They attracted me like a natural phenomenon.

To this list one ought to add Gauguin, not only because of his color but also because of his insistence on the need for an art that went beyond realism and rationalism. The impact of this earlier generation of the School of Paris has long since been absorbed and transformed by Chagall's own highly distinctive style, but there was undoubtedly a time when it and its liberating effect were of decisive importance.

Decisive? The word may be too strong. There is always an awkward moment in an account of influences on artists when the explanations begin to seem circular, for finally only the influenceable are influenced. The palette of van Gogh, for example, like that of Chagall, became lighter and brighter in Paris, and exploded into dramatic color in southern France. But nothing of the kind happened to the

palette of Picasso. He remained primarily a draftsman throughout his revolutionary years in Paris, and one feels that no amount of time on the Riviera would have made him more than the ordinary, even perfunctory, colorist he became. On this line of thought one is apt to end up arguing that Chagall is a marvelous colorist simply because he is Chagall; and that is roughly what he himself, forgetting momentarily his account of the influence of Paris, has said: "You might say that in my mother's womb I had already noticed the purity of the colors of the flowers. . . . I don't know if color chose me or I chose color, but since childhood I've been married to color in its pure state. . . ."

As that quotation may suggest, Chagall is an unabashed sensualist and even a sentimentalist about color, light, and substance in painting. He is also an ardent, indefatigable theorist on the general subject, and his theory is worth some attention both for its own sake and because it has clearly been affecting his practice more and more during the past decade. It lies behind a certain new note of intensity in many of his recent works, a note that at least one critic has labeled Expressionist and that I think might be better described as metaphysical and ethical. In any event,

that is how it might be described by Chagall, although he would use other terms.

The two key words in his theory are "tissue" and "chemistry." He is reluctant to define them with any great precision, and one can see why: they are evidently metaphors for something that he feels is of fundamental importance and ought to be recognized instantly by any art lover who is in a proper state of grace, but that he admits is as indefinable as poetry or music. If he were interested in jazz he might echo in this connection Fats Waller's famous "Man, if you got to ask you'll never know."

Nevertheless, it is possible to see, from the contexts in which he uses them, roughly what the words refer to. (I should add that one can see this without always accepting the judgments in his remarks, just as one can see what a man means by "beautiful" without agreeing that a particular object is indeed beautiful.) "Tissue" and "chemistry" are both life metaphors, just as "vivid" and "vital" were once upon a time, when derivations were fresh and art criticism was young. For Chagall, that is, "tissue" means organic tissue, and refers to whatever it is in pictorial color, light, and substance that can make a painting seem like flesh. "Chemistry" refers to essentially the same thing, regarded more as a process than as a collection of living microstructures. Both terms connote praise, of course, and so Chagall's use of them is sometimes inconsistently narrow and sometimes disconcertingly loose. He may, for instance, contrast "tissue" with "muscle," which is one of his terms for the structure or composition of a painting, and on such occasions he appears to ignore the fact that his "muscle" is also a life metaphor and ought therefore to indicate approval. He is especially apt to use "chemistry" simply to refer to the personal style of an artist he admires, and then the word appears to embrace the formal aspects of painting as well as the colored substance—the macrostructures as well as the microstructures. But always one can feel the pressure of his conviction that art must be emotional and organic rather than rational and mechanical. For him a good painting is never an inert object from which a ghostly lump of significance can be extracted for separate appraisal: mind and meaning are in every square inch of pigment, just as they are in every bar of a composition by Mozart.

How can we judge the quality of the "tissue" and "chemistry" in a painting? This question, raised during a conversation in Vence, brought from Chagall a demonstration that his metaphors are perhaps for him not so metaphorical after all. Holding his hand close to the surface of one picture, he said: "That is one test. The paint must stand comparison with the flesh of your hand, or with something else that is natural and alive—flowers, for example." He went on to say that he had long dreamed of organizing special exhibitions of masterpieces that would call attention to his theory. The pictures would be hung upside down, to avoid any figurative meanings that might distract the literary-minded viewer from their "abstract" colors, and there would be potted plants everywhere to let people test the "tissue" and "chemistry" for themselves. He emphasizes that such tests should not be allowed to imply that a painting ought to be an imitation of nature—a piece of illusion-

ism. The whole point should be rather that a good painting, like properly baked bread, is itself a part, or at least a continuation, of nature.

How can the ability to produce effective "tissue" and to make the "chemistry" work be acquired? The answer, strictly speaking, is that it cannot be acquired at all, and certainly not in any academy of painting. It is an aspect of an artist's personality and moral character: the "tissue" and "chemistry" of Renoir, for example, are Renoir himself. But Chagall does grant that a kind of ripening of sensibility may occur. "When you are young," he has said, "you are particularly sensible to form, to muscle. I had to wait until I was an old man, until after my return to Paris from the United States in 1948, to understand the importance of tissue." He thinks that what is essential is to be somehow in tune with nature, even with the cosmos: "You must feel the microbes of the universe in your belly." (It is characteristic of his thinking to prefer "microbes," in spite of the unpleasant connotations, to "atoms" or anything that would not imply living matter.) What these "microbes," these minute subdivisions of reality that, apparently, are at once matter and particles of psychic energy, happen to constitute in the outer universe is of little importance to the artist: "It can be manure or urine, no matter what, but you must feel it in your belly." Painters can be ranked according to their ability to resonate in this somewhat occult fashion: "The Douanier Rousseau really had the microbes in his belly. In this respect he was greater than even Cézanne or Monet." (pp. 14-27)

Roy McMullen, in The World of Marc Chagall, *Aldus, 1968, 267 p.*

Susan Compton (essay date 1985)

[*The following excerpt is from Compton's catalog of the major Chagall retrospective which originated at the Royal Academy of Arts in London and appeared in 1985 at Philadelphia's Museum of Art. Here, she outlines central themes in Chagall's work.*]

Throughout his life certain themes recur in the work of Chagall: the circus, lovers and peasants take their place beside more sombre themes of suffering and death. Very often, angels and animals accompany man, in his role as the mediator between God and his creation. For the themes in Chagall's art are timeless, not confined to a single epoch of history, but reminding man of the continuity of life for generation after generation, since the earliest days of recorded time. Thus his recent *Players* greet their public wearing masks from ancient art, bringing an ancient tradition into a present-day Parisian setting. Likewise, ancient gods can be found in pictures painted long ago in Paris, masquerading as cows or bulls.

Nevertheless, as Chagall himself avers, the figures in his pictures are dictated as much by the needs of the composition as by their power to convey a particular theme. In this way he breaks new ground, working on his canvas in a manner which is almost as abstract as other masters of twentieth-century art, though he does not restrict himself to the formality of their geometric shapes. But it is also possible to analyse the organisation of his compositions

using traditional art-historical terms; moreover, he has often returned to a much earlier mode of representation found in the Italian frescoes by Giotto and other masters whom he admires and, equally, in the less familiar tradition of ikon painting in Russia.

Ikons prefigure much twentieth-century art, since their pictorial space is created not so much by reference to the world which surrounds the artist, as to a world of other realities, prompted by tradition and periodically revitalised by imagination. Chagall has made great play with that compartmentalisation which is characteristic of the composition of Russian ikons, allowing the religious artist to include events, irrespective of a particular time or place, in scenes distributed over his picture surface in a unity of space in an illogical sequence. Chagall has made use of the device over and over again to convey the narrative form which many of his themes require. For instance, in *The Large Circus* the episodes are given their own coloured spaces, each incorporating its appropriate scale, so the picture can be more readily received by the viewer as a series of allusions to different times and places (in this instance, perhaps all in the mind of the artist). He has included himself, looking down on the scene with his palette, in a compartment next to a motif borrowed intact from the ikon tradition, representing as it does the hand of God. The circus theme of this painting is especially poignant and mysterious, readily illumining the words written by the artist himself:

> These clowns, bareback riders and acrobats have made themselves at home in my visions. Why? Why am I so touched by their make-up and their grimaces? With them I can move toward new horizons. Lured by their colours and make-up, I dream of painting new psychic distortions.

(Marc Chagall, *Le cirque,* New York, Pierre Matisse Gallery, 1981).

Throughout his working life, Chagall has been fascinated and entranced by the theme. One of his earliest pictures, *Village Fair,* includes a clown and acrobats: the same characters inhabit many of his most recent works. But although one could point directly to the evenings he spent at the Cirque d'Hiver with Vollard in the late 1920s (when the artist was going to make a suite of etchings on the circus), or those months in Vence (when he was invited to attend the shooting of a circus film in 1956), his clowns and acrobats, his equestriennes and musicians are clearly not a simple record of a particular time or place.

The circus has a profound relevance for the artist as a mirror of life; it is no surprise to open a 1953 edition of *The Great Fair,* the autobiography of the great Yiddish writer, Sholom Aleichem, and find a frontispiece drawn by Chagall. With a rather similar Russian-Jewish background, Sholom Aleichem explained his choice of title, by drawing an analogy between the experience of his own fifty years and a Great Fair. Chagall has seen a parallel between life and a circus, rather than a fair: 'It is a magic word, circus, a timeless dancing game where tears and smiles, the play of arms and legs take the form of a great art' [*Le cirque*].

So the artist included the theme in some of the most im-

portant works of his life: in the murals that he painted in Moscow in 1920-21; in the monumental canvas, *Revolution* that he planned in the 1930s; in *The Concert* which, twenty years later, is introduced by clowns.

In each of these instances Chagall was following the practice that he had first devised in his early years in St. Petersburg, when he painted *Village Fair.* For none of these pictures is specifically a circus, though in each of them, characters whom we can identify from the sawdust ring add a nuance to a complex subject. Using clowns and acrobats, Chagall introduces by inference a question about the complex relationship of life and art: does it simply portray a familiar world of scenes from everyday? In *Village Fair* this is invoked by the group on the balcony, merrily pouring water onto the figures below. They are watched by an enigmatic clown whose presence indicates that this is no ordinary genre scene, as does the coffin bearing a wreath, borne away to the right. These elements provoke another query: is the painting an illustration of some well-known story that we should recognise? Surely not, although Chagall has introduced an old symbol in a new guise (the figure of Death was represented traditionally in Western art as a living figure, holding a scythe. He has here shown death in the form of a coffin which is 'real' enough, as are the loved-ones left behind, but the clown and the acrobats add a note of uncertainty: they are humans whose work is to act a role in life, inviting the viewer to ponder on problems of what is real and what is not.

In contrast, in the vast canvas which Chagall painted for the foyer of the new State Kamerny Theatre in 1921, acrobats play a rather different part. They take their place alongside figures who are recognisable as the artist and the director of the theatre, with a group of musicians occupying the centre of the scene. No doubt they remind the audience of the performance which is about to take place on the stage: by its very nature, the play will ask questions about reality and illusion. However, the acrobats also commemorate the tradition of impromptu dance and tumbling, a folk-art performed informally by the Purim players each year in Vitebsk at that Jewish feast. They share the canvas with farm animals in a juxtaposition which must also have reminded the audience of the words of a fellow artist, Annenkov, who had promoted the circus as a therapeutic agent in city life, seeing it as a welcome return to the healthy and 'natural' life of the countryside, an aspect which Chagall reiterated in an amusing lithograph quoted from the mural.

When Chagall came to paint *Revolution,* another large oil-painting, he again borrowed motifs from the circus to make a telling political point. He depicted Lenin in a more fantastic manner than the acrobats standing on both hands in the mural dating from the days of the Revolution. He gave the hero an unlikely position, balancing upon one hand on a table, using the other to indicate a scene taking place on a disc like a circus ring. By this means, he likened Lenin's task of leading the people and giving freedom to the oppressed, with the delicate balance which a circus acrobat needs to maintain the fine line between comedy and tragedy.

In contrast, in 1957, Chagall used clowns to introduce his

rapturous *The Concert,* bordered by musical clowns—not now associated with the drama of death, but celebrating the initiation of new life by the couples who dominate the scene. Here the circus figures help to provide the music of the concert; they are a human counterpart to the divine figure, the David/Orpheus musician who accompanies the central lovers. Here also, the clowns bridge the gap between art and life, as well as pointing to different levels of reality suggested by the sweeping arcs of colours of contrasting pitch. In this picture, more than in any of the circus themes discussed so far, the artist has integrated his subject and his manner of execution: here his colours have as much importance as any of the musicians, clowns or lovers. The colours play an independent role, but the figures add that element of recognition which allows us to participate more fully in the scene.

Chagall is perhaps most popularly known for his theme of lovers, one that continues in his work to the present day. Indeed, some of his most recent paintings are of lovers, for instance, *Couple on a Red Background* of 1983, dedicated to a young couple whose love is symbolised by intense colour, much brighter than that of *The Concert.* It is now dazzling, with the reds heightened to a new pitch of intensity. Here, too, with a casualness which at first seems naïve—but is actually very sophisticated—he has placed his own figure in the position that we have come to expect to find a clown. He has again linked two themes, with their separate overtones of meaning. Whether in this picture the artist introduces the scene, remembered from his own youth, or alternatively stands for the vision seen by the young lover reclining on the bank, we are left free to decide; the picture evokes a stream of lovers that Chagall has invented throughout his lifetime, though here enjoying a new freedom of brushwork as well as masterly use of colour.

It was a vision of 'real' love, that love which the artist was to share with his bride Bella, which in 1915 transformed the *Lovers* imagined in Paris the year before, into the positive couple of *Birthday.* In its own way, this celebration by the lovers is equally fantastic, for their joy has levitated them from the ground. Their faces are real enough (unlike the masks of *The Lovers*), but now their position is imaginary. Yet by this device Chagall has conveyed the magic carpet of human love, borrowed perhaps from the world of the folk-tale, where the hero and heroine live happily ever after. Moreover, the story of the artist's wooing of his bride matches the conventional fairytale, for the way of true love was displeasing to Bella's parents, foremost citizens of Vitebsk. Even seventy years later, in *Couple on a Red Background* he remembered the need he had had to become a great artist, covered with glory and honour, to vindicate his marriage.

In the 1920s Chagall continued the theme with a series of paintings including the sensuous *Lovers under Lilies* where he tricks the viewer into confusing the couple with a flower vase. In *The Rooster* he plays a different game, by placing the woman astride a life-sized bird, borrowed perhaps from *Chantecler,* a play performed in Paris in 1910, which had been a *cause célèbre* (nine hundred kilos of feathers had been needed for the costumes of the actors,

dressed as life-sized inhabitants of a poultry-yard). However, Chagall indicates that he intends his *Rooster* as an allegory, by marking the background with little drawings. In this way he anticipates a device which he developed a decade later, when he painted a different type of lovers' scene, his *Madonna of the Village* begun in 1938. There the smaller figures and animals begin to contribute a much more open element of fantasy to the composition, which includes a cow and a violin.

This introduces another theme in the art of Chagall: his love of music, nowhere more movingly expressed than in the mythical *Solitude.* There the quiet meditation of the seated Jew—holding his Torah scroll as tenderly as an infant—is accompanied by the curious juxtaposition of a cow and violin. The artist has even gone so far as to place the bow across the instrument, which is tucked under the heifer's chin, as though in some illogical way she could match the profound music of the psalms, or rival the hosannas of the angel, hovering quietly above.

Chagall had himself learnt the violin as a boy and one of his uncles was a fiddler. It was that music which cheered many a Russian wedding and individual players featured in Chagall's work from the earliest time. Yet in *Solitude* the inclusion of a cow and a violin has a more precise connotation for many viewers . . . : years before in Vitebsk, by placing a cow on top of a violin, the Russian artist Malevich had attempted to clarify the a-logical approach put forward by fellow avant-garde artists as an alternative to Realism and Symbolism. By developing a kind of psychic nonsense, they had hoped to shift the mind from a predictable path onto a plane where other realms of imagination would appear as real as the reality of everyday. So the logic which had governed so much art of the past was over-ruled in order that a new art might have a more profound effect on the viewer.

In a similar vein, Chagall made unlikely juxtapositions; for instance, in *The Musician* he used a cello to double as the body of its player. But many of his a-logical pictures are not painted in an arrestingly avant-garde style, for he returned the cow and violin to a more naturalistic mode. So *Solitude* gives even more curious vibrations, for the eye accepts the convention; only the mind finds the imagery puzzling.

The violin occurs again in *Red and Black World* where the artist himself, streaming down from the disc-shape of the sun, makes the music to accompany his pair of lovers; a cow-like creature is released from its violin and offers a bouquet instead. Here, in a forceful maquette for a tapestry, the artist has finally resolved his different layers of reality and illusion by allowing his imagination to play over the entire surface, unbounded by laws of logic or pictorial convention. (pp. 14-16)

[When] music became the subject of *The Concert,* colour was allowed such a free role that it served as a kind of music in itself—a device which Chagall developed in *Music.* From the late nineteenth century, artists and writers had been fascinated by an analogy between colour and music: it was thought that the one might play on the emotions as the other. But whereas music was accepted as an

abstract art form, painting was not, so artists discussed whether colour could play an equivalent role without the need for representation. In his later paintings Chagall has given colour a controlled freedom, very like the bursts of sound from some great symphony concert, but his colour additionally denotes the figures of musicians themselves.

It would be a mistake to give the impression that Chagall's themes were always lighthearted. . . . [His] art is equally imbued with seriousness and even tragedy. Nowhere better is this revealed than in his many depictions of a crucifixion. For generations growing up with the trivialisation of agony, agony repeated over and over as it happens, relayed on the small screen in the living-room, Chagall recreates an individual pain which each person conceals even from himself. He has not shunned placing himself on the canvas on a cross, where, in *In Front of the Picture* he marries the theme of suffering with the theme of love. Although that picture superficially records his personal experience, the deliberate pairing of the two themes has a wider religious interpretation: from the time of the Prophets, Israel has been likened to the Bride of God; God's people have for the most part rejected that precise symbol of suffering, Jesus crucified. Chagall places his own parents next to his figure on the cross, as though reinforcing an interpretation of the Crucified as human, like himself.

Chagall sees the Cross, that potent symbol of suffering, not as a symbol belonging only to Christians, but as the inheritance of all descendants of the Jewish Jesus. Nowhere is this more forcefully stated than in *Exodus,* in which the crucified figure dominates a tableau of figures from the Old Testament, balanced by scenes from the history of this century. Many people of the Jewish faith find his use of the Crucifixion profoundly disturbing. Likewise, Christians wonder at the profundity of thought and understanding which allows this artist of Jewish upbringing to juxtapose imagery which they have always received as a Christian interpretation of the history of Israel.

The misunderstanding of Chagall's position—which, today, he explains by his reluctance to be bound by any single set of religious beliefs—has surely arisen in part because of an early feature of his Russian background. This is set out in a revealing article by the Israeli scholar, Ziva Amishai-Maisels. . . . She gives a reminder that the most important sculptor in Russia at the turn of the century was a Jew, Mark Antokolsky, whose letters were published posthumously in St Petersburg in 1905; they contain a frank and considered exposition of how he was able to reconcile two conflicting religious viewpoints, the Jewish and the Christian. Antokolsky accepted Jesus in the line of biblical prophets, as one whose teaching was apt, not simply for the times in which he lived, but also for our own. He welcomed that love which was, he felt, displayed at its highest in this figure, believing that the followers of Jesus had distorted his teaching and turned it into that Christian religion which he could not accept. When Chagall was studying in St Petersburg, it was hoped by his enlightened Jewish patrons that he, too, would become a second Antokolsky a hope that was expressed each time a young art student showed signs of promise. But in this case, it is even possible that Moshe Shagal gladly took the name of Marc

Chagall on account of that well-known sculptor who had reached the heights of fame, then open to so few Jewish artists in Russia.

None the less, beyond drawing attention to the precedent, it would be misleading to suggest that Chagall followed in the footsteps of the nineteenth-century sculptor: to begin with, the name of Antokolsky is little-known outside Russia and his art is not of international significance. In contrast, Chagall has enlarged and enriched the field of religious art in this century and, by accepting commissions for stained glass in Christian churches, he has carried his own vital interpretation of the Biblical Message beyond the restrictions of any one location. Furthermore, by his astonishing conception of the Prophets and his technical invention in using the huge areas of, for example, the windows in the Fraumünster in Zurich, he draws countless visitors who, through him, gain a remarkable religious experience.

On another scale entirely, in All Saints' Church at Tudeley in Kent, the Russian-Jew of French nationality gives way to the man with a unique message for all God-seeking people in our times. The windows for that church show the way Chagall has married the peaceful countryside without to the worshipping congregation within, by using a sonorous blue as a paradigm of a summer sky and filling the branches of trees with the presence of the angels of God. The east window there may seem the most Christian Crucifixion that the artist has made: it is a memorial to the accidental death of a girl, whose soul rises in successive states past the crucified figure above. Yet although it seems to confirm a vision of the resurrection of man—the ascension of an individual following the story of Elijah [as in *The Flying Carriage*]—it would be mistaken to see the imagery of this window as signifying the Christian view of the Resurrection of Christ. Nowhere in the art of Chagall is this implied or set out; rather, in each of his crucifixions, the cross is partnered by a ladder—a traditional symbol found especially in folk-art to be interpreted as a bridge between man and God. The ladder is, of course, seen entirely in that light in the story of the *Dream of Jacob* which Chagall has used for stained glass and in illustrations for the Bible; it has also inspired his poetry.

Since the 1930s Chagall has visualised the Old Testament, thereby, as he would see it, remedying the lack of a visual tradition hitherto developed by Jewish artists. But his earliest religious subjects were treated in a very different way: for instance, *The Family; or, Maternity* has been recognised as a Jewish 'in-joke' in the catalogue entry. When he first drew a Crucifixion he represented Jesus like an old man, closely related to the type of a popular French woodcut from the early nineteenth century. When he came to paint the subject, he replaced the old man by a child [in *Calvary*], because, as he said later, he wanted to get away from the tradition of Russian ikons. Nevertheless, it was that tradition—as has been said above—which allowed him to paint *White Crucifixion* in the tense political climate of the 1930s.

That masterpiece gives a fine instance of how Chagall's earlier approach to *Calvary*—with its multiple references to different cultures—gave way to a sober confrontation.

But in **White Crucifixion** there is an unexpected 'secret' reference to a classic Hasidic story, 'The Burning of the Torah'. Near the bottom right the unwound Torah scroll has white light streaming from it: once, when a bishop tried to burn the sacred writings of the Jews, the mighty prayers of Rabbi Israel went to the palace of the Messiah; the bishop thereupon fell in a fit, frightening all the others who had been intending to burn the Torah scrolls. Chagall's white light, symbolising the power of the Word of God, is traversed by a green-clad figure with a bundle, the Elijah from **Over Vitebsk,** who comes back to help his people in times of trouble. This figure is a favourite of Chagall: he is seen on the easel in the frontispiece for *The Great Fair,* in the centre of **War** and even in the **Dream of Jacob** window, although he is clearer in the maquette. He is so vividly portrayed that he brings alive Chagall's childhood expectation of seeing Elijah each year at the Passover seder.

Chagall has said: 'If a painter is Jewish and paints life, how can there help being Jewish elements in his work! But if he is a good painter, there will be more than that. The Jewish element will be there but his art will tend to approach the universal' (to S. Putnam, when asked about the Jewish sources in his art). Twenty-five years after these words were published (by A. Werner in 'Chagall in the Anglo-Saxon World', *Jewish Book Annual,* 1958), the universal nature of Chagall's art is even clearer than it was then. This is because, in addition to extending the religious theme (in the ways outlined above), he has dedicated major works to the great myths of the classical tradition. Early on in Paris, his choice of **Orpheus** can be seen in the context of the current art movement, Orphism, but in 1977 **The Myth of Orpheus** is a far more complex work. Here Chagall has alluded to an ancient parable of life and death, which he has seen as a pictorial conundrum: the juxtaposition of figures with abstract forms and colour. Whereas he often cuts out shapes and adds them to sketches for stained glass as an indication of colour intensity, here he paints the shapes, which double as figuration in the work. Thus he approaches the universal in his theme with full awareness of the possibilities open to the artist of today. On a huge scale and with consummate skill he has captured **The Fall of Icarus,** making a parable for the space age as well as pointing to an ancient dilemma of man's folly and ambition.

It must be clear from these pages that themes in Chagall's art cover a wider range than in the work of most twentieth-century artists, but, in spite of the fascination of following from one to another throughout his long life, it is finally the works themselves that must reveal to the viewer his joy in painting, in marking the surface, which shines triumphantly through his intensely human works. (pp. 16-19)

> *Susan Compton, in her* Chagall, *Harry N. Abrams, Inc., 1985, 278 p.*

Hilton Kramer (essay date 1985)

[*An acclaimed American art critic, Kramer is best known for his collection of critical essays* The Age of the Avant-Garde: An Art Chronicle of 1956-1972 *(1973). His writings are praised for their thorough scholarship and enthusiasm, although occasionally criticized for avoiding a definable ideological stance. Kramer has also contributed to and served as an editor of numerous contemporary art journals. In the following excerpt from a review of the 1985 retrospective, he contrasts Chagall's early and later artwork, questioning his status as a major figure of twentieth-century art.*]

It was inevitable, perhaps, that the headline on *The New York Times*'s front-page obituary of Marc Chagall would describe him as "One of Modern Art's Giants." This was the status which the press had routinely conferred upon the artist for as long as anyone could remember, and it would have been churlish—if not something worse—to deny him this outsize claim on the occasion of his death at the age of ninety-seven. It may, after all, have been one of the last occasions on which the claim could be made without risking ridicule. Posterity, which can always be counted on to observe a different code of etiquette in regard to fame of this sort, is unlikely to be so kind.

Yet if Chagall was never exactly the towering "giant" which his admirers had long taken him to be, he was certainly a better painter and a more interesting artist than his detractors—who were also numerous—were generally willing to grant. It was in fact Chagall's reputation as a "giant" which came more and more to act as an obstacle to any clear understanding of his achievement. To that reputation he owed the large decorative commissions of his later years—commissions which proved, in all too many cases, to be unmitigated aesthetic disasters, and which had the effect of making the artist an object of contempt for anyone capable of distinguishing artistic quality from its meretricious counterfeit. The generation that knows Chagall primarily as the author of those ghastly murals at the Metropolitan Opera in New York, for example, can easily be forgiven for regarding him as something of a hack. It was New York's misfortune—and not only New York's, of course—that such commissions came to Chagall when he was no longer in a position to do them justice, and it was Chagall's misfortune that they came to loom so large in the public's perception of his gifts.

But there is another Chagall, as we know. He is a smaller and more distant figure, to be sure, than the hyped-up colossus who, in the last three decades of his life (when his artistic powers were clearly on the wane), became a kind of mascot of government agencies, cultural bureaucrats, and religious publicists the world over; but this figure is a more authentic one. And it is to him that we must turn if we are to recover a sense of the artist's special quality and power. In this other Chagall—the young and vigorous artist who had made his way from the provincial backwater of Vitebsk to the cosmopolitan art worlds of St. Petersburg and Paris in the first decade of the century—we shall find the originals, so to speak, from which all those later counterfeits were made and remade with such an easy, dispiriting fluency. We shall find something else as well—an artist of far narrower and more intensely inward interests than could ever be suspected from the anodyne public symbols and universalist sentiment which made the deco-

rative projects of the later years so appealing, so popular, and so empty.

By a happy stroke of timing, the retrospective exhibition needed for the recovery of this more interesting and authentic Chagall was already in place at the time of his death on March 28. Organized by Susan Compton at the Royal Academy of Arts in London, where I saw it in March, the exhibition goes on view this month at the Philadelphia Museum of Art—its only American showing. While it is anything but complete—particularly in the way it scants, for example, the artist's immense graphic oeuvre, where some of the best of his later work is likely to be found—this exhibition is at once a fitting memorial to Chagall and something of a milestone in itself. Dr. Compton is a specialist in modern Russian art. She thus brings to this exhibition precisely the perspective which in the past has so often been missing from the study of Chagall's art—a perspective which places the artist and his work firmly in the context of the Russian cultural milieu which exerted so great an influence on his artistic outlook. Much has been made—and properly made—of Chagall's life as a Jew, of course, and Dr. Compton does not neglect this crucial element in the artist's identity and in the subject matter of his art. But even this crucial matter is not easily separable from the Russian context, and it is especially to the illumination of the latter that Dr. Compton makes an important contribution. Hers is, I believe, the first major Chagall exhibition to give this subject its due. The essay Dr. Compton has written on "The Russian Background" for the catalogue of the exhibition, together with some of the detailed commentaries on individual paintings, adds a great deal to our understanding of the oeuvre as a whole. In the end we are fully persuaded that in some important respects "the Russian Chagall," as Dr. Compton writes, "takes precedence over the adoptive Frenchman, or even the Jew."

It certainly alters our view of the young Chagall to be made aware, as we are on this occasion, that until 1922, when the artist was thirty-five years old and had already produced the bulk of the work likely to retain a place among the classics of twentieth-century art, he had spent a total of less than four years outside his native Russia. For the better part of those four years (1910-1914) he was in Paris, and, as everyone knows, his encounter with the Paris avant-garde brought decisive and permanent changes in his painting. Yet even in this pivotal stage of Chagall's development he tended, not surprisingly, to frequent a distinctly Russian milieu—and this, in turn, had very specific consequences for both his art and his life. . . . It wasn't until 1923 that Chagall settled in France, and even then the first task he undertook on his return to Paris was to produce a series of etchings based on Gogol's *Dead Souls*.

Thus, the crucial turn in Chagall's life and work occurs not—as we have tended in the past to believe—in 1910, when he goes to Paris for the first time, but in 1922 when he uproots himself from his native Russia for the last time. From 1923 onward Chagall is a different kind of artist—an artist adrift in a dream of the past. There is even something apt in the choice of Gogol as the author he illustrat-

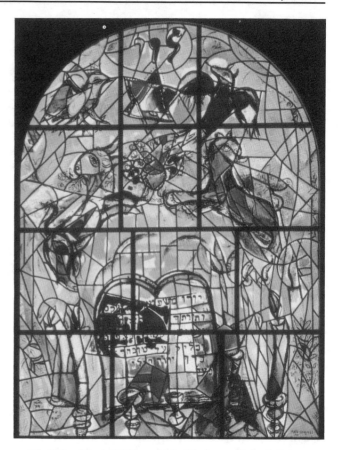

The Tribe of Levi *(1961), one of the Windows at Hadassh-Hebrew University.*

ed at this important juncture in his life, for not only does Chagall at that moment take leave of the present in order to find refuge in the past but there is a sense in which it can be said that he, too, now turns to trafficking in dead souls. The present is never again quite as real for Chagall as it was before 1922. Perhaps another way of saying this is that from this time onward he severs his connection with history. Thereafter, like those floating figures who now become so ubiquitous in his paintings—is this, perhaps, their real meaning?—he quits the realm of earthly events to enter a world of timeless and homeless archetypes, which, the further removed from real experience they become, the more they succumb to an unalloyed sentimentality. After his exit from Russia—which was also, it is worth recalling, his exit from the Revolution he served as an artist and a commissar—Chagall made some periodic attempts to re-attach his art to the realm of historical experience, most notably in the paintings he produced in 1944 as a response to the Holocaust. But by then it was too late. He no longer possessed the means of bringing that effort to an effective realization. In a sense he never touched earth again.

The difference between this "floating" Chagall, aloft in a world of increasingly unreal archetypes, and the young artist who preceded him is so striking and definitive that in the exhibition at the Royal Academy, where each period was afforded a separate gallery, one had the sensation

of encountering the work of a quite alien personality as soon as one entered the third gallery, devoted to "France 1923-41." In the first two galleries, given over respectively to "St. Petersburg 1907-10 and Paris 1910-14" and "Russia and Berlin 1914-22," one saw an artist vibrant in his response to the diverse worlds he inhabited, an artist keenly observant of both familiar surroundings and new experiences, and eager to provide a vivid account of them in his painting. At the same time, it is painting itself that is clearly the most highly charged area of experience for this young artist. The intensity of Chagall's engagement with his medium is there in the earliest pictures—those dark and melancholy portraits and genre scenes, painted in St. Petersburg in 1908-1910, which have nothing of the light, the clarity, or the complexity that came into his art once he immersed himself in the Paris art scene, but which sing, all the same, with a vitality and tenderness that remain irresistible. They are the pictures of a young man for whom painting has become the central experience of life.

This headlong engagement is further intensified and brought to maturity in the pictures which Chagall produced with such dizzying speed and confidence in that first encounter with the Paris avant-garde. Let us remember that he was twenty-three years old when he arrived in Paris in the fall of 1910, and scarcely twenty-five when he painted *Half-Past Three (The Poet)*, *Homage to Apollinaire*, *The Soldier Drinks*, *I and the Village*, and *The Cattle Dealer*—his first masterpieces and almost his last. His entire experience until this time had been that of a Northerner, nurtured on the long, dark, snowbound ordeals of the Russian winter and the white nights of the Northern summer—a climate that is the natural habitat for the kind of introspective and melancholic expressionism that characterized the paintings of the St. Petersburg period. Upon a Northern sensibility of this sort we naturally expect the impact of Paris to have had the customary salutary effect—which it did, of course, but not always in the ways that might have been predicted. Chagall does not at this time become what Dr. Compton calls an "adoptive Frenchman." That was a development which came later, in the Twenties, when his art was already in decline. In this first Paris period Chagall's painting becomes, if anything, more deeply entrenched than ever in exploring his memories of Russia. Despite the Paris-from-my-window motif—a theme probably traceable to the influence of Robert Delaunay and never, in any case, a major one for Chagall—France remains a largely unrecorded experience in his painting. It never takes possession of his soul. What consumes his imagination is the life he left behind in Russia. What Paris gives him is a new way of encompassing that life in his painting.

Except in the case of Cendrars, for whom he always retained a tender and grateful memory, Chagall was notoriously ungenerous in acknowledging the influences—especially the avant-garde influences—which shaped his painting at a crucial stage of its development. Cubism, for example, he was later in the habit of mocking. Yet it was from Cubism that he derived the syntax of his greatest paintings. The entire design of a picture such as *Half-Past Three (The Poet)* (1911) is unimaginable without that syntax, and so is the modeling of the face and the hands in

The Soldier Drinks (1911-12). The whole subject is really beyond argument. The hard, crystalline quality of the forms in Chagall's painting, together with their transparency—which has the effect of radiating an inner light—and the discipline of their control, all this owes everything to Cubist precedents, and it is nonsense to claim otherwise. The precedents in question might have been Le Fauconnier's and Delaunay's rather than Picasso's or Braque's—as Norbert Lynton suggests in his essay for the catalogue—but that is a subsidiary issue. Cubism of one sort or another is central to Chagall's pictures in this period.

The question of Chagall's color, which also becomes an important element in his painting for the first time in this period, is less easily resolved. Fauvism is often claimed as the principal influence on Chagall's use of color, and it would be foolish to deny that Fauvist color played some role in the formation of his style. After all, it affected virtually every painter who followed closely in the wake of Matisse's chromatic audacities. Yet the fact remains that Chagall's color isn't really Fauvist in quality. Mr. Lynton shifts the emphasis in claiming that "it is primarily and specifically Delaunay from whom [Chagall] learnt the art of . . . using colour not just brightly (after his often dark Russian paintings) but also lightly, strong enough to give sensations of light but also transparently, freshly, so that light seems to come through the canvas as well as from it." This too is not to be denied. Yet it doesn't solve the problem, for Chagall's color isn't really Delaunay's either.

It seems to me there is a specifically Russian quality to Chagall's color that is not accounted for in these explanations. No doubt Fauvism—and Delaunay, too—taught Chagall much about the *importance* of color, but they would appear to have contributed little to the particular *quality* of the color he came to use. My own hunch is that the key is to be found in Post-Impressionist color (Gauguin especially) as it was adapted to Russian taste by Bakst, Chagall's teacher in St. Petersburg. There is a nocturnal, artificial, theatrical quality to Chagall's color we do not find in Matisse or Delaunay—but it is pervasive in Russian painting of this period. It is color which has almost nothing of the sun in it—it is interior and mystical, it has more to do with lamplight and memory than with the sun-drenched color of the French landscape or cityscape. It is color which has virtually nothing to do with natural light—color which therefore easily lends itself to illuminating the scenery of dreams. This, it seems to me, is its real function in Chagall's painting—to serve the interests of a dreamlike narrative.

Chagall was very touchy on the subject of "literary" painting. In Paris he was often said to be a literary painter—a "poet"—and he knew very well that in the avant-garde climate of the time, it was anything but a compliment. He was thus much concerned to deny the narrative character of his best paintings. But his was surely a tactical maneuver designed to outflank his "purist" critics. He could scarcely have believed it himself, for his whole conception of painting then and thereafter was inseparable from the narrative mode. It was indeed the narrative character of his painting which survived the loss of so much else when

Chagall's whole pictorial enterprise began to come apart in the Twenties. Alas, it was what accounted in large part for his prodigious success when all else was gone.

It would be a mistake, however, to base our judgment of the narrative element in Chagall on his later, quite shameless exploitations of it. In the paintings of his first Paris period it is his highly imaginative use of the narrative mode that accounts for what is most truly original in the work. That he felt compelled to deny the very source of his own originality tells us something about the real relation in which Chagall stood to the world of "advanced" art in pre-1914 Paris—it was, in fact, an extremely tenuous relation—but it does nothing to alter the centrality of the narrative mode in his own art.

The narrative element continued to be a source of strength in the paintings Chagall produced when he returned to Vitebsk in 1914. But the ground shifted for the artist once he left behind the heady atmosphere of the Paris avant-garde, and his art changed, too. In important respects, it drew back even further from the radicalism of the avant-garde.

Chagall had journeyed to Berlin in the summer of 1914 for the opening of his one-man show at the Sturm gallery. From there he travelled to Vitebsk to see his family and the girl he hoped to marry (and whom he did marry the following year)—his beloved Bella. If it was the coming of the First World War that at first prevented Chagall from returning to Paris, it was no doubt the Revolution that kept him in Russia after 1917. For the Revolution, which he welcomed with enthusiasm, made him a power in the new Soviet art world. In 1918 he was named Commissar of Art for Vitebsk and the surrounding region. He presided over a museum, an art school, and theater production. By 1920-21, moreover, he was also designing productions for the new State Kamerny Theater in Moscow. It was to the Revolution that Chagall owed his emergence as a "public" artist.

But the power and position which he now enjoyed were anything but secure. In art matters, no less than in other realms of revolutionary ideology, factionalism abounded, competition for preferment was fierce, and the debates often acrimonious. The avant-garde was given unprecedented authority under Lunacharsky's short-lived reign as Commissar of Education, but did Chagall really qualify as a member of this new avant-garde? There were important figures in the expanding Soviet art establishment who thought not. In a cultural milieu that came more and more to look upon a doctrinaire commitment to abstraction as a test of revolutionary orthodoxy, Chagall's figurative paintings—which were even more avowedly figurative than thitherto—looked old-fashioned, a throwback, perhaps, to the despised bourgeois era. There were plots and intrigues and bureaucratic squabbles. Malevich, the leader of the Suprematists, was dispatched to Vitebsk to assist Chagall in his duties. There was a power struggle, and Chagall lost out. Whenever, years hence, Chagall could be heard denouncing abstract art, one could be reasonably certain that it was the power struggle with Malevich and his gang he had in the back of his mind.

Chagall's own paintings in this period are of several kinds. The best of them—*The Birthday* (1915), for example—continue very much in the narrative Cubist vein he developed in Paris. But joining these pictures now are others, like *David in Profile* (1914), a portrait of his brother, that are more studiedly objective in style—they resemble, in fact, some of the portraits that emerged from the New Objectivity movement in Germany in the Twenties. In still others, of which the marvelous *Bella with a White Collar* (1917) is the outstanding example, the narrative and objective modes are combined. There is also in these years a more concentrated interest in Jewish themes. Chagall's religious outlook does not succumb to the facile universalism he made famous in later years until he quits the scene of his childhood associations and family connections.

There are ample signs, even in this second Russian period, that Chagall had lost a certain sense of direction in his painting. The really achieved paintings come less often now and are less consistent in their strengths than the paintings he produced in Paris before 1914. But he remains recognizably the same artist who produced those earlier masterpieces.

What happened to that artist once he had left Russia for the last time is really terrible to behold. As one made one's way around the remaining galleries at the Royal Academy, the descent into banality, ineptitude, and a facile, repetitious attitudinizing was rapid and unremitting. Chagall had never been a leader of artistic thought, but he had once been a painter of authentic feeling and original vision. From the early Twenties onward, all that was over. He became an artist attached to nothing more profound than his facility and his fame. Although from time to time he still attempted the gravest subjects—as in *The Revolution* (1937) and *White Crucifixion* (1938)—he was no longer equal to them. Longevity conspired with a ghastly fluency to produce a mountainous oeuvre of clichés.

This is not, of course, Dr. Compton's view of the matter. She speaks of Chagall as "the greatest religious artist of our times." She doesn't, however, attempt to make a case for this extraordinary claim, and indeed, no very clear account of Chagall's religious beliefs is adduced to support it. Perhaps it is just another way of giving the artist the status of a "giant" without having to defend the claim on purely artistic grounds. Norbert Lynton is likewise much occupied with Chagall's role as a religious artist. What he offers us is a wildly misconceived rumination in which Chagall's putative religious outlook is compared with that of Mark Rothko and Barnett Newman. It would be hard to think of a less rewarding line of inquiry into the "meaning" of twentieth-century painting than this one, which carries the whole subject straight into the realm of absurdity. Which is where, I think, it is destined to remain if we insist on regarding Chagall—or, for that matter, either Rothko or Newman—as a significant figure in religious art or thought.

Implicit—but unacknowledged—in this attempt to confer a kind of religio-aesthetic sainthood on Chagall is a realization that on artistic grounds alone there is little to defend or reclaim in the long stretch of years that reaches from the early Twenties to the artist's death in 1985. The

picture would not be quite so bleak, perhaps, if the best of Chagall's graphic art had been included in this retrospective—but that is probably material for another exhibition.

It was Marc Chagall's tragedy to become, early on in his long career, an artist orphaned by history. It is not for us to pretend that this tragedy had a happy ending. (pp. 1-6)

Hilton Kramer, "Marc Chagall 1887-1985," in The New Criterion, *Vol. III, No. 9, May, 1985, pp. 1-6.*

FURTHER READING

I. Writings by Chagall

"The Artist." In *The Works of the Mind,* edited by Robert B. Heywood, pp. 21-38. Chicago: University of Chicago Press, 1947.

> Offers a transcription of Chagall's 1946 lecture to the Committee on Social Thought at the University of Chicago in which the artist expounds on currents in early twentieth-century art and defines his aesthetic objectives.

My Life. Translated by Elisabeth Abbott. New York: Orion Press, 1960, 173 p.

> Translation of Chagall's autobiography which was completed in 1922 and covers the first 35 years of his life. Includes illustrations by the artist.

"Why Have We Become So Anxious?" In *Bridges of Human Understanding,* edited by John Nef, pp. 115-20. New York: University Publishers, 1964.

> Transcript of a 1963 lecture by Chagall at the Center for Human Understanding of the University of Chicago in which the artist asserts the redemptive potential of art in modern existence.

II. Interviews

Goldwater, Robert, and Treves, Marco. "Marc Chagall: A Recorded Interview." In their *Artists on Art: From the XIV to the XX Century,* pp. 432-34. 1945. Reprint. New York: Pantheon Books, 1964.

> Offers a statement by Chagall outlining the role of anecdote and fantasy in his work and explaining his concept of plasticity.

Roditi, Edouard. "Marc Chagall." In his *Dialogues on Art,* pp. 16-38. London: Secker & Warburg, 1960.

> Contains autobiographical and aesthetic commentary by Chagall.

Verdet, André. *Chagall's World: Reflections from the Mediterranean.* Garden City, N.Y.: Dial Press/Doubleday & Co., 1984, 124 p.

> Focuses on Chagall's later works created in his studios in Southern France. The book features an extensive interview with Chagall, in which he elaborates on his aesthetic objectives, and includes an introduction and essays by Verdet addressing Chagall's works that treat bib-

lical subjects, his mosaics, and the depiction of animals in his paintings.

III. Biographies

Alexander, Sidney. *Marc Chagall: An Intimate Biography.* New York: Paragon House, 1978, 526 p.

> Based on numerous interviews with Chagall's friends, acquaintances, relatives, and fellow artists.

Chagall, Bella. *First Encounter.* Translated by Barbara Bray. New York: Schocken Books, 1983, 348 p.

> Collects autobiographical narratives by Chagall's first wife—including *Burning Lights* and *First Encounter*—that contain biographical information on and illustrations by the artist.

Crespelle, Jean-Paul. *Chagall.* Translated by Benita Eisler. New York: Coward-McCann, 1970, 287 p.

> Provides substantial biographical and historical background of Chagall's life and career in a translation of *Chagall: L'amour, le rêve et la vie* (1969).

Greenfeld, Howard. *Marc Chagall.* Chicago: Follett Publishing Co., 1967, 192 p.

> Informal narrative of the artist's life, featuring color and black-and-white reproductions of Chagall's paintings and etchings.

Haggard, Virginia. *My Life with Chagall: Seven Years of Plenty with the Master as Told by the Woman Who Shared Them.* New York: Donald I. Fine, 1986, 190 p.

> Contains substantial insight into Chagall's life, aesthetics, and technique, as well as his views of contemporaries such as Pablo Picasso and Henri Matisse, focusing especially on the years 1945-1952, when Haggard lived with Chagall as his companion.

IV. Critical Studies and Reviews

Breton, André. "Artistic Genius and Perspective of Surrealism." In his *Surrealism and Painting,* translated by Simon Watson Taylor, pp. 49-82. New York: Harper & Row, 1972.

> Contains Breton's famous statement of 1941 in which he claims that Chagall was an early practitioner of Surrealist methods and judges his work "the most resolutely magical of all time."

Brion, Marcel. *Marc Chagall.* Translated by A. H. N. Molesworth. London: Oldbourne Press, 1960, 85 p.

> Surveys Chagall's life, technique, and the themes of his work, offering thirty-four small-format color reproductions of his paintings.

Bucci, Mario. *Twentieth-Century Masters: Chagall.* London: Hamlyn, 1971, 94 p.

> Presents biographical and critical commentary on Chagall's career through the 1950s, thirty-five black-and-white and thirty-seven color reproductions of his works, and a bibliography.

Coates, Robert M. "Marc Chagall." *The New Yorker* XXII, No. 10 (20 April 1946): 72-3.

> Reviews the 1946 retrospective exhibition jointly organized by New York's Museum of Modern Art and the Chicago Institute of Art, providing an overview of Chagall's career.

Daix, Pierre. "The Miracle of Chagall." *ARTnews* 83, No. 8 (October 1984): 118, 121.

Favorably reviews Chagall's earlier paintings exhibited in Saint-Paul-de-Vence and his works on paper which appeared at the Pompidou Center in Paris.

Danto, Arthur C. "Marc Chagall." *The Nation,* New York 241, No. 1 (6-13 July 1985): 22-5.
Reviews the retrospective organized by London's Royal Academy of Arts and appearing at Philadelphia's Museum of Art. Danto praises Chagall's earlier artwork, and suggests that most of his paintings created after World War II appear repetitive and shallow.

Duchen, Monica Bohm. "Religion and Marc Chagall." *Art & Artist,* No. 220 (January 1985): 18-21.
Focuses on the relation of Chagall's art to the Jewish culture of his youth and to both Jewish and Christian religion.

Frankfurter, Alfred M. "The Daring Chagall." *ARTnews* XLV, No. 3 (May 1946): 24-5, 72.
Lauds the 1946 retrospective, paralleling the themes of Chagall's works with those of the poetry and dramas of Armenian-American author William Saroyan.

Friedman, Mira. "Metamorphoses in Chagall: The Creation of Man." In *Norms and Variations in Art: Essays in Honour of Moshe Barasch,* edited by Lawrence Besserman, pp. 260-76. Jerusalem: Magnes Press/Jerusalem University, 1983.
Examines Chagall's adaptation of iconographic and formal elements in his portrayal of biblical themes as reflected in representative drawings, etchings, and paintings.

Greenberg, Clement. "Chagall." *Commentary* 23, No. 3 (March 1957): 290-92.
Praises Chagall as a graphic artist in a review of his *Illustrations for the Bible* and of Lionello Venturi's study of the artist (see below).

Hodin, J. P. "Marc Chagall: In Search of the Primary Sources of Inspiration." In his *The Dilemma of Being Modern: Essays on Art and Literature,* pp. 42-50. London: Routledge & Kegan Paul, 1956.
Recounts a visit with Chagall in Orgeval, featuring discussions with the artist on modern art and on his own work.

Kapos, Martha. "Chagall and Figurative Painting." *Artscribe* 52 (May-June 1985): 30-3.
Examines the imagery and style of Chagall's paintings as they reflect postmodernism in art and suggest the role of the self in artistic expression.

Kloomok, Isaac. *Marc Chagall: His Life and Work.* New York: Philosophical Library, 1951, 119 p.
Features Kloomok's essay, "Chagall's Place in Modern Art," his remarks on Chagall's life and on individual works, and thirty-four black-and-white reproductions of Chagall's works created between 1909 and 1950.

Kramer, Hilton. "Chagall." In his *The Age of the Avant-Garde: An Art Chronicle of 1956-1972,* pp. 223-29. New York: Farrar, Straus and Giroux, 1973.
Focuses on Chagall as a Jewish artist within the School of Paris and surveys his early career.

Kuh, Katharine. "Marc Chagall." *Bulletin of the Art Institute of Chicago* XL, No. 7 (December 1946): 86-92.

Outlines the media and characteristics of Chagall's oeuvre in a review of the 1946 retrospective.

Lake, Carlton. "Artist at Work: Marc Chagall." *Atlantic Monthly* 212, No. 1 (July 1963): 85-90, 95-112.
Recollects extensive on-site conversations with Chagall during the creation of his stained glass works in the cathedral of Reims.

Lozowick, Louis. "Chagall's 'Circus'." *Theatre Arts Monthly* XIII, No. 8 (August 1929): 593-601.
Favorably evaluates "The Circus," an unfinished series of gouaches.

Mosby, Aline. "Chagall at 90: 'When You Have Love, You Work. That Is My Life'." *ARTnews* 76, No. 6 (Summer 1977): 44-8.
Quotes from a personal interview with Chagall on his life and aesthetics, and offers biographical background.

Neumann, Erich. "Chagall and the Bible." In his *Essays of Erich Neumann, Vol. 2: Creative Man,* translated by Eugene Rolfe, pp. 113-37. Princeton: Princeton University Press, 1979.
Translates a 1958 essay in which Neumann discusses Chagall's depiction of biblical figures and images in his illustrations for the Bible.

Roditi, Edouard. "Chagall's Windows." *Commentary* 33, No. 2 (February 1962): 152-54.
Discusses Chagall's stained glass works in Jerusalem within the context of Jewish devotional art.

Schneider, Daniel E. "A Psychoanalytic Approach to the Painting of Marc Chagall." *College Art Journal* VI, No. 2 (Winter 1946): 115-24.
Applies psychoanalytical theories of Freud to interpret Chagall's personality through images and motifs in his works.

Shneiderman, S. L. "Chagall: Torn?" *Midstream* XXIII, No. 6 (June-July 1977): 49-62.
Suggests that a conflict between Judaism and Christianity informs Chagall's life and art, tracing in particular his depiction of the crucifixion in his work.

Spencer, Charles S. "Vitebsk to Vence: Chagall's Pilgrimage." *Studio International* 168, No. 860 (September 1964): 256-61.
Discussion of Chagall's work based on a conversation with the artist.

Sweeney, James Johnson. *Marc Chagall.* New York: Museum of Modern Art/Art Institute of Chicago, 1946, 102 p.
Catalog of the retrospective including a biographical and critical essay by Sweeney, a discussion of Chagall's prints by Carl O. Schniewind, numerous reproductions, and a bibliography.

Underhill, Elizabeth. "Marc Chagall Prints, 1922-1927." *Print Quarterly* I, No. 4 (December 1984): 272-76.
Addresses Chagall's career as a graphic artist, focusing particularly on the illustrations he created for his *My Life* and for Nikolai Gogol's *Dead Souls.*

Venturi, Lionello. *Marc Chagall.* New York: Pierre Matisse Editions, 1945, 47 p.
Provides biographical and critical commentary on Chagall's career through 1944 and a chronologically arranged bibliography, as well as illustrations by the artist

and sixty-four black-and-white reproductions of his paintings.

Weisstein, Allyn. "Iconography of Chagall." *The Kenyon Review* XVI, No. 1 (Winter 1954): 38-48.
Suggests biographical and historical sources for the images and subjects of Chagall's paintings.

Werner, Alfred. "Marc Chagall: Painter of Love." *Free World* 11, No. 4 (April 1946): 42-6.
Stresses Chagall's affection for subjects from his native land and his Jewish background as influences on his work, quoting frequently from conversations with Chagall.

————. "Chagall's Jerusalem Windows." *The Art Journal* XXI, No. 4 (Summer 1962): 224-32.
Transcript of a lecture delivered at New York's Museum of Modern Art during a traveling exhibition of Chagall's *Jerusalem Windows.* Werner discusses the history, themes, and technique of the stained glass works.

Wernick, Robert. "In His Tenth Decade Marc Chagall's Brush Still Danced." *Smithsonian* 16, No. 2 (May 1985): 67-77.
Obituary tribute surveying Chagall's career.

V. Selected Sources of Reproductions

Ayrton, Michael. *The Pitman Gallery: Chagall.* New York: Pitman Publishing, 1950, 24 p.
Presents ten large-format color plates and an introduction by Ayrton tracing Chagall's career and aesthetics through the 1940s.

Compton, Susan. *Chagall.* New York: Harry N. Abrams, 1985, 278 p.
Contains color and black-and-white reproductions. The book also offers a discussion by Norbert Lynton of Chagall's painting in relation to the aesthetics of his contemporaries, and essays by Compton on Chagall's Russian background and on the themes of his works (excerpted above).

Erben, Walter. *Marc Chagall.* Translated by Michael Bullock. London: Thames and Hudson, 1957, 158 p. + 64 plates.
Offers twelve color plates and sixty-four black-and-white reproductions, with a discussion of Chagall's career through 1956 by Erben.

Haftmann, Werner. *Marc Chagall.* Translated by Heinrich Baumann and Alexis Brown. New York: Harry N. Abrams, 1973, 162 p.
Features forty-eight color plates and numerous black-and-white reproductions of Chagall's work in virtually every medium of his career and provides a critical introduction and relevant commentary by Haftmann.

Kagan, Andrew. *Marc Chagall.* New York: Abbeville Press, 1989, 128 p.
Includes small-format color reproductions of Chagall's work in numerous media and critical and biographical commentary by Kagan. The discussion of Chagall's late career is excerpted above.

Lassaigne, Jacques. *Marc Chagall: The Ceiling of the Paris Opera.* Translated by Brenda Gilchrist. New York: Frederick A. Praeger, 1966, 85 p.

Contains large-format color reproductions of the Paris Opera ceiling paintings by Chagall, their preparatory sketches, and a fold-out reproduction of the ceiling's final study. The book also presents an introduction by Lassaigne and a transcript of Chagall's address to the opera.

————. *Chagall: Unpublished Drawings.* Geneva: Editions d'Art Albert Skira, 1968, 95 p.
Reproduces forty-five previously unpublished drawings by Chagall. The collection also features an introduction and chronologically arranged commentary by Lassaigne.

————. *Marc Chagall: Drawings and Water Colors for the Ballet.* Translated by Joyce Reeves. New York: Tudor Publishing Co., 1969, 155 p.
Provides numerous large-format color reproductions of Chagall's stage designs for performances of the ballets *Aleko, The Firebird,* and *Daphnis and Chloe,* with historical information and critical observations by Lassaigne.

Le Targat, François. *Marc Chagall.* Translated by Kenneth Lyons. New York: Rizzoli, 1985, 128 p.
Offers 152 reproductions and commentary by Le Targat on Chagall's life, themes, and techniques, as well as a substantial biographical outline.

Leymarie, Jean. *Marc Chagall: The Jerusalem Windows.* Translated by Elaine Desautels. New York: George Braziller, 1967, 89 p. + 6 plates.
Presents a large-format color reproduction of each of the stained glass windows, chronologically arranged reproductions of the preparatory drawings and models, and background information and critical observation by Leymarie.

McMullen, Roy. *The World of Marc Chagall.* Garden City, N.Y.: Doubleday & Co., 1968, 267 p.
Contains numerous large-format reproductions and photographs of the artist at work. McMullen provides critical commentary on the techniques, themes, and media of Chagall's career. His discussion of Chagall's use of color in his paintings is excerpted above.

Meyer, Franz. *Marc Chagall.* Translated by Robert Allen. London: Thames and Hudson, 1964, 775 p.
Provides numerous color reproductions in the most comprehensive catalog of Chagall's work. The book also features a bibliography and close analyses of individual works; Meyer's examination of Chagall's paintings of 1911 and 1912 is excerpted above.

Sorlier, Charles, ed. *Chagall by Chagall.* Translated by John Shepley. New York: Harry N. Abrams, 1979, 263 p.
Contains an introduction, poetry, and autobiographical remarks by Chagall, accompanied by 239 reproductions of his works, an extensive biographical outline, and a bibliography.

Werner, Alfred. *Chagall: Watercolors and Gouaches.* New York: Watson-Guptill Publications, 1970, 87 p.
Offers thirty-two color plates with an introduction and accompanying remarks by Werner.

Giorgio de Chirico

1888-1978

Italian painter.

One of the most influential and provocative figures in modern art, Chirico was the founder of the *Scuola metafisica,* or Metaphysical school of painting. In his Metaphysical works, he sought through unusual juxtapositions of objects and dreamlike landscapes to produce a revelatory experience in the viewer, providing insight into the true nature of existence. Widely acclaimed, these works exerted great influence on the development of Surrealism, which also depended upon irrationality and oneiric imagery as a means to transcendent awareness. However, after 1930 Chirico abandoned Metaphysical painting, adopting a more realistic style in which he concentrated on classical subjects and imitated the techniques of the Italian masters. These later works are considered vastly inferior to those of the earlier period.

Chirico was born to Italian parents in Greece, where his father worked as a railroad engineer. Receiving his first instruction in drawing from his father, he later studied with a variety of private tutors, and in 1900 he entered the Polytechnic Institute in Athens. After the death of his father in 1905, he moved with his mother and brother to Munich and attended classes at the Munich Academy. There, in addition to learning the techniques of painting, Chirico encountered the influences that shaped his ideas about art, most notably the Romantic fantasy paintings of Arnold Böcklin and the philosophy of Friedrich Nietzsche. In particular, Chirico was impressed with Nietzsche's description in *Die Geburt der Tragödie aus dem Geiste der Musik* (1872; *The Birth of Tragedy*) of the experience of the ideal artist: "Through Apollonian dream-inspiration, his own state, i.e., his oneness with the primal source of the universe, reveals itself to him in a *symbolical dream-picture.*"

Chirico's early paintings, executed after he moved to Milan in 1909, reflect this concept of the symbolical dream-picture. In *The Enigma of an Autumn Afternoon* (1910), for example, Chirico placed a headless, shrouded statue in a landscape which is barren but for a few shapes resembling classical architecture, evoking the sense of a deserted square in a Mediterranean city. In subsequent paintings, he continued to use the desolate, deserted square as a setting, often increasing the oneiric quality of the composition through nonrealistic lighting, unusual perspectives, and such surprising images as gigantic artichokes, cookies, or bunches of bananas. These compositions are dominated by the persistent presence of mutilated classical images, which are widely interpreted as symbols of nostalgia for the lost ethos of Classical civilization. Describing the works of this period, Chirico explained: "The appearance of a Metaphysical work of art is serene; it gives the impression, however, that something new must happen amidst this same serenity, and that other signs

apart from those already apparent are about to enter the rectangle of the canvas." In one of his best-known works of this period, *The Child's Brain* (1914), Chirico depicts a bare-chested man resembling his father, with his eyes closed and half obscured by what appears to be a pillar. Critics have noted the painting's Freudian themes of frustration, sexual repression and Oedipal guilt, and have explored intimations of psychoanalytic depths in all his works.

Chirico's paintings were exhibited at the Salon d'Automne in Paris in 1912 and 1913, bringing him to the attention of the noted avant-garde poet and art critic Guillaume Apollinaire. Apollinaire became Chirico's strongest proponent, and through his advocacy Chirico's works received increasing attention in the years before World War I. In 1915, Chirico was inducted into the Italian army, but he soon afterward suffered a nervous breakdown and was sent to recuperate at a military hospital. There, in 1917, he met the painter Carlo Carrà, who quickly adopted Chirico's methods, and together the two codified and disseminated the principles of Metaphysical painting, publishing a number of articles in the journal *Valori plastici.* However, the association between Chirico and Carrà was short-

lived; after Carrà independently published a volume of writings entitled *Pittura metafisica* in 1919, Chirico accused him of taking all the credit for the theories of Metaphysical painting, ending both their friendship and their collaboration.

Chirico's works of the 1920s continued to feature the characteristic landscapes of the Metaphysical period, often incorporating eerie figures resembling mannequins as in the highly regarded *Disquieting Muses* (1924). However, throughout the decade he became more interested in classical painting, and by 1930 he was primarily producing Romantic depictions of classical myths, and critics, while generally conceding the technical proficiency of these works, dismissed them as unoriginal and uninspired. Despite universal condemnation, including a bitter denunciation by Surrealist leader André Breton, Chirico continued to paint in this style until the end of his career, maintaining that his aesthetic goals had remained consistent.

Although Chirico's period of successful work lasted for less than two decades, his achievements during that time are considered remarkable. His Metaphysical paintings are acknowledged as masterpieces of modern art, applauded for their stylistic originality and poetic expression. In addition, critics view his use of symbolism to convey the anxiety of existence as a major influence in the development of modern art. Elizabeth Frank has written: "What de Chirico gave us in the great Metaphysical paintings are dreamlike and shadowy passageways into the world of subjective space and time. And this world, apart from that of pure form itself, is truly the only one the modernist enterprise has recognized as its own."

ARTIST'S STATEMENTS

Giorgio de Chirico (essay date 1912)

[*In the following excerpt from an unpublished manuscript written in 1912, Chirico summarizes his aesthetic aims.*]

What will the aim of future painting be? The same as that of poetry, music and philosophy: to create previously unknown sensations; to strip art of everything routine and accepted, and of all subject-matter, in favor of an esthetic synthesis; completely to suppress man as a guide, or as a means to express symbol, sensation or thought, once and for all to free itself from the anthropomorphism that always shackles sculpture; to see everything, even man, in its quality of *thing*. This is the Nietzschean method. Applied to painting, it might produce extraordinary results. This is what I try to demonstrate in my pictures.

When Nietzsche talks of the pleasure he gets from reading Stendhal, or listening to the music from Carmen, one feels, if one is sensitive, what he means: the one is no longer a book, nor the other a piece of music, each is a *thing* from which one gets a sensation. That sensation is weighed and judged and compared to others more familiar, and the most original is chosen.

A truly immortal work of art can only be born through revelation. Schopenhauer has, perhaps, best defined and also (why not) explained such a moment when in *Parerga und Paralipomena* he says, "To have original, extraordinary, and perhaps even immortal ideas, one has but to isolate oneself from the world for a few moments so completely that the most commonplace happenings appear to be new and unfamiliar, and in this way reveal their true essence." If instead of the birth of *original, extraordinary, immortal* ideas, you imagine the birth of a work of art (painting or sculpture) in an artist's mind, you will have the principle of revelation in painting.

In connection with these problems let me recount how I had the revelation of a picture that I will show this year at the *Salon d'Automne,* entitled **Enigma of an Autumn Afternoon.** One clear autumnal afternoon I was sitting on a bench in the middle of the Piazza Santa Croce in Florence. It was of course not the first time I had seen this square. I had just come out of a long and painful intestinal illness, and I was in a nearly morbid state of sensitivity. The whole world, down to the marble of the buildings and the fountains, seemed to me to be convalescent. In the middle of the square rises a statue of Dante draped in a long cloak, holding his works clasped against his body, his laurel-crowned head bent thoughtfully earthward. The statue is in white marble, but time has given it a gray cast, very agreeable to the eye. The autumn sun, warm and unloving, lit the statue and the church façade. Then I had the strange impression that I was looking at all these things for the first time, and the composition of my picture came to my mind's eye. Now each time I look at this painting I again see that moment. Nevertheless the moment is an enigma to me, for it is inexplicable. And I like also to call the work which sprang from it an enigma.

Music cannot express the *non plus ultra* of sensation. After all, one never knows what music is about. After having heard any piece of music the listener has the right to say, and can say, what does this mean? In a profound painting, on the contrary, this is impossible: one must fall silent when one has penetrated it in all its profundity. Then light and shade, lines and angles, and the whole mystery of volume begin to talk.

The revelation of a work of art (painting or sculpture) can be born of a sudden, when one least expects it, and also can be stimulated by the sight of something. In the first instance it belongs to a class of rare and strange sensations that I have observed in only one modern man: Nietzsche. Among the ancients perhaps (I say perhaps because sometimes I doubt it) Phidias, when he conceived the plastic form of Pallas Athena, and Raphael, while painting the temple and the sky of his *Marriage of the Virgin* (in the Brera in Milan), knew this sensation. When Nietzsche talks of how his *Zarathustra* was conceived, and he says "I was *surprised* by Zarathustra," in this participle—surprised—is contained the whole enigma of sudden revelation.

When on the other hand a revelation grows out of the sight

of an arrangement of objects, then the work which appears in our thoughts is closely linked to the circumstance that has provoked its birth. One resembles the other, but in a strange way, like the resemblance there is between two brothers, or rather between the image of someone we know seen in a dream, and that person in reality; it is, and at the same time it is not, that same person; it is as if there had been a slight transfiguration of the features. I believe that as from a certain point of view the sight of someone in a dream is a proof of his metaphysical reality, so, from the same point of view, the revelation of a work of art is the proof of the metaphysical reality of certain chance occurrences that we sometimes experience in the way and manner that *something* appears to us and provokes in us the image of a work of art, an image, which in our souls awakens surprise—sometimes, meditation—often, and always, the joy of creation. (pp. 251-52)

> Giorgio de Chirico, "Appendix B: Manuscript from the Collection of Jean Paulhan," in Giorgio de Chirico *by James Thrall Soby, 1955. Reprint by Arno Press, 1966, pp. 251-53.*

Giorgio de Chirico (essay date 1919)

[*The following is Chirico's 1919 essay "On Metaphysical Art," in which he provides an introduction to the intent and ideas behind his paintings.*]

We should keep constant control of our thoughts and of all the images that present themselves to our minds even when we are in a state of wakefulness, but which also have a close relationship with those we see in dreams. It is curious that in dreams no image, however strange it may be, ever strikes us because of its metaphysical strength; and therefore we flee from seeking a source of inspiration in the dream—the methods of people like Thomas de Quincey do not tempt us. Yet the dream is an extremely strange phenomenon and an inexplicable mystery; even more inexplicable is the mystery and appearance that our mind confers on certain objects and on certain aspects of life. Psychically speaking, the fact of discovering the mysterious aspects of objects could be described as a symptom of cerebral abnormality akin to certain forms of madness. I believe that every person can undergo such abnormal moments, and that this is all the more fruitful when made manifest in an individual gifted with creative talent and clairvoyance. Art is the fatal net that catches these strange moments in flight, like mysterious butterflies, unnoticed by the innocence and distraction of ordinary men.

Joyful but involuntary moments of the metaphysical can be observed both in painters and writers, and speaking of writers I would like to remember here an old French provincial who we will call, for clarity's sake, the armchair explorer. I refer to Jules Verne, who wrote travel and adventure novels, and who is considered to be a writer for children.

But who was more gifted than he in capturing the metaphysical element of a city like London, with its houses, streets, clubs, squares and open spaces; the ghostliness of a Sunday afternoon in London, the melancholy of a man,

a real walking phantom, as Phileas Fogg appears in *Around the World in Eighty Days?*

The work of Jules Verne is full of these joyous and most consoling moments; I still remember the description of the departure of a steamship from Liverpool in his novel *The Floating City.*

NEW ART

The restless and complicated state of the new art is not due to the whim of Destiny, neither is it the result of a yearning for novelty or of a sense of opportunism on the part of a few artists, as some people innocently believe. It is rather a fatal state of the human spirit which, held by fixed mathematical laws, ebbs, flows, departs, returns and is reborn like all the elements manifest on our planet. At the beginning of its existence a race loves myths and legends, the unexpected, the monstrous, the inexplicable, and seeks refuge in these. As time goes on and the race matures into a civilization, the primitive images are whittled down and reduced, moulded and clarified according to the needs of the intellect, and a history scattered with the myths of origin is written. A European era like ours, which carries with it the enormous weight of infinite civilizations and the maturity of so many spiritual and fateful periods, produces an art that in certain aspects resembles that of the restlessness of myth. Such an art arises through the efforts of the few men endowed with particular clearsightedness and sensibility. Naturally such a return brings with it signs of the various antecedent epochs, hence the birth of an art that is enormously complicated and polymorphous in the various aspects of its spiritual values. Therefore, the new art is not a fashion of the moment. Nevertheless it is pointless to believe, like certain deluded and utopian people, that it can redeem and regenerate humanity, or that it can give to humanity a new *feeling* for life, a new *religion.* Humanity is, and will always be, as it has been. It accepts and will increasingly accept this art; the day will come when people will go to museums to look at it and study it. One day they will speak of it with aplomb and naturalness, as they do today of the more or less remote heroes of art, who, already listed and catalogued, have their place and their pedestal in the museums and libraries of the world.

The fact of comprehension is one that disturbs people today, but tomorrow it will do so no longer. To be understood or not is a problem of today. In our work, too, men will one day cease to find the appearance of madness, that is of that madness that they see, since great madness is precisely that which cannot be seen by all, and will always exist and continue to gesticulate behind the inexorable screen of materiality.

GEOGRAPHICAL FATALITY

From the geographical point of view it was inevitable that the initial conscious manifestation of the metaphysical movement should have been born in Italy. In France this could not have happened. The facile talent and carefully cultivated artistic taste, mingled with the dose of *esprit* (not only in their exaggerated use of the pun) sprinkled on ninety-nine per cent of the inhabitants of Paris suffocates and impedes the development of a prophetic spirit. Our soil, on the other hand, is more propitious to the birth and development of such animals. Our inveterate *gaucherie,*

and the continual effort we have to make to get used to a concept of spiritual lightness, bring with them as a direct consequence the weight of our chronic sadness. And yet the result would be that great shepherds can only appear among very similar flocks, just as the most monumental prophets throughout history have sprung from the tribes and races whose destinies are the most miserable. Hellas, aesthetic in art and nature, could not have given birth to a prophet, and Heraclitus, the most profound Greek philosopher I know, meditated on other shores, less happy because closer to the hell of the desert.

MADNESS AND ART

That madness is a phenomenon inherent in every profound manifestation of art is self-evident.

Schopenhauer defines as mad the man who has lost his memory. A definition full of acumen since that which forms the logic of our normal acts and of our normal life is indeed a continuous string of memories of relationships between objects and ourselves and vice versa.

Let us take an example: I enter a room and see a man seated on a chair, hanging from the ceiling I see a cage with a canary in it, on a wall I notice pictures, and on the shelves, books. All this strikes me, but does not amaze me, since the chain of memories that links one thing to another explains the logic of what I see. But let us suppose that for a moment and for reasons that are inexplicable and independent of my will, the thread of this chain is broken, who knows how I would see the seated man, the cage, the pictures, the bookshelves; who knows what terror and perhaps what sweetness and consolation I would feel when contemplating that scene.

But the scene would not have changed, it would be I who would see it from a different angle. And here we have arrived at the metaphysical aspect of things. One can deduce and conclude that every object has two aspects: one current one which we see nearly always and which is seen by men in general, and the other which is spectral and metaphysical and seen only by rare individuals in moments of clairvoyance and metaphysical abstraction, just as certain hidden bodies formed of materials that are impenetrable to the sun's rays only appear under the power of artificial lights, which could, for example, be X-rays.

For some time, however, I have been inclined to believe that objects can possess other aspects apart from the two cited above: these are the third, fourth and fifth aspects, all different from the first, but closely related to the second, or metaphysical aspect.

THE ETERNAL SIGNS

I remember the strange and profound impression made upon me as a child by a plate in an old book that bore the title *The World Before the Flood.*

The plate represented a landscape of the Tertiary period. Man was not yet present. I have often meditated upon the strange phenomenon of this absence of human beings in its metaphysical aspect. Every profound work of art contains two solitudes: one could be called 'plastic solitude', and is that contemplative beatitude offered to us by genius in construction and formal combination (materials and el-

ements that are dead/alive or alive/dead; the second is the life of the *nature morte,* still-life captured not in the sense of pictorial subject, but of the spectral aspect which could just as well belong to a supposedly living figure). The second solitude is that of signs, an eminently metaphysical solitude and one which excludes a priori every logical possibility of visual or psychic education.

There are paintings by Böcklin, Claude Lorrain and Poussin which are inhabited by human figures, but which, in spite of this, bear a close relationship with the landscape of the Tertiary. Absence of humanity in man. Some of Ingres's portraits achieve this too. It should, however, be observed that in the works cited above (except perhaps in a few paintings by Böcklin), only the first solitude exists: plastic solitude. Only in the new Italian metaphysical painting does the second solitude appear: solitude of signs, or the metaphysical.

The appearance of a metaphysical work of art is serene; it gives the impression, however, that something new must happen amidst this same serenity, and that other signs apart from those already apparent are about to enter the rectangle of the canvas. Such is the revealing symptom of the *inhabited depth.* For this reason the flat surface of a perfectly calm ocean disturbs us, not so much because of the idea of the measurable distance between us and the sea bed, but more because of all the elements of the unknown hidden in that depth. Otherwise we would feel only a vertiginous sensation similar to that experienced at a great height.

METAPHYSICAL AESTHETIC

In the construction of cities, in the architectural forms of houses, in squares and gardens and public walks, in gateways and railway stations etc., are contained the initial foundations of a great metaphysical aesthetic. The Greeks possessed certain scruples in such constructions, guided as they were by their philosophical aesthetic; porticoes, shadowed walks, and terraces were erected like theatre seats in front of the great spectacles of nature (Homer, Aeschylus): the tragedy of serenity. In Italy we have modern and admirable examples of such constructions. Where Italy is concerned, for me the psychological origins remain obscure. I have meditated at length upon this problem of the metaphysics of Italian architecture and all my painting of the years 1910, 1911, 1912, 1913 and 1914 is concerned with this problem. Perhaps the day will come when such an aesthetic, which up to now has been left to the whims of chance, will become a law and a necessity for the upper classes and the directors of public concerns. Then perhaps we will be able to avoid the horror of finding ourselves placed in front of certain monstrous apotheoses of bad taste and pervading imbecility, like the gleaming white monument to the Great King [Victor Emmanuel] in Rome, otherwise known as the Altar of the Fatherland, which is to architectural sense as the odes and orations of Tirteo Calvo are to poetic sense.

Schopenhauer, who knew a great deal about such matters, advised his countrymen not to place statues of their famous men on columns and pedestals of excessive height, but to place them on low platforms 'like those they use in

Italy' he said, 'where every marble man seems to be on a level with the passers by and to walk with them.'

The imbecilic man, that is, the a-metaphysical man, inclines by instinct towards an appearance of mass and height, towards a sort of architectural Wagnerianism. This is a matter of innocence; they are men who are unacquainted with the terribleness of lines and angles, they are drawn towards the infinite, and in this they reveal their limited psyche enclosed as it is within the same sphere as the feminine and infantile psyche. But we who know the signs of the metaphysical alphabet are aware of the joy and the solitude enclosed by a portico, the corner of a street, or even in a room, on the surface of a table, between the sides of a box.

The limits of these signs constitute for us a sort of moral and aesthetic code of representation, and more than this, with clairvoyance we construct in painting a new metaphysical psychology of objects.

The absolute consciousness of the space that an object in a painting must occupy, and the awareness of the space that divides objects, establishes a new astronomy of objects attached to the planet by the fatal law of gravity. The minutely accurate and prudently weighed use of surfaces and volumes constitutes the canon of the metaphysical aesthetic. At this point one should remember some of Otto Weininger's profound reflections on metaphysical geometry: 'As an ornament the arc of the circle can be beautiful: this does not signify the perfect completion which no longer lends itself to criticism, like the snake of Midgard that encircles the world. In the arc there is still an element of incompletion that needs to be and is capable of being fulfilled—*it can still be anticipated.* For this reason the ring too is always the symbol of something non-moral or anti-moral.' (This thought clarified for me the eminently metaphysical impression that porticoes and arched openings in general have always made upon me.) Symbols of a superior reality are often to be seen in geometric forms. For example the triangle has served from antiquity, as indeed it still does today in the theosophists' doctrine, as a mystical and magical symbol, and it certainly often awakens a sense of uneasiness and even of fear in the onlooker, even if he is ignorant of this tradition. (In like manner the square has always obsessed my mind. I always saw squares rising like mysterious stars behind every one of my pictorial representations).

Starting from such principles we can cast our eyes upon the world around us without falling back into the sins of our predecessors.

We can still attempt all aesthetics, including the appearance of the human figure, since through working and meditating upon such problems, facile and deceitful illusions are no longer possible. Friends of a new knowledge, of new *philosophies,* we can at last smile with sweetness upon the charms of our art. (pp. 87-91)

Giorgio de Chirico, "On Metaphysical Art," in Metaphysical Art, *edited by Massimo Carrà, translated by Caroline Tisdall, Thames and Hudson, 1971, pp. 87-91.*

SURVEY OF CRITICISM

W. Gibson (essay date 1927)

[*In the following excerpt, Gibson examines the elements of the Renaissance tradition evidenced in Chirico's art.*]

An essay on the art of Giorgio de Chirico may conveniently begin with a definition of it as an attempt to express the modern equivalent of the emotional and intellectual content of renaissance art by a similar method of expression. It is, therefore, traditional and in a sense academic, but it is not academic in the sense in which the term is applied to the art of the schools of the last few centuries. The difference becomes more apparent when the gradual development of renaissance art into that of the so-called academic is considered.

The intellectual activity of the renaissance was characterised by a suddenly awakened consciousness of the material world and a consequent interest in physical phenomena. Man gave up speculating upon Heaven and began speculating upon natural forms. The artistic expression of the thought of the time was naturally characterised by the same realistic quality. Artists wished to express in their painting what they had learnt of the construction of the visible world, and the means of pictorial expression changed from the purely symbolical expression of the Byzantines to something more closely related to a literal reproduction of things. The means was perfectly suited to what the artists had to express, and the realism which they had employed only became pernicious when the intellectual vigour of the renaissance had died down and artists had nothing left to say.

Then the realistic trend which art had taken became a danger. A painter who has nothing to express cannot produce a work of art, but he can always continue to develop a dexterity in the *trompe l'oeil* representation of objects, which will appeal to that craving so satisfactorily catered for by Maskelyne. When the public has been accustomed to find some degree of this magic in the pictures of the past which they have been directed to admire, and when they have probably contentedly been admiring in the latter this quality alone, as the most easily appreciated, the path of the illusionist painter is of a rosiness to which the diploma gallery bears witness.

Now the pictures of Giorgio de Chirico are in the renaissance tradition, which, therefore, implies that, although for a different reason than in the case of the earlier pictures, a reason later to be discussed, they also contain a representation of material forms. But they are in the renaissance tradition in the sense that Chirico employs the same means of expression as did the renaissance artists, not that he seizes the superficial characteristics of renaissance pictures, their figures, grouping, manipulation of drapery and so on to express nothing, as did the history painters of the 17th and 18th centuries, nor that he further develops the realist element of their work into illusionism as an end in itself, as did the artists of the 19th century, with the exception of a small group in France.

Chirico uses the same means of expression as did the old

masters, namely, material forms, but he has his own thoughts to express, and these thoughts differ from those of the renaissance painters, as the two ages differ, with a corresponding difference between his forms and theirs. For one thing, the present is an age of greater sophistication, greater self-consciousness, given over, as the renaissance never was, to self-analysis and examination of motives. The result of this is found in those pictures of about 1919 in which the forms approximate more closely to those of the earlier artists. In these pictures one finds the human figure introduced, as it was by the Florentines, as a reproduction of sculpture, not of living human beings. But in the case of Chirico's work the sculptural form is used more intentionally, more deliberately as a means to his end. Whereas in a Florentine work the sculptural quality may at first escape the notice, in those of Chirico one is at once made to feel that the scene is peopled by statues.

Another difference between the present and earlier times accounts for the introduction of mechanical forms into Chirico's later pictures. The advent of machinery, practically unknown until the last century, has introduced a large number of fresh shapes and objects into the material world, which differ from those of nature in being precisely geometrical. At the same time the mental processes of speculation have become more exact, more mathematical; no one, for example, would now propound the theory that the pineal gland is the seat of the soul or seek the function of the thyroid in the aesthetic requirements of the neck. The result of this is that geometrical shapes make a natural appeal to the modern mind as a means by which to express itself. Abstract artists tend to use geometrical shapes in their designs, and artists, such as Chirico, who insist on a use of forms drawn from the material world, tend to use the forms of machinery rather than of nature. Added to this is the fact that the precise geometrical forms of machinery and other artificial objects lend themselves more appropriately to design. Hence the tendency of artists dealing with natural forms to modify these to something more geometrical. One can imagine, for example, how Ucello would have delighted in the subjects with which modern machinery would have provided him.

There is also a reason why Chirico in particular should show a preference for mechanical forms. He has enunciated the doctrine that a work of art must tell something beyond the limits of its volume; that the object or figure must tell poetically something which is even distant from it, something which its volume even may materially conceal. In a picture the subject of which is a scene from some story (such, for example, as his picture of the prodigal son), Chirico does not attempt to give a substitute for being present at the scene; a reproduction of it as he imagined it to happen, as close to the scene itself as his ability allows him to make it. His use of statuesque figures in that picture and his use of machine-like figures in other pictures are a sufficient denial of it. But he wishes to express on the canvas not only a particular rhythmical relationship of forms for the sake of their relationship alone, but also a significance in the scene outside the actual moment of it. And so, just as one sees in the strange rocks and barren land and sea, which constitute so often the landscape element of Leonardo's pictures, a desire on his part to express something

of his speculations on the past and the elements from which life sprang; so in the machine-like forms introduced into Chirico's pictures one sees a desire to express his speculations on the future, on the final domination of mathematics and the machine.

It might be asked why Chirico insists on using concrete images; why, if he wishes to express something beyond the material, he uses the material at all. The reason lies in a peculiar quality of his psychology. Chirico has a horror of the purely abstract as of something terrifying in its emptiness, from which he can only be rescued by a contact with concrete things. He speaks of it as the empty, silent vault of the sky at night from which the terror is removed by the presence of a cloud, its form emphasised and solidified by the light of the moon. And yet he is a metaphysician, interested in the reactions and processes of the mind; and to him material forms are valueless for their own sakes, deprived of an ulterior metaphysical significance. Consequently in his art he attempts to make use of material forms to express the non-material, to the end that by that means he may avoid the horror of pure abstraction and yet express something outside of the material world.

One may find it difficult to understand and to sympathise with the artist's horror of abstraction, the sensation of vacuity which it gives to him. The writer, for one, finds it hard to understand him when he cites the art of ancient Egypt as having that effect of terror over him. One may disagree with his doctrine that art to be significant must necessarily contain a significance, in the objects depicted, outside of their actual physical interrelationships. But one's judgments on these points are irrelevant to one's judgments on his work as art, although they have their effect on his choice of forms and his handling of them.

A picture to be a work of art must express an emotional reaction by visual means, that is to say by a series of rhythms connecting the lines, colours and masses. Definite systems of proportion must exist between the various lines, colours and masses, the systems chosen and the manner in which they are combined depending upon the emotional reaction to be expressed. Such a definition of the art of painting implies that an emotional reaction to a momentary arrangement of objects in the physical world, if expressed by these means, will constitute a work of art. This Chirico's theory denies, as he considers a picture valueless which does not express something beyond the momentary physical facts, which the painter is handling, and beyond his momentary reaction to them.

But such a definition does not qualify the emotional reaction of the artist in any way. It only qualifies the means of expression. It states that the means of expression must lie in the picture itself, not in any associations in the spectator's mind which the picture might awaken. The reason for this qualification is obvious; it is only by such a means of expression that the spectator can be made to experience the emotion himself. By the means which this qualification rules out, the spectator's desire for the emotion would alone be aroused without being satisfied in the actual experience of it. The typical salon nude and picture postcard landscapes are sufficient instances of this bad painting which is no art at all.

This definition of art, then, does not condemn pictures painted in accordance with Chirico's views on what a picture should be. The artist may express an emotion outside of the physical world, but he must have something to express, and something to which he has reacted with emotion; and the expression must be definitely bound up with the design. That is the true test of a work of art, and Chirico's painting is art as tested by it.

The fact that his interests of a speculative order lend to the mechanical forms which he employs an added interest for him, extrinsic to their artistic significance (just as Leonardo's rocks, land and sea had an added interest for him apart from the pictorial) is neither here nor there in valuing his work as art. What is important is that, passing from a phase in which his use of the human form is closely akin to that of the Renaissance, Chirico in his later work makes use of the forms with which machinery has provided him to build up similar monumental designs, in which he expresses what he has to express by means of the relationships of the lines, colours and masses, quite apart from their further significance to him.

An example may make the point clearer. The solitary seated figure of a mannequin, painted in 1926, has a distinct similarity to a Masaccio Madonna in the impression which it gives of a statue, static in feeling and of gigantic size. Whereas in the Masaccio there is a simple rendering of the Madonna's figure, the figure in the Chirico is largely built up of artificial shapes, a picture in its frame and blocks of simplified architecture. But the forms which in either case go to make up the complete figure have a definite part to play in establishing a series of rhythmical relationships, which shall express the artist's emotion. This use of the forms, which is the reason why these pictures are works of art, is common to both painters. The difference between the two lies in their manner of arriving at the forms they shall use to express their meaning.

Either artist makes use of a visionary world, but a visionary world built up of forms suggested by the material world. Thus Masaccio makes use of the visionary world of Christian mythology. His Madonna is seated on a heavenly throne, and at her feet two angels play the lute; throne, lute and figures are drawn from the material world to construct a visionary one. Chirico makes use of a visionary world, created by himself in accordance with his theories and speculations, and this world also is built up of forms drawn from the material world, namely, the human figure, architecture and machines. Just as Masaccio's angels are imagined partly from human beings, partly, as regards their wings, from birds, so Chirico's mannequin has for head the handle by which the head is replaced in a tailor's lay figure. Either artist draws the suggestion for the relationships of the objects in his picture from his visionary world in the same way in which a still life painter draws the suggestion for those of his from the grouping of the objects in the material world about him.

Such a means of arriving at the constituent elements of his pictures is unusual in an artist to-day. Good modern painting is usually based on a modification or abstraction of things seen in the material world. Consequently when one is suddenly confronted with an art which makes use of definite, realistic forms, but forms which are combined into figures and objects not of the physical world, one finds oneself, perhaps, distracted from considering it as one does other pictures for its artistic significance. If, however, the latest developments of Chirico's work are considered in relationship with his earlier paintings, of, say, the 1919 period, and through those with the art of the Renaissance, the difficulty is removed. One sees at once that this strange world, from which the subject matter of his pictures is drawn, bears the same relationship to the artistic content of his art as does the world of Christian mythology to that of such an artist as Masaccio. And when that is fully understood, one perceives in the emotional significance of Chirico's pictures that quality of immensity, dignity and calm which characterises the art of Piero and Masaccio. (pp. 9-14)

W. Gibson, "Giorgio de Chirico," in The Enemy, *Vol. 1, No. 1, January, 1927, pp. 9-14.*

Lloyd Goodrich (essay date 1929)

[*An American art historian, Goodrich was associated with the Whitney Museum of American Art from its founding in 1930. He was also the author of numerous studies of American art, including* Pioneers of Modern Art in America: The Decade of the Armory Show, 1910-1920 *(1960). In the following essay, Goodrich examines the psychological and aesthetic aspects of Chirico's images and symbols.*]

Among the comparatively few new figures who have stepped into the limelight in Paris in recent years, Giorgio de Chirico is certainly one of the most remarkable. As an inventor of startling and entertaining new formulas he already stands next to Picasso, to some of whose fifty-seven varieties of style his work has certain resemblances. From most of the other leaders of present-day Parisian painting he differs fundamentally. The one quality which unites such contradictory temperaments as Matisse, Braque, Derain and Léger, is the fact that they are all using form and color as direct mediums of expression, without recourse to "literature". In Chirico's pictures, on the other hand, the "literary" element predominates. He is one of the few modern painters whose work has any philosophical or metaphysical implications.

Chirico is primarily a symbolist and an image-maker. He uses the formal elements of painting as means to the creation of images which will evoke emotion in us, rather than as direct means of creating emotion. His art speaks to us less in the physical language of form and color than in the psychological language of imagery and associations, of objects and places and the emotions which we connect with them. His pictures are diagrams of ideas, plans and elevations of metaphysical concepts, rather than representations of the visible world or self-sufficient æsthetic creations.

The peculiar neo-classical character of Chirico's symbolism is determined by his race. He is an Italian, born in Greece—a double bond with antiquity. Few artists of his country today can escape from the overwhelming burden of their great past. Some it turns into archæologists; some,

by revolt, into futurists. Upon Chirico's fundamentally romantic temperament the results have been more complex. With him the sense of the past has become an obsession which colors everything that he paints.

In his early work, done about 1914, one feels this sense of the past in its simplest and most poignant form. His paintings of this time are permeated by an intense sensation of loneliness, of desolation, such as might overtake one in an abandoned city. The subjects are of the simplest description: under the pitiless sky of the South, in a deserted square, stands a headless statue; in the relentless sunlight its black shadow is prolonged across the empty pavement. In another picture, two solitary figures are saying farewell, surrounded by endless vistas of classical arcades vanishing into the distance; a train is seen waiting. All of these works are images of solitude, of desertion; they have some of the melancholy of long afternoons in the midst of monuments of past glory, which one feels in Guardi and Canaletto and other Italians of the very end of the Renaissance; but here the feeling is conscious and intentional. There is of course a strong element of the theatrical in them, a feeling that they are stage-settings for some Freudian drama; but they are nevertheless effective and moving. In these early pictures Chirico has made full use of the potent suggestiveness of perspective—a science despised by most modern painters—to convey the sense of loneliness, of great vistas unpopulated by any human figure.

Since these simple early days Chirico's symbolism has taken on a more complicated and sensational character, but through its intricacies one can still trace his obsession with the past. In his pictures nowadays he expresses himself in terms of the whole neo-classical paraphernalia of ruined temples, broken columns, statues, trophies, helmets, shields, spears. But these shopworn properties are used in a very different spirit from that of earlier and less sophisticated neo-classicists. Chirico looks upon antiquity with the eyes of a modern who is also the member of an ancient civilization. For him it is a dead world, cluttered with the wreckage of past glories and peopled with the ghosts of old traditions. Sometimes it amuses him, sometimes it bores him, sometimes, judging by certain pictures, it causes him positive horror; but he is still a part of it; he cannot escape from it. This obsession he expresses in a kind of perverse neo-classical masquerade, in which the gods and goddesses and all the other heroic figures of antiquity are brought down to the level of a collection of casts in a museum, and displayed in the most unlikely and unseemly surroundings—a type of neo-classic sport which had already been made à la mode by Picasso, but of which Chirico is now perhaps the most complete exponent.

In hardly any of these paintings is there a human note. In his early pictures the cities and squares had always been deserted, except sometimes for a solitary melancholy figure in the distance, which might symbolize the artist himself. His recent work is peopled with many fantastic creatures—statues, mannikins, automatons, abstractions, spectres,—but not by living beings. Similarly the scenes he paints seldom suggest any actual place—they are types of landscapes, romantic evocations, or regions outside of time and space, sections of the ether mathematically mea-

sured off and marked by the abstract vanishing lines of perspective. This lack of humanity and locality makes many of his pictures seem like huge spectral still-lives.

In this metaphysical masquerade the most constantly recurring motive is that of the ruin and destruction of the past. In a bare room, in plush armchairs, sit two togaed figures with ovoid, featureless heads, holding in their laps ruined temples, broken arches of aquaducts, fragments of columns, parts of city walls; they might be the abstract entities of archæology brooding over the debris of a civilization. Again the subject is a group of goddesses, august figures—but their flesh is marble, blackened in places like statues which have stood out in the sun and rain for centuries. Or the image is that of a room with trees growing through the floor and the sea breaking in—another symbol of disintegration. Recently he has painted several canvases in which piles of furniture—chairs, bureaus, dismantled beds, knick-knacks—surrounded by a few fragments of walls, stand in the midst of a desolate plain, under a cold blue sky. These grotesque assemblages of objects, like the remains of a house which is being torn down, exposing to the gaze of the passerby the designs of its wallpaper and the places where the furniture has stood, echo the note of wreckage, of desolation, which seems to be inseparable from Chirico's work.

Chirico's method in these pictures is a distortion of reality analogous to that of other modern painters when they distort form; but in his case it is a distortion not of the things themselves but of their relationships one to another. Just as Picasso will deliberately magnify the proportions of a foot or hand, so will Chirico place a ruined temple inside a bedroom, or the furniture of the bedroom in the midst of a plain. It is largely this trick of grouping incongruous objects, or of placing objects in incongruous surroundings, that accounts for the nightmare quality of his work. As in a dream, these juxtapositions have a suggestive and troubling quality; they seem to imply much more than they actually state.

These strange images would be much more potent emotionally if one could believe that they represent something genuine and profound in the mind of the artist. Unfortunately, however, the impression which they give is that of a baffling mixture of sincerity and sensationalism, with the sensationalism gaining ground year by year. Even in Chirico's early pictures, with their real poetic content, there was a strong element of theatricality; but they at least gave some of the feeling of being authentic projections of the subconscious mind. This feeling grows less and less strong in his more recent paintings, which seem not so much like products of the subconscious as deliberate, ingenious attempts to produce images that will startle, intrigue and perplex the onlooker. The sense of inwardness that one felt in his early work has all but disappeared; from an introvert setting forth his inner visions he seems to have changed to an extravert seeking to impress himself upon the world by more sensational methods. The element of genuine magic that was present in his first pictures has turned into something more nearly resembling hocus-pocus.

The weakness of this kind of painting, of course, is that everything is concentrated on the least permanent ele-

ments. At first the spectacular imagery and the no less spectacular style in which it is clothed give one a powerful "kick", but once this initial excitement is past, there is not much left to fall back on. The masquerade begins to seem empty: the enormous stony goddesses, the statuesque horses, the doll-like gladiators, begin to grow tiresome. Chirico's pictures often look best the first time one sees them, and lose something on each subsequent occasion.

One of the reasons that one is apt to tire of Chirico's work is its lack of real æsthetic substance. Its style is more a question of mannerism than of anything fundamental. Not that he lacks technical ability; on the contrary, purely as a painter, he displays an astonishing virtuosity. His earliest work, with its sombre, volcanic color, showed no more skill than was needed to express its thought, and gave little foretaste of the variety and ingenuity of the later styles, but today he has many different manners at his finger-tips, from the pale cameo-like harmony of warm gray and cold gray in the **Horses Pierced with Arrows** to the facile full-blooded brilliancy of **The Chagrins of Victory.** He has some of Picasso's versatility and encyclopedic knowledge of past styles and his ability to assimilate them to his own use; but unlike the Spaniard, in whom eclecticism amounts almost to a disease, and whose borrowings range from African Negro carvings to Dresden china, Chirico has confined himself mostly to his own native tradition, except, of course, for the inevitable debt to French painting. Etruscan terracottas, Roman marbles and mosaics, Pompeian wall paintings, Quattrocento frescos, the paintings and drawings of the great Italian masters of the Renaissance, have all been pressed into service to furnish models and hints. Some pictures show the whites and pale grays of marble; some the warm earthy colors of terracotta; in some he uses the flat, plaster-like tones of the fresco, reinforced with cross-hatched lines. But amid all these styles it is a puzzle, as in the case of Picasso, to find the real man. None of them are convincing; they suggest that in each case the painter has voluntarily chosen a manner as one would choose a suit to wear for the day. Chirico's style, or styles, have always too much the air of *tour de force* to be moving; they lack the power, the bigness, the depth of genuine style.

Chirico's first work, which was no less original than that of today but without such an obvious attempt at originality, seemed to give promise that he would contribute something unique to contemporary painting. Since then he has spent more time in Paris; he has looked at Picasso and has not been unmoved by the sight. His work now is more brilliant, more varied, more spectacular; but it is less his own and less genuine. The strong element of *chic* in his most recent canvases, the hasty, perfunctory handling of many of them, and the constant repetition of certain subjects, suggest that he has fallen a victim to the malady that sooner or later afflicts most successful Parisian artists—overproduction. He has found his set of formulas and he is making them work.

He remains, however, one of the most ingenious of contemporary painters, as well as one of the strangest phenomena in the art of today. (pp. 5-10)

Lloyd Goodrich, "Giorgio de Chirico," in The

Arts, *New York, Vol. 15, No. 1, January, 1929, pp. 4-10, 72.*

Chirico on the meaning of his work:

For years people have said that my work is filled with mysterious meaning. I can assure you it is not. Life may be mysterious, but my work is totally devoid of mystery. It is realism at its highest and clearest. Above all, my work is not Surrealistic. I am not a Surrealist—never have been. I do not like Surrealism. Nobody likes Surrealism.

People have called me the father of Surrealism. What utter nonsense! I am neither the father, the son, nor the uncle of Surrealism. I paint what I see, and I paint what I remember of my childhood. Those shadows . . . that appear in my paintings—those were real shadows I observed in certain small Italian towns. They were autumnal shadows that came when the sun began to set. They are not a mystery. They were merely something that interested me. At times, I paint visions that appear to me in dreams.

From an interview in Vogue, *April, 1972.*

Robert Motherwell (essay date 1942)

[*An American artist, Motherwell is recognized as one of the most adept practitioners of Abstract Expressionism. In the following excerpt, he lauds Chirico's early metaphysical works while dismissing his later works as commercial and sterile.*]

Standing before these late (1939) gouaches *á la mode,* who finds any stimulus to remembrance of Chirico's early scenic stage? Not the empty stage of his subsequent imitators, where the tragic action has already taken place, and we are presented with no more than the scene of the crime; but Chirico's stage, where the strange symbols have an irresistible attraction for one another, where if they do not interact before us, they will after we are gone. They are filled with incredible potentialities. Or, more specifically, what remains now of the expressiveness in that work of 1914 symbolizing the content of **The Child's Brain,** with its father-image? Yes, the father! Shockingly naked but unrevealed, hairy, immovable, inescapable, standing like a massive rock on the silent shore of the unconscious mind, a rock unseeing, with its closed eyes, but a rock resisting all attempts to pass beyond, a rock to burrow into, if that is the only possibility of getting beyond, but a rock eternally waiting, waiting for when it will be at once judge and executioner, judge of the guilt inherent in killing the origin of one's being in order to be, and executioner by virtue of one's fear of being free. What remains of that? Nothing. Nothing but the problem of how this awful degeneration came about. Was it, as I suppose, the consequence of a tragic action, the result of choice between irreconcilable values; or was the actual circumstance as banal as Dali's? . . . Certainly the conventional thesis (which holds that Chirico's genius simply burned itself out) explains nothing; it merely remarks the phenomenon to be explained. . . . The evidence of his works suggests a hy-

pothesis which, if not complete, does dispel the mystery in part; and the hypothesis has the advantage of being tested, just as it is suggested, by the works themselves. From them the central fact is plain enough: c. 1910-1917 young Chirico produced a quantity of pictures, of which the majority are indubitable masterpieces, pervaded by a binding poetry: the paintings after that date are filled with meaningless classic paraphernalia, and a plasticity expressly designed for contemporary taste. The few other relevant facts are well-known: Chirico's great period corresponds to cubism's great period, of which Chirico was either in ignorance, or to which he was indifferent. At any rate, his own historical influence came (c. 1920) as the poetic opposition to cubism's architectonics; and he was made influential largely through the interest in his work of Breton, critic and poet, and Ernst, painter and poet, which is not surprising in view of Chirico's essentially poetic, rather than essentially plastic gift. His particular plastic inventions, like the shadow cast by an object unseen in the picture (a device later to be exploited by Dali), *derive from poetic insight; i.e.* the remarkable intensity of feeling in the early work arises more from the nature and juxtaposition of his symbols than from their formal relations to one another, adequate as the latter may be. This emphasis on his poetry has important outside evidence: years after the decline of his painting into an incredible academism, Chirico was still able to produce his superbly poetic novel *Hebdomeros*. . . . Now it is scarcely plausible to suggest, as [James Thrall] Soby does, 'that Chirico's genius died a lingering death, that at times, as in certain paintings and his novel *Hebdomeros,* it has raised itself in bed.' It is more plausible to suppose that *something happened to alter Chirico's conception of painting,* something radical enough to cause the poetry to disappear from it. It so happens that Chirico first became interested in Parisian painting at a moment when it was turning from many years of experiment to a normative authoritarianism, to a painting relying on the weight of traditional images understood by everyone, as in the 'classic' period of Picasso, Derain, and so on. It is not difficult to suppose that Chirico was ravished by the 'objective' authority of such painting, and determined to participate in its creation. His pictures after 1918, being failures, are generally ignored by critics, but they afford the clue. The intention of the later pictures is *authoritarian,* the observer looking from below *up* to white horses, as he must look up to an equestrian monument; *traditional,* the subject-matter being reminiscent of antiquity, with its 'classic' columns, and its treatment of personages and horses in shades of white, like ancient statues; *normative,* being intelligible to any normal person, since it depends on neither personal sensitivity nor insight, but on associations commonly known in the occident; and (no doubt most important in Chirico's mind) *plastic,* the attempt to have the painting itself constitute the 'meaning,' as in cubism, not poetic insight, hence the fat impasto, the simplification of forms, the colour by local areas, the importance of contour, the emphasis of surface texture, and the other devices in the contemporary taste. Of course he was foredoomed to failure in his effort to create such painting, because his gift was not normative, authoritarian and plastic, but in actuality the precise opposite, unique, personal, and poetic. And it is unforgivable that these later

works are not even an honest attempt to enlarge his experience, and ours; they are instead deliberate attempts to cater to the luxury trade. Like all such work, they are unnecessary; they fulfill no genuine need.

If this later work is the result of a deliberate choice, as I suppose, the choice represents a moral action, the choice between two irreconcilable values; and where the action becomes tragic is in his pursuit of that thing Chirico chose as the final good, to the necessary exclusion of other goods, so that whatever value the original good may have had for him ends in a final evil, as other goods are vanquished in the struggle. His tragic flaw reveals itself as his arrogance, his refusal, in relation to his true gift, to accept his limitation, and admit his error. He defended himself against the bitter attack of the surrealists in the '20's by replying that at last he painted like the old masters. He was bound finally to dupe himself. He grew to believe in the authoritarian; the petrifaction of his talent, plus his alliance with those states which alone could accept his later work, represent the material consequences of his action. Understood so, Chirico becomes one of the clearest examples of the historic issues of our time. His sterility and that of the authoritarian state have the same origin, fear and contempt of the human. It is only just that, as that state will, so has Chirico brought about his own ruin. (pp. 60-1)

> *Robert Motherwell, "On Mondrian & Chirico," in* VVV, *No. 1, June, 1942, pp. 59-61.*

Clement Greenberg (essay date 1947)

[*Greenberg is considered one of the most important American art critics of the twentieth century and is renowned in particular for his eloquent arguments in favor of abstract art. In the following excerpt, he discusses the development of Chirico's career to 1947, noting the progressive deterioration of the painter's style.*]

The Chirico revealed by his latest paintings . . . is surprising only as an objective fact, but not in the perspective of his whole development, which was always colored by an ambiguous and guilty but thoroughly logical hostility to all truly modern painting since Courbet.

At the beginning of his career Chirico was struck by the German Swiss painter Böcklin, whose work is one of the most consummate expressions of all that we now dislike about the latter half of the nineteenth century; however, I cannot believe there was not some perversity, half-concealed from himself, some desire to shock his peers and betters, in this admiration of Chirico's—a desire that sprang perhaps from his despair of equaling the profound matter-of-factness of the impressionists and of Cézanne and Matisse. Like many a twentieth-century Italian, with the glorious past behind him and the glorious present elsewhere—in Paris, London, Berlin—he clowned out of a historical instinct that he himself was half unconscious of.

But Chirico still was and is a gifted painter, as he demonstrated in some of the pictures he painted before 1919. Although they show portents of the bankruptcy to come and signal across a decade to that retreat of avant-garde painting which began with the surrealists in the late twenties,

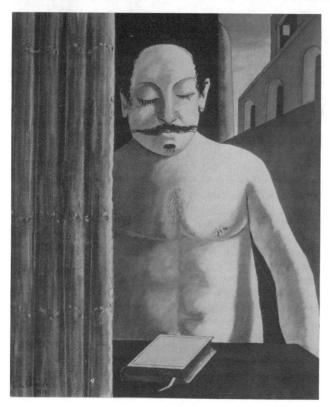

The Child's Brain *(1914).*

these canvases have a substance and plastic quality that justify, in plastic terms, this last serious attempt to save literary easel painting. They will survive because they are *sui generis.* Though certain aspects of their design and subject matter owe much to cubism, they do not exist within the same order of criticism, and must be treated as a point of exception and not approached with the demands we make on the great and *typical* painting of the first twenty years of the century. They are one of those tours de force that, like Michelangelo's frescoes, founded a misguided school.

As a colorist, Chirico was in this period a last emissary of mannerism, three hundred years behind Delacroix in its use. The emphasis of his gift lies in his draftsmanship, and his best works are tinted drawings in which color does not interfere or speak in its own right. (Thus his most prominent disciples—Dali, Ernst, and Tanguy—are likewise draftsmen, but so exclusively so that they cannot handle color at all, and in their painting it gets in the way of the drawing.)

Chirico's deep space, foreshortenings, and exaggerated perspective announce, in spite of himself, the absolute flatness of Mondrian. It is the latter who drew the correct conclusion from the Italian painter's early work, not Dali. The early work parodies the perspective of the Quattrocentist masters and the means in general by which the Renaissance attained the illusion of the third dimension; and because it parodies, it destroys. From his tangential position Chirico, by an exaggeration that amounted to ridicule, helped the cubists exile deep space and volume from

painting. See only how completely schematic and second-hand is his delineation of depth, how flat all surfaces in these early pictures, how the shading and modeling are applied in undifferentiated patches, like a decorative convention, and how light is handled as if in a shadow box.

Having performed this parody, which was in the nature of a final summing up and relegation of all the problems that had occupied Western painting between Giotto and Courbet, Chirico had no place left to go. Failing or unwilling to understand either what he had done or the character of painting since Manet, he could find nothing to replace that remnant of the Renaissance which he had destroyed. His destruction had been too exclusively negative—unlike the cubists, whose attack on the third dimension had of itself generated something equally positive to take its place; a new conception of pictorial space.

Chirico went on into the twenties continuing to parody, this time Davidian neo-classicism, sculpture, architecture, literature. This was the period of broken columns, toppled statues, pale horses, and whitewashed gladiators, but handled with baroque or romantic technique. The objects of the parody and the painterly means were both irrelevant. The literary effects themselves were boring, while the loose brush-stroke, the thicker paint, and the warmer colors were just so much inert machinery. His draftsmanship, now that it had abandoned the original inspiration of mannerism and nineteenth-century popular illustration, became as weak as his color. Chirico had lost touch completely. It was not even easel painting; it was elementary interior decoration.

This was not, however, Chirico's last word. He has now performed one more parody. [His] very latest, post-1939 paintings . . . , more or less literal pastiches of Rubens, Delacroix, Géricault, Chardin, Courbet, and the baroque still life reduced in scale and simplified, are frontal attacks on the *malerisch* or "painterly" school, to which Chirico's own Florentine temperament, with its leaning toward hard, cool colors, firm modeling, and clear contours, seemed so directly opposed at the beginning of his career. Here, nevertheless, he has aped the heated, swirling effects of the baroque and romantic masters. The results that in their hands took days or weeks to be achieved are stimulated and mocked in a few hours of slapdash, *alla prima* painting (though it should not be overlooked that baroque and romantic painting was fast and broad by definition). All that is added to the originals is a curious detachment and nostalgia toward the subject matter, an emotion that is the only overt testimony to the fact that these pictures were painted in the twentieth century.

Chirico admires Delacroix, Rubens, Courbet, *et al.;* he could not have imitated them so successfully—up to a point—did he not. He seems to be saying: this is the finest fruit of the painting of the *old* past, and now it is all over with; here is an anthology of ironic reminiscences—in any case, the end, the finish, the funeral; and as for myself, all I can do is comment on other painters.

These pictures are of no importance whatsoever in the development of painting. They are not even tours de force; they are just stunts. But this does not prevent a few of

them—*The Folly of Horses, Departure,* and the Char-
dinesque *Still Life*—from coming off on their own terms
and so revealing Chirico's gift for unity again after a lapse
of twenty-five years, during which nothing he did came
off, on its own or any other terms. And negligible as this
stuff is at its best and symptomatic as it may be of a real
degeneration and of an impotence to react cogently to
modern life, still it has some reality as a gloss on the histo-
ry of painting, an illustrated lecture on the ABC's of ba-
roque painting. Irrelevant as painting inside painting, it is
sheer cultural evidence, a kind of funeral oration more af-
fecting than anything that could be put into words. (pp.
134-37)

> Clement Greenberg, *"Review of an Exhibition
> of Giorgio de Chirico," in his* The Collected
> Essays and Criticism: Arrogant Purpose,
> 1945-1949, Vol. 2, *edited by John O'Brian,
> The University of Chicago Press, 1986, pp. 134-
> 37.*

Robert Hughes (essay date 1972)

[*An Australian-born American art critic and writer,
Hughes gained widespread recognition for his television
series and book on modern art, both titled* The Shock
of the New *(1980). In the following excerpt from a re-
view occasioned by a retrospective exhibition of Chirico's
works at the New York Cultural Center, Hughes ap-
praises his artistic career, finding the later works wholly
unsuccessful.*]

No living artist enjoys a more bizarre reputation than the
Italian painter Giorgio de Chirico. Up to 1918, he turned
out a body of work that set him firmly among the masters
of European modernism. His "mysterious objects," moon-
struck piazzas and tilting, empty colonnades fascinated
the Surrealists and became one of the inspirations of their
movement. René Magritte and Salvador Dalí were both
de Chirico's debtors; Yves Tanguy resolved to be a painter
only after seeing an early de Chirico in a dealer's window
in 1923. André Breton, the pope of Surrealism, hailed him
as one of the "fixed points" of the new sensibility. But then
de Chirico's own aims switched, and the admiration was
reversed. Hardly anyone in 50 years has had a kind word
for de Chirico's later output. It is generally written off as
the work of a self-plagiarizing bore.

On the other hand, very little of it has been shown outside
Italy. So the chance existed that a gross injustice had been
done to the mature work of a gifted painter; in 1918, after
all, de Chirico was only 30, and he has kept working ever
since, denying that he ever was a modern artist and grum-
pily insisting that the Surrealists totally misunderstood
him and his work. To present the evidence, the New York
Cultural Center has assembled a retrospective of some 180
paintings, drawings, lithographs and bronzes, nearly all
from de Chirico's own collection, spanning six decades
from 1911 to 1971.

It would be pleasant to report that all rumors of the mae-
stro's decline are greatly exaggerated. But they are not. No
20th-century artist—not even Dalí—went down so fast.
The homage at the Cultural Center is a lugubrious affair,

but an interesting one nevertheless; for it records in great
detail how one gifted painter went backward under pres-
sure, like an irritated crab, into a historical impasse—and
has stuck there ever since, snapping his crusty pincers at
every stir in the water.

The obsessions of childhood memory permeated de Chiri-
co's work, and his childhood with its Levantine eccentrici-
ties might have come from Durrell's *Alexandria Quartet.*
The son of a peripatetic Sicilian engineer, a man of fiery
temperament much given to dueling, de Chirico was born
in Greece and constantly moved house. "In my life," he
observed in a memoir, "there is something fatal which
makes me change addresses." The character of these
years—a melancholic idyll of transience, conducted in a
series of sirocco-damp villas across a classical landscape—
is built into his early paintings. It was reinforced when, as
an art student in Munich, he encountered the dreamlike,
proto-surrealist canvases of the 19th century Swiss roman-
tic Arnold Böcklin. By the time he settled in Turin in
1911, the meditative cast of his mind was set.

What de Chirico's work from 1911 to 1918 brilliantly per-
forms is an archaeology of the self. Images rise from child-
hood memory with a peculiar, disconnected intensity;
they are fragments of a lost life, like sculpture found in the
rubble of an ancient city. "If a work of art is to be truly
immortal," he proclaimed, "it must pass quite beyond the
limits of the human world, without any sign of common
sense or logic. In this way the work will draw nearer to
dream and to the mind of a child."

De Chirico's empty squares and silent towers seem at first
to be conceived as a partial homage to the Italian Renais-
sance. It is a windless, ideal space where the light never
changes and shadows do not move. Human figures are ei-
ther distant specks or huge, sculptural presences—bronze
father figures on plinths, reclining "classical" marbles or
faceless wooden dummies. But this world has none of the
solidity of Renaissance townscape. Instead, it is enigmatic
and spectral: the perspectives tilt irrationally and contra-
dict one another, the façades are cardboard, the inhabi-
tants ghosts. "These characters in costume who gesticu-
late under a 'real' sky, in the middle of 'real' nature, have
always given me the impression of something as stupid as
it is fake," de Chirico wrote later. He was speaking of the-
ater, but the preference is equally true of his early paint-
ing. De Chirico had intelligently brought some of the flat-
tening devices of Cubism to bear on a wholly anecdotal
art. The fragments of memory found their distorted space;
the means fit the end.

Ironically, the decline set in when de Chirico resolved to
be a Great Artist in the traditional, Italian sense of the
word. "I have been tormented by one problem for almost
three years now—the problem of craftsmanship," he
wrote to Breton in 1922. The gulf between the early work
and de Chirico's *St. George Killing the Dragon,* 1940, can
only be explained in terms of this problem. *St. George,*
with its glutinous, worried paint, its muddily incoherent
color and its torpid drawing, would hardly pass as a stu-
dent academy piece; it is recognizable, though only just,
as a mock Titian. But behind it one can sense manic obsti-
nacy, as though de Chirico were trying to root himself in

the past and abolish the present. Significantly, it bears a Latin inscription: "de Chirico, the best painter, painted this."

The dream of antiquity becomes concrete in de Chirico's later work, and all his efforts are posited on the belief that somehow it can be given life—if not by talent, then by sheer will. De Chirico's self-magniloquent portraits in armor and 17th-century lace are not simply costume pieces, but efforts to inhabit the dream and be a one-man Renaissance. His interminable pairs of Bambi-eyed horses prancing on a marble-littered beach have the same intention. The sum effect is, inevitably, absurd: for de Chirico has no more talent for illusionism than the average calendar artist. It becomes parody—and when de Chirico is not parodying Rubens, Tintoretto or Rembrandt, he parodies himself, as in *The Sadness of Springtime,* 1970, producing stiff, cluttered repaints of his "metaphysical" period. But the tension has gone. One has seen the originals—except when the "originals" are recent products, for it is an open secret in the Italian art world that de Chirico has painted numerous works supposedly from 1916-17 over the past few decades. Perhaps the most vivid lesson to be drawn from the Cultural Center's retrospective is that in art, obsessiveness does not win back what defensiveness loses.

> *Robert Hughes, "Looking Backward," in* Time, *New York, Vol. 99, No. 4, January 24, 1972, p. 48.*

James Beck (essay date 1982)

[In the following excerpt from a review of the 1982 retrospective at the Museum of Modern Art, Beck examines the eclectic elements of Chirico's art.]

Giorgio de Chirico provides a veritable banquet. The issues that surround nearly every aspect of this painter, who died a nonagenarian in 1978, are not merely endless and fascinating, but belong to quite the proper categories to engaged art scholars. Already a vast literature, one that threatens to grow by geometric proportions, has been produced. Consider alone the problem of his cultural and artistic origins! Born in Greece of Italian parents he received his early education there. After a short stay in Italy, he went off to Munich for two or three years (the information is conflicting) to study art. Following another brief residence in Italy, de Chirico proceeded to Paris (1911-1915), still a young and not entirely formed artist. He sometimes called himself a Florentine (his mother came from that city, his father from Palermo) but he spent the bulk of his adult life in Rome, after leaving Paris and following military service in the Italian army. Is de Chirico really an "Italian" much less a "Florentine" artist? After all, he admits strong impulses from Germany (and admiration for Arnold Böchlin and Max Klinger, but one might also add the name of Hans von Marées), and the Paris of the period immediately before World War I was surely the most exciting artistic center in Europe. There, like it or not and admitted or denied, he could hardly have remained unaffected by the visual experiments then going on. One thing is certain: there is no easy answer about de Chirico's origins. Without insisting too strongly, I suggest a description that sees de Chirico as a kind of adopted Italian, or more exactly, a converted foreigner much taken with the vast visual fare and tradition that Italy could offer, is close to the actual situation.

When considering the question of national origins, one must make a distinction between the intellectual components, the basic ideas under which he operated, and the visual or pictorial formation. He was heavily dependent, we are always told, upon Nietzsche and Schopenhauer, and presumably (according to new proposals) the Florentine writer and critic Giovanni Papini. De Chirico's ideas have also been studied as they interconnect with those of his brother Andrea Savinio, a writer, poet, musician, and occasionally a painter; there are those observers who would even give Savinio a priority in the invention of many of de Chirico's most winning images, including the mannequins.

In determining de Chirico's visual sources, broadly speaking we can readily isolate four groups: (1) Classical art; (2) Late Medieval, Renaissance, and Baroque Art; (3) his immediate predecessors; and (4) some contemporaries. A debt to Douanier Rousseau, overlaid upon aspects of Böchlin's manner, not to exclude the influence of his extraordinary modernist colleagues in Paris, can only give the feeblest notion of how he achieved his own style. In a contribution to the catalogue (or really book) connected with the de Chirico exhibition held at the Museum of Modern Art . . . , the organizer of the show, William Rubin, has an essay entitled "De Chirico and Modernism" [See Further Reading, Section III]. Here Rubin emphasizes the close parallels between de Chirico and the leading progressive painters of the moment. De Chirico and his apologists denied connections with Cubism and Futurism and nearly any other modernist movement one could care to name, seeing himself as the *Pictor Classicus,* amid the modern rabble. Rubin quite rightly exploded the notion that early de Chirico was Classical or Renaissance, in any sensible way. (p. 84)

An evaluation of how de Chirico benefited or made use of Classical Antiquity would be a study apart. He and his brother were the "Argonauts," "The Horse Tamers," and de Chirico makes constant use of myths and Latin inscriptions. He even occasionally dates his works with Roman numerals. The everpresent ancient sculptures depicted in his paintings, however, are often mutilated, severely transformed, or they are plaster casts of parts of the body, familiar objects to art students in the academies. A good example is found in the so-called *Self-Portrait* in the Alex Hillman Family Foundation (New York) of 1913-14, with a pair of gesso feet on a table. Props in the still life remind me of Mantegna's use of classical fragments in his Louvre *St. Sebastian.*

The subject of many of de Chirico's paintings, or at least a large number of objects that occur in them, even those dating from the Metaphysical years (1910-1918), are studio objects: frames, easels, straight-edges, stretchers, and paintings. I wonder whether the mannequins which entered into de Chirico's arsenal of forms around 1915, and which became successful and exceptional influential images, did not have their origins in those wooden moveable

figurines (known as "lay figures") used by artists since the fifteenth century to study different poses and movements (and still sold in art supply stores today). These faceless constructions have moveable joints, and in the de Chirico mannequins one can still notice, despite his transformation, the pegs that keep the various parts attached and yet permit movement, unlike dressmakers' mannequins which also may have played a part in the evolution of his figures.

Systematic study of de Chirico's sources—and precisely how he made use of them—is still an evolving critical task. New connections are constantly being discovered or at least suggested, ranging from those based upon an assumed devotion to Venetian Renaissance painting to a well-founded relationship to the art of Gauguin. But with all the subtle interconnections that have been perceived, there is little determination of one-to-one borrowing, direct imitation, or copying that would help explain how de Chirico came to invent the Metaphysical picture or to elucidate its meaning. He achieved a unique set of images, unexpectedly and intriguingly thrown together, which have been painted in a style that is unequivocally suitable to them. In the final analysis there were no true sources as such, for his remarkable voyage. The same may be said for only a tiny number of masters in the history of art where the stimulae available did not inevitably lead to the discovery of a new idiom. One has the idea that if Masaccio had not turned up to do what he had done, Filippo Lippi, Paolo Uccello, Domenico Veneziano, or Piero del la Francesca would have done something quite similar: all the conditions were there. In de Chirico's case, his language came mostly out of himself, which is why his art appears to be so enigmatic to us (still, after nearly 70 years) and will always remain so. I suspect that it was enigmatic for de Chirico too, as if he had been standing behind himself watching the unfolding of the imagery on the canvases before his eyes.

We can, of course, continue to draw parallels and to seek out new possibilities; one that I think needs some exploration is a rapport with the art of Bosch and especially Brueghel, whose townscapes often have the same high horizon and closed "piazza," though now emptied of the crowds by de Chirico, and where great distances with tiny images remain intact. The little girl playing with a hoop on the front plane in *The Mystery and the Melancholy of a Street* recalls analogous figures in Brueghel's *Children's Games* in Vienna. And those ever-present towers resemble the *Tower of Babel* by the sixteenth-century painter, at least in its overwhelming scale, in a picture like *The Great Tower* of 1913. It is also worth bearing in mind that de Chirico's pictures are almost always small tableaux (and when they are enlarged, they are less effective). He also mixes fool-the-eye qualities, like a projected nail, a tack, or a crack in a building, or the shiny wrapper of a chocolate with linear and even abstract passages.

De Chirico proclaimed admiration for the art of the so-called Italian Primitives, that of Giotto but also of Uccello and Masaccio. If most of us today see important distinctions among them, de Chirico and his contemporaries still tended to lump these champions of Italian painting together. Some generic connections between his art and theirs may be cited, especially in their predella paintings, but we should be alerted not to take too seriously, or at least too literally, what de Chirico had to say in words about his work. There was a good deal of rhetoric and art politics besides tongue-in-cheek colorations to his observations about art. If, for the study of de Chirico's sources for the metaphysical pictures, we have his own claims, they were often written as much as a decade or more after the event in question was discussed. With one eye toward history and another toward his enemies, his statements must be pondered.

Two issues that are commonplace for earlier art but somewhat unexpected when treating painting of our own century also need to be faced when treating de Chirico: chronology and authenticity. There are forgeries by the dozen of paintings by great twentieth-century masters. But how many were made by the very painter of the "originals" as de Chirico seems to have done—by reproducing endless replicas and versions of pictures from the Metaphysical period—decades later? Besides, he is known to have inscribed his own works with inaccurate dates, making them appear more precocious than they actually were. And to the exasperation of dealers and museum curators, he was wont to repudiate works that were actually his. His behavior was often quite naughty as everyone seems to agree; but what were his reasons? Pure malice? I doubt it. It is said that he wanted to sell his current works and not propagate the older ones. Perhaps it was the mistreatment de Chirico received at the hands of some Italian critics headed by Roberto Longhi, or his exclusion from their circle by some of his fellow painters, that was behind the traumatic bitterness which deeply affected him and the direction of his art (for the worse). One senses in his letters (to Carra) an isolation in the very movement that he had created and in which he was far the superior artist.

And what of the iconography or the content of his pictures, especially those painted between 1910 and 1920? What is the meaning of those desolate piazzas, virtually uninhabited except for a rare figure, headless statues, and a menacing shadow of gigantic dimensions? Why does de Chirico often include in the distance (or occasionally on the front plane) a train with white smoke bellowing forth from its engine, or banners fluttering in an otherwise windless sky; what special meaning do the everpresent arcades have for him; the clock, the brick walls, or the chimneys? Favorite still-life materials include busts or heads, artichokes, bunches of bananas, pineapples—the latter items interpreted as references to Italian colonial wars in Africa as de Chirico learned of them in Paris. Sexual meanings appear to be equally possible. And what of the cannons, the sailing ships, and equestrian statues (from little tin war games figurines), pictures, signs, toys? There is much that is shared with a world of children and all that is implied in it.

I had planned to hate the exhibition of de Chirico's work, having in mind the more uncelebrated de Chiricos of the 1940s, 1950s, 1960s, and even the 1970s which, however, are excluded from display. And only a few examples of the 1920s were reluctantly included. None of those vulgar rehashings of older things are to be found. On that score, at

least he was getting mileage out of his *own* inventions, and who had more right to repeat them? The pictorial style of de Chirico became barren, the painted surfaces ugly, the color garish and tasteless. Deep down I cannot help wondering if it is possible for someone who had been so bad for so long, to have ever been really good, at least hypothetically. Or conversely, is it possible for an artist who was early on very, very good to become truly bad?

Unfortunately, the founders of the exhibition were unwilling for us to have a try at resolving this dilemma, for they have chosen not to present a serious look at the bulk of his work. The question behind what appears to be an absolute decline in invention and the loss of the electrifying technical skill is not an altogether isolated one, and involves the mysteries of creativity and the loss of it. On the other hand, perhaps those later works are really not all that bad; perhaps, too, we are merely unable (as yet) to understand their place in a modernist context and consequently reject it outright.

One fact results with absolute certainty from the exhibition at the Modern: de Chirico was an excellent painter, and came upon appealing and unforgettable images. The genial idea of putting sunglasses on a white plaster bust or of making a central motive of a red rubber glove are demonstrations of flashes of the creative power of the Metaphysical Giorgio de Chirico. For the rest, we'll have to wait and see. (pp. 84-5)

> *James Beck, "The Metaphysical de Chirico, and Otherwise," in* Arts Magazine, *Vol. 57, No. 1, September, 1982, pp. 84-5.*

Jean Clair (essay date 1983)

[*In the following essay, Clair provides an overview of Chirico's work, noting in particular the influences of the painter's ambiguous attitudes toward the classical era.*]

Goethe published his *Essay on the Metamorphosis of Plants* in 1790. Four years earlier in the Palermo Botanical Gardens he had had an intuition of the *Urpflanze,* the original plant, "model and key (from which) one can derive an infinity of other plants which must be logical; or rather, even if inexistent, they could nevertheless exist . . . The same law can be applied to all other living beings." This was at the time of his travels in Italy, during which he was absorbed in reading Winckelmann, and in Rome met Angelica Kauffmann, Hirt, and Tischbein. Before the temples of Paestum and Segesta, he too had been overwhelmed by the "noble simplicity and calm grandeur" of classical art. Like the *Urpflanze,* the temples also seemed to provide a "universal *key* . . . These sublime works of art were produced by men, but like Nature's greatest works they were made according to true and natural laws. All that is arbitrary and imaginary is abandoned: what remains is necessity . . . "

Vienna at the turn of the century. The Ringstrasse is in the final stages of completion. It is to architecture and space what Wagner's *Ring* is to music and time: a circular recapitulation. Historicism triumphs. Painters and architects rummage in the past as if they were in the props depart-

ment of an opera house: built in classical Greek style, the parliament building symbolizes Power; in Palladian style, the university symbolizes Knowledge; the Brabançon Gothic town hall represents Civil Liberties; the Renaissance opera house, Culture; and finally, in baroque style, the Theatre symbolizes itself.

At number 19 Berggasse, there is a bourgeois mansion built in an eclectic style that blends *Biedermeier* and *Jugendstil* with *Noblétage.* In a study crammed with antiques, the owner is elaborating a strange psychological theory. He has just published *The Interpretation of Dreams,* whose pages frequently reflect a nostalgia for Rome "the Eternal City." Much later, when his theory is complete, he will say that the unconscious is *zeitlos;* does not obey the laws of time and the structure of memory, which resembles a city in ruins. He makes special reference to the *Domus Aurea.* To explain the sicknesses of the soul, he calls on Oedipus and other figures from Greek mythology, while, on the Acropolis in 1904, he himself is struck by a strange disturbance of the memory. His aim is to describe the unconscious: its organization, its "topics" and its function: the dynamic by which memories are repressed, preserved and recovered. To explain the latter he uses models that come in part from the archaeology of the previous century; from Schliemann, Burckhardt and Bachofen. At the moment, he is absorbed in Wilhelm Jensen's Pompeian fantasy *Gradiva,* which offers a possible model for the therapy he is developing. Each patient under analysis will be implicitly invited to re-live the adventure of Dr. Norbert Hanold. The transformations of Gradiva-Rediviva-Zoe-Bertgang dot the odyssey of a nostalgic soul as it journeys toward the sun of its liberation.

Munich, 1906. The young de Chirico arrives in the Bavarian capital, the "new Athens," thanks to Klenze's reconstruction in neoclassical style with a tumult of arcades, columns and propylaea. In Munich, de Chirico cultivates a nostalgia for his family origins (he was born in Thessaly) and through the works of Böcklin, Klinger, Schopenhauer, and above all Nietzsche, (the theoretician of that other spiritual *Ring,* the eternal return), he has a first intuition of what will later be *Metaphysics,* destined to have a revolutionary impact on the artistic movements of Europe. But later, in 1920, de Chirico himself wrote *Pictor classicus sum* (I am a classical painter) on one of his canvases and re-presented himself in the form of an antique marble bust. Soon he would be saying that Munich was the cradle of the two worst evils of the century: nazism and modernism.

Nazism did, indeed, first break out in Munich. Prinzregentenstrasse, 1937: we are at the inauguration of the German Art Museum, housed in a building designed in Doric style by Troost. Young Bavarians are on parade, dressed in Greek tunics and carrying gigantic effigies of Pallas Athena. This is because according to Nazi ideology, the Germans are the natural descendents of the Dorians, and therefore German culture must reclaim its Greek heritage. The architecture and sculpture of the Third Reich will thus be *frühgriechish* (Early Greek) in style. Hitler makes speeches condemning innovation in art as a source of decadence, but glorifies the *arché,* "the bridge with tradition," and demands that artists respect it. Goebbels explains that

"it is a question of return . . . the natural quality of the State is its bond to a world vision; a quality shared by both the Christian and Classical states . . . "

These four examples have in common the idea of return, the *regredientes Rückschreiten* which Freud described. They all reveal a fascination with the Ancient World, and specifically with classical Greece, which is viewed as a natural origin to be jealously guarded. We only have one mother and we are not going to share her with anybody.

In reality, however, there are differences. The Viennese architects' historicism is motivated by what Panofsky calls a fashion for *renovatio,* a desire to *renovere;* to which we can also attribute the neoclassical investiveness of Troost and Speer. In contrast, the neoclassical reaction of Goethe, like that of Petrarch before him, comes from a desire to *reviviscere,* to revive or bring back to life. In this second case, we have a *renaissance,* a movement toward life and liberty, while the former is a *restoration,* the authoritarian and artificial recovery of archaic forms. So where does de Chirico fit in? Shall we say that he participates in both? Simultaneously? Or one after the other? Was he first the genius of a renaissance and later the artisan of a restoration? What is his precise position in the history of forms?

Throughout the history of art and literature we find nostalgic reactions of the kind we are considering. Perhaps no esthetic revolution can occur unless it is the fruit of such a reaction. The two events, the *innovatio* which breaks with tradition and the *reviviscere* which picks it up again as something new, are not mutually exclusive. As in the life of an individual, so in the history of forms they coexist: there is no progress in art that is not accompanied by a reaction, no "return" that does not lead to progress. The Modern Age has nourished itself entirely on this perpetual to and fro. And de Chirico is the incarnation of a kind of modernism that completely seduced both poets and painters: Apollinaire and Breton, but also Pierre Jean Jouve, Ernst, Dalí and Tanguy, perhaps even Balthus. No other art can rival his in its subtle evocation of inventive nostalgia combined with a truly prophetic sense of the present. The romantic *Heimweh* of a return to the roots is contradicted by a projection of the future, making the painter at once the Orpheus and the Cassandra of the Modern Age. No other art of his time was marked with such a tension between the call of a dying past, whose last heralds were Böcklin and Klinger, and the anticipation of a future that would be the world of industry and technology. That tension was the lifeblood of de Chirico's work: its removal would have been fatal. His fixation with the past, his own past as a native of the land of the Argonauts, exiled in Italy, his attachment to the classical culture that was in such danger at the turn of the century, his nostalgia for a family life he had never known, his lifelong search for a spiritual fatherland, all this was coupled to a projection of the future. The result, from 1910 on, was the construction of a world that was as revolutionary in its iconography (which antedates surrealism by fifteen years) as it was in its new spatial construction (which shared the formal characteristics of cubism and abstractionism).

It is fascinating to follow step by step, painting by painting, the journey of this prodigal son, and to feel the growth of his nostalgia. His pictures are maps on which dotted lines indicate both real departures and imaginary returns (*The Melancholy of Departure,* 1916). They are the evocation of an idealized Greece, mother of gods and forms, womb of meaning. In the Ferrara paintings, the evocation of the mother world, the imaginary Helladic *Heimat,* is reinforced by the more unusual and autobiographical image of a childhood paradise full of toys and sweets. Dry biscuits, which he glimpsed in the shop windows of Ferrara's Jewish quarter, brioches, barley-sugar sticks imported from England by Tudor House, the hoop game, and finally the two-horned *coppietta,* or in Ferrara dialectic the *ciupeta* (a kind of croissant): all these form in red, yellow and deep green, the blazon of a distant childhood (*The Language of the Child,* 1916). But there is a skeleton in the cupboard. Other elements work their way in: gloves and sewing things that are too empty, too unused—images of solitude, abandon and regret.

If de Chirico's work had been solely an expression of nostalgia, it would never have reached the level it did. We are fascinated by his paintings, as were his contemporaries, because the romantic feeling of return to the lost world of childhood is no longer tender and faded, as it was in Novalis and Schiller: it has become bitter and desperate in the manner of Hölderlin and Nietzsche. This was a contradiction, a kind of exclusion of the romantic *Heimweh* in favor of another feeling: acute apprehension of the world into which the self had entered, or rather to which it had been banished; that modern world of industry and technology, of incessant exchange, of non-performance, of the unstable and the ephemeral, of mass manipulation, a world that we can agree with Mircea Eliade in describing as "terrorized by History." And so the day would come when de Chirico would equate in his memory the esthetics of modernism with the ideas of Nazism.

De Chirico was not indulging in a taste for paradox when he identified modernism with the historicist regimes. It was a recognition of the fact that both were seeded by the Enlightenment, by the will to rationally organize society, and that both ended in the same way—the first in barbarism, even if it was masked by progressive theories, the second in terrorism disguised in neo-Grecian robes (thus going the way of all totalitarianism). It was especially in Munich, through contact with Makart, Hans von Marées and Thoma, that de Chirico acquired his taste for the acid and dissonant effect of juxtaposed blues and greens. But he also fell for the disquieting charm of historicism and the *Biedermeier.* In the polished, cold and nostalgic style of the Nazarenes it is all there: the fascination of the broken arch, a taste for Raphaelesque disguise, and nostalgia for an imaginary South. But there is also a presentiment of the danger of an ideology which not only claimed to recapitulate history but also to bring it to completion.

At the beginning of this century, tall smokestacks began to appear on the traditional skylines of our cities, taking over from the old bell towers and castle turrets. Today, when most of them have been demolished or shifted to the suburbs, we cannot recapture the impression they must have made on the people who watched them rise. Gustave Doré and Adolph Menzel, followed by the illustrators of

CHIRICO

MODERN ARTS CRITICISM, Vol. 2

Jules Verne, were among the first to register their disturbing presence: giant pillars, they stood erect, as if produced by the urban soil itself, blatant, brutal signposts of the new and mysterious activity lurking in the towns. It was no coincidence that the reassuring Nazi esthetic planned to eliminate them from the landscape. Projects for Berlin and Munich in the "Thousand Year Reich" included the camouflaging of the realities of the industrial world, leaving only the uncontaminated Greek columns standing in pure triumph. And yet the very smokestacks which were to be so conveniently hidden, returned as the most horrible and unambiguous symbols of rationality gone mad.

Guillaume Apollinaire, in 1913, had perhaps already seen the new painting: he was certainly seized by enthusiasm for these symbols if virility, and they are a key element in the industrial mythology of the _Alcools_ poems. De Chirico, on the contrary, made no attempt to glorify modernity and even less, under the terror of History, to hasten its progress. He was the first to paint an unforgettable portrait of the Modern Age from its glorious beginnings to its pitiful end. Sharing with Apollinaire a fascination for Ancient Greece and a sense of nostalgia, de Chirico had the genius to see these towers for what they were. Mixing classical forms with the sombre emblems of an infantile, virile and cruel vanity, they were the signposts of the Modern Age. But they did not signal man's liberation, as the Zone poets, the futurists and other enthusiasts of modernism believed: on the contrary, they marked the beginning of an appalling barbarity.

The totalitarian ideology and the modernist esthetic both isolated historical epochs in order to use them for different ends. De Chirico brought them together in a mixture that created a new world: our world. The meeting of the Greek colonnade with the smokestack, of the ancient ship with the locomotive, of the antique temple with the modern factory: these became the signs of an original iconography that would be as upsetting for modern man as the iconography of the Renaissance painters had been for their contemporaries (as it, too, developed from the tension between ancient and contemporary elements). It is the tension of the contrast that creates the absolute originality and inflammatory power of the work. The strange encounters in de Chirico's paintings are of the same kind as that between Norbert Hanold and Gradiva: the past seeds the present, the present revives the past under the strange and troubling sun of consciousness. And this because, as Freud would later show, any genuine return, any real rebirth is charged with apprehension. If it is true, as the proverb says, that _Liebe ist Heimweh_ ("Love is homesickness"), then the modern condition transforms the feeling into a discomforting extraneousness. Perhaps no other work of our time has gone so far in expressing the end of the intimacy that once existed between men and things. Certainly, no one more than de Chirico sensed the measure of this loss.

From 1910 to 1916 the paintings repeat, with endless variations, the same images of privation, nakedness, depossession and incompleteness. The desert prophesied by Nietzsche begins to spread. And the imagery was an unexpected boon for the psychoanalysts, proffering signs of impotence

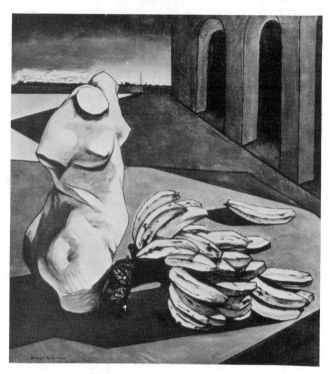

The Uncertainty of the Poet _(1913)._

in all directions. In _**The Uncertainty of the Poet**_ (1913), for example, a truly royal regime of bananas uselessly multiply their virile vanity, and come to die in front of the glacial pubis of a headless, limbless, marble Venus. Nothing will ever _happen_ again. Space has ceased to be, and bodies to live. No air has ever swirled across these terraces. Shadows are depicted here only to show the loss of atmosphere, of the breathable world that painting once was. Leonardo and the Renaissance invented chiaroscuro to show that the space of painting was consubstantial with real space and that, therefore, their paintings were our spiritual home. In de Chirico's works, the shadow becomes opaque and hard as a wall, blocking our access to the kingdom, cruelly denouncing illusions. For the whole history of painting, the shadow honored its being, acted as a halo to its glory: here it is reduced to a mere sign of the shame that comes from having a body (and perhaps de Chirico had profited, in this sense, from his studies of Klinger's masterly 1887 engraving _Shame,_ in which the shadow is cast on a "murmuring wall"). Nothing gets out of this contemporary _Inferno._ Signs of travel and escape are masked, forbidden: locomotives and sailing ships appear, but hidden behind infinite brick walls.

Symbolic again, almost irritating in its obviousness, is the cannon in _**The Philosopher's Conquest**_ (1914), with two enormous balls attached to its base. One can see in this a modern version of the Delian _Omphalos._ Aimed at the shadowed opening of the arcade, it will never strike its target: above it, high up, an immense, imperial clock is enthroned, the fearful figure of _Cronos,_ the Father who prevents the act. The barrel remains as a symbol of wounded virility or forbidden desire. The creative power that came to us from the Greeks has run dry. The great god Pan is

158

dead. The procession of Dionysus has scattered. Arcadia is no more than a hollow dream. And the two artichokes lying on the ground ill conceal their likeness to broken thyrses of which only the fruit is left.

It might seem futile to indulge in this kind of interpretation, but, in fact, what we know of de Chirico's life fully authorizes us to do so: the engineer father who left too soon, but whose moustached image lingers on until the last paintings; the possessive mother, adored and feared; and other details—de Chirico had been introduced to sexual symbolism very early on by reading Otto Weininger's *Sex and Character.*

It is not only the revelation of symbols, and a new form of hermeneutics that inspires the work, but also, on an abstract and formal level, the definition of a new space. An original topology is sketched, involving the fusion of the primitive with new data. De Chirico takes up the perspective system of the Ancients, he again uses a *scenografia* that is an evocation of the *perspectiva artificialis,* but he does this in order to confuse the code. No being ever inhabited this space. No horizon ever bounded it. No vanishing point ordered it, no depth crossed it.

All the work is thus founded on sterility. But its genius and fascination come from the fact that it was created at a time when European thought itself was lost in the same feeling of deprivation. De Chirico's false perspective, this deceitful game of porticos and shadows, this wayward sundial that no longer tells us anything about time or space, create the space of modernism with just as much conviction and power as cubism and abstractionism did at the same time, around 1910. But Braque and Picasso in France heralded modernism by breaking up the classical space of representation in a purely conceptual fashion. Malevich and Kandinsky in Russia inaugurated this new topology starting from mystic speculation. De Chirico followed an existential path, spurred on by the reading of Schopenhauer and Nietzsche, but also the Greek philosophers, thus preparing the somber mirror in which Magritte, Ernst, Dalí, Tanguy, Delvaux and others after him, would find their reflection.

Three 1916 paintings, **The Jewish Angel, Greetings from a Distant Friend** and **Metaphysical Interior I,** develop the theme of an eye painted conventionally, as it was in the treatises on classical perspective by Abraham Bosse or Sebastien Le Clerc, and placed near a pile of geometrical instruments: setsquares, curve-makers, tools for surveying and trigonometry. But, while in *perspectiva artificialis* the pupil was the center of the painting, conceived as a representation of the world, here it appears as an unexceptional element in a puzzle, an object abandoned among forgotten instruments. **The Still Life with Violin** of 1920 repeats the theme: here, in fact, we are presented with a modern version of Dürer's *Melancolia I.* The represented space has ceased to be consubstantial with the real space. Painting has ceased to be a sign of power over the world, becoming instead the recognition of deprivation. The great clock that appears so often in de Chirico's work, is a clear enough indication of which god it is that looms over modernism. It is not Mnemosyne, the goddess of memory celebrated by the painter's brother Savinio, who assures the

peaceful transmission of recollection. It is the cannibal and castrating god of Time, who devours his own children and prevents the transmission of knowledge; the Titan whose kingdom is identified with primitive and brutal force, with times of terror and revolution, with history lived as fear.

This anguish induced by space—which Worringer, writing at the time, called *eine gestige Raumschen*—would become the distinguishing mark of "modern" art. But the latter is denied mastery of real space because of the conception of time, which prevents a mastery of the past. This "contempt" is, however, the source of the value of modern art, its critical essence, so much so that the mastery to which totalitarian regimes aspire, based on an esthetic of simple restoration, with perspective and a vanishing point, only succeeds in revealing its own radical falsity.

Modernism is only genuine when there is this tension between the past and the present: if it is placated or negated in favor of either the future or the past alone, then modernism is reduced to mere fashion or pastiche. This brings us to the problem of judging de Chirico's work after 1920, when he became *pictor classicus.* Until then, in his relationship to the *arché,* he had been the founder of a renaissance: from then on, with his return to the *bel mestiere* and the exclusive *maniera antica,* does he not become the agent of a simple restoration? The Renaissance had already produced a similar phenomenon. Mantegna, its leading figure, undertook to effect a total restoration of the classical world using its visible and tangible vestiges. This meant running the risk, as Panofsky has written, of "transforming into statues figures that live and breathe, instead of giving statues the breath of life." Mantegna's strange *San Sebastian,* in the Louvre, came from an impulse similar to the one that led de Chirico to the archaeological petrification of his self-portraits, as he waited for the entire corpus to become an archaeological piece. And surely he had previously felt the fascination of this petrification in Turin, "a town peopled by statues," where he had fallen for the charm of those effigies in bronze and marble, placed on low pedestals almost at street-level, which seemed to share in the life of the citizens.

But that is not all. It was easy for the surrealists to "kill" de Chirico. The assassination of the father was part of the group ritual, and even assured its foundation. Breton's domination of the surrealists could not, in fact, be assured until he had been recognized as the leader, or substitute father. Breton's symbolic assassination of de Chirico in 1929 was thus destined to institutionalize surrealism. It was transformed from a primitive horde into a social group whose members had a common ideal and a common social ambition. But, by a strange coincidence, which only careful psychoanalysis could clarify, it was in the same year as this "execution" that de Chirico painted the most intense version of the *Prodigal Son.* In fact it seems that de Chirico's strange life, the symbolic "murder" which he appears to have performed on his own father (who was always away from home, and left completely when the boy was still an adolescent), together with a powerful, long-lasting attachment to his mother, all resulted in a deep feeling of guilt which transpires from both his paintings

and his writing. This feeling predisposed him—enigma of fate—to offer himself, in a well-known process of self-punishment, as a scapegoat for those unnatural children, the surrealists.

The fact remains that there were people outside the surrealist group who did not consider that de Chirico had ceased to exist in 1919. Marcel Duchamp, in the catalogue of the Société Anonyme, expresses with his usual lucidity the opinion that "posterity would have something to say" about de Chirico's later evolution. An equally free spirit, Roger Vitrac, observed in a *post scriptum* to his brief text on the artist which appeared in 1927: "Nothing allows me to doubt de Chirico's recent work. Nothing. On the contrary." And, in fact, as the "neoclassical" Goethe of the Italian journey is no less fascinating than the Goethe of the *Sturm und Drang,* so the "neoclassical" de Chirico of the twenties is no less moving than the de Chirico of Metaphysical Painting. Perhaps it would be more correct to speak of neoromanticism? The Roman villa series, **The Departure of the Knight** (1923), **The Echo** (1922) are landscapes full of the elegiac feeling of Leopardi's poetry, and are among the most beautiful that I know. The most complete painting of this period. **The Ottobrata** (1924), a peaceful reflection of the declining day, reveals a feeling worthy of the most beautiful elegies of the Renaissance *Seasons.* As the games and torments of *Pleasure, Play, Deceit* and *Jealousy* dissipate into the mist which reigned in the works of other times, the figure of *Cronos* fades too, giving place in the sky to a little winged Mercury who moves off into the distance.

The year 1935 seems to mark a real turning point in de Chirico's work, and perhaps the beginning of its decline—until the marvellous last flare-up of the years 1974-78. It was also the year of his mother's death. A year earlier, de Chirico had published in *Minotaure* his text "On Silence"—the frontispiece reproduced his painting **The Duo.** In it, de Chirico showed himself heir to a long literary tradition that can be traced back to the first romantics. Coleridge, in *The Ancient Mariner,* was doubtless the first to imagine a seascape in the form of an abyssal and prehistoric fantasy, mixing naturalistic notions with fantastic archetypes. Jules Verne, whom de Chirico liked to read, would later popularize this fantasy in *Twenty Thousand Leagues Under the Sea.* The primordial sea of the primitive age, shaken by volcanic tremors, is also the sea of our culture, the *mare nostrum* of civilization, and that of the infancy of humanity. Eruptive, it reveals to the eyes of the mystic the ban on his own birth. Rimbaud, too, had read *Twenty Thousand Leagues Under the Sea* and remembered it when he composed *Le Bateau Ivre.* But de Chirico's text, when confronted with his "models," retains the hallucinatory precision of a vision. Yet nothing of what he describes is imaginary. We recall that in a text written during his first stay in Paris, between 1911 and 1915, de Chirico had already invoked the "sense of prehistory," saying that for an artist today nothing is "sufficiently profound, sufficiently pure" to give him a feeling of newness. Here it is the most ancient, the "deepest," which is the "newest." The experience of the new is the experience of something-already-known: discovery is reminiscence, literally uncovering what was buried; we only find what has

always been there. As the poet says, it is a question of "diving into the depths of the unknown to find the new."

In May 1919, an article in *Valori Plastici,* on the subject of "eternal signs," recalled the "strange and profound impression" made on de Chirico as a child by an illustration in a book "which was titled *The Earth Before the Flood:* it represented a landscape from the Tertiary period." A book by Louis Figuier with this title was in fact published by Hachette in 1894: two of its engravings correspond exactly to the description that de Chirico gave fifteen years later. They were engraved by Edouard Rio, that unknown genius who was also the illustrator of Verne's *Extraordinary Voyages,* the publication of which heralded the "age of the finite world," coinciding as it did with the discovery of the Poles and the foundation of the Trans-Siberian railway: events which had closed the world in on itself.

His fidelity in this context might seem surprising. This world where the god of silence reigns, where forms are glimpsed that are describable but as yet unnameable, this embryonic universe is also the *infant* world where things are mute: source of meaning, it reveals no meaning; womb of forms, it leaves them nameless. But this *pre*-historic world, in which things are formed, will become through evolution the *post*-historic world—our world, divided from the past; this Nietzschean desert in which de Chirico would be condemned to live; a world where things are deprived of cultural memory and "have nothing more to say." *Stilleben,* silent life, still life: the modern world is dumb because we have forgotten how to read the signs. Life petrifies and the god of silence reigns again, as in the Beginning, because the gods and demons have deserted the world.

This World before the Flood presents itself as a fantastic projection of the child's world, an archaeological double of his own life as a painter: it corresponds to the silent womb from which he was expelled in order to fulfil his destiny. The phylogenetic fantasy of the Beginning reinforces and generalizes the ontogenetic phantoms of childhood, but at the same time it recapitulates and rationalizes them, thus assuming the role that the "discovery" of the *Urpflanze* ("key to all things") must have played in Goethe's vision. It inserts the structures of individual consciousness into the global picture of cultural history. As an Italian subjected to fascism and as an artist subjected to the *diktat* of the avant-garde, de Chirico suffered from both totalitarianism and modernism, and the continuation of his suffering was both natural and necessary. But it is clear that he was also caught up in a more generalized "sickness of civilization," and that the *Urpflanze,* with its neo-Darwinian phylogenetic basis, was an expression of it.

The theme of the **Furniture in the Valley,** which appeared late in his career, was a painted manifestation of the same fantasy. The pieces of furniture in the paintings are domestic objects *par excellence,* charged with *heimat* sentiment, emblems of the home and its security. But they have been "displaced" and no longer have a place in the present: removed, evacuated, they are now effectively in a *vacuum,* a non-place that recalls the non-place of modernism. De Chirico implies that they alone have the capacity to create a place away from all places, to restore a presence in the

heart of nothingness "a sanctuary," he says, "on whose threshold the Furies stop, as if held back by an invisible and omnipotent hand." These objects are inseparable from the soil, from solidity, from the original earth. From childhood we turn to them for support in our being-in-the-world. Their apparition matches, almost by necessity, the evocation of the Greek temple which also establishes its relation to the world, if not to humanity, through its *solidity*. Rejects of a domestic removal during which the sense of intimacy was lost, huddled on a raft-platform, they are set in a landscape dotted with column bases and pediment fragments: the individual destiny of the artist is once again inscribed in the general *fatum* of his culture (**Furniture in the Valley,** 1927).

De Chirico woke to his art in the secessionist climate and *Gründerzeit* of the Munich of Klinger, Hans von Marées and Von Stuck. He created his masterpieces in the light of the philosophers of decadence. And he closed his career in the frivolous atmosphere of the late seventies, when the "avant-garde" was already an illusion kept alive by the market, and totalitarianism had become an almost universal system of government. The only immortality he could claim at that time was the derisory version proffered by the *Academie Francaise.*

A soothsayer sent to decipher the signs of a new melancholy, a child dear to all mothers, a new Hermes destined to restore the demons to the world, de Chirico became, as the years passed, a disenchanted Cassandra. As he grew further and further away from childhood he saw things fix themselves before his very eyes and fall silent: as if his ability to revive archaic forms had turned into a power to petrify living ones. And what happened, over the years, was that he petrified himself in the form of a hypnotic Buddha, lost for hours in the contemplation of a television screen, bitter, acrimonious and indifferent to everything, as if his only way to escape from the terror of History was to parody its frenzy and fake its trickery. Plagiarist and wrecker of his own work, he had the last laugh on his time. The tireless copying of **The Disquieting Muse,** the endless repetition of the same ancient themes, all this sterile and senile activity, whose function was to purge himself down to a shadow of what he once was, now mimicked in a derisory fashion the sad and indifferent evolution of an eternity without meaning.

Alone, de Chirico had explored and recognized that desolate, mineral world which fifteen years later would be claimed by the surrealists before becoming part of today's consciousness. He was also the first to leave that world as others arrived. Between 1910 and 1920, like Picasso, Malevich and others, he had tasted the infinite freedom of feeling "modern." Much sooner than they, he felt the terror and the nausea of finding himself part of history. His "renunciation" is not without greatness: it prefigured what are perhaps the only real conquests of the art of our time.

His brother Andrea, sensing the ill-fate that pursued the Dioscuri, had outfoxed it by assuming a pseudonym, Alberto Savinio: *promachos,* he could proceed behind his mask to the completion of his work. But de Chirico's body was interred in the grave of another, to give *post mortem*

notice of the fate that would have rid his painting of what was most foreign and most hostile. He was buried anonymously: his work, like his tomb, still awaits a name. (pp. 12-20)

Jean Clair, "Giorgio de Chirico: The Terror of History," translated by Philip Swann, in Flash Art, *Vol. 111, March, 1983, pp. 12-20.*

Achille Bonito Oliva (essay date 1983)

[*In the following excerpt, Oliva presents a sympathetic overview of Chirico's work.*]

Giorgio de Chirico died on 20 November 1978 at the age of ninety. Born in the Greek town of Volo of Italian parents, he studied in Germany together with his brother Savinio, and then moved on to Italy and France.

This nomadism gave de Chirico's paintings a complex breadth and a cultural background that ranges from Schopenhauer to Nietzsche and Weininger, from Böcklin, Klinger and Lorrain to Poussin. Through his Metaphysical Painting, he influenced many generations of artists, from the French surrealists who later disowned him, to the so-called Novecento and the more recent trans-avantgarde artists, who have taken from him the eclectic use of quotation, the stylistic recovery of linguistic models belonging to art history.

Throughout his career, de Chirico maintained the same viewpoint, that of shifting the inanimate objects of everyday life to the realm of art, and imbuing inert objects or fragments with a diffuse and mysterious intensity. Reality thus found in art the reason for its own disorder, for its accidental nature and the patent senselessness that pervades existence and the history of all existences.

De Chirico wrote: "The metaphysical artwork is serene at first glance; nonetheless it gives the impression that something new is about to happen within that serenity, and other signs, not those which are already manifest, are about to take over the square of the canvas." He transposed this philosophy of life in his paintings; this concept of a continuous and senseless mystery that underlies reality, a halo surrounding ordinary things, making them rumble with distant echoes.

Paradoxically, he used the sensible canon of perspective, the illusory depth of Renaissance painting, to represent the senselessness of the world. In this respect he was far more subtle and problematic than his surrealist imitators, who traced the accidental nature of the unconscious using automatic techniques, creating a sort of psychic naturalism and falling into that preoccupation with content over form which Freud accused them of. De Chirico managed to keep artistic language outside the schematics of surrealism by subjugating it to a dazzling, heliacal enigma.

For de Chirico, life is characterized by a cordial sense of tragedy, creeping and absolute, which pervades every human expression and which, day and night, conditions everyday actions and oneiric abandon. The use of Renaissance perspective is meant to set up a visual paradox which is not concerned with framing a mythical or heroic

event as in fifteenth-century painting, but is intended to communicate the uncommunicable: an enigma, patent or almost imperceptible. The paradox arises when Euclidian geometry, and the myth of reason, are used to sustain what the rational faculties cannot fathom: the mystery of life. De Chirico's paintings check us in our steps, as though we stand before the Delphic oracle, and instead of hearing our fate, we hear only obscure phrases which drive us back through the intricate paths of life. Here, the oracle is a secular revelation of the senselessness of existence, and appears under the guise of art images to provide an answer that falls short of our expectations, which are based on the principle of reason.

De Chirico also wrote:

> One may deduce that everything has [see Artist's statements] two aspects: a familiar one which we see most of the time and which man sees in general; and another spectral or metaphysical aspect that only rare individuals can see in moments of clairvoyance and metaphysical abstraction, just as certain bodies occulted by impenetrable matter from the sun's rays can only be seen by the power of artificial light, such as X-rays, for instance.

Art, too, has this great quality of tearing aside the veils that keep things hidden, but a tragic surprise lies in the discovery that the enigma resists our every attempt at knowledge and rational penetration. Thus de Chirico's painting becomes a sort of recognition which revolves and slides on itself, rotating on the eternal question without ever arriving at an answer. There is no doubt that he claims for the artist a secular version of the prophetic prerogative of the bards of myth. Now myth has become twisted up in its own impossibility, in a world without heroes. And this is what divides de Chirico from the contemporary world, wholly taken up with its own rational coercion and with the pathetic certainty of being able to provide an answer to every problem with the demythologizing arms of technology. Here, too, is the source of de Chirico's profound solitude as a man and artist who continues to dialogue with the great figures of the past; for he sustains that the basic question of life remains unchanged for artists of all epochs, forever heroically occupied with this primeval problem.

Thus one may find repetition in de Chirico's works, but never imitation, copy or counterfeit, because there is no change or solution. His joking attitude toward the market and the fetishism of collectors also grows out of this awareness. The critics go to great lengths to catalogue vintage paintings because they feel the need to censure and select art. In recent years, we have witnessed the pathetic personal vindications of critics and dealers involved in the "scandal" of fake de Chiricos which throw all blame onto the artist, as though the problem were to determine who stole the jam.

In fact, de Chirico loosened his ties with the world through a series of playful and deliberately reckless actions, showing the irresponsibility of the child (Dionysus) who knows he is playing a game which is eminently his, and which others cannot always understand because of

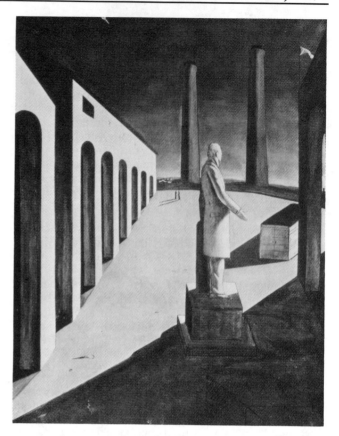

The Enigma of a Day *(1914).*

their blindness or preoccupation with immediate concerns, and their inability to fathom the depths of reality—even the simple reality of everyday events. De Chirico's death marked the passing of one of the greatest artists of the century. His paintings remain, ciphers of an enigma that belongs to us inasmuch as it is traceable in every aspect of existence; an enigma that goes beyond philosophical investigation and cultural inquiry. The enigma often shows the signs and disguises of a mocking, sardonic style, and sometimes even invests the specific identity of the work, to the chagrin of those collectors who fetishistically pursue vintage paintings. (pp. 21-3)

> *Achille Bonito Oliva, "Giorgio de Chirico and the Trans-avantgarde," in* Flash Art, *Vol. 111, March, 1983, pp. 21-4.*

Claude Gintz (essay date 1983)

[Gintz's essay examines the elements of repetition evidenced in the artist's early and later works.]

Museum curators, it seems, must be unusually circumspect when dealing with Giorgio de Chirico's pictorial production. For William Rubin, the reason for their caution is self-evident: only the artist's metaphysical period is worthy of consideration. The "seeming affinity of his early painting with that of the Florentine masters of the Quattrocento" which some critics have found is deceptive; "Despite first appearances," Rubin writes [see Further

Reading, section III], "de Chirico will emerge as much a modern painter as the poet of a specifically modern sensibility." The "modernist sensibility" of the metaphysical de Chirico worked to subvert "classicism, by turning it inside out," in order to empty it of all spatial illusionism and to communicate "the singular malaise of modern life."

This view of de Chirico as a critical artist—critical, because despite his nostalgia for the classical order, he knew that it was unavailable to him—governed the selection of works for the Museum of Modern Art's 1982 de Chirico exhibition, which tended either to accredit or confirm the idea that the artist's career began around 1911, somewhere between Florence and Paris, and that it was over by 1918 in Rome. Thus, the majority of works in the exhibition were produced between 1910 and 1917; the Roman period of a return to classicism (1920-24) was represented by an extremely limited number of paintings, as though it merely marked the end of a career, beyond which point it is better not to venture.

Jean Clair, who was responsible for the de Chirico exhibition at the Centre Georges Pompidou in Paris this past spring, prefers to date to 1935 "the career's real turning point, and perhaps its decline, until the unexpected final efflorescence of 1974-76." For Clair, the "Neoclassical" (perhaps even Neoromantic) works of the '20s—the "Roman Villas," for example—are "no less affecting" than the metaphysical paintings. But if the selection of works at the Pompidou Center seemed much less restricted than that in New York, it still displayed an exemplary prudence. After the works of the Roman period there was only a handful of paintings representing the various new themes to which de Chirico turned during his second visit to Paris, in the mid-'20s (*The Archeologues,* 1926; *Furniture in a Valley,* 1927; *Horses by the Seaside,* 1926-27; *Gladiators,* 1927; *Mysterious Baths,* 1934.)

Of works executed between 1934 and de Chirico's death in 1978, the public was permitted to see only two portraits of the artist's wife Isa—one from 1935, the other from 1940—and a self-portrait of the artist dressed as a 17th-century gentleman. Except for a 1934 academic portrait, the five other self-portraits in the exhibition all belong to the "classical" period of the early '20s. But when we learn that during some 60 years of artistic activity de Chirico painted a good one hundred self-portraits, we get an idea of just how much this exhibition withheld from us, as though the reality of de Chirico's production constituted a scandal of sorts. . . .

If the repetition of self-portraiture gives rise to difference, it also proves that there is more than one way to repeat. De Chirico specialists generally maintain that it was in 1924-25—that is, just before or at the beginning of his second visit to Paris—that the artist began to copy himself (a phenomenon Breton denounced in 1926), and that beginning in the '40s de Chirico's studio transformed this practice into a production organized on a massive scale. It was at this time that the paintings *in the style of*—from Titian to Fragonard via Veronese and, above all, Rubens, to mention only a few—began to proliferate. The 6-volume general catalogue of de Chirico's work gives 18 versions of *The Disquieting Muse* executed between 1945

and 1962, as well as some 45 more or less identical *Piazza d'Italia*s from the last 10 years of the artist's life alone—not to mention his many *Troubadour*s and *Hector and Andromache*s.

De Chirico's repetitive activity could take multiple forms. Although from the end of the '50s through the mid-'60s pictorial production in general pursued a kind of geometric abstraction, de Chirico never stopped painting series of antique landscapes, galloping cavaliers, or horse-trainers in the Hellenistic tradition. Nor does he seem to have distinguished the copy pure and simple from quotation or self-quotation, or even from pastiche. The Pompidou exhibition, however, gave no indication whatsoever of this phenomenon.

To get some idea of just how pervasive it was, one had to visit the Right-Bank gallery Artcurial, where some 60 canvases from the last period of the artist's life (1960-78) were exhibited concurrently. Because of his involvement with pastiche, the old Master seemed suddenly to have acquired an unexpected contemporaneity, making Italian artists of the current generation appear as simple epigones. But what is most interesting about this very last period is not so much pastiche per se, but rather the artist's technique of recapitulating earlier periods of his own work through their amalgamation.

This procedure is already apparent in *The Friend's Departure* (1961): on the disquietingly empty stage of what was once *The Anxious Journey* (1913), repeated here in painstaking detail, de Chirico has placed two diminutive figures in business suits taken from his 1934 album of prints titled *Mythology.* The presence of these figures dispels the anxiety that permeated the earlier work; only its memory remains.

Sometimes, de Chirico's recapitulation through amalgamation is more complicated: in *Ulysses' Return* (1968), for example, an armoire and a Voltaire armchair once placed in a valley now occupy an interior while at right, a *veduta* opens onto the landscape of hills and a Greek temple they previously inhabited. At left, a *Piazza d'Italia* in the form of a painting within the painting evokes the metaphysical period. Finally, the boat and oarsman come straight out of *Mysterious Baths,* except for the fact that the vessel no longer floats on a sea of glittering waves, but in a puddle as blue as the Aegean, and the oarsman has changed his two-piece suit for a linen toga.

In these works the nocturnal atmosphere which pervaded the interiors from the Ferrara period (1916-17) has disappeared. The *Metaphysical Interior with Head of Mercury* (1969), for example, is characterized by light, airy tones—luminous ochers, tender greens and azure blues—which create the atmosphere of a nursery or an animated cartoon. Indeed, the montage in *Battle on a Bridge* (1969)—figures, a chateau, a bridge over a river—imparts a comic-strip ferocity to a subject appropriate to classical painting. And in *Mysterious Spectacle* (1971) the typical de Chirico iconography, drawn from every period of his career, is redeployed on a stage separated from the viewer by an orchestra pit filled with the eyes of "a distant friend."

In quoting himself, de Chirico ultimately quotes his own

sources as well. For example, in the foreground of *Still Life with Head of Apollo* (1974)—the scenographic orientation of which is indicated by the drawn curtain to the left—there is a still life of scattered fruit. This subject originally belongs to classical painting; de Chirico, however, had already treated it many times before. Similarly, the head of the Belvedere Apollo previously figured in his famous *The Song of Love* (1914). But we also know that the *original* Apollo in the Vatican is itself probably only a Roman copy of a Greek original and that, despite its mediocrity, it has long been considered as a kind of symbol of Greekness, especially by generations of Beaux-Arts students who have tried to copy it as best they could. In this still life, however, de Chirico's quotation of his sources is not simply a form of self-quotation, for the painting's entire background was taken directly from an 1879 drawing by Max Klinger, in which a bust appears in profile against a backdrop of hills. De Chirico's displacement of this source consists merely in shifting the hill from the left to the right, and in placing the Apollo in an informal three-quarter view.

How long, then, can we continue to present only the artist's good copies, while prudently "forgetting" all the bad ones? Quotation is not limited to a particular period of de Chirico's career; nor was it an aberration to which he succumbed once inspiration had left him. It is already apparent in his much-esteemed early works. Thus we find, reversed in *The Enigma of an Autumn Afternoon* (1910) and in three-quarter view hidden behind a curtain in *The Enigma of the Oracle* (1910), the same statue which occupies the center of *Autumnal Meditation* (1912). (This statue also appears in a painting by De Chirico's brother Savinio titled *Oracle.*) But all these *traces* themselves lead us back to the statue in Arnold Böcklin's 1883 *Ulysses and Calypso,* itself inspired by a 19th-century statue of Dante that stands in the Piazza Santa Croce in Florence. And how far back must we go to locate *its* origin?

In Munich, at least when de Chirico lived there as a youth, smokestacks rose up behind the tranquil alignment of traditional public buildings, and banners flew from the towers in the Königsplatz; they reappear behind the arcades of the metaphysical paintings, which were probably inspired by another Böcklin painting (compare *The Enigma of the Hour,* 1911, with Böcklin's *Three Arcades in a Landscape,* 1872)—unless these are the long, severe avenues of Turin. And the statues in the *Piazza d'Italia*s—what are they if not the traces of some Ariadne in the Louvre or the Vatican? What is more, the "disembodied shadows" which populate these same piazzas appear to come right out of a Klinger etching (*Shame,* 1887). What we witness here is a kind of fixation in de Chirico's iconographic vocabulary; the various "Enigmas" of the metaphysical period appear as an incessant permutation of the same elements—arcades, trains, towers, factory smokestacks, exotic fruits—which circulate from one painting to another according to the artist's whim. As Jean Clair has written, "From 1910 to 1916, the paintings will repeat the same images with minute variations" [see excerpt above].

It therefore seems more and more arbitrary to attempt to distinguish the paintings of the *good* period—in which the

tension between "the attraction of a past which was about to die . . . and a future world of technology and industry" (Clair) reads as a translation of the lived experience of modernity—from all the others, in which this tension seems to have disappeared in the wake of some sudden psychic transformation which would have unburdened the artist of all creative anxiety and would thereby account for his lapsing into pastiche. For this distinction does not account for the fact that the structure of the latter works appears to refer back to that of the former. If de Chirico's historicist veneration of the past expresses a hypotrophy of the vital forces of the present and therefore a refusal of modernity—first implicit, then explicit—perhaps this is only one symptom among many of a discontent in European (i.e., Western) civilization in general. This discontent surfaces in all of de Chirico's work in the form of a recapitulation of the history of Western painting, a recapitulation which oscillates perpetually between the pathetic and the grotesque. Certainly, de Chirico's work would not be so compelling if its very form did not correspond to an attitude of contemporary thought. Repetition is no longer experienced as a return of the same by the reiteration of identity, but rather as the production of difference. Can we not, in fact, say that de Chirico's painting, to paraphrase Jacques Derrida, is the "supplement par excellence which presents itself as the supplement of a sign, the sign of a sign, taking the place of a speech which is already meaningful"? As if the old master had so loved and respected the old masters that he staged for us that *originary delay* according to which, in art as in everything else, the first comes into being only through the second, through the power of its delay. . . . (pp. 105-08)

> *Claude Gintz, "The Good, the Bad, the Ugly: Late de Chirico," in* Art in America, *Vol. 71, No. 6, Summer, 1983, pp. 104-08.*

FURTHER READING

I. Writings by Chirico

The Memoirs of Giorgio de Chirico. Translated by Margaret Crosland. London: Owen, 1971, 262 p.
 Compilation of writings by Chirico on art, philosophy, and related subjects with accompanying illustrations.

II. Interviews

Gruen, John. "Art vs. Fakes: De Chirico Talks." *Vogue* 159, No. 8 (15 April 1972): 128-29.
 Interview in which Chirico discusses both his personal life and the meaning of his work.

Mazars, Pierre. "Giorgio de Chirico." *Yale French Studies* No. 31 (1964): 112-17.
 Interview originally published in the French magazine *Le Figaro littéraire* in which Chirico denies any connection with Surrealism.

III. Critical Studies and Reviews

Alloway, Lawrence. "Art." *Nation* 214, No. 9 (28 February 1972): 284-85.
> Provides an overview of Chirico's artistic development.

Benson, E. M. "Giorgio de Chirico—Surrealist Minnesinger." *American Magazine of Art* 29, No. 1 (January 1936): 42, 60.
> Laudatory review of Chirico's exhibition at the Pierre Matisse Gallery in which Benson declares Chirico a "full-fledged Surrealist."

Bohn, Willard. "Appollinaire and De Chirico: The Making of the Mannequins." *Comparative Literature* XXVII, No. 2 (Spring 1975): 153-65.
> Comparative study of the similarities in inspiration and style of French poet Guillaume Apollinaire and Chirico with emphasis on their use of mannequins in both art and literature.

————. "Metaphysics and Meaning: Apollinaire's Criticism of Giorgio de Chirico." *Art Magazine* 55, No. 7 (March 1981): 109-13.
> Traces Apollinaire's criticism of Chirico's art.

————. "Phantom Italy: The Return of Giorgio de Chirico." *Arts Magazine* 56, No. 2 (October 1981): 132-35.
> Analysis of *The Child's Brain,* noting allusions to figures from Italian history in the painting.

————. "Giorgio de Chirico and the Paradigmatic Method." *Gazette des Beaux-Arts* 106 (July/August 1985): 35-41.
> Seeks "to identify some of Chirico's most persistent characters."

Breton, André. "Surrealism and Painting." In *Surrealism and Painting,* by André Breton, translated by Simon Watson Taylor, pp. 1-48. New York: Harper & Row, 1972.
> Provides a scathing analysis of Chirico's shift from Surrealism to classicism, maintaining: "We have spent five years now despairing of Chirico, forced to admit that he no longer has the slightest idea of what he is doing."

Buchanan, Peter. "Contemporary de Chirico: Precursor to Post-Modernism." *Architectural Review* 172, No. 1025 (July 1982): 44-7.
> Views Chirico's unsuccessful synthesis of Classical and Modernist elements as a precursor of Post-Modernist art.

Calas, Nicholas. "Three Oblique Situations." *Artforum* 18, No. 9 (May 1980): 47-9.
> Suggests that the Surrealists misinterpreted Chirico's aims in their endorsement of his early works.

Davidson, Martha. "The New Chirico: A Classic Romantic." *Art News* 35, No. 5 (31 October 1936): 16-17.
> Positive review of a Chirico exhibit at the Julien Levy Gallery in New York.

Davies, Ivor. "De Chirico: The Towers, Arcades and Squares of Turin." *Artscribe* No. 36 (August 1982): 28-34.
> Examines the influence of the architecture and arrangement of the city of Turin, Italy, in Chirico's work.

————. "Giorgio de Chirico: The Sources of Metaphysical Painting in Schopenhauer and Nietzsche." *Art International* XXVI, No. 1 (January-March 1983): 53-60.
> Examines the formative influences in Chirico's career.

Dell' Arco, Maurizio Fagiolo. "De Chirico in America, 1935-37: His Metaphysics of Fashion." *Artforum* XXIII, No. 1 (September 1984): 78-83.
> Discusses Chirico's stay in America and how it influenced his art and view of the world.

Frank, Elizabeth. "Archetypes and Anxiety Dreams." *ARTnews* 81, No. 7 (September 1982): 100-03.
> Exhibition review which provides an overview of Chirico's career.

Gale, Matthew. "The Uncertainty of the Painter: De Chirico in 1913." *Burlington Magazine* CXXX, No. 1021 (April 1988): 268-76.
> Extensive analysis of the works Chirico produced in the autumn of 1913.

Hughes, Robert. "The Metaphysician's Last Exit." *Time* 112, No. 23 (4 December 1978): 94.
> Evaluation of Chirico's artistic career on the occasion of his death.

Hunter, Sam. "Two Contemporary Voices: Guttuso and de Chirico." *Magazine of Art* 43, No. 7 (November 1950): 266-71.
> Examines the motivations behind Chirico's antipathy to abstractionism.

Rubin, William, ed. *De Chirico.* New York: The Museum of Modern Art, 1982, 207 p.
> Catalog of a retrospective exhibition held at the Museum of Modern Art in New York City in 1982, with color illustrations and critical analysis by Maurizio Fagiolo dell'Arco, Joan M. Lukach, William Rubin, Marianne W. Martin, Wieland Schmeid, and Laura Rosenstock.

Soby, James Thrall. *Giorgio de Chirico.* New York: The Museum of Modern Art, 1966, 267 p.
> The definitive monograph on Chirico.

Thornton, Gene. "Contrary Father of Surrealism." *Saturday Review* LV, No. 9 (26 February 1972): 54-5.
> Review of Chirico's works exhibited at the New York Cultural Center.

IV. Selected Sources of Reproductions

Gimferrer, Pere. *Giorgio de Chirico.* New York: Rizzoli, 1989, 128 p.
> Large-format color reproductions with a brief bibliography.

Joseph Cornell

1903-1972

American multimedia artist, collagist, and filmmaker.

A highly innovative artist, Cornell designed boxes and collages featuring decorative memorabilia and mundane objects reorganized into original and poetic microcosms. Cornell's work drew upon the aesthetics of Surrealism, and he sought inspiration in French Symbolist poetry, particularly that of Arthur Rimbaud and Charles Baudelaire. Incorporating the Surrealists' startling imagery and the Symbolists' fascination with the exotic, Cornell aspired to mysterious and personal accumulation of meaning within a self-contained environment. "To Cornell," wrote Harold Rosenberg, "a sliver of mirror or some sticks nailed to a board are the equivalents of the sunlit oceans and glistening temples of the Symbolist poets."

Cornell was born on Christmas Eve into a prominent Dutch New York family and attended the Phillips Academy at Andover, Massachusetts. Cornell's brother Robert was partially paralyzed, and Cornell spent much of his life caring for him at their home on Utopia Parkway in Flushing, New York. Having no formal training, Cornell's artistic endeavors began in the secondhand bookstores on Fourth Avenue in Manhattan, where he collected bric-a-brac. Throughout his life, he saved cuttings from magazines, watch springs, maps, and toys because, as he said, "Everything can be used. Sometimes . . . one appreciates an object that's been lying around the house for a long time. Suddenly, you see its true nature." Influenced by Max Ernst's collaged Surrealist "novel" *La femme 100 têtes* (1929), Cornell began making his own collages, some of which were included in a Surrealist group show at the Julien Levy Gallery in 1932. Though he often made use of Surrealist-inspired iconography, critics observe that Cornell lacked their sense of irony and their desire to shock the public. Cornell's collages, as well as the boxes he later designed, instead demonstrate a reverence for birds, children, seashells, and above all, female beauty. Cornell maintained private dossiers on various ballerinas and actresses and often incorporated their images into his works. In 1937, Cornell spliced and rearranged the adventure film *East of Borneo* and renamed it *Rose Hobart,* after the film's star. Salvador Dalí, himself a pioneer in avant-garde film, was present at the screening and was visibly jealous of Cornell's achievement, according to reports.

A shy and idiosyncratic character who rarely left his home, Cornell maintained correspondences with fellow artists and with female performers whom he admired. Throughout his career he continued to concentrate on familiar themes and images, virtually ignoring major trends. During his lifetime Cornell often expressed doubt that the exalted reputation of his works would last after he was gone, yet they continue to elicit critical praise, and Cornell's influence is evident in the assemblages of Robert Rauschenberg and the celebrity prints of Andy Warhol.

INTRODUCTORY OVERVIEW

Diane Waldman (essay date 1967)

[*Waldman is an American critic and museum administrator who has assembled numerous exhibitions at the Guggenheim Museum in New York. In the following essay, she offers an overview of Cornell's life and work.*]

Little is known of Joseph Cornell's early life. Born on Christmas Eve 1903 (the major exhibitions of his work have usually been held towards the end of December) at Nyack, New York, Cornell attended the Phillips Academy at Andover, Massachusetts. In 1929, he and his family moved to Flushing, Queens, to the modest house in which he still lives. A shy and reticent man, he is as reluctant to reveal the details of his life as he is to part with one of his boxes. The boxes are his progeny; they have engaged in a dialogue with him and with each other over the years as, indeed, they speak to us. They were created within the milieu of family life—of commonplace living—not in the isolation of a studio. The rhythm of daily life—daytime, nighttime, time passing, another day, a change of season—seemed to him like the unfolding of life in the *Les très rich-*

es heures du Duc de Berry. Way back, before the boxes began, Cornell recalls the Sunday afternoons, after church, listening to Protestant services on the radio, and the great sense of religion within the wonderful warmth of family life. During the twenties, Cornell was involved with the life and culture of New York, absorbing classical music, going to the opera, and collecting on a small scale, mostly Japanese prints and Americana. He speaks of the boxes as having been fashioned of a great love of the city—of a city and a time, with its seemingly endless plethora of books and material, that is gone now. All of this has been captured in his boxes and given to us, in wave after wave of memories, with a pulsating sense of life and as a living presence.

With little formal art training, most of Cornell's schooling during the early years was largely the result of the lively artistic climate that existed in New York during the 1930's. If the scene was lively, it was also confined, and for lack of a meeting place, many of the New York and expatriate European artists would frequent the few avant-garde galleries then in existence. It was at the Julien Levy Gallery, which opened in 1931, that Cornell met most of the painters and writers associated with the Surrealist movement who were in the United States prior to and during World War II. The first American exhibition of Salvador Dali took place there in December 1933. The next year, for his second exhibition at the gallery, Dali arrived in New York to much acclaim, followed by the other leading Surrealists.

Soon after Cornell first saw Max Ernst's album, *La femme 100 têtes,* he showed his own initial efforts at collage to Julien Levy. These consisted of montages, on cardboard, done in the style of Ernst, which Levy included in a Surrealist group show in January 1932. For this exhibition, which launched the movement in New York, Cornell designed the cover of the catalogue. The exhibition included collages by Ernst, paintings by Dali, Ernst, Picasso, Man Ray and others, photographs by Atget, Boiffard, Man Ray, Moholy-Nagy, and George Platt Lynes, and a Man Ray *Snowball,* a commercial souvenir in the shape of a glass globe.

Besides the collages, Cornell exhibited a glass bell containing a mannequin's hand holding a collage of roses. The glass bell, of course, was a common Victorian decorative motif for showing clocks, artificial flowers, or other "bibelots"; the mannequin's hand was a standard prop of the Surrealists. The catalogue preface for another Surrealist exhibition, held at the Galerie Pierre Collé in June 1933, gives ample evidence of Surrealist obsessions and some of Cornell's as well:

> disagreeable objects, chairs, drawings, paintings, manuscripts, objects to sniff, surreptitious automatic objects, books, ordinary objects, maps, hands, exquisite corpses, palaces, butterflies, blackbirds, pharmacies . . .

Later that year, Julien Levy held an exhibition of Cornell's "Minutiae, Glass Bells, Shadow Boxes, Coups d'Oeil, Jouets Surréalistes". Cornell's shadow boxes were all small, the largest measuring 5 × 9″. They were complemented by thimbles propped on needles; small bisque angels and miniscule silver balls placed under small glass bells; and bright colored sequins, sewing pins, cut-up engravings of fish and butterflies, colored sand, and brass springs moving freely about in small round boxes which resembled compass cases. Both the objects and their containers varied only slightly from their original state; they were "transformed", in the manner of Duchamp and of the period, with only slight alterations to the readymade. All of his objects of this period have several features in common—they are small, fragile and modest in ambition—yet there is a particular charm to them. The emphasis is on the object, *per se,* without attempting to situate it within a larger, i.e., a plastic, context.

In 1936 Cornell was included in a major exhibition, *Fantastic Art, Dada, Surrealism,* at The Museum of Modern Art. His ***Soap Bubble Set,*** of that same year, is listed in the catalogue as a "Composition of objects, 15½ × 14⅛″, photographed with additional effects by George Platt Lynes". This arrangement was later regrouped into its present form and subsequently acquired by the Wadsworth Atheneum in 1938. In its final form there is a reorientation of emphasis in which each of the objects is located both within its own compartment and in fixed relationship to the others—an early attempt to group these separate objects into a coherent unit with a sense of three-dimensional form, scale, and structure new to the work. To achieve this, he temporarily abandoned the random movement of the earlier objects. Later, the use of movement became subject to greater esthetic control appearing in all phases of his work, both literally (***Taglioni's Jewel Casket,*** 1940; ***Multiple Cubes,*** 1946-48; the Sand Fountains and Sandboxes of the fifties) and implicitly (the Medici series, etc).

Symbols which recur throughout his work appear here for the first time: clay pipes (associated with memories of lower New York, Chambers Street, and old houses near the water), glasses, engravings, mirrors, maps. The objects lend themselves to a fairly plausible interpretation: the egg as the symbol of life; the glass, the cradle of life; the four cylinders above are thought to represent his family, and the doll's head, himself. The moon, placed above the clay pipe, is both soap bubble and the world, and it controls the tides. In the catalogue for his exhibition at the Copley Galleries in 1948, Cornell wrote of the Soap Bubble Sets:

> Shadow boxes become poetic theatres or settings wherein are metamorphosed the elements of a childhood pastime. The fragile, shimmering globules become the shimmering but more enduring planets—a connotation of moon and tides—the association of water less subtle, as when driftwood pieces make up a proscenium to set off the dazzling white of seafoam and billowy cloud crystallized in a pipe of fancy.

In the same catalogue, Cornell is listed as an American Surrealist, a label which has persisted to this day. From the present vantage point, it hardly seems accurate or adequate; in its original context and at that time, he did draw his initial source of inspiration and ideas from the methods, if not the mannerisms, of the Surrealists. It was the stimulation of their presence during the formative years of his career that proved invaluable to him, as it did to so

many of the younger artists then at work in New York. It is, however, primarily in the ideas of the Surrealist poets, rather than the hard-core painters, that we capture the imagery of Cornell.

The Surrealist poets realized that, in order to renovate poetic imagery, it would be necessary to free words from their customary role—that of description. The selection of the appropriate word, as a symbol, and its illogical juxtaposition with other words would act as a stimulus to the senses of the reader and would, in turn, arouse multiple images and associations, differing according to individual sensibility. Thus the function of the poem was, to Paul Éluard, "donner à voir" (to give sight). From this followed the Surrealist concept of revealing the object in its fullest depth by, as Éluard said, stripping it of its accepted roles and admitted physical properties, a process which Breton called the "crisis of the object". In their efforts to make the dream concrete, the Surrealist poets concerned themselves with developing a vocabulary precise in form and color, shape and intent. It was this method that brought them close to the technique of the painter. Breton, in speaking of his thirty-word poem, *Fôret-noire,* which took him six months to write, said that he had to juggle the words to determine their proper associations with each other and with the words that were eliminated from the poem but figured in its composition.

The emphasis on the object itself started around 1930: "an 'external object' constitutes a closed unity resistant to our imagination and our desire to alter it at whim. This unity and consistency are the essence of the object—a complex of fantasy and restraint, of desire and resistance, which possesses a material substance". As Marcel Jean pointed out, the German word for object, *Gegenstand,* literally means counter-stand, resistance. The estrangement of the object, particularly its separation from the objects generally associated with it, became the basic technique of Surrealism. Paul Nougé speaks of the Surrealist as painting the "bewildering object and the accidental encounter . . . by isolating the object . . . breaking off its ties with the rest of the world . . . We may cut off a hand and place it on the table or we may paint the image of a cut-off hand on the wall". It is noteworthy that the emergence of the object coincided with Cornell's beginnings as an artist. Although Giacometti, Dali, Ernst, Breton and Tanguy were among the many producers of objects, and both Schwitters and Duchamp, the latter with his portable museum, the *Green Box* of 1934, tended to box configuration, it was Cornell's selection of the box as a form, in combination with the object, which proved a major innovation. It was Cornell who made the box memorable as a realm for both a real and imagined existence.

The first one-man show of Cornell to receive some notice in the press (it is actually debatable as to which of the shows, in 1932 or 1939, should be called the first one-man show) opened on December 6, 1939 at the Julien Levy Gallery. The press release for the show states that his objects "derive from a completely pure subsconcious poetry unmixed with any attempt to shock or surprise. They are essentially pure creation, no professionalism, no ulterior motive but the concrete expression of Cornell's person-

al lyricism. They are useless for any purpose except to delight the eye and everyone's desire for a lovable object . . . ". *Art News* of December 23, 1939, commented: "Much, if not all, is done with mirrors . . . and the reflections which do not have the aid of quick-silver are images drawn from the unconscious". The objects were placed in a darkened room; they included . . . "bubble pipes, thimbles and china dolls showered with confetti, in and out of shadow boxes . . . birds, books and balls suspended on strings, and its strange alchemy of bottles, artificial green leaves and bits of broken glass." The *New York Times* of December 10, 1939, mentioned a . . . "whirling eyeball under a bell jar, or a book which is a box in which things slide and kaleidoscope . . . ". There were even objects which, like a music box, played tunes. The *New York Herald Tribune* of December 10, 1939, described the show as a "holiday toy shop of art for sophisticated enjoyment, and intriguing as well as amusing".

In addition to the pieces on exhibit, Cornell built objects to order, for Christmas gifts, incorporating the photograph of the purchaser into the object. Approximately five inches high, six inches wide and one inch deep, these "daguerreotypes", forerunners of the later sandboxes featured the photo, tinted deep blue or brown, secured against the rear wall of the box. Placed over the photo but not touching it was a tinted mirror which Cornell cut to silhouette the form in the photograph. Between these two layers, particles of colored sand, slivers of glass and tiny seashells created ever-changing patterns as the box was manipulated. The image of the spectator, trapped in the mirror's reflection, became a part of the object, establishing, at an early date, Cornell's awareness of the physical presence of the spectator, the relationship between the spectator, the object, and the space between.

If much of the 1930's was a time of tentative beginnings, the forties was witness to a number of major innovations. Characteristic of much of the early years is a feeling for Victoriana—for quaint beauties, elegant fabrics and exotic papers—a recapitulation of the "objects" of the thirties. Often a work is accompanied by a saying (*Francesca da Rimini*), a poem (*Taglioni's Jewel Casket,* in the collection of The Museum of Modern Art), descriptive matter (*Cléo de Mérode*), or some other "*leitmotif*", or, more rarely, it becomes part of the form itself (*Mémoires Inédits de Mme. la Comtesse de G.*). In an effort to secure the fleeting, Cornell seems to have wanted to document and annotate, "to make a monument to every moment".

In the majority of these early boxes, there is a definite distinction between the container and the contained. Some, like *Francesca da Rimini* or *Swan Lake for Tamara Toumanova,* resemble his early flat collage assembled in depth. Others are table-top, horizontal boxes, often lidded, suggesting a jewel box, a sewing box, a cosmetic case, a place to store treasures, a Pandora's box. *L'Egypte de Mlle. Cléo de Mérode: Cours Élémentaire d'Histoire Naturelle* is typical of this type. The interior, with its rows of bottles and side compartments, recalls the display cases of a museum or a department store. The box, a Victorian oak writing or strong box, contains a piece of glass mounted about one and a half inches from the bottom which acts

as a supporting rack for the bottles. Underneath the glass is a layer of red sand with a few broken bits—a small piece of comb, slivers of plain or frosted glass and a porcelain doll's hand broken at the elbow. Much of the interior is covered with an ivory paper delicately marbled in brown and blue and framed by bands of marbled paper in blue, blue-grey, ivory and orange spots. All but one of the glass bottles bear a label and contain different objects. A description of one of the bottles gives some idea of its contents: *Sauterelles* (grasshoppers or locusts) contains a cut-out of two camels and bedouins from an old photograph of the Pyramids and a small green ball, both set in yellow sand.

Cléo de Mérode was a famous ballerina in the 1890's. The goddess Hathor, pictured on the inside lid, is the goddess of love, happiness, dancing and music, also goddess of the sky. Cléo in the title is also Cleopatra of Egypt. The composition of the box can be paralleled to the Egyptian involvement with the tomb and the afterlife, to the custom of securing in the tomb the articles most required by the deceased in his life after death, as well as a description of the individual's life as he lived it on earth. It suggests, as well, the structuring of life into registers on the wall reliefs of the tombs. Simultaneously, the objects offer clues to the essence and mystery of Woman, whether Cléo de Mérode or Cleopatra.

The transition from this work to the masterpiece of the early forties, the *Medici Slot Machine* of 1942, is both rapid and profound in its implications. The image of the young boy, Moroni's *Portrait of a Young Prince of the Este Family*, in the Walters Art Gallery, Baltimore, is viewed as if through a gun-sight or lens, telescoping both near and far distances simultaneously. The spiral at his feet evokes multiple associations: in the natural world, ocean currents form a spiral pattern; the growth of many plants is that of a spiral—for example, the way rose petals unfold—as is the structure of a chromosome. The spiral, symbolic of life repeating itself in a cycle of seasons and a cycle of generations, is also an abstract form, bringing with it references to Duchamp and Leonardo. The complex play of imagery, sequentially strung out (or spliced) like a series of film clips, with the implication of movement both in time and in space, reconstructs the history of a Renaissance prince and juxtaposes these images of his imaginary childhood (diagrams of the Palatine fashioned from pieced-together Baedeker maps, etc.), with current objects (marbles and jacks) so that the Renaissance child becomes a very real and contemporary child, alive and very much in the present. The objects are brought into reality with color, while the monochromatic images recede into the past.

The influence of film techniques on his art, and the actual translation and incorporation of its devices into his constructions, was another major innovation which he has developed and elaborated on since its early inception in the *Medici Slot Machine,* and one which has proven of enormous significance to many younger artists. Cornell's interest in the films originated in the twenties when he, like the Surrealists, found that it offered new possibilities of fantasy and illusion, abrupt changes in time, sequence and

event, and illogical juxtapositions. Cornell made several movies, the earliest in the thirties, by re-editing and collaging discarded film clips and occasionally having a sequence shot. In a comment published in *View* magazine, on Hedy Lamarr, a Marilyn Monroe of the day, Cornell wrote of the "Profound and suggestive power of the silent film to evoke an ideal world of beauty, to release unexpected floods of music from the gaze of the human countenance in its prison of silver light . . . evanescent fragments unexpectedly encountered". A shy and secluded man, his limited travels have permitted him great freedom of the imagination, the ability to leap back and forth in time, to visualize places, events, and people never seen. His sources, whether movie queen or Medici prince, marble or jack, are lifted out of context and placed in a timeless world, the world of the dream. The sensation of disorientation, of the unexpected encounters between his "objects" recalls de Chirico:

> One must picture everything in the world as an enigma, not only the great questions one has always asked oneself—why the world was created, why we are born, live and die, for after all, perhaps there is no reason in all of this. But rather to understand the enigma of things generally considered insignificant, to perceive the mystery of certain phenomena of feeling, of the character of a people, even to arrive at the point where one can picture the creative geniuses of the past as things, very strange things that we examine from all sides.
> [Marcel Jean, *The History of Surrealist Painting*]

In the *Medici Slot Machine,* space is cubistically fragmented into small facets which co-mingle, separate and fuse again in kaleidoscopic effect. The black lines which crisscross the surface act as connective tissue organizing both the multiple images and the several spatial levels. This diagrammatic pattern of horizontals and verticals, superimposed on the surface rather than functioning as the substructure for the image, creates a sense of order and calm that might best be described as early Renaissance. The emphasis on the object as a literary symbol, in an earlier work like the *Cléo de Mérode,* gradually gives way to the object as both symbol and plastic form, and finds its first realization in the *Medici Slot Machine.*

The numbers on the side wall of the box refer to the title of the construction and to the element of play. Cornell's comments for his *Penny Arcade Portrait of Lauren Bacall,* exhibited in 1946, reveal his fascination for the game:

> . . . impressions intriguingly diverse . . . that, in order to hold fast, one might assemble, assort, and arrange into a cabinet . . . the contraption kind of the amusement resorts with endless ingenuity of effect, worked by coin and plunger, or brightly colored pin-balls . . . traveling inclined runways . . . starting in motion compartment after compartment with a symphony of mechanical magic of sight and sound borrowed from the motion picture art . . . into childhood . . . into fantasy . . . through the streets of New York . . . through tropical skies . . . etc. . . .

into the receiving trays the balls come to rest releasing prizes . . .

It would be difficult to imagine a more startling contrast to the elusive and even melancholy prince than the **Pantry Ballet for Jacques Offenbach** of the same year, or the later, equally light-hearted **Swan Lake for Tamara Toumanova** of 1945, or **La Favorite** of 1948. Yet they represent a counterpoint to the main body of work, and play an important, if subsidiary, role during the 1940's. Here, references to theater abound, whether to the stage sets of the theater or ballet or to the court pagentry of Watteau. Delicately frivolous in spirit, they also invoke reminiscences of a child's cardboard theater or a fairy tale. Red plastic lobsters cavort gaily about with their partners, little silver spoons, while seashells and crockery nod in merry enjoyment. Elsewhere, feathers accompany a swan in the midst of a performance and sheet music graces the exterior of a box, in which an angel is playing, in a world of lyric enchantment.

For **The Crystal Cage: Portrait of Berenice,** a series of collages and related documents published in the "Americana Fantastica" issue of *View* magazine of January 1943, Cornell established in a word portrait of the Pagode de Chanteloupe, a chinoiserie of the late nineteenth century, his interests of this and of all times:

> Mozart, sunbursts, Baedeker, Piero di Cosimo, Hans Christian Andersen, daguerreotypes, balloon, Edgar Allan Poe, shooting stars, Hôtel de l'Ange, soap bubbles, solariums, snow, Gulliver, Carpaccio, phases of the moon, star-lit field, palaces of light, tropical plumage, Liszt, barometers, Queen Mab, owls, magic lanterns, Milky Way, Vermeer, camera obscura, Seurat, Erik Satie, calliopes, Gilles, cycloramas, castles, Rimbaud.

It is a world of tender innocence, a world that is replaced in the fifties by a melancholy and sophisticated, but still innocent spirit.

Both the **Medici Slot Machine** and the **Soap Bubble Set** of 1936 are ideas that Cornell has developed over the years in constructions which are not radically different from their original premise. They are a reprise of a theme worked out over many years, in contrast to another type—a "theme and variations"—such as the Aviary, Dovecote, and Observatory series, which took shape in a relatively short and concentrated time span. Within the first category the progression from a Medici boy of the forties to one of the fifties is a distillation of a rich and elaborate imagery to one of the utmost simplicity. In the second type of series the constructions have a much greater consistency of expression but vary in their imagery from construction to construction. A certain amount of confusion has developed with regard to the serial elaboration or "duplication" of his boxes and the attendant difficulties of dating. The dating problem is admittedly severe but no more so than in the working procedure of any artist who returns to his canvases or sculpture and reworks them over a period of years. Cornell has transferred this procedure—a continuation of a visual process—from one box to another rather than reworking his boxes over and over again (al-

though he does this too). The idea of *duplication,* per se, did not originate with Cornell, for Arp, in 1918-19, made a practice of tracing the same drawing over and over again with variations occuring automatically. It is a premise contained in Dada (one need only think of Duchamp's *Readymades,* and of Surrealist automatism), if not realized in its fullest sense. The use of the repeti-image represents a change in *process* on the part of the twentieth-century artist; it is Cornell who recognized it as such and gave it its first viable plastic expression.

His working method offers ample explanation for the impulse propelling the use of the repeat: an initial idea is supplemented by "documents"—both original material and notes—which takes visual shape after a long period of gestation. Cornell has often spoken of the frustrations of the medium and of his ability to encompass all the extra-visual material (poetic, emotional and other ephemera) that went into its making. The duplication or elaboration of a theme becomes a way of working *out of* an obsession—a natural consequence of the Surrealist belief in taking the inner imagination rather than the outer world as a starting point and the multitude of possibilities this suggests. Once brought into existence, the boxes appear to act upon one another establishing a familial relationship, through the reiteration of certain objects (driftwood, seashells, cordial glasses, nails, stamps, toy blocks, bubble pipes, etc., and especially photographs and forms—circles, cubes, spirals, arcs) which take on added reverberations over the years and establish a physical displacement in time.

The implications of the repetitive image, which began with the **Medici Slot Machine** in 1942, are given another definition in the **Multiple Cubes** of 1946-48, one of Cornell's earliest explorations into total abstraction, with connotations of both Mondrian's grid paintings and Duchamp's readymade, *Why not sneeze?* of 1921. The photographic images of the Medici box are metamorphosed into white wooden cubes which move freely about in their separate cubicles, a series of compartments created by a skeleton of horizontal strips bisected by smaller vertical ones. This grid structure, an extension of the reticulated black lines superimposed on the Medici boy, functions here in a purely plastic context.

In these and related constructions, Cornell was undoubtedly influenced by Mondrian, whom he knew in New York in the early forties. Robert Motherwell speaks of Mondrian's "formulation of color relations and space relations arising from a division of space. He uses color and space to communicate feeling . . . a definite and specific and concrete poetry breaks through his bars . . . Cornell's works of the fifties bear affinities to Mondrian in their classic purity, in their chromatic restriction to white as the predominating color with the primaries blue and yellow as important components, and in their breakdown of space. Both approach geometry through sensibility, but the differences between the two artists are great. Cornell conveys a physical sense of space, in a three-dimensional structure, by overlapping planes and the use of diminishing forms. He loves the irregular surface or edge, the curve, the sphere; he uses natural and man-made forms and representations of the figure. His boxes are infused

with a light that goes back beyond Mondrian—to Vemeer, or to Piero della Francesca. It appears to be, in Cornell's case, an intuitive process in which he grasped certain essentials of Mondrian's art, adapted them to his own needs, and fused them with his own highly developed poetic imagery.

The very narrow depth of the *Multiple Cubes* prevents too much of a reading in space and tends to flatten out a very real depth into a pictorial one. Cornell is a master at this sleight-of-hand, for *Nouveaux Contes de Fées,* of around the same time, restates this idea in another context. The pattern of the paper which caresses the surface of the box blurs the distinction between the three-dimensional box and the two-dimensional paper.

In December 1949 Cornell showed twenty-six constructions, based on the Aviary theme, at the Egan gallery. These new works "of sunbleached and white-washed boxes filled with drawers and birds and little springs and mirrors have a strict honesty, a concentration on texture and ordering of space . . . " [Thomas B. Hess in an exhibition review in *Art News,* January 1950] that continued the direction initiated by the *Multiple Cubes.* The earlier interest in literary detail disappears in favor of an abstract arrangement of forms, a play of line, volume and shape that is breathtaking in its beauty and simplicity. In these works Cornell moved away from Surrealism in a manner similar to that of the Abstract Expressionists who grew out of Surrealism. It is from the time of this show that the literary becomes subsumed into the abstract.

Both *Deserted Perch* of 1949 and *Chocolat Menier* are notable for incorporating emptiness into the work—the vacuum of an action that has occured, of birds that have flown from the cage. The mood of loneliness and futility in *Chocolat Menier* is established by the worn and bare wood, the rusting chain supporting the perch, and the slivers of mirror, pitted and chipped away at the edges, waiting to catch the reflection of the departed bird and catching, instead, only the reflection of the spectator and another more jagged mirror. In a less violent mood, a few feathers in the *Deserted Perch* suggest the missing bird. Color is almost non-existent, kept to small touches in the use of print, string and feathers. The austerity of these aviaries is offset by other constructions in which the birds play a lively and colorful role.

Forgotten Game restates the game idea but includes the movement of a ball on a runway accompanied by its own sounds as it descends. Cornell was very early in incorporating sound, light and movement within the dimensions of a construction. The geometric simplicity in the precise repeat of the diminishing circles is offset by the peeling surface which surrounds it, recalling old walls. He often speaks fondly of buildings in the process of demolition, finding beauty in the fading colors, in the warmth of human association, and in the fragments of decay and destruction. In this he echoes Schwitters; both have a fascination for the "found" object, for collecting bits of glass, threads, old papers, labels and other "trivia" from life. Cornell's love for remnants of human use, weathering, and craftsmanship is incorporated very sparingly into his constructions, organized into formal relationships by means

of compartments and the use of one predominating color—usually white.

Compared with the "Aviary" theme, the works of 1950-53 (Observatories, Night Skies, Hotels) are richer, more sensual and more painterly, while retaining the haunting and poetic mood of the bird cages. These are hotel lobbies such as Colette might write about, and yet they are not literary. They have both a great clarity of image, a dreamstate of unreality, of atmosphere and emotion. The surfaces are coated with thick white paint. Placed with an impeccable sense of order are glasses, shattered and whole, wire mesh, mirrors, labels of faraway places, and sky charts. Into an aperture cut into the rear wall, Cornell often places astrological maps which revolve and change their image, or windows looking out on star-studded skies. Subtle placements of pilasters, columns, columnettes, windows and mirrors convey a shorthand version of deep Renaissance perspective, of the kind one might apprehend from an *illustration* of a Renaissance monument rather than from the monument itself. His frequent use of mirrors suggests Saint Pol-Roux, a poet considered by the Surrealists as one of the precursors, who wrote of the poet as possessing the magical powers of a Merlin who can change a world of innumerable objects into wonders by the use of an inner mirror: "I acquired, then, a fabulous mirror that makes you see within". This enabled the poet to reach "the isle of the inside of my being."

The theme for Cornell's show in 1955 at the Stable gallery was *Winter Night Skies,* a series of constructions referring to the constellations Auriga, Andromeda and Camelopardalis. While related to the earlier Hotels in both theme and structure, these works take as their departure an even more painterly and two-dimensional approach. The recent series of collages are a natural outgrowth of this direction toward the two-dimensional. They restate, in new terms, his earlier collages of the thirties, the series that he did for *View* magazine in the forties, and the use of collage over the years in many of his constructions.

In speaking of a frame for one of his collages, Cornell mentioned that he wanted a Victorian frame to "take it out of this time". Indeed, the frame of each construction is considered in relation to its contents. The idea of the box as a frame establishes an awareness of the frontality of the images and, in this sense, the work enters the domain of painting. The frames themselves, with their carefully missing corners, the over-all attention to the surface of the box, and the very real existence of the objects contained within, re-situate the work within the context of the sculptural. His space is the illusionistic space of a painter, re-created in three-dimensional terms. One thinks of painters, particularly Vermeer, in relation to Cornell. It is this ability to maintain a dialectical tension between the painterly and the sculptural that is unique to his work.

All of his objects are as carefully considered as his frames and many of them are reworked, altering their original condition—glass is usually tinted; nails, cork balls, driftwood, and toy blocks are painted, as are maps and charts; old print from books, which often covers the exposed surfaces of his boxes, is usually stained in tints of blue, green or brown. Tenderness and despair, poignancy and loneli-

ness are locked into each compartment, changing within each box and from box to box. Fantasy and architectural constructivism exist side by side in a world where knowledge alternates with the innocent wonder of a child. The slightest scrap of paper sets off an endless chain of associations, both emotional and visual, and a paper parrot brings to life a hotel lobby full of sounds and movement, sumptuous wallpaper, and brass cages filled with brilliant birds. His work is deeply personal and ultimately elusive, never divulging the mystery of its existence. (pp. 11-21)

> *Diane Waldman, in an introduction to* Joseph Cornell, *The Solomon R. Guggenheim Museum, 1967, pp. 11-21.*

SURVEY OF CRITICISM

Ellen H. Johnson (essay date 1965)

[*Johnson is an American critic and biographer. In the following essay, she analyzes formal and aesthetic qualities of Cornell's boxes.*]

Joseph Cornell was born on Christmas Eve in 1903, was his own teacher in art, and lives in a house on Utopia Parkway. For almost thirty-five years he has exhibited boxes which hold the light of the sun, the moon and the stars, the movement of the planets, sands and currents of the sea, the fragrance of the lily of the valley, and the solemn innocence of a child. Among the most beautiful of his boxes is a series called *Winter Night Skies* which are like the wondrous, blue-black and white world of silent snow through which processions of sleighs used to glide to early Christmas morning service. Snow is evoked in much of Cornell's work; it falls incessantly in the scenario he wrote in 1936, *M. Phot,* which reads like a source-book for his subsequent imagery: snow, night, glass (chandeliers, windows, a glass store, mirrors), "distant harp music . . . caused by the falling drops of water . . . The scene is one of inexpressibly serene and satisfying beauty . . . A street corner at night, at which time it takes on an appearance of supernatural beauty. Enclosed by a low lattice-work fence are two lamp posts placed among life-sized marble statues of women in classical poses. The bluish light from the gas flames gives the statues the appearance of figureheads on old ships, illumined by phosphorescent seas. Snow is falling."

Surrealist as it may be in unexpected juxtapositions and irrational shifts of time and place, Cornell's scenario, like his boxes, is closer to Hans Christian Andersen's *Snow Queen* or Resnais's *Last Year at Marienbad* than it is to the shocking, fearful or morbidly sexual world of Breton and Dali. Although changes of speed in action do occur, the over-all tempo of his scenario is that of his boxes: the slow, measured rhythm of a saraband, resting "At the still point of the turning world."

If in some fantasy of an art historian Duchamp, Watteau

and Mondrian joined forces to create a single work, it might have something of the quality of a box by Joseph Cornell. *Taglioni's Jewel Casket* (1940) is visually related to Duchamp's *Why Not Sneeze?* (1921); but in content it has nothing to do with the Dada master's particular kind of ironical wit. Cornell's construction is a fragile romance, remote and nostalgic as a pair of lovers in the "rarefied realms" of Watteau. Inside the lid of the jewel box, which is lined with old dark blue velvet, Cornell has inscribed:

> On a moonlight night in the winter of 1835 the carriage of Marie Taglioni was halted by a Russian highwayman, and that enchanting creature commanded to dance for this audience of one upon a panther's skin spread over the snow beneath the stars. From this actuality arose the legend that to keep alive the memory of this adventure so precious to her, Taglioni formed the habit of placing a piece of artificial ice in her jewel casket or dressing table where, melting among the sparkling stones, there was evoked a hint of the atmosphere of the starlit heavens over the ice-covered landscape.

The text, in light blue on the dark ground, begins and ends with a band of squares like the cubes of ice—a characteristic example of Cornell's accord of form and idea. Among the bluish crystals "melting" in the bottom of the box one glimpses bits of red, yellow and purple jewels.

The crystal ice cubes and marbles, the mirrors, the liqueur, wine and whisky glasses so often present in his compositions reflect, refract and intensify the light which fascinates Cornell. Light for him is not so much an optical phenomenon as it is a state of being. He does not reproduce light; he presents it in itself. This is one of the many ideas of Cornell's which younger generations of Americans have pursued.

Cornell's affinity with Mondrian rests primarily in the purity and subtlety of his formal adjustments—basic horizontals and verticals brought to life through delicate balancing of asymmetric elements. In the spatial dynamism of Mondrian's paintings, which as De Kooning says "keep changing in front of us," the spectator plays no role (except with his eyes) in shifting the forms in space. In Cornell's work, on the other hand, the observer is intended to set certain of the objects into motion, to modify the design. *The Dovecote* (1950) can be rolled so that the white balls (the doves) perch or peep out from different openings, and in *Cassiopeia No. 3* (c. 1954) the rings and cork ball glide on suspended bars.

The 1936 *Soap-Bubble Set,* which was included in the historic "Fantastic Art, Dada, Surrealism" exhibition of that year at the Museum of Modern Art, does not have the mobile asymmetry of the later work, but it has the same kind of formal and evocative consistency. The objects which Cornell assembles into his boxes belong together: the globe of the moon, the cylindrical blocks—two of them with stellar images—the egg in the glass, the white clay pipe for blowing the bubbles evoked in the circular forms throughout the composition, and the sweet doll's head (like the later smiling suns). In more recent pieces, light is more dazzling as it penetrates and bounces off the glasses and through the crystal bubbles (marbles); but the character

of Cornell's world was already established in the early work: the inviolable magic of fairyland and the simple mystery of light, space and sea. Although the actual space in his constructions is shallow, the series of planes moving back into depth and repeated in mirrors expands into the endless space of dreams.

Within the consistency of Cornell's objects and forms is an astonishing variety wherein the elements of texture and color play a special role: sparkling glass, light-absorbing cork and clay, blistered paint, crisp metal bars, sand-and-sea-worn shells and weather-silvered wood which keep the rhythm and the presence of the ocean. The background of his sea and sun pieces is usually white, sometimes touched with pale yellow; the corks are often softly colored blue or yellow; most of the crystal marbles are clear, but occasionally they have subtle touches of translucent color. The frames and backs of the boxes are frequently covered with pages of old books through which one reads tantalizing bits of text in a foreign language. Cut out of context and robbed of identity, these veiled phrases further encase Cornell's boxes in mystery. The sand moving over layers of glass in some of his "tray" boxes is tinted blue or pink like the exotic shores of Tahiti in Gauguin's paintings. But Cornell has a more basic affinity with Gauguin in that both artists deal in the realm of feeling which poetry evokes. In its reliance on metaphor and enigma Cornell's work is equally a fulfillment of the Symbolist poets' aims.

One of Cornell's most enigmatic works, the ***Medici Slot***

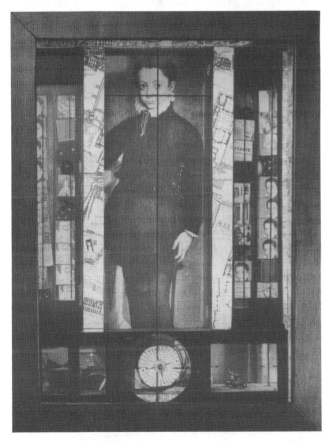

Medici Slot Machine *(1942).*

Machine (1942)—composed of parts of reproductions and photoengravings of paintings, fragments of maps (the Palatine Hill and other areas of Rome and a section of Sicily), a compass, a child's block, jacks and marbles multiplied by mirrors—stands behind Rauschenberg's combines. Certainly there are many other ancestors of Rauschenberg's work, and his rich and raucous painting is entirely different in spirit from Cornell's slightly melancholy, aristocratic and quietly symmetrical image withdrawn behind glass. Like the cabalistic texts on many of Cornell's boxes, the fragments of reproduced paintings in ***Medici Slot Machine*** are not intended to be precisely "read"; but recognizing such details as the head of Botticelli's *Giuliano de' Medici* and Pegasus or the dancing figures from Mantegna's *Parnassus* makes the whole work, including the title, that much more piquant. A metaphorical coin in a magical machine sets in motion before us all the wonders of the court of Apollo and the muses preserved in the Renaissance. In the compartmented space of ***Medici Slot Machine*** the details from paintings are repeated with slight shifts in their placement behind the vertical bands like the moving frames of a film. Twenty years before Andy Warhol and other younger artists, Cornell used this cinematic technique in his constructions, and he too made films.

But in spite of this interest and in spite of the actual motion of rolling balls and gliding rings, an effect of stillness prevails in all of Cornell's boxes—as it does in the appreciation he wrote of Hedy Lamarr, which begins with this significant statement: "Among the barren wastes of the talking films there occasionally occur passages to remind one again of the profound and suggestive power of the silent film to evoke an ideal world of beauty, to release unsuspected floods of music from the gaze of a human countenance in its prison of silver light." Cornell pays tribute to "the enchanted wanderer, who again speaks the poetic and evocative language of the silent film" and whose "depth and dignity enable her to enter this world of expressive silence."

Each box by Cornell is "a garden inclosed," suspended in a timeless silence. The boxes themselves, as the individual objects within them, exist so intensely that they create their own inaccessible and motionless space around them. Theirs is an Arcadian calm stirred only by such sound and motion as

> The rising of the sun
> And the running of the deer . . .
> Sweet singing in the choir.

(pp. 35-7)

Ellen H. Johnson, "Arcadia Enclosed: The Boxes of Joseph Cornell," in Arts Magazine, *Vol. 39, No. 10, September-October, 1965, pp. 35-7.*

Max Kozloff (essay date 1967)

[Kozloff is a highly esteemed art critic and the winner of the Pulitzer Prize for his articles in the Nation *magazine. His book-length studies include, among others,* Photography and Fascination *(1979) and* The Privileged Eye *(1987). In the following essay, which first ap-*

peared in the Nation *in 1967, Kozloff characterizes Cornell's art as poignant and his methods as inventive.*]

"The first crime occurred at the Hotel Du Nord—that high prism that dominates the estuary whose waters are the colors of the desert. To this tower (which most manifestly unites the hateful whiteness of a sanitarium, the numbered divisibility of a prison, and the general appearance of a bawdy house), on the third day of December came the delegate from Podolsk to the Third Talmudic Congress, Doctor Marcel Yarmolinsky. . . . " The words are by Jorge Luis Borges, opening a story called "Death and the Compass," but they could almost have come from the interior of a box by Joseph Cornell. In the vision of the blind Argentinian and of the man who lives on Utopia Boulevard, Flushing, there is a comparable enchantment—a little pedantic and very cosmological. One finds a fey horror and a genteel, almost Victorian stiltedness in Cornell that may precipitate easily into waters "the colors of the desert." The sense in which each of his creations is a microcosm of nostalgia, judged with lapidary precision and embedded in a poetic recall that mingles music and the stars, film and mathematics, accords very well with a certain aspect of the modern imagination. For underneath the positivism of the nineteenth century lies a substratum of disquiet, anticipating our own—there to be mined simultaneously for its campy charm and its darker hints of void. It is ironic to see the boxes of Cornell . . . housed in the buff-and-white Guggenheim, whose form resembles a rounded-off and inverted ziggarat spiraling into a "Futuristic" vortex.

For, with unwitting relevance, the museum mimes one of Cornell's pervasive images: the coiled watch spring, cut off from its cogs and gears, existing in fruitless, ornamental tension. The convoluted spring is a pirouette divorced from the measuring of time it otherwise suggests. It partakes, as well, of Cornell's penchant for circularity—disks or spheres, rounding about themselves: the sun, balls, rings, arches, celestial bodies. The most fragile and evasive suggestion of it is soap bubbles; but these exist only by implication—white clay pipes with bowls grasped by sculpted hands almost being Cornell's signature. He manages to suggest by such iconography the idea of endlessness, infinity, all the more poignant since his chosen means are eggshell or hairline in their physical embodiment. It is almost as if the glance has to touch as lightly as it can upon these objects for fear of crumbling or mauling them. The artist's intuition that the past and the future are in the same revolution, without start or end, is given as a kind of tracery in which the mechanism of nature hushes precariously into itself.

Like Paul Klee in wanting to invent as nature does, to create a miniature universe of his own, Cornell is yet much more directly involved with the stoppage of time, or more exactly, the mixing of tenses. In this sense, though it has a highly metaphoric content, the primary condition of his art is of a peculiar interior voyage. (The equation of many of his tableaux with hotels, temporary homes of the restless, is hardly a coincidence.) Each of the boxes is a self-contained journey, a time capsule or memory receptacle where the here and now cohabit with the distant and the exotic on the same level of suspended animation. It is pre-cisely because the widest ranges into space suggest a temporal immensity as well that their compression has a hallucinatingly timeless quality.

In Cornell the roots of German Romanticism have been overlaid with the tradition of French Symbolism, particularly that aspect of it which yearns for ineffable realms of experience, vicarious regions in which one can participate more substantially than in the undifferentiated chaos of immediate reality. Not for nothing does he bottle specimens of evanescent life, such as butterfly wings; nor is it accidental that the hourglass, like Mallarmé's *horloge de son ame,* evoked in drifts of glittering sands, becomes a wavering imminence in his vision. The city, even history itself, exist only as scavenging ground for Cornell's compartmented fancies; the present has no "feel," nor does it impart qualities of identifiable environment to an artist who retreats or escapes into surrogate environments.

It is surely not a contradiction that Cornell embodies all this in a theatrical mode which is a self-acknowledging form of his own artifice. These closed firmaments are little stages, with their own flats, sidelights, and props. Much as with the old stereopticons, depth is incised by a series of images pasted on flattened planes, marked off, or separated from one another by an "illusion" whose very imperfection is charming. Not only is this a charade that strives to elicit some of the wonder of the first conquests of photography, but it is also an ironic pleasure taken in revealing the conceits of the artist's own poetics. He is simultaneously the creator and the spectator of his own gamesmanship.

Nothing is more indicative on this score than a use of mirrors that Cornell not only pioneered but of which he remains still the most exquisite practitioner. Innumerable boxes are gridworks of transparent or reflecting screens. To look into them is to see not merely one's own features, staggered or fragmented, but back views of areas nominally averted from the gaze. But such glasses are obfuscations as much as they are extensions of space. Front and rear are reversible; the backdrop falls away, an oblique antechamber is partially revealed. Yet diagrams drawn on such surfaces seem suspended in "air"; supports are suddenly implausible and reflections dissolve, as surely as transparency reveals, material things. The mirror or glass is an agent of Cornell's liking for replication at the same time that it is the most fragile of his elements. Additionally, it is so indeterminate in value, so specious and variable in the way it bounces back available light, that it deliberately intensifies the illusory quotient of his enterprise. Yet, to compose a lattice of vacancies is also, curiously, to introduce a certain voyeuristic coloring. The multiple innuendos, the scattering and faceting of images, are all reminiscent of the coquettish thrills of a peep show. Still more, Cornell is forever partially imposing some porous veil mesh, darkly tinted glass, chiffon, feathers, twigs, screen doors, upon "backgrounds" that are in reality his protagonists. When, as in *The Crystal Palace* (1949), mirrors reflect only the chance shadows that might animate a glittering prison timbered in struts, the real meaning of his statement is illuminated: fantasy does not lead toward liberation but rather provides its own lovely cage.

Whenever, at widely scattered intervals, Cornell previously showed his work, it became for the most part, and with reason, an underground pet of criticism. The usual treatment at one time was to sing or chirp along with the boxes in verbal mimicry of their winsome oddments. More recently it has become harder to resist giving factual but fascinating lists of Cornellian imagery—with the effect, perhaps, of some of the more titillating recipes in the gourmet cookbooks. Yet these approaches, while often yielding insights, tended to overweight the part against the whole, or vice versa, through their reluctance to use analysis. After all, the man is not an inexplicable mage nor a mere customs official of the imagination; definite devices, even mechanics, put his materials into their special combinations.

It is obvious, for instance, that he relies heavily on the idea of the contained within the contained. Not only are goblets or bottles, dovecotes or portholes, receptacles for stored or concealed information but sometimes the frames of his compositions are included with the frames of the boxes. Even more frequently the outer frames are papered over with engravings or words in a kind of vacuum-filling program (linked with the contents), in which it is impossible to tell whether they are decorative or literary. Also, there is a surprising substitution of part for whole, still more direct than that which I have just mentioned. In *A Swan Lake for Tamara Toumanova* (1946), for instance, an engraved or photographic cutout of a swan under blue glass is surrounded by real white feathers. Scale, too, is one of the most ingenious and important of Cornell's poetic sources. In *Pink Palace* (1946), an engraving of an old building with minute foreground figures is backed with hair-raising sprigs of twigs, grotesquely out of proportion with the scene. Maps are an even more extreme, though schematic, indication of his juggling of depicted and infinitely small-scale references with real objects, not large in themselves but Gargantuan in comparison with their surrounds. Finally, just to notice one more of several subtleties, there are frequent echo or rhyme effects in Cornell. I am not speaking of the repetitions of identical elements, like mute votives, in great pieces like *Multiple Cubes* or *Bebe,* but rather *A Parrot for Juan Gris* (1953-54), in which the shadow profile of the flattened parrot occurs in white and black cutouts against the newsprint behind it. What is volumetric becomes flat, what is solid becomes transparent. And yet, however different the incarnation, the morphology is the same.

It is just this kind of syntax, in the final analysis, that confirms Cornell as an extremely knowing artist. With extreme deftness he has skirted through and around the methodology of de Chirico and Gris, Ernst and Mondrian, who are as present in his formal intelligence as the Renaissance masters are evident in the reproductions he includes. His compressions and elisions, always dovetailing with each other, are of such a high level of inventiveness that his work cuts itself entirely free from those merely tasteful congeries of small antiquities to be found in the Rue Jacob or on the Quai Voltaire. Yet Cornell is indifferent, in the end, to the structural imperatives of Cubism. And he is innocent of the aspirations to tap some collective unconscious that typifies Surrealism. Even Magritte's epistemological puzzles are foreign to Cornell's diffident narcissism

and his homespun refinement centering usually upon the pretty underwear of culture. His art reminds me of Lichtenberg's remark: "Her petticoat had very wide red and blue stripes and looked as if it were made of theater curtain. I'd have paid a lot for a front-row-center seat, but the curtain was never raised." Perhaps Cornell is too modest to raise the curtain, perhaps too sophisticated. (pp. 153-58)

Max Kozloff, "Joseph Cornell," in his Renderings: Critical Essays on a Century of Modern Art, *Simon and Schuster, 1969, pp. 153-58.*

Harold Rosenberg (essay date 1967)

[*Rosenberg was a prominent American critic, translator, and poet who helped legitimize the school of Abstract Expressionism, recognizing its place in art history as "action painting." Bill Marvel has written, "With Harold Rosenberg . . . , one gets a sense of conscience, a conviction that art does matter, and because it matters there are moral issues involved." In the following essay, Rosenberg emphasizes the poetic qualities of Cornell's boxes.*]

The boxes of Joseph Cornell . . . are primarily descendants of the slot machine. The tall, narrow portraits in the *Medici* series of boxes are kin to reflections in the mirrors of penny-candy dispensers (when Cornell discovered a particularly brilliant chewing-gum machine in the Thirty-fourth Street station of the B.-M.T., he rushed around urging his friends to go see it); the boxes comprising rows of bins that contain cubes, jars, or smaller boxes (*Multiple Cubes, Pharmacy, Nouveaux Contes de Fées*) recall the glass-covered cells in the Automat. Other Cornell objects are assembled in containers that derive from showcases, jewel caskets, and the old-fashioned drygoods-store cabinets of tiny drawers for thread and buttons. But among Cornell's variety of compartments the candy slot machine carries the most significance. It is both receptacle and contraption, storage space and toy. Offering its contents to all in an apparatus for delivering them, it yet isolates them from the crowds of passersby. It also isolates the customer by engaging him in the game of inserting coins and pulling or turning knobs, and further accentuates his separateness by giving him a glimpse of himself in the glass. *Medici Slot Machine* . . . combines bustle—represented by strips of film bordering the central figure, a compass under his feet, maps papering the walls and floor of the box—with timeless meditation. In the major vertical compartment, equivalent to the mirror of the penny machine, appears the artist's self-image, transposed into the almost full-length portrait of a big-eyed Renaissance princeling, sword at his side, encased behind crossed lines as in a gunsight. In smaller compartments on both sides of the prince, vertical rows of Renaissance faces in frames of movie film, and jacks and balanced balls, are poised as if to slide out when the mechanism is started. If the machine could be worked, it would yield a magical jackpot: self, a noble birth, the romance of the Renaissance, love, scientific discovery, entertainment.

The slot machine in which Cornell encases his symbolic accretions is thus itself his most inclusive symbol. It repre-

sents his means of participating in the common life while holding himself strictly apart from it. He becomes a member of the crowd by making anonymous use of its games. Probably the most self-secluded artist in America—the catalogue of his exhibition [see Introductory Overview] begins by declaring that "Little is known of Joseph Cornell's early life," and it contains none of the usual revelations provided by artists for such occasions—Cornell has always been drawn to popular-art products, but only when they have ceased to be popular, he has been a devoted collector of old movie films, old phonograph records, old picture postcards. His adaptation of the vending and amusement-park machine as the setting for his compositions, as well as his use of junk, printed matter, and ready-made commodities has led to the linking of his work with the billboard and comic-strip images of the Pop painters and sculptors. But though it is founded, like theirs, upon the artifacts of the street, Cornell's art belongs to an entirely different aesthetic and emotional order—one might almost say a different culture. Warhol, Wesselmann, Lichtenstein, Rosenquist manipulate the soup labels, the comic-strip "box," the photographic blowup as tokens of the public realm; Oldenburg's aggrandized pies and hamburgers outshout anything in Horn & Hardart. Cornell, by contrast, converts hardware-store goods—curtain rods, glasses, a piece of wire mesh—into elements of his inward, once-occurring vision that is both displayed and hidden in its container-theatre, as if one glimpsed it through a peephole. His materials are available to anyone, but in his use of them they take on an entirely subjective character. Each object enters his imagination carrying a large cargo of associations—in the box, it is redefined so as to become a term of a unique metaphor.

Nor do Cornell's displaced clocksprings and illegible scraps of printed matter, though they draw on Duchamp's Dada experiments, have much in common with Dada or Surrealist assemblages. Cornell balances a ball of cork above a pair of rings and a broken clay pipe, not in order to induce a quiver of dissociation and disorder—or, like Duchamp, to construct an absurd machine—but to unveil secret affinities; his aim is not shock or "black humor" but to pin down a state of being in the concreteness of things. In **Deserted Perch,** one of his more obvious compositions, the suggestion of diagonal movement from the lower-left-hand joint of the box, through a block affixed to the rear wall of the box, to a coiled spring and a decorative, curved piece of wood at the upper-right-hand corner conveys with simple immediacy the flight of the vanished bird and the desolation of absence, before one notices on the floor of the box some colored bits of what must be plumage.

Cornell's ties with Surrealism are biographical rather than aesthetic or ideological; he began his career in 1932 by exhibiting in Julien Levy's Surrealist gallery, on Fifty-seventh Street, and in one of his earliest collages he pays tribute to Surrealism by including the sewing machine and operating table which the Surrealists had taken from Lautréamont as a trademark, though the oilcan and ears of corn Cornell incorporates in his composition seem to hint at irreverence. He also made a few attempts at Surrealist metamorphosis; another early collage represents a sailing vessel sprouting a cloudlike rose with a spider web

inside it. By temperament, however, Cornell has more in common with New England spareness and transcendentalism, with Emily Dickinson's

> If I could see you in a year,
> I'd wind the months in balls,
> And put them each in separate drawers,
> Until their time befalls

than with Surrealist diabolism, and he quickly abandoned nightmare, tricking the eye, and manipulation of scale in favor of the suggestive power of real things and lucid placement. To identify his boxes with the assemblages of Man Ray, Ernst, Dali, or Duchamp, or with recent "combines" of unrelated things, is to risk distorting the poetic dimensions of his work. Miss Diane Waldman's introduction to the Guggenheim catalogue seems to me to overstress the part of Surrealism in Cornell's imagery—probably out of fidelity to the historical record of his association with Surrealists; in her perceptive and informed readings of the boxes, they become, however, typical Symbolist creations. *L'Égypte de Mlle. Cléo de Mérode* is an open chest of oak lined with cream-colored marbled paper and containing twelve jars sealed with the same paper. "A description of one of the bottles," writes Miss Waldman, "gives some idea of its contents: *Sauterelles* (grasshoppers or locusts) contains a cut-out of two camels and bedouins from an old photograph of the Pyramids and a small green ball, both set in yellow sand. Cléo de Mérode was a famous ballerina in the 1890's. The goddess Hathor, pictured on the inside lid, is the goddess of love, happiness, dancing, and music, also goddess of the sky. Cléo in the title is also Cleopatra of Egypt. The composition of the box can be paralleled to the Egyptian involvement with the tomb and the afterlife, to the custom of securing in the tomb the articles most required by the deceased in his life after death," and so on. *L'Égypte,* a synthesis of romantic fact (the ballerina of the eighteen-nineties), mysteries casually introduced (the goddess, the photograph of the Pyramids), and metaphysical overtones (love, death, eternity), belongs to the family of Thomas Mann's black gondola in *Death in Venice* and of the lovers exchanging their chest X-rays in *The Magic Mountain.*

To Cornell, a sliver of mirror or some sticks nailed to a board are equivalents of the sunlit oceans and glistening temples of the Symbolist poets. He responds like Valéry to the infinity of the night, and shares with Mallarmé the idea of art as a cosmic game of chance. His objects are, to adopt the Symbolist phrase of Malraux, "money of the absolute." Sand, firmaments, and figures of the zodiac recur in the boxes done in the fifties, in which strips of sky starred by flecks of white paint replace the portraits of the *Medici* boxes. It is almost as if these works were responses to Baudelaire's lines in "The Voyage":

> Show us those caskets of your rich memories,
> Those marvellous jewels made of stars and ether.

In the constructions called **Hôtels** that Cornell did in this period, French names and settings that are suggestive of France's African colonies—parrots, adobe walls, sinister entrances, signs partly erased—evoke the Moorish paintings of Matisse, but with luxury changed to shabbiness. Structurally, these boxes, crudely nailed together out of

rough-surfaced pieces of found wood, and papered with old maps or covered with thick white or yellow paint, tend—with their columns made of a dowel or slat—to parody classical architecture in the manner of provincial buildings. Shallow in depth, airless as Poe's House of Usher, with their old-fashioned lettering, words like "Piano Forte," and names affixed with dripping glue, they diffuse an atmosphere of poverty and aging. In this context, Cornell's fondness for French titles places him in the tradition of American writers and painters, from Poe to Max Weber, who were immersed in the romance and decay of the Old World. His much-noted nostalgia is a longing less for childhood and his own past, as in the early collages of Rauschenberg, than for an order by which broken and faded things might be rescued and renewed. They are mementos of an abstract past comparable to the objects stripped of particulars in Eliot's "Rhapsody on a Windy Night":

> The memory throws up high and dry
> A crowd of twisted things;
> A twisted branch upon the beach
> Eaten smooth and polished . . .
> A broken spring in a factory yard.

The "game" boxes (for example, *Dovecote,* with its balls and open and closed apertures), which have most influenced younger artists, and the sandboxes are, like *Medici Slot Machine,* toys of a mind playing with possible relations and regaling itself with invented landscapes. The success of a Cornell depends upon the inner references of the objects as objects and of their spatial arrangement within the preconceived limits of the box. His few attempts at external statement, as in the collages for the "Americana Fantastica" issue of *View,* in which an Indian in a headdress, a levitating drummer boy, a tightrope walker, and a trapeze act are posed against a background of Niagara Falls, are astonishingly weak, and some recent commentary collages, such as *Interplanetary Navigation,* which features angels and doves (of peace?), are rather superficial in conception and dissolute in color. These failures underline the distinction between mere messy juxtaposition and "simultaneity," which constitute so much of current "assembled" art, and the translation of objects into unique, untranslatable symbols that occurs in Cornell's best work. The power of his boxes lies in the recognitions of affinities that are unexpected yet as absolute as the placement of a line by Mondrian or a stroke by Kline. To have attained remoteness and fixity in everyday things, thus enabling them to serve as a language of signs, is Cornell's most remarkable achievement; his transmuted trash liberates metaphysical art from reliance upon traditional poetic emblems—fauns, swans—and mathematical forms in a manner comparable to the colloquialisms and snatches of song in *The Waste Land.* (pp. 112, 114-17)

> *Harold Rosenberg, "Object Poems," in* The New Yorker, *Vol. XLIII, No. 15, June 3, 1967, pp. 112, 114-18.*

John Ashbery (essay date 1967)

[*Ashbery is an American poet and critic. He is best known for his poetry, which rejects conventional syntax,* traditional structure, and easily definable meaning. *These techniques, he has acknowledged, demonstrate the influence of Abstract Expressionist painting on his work. In his criticism, he often stresses the interrelation of artistic mediums. In the following excerpt, Ashbery discusses the appeal and influence of Cornell's art.*]

Cornell's extremely retiring nature, his exemplary reluctance to give out biographical data or make statements about his work, compounded the aura of uncertainty that seemed to hang over that work like an electrically-charged cloud. Not uncertainty as to its merits, for these, though seldom understood, have been almost universally recognized by artists and critics of every persuasion—a unique event amid the turmoil and squabbles of the New York art world. The uncertainty was rather an obscure wondering whether one could go on *having* this work, whether the artist would not suddenly cause it all to disappear as mysteriously as he gave it life. For Cornell's boxes embody the substance of dreams so powerfully that it seems that these eminently palpable bits of wood, cloth, glass and metal must vanish the next moment, as when the atmosphere of a dream becomes so intensely realistic that you know you are about to wake up. (pp. 57-8)

Our knowledge of Cornell's life is as sketchy as our knowledge of Carpaccio's or Vermeer's. He was born in 1903, lived as a child in Nyack, N.Y., and moved in the late 1920s to the house in Flushing, L.I. where he still lives. As a young man he attended Phillips Academy at Andover, Mass. and worked for a while in the family textile business. One imagines that his day-to-day existence in Queens must be as outwardly routine and as inwardly fabulous as Kant's in Koenigsberg. The latter once astounded an English visitor with a graphic description of St. Paul's in Rome; the visitor could not believe that Kant had never traveled beyond the borders of East Prussia. It is likewise hard to believe the Cornell has never been in France, so forcefully does his use of clippings from old French books and magazines recreate the atmosphere of that country. Looking at one of his "hotel" boxes one can almost feel the chilly breeze off the Channel at Dieppe or some other outmoded, out-of-season French resort. But this is the secret of his eloquence: he does not recreate the country itself but the impression we have of it before going there, gleaned from Perrault's fairy tales or old copies of *L'Illustration,* or whatever people have told us about it. In fact the genius of Cornell is that he sees, and enables us to see, with the eyes of childhood, before our vision got clouded by experience, when objects like a rubber ball or a pocket mirror seemed charged with meaning, and a marble rolling across a wooden floor could be as portentous as a passing comet.

Cornell has said that his first revelation of modern art came at the memorial show of paintings from the John Quinn collection, which was held at the Art Centre in New York in 1926 and included works of Picasso, Matisse, Braque and Brancusi, as well as Rousseau's *Sleeping Gypsy* and Seurat's *The Circus.* His second revelation was the first New York exhibition of Surrealist art, at the Julien Levy Gallery in 1931, where he saw work by Ernst, Dali, Tchelitchew and Cartier-Bresson among others. Cornell was especially impressed by Max Ernst's collages

of 19th-century engraved illustrations: a 1932 Cornell collage in a similar spirit is reproduced in Levy's *Surrealism,* while a 1942 number of *View* devoted to Max Ernst reproduces a series of 16 marvelously delicate and witty Cornell collages called *Story without a Name: For Max Ernst.*

[One of his works] is an untitled collage of 1931, an engraving of a clipper ship with a giant cabbage rose nested in one of its sails: inside the rose is a spiderweb and at the center of the web lurks a spider. One might at first be tempted to dismiss this work as an over-zealous homage to Ernst, but further inspection reveals fundamental dissimilarities which place it in quite another and in my opinion superior category to the collages in *Une semaine de bonté* or *La femme 100 têtes.* For Cornell's collage, Surreal as it is, also has extraordinary plastic qualities which compete for our attention with its "poetic" meaning. He wishes to present an enigma and at the same time is fascinated by the relationship between the parallel seams in the ship's sails and the threads of the web, between the smoky-textured rose and the smudged look of the steel-engraved ocean. He establishes a delicately adjusted dialogue between the narrative and the visual qualities of the work in which neither is allowed to dominate. The result is a completely new kind of realism. This, I suspect, is why Cornell's work means so much to so many different kinds of artists, including some far removed from Surrealism. Each of his works is an autonomous visual experience, with its own natural laws and its climate: the thing in its thingness; revealed, not commented on; and with its ambiance intact.

I don't wish to belabor Max Ernst's collages but since they apparently started Cornell on the road to discovering his own art, it seems fair to examine further the differences between them and Cornell's own collages. In *Story without a Name: for Max Ernst,* he appropriated, for the purposes of an homage, Ernst's collage-novel form; but in so doing he made it his own (a phenomenon not unknown in the history of art—few would argue that the authorship of *Romeo and Juliet* is Arthur Brooke's because he wrote a poem called *Romeus and Juliet* which Shakespeare copied). Ernst's collage novels, clever and startling as they are, pall very quickly—after the first 20 or so pages one finds oneself skipping ahead. This may be because he tries to intervene too summarily in the spectator's attention, to capture him without a struggle. Surprises and shocks descend in an avalanche as in the tragedies of Thomas Kyd, so that one is very quickly immunized to this barrage of the erotic and the bizarre. The reader reacts to an obvious desire to engage him as instinctively as a wheedled child.

But the child—and ourselves—immediately becomes curious when the wheedling stops, or when an artist turns away from us into his own visions. Such is the case with *Story without a Name:* one keeps returning to it to verify certain details, but remains tantalized: the spirit of the work flickers everywhere but stays as elusive as mercury. There is no attempt to shock the viewer (this is an idea that has probably never occurred to Cornell); on the contrary these fabulous landscapes somehow look natural, integrated, adjusted. Even at their most violent or fantastic they have, unlike Ernst's, a romantic tenderness which is all the more moving for its context: firemen are spraying

a burning building out of which erupts a giant flower: the apparition of a little girl appears against a spectacular shipwreck. Violence is rare in Cornell's work (another example would be the 1956 *Sand Fountain*—a jagged goblet holding black sand, like a smashed hourglass). When it occurs it is like the violence of Mozart whom Cornell resembles in so many ways—where a sudden shift into a minor key is as devastating as an entire Wagnerian battalion.

Much has been made of Cornell's transition from early, so-called picturesque works like the *Medici Slot Machine* to the bare, quasi-constructivist "hotels" and "dovecotes" of the 1950s. In fact, Cornell seems to have continued to use "picturesque" materials throughout his period of presumed austerity: *Sun Box* (1956) and *Suite de la Longitude* (1957) are two examples. But it is important to note that the more complex works are far from picturesque, if by picturesqueness one means an anecdotal residue in a work of art. On the contrary, even when it seems frivolous on the surface, as in *Lobster Ballet* which is dedicated to Offenbach or in *A Swan Lake for Tamara Toumanova,* Cornell's work exists beyond questions of "literature" and "art" in a crystal world of its own making: archetypal and inexorable. Like Chirico or the French poet and novelist Raymond Roussel, with whom he has much in common, Cornell has discovered how to neutralize romanesque content in such a way that it becomes the substance of his art rather than its embellishment: matter and manner fuse to form a new element. Thus we are allowed to keep all the stories that art seems to want to cut us off from, without giving up the inspiring asceticism of abstraction.

A glance at the work of Cornell's imitators, and there are quite a few, is enough to confirm that this higher order of his art is no mere figure of speech. This becomes even more evident when we look at artists who have been able to profit from his art, including some who may be unfamiliar with it but whose work would not exist in its present form without Cornell's example. Certainly Rauschenberg, one of the most significant influences on today's generation, looked long and deeply at Cornell's work before his show . . . in 1954. It may seem a long way from the prim, whitewashed emptiness of Cornell's hotels to Rauschenberg's grubby urban palimpsests, but the lesson is the same in each case: the object and its nimbus of sensations, wrapped in one package, thrust at the viewer, here, now, unescapable. Largely through the medium of Rauschenberg's influence, one suspects, Cornell's work is having further repercussions today, not only on whole schools of assemblagists, but more recently in the radical simplicity of artists like Robert Morris, Donald Judd, Sol LeWitt or Ronald Bladen.

It would be idle to insist too much on the resemblance, say, between one of LeWitt's constructions and Cornell's *Multiple Cubes* of 1946-48 or his *Crystal Palace* of 1949—there is physical resemblance, certainly, but it could easily be coincidental. What is not coincidental is the metaphysical similarity linking Cornell with these younger men (the same holds true for the Abstract-Expressionists: the night sky outside Cornell's hotel windows is sometimes spattered with white paint to indicate stars, but the key to the kinship between Cornell and an

artist like Pollock lies elsewhere—in the understanding of a work of art as a phenomenon, a presence, of whatever sort). Cornell's art assumes a romantic universe in which inexplicable events can and must occur. Minimal art, notwithstanding the cartesian disclaimers of some of the artists, draws its being from this charged, romantic atmosphere, which permits an anonymous slab or cube to force us to believe in it as something inevitable. That this climate—marvelous or terrible, depending on how you react to the idea that anything can happen—can exist is largely due to Cornell. We all live in his enchanted forest. (pp. 59, 63-4)

> *John Ashbery, "Cornell: The Cube Root of Dreams," in* ARTnews, *Vol. 66, No. 4, Summer, 1967, pp. 56-9, 63-4.*

Cornell on the Romantic element in art:

I'm the sixth Joseph Cornell, but with the world as it is today nobody cares—there's a letdown in the feeling for family. Life is going to be so different in the future. I have a feeling of freshness for an era that's past, the romantic era, when there was more unity: Taglioni, Berlioz, Delacroix, Chopin, Liszt—all of one piece. If you can go back and get this spirit you can in a way recapture all the wonderful things that have disappeared with civilization.

From Newsweek, *5 June 1967.*

Hilton Kramer (essay date 1970)

[*An acclaimed American art critic, Kramer has been described by James Ackerman as "probably the best art journalist of our time." His writings are praised for their thorough scholarship and enthusiasm, although he is occasionally criticized for avoiding a definable ideological stance. In the following essay, Kramer compares Cornell's aesthetics to those of the French Symbolist poets.*]

There is a passage in Baudelaire's prose poem called "L'Invitation au voyage," written in 1857-60—not to be confused with the more familiar poem of the same title, written in verse a few years earlier—which, it has sometimes occurred to me, sums up the peculiar poignancy, lyricism and yearning we find in certain forms of modern art. This is the passage as it has been translated by Francis Scarfe:

> Do you know that fever which grips us in moments of chill distress, that nostalgia for some land we have never seen, that anguish of curiosity? There is a land that resembles you, where everything is beautiful, sumptuous, quiet, and authentic, where Fancy has built and adorned a Cathay of the West, where life is sweet to breathe, where happiness is wedded to silence. There we must go to live; there we must go to die.

Further on in the same poem, the poet speaks of "A unique land, superior to other lands, as art is superior to Nature, where nature is reshaped by reverie, where it is corrected, beautified, remolded." I thought of this poem

again the other day going around the new exhibition of collages by Joseph Cornell, which Henry Geldzahler has organized at the Metropolitan Museum of Art. And the more I thought about it, the more I wondered if Mr. Cornell was not, among the American artists of his generation, our most authentic French poet.

In terms of the art history of his career, of course, Mr. Cornell comes out of a later development in the line of French poetry that begins with Baudelaire. He comes out of Surrealism, which transformed the collage and the collage-like construction into a species of visual poetry. Surrealism provides the syntax of Mr. Cornell's style—

Not enough, I think, has been said about the scale of Mr. Cornell's work. He works small. His boxes are rarely larger than 18 by 12 inches in size, and many are smaller. His collages conform to these general dimensions—the dimensions of intimacy. It is no more conceivable for Mr. Cornell to produce a work the size, say, of a painting by Rothko or Newman than it would have been for Baudelaire or Mallarmé to write a poem the length of *Paradise Lost* or *The Prelude*. It was Edgar Allan Poe who first wrote: "I hold that a long poem does not exist. I maintain that the phrase, 'a long poem,' is simply a flat contradiction in terms," and the French Symbolist poets ratified this esthetic philosophy both in theory and in practice. Not for them—or for Mr. Cornell—what Poe called "the epic mania."

Mr. Cornell's work rigorously observes the Symbolist notion of a work of art as something highly concentrated, distilled, and brief, something hermetic and enigmatic, an utterance at once deeply personal and yet infinitely mysterious. Poe said of poetry: "Its sole arbiter is Taste. With the Intellect or with the Conscience, it has only collateral relations. Unless incidentally, it has no concern whatever either with Duty or with Truth," and this—while surely not the last word on everything we might want to demand of a work of art, or of some works of art—is a perfectly accurate way of defining the kind of art Mr. Cornell has perfected. Yes, he is indeed our most authentic French poet, if we think of French poetry as consisting primarily of the Symbolist followers of Poe.

Three years ago the Guggenheim Museum gave us a sizable review of Mr. Cornell's accomplishment. (Diane Waldman's essay for the catalogue of that exhibition [see Introductory Overview] remains, incidentally, the single best account of this accomplishment I know.) And we have had other, briefer glimpses of Mr. Cornell's work in other exhibitions during the last decade. The current show at the Metropolitan adds to our pleasure and our knowledge of this very singular artist, but it also makes one impatient for a really large, definitive exhibition. The history of art in our time will not be complete without it.

> *Hilton Kramer, "Joseph Cornell's Baudelairean 'Voyage',"* in The New York Times, *December 20, 1970, p. 27.*

Octavio Paz (poem date 1974)

[*An author of works on literature, art, anthropology, cul-*

ture, and politics, Paz is recognized primarily as one of the greatest modern Spanish-American poets. Early in his career he met André Breton, founder of Surrealism, and Paz's work shares the Surrealist quest for personal freedom and the high value placed on love relationships. Paz's poetry is characterized as visionary and experimental, and his critical writings are regarded with respect. In 1990, he was awarded the Nobel Prize in Literature. In the following poem, Paz expresses his wonderment at Cornell's boxes.]

Hexagons of wood and glass,
scarcely bigger than a shoebox,
with room in them for night and all its lights.

Monuments to every moment,
refuse of every moment, used:
cages for infinity.

Marbles, buttons, thimbles, dice,
pins, stamps, and glass beads:
tales of the time.

Memory weaves, unweaves the echoes:
in the four corners of the box
shadowless ladies play at hide-and-seek.

Fire buried in the mirror,
water sleeping in the agate:
solos of Jenny Colonne and Jenny Lind.

"One has to commit a painting," said Degas,
"the way one commits a crime." But you constructed
boxes where things hurry away from their names.

Slot machine of visions,
condensation flask for conversations,
hotel of crickets and constellations.

Minimal, incoherent fragments:
the opposite of History, creator of ruins,
out of your ruins you have made creations.

Theater of the spirits:
objects putting the laws
of identity through hoops.

The "Grand Hotel de la Couronne": in a vial,
the three of clubs and, very surprised,
Thumbelina in gardens of reflection.

A comb is a harp strummed by the glance
of a little girl
born dumb.

The reflector of the inner eye
scatters the spectacle:
God all alone above an extinct world.

The apparitions are manifest,
their bodies weigh less than light,
lasting as long as this phrase lasts.

Joseph Cornell: inside your boxes
my words became visible for a moment.

(pp. 117-18)

Octavio Paz, "Objects and Apparitions," translated by Elizabeth Bishop, in A Joseph Cornell Album, *by Dore Ashton, The Viking Press, 1974, pp. 117-8.*

John Bernard Myers (essay date 1975)

[Myers was an American art dealer, publisher, and critic. Highly respected in the New York artistic community, he used his influence to promote such artists as Fairfield Porter and such writers as John Ashbery at the beginnings of their careers. In the following essay, he seeks to understand Cornell's art through an examination of his circumstances and attitudes.]

The images of Joseph Cornell yield up notions of nostalgia, evocations of historical moments, lyrical flights, romantic daydreams, childlike games or playful paradoxes. His enthusiasts enjoy interpreting his imagery in the light of art history or allusions to literature. There is a sense in which each of these admirers can be "correct" in his sometimes ingenious explications, and sometimes quite "wrong." Few of the works are easily understood because few lack mystery. This is true from the first 1930s collages to the last boxes of the late 1960s; their ambiguity is as constant as their elusiveness. They are a revelation of the whole man, but a man whose mind and personality are complex, subtle and hard to pin down.

Cornell spent the whole of his life within the area of New York City, with occasional forays to Nyack or Long Island. After a secondary-school education at Andover, he went into his father's dry-goods business. Upon his father's death, he became head of the household and took care of his mother and younger brother, Robert. He never married and carried out his familiar responsibilities to the end of his life in 1973. Cornell brought the world to Utopia Parkway in Flushing.

The historian looking at the work of so unique a creator as Cornell is hard put to explain him. There is no one quite like him in the history of art. Of course there were artists and craftsmen through the centuries who made three-dimensional objects and shadow boxes of varying degrees of beauty and interest. But few works were meant to carry the weight of a vision both personal and profound. Cornell chose a medium through which the whole of himself and his imagination would be expressed. That he did it with so much finesse and sophistication is baffling, considering that he had no formal training in painting, sculpture or drawing. But as a self-taught artist he never fell victim to provincialism or the self-satisfaction which invariably afflict the amateur or the artist *manqué*. There is not a trace of dilettantism. Cornell never dabbled.

Another problem confronting the historian is Cornell's "subject matter," the wide-ranging and often recondite visual-poetic material of his work. If a scholar-gentleman is possessed of such knowledge, we are not surprised; when an artist of modest means and real responsibilities is similarly endowed, it is surprising. One cannot but wonder how he did it. How did he collect so much information? How could he know so much?

One clue can perhaps be found in Cornell's passion for collecting what he called "ephemera," a passion he pursued from an early age. When the Cornell family gave Cornell's letters, documents and memorabilia to the Archives of American Art, the curators were staggered by the immensity of the material that had been stored away in cellar,

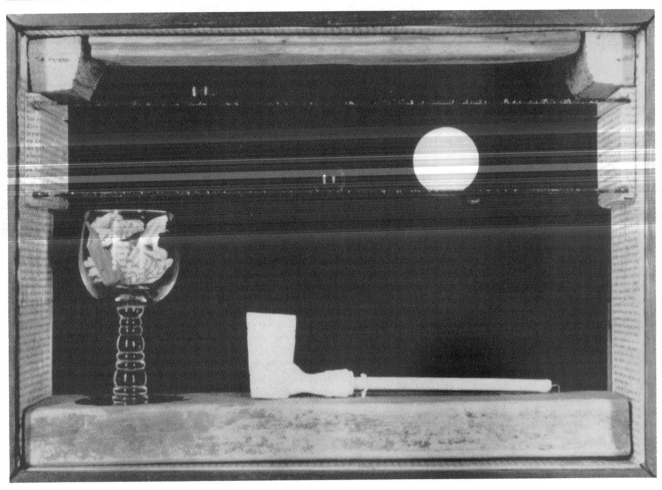

Soap Bubble Set *(1948)*.

attic and garage. At one period of his life, art directors of New York's periodicals would ask Cornell to locate old prints or photographs that could be found nowhere except in his collection. But, unlike other hoarders of curiosa, Cornell made a point of knowing what there was to know about the items he collected, stored and filed, including thousands of still photographs from silent movies and a rich accumulation of prints and engravings of dancers and singers of the early 19th century. (The portfolio of material relating to the diva Malibran is in itself a work of art.)

The deep desire to know protected Cornell from mere antiquarianism. The lack of formal education became an asset; in his need to educate himself, it became imperative that he penetrate what he had collected for meanings and connections. Inevitably, this led him to find wider correspondences between images and meanings, which in turn forced him to discover what was within himself.

A second and perhaps equally important clue in appreciating Cornell's uniqueness is his relationship with his brother. Robert Cornell was born with a physical condition that would prevent growth and maturity. He remained for the 46 years of his life an all but helpless human being, completely dependent upon the care and love of others. Few adults are capable of a sustained and committed attach-

ment to a person thus handicapped, and even fewer would find in such a relationship an abiding source of inspiration—with the possibility of fun and even happiness. The Land of Counterpane (recalling Stevenson's child invalid) was re-created for Robert: the eight-pointed cardboard star turning in its kaleidoscope, the boxes with surprises, the eight-millimeter silent movies screened on the living-room wall, the amazing toy landscape with electric trains controlled by Robert from his little chair with buttons that made lights go on and off, made trains stop and go while villages, waterfalls, farms and mountains vibrated with life.

Joseph had identified with Robert's "otherness" and his suffering. We can only define such love as transcendent. After Robert's death in 1968, this was touchingly evident in the exhibition Joseph presented at the Schoelkopf Gallery of Robert's drawings in crayon and pencil of bunnies, kittens and other vulnerable creatures that exist in purity and unworldliness. It was Joseph's declaration of fidelity to the innocent.

Still, we have not clarified or come close to the heart of Cornell's uniqueness. Other people have collected, others have sacrificed and others have been alone; a psychological interpretation does not suffice, nor is it in the end possi-

ble to "explain" the mystery of a great artist. Even the contemplation of suffering in an artist will not necessarily reveal hidden meanings.

The search for the self was a perennial and long one. Cornell had to recognize his relationship with suffering—especially the suffering of others; he sought to ameliorate when he could the lot of shattered and hopelessly handicapped children. His belief in Christian Science was a spiritual strategy to lessen the impact of horror. The oddity of his work is that it contains not a single horror, only the faintest allusions to the real 20th-century world, where pain, torture and mass death are commonplace.

And yet the work reveals a pathos, despite its glamour and enchantment, a malaise all the more striking in its revelations of nature, places, people, things, the universe. Cornell had discovered the human condition which all of us share. Montaigne at the age of 69 described it perfectly in his essay "On Presumption." "I feel oppressed by an error of soul [*erreur d'âme*] which offends me as both unjust and even more as annoying. I try to correct it but I cannot root it out. It is that I attach too little value to things I possess, just because I possess them; and over-value things which are strange, absent, and not mine. This frame of mind extends very far." The Jesuit poet Gerard Manley Hopkins considered himself a "spiritual failure," surely another example of *erreur d'âme* in Montaigne's context. Montaigne adds, "Exotic societies, customs and language attract me, and I realize that the dignity of Latin impresses me more than it should." Cornell yearned for perfection, the infinite, the past and for that which was absent. Childhood alone represented a possible state of pure being. How could such impossible desires be a basis for art? Would they not lead to sentimental nostalgia, spiritual arrogance, intellectual aridity, *folie de grandeur*? Would not such conceit end in despair? Luckily, Cornell had one desire that outdistanced the others, and he somehow remained sufficiently detached from his yearning to recognize his own "soul sickness." It was his passionate need for wholeness. He would find his inner reality through *correspondences:* in life, in history, in art—"the way" of another who had suffered, Baudelaire. Salvation would come through the making of art; only through art could the tyranny of time, of place, of illness, of pain be erased. Reticence would be his guardian angel.

We can never know whether Cornell succeeded in his aim. But his documents, his films, his collages and boxes remain for us to contemplate that quest.

A rebus, Webster tells us, is a "mode of expressing words and phrases by pictures of objects whose names resemble those words, or the syllables of which they are composed; hence, a form of riddle made up of such representations." In saying that Cornell's work is often a rebus, one would not be too far from the truth; objects are put together, "composed," in such a way that they seem to be a "riddle," but, unlike ordinary riddles, they do not yield single answers. Thus, when someone asks, "What is the meaning of this box?" a precise answer is not possible or even desirable. Cornell worked in the same way as poets, using visual materials instead of words. Like a poet he used symbols, suggestions, allusions, to build metaphors, to create

drama, to evoke mystery. This does not mean that Cornell was a "literary" artist who illustrated works of literature, philosophy, natural science or history, even though there are allusions to all of these disciplines.

The *actuality* of an experience was Cornell's first concern; each work must *exist* as the viewer regards the box or collage in front of him. Since much of what the artist is alluding to occurred in the past or outside chronological time, the images must project their real-ness and present-ness. The shadow box is the perfect medium for such a notion: it is like a little theater, it is three-dimensional, the objects within the proscenium are actual "props" and the light in which they are bathed, theatrical. A drama occurs—the encounter between two imaginations, Cornell's and the viewer's.

We know that the artist collected his materials over a long period of time; certain of them appear again and again from the earliest work to the last: clock springs, cork or wooden balls, glasses, marbles, clay pipes, cubes, metal rings, jacks, feathers, colored sand, bits of driftwood, shells, mirrors, fragments of old newspapers, posters, letters, programs, sheet music, engravings, postage stamps, cylinders, small bottles. These were arranged in labeled containers in his studio, ready to be selected for the work at hand. The various-sized boxes were also in readiness. Cornell could start a new work or continue with a box long in progress as it suited him. Sometimes he worked on several in varying stages of completion; some he never considered "finished." There was a constant shifting back and forth, a repetition of themes and metaphors, a continuity of ideas. When certain boxes were called "variants," the definition was not quite true—all Cornell's works are variants on one idea or another. Continuity and repetition were necessary to the unfolding of the basic themes, to the vision.

Time was probably Cornell's deepest obsession; he wished to be delivered from its inexorability and rescue what he could from the past, the dead, the forgotten. In the early work there are numerous references to romantic figures of the 19th century—ballet dancers, opera singers, composers and poets; in fact, Cornell saturated himself in the romantic epoch, and certain of those personalities are alluded to again and again: Taglioni, Cerrito, Grisi, Elsler, Pasta, Malibran, Novalis, De Quincey, Nerval, Hans Christian Andersen, Schumann, Debussy, Mendelssohn, Berlioz, Baudelaire, Rimbaud and Mallarmé, among many others.

Then there is the division between daytime and nighttime—the former represented in the boxes painted white and yellow, the latter in deep blue. "Nature is implied through its effects, the effect of time, another human abstraction, or of number, with a suggestion of vast distance and quality," wrote Fairfield Porter, in an essay Cornell liked [see Further Reading, section II]. Thus the daytime boxes with their birds, sand, shells, bits of flotsam, rings, a sun made of tin, mirrors. "Infinity is not a matter of physical size," wrote Porter. In the night boxes through windows we see the skies, the spectacle of constellations and galaxies, the blue of the infinite. Dreams, however, are

possible in the day or night, and Cornell incorporated his dream material equally.

Cornell's work, like Pascal's prism, can be seen *through.* He invites us to imagine anything we like, but carefully divides his world into three parts: the bodily world of immediate beauty (ballerinas, jewels, the opera, romantic lives); the world of nature (animals, flowers, birds, the sea, the tides, geologic or fossil deposits, children); and the infinite (sun, moon, the planets, constellations, the vastness of the skies). Neither purgatory nor hell exists. It is a perpetual Garden of Eden, devoid, however, of cheap nostalgia or forced emotion. (pp. 33-5)

> *John Bernard Myers, "Joseph Cornell: 'It Was His Genius to Imply the Cosmos'," in* ARTnews, *Vol. 74, No. 5, May, 1975, pp. 33-6.*

Lucas Samaras on Cornell:

When I first saw his work I didn't like it but I absorbed it.

I used to think of size as something constant. His pieces were small. Now I think differently. Things are as big as the amount of space they fill in the field of vision. Up close his works are enormous.

> *From* Arts Magazine, *May 1967.*

Thomas Lawson (essay date 1980)

[In the following excerpt, Lawson analyzes Cornell's understanding of art in a discussion of his films and scripts.]

After leaving Phillips Academy at Andover in 1921, but before committing himself fully to the life of an artist, Cornell developed two passionate interests—symbolist literature and a growing collection of ephemera and memorabilia concerning the famous ballerinas and divas of the nineteenth century, a collection which grew naturally to include the numerous stars and starlets of Hollywood. There can be no doubt that the one passion gave validity to the other, nor that both were of great significance to the development of his art. It was the collection of pamphlets, photographs, and short films which was to have the most direct impact on that development, for it provided a bottomless well of related images from which he was to make his reconstructions of a past he did not know. But it was not just as a fecund source of material that the collection is to be understood as important to the growth of Cornell's art; more pertinent is the simple fact that he was a collector.

A collector has a passion for order, one that he can discover in obscure corners, but it is a passion that is constantly denied by the sheer multiplicity of things. Focusing his attention on one kind of thing, he can afford to revel in seeming chaos, knowing (hoping) that at some point, when his collection of artifacts, and their individual histories, has been absorbed in his memory, he will be able to re-collect

a new and more profound history. Ever looking forward to that moment of synthesis when the metaphorical chains which give the collection its coherence lock into place with the metonymy of its completion, he is trapped in a mechanism of frustrated desire. The individual items begin to lose their importance as the idea of the collection takes over; they come to be seen merely as fragments, fragments rebuilding an edifice which can never reach completion. That Cornell's collection was a largely photographic one can only have intensified this fragmentary quality.

It was as a collector that Cornell first came to understand art, not as an art collector, but as a collector of these incomplete memories. It was as a collector that he was prepared for the first waves of surrealism to reach the United States in the late twenties, and it was only then that he began the process of editorial synthesis that was to make collection the first step towards the creation of the work that we know today. His earliest known works, clearly derivative of Max Ernst, are small collages which use old engravings to create gently provocative versions of Lautréamont's famous juxtaposition. His first exhibited work (shown at the Julien Levy Gallery in 1932) included these collages and what was in effect a miniature environment, a display case of bits and pieces—glass bells, thimbles balanced on needles, uncoiled watch springs in little sewing boxes, bisque angels, and so forth. Already there is evidence of that airless space of the later boxes, an interior space, a collector's space, a space for reverie.

It was not, however, until the end of the thirties that he finally developed a complex body of work inspired by a variety of performers, and the subject of his collection became integrated into his art. All his energies seem to have been engaged in the enterprise, for it was during this time that he indulged his eccentric knowledge of nineteenth-century dance as a regular contributor to the magazine *Dance Index,* while also publishing short essays and collaged page displays in *View,* such as the one excerpted at the beginning of this essay.

In the midst of this activity, in 1940, Cornell embarked on a series collectively entitled **Homages to the Romantic Ballet.** Most of the works in this series are miniature in scale, but there is one comparatively large, major work, **Taglioni's Jewel Casket,** now in the collection of the Museum of Modern Art in New York. A sturdy wooden box with a hinged lid, it opens to reveal a plush, velvet-lined interior. The tray of this jewelry box contains no jewels, however, but an extremely orderly array of simulated ice cubes which can be lifted to expose slivers of crystal and rhinestone lying loosely on the mirrored surface of the bottom. Across the center of the lid interior hangs a crystal necklace partially framing an inset inscription. This inscription reads:

> On a moonlit night in the winter of 1835 the carriage of Marie Taglioni was halted by a Russian highwayman and that enchanting creature commanded to dance for the audience of one upon a panther's skin spread over the snow beneath the stars. From this actuality arose the legend that to keep alive the memory of this adventure so precious to her, Taglioni formed the habit of placing a piece of artificial ice in her jewel casket

or dressing table where, melting among the sparkling stones, there was evoked a hint of the atmosphere of the starlit heavens over the ice-covered landscape.

The extraordinary thing about this object is that in it the artist mimics exactly the tactics of his subject, but to evoke in memory not an event but an image, a picture which, like that of Hedy Lamarr, is understood in terms of black and white. The dancer is certainly not there; there is nothing in the box to recall her but the formalized repetition of her gesture. The anonymous voice of the text describes her only as "the enchanting creature." And yet she does seem present, not as an individual, but as a symbol of fleeting beauty and intense pleasure. This presence comes not from any perception or projection of personality, but simply from the syncopation of repetition, the repetition of forms within the work and the repetition of themes within the series as a whole. This use of repetition, which is one of the most conspicuous features of Cornell's work, is a device which can only work through the operation of memory.

By its very nature memory is fragmentary, crying out for completion. Everything is seen as part of something else, for behind the operation of memory is the repressed recollection of a happier state when the self and the world were still perceived as one. It is a commonplace of psychoanalysis that as cognition gives way to re-cognition, the forbidden images and impulses of childhood tell a truth that reason would deny. Memory imbues fantasy with content, and it was this content which most interested the surrealists.

The *Homages to the Romantic Ballet* address the evocative powers of recollection, attempt to arrest the fleeting moments of the past in the frozen gestures of the chosen ballerinas. Again and again the works return to the notion of the metaphoric transparency of the dancer, a transparency often enough made literal in the work with its reliance on photographic effects—from simple negative/positive manipulations to the more sophisticated play of slow fades and dissolves in the films.

In 1936 Cornell worked with Julien Levy on the design and publication of a small anthology of surrealist writings. It contained a selection of manifestoes by Levy himself and by Breton; translations of the poetry of Eluard, Tzara, and others; and reproductions of surrealist paintings, sculptures, and photographs. The largest section however, was devoted to cinema, for Levy was of the opinion that cinema was the perfect medium for surrealist expression. This section contained, along with an essay by Levy, the screenplay by Buñuel and Dali for *Un Chien Andalou* and an unrealized screenplay by Cornell, called *Monsieur Phot.*

Monsieur Phot is an ambitious script, calling for more technical ability than Cornell could have possessed or hired at that time. A film in sound, the voices of the actors were to be silent. It was to be shot in black and white, with sequences of color at climactic moments. It was, above all, to be an editor's film, pieced together like a temporal collage. This radical editing allows Cornell to dramatically manipulate perceptual habits. There are sudden shifts in

scale, bursts of color, and inexplicable metamorphoses, as the protagonist, a photographer, tries to capture the visual world within the frame of his camera lens.

Such an ambition recalls a passage in Levy's article on cinema in [*Surrealism*], a passage which seems to describe *Monsieur Phot* while predicting *Rose Hobart.*

> Thoughts and dreams almost universally operate as a sequence of moving images, usually in monochrome, with occasional flashes of color, captions, and sound; not to mention the tricks so accessible to the camera such as superimposed concepts and the double exposure, flashbacks of memory, and tentative forecasts into the future. It is never the plot of such a film that should receive attention, but rather the wealth of innuendo which accompanies each action and which forms an emotional pattern far richer than that of the usual straight story to which our logical mind is accustomed.

Rose Hobart was first screened at the Julien Levy Gallery on an evening in December 1937. It is a collage film made up mostly of cuts from *East of Borneo,* a Columbia Pictures release directed by George Melford in 1931 and starring Rose Hobart. Some of the additional footage—the storm-tossed palm trees, an eclipse of the sun, a pebble dropping in a shallow pool, and a burning candle—come from some other, as yet unidentified source. Cornell removed the sound track from the original movie and replaced it with Latin American dance music on tape. He also tinted his final print blue. The silence of the performers and this dusty blue coloring—the *azur* of Mallarmé—give the short film the air of reverie. Everything seems slightly out of focus; our perception of time and space is thrown off balance.

In reediting *East of Borneo* Cornell dispenses with the narrative, reversing the order of scenes and repeating those he chooses to be of central importance. The action of the Hollywood production, which seems so comic today, is based on a populist understanding of Freudian psychology. It is a movie about seduction, and the image chosen to represent the Sultan's lust is the volcano he proudly displays as his "ancestor." In the end it is this volcano which erupts to destroy the jungle palace when Rose, fighting off her seducer, fatally shoots him with her elegant little automatic. Cornell takes this rather crude expression of sexuality and turns it into a refined erotic fantasy.

The movement of his film suggests that he returned to the idea expressed in the scenario for *Monsieur Phot* that the action should be carried out "as in a ballet." *Rose Hobart* consists for the most part of sequences featuring the actress on her own, moving gracefully through different sets and wearing different costumes. She is often contemplative, sometimes tense and apprehensive. She talks seriously to someone beyond the frame, or smiles politely as she is courted by the Sultan.

Just as the boxes dedicated to ballerinas and divas center on the untouchable quality of the performer, so this film presents us with a figure who must remain out of reach if she is to retain her ability to represent a fantasy. The structural principle informing the film, as in most of Cornell's

work, is that of repetition. He returns again and again to the same group of images, bringing the relationship between them into sharper focus at the expense of the images themselves. For although repetition works as a function of memory, it is paradoxically true that it is easier to remember a sequence of events if it is situated within a narrative. As a result, the sequences in **Rose Hobart** lose their individuality, pointing instead to a latent meaning not manifest in a catalogue of the discrete elements. As she moves around the twilight space of the film, strangely silent, paying no attention to the raucous music on the sound track, Rose Hobart becomes almost invisible. (pp. 52-7)

The working notes for a film treatment, which appear to date from 1940, are, of course, directly related to the romantic ballet series, but also stand in a close relation to the thematics of the film work, those of **Rose Hobart** in particular. The sole protagonist is a dancer, but she is isolated from her usual place, the stage, with its expectations of narrative, and presented within an abstract, fantastic space which is purely cinematic. It is a space which affords the illusion of freedom while all the time representing a far greater degree of control than a stage choreographer could ever exert. **Nebula** is a lightweight piece, one which Cornell himself presumably found wanting. Its interest to us, however, lies in its unfinished state, for this allows us a clandestine look at the artist's working method in the hope that some secret might thus be revealed.

What is revealed is perhaps less a secret than a confirmation, for we discover that Cornell, in working on a piece, would take an idea, or a facet of an idea already familiar to him, and concentrate on reordering it, refining it. Often enough the original impulse seems to have been banal—in this case a children's story cliché, colored perhaps by too intimate a knowledge of Disney productions—but this banality of inspiration, this rather tedious fascination with matters "marvelous" or "magical," is exactly what gives his work the power it undoubtedly has. For in the slow process of editing the original idea Cornell marries an acute formal sense to an ability to build a vertiginous crescendo of allusions, allusions to his own work, that of other artists, and to a range of ideas of wider currency in the culture of the time, finally transcending his point of origin in a complex allegorical structure.

Like so much of Cornell's work, **Nebula** is a network of hints and suggestions, a mental collage in which the dynamics of connection and disconnection are of more significance than the actual images themselves. Like perfume, they are there simply to attract our attention, to present one set of expectations which are slowly disfigured by the multiplicity of cross-referencing intrusions. This unraveling of layers of meaning, once started, is never-ending, and as it progresses it becomes more and more dangerous. The more successful the work of interpretation, the more seductive the work becomes, until the whole enterprise becomes meaningless, circling in on itself in mimicry of the perverse eroticism of the art.

Reading the script one notices how quickly the narrative excuse is dropped, replaced by the repetition of action and of camera movements. A counterpoint is built up between these elements, between the movements of the dancer as she moves across the screen and the movement of the camera as it moves across her body, moving in closer. This counterpoint is a flirtatious one. Like Rose Hobart, like Marie Taglioni on that fateful night, Nebula dances for an audience of one, the spectator. The spectator's privilege as voyeur is underscored by those impossibly romantic environments against which the dancer and camera move— the falling snow, the deep sea, the night sky—flickering backdrops like the eidetic images projected against the eyelids in a daydream. The dancer is a fantasy figure and, as is made clear in the final fade as she blows a kiss at the spectator while looking adoringly at him, the fantasy is erotic. But Nebula is not really there, and even her image soon fades. The treatment suggests an erotic cinema, but since it is cinema, the suggestion cannot be fulfilled.

Nor is this simply the frustration of distance, for one's attention is constantly being diverted. Even here, in such a short and abandoned effort, the allusiveness of Cornell's art, his desire forever to make connections, is apparent. Reading the treatment, one is constantly reminded of elements in other works. One remembers, for example, sequences of dance and images of the night sky in the trilogy he began to make just before **Rose Hobart,** rather crude, funny images with a bawdy vitality. Or again, the closing sequence, which calls for the dancer to be placed on a balcony as she seduces the spectator from afar, seems an echo of the close of **Rose Hobart,** as Rose leans over a parapet, watching ripples in a pool.

Nor were Cornell's references solely to his own work. In subtitling that final section not simply *The Milky Way* but *La Voie Lactée,* it is possible that he is drawing attention to the notes Marcel Duchamp published in *The Green Box* as a guide to his *Large Glass,* notes which identify the sexual aura of the bride as "La Voie Lactée (the cinematic blossoming)." Throughout Cornell's aborted script there are references which insistently point back to this parallel consideration of the mechanics of frustrated desire: not only the epiphany of delay, the hopelessness of repetition, the unbearable poignancy of a film image which can arouse desire but not fulfill it—not only these, but also the more direct recollection suggested by the pictures of Cornell's dancer ecstatically welcoming the falling snow into her arms, flirting with shooting stars and, across an impassable divide, the spectator.

Once again, in the rhyming cross-currents of Cornell's art, we are reminded of something else, a beginning and an end, a reverie of Hedy Lamarr, virginally white, making some obscure but instantly understood appeal, silently, by means of a flashing light. Over and over we find ourselves on this same, limitless spiral of frustrated interpretation. The work is a tease, a discourse of contraries, a semblance of one thing, the insinuation of something else. Cornell assumes the disguise of innocence, the too sweet insistence on mystery and magic, but, by inserting a seemingly endless array of disconnected fragments and allusions, he gives his production the undercurrent of troubled sexuality.

As an artist he is obsessed, obsessed with a need to know and possess the past, to take refuge there. But his obses-

sion is so overwhelming that it undermines that wish. The more greedily he hoards his pictures, and treasures the connections between them, the more pictures and connections he must acknowledge (dancers, starlets, birds, butterflies, seashells . . . the catalogue of props is immense). Seeking the assurance of completion, he discovers an unsuspected uncertainty; he discovers that there is no end, that another rhyme, another allusion can always be added. The pathos of Cornell's enterprise is to be found in these transcendent combinations, this inundation of meaning with meaning. (pp. 58-60)

Thomas Lawson, "Silently, by Means of a Flashing Light," in October, No. 15, Winter, 1980, pp. 49-60.

FURTHER READING

I. Critical Studies and Reviews

Anderson, Alexandra C. "How To Make a Rainbow." *ARTnews* 69, No. 10 (February 1971): 50-2, 72-3.
Discusses form and imagery in some of Cornell's most famous works.

————. "The Fabulist of Utopia Parkway." *Portfolio* II, No. 5 (November/December 1980): 68-71.
Recollections of the writer's experiences as Cornell's studio assistant.

"Notes on the Nature of Joseph Cornell." *Artforum* 1, No. 8 (February 1963): 27-9.
Profile of Cornell in which the critic states, "Cornell's art appears to be based upon the notion that the most basic data on the nature of things is recorded in all manner of ephemera."

Ashbery, John. "A Joyful Noise." *New York* 11, No. 23 (5 June 1978): 91-3.
Enthusiastic review of an exhibition of Cornell's collages, terming them "freer and wilder" than the boxes.

Cortesi, Alexandra. "Joseph Cornell." *Artforum* 4, No. 8 (April 1966): 27-31.
Discussion of themes and patterns in Cornell's art.

D'Harnoncourt, Anne. "The Cubist Cockatoo: A Preliminary Exploration of Joseph Cornell's Homages to Juan Gris." *Bulletin* (*Philadelphia Museum of Art*) 74, No. 321 (June 1978): 2-17.
Relates Cornell's art to that of Gris.

Goossen, E. C. "The Plastic Poetry of Joseph Cornell." *Art International* III, No. 10 (1959-60): 37-40.
Links Cornell's aesthetic goals to those of the French Symbolist poets and the Surrealists.

Griffin, Howard. "Auriga, Andromeda, Cameleopardalis." *Art News* 56, No. 8 (December 1957): 24-7, 63-5.
Discussion of time and how it affects the objects assembled in Cornell's boxes. The essay includes an overview of Cornell's work and extracts from a conversation with the artist.

Hammond, Paul. "Fragments of the Marvelous." *Art and Artists* 8, No. 4 (July 1973): 28-33.
Evaluation of Cornell's boxes and films that describes them as "reveries, attempts to erect a bridge of symbols to link the outside world of the city to the interior world of the artist."

Haroutunian, Helen H. "Joseph Cornell in *View.*" *Arts Magazine* 55, No. 7 (March 1981): 102-08.
Asserts that Cornell's collage for the cover of the January 1943 *View* magazine prefigures his collages to come.

Hennessey, Christine. "Joseph Cornell: A Balletomane." *Archives of American Art Journal* 23, No. 3 (1983): 6-12.
Biographical essay focusing on Cornell's interest in ballet.

Henning, Edward B. "The Language of Art." *The Bulletin of the Cleveland Museum of Art* LI, No. 9 (November 1964): 219-21.
Discussion of the Cornell box *Video,* on the occasion of the museum's acquiring it. "This box," writes Henning, "is the brilliant and lovely offspring of a marriage between reason and intuition, geometry and poetry, which suggests the idea of an absolute order which culminates relativity."

Hoberman, J. "The Strange Films of Joseph Cornell." *American Film* V, No. 4 (January-February 1980): 18-19.
Addresses Cornell's innovative film manipulations, describing him as "the progenitor of American avant-garde film."

Hopps, Walter. "Boxes." *Art International* VIII, No. 2 (20 March 1964): 38-42.
Discussion of the uses of boxes in contemporary art. Of Cornell, Hopps notes: "No other artist, ever, has so totally commanded the form of the box as a metaphor for a realm of both precise and enigmatic existence."

Hughes, Robert. "The Last Symbolist Poet." *Time* 107 (8 March 1976): 66.
Characterizes Cornell as a private and enigmatic artist.

Hussey, Howard. "Joseph Cornell (Towards a Memoir)." *Prose* 9 (Fall 1974): 73-85.
Recounts the writer's friendship and association with Cornell.

Kent, Allegra. "The Secret Sharer." *Art & Antiques* (November 1984): 65-9.
Recollections by the ballerina of her unusual friendship with Cornell.

Kramer, Hilton. "The Enigmatic Collages of Joseph Cornell." *The New York Times* (23 January 1966): 15.
Finds the same appeal in Cornell's collages as in his boxes.

————. "The Poetic Shadow-Box World of Joseph Cornell: Large Exhibition Opens at the Guggenheim." *The New York Times* (6 May 1967): 27.
States that the emotive qualities of Cornell's boxes survive even their incongruous placement in the Guggenheim's Frank Lloyd Wright architecture.

————. "Collage Show Honors Joseph Cornell." *The New York Times* (21 March 1973): 52.
Describes Cornell's work as "a kind of three-dimensional poetry."

———. "Cornell's Innocent World." *The New York Times* (18 March 1975): 35.

> Enthusiastic review of the first of Cornell's posthumous exhibitions.

———. "Collages of Joseph Cornell—The American Surrealist." *The New York Times* (9 March 1980): D27-8.

> Traces the sources of inspiration of Cornell's collages to the French Surrealists, specifically Max Ernst.

Kuh, Katharine. "Joseph Cornell: In Pursuit of Poetry." *Saturday Review* 2, No. 25 (6 September 1975): 37-9.

> Reminiscences on Cornell occasioned by the publication of Dore Ashton's *A Joseph Cornell Album* (cited below).

Leider, Philip. "Cornell: Extravagant Liberties within Circumscribed Aims." *The New York Times* (15 January 1967): 29.

> Favorable review of a Cornell exhibition at the Pasadena Art Museum.

Martin, Richard. "Some Lobsters, Some Elephants: Surrealist Reflections on Joseph Cornell's *A Pantry Ballet (For Jacques Offenbach*)." *Arts Magazine* 60, No. 6 (February 1986): 30-2.

> Discusses imagery in the *Ballet.*

Michelson, Annette. "*Rose Hobart* and *Monsieur Phot:* Early Films from Utopia Parkway." *Artforum* XI, No. 10 (June 1973): 47-57.

> Describes the innovations Cornell brought to film.

Pennington, Estill Curtis (Buck). "Joseph Cornell: Dime Store Connoisseur." *American Art Journal* 23, No. 3 (1983): 13-20.

> Suggests various approaches for placing Cornell in the history of art.

Porter, Fairfield. "Joseph Cornell." *Art and Literature* 8 (Spring 1966): 120-30.

> Analysis of Cornell's art which the artist reportedly appreciated. Porter contends that critics have failed to discuss Cornell in an appropriate manner, and suggests that the literary critic Albert Béguin's preface to a volume of Gérard de Nerval's poetry comes closer to capturing Cornell. "Like all true poets," wrote Béguin, "he invites us to see things in a light in which we do not know them, but which turns out to be almost that one in which we have always hoped one day to see them bathed."

Russell, John. "Worlds of Boxes, Packages and Columns." *The New York Times* (14 March 1976): 29-30.

> Describes an investigation into Cornell's work as "one of the oddest and most rewarding journeys which art has to offer."

Schwartz, Ellen. "Can Innocence Be Recaptured?" *ARTnews* 80, No. 3 (March 1981): 96-9.

> Review of a major exhibition. Schwartz judges Cornell's work uneven and views his art as a manifestation of his obsessive personality.

Smith, Roberta. "Sorting Out Cornell." *Art in America* 69, No. 3 (March 1981): 74-80.

> Enthusiastic review of a career retrospective at the Museum of Modern Art.

"The Compulsive Cabinetmaker." *Time* 88, No. 2 (8 July 1966): 56-7.

> Profile of Cornell that finds him theorizing, "My boxes are life's experiences, esthetically expressed."

Waldman, Diane. "Cornell: The Compass of Boxing." *ARTnews* 64, No. 1 (March 1965): 42-5, 49-50.

> Cites Cornell as an influence on such contemporary artists as Andy Warhol, Robert Morris, and Jasper Johns.

———. "Joseph Cornell, 1903-1972." *ARTnews* 72, No. 2 (February 1973): 56-7.

> Memorial essay calling Cornell's work "deeply personal, ultimately elusive, never divulging the mystery of its existence."

Wernick, Robert. "The World Inside the Magical Boxes of Joseph Cornell." *Smithsonian* 11, No. 10 (January 1981): 45-51.

> Focuses on Cornell's enigmatic personality.

Wright, Martha McWilliams. "A Glimpse at the Universe of Joseph Cornell." *Arts Magazine* 51, No. 2 (October 1976): 118-21.

> Discusses Cornell's beliefs about art and science as they are communicated in his *Circe* suite of collages.

II. Selected Sources of Reproductions

Ashton, Dore, ed. *A Joseph Cornell Album.* New York: Viking Press, 1974.

> Multifaceted homage to Cornell, including essays by Ashton and others, poems, essays by Cornell, "Cornell's Recommended Readings," a photo essay, and 233 illustrations.

McShine, Kynaston, ed. *Joseph Cornell.* New York: The Solomon R. Guggenheim Museum, 1967, 55 p.

> Presents reproductions of Cornell's works and five essays: "Introducing Mr. Cornell," by McShine; "The Transcendental Surrealism of Joseph Cornell," by Dawn Ades; "Joseph Cornell: Mechanic of the Ineffable," by Carter Ratcliff; "The Cinematic Gaze of Joseph Cornell," by P. Adams Sitney; and "Joseph Cornell: a Biography," by Lynda Roscoe Hartigan.

Richebourg, Betsy. *Joseph Cornell: Collages 1931-1972.* New York: Leo Castelli Gallery, 1978, 125 p.

> Includes reproductions of Cornell's collages, with text by Donald Windham and Howard Hussey.

Starr, Sandra Leonard. *Joseph Cornell: Art and Metaphysics.* New York: Castelli, Feigen, Corcoran, 1982, 92 p.

> Contains fifteen color reproductions of Cornell's boxes, with an interpretive essay for each.

Waldman, Diane. *Joseph Cornell.* New York: The Solomon R. Guggenheim Museum, 1967, 55 p.

> Contains black-and-white reproductions from a Cornell exhibition and an essay on Cornell (excerpted above).

———. *Joseph Cornell.* New York: George Braziller, 1977, 127 p.

> Contains one hundred color and black-and-white reproductions and a biographical essay.

Otto Dix

1891-1969

German painter and graphic artist.

Associated at various stages of his career with several artistic movements including Impressionism, Expressionism, Dadaism, and Cubism, Dix is best remembered as one of the leaders of the German *Neue Sachlichkeit* ("New Objectivity"), a movement prominent in the 1920s and noted for its exaggerated realism and commitment to exposing the social pretensions, absurdities, and horrors of postwar Germany. Of the various subjects on which Dix focused during this period, his portraits of noted Germans are particularly praised for their candor and sharp satire. Regarding the violence and debased sexuality prominent in his paintings of war cripples and prostitutes, Sheldon Williams wrote, "Dix was certainly the champion when it came to mirroring vice, corruption and decay. . . . In stepping towards the pit of despair, one might . . . finally come to the brink of the abyss with Otto Dix."

Dix was born to working-class parents in Untermhaus bei Gera, an industrial region in the eastern province of Thuringia. As a student in the public schools, he was recognized for his artistic talent and in 1905 was apprenticed to a painter and decorative artist in the nearby city of Gera. Through this apprenticeship Dix won entrance to the Dresden School of Arts and Crafts, where he studied from 1909 to 1914. While the school's curriculum emphasized decorative and plastic arts, Dix spent much of his free time painting and studying the works of the Italian Renaissance artists as well as the avant-garde French and German Impressionists, Symbolists, and Cubists exhibited at the Dresden Art Gallery. His paintings during this time—mainly landscapes, still lifes, and self-portraits—reveal that he emulated the meticulous detail characteristic of works by Albrecht Dürer while experimenting with a variety of styles.

Dix enlisted in the army at the onset of World War I, serving as a gunner on the German front in France from 1915 to 1918. Critics generally cite this experience as having a profound effect on the subject matter and style of Dix's art. He sketched during the long hours in the trenches, producing portraits of himself in uniform and depictions of the horror of war which he later used as the basis for a series of etchings entitled *Der Krieg* (*The War*).

Upon returning to Dresden in 1919, Dix enrolled in the masters' class of the Dresden Academy of Art, where his work gained immediate support and encouragement from instructors and students. As a member of *Gruppe 1919,* a small coalition of Dresden artists committed to the spirit of the avant-garde, he experimented with the techniques of the Berlin Dadaist movement, producing linear compositions and collages depicting soldiers with prostitutes and veterans disfigured in battle. Some critics suggest that these Dadaist paintings, intended as sociopolitical commentary and harsh satire on the effects of war, are among

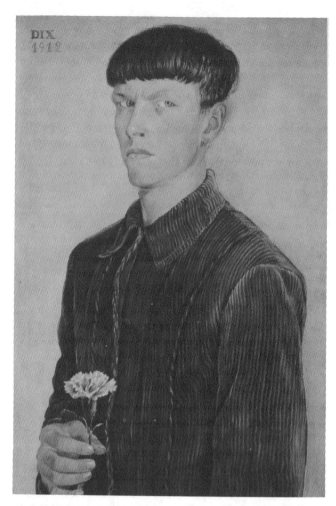

Dix's most effective. By 1920, he enjoyed the recognition and patronage of the citizens and art dealers of Dresden.

The 1920s are generally viewed as Dix's most productive and successful period. Emerging as a central figure in Germany's *Neue Sachlichkeit* movement, Dix engineered a style known as Verism in which realism is exaggerated to the point of garishness, creating a coolly objective and sometimes cynical treatment of the subject. Two of the best known of Dix's works in this style are *The Match Seller I,* in which a limbless war veteran is portrayed propped up against a storefront, in contrast with the people rushing past him on the sidewalk, and *The Artist's Parents I,* a portrait of Dix's mother and father emphasizing their working-class status through large, bony hands, careworn faces, and slumped postures. During this time Dix also confronted issues of violence and sexuality, often concomitantly, as in the controversial piece entitled *Lustmord* (*Sex Murder*). While sociopolitical motivation was characteristic of the *Neue Sachlichkeit* movement, some critics have noted that Dix's depictions of corruption in German society serve to expose rather than to accuse; his political opinions remained ambivalent throughout his career, and

he continued to assert that his paintings were objective portrayals not meant to effect pity in the viewer.

Moving to Düsseldorf in 1922 to study at the Düsseldorf Academy, Dix became affiliated with a group of artists known as the "Young Rhineland" and came under the patronage of Johanna Ey, an art dealer who helped to popularize the works of the Young Rhineland artists and who sat for one of Dix's most famous portraits. In Düsseldorf Dix also met Martha Koch, the owner of a graphics gallery, whom he married in 1923. Containing none of the controversial, satirical qualities present in most of his Verist works, Dix's portraits of his wife and their infant daughter signaled, as Brigid Barton has noted, a change in Dix's aesthetic sensibility. Sexual violence, disfigurement, and war motifs became less integral to Dix's work.

Encouraged by Karl Nierendorf, a prominent art dealer, Dix and his family moved to Berlin in 1925; there Dix had his first major exhibit, consisting mostly of portraits. He returned to Dresden with his family in 1927, accepting a position as an instructor at the Academy of Art. In 1933, however, the Nazi regime denounced Dix's work as "antimilitaristic" and "degenerate," dismissed him from his teaching post, and confiscated about 260 of his works, many of which have been lost as a result.

Forbidden to teach or exhibit his works, Dix remained in Germany, settling in 1936 with his wife and children in Hemmenhofen, a rural area which inspired him to return to the landscape painting he had favored in his youth. In 1945 Dix was drafted into the "home guard" of the German army. Captured months later by the Allies, he was imprisoned in Colmar in northeastern France where he produced his renowned self-portrait as a prisoner of war. Dix returned to Hemmenhofen the following year, whereupon the focus of his art again shifted, incorporating religious themes in oil paintings and lithographs such as *The Great Resurrection of Christ II.* During the 1950s, Dix achieved international recognition, receiving several major awards and commissions. He died in 1969, after suffering a stroke during a vacation in Greece.

SURVEY OF CRITICISM

Gertrude Mander (essay date 1978)

[In the following excerpt, Mander reviews an exhibit of the etchings and drawings of Dix, finding their graphic realism disturbing.]

First to occupy [the exhibition area of renovated Goethe Institute in Berlin is] a selection of etchings and drawings by Otto Dix (plus documents relating to the film *The Cabinet of Dr. Caligari*) to celebrate the opening of the new Institute. Arranged with solemn reverence on the gleaming white walls and the two sides of a white folding screen, lit sharply and efficiently from above, the hundred-odd items from the collection of Martha Dix through Galerie Klihm,

Munich, most of which have already been to the Goethe Institutes of Dublin and Glasgow, are allowed to exert maximum poignancy and power. Particularly the grim and brilliant etchings of the **Kriegsfolge,** the war series, published in 1924 by the enterprising Galerie Nierendorf in Berlin in an edition of 70 of which few survive complete to our day. In Paris, recently, the portraits of Otto Dix created a stir as if they were a new discovery. The etchings, too, assault the contemporary of 1978 with an immediacy that belies their age. Here the obsessive accuracy and correctness of detail, which Dix got from the 16th century German masters, serve both to convey and to contain the passion of suffering experienced in World War I which haunted the volunteer to the Western front for decades after the war was over. He managed to externalise the apocalyptic nightmare with a realistic directness resembling Goya's *Desastres de la Guerra,* without blaming anyone overtly or escaping into caricature in order to distance himself from his pain. The prints based on sketches made in the trenches and sent home as 'letters from the front' were published in 1924 to remind people of the war they were busy forgetting. Yet through this public gesture the personal urgency still makes itself strongly felt. It seems the artist has only just survived what he experienced and recorded. He had gone to the front in the Goya spirit of 'see and live for yourself what you intend to draw'. Yet then it proved almost more than he could stand and communicate by artistic means. Later he explained laconically, 'I am a realist, therefore I volunteered . . .' Yet the experience of the trench and its barbaric reality was truly traumatic. The obsessive detailing of trench scenery in the etchings betrays an almost unbearable emotional pressure: the artist cannot let go, he tries to exorcise the trauma by going over it compulsively, thus reenacting and reliving whatever he is recording again and again. In Goya's drawings massacred bodies form irremovable mountains and bleak still landscapes; the dreadful silence and immobility of the scenes etched by Dix stems 'not from the gruesome setting of the battlefield but from the relentless definition of individual mutilated objects' (Haftmann). Thus, in the hand of the Expressionist-Realist Dix the fine technique of Durer serves a penetrating urge to define, to use objects—or bits of objects, viz. bits of people, animals, landscape—as illustrations for a corresponding inner experience. The compulsion to define often leads to over-sharp forms, so sharp that they seem removed from the natural context, sticking out with cruel autonomy. 'Hardest actuality', 'aggressive ugliness', 'masochism', 'the nakedness of stark reality', these and similar labels became affixed to the Dix whose prints shocked the public and even his Expressionist colleagues by the brutal realism of their images: a moon-lit desolate crater landscape, in Flanders, not on the moon, dismembered soldiers in grotesque body positions, crumbling trenches, ruins, mud and barbed wire breathing an eerie calmness, faceless soldiers plodding through the dark, setting out to attack with shaking limbs, leprous faces with festering wounds, eyes breaking in death, eyes bursting with pain, skeletons dressed in ragged uniforms and helmets, a skull, eyeholes and mouth crawling with maggots, a dead horse piercing the sky with stiff legs like a scream . . . The massacred corpses of Goya are still recognisably human, whole bodies, in Dix the scarred land-

scape is strewn with fragments of bodies mingling with fragments of trees, equipment, earth. This produces even greater anonymity, inhumanity, totality of annihilation. Goya disguised his pain in the bitter sarcasm of his titles. Daumier intellectualised it into allegory and political attack. Dix gives a precise anatomy of despair. Yet occasionally he, too, mollifies the cruel image by twisting it into grotesque or cynicism: a spring flower on the edge of a bomb crater signifies horror, not hope, the horseplay of soldiers in their mess-room stupidity not humanity, and the frequent allusions to Bosch, Altdorter, Durer in line, texture, light and composition can convey the nihilistic mood of parody. Where in the face of senseless slaughter beauty and dignity fail, horror is translated into a stylised ugliness that has its antecedents in certain 16th-century moralistic iconography—the *Totentanz, Frau Welt,* the deadly sins . . . The helmeted skull is Dix's stock image of death in the trenches, or, more objectified even, figures wearing gasmask and helmet, the truly levelling props of this most inhuman of wars. Yet perhaps the most strident expression of the artist's despair in humanity are his whore scenes: fat women with faces split by deathly grins, bottoms and tits indistinguishably disgusting, bodies distorted in the sex act as if caught in rigor mortis. *The Trench* (1923), now lost and probably destroyed, was a canvas similar in size and content to *Guernica,* and has been compared to Hieronymus Bosch's *Temptation of St. Anthony,* the decisive difference being that here the horrible sights and shapes are bits of soldiers, dug-outs, machinery, animals, land instead of hallucinations. Here, 'inner' and 'outer' are in reverse order to that found in Bosch where inner fantasy becomes outer reality. The same applies to these etchings—they also have a hallucinatory quality as if they dealt with a 'visitation on earth'. Yet we know that this really happened, that this is the truth. It has a terrible beauty.

Next to these haunting images of war some of the drawings pale. Though the early ones, particularly the pen-and-ink *Prostitute and War Invalid* (nicknamed *Two Victims of Capitalism*) spell out the same bitter message. Here we encounter the Dix who is often paired with George Grosz, having passed through the energising school of post-war Dada in Berlin. Yet we also meet the private artist who deftly sketched nude models and made bold preparatory studies for portraits, also of himself, the most poignant of which is the death-head drawing of 1968, a year before his death. Dix, the realist among the Expressionists, as he is labelled in the text-books, could not have been an Englishman, said Norbert Lynton in his opening speech, singling out the engagé, the aggressive, the tough quality of his work. And yet the same qualities, considered typically German, grate on many of Dix's fellow-countrymen, too. So much for national characteristics and national images. Similarly, as for adherences to schools or movements: Dix was disowned by the Expressionists for sacrificing his personal idiom to a vain pursuit of the truth, while he considered his war pictures truly expressive, favouring a realism which embodied the passion of felt experience. His obsessive realism, his 'verismo', always steered clear of the danger besetting the painter representing 'things as they really are'—romantic illustrationism. In later life, Dix came to draw landscapes as idyllic and calmly picturesque as

Durer's by using the same fine lines and horizontal pile-up compositions as his master, and allowed his eyes precedence over his feelings at last. There are some beautiful examples of these drawings in the exhibition. Ironically, they all bear dates from the 30's and 40's, the years of Dix's 'inner emigration' (he was one of the Nazis prize 'degenerate' artists). After the devastating trauma of World War I, was he perhaps emotionally incapable of experiencing fully another, even more harrowing nightmare? (pp. 36-7)

Gertrud Mander, in a review of "Kriegsfolge," in Art & Artists, *Vol. 13, No. 8, December, 1978, pp. 36-8.*

Dix on his art:

I have never made written confessions, since, as you will see if you inspect them, my pictures are confessions of the most candid sort such as you will rarely find in this age. Also, I am altogether unwilling to discuss aesthetics and philosophy, nor am I qualified to, and all else would be vain subjective chatter. Nor am I willing to reveal to the astonished gaze of our citizens and contemporaries the 'depths' or even 'shallownesses' of my soul. He who has eyes to see, let him see!

From Otto Dix: Life and Work, *by Fritz Löffler, 1982.*

Art International (essay date 1979)

[*In the following excerpt, the reviewer characterizes Dix's paintings as cynical and despairing.*]

The crisis of confidence immediately following World War I produced in Germany an art of particular directness and horror. The war to end wars produced senseless heroics and wholesale slaughter, and culminated in the destruction of Germany, of the Germans' sense of themselves and of their hopes for the future. Everywhere the prevailing atmosphere was one of despair, futility and cynicism, and nowhere was it more manifest than in the art of Otto Dix. . . . (p. 30)

Dix's work as a youth was characterized by an attempt to apply the lessons of Cubism over the flatter, freer, German Expressionist idiom of the time. But he returned from the war, in which he had served as a front line soldier, seared by the experience, and his work underwent a dramatic change. Ersatz Cubism broke down into a flat patchwork structure that moved increasingly up to the picture plane, and his palette became ever more somber. The blues, greens and reds of a 1916 self-portrait became ochre, maroon and brown in the later work. Most importantly, he began directing his energy toward externalizing and exaggerating everything that was common, unattractive and sinister about his subjects. His women are fat, deformed, grotesque. A funeral procession is amusing. His *Portrait of Dr. F,* 1923, which could have portrayed an educated aristocrat becomes instead an embodiment of everything sinister.

Dix's style became flatter and simpler, reduced to broad, amorphous washes of color reinforced in places with a loose outline. In his subjects, what was normal was probed for its ugliness and whatever was naturally ugly and unpleasant became his ideal subject. His new style was perfect for communicating in a direct, unornamented way the ugliness in everything he saw. *Rape 2,* depicts a dumpy, naked woman, her genitals savaged and a man standing over her obscuring her face. It is a portrait of depravity. To Dix this is the depth of moral squalor, the lowest to which humanity can sink. One gets the feeling that it does not surprise him much.

For the most part Dix's art was self-reflexive—it expressed the tenor of the times through what it said about him. But at least one work here is something of a portrait of the sense of exhaustion and futility of the postwar years. In *2 Browns,* executed in a style closer to that of Grosz in its emphasis on line, two figures appear as if in a parade. The man wears a guarded expression while the woman's is one of emptiness. Between them walks a figure holding aloft a fistful of flags, presumably celebrating the Armistice. He is both crown and death's head, the embodiment of the senseless evil in man that makes war—and rape—possible. For Otto Dix, this was the sum and substance of the world. (pp. 30-1)

"Otto Dix," in Art International, *Vol. XXII, No. 9, February, 1979, pp. 30-1.*

Linda Nochlin　(essay date 1981)

[*In the following excerpt, Nochlin discusses anger and violence as the predominant qualities in Dix's paintings.*]

In the paintings of Otto Dix, whose work is perhaps most strongly identified with the *Neue Sachlichkeit,* the imperfections of the flesh are envisioned not as tokens of passionate intimacy, but rather as emblems of an all-pervasive social malaise. With the distorted bodies of women, Dix creates a fierce metaphor of Weimar venality. He endows his women with the faults of the society that exploits and dehumanizes them, identifying—symbolically, one supposes—whores and bloodsuckers with the ills of the social order. For Dix, imperfect flesh is not a unique shrine, a locus of tenderness, as in Spencer, but an icon of social decay.

The whore as metaphor for corrupt society is not, of course, Dix's own invention, nor does it end with him. Having served effectively from Zola's *Nana* down to Godard's *Sauve qui peut,* it is an eminently satisfying trope in patriarchal culture because it does double service. It allows male artists to articulate their hatred of woman's sexual being (and their degrading need for her) under the justifying cloak of social criticism. The hate-filled distortion of female bodies, the terrifying grotesquerie of the images of women in the works of Grosz, Dix and others, is presumably sanctioned by a larger social rage.

A work like Dix's *Three Prostitutes* of 1926 . . . is intended as "social commentary" rather than merely an expression of the artist's personal loathing of women. As is often the case in Dix's icons of misogyny, classical precedent

adds a touch of parodic piquancy. Surely these three repulsive creatures are meant as the Three Anti-Graces, each distinguished by a particular violation of classical norms of beauty: richness of flesh in the obese figure to the right; adolescent ethereality in the standing figure; piquant curvaciousness in the crouching figure playing with the dog in the foreground.

It must be admitted that, for those of us today for whom feminism constitutes a central political position, it is hard to swallow this unremitting hostility towards women rationalized as valid social criticism from the Left. Certainly there were other options open to Leftist artists; Kaethe Kollwitz, for example, managed to be socially critical with a radically different kind of feminine imagery.

By the early '30s, Dix's imagery of the naked female became less overtly satirical, more subtle and haunting. His *Venus with Black Gloves* of 1932 is not only childlike in the nubile Balthusian mode; particularly German in its kinky asceticism, it is also reminiscent of fin de siècle vampires. Even more like Balthus's sinuous and disturbing adolescents, the brilliant *Young Blond Nude* of 1931 is more rigid, homely, individuated and Northern than any of Balthus's figures. With her iridescent drapery, gold-wire hair and dimpled, flexible fingers, she is the kind of nude Grünewald might have painted.

Indeed, Dix gets closer and closer to Grünewald, the supreme painter of Hell, as the Hitler years proceed. By 1939, in the large-scale *Lot and his Daughters,* a version of the Isenheim Magdalene plies her father with wine as the city of Dresden burns, prophetically, in the background. To the right, beneath a Grünewaldian tree, a sensual, doll-faced Eve displays her nude body for the old man's delectation. To flesh out this political allegory of Hitler's Germany, Dix resorts to the traditional topos of incest, that ultimate violation of civilized norms, of the sexual taboos that mark the boundaries of the social order. Paradoxically, the female figures here are far less distorted than those in his paintings from the Weimar period. Perhaps Dix's satirical powers were fading; but it may well have been that no pictorial distortion seemed horrific enough to convey a sense of what was happening in Germany at the time. (pp. 80-2)

In his prime, Dix was not much kinder to the subjects of his portraits than to his nude models. His portraits are usually vicious yet penetrating caricatures, savage exaggerations of the Holbein *portrait à l'apparat* in which the sitter seems to be infected by his own psychology, his social position or his profession, as though by some fatal disease. Barely concealed rage blurs the borders between Expressionism and *Neue Sachlichkeit* in the epicene curves and painterly red, green and violet mask of Dix's *Portrait of Karl Krall* of 1923. His portrait of his parents of a year later is far more sympathetic, both a contemporary image of a working-class couple with authentically red-rimmed eyes and gnarled hands, and a return to the German tradition of graphic incisiveness instituted by Dürer and continued by Leibl. In the *Portrait of Johanna Ey* the enormous and legendary art dealer, known as Mütter Ey (Mother Egg) and responsible for bringing Dix to Düsseldorf from Dresden in 1922, is portrayed as a monster—a

benign monster, but a monster nevertheless, bulging massively out of her purple dress against a blazing red background. It is as though sophisticated Weimar society simultaneously repressed yet encouraged the beast beneath the skin. In Dix's pencil study for his *Portrait of the Photographer Hugo Erfurth,* himself known for his incisive portraits, the beast is literally present as a German shepherd, his savage muzzle and lolling tongue belying the civilized reticence of his anxious, bespectacled master. (pp. 82-3)

> Linda Nochlin, *"Return to Order,"* in Art in America, *Vol. 69, No. 7, September, 1981, pp. 74-83, 209, 211.*

Brigid S. Barton (essay date 1981)

[*In the following excerpt, Barton presents an overview of the major themes in Dix's paintings during the* Neue Sachlichkeit *period (1918-1925).*]

Otto Dix considered those on the fringes of respectable society to be of great importance to his life and art, and his work between 1918 and 1922 is replete with portrayals of sailors as adventurers and revolutionaries, circus performers, and prostitutes. During these years he completed at least 22 paintings, 90 watercolors, several hundred drawings, and 30 graphic works on such subjects. In dealing with these people Dix vacillated in mood from sympathy to anger, from humor to outrage, depending upon the social intent of his work. The first group to be developed from among these societal remnants was that of sailors, and Dix used the opportunity to display a bawdiness and gaiety lacking in much of his other work.

The known works by Dix on the subject of sailors include three paintings, *Matrose Fritz Müller aus Pieschen* of 1919, *Abschied von Hamburg* of 1921, and *Matrosen Liebste* of the same year. In addition, there are approximately 13 watercolors, several drawings, and 7 graphic works recorded on this subject. These works are intimately related to several of the circus subjects and to some of the works on war, but they differ from these in their uniformly humorous and sympathetic approach to the characters. The sailors are always presented in some context with women, either in a collage arrangement surrounded by vignettes of sexual exploits and exotic locales (as seen in *Fritz Müller, Abschied von Hamburg,* and the watercolor *John Penn* of 1922), or in a more direct relationship (as seen in the watercolor *Matrose und Mädchen mit Zigarette* of 1923, the etching *Matrose und Mädchen* of 1920, and the watercolor *Matrose mit Negerin* of 1922).

The sailor subjects appear early in Dix's postwar work and mark an important transition in his approach to both style and theme during these critical years. The early sailor painting, *Fritz Müller,* is done with collage elements and a linear style which relate directly to the influence of Berlin Dada in Dix's work. The swirling, wave-like character of the space surrounding the central figure of Fritz also harks back to Dix's pre-realist style in its similarity to such works as his *Schwangeres Weib* and *Leda* of 1919. Even the mood is in keeping with Dix's eclectic 'Dresden style' of 1918-1919 in that the emphasis is upon the visionary and ecstatic, rather than upon the description of actual facts. Fritz Müller, with eyes dilated as if in a trance, floats in an ambiguous space filled with his recollections of the nautical life. The four corners of the world are described in humorous, cartoon-like vignettes of the American west, Egypt, Africa, and the Far East, while representations of women frame Müller above and below.

The later *Abschied von Hamburg* of 1921 differs from the 1919 painting in both style and mood. Once again a sailor is surrounded by recollections of his life, but these recollections are now illustrated in an exact, concrete style and the nature of the recollections is, if anything, mundane. This sailor recalls ships, lighthouses, marine life, and the inevitable woman, all of which are represented in well-defined spatial contexts with consistent diminution and exact rendering of detail.

This comparison of the 1919 and 1921 paintings demonstrates a shift in Dix's work during these years from an earlier Dada-influenced style to a more realistic emphasis, and this shift parallels that which has already been noted in the portraiture of these years. However, all of Dix's sailor subjects retain a sense of sympathy and humor which is missing in much of his work as a whole after 1921. For Dix, the sailor is seen as one who acts out desires which the rest of humanity often represses. He symbolizes a freedom both in his ability to travel and in his sexual exploits which contrasts vividly with the inhibited world of the typical bourgeois citizen, and particularly in his relations with women is presented as earthy, full of life, and unrestrained in his physical enjoyment. This freedom represented by the sailor includes his freedom from restraint in the political areas as well. Dix presented the sailor as revolutionary in several works of this period, notably his *Die Barrikade* of 1920 in which a sailor fights on the barricades against soldiers representing the Social Democratic government of Friedrich Ebert. This image of the sailor is directly related to the recent mutiny of German sailors at Kiel in the last months of the First World War.

The watercolor *John Penn* of 1922 and the *Matrose und Mädchen mit Zigarette* both exemplify this approach in Dix's work. John Penn appears in the foreground with his thoughts visualized behind him, a technique utilized in the 1890s in a number of works by Edvard Munch. A ship on the sea is pitted against the apparition of three nude women who represent different areas of the world, as was also suggested by the vignettes in the corners of the painting *Fritz Müller aus Pieschen.* While travel and sexual adventures are intertwined in the John Penn work, sexual adventures alone become the focus of the *Matrose und Mädchen mit Zigarette* of 1923. A sailor exposing a hairy chest licks his lips while fondling a woman covered with tattoos, both characters exuding a sense of lusty enjoyment. (pp. 36-7)

A second important area for Dix in his investigation of bohemian types was the world of the circus, and between 1918 and 1925 he completed one painting, 13 watercolors, approximately 5 drawings, and a graphic series of 10 etchings on the subject. The painting *Suleika, das Tätowierte Wunder* illustrates the close affiliation between the *Matrosen* and *Artisten* works by Dix in these years. Suleika

is a 'kitsch' figure similar to Fritz Müller and one who could easily have come from his milieu. She is covered with tattoos, some of which have nautical references, and the overall mood of the painting is similar to that of the *Matrosen* works in its delightful humor. In the graphic portfolio of 1922 entitled *Zirkus* there are two etchings which further link the *Matrosen* and *Artisten* themes. The *Maud Arizona* is subtitled *Suleika, das Tätowierte Wunder* and resembles the 1920 painting closely in pose and figure type. It is even done in reverse, suggesting that the painting and etching were taken from the same drawing and carried out in different media. Another etching from this series, *Technisches Personal,* depicts tattooed characters with sailor hats who bridge the worlds of the sailor life and the circus.

But while a number of the *Artisten* works retain the mood and characters of the *Matrosen* series, others display a very different approach which is most apparent in the *Zirkus* etchings. An ominous and morbid mood permeates the first etching of the portfolio, *Die Verächter des Todes.* This circus couple grimaces at the viewer, prominently displaying skulls which have been tattooed onto their chests. Their faces have taken on a cadaverous quality similar to that seen in the works of Edvard Munch, and although there is a suggestion in the title of the flamboyance characteristic of some of the *Matrosen* works, the mood of the piece is definitely macabre. Another etching, one entitled *Sketsch,* depicts a dwarf in the act of shooting a larger figure who seems to be defying both death and gravity simultaneously. Here too an air of fantasy and flamboyance associated with Dix's treatment of sailor scenes is accompanied by a more morbid preoccupation with death. Yet another etching, the *Dompteuse* depicting a woman armed with whip and gun, recalls in figure type and mood many of Dix's women from the world of prostitution, particularly the *Kupplerin* of 1923. The woman here is at one and the same time affiliated with sexuality and sadism, and as such embodies the more complex and sophisticated thematic approach to women characteristic of Dix's work after 1921.

The style of the *Artisten* works also reflects Dix's increasing sophistication. The painting *Suleika, das Tätowierte Wunder* of 1920 and several of the etchings from the 1922 *Zirkus* series display elements of Dix's linear style of 1919-1920. But the *Verächter des Todes, Artisten, Lili, die Königin der Luft,* and *Dompteuse* from the same series are done in a much more realistic mode. Dix probably completed the etching series over a period of two years, between 1920 and 1922, the former etchings being done earlier than the latter. (pp. 39-40)

Probably the most important theme which Dix developed, and one which preoccupied him more than any other among his works in these years, is that of prostitutes. Between 1918 and 1925 the artist completed approximately 13 paintings, 60 watercolors, almost 200 drawings and 15 graphic works on the subject. He had already exhibited an interest in sexual themes in such immediate postwar works as the woodcuts *Der Kuss* and *Der Morgen* of 1919, but the first major work which clearly deals with prostitutes is the 1920 painting *Altar für Cavaliere.* Between

1920 and 1923 Dix executed the vast majority of his works on this theme, while between 1924 and 1925 he began to turn away from the subject in favor of portraiture and other more sexually neutral subject matter.

Dix's approach to prostitutes in his art is a very complex one, one in which a number of often contradictory attitudes are apparent. Certainly one attitude expressed in such works as *Venus des kapitalistischen Zeitalters* of 1923 or *Der Salon* of 1922 is a sociopolitical one in which scenes of prostitution are meant to symbolize the more general horrors of a diseased and decadent society. Dix also often combines these symbols of ugliness with the theme of *vanitas* and contrasts self-delusion with grotesque physical realities. The etching *Am Spiegel* of 1922 is the most outstanding example of this kind of combination in Dix's work. An aging prostitute adjusts her hair before a mirror and smiles at herself, while the viewer is presented with a hideous depiction of bone and hair where parts of her brief costume give way to reveal her body underneath. But although Dix uses the prostitute in these works as a means of exposing what he saw as the ugliness and decay within his own culture, in other works he presents prostitutes in a much more sympathetic light. It is particularly in his drawings that Dix seems to identify the prostitute with sincerity as one who presents herself to the world with a naturalness and lack of deceit typical of the 'normal' world. Such drawings as *Die Schöne Mally* and *Die Süsse Kleine Elly* of 1920 exhibit a warmth and sympathy which is totally lacking in his major paintings on the subject. Frau Martha Dix has stated that her husband always liked his prostitute models in the Dresden years and often felt more at ease with them than he did with more 'respectable' members of society.

The mood of some of these early drawings of prostitutes is similar in its *joie de vivre* to the sailor works of the same period. Dix's *Matrose und Mädchen mit Zigarette* with its outspoken carnality and good humor is close in atmosphere to the drawing of Gretel and the *Alma I* of 1921. It seems clear that the more formal oil paintings generally dealt with the prostitute as a symbol for what Dix thought to be the worst aspects of his society, while the more intimate drawings done from the model constituted a much warmer, more sympathetic, and a more individualized interpretation of such women.

The major paintings on the subject of prostitution are the *Altar für Cavaliere* of 1920, *Der Salon, Zuhälter mit Nutten,* and *Gräfin Else* of 1922, *Venus des kapitalistischen Zeitalters* of 1923, and *Drei Dirnen auf der Strasse* of 1925. Stylistically and thematically these paintings illustrate the shift from Dix's Dada mode of 1919-1920 to his Verism of the twenties. The *Altar für Cavaliere* is a particularly good example of Dix's transformation of Berlin Dada into his personal style in its macabre humor and use of collage. The painting presents a street scene with a man and woman walking past a building, but a closer look reveals flaps which open at strategic points to reveal a new order of reality. The female pedestrian is transformed into a hideous skeleton with emphasized genitals and a bald head, while the male pedestrian exposes a head full of nationalist headlines and a photograph of the Kaiser. Even

the building takes on a new reality. The shutters of the ground-floor window open to reveal a room full of prostitutes waiting for customers. The entire piece represents a literal interpretation of Dix's developing definition of realism, whereby the artist tears away the social façade in order to expose the inner ugliness of the world. But his exposé of the seemingly mundane is done in a highly humorous manner, with the spectator playing the part of a 'peeping Tom' by opening shutters and flaps to get a good look at the hidden truth. The reference to religious altars in the title and the accompanying play on *Flügel* or wings only adds to the ribald quality of the piece.

The later paintings involving prostitutes, particularly the *Salon* and *Venus des kapitalistischen Zeitalters,* illustrate Dix's rejection of Dada in favor of an unyielding representation of hard facts. In both of these works the illusion of sexual allure often associated with prostitution is pitted against the harsh realities of aging, physical ugliness, and, in the case of *Der Salon,* boredom. The four prostitutes in their brothel gather around a garish table and wait for customers. Three of the four women are young, but the fourth is a withered old hag whose wasted body appears beneath a semi-transparent slip. The prostitute in the extreme foreground is taken from the 1921 drawing of the model Gretel and provides an excellent example of the kind of transformation which often occurs when Dix develops a drawing into a larger painting.

Gretel appeals to the viewer as a sympathetic, albeit somewhat ludicrous figure in the drawing. She squeezes her breast as if to call attention to her sexuality, but the gesture is almost playful and the overall mood is warm. In the painting, however, Gretel has been altered to fit into the more symbolic and morbid context of the bordello. The face has become hardened and garish with makeup, the hair has been worked into iron-textured curls, and the folds in the skin have been exaggerated to accentuate the figure's obesity. The facial expression of the drawing has been transformed into a grimace, one which leaves the viewer with a sense of horror at the sociological type confronting him.

In the *Venus des kapitalistischen Zeitalters* Dix again couples the themes of prostitution and aging. Venus is here presented as a painted hag, dressed up in hat, earrings, and stockings. She peers out at the viewer with glazed eyes and a hideous grin, displaying her body as if she were trying to convince a customer of her superior beauty. The 1925 *Drei Dirnen auf der Strasse* is yet another variation on the theme of spiritual corruption and physical decay with its three preening women displaying themselves like merchandise before a shop window. Each prostitute carries an attribute, one a small dog, another a purse, and yet a third an umbrella which becomes a phallic symbol. Behind them in the shop window a lady's leg and shoe touch upon a globe of the world, as if to indicate the power of women over man in society. But in this context it is a power brought about by her ability to sell herself as a physical object, rather than by powers of intellect or charm.

Dix's juxtaposition of women as merchandise against a shop window is intended to be a commentary upon contemporary society as one in which people become saleable objects similar to dry goods in department stores. (pp. 41-4)

Dix had actually utilized the juxtaposition of shop merchandise against human merchandise as early as 1920 in his *Prager Strasse* and *Altar für Cavaliere.* The *Prager Strasse,* with its presentation of war cripples silhouetted against shop windows filled with artificial limbs and wigs, stresses the theme of the callousness of the German public in the face of the plight of the maimed, as will be discussed in a later section. The *Altar für Cavaliere,* on the other hand, is closer to the *Drei Dirnen auf der Strasse* in its display of prostitutes awaiting customers from a ground-floor apartment open to the street.

Dix's use of color and glazing techniques reaches a peak in the *Drei Dirnen auf der Strasse.* He utilizes a bright, shocking series of color combinations which give the surface of the painting a garish brilliance of its own. The artist is using an oil and tempera technique here, one in which he has applied thin oil tones onto a chalk-and-tempera ground and then completed the painting with a tempera surface. In this way the color is intensified through the layering of glazes, while the surface retains a slickness which adds to the 'kitsch' contemporary mood of the work as a whole.

The *Drei Dirnen* is also a good example of Dix's developing sophistication in his treatment of the object. By 1925 he had completely dropped the linear style of Dada in favor of a mode based upon a careful delineation of volumes in realistic terms. Each object in the painting takes on an extreme tangibility by means of harsh color and value contrasts. By defining reality in such unrelenting terms, Dix intensifies the underlying social realism of the scene and adds to the strength of the work. (p. 45)

Dix also dealt with the theme of prostitution in the context of urban corruption, as in the *Drei Dirnen auf der Strasse* where he pits the glitter of urban merchandise in shop windows against the human merchandise displayed on the street. But in general Dix preferred to analyze the prostitute in a more directly sexual environment, either by placing her in a brothel or by singling her out for individual study as the epitome of ugliness and societal decay. This gives to such works as *Gräfin Else* and *Venus des kapitalistischen Zeitalters* an unrelenting forcefulness, a shocking directness that can hardly be passed off as a vignette of city life. These figures become instead symbols for the state of society as a whole in its diseased condition. (p. 46)

The theme of the societal fringe was central to Dix's work in the years after the First World War, but another theme of importance at this time involved the investigation of sexuality with violence and death. It has already been demonstrated that in dealing with prostitution Dix would often couple sexuality with violence and death, and this is apparent even in his earliest work on the subject. The woodcut *Der Morgen* of 1919 involves a man in the act of assaulting a woman and the drawing *Vohse und Louis* of 1921 depicts a grim interchange between a pimp and his prostitute, complete with blood and liquor.

Although much of Dix's work as a whole in these years deals with themes of violence, sex, and death, Dix did complete several series of works on specific subjects in which sexuality, violence, and death are interrelated in a novel way. These are the subjects of **Lustmord** (sex murder) in which a man kills a woman for reasons involving sex, and the **Mädchen und Tod** (maiden and death) in which the traditional *vanitas* theme is given a more contemporary rendering. Works dealing with these subjects and other more general treatments of violence, sex, and death constitute at least 9 paintings, approximately 27 drawings, and 16 watercolors from Dix's total output during the years 1918 to 1925.

The *Lustmord* theme is one which the artist developed first in 1920 with a painting depicting himself hacking a woman to pieces in a bedroom. The work, entitled **Lustmord** or **Der Lustmörder,** displays in a more extreme manner the black humor typical of Dix's art at this time. Paintings such as the **Altar für Cavaliere** or **Der Fleischerladen** demonstrate a similar mix of the macabre and the outrageous, but in this particular painting Dix has exaggerated the mood to the point where the scene becomes almost unbearable in its gross brutality. The artist himself stands triumphant before the viewer brandishing a knife and laughing, while dismembered female parts literally fly around the room. A similar intensification of the macabre characterizes the 1922 watercolor on the same subject, a work dedicated to Dix's wife Martha on her birthday! In this rendition of the subject, the female figure is seen alone after the violent act has been completed. She has tumbled from the bed and is now stretched out on the floor in a tangle of bloody sheets and mangled limbs. In addition to these two works on the theme, Dix completed another painting entitled **Lustmord** in 1922, studies for the 1920 painting, two etchings and two watercolors on the subject, and a pen and ink study for the 1922 painting. (pp. 46-7)

Another subject dealing with sexuality and death developed by Dix in this period is that of *Mädchen und Tod,* the maiden confronted by death. It is related to the traditional theme of *vanitas* rooted in the art of the Middle Ages and embodied in masterpieces by early Netherlandish painter Hieronymous Bosch and the German painter Hans Baldung Grien. Dix deals with both the specific subject of death as a skeleton enfolding a young girl and the more general subject of the passing away of youth and beauty. As early as 1918 he completed several studies of women being seized by death, and his interest in the subject continued throughout most of his life. In the years from 1918 to 1925 the artist completed four paintings, approximately 14 drawings, and four watercolors on either the *Mädchen und Tod* or *vanitas* themes.

In his major paintings on the subject of sexuality and death in relation to the *vanitas* theme Dix pits amorous couples against chilling portrayals of physical decay. The **Altes Liebespaar** of 1923 presents a woman whose face is still young but whose body is shriveled with age in embrace with an old man, thus compounding the confrontation between youth and age, sex and death. The face of this woman bears resemblances to works by the earlier Northern Renaissance master Lucas Cranach the Elder such as

his *Judgment of Paris* of 1530 in the Staatliche Kunsthalle in Karlsruhe with its high forehead and thin nose and lips. This could be an attempt on Dix's part to emphasize the affiliation between his works and those of the earlier masters who he revered in not only his choice of the traditional *vanitas* theme, but also in his style.

The couple is placed in the extreme foreground of a dark room, with a well-worn broom and a large ladder juxtaposed behind them in a corner. The German word for easel, *Staffel,* is the same as the word for ladder, which suggests that Dix could have been playing with the interrelationship between art, which gives to the individual portrayed a degree of immortality which he would not otherwise have, and life itself in its transitoriness. This interpretation of the **Altes Liebespaar** is reinforced by the fact that a work done one year later, the **Stilleben im Atelier** of 1924, contains an actual easel which as been placed in front of a young model posed beside a grotesque stuffed mannequin riddled with holes, as if to frame them. The reference to art which captures the transitory in contrast to the figures who are related to death and decay is unmistakable.

In this later work, the female figure takes on the same pose as the inanimate mannequin, so that the juxtaposition between youth and decay is made all the more forcefully. Both the mannequin and the easel are reminiscent of works by the Italian painter of *Pittura Metafisica,* Giorgio de Chirico, but the context in which they are placed is pure 'Dix.'

Yet another painting on this theme is the **Ungleiches Liebespaar** of 1925, presently in the *Städtische Galerie* in Stuttgart. In this work, the *vanitas* theme is portrayed in a more traditional manner by placing a young Nordic beauty on the lap of a decrepit male figure who embraces her with fumbling, thickly veined hands. An important precedent for this work in nineteenth century art is Wilhelm Leibl's *Das Ungleiche Paar* of 1876-77 in Frankfurt-am-Main. But while Leibl is concerned with the pairing of an old man and a young girl in the context of village life in a specific setting without larger symbolic overtones, Dix is more interested in making both a statement about his own time and a broader comment about the nature of humanity. He relates the work to a specific historical period by including a view of belching smokestacks against a red sky from a window beside the pair, thus implying a relationship between the grotesque mating of this twosome and contemporary city life. But he is also interested in relating the work to more traditional renderings of the *Mädchen und Tod* theme by emphasizing the sexual nature of the encounter between a nude female and death. Dix continued to develop this theme in his later work in such paintings as **Vanitas** of 1932 and **Triumph des Todes** of 1934-35, but he never again reached the degree of morbidity prevalent in these earlier works.

Dix's fascination with death in general is characterized in this period by a feeling for the contrast between spirit and flesh, the everlasting and the temporal. The graphic series **Tod und Auferstehung** of 1922 illustrates this tendency in Dix's work as a whole between 1918 and 1925. Each of the etchings deals with the contrast between death and life; a

woman subjected to a murder for lust lies next to a pair of copulating dogs, a pregnant woman stands in mourning above the body of her dead husband, a soldier decays in a field filled with flowers. Each etching provides another vignette in the relationship between individual destruction and ongoing life, and Dix develops this relationship in a particularly forceful manner by combining such macabre subject matter with horrifying realistic details.

Nowhere is Dix's fascination with death and dying more apparent than in his depictions of war and revolution, and it is also in these works that the artist achieves his most searing portrayals of despair and destruction. The source for Dix's interest in such themes is due in large part to his experiences in World War I. He went into the army as a volunteer in 1914 and participated in the German advance through Belgium to France, where he fought in the Battle of the Somme. During the retreat he was seriously wounded. After a period spent in a hospital he was sent to the eastern front in Russia, and then early in 1918 he began training as a *Beobachter* for the *Luftwaffe*.

When he was finally released from service and returned to Dresden, he brought with him hundreds of drawings depicting his experiences as a soldier, drawings which were preparatory to major paintings on war completed in the twenties and early thirties. Specific areas of interest for Dix in the early Weimar years were war cripples, revolutionaries, and soldiers at war. The number of works dealing with all three subjects during the period from 1918 until 1925 is large in proportion to his other work: it includes six paintings, well over a hundred drawings (in addition to those done during the war), approximately 20 watercolors, and a major graphic series entitled *Der Krieg.*

Dix completed four paintings of war cripples in 1920, *Prager Strasse, Die Skatspieler, Der Streichholzhändler I,* and *Die Kriegskrüppel.* In 1921 he painted the *Alter Mann* or *Blinder Bettler,* and in 1922 the *Porträt eines Blinden Bettlers.* In addition to these six paintings, Dix did four drawings on the subject between 1919 and 1920 and five graphic works between 1920 and 1923.

The 1920 paintings are by far the most important works on this subject, and each portrays in dramatic terms Dix's manipulation of the theme for purposes of social criticism. *Prager Strasse* and *Der Streichholzhändler I* present the viewer with a contrast between the plight of the war cripple and the callousness of the public, while *Die Skatspieler* and *Die Kriegskrüppel* are concerned in more general terms with the grotesqueness of war and its effects. Already at the beginning of the war members of the German government realized that the traditional *Rentenbührnisse* for those wounded during the war would not be sufficient to cover the numbers of soldiers wounded in the First World War, and in September of 1915 a new bureau was created to deal with the problem of pensions for these people, as well as for widows and children of war casualties. In the period immediately after the war, however, chaos in government coupled with severe economic handicaps brought on by inflation rendered the pension program largely ineffective, and it began to respond successfully to the plight of the pensioners only in 1924 when a number of reforms in the organization of the bureau were made.

The Prager Strasse was the major city street in old Dresden, lined with expensive boutiques and exclusive restaurants. In Dix's painting of the same name two paraplegics are silhouetted against a window display for artificial limbs, while pedestrians and dogs pass back and forth. Small touches add an additional sense of irony to the scene: a nearby window displays wigs for ladies as a parallel to the display of plastic limbs, several dogs sniff the cripples with curiosity and show a greater interest in them than any of the passersby, while in the midst of this spectacle of inhumanity an anti-Jewish flyer is stamped underfoot. The collage elements are used to exaggerate these juxtapositions and in this respect the *Prager Strasse* is close in treatment to the *Altar für Cavaliere* of the same year. Shop-window wigs of artificial hair, real ribbons, and bits of newspaper all call attention to the satirical nature of the work and underline the relationship between art and reality in terms of the socially critical theme. The *Streichholzhändler I* is characterized by the same stylistic format and mood. The cripple is seated in the center of the canvas while pedestrians move away from him on left and right. The viewpoint is again from above, so that the cripple is the only full figure that can be seen. The other figures are cut off at the waist, as if to emphasize the very parts which the maimed man below them is missing. This time a dog relieves himself on the matchseller in a gesture of indifference, while the passersby equal that indifference in their own fashion by moving away from the cripple in all directions.

The other two paintings done in 1920 emphasize the grotesque qualities of war's aftereffects rather than the callousness of civilian society. Both *Die Skatspieler* and *Die Kriegskrüppel* display almost ludicrous examples of maimed humanity engaged in activities that only emphasize their handicaps. The card players work at their game holding cards in mouths or with toes, while the parading war veterans in *Die Kriegskrüppel* attempt to perambulate against almost insurmountable physical odds. The later paintings of 1921 and 1922 lack the outrageous sense of exaggeration and satire of these works, but deal instead with the subject of the blind in confrontation with an unfeeling public. (pp. 49-52)

Another subject from Dix's early work which relates directly to larger events in German society immediately after the war is that of revolution on the barricades. At a time when leftist groups in cities as major as Berlin, Dresden, and Munich rose up against their local governments and engaged in street warfare, the subject became one with a widespread and immediate topical appeal. Dix completed only two works on this subject between 1918 and 1925, a painting called *Die Barrikade* in 1920 and an etching with the same title in 1922, although the later *Strassenkampf* of 1927 is related to these earlier works in theme.

The painting *Die Barrikade* is another of Dix's intensely felt pronouncements indicting his own time. The fight takes place on the Marschallstrasse in Dresden, where three men crouch behind a barricade made up of old furniture, a broken crucifix, a classical bust, and other paraphernalia symbolic of the "burgerliche Welt." Several

dead bodies are heaped up over the debris, and in the far right-hand corner of the painting there is a cart containing a pair of women's underpants and a reproduction of Titian's *Tribute Money,* part of the collection of the Dresden Zwinger galleries. The world of the living and dead is pitted against symbols of religion, the fine arts, betrayal, and sexuality. (pp. 53-4)

The three men engaged in the fight in the Dix painting are representative of three types often encountered in his work of these years—the sailor, the worker, and the old man. Here the sailor is presented as a revolutionary, which was historically accurate in that sailors had participated in both the 1905 rebellion in Russia and the more recent rebellion involving the German fleet in 1918. Each of these three figures is totally engrossed in the act of fighting the enemy, but on a more symbolic level each is a participant in the attempted destruction of the bourgeois world so blatantly symbolized in the debris surrounding them.

The intense satirical mood incorporated into this work is much less apparent in the 1922 etching on the same theme. Here, only one fighter confronts the enemy, while two of his fellows lie dead around him. Once again the major protagonist is a sailor, but the barricade on which he crouches has none of the crude symbolism of the earlier one. Instead, one is confronted only with the violence and bloodshed of revolution, where the living fight over the bodies of the dead. This simplification of the elements within the work in order to concentrate more intensely upon one aspect of the scene is due in part to the medium used, but also to Dix's stylistic evolution between 1920 and 1922. This etching is close to later works of 1923 and 1924 in its reduction of visual elements to a few well-chosen macabre details. The figures are brought to the extreme foreground so that nothing detracts from the shock of their existence, and they confront the viewer in a fashion very similar to the Venus of *Venus des kapitalistischen Zeitalters.* (p. 54)

As with the scenes of war cripples and urban revolution, the scenes of war depicted by Dix in the period of the early Weimar Republic were an outgrowth of intensely felt personal experiences. Having participated in the First World War at the front lines for most of the four years of its duration, Dix developed strong attitudes about war which had none of the doctrinaire political character of George Grosz's position. Dix had 'been there' and because he had seen the wanton destruction of human life the subject of warfare in his work took on a deep, personal intensity that no other art of this period can rival. Dix was convinced that one cannot depict such scenes of holocaust without having lived through them as a participant. (p. 55)

The artist's interest in subjects involving warfare continued throughout the Weimar years, prefaced by the drawings done during the First World War and including the painting *Schützengraben* of 1923, the graphic series *Der Krieg* of 1924, the triptych *Der Krieg* of 1929, and the painting *Flandern* of 1933-36. With the exception of several of the etchings, the focus of all of these representations is upon the most macabre aspects of modern warfare. *Der Schützengraben* is both one of Dix's most important and most controversial paintings. Now destroyed, it provoked

during its brief existence diametrically opposed points of view and did more than any other work by the artist to make his name known throughout Germany. The painting depicts a trench after the battle is over, filled with decaying human corpses, broken weapons, and mounds of blood-spattered mud. The size of the canvas was intended to increase the shock effect of the visual images: it measured 227 by 250 centimeters.

Preparatory drawings for this masterpiece were done during the war years and at a hospital in Dresden after the artist's return when the war ended. In comparison with these earlier drawings, *Der Schützengraben* is much more explicit in its use of hideous details. The 1918 drawing entitled *Soldat* depicts a soldier walking through a battlefield strewn with the bodies of the dead, all described in a generalized fashion through the use of strong outlines and patchy areas of shading. The artist has made no attempt here to depict a specific locale or specific characters and there are no details of open wounds and decaying flesh, carefully delineated faces and well-defined spatial areas. One dead soldier has been raised above the trench on twisted bars of steel and silhouetted against the sky as if to parallel the laying of the dead upon a bier, while the remaining corpses are presented in a heap below him in various stages of decomposition. The most gruesome details are reserved for the foreground of the painting in order to increase the shock effect of the work, and a series of repeated diagonals as well as the receding trench draw the viewer's attention in the swampy interior of the trench. In its macabre mood and stark realism the Dix work parallels the widely-read book from this period by Erich Maria Remarque, *All Quiet on the Western Front.*

Der Schützengraben was begun in 1920 and completed in 1923, thus spanning the years of Dix's transition into a mature Verist style when the theme of war was allied with meticulously rendered macabre details of rotting corpses and bloody limbs, and the work relates both to earlier paintings such as *Die Barrikade* of 1920 and to later paintings such as the *Venus des kapitalistischen Zeitalters* of 1923. The fascination with violence and the self-conscious attempt to shock the viewer link *Der Schützengraben* to the 1920 depiction of street warfare, and there is even a repeated image of a dead man with tongue hanging out in the foreground of each work. The extreme concern for realistic detail, however, places the finished work within the later period.

The etching series of 1924 continued in the same vein as *Der Schützengraben* in dealing with stark, horrifying scenes of human slaughter, but it also included scenes reminiscent of Dix's earlier interest in adventuring sailors. A work such as *Fliehender Verwundeter* with its ghastly apparition of death is presented alongside *Frontsoldaten in Brüssel* with its parade of prostitutes, thus bringing together in one portfolio two of Dix's major preoccupations from this period of his life. (pp. 56-7)

Of all the subjects which Dix developed in the twenties, that of warfare is most distinctly his own. Although a number of other artists such as George Grosz, Erich Drechsler, and Otto Griebel included war related subjects in their work of these years, no other artist of Dix's time

approximated to any degree the style or mood of his art on this theme. Otto Griebel's *Im Granattrichter* of 1924, for example, utilizes the same realistic style as the Dix *Der Schützengraben* but without the hideous details. A group of emaciated soldiers huddle in a shell crater, numb from the cold and the horrors of war. The general mood of despair is reminiscent of the Dix painting, but the shock value of the Dix work is missing. Erich Drechsler's *Nahkampf I* of the same year describes an actual battle with vicious clarity, but it too lacks the emphasis upon the macabre which makes the Dix work so intense.

If Dix's greatness as an artist in these years can be attributed to a specific cause, that cause is the war experience and its influence upon the personality and perceptions of a young and sensitive man. After 1918, Dix altered his life in many respects: he determined to become a painter, he chose to live among prostitutes and pimps, he changed his art style, and he created masterpieces of bitterness and disillusionment. After 1925, as an older man with a family and a growing reputation as an artist, Dix lost something of that youthful intensity and bitterness, and his work no longer exuded the strength and sense of outrage brought on by the experiences of the teens. Instead, outrage gave way to an increasingly neutral mood and with the new mood came a group of pictures that cannot compare in intensity with the *Schützengraben, Gräfin Else,* or *Venus des kapitalistischen Zeitalters.* (p. 57)

> Brigid S. Barton, in her *Otto Dix and Die neue Sachlichkeit, 1918-1925, UMI Research Press, 1981, 170 p.*

Tim Hilton (essay date 1983)

[*In the following excerpt, Hilton finds Fritz Löffler's portrayal of Dix in* Otto Dix: Life and Work *(see Further Reading, Section I),problematic, suggesting that Dix is best remembered as an original graphic artist rather than an influential painter.*]

Everyone should have an opinion of Otto Dix, for his kind of art is increasingly recommended as a model for our own young painters. And indeed there is much about the German artist that people like to see in student endeavours. His pictures are vehement yet also deliberate; most of them offer evidence that he "can draw"; they often have social themes, which make them the more vivid; they are evidently a part of the modern world yet not obviously a part of that modernism which is held to be "self-regarding". Their satiric aspects show a commendable interest in society, while careful oil techniques and classical motifs announce his reverence for Dürer and Grünewald; and our respect is more or less compelled by Dix's hideous experiences in the First World War, his leading position in the *Neue Sachlichkeit* and courage during persecution by the Nazis.

Fritz Löffler's [*Otto Dix: Life and Work*] is not concerned to place Dix in any broad context, and it rather assumes that his merits are unquestioned.

"I was always a conservative", Dix told Löffler, late in life. This is not entirely true, but we can now see that his first painting was made in a spirit of corrective revivalism. He grew up in Dresden at the time of the *Brücke,* when any number of Expressionist and French-based Post-Impressionist and Cubist painters were exhibited, surely tantalizingly. One would not imagine so from his assured *Self-portrait with Carnation* of 1912-13 which, as Löffler points out, belongs to that strain of "Saxon Florentinism" established at Dresden, a strain quite at odds with vanguard Expressionist painting. Though it is obviously Italianate, and Düreresque, I fancy that this picture also owes something to the cult of Beardsley, which we know to have been potent enough in Dresden to have gained the admiration of the young George Grosz, the artist with whom Dix is most commonly (though not in this book) associated. Other *jugendstil* influences are apparent in these early years but seem irrelevant, juvenile—and belonging to the nineteenth century—so quickly were they swept away by the war and by Futurism.

One might think that the modern Italian style, with its sharply repeated forms and disruption of painterly manners, would be appropriate to contemporary warfare. Many found it so, and Dix painted a number of Futurist canvases, but it is hard to believe that they answered to his needs. For it is a great deal easier to paint like a Futurist than (for instance) as a Cubist, or an academician; and the superficial aspects of the new Italian painting were simply not in accord with Dix's experience of four years as a machine-gunner on fronts in France, Flanders and Russia. It was a war that was not to be considered by a new and flashy idiom. Evidently, from a number of works reproduced here, Dix also thought to make something of the romantic alienation and "childishness" we find in Chagall; but this was not pursued; and perhaps it is best to consider these modernist paintings, with Löffler—echoing Dix's own estimate?—as "experiments".

Dix found a manner for his art in the early 1920s, when he also developed an iconography of prostitutes, sailors, cripples, sex murderers. There are many references to Dresden itself: the limbless match-seller on the Pragerstrasse and the brothels of the Ziegelgasse were recognizable, not generalized. Such local and topical material no doubt helped to keep the art edgy, as did the style: it has elements of caricature and the grotesque mingled with deliberate imitations of the amateurishness of the Sunday painter. Löffler regards all this as an attack on "bourgeois morality" and the corruptions of the Weimar Republic, as though that is all that needs to be said. But he neither explains Dix's political position, if indeed he had one, nor gives the relevant background to the controversies that the painter engendered. One would like to know more about Dix's disputes with Kokoschka, who called him a philistine, and about Julius Meier-Graefe's vehement (and public) opposition to his war-painting *The Trench:* does Löffler consider that this extremely interesting critic and historian had a bourgeois mind? It would also be good to have first-hand evidence about the way that Dix viewed his career and his comrades, and to know how calculated were his brushes with such authorities as the Berlin Public Prosecutor who brought him to trial for exhibiting "obscene" paintings. For there is such a thing as the cause of

art, and one cannot help suspecting that Dix (like many another "political" artist after him) too readily cast himself as the martyr of that cause rather than as its champion.

Even after he joined the group around the avant-garde Düsseldorf dealer "Mutter" Ey it is difficult to be clear about Dix's affiliations. Löffler cannot agree with Frau Ey's recollection that "the fools who harassed us always believed we were making politics but all we were fighting for was a progressive art", since that group was certainly of the Left. But there is little evidence that Dix was politically active (it appears that one reason for his survival under Hitler was that the Nazis could find none) and in what sense can his art be described as progressive? It gained in point precisely by its wedding with reaction. Dix must always have felt that he needed to be close to classical instruction and discipline. Perhaps this was connected with his hostility to the Expressionists, who were largely self-taught.

In any case his first training (which was probably of an arts-and-crafts type) was not enough for him. He enrolled in the Dresden Academy immediately on his return from the war, at the age of twenty-nine. In Düsseldorf (and this is the time when Löffler encourages us to think of him as an independent artist) he again entered the Academy as a "master-pupil", this despite his membership of the Cartel of Progressive Art-Groups, whose first session had unanimously resolved on the abolition of all academies; by 1927 he was back in the Dresden Academy, five years after he had left it, and this time as professor. His painting, meanwhile, became ultra-conservative, mastering sixteenth-century techniques gleaned from ancient manuals. One cannot but see in it the negation of that spontaneity and autographic quality found in all the best German painting of the new century.

These few years before Hitler's rise to power in 1933 are the centre of Dix's career, and the period when he appears to be something more than a minor artist. Perhaps this is because of the peculiarly illustrational nature of the *Neue Sachlichkeit,* a movement (but I would prefer not to call it a movement) whose importance is derived from the times it reflects, not from its creativity. Dix is the representative artist of the *Neue Sachlichkeit,* the "new objectivity" of Weimar, because of that culture's characteristic examination of its own circumstances. Appropriately, portraiture is now to the fore, in Dix even more than in Grosz, Schad, Schlichter, Radziwill. In opposition to that German tradition of spiritual self-portraiture at its height in Expressionism, Dix took to the calculated observation of others. Practically always (the pictures of his parents and of Frau Ey are exceptions) his subjects appear to their great disfavour: strangely, they appear to have colluded in his scorn. The horsefaced, monocled journalist Sylvia von Harden, represented in poisonous pinks and crimsons, varicose veins showing above silk stockings, kept the dress Dix painted her in and posed for photographers in it when her portrait was bought for the Pompidou Centre thirty years later. The lesbian, heroin-addicted dancer Anita Berber, the hated dealer in Cubist paintings Alfred Flech-

theim, the dermatologist, surrounded by sinister medical apparatus, all seem to have bowed to Dix's vision of them.

It is as though Dix, with the acquiescence of those he knew, willed the reversal of that Renaissance humanism—constantly apparent to all German artists in the example of Dürer, the first self-portraitist—which had made a dignified genre of the portrait four centuries previously. The tactic was to combine the summary, antagonistic methods of the caricaturist with laborious old-master procedures. Heads, hands and eyes are enlarged, the nose accentuated, wrinkles and sags of flesh carefully explored. Dix ground his own colours and used panels that had been treated with repeated coats of gesso and scraped down to a hard smoothness with a razor blade. A complete and detailed cartoon of his subject was transferred, probably with tracing-paper, before he started to paint.

With such preconceived methods, notably akin to those of the forger, Dix built up his gallery of decadents. He also essayed more complex compositions. These seem the less telling because of their tendency to generalize. Notable among them is the *Grossstadt.* This is a night-club scene whose two flanking panels show streets and prostitutes. It was not Dix's first use of the triptych, nor his last. He often applied himself to religious subjects, made contemporary by female attitudes taken from *poses plastiques* or perhaps pornographic photography, and updated to a twentieth-century setting. Dresden, for instance, becomes Gomorrah in *Lot and his Daughters,* Hitler takes his place as Envy in *The Seven Deadly Sins.* Such subjects accorded with the stance of Dix's art, whose challenge lay not in innovation but in its peculiar adherence to the traditional.

At the end of the Second World War Dix was held in a French camp. On his release in 1946 he once again announced the future of his art with a self-portrait, amid barbed wire as a prisoner-of-war. This unexpected painting set the style for two decades of comparatively uninterrupted work that remained to him. The picture is done straight on to the canvas in a rough, improvised style; as though in only one or two sessions at the easel; the drawing is with a brush; and the colour is fresh, in the sense that it seems to come straight from the tube. Dix worked in this manner (and, cognately, in lithography rather than etching) until the end of his life in 1969. Löffler's selection from these paintings is instructive, but in a negative way. Although they retain Dix's gift for demanding attention the pictures do not convince. The application is noticeable, but there is no real touch; the witches and crucifixions are routine; the palette seems either to be over-emphatic or dirtied.

Löffler seems not to wish to commit himself to these paintings, unable to assert that they match the effect of the art of the *Neue Sachlichkeit* period. Nor do they: but it is in their tendency to disappoint that one finds a kind of significance. There is a contemporary lesson in them. In their manner, aspirations and repeated failure they resemble the "New Spirit" painting that nowadays has currency in Germany (where it arose), in England and in New York. The point is not so much that Dix was an influence or a significant precursor of what today seems to be of the moment. It is that the "New Spirit" is not a vanguard style

but an amalgam of painterly academicism. There exists a sort of *pompier* figurative modernism in twentieth-century art, an undertow to the genuine tradition with its own vernacular. Thus Dix can seem to have affinities not only with Baselitz but also with Rouault and the late De Chirico (that rediscovery of the New Spirit). One wonders whether there was not always a weakness in his feelings for art that was bound to relegate him to such company.

Tim Hilton, "A Gallery of Decadents," in The Times Literary Supplement, *No. 4173, March 25, 1983, p. 291.*

Matthias Eberle (essay date 1986)

[*In the following excerpt, Eberle traces the evolution of Dix's style from his early works influenced by the philosophy of Nietzsche to his last religious paintings.*]

[Dix] confirmed late in life how deeply Nietzsche had impressed him. In 1912, fascinated by the man who 'revalued all values', Dix modelled a bust of Nietzsche and painted it green. The philosopher's revolutionary ideas entered his painting first under the influence of van Gogh and then of the Italian Futurists. Van Gogh was surely the model for Dix's *Self-Portrait as a Soldier,* while the Futurists inspired his *Self-Portrait as Mars.*

This picture, which Dix painted shortly before going into action as a machine-gunner, has been described in the most contradictory terms. It is worth discussing, if only because it shows how difficult it is for a post-war generation to understand the fascination of war. Diether Schmidt, for instance, described the picture in 1968 as 'a kaleidoscopic overview of war . . . which takes complete possession of men, dismembers and fragments them, crushes their individuality, and scatters them as things among things in the horrifying realm of strategic planning for destruction'. Ten years later, after an intensive study of the painter's work, Schmidt arrived at a somewhat different conclusion. Dix had not depicted himself as a 'chosen man' but 'romantically styled himself as craving experience . . . actively defying the war, even directing its course like Mars, the god of war'. The best description of the image is probably the following [by Dietrich Schubert]:

> in this *portrait-histoire,* a historical allegory, Dix portrays himself as Mars, the war god. Both the notion of a cruel, Dionysian principle of chaos, destruction and rebirth, and the notion of a dancing star, derive from Nietzsche. As Zarathustra said, one must have chaos within oneself to be able to give birth to a dancing star.

In the *Self-Portrait as Mars,* Dix obviously and painfully feels this chaos at the centre of his being. War has thrust the world back into chaos, the destructive impulse rages, and human instincts are set free. The old world of ordered responsibilities and solid objects has been rent apart, making way for new possibilities and new combinations. Human acts and thoughts split the world into atoms only to rearrange them. Zarathustra's dancing star rotates and glows on the warrior's head and shoulders, heightening and expanding the wild, volatile sensuality of the earlier

portraits to a spiritual principle that seems capable of displacing the universe.

Fragmentation and metamorphosis, movement and rotation are the central principles of this image. Rotating stars or suns dance around the soldier's head, a spoked wheel revolves over his heart, a horse rears inwards towards his neck repeating the circular motion, and over his helmet the crest of an antique helmet is superimposed. These pervading motions seem to set the segmented elements around the head and figure in rotation, a tumultuous dance of destruction and transformation. Earth, air and water mingle with fire, a merging of the four elements seen again in Dix's *Flanders* (1934-6). Men and animals, buildings and elemental matter all spin in the tempest, and the boundaries between them blur. A gaping mouth becomes the span of a bridge, decorations on helmet and epaulettes evoke heavenly bodies, blood and water stream over the ruins of this world, the collar of the soldier's uniform metamorphoses into a rearing stallion. To the upper right, implements and buildings change into faces, and faces become natural elements to the lower left. This is a world of fragments, both witnessed and ruled over by the artist-war god. By depicting them he shows that he is not only the perpetrator of this destruction and transformation but part of it. This warlord wills chaos because he feels it within himself and because he sees it as an opportunity to transform the world. He does not merely face the horror of war but immerses himself in it completely. (pp. 27-30)

Nietzsche's view of the world as a cruel and Dionysian cycle of birth and death, growth and decay, coloured the young artist's experience of war. Among the 600 or so scenes he rapidly recorded in tense, excited line during lulls in the fighting over the subsequent three years, there are only a few that predict his later and typical anti-war stance. Most of them depict war as a primal experience: soldiers are locked in battle, men and women locked in an embrace (*Hand-to-Hand Fighting,* 1917; *Lovers on Graves,* 1917). Soldiers emerge out of the earth as if from the womb, grapple on it in inextricable, organic tangles, sink dying back into the mud (*Going over the Top,* 1917; *Dying Warrior,* n.d.). And finally, flowers sprout from the graves and from the decaying body of a man in a devastated field which a helmet-like sun on the horizon raises to a symbol of the universal life-cycle (*Grave, Dead Soldier,* 1917). As Nietzsche wrote in *The Will to Power,* 'The world exists, but not as what will be nor what has been; it has never started becoming and never stopped passing away—it maintains itself in both. . . . It lives from itself: its excrement is its nourishment.' And just as battle includes the possibility of death, death includes the possibility of a new beginning. In this eternal cycle, men and their works merely represent certain special combinations of the matter which makes up the entire universe.

This principle is also revealed in Dix's portrayals of the devastated earth itself. Gaping wounds have been torn in it by shells, but these are like great vulvas evocative of the earth's fecundity. The trenches, gouged as if with a giant plough, transform the front lines into a fruitful field on whose edges flowers and grass already grow (*Shellhole with Flowers,* 1915; *Trench with Flowers,* 1917).

Not only does war set tremendous human energy free, it also releases the potential force of technology. When a shell explodes, it tears men and emplacements to pieces, as if reducing the earth and organic life to its elementary, geometric constituents. Heavy machine-gun fire splits the air like lines of force, dividing it into angular segments, mercilessly dismembering its victims into spinning fragments (**Direct Hit,** 1916-18; **Falling Ranks,** 1916). Yet it is from just these fragments that the artist constructs new compositions, a new world.

Dix's imagination was equally fired by the manifestation of the beast in men (**Crouching Man,** 1917) and by the superhuman, almost mechanical energy they developed under extreme pressure (**Charging Infantryman,** 1916). In the young artist's eyes, the universe was dominated by vital and mechanical forces that simultaneously destroyed and created life and matter. (pp. 30-1)

Dix never publicly exhibited the drawings he did during the war; they were not rediscovered until 1962. The more popular he became as an anti-war artist, the more he tried to cover his tracks. His later war paintings not only showed its horrors but uncovered the cruelty of life itself, of which war was only one part. In his war diary he noted that 'war, too, must be considered a natural event'. Reflecting on the driving force behind this natural event, he concluded that 'Ultimately all wars are fought over and for the sake of the vulva.' Dix lying in the mud under artillery fire on the Somme, then quotes Jeremiah: 'Cursed be the day on which I was born; the day on which my mother gave birth must have been unblessed.' To paraphrase another passage he quotes, his philosophy of life might be reduced to this: all emerge from the vulva and all are drawn back to it in the end.

If Dix experienced the cruelty of the life-force in wartime and saw woman as its source, peacetime showed him its true face, the wasted face of the streetwalker. His countless depictions of prostitutes seem to have been made under some inner compulsion. Their bodies are just as nauseatingly alive as the damp belly of the earth, torn open in his etching **Shellhole with Flowers** (1924). One begins to understand how Dix arrived at those brutal images of sex murders, one in the etching sequence **Death and Resurrection** (1921), and another disguised as a self-portrait, **Sex Murderer** (1920). These images represent an attempt, at least imaginatively, to break out of the vicious circle. Yet in art, as in life, the attempt is in vain: next to the prostitute's mangled body in **Rape and Murder,** two dogs copulate. The great wheel continues to turn. Just as the war could destroy only certain of life's configurations but never life itself, here, too, the vital principle triumphs over an individual's action.

Viewing Dix's work in this light, it becomes apparent why instead of inquiring into the social causes of the war he concentrated on the slaughter itself. If he focused not on its perpetrators but their victims, it was because he considered the victims just as guilty. It is evident from his **Self-Portrait as Mars** of 1915, and from the pen and ink drawing **This Is How I Looked as a Soldier,** the frontispiece to his etching sequence **War** dedicated to Karl Nierendorf in 1924, that Dix saw himself as both perpetrator and vic-

tim. It is worth looking more closely at this belligerent machine-gunner, striding towards the spectator with his punctured helmet and torn uniform, cradling his murderous weapon. If it were not for the proud twist of his moustache, cigarette dangling nonchalantly from the corner of his mouth, and his gunner's squint, it would be tempting to read sheer will to survive in this face. Yet it is also proud, defiant, determined, and full of the arrogance of a man who has been through all the horrors depicted in his war engravings. Over thirty years later, Dix still believed that

> You have to see things the way they are. You have to be able to say yes to the human manifestations that exist and will always exist. That doesn't mean saying yes to war, but to a fate that approaches you under certain conditions and in which you have to prove yourself. Abnormal situations bring out all the depravity, the bestiality of human beings. . . . I portrayed states, states that the war brought about, and the results of war, as states.

It was saying yes to fate that turned Dix's face to stone, and led him to assume the admittedly somewhat melodramatic role of a hardened warrior as he appears in almost all the self-portraits of the post-war years, with his chin jutting, the corners of his mouth turned down, and eyes closed to slits. He armed himself morally with frank cynicism, and artistically with a brilliant, machine-like technique, as is shown below.

When Dix began to record the consequences of the great slaughter, the fundamental rejection of society which he had taken from Nietzsche turned to hate. This can be seen from his depictions of disabled veterans of 1920; but it should not be thought, as has been frequently alleged in recent years, that Dix, in holding capitalism responsible for all of its ills, hated society altogether. Human beings remained only human, whether under capitalism or socialism, as far as the artist was concerned. There can be no doubt that the title of one of his best-known drawings, **Prostitute and War Cripple—Two Victims of Capitalism** (1923), was not his own but provided by the Communist editors of *Die Pleite,* the journal for which he made it. Dix's opinion of the German Communist Party was anything but favourable. When his friend, Conrad Felixmüller, asked him if he would like to join, Dix countered by asking how high the dues were. 'Five marks a month,' said Felixmüller, and Dix, 'For that I'd rather go to a whorehouse.'

Dix's treatment of the subject of war veterans reveals just as much scorn of their twisted bodies as anger at the indifference of survivors and non-combatants. And here again, his criticism included self-criticism. In his etching **War Cripples** of 1920 he set his signature in the keystone of a window frame past which the sad procession limps. In **Match Vendor** of the same year, an invalid sits before the door of a house with a notice prohibiting begging and peddling. A name plate next to the bell shows that Mr Dix lives here. If *he* were here on the pavement, his predicament would be no better; but fortunately someone else is there instead.

These images also reveal a certain detachment from the technology whose violence so fascinated Dix during the war. Though these men can still get around with their artificial limbs, they use them to march in grotesque belligerence down the street (*War Cripples*) or to play cards at the same table in the same café as before the war (*Disabled Man Playing Cards,* 1920). Dix portrays them as diehards who wear their country's decorations with undiminished pride. The acid irony of these pictures is directed not only against society in general. As Bernd Weyergraf says of Dix's *War Cripples,*

> A hook makes a perfect cigar holder, and the shell-shocked veteran's amputated leg has its uses—the last man in the procession with his patented spring joints and bolted jawbone has apparently inherited the right boot his companion no longer needs.

This bitter cynicism, in other words, was probably inspired by a technology that was capable of turning men into cripples but not of making them whole again. Yet Dix was equally cynical about the victims themselves, condemned to lead a grotesque hybrid life, half men, half machines, on the indifferent big-city streets. Being a vitalist, Dix could not help but see them with a scornful eye, in spite of the fact that their plight was a consequence of war. According to Conrad Felixmüller, this attitude led Dix to subtitle his image, with a survivor's cynicism, 'four of these don't add up to a whole man'. Crushed by the mechanism of war and glued back together by the mechanism of peacetime, these men have become invisible to the self-satisfied crowd. The contrast could not be greater between their deformed bodies and the well-rounded female legs and backsides parading past them (*Prague Street,* 1920). The bitter irony of these images is heightened still further by their montage technique, a careless patching together of elements from diverse sources much like the one the men themselves have submitted to. Yet not even the passers-by are 'whole human beings', as can be seen in *Prague Street.* Dix depicts only fragments of these people, suggesting that the missing parts be supplied from the well-stocked display windows in the background—wigs, cosmetics, corsets and more artificial arms and legs. Everyone, maimed and sound alike, becomes complete only by buying and consuming, Dix seems to say. Technology may cripple men by isolating them from normal life, but the exchange principle fragments them into purchasable parts. The poor are the peacetime disabled.

If these images criticize both technology and post-war consumerism, Dix's contemporaneous drawings of nudes show him beginning to question the optimistic vitalism characteristic of his pre-1914 work. Then he had celebrated the healthy, animal vitality of women. After 1918 his nudes remained just as full of life, but contained in what ruined shells! Gone were the Dionysian ecstasies of his earlier drawings, the ample, inviting abundance of *Sleeping Woman* (1914), spread out before the observer like the earth itself, or his *Dancer* (1914). The women he now began to depict had ugly bodies, terribly fat or terribly emaciated, and their faces were marked by professional cunning or vice (*Gretel,* 1921; *Nude,* 1921). One of the most horrifying examples is probably the *Girl before a*

Mirror, a painting of 1921 that has since been lost. It showed a woman with pendulous breasts putting on lipstick, her underclothes gaping. This woman, too, is out to catch a man, she too instinctively seeks love though her body may be desiccated and sterile. This interpretation is underscored by the oval mirror, part of the ancient *Vanitas* motif. It is hard to imagine a more radical criticism of the principle that Dix revered throughout his younger years—under these conditions, in bodies like these, the will to live is perverted into a disgusting vice.

Dix's detachment from his pre-war self and philosophy expressed itself initially in terms of subject-matter, and only later, in about 1923-4, in terms of technique, as the comparison of his war drawings with the etching sequence of 1924 shows. In his oil paintings, the agitated, spontaneous style of 1913 to 1915 gradually gave way to a sharp-focus image built up of fine strokes and old-master glazes. Yet though Dix returned to the techniques he had learned at the academy, they were now informed by new experience. The life-force, he realized, was cynical and absolutely indifferent to human values and philosophies. In this connection, it is worth taking another look at *Skull,* in the war portfolio. The teeming maggots, unthinking organic life, make a mockery of human reason, taking over the shell that once contained everything that raises man above insensate matter. This form of life could not care less about what human beings think of it. It usurps its right to exist, feeding on brain and once-bright eye, sensuous lips, eloquent tongue, listening ear. Yet by drawing this grisly scene, the artist has attempted to reassert the power of his intelligence over insentient life, regain some of the lost terrain, and find himself again. This was basically Dix's dilemma, and it was insoluble. As much as he would have liked to, he could not defeat nature; and the more his own vitality waned, the more he was forced to look for some other solution.

The old-master technique Dix developed during his years of stylistic change was a conscious break with the direct, *alla prima* method of the pre-war period and the optimistic vitalism that gave rise to it. In terms of method, Dix's new paintings were out of time. The word 'time' in this connection has two meanings. It implies, first, the flux of time, which is heedless of human beings and their efforts to create something lasting; and second, Dix's own time, the early 1920s, when Expressionism still had a great deal of life in it and the late Impressionists, like Liebermann and Corinth, were respected masters. Dix's paintings were out of synchrony with both natural and human time. Their carefully honed shafts and gears grated and screeched in the machinery of the art world. And the artist had intended them to grate and screech: 'By running stylistically counter to the developments of the period, his pictures visibly deflected the stream of time' [Eberhard Roters, *Aspekt Großstadt*, 1977]. Or, as a contemporary of Dix put it,

> The penetrating, even piercing quality of their effect is heightened to the utmost by their technique. . . . Precise, lucid design, a painful care in execution down to the last detail, an exactness one is tempted to call mechanical. A technique adequate to modern precision—

machine manufacture, whose touch has something of the cleanliness and mirror-finish elegance of a honed ball-bearing, but also something of the actuality of a photogram.

Dix rejected the mechanical age yet turned himself into a piece of precision machinery. Emerging unscathed from the technology of war, he depicted mechanized ***War Cripples*** and behind them his own profile on the wall, with superimposed crosshairs to show that he, too, had been under fire, but that he had overcome technology as a craftsman. And through art he also attempted to subdue those cruel, fascinating forces of nature from which he had escaped. In his paintings, he brought the inexorable cycle to a halt and at the same time triumphed over the artists' greatest technical competitor, the camera. 'That portrait painting has been superseded by photography, is one of the most modernistic, arrogant and also naïve misconceptions there is,' Dix stated in 1955.

> Photography can only record a moment, and that only superficially, but it cannot delineate specific, individual form, something that depends on the imaginative power and intuition of the painter. A hundred photographs of a person would only result in a hundred different momentary aspects, but never capture the phenomenon as a whole.

Here, the 'skull' definitely asserts its supremacy over the momentary character of natural phenomena and over its mindlessness, the indifference of nature to the individual. And the painter asserts his superiority over the mechanical instrument.

Thus by reviving an old technique, which involved great renunciation and effort, Dix took his lone stand against the mechanical principle that dominated the age, exemplified in the passage from Westheim quoted above, at the same time gaining perspective on the inexorable cycle of birth and death. He captured moments from the flux of time, fixing them in a form that was entirely his own. Yet though his paintings still expressed the force which he felt moved the universe, this force had been tamed. He had abandoned his earlier impasto technique 'since it depended much too much on accident, while a more controlled painting style presupposes a conception of the image, an idea'. Here, again, the thinking 'skull' defends itself against fortuitousness, attempting to grasp the essence of insentient nature. 'Once you've begun, you have to go on, and mistakes are very hard to correct. And establishing the image at an early point precludes spontaneity.' Dix curbed even his own natural vitality and temperament, saying that the drawing 'had to be very strong from the start'. And asked about the durability of his paintings, he replied proudly, and with a sigh of relief, 'Yes, that's the great thing. They last much better than any wet-in-wet painting ever would—forever, really.'

With the aid of an idea, a mental conception expressed in clear, solid form established from the start and dependent solely on individual skill, not on any apparatus, artists took their stand as unique, thinking individuals against the modern world and the flux of time. This stand crucially shaped the New Objectivity, which was primarily a German style. From tentative beginnings immediately after the war, it emerged full blown when inflation ebbed and the currency was stabilized, in 1924 and 1925. While the mark remained almost worthless, no artist could invest the incredible time and effort that painting in this style demanded. An entire generation pursued the same goals as Dix—to quell primal forces and to triumph over the machine. The recourse of many artists of the New Objectivity to iconography and techniques of the Renaissance can probably be explained partly from their feeling that the Great War marked the beginning of a new era in human history, and partly from their desire to reinstate artistic individuality with the aid of traditional approaches. Their precise technique conformed to the industrial age and kept nature in check while establishing the individual as master of both. Yet when their paintings are compared to the works of the Renaissance, it becomes obvious that most of these artists were on the retreat. Frequently they resorted to traditional types of composition, anxiously expecting that tradition would compensate for their lack of original ideas. Not all artists of the New Objectivity succeeded in using the style to shed critical light on their own age.

Dix differed from most of his contemporaries not only in technical brilliance but in imaginative power. His reliance on tradition went beyond imitation of forms and methods. He realized that pictorial conceptions had to be developed for an age in which art could no longer rely on general agreement, religious cult, or social status. Dix's mastery of inventing new types of composition by ironically twisting and updating old ones has already been illustrated in ***Skull,*** a contemporary version of the *memento mori* theme, and ***Girl before a Mirror,*** a reworking of the *Vanitas* motif.

Many contemporary observers already suspected that Dix's biting criticism of post-war society may have veiled profound disappointment:

> Possibly his obstinacy is only inverted love, the resentment of a man who imagines his surroundings in terms so completely different from his daily experience. This may explain why his oversharp portraits, seen with a policeman's eye, so often resemble wanted posters, even to the way they mercilessly state and publicize the facts. [Paul Westheim in *Das Kunstblatt*, no. 10, 1926]

The intention behind Dix's painting, Paul Westheim thought, was to convince people and improve social conditions in the only way that was still possible, by confronting them with 'facts, stark, brutal facts'.

The people whose faces appear on wanted posters have failed to conform to the rules of society. Yet since Dix believed that society had forfeited its right to set up rules, his portraits naturally became arraignments of its members. In this sense he was critical of society as a whole, but without having an alternative model. What disturbed him most was the fact that society could not deal with the contradictions of human nature; he, too, had difficulty enough in being reconciled to them. Therefore he attacked the hypocrisy of people whose psychological problems were very much the same as his own. He condemned himself to

being an outsider, since no one enjoys bitter jokes at his own expense. When after the Second World War he was asked about his inconsistent attitude to the First World War, he immediately shifted the blame to middle-class complacency in general:

> So now you want me to explain this whole paradox to those people out there . . . sitting in front of their radios. Well, it'll really give them the shivers. . . . What kind of a fellow is this, some kind of animal . . . saying all this straight out . . . it's not done. You have to observe the conventions. You're supposed to be moderate, reasonable, middle-class average in everything you say, right?

Dix was always fascinated by people who disregarded conventions. He portrayed people whose faces, like gaps in the veneer of civilization, revealed primeval depths beneath. Some of them were conscious rebels; others were rebels unawares, who needed the artist's help to realize their non-conformity. In any event, Dix showed them that they were not what they pretended to be. The self-satisfied visages that Grosz never tired of belabouring did not tempt Dix, however. He was not interested in throwing the small change of agitation to the masses. Seeking no political or social panaceas, he mounted no political accusations. What he sought was something eternal and unchanging— human nature. If Westheim was right in saying that Dix was out to change society by confronting it with naked, brutal facts, then his attempt was doomed from the start. The fact that amoral, cruel nature stared from the faces of his portraits certainly did not change them. If an artist is fundamentally convinced of the brute violence and deep inherent contradictions of nature, his depictions of these things, no matter how critical, will only serve to confirm them.

A good example is the well-known portrait he painted of **Alfred Flechtheim** in 1926. Flechtheim, with Cassirer, was one of the most influential and important art dealers in Berlin at that time. While Cassirer held to established styles, Flechtheim represented the French vanguard. (pp. 41-50)

In Dix's portrait, Flechtheim seems to be waiting for just such a casual customer to drop in. He stands before an ink-blue wall, ensconced behind a small, round table on which he has spread his bait—two Picasso drawings of nudes. His flank is protected by a Braque oil. Encased spider-like in his jacket, he reaches out slender arms to secure his possessions. As he measures his prospective client, his mouth mobile, and lower lip ironically protruding, Flechtheim seems ready for anything that may come. His right hand rests firmly but not too possessively on the drawing of a naked couple, partially concealing it; his left holds a Braque still-life. If his erotic bait works, the customer can probably be made to swallow the painting, too.

This portrait is certainly an attack on Flechtheim, whom Dix described as 'avaricious and decadent', but it was just as certainly intended as an attack on the lasciviousness and stupidity of buyers whose interest in art is anything but aesthetic. Moreover, Dix had a very personal bone to pick with Flechtheim. His own dealer, Nierendorf, who

disliked Flechtheim, had informed Dix that he 'has been cussing again, calling you a "fart painter" and telling everybody your pictures stink. He's still enthusing about his Frenchmen and always giving you as their German antithesis.' Behind the figure Dix has put a still-life by Juan Gris, signing it with his own name as if to say that he could do as well any day. This irony infuses the entire composition, which is constructed in an almost Cubist manner. The contours of the figure and its attributes correspond to those in the still-life on the wall. The table with its striking grain and the drawings overlapping and curving away from one another recall certain of the still-lifes of Braque and Picasso. The perspective has been consciously distorted. Dix's verism, instead of imitating reality, like Cubism combines diverse fragments of reality. As Carl Einstein wrote [in *Das Kunstblatt,* vol. 7, 1923],

> There is a tremendous tension between the poles of contemporary art. Constructivists and non-objective painters establish a dictatorship of form; others like Grosz, Dix and Schlichter smash reality by poignant objectivity, unmask the period and compel it to self-irony. Their painting is a cool death-sentence, their observation an aggressive weapon.

It remains unclear as to who commissioned Flechtheim's portrait or whether it was commissioned at all. It is unlikely that the model himself ordered it.

Dix maintained his style and with it his critical stance longer than many other artists of his generation. He aimed at the centre of the target, the primal impulse of nature, which he simultaneously hated and worshipped. His confession that his own temper frightened him fits perfectly with his admission that his technique prevented spontaneity, the free expression of his own nature. His personality was just as unfathomable to him as the elemental violence of war. Basically, he blamed society for the split he felt within himself. As long as he felt strong enough to take up the challenge of nature, he remained true to his precise style. The lonely years of inner emigration—after being ousted from his professorship at Dresden in 1933, Dix lived in isolation at Lake Constance—and the war years and internment, apparently broke his will. His *Self-Portrait as a Prisoner of War* (1947) not only shows a humbled, frightened man but is painted in his old *alla prima* style.

This inner change had already been predicted during the 1930s. In the large *War Triptych* of 1929-32, Dix could still depict the natural cycle of death and rebirth. To the left, soldiers go into battle like Jesus went to Golgotha. In the centre, mechanical death reigns, leaving destruction and grotesquely mangled corpses in its wake, witnessed by a man in a gas mask entering the trench. To the right, illuminated by a flare, Dix himself carries a wounded comrade out of the line of fire. In the predella at the bottom of the picture lie men sleeping the sleep of death, like Christ in His grave; when they awake, the murderous cycle will begin again.

Here war is depicted as a Passion which each man must live through alone. The mangled body cast up in the centre of the image recalls Christ crucified and the remnants of

his uniform Christ's loincloth in paintings by Grünewald. Yet for all the parallels, one decisive aspect of the Christian Passion is missing here, the Salvation. The Resurrection of Christ transcended the cycle of death and rebirth, while Dix's 'resurrection', depicted on the right-hand panel, only inexorably continues it. And the artist's own face, marked by exhaustion and anger, reveals that he no longer believes in the positive message of this eternal return. He wants to interrupt the process, bring it to a halt. Dix intended his triptych to be installed 'in a bunker built in the midst of a big city's sound and fury' as if in a chapel, but certainly not in order to put people into the mood for the next war.

In *Flanders,* painted in 1934-6, even greater emphasis has been placed on the motifs of sacrifice and salvation. By this time Dix had already gone into the inner emigration caused by his expulsion from his teaching post. The hope that those who saw his paintings would or could do anything to prevent the coming war, had certainly diminished, as can be seen from the composition of *Flanders.* It was influenced by Henry Barbusse's war novel *Under Fire,* which the artist had read. Torrential rains have transformed this battlefield into a primeval landscape. Sun and moon both shine; water mixes with earth and both merge with the sky at the horizon; human beings can hardly be distinguished from inorganic matter. The life cycle, spurred by division and separation, has been arrested in a state like that which must have preceded Creation. The image is dominated by the horizontal. The group of three figures in the foreground not only recalls St Sebastian, a drawing of whom Dix had made as early as 1913, but again evokes the motif of Golgotha and transcendence of the eternal cycle. This image, in other words, not only anticipates the Second World War, as many observers have noted, but expresses the hope that the victims of the First World War might prevent it. Through sacrifice, a new order might emerge from chaos, a primeval state like that which preceded the creation of the universe. At least in terms of motif, Dix abandoned the old stance of opposition and accusation by which he had hoped to change men and conditions by ruthlessly recording the facts. In his vision of *Flanders* accusation is replaced by an almost mystic hope, since at the time it was painted he had been deprived of every opportunity to influence public opinion. The idea that the vicious cycle might be broken by sacrifice appealed to him more and more. And in 1943, when many millions of human beings had again been sacrificed in vain, he painted his first *Resurrection of Christ,* followed by a second in 1948. In place of the front-line soldiers of 1914-18 now appeared the Son of God.

During the hopeless war and post-war years Dix laid down his weapons one by one, took off his armour, and submitted to the grace of God and what he called 'the inner immediacy of life'. His style changed accordingly. His frank, objective, and sometimes cruel record of a great and awesome nature was over. Yet he remained fascinated by natural forms and appearances, so much so that he never crossed the border to abstraction. His self-perception remained linked to perception of the world outside, his subjectivity continued to test itself against fact. Recognizing nature's awesome force, he had attempt-

ed to transcend it; when he did not succeed, he succumbed to resignation. After 1945 his art, like that of many of his German contemporaries, lost its force. (pp. 50-3)

> *Matthias Eberle, "Otto Dix: Fighting for a Lost Cause—Art versus Nature," in his* World War I and the Weimar Artists: Dix, Grosz, Beckmann, Schlemmer, *translated by John Gabriel, Yale University Press, 1986, pp. 22-53.*

William H. Robinson (essay date 1987)

[*In the following excerpt, Robinson discusses Dix's career as a portraitist.*]

While the twentieth-century has produced few great portraitists, Dix made portraiture central to his investigation of the human condition and the nature of the modern age. From his early *Sister Toni by a Window* of 1908, painted while still a student in Gera, to his late *Mrs. Rosennast* of 1969, Dix may have executed more than two hundred portraits, or portrait subjects, many of extraordinary power and originality.

Dix's early *Neue Sachlichkeit* portraits—such as *The Old Worker* of 1920 and *Portrait of The Artist's Parents I* of 1921—tend to emphasize class distinctions and the dreariness of life during the early years of the Weimar Republic. Most of these portraits depict friends or fellow artists; Löffler and Barton note that such paintings were probably not commissioned [see Löffler entry in Further Reading, section I, and Barton essay dated 1981].

Toward 1924-25, striking changes began to occur in Dix's portraits that can be linked both to events in the artist's personal life and to changing political conditions in Germany. One such event was the implementation of the Dawes Plan in 1924, which initiated a brief period of economic and political stability lasting until the world financial collapse of 1929. During this period (1924-29), living conditions in Germany improved vastly and large numbers of people, including many in the middle class, could afford to purchase works of art. Consequently, Dix began to paint more and more portraits on commission, and often for a more prosperous clientele. His relationship with his new patrons tended to be less personal than it was during his early *Neue Sachlichkeit* period. These changing conditions certainly contributed to the shift in emphasis from concern with social commentary, which dominates Dix's portraits of the early 1920s, to the greater interest in exploring the individual personality of his sitters, which characterizes his portraits of the later 1920s.

This was also a decade of increasing personal prosperity and happiness for Dix. After moving to Düsseldorf in 1922, he married Martha Lindner, and the couple's first child—a daughter named Nelly—was born in 1924. Dix then spent two years in Berlin (1925-27), where he acquired a considerable reputation as a portraitist. Finally, he accepted a teaching position at the Dresden Academy in 1927, which gave him a secure income for the next six years. All of these factors seem to have contributed to the

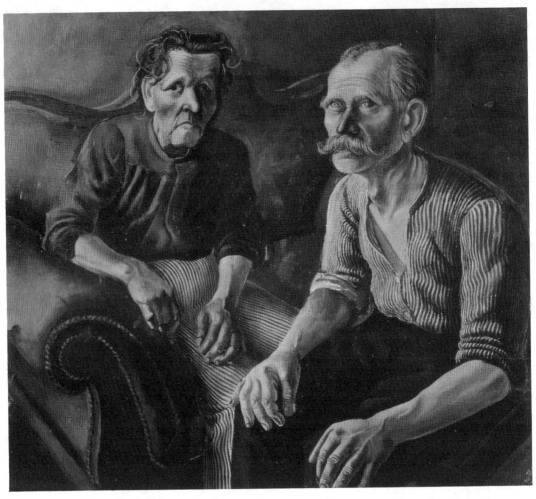

Portrait of My Parents I *(1921).*

generally more sanguine tone of Dix's portraits of the mid- to later 1920s.

Around 1925, Dix also began to employ new techniques that significantly altered his portrait style. In particular, he abandoned all traces of collage and *alla prima* brush- work for a laborious method (which he claimed was based on the methods of the old masters) of applying numerous thin, transparent glazes of tempera and oil applied over gesso grounds and wood panel supports. These new tech- niques produced a style of pristine clarity, brilliant hues, smooth surfaces, and extreme linear precision (even more so than in Dix's early *Neue Sachlichkeit* paintings). Schol- ars have often attributed these changes to the influence of Dürer and Philipp Otto Runge, as well as to the influence of the mannerist portraits of Agnolo Bronzino and Jacopo Pontormo that Dix saw on a trip to Italy in 1925. New ideas about the sources of this change in Dix's technique, however, are presented by Bruce Miller [see Further Reading, section II].

If one compares Dix's **Portrait of the Artist's Parents I** of 1921 with his **The Artist's Parents II,** painted in 1924, it becomes apparent that subtle changes began to appear in the artist's style nearly a year before his trip to Italy.

The mood of the first portrait is dreary and oppressive. Il- luminated by a stark, dramatic light, his parents are seated on an old couch set before a bare wall. Forms are pushed forward in space by the diagonal in the lower left. While the rolled-up shirtsleeves and gnarled hands of his parents point to their proletarian social status, the gloomy setting speaks of their depressed psychological state. The 1924 portrait, on the other hand, is filled with bright, cheerful colors and lively, linear patterns: distortions of space and anatomy are now used for comic effect. Dix thus replaced the intense drama and harsh social commentary of the early portrait with delicate decorative patterns and light- hearted humor in the latter.

In the fall of 1925, Dix moved to Berlin, where he painted many of his finest portraits. Still the center of German fi- nancial and political power, of commerce and the national film industry, Berlin in the 1920s was a city teeming with exotic personalities. The depressed value of the mark and the collapse of social conventions had transformed the old Prussian city into a mecca for international travelers and adventurers of all sorts. "Berlin had become a kind of ba- zaar," wrote Marc Chagall, "where everyone coming and going between Moscow and the West met. . . . You felt as though you were living in a dream and, at times, a

nightmare." This was also a city of vast contrasts: of both bohemian and "official" culture, of wealthy industrialists and immense poverty, of international banking and experimental theater, of great scientists (Albert Einstein, Niels Bohr, Max Planck) and the decadent cabarets romanticized in the novels of Christopher Isherwood.

During his two years in Berlin (1925-27), Dix was besieged with requests for portraits. He painted exotic dancers, journalists, art dealers, photographers, doctors, industrialists, wealthy financiers, merchants, lawyers, politicians, fellow artists, and the bohemians who frequented the infamous Romanische Café.

Dix's Berlin portraits provide remarkable insights into the personalities that made up this cynical, dispirited society. Anita Berber, for example, the subject of one of Dix's most famous portraits, was an exotic dancer and a notorious underworld figure, a lesbian who married several times and suffered from tuberculosis, alcoholism, and heroin addiction (she died at age twenty-nine of a drug overdose). Dix has appropriately portrayed her in a dazzling scarlet dress that clings tenaciously to her sinuous body; menacing nails sprout from her clawlike hands; her puckered face is punctuated by ruby-red lips and two dark, languid eyes lying beneath flaming orange hair. In Dix's portrait, Berber seems part serpent, part corpse—a symbol of the nihilistic, self-destructive impulses of the age.

The journalist Sylvia von Harden, the subject of Dix's best-known Berlin portrait, wrote for *Die Rote Erde* and was known as both a "morbid character" and "the terror of the middle class." Dix consequently painted her with yellow teeth and in strident blood-red and black tones that convey something of her combative, predatory personality. "Every person," Dix once observed,

> has his own quite specific color which affects the whole picture. The nature of every person expresses itself in his exterior. The exterior is the expression of the interior, that is the outside and inside are identical. This goes so far that even the folds of the dress, the person's bearing, his ears immediately afford the painter information about the model's soul—the last more than the eyes or mouth.

In this particular portrait, von Harden's monocle, shapeless body, affected gestures, and even the "von" of her surname—can be interpreted as references to the debauched state of the former aristocracy and to the sexual amorality of the era.

Dix reserved some of his most pungent satire for his portrait of Albert Flechtheim, an influential art dealer who believed the French Cubists were the greatest modern artists and privately derided Dix as a "fart painter." Dix returned the compliment . . . [by] painting Flechtheim with spiderlike fingers, hunched shoulders, a rat-like face, enormous ears, sickly yellow skin, and greedy myopic eyes (perhaps a pun on Flechtheim's "short-sightedness"). In a gesture of supreme irony, Dix signed the Cubist painting hanging on the wall directly behind Flechtheim with his own name. Löffler notes that, despite the satirical tone of this portrait, "Flechtheim's only reaction . . . had been

to criticize Dix for dressing him in an unfashionable jacket."

Not all Dix's sitters were so imperceptive (or ironic!). It has been reported, for example, that the Oberbürgermeister (mayor) of Dresden "refused to allow Dix's portrait of him to be hung in the Rathaus [city hall]," and when Dix gave the banker Kurt Arnoldt his portrait, Arnoldt silently set the painting face down on the floor.

We may assume that Dix's distortions of color and form, often used to caricature his sitters, were quite deliberate, because he did not always depict his sitters so unfavorably. It is instructive in this regard to compare Dix's portrait of Flechtheim with his *Portrait of the Photographer and Art Dealer Hugo Erfurth.* In the latter, Erfurth delicately holds a camera lens as a Renaissance scholar might have held a globe or a scientific instrument in a sixteenth-century painting by Holbein or Dürer, thus suggesting that Erfurth is a sensitive, intelligent man. Both Flechtheim and Erfurth sold works of art, but Dix clearly had far more respect for Erfurth and consequently portrayed him in a sympathetic manner.

Even during his *Neue Sachlichkeit* or "realist" period, Dix continued to exaggerate and distort forms—sometimes to grotesque proportions—in order to intensify and exaggerate the essential character of his sitters. Sometimes, as in his portrait of the laryngologist **Dr. Mayer-Hermann** of 1926, these distortions are employed for comic effect. At other times, as in the portrait of Flechtheim, Dix relentlessly stripped his sitters of self-delusion to reveal their true nature. (pp. 318-24)

Dix painted [Josef] May with the same dry, dispassionate "objectivity" that characterizes his finest *Neue Sachlichkeit* portraits. The drooping, flaccid skin around May's heavy-lidded eyes, his deep-furrowed brow, thinning hair, and stubby moustache are all rendered in extraordinarily meticulous detail. Equally laborious attention has been given to the depiction of the veins lying just beneath the skin of May's hands, to the tiny bristle-like hairs on his forearms, and to the individual braids of his wicker chair. Razorfine lines delineate May's hands and face, making him appear frozen and static, as if chiseled in stone. The sinuous lines that establish the contours of May's sleeves, on the other hand, are overly energetic; they twist and writhe like coiled springs, stubbornly refusing to let May rest comfortably or naturally in his chair. And May's lilliputian tie seems oddly proportioned in relation to his large, imposing head and the wide collar that wraps tightly around his bullish neck. "There is not one portrait [by Dix]," observed Schmied [in *Neue Sachlichkeit and German Realism of the Twenties*], "that fails to suggest something obscurely horrific, even in details normally taken for granted, such as the sitter's posture or the position of the hands . . . behind the civilized veneer Dix shows us the animal vitality of human nature."

Dix's **Portrait of Josef May** is filled with subtle psychological tension. May stares toward our left, but at nothing in particular. His eyes seem uncoordinated: while the left looks upward, fixed and intent, the right looks lazily ahead. The tensions generated by May's gaze are rein-

forced by the taut lines of his lips, clinched jaw, gnarled hands, wiry contours, and the obsessive rendering of details throughout the entire picture. As his lower lip pushes outward, the poisonous yellows of his skin clash with the greens of the background. By exaggerating the proportions of May's overly large head and ears, as opposed to the compressed size of his torso, Dix made the sitter appear awkwardly squeezed into this airless compartment of clashing hues: garish greens, rust reds, dull blues, and mustard yellows.

Although Dix may have imitated the style of Renaissance portraits, the mood and "meaning" of his *Portrait of Josef May* are entirely different from that of Dürer's *Self-Portrait* of 1498 or Hans Holbein the Younger's *Portrait of the Merchant Georg Grisze* of 1532. Instead of staring blankly into space, Dürer engages us confidently in his portrait with a sure, direct gaze. He appears to command his environment, represented symbolically by the landscape in the upper right, as if proclaiming the Renaissance view that man exists at the center of a fixed, hierarchical universe, which he dominates by virtue of his superior intellect. In the Holbein portrait, Grisze is surrounded by symbols of wealth and knowledge, which function as extensions of human reason and attest to the artist's faith in man's ability to control and understand the world. May, on the other hand, is cut-off from contextual relationships. Clutched tightly by the tentacular arms of his chair like the prey of some predatory animal, May seems a Kafkaesque figure of modern alienation and anxiety, the victim of a world he can neither understand nor control.

Although "realistic," Dix's *Neue Sachlichkeit* style conveys an entirely different meaning from that of Dürer's precise, linear draftsmanship and its implied "rationality." It informs us of Dix's revolt against the painterly tradition that dominated German art in the early twentieth century and its corresponding glorification of the individual. Instead, Dix's cold, hard, meticulous realism, which often revels in hideous and grotesque details, seems to place physical facts above human concerns. By giving equal emphasis to all elements—i.e., treating both animate and inanimate elements with the same relentless, machine-like objectivity, Dix's portraits suggest an absence of ordering and values, as if the product of a deliberately dispassionate, anti-aesthetic attitude. Moreover, Dix's *Neue Sachlichkeit* style implies a denial of sensuality and freedom, as if a metaphor for the repression of the individual by bourgeois values and authority. "The New Objectivity," observed Matthias Eberle, "mistrusted primal force as much as mechanical power" [see excerpt dated 1986].

Dix was clearly interested in more than the imitation of nature. In a sense, it is misleading to label his style "realistic" because of the way he intentionally exaggerated and distorted form. Although not illusionistic, Dix's portraits are characterized by a profound *psychological* realism. His sitters often stand or sit uncomfortably, their bodies sometimes twisted, contorted, and squeezed into tight, constricted spaces. Illogically shifting viewpoints generate disconcerting spatial tensions. Yet, in spite of their discomfort, Dix's sitters seem frozen in static poses and constrained by the artist's hard, unyielding outlines, as if

trapped in a hostile world that remains indifferent to human suffering. Moreover, the colors, gestures, and poses that Dix selected for his models often convey symbolic meaning. "Photography," Dix observed,

> can only record a moment, and that only superficially, but it cannot delineate specific, individual form, something that depends upon the imaginative power and intuition of the painter. A hundred photographs of a person would only result in a hundred different momentary aspects, but never capture the phenomenon as a whole.

In his *Neue Sachlichkeit* portraits, Dix examined his contemporaries with brutal honesty, often exposing their inner ugliness, as well as the demoralizing, corrupting effect of their environment on the human spirit. He intensifies our psychological experience of each individual sitter, revealing through his portraits the tragedy, the confusion, and the horror of a particular time and place. In his attempt to investigate the moral climate of his age by studying the individual, Dix's portraits invite comparison with the novels of Thomas Mann and the photographs of August Sander. Like playwright Bertolt Brecht, Dix used satire and irony to expose human weakness and to condemn the false values of the era. Like novelists Alfred Döblin and Franz Kafka, Dix explored the anxiety and alienation that permeated postwar society. In their own unique and powerful way, Dix's *Neue Sachlichkeit* portraits refer to the absurdity of the human condition in a world in which value systems have collapsed, in which man feels alone and abandoned. (pp. 326-28)

William H. Robinson, "Otto Dix's 'Portrait of Josef May'," in The Bulletin of the Cleveland Museum of Art, *Vol. 74, No. 8, October, 1987, pp. 306-31.*

FURTHER READING

I. Biographies

Löffler, Fritz. *Otto Dix: Life and Work.* Translated by R. J. Hollingdale. New York: Holmes & Meier Publishers, 1982, 420 p.
 Critical biography which includes 231 plates.

II. Critical Studies and Reviews

Karcher, Eva. *Otto Dix.* New York: Crown Publishers, Inc., 1987, 96 p.
 Richly illustrated biographical and critical study focusing on Dix as an innovative artist.

McGreevy, Linda F. *The Life and Works of Otto Dix: German Critical Realist.* Ann Arbor, Mich.: UMI Research Press, 1981, 146 p.
 Focuses on Dix's work during the 1920s, claiming that Dix's "style is firmly based in those of the Medieval and Renaissance masters and in the strain of expressionism inherent to most German art."

Miller, Bruce F. "Otto Dix and His Oil-Tempera Technique." *The Bulletin of the Cleveland Museum of Art* 74, No. 8 (October 1987): 332-55.
 Detailed analysis of the process and effect of Dix's use of tempera and glaze.

"Fame by Installments." *Time* 81, No. 16 (19 April 1963): 86.
 Brief biographical sketch of Dix, assessing critical reaction to the artist's works.

Lee Friedlander
1934-

American photographer.

Considered one of the most significant and influential photographers of the twentieth century, Friedlander is best known for his black-and-white "social landscapes," seemingly casual and often humorous depictions of street scenes, window displays, monuments, and social gatherings that belie the complexities and incongruities in modern American life. Regarded as subtle and elusive commentary on contemporary culture, Friedlander's photographs elicit a variety of responses and interpretations and are praised for capturing, as Richard Woodward has noted, "the revolutionary geometry of everyday life."

Friedlander began taking pictures and developing them while a teenager in Aberdeen, Washington. In 1954 he moved to California, enrolling in the Los Angeles Art Center School. After attending classes for three months, however, he withdrew from school, remaining in Los Angeles to study privately with artist Edward Kaminsky and to associate with the city's community of artists and jazz musicians. Following the advice of Kaminsky, Friedlander moved to New York City in 1956, where he received photographic assignments from such popular magazines as *Esquire* and *Sports Illustrated* and won a contract with a major recording company to take portraits of jazz and blues musicians for their album covers. While commercial photography provided him with a steady source of income during the late 1950s, Friedlander became increasingly interested in the medium as a means of artistic expression. Influenced by the documentary works of Robert Frank and Eugène Atget, and encouraged by friend and colleague Garry Winogrand, Friedlander's distinctive style, characterized by critics as direct, witty, and thoughtful, emerged in his early noncommercial work depicting New York's proliferation of people, shops, restaurants, and nightclubs. In 1958, Friedlander traveled to New Orleans where he photographed moments from the private lives of his favorite jazz performers. These photographs, some of which were reproduced in *Photography* magazine, attracted much critical attention and led to widespread recognition of Friedlander's artistry.

Considered experimental and innovative, Friedlander's photographs during the 1960s disregarded traditional theories of composition, allowing signposts, power lines, and often his own shadow or reflection to dissect the picture plane. One of the best known of these works, *Cincinnati, Ohio, 1963,* centers on a downtown window display of bedroom furniture; in capturing the reflection of the city in the shop's window, it creates an image crowded with buildings, towers, bright lights, and consumer goods. While some commentators emphasize the criticism of commercialism and technology implied in this and other pictures, others find that Friedlander's works also produce a humorous effect that undercuts the social commentary.

Nevertheless, Friedlander's photographs are considered important for offering new ways of visualizing and appreciating the remarkable in commonplace scenery and events.

In 1960 and 1962 Friedlander received Guggenheim Fellowships which allowed him to travel throughout the United States, photographing the "social landscape" of American small towns and cities. These works, along with several self-portraits, became part of a 1967 exhibition entitled "New Documents" at New York's Museum of Modern Art. The show, consisting of photographs by Friedlander, Winogrand, and Diane Arbus, had, according to one critic, a "bellwether impact," expressing the artists' dissatisfaction with American culture and values, popularizing modern photography as an art form, and garnering critical acclaim.

During the 1970s, Friedlander widened the scope of his photography, becoming less socially motivated and more interested in perception and techniques of representation. Photographing such subjects as flowers, sculpture gardens, and nudes, Friedlander maintained the distinctive humor and candor of his style. However, some critics upbraided him for his concentration on the personal and the abstract at the expense of social criticism. In 1976 Friedlander published *The American Monument,* considered one of his most important collections. The book documents famous and obscure monuments and statues across the United States, contrasting their historic and commemorative intent with their often nonheroic surroundings. Another notable series, *Factory Valleys,* consists of photographs documenting the personalities and working conditions of people in the industrial pockets of rural Ohio and Pennsylvania.

Critics generally maintain that Friedlander's style and innovations in composition have influenced the direction of modern photography by emphasizing artistic as well as documentary effects. Andy Grundberg has written that "[Friedlander's] pictures do not prescribe a previsualized universe; rather, they investigate possibilities of visual meaning while rendering visual fact."

ARTIST'S STATEMENTS

Lee Friedlander with Sue Allison (interview date 1984)

[*In the following excerpt, Friedlander discusses his technique and artistic vision.*]

[Allison]: *For someone whose pictures are so well known, you yourself have remained elusive. Don't you like to talk about photography?*

[Friedlander]: It's not a pleasure to talk about one's work, and I don't know how to talk about it. Photography is a bit sacred to me. When you base your life on doing it—as I do—you don't always want to know the mechanisms.

Would it be possible to say, then, that you make your photographs instinctively?

A photographer is stuck with that moment, so it almost inevitably is instinctive. You don't think about it before or after you do it. A painter or a writer can re-work something, but a photographer really can't do it again. The sun goes behind a cloud and the whole thing changes. If you asked that question of an athlete, he wouldn't be able to say how he makes the choices he makes in a game. Photography is quite similar to athletics—more so, maybe, than to art.

Do you consider yourself a "street photographer"?

If you're in the street, I guess they're street pictures. If you're in the woods, then they're woods photographs. When I do a portrait, then it's a portrait. I don't have any concepts about where I should be, except that I'm interested in the subject.

Why are there so many compositional elements crammed into each picture?

I like to keep as many balls in the air as I can. That's kind of a fun thing, when you keep learning how to put more stuff in. But only when it demands it. Some pictures you have to keep very simple.

You change subjects pretty often. How do you decide when?

What happens is that your interests change. You probably wouldn't photograph the same things in a scene one year to the next. You change your photography a great deal by what you know and what your interests are.

You have made photographs that seem socially caustic, but in **Factory Valleys** *you seemed very sympathetic towards American industry. Why?*

Well, I simply loved Pittsburgh. It's a very beautiful city. Admittedly it's not Florida, but still I loved being there, with those river valleys and those hills with the little houses on them. But when I was there, it was a little before all the unemployment problems.

Taking pictures is one thing, being recognized for them is another. How did that happen?

People like Garry Winogrand and myself were working as commercial photographers before being discovered by the art world. We were doing our own work for our pleasure. Then this boom came along and it became possible to be a photographer without doing other things if you didn't want to.

What did you learn from, mostly?

Just by myself. You listen to people, to your friends, then you sort things out for yourself. You look at pictures by other photographers, like Walker Evans and Cartier-Bresson; those are real urgent places to look.

Have you developed a style you feel comfortable with?

I don't know if feeling comfortable is a condition, or an attribute. You're better at your craft when your whole life is devoted to doing it, so the more experience you have, the more agile you are at being able to do what you want to do. It still doesn't make taking pictures more comfortable or easier. As soon as you tackle something new, it's hard again.

What makes it so hard?

Photography is harder than it seems. It seems simple, but a lot of it is there just to edit it down to what matters. You're learning all the time. I think it's a hard medium because you can't take a photograph apart and rebuild it.

Is there an easy way to learn?

It's only hard when you don't know how to do it. You just have to learn. For instance, I'd like to learn how to do nature landscapes. I'm working on it by starting with a plan. Probably my earlier interest in brush and trees is my emergence into doing landscapes. But right now, I'm into making photographs about 12 or 15 feet from the subject. Gradually, I'll start to move back.

When did you decide that photography was what you wanted to do?

I think everybody who has become a photographer had that strange experience of seeing something come up in the developer. At the age of six or seven somebody showed me a piece of blank paper going in water and an image coming out. That's so seductive that there's no way you can't be interested in it. If somebody who is a photographer told me they didn't find that interesting, I wouldn't believe them.

Is that why you do black and white?

You have to think of your materials, and you think differently if you're using color. I've never learned how to do color, but I don't have anything against it.

Do you spend much time printing?

Not enough. I'm four years behind.

You don't hire a printer to help out?

No. That's one of the nice things about photography—you can do it yourself. You don't have to, of course. Cartier-Bresson never prints and his pictures are beautiful. I'm not much of an administrator, so I prefer to do it myself. It's not any better. It's just my way.

You teach from time to time. What's your approach?

You can give the most help to people who want to work hard. It's been my experience that most of them don't want to work very hard. They're 20 or 30 years younger than I am, and I always expect that they'll have all this energy, like a young calf or something. But they're all wrapped up in themselves, in their own heads. They don't know how to work. The ones that work, you can always

deal with. They're making pictures. The ones that don't work, nothing is going to help.

When you make a picture, are you thinking about how the viewer is going to react?

Absolutely not. I don't think that kind of communication exists in photography. One person can say one of my pictures is such and such and two months later someone else says that picture is something else. I mean, if communicating through pictures really worked, wouldn't there be no wars after everybody saw photographs of wars? On the other hand, it seems that if you watch a McDonald's commercial it can make you salivate, even though you might not like hamburgers. So I don't know how those things work. Don't ask me.

You don't care whether people like to look at your pictures?

I'm not preoccupied with that. It doesn't help. Sure, it obviously does give me satisfaction. But making the picture is what's important.

What do you think of photography books?

I love books. There's a lot of information in them. Photographs often seem easy to read, but they're not always. There are lots of layers to them. I've never picked up a book by someone like Walker Evans or Cartier-Bresson or Garry Winogrand and not seen something that I never saw before, even though I might have had that book in my possession for 20 or 25 years. I always see something. So I think books are the best way to look at photographs.

Are you aware of putting your own "signature" on your photographs?

It's purposeful in the sense that you photograph the way you know how, but you don't consciously think about it. For instance, I've just put together some portraits I've done over the last 20 years. I looked through them and saw that I had a body of work. Every time I show them to someone, they say, "I didn't know you did that kind of picture." I never thought everybody should know what you're doing all the time.

How do you decide what to shoot? Do you start with an idea?

It's not ideas. It's conditions. I'll find I'm interested in a subject because I've already started photographing it. A subject will continue to come up in my contact sheets. Once I find myself interested in a subject I pursue it as if it were an idea. Some people work with ideas, but an idea comes to me after I'm already involved in it. It's like the monument series. I had been working on them about six months before I realized I was interested in them. So I thought, well, I'll do another 20.

Do you try to make a point of looking at other people's work very much?

No, not much. It's inevitable that I see it, but I'm not much of a critic, really. I don't really understand a lot of it. I like to look at Garry's pictures because they're so exciting. His pictures are intelligent. I love to look at them.

You once said that you're fascinated with the camera's abil-

ity to freeze time. Is that an important part of your photography?

Part of it. But part of it's the subject. After all, you could point your camera at the sky and it would certainly freeze time as well as if you pointed it at something interesting. Subject matter is very important. That a picture stops time is inevitable.

Your composition is always very strong. Is this conscious on your part?

I think so, but that's the kind of thing you're mainly aware of when you're first learning things like that. Somebody once asked Garry Winogrand what was the most important thing about Eugene Atget. Garry said, "He knew where to stand."

How do you know when you've found where to stand?

You don't until you find it, and then only if you're lucky. You're *really* lucky if you can then make a good photograph. A lot of it is being ready, but a lot more is luck.

Do you photograph every day?

Not every day, but most of them. It's not an encumbrance to carry a Leica, a couple of extra rolls of film or even a flash. I can carry it all in one tiny bag. If I'm traveling, I take two cameras in case one breaks. Two lenses. It just depends on what you need. It's easier for me to work light. I know that some people like to carry a lot of stuff around with them, but photography doesn't care how much equipment you use.

So you're literally always photographing?

I'm always ready. It's not as if you say, "Oh, there's a picture, I must get my camera out." My camera is usually out. I like to do it, but it's become a habit, too. I think that by now if I didn't do it all the time I'd have withdrawal anxiety, just as you would from caffeine.

What do you look for?

One of the reasons you photograph is that you're curious about what things are going to look like as a photograph. You're not so sure about what's there. You don't have expectations.

Are you surprised sometimes?

Always. It's either exciting or curious. You say, "Boy! I wonder what that's going to look like!" But in a way, you're also not surprised. You have an inkling of what things might look like because you work all the time and you kind of recognize what happens in the transformation. A photograph is not reality. It's really something else. It's a photograph.

Do you stalk pictures?

I don't know if you stalk pictures. You stalk the world. When you see a condition, like a parade, you say, "Parades are always interesting. There's got to be something there to be photographed." And there is.

A lot of your pictures look like clichés. Do you care?

I like sort of mainstream conditions. If you saw an Ansel

Adams scene, at first it wouldn't seem needful to do it. But that doesn't mean that you can't work in Yosemite. Photographers like me are junkies. You have to do it. So if your backyard is where you have to do it, that's where you do it. If you go somewhere else, well, then *that's* better.

Do you ever go to exotic places?

Every place is exotic. I'd like to go to India or China, and I intend to. Fortunately, I can afford my habits at this stage. I just came back from Egypt.

What did you do there?

Everything. The light is beautiful. But I didn't go into any of those things where I should have gone for my own education, like inside those tombs. It was too beautiful outside, so mostly I just walked among the ruins of the Egyptian towns—not the ancient ruins, the contemporary ones.

Did you know what you were going to photograph there?

I didn't know what I was going to do.

Does it take time for you to adapt?

I suppose it does, but I don't mind that. I like being an outsider. I don't want to be an Egyptian or a Japanese. I truly don't. A photographer is sort of a high-class tourist, who basically has an accentuated curiosity about the same stuff that other people go for.

Where do you think you fit into the art world?

I couldn't care less. That's for somebody else to decide. I just like doing it. I'm happy being called a photographer. That's good enough for me. (pp. 52-61)

Lee Friedlander and Sue Allison, in an interview in American Photographer, *Vol. XII, No. 3, March, 1984, pp. 52-61.*

INTRODUCTORY OVERVIEW

Rod Slemmons (essay date 1989)

[*In the following excerpt, Slemmons describes the development of and influences on Friedlander's career in photography.*]

Lee Friedlander is today acknowledged as a master of American photography. His style—clear, witty, direct, and at the same time evasive—has remained consistent though applied to a wide variety of subject matter. After thirty years of photographing nearly every day, he continues to search with great enthusiasm and curiosity for more precise interactions between what we see and how the photograph represents what we see. Yet he doesn't fit neatly into any of the accepted categories of photography: in the late 1980s it has become common to find critics excepting Friedlander from the particular fashionable theory they are advancing.

For the past thirty years, the span of Friedlander's career, photography has been dismembered and put back together physically and theoretically by both artists and critics in a frenzied search for innovation and acceptance. Artist-photographers have moved from small cameras to large cameras and back again; they have painted on prints and negatives; and they have experimented with new developments in color. Writers on photography have enlisted economic and social theories as well as linguistic and literary analyses in attempts to develop an art history of the medium. During this time Friedlander has continued to work every day with a viewfinder 35mm camera that suits his proclivity for quick, precise decision making. He uses a simple, clear, unmanipulated black-and-white printing technique. He is more concerned with surprising ways of seeing than with unusual techniques and subjects.

In 1963, when his work was beginning to attract attention, Friedlander described what he was photographing as "the American social landscape and its conditions." The phrase "social landscape" was subsequently used in the titles of two exhibitions in 1966 and 1967 that included his work. It implied that he brought the studied, leisurely technique of photographing a static landscape to the highly mutable, necessarily abstract notion of "society." Both the irony and essential humility embodied in this phrase set him apart from reformers and social critics. His photographs of the 1960s defined an increasingly pervasive, rootless existence. They contained a skepticism about American society and the ability of the individual to understand it fully, let alone change it. Tempered by distance and wit, Friedlander's images accepted contingency as a prime condition of the social landscape. In a decade that offered great promise for personal involvement in social and political change, this was an iconoclastic position.

In the twenty years following his first museum exhibitions, Friedlander has developed his art in a surprising number of directions. Through travel and commissions, he has taken his camera off the street and into many new areas; but he continues to build on his initial feelings and discoveries made in the street, where he was the confident stranger juggling observation and participation, diffidence and intrusion. He has acquired subsequent generations of admirers—not all of them artist-photographers, as was initially the case—who have followed his search for the elusive visual metaphors that may at first seem confusing and intentionally difficult but that in fact clarify his and our position in the social landscape. (p. 111)

Lee Friedlander has not elaborated in depth on his work in lectures or writing; his practice is to identify his photographs by place and date only. Keeping his intentions to himself must be respected as a part of his art. He has consciously closed off avenues of interpretation that are open in traditional documentary and journalistic photography as well as in contemporary Conceptual work accompanied by text. We must therefore establish context and meaning from internal evidence, the brief identifying caption, and our knowledge of photography's role in our culture. However, some clues to his operating method and his general desires for how we see his work can be gleaned indirectly from his anecdotes.

He remembers at age sixteen in Aberdeen being strongly affected by hearing a recording of the great jazz saxophonist Charlie Parker: "I was dumbfounded. I somehow knew exactly where he was coming from. He made me understand that anything is possible." He began to learn as much as he could about jazz and hitchhiked often to Fort Lewis, near Tacoma, Washington, to hear the bands that traveled there to play at the military post. A short time later he heard Parker live in Seattle. Edward Kaminski, the artist with whom Friedlander worked in Los Angeles a few years later, was known to promote improvisation and perhaps reinforced the feelings and pleasures Friedlander gained from listening to Parker.

Friedlander's skill at freewheeling improvisation is evident in his first book, *Self Portrait.* Like Parker working within the structure of a jazz piece, Friedlander set himself a limiting conceit—his reflection or his shadow appears in every frame. This trick constantly makes us aware that we are observing intention and not accident and that the artist is intimately involved in photography—as opposed to the conventional notion of the machine doing the work. Like the jazz musician, Friedlander anchored his flights of improvisation to a repeated theme. . . . The devices of scale shift, reflection-reversal, distortion, repetition, counterpoint, and formal association by shading and contrast are all familiar to jazz musicians. Friedlander used these devices in his work to suggest open-ended alternatives to normal seeing.

Knowing that Friedlander began at an early age to understand and love the work of jazzmen such as Parker, Count Basie, Louis Armstrong, Slim Gaylord, Jimmy Witherspoon, Ray Charles, and Eddie Lockjaw Davis provides an important clue to his intentions. Much of Friedlander's work, especially the street photography and flowers and trees series, suggests the jazz tradition: gestural freedom of improvisation combined with highly complex—and cumulative—formal structures.

Consider, for example, the broken but contained rhythms and line-of-sight gestures in *Paris, 1978* and the dancing trees in *Santa Barbara, California, 1984.* In the former, the people on the sidewalk suddenly become monuments to their own balance and intentions—appearing to stagger in the presence of the solid cement truck. Under the paralyzing influence of the camera, however, they cooperate and become one articulated but uncoordinated gesture. Their appearance in the photograph no longer has anything to do with who they are as individuals, and their bodies act out a silent, surreal drama. In the latter, the trees were immobile before the camera arrived. Rather than time being removed by the shutter, here the placement of the frame and the choice of the hour, to control the shadows, creates a dance. In both photographs, gestures, large and small, graceful and awkward, act in counterpoint—like coherence and chaos in a Charlie Parker solo.

The delicate balance of intelligence and intuition and the need to make the music personal are elements of jazz that Friedlander greatly admires. He enjoys the irony that the jazz musician must have a profound knowledge of the music's traditions and must repeatedly strive for perfection in order to sound as if he is inventing the music out of nothing, unrehearsed. It is not difficult to relate this to Friedlander's own juggling of visual meaning and discovered order and his need, which approaches addiction, to photograph every day.

By his own admission, Friedlander makes a great many bad exposures, meaning that he chooses to print a very small percentage of what he shoots. He makes a second decision—the first is whether to expose or not—based on the examination of contact sheets. He refers to both decisions as being more athletic than artistic: "I try not to think about it, to work intuitively. When I choose the negatives to print, I do it partially by whim: I let my eye do the thinking. There is something elusive out there and what you are doing is trying to get it on film"—and also, he might have said, to find it on film. These statements are revealing. They reflect a very strong conviction that to rationalize the visible world with the camera would produce nothing more than visible jargon. Friedlander resists corruption of sight in the way that good writers resist corruption of language by jargon and cliché. For him, it is better to see clearly but not obviously. Seeing with our minds requires identification with known symmetry and order. For our eyes to increase their contribution to what we know, Friedlander implies, they must do it behind our rational backs.

Like most photographers, and artists in other media for that matter, Friedlander is drawn to subjects and ideas that tend to organize themselves into groups of repeated, similar challenges. Working in series or groups implies to the casual observer that the photographer goes out in the morning having decided to photograph nothing but trees and flowers, for example. In fact, every subject is related to an array of previous photographs. When new subjects advance old interests, they are engaged. In this way, threads of meaning can be pursued without closure or isolation. For example, Friedlander was asked in 1985 by John Rollwagen of Cray Research, Inc., to photograph the company's computer manufacturing facilities in Wisconsin. Rollwagen wisely gave the photographer free rein. The final selection of images was made into a gift book for Cray's employees. Yet, before he entered the Cray plants, Friedlander walked and drove around the area, adding to earlier projects—trees, street photographs, views from inside his rented car, signs in the landscape—both accumulating new material and quoting from himself. Such imagery prefaces pictures of the technicians in the manufacturing plants in the finished, carefully sequenced book. The result of this multilayered seeing is a unique visual metaphor for what goes on at Cray: the sensuous chaos of the trees suggests the impossibly numerous wires of the supercomputers as well as the tousled hair of the computer technicians. An extension of these formal connections is the suggestion that the complexity of communication and thought going into the computers is at least matched by a view from the car window or by the face of an employee.

When Friedlander was invited by the Seattle Arts Commission to make a set of photographs of Washington State in 1980, he chose from all of the exposures he made of a variety of subjects on the visit only images of foxgloves along mountain roads. He may have been saying, to para-

phrase Edward Kienholz's famous quip, "This is a portrait of Washington if I say it is." On the other hand, based on Friedlander's own comment on this choice—"You have to be responsible to the subject. A flower can't look like concrete"—we may assume that the problem of photographing flowers was the one that he solved that week in Seattle: "I make photographs of specific things because people ask me to. But it is all a continuity to me." Again, like the jazz musician, his choices are determined partly by problems he has set for himself in the past and partly by intuition and improvisation at the moment.

Seattle photographer Michael Burns has said of Friedlander's work that it appears to be both a horizontal and a vertical search. The vertical axis is from the known to the unknown, a process of discovery through an infinite number of unsorted subjects. The horizontal axis is an exploration or elaboration within a particular subject. When Friedlander found that garishly colorful partygoers locked in black and white within the 35mm frame would add a gritty new dimension to portraiture, he tried it again and again. This kind of exploration takes precision and patience. The first step into the unknown to find such a series, to hear Friedlander talk about it, takes great freedom and curiosity. Once the photographs are thought of in this way, threads of significance begin to stretch from one group to the next, unhindered by context or verbal description.

By moving on both axes of exploration simultaneously, Friedlander has been able to combine visual knowledge acquired from each and to create entirely new ways of seeing, year after year. But while he changes, there is a cumulative process going on as well. A core group of images keeps cropping up in his exhibitions and publications. These have repeatedly made it past his intuitive selection and have remained, growing in meaning for him—and for us—as new images are added. Friedlander tells a story that reveals something about this cumulative responsibility to his own talent. He once saw a quilt in the Kentucky State Fair that, in his words, made his hair stand up. An elderly woman who had been winning awards at the fair all her life decided to enter a huge quilt made of all the ribbons she had ever won: "It was not only beautiful, it was her history."

Identifying visual issues that transcend thematic groups helps to reveal Friedlander's overall strategy. Compare, for example, *"Wooden Joe" Nicholas, New Orleans, 1957* in the jazz group with *Sidney, 1977* and *William Christenberry, Tuscaloosa, Alabama, 1983.* In all three, the subjects are intersected by unruly, twisting branches. We may be tempted to read these as symbols of the conflicting demands of a song out of which the jazz musician makes new sense, in the first photograph; or the rich and varied imagination of the photographer Christenberry, in the third. But what about the people in Sidney whom we don't know?

These three photographs are better seen as addressing a larger issue of picture making. The metaphoric possibility of an image, its ability to carry meaning other than itself, depends upon a knowledge of its artificiality. A picture is an intermediary between us and the world it clarifies. If

we slip past the outer frame and become involved in the illusory reality of the picture, Friedlander has provided internal obstructions that we can't miss. The branches and vines distance us from the subject and from the picture itself, like a hand in front of our face, holding us back to make sure we are aware of the filters we see through. This ploy takes other forms in Friedlander's work: chainlink fences, window frames, hair, wires, mirrors—all conspire to keep us back, to keep us from falling into the picture looking for literal or symbolic meaning. They prepare us for a formal recognition: the picture is two-dimensional, black and white, and prepared on purpose by another thinking individual.

This formal understanding is not just an exercise in learning about how pictures work, although that is implicit. And it is certainly far from the knowledge we are meant to carry away from documentary photographs. The human consequence of the photographs of Lewis Hine, for example, was to arm us with information that would encourage change in abusive child-labor practices. Friedlander has less confidence in the direct power of the image to implement social change. But he is doing more than just seeing and knowing, as Szarkowski suggested he was doing in the 1967 *New Documents* exhibition. Friedlander, as he says himself, is after something more elusive. If we learn about how pictures work—and keep our distance from them—we are able to learn something about how extensively our eyes are controlled by pictorial conventions. This is knowledge beyond formal considerations that has the human consequence of preserving our freedom of choice.

To the extent that the meaning of Friedlander's photographs is defined by what is in the frame, they are in the formalist tradition of modern art. The exceptions are portraits of family and close friends that gain from knowledge of these people. But formalism implies a closed system with little or no reference to our lives, or the artist's for that matter. These photographs, however, refer to those parts of the world where we spend most of our time: backyards, factories, sidewalks, offices, cars, and so on. Specifically, they refer to elements of those areas where our eyes are normally free to do what they want, outside of the demands of feeding the brain critical information. In a lyrical sense, these pictures are ours to begin with, without any knowledge of art or how it works. We have a working knowledge of even the most anonymous interiors and the unknown streets. They are where our incoherent collective humanity pays off with either joyful freedom or confining repetition. With careful structure and abrupt photographic frames, Friedlander intersects both our visual expectations and our working knowledge of what we see.

Given the scope and diversity of thirty years' work, it is very difficult to make definitive statements about Friedlander's intentions and successes. He is unwilling to indulge in increasing our familiarity with any specific subject. Unlike Arbus and Winogrand—and many other photographers—whose subjects are more often than not bizarre and inherently demanding of our attention, Friedlander starts with the commonplace and builds our visual understanding of it in uncommon ways. It would be easy

merely to succumb to his unique way of seeing and to adopt it for ourselves, as we are used to doing with other socially determined, media-established visual conventions, but he denies us this luxury by continually changing his uncommon ways of seeing. A good example is a series of portraits of computer workers he made for the Massachusetts Institute of Technology. We know that the American workplace can be dehumanizing, although not all of us know what the latest manifestation of dehumanization looks like. After the initial impression the series gives of workers in a common trance—induced by concentrating on computer screens—we begin to notice subtle signs of composure and vital individuality. We realize that the difference between the order our eyes seek—based on clichés about dehumanization—and the order ultimately provided by the series of photographs is disturbing. We find ourselves informed by the seemingly dull repetition of the photographs rather than by what we think we know about the dull repetition of the computer jobs.

Both the evolution of Friedlander's later work and the cumulative discoveries of his career are perhaps best observed in a series of photographs he made in Ohio and Pennsylvania in 1979 and 1980. This body of work was commissioned by the Akron Art Museum and subsequently published in 1981 in the book *Factory Valleys.* Museum director John Coplans gave the photographer no explicit instructions other than to photograph in the areas indicated. Friedlander's portrait of the region ranges from workers at machines to winter landscapes that include factories and houses, torn-up earth and railroad tracks, and bare winter trees. On the surface, the series as a whole presents economic decline, environmental wear and tear, and a generally bleak image of the Rust Belt. But there is great underlying formal beauty in the photographs. This deliberate contrast is heightened by idiosyncratic and unexpected flashes of humor and humanity. Like his photographs of the 1960s, in which he seemed to ignore the tumultuous cultural context, this humanistic formalism that finds something beautiful and something to laugh at in the context of social, economic, and environmental decay is iconoclastic. In *Pittsburgh, 1979,* Friedlander juxtaposed an idle steel mill with a nearby neighborhood. Dividing the two are a highway and a tree, both gracefully curving out of the frame. Their "gestures" contrast with the jagged factory and the rundown homes. The entire frame is veiled by a scrim of young trees and branches. The photograph reveals and releases tension and meaning slowly. Both the possibility and the impossibility of flight from the bleak area are suggested. Scraps of old dreams of a good job in the mill and a nice house in the woods remain in the area. The picture is as confusing and full of questions as the world it depicts. It contains no answers and no promise of reform.

In another photograph in the series, *Canton, Ohio, 1980,* a grandmotherly worker makes what appears to be a mock gesture of disbelief at something her machine has done. Actually, she is keeping her hands from being crushed by executing a graceful, often-repeated motion. Another worker appears to be offering himself absurdly to an impaling wire. The humor in these images is an artifact of our reading of the photograph, not our knowledge of its

subject. The function of the humor is to contrast with and more clearly reveal what appear to be dangerous places for the photographer as well as the workers. In *Pittsburgh, 1979,* reported by Friedlander to be disturbing to some people connected with the Factory Valleys project, a piece of structural steel is covered with wildly incoherent profanity. It also serves to establish an uneasiness, a watchful anxiety that enriches our perception of the whole series.

While the Factory Valleys, Cray, and M.I.T. projects may have the look of reformist documentary photography, they have none of its effects. Friedlander may have a profound reverence for seeing itself and feel a sincere responsibility to his subject in terms of its representation, but he reserves a sly irreverence for what he sees. The photographs are not going to make us into supporters of trade unionism or into ecologists or even make us socially aware. They do, however, cause us to see the world, and representations of the world, in ways sufficiently new so as to make us suspicious of social and political pronouncements based on simplistic descriptions—verbal or visual. (pp. 114-17)

Friedlander's delight in modulating the strength and speed with which each image enters our imagination is evident across the entire body of his work. The constructed reality of *New Orleans, 1968* is revealed slowly, by fits and starts. The reflective surfaces of the window and the mirror beyond the window are hard to reconcile with the surface of the photograph. The photographer and a bystander—who stands for us, perhaps—are reflected back and forth by the surfaces and are hard to place within the illusory space of the photograph. The photograph demonstrates that seeing is not an act that can be simply described, even with a camera.

Just when we develop a taste for Friedlander's photographs or think that we can identify a style, a hallmark, a common tool for understanding, he changes. He refuses to follow conventions even if he established them himself. His photographs of nudes are a good example of this. Perhaps the thickest layers of visual preconceptions to be found anywhere are those that adorn the photographs of people in the nude. However, Friedlander's subjects refuse to become figure studies or voyeurs' abstractions. They twist slowly and comfortably in the frame and turn into images of self-composed, living women, aloof to the gaze of the "one-eyed cat." Friedlander has taken on the seemingly impossible challenge of retrieving sensuality from a photographic genre intent on destroying it. *Baltimore, 1968,* on the other hand, is a raunchy visual joke, as quick as the movement of the camera shutter. It is like a null set, bringing everything abruptly back to a known starting place.

Friedlander does not hesitate to quote and reuse elements of the photographic idiom that he has learned from others. The lettering in *Chippewa Falls, Wisconsin, 1986,* from the recent Cray project, is a clear reference and homage to Walker Evans. Evans was fond of including lettered signs in his frames to remind the viewer of the opaque, intentional qualities of his photographs and to dissuade him from looking through the surface to an expected reality beyond. In his early work, Friedlander elaborated on this

device by cutting up the rectangle of the 35mm frame with the vertical interruptions of power-line poles close to the camera. Dividing the frame is another reminder of the artifice and illusion at work in an other wise very "real-looking" two-dimensional picture. The process is similar to an actor turning to speak directly with the audience. Suddenly the proscenium arch appears and the audience reestablishes the otherness of the play. Being aware of the "otherness" of the photograph is necessary before we can truly indulge in the pleasures of form offered by multiple-frame images such as *Houston, 1977* and *Cambridge, Massachusetts, 1980.*

His use of a viewfinder 35mm camera and black-and-white materials and his consistent print size and technique—only recently has Friedlander printed in any size other than 11 by 14 inches—comprise a cleanliness of craft and precision of abstraction rare among his contemporaries. While he has worked in color on occasion, he insists of color prints, "It can't look like that." By translating into black and white traditional photographic subjects, such as colorful cherry blossoms in Japan, lush green landscapes in Washington, and straightforwardly sensuous women, Friedlander continues to insist on the simple aesthetic position of making pictures about the world, not of the world.

The writer and critic Andy Grundberg has observed: "Lee Friedlander's work, despite having earned a reputation as formalist in some quarters, consists largely of a critique of our conditioned ways of seeing." To accomplish this, Friedlander is careful to inhabit, with his camera, places that we all have access to. But he makes photographs that none of us would make. We would be prevented by the conditioning Grundberg alludes to. The viewfinder would look either too cluttered or too empty; the subject would be ambiguous, too dreamlike, or too straightforward. We would call ourselves too shy or too professional, anything to keep from making that particular exposure that is the one Friedlander would select from the roll. His genius in finding the "something elusive out there" derives in large part from his ability to celebrate unexpectedly and suddenly the existence of a thing or person, helping us to understand better the relationship between seeing and knowing. (p. 117)

Rod Slemmons, "Lee Friedlander: A Precise Search for the Elusive," in Like a One-Eyed Cat: Photographs by Lee Friedlander 1956-87, *Harry N. Abrams, Inc., Publishers, 1989, pp. 111-19.*

SURVEY OF CRITICISM

James Thrall Soby (essay date 1960)

[*Soby was an influential critic, editor, curator, and promoter of Modernist art. He is noted in particular for his long association with the Museum of Modern Art in New*

York City and for his many highly regarded critical studies. In the following excerpt, he praises Friedlander's series of photographs of New Orleans jazz musicians.]

Of all aspects of modern American cultural life surely none has been more colorful and persuasive than jazz music. Moreover, its underlying fervor has been so strong that no single region could contain or define it entirely. Instead, we speak of the Dixieland style, of the Chicago style, of a Harlem beat. In jazz we have arrived at an order of principalities not utterly unlike that of Renaissance Italy, and some of the central figures have assumed a beguiling nomenclature ranging from "King," "Duke," and "Count" to "Kid Punch" and "Big Head."

Many of the figures, of course, are Negroes, and many have come from or settled in New Orleans. These admirable musicians have taken the world by storm, and in the process "Satchmo" Armstrong has become—in terms of European réclame—the peer of Poe and Whitman, Mark Twain and Frank Lloyd Wright. The musicians have been photographed endlessly playing their instruments in clubs, theatres and concert halls. But the young photographer, Lee Friedlander, had a different idea. Taking New Orleans as a focal point, he wanted to show the private as well as the professional lives of the men who have created jazz, to record the intimate no less than the theatrical ambiance which has nurtured their talents.

The result has been a brilliant series of photographs. . . . Could any photographic image be more haunting than that of the late *"Wooden Joe" Nicholas,* who sits in his disheveled garden, quiet, holding his trumpet as if it were a talisman against all evils? Or, consider the extraordinary fellowship between *Joe James,* with his aging, veined forehead, and the homely upright piano before him. There is a skull on top of the piano. Perhaps it is not too fanciful a symbolic interpretation to claim that the intervening keyboard protects, for James, life's whole meaning.

In a different spirit, there is the exuberance of the young Negroes following a band in the print called *Second Liners.* (In such frequent New Orleans parades, the "first liners" are members of an organization with the deliciously cogent title, "The Social Aid and Pleasure Club.") And then, the mood changing again, there is the immense dignity of the trombonist *Eddie Morris,* photographed with his wife, in their home. There is the portrait of *"Slow Drag Pavageau,"* wherein the old Victrola trademark, "His Master's Voice," is evocatively transformed into unrehearsed and living incident.

A word must be said as to Friedlander's procedure in creating these photographs. They were taken over the past three and a half years whenever he could get to New Orleans. Deeply interested in jazz, he knew about some of the New Orleans musicians and sought them out. They in turn told him about others whom they respected and whom he looked up. "They are wonderful people," Friedlander says, "and I wanted first to meet them and secondly to photograph them." Probably this approach accounts in part for the warmth and reality of Friedlander's imagery. He works with the minimum equipment, though like nearly all fine photographers (one thinks at once of the early

Cartier-Bresson as an exception) he uses extreme care in preparing his prints, of which very few copies exist. But it cannot be repeated too often that technique alone is never what makes an unforgettable photograph. Imaginative vision and sensitivity of eye are absolute requirements. Friedlander has both in heartening measure. (pp. 67-8)

James Thrall Soby, "Lee Friedlander," in Art in America, *Vol. 48, No. 2, 1960, pp. 66-8.*

Martha Rosler (essay date 1975)

[*In the following excerpt, Rosler addresses various elements in Friedlander's photographs, stressing his distancing techniques and the multiple meanings of his compositions.*]

Lee Friedlander's photos are in a sense exemplary. Their cool, gentle disdain places them at a crossing point between photography and high art, where meaning can be made to shift and vanish before our eyes. In 1967, when The Museum of Modern Art showed photos by Diane Arbus, Garry Winogrand, and Friedlander, the exhibit was called "New Documents"; at the recent MOMA exhibit of 50 of Friedlander's photos curator John Szarkowski termed the photos "false documents." Szarkowski's rhetoric about Friedlander has undergone the corresponding shift from asserting that the work represents a kind of device for improving our vision of the commonplace to asserting that it represents the outcome of personal "hedonism" while stemming nonetheless from "an uncompromisingly aesthetic commitment." The overriding assertion now is that Friedlander's concern is both "disinterested" and "artistic," and the corollary disclaimer is about instrumentality. That is, the work is firmly claimed as part of an art tradition and distinguished from the documentary photography of the '30s and earlier, which was meant to "change the world."

Quite a few of the photos in the recent show had appeared either in Friedlander's book *Self Portrait* or in the joint *Work from the Same House,* which coupled Friedlander photos with hairy, somewhat pudendal etchings by his friend Jim Dine. The ones exhibited at the Modern were those closest to elegance, geometry, cleanness, and high-quality camerawork, and, among the humorous photos, those displaying pure-minded irony and wit untainted by lowness or sexuality, which the book done with Dine had plenty of. All the rawest photos, in both subject and handling, were absent.

Friedlander's work provides some of the first and best examples of what has become a widespread approach to photography. It was part of the general reorientation of the '60s within American art. Within photography his work violated the dominant formal canons not by inattention but by systematic negation. High-art photography had had a tradition of being directed, by and large, toward some "universal" message. It had aimed to signify a "transcendental" statement through subtraction or rationalized arrangement of elements within the photographed space, dramatic lighting, expressive intensity of glance or gesture, exotic or culturally loaded subjects, and so on. If Friedlander uses these devices, it is only to subvert them,

to expose their arbitrariness. But in shifting the direction of art photography, Friedlander has not rejected a transcendental aim—nor has he specifically embraced it. Instead his attention is on the continuum whose poles are formalist photography at one end and transparent, or information-carrying, photography at the other. Imagine a mapping system for photographic messages: the continuum formal versus transparent is at right angles to the continuum transcendent versus literal. (A photo of a fiery helicopter crash in combat, for example, is "transparent" and literal when it functions to document the particular crash; it is moved toward the formal if the style of the photograph or the "oeuvre" of the photographer becomes an issue, but it may still be a literal document. It is moved toward the transcendent range of meaning if it is taken as embodying a statement about, say, human inhumanity, heroism, or the tragedy of war, and into the formal-transcendent range of its efficacy as a bearer of this message is held to lie with its formal rather than strictly contentual features.) Without insisting on this device we can observe that even if an artist locates his work near the formal end of the one continuum, his messages no matter how commonplace or "vernacular," are still free to wander anywhere along the other, from literalness to transcendence.

In moving toward "vernacular" photo images, photography has had to confront some of the issues behind Realism, such as whether a photograph is in any sense a document and, if so, what kind. Is it "about" what it shows concretely, metaphorically, representatively, allegorically? Does it refer to a moment alone? If so, how long a moment? Does it reveal only that moment, or does it indicate past and future as well? Or, is a photo a record of sensibility, or, is it most specifically about photography itself? These are metacritical questions about the range of messages a photo can convey as well as about how it signals what it signals. These questions are both contentual and formal, and they are all at issue in Friedlander's work.

The meaning of a photographed instant is pivotal here, though the problem is not flamboyantly explored. Among the reasons why it is unwise to compare Friedlander's photos to "snapshots" the most telling may be that they are not commemorations of a moment; once you have seen more than one, his critical concerns clearly emerge. His conscious presence assaults the notion of transparency, breaking our experience of the moment photographed while at the same time alluding to it. Whereas the photos display the look and the subjects of literal and transparent photography, Friedlander's use of these commonplace features shifts their meaning to another plane.

In commenting on E. J. Bellocq's straightforward photos of New Orleans prostitutes—photos that Friedlander had "found" and carefully reprinted—Friedlander calls Bellocq an "ultraclean realist." He continues: "I think in photography that's even more artistic than making [everything] romantic and fuzzy." Friedlander uses the word "magic" to describe the camera's ability to render things "in astonishing detail," as he phrased it elsewhere. In Friedlander's framing discussion of Bellocq, and in Szarkowski's of Friedlander, the literalist image is somehow

transformed into art-magic, but it seems that the only acceptable topic of discussion is the image—only the image is subject to control. Photography is something you do; magic is an ineffable something that happens. Friedlander has remarked that "the pleasures of good photographs are the pleasures of good photographs, whatever the particulars of their makeup."

The locus of desired readings is, then, formalist modernism, where the art endeavor explores the specific boundaries and capabilities of the medium, and the iconography, while privately meaningful, is wholly subordinate. Whatever meaning resides in Friedlander's photographs, and it is more than the image management at the Modern has let show, this set of claims allows Friedlander, and the hundreds of young photographers following the same lines, to put playfulness and pseudopropositions forward as their strategy while identifying some set of formal maneuvers as the essential meaning of their work. The transiency or mysteriousness of the relations in their photos suggest the privatization of the photographic act. The result is an idiosyncratic estheticizing of formerly public and instrumental moves.

Yet the ambiguity of presenting a set of familiar images while simultaneously denying both their exoteric reference and their commonly understood symbolic meaning is problematic in such work, as in Pop art in general. Friedlander shares with Pop the habit of converting instrumental uses of a medium into formal and metacritical ones using the techniques and images of naive photography where Pop might use those of graphic art. "Composition," control of pictorial elements, isn't really enough to distinguish work that quotes naive imagery from what is being quoted, especially in photography, where the format and the framing of art and nonart are basically the same (in painting and sculpture there is usually at least a medium or a scale change). What is required in such work is aggressively conscious, critical intelligence (as opposed to sensibility or expressiveness), signaled by esthetic distancing.

Friedlander's presentation is exhaustive yet cool, the effect markedly distanced. The voraciousness of a view that yields, in good focus and wide tonal range, every detail in what passes for a perfectly ordinary scene, the often kitschy subject handled in a low-key way, the complete absence of glamour, and the little jokes, these put intelligence and humor where sentiment or anger might have been. Distancing is everywhere evident in the palimpsests of shadow, reflection, and solidity, in the fully detailed, small-town-scapes empty of incident, in the juxtapositions and the carefully composed spatial compressions and sliced reflections that are significant only in a photo. Art-making here entails a removal from temporal events, even though the act of recording requires a physical presence, often duly noted. Friedlander records himself passing through in a car, standing with eye to camera, and so on, in widely separated locations, always a nonparticipant.

Control is evidenced by Friedlander's hard-headed, patiently systematic formal moves. Most of the issues of painterly "design" within a rectangular format turn up in his photos. There are echoes of analytical Cubism in the

deconstruction, crenellation, fragmentation, and other deformations of space and image. He gives, too, the look of collage—the (apparent) joining of disparate elements and image fragments—filtered through the attitude toward stylistics, and even in the homeyness of the subjects. When Friedlander breaks the rules of "good" photography, his doing so amounts to an insistence on photography as photography. These rules are violated by a broader set of pictorial conventions. Take the compression of foreground and background fairly common in Friedlander's photos. It violates the tacit rule that a representational photo should suggest space as we perceive it in the world, with any deformations being easily decodable. Friedlander's deformations rarely result from the optics of lenses, which we have learned to cope with. Rather, he arrays the pictorial elements so that they may connect as conceptual units, against our learned habit of decoding the flat image into rationalized space.

More importantly, spatial compression is a possibility peculiarly inherent in photography, where such junctures can happen accidentally. Friedlander characteristically locates the issue in the domain of control, which he equates with insisted-on consciousness. Once you accept that photography need not rest on the history of painting (where, before the heavy influx of photographic influence, at least, there had been no concept of chance imagery, only accident or better or worse decisions about intentional juxtaposition), you can accept as the outcome of conscious and artistic control, photos that have the look of utter accident. Friedlander's work may make us think of naive photos that incorporate unwanted elements until we inspect a body of his work, when his habitual choice becomes evident, and chance and accident can be seen to diverge.

Chance imagery figures in the wider strategy of juxtaposition and collage. Collaging in Friedlander's photos, no matter how it is accomplished, once again points out the nature of photography, its impartial mapping of light-dependent images at a single instant in time. All types of visual phenomena have essentially the same "weight" in a photo, formally speaking—but conceptually that is obviously not true. Friedlander's collages involve not just spatially disjunct imagery but a conceptually based welding of elements of different time scales into a unitary image. He tends to go for the dryly humorous junction, as in *Knoxville, Tennessee, 1971,* a rather typical naturalistic collage: a perky little cloud seems to sit like cartoon ice cream atop the back side of a leaning "yield" sign whose shadow angles down the unremarkable street. The sign is a long-term, weighty, manufactured element, the shadow is a natural, regularly recurring light-produced image that moves only gradually, and the cloud is a natural, randomly appearing visual element not as substantial as the sign but much more so than the shadow. Clouds, shadows, and signs feature fairly often in Friedlander's iconography, along with clumsy statues and telephone poles, as types of phenomena marked for duration, solidity, provenance, and iconicity. Reflections and mirror images, like shadows, also appear often, and all are, in a sense, proto-photographs. All raise questions about the immediacy and the validity of the photographic document.

Friedlander's reflection photos tend to be less casually humorous than some of his more naturalistic ones. Window reflections, a subset of light-dependent chance images, produce superimposed collaging that often is so strong it is Hofmann-esque in effect. The substrate of the reflection is a manufactured surface, usually a commercial one. Images of people are cut by or paired with other images, often without any possibility of their consent. The high number of partial inclusions in these photos makes it difficult to determine exactly what is depicted—do we see, for example, a person's reflection (is it the photographer's or someone else's?) on a storefront window or a person standing inside? Images of signs, of material objects, of natural phenomena, and of shadows—as well as of photos—are as much there as straightforward images of people. We grow confused. In a regionally marked photo, *Los Angeles, 1965* photo cutouts of two implacably smiling TV stars, conspicuously taped on a storefront window, are the only clear elements, against ripply reflections of palms, clouds, and cars. It is only the simulacra of people we see without obstruction and must, on some level, respond to as though they were photos of people, unmediated.

A photo of a mirror image, like one of a photo, provides no superimposition and so is like a direct photo of the thing mirrored. The importance of the instant is subordinate to the cognitive tension about what is seen and which side of the camera it's on. In some photos, large car-mirror reflections disrupt the unity of the image, turning the photos into diptychs or triptychs. Whether they form part of the ostensible subject, modify it, or subvert it, these images box in the space and provide a "fourth wall." Such closure is accomplished in other photos by an obstructing foreground element. Like the oblivious passerby who ruins a snapshot, these elements obtrude between camera and ostensible subject. The fronted barrier provides a cognitive, not a formal, tension like the annoyance you feel when your theater seat is behind a pole or your view out the car window is blocked by a passing truck. Friedlander's famous shadow or reflection, in virtually every photo in *Self Portrait,* also is a closing element. It is not a stand-in for our presence in the real-world moment referred to by the photo but an appropriation of it.

Some photos are falsely lame apings of genre, like the regional stereotype (the parking lot at the Lone Star Cafe, El Paso, composed into a pyramid with a pickup truck seemingly on display with the cafe sign on its roof and with cacti, gravel, and a neon star against the sky); individual or group portraiture (a flash-lit photo of potted flowers or, not in the show, a grinning group of firemen quickly posed class-portrait style before a smoking ruin); nature photography (pathetic, scraggly flowerbeds or trees); or architectural tableaux.

Portraiture is extensively undercut; people are opaque. We are kept mostly at arm's length or further. The closer shots at the Modern were party photos in which several people pressed together across the picture plane or formed a shallow concavity. They seem to be ordinary youngish middle-class urban or suburban people—the kind of people who look at photos. Their expressions, although sometimes bizarrely distorted, say more about the effects of flash light-

ing than about personality or emotion, except the most conventionalized kind. The close-up is a form suggesting psychological encounter, and Friedlander uses it to negate its possibilities. People shown interacting with things often look unwittingly funny, or sometimes peculiarly theatrical, bringing a suggestion of seriousness to the irony of their situation. This is perhaps clearest in the photos with statues.

In *Connecticut, 1973* a statue of a soldier, rifle at the ready, crouches on a tall pedestal in a small clump of greenery bordering a street of stores. Two women, one pushing a child in a carriage, have just passed it. The child, a small image at the right, is looking back. We are separated from the horizontal tableau by an almost-centered telephone-pole shaft and a street sign. In this photo are images of the immovable and noniconic (the pole), the iconic immovable looking movable (the statue), the fleeting human (the walking women and the child), and the stationary human (women seated at the statue's base). Can we extract any transcendent message? If so, it is not about war but may be about human durations—perceived durations relative to those of icons. The humanly produced statue has a potential "life span" far longer than that of any person and exists in a different time frame: everyone in these photos ignores the statues, which remain fixed against a changing backdrop of temporal events. And the time frame of the photo is that of the statue, not that of the people. Or suppose this photo is more centrally about interaction. Its dominant vectorial geometry seems to tie the gazes of statue and infant, but no interaction occurs. The child's back is to its mother, hers is toward the woman behind, and the other women in the foreground look off at right angles.

The possibility of such heavy metaphysics, despite their ordinariness, at first seems rather remote. The viewer must make some observations and decisions before considering it. The facticity of the image is in doubt: unquestionably the elements were present in the real world and the photo was not set up like a Michals, a Meatyard, or an Uelsmann photo; but it *was* set up like a Cartier-Bresson, in which the architecture required the presence of a human figure falling within a range of specifications in order to elicit the desired internal comparison between figure and ground. That is, Friedlander presumably positioned himself in the right spot and waited for someone to appear. And of course the irony is only in the photo—it is the photographer, with his prevision of a flat representation, who can present the people as transient self-absorbed entities enclosed in a humanly created space that has gotten away from its creators. The viewer recognizes that the statue's impingement is unreal; its iconicity fools us into considering that it might be implicated, whereas we know it is no more so than the street sign or the telephone pole. The viewer can decide that the photo conveys something truer than the commonplace apprehension of reality, putting the photo within the bounds of surrealism. The viewer is unlikely to accept the as-if proposition that the statue is invested with more than the surface appearance of the real and can in fact interact with the people. (The backward-glancing child is tantalizing; is he a Wordsworthian creature, trailing memories of immortality, that is, of nontem-

porality, or is he, impossibly, conscious of the statue's false menace? Is he not yet fully human and paradoxically not yet fully unconscious? Or is he just glancing back at the woman we assume to be his mother?)

The viewer accepts the simile that the statue looks as if it were engaging with the passersby only on the level of estheticized experience, or story-telling. We do not imagine that the photo is a literal document, about this particular spot in Connecticut or the figures in a townscape who appear in it. We assume the photo is synecdochic, intended to convey, if anything, something about people in general, or about some class of people, or about some class of images, or most attenuatedly, about some class of images of images.

The particular conjoinedness of images can be taken as a witticism rather than as a serious assertion about the real world. Interpretation, if it occurs, is a private task of the viewer's. Grossness or fineness of interpretation is a covert issue in Friedlander's work, just as grossness or fineness of looking is an overt one. It is likely that Friedlander doesn't care to decide at what level his photos are to be read. He presents tokens of the type that might be called "significant pseudojunctures"; his images function like the mention rather than the use of a word, noninstrumentally. Ultimately we are unjustified in associating the statue with the people just because their images share the same frame. This metamessage applies as well to photos of people with people; that is fairly clear in the party photos, for example, where you can't tell who is associated with whom, except for the one in which a man is kissing a woman's neck, and what does that signify at a party, anyway?

We can't know from a single image what relation the people in it have to one another, let alone whether they communicate or what they did before or after shutter release, and the photos rely on our presuppositions to bias them toward a reading. The general lack of such personal markers as foreignness, poverty, age, and disability allows Friedlander an unbounded irresponsibility toward the people he photographs. His refusal to play psychologizing voyeur by suggesting that a photo can reveal some inner or essential truth about an individual or a stereotyped other is admirable. But it is part of the larger refusal according to which photographic propositions have truth value only with respect to photos, not to what is photographed. Even this refusal is unstated. Friedlander has laid vigorous claim to control over his camerawork but has omitted any active claim to control over reading. His work can be taken by casual viewers as value-free sociology and, because of his denial of photographic transparency, as artful construction for photography buffs.

Friedlander's work has antecedents in the small-camera photography and street photography of such people as Eugène Atget and Walker Evans, to mention only two, but both Atget and Evans appear serious where Friedlander may seem clever, light, or even sophomoric. Atget and Evans photographed people of various classes, in their work roles and out. They cannot be accused of making their subjects the butt of jokes, whereas Friedlander does so almost always, though not the savagely involved ones of Arbus or Robert Frank. For both Atget and Evans,

photography's ability to convey hard information was not much in doubt.

In Evans's *American Photographs* there is a deadpan photo, a Friedlander precursor, of a similarly deadpan statue of a doughboy on a personless street in a Pennsylvania town. He follows it with a Vicksburg statue of an unmounted Confederate officer and his horse, a monument to heroism in defeat; Evans's framing of the statue and its isolation against the sky exaggerate the transcendental histrionic gesture enough to kill it by overstatement. Next in the book are some pretty unappealing portraits of men and boys wearing uniforms. The sequence narrows down the range of meanings of the photos to the subject of war and violence and how they are represented in the world. Evans, like Friedlander, is not psychologistic, but his photos are seated much more firmly in their social context; even his captions are more informative: *Coal Dock Worker, 1932* and *Birmingham Steel Mill and Workers' Houses, 1936* are more than the bare bones of place and year. Evans, too, used collage, including in a photo both "positive" and "negative" cultural elements: heroic statues and clean streets meeting up with prosaic power lines, icons denoting beauty or sleek commercial messages embedded in degraded human environments, people in rags lying in front of stores. Like Evans's collages, Friedlander's may preserve the impression of simple recording and mass-produced iconography at the same time as exquisite awareness of both formal niceties and telling juxtapositions. But Friedlander's collages, hung on chance and ephemera, are not consciously invested with social meaning and may or may not aspire to universal import. What for Evans occurs in the world occurs for Friedlander in the mind and in the camera. The emerging cultural icons in Evans's photos that represent the directed message of the haves imposed on the have nots are solidified and naturalized in Friedlander's. The have nots have disappeared.

In Friedlander's books Friedlander comes across as a have not himself—significantly, though, one psychosocially rather than socioeconomically defined—a solitary guy who slipped around with a camera in a crazy-clockwork world, fantasizing with mock voyeurism about sleazily sexual targets while never forgetting the meaning of a photo. More recently, as in the latest exhibition at the Modern, selected by Szarkowski, Friedlander has shown us a sanitized if unglamorous but uniformly middle-class world. His human presence has been submerged under his professionalism, and nothing is serious but the photographic surface—he is approaching the status of classic in his genre. Minute detail in these photos does not add up to a definitive grasp of a situation or event; it would be an ironically false presumption to suppose we can infer from the photo something important about the part of the world depicted in it. Yet making connections is an ineradicable human habit, and the metamessage of framing is that a significant incident is portrayed within. Looking at his photos, we are in the same situation as Little Red Riding Hood when she saw dear old Grandma but noticed some wolflike features and became confused. Our pleasant little visit has some suggestion of a more significant encounter, but we don't have enough information to check. The level of import of Friedlander's work is open to question and

can be read anywhere from photo funnies to metaphysical dismay. (pp. 47-53)

> Martha Rosler, *"Lee Friedlander's Guarded Strategies,"* in Artforum, *Vol. XIII, No. 8, April, 1975, pp. 46-53.*

Phil Patton (essay date 1975)

[*In the following excerpt, Patton reviews Friedlander's retrospective at New York's Museum of Modern Art, characterizing his work as self-conscious.*]

The photographs included in Friedlander's retrospective seem to begin from a sort of embarrassment. They are the work of a photographer who is embarrassed by the simple image, self-conscious about the illusory worlds his camera creates, too inhibited to indulge in the romanticism of deep insights or deep perspectives. His formal conquest of this embarrassment gives Friedlander's photos their strength.

The earliest in the show date from 1962, and they express a refusal to open the image up into full, simple perspectives. They sense the naiveté and misstatement implicit in the simple image and instead *discover* images they can attach to the flatness of the photograph. They go looking for images already in the world, already contained in television screens, reflective store windows or political posters on walls. Often these found images are transparent and confusing in their multiple intersections. They show Friedlander following the involuted forms of a writer postulating a manuscript found in a bottle—or a sculptor displaying *objets trouvés.*

But Friedlander is not only embarrassed by the constructed depth of the simple image; he is also self-conscious about the way it poses as anonymous and simply mechanical. So, in his work from the later '60s, he often includes himself holding the camera, reflected in a mirror or casting a shadow across the picture's putative subject. We see Friedlander in a car mirror, obscuring a quarter of the distant mountain range he is shown in the process of photographing. Or we see his shadow beside a pretty majorette, darkly possessing an area of the frame. These are pictures of a photographer taking pictures. They build the apparatus right into the images it produces.

Friedlander's self-consciousness might have led to empty autobiography, the vacant formalism of two mirrors face to face. But instead it has worked to free the personal and to a certain extent the social specifics of the pictures from the original embarrassment. Friedlander catches things between the mirrors that are new and interesting. He caresses details: the afternoon shadows of signs or lamp posts, stretched beside his own shadow; the juxtaposed planes of phone booths; the straight-line recession of a street mocked by a purely flat foreground shape. He rejoices in surface coincidences—the kind that seem to require an explanation stronger than the real one, which is a photographer's whim and eye—like one image in which he managed to catch a pyramid of three neat clouds piled atop a triangular sign of the same size.

While some of the photographs tend to a content that is nearly completely personal—like one shot of Friedlander's friend Jim Dine with a pale, overexposed foot in the foreground—others can be read as social statements not so very different from those of an Evans or a Frank. In one of Friedlander's very carefully matched groups of pictures, the subjects are monuments, contrasted with the pedestrian worlds around them, implicitly criticized for the values they monumentalize or the hypocrisy of their monumentalization. A giant plastic bull atop a tower in Kansas City and a statue of a World War I doughboy are reduced to peripheral, not central, elements in photographs that also belie critical notions of Friedlander's self-centeredness.

Friedlander could not give up the sort of social criticism that has dominated American photography since the '30s because he needs the social world to push off against. Like many photographers after him, Friedlander revels in his alienation from the world around him. Putting himself in the pictures at once states that alienation—his shadow intrudes—and takes revenge on it by solipsizing the image. Being conscious of the faults of the American scene is part of Friedlander's self-consciousness.

Several pictures from the early '70s included in the show seem to indicate a new direction. They show a stronger interest in defining the essence of a locale through the subtlest of images: Paris, through its flower markets; Rockland County, New York, through its groomed lawns and ranch wagons in the driveways. Date and place (the only titles provided for any of the photos in the show) are essential to Friedlander's autobiographical method, and his latest work seems aimed at an elegant, less involuted, more sympathetic expression of those particulars. Having treated his embarrassment with stiff doses of formal self-criticism, Friedlander may be about to release the repressed romantic inside him.

> Phil Patton, in a review of *"Lee Friedlander at the Museum of Modern Art,"* in Art in America, *Vol. 63, No. 3, May-June, 1975, p. 77.*

Leslie George Katz on Friedlander:

[Friedlander's] pictures enjoy qualities of poetry and prose. They are to be read as well as seen. The prosaic at full intensity becomes poetry. Every element has coherence. No detail is incidental, meaningless, arbitrary. Each aspect shares every other. The inner life of the landscape or portrait has the strange and awful integrity of a relentlessly consistent matrix; the outcome of conflicting, competing forces. The environment is at once permanent and ephemeral, catastrophic and casual, purposeful and chaotic.

A picture by Friedlander finds order in disorder by vantage. The unifying perspective is intelligence. The intended ideals of the environment that have lapsed or failed or struggle on are evoked by balancing the elements.

From an afterword to Factory Valleys.

Gerry Badger (essay date 1976)

[In the following essay, Badger discusses Friedlander's association with the Social Landscape school of photography.]

In almost every generation there emerges a photographer whose work seems to serve as a touchstone for that generation, both in terms of the stylistic advancement of the medium and in terms of our understanding of the era. Such a photographer therefore will employ the camera not only to mirror the visible facets of society's cultural and social milieux at a particular time, but will also invent, or intuitively find a manner of expression perfectly in accord with its deepest psychological mores. Thus in the modern medium for example, we have the exemplary documents of Eugene Atget and the Paris of the Belle Epoque: Walker Evans and the America of the Thirties: Robert Frank of the America of the Fifties: and—or so it seems to me although it may be a little premature for me to stick my neck out—Lee Friedlander and the Western civilisation of the Sixties and early Seventies. I say Western civilisation in Friedlander's case rather than American, because although most of his work is done in the States and although it has stylistic and content features which stamp it firmly as American, there are I think, enough manifestations of his vision over here—in our society and in our photography—to render its implications more widely felt.

Friedlander is of course, along with alter-ego Garry Winogrand, the leading light in what has come to be known as the 'Social Landscape' school—indeed it is Friedlander who is credited with the coining of that term. There is however, a certain amount of confusion regarding the 'Social Landscape'; it is all too often mistakenly recognised as a neo-category, a genre, when it was rather a reference-point for an expanded understanding of the medium. As such therefore, it is important that we define the concept and examine its background before dealing with Friedlander himself.

The key to this new thinking and the whole approach of the sixties was fashioned by that seminal figure in American photography, Robert Frank—specifically in his book, *The Americans,* which appeared in 1959. Frank's remarkable book had a far-reaching and profound effect upon American photographers, for his camera fundamentally challenged their whole way of seeing, seeming to touch upon so many areas of life which were known and recognised but had been hitherto disregarded—certainly as an artistic concern. To be sure, the iconography was in part familiar—the transport cafes, the bus depots, the empty spaces, the jukeboxes could have come from Evans or Lange—but Frank was concerned neither with the objective, analytical recording of external topographical or sociological fact in a strictly documentary sense, nor with sociopolitical polemicising in a reformist sense; he was totally committed to an examination of directly perceived experience. There was no effort to judge, but instead to express—although the kind of direct expression achieved by recording the spontaneous, unpremeditated sensation is by definition a total and honest expression of the photographer's sensibilities, and by implication an often remarkably authentic expression of event. Thus Frank intuitively caught a face of America which artists had tended hitherto rather scrupulously to ignore. As he said 'I had never travelled through the country. I saw something that was hidden and threatening. It is important to see what is invisible to others. You felt no tenderness.'

Frank had, in a sense, lifted a stone. But what was even more shocking to the photographic world was the means of expression employed. He complemented his vision with a near perfect marriage of form and content. His experiences were fragmentary, reflecting a society which had lost a sense of whole relationships: his camera was rapid, the snapshot or passing glimpse capturing precisely the spontaneity of the perceived event, and mirroring its incompleteness. Therefore, there was a feeling of incompleteness—in the technical sense—about his pictures. They looked unfinished,—grainy, out of focus, harshly lit, badly composed, badly printed. Overall, Frank's work offended conventional canons of artistic taste on several levels: it seemed casual, unconstructed, and bleak, cynical in its outlook. Yet its honest, and ultimately heart-rending expressiveness touched the imagination and reflected absolutely the mood of the post-War generation, a generation in rebellion against hypocrisy, a generation which seemed fresh, open, spontaneous, and contemptuous of what they saw were strictly admass values of modern society.

To younger photographers such as Friedlander, Frank's vision was a blast of welcome fresh air which helped to disperse much of the overt sentimentality which inflicted much fifties photography, as exemplified by the 'Family of Man' syndrome. Robert Frank reaffirmed the vitality and the expressive potentiality of social landscape as a primary subject, and in so doing also effected a change in the structural disposition and denotive possibilities of the photograph itself. It is important to note this last point particularly in order to understand the fullest implications of Frank—both upon individual photographers and upon the philosophical precepts of the medium itself.

Although Frank and the Social Landscapists tend to be seen as a single, homogenous strand in the development of American photography, and in a strictly chronological sense they are there are basic differences between them. Principally, Frank was a photojournalist his background was the established European journalistic tradition, and although *The Americans* exploded traditional tenets held about the documentary ethos, it was nevertheless still primarily rooted in journalism in that the need to 'tell a story' was paramount, however unconventional the means used. Friedlander and the other Social Landscapists did not feel that need. Although they may have earned their daily bread as commercial or magazine photographers, they felt no need while making their personal pictures to try and communicate or proselytise—at least not in the literary sense of the photojournalist.

Friedlander and Winogrand were products of the rapid shift in the cultural status of American photography during the late Fifties and early Sixties, and thus exemplify a certain intellectual approach to the problems of photographic expression. Friedlander is very conscious of his roots—principally Atget and Evans—and is therefore,

very conscious, as he has stressed, that the 'social land-scape' as he defines it does not constitute only the actual landscape—the landscape of his environment—but also his perceptual landscape as a photographer and as one interested in photographs; that is a 'landscape' which includes the 'landscape' of Atget, the 'landscape' of Evans, the 'landscape' of Frank, etc. It is perhaps subtle, yet nevertheless root distinction between Frank and the Social Landscapists. Frank was concerned with a direct, emotive, totally expressive statement—he generally engaged the immediate impulse of lived experience: Friedlander however, although drawing from the same well as Frank, makes a more intellectually 'hip' statement—in the sense that he engages the obviously more remote impulse of 'art'. This is not to say that Frank was intellectually unaware of the medium or cared little about it—one only has to look at *The Americans* and the superb, deeply intelligent way the language of the medium was employed to point its statement. But there were differences in emphasis between Frank and those who followed: the tone of the Social Landscapists was patently cooler, due in some measure to the fact that they were all native Americans and therefore less startled than Frank by their own culture, but particularly due to the intellectual distancing generated by a more conscious exploitation and more overt awareness of the 'landscape of the medium'.

The Social Landscape concept was therefore broader in implication than it appeared at first sight to critics. It was not just a new, more personalised approach to the documentation of the social scene, but the product of a broader understanding and a clarification of the expressive possibilities of the photograph. Friedlander and Winogrand are only two—albeit leaders—of a large, loose body of American photographers who have eschewed both a systematic high-art formulism on one hand and a socio-political documentation on the other, and are exploring a more basic and personal use of the medium—that of understanding and recording their perceptions through the agency of the camera. Photography in effect becomes about photography—not about pseudo-painting, not about graphic schema or chemical manipulation, not about social or political propaganda, not even about itself as an art medium, though it can embrace all of these things—but essentially about the act of taking a photograph, not in a physical but in a spiritual sense. It becomes about the act of seeing, knowing and understanding some small part of the world or fragment of experience, and placing oneself in a singular physical relationship to that in order to make a record with the camera. Of course all this is more or less what most of the great photographers—from Atget to Arbus—have been doing, consciously or not, for the greater part of this century, but it is only perhaps within the last decade and a half or so that we have approached a generally accredited intellectual conception of the philosophy as a whole—with the Social Landscapists as prominent and exemplary emissaries.

The photographs of Lee Friedlander then, provide some of the first and best examples of what has become a widespread approach to photography—an approach which is making more and more inroads into this country. His images are specifically about photography, about the basic

nature of making a photograph and about the way that we perceive the world *through the camera and in photographic images*. And within this precept, his image meaning may shift anywhere from literalness to metaphor, and display either principally formal or content features—although keeping usually to his prescribed locus of subject-matter, that ubiquitous 'social landscape'.

At first glance, Friedlander's subject-matter and means of presentation would seem to place him closer to Walker Evans and the precise, analytical objectiveness of the Thirties documentary approach than Robert Frank. Friedlander certainly echoes the coolness and the dry texture of Evans in the long-scale, silvery grey tonalities of his prints, some way from the grainy chiaroscuro of Frank, and indeed his lucid, almost limpid detachment points the way from the generally romantic visions of the Fifties toward the ice-cool minimalism of the latest generation of young Americans such as Lewis Baltz or Robert Adams. Friedlander, however, is not content either to blandly reflect or conventionally order the apparently stereotyped world within his viewfinder—he wholly restructures it in a seemingly casual yet subtly disorientating manner. His usual visual vocabulary is the common coinage of our urban culture—telegraph poles, fire hydrants, street lights, statues, posters, shop windows, cars etc—and he records them faithfully, remaining completely true to the basic roots of the medium, but by a razor-sharp, reflex command of viewpoint and timing, controls and moulds them in a highly disciplined and often dazzling display of formal manoeuvres and sight-jokes.

Much of his formal language emanates from the interest that Frank and the Social Landscapists had in the primary and most authentic photographic form—the 'snapshot'. But whereas Frank used the idea of snapshot as process—the natural, expressive, intuitive response to the moment, Friedlander rather uses the idea as concept—employing its premises with an almost ruthless precision to reform his landscape. In particular, he will use the propensity of the uncontrolled camera for giving equal pictorial weight to every visual element within its field of view, and the sometimes startling chance juxtaposition produced by the naive snapshooter through bad timing and the ill-use of the camera—effects used quite deliberately in his formal armoury. Therefore, Friedlander will focus upon a typical, formless small-town-scape and jolt the viewer by a telling, often dryly humorous conjunction of incongruous elements—as in *Knoxville, Tennessee, 1971,* where a small cloud alights perkily upon a tilting street sign with a triangular top, transforming it into an ice-cream cone, while the sign's shadow (minus cloud) points somewhat forlornly down a bleak, empty street; or in *Connecticut, 1973,* where a crouching, menacing soldier (a statue) seems to pursue two suburban housewives (and baby) through a landscape of barrier-like street poles.

This is fairly typical of Friedlander, the carefully composed spatial manipulations and sliced temporal reflections combining to effect a distinctive, low-key surrealism. For he never forgets that unique interaction of reality and illusion which is a photograph, so another highly favoured, almost compulsive theme is the shop window, or

any other reflective surface in the landscape. He uses shadows, reflections, double-images, to dissolve the actual into paeons of metamorphosis, subverting and modifying our notion of the ostensible subject of his imagery. Or, shooting from the inside of a car, he will use the driver's mirror or the edges of the windows to interrupt the unity of the exterior spaces, turning the images into diptychs, even triptychs. Again, utilising the profligacy of extraneous visual imagery within the urban fabric, he will pile image upon image upon image, picture within picture within picture. The fusion of reality and myth is a fundamental part of his thinking, and he frequently evokes the word 'magic' to describe the camera's ability to uncannily transcribe, but yet transform the actual. Once, when challenged by a hyper-intellectual questioner at a lecture, who discerned phallic symbols everywhere in his work, Friedlander's feeling was plain: 'They're not symbols; they're real ones,' he dryly retorted.

Again, relative to this idea of 'magic', Friedlander never forgets about the near-ritual of making the picture, and often pays homage by including a direct record of the act in his images. His physical presence looms large in his work: he can be glimpsed in many of his pictures, a hovering shadow, an abstruse reflection, sometimes even a straight mirror image, standing with eye to camera, a curiously detached figure, frequently looking rather 'spaced-out' himself inside his quite literally spaced-out landscapes—as Martha Rosler aptly put it, 'a solitary guy in a crazy-clockwork world' [see excerpt dated 1975].

Yet although these formalistic and conceptual games are executed with great humour and panache, Friedlander's work does beg several questions. His images slip and slide between the demand for transcendent meaning inherent in the notion of art and the total respect for naturalism necessary to the documentary motive—that is clear; but this transience serves to raise a lot of critical speculation about the precise message and perhaps the ultimate worth and validity of his vision.

Just what is Friedlander's work about? What does it refer to either concretely, metaphorically, formally, allegorically or representatively? In what sense are his photographs documents—either of the world or of his true perceptions? Is he confronting us directly with our perception of reality—or merely an abstract, ultimately barren non-reality? Is his work an allegory for his view of civilisation and humanity—or is it only about the medium in its narrowest sense? Is it a series of facile formal manoeuvres? Or even a kind of existentialist jerking-off?

These questions are important because Friedlander is such a prominent influence upon so many young photographers, and an understanding of the issues raised is crucial to a proper understanding of the contemporary medium. Of course, in essence these questions can only be answered by each individual coming to Friedlander: the nature of his art is such that he cannot be pinned down, and therefore one's answers will be a reflection of what one considers the medium is about.

For my part, I believe that photography can aspire to creative expression at the highest level—it can be 'art', in other words—but I also firmly believe that its creative roots lie in the world—in the documentary rather than the imagination if you like; and thus the best of photographic art is the measure of a true spiritual and creative interaction between the photographer and the world, a full measure of his singular vision, amounting to a perhaps private, yet nonetheless political statement in its widest sense, fully capable of a communication to the aware and responsive viewer.

The idea of being interested primarily in the 'act' of taking the photograph is an intriguing one, for it has in my opinion, the general potential to function as a transparently more honest record—good or bad—of the photographer's sensibilities than either the intellectual posturing of the 'conscious' image-maker in the fine-art sense, or the necessarily simplistic and biased viewpoint of the propagandist. However, process becomes potentially more important than image; and the danger is that it be allowed to gain an overriding importance, for the image is after all the record and the mnemonic of the photographer's perception at that moment. In other words, it is all too easy to become seduced by camera 'games', those odd and clever juxtapositions which have significance only in a photograph, and thus fall into the wide open trap of making pictures about photography in an empty formalistic sense, rather than about the broader world.

In Friedlander's case, I do not think that he has fallen into this trap, although many of those who have followed him have. Consider the work of Charles Harbutt, who though he is not a follower of Friedlander, could be said to hold similar stylistic precepts and work in a similar manner to the Social Landscapists. Harbutt had a show at The Photographers' Gallery about three months ago: then it seemed to me that he is in great danger of allowing process to override his vision, and that his pictures have become more about making photographs in an abstract rather than in an instrumental sense. Harbutt's work is extremely interesting, but I felt that his formal manoeuvres were rather arbitrary and forced, and precluded any real involvement with the fabric of life, consequently leaving them perhaps admirable but yet unlovable.

Friedlander on the other hand, remains entirely convicing, for despite the complexity of his formal moves he makes them with a tremendous and consistent discipline, almost always persuading the viewer that his restructured landscapes actually exist instead of being camera products. His images are relatively free of obvious wide-angle distortion; there is a sense of being able to step into the landscape, consequently we are assured that Friedlander's prime reason for making the photograph, notwithstanding the formal restructuring, was to fully describe the world or his particular experience as he saw it at the time.

Friedlander then, never forgets that he is documenting a place or an event: in his vision the straightforward, simple reference usually coexists with the oblique, esoteric paraphrasing. Whether the result of intuition or intellect—a bit of both one would suspect—Friedlander has succeeded, as I stated at the beginning of this piece, in demonstrating his visual experiences of society, the face of a 'sanitised if unglamorous middle-class world' as Martha

Rosler put it, and creating a formal language which reinforces succinctly the dissociated, fragmentary and uneasy nature of many of our experiences of this modern urban civilisation. For all his lightness of touch in the visual jokes and his obvious enjoyment of making photographs, Friedlander is never flip and his ultimate intentions never anything less than serious. The key to this seriousness is in his photographs of people—in groups or at parties—which serve as an important and related strand to the general pictures of the urban scene.

In these pictures, Friedlander restructures the space within the picture-plane as usual, mainly by employing the close-up in a manner which negates its normally assumed denotive possibilities. Whereas the close-up usually would suggest intimacy and personal contact, in Friedlander's group photographs it patently suggests the opposite or at least the brief, non-contact kind of communication habitual to the kind of gathering he deals with. He gets so close to his group subjects that heads, elbows, arms, glasses, etc, break up the image structure in a similar manner to poles, telephone booths, car mirrors and so on, in his exterior images. Here, however, Friedlander is less intellectually distanced and approaches the direct expressiveness of Frank; these images are a powerful expression of the desperate search for intimacy and fraternity in our culture, and the most extreme examples of the underlying unease inherent in his vision in spite of its outward cool. Above all they confirm the seriousness and the coherence of Friedlander's artistic statement.

There is no doubt therefore that Friedlander is an important artist: his influence upon contemporary photographers has been widespread and his work has been instrumental in defining a major shift in photographic concern. Essentially, he and the other photographers of the 'Social Landscape' represent a personalised approach to the medium which explodes or at least drastically modifies, traditional formal / content, art / documentary poles of opinion. Certainly, we are brought closer to an understanding of the profound act of taking a photograph, and to a wider appreciation of the photographic medium as an entity, in the sense that, as the wise Mr Friedlander himself stated: 'The pleasures of good photographs are the pleasures of good photographs, whatever the particulars of their make-up.' He might also have added that good photographs have almost invariably been made by solitary guys (or gals) who slipped around with cameras in crazy-clockwork worlds. (pp. 198-200)

Gerry Badger, *"Lee Friedlander,"* in The British Journal of Photography, *Vol. 123, No. 6032, March 5, 1976, pp. 198-200.*

Leo Rubinfien (essay date 1977)

[*In the following excerpt, Rubinfien favorably reviews Friedlander's collection of photographs entitled* Flowers.]

Painting knows no counterpart to that half-world which parallels that of serious photography. Photography, which finds uniquely prolific employment among advertisers and journalists, has bred an entire, coherent esthetic—trite, seductive and enmeshed in camera mechanics—alongside the concerns of its real masters. The pictures I am thinking of turn up in magazines like *Popular Photography.* These might be distorted nudes in vivid purple, gaping wide-angle views of skyscrapers seen from the street, or impossibly luscious views of flowers. Their ubiquitous presence, unfortunately, makes things difficult for serious photographers, who risk cliché whenever they enter kitsch's territory. Unafraid, Lee Friedlander has recently published a magnificent portfolio, *Flowers,* in which he retrieves perhaps the most emblematic of the popular photographers' themes.

Of course, major photographers in the tradition out of which Friedlander's work, stems, among them Atget, Kertesz and Frank, have photographed flowers too. Yet excepting Atget, who (perhaps because he worked during his medium's youth) could construct a world that encompassed every kind of human and natural object, these photographers have had to qualify their lyrics, planting human artifacts around their blooms. Robert Frank gave us tulips in a suitcase, while Kertesz gave us the tulips Mondrian had smothered in white paint because he could not stand the sight of fresh flowers in his house. Friedlander does not forego vases, plant pots and an occasional mirror or receding garden view, but he deemphasizes the presence of human objects, only to let *the human* reemerge in another way.

If Friedlander's flower pictures are of flowers plain and simple, if the background buildings in **Chrysanthemums in Flower Market, Paris** are secondarily important and do not qualify his fascination in and love for the ostentatious blooms, he has insisted on the presence of a human eye and mind by a unique means. Friedlander has attacked the chrysanthemums (and roses and cacti in many other pictures) with a flash that illuminates them garishly, deprives them of any solace in shadows, and strips them of comforting, conventionally lovely ranges of tones. He offers us no bed of roses, but a thorny, glowing, numinous, forbiddingly fecund natural world that leads a life of its own.

The extraordinary thing is that Friedlander has not made the flowers grim and ugly, but has kept them gorgeous. Theirs is a not-so-recognizable beauty, like that Keats indicates when he writes of "buds and bells and stars without a name." The flowers' special beauty is in their flash-wrought peculiarity, and their peculiarity is in their audaciousness, a kind of self-assertiveness that human objects have humbly given up. Friedlander's bristling, shaggy potted fern intimidates the familiar salt and pepper shakers someone has left on a table beside it, his chrysanthemums arrogantly elbow a large garden urn aside, his chrysanthemums at the market celebrate a small fireworks among themselves.

The best of Friedlander's flower photographs are great pictures, and radical ones in the extreme antitheses they sustain between harshness and softness, glare and shadow, and detail and large form. The space around each plant or bush, often wide, vacant and crepuscular, is freed to retreat in silence and forces us to confront the bloom at hand. The Popular Photographers' flowers are childish by comparison, while Paul Strand's appear all too much a te-

dious game with form. In Friedlander's, slight, barely proposed nuance—the glossy, spiny ridge of 'a potted cactus' branch or two translucent leaves which a sapling extends like pennants at arm's length—flourishes into meaning. From Atget, perhaps, Friedlander is taking up the notion of a garden that is too profound for human tenancy, even as it is a garden that sprouts from the imagination. And this notion is rooted in hard, tangible facts—in spines, thorns, crooked glowing stalks and incandescent petals. Biologists have lately suggested that flowers respond to stimulus, feel pain, make sounds, and recoil in self-defense. Beside this hypothesis, Friedlander's photographs conceive an even more plausible myth. (pp. 70-2)

> *Leo Rubinfien, in a review of* Flowers, *by Lee Friedlander, in* Artforum, *Vol. XV, No. 9, May, 1977, pp. 70-2.*

Steve Cagan (essay date 1982)

[*In the following excerpt, Cagan examines the photographs collected in* Factory Valleys, *finding Friedlander to be more concerned with his artistic presentation than with portraying and commenting on his subjects.*]

In 1979 and 1980, Lee Friedlander made four trips to western Pennsylvania and eastern Ohio to photograph for a project that was to be called "The American Ruhr." The project was commissioned by the Akron Art Museum and supported by grants from the National Endowment for the Arts and the Central Bank of Akron. (p. 19)

An enterprise of this kind inevitably raises questions about the goals and functions of documentary photography. What do we want from an exhibition called "Factory Valleys"? What do we think photography can provide?

One thing we *don't* get from Friedlander is any serious comment on his ostensible subject—the "industrial environment of North-eastern Ohio and Western Pennsylvania." For his sponsors, this silence is precisely the virtue: "Friedlander . . . distinguishes himself to a great extent from his predecessors who dealt with this topic by virtue of the fact that in his work he neither advocates nor admonishes." An Ohio reviewer congratulated Friedlander for creating images which "are not didactic; nor do they offer solutions to our current economic malaise—a task clearly beyond the scope and purposes of photography."

If Friedlander's photographs are not about the issues confronting the "factory valleys," what are they about? They are, of course, about Lee Friedlander's "unique photographic vision." Further, "in their rich geometry, in their subtle rendering of light, in their wonderful contrasts of textures [they are] more than just a document of the worker and his [sic] environment in the beginning of the 1980s." They seem "to synthesize the iconography and formal strategies of Friedlander's work," and they are yet another reflexive exercise in modernism. "The pictures are the reality they show." Subject matter, while acknowledged to have some intrinsic interest, is important to the extent that it provides raw material for the "artist's intelligent discerning eye."

Of course, Friedlander does not photograph the spirit

world. His images are reasonably straightforward, and we have no trouble identifying objects, buildings, and places. Indeed (rather in contrast to the approach taken above and apparently in ignorance of photographers like Earl Dotter, Fred Lonidier, and Ken Light), we have been told that the importance of *Factory Valleys* "derives from the fact that it represents the first time in over a generation that the American factory system has been brought under close scrutiny by an American photographer." The same critic also claims: "*Factory Valleys* does as much as photography can be expected to do. By reflecting the complex forces that shape our lives, it asks the same sorts of questions that most of us are beginning to ask whenever we turn on our television sets to the latest news from Wall Street." My contention is that *Factory Valleys* does not reflect "complex forces," though the confusion between using images which suggest the possibility of addressing real questions and actually addressing those questions is perhaps inevitable for critics and artists who actively resist any "intrusion" of politics into Art—even art whose subject is politically charged.

What is the experience communicated by *Factory Valleys?* The most striking feature of the industrial environment portrayed in these images is that it is *uninhabited.* Nothing new in this; it's the Friedlander we have known for over a decade. The first 68 prints, by far the most striking part of the exhibition, are "urban landscapes," predominantly Pittsburgh, Akron, and Cleveland. The subjects are empty streets, generally empty roads, houses, factories, and office buildings which function as compositional elements, not centers of human activity. The skies are generally gray, the trees usually leafless. There are no shoppers, very few pedestrians. Even vehicles take on an eerie quality; they seem to have no drivers. Roads end abruptly.

But the desolate character of the "factory valleys" is an artifact of Friedlander's methods, not an accurate—or even reasonable—representation. Akron Art Museum staff explained to me that Friedlander had to photograph early in the day in order to get the sort of even light he wanted (although, in fact, overall gray is characteristic of this area at any time of day from November to May). That also means he decided to photograph when he would find relatively little activity in the streets and highways. Thus, time of day—and light—were evidently more important to him than representational accuracy. While any artist is free to make such choices, the consequence is a set of photographs which seriously distorts the "scene" being "documented."

To choose just one example, we can look at Friedlander's treatment of highways. Both Andy Grundberg and Carolyn Carr say that Friedlander has recognized the importance of truck traffic, of transportation, to the area. Yet though there is a little traffic on some of Friedlander's highways, most are empty. They are portrayed not as arteries of transportation (which would have directed our attention to what goes on on highways) but as useful compositional elements (which directs our attention to the artist's "discerning eye").

Transportation has been a major industry in the area

(along with steel, auto, and others). How has it been affected by the industrial depression which has hit the region? Are there better ways to deal with transportation needs? And so on. Such questions would divert the audience from considering the image as an *end* into treating it as a *medium,* as a means of engaging with aspects of the social reality which is being treated. This might have required the inclusion of more information in the form of texts or other supporting materials, in order to allow the photographs to be *part* of a serious approach to the subject being documented.

And here we reach the heart of the problem. For me, for people who consider documentary photography as a (potentially) serious medium of communication and investigation, the effects described above are very much desired. We want to see documentary photographers as investigators, communicators, and partisans. Apparently for Lee Friedlander, and certainly for the Akron Art Museum, such roles would represent a loss. (pp. 19-20)

"What kind of factory is it? Why are the tires in the road? . . . Friedlander obscures the answers to such niggling questions even as he provokes them." But these are not niggling questions. The tires are on the road for a simple reason: funds have been cut off; construction has been (temporarily) halted. The tires represent a more or less successful attempt at creating a road barrier. These very highways, not incidentally, have been the center of much discussion. They have cut off part of a working-class neighborhood in Cleveland, creating a virtual island of houses between highways and steel mills. They have been resisted, in some cases successfully, by neighborhood groups. None of this can be shown directly in a photograph. But at the very least it can be explained in a wall card, or in the text of a book. Instead, the picture I'm referring to is one of several titled ***Cleveland, Oh.*** This is the method used throughout.

Similarly, if one's goal is understanding, it is anything but niggling to ask what actually goes on in a factory, an office building, or a house. In the period in which Friedlander was making his photographs, many of these mills and factories were closing. Unemployment, recession, declining social services, profound and wide-spread disruptions were (and are) critically important factors in the social landscape. They make no appearance, either in images or words, in this exhibition. (Should we expect them to, when one sponsor is a local bank?)

I should say a few words about the portraits of factory workers. Grundberg called them "cool and tender." Cool they certainly are, but with a couple of notable exceptions (a bakery worker; a couple of punch press operators surrounded, almost nested, by their machines; a man intently watching heavy rollers) these are pictures of alienation— not so much the alienation of the workers from their jobs, but of Friedlander from the workers. In too many of these photographs, workers are cut apart, or portions of their faces or bodies are rudely obscured by their machines. Rods pass through heads, random parts of machines or work are illuminated while faces are hidden, obscured in darkness, or washed out. The effect is not to demonstrate the relationship between workers and machines, but to inflict a kind of visual violence. These portraits, far from the caring and respectful treatment Grundberg would like to see, exhibit the very detachment and lack of involvement which he knows (and says) is a poor substitute for the kind of real, engaged objectivity we need.

In response to these criticisms, Akron Art Museum staff have replied, "This is meant to be an exhibition of how Lee Friedlander sees the area"—almost as if that were simply a consequence of the fact that he happened to be the photographer. But Friedlander's vision was precisely what the Akron Museum wanted: "a paramount concern of Friedlander . . . is the making of great photographs; the creating of images that are, above all, self-contained works of art," explains Carr. Perhaps this is not the place to argue with the notion of "self-contained works of art," but we do have a choice to make. Either we want a show whose main purpose is to encourage and aid engagement with the ostensible subject, or we want a show in which subject matter is primarily an opportunity for the artist to display his or her "unique" vision. The Akron Art Museum chose the latter course. There is nothing inherently wrong with exhibitions of pretty pictures of industrial scenes, or of any scenes. The problem is that, presented as a show about "industrial landscape," this kind of exhibition literally obstructs the audience from considering what is being capitalized on as content.

In *My Dinner With André,* Wallace Shawn asks André Gregory why, since direct experience of reality was his goal, he had to travel to exotic places. Protests Shawn: "There's as much reality in the cigar store next door as in Mount Everest!" If that's true, then there's no difference between the "factory valleys" and New City. It may follow that there's no reason for Lee Friedlander to photograph the "factory valleys" except perhaps to provide his somewhat jaded sensibilities with a new set of stimuli. Where the difference (and for that matter, the similarities) of substance lie is not in the shape of the buildings or quality of the light, but in the texture, issues, and qualities of daily life. These Friedlander has ignored. The problem is not, as John Szarkowski would have it, that photography is incapable of substantive comment, but rather that many photographers, in this case Friedlander apparently among them, have little of substance to say. The understanding— and anger—which is to be gained by contemplating the actual, social, reality of a concrete situation is blocked by an exhibition that demands that we rather pay attention to the photographer. Art interferes with understanding, and ritual worship of the artist interferes with respect for a world which comes to exist only as grist for her or his mill. (pp. 19-20)

Steve Cagan, "Grist for the Mills," in Afterimage, Vol. 10, No. 3, October, 1982, pp. 19-20.

Sanford Schwartz (essay date 1982)

[*In the following excerpt, Schwartz discusses detachment and tentativeness in Friedlander's work.*]

Lee Friedlander's photography is a chronicle of the look and character of recent American life made by a man who is always on the outside and always looking in. This may

be said about any photographer whose work comes under the label of social commentary, but the description fits Friedlander as it does no one else. Repeatedly, he photographs what it's like to be, happily or regrettably, outside the flow of everyday life. Sometimes you feel his happiness and regret simultaneously. In his self-portraits, probably his most jam-packed and original works, the role of the outsider becomes the literal subject-matter of the image. The often barren, inhospitable, lonesome appearance of Lee Friedlander's pictures derives not only from the absence of people in them, but from the way the pictures suggest that people were just recently a part of the scene. From such a description one might imagine that his photographs risk having an edge of the maudlin, or skirt being essays on the theme of how people let themselves live in spiritually and aesthetically empty settings. But neither tone makes itself felt. You are more aware of the photographer himself, on the prowl, looking for images.

In a recent show at the Witkin Gallery, the only person to make an appearance in the many prints was Friedlander. He's seen obliquely; we catch his silhouette reflection as he trains his camera on a window, or we see his shadow as it falls on someone's back. Yet what matters in the self-portraits is the milieu and the situation this photographer—not this particular personality—finds himself in. Friedlander is a demanding and complicated photographer. This has to be said, because his work can annoy people by its apparent "easiness." On a quick viewing, it's possible to feel that his subject is banality itself, untransformed by thought. It is true that his pictures—of dusty windows of untenanted stores; of Victorian monuments in American towns that have long lost their charm and are now crisscrossed with telephone poles and power lines; of passing traffic, as seen from the partially blocked-off vantage point of a seat on a bus or a pay phone booth; of crossroads in western United States towns, where all the buildings have been torn down and only a lot or a bit of sidewalk remains; of suburban dwellings seen through a net of trees and shrubs—appear to be casually lifted from reality. But Friedlander, you feel, has worked hard for a certain pitch of casualness. He likes his images, on initial viewing, to appear as empty and uninviting as possible. He wants the fruits of a purely photographic way of chopping up space—a way that forces us to see many unrelated things simultaneously—to reveal themselves very slowly. Friedlander uses his camera as if he were accumulating notes in a journal, whereas Walker Evans or Robert Frank, for example, make more individually assertive, self-sufficient photographs, using the camera as if they were producing novels. Most Evans pictures say, "This is it." Most Friedlander pictures say, "This is tentative." For these reasons, his prints are best seen in numbers, where his haphazard and "unartistic" touch can be judged as something deliberate, a distinct and developed photographic style that uses shallowness as a mask or a tease.

[A] recent exhibition might have been selected to give a greater sense of his range than it did; if this were anyone's first view of Friedlander he would probably have walked away with a generalized image of a parking lot in his mind. Even a few more self-portraits or some interiors would have helped lighten the load. It was good, however, to see

that Friedlander's latest pictures are as disquieting and haunting and obliquely humorous as those he was making a decade ago, when he first became known. In 1962 he made the since then much reproduced photographs of televisions, some turned on, some off, in drab, inexpensive hotel bedrooms. The most recent pictures are of flowers. These pictures are even "emptier" than the television ones, but they seem more a product of his own way of seeing. Some of the flowers, taken from a garden or a flower show, are menacing; they're a bit like the sturdy, suspiciously anonymous ones in science fiction movies. Some flowers are weighted down, over-petalled; others are lank, forlorn. Still others protrude in our line of vision. We feel as if they've been shoved in our face, and that the real subject of Friedlander's attention is what has been pushed to the side of the leaves or branches. We peer closely, but then return to the chaotic flowers or ferns in the foreground, and wonder if they themselves could be telling a story. Friedlander's flowers and plants and branches come across as essentially a comment, somehow both bitter and touching, about the people who have fussed over them so much, or ignored them. Depressing and pathetic as some are, these still lifes are among the most living any photographer has made. (pp. 152-54)

> *Sanford Schwartz, "Lee Friedlander," in his* The Art Presence, *Horizon Press, 1982, pp. 152-54.*

FURTHER READING

I. Critical Studies and Reviews

Davis, Douglas. "A Walker in the City." *Newsweek* XCII, No. 4 (24 July 1978): 77-9.
> Provides an introduction to the life and works of Friedlander in anticipation of the opening of his retrospective exhibition in New York.

Grundberg, Andy. "Lee Friedlander: Extending the Play of Perception." *Modern Photography* 42, No. 7 (July 1978): 102 ff.
> Discusses Friedlander's work, concluding that its chief aim is "not to harass or confuse, but to widen our knowledge of the world by widening our perception of it."

"Lee Friedlander's Inclusive Eye." *Horizon* 21, No. 7 (July 1978): 86-91.
> Previews Friedlander's retrospective at the Hudson River Museum, noting that "in his often unsettling photographs of the ordinary, nothing is left out."

Szarkowski, John. "The Study of Photography: 'Touching the Broader Issues of Modern Art'." *ARTnews* 72, No. 7 (September 1973): 50-5.
> Includes an assessment of Friedlander's technique as "a kind of game. . . . The point of the game is to know, love, and serve sight."

Woodward, Richard B. "Lee Friedlander: American Monument." *ARTnews* 88, No. 9 (November 1989): 140-45.

Chronicles Friedlander's career, commenting that his photographs capture "the revolutionary geometry of everyday life."

II. Selected Sources of Reproductions

Callaway Editions. *Factory Valleys: Ohio and Pennsylvania.* New York: Callaway Editions, 1982, unpaged.

Collection of prints by Friedlander, commissioned by the Akron Art Museum in Ohio, depicting the presence of industry in the American Midwest. Includes an afterword by Leslie George Katz.

Friedlander, Lee. *The American Monument.* New York: Eakins Press Foundation, 1976, unpaged.

Reproductions of Friedlander's photographs of public monuments and memorials throughout the United States.

———. *Lee Friedlander Photographs.* New York: Haywire Press, 1978, 137 p.

Reproductions of many of Friedlander's black-and-white prints.

———. *Lee Friedlander Portraits.* Boston: Little, Brown, and Company, 1985, 71 p.

Includes reproductions of many of Friedlander's portraits of blues musicians and fellow artists and photographers, as well as a foreword by R. B. Kitaj.

Friedlander, Lee, and Katz, Steve. "Composit 3: Lee Friedlander." *Camera* 48, No. 1 (January 1969): 28-36.

Eight reproductions of photographs by Friedlander with captions by Katz.

Slemmons, Rod. *Like a One-Eyed Cat: Photographs by Lee Friedlander, 1956-87.* New York: Harry N. Abrams, Inc., 1989, 119 p.

Contains more than one hundred of the prints that comprised a retrospective exhibition of Friedlander's work. Includes an introduction by Rod Slemmons (excerpted above).

Naum Gabo

1890-1977

(Born Naum Borisovich Pevsner) Russian-born sculptor, painter, and graphic artist.

Gabo is renowned as an important exponent of Constructivism, an abstract art movement originating in Russia during the early twentieth century. Rejecting traditional modeling and carving techniques in sculpture, Constructivist artists sought to express the spirit of the modern age through objects assembled of such industrial materials as glass, metal, and plastic. Gabo's constructions, which apply principles of science, mathematics, and engineering to sculpture and communicate innovative concepts of volume, space, and time, are among Constructivism's most representative works.

Gabo was born in Bryansk, Russia, into a family of metallurgists and engineers. Influenced in part by his older brother Antoine, who was training to become an artist, Gabo began to draw and paint around 1907. Between 1910 and 1914, he studied medicine, natural science, and engineering in Munich, Germany. During his Munich years, Gabo became acquainted with Albert Einstein's revolutionary mathematical theories, Henri Bergson's philosophy, and Wassily Kandinsky's spiritualist view of art. He also visited Antoine, who was then living in Paris and associating with Cubists, Futurists, and other abstract artists. Affected by the spirit of innovation he perceived in their ideas, Gabo embraced the notion that art, in order to reach a higher level of expression, must relinquish its naturalistic and figurative moorings. Cubist art in particular inspired Gabo to investigate the unexplored possibility of sculpture as a modern medium of expression. When World War I erupted in 1914, Gabo fled to Norway. His first work, *Constructed Head No. 1* (1915), was executed there and displayed the combined influences of abstract art, scientific concepts, and the figural motifs of Russian icons. Basing the construction of this sculpture on geometric methods for measuring volume, Gabo built the head from a series of intersecting plywood planes, allowing space rather than mass to define its graceful shape. As scholars have stated, the emphasis on space and transparency as opposed to mass became not only a hallmark of Gabo's early sculptures but also the theoretical foundation of his conception of art.

Returning to Russia in 1917 at the outbreak of the Revolution, Gabo settled in Moscow, having decided upon sculpture as a career. Sharing in the revolutionary fervor of the times, he taught at the state art school and met other artists, among them Vladimir Tatlin, who had been working on Constructivist ideas for a number of years. Under Tatlin's influence, Gabo abandoned representation for total abstraction and introduced transparent plastic into such constructions as *Space Construction C* (1921) and *Square Relief* (1921). *Kinetic Construction,* executed in

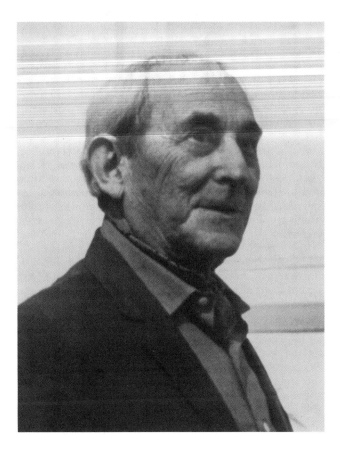

1919-20, is notable as the first experiment in the rhythmic potential of motorized sculpture.

By 1920, Gabo and the other adherents of Constructivism had become divided over the relation between political ideology and aesthetic doctrine. In disagreement with Tatlin's government-supported faction of the movement, which asserted that art should be socially useful, Gabo wrote and distributed *The Realistic Manifesto* (1920), declaring that Constructivist art was a powerful force for change independent of politics. In this document, a complete statement of the Constructivist sculptural principles that Gabo would refine throughout the remainder of his life, he advocated the application of mathematics and engineering to art, calling for an aesthetic more thoroughly modern than Cubism or Futurism. Gabo's conception of Constructivism directed artists to eschew volume and redefine the function of line, depth, and kinetic rhythm in the representation of objects. He maintained, in addition, that the ultimate aim of art is "the realization of . . . perceptions of the world in the forms of space and time." As the Soviet government became less tolerant of and, eventually, hostile to avant-garde artists, Gabo left Russia for Germany in 1922. Here his ideas gained a wide audience

among other artists and his reputation grew as he experimented with the architectural possibilities of sculpture, creating a series of abstract small-scale tower constructions, the principles of which could be applied to full-scale monuments. To the transparent rectilinear shapes and vertical and horizontal planes of these and earlier works, he then added curves and spirals to express kinetic properties. *Construction in Space with Balance on Two Points* (1925) and the set and costumes he designed for Sergei Diaghilev's ballet *La chatte* (1927) illustrate this phase of his development. When the political climate in Germany changed with Hitler's rise to power in 1933, Gabo went first to France and then to England in 1936, where he remained throughout World War II. The group of artists and architects working in London proved highly receptive to Constructivist theory and sculpture; during this period, Gabo contributed articles to *Circle,* an influential publication dedicated to avant-garde art. While he was in England, Gabo's art continued to develop in new directions and his reputation as an artist became international. Inspired by three-dimensional mathematical models and his discovery of new materials more malleable than plastic, he created such constructions as *Spheric Theme* (1936) and *Construction in Space with Crystalline Center* (1938), whose transparent, curvilinear lines were designed to be suggestive of motion, space, and time. During the 1940s, he began to string these constructions with transparent nylon thread, a practice that became a significant feature of his later work.

In 1946 Gabo moved to the United States, where he lived for the rest of his life. At this stage in his career, he reexamined themes from earlier years and concentrated on the architectural application of his sculptures, designing such monuments as the *Bijenkorf Construction* (1957) in Rotterdam and *Revolving Torsion, Fountain* (1973) in London in an attempt to demonstrate the independent, communicative power of art as outlined in his *Manifesto.* Gabo died in his studio in 1977 after a long illness. His pioneering efforts in the articulation of Constructivist theory expanded the movement internationally, and due in large part to his advocacy, it has exerted an important influence on the evolution of twentieth-century abstract art.

ARTIST'S STATEMENTS

Naum Gabo (essay date 1920)

[*In the following excerpt from* The Realistic Manifesto, *originally published in 1920, Gabo outlines the principles of Constructivist art.*]

Above the tempests of our weekdays,

Across the ashes and cindered homes of the past,

Before the gates of the vacant future,

We proclaim today to you artists, painters, sculptors, mu-

sicians, actors, poets . . . to you people to whom Art is no mere ground for conversation but the source of real exaltation, our word and deed.

The impasse into which Art has come to in the last twenty years must be broken.

The growth of human knowledge with its powerful penetration into the mysterious laws of the world which started at the dawn of this century,

The blossoming of a new culture and a new civilization with their unprecedented-in-history surge of the masses towards the possession of the riches of Nature, a surge which binds the people into one union, and last, not least, the war and the revolution (those purifying torrents of the coming epoch), have made us face the fact of new forms of life, already born and active.

What does Art carry into this unfolding epoch of human history?

Does it possess the means necessary for the construction of the new Great Style?

Or does it suppose that the new epoch may not have a new style?

Or does it suppose that the new life can accept a new creation which is constructed on the foundations of the old?

In spite of the demand of the renascent spirit of our time, Art is still nourished by impression, external appearance, and wanders helplessly back and forth from Naturalism to Symbolism, from Romanticism to Mysticism.

The attempts of the Cubists and the Futurists to lift the visual arts from the bogs of the past have led only to new delusions.

Cubism, having started with simplification of the representative technique ended with its analysis and stuck there.

The distracted world of the Cubists, broken in shreds by their logical anarchy, cannot satisfy us who have already accomplished the Revolution or who are already constructing and building up anew.

One could heed with interest the experiments of the Cubists, but one cannot follow them, being convinced that their experiments are being made on the surface of Art and do not touch on the bases of it seeing plainly that the end result amounts to the same old graphic, to the same old volume and to the same decorative surface as of old.

One could have hailed Futurism in its time for the refreshing sweep of its announced Revolution in Art, for its devastating criticism of the past, as in no other way could one have assailed those artistic barricades of 'good taste' . . . powder was needed for that and a lot of it . . . but one cannot construct a system of art on one revolutionary phrase alone.

One had to examine Futurism beneath its appearance to realize that one faced a very ordinary chatterer, a very agile and prevaricating guy, clad in the tatters of worn-out words like 'patriotism', 'militarism', 'contempt for the female', and all the rest of such provincial tags.

In the domain of purely pictorial problems, Futurism has not gone further than the renovated effort to fix on the canvas a purely optical reflex which has already shown its bankruptcy with the Impressionists. It is obvious now to every one of us that by the simple graphic registration of a row of momentarily arrested movements, one cannot re-create movement itself. It makes one think of the pulse of a dead body.

The pompous slogan of 'Speed' was played from the hands of the Futurists as a great trump. We concede the sonority of that slogan and we quite see how it can sweep the strongest of the provincials off their feet. But ask any Futurist how does he imagine 'speed' and there will emerge a whole arsenal of frenzied automobiles, rattling railway depots, snarled wires, the clank and the noise and the clang of carouselling streets . . . does one really need to convince them that all that is not necessary for speed and for its rhythms?

Look at a ray of sun . . . the stillest of the still forces, it speeds more than 300 kilometres in a second . . . behold our starry firmament . . . who hears it . . . and yet what are our depots to those depots of the Universe? What are our earthly trains to those hurrying trains of the galaxies?

Indeed, the whole Futurist noise about speed is too obvious an anecdote, and from the moment that Futurism proclaimed that 'Space and Time are yesterday's dead', it sunk into the obscurity of abstractions.

Neither Futurism nor Cubism has brought us what our time has expected of them.

Besides those two artistic schools our recent past has had nothing of importance or deserving attention.

But Life does not wait and the growth of generations does not stop and we who go to relieve those who have passed into history, having in our hands the results of their experiments, with their mistakes and their achievements, after years of experience equal to centuries . . . we say . . .

No new artistic system will withstand the pressure of a growing new culture until the very foundation of Art will be erected on the real laws of Life.

Until all artists will say with us . . .

All is a fiction . . . only life and its laws are authentic and in life only the active is beautiful and wise and strong and right, for life does not know beauty as an aesthetic measure . . . efficacious existence is the highest beauty.

Life knows neither good nor bad nor justice as a measure of morals . . . need is the highest and most just of all morals.

Life does not know rationally abstracted truths as a measure of cognizance, deed is the highest and surest of truths.

Those are the laws of life. Can art withstand these laws if it is built on abstraction, on mirage, and fiction?

We say . . .

Space and time are re-born to us today.

Space and time are the only forms on which life is built and hence art must be constructed.

States, political and economic systems perish, ideas crumble, under the strain of ages . . . but life is strong and grows and time goes on in its real continuity.

Who will show us forms more efficacious than this . . . who is the great one who will give us foundations stronger than this?

Who is the genius who will tell us a legend more ravishing than this prosaic tale which is called life?

The realization of our perceptions of the world in the forms of space and time is the only aim of our pictorial and plastic art.

In them we do not measure our works with the yardstick of beauty, we do not weigh them with pounds of tenderness and sentiments.

The plumb-line in our hand, eyes as precise as a ruler, in a spirit as taut as a compass . . . we construct our work as the universe constructs its own, as the engineer constructs his bridges, as the mathematician his formula of the orbits.

We know that everything has its own essential image; chair, table, lamp, telephone, book, house, man . . . they are all entire worlds with their own rhythms, their own orbits.

That is why we in creating things take away from them the labels of their owners . . . all accidental and local, leaving only the reality of the constant rhythm of the forces in them.

1. *Thence in painting we renounce colour as a pictorial element, colour is the idealized optical surface of objects; an exterior and superficial impression of them; colour is accidental and it has nothing in common with the innermost essence of a thing.*

We affirm *that the tone of a substance, i.e. its light-absorbing material body is its only pictorial reality.*

2. We renounce *in a line, its descriptive value; in real life there are no descriptive lines, description is an accidental trace of a man on things, it is not bound up with the essential life and constant structure of the body. Descriptiveness is an element of graphic illustration and decoration.*

We affirm *the line only as a direction of the static forces and their rhythm in objects.*

3. We renounce *volume as a pictorial and plastic form of space; one cannot measure space in volumes as one cannot measure liquid in yards: look at our space . . . what is it if not one continuous depth?*

We affirm *depth as the only pictorial and plastic form of space.*

4. We renounce *in sculpture, the mass as a sculptural element.*

It is known to every engineer that the static forces of a solid body and its material strength do not depend on the quantity of the mass . . . example a rail, a T-beam etc.

But you sculptors of all shades and directions, you still adhere to the age-old prejudice that you cannot free the vol-

ume of mass. . . . *[We] take four planes and we construct with them the same volume as of four tons of mass.*

Thus we bring back to sculpture the line as a direction and in it we affirm depth as the one form of space.

5. We renounce *the thousand-year-old delusion in art that held the static rhythms as the only elements of the plastic and pictorial arts.*

We affirm *in these arts a new element the kinetic rhythms as the basic forms of our perception of real time.*

These are the five fundamental principles of our work and our constructive technique.

Today we proclaim our words to you people. In the squares and on the streets we are placing our work convinced that art must not remain a sanctuary for the idle, a consolation for the weary, and a justification for the lazy. Art should attend us everywhere that life flows and acts . . . at the bench, at the table, at work, at rest, at play; on working days and holidays . . . at home and on the road . . . in order that the flame to live should not extinguish in mankind.

We do not look for justification, neither in the past nor in the future.

Nobody can tell us what the future is and what utensils does one eat it with.

Not to lie about the future is impossible and one can lie about it at will.

We assert that the shouts about the future are for us the same as the tears about the past: a renovated day-dream of the romantics.

A monkish delirium of the heavenly kingdom of the old attired in contemporary clothes.

He who is busy today with the morrow is busy doing nothing.

And he who tomorrow will bring us nothing of what he has done today is of no use for the future.

Today is the deed.

We will account for it tomorrow.

The past we are leaving behind as carrion.

The future we leave to the fortune-tellers.

We take the present day. (pp. 151-52)

> *Naum Gabo, in his* Gabo: Constructions, Sculpture, Paintings, Drawings [and] Engravings, *Lund Humphries, 1957, 193 p.*

Naum Gabo (letter date 1944)

[*In the following excerpt from a letter to Herbert Read, Gabo defines the nature and purpose of Constructivist art.*]

Ever since I began to work on my constructions, and this is now more than a quarter of a century ago, I have been persistently asked innumerable questions, some of which are constantly recurring up till the present day.

Such as 'Why do I call my work "Constructive"? Why abstract?'

'If I refuse to look to Nature for my forms, where do I get my forms from?'

'What do my works contribute to society in general, and to our time in particular?'

I have often tried to answer these questions. . . . Some people were satisfied, but in general the confusion is still there, and the questions still persistently recur.

I am afraid that my ultimate answer will always lie in the work itself, but I cannot help feeling that I have no right to neglect them entirely and in the following notes there may be some clue to an answer for these queries.

(1) My works are what people call 'Abstract'. . . . [It] is true they have no visible association with the external aspects of the world. But this abstractedness is not the reason why I call my work 'Constructive'; and 'Abstract' is not the core of the Constructive Idea which I profess. This idea means more to me. It involves the whole complex of human relation to life. It is a mode of thinking, acting, perceiving and living. The Constructive philosophy recognizes only one stream in our existence—life (you may call it creation, it is the same). Any thing or action which enhances life, propels it and adds to it something in the direction of growth, expansion and development, is Constructive. The 'how' is of secondary importance.

Therefore, to be Constructive in art does not necessarily mean to be abstract at all costs: Phidias, Leonardo da Vinci, Shakespeare, Newton, Pushkin, to name a few,—all were Constructive for their time but, it would be inconsistent with the Constructive Idea to accept their way of perception and reaction to the world as an eternal and absolute measure. There is no place in a Constructive philosophy for eternal and absolute truths. All truths and values are our own constructions, subject to the changes of time and space as well as to the deliberate choice of life in its striving towards perfection. I have often used the word 'perfection' and ever so often been mistaken for an ecclesiastic evangelist, which I am not. I never meant 'perfection' in the sense of the superlative of good. 'Perfection', in the Constructive sense, is not a state but a process; not an ultimate goal but a direction. We cannot achieve perfection by stabilizing it—we can achieve it only by being in its stream; just as we cannot catch a train by riding in it, but once in it we can increase its speed or stop it altogether; and to be in the train is what the Constructive Idea is striving for.

It may be asked: what has it all to do with art in general and with Constructive art in particular? The answer is—it has to do with art more than with all other activities of the human spirit. I believe art to be the most immediate and most effective of all means of communication between human beings. Art as a mental action is unambiguous—it does not deceive—it cannot deceive, since it is not concerned with truths. We never ask a tree whether it says the

truth, being green, being fragrant. We should never search in a work of art for truth—it is verity itself.

The way in which art perceives the world is sensuous (you may call it intuitive); the way it acts in response to this perception is spontaneous, irrational and factual (you may call it creative), and this is the way of life itself. This way alone brings to us ultimate results, makes history, and moulds life in the form as we know it.

Unless and until we adopt this way of reacting to the world in all our spiritual activities (science above all included) all our achievements will rest on sand.

Unless and until we have learned to carry our morality, our science, our knowledge, our culture, with the ease we carry our heart and brain and the blood in our veins, we will have no morality, no science, no knowledge, no culture.

To this end we have to construct these activities on the foundation and in the spirit of art.

I have chosen the absoluteness and exactitude of my lines, shapes and forms in the conviction that they are the most immediate medium for my communication to others of the rhythms and the state of mind I would wish the world to be in. This is not only in the material world surrounding us but also in the mental and spiritual world we carry within us.

I think that the image they invoke is the image of good—not of evil; the image of order—not of chaos; the image of life—not of death. And that is all the content of my constructions amounts to. I should think that this is equally all that the constructive idea is driving at.

(2) Again I am repeatedly and annoyingly asked—where then do I get my forms from?

The artist as a rule is particularly sensitive to such intrusion in this jealously guarded depth of his mind—but, I do not see any harm in breaking the rule. I could easily tell where I get the crude content of my forms from, provided my words be taken not metaphorically but literally.

I find them everywhere around me, where and when I want to see them. I see them, if I put my mind to it, in a torn piece of cloud carried away by the wind. I see them in the green thicket of leaves and trees. I can find them in the naked stones on hills and roads. I may discern them in a steamy trail of smoke from a passing train or on the surface of a shabby wall. I can see them often even on the blank paper of my working-table. I look and find them in the bends of waves on the sea between the open-work of foaming crests; their apparition may be sudden, it may come and vanish in a second, but when they are over they leave with me the image of eternity's duration. I can tell you more (poetic though it may sound, it is nevertheless plain reality): sometimes a falling star, cleaving the dark, traces the breath of night on my window glass, and in that instantaneous flash I might see the very line for which I searched in vain for months and months.

These are the wells from which I draw the crude content of my forms. Of course, I don't take them as they come; the image of my perception needs an order and this order

is my construction. I claim the right to do it so because this is what we all do in our mental world; this is what science does, what philosophy does, what life does. We all construct the image of the world as we wish it to be, and this spiritual world of ours will always be what and how we make it. It is Mankind alone that is shaping it in certain order out of a mass of incoherent and inimical realities. This is what it means to me to be Constructive.

(3) I may be in error in presuming that these maxims are simple to explain and easy to understand. I cannot judge, but I know for certain that for me it is much more difficult to prove the social justification for my work at this time.

A world at war, it seems to me, may have the right to reject my work as irrelevant to its immediate needs. I can say but little in my defence. I can only beg to be believed that I suffer with the world in all the misfortunes which are now fallen upon us. Day and night I carry the horror and pain of the human race with me. Will I be allowed to ask the leaders of the masses engaged in a mortal struggle of sheer survival: '. . . Must I, ought I, to keep and carry this horror through my art to the people?'—the people in the burned cities and scorched villages, the people in trenches, people in the ashes of their homes, the blinded shadows of human beings from the ruins and gibbets of devastated continents. . . . What can *I* tell *them* about pain and horror that they do not know?'

The human race is ill; dangerously, mortally ill—I offer my blood and flesh, for what it is worth, to help them; my life, if it is needed. But what is the worth of a single life— we all have learned to kill with ease and the road of death is made smooth and facile. The venom of hate has become our daily bread and only nurture. Am I to be blamed when I confess that I cannot find inspiration for my art in that stage of death and desolation.

I am offering in my art what comfort I can to alleviate the pains and convulsions of our time. I try to keep our despair from assuming such proportions that nothing will remain in our devastated life to prompt us to live. I try to guard in my work the image of the morrow we left behind us in our memories and foregone aspirations and to remind us that the image of the world can be different. It may be that I don't succeed in that at all, but I would not accept blame for trying it.

Constructive art as a whole, and my work as part of it, has still a long way to go to overcome the atmosphere of controversy that surrounds it. It has been and still is deliberately kept from the masses on the grounds that the masses would not understand it, and that it is not the kind of art the masses need. It is always very difficult to argue with anybody on such obscure grounds as this; the simplest and fairest thing to do would be to allow the masses to make their own judgment about this art. I am prepared to challenge any of the representatives of public opinion and put at their disposal any work of mine they choose to be placed where it belongs—namely, where the masses come and go and live and work. I would submit to any judgment the masses would freely pronounce about it. Would any leader of the masses ever accept my challenge—I wonder!

Meantime I can do nothing but leave my work to the few and selected ones to judge and discriminate. (pp. 171-72)

Naum Gabo, in a letter to Herbert Read in July, 1944, in his Gabo: Constructions, Sculpture, Paintings, Drawings [and] Engravings, *Lund Humphries, 1957, pp. 171-72.*

SURVEY OF CRITICISM

David Thompson (essay date 1966)

[*In the following excerpt, Thompson comments on Gabo's concept of Constructivism.*]

Inasmuch as Gabo is often thought to *be* Constructivism, his career brings us up against the two contradictory things about it as one of the seminal movements of modern art—that it is in a sense already static, completed, realized, and at the same time hardly begun.

The first of these statements is obviously heresy to any Constructivist artist, let alone to Gabo himself, for one of the most conspicuous characteristics of the movement is that 'brave new world' tone which rang out so thrillingly in Moscow between 1917 and 1920, became the keynote of *The Realistic Manifesto* [see Artist's Statements dated 1920] and has been sustained ever since, without loss of challenge or idealism, in Gabo's own writings. Gabo himself avoids talking about his own art as 'an art of the future': he states quite emphatically that it is about the present and exists in the present. Yet the assumptions behind it are always those of human progress and development; when he writes of the 'Constructive Idea' he uses the word 'constructive' in its most conversational sense, meaning simply 'helpful' or 'contributing towards progress', quite as much as its more technical one. ('The artist in his art is led by an idea of which he believes that it epitomises . . . what the collective human mind of his time feels and aspires towards. . . . Though his idea may or may not eventually prevail . . . it nevertheless is performing a function without which no progress is possible', as he says in the Trowbridge Lecture [see Gabo, "On Constructive Realism," in Further Reading, section I].) The Constructive aesthetic is sustained by the belief that because of the logic inherent in its assumptions about the role of art in the modern world it can in the end contribute something towards making that world a saner place to live in.

What is there, then, static, completed or realized about it? I don't intend to imply that it is anything which, in fact, cancels out Constructivism's potential as a forward-looking art, but only to recognize the existence of a criticism which Gabo has himself recognized, at least to the extent of feeling obliged to contradict it. 'I have often used the word "perfection",' he wrote to Herbert Read, 'but "perfection", in the Constructive sense, is not a state but a process; not an ultimate goal but a direction. We cannot achieve perfection by stabilizing it—we can achieve it only

by being in its stream' [see excerpt dated 1944]. That such a fundamental point should be misunderstood may be naive, but it is, frequently, misunderstood.

One of the most extraordinary things about *The Realistic Manifesto* (one of the very few manifestos of its kind in the early history of modern art which doesn't read slightly embarrassingly today) is that in it Gabo set out in its entirety a programme which has barely required modification since. In spite of slight shifts of style (notably the one around 1936, when his feeling that the visual character of space was not angular but 'spheric', led to a more gracefully curvilinear manner in his constructions), Gabo's own realization of the programme in practice has not only been brilliantly thorough but quite remarkably consistent, with the inevitable result that it has been accused of 'not leading anywhere'. Even perceptive admirers of his art have been drawn into making this reservation: 'I see little possibility of modification in the work of the most important Constructivist of all', [Patrick Heron] has written: 'this abstract art seems to me a futile if noble attempt to suppress a whole universe of legitimate pictorial ingredients in order to take other valid aspects to their furthest limits. It is the sort of operation which . . . conclusively demonstrates a *cul-de-sac*'.

Gabo has written more, and more profoundly, about the relation between his beliefs and his art than almost any major artist of our time. What he has written could hardly provide a more cogent or more humane and passionately reasoned refutation of such criticism. Is there then, in fact, a gap between his writings and his work which makes such misunderstanding possible? Only, I think, to the extent which makes it true to say that Gabo's work has not, in fact, been in tune with its own time, and has not yet itself fully realized its aim as a public art. The **Bijenkorf Structure** in Rotterdam does, certainly, fulfil the premise of *The Realistic Manifesto* that 'art should attend us everywhere that life flows and acts . . . on working days and holidays, at home and on the road'; its creator's hopes for an art that had a social character superior to its role as personal statement seem in this instance, at least, to have been met by the very fact (which he recounts with deep satisfaction) that the citizens of Rotterdam now refer to it as 'Our Thing', not even any longer as 'Gabo's Thing'. But Gabo's work as a whole seems to be for ever waiting to rise to the sort of opportunity which suddenly ('almost by accident', he says) offered itself at Rotterdam—an art about the definition and articulation of space repeatedly limited to functioning on a scale about three feet high: an art linked with modern engineering and modern architecture, and conducting its own intuitive research into problems of structural stress (the engineers engaged on the Bijenkorf project had to concede to Gabo a structural solution which was pragmatically sound but unprovable by mathematics), yet confined to the sphere of personal aesthetics.

Between 1919 and 1932, Gabo's practical yet visionary imagination produced one 'monumental' invention after another—**Project for a Radio Station, Monument for an Observatory,** a series of Towers and Columns, **Monument for an Airport, Project for the Palace of the Soviets,** and constructions whose architectural relevance was implicit

even when untitled. In his work since the mid-thirties one senses a change possibly more subtle than that from an angular to a 'spheric' conception of space. After the thrusting and virile energy of projects that obviously would never be built, the more yielding delicacy, fragility, and gracefulness of what Constructivism was supposed not to be about—*objets d'art* for the connoisseur. Gabo's later works are marvels of exquisite invention and precise beauty, but they tend to have given up their former implied sense of heroic scale, although it still haunts him. Looking back at the constructive heads he first made in Norway in 1915, and admitting a special fondness for them, he has said that he still dreams of remaking one of enormous size, so that it would function not spatially but as a huge silhouette in the tradition of the giant heads of Buddha or of the Egyptian sculpture he admires more deeply than any other art of the past.

I suggested above that Gabo's Constructivism, in the last analysis, was not in tune with its own time. What I mean more precisely is that his work is conceived in the spirit of a twentieth century which is postulated in his writings but has not been recognized in his experience. To that extent it is deeply and romantically idealistic. He left Russia for good in 1922, when it became clear that plans for the New Society were not going to include toleration of a new art. But Gabo is typical of those expatriate Russians who have known at first hand the sense of spiritual rebirth that the Revolution inspired: they carry their original vision of the New Society always with them, and most Western values are made to look tarnished or superficial when set against it. Gabo's Constructive Idea—more of a philosophy of life than an artistic credo—pleads for the primacy in art of most of the old-fashioned virtues Western art currently affects to have outgrown (clarity, logic, order, etc); it justifies the effacement of the artist's personality in his work in terms which make nine-tenths of recent art seem self-indulgent and narcissistic; and it gives the classic definition of how the roles of art and science would be related in a more reasonable world. The case is put with what certainly amounts to moral fervour, ('I have ever so often been mistaken for an ecclesiastic evangelist which I am not'), and it is coupled with a profound distrust about the times he lives in and the kind of art they produce (doctors will tell you, as he puts it, that there are patients who grow to enjoy their own illness).

Antoine Pevsner, Gabo's elder brother, showed how an art with its origins in Constructivist practice could be turned to the expression of something very near to psychic tension and anxiety. But Gabo's own work is probably as far removed as it is possible to get from the faintest intimation of the tragic—even that power of darkness that any sculptural mass contains is banished by the Constructivist renunciation of mass as a valid spatial element. In fact, it has been called, in the most profound sense, an optimistic art. If that merely meant that its cleanness, precision, grace, and logic were pleasanter (perhaps even 'better') things to contemplate than other, grosser, qualities, its optimism would be sentimental in spite of the moral preferences behind it ('the image of good—not of evil; the image of order—not of chaos; the image of life—not of

death . . . I should think that this is all that the constructive idea is driving at').

But its optimism goes beyond that. Quite as remarkable as the fact that *The Realistic Manifesto* outlined all the essentials of a Constructivist aesthetic *à premier coup* is the way in which its most radical-sounding principles have refused to date. Gabo's classically minded, traditionally based, logically argued position supplies the blue-print (as relevant now as it ever was) for a twentieth-century art integrated into the society and philosophy of an ideal future. An art so unshakeable in its premises, so clear in its conception of its role in the perspective of history, can afford to trust that history will be on its side. (pp. 133-39)

> *David Thompson, "Outlines for a Public Art," in* Studio International, *Vol. 171, No. 876, April, 1966, pp. 132-39.*

Eric Gibson (essay date 1986)

[*In the following review of a major Gabo retrospective at the Guggenheim Museum, Gibson traces the artist's development and decline.*]

The term "Constructivism" is one of the most unstable in the modernist lexicon. Broadly speaking, it describes sculpture that is made by joining discrete masses into open-form, usually abstract compositions. It differs from traditional sculptural methods which require the artist to cut away (as in carving) or build up (as in modeling) his materials so that they form a self-contained, monolithic mass. The Constructivist method was initiated by Picasso in the open-form sculptures he produced in the years immediately preceding the First World War. Extending into three dimensions the formal premises of his paintings of the period, Picasso used cardboard, sheet metal, and other materials to represent a particular object—the most famous is his *Guitar* of 1911-12—by reconstituting its elements into a series of open, overlapping planes. As a result, a new role was assigned to space in defining our perception of sculptural volume. Picasso's innovations in this field were taken up by scores of later sculptors, the most distinguished among them being Julio González, David Smith, Anthony Caro, and Mark di Suvero.

There is another Constructivist tradition, however, which tracks a different artistic course. It, too, grew out of Picasso's sculpture, but evolved in Russia in the Revolutionary period largely under the leadership of Vladimir Tatlin. On a trip to Paris in 1913, Tatlin saw some of Picasso's constructed reliefs in the artist's studio, and on returning home immediately set to work in developing his own version of this new sculptural genre. He thus laid the groundwork for what was to become the Russian form of Constructivism.

Despite the debt which this new sculptural genre owed to Cubism, and, incidentally, to Futurism as well—examples of which were readily accessible in Russia at the time—the Russian avant-garde made something very different out of it. In the Constructivist vision as it evolved in pre- and

Gabo on abstract and absolute shape in sculpture:

[It] is always stated as a reproach that we form our materials in abstract shapes. The word 'abstract' has no sense, since a materialized form is already concrete, so the reproach of abstraction is more a criticism of the whole trend of the constructive idea in art than a criticism of sculpture alone. It is time to say that the use of the weapon 'abstract' against our art is indeed only the shadow of a weapon. It is time for the advocates of naturalistic art to realize that any work of art, even those representing natural forms, is, in itself, an act of abstraction, as no material form and no natural event can be re-realized. Any work of art in its real existence, being a sensation perceived by any of our five senses, is concrete. I think it will be a great help to our common understanding when this unhappy word 'abstract' is cancelled from our theoretic lexicon.

The shapes we are creating are not abstract, they are absolute. They are released from any already existent thing in nature and their content lies in themselves. We do not know which Bible imposes on the art of sculpture only a certain number of permissible forms. Form is not an edict from heaven, form is a product of Mankind, a means of expression. They choose them deliberately and change them deliberately, depending on how far one form or another responds to their emotional impulses. Every single shape made 'absolute' acquires a life of its own, speaks its own language and represents one single emotional impact attached only to itself. Shapes act, shapes influence our psyche, shapes are events and Beings. Our perception of shapes is tied up with our perception of existence itself. The emotional content of an absolute shape is unique and not replaceable by any other means at the command of our spiritual faculties. The emotional force of an absolute shape is immediate, irresistible and universal. It is impossible to comprehend the content of an absolute shape by reason alone. Our emotions are the real manifestation of this content. By the influence of an absolute form the human psyche can be broken or moulded. Shapes exult and shapes depress, they elate and make desperate; they order and confuse, they are able to harmonize our psychical forces or to disturb them. They possess a constructive faculty or a destructive danger. In short, absolute shapes manifest all the properties of a real force having a positive and a negative direction.

From "Sculpture: Carving and Construction in Space."

post-Revolutionary Russia, the artist came to be regarded as an indispensable agent in the creation—or rather, the *construction*—of a new and better (by which was meant a socialist) society. And while these new Constructivists made use of Cubism's vocabulary of open forms and its syntax of interlocking planes, they did so in an entirely nonobjective style. The materials used by the Constructivists were hailed for their superior "reality"—their congruence with the world of everyday things—and were employed in compositions which rejected whatever had remained of Cubism's illusionism. The new Constructivism attempted to remove the barriers separating the actual space of the viewer from the virtual space of the work of art. Out of this approach Tatlin evolved his doctrine of the "culture of materials," which enjoined the artist to exploit the characteristic properties of his materials (one of these

materials being space itself). Thus, while Cubist construction was exclusively an aesthetic matter, with no concern beyond its artistic realization, its Russian counterpart, fired by a utopian vision, embodied an entire social ethos.

It is to this Russian branch of Constructivism that Naum Gabo, whose retrospective was lately seen at the Guggenheim, belongs. Gabo's place in the Russian avant-garde was rather an equivocal one, however. He was abroad from 1911 to 1917, so his artistic outlook was formed on his own, outside the Russian avant-garde movements which flourished at the time. Shortly after his return to Russia in 1917, moreover, he led the split away from Tatlin's group, which advocated a purely utilitarian, propagandistic role for art. In his *Realistic Manifesto* of 1920 [see Artist's Statements dated 1920], Gabo advocated an art that addressed itself exclusively to the spirit, maintaining that such an art need not be incompatible with the aims of social and political reform. The "publication" of the manifesto—it was posted in places formerly reserved for decrees from the Czar—coincided with the only public exhibition Gabo ever had in Russia, an exhibition organized by himself. One might expect that, having seized the initiative in this way, Gabo would have moved into a position of leadership within the avant-garde. But this was not the case. He remained aloof, as he always had been, participating in discussions and debates at the VKhUTEMAS—State Free Art Studios—in Moscow but accepting no official position there. His open break with the utilitarian Constructivists notwithstanding, Gabo never disavowed the Constructivist movement's emphasis on modern materials, its view of the Constructivist idea as emblematic of the modern age—nor, for that matter, its utopian vision.

Despite Gabo's equivocal relationship to the Russian avant-garde, it is against the backdrop of its personalities and events that his work needs to be understood. His sculpture constitutes a kind of dialogue between the opposing attractions of orthodox Constructivism's public voice and the private, very different dictates of an inward sensibility. For Gabo brought something personal and extra-artistic to the avant-garde circles of Russia at this time—an interest in the new discoveries concerning space and time in physics, and an ardent desire to give them artistic expression. In Gabo's mind, these discoveries represented the defining issues of the modern era, and no contemporary art claiming to represent the spirit of the time, he felt, could afford to ignore them.

Gabo is one of the few members of the Russian avant-garde to have made anything enduring from Constructivism once outside the white heat of the Revolutionary environment. Yet in spite of his importance, past retrospectives of his work—the last one was nearly twenty years ago—have been hampered by serious difficulties because much of his work was lost, partially disassembled, poorly restored, or withheld from exhibition. More than is usually the case, therefore, this retrospective represents a concerted effort to unlock the many mysteries surrounding Gabo and to present as nearly as possible a definitive account of the artist. Works have been retrieved from obscurity and restored. (***Constructed Head No. 1,*** Gabo's first constructed sculpture, is exhibited for the first time in half

a century.) Elaborate research and documentation have also been undertaken to put the Gabo *oeuvre* in order.

There is one omission worth commenting upon, however. That is the important *Hanging Construction* of 1959 from the Baltimore Museum of Art. Installed in a stairwell in that museum, where it is attached to the ceiling, this sculpture is the realization of longstanding ideas concerning the use of a staircase to afford continuous, changing perspectives of a single work. At fifteen feet in height, it would have looked superb in the well of the Guggenheim's rotunda, and would have offered viewers making their way down the ramp their one complete experience of a critical element in Gabo's aesthetic: dynamic motion in space experienced through time. As the show was mounted—with many of Gabo's works backed into the bays that form the museum's temporary exhibition space—the viewer could glimpse this aspect of Gabo only sporadically and imperfectly.

Gabo's artistic career is one of very definite highs and lows. During the decade 1915-1925—the time of his debut as a mature artist—he produced work in which there is scarcely a false note. This phase coincides with his wartime residence in Norway, his return to Russia and involvement with the avant-garde, and his later sojourns in Berlin and Paris. If one knew nothing of the artist who made the work of this period, one would easily conclude that he had spent all those years in a basement studio, so steady and assured is his achievement.

During the following two decades, however, this consistency diminishes, until by 1950 it becomes clear that Gabo's career as an innovative artist is effectively over—a fact tacitly acknowledged by Steven A. Nash in his catalogue essay, where scant consideration is given to this concluding phase of Gabo's career [see Further Reading, section V]. The art of these years turned lifeless as the artist began thinking more and more in terms of monumental public sculpture. As a result of this dramatic falling off, the Guggenheim exhibition ends—inevitably—in anticlimax.

Gabo's first sculptures, composed of interlocking planes and entitled *Constructed Head*s, are often thought to constitute critiques of comparable Cubist sculptures by Picasso, work of the sort Tatlin had seen in 1913. In fact, they are critiques of sculpture in general—of the traditional closed monolith—as well as manifestos for the new, more modern form of three-dimensional expression Gabo envisioned. In 1913 he had gone on a walking tour through Italy but had been unable to respond enthusiastically to what he had seen, feeling it was "dead" and that consequently, "something ha[d] to be done in sculpture." The *Constructed Head*s are Gabo's answer to this quandary.

Although derived to some degree from the contemporary geometric abstraction Gabo would have seen in Munich and Paris, these early sculptures reflect more directly his studies of engineering, one of many subjects he turned to after studying medicine for a while in Munich. In particular they draw on principles of structural engineering, using thin planes to create volume with the minimum of mass, just as steel-girder construction does. At the same

Constructed Head No.1 *(1915).*

time they show Gabo's new attitude toward the role of space in sculpture. Like Tatlin, Gabo considered Cubism to be inherently "false"—an illusion—and believed that space in sculpture had to become more "real." But unlike Tatlin, Gabo was not aiming at a metaphor for a new social reality. Rather, he wished to express the spirit of the age by taking as his "subject" newly formulated concepts concerning the nature of space and time (e.g., Einstein's theory of relativity).

In *Constructed Head No. 1* and *Constructed Head No. 2,* both from 1915, mass is expressed entirely in terms of interior structure, where volume is suggested by the linear contours of the plane edges. With the figure opened up so thoroughly, interior space—articulated by planes—is revealed in order to fuse with the surrounding, literal space of the viewer.

In spite of this bold approach to problems of sculptural language, and their considerable degree of success, these *Head*s remain tied to the past in important respects. Because the plane edges defining the volume of the figure imply a skin around it, Gabo reveals only an *interior* space, a space permanently separated from ambient space. The *Constructed Head*s thus fall short of that direct relationship between actual and aesthetic space which Tatlin achieved at about this time in his own reliefs, where metal rods project directly off the background plane and out into the space of the room. Ironically, Gabo's sculptures are set off from ambient space in a way that is very much akin to the Renaissance sculpture he had felt such antipathy toward on his trip to Italy.

A further respect in which the **Constructed Head**s belong to the past is in the play of light and shadow that animates them. This play endows them with a pictorial, *un*-sculptural quality which goes against the greater sculptural purity Gabo was seeking. Finally, **Constructed Head No. 2,** with its folded hands and tilted head, projects a deeply contemplative mood. Dr. Nash accounts for this by alluding to Gabo's affinity for Russian icons—an affinity he shared, as Dr. Nash also points out, with Tatlin, Malevich, and other members of the avant-garde.

Gabo's idea that sculpture should express the new dynamics of space found its earliest successful realization ten years later in **Construction in Space with Balance on Two Points,** one of the pre-eminent works of modern sculpture. Gabo uses celluloid here, a contemporary antecedent of plexiglass. Its transparency makes it appear immaterial and weightless, and helps to reduce sculptural mass. The main portion of the work is a complex of two interlocking cubic volumes placed at forty-five-degree angles. Both are reduced to the barest form. One volume, perpendicular to the sculpture's base, is formed by a vertical, transparent plane bisecting a negative horizontal plane formed only by four black edges. The second volume is made up of four narrow white strips, two attached to one side of the vertical transparent plane of the first volume and two attached to the other side. This structure is then suspended above a semicircular strip resting on its outer, curved edge.

Throughout **Points** there is the barest indication of volume, or even material presence. By opening up the sculpture, and by underscoring the immateriality of the transparent planes, Gabo achieves that free interaction with space that eluded him earlier. So successful is he in this respect, that **Points** engages with space in a manner quite different from any sculpture before it. It goes beyond a simple physical involvement with space in the manner of Picasso and Tatlin and enters a realm in which it is no longer clear where matter ends and space begins. **Points** seems at once to contain space and to be constructed from it, even to move through it while remaining at rest.

Gabo achieves these extraordinary results with a series of deft oppositions. Movement, for example, is suggested by the syncopated rotary motion of the white planes, the zigzag horizontal trajectory of two black edges, the luminescent white edges of the transparent planes, and, finally, by the rotation of the cube structure and balancing support around a central vertical axis. Against this is set an almost classic stasis, achieved by the seemingly weightless suspension of the vertical clear plane and by the position of the entire structure on a single plane edge. The opaque black and white planes seem to affirm the work's material presence; the transparent sheet calls materiality into question.

Points highlights an important aspect of Gabo's art: his commitment to an *aesthetic* realization of his experience of the new scientific reality he perceived around him, one based on line, texture, volume, and, of course, space. This is why one need not be familiar with the science that was so often Gabo's starting point in order to appreciate the work that came out of it. And it remains the key to his enduring importance in an era in which nonaesthetic ele-

ments—mechanics and technology among them—have come to play an ever-larger role in art.

During the years between his **Head**s and the making of **Points,** many of Gabo's sculptures and drawings were designed for fountains and other types of monuments. Architecture and monumental sculpture had increasingly made their way to the center of the Constructivist aesthetic. For example, Tatlin's *Monument to the Third International,* never finally built, was to have been an enormous, rotating structure of conference and assembly halls. The appeal of the monument lay partly, of course, in the means it offered of symbolizing and publicly proclaiming the new gospel of utopia. Further, it reflected the Constructivists' changing view of art and of themselves. During the Twenties, they gravitated to architecture, believing it to be the logical extension of the Constructivist method in sculpture. It also fulfilled their image of themselves as builders, common laborers in the forming of a new society—this in contrast to the self-absorbed, bourgeois aesthetes of capitalist society.

Gabo, of course, never shared this utilitarian view of the artist's place in society. But he did subscribe to the utopian ethos, and it is this that explains his commitment to the idea of the monument as a standard part of the repertory of sculpture. The fact is, however, that Gabo was never able to translate his private vision into public sculpture. **Monument for an Airport,** for example, was executed shortly after **Points,** and out of identical materials—black, white, and transparent planes. But how different it is! Wanting to express the concept of dynamic aerial motion, Gabo "floats" the planes above the base and angles them forward, even shaping the transparent forms into parallelograms to suggest forward impulsion. After the quicksilver energy of **Points,** the **Monument for an Airport** communicates all too literally the nature of flight—the lofting of inert, heavy masses with great effort. The transparent planes have none of the weightlessness or immateriality of their counterparts in the earlier sculpture. Nor are we inclined to read the planes as fields of energy, as we do in **Points.** They are simply hard, flat surfaces that happen to be transparent.

It seems Gabo alone was unable to recognize this limitation in his work. As late as 1952, when his international reputation was firmly established, Gabo's entry into the English competition to construct a monument to an unknown political prisoner was turned down by the jury. While they felt the model worked moderately well, they said that " . . . on a monumental scale . . . it would register much less effectively, making us all too aware of its lack of pity and terror." Success eluded the artist in a similar proposal carried out in Rotterdam five years later—and for the same reason. Its large size notwithstanding (it is 85-foot tall), it never bridges the gap between its self-referential abstract idiom and the ideal of physical and spiritual regeneration it is intended to symbolize. Gabo's pursuit of monumental expression is part of the reason the exhibition at the Guggenheim ends on such a dull note. The last major project he executed . . . was a rotating brass fountain designed to shoot jets of water from its edges. In such a situation the suggested dynamism of

Gabo's personal aesthetic is sacrificed to the superficial literalness of public display.

Gabo was always a small-scale sculptor, almost an intimist. His preparatory "sketches" are miniscule, never more than five inches in height and often smaller. They feel just right at that size, too. Even the sculptures worked up from them are not much bigger. Every photograph of Gabo at work . . . shows him at a table holding something small in his hand, looking more like an architect than a sculptor. All this suggests an ease with a mode of sculptural operation that is the antithesis of the heroic or monumental.

Looking at *Construction in Space with Balance on Two Points,* one finds it hard to imagine how Gabo could possibly equal it. He does, of course, although one has to traverse some pretty rough terrain to get there, through the stone carvings, for example, which strive for the dynamism and weightlessness of the plastic sculptures but which—needless to say—fail to achieve them.

By the Thirties, Gabo had come to feel that the planar language no longer communicated the spatial reality he sought. He began exploring ways of articulating his perception that space is curved. He did this first in a series entitled *Spheric Theme,* in which he cuts two plexiglass discs and joins them around an axial armature to create a single, spheric structure. Once again, these pieces articulate interior structure with almost no mass. They also dematerialize, irradiated by the light that is caught in the incisions along their surfaces. The *Translucent Version on Spheric Theme* owned by the Guggenheim is particularly fine, extending, in its absence of any vestige of solid matter, the weightlessness and immateriality of *Points.* It appears to be poised on the brink between the physical and the optical.

The Linear Construction series of the early Forties—one of Gabo's masterpieces—crosses that brink. In the variations that constitute *Linear Construction No. 1,* a square plexiglass armature is densely strung with a network of nylon monofilament in such a way as to leave a void at the center resembling a twisted almond. Its two ends are off-axis and point in opposite directions.

In this series, Gabo overturns the longstanding definition of sculpture as tangible form in space. For the almond opening at the center of these pieces is not a "void" in the traditional sense. The nylon monofilament constitutes mass reduced to the bare minimum. When it picks up the light, each thread glows, just as in earlier pieces the edges of the plexiglass planes glowed. Only here the accumulated fibers—which have a loose, in-between sort of form—dissolve into a haze of light and space. This transformation acts on the central opening, endowing it with an unexpected quiddity and turning it before our eyes into solid form moving through space. Gabo here seems almost to have created sculptural form out of nothing.

Needless to say, he doesn't actually do this; the effect is purely optical. But in *Linear Construction No. 1* he gives free rein to the strong pictorial element that has been present in his art from the beginning, when light and shadow first played across the *Constructed Head*s. The pictorialism now gives way to complete illusion. The focal element of the work, the almond shape, is completely unsculptural; there is nothing to touch.

Just how important this element of unreality is to the success of Gabo's work becomes apparent when he moves to the variations in *Linear Construction No. 2.* In these, two plastic planes shaped like the near-void of the previous series interlock at right angles. Again, nylon monofilament is used, stretched between the interlocking planes to create gently curving surfaces. These sculptures either hang vertically or lie on their side, and they have all the luminescence of the constructions in the first series. The one lying on its side has a talismanic quality. We want to pick it up and hold it.

The *Linear Construction*s can survive this new graspability because, being translucent, they are able to maintain a balance between form and pure light. However, the story is very different in the work of the next twenty-five years. Wanting to see as many sculptures as possible installed in public locations, Gabo shifted from plastic and nylon to sheet metal and wire. Although the sculptural language remains the same, the new opaque materials drastically alter the character and feel of the work. In contrast to the vibrancy of most of the previous pieces, this sculpture is curiously inert and flat. At the Guggenheim this sensation was particularly acute, since almost half of the four alotted ramps were given over to displaying it. As one moved along them, one realized that Gabo's career as an innovative artist was long over, having ended with the second Linear Construction series, the apogee of his sculptural dialogue with space. For the change in materials effected a dramatic reshuffling of the aesthetic equation. Where sculptural line, expressed as edge or plane, had previously functioned as a carrier of energy, it now served as the outer limit of a static physical form. And whereas multiple nylon threads, aided by light, exerted a transfiguring effect upon the sculptural object, their wire counterparts served only to activate a stilled interior space.

Once this happens, Gabo's *oeuvre* comes full circle, and we find ourselves back where we were at the beginning with the *Constructed Head*s—in a realm where sculpture and space are separate entities. In the sculptures of Gabo's last twenty-five years, one feels the artist going to great lengths to infuse his work with the energy and vision of some of the earlier pieces. Alas, the flood tide of inventiveness has receded, leaving us to contemplate the empty shell of an idea. (pp. 34-9)

> *Eric Gibson, "Naum Gabo at the Guggenheim," in* The New Criterion, *Vol. IV, No. 10, June, 1986, pp. 34-9.*

Martin Hammer and Christina Lodder (essay date 1987)

[*In the following essay occasioned by a retrospective exhibition of Gabo's works, Hammer and Lodder review the major themes of Gabo's art.*]

The constructions of Naum Gabo possess a beauty, subtlety and elegance that one can respond to directly. Yet behind the resolved simplicity of his forms there existed a

constant experimentation and a search for coherent intellectual foundations upon which an art for the twentieth century might be built. Before considering Gabo's evolution and the relationship between his art and the ideas and attitudes so forcefully declared in his writings, it is necessary to establish the outlines of his remarkable career.

Gabo was born Naum Pevsner in August, 1890. He grew up in Bryansk, in provincial Russia, where his father owned a metal works. After attending the gymnasium at Kursk, he spent four formative years in Munich, just before the First World War, studying the sciences and engineering and absorbing the ideas not only of Albert Einstein and his fellow innovators in scientific theory, but also those of the philosopher Henri Bergson and the art historian Heinrich Wölfflin (whose lectures Gabo attended). At this time Gabo also discovered contemporary art. He read Kandinsky's *Concerning the Spiritual in Art* (1912), one of the key proclamations of the principles of abstract art. He also became familiar with Cubist art in the course of visits to Paris in 1912 and 1913 to see his artist brother Antoine Pevsner.

For Gabo, as for so many of his generation, cubism provided an essential catalyst for his own artistic explorations, and in 1915, while living in neutral Norway, he established his personal language as a sculptor in *Head No. 1.* At the same time he changed his name from Pevsner to Gabo, to symbolise his newly found identity as an artist and distinguish himself from his brother. In 1917 he returned to Russia, inspired by the apparent promise of the Revolution to create an ideal new society on the ruins of the Tsarist autocracy. Arriving in Moscow, he became acquainted with other avant-garde artists committed to the concept of social change and facing the challenge of expressing the new society through new forms of art. During the next five years Gabo contributed to this remarkable ferment of artistic debate and experimentation, both through his work and through *The Realistic Manifesto,* published in 1920 under the joint signature of himself and Pevsner on the occasion of an open air exhibition in Moscow [see Artist's Statements dated 1920].

Two years later Gabo emigrated, just as the Bolshevik government's toleration for avant-garde approaches was beginning to turn into more active hostility. He spent the next decade in Berlin, another important centre of artistic and architectural innovation. Although acquainted with other Russian emigrés such as El Lissitzky, he also established friendships with artists including Hans Richter and Kurt Schwitters. He exhibited with the Novembergruppe and had some contact with the Dessau Bauhaus where he gave a few lectures. At this time he worked on the highly original set and costume designs for Diaghilev's ballet *La Chatte* which played in Monaco, Paris and London in 1927. Impelled, as a Jew, to flee the 'spiritually unbreathable' atmosphere of Nazi Germany in 1932, Gabo moved briefly to Paris. Four years later he settled in London after participating in the first exhibition of international abstract art in England since the First World War, the Abstract Concrete show of 1936. In 1937, together with Ben Nicholson and the architect Leslie Martin, Gabo edited *Circle,* a compilation of essays and illustrations of contemporary work which epitomised that brief moment when London seemed to possess as lively an avant-garde as anywhere in Europe. The outbreak of the Second World War interrupted these developments, and Gabo and his wife Miriam joined Ben Nicholson, Barbara Hepworth, Bernard Leach and Adrian Stokes in Cornwall. Finally, in 1946 Gabo moved to America, where he enjoyed international success until his death in Connecticut in 1977.

Subsequently, the contents of Gabo's studio have revealed much fascinating material, including models, drawings and sketchbooks which shed new light on his creative processes. Most remarkable, however, was the discovery of a group of his sculptures which had been taken apart and wrapped up for removal and storage. In this way they had survived Gabo's journeys from Moscow to Berlin, Berlin to Paris, Paris to London, London to Carbis Bay and Carbis Bay to Connecticut. A number of highly important early works, not exhibited for decades and assumed to be lost and possibly destroyed, have now been reassembled and restored with immense skill and sensitivity by Charles Wilson, who was Gabo's assistant in the 1960s and 1970s. (pp. 41-2)

In complete contrast to the unsettled quality of the earlier part of his life, Gabo's art displays a remarkable consistency of approach and intention. This is epitomised by his tendency to make variations of his images years and even decades after their first realisation. Each work, and each phase of his work, seem to develop quite naturally out of what has gone before, and yet each new form is invested with its own distinct identity. This interaction of continuity and progression is especially clear if one focuses on particular themes that were central to Gabo's work throughout his career: the sculptural exploration of space and movement; the interest in affinities between sculpture and architecture; and the 'constructive' approach that expressed the essence of his artistic philosophy.

The sense of space as a positive element in his constructions was a product of Gabo's radical opening up of form. From the beginning his sculpture developed from the insight that a three-dimensional form could be described not only in terms of its outer surface, but also in terms of an internal armature of structural planes. He illustrated this distinction diagramatically with two cubes, one solid, the other a 'stereometric' construction; 'the first represents a volume of mass; the second represents the space in which the mass exists made visible' [see Gabo, "Sculpture: Carving and Construction in Space," in Further Reading, section I]. In Gabo's early constructions of heads he elaborated this method of evoking the interpenetration of form and space. They are neither modelled nor carved, but constructed from interlocking planes, which imply the volume without describing it as a solid mass. This method of building up form out of distinct planar and linear elements was the technical basis of his idea of 'constructive' sculpture.

Although the results were remarkably original, Gabo's approach did not emerge out of a vacuum. Like many of his Russian contemporaries, he found a stimulus towards abstraction in the native tradition of icon painting which disregarded the world of everyday appearances to evoke an

absolute, transcendental realm. This inspiration is evident in the simplified facial forms and Madonna-like treatment of **Constructed Head No. 2** and in some of the related studies. The format of **Constructed Head No. 3, Head in a Corner Niche** may well allude to the customary display of devotional icons in the corner of domestic interiors. The early sculptures undoubtedly expressed Gabo's excitement at the use of planes to describe volume and space in the cubist art of Picasso, Braque and their followers. For Gabo, with his background in science, these visual qualities must also have seemed vividly in tune with the disintegration of the distinction between solids and surrounding space in current physics, as well as with the structural principles of engineering that had absorbed him in Munich. As he proclaimed in *The Realistic Manifesto:*

> We renounce in sculpture, the mass as a sculptural element.
>
> It is known to every engineer that the static forces of a solid body and its material strength do not depend on the quantity of the mass . . . example—a rail, a T-Beam, etc . . .

A progressive diminution of the sense of solidity became possible once Gabo had abandoned direct references to a figurative subject. He made this breakthrough in Russia, stimulated no doubt by looking at the Suprematist paintings of Malevich, and at the abstract constructions that Tatlin and his followers were making. Gabo began to compose with pure geometric planes, creating forms that were not only open in their construction, but also transparent, for he began to incorporate glass and plastic in conjunction with metal elements. A work like **Column,** conceived in Russia, illustrates this approach in a fairly simple freestanding structure, built up around a core of two intersecting planes. In Berlin, Gabo began to devise forms more fully penetrated by space. In **Construction in Space with Balance on Two Points,** diverse spatial axes are woven into a complex configuration in which opaque planes are juxtaposed with transparent, curved with rectilinear and frontal with diagonal. Such oppositions are held in a taut balance, beautifully sustained from all viewpoints. The transparency and open structure combine with the minimal contact between form and base and the suspension of the central element to evoke a vivid sensation of weightlessness.

In Gabo's subsequent work, angularity and flat planes gave way to more rhythmic and rounded forms. He felt that such an impulse crystallised in England, when he invented the Spheric Theme form, a skeletal description of a sphere equivalent in some respects to the earlier stereometric cube. He later wrote [see Lund Humphries in Further Reading, section V]

> The Spheric Theme is the result of many years of research for a constructive method of transferring my perception of space in terms of visual experience of it . . . I felt that the visual character of space is not angular: that to transfer the perception of space into sculptural terms, it has to be spheric . . . Instead of indicating space by an angular intersection of planes, I enclose the space in one curved continuous surface . . . There is an immense variety of images

which . . . can be executed with the help of this system.

Other works from Gabo's years in England express with new purity his ambition to create an immaterial sculpture that appears to shape and articulate space itself. He made a series of sculptures using only transparent materials, and the effect, as in **Arch** and **Construction on a Line,** is one of remarkable delicacy and subtlety, as the edges of the planes catch the light to create a luminous drawing in space. Gabo was aided by his discovery of Perspex, a new type of plastic first marketed in 1935. The advantages of Perspex over earlier plastics such as celluloid, were its pristine transparency and its greater malleability so that sheets could be heated and bent into the rhythmic shapes Gabo wanted.

In certain of the plastic pieces, such as **Construction in Space: Crystal** of 1937, Gabo introduced incised lines, in close repetition, as a means of giving visual definition to the transparent plane and of highlighting the sense of movement in space. The effect is to dissolve the plane into a dynamic field of linear energies. This idea foreshadowed his interest in the device of stringing, a dominant feature of his sculpture from the 1940s onwards. At first he used the new medium of nylon, a transparent plastic available as a monofilament, or thread. In **Linear Construction No. 1,** the intricate web of stringing is literally permeated by space while evoking visually continuous planes that shimmer with reflected light. This flowing surround seems to define the central opening as a positive form in its own right. The sculpture expresses with poetic intensity Gabo's conviction that space is no less tangible than supposedly more solid forms of matter:

> I do not hesitate to affirm that the perception of space is a primary natural sense . . . Our task is to penetrate deeper into its substance and bring it closer to our consciousness; so that the sensation of space will become for us a more elementary and everyday emotion, the same as the sensation of light or the sensation of sound.
>
> In our sculpture space has ceased to be . . . a logical abstraction or a transcendental idea and has become a malleable material element.

This remarkably intricate and immaterial mode of sculpture was further explored in the many subsequent works that employ stringing, and particularly perhaps in **Linear Construction in Space No. 4,** where the entire form consists of membranes of metal springwire, interweaving within a skeletal framework.

Gabo's interest in movement and rhythm in sculpture, like his spatial concerns, stemmed from his rejection of the monolithic and massive emphasis of sculptural tradition. In *The Realistic Manifesto* he announced an interest in dynamism that would remain fundamental to his art:

> We renounce the thousand year old delusion in art that held the static rhythms as the only elements of the plastic and pictorial arts.
>
> We affirm in these arts a new element, the kinetic rhythms, as the basic forms of our perception of real time.

This aspiration of 1920 found its first visual counterpart in *Kinetic Construction,* a work of the same year. It consists merely of a metal rod caused to oscillate so rapidly by an electric motor that its movement describes the image of a standing wave, poised vertically in space. The work can be seen as the most extreme expression of Gabo's impulse to dematerialise sculpture, distinguishing our optical perception of form in space from the tactile response to physical structure and materials. Although the idea was extraordinary, a premonition of much kinetic sculpture that was to follow, for Gabo its approach was rather too literal. Later he remarked 'the design is more an explanation of the idea of a kinetic sculpture than a kinetic sculpture itself'. Thereafter, the evocation of dynamic forces became more of a compositional challenge, addressed for example in the cantilevered diagonal energies so expressive of speed and flight of *Monument for an Airport.*

From the 1930s onwards it was above all the interplay of flowing linear rhythms that Gabo used to suggest movement in space. Hence a work such as *Kinetic Stone Carving,* where the medium might appear less compatible with the stated kinetic intention. The use of carving may reflect his proximity in England to Henry Moore and Barbara Hepworth, for whom direct carving and sensitivity to the resistances inherent in materials were fundamental commitments. Yet Gabo's emphasis is not on the density of an inert mass but upon the accentuated linear edges that spiral round the form, expressing the dynamic energies within the stone. The culminating expression of this type of centrifugal composition is found in *Spiral Theme* of 1941, a transparent construction made in St. Ives and vividly described by Herbert Read on the occasion of its first showing:

> This form, hovering like a still but vibrating falcon between the visible and the invisible, the material and the immaterial, is the crystallisation of the purest sensibility for harmonious relationships: and whereas, in constructivist art generally, this crystallisation is a mere planning of static relationships, here an axial system crystallises energy itself.

The kinetic quality characteristic of Gabo's later work was established in *Linear Construction No. 2,* the first significant new image devised after his move to America in 1946. Its core consists of two planes of transparent plastic intersecting at right-angles, a structure foreshadowed in *Column* and even in the stereometric cube. Yet now the planes are 'lobed', and the sense of dynamic rhythm is enormously enriched by the complex layering in space of the nylon stringing. With each slight shift of viewpoint, the iridescence of reflected light takes on a new configuration. To accentuate the sense of immateriality, Gabo suspended some versions from the ceiling to about an inch above the base, so that the form literally hovers, moving very slightly in response to air currents. Some later works are indeed made to rotate mechanically, for example *Vertical Construction No. 2,* but by now the essential kinetic energies are embodied in the formal language of Gabo's sculpture, without being dependent on literal motion.

Although his primary achievement was as a sculptor, Gabo believed firmly in the unity of the arts and in the uni-

versal application of the 'constructive' idea. His painting, printmaking and design work clearly pursue formal and spatial ideas similar to those explored in the sculpture. The paintings mostly date from the 1930s onwards, and the monoprints from after 1950. Although Gabo's interest in architecture produced less tangible results, it was perhaps more deeply rooted and of more profound significance for his concept of sculpture. Some of his closest associates were involved in architecture—Konstantin Mel'nikov in Russia, Mies van der Rohe, Hugo Häring, Eric Mendelsohn and Walter Gropius in Germany, Leslie Martin in England, and the architectural writer Lewis Mumford in America. Gabo himself conceived a number of architectural projects, of which the most fully realised were the designs he submitted in 1931 for the Palace of the Soviets Competition in Moscow. This consisted of two shell-like auditoria cantilevered out from a main service block. For this daring conception he had to devise a special structural system of prefabricated units in reinforced concrete, based on the stereometric cube. This would have created a lightweight structure capable of spanning large spaces without support. Construction techniques based on the same principle are now widely used.

Gabo perceived a direct link between contemporary architecture and his approach to sculpture in that both involved a process of construction, the use of materials such as glass and steel and a reliance on skeletal structure to support form. Both are concerned with the definition of spatial volume and manipulation of spatial axes. This link was implicit in his assertion that 'The Constructive idea has given

Column *(1923).*

back to sculpture its old forces and faculties, the most powerful of which is its capacity to act architectonically'. However, Gabo also had in mind the function of his sculpture as well as its form. It was his constant ambition to create sculptures which possessed the potential for elaboration into public monuments or buildings. This aspiration again had its genesis in Gabo's experience of revolutionary Russia. For the most radical of his artistic contemporaries in the new Soviet State, who adopted the name Constructivists, the task for artists was to design prototypes for mass production and to participate in the creation of a new environment expressing a socialist and industrial society. In practice they produced designs for numerous items, from posters and textiles to enormous abstract decorations for cities and visionary architectural schemes such as Tatlin's famous *Monument to the Third International,* 1919-20. Gabo rejected their more extreme utilitarian attitudes, but he was clearly excited by the widespread impulse to create bold structures symbolising new functions and new technologies. While in Russia, he produced sketches for public structures, monuments for city squares and even a project for a radio station. After the move to Berlin he made a series of sculptures, with such titles as *Tower, Model for a Fountain* and *Model of a Monument for an Observatory.* He recalled:

> From the very beginning of the Constructive Movement it was clear to me that a constructed sculpture, by its very method and technique, brings sculpture very near to architecture . . . My works of this time, up to 1924 . . . are all in the search for an image which would fuse the sculptural element with the architectural element into one unit. I consider this *Column* the culmination of that search.

Column does beautifully combine a purely sculptural interplay of forms with a metaphorical allusion to some futuristic structure which Sir Leslie Martin has imagined thus:

> In terms of architecture it would . . . be a structure with a steel framework glazed with a skin of glass . . . At its core there would be the solid forms of its lift towers and service ducts and its feet would be encircled by elevated roads.

As Gabo implied, it was in this early period of his career that his sculptures contained the most direct architectural references. Paradoxically, perhaps, his forms had become much more evocative of an organic and natural order by the time that he finally received commissions for large public works. This followed his arrival in America, when Gabo began to enjoy a new measure of recognition after his joint exhibition with Antoine Pevsner at the Museum of Modern Art, New York in 1948. Two years later Gabo finally realised his ambition to make public sculpture when he was asked to make a *Construction for a Stairwell* in the Baltimore Museum of Art. Of the prestigious commissions that followed the most notable were the *Bijenkorf Construction,* unveiled in 1957 and standing 85 feet high outside the department store in Rotterdam, and the large revolving fountain installed outside St. Thomas's Hospital in London in 1976. For Rotterdam Gabo devised an elongated variation of the spheric theme form, with two

planes twisting through 90° in space to meet at the summit. The extent of his departure from a more architectonic idiom is indicated by a . . . letter [to Herbert Read, dated January 10, 1956]:

> in the world of plants, in the structure of a tree . . . there lies a structural principle which was, as far as I know, neglected yet which could be with great advantage applied to many a structural task . . . once this principle became evident to me, the image of the whole sculpture evolved out of it naturally. I conceived it as a tree, the trunk, the roots and the branches. . .

The fountain, completed in Gabo's eighty-sixth year, was an enlarged version of *Torsion,* a sculpture he had made in the late 1920s. The form rotates slowly at the centre of its pool, myriad jets of water creating a delicate and ephemeral counterpoint to the underlying stainless steel structure. The beauty of the conception is Gabo's integration of the water into the form, a poetic extension of his previous use of stringing, but now using an even more fugitive and dynamic medium.

Just as certain ideas and forms continued to inspire Gabo throughout his career, so he maintained a consistent intellectual commitment to the concept of 'constructive art'. Beyond its technical connotations, the term expressed for Gabo an affirmation of the contemporary world:

> Sculpture personifies and inspires the ideas of all great epochs. It manifests the spiritual rhythm and directs it.

Thus the qualities of clarity, precision and order in his sculptures had a resonance beyond the purely aesthetic. A key passage of *The Realistic Manifesto* asserted:

> The plumb line in our hand, eyes as precise as a ruler, in a spirit as taut as a compass . . . we construct our work as the universe constructs its own, as the engineer constructs his bridges, as the mathematician his formula of the orbits.

Gabo emphasised the importance to artists of 'the growth of human knowledge with its powerful penetration into the mysterious laws of the world which started at the dawn of this century'. Modern science provided a model for thinking that abstract structures could have some correspondence to a deeper understanding of reality itself [see Gabo, "On Constructive Realism," in Further Reading, section I]:

> . . . a world in which forces are permitted to become mass and matter is permitted to become light; a world which is pictured to us as a conglomeration of oscillating electrons, protons, neutrons . . . If the scientist is permitted to picture to us an image of an electron which under certain conditions has less than zero energy . . . and if he is permitted to see behind this simple common table, an image of a curvature of space—why, may I ask, is not the contemporary artist to be permitted to search for and bring forward an image of the world more in accordance with the achievements of our developed mind . . .

The forms devised by engineers and designers of machine-

ry clearly provided an impetus for some of Gabo's early sculptures. For example, in **Circular Relief** of 1925, the armature of the composition bears an affinity with one of the small illustrations of contemporary machines that Gabo assembled in a Berlin sketchbook. The models made by mathematicians to demonstrate complex formulae possessed an abstract precision and elegance that was undoubtedly inspiring to Gabo. For example, certain stringed models may well have encouraged him to introduce a version of this device into his sculpture, just as Henry Moore's more fleeting use of stringing was inspired by visits to the Science Museum. Equally exciting to Gabo was the current argument that organic forms in nature were in essence mathematically determined. His contemplation of the structural principles of shells whilst living for seven years by the Cornish coast might well have stimulated such forms as **Spiral Theme,** 1941/2 and **Linear Construction in Space No. 2.**

The constructive ideal, however, involved more than a passive reflection of the contemporary order of experience. In Gabo's view, to be constructive as an artist meant involving oneself in the communication of progressive and optimistic values to as wide an audience as possible and across a range of visual media. [In *The Realistic Manifesto,* he] stressed:

> In the squares and on the streets we are placing our work . . . Art should attend us everywhere that life flows and acts . . . at the bench, at the table, at work, at rest, at play . . . in order that the flame to live should not extinguish in mankind.

Beyond his commitment to public sculpture, Gabo believed that the artist, through his understanding of form, could contribute to the design of the environment in a wider sense. Gabo himself was particularly active in this sphere during the Second World War, when he worked with the Design Research Unit on various unrealised projects including a car design for Jowetts.

Ultimately the role of art in human culture was, for Gabo, far more profound than any mere visual embellishment. His idealism remained passionate, intense and undiminished by the many disillusionments that he experienced both personally and in the wider progress of twentieth-century art and history. In 1944, towards the end of the Second World War, he wrote to his close friend Herbert Read, eloquently summarising the moral basis of his art [see Artist's Statements dated 1944]:

> I have chosen the absoluteness and exactitude of my lines, shapes and forms in the conviction that they are the most immediate medium for my communication to others of the rhythms and the state of mind I would wish the world to be in. This is not only in the material world surrounding us, but also in the mental and spiritual world we carry within us . . .

> I think that the image they invoke is the image of good—not of evil; the image of order—not of chaos; the image of life—not of death. And that is all the content of my construction amounts to.

I should think that this is equally all that the constructive idea is driving at.

(pp. 42-51)

Martin Hammer and Christina Lodder, "Naum Gabo and The Constructive Idea of Sculpture," in Naum Gabo: The Constructive Idea, Sculpture, Drawing, Paintings, Monoprints, *South Bank Centre, 1987, pp. 41-51.*

John E. Bowlt (essay date 1988)

[*In the following excerpt, Bowlt discusses the significance of transparency in Gabo's works.*]

> Nikolai Ivanovich Stupin lives in our house and he has the theory that everything is smoke. But in my opinion not everything is smoke. Maybe there is no smoke. Maybe there's nothing. All there is is division. But maybe there's no division either. Hard to say.

> The story goes that a famous artist was observing a cockerel. Kept observing it and came to the conviction that the cockerel didn't exist.

> The artist told his friend about this—and his friend started to laugh. "What do you mean doesn't exist," he said, "when it's standing right in front of me and I can see it clearly?"

> And the great artist lowered his head—and, as he had been standing, so he sat down on a pile of bricks.

> THAT'S ALL.

This story was written in 1934 by Daniil Kharms, a member of the Absurdist group of Leningrad writers known as the OBERIU [Russian acronym for "Association for Real Art"]. By then the tempestuous debates and momentous innovations of the avant-garde were already part of history, but instinctively Kharms still expressed a key polemic identifiable with the artistic and literary achievements of Russian Modernism. In his story—for all its "absurdity"—Kharms compresses two incompatible world views, i.e. that reality is nothing and that reality *is* what it seems to be. In both arguments, the pivotal, but silent, connection is the concept of transparency, for at all times we look through space, through a physical medium that may or may not distort and conceal the true world. Some observers such as Kazimir Malevich, the Symbolist painter Mikhail Vrubel, and the fictitious Ivan Stupin felt that the material world is merely a smoke screen that has to be dispelled before the artist can depict the "mirror of mirrors." "Objects have vanished like smoke," wrote Kazimir Malevich in 1915. Others such as Naum Gabo, Pavel Mansurov, Alexander Rodchenko, and Vladimir Tatlin believed that the cockerel does exist because "it's standing right in front of me." (p. 15)

In 1910 the Russian Symbolist poet and philosopher Viacheslav Ivanov wrote that the artist's mission was to create a "second nature, one more spiritual, more transparent than the multi-colored *peplos* of nature." Ivanov then went on to explain that only the genuine artist could fulfil this mission, for the artist was the seer—a sentiment

shared by many artists and thinkers of the *fin de siècle,* not least Henri Bergson and Vasilii Kandinsky. This search for a "more transparent" reality derived from the widespread conviction, characteristic of the aesthetic and philosophical ambience of the late nineteenth and early twentieth centuries, that the reality of phenomena was a false one; that, as Andrei Bely asserted, "reality seen is the enchantress Lorelei", and that the arts should aspire to "remove material" and penetrate to the ulterior (or perhaps we should say interior), essential source. These general ideas also connect to two issues vital to the Russian avant-garde: the entire notion of abstract art on the one hand (e.g. Malevich's *White on White* series of 1917-18), and the practical application of transparent and translucent materials on the other (e.g. Gabo's glass, celluloid, and perspex constructions). It can be argued that a primary stimulus in both cases was a general fascination with seeing through and beyond the "real reality," even if for some observers such as the Nothingists, the ulterior reality proved merely a reflection of the initial one. The aspiration to overcome the false appearances of external nature (false because of our inadequate, "astigmatic" sight) encouraged many artists to assume that the essence of life lay "there," not "here." The art historian, mathematician, and Orthodox priest Pavel Florensky summarized the predicament in his brilliant essay of 1921, "The Analysis of Perspective," proposing that the aim of art is to "overcome sensual visuality." The logical conclusion to this assumption is that the less material used in a perceived object, the better—and that art should aspire towards the invisible. In this sense, we can understand why so many thinkers of the Modernist age identified artistic primacy with music, i.e. with the art of the unseen. As Bely said, "the smallest quantity of material should express the most content."

As a matter of fact, Bely's idea of physical economy was expanded by the Constructivists in the 1920s, especially by the Literary Center of the Constructivists (LTsK) led by Ilia Selvinsky and Kornelii Zelinsky. The LTsK was guided by the principle of "loadification," according to which every artistic unit (sound, color, etc.) must contain maximum formal and thematic power. They maintained that:

> From the airplane engine to the radio transmitter, size and substance have decreased while power has geometrically increased. From Neanderthal man to the nineteenth century, the load of energy per man has increased from 1.4 hp to 6.6 hp. Thus, in the course of tens of thousands of years, this load has scarcely increased, but in the dynamic epoch of the twentieth century the curve of this load has flown dramatically.

Once again, the inference was that invisibility or silence are the most expressive forms in art, something the Romantics and the Symbolists had realized long before. "A thought uttered is a lie," wrote the poet Fedor Tiutchev in his poem *Silentium* (1830-54). "Dear friend, don't you see / That all that is seen by us / Is only a reflection, only shadows / Of what the eye cannot see?", rejoined the poet and philosopher Vladimir Soloviev in 1892. (pp. 15-16)

One artist whose visual perception and basic aesthetic system were much influenced by the concept of transparency was Naum Gabo. The immediate impression evoked by his constructions and sculptures is of light, lightness, translucency, and reflection. Gabo's careful combinations of glass, plastic, wire, and metal assimilate and reprocess light, serving as fragile intermediaries between the viewer and the space or depth beyond. Gabo and his brother Antoine Pevsner wrote about this depth in their *Realistic Manifesto* of 1920 [see Artist's Statements]:

> We renounce *volume as a pictorial and plastic form of space; one cannot measure space in volumes, as one cannot measure liquid in yards: look at our space . . . what is it if not one continuous depth?*
>
> We affirm *depth as the only pictorial and plastic form of space.*

The implication is that the only valid component of reality is depth (transparency), and that any physical imposition such as a line or a color is a mere provisional sign, a metaphor for the vast beyond of outer space. Gabo's artifacts, therefore, link us directly with depth, instead of deflecting us with allusions to the phenomenal world, as a figurative painting does. We see *through* the work of art, *through* the transparent elements, as in *Columns* (1922-23), *Translucent Variation on Spheric Theme* (1937-51) or *Construction in Space with Crystalline Center* (1938-40). These works are almost "outside material." Gabo takes us through the looking-glass.

How did Gabo arrive at this particular effect? How do we explain his interest in the presence of absence? One answer is to be found in the concurrent interest in glass as a construction material in Russia—from the atriums of the Upper Trading Rows (GUM) in Moscow to the plate glass sidings projected for Tatlin's Monument to the III International of 1919-20 (a "hot-house for growing pineapples"). In its capacity to remove Stupin's "divisions" and connect the inside and the outside, glass serves a democratic purpose. Constructivist architects realized that glass could expose the function of a building, could emphasize the interconnectedness of human society and, therefore, undermine the notion of bourgeois privacy and individual space. This is the primary ideological value of Alexander Vesnin's project for the Leningrad *Pravda* building of 1924.

Gabo's approach to transparency, however, is not really influenced by the question of democracy. Gabo was interested not in reconfirming the concreteness of reality (as Vesnin was), but rather in summoning the condition of infinity. Like the Symbolists, Gabo invites us not to look at, but to look through, and to understand that space is the only constant beyond our noumenal perception. This is especially clear in the sets and costumes created by Gabo and Pevsner for Sergei Diaghilev's production of *La chatte* in Monte Carlo and Paris in 1927. The ballet is based on an Aesop fable. A young man, in love with a cat, beseeches Venus to change her into a woman. Although granting his wish, Venus also causes a mouse to enter the scene. The woman chases the mouse and is transformed back into the cat. As a result, the young man dies of a broken heart. The ballet is an allegory about the instability of outward appearances *vis-à-vis* eternity. To this end, Gabo placed

Construction in Space with Crystalline Center *(1940)*.

translucent constructions of talc, mica, celluloid, and oil-cloth about the stage, presenting the spectators as it were with a series of stereoscopic lenses to remind them constantly of the permanent space beyond capricious external surfaces. In other words, just as the plot was based on the physical displacement of one creature by another, so the objects that related to this transubstantiation were just as displaced and, with the exception of Pevsner's statue of Venus, resembling his concurrent celluloid torsos, were deprived of figurative value. Moreover, the circular stage itself revolved, constantly shifting the audience's viewpoint and further emphasizing the unreliability of appearances.

Artists such as Gabo, Rodchenko, and Tatlin are usually identified with the Constructivist movement, with its mechanical logic and sobriety of forms, but we should not forget that these artists received their early training during the twilight of Symbolism (ca. 1910). The cult of ulterior worlds, of secret doctrines and apocalyptic imagery could not fail to affect even the most impervious psychology, and we should not be surprised to learn that the Positivist statements of the Constructivists, e.g. the *Realistic Manifesto,* often employ a Symbolist vocabulary:

Above the tempests of our weekdays, Across the ashes and cindered homes of the past, Before the gates of the vacant future, We proclaim today to you artists, painters, sculptors, musicians, actors, poets . . . to you people to whom Art is no mere ground for conversation but the source of real exaltation, our word and deed.

This is the vocabulary of Kandinsky, Rudolf Steiner and Sar Peladan and it brings to mind the tormented imagery of Mikhail Vrubel, Russia's greatest *fin de siècle* artist. Vrubel exerted a permanent influence on the young Gabo. His crystalline facets, interpenetrating planes and prismatic surfaces give the impression of shift and mobility; these are tectonic masses that are about to disintegrate and fall away to reveal an inner incandescence. Vrubel's figures peer dimly through the strata of his overpainted surfaces, reminiscent of the "geometrical transparency" of Alexander Ivanov's biblical watercolors and Mikalojus Čiurlionis' cosmic panoramas.

In his cycle of lectures, *Of Divers Arts,* delivered at the National Gallery in Washington, D.C. in 1959 [see Further Reading, section I], Gabo focused particular attention on Vrubel.

Vrubel freed the arts of painting and sculpture from the academic schemata. He revived the concept in visual art that the fundamental visual elements are of decisive importance in the creation of a pictorial or plastic image; and, in that respect, his influence on our visual consciousness was as decisive as Cézanne's. . . .

Gabo's *Study for a Constructed Head* (1916) is surely a paraphrase of one of Vrubel's Demon heads, which also reappears as one of Gabo's three-dimensional metal torsos. These in turn anticipate Gabo's anthropomorphic design for a radio tower in 1919-20 (the head, the inclined shoulders, the clasped hands). Both artists traverse transparency and, having crossed the boundary, convey the primordial energy—light—through the forcelines and articulations of their paintings and constructions. Gabo would have agreed with Vrubel's conviction that,

> The contours with which artists normally delineate the confines of a form in actual fact do not exist—they are merely an optical illusion that occurs from the interaction of rays falling onto the object and reflected from its surface at different angles.

Vrubel anticipated the total removal of external surfaces and the reduction of matter to basic geometric arrangements, implemented later by abstract artists such as Gabo, Malevich and Rodchenko. Ultimately, this process of simplification removed all "accidental" elements, including color, from the work of art. The remaining aesthetic was process, movement, rhythm, i.e. an almost invisible action that mediated easily between "here" and "there," as in Gabo's *Construction in Space with Balance on Two Points* (1924-25). In spite of his claim that Suprematism was an art of color, Malevich also had a particular interest in pure black and white contrast, as in his lithographs for *On New Systems in Art* (1919) and *Suprematism: 34 Drawings* (1920-21). Also, Rodchenko painted his black on black series just before embarking on his career as a professional photographer. For some critics of the time, these extreme abstractions were the "total affirmation of the cult of emptiness, of the gloom of nothing," and seemed to parallel the general disintegration of moral and social values that was associated with Russian society just before and after the Revolution.

However, the dissolutions or transparencies of Gabo. Malevich and Rodchenko also contained a positive, assertive meaning. Vrubel and the Symbolists interpreted depth as the constant energy beneath the surface of things, and many members of the Russian avant-garde felt that the aim of art is precisely to expose and illustrate this energy. Malevich referred to the "energies of black and white" and to Suprematist forms as if they contained a trace element that could be harnessed to drive machines. Gabo spoke of the "kinetic rhythms as the basic forms of our sensations of real time," and was one of the first to incorporate motorized elements into his art. Some artists of the 1920s, including Ivan Kudriashev and Sergei Luchishkin, tried to describe this energy scientifically, illustrating phenomena such as fission, luminescence and light refraction in their paintings. The endeavor to see and represent natural energy is implicit in Gabo's statement that "we do not

turn away from nature, but, on the contrary, we penetrate her more profoundly than naturalistic art ever was able to do [see Lund Humphries (Herbert Read's introduction) in Further Reading, section V].

While this helps to explain Gabo's use of transparent materials (we can see through to the depth and limitless source of light or energy), it does not explain his marked tendency to favor organic forms in his sculptures and to assemble somatic structures within the ribbing and interlacing of his plastic molds. Transparency was obviously a major concern, but many of Gabo's constructions also carry opaque elements, internal schemes, and even colors, suggesting contrasts between an epidermic outline and a skeletal arrangement. Similar somatic geometries are seen in Rodchenko's and the Stenberg brothers' constructions and in Tatlin's and Petr Miturich's aerodynamic frameworks. How, then, can these abstract anatomies be related to the theme of transparency?

One answer to the question might be found through reference to the traditional academic method of depicting the human anatomy from the nude and from textbooks. This was a convention practised at all the art academies from St. Petersburg to Munich, and, inasmuch as Gabo was familiar with the convention, we should not be surprised to find direct parallels between anatomical exercises and Gabo's own geometric heads of 1915-16. Gabo's purpose, however, is contrary to that of the European academy. Like Rodchenko in his constructions of 1918-21, Gabo presented the complex of inner articulations as the finished work of art, whereas the academy regarded it merely as the basic structure upon which to build the outer, physical illusion—the very facade that Gabo and his colleagues dismantled. How else then can we explain the peculiar somatic geometries of Gabo's sculptures?

In 1910 Gabo's father sent his son to study medicine at the University of Munich. It is often repeated that while in Munich (through 1914), Gabo attended lectures by Heinrich Wölfflin, met Kandinsky, and saw examples of French Cubism at the exhibitions of the Neue Künstlervereinigung. But it is also often forgotten that first and foremost Gabo was studying the natural sciences and mathematics in Munich, and that his primary academic encounter was with Wilhelm Conrad Röntgen, the crystallographer, magnetist, and inventor of the X-ray (1895) who received the Nobel prize in 1901 for his experimental research. Surely, this was of much greater importance to Gabo (and maybe to other artists in Munich at that time such as Kandinsky) than the formal theories of Wölfflin. He must have been amazed to see those early lantern slides of the interiors of insects, fish, animals, birds and the human body. No doubt Gabo discussed these data with scientific colleagues such as Vladimir Chulanovsky and Stepan Timoshenko at the Physics Institute of the University of Munich. By the time Gabo returned to Russia in 1917, X-ray photography was well advanced there, too, thanks especially to the efforts of Röntgen's brilliant assistant Abram Ioffe. Also a Russian Jew, Ioffe became a prominent exponent of X-ray application to crystals, especially quartz. With Mikhail Nemenov, he established the State X-ray and Radiological Institute in Petrograd in

1918 and encouraged the erection of the monument to Röntgen in Leningrad in 1927. X-ray research was so popular in Russia after the Revolution that Kandinsky, himself recently returned from Munich, ensured that a special position be created for an X-ray specialist at the Russian Academy of Artistic Sciences in Moscow.

Röntgen's X-ray photographs were of momentous importance in the artistic world of the early twentieth century; one could now see beyond the world of appearances. Röntgen's plates showed internal structures that scientists had delineated through anatomical mapping and that artists knew about from academic textbooks. For the rational here was undeniable proof of natural, indefeasible connections between the outer and the inner; for the irrational, these photographs were also proof of the existence of a "more real" reality behind the facade of physical objects. Indeed, no sooner did Röntgen perfect his X-ray technique, than the method entered the world of the occult, and X-ray photography was applied by spiritualists, telepathists, and other diviners of the ultimate truth. The wide publicity given to Röntgen and his X-rays in Russia, including the translation of his treatises, could not fail to attract the attention of artists. (pp. 16-20)

[However, the utilization of Röntgen's discovery as an artistic medium was] perhaps more a gesture to fashion than a calculated aesthetic consequence of the study of X-ray photography. For examples of a serious and intelligent application of X-ray to art we should turn once again to Gabo.

A number of Gabo's constructions look like stereoscopic X-rays, with a taut organization of filaments within gelatinous tissue, emphatic articulations and forcelines, and vessels and arteries connecting one member to the next. *Construction in Space: Crystal* (1937-39) and *Linear Construction in Space No. 2* (1949-73) can be regarded as artistic metaphors for Röntgen's photographic plates. Some of Gabo's early pieces even recall specific anatomical structures, e.g. the common house-fly (*Construction in Space: Soaring*, 1929-30). Nurtured on the sentiments of the Symbolists, Gabo was now confronted with a mechanical exposure of the divisions between transparency and eternal depth. That Röntgen chose inductor apparatuses to see beyond, while the Symbolist poets often used drugs and alcohol does not matter. Both saw the "enchanted shore" of configurations and convolutions invisible to the naked eye. But it must have pleased Gabo the scientist (and perhaps other rational artists such as Rodchenko and Tatlin) that the invisible world, now rendered visible by Röntgen, was disciplined and calculated, and not amorphous in the way most Symbolists had imagined it. Even physical disturbances and interferences could now be seen to be consistent and symmetrical. (p. 20)

The concept of transparency within modern art and its relationship to the Symbolist quest for "otherworldliness" and in turn, to X-ray photography, is an important avenue of enquiry that has yet to be explored and analyzed in detail. Many Russian avant-garde artists were fascinated with transparency, although Gabo seems to have been the only major artist then who actually studied X-ray effects and experimented with them consistently. Naturally,

other artists such as Malevich, Rodchenko and Tatlin were aware of this new photographic development, but they seem not to have regarded it as a principal source of inspiration—even though, as a matter of fact, Laszlo Moholy-Nagy's tract on photography was published in Russia in 1929, reproducing a superb X-ray of a shell (*triton tritonis*). But the kind of culture that followed did not encourage transparency, for Stalin's culture was one of facades, a desperate attempt to present surface appearance as the absolute truth. Looking through was encouraged only if it reconfirmed the legitimacy of the status quo— something that the writer Evgenii Zamiatin prophesied in his Utopian novel, *We* (1920), in which a glass dome hermetically protects the perfect Socialist state from the primitive natural order outside.

Gabo, like Kandinsky and Mansurov, went on to develop his artistic perspicacity in the West and to prove that he was one of the few artists of our time who, while applying concepts from physics, zoology and structural engineering, really understood these concepts. He used aesthetic configurations as counterparts to scientific fact, while refusing to resign himself to reason. He once said to Herbert Read,

> the only thing I maintain is that the artists cannot go on forever painting the view from their window and pretending that this is all there is in the world, because it is not. There are many aspects in the world, unseen, unfelt and unexperienced which have to be conveyed and we have the right to do this.

Gabo made new windows of glass and perspex, and with these instruments of transparency he removed division, enabling us to see continuous depth. Here are works of art virtually "without material," and the result is a unique sensation; we feel and experience the presence of absence. (pp. 21-2)

> *John E. Bowlt, "The Presence of Absence: The Aesthetic of Transparency in Russian Modernism," in* The Structurist, *Nos. 27-8, 1987-88, pp. 15-22.*

FURTHER READING

I. Writings by Gabo

"The Constructive Idea in Art" and "Sculpture: Carving and Construction in Space." In *Circle: International Survey of Constructive Art,* edited by J. L. Martin, Ben Nicholson, and N. Gabo, pp. 1-10, pp. 103-11. London: Faber and Faber, 1937.

> Discussion of the origin and nature of Constructivism and defense of the sculptural qualities of Constructivist works.

"Toward a Unity of the Constructive Arts." *Architectural Forum* 69, No. 6 (December 1938): 3-6.

Argues that the Constructivist ideal effectively unites the aims of both art and architecture.

"On Constructive Realism." In *Three Lectures on Modern Art,* by Katherine S. Dreier, James Johnson Sweeney, and Naum Gabo, pp. 65-87. New York: Philosophical Library, 1949.

Gabo delineates the principles of his art.

Of Divers Arts. New York: Pantheon Books, 1962, 205 p.
Explores the origin and development of Gabo's art.

"Naum Gabo Talks about His Work." *Studio International* 171, No. 876 (April 1966): 127-31.
Overview of Gabo's career that traces his growth as a sculptor.

II. Interviews

Chanin, A. L. "Gabo Makes a Construction." *Art News* 52, No. 7, Part 1 (November 1953): 34-7, 46.
Gabo discusses his work methods.

Gray, Cleve. "Naum Gabo Talks about Constructivism." *Art in America* 54, No. 6 (November-December 1966): 48-55.
Summary of the history and theory of Constructivism.

III. Biographies

Pevsner, Alexei. *A Biographical Sketch of My Brothers Naum Gabo and Antoine Pevsner.* Translated by Richard Scammell and W. R. Burke. Amsterdam: Augustin & Schoonman, 1964, 51 p.
An account of the lives of Gabo and Pevsner containing previously unavailable information on their early development.

IV. Critical Studies and Reviews

"Sculpture by Naum Gabo." *Architectural Record* 122, No. 5 (November 1957): 175-78.
Review of Gabo's works that focuses on the construction for the Bijenkorf department store in Rotterdam.

"Two Works by Naum Gabo." *The Architectural Review* 117, No. 699 (March 1955): 203-04.
Comments on Gabo's designs for two entrances to the Esso offices in Rockefeller Center, New York City, and for a suspended stairwell construction at the Baltimore Museum of Art.

Burr, James. "Machine-Age Beauty." *Apollo* n.s. LXXXIII, No. 49 (March 1966): 220-22.
Discussion of a Gabo retrospective at the Tate Gallery. Burr states: "Gabo is really a non-functional structural engineer: as such he has not only invented an art-form that has permanently altered the 'look' of sculpture, but he has recalled a new beauty, platonic in origin, and has expressed it in the cold, detached geometric manipulation of space and in severely and precisely articulated forms."

Chermayeff, Serge. "Naum Gabo." *Magazine of Art* 41, No. 2 (February 1948): 56-9.
Laudatory review of a Gabo exhibition at the Museum of Modern Art that emphasizes the lasting importance of the artist's works and theory.

Ernest, John. "Constructivism and Content." *Studio International* 171, No. 876 (April 1966): 148-56.
Considers the nonfigurative quality of Constructivist art,

examines its subject matter, and discusses two manifestations of the movement: English Constructivism and transformable art. Gabo's contributions to Constructivist theory and art are mentioned.

Fenton, Terry. "Two Contributions to the Art and Science Muddle: Constructivism and Its Confusions." *Artforum* VII, No. 5 (January 1969): 22-7.
Analyzes Constructivist theory and the works it has inspired, concluding that the movement "has failed to produce works of art that transcend their didacticism."

Grieve, A. I. Review of "Naum Gabo, Sixty Years of Construction" at the Tate Gallery in London. *The Burlington Magazine* CXXIX, No. 1009 (April 1987): 265-66.
Positive review of a Gabo retrospective.

Hill, Anthony. "Constructivism—the European Phenomenon." *Studio International* 171, No. 876 (April 1966): 140-47.
Provides an analysis of the history of Constructivism that includes Gabo's contributions.

Krauss, Rosalind E. "Analytic Space: Futurism and Constructivism." In her *Passages in Modern Sculpture,* pp. 39-66. New York: The Viking Press, 1977.
An examination of Futurism and Constructivism as movements that view "sculpture as an investigatory tool in the service of knowledge."

Lodder, Christina. "Non-Utilitarian Constructions: The Evolution of a Formal Language." In her *Russian Constructivism,* pp. 7-46. New Haven: Yale University Press, 1983.
Contains an historic overview of Gabo's contribution to Russian Constructivism.

Nash, Steven A. "A Head of Its Time." *Artnews* 82, No. 5 (May 1983): 120-22.
Investigates the genesis and significance of Gabo's *Constructed Head No. 2.*

Read, Herbert. "Constructivism: The Art of Naum Gabo and Antoine Pevsner." In his *The Philosophy of Modern Art,* pp. 255-78. New York: Meridian Books, 1955.
Discussion of Constructivist theory. Read states that Gabo's vision of reality "is derived, not from the superficial aspects of a mechanized civilization, nor from a reduction of visual data to their 'cubic planes' or 'plastic volumes' . . . , but from an insight into the structural processes of the physical universe as revealed by modern science."

Rickey, George. "Origins of Kinetic Art." *Studio International* 173, No. 886 (February 1967): 65-9.
Reviews the history of kinetic art, paying tribute to Gabo as an artist who "defined the field." Rickey defines a kinetic work of art as one that "moves within itself, changing the space relation of the parts; and this movement is a dominant theme, not an incidental quality."

———. "Naum Gabo: 1890-1977." *Artforum* XVI, No. 3 (November 1977): 22-7.
Summary of Gabo's life and work.

Soby, James Thrall. "The Constructivist Brotherhood." *Art News* XLVII, No. 1 (March 1948): 22-5, 57-9.
Explores the origins and aims of Constructivism, focusing on the lives and careers of Gabo and his brother, Antoine Pevsner.

Stonyer, Andrew. "Transparency and Reflection in Sculpture

and Architecture." *The Structurist* No. 27/28 (1987/1988): 80-7.

> Includes an examination of the meaning of transparency in several of Gabo's sculptures.

Sweeney, James Johnson. "Construction Unconstructible?" *Art News* 50, No. 1 (March 1951): 34-5, 61-2.

> Discusses Gabo's unrealized plan for the lobby of the Esso Standard Oil Company in New York City.

Whitford, Frank. "Gabo and Constructivism." *The Architectural Review* 139, No. 832 (June 1966): 469-72.

> Review of a Gabo retrospective at the Tate Gallery in London. Whitford discusses the intellectual and scientific background of Gabo's art, concluding that "the concrete manifestation of his perception is not formed of rules and laws alone, but is in the end a personal metaphor."

V. Selected Sources of Reproductions

Lund Humphries. *Gabo: Constructions, Sculpture, Paintings, Drawings, Engravings.* London: Lund Humphries, 1957, 193 p.

> Color and black-and-white reproductions of Gabo's works. Also included are an introduction to Constructivism by Herbert Read; an essay by Leslie Martin on the relationship between Gabo's sculpture and architecture; and a number of Gabo's writings on art.

Museum of Modern Art. *Naum Gabo, Antoine Pevsner.* New York: Museum of Modern Art, 1948, 83 p.

> Exhibition catalog that includes black-and-white reproductions of Gabo and Pevsner's works, an introduction to Constructivist theory by Herbert Read, and biographical sketches by Ruth Olson and Abraham Chanin.

Nash, Steven A., and Merkert, Jörn, eds. *Naum Gabo: Sixty Years of Constructivism.* Munich: Dallas Museum of Art and Prestel-Verlag, 1985, 272 p.

> Exhibition catalog that includes color and black-and-white reproductions of Gabo's works. The book also contains an introductory overview of Gabo's life and career by Nash, biographical studies by Christina Lodder and Jörn Merkert, and a catalog raisonné by Colin Sanderson and Lodder.

South Bank Board. *Naum Gabo, The Constructive Idea: Sculpture, Drawings, Paintings, Monoprints.* London: South Bank Board, 1987, 64 p.

> Includes color and black-and-white reproductions of Gabo's works as well as introductory essays by Caroline Collier, Martin Hammer, and Christina Lodder. Brief extracts from Gabo's writings on art are also included.

Williams, Graham. *Naum Gabo Monoprints from Engraved Wood Blocks and Stencils.* Ashford, England: The Florin Press for Kettle's Yard, Cambridge & The Talbot Rice Gallery, Edinburgh, 1987, 71 p.

> Contains color and black-and-white reproductions of Gabo's prints with essays on Gabo as printmaker by Sir Norman Reid, Martin Hammer, Christina Lodder, and Graham Williams.

Barbara Hepworth

1903-1975

English sculptor and graphic artist.

One of the first English artists to advocate abstractionism, Hepworth is best known for such prominent public sculptures as *Meridian* (1958), constructed for the State House in London, and *Single Form* (1964), displayed at the United Nations building in New York as a memorial to Dag Hammarskjöld. In her nonrepresentational forms Hepworth sought to convey her emotional as well as intellectual responses to landscape. Praised as subtle evocations of mood, Hepworth's works reflect what biographers describe as her virtually pantheistic love of nature and have been viewed by many as a Modernist continuation of English Romanticism.

Hepworth was born in Wakefield, Yorkshire, where her father worked as a civil engineer. Impressed by a lecture on Egyptian sculpture that she attended at the age of seven, Hepworth began visualizing the artistic possibilities inherent in the varying vistas of Yorkshire. At the age of sixteen she received a scholarship to attend the Leeds School of Art, where she met fellow sculptor Henry Moore. After three terms at Leeds, Hepworth earned a second scholarship and enrolled at the Royal College of Art in London. She received her diploma from the College in 1923, and was granted a county scholarship for one year's travel abroad. Hepworth journeyed to Florence, where she met and married English sculptor John Skeaping; the two remained in Italy until late in 1926. During these years, which Hepworth considered her most formative, she studied classical and Renaissance art and architecture, learned to carve in marble, and developed an appreciation for the varying effects of light and shadow on the forms of objects in a landscape.

Following this period of apprenticeship, Hepworth and Skeaping launched their artistic careers with a successful joint exhibition in London. Hepworth's early works were simplified versions of the human figure and have been likened to those of Moore. In 1931 she met the painter Ben Nicholson, who later became her second husband, and with him traveled to France the following year, visiting the studios of Constantin Brancusi, Jean Arp, and Pablo Picasso, among others. Already a member of England's "Seven and Five Society," a select group of painters and sculptors, Hepworth together with Nicholson joined the French "Abstraction-Création" association in 1933. That same year, she and Nicholson joined Moore, the painters Edward Wadsworth, Paul Nash, Frances Hodgkins, Edward Burra, John Bigge, and John Armstrong, as well as architects Wells Coates and Colin Lucas, in forming England's "Unit One" society of artists. This group sought to define a modern style, and in so doing advanced the interests of abstract art. Reflecting her growing familiarity with the art and ideas of her contemporaries, Hepworth's work during this period became increasingly abstract. Her

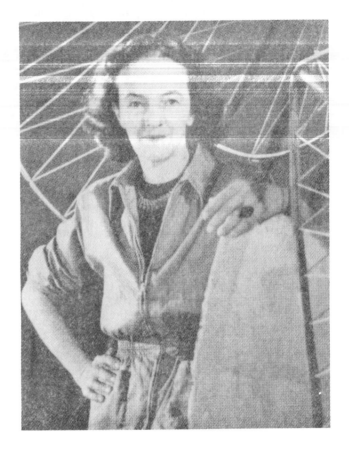

Pierced Form (1931), exhibited in 1932 under the title *Abstraction,* was one of the earliest sculptures to utilize the hole, later popularized by Moore, in order to enhance the three-dimensionality of the solid figure, while establishing a new balance between a form and the space that surrounds and passes through it. By the end of 1934 all traces of naturalism in Hepworth's works had disappeared. Turning away from Moore's humanism and anthropomorphism, which had influenced her own *Reclining Figure* (1933) and *Mother and Child* (1934), Hepworth began producing geometric forms representative of her poetic responses to various landscapes. In a short introduction to the book *Unit One* (1934), Hepworth explained her views on the relationship between art and nature: "In the contemplation of Nature we are perpetually renewed, our sense of mystery and our imagination is kept alive, and rightly understood, it gives us the power to project into a plastic medium some universal or abstract vision of beauty."

Hepworth, Nicholson, and their children moved to St. Ives, Cornwall, at the beginning of World War II in 1939. During the early years of the war Hepworth did not carve at all, but completed several abstract drawings that encap-

sulate many of the ideas that she translated into sculpture in later years. Hepworth also read extensively during this time, becoming especially interested in the relationship between the artist and society. In 1943, her family's move to a larger house afforded studio room for both Hepworth and her husband, and she resumed carving. For the next several years Hepworth produced drawings and sculptures that are considered among her best. Reflecting her deepened appreciation of the relationship between sculpture and landscape, and relating her own experience as a figure in the landscape, Hepworth began adding color and strings to wood carvings such as *Wave* (1944) and *Landscape Sculpture* (1944) in order to convey the visual and rhythmic sensations evoked by the landscape, as well as the tension which exists between "the sea, the wind, or the hills" and the observer.

In 1947 Hepworth was invited to witness a surgical operation in a hospital. Impressed by what she considered the "beauty of purpose" and graceful, coordinated movements of the operating surgeons and their assistants, she began a series of drawings based on figures in the operating theater. *The Child's Hand* (1948) and *Hands Operating* (1949), numbered among her finest drawings, were followed by the carvings *Biolith* (1949) and *Contrapuntal Forms* (1951) as Hepworth began focusing once again on representations of the human form. Reviewing an exhibition of the earliest of these works in 1948, Herbert Read wrote that Hepworth had "emerged from a phase of abstraction with her sympathy for natural forms greatly enhanced," indicating the general critical perception of the quality of these works. As a result of her preoccupation with human figures, rhythm, and movement during this time, Hepworth agreed to design the costumes and decor for Michel St. Denis's production of Sophocles' *Electra* at the Old Vic in 1951, and later for Michael Tippett's opera *The Midsummer Marriage* in 1955. At this time she also began producing a series of works inspired by her journey to Greece in 1954. Larger in scale than any of her earlier carvings, such studies as *Corinthos* (1954-55), *Delos* (1955), and *Delphi* (1955) reemphasized the geometric, abstract form that best distinguishes her art from that of Moore.

Hepworth began experimenting with metals in the late 1950s, and many of her works for the remainder of her career were cast in bronze. Coinciding with this last phase in Hepworth's artistic development were important public and private commissions: in addition to *Meridian* and *Single Form,* Hepworth completed the nineteen-foot aluminum *Winged Figure,* which was displayed prominently on the façade of a London store in 1962. Now internationally recognized as a leading sculptor, she was awarded honorary degrees from the Universities of Oxford, Exeter, Birmingham, and Leeds, and received the prestigious and lucrative Grand Prix award at the 1959 São Paulo Biennial Art Exhibition in Brazil. Discussing her later works during an interview in 1970, Hepworth said: "I'm not exactly the sculpture in the landscape anymore. I think of the works as objects which rise out of the land or the sea, mysteriously." Reflecting this changing perception of her art, two of the most notable works of her last years, the multifigured *The Family of Man* (1970) and *Conversations with*

Magic Stones (1973), are indeed less emotive and more purely visual in conception, conveying a sense of mystery rather than resolution. Yet each retains, in monumental form, the conspicuous features of Hepworth's art: tension, verticality, and pierced volume. Hepworth died tragically in a studio fire in 1975.

ARTIST'S STATEMENTS

Barbara Hepworth (interview date 1946)

[*In the following excerpt from an interview in* Studio International, *Hepworth describes the conception and execution of her sculpture.*]

[Editor]: *For how long have you been interested in, may I say, "Ovoid" shapes as a basis for sculptured form?*

[Hepworth]: I have always been interested in oval or ovoid shapes. The first carvings were simple realistic oval forms of the human head or of a bird. Gradually my interest grew in more abstract values—the weight, poise, and curvature of the ovoid as a basic form. The carving and piercing of such a form seems to open up an infinite variety of continuous curves in the third dimension, changing in accordance with the contours of the original ovoid and with the degree of penetration of the material. Here is sufficient field for exploration to last a lifetime. Actually one cannot, however, be thinking about ovals and ovoids all the time, and their fascination comes in cycles. Every sculptor needs to turn from one basic form to another; the spontaneity of the carving stimulus demands this. The "aggressive weight" of a sphere, the "massive" quality of a cube, and the "upward growth" of a cylinder—all play their part. These are basic concrete forms—vehicles by which emotional interest in the standing figure or seated figure, the group or the head, finds its outlet. Inevitably interest in one leads to interest in another. The satisfaction to be found in carving is in the pleasure of fresh impact of shape and in the joy of attack on different material.

To what extent is the form dictated by the nature of the wood or stone?

I like to have a lot of material lying about the studio for a long time—even for years—so that I feel intimate with each piece. An idea comes and the right piece of wood or stone—the absolutely right piece—must be found for it, and it is the greatest hardship for a sculptor to be short of material.

Before I can start carving the idea must be almost complete. I say "almost" because the really important thing seems to be the sculptor's ability to let his intuition guide him over the gap between conception and realization without compromising the integrity of the original idea; the point being that the material has vitality—it resists and makes demands. The idea makes demands also; and the "life" of the finished carving depends on how successfully

the demands of both are met and how sensitively adjustments take place during the process of working.

I think a new discipline has to be discovered with each new sculpture, and that is why I do not feel in sympathy with any theories and disciplines imposed from outside.

What woods do you most frequently use?

I prefer the foreign hardwoods with their great variety of colour and surface finish. The war stopped all imports of foreign timber, and I have been seasoning my own logs from trees felled in the Cornish woods. I have enjoyed carving English timber; but after so many years of restriction I long for the excitement of "blackwood", "lignum-vitæ", "greenheart", and "ivory-wood", to mention only a few of the wonderful foreign hardwoods.

From what sources does your inspiration derive? I ask this in case fruit, negro sculpture, the human figure, aerodynamics, or dreams might have some connection.

The main sources of my inspiration are the human figure and landscape; also the one in relation to the other.

Have you any special technique for achieving such smoothly textured surfaces; particularly the concaves?

I have never really thought much about technique—it seems to me to be a very personal thing which each artist discovers for himself, perhaps almost unconsciously. The degree of finish or polish should be intuitive. It varies with each sculpture.

I do not like using mechanical devices or automatic tools. Even if the work was done ten times more easily I should miss the physical pleasure of direct contact with every part of the form from the beginning to the end. Generally speaking I prefer using an adze or gouge for wood, a puncher or "bouchard" for stone and marble, and then a rubbing-down process rather than using the chisel.

Is your work polychromatic? If so, how and where is the pigment applied and what are its nature and colour?

I have been deeply interested during the last ten years in the use of colour with form. I have applied oil colour—white, grey, and blues of different degrees of tone. Except in two instances I have always used colour with concave forms. When applied to convex forms I have felt that the colour appeared to be "applied" instead of becoming inherent in the formal idea. I have been very influenced by the natural colour and luminosity in stones and woods, and the change in colour as light travels over the surface contours. When I pierced the material right through a great change seemed to take place in the concavities from which direct light was excluded. From this experience my use of colour developed.

One can experience the colour change in nature in a cave, a forest or a pool and sense similar change in the emotional effect of all forms when the quantity and quality of light playing upon it changes.

Do you take into consideration the effect of any specific lighting arrangement when designing the work and have you any strong feelings about appropriate settings: colour and texture of backgrounds, bases, etc.? (pp. 97-100)

I have always felt that there were three different degrees of size in sculpture. Roughly they are: first, the small intimate "hand sculpture", small enough to carry about, appealing to the sense of touch as well as to the eyes and finding its position in a house very easily. Secondly the "arm" sculpture: that is a sculpture which falls into the span of one's arms. Such a sculpture, however, does require some thought in placing in a house or garden, as it demands a certain kind of space and a particular elevation. Finally there is the large sculpture: the size of the human figure. This remains static in its setting and commands us to move round it. It is seen at its best when it is in the place for which it is designed and which is always a site related to landscape or architecture.

One of the functions of sculpture is to fulfil the demands and conditions of a given site. Present conditions restrict this idea so that the sculptor works mainly in his studio and eventually, if he is fortunate, a suitable place is found for the sculpture by somebody who has the money to buy it. This means that the creation of large sculptures is restricted; but it is partly compensated for by the growth among all kinds of people of a love for sculpture and the desire to have a small sculpture in their home or garden—not placed on a pretentious pedestal but cared for in a more intimate way. This kind of appreciation will help to develop the sense of form (nearly atrophied in Western civilization) until it becomes a part of our life in a way that poetry, music, and painting have been and are increasingly part of our life.

As regards lighting and setting for my work, I like as much light as can be obtained, and I like a feeling of space. This does not mean actual physical area; but more the feeling that one gets near a window where the eye travels outwards, or a perpendicular clear space where there is a sense of upward growth.

I have never felt that sculpture was too formidable to live with. The chief error in the past has been the pretentious way of showing it and the conventional habit of associating sculpture with symbolic or commemorative monuments, and very rarely for the purpose of enjoying its inherent qualities. Quite large sculptures can be placed in small rooms where their presence gives a new sense of enjoyment—a new æsthetic experience which cannot be got through any other art.

Some simple architectural feature as a site for sculpture does seem necessary in our houses and gardens of the future. A cube or rectangular form in the architecture of a room which gives a clear, stable, horizontal surface on which to place a sculpture. It is one of the rare pleasures of this life to have a carefully conceived space on which to place some chosen object (found or made) in order to enjoy it in all its aspects.

What preliminary plans or designs do you make before actually starting on the wood or stone and what is the proportion of time spent in conceiving, planning, and designing a project in ratio to that spent in its execution?

I rarely make drawings for a particular sculpture; but often scribble sections of form or lines on bits of scrap paper or cigarette boxes when I am working. I do, howev-

er, spend whole periods of time entirely in drawing (or painting, as I use colour) when I search for forms and rhythms and curvatures for my own satisfaction. These drawings I call "drawings for sculpture"; but it is in a general sense—that is—out of the drawings springs a general influence. Only occasionally can I say that one particular drawing has later become one particular sculpture. I like to think of the drawings as a form of exploration and not as a two-dimensional representation of a particular three-dimensional object. They are abstract in essence—relating to colour and form but existing in their own right.

It is difficult to say how much time is spent in conceiving a project. I like to work all day and every day; the major part of the time is spent in actually carving, but all the time I am not working I am thinking about sculpture. Looking out of a window or walking down the road it is impossible not to be aware of form and colour. Then a new project suddenly appears, and demands realization as a result of accumulated emotional experience. The carving process is a slow process and the conceiving of a project seems to spring more out of a general and sustained experience than one particular incident. Consequently the carrying out of one idea and the conception of new ideas usually run concurrently.

I have gained very great inspiration from Cornish land- and sea-scape, the horizontal line of the sea and the quality of light and colour which reminds me of the Mediterranean light and colour which so excites one's sense of form; and first and last there is the human figure which in the country becomes a free and moving part of a greater whole. This relationship between figure and landscape is vitally important to me. I cannot feel it in a city. (pp. 100-01)

> *Barbara Hepworth and the Editor in an interview in* Studio International, *Vol. 132, No. 643, October, 1946, pp. 97-101.*

Barbara Hepworth with Edouard Roditi (interview date 1960)

[In the following excerpt from an interview, Hepworth discusses the importance of material and setting both in conceiving and executing her works.]

[Roditi]: *What are the advantages, in your opinion, of working in the open air?*

[Hepworth]: Light and space are the sculptor's materials as much as wood or stone. In a closed studio, you cannot have the variety of light and shadow that you find in the open air, where even the colours of the shadows change. I feel that I can relate my work more easily, in the open air, to the climate and the landscape, whereas the light and the space of a closed studio are always more or less the same, and more or less artificial.

In almost every explanation of your work that I have read, I find that the word landscape occurs, obviously used with a very special meaning. Certainly, when you refer to the relationship of one of your works to a landscape, you are not thinking of a view such as one finds in a painting by Constable or by Turner.

Certainly not. I think of landscape in a far broader sense. I extend its meaning to include an idea of the whole universe.

The landscape of one of your works might thus be interpreted as its ecology, I mean its relationship to nature.

Yes, I suppose that would be a correct interpretation of what I mean by landscape.

But the relationship of a sculpture, as a man-made object, to its natural surroundings might be based either on harmony or contrast.

That would depend on the artist's response to a specific landscape. A sculpture, as I conceive it, is for a specific landscape. My own awareness of the structure of the landscape, I mean the individual forms too that contribute towards its general quality, provides me with a kind of stimulus. Suddenly, an image emerges clearly in my mind, the idea of an object that illustrates the nature or quality of my response. This object, once I have created it as a sculpture, may harmonize with the landscape that inspired it, in that its form suggests those that I observed in nature. On the other hand, the form of the sculpture may also contrast with the forms of the landscape. But, whatever the formal quality of this relationship, the sculpture remains, in my mind, so closely associated with the landscape to which I originally responded that I often try to perpetuate this relationship in the title that I choose for the work.

Do you mean that you give your works specific titles like those that landscape-painters choose? I mean like the titles of paintings of Constable or Whistler?

Not exactly, since I'm always thinking of landscape in a broader and less specific sense. For instance, one of my sculptures is entitled **Pelagos,** meaning "the sea". Well, from my studio, I could see the whole bay of St Ives, and my response to this view was that of a primitive who observes the curves of coast and horizon and experiences, as he faces the ocean, a sense of containment and security rather than of the dangers of an endless expanse of waters. So **Pelagos** represents not so much what I saw as what I felt.

Do you believe that it is possible to explain or justify in words such an individual response to a landscape?

No such explanation would be entirely satisfactory. It would always fail to convince some individual spectator. But the individual also remains free to repudiate my particular response and to affirm his own different response to the same landscape. Still, the violence of such an individual's repudiation of my response may also serve its purpose in clarifying his own response. The important thing is that there should be a genuine response, whether to my own work or to the landscape that originally suggested it to me. . . .

So you admit that different artists may conceive different forms as responses to one and the same landscape?

Certainly, and each different form, each different response, is valid as a kind of testimony. My own testimony represents the sum total of my own life and experience, in

that particular moment, as a response to that particular experience.

In terms of Platonic philosophy, your works should thus be defined as imitations of something that occurs in your own mind rather than of nature as it is or as it might ideally be.

Yes—an imitation of my own past and present and of my own creative vitality as I experience them in one particular instant of my emotional and imaginative life.

Would you say that you set out to impose upon your material a very clearly conceived form, or that you allow your material, as you work on it, to suggest to you the final form of the sculpture?

I must always have a clear image of the form of a work before I begin. Otherwise there is no impulse to create. The kind of sculpture that I indulge in is hard work, and I would always hesitate to start doodling with a mass of wood or stone as if I were waiting for the form to develop out of the work. Still, the preconceived form is always connected with a material. I think of it as stone, or as bronze, or as wood, and I then carry out the project accordingly, imposing my own will on the material. The size of the sculpture is also important, in my first clear image of what I want to do. I can see the material that I want to work on, and also the exact relationship of the object to its surroundings, I mean its scale. I hate to think of any of my works being reproduced in a smaller format.

You mean as a kind of pocket edition reproduced in ceramic and tucked away on the shelf of a book-case, in front of a row of cookery-books?

Yes—that might well be one of my nightmares.

But doesn't the material, as you work on it, ever suggest to you any modification of your original image?

Of course it does, and that is the great temptation. Halfway through any work, one is often tempted to go off on a tangent. But then one knows that there can be no end to such temptations, such abandonments of one's plan. Once you have yielded, you will be tempted to yield again and again as you progress on a single job. Finally, you would only produce something hybrid, so I always resist these temptations and try to impose my will on the material, allowing myself only, as I work, to clarify the original image. At the same time, one must be entirely sensitive to the structure of the material that one is handling. One must yield to it in tiny details of execution, perhaps the handling of the surface or grain, and one must master it as a whole.

It sounds rather like the art of mastering a thoroughbred horse.

I've never ridden a horse, but I can well imagine that this is a good simile.

As I look around your studio and see all these samples of your work, I feel that you have an awareness of what I would call the different epidermis of bronze, stone or wood. Your bronzes, for instance, have a rougher surface that is peculiar to them, whereas your stone and wood sculptures

achieve as smooth a "skin" as the grain of the material can allow.

It requires an extra effort, some additional strength, to discover the wonderfully individual quality of each material. In the case of bronze, this problem of the finish is particularly subtle as the model which I send to the foundry is of an entirely different material. I have to visualize it, as I work on it, as if it were bronze, and this means disregarding completely its own material qualities. That is why I find it necessary to work with a foundry that has an artistic understanding of the quality of finish and of colour that I want to obtain in the bronze. I enjoy working for instance with Susse Frères, the great Paris foundry. They are artists and masters and I can always trust them to interpret my ideas. Look at the colour, for instance, of that bronze, which came back from Paris only recently. The blue-grey quality of the shadows, on the interior surfaces, is exactly what I wanted, though I had never seen it before in any bronze. It turned out exactly as I had visualized it when I was still working on the plaster model.

This awareness of the specific qualities of various materials is what strikes me as lacking in most nineteenth-century sculpture.

Many sculptors then tended to misuse clay, wax or plaster. In handling something that is soft and yields, they would forget too easily that their model was to be reproduced in stone. Generally, it was another man, a craftsman rather than an artist, who carried out in marble the model that the sculptor had entrusted to him.

The French poet Léon-Paul Fargue once referred to this kind of art as "noodles camouflaged to look like steel". I suppose that is why so many marble figures of that period look as if they had been squirted out of a toothpaste tube, then hastily and quite easily licked into shape and allowed to cool off and harden.

That sounds rather revolting to me. But so many of these human figures of the nineteenth century are like petrified humanity, as if they had been injected with a chemical that immediately transformed living flesh into bronze or stone.

The Greeks were already aware of the dangers of this kind of naturalism. Medusa, the gorgon, could turn human beings to stone by merely looking at them, and the legend horrified the ancient Greeks.

Well, I share their horror of a living being that has been overcome by a kind of *rigor mortis*. I feel that a work of art should always reflect to some extent the peculiar kind of effort that its material imposed on the artist. (pp. 91-5)

When did you first begin creating abstract forms?

Around 1931, I began to experiment in a kind of organic abstraction, reducing the forms of the natural world to abstractions. Then, in 1934, I created my first entirely non-figurative works. But it was in 1931 that I began to burrow into the mass of sculptured form, to pierce it and make it hollow so as to let light and air into forms and figures.

Is there any connection between this idea of an inner surface, I mean of a hollow mass that is penetrated by light, and the concave-convex ambiguity of certain Cubist paint-

ings—it's actually a kind of optical punning—where objects that are convex in real life are depicted as concave, or vice versa?

No, I don't think there is any such play, in my work, with the ambiguities of optical impressions. I think this development, in my sculpture, was a response to an organic sensual impulse. I believe that the dynamic quality of the surfaces of a sculpture can be increased by devices which give one the impression that a form has been created by forces operating from within its own mass as well as from outside. I have never seen things, even inadvertently, in reverse, though I have often observed that some other artists tend to suggest that they have seen in relief what is actually hollowed out, or vice versa. In my own work, the piercing of mass is a response to my desire to liberate mass without departing from it.

This is indeed a curiosity of the senses rather than of the intellect. It suggests a desire, on your part, to explore the inside of a mass with your finger-tips rather than with your mind. But the Cubists were more intellectual, as artists, than sensual; besides, they invented and tested most of their devices, even those that suggest sculptural effects, in paintings rather than in sculptures.

Still, there is an element of intellectualism in my sculpture too. I feel that sculpture is always, to some extent, an intellectual game, though the sculptor generally obeys sensuous impulses. The sculptor sets out to appeal to all the senses of the spectator, in fact to his whole body, not merely to his sight and his sense of touch.

In most Cubist sculpture, I seem to miss, above all, this appeal to the spectator's sense of touch, except when the Cubist sculptor sets out to fool the spectator by offering him a convex form where one expects a concave one.

But there is a certain amount of fooling of this kind in all art. You are perhaps right when you suggest that the Cubists refrained from appealing to our sense of touch, except perhaps when they set out to deceive us. But my own sculpture also sets out, at times, to deceive the spectator. I thus try to suggest, in my forms, a kind of stereoscopic quality, but without necessarily allowing the spectator to touch these forms. The piercing of masses, by allowing light to enter the form, gives the spectator a stereoscopic impression of the interior surfaces of this mass too. I set out to convey a sense of being contained by a form as well as of containing it, I mean of being held within it as well as of holding it, in fact of being a part of this form as well as of contemplating it as an object. It is as if I were both the creator of the form conceived and at the same time the form itself, and I deliberately set out to convey this ambiguity to the spectator, who must feel, as I did, that he is part of this sculpture, in its relationship to space or landscape.

This would indeed be the ideal of communication between artist and spectator. But it requires a kind of contemplative approach to the work of art, on the part of the spectator, that has become almost impossible in our overcrowded world where one often feels that there is already standing room only. In the Museum of Modern Art in New York, for instance, the modern sculptures are so crowded that one can

sometimes see a detail of a César through a hollow in a Henry Moore. I found that very disturbing, like a vision of skulls and bones piled up promiscuously in a charnel house.

To me it sounds quite macabre. Besides, it is contrary to the basic idea that underlies most sculpture ever since that of ancient Greece. A human figure, set in the daylight and in a landscape, should give us there the scale of everything. If you wish to suggest a deity that dominates nature, a colossal figure will do the trick. But if you crowd together, in a single space, a lot of figures conceived on different scales, you deprive them all of their aesthetic purpose and reduce them to the status of "ancient remains", I mean of objects of interest to an antiquarian. In the case of modern sculpture too, this overcrowding in galleries and museums deprives each work of its intended relationship to space, I mean of its ideal landscape. Once, when I was in Greece, I became intensely aware of the relationship that a single human figure might bear to a whole vast landscape. It was on Patmos, and I was coming down a mountain-side when I saw a single black-robed Greek Orthodox priest standing beneath me in a snow-white courtyard, with the blue sea beyond and, on the curved horizon, the shores of other islands. This single human figure then seemed to me to give the scale of the whole universe, and this is exactly what a sculpture should suggest in its relationship to its surroundings: it should seem to be the centre of a globe, compelling the whole world around it to rotate, as it were, like a system of planets around a central sun. That is why each sculpture should be contemplated by itself. (pp. 99-101)

Barbara Hepworth and Edouard Roditi, in an interview in Dialogues on Art *by Edouard Roditi, Secker & Warburg, 1960, pp. 90-102.*

INTRODUCTORY OVERVIEW

Patrick Heron (essay date 1955)

[Heron is an English painter and art critic who has written extensively on various artists and their methods. In the following excerpt, he examines Hepworth's technique and traces the development of her style.]

Barbara Hepworth's distorted spheres, her variations upon egg forms, complicated by partial planing and scooping out and tunnelling, are . . . devoid entirely of representational intention, and express with brilliant directness (and as the result of great technical skill) their maker's intuitions of such natural forces (it seems to me) as are displayed in the action of waves upon pebbles, for instance. There the moving water and time invariably reduce the jagged rhythms of a chip of granite to ones which bear closer relation to the sphere. Pebbles are beautiful and they are never exactly alike: Barbara Hepworth's sculpture has a beauty of this order. It is possessed of a passionate coldness. Although allied at the level of form to Henry Moore (but the form of her 'forms' is far simpler than

Moore's), she is at the very opposite pole so far as temperament and feeling are concerned.

For the sculptor, form and space are always actual, not illusory: the illusion of either is the painter's province. When the sculptor drives a narrowing tunnel through wood or stone he is creating a physical reality in terms of actual space—or, rather, in terms of solid form meeting a defined aerial space at a mutual boundary of definition. The surface, of wood or stone, *is* that defining boundary, definitive of a solid (reading inwards) and a volume of air (reading outwards): the true sculptor thus creates in terms of volume, and whether the work is abstract or figurative, we inevitably apprehend it at first as a harmony of contrasted volumes—volume in every case becoming articulate as form. Barbara Hepworth has always thought in these terms. Indeed, the main criticism which her work has prompted in me from time to time has been that the formal discipline was too intense; the concentration on formal purity had excluded every non-formal ingredient.

If Barbara Hepworth enjoys a reputation unrivalled by any other woman artist in this country, this pre-eminence is due not only to the quality of her vision but also to her mastery of a masculine technique. Many woman sculptors model in clay—very few carve stone, or even wood. Yet it is essentially as a carver that Barbara Hepworth approaches sculpture. At her best she has bent this carving technique to the service of a three-dimensional imagery that no male artist could have conceived; and this is one of the qualities in her work that fascinates: we find a lyrical, feminine line everywhere breaking out among the masses of an art form, an idiom, which one thinks of as masculine. It is by no means always the volume or the mass of her sculptural form that chiefly pleases one: as often as not the linear rhythms, that emerge when two planes meet in her surfaces, are the first to arrest one's eye. And planes are always meeting in this way in her sculpture, because her surfaces are not often continuous: they are always going round corners; indeed, they often consist of a series of clearly distinguished facets. . . . Unlike Henry Moore, from whose example she has certainly learnt much, Barbara Hepworth does not conceive of form from the inside outwards, but the other way round, from the outside inwards, or so it appears to me. And this is the reason her planes are so much emphasized, remaining clearly discernible even when they are blended together by a rounding off of the slight ridges where they meet, or run one into the next.

In other words, I believe Barbara Hepworth's approach to volume and mass is pre-eminently visual. I feel that it is by *looking* at her block of wood or stone—from the outside—that she decides on her forms at each stage in their emergence, taking off first a slice here and then a slice there—compressing the core of the mass between the planes of its own surface. One does not feel that a sculpture by Barbara Hepworth has *grown* from tiny to big; there is no feeling of her forms having expanded from an original germ until, like fruit or living creatures, they are full and ripe. Her forms seem to have been arrived at by a process almost the opposite of that of growing flesh. Instead of expanding from the inside, they have been shaped

by a wearing away from the outside. Their peculiar beauty, their unique poetic quality, is that of smooth, weather-worn, grooved, fluted or hollowed-out objects such as seashore pebbles and shells, wooden pier-stakes, half-burnt logs or rain-washed rock. Like these, her sculpture bears the imprint of vast, impersonal forces, the forces that produce erosion in a hundred different forms. If her sculpture, like the worn pebble, gives off a sense of space far in excess of the actual space that it itself inhabits, it is because the forces of space—of sea and wind, as it were—have done the shaping, and produced this cold, other-worldly, moon-like, feminine imagery.

Barbara Hepworth's development as a sculptor falls into three distinct periods. First came the early figurative carvings in which the frequent changes of idiom were an indication of growth and a capacity for aesthetic exploration, rather than uncertainty. Indeed, the accomplishment she showed in any one of the first eleven works numbered in the catalogue of her Retrospective Exhibition at Wakefield in 1951, was such that she need have explored no further if a distinguished reputation had been all she was in search of. But she never rests long in one place: and towards the end of this first period, in, for instance, *Mother and Child,* Pink Ancaster Stone, 1934, she was moving rapidly away from figuration towards abstraction.

Complete abstraction was arrived at in 1934, and from then until 1948 all trace of representational or figurative form was banished from her sculpture. In the smooth, geometric forms—geometric in suggestion more often than in fact—of this abstract period Barbara Hepworth first isolated those shapes, those movements of form, which register most clearly the 'wearing away' actions of air and water, which I have already mentioned. Stripped of any figurative function, her forms now expressed these movements in their purest, most extreme aspect: some of her titles indicate the nature of her form at this time. For instance we get *Pierced Hemisphere; Conoid, Sphere and Hollow; Oval Sculpture; Helicoids in Sphere* or *Convolute.* The words themselves invite one to seek no further than the actual form of the stone itself for meaning. And thus focused, the mind may re-discover the beauty and significance of the elementary formal relationships inherent in the structure of solid matter, relationships which she demonstrates in her distorted spheres, her hollowed-out egg forms or her single, springing columns or pillars, with their suggestion of an inverted, attenuated cone. Even more than Arp she has laid emphasis in her non-figurative work upon an impersonal purity of line and contour which is, in fact, one of her most personal qualities. With her, mass is a comparatively neutral, disenchanted force. Unlike Moore's, her *mass* is, one feels, simply the volume a lively line or silhouette bequeaths inescapably. Line, not mass, is the living reality in a Hepworth sculpture. And by using the word 'purity' in this context I suspect that what I am trying to suggest is a quality that, in the final analysis, would have to be called *mathematical*—geometric as opposed to organic; crystalline as opposed to the richer more complex shapes of, say, the biological world. Organic shapes carry overtones, are more suggestive of something else: they often act as visual metaphors, evoking the warm, familiar forms of physiological life—

and even of Man himself. But Barbara Hepworth's abstract pieces have always a cosmic coldness—'cosmic' because the perfect sphere is only found, perhaps, in the natural world, in the astral bodies that float in outer space.

But all this time, too, she was developing an ascetic concern for the purely structural aspects of her forms: in her carvings of this period she would explore the structural forces and tensions manifest in the simplest of nature's sculptural objects, like the seashore stones and shells I have mentioned. Shells display a fascinating relationship between smooth convex surfaces on the outside, and a twisting, possibly fluted, concave surface on the inside. The results of her meditations upon such themes as this seem evident in a work like *Oval Sculpture,* Beechwood and White Paint (dating from 1943), which is a most beautiful and original thing—light, airy, taut and utterly self-contained in its perfect balance and unity—and also in the exquisite and extremely economical *The Wave,* Wood with Colour and Strings, 1943-44. The twisting cavities, the diminishing tunnels, have been scooped out and worn smooth by the great impersonal anonymous forces of exterior space. Nothing could be more remote from human kind than these superbly cold, calm, faceless works in an abstract idiom. And again we may remark the contrast with Moore, whose figures are saturated by human feeling and personality.

Barbara Hepworth's third phase began in 1947 or 1948. It reveals a slow return to near-figuration; to the creation of forms that contain a comment on realities outside themselves, which the completely abstract (or non-figurative) work does not. In most of the works of this third period it is the human form that everywhere begins to emerge, pressing through the skin of the springing column or the flattened lopsided sphere. I say human; but possibly the sort of beings evoked in some of these later sculptures are visitors from another planet. Or are they aquatic in origin? There are no separate, articulated limbs, free of the body. And it is interesting to see that the geometric quality is now rarely in evidence. The shallow convexities of the surface planes increase in subtlety: indeed, they occasionally become too subtle to relate satisfactorily with the mass behind them and then we almost have the feeling that a loose silk garment is obscuring our view of the real, the underlying form. But not for long. The bare bones of the structure are there, like rock under the grass. If Barbara Hepworth had long been exclusively preoccupied with structure, there were soon signs that, in her work, of this latest phase (from 1947), her figures were almost succeeding in putting on that flesh which, before, they had always, so to speak, rejected. And this continues to be the tone of her work up to the present time.

The addition of an element of representation has resulted in her abstract rhythm being elevated from a geometrical to a poetic condition. Instead of a demonstration in stone of the mechanics of form, we are now presented with an image, and an image, often, of great beauty.

To describe this beauty is not easy. Where Henry Moore involves us always in human loves and fears—troubled emotion concerning our own origin and fate—Barbara Hepworth's world is crystalline, remote; her beings are

visitors from a subterranean or a lunar region. Indeed, her superbly simple *The Cosdon Head* has the lively, rocking, lopsided form of the waning moon and wears the same expression—inscrutable, cosmic, remote; but alive. It is very natural that this new willingness to admit into her works the disturbing and disordering representational element should be accompanied by a less stringent, less geometrical attitude to the actual forms themselves.

It is a possible criticism of Barbara Hepworth's sculpture that in her eagerness not to violate her material she in fact allows it to influence, or modify, her conception too much. The sculptural problem she sets herself is not usually as complex as that of a Moore reclining figure: indeed, it frequently involves no more than a single trunk variously planed and gouged—for example *Rhythmic Form,* 1949, in rosewood. Even the mother and child, *Eocene,* of the same date, is but a single body of stone, eaten away by concavities at the front, like an extremely complicated sea-rock (but possibly this piece is also too pictorial in its rhythms?). She rarely tackles the sort of problem you get when the arm leaves the main body at the shoulder and, after piercing space with the elbow returns to it again at the hip. There are no complex bridges of this sort. To all this, however, it could be replied that she has made the single, slim, taut, gouged, slightly bending column her own: that, for her artistic purpose, she has no need to cut away as deeply as Moore, for instance: that the exquisite and comparatively shallow undulations of a tense surface, in which the concave and convex are fascinatingly interwoven, is adequate recompense for the absence of weightier contrasts.

Perhaps the most ambitious of these semi-figurative works was *Biolith,* which dates from 1949. Completely original, and remarkably successful, this ton of blue ancaster stone has the outline—again—of the waning (or waxing?) moon: in mass a flattened sphere, grooved down the middle and pierced by a hole which becomes the second eye of two faces engraved on back and front. Thus one profile of a face is visible from any angle and this may be doubled by a shadow in a certain light, giving the suggestion of a face in movement—the natural turning movement of head and neck. A work of this quality is a work of poetic as well as plastic invention. And this mood has lasted. Between 1949 and 1952 her preoccupation with streamlined, vertical, limbless forms suggestive of torsos continues. Many of her pieces are figures nearly human. Some of these new vertical figure forms, in honey- or wine-coloured woods, twist upwards, lean, and almost sway with a life if not that of trees perhaps of . . . tree-spirits! Whereas her stone is sometimes impersonal to the point of being dead—dead of over-refinement—her wood forms breathe: they are statements about personality and about the personality of wood. It is still true, as I have said, that all her shapes have been produced essentially *from the outside*—rather than felt from the inside outwards. She is visual where most sculptors are tactile in their approach. Her forms interest more for their profiles than for their volumes; they have nothing of that extreme subtlety of movement in the surface which can only result from the second process—the process where the sculptor, working blind, makes his form from the blind muscular dictates of his own hands, arms,

his whole body . . . and then, when he pauses, *looks* at the result, as if for the first time. Yet her opposite method of constructing her forms, at each stage, to the demands of a most sensitive eye, has had its reward. She has created a species of perfection. (pp. 216-21)

Patrick Heron, *"Sculpture: Fruit or Thorn?"* in his The Changing Forms of Art, *Routledge & Kegan Paul, 1955, pp. 208-36.*

SURVEY OF CRITICISM

Adrian Stokes (essay date 1933)

[*Stokes was an English critic who wrote extensively on classical, Renaissance, and modern art. In the following excerpt, he praises Hepworth's early stone carvings.*]

A glance at [Hepworth's stone] carvings shows that their unstressed rounded shapes magnify the equality of radiance so typical of stone: once again we are ready to believe that from stone's suffused or equal or slightly luminous light, all successful sculpture in whatever material has borrowed a vital steadiness, a solid and vital repose. This steadiness of shape, through many ages unconsciously expressed by visual art, in recent times had been altogether lost. To cultivate a reverence for stone thus became an aesthetic need. Miss Hepworth is one of the rare living sculptors who deliberately renew stone's essential shapes.

What are the essential shapes of stone? Pebbles are such shapes since in accordance with their structures they have responded to the carving of the elements. They are nearly always beautiful when smooth, when they show an equal light, when that light and the texture it illumines convey the sense of all the vagaries of centuries as one smooth object. Thus a slate pebble, suitable for "ducks and drakes," with an equally lit and homogeneous emaciation, thin yet no wise sharp, suggests an incontrovertible roundness; for it has been worked upon and flattened; a deeper roundness has emerged. Similarly the human carver thins the stone, reveals smooth and gradual forms. As pebbles by natural forces, so forms by the true carver are rubbed: though it is sufficient for him to rub the stone in the final process only.

You may see the rubbed forms from every angle of Miss Hepworth's carving. . . . These stones are inhabited with feeling, even if, in common with the majority of "advanced" carvers, Miss Hepworth has felt not only the block, but also its potential fruit, to be always feminine. These sculptors approach the block with such gravity that more ebullient, more masculine, forms evade them. None the less, after Miss Hepworth's exhibition, her contemporaries and Miss Hepworth herself, I feel, will modify their attitude. ***Composition*** caps what has been a trifle too stolid a feeling in our modern carving. Nothing, it would appear, should be attempted for a time on the mountain and mother-and-child themes in view of what Miss Hepworth has

here accomplished. The stone is beautifully rubbed: it is continuous as an enlarging snowball on the run; yet part of the matrix is detached as a subtly flattened pebble. This is the child which the mother owns with all her weight, a child that is of the block yet separate, beyond her womb yet of her being. So poignant are these shapes of stone, that in spite of the degree in which a more representational aim and treatment have been avoided, no one could mistake the underlying subject of the group. In this case at least the abstractions employed enforce a vast certainty. It is not a matter of a mother and child group represented in stone. Miss Hepworth's stone *is* a mother, her huge pebble its child. A man would have made the group more pointed: no man could have treated this composition with such a pure complacence. The idea itself is a spectacular one, but it gains from Miss Hepworth's hands a surer poignancy. Her carving is astonishingly mature: whereas the appreciation and critique of sculpture remain fatuous.

Adrian Stokes, *"Miss Hepworth's Carving,"* in The Spectator, *Vol. 151, No. 5497, November 3, 1933, p. 621.*

J. P. Hodin (essay date 1950)

[*An English biographer and art critic, Hodin has written extensively on twentieth-century art and literature. In the following excerpt, originally published in the journal* Les arts plastiques *in 1950, he traces the development of Hepworth's sculpture.*]

Abstract art is the expression of the idealism of a time which is in a state of transition and of crisis. Violent changes are taking place in all spheres of thought and activity. The abstract artist does not rebel against his age but against certain of its shortcomings and tradition-bound errors, and he does so because he believes in the new vistas that constructive scientific thought is opening up for mankind. He accepts them as the next goal to be reached. Barbara Hepworth says: 'In his rebellion he can take either of two courses—he can give way to despair and wildly try to overthrow all those things that seem to stand between the world as it appears to be and the world as it could be—or he can passionately affirm and reaffirm and demonstrate in his plastic medium his faith that this world of ideas exists.' Barbara Hepworth has chosen the latter course, and her work is an acceptance not only of her own time but of herself. Matisse once expressed this same attitude with the words: 'Il faut s'admettre.' And for Barbara Hepworth 'the present moment is the only time'. There is a mighty formal tradition of global extent which supports the abstract artist of to-day from prehistoric times onward. The work of Barbara Hepworth shows that, contrary to the assertions of some psychologists, there are even elements of myth in an abstract work of art. She herself has said: 'At the moment we are building up a new mythology.' (pp. 130)

It is significant to note that [the ideas she articulated early in her career] expressed her style, her inner certainty and direction even before she was able to give them a definite shape. The works she produced in those years, were only steps towards those which, in their transmutation of musi-

cal and metaphysical values into plastic values, finally formed a unity of idea and execution. These are masterworks of a new imagery in which the surrounding space is made an active partner of the figure, and without a doubt they win for her a place among the foremost sculptors of our time.

Barbara Hepworth's early work was representational, and consisted of portraits, single figures and groups. It was in Italy in 1923-26 that she began to carve directly in wood and stone. At that time great emphasis was laid upon direct carving, especially in England. Eric Gill, the early Epstein, Henry Moore, Gaudier-Brzezka and Skeaping all advocated and practised it. These artists believed in it as the only method, and refused to model and transfer the clay form to wood or stone. Direct carving changed for them their whole outlook on sculpture. The material had its character and imposed that character on the work, sometimes, when the imposition exceeded a certain measure, to the disadvantage of the work as a product of the artist's imagination. But on the whole this direct approach to the final material had a liberating effect and justified itself by its fruitful results. A perfect unity was sought between the idea, the material and the dimension. This unity was manifest in the works of primitive peoples—Neolithic, Archaic Greek, Etruscan, Negro, Pre-Columbian, Aztec, Easter Island sculptures, etc. See in this context Barbara Hepworth's *Head,* 1930. In *Torso,* 1929, the forms are not so much the naturalistic forms of a female body as forms belonging essentially to the wood

Infant *(1929).*

which embodies them. Up to 1934 her work was inspired exclusively by the human shape; simplified, sometimes so as to verge upon the abstract, it was always easy to recognize whence the inspiration came. From 1934 onwards there is a complete change. She began to be occupied with geometric shapes, but only for a relatively short period. The more organic forms returned, and later on those of the human figure. The titles of her sculptures were now: Conoids, Conicoids, Spheres, Hemispheres, Helicoids, Discs, etc. This purist-geometric thought not only changed, but also, to a certain extent, frustrated her outlook. It was through a long process of inner assimilation that the geometric element became fused with her work and then not as a separate idea, but as an organic part of a whole which could no longer be broken down into its parts by analysis. Barbara Hepworth's development is characterized by the impact of a constructive thought, the realization of that thought in a more or less rational theoretical form, the submerging of it in the unconscious and its reappearance as an integrated, inseparable part of her imagination.

Free forms constitute a further experimental stage in Barbara Hepworth's development. In 1934, abstract free forms appeared in her work for the first time, bringing with them a new version of an old problem, that of the perceptual unity of shapes separated through space; the solution was that no physical continuity was necessary (*Two Forms,* 1935). *Mother and Child* shows another aspect of the same problem. It is an assemblage of two forms, necessarily connected but not carved in one piece. In 1932 Barbara Hepworth made her first pierced work. A new function of space was discovered and she explored its possibilities with unfailing enthusiasm. But she did not and does not now use concavities and holes in the same sense as does Henry Moore. Hers is a classical, a static conception; his is basically organic, nature-bound, romantic. Whereas the hole in a work of Barbara Hepworth pierces straight through a figure, Moore's is inclined to widen and to wind through it. In reducing the mass he often diminishes the figure to a shell covering, as it were, the most important of its messages, the Secret of the Within. Endless new aesthetic possibilities appeared to Barbara Hepworth of exploiting the music and the rhythm of lines created by light and shadow and by the boundaries where form and space meet. The roundness, the unity of the object lies . . . in the penetration of light and air into the closed form, in the new entity of figure and surrounding space. In works like *Pendour,* 1947-48, Barbara Hepworth attains absolute beauty. Here colour appears as part of sculpture. Colour was used by the old Greeks, by the Egyptians, by the Assyrians and by primitive peoples. With Barbara Hepworth, who is one of the few sculptors who have explored this special field, it is not a question of 'coloured sculpture', of applied colour (she very seldom uses colour on the outside, mostly in the concavities), but of intensifying through colour—white, grey or blue in different shades—the form and the depth required by the volume. This artistic problem occupied her from 1937 onwards. She accorded to colour an organic function similar to that which nature accords to the colouring on the inside of certain flowers. Wood, especially foreign hardwoods like blackwood, lignum-vitae, ivory wood, etc., and stone are the materials she prefers. She does not use either perspex or

plaster, cement or metal, and that for the reason that they are not living materials. In 1939-40 we find her producing her first stringed sculptures. The strings give both transparency and form. *Pelagos* of 1945 is a good example of the introduction of this new element. Sometimes the strings have another function; in running together towards a common focal point they suggest a greater depth than the sculpture itself could convey. Or again they produce an effect of tension, the solid form thrusting in one direction and the strings offering a counter strain in the other. Devices and inventions similar to those in the work of Barbara Hepworth are to be found in the *oeuvre* of Archipenko, Lipschitz, Arp, Brancusi, Giacometti and Moore; taken together they provide a complete compendium of modern abstract sculpture. The question of precedence is thereby not raised.

In 1939 Barbara Hepworth moved from London to Cornwall. The Cornish sea and landscape had a beneficial effect on the cerebral component in her work. Through the influence of nature the constructive-geometrical forms became softer and her whole conception of sculpture more organic. There also she found the inner relationship between sculpture and landscape. Before this change of scene she had been preoccupied with the relationship of sculpture and architecture. In Cornwall Barbara Hepworth's sculptures became more subtle, and some of her works, as, for example, the four recumbent non-figurative compositions made in the competition for the ends of Waterloo Bridge, reveal a beauty which can be enjoyed directly without reference to the principles of abstract art. Of her latest works, *Dyad* in rosewood, with two engraved profiles, the lyrical *Rhythmic Form,* also in rosewood, and *Biolith* in blue Ancaster stone, all of 1949, may be mentioned. In the *Biolith* a face appears on each side of the sculpture, the one male, the other female. Seen from the point of view of construction, there is a hole pierced through the stone, and this forms the eye of the one face and leads through to the other on the opposite side, whilst a deep groove down the middle imparts a spiral movement to the solid mass, forcing the beholder to go round it. This work shows a new approach to the problem of the front view and back view of a sculpture; it eliminates them by emphasizing the unity of two elements, of male and female. In the *Cosdon Head* of 1948, four times life-size in blue marble, the idea of the two faces is anticipated. The most sophisticated work that Barbara Hepworth has yet created, and one that may be regarded as the climax of her achievement hitherto, is the *Biocentric Form* of the year 1950. The interplay of crystal and human organic forms radiate living energy. The richly faceted monolith itself casts a spell over the mind, but in addition, as we contemplate it, we become aware of suggested images—an image of the human figure with trunk and limbs fused, as always in Barbara Hepworth's work, into one volume, and a mythological image similar in form and style to those in Egyptian works, but charged with a different meaning for our contemporary minds. There is a lyrical and at the same time a monumental quality in this *Biocentric Form,* and this dual appeal to our sensibilities arises from the harmony of soft and severe contours which create fascinating and seemingly endless surprises. In *Monolyth-Empyrean,* 1953, Barbara Hepworth created a new ver-

sion, both powerful and poetic, of the *Biocentric Form.* And *Pastorale,* of the same year, in white Serravezzia marble uses in an exquisite way again, the contrast of angular and rounded forms.

Parallel with her sculptural work, Barbara Hepworth has often devoted whole periods to drawing. These drawings (also small sketches and sometimes even small clay figures) are not working drawings or maquettes serving as memoranda or annotations for sculpture, but exist in their own right, although it goes without saying that they have an ultimate bearing upon her sculptured work. Recently figurative drawings of nudes, group compositions and heads have taken the place of her former drawings of crystal and geometric forms. The surgeon with his assistants at work in the operating theatre, a dramatic theme, occupied a great deal of her attention during 1949, and many drawings and paintings witness to the intensity of her interest. Barbara Hepworth's drawings have some of the quality of fresco. She draws with firm lines, sometimes with, sometimes without shading or cross-hatching, and occasionally she adds colour or a toned ground of chalk or plaster of Paris applied to wood panels. Her drawings suggest that she was inspired by Degas, by Renaissance masters, such as Giotto, by the Pre-Raphaelites, by Braque and others, but every influence is assimilated in the personal experience of the artist. It is of interest to note the tension set up between these representational drawings and the abstract sculptures produced at the same time. We feel that just here is the key to the understanding of her working method, which is that of a constant interchange of outward observation and inner reflection. And behind the visible creation of the plastic artist we divine also the reconciliation of those other opposites, of art and life with their often conflicting exigencies, of nature with her imperious realities and the human spirit with its passionate affirmation of the ideal. (pp. 130-34)

> *J. P. Hodin, "Barbara Hepworth: The Meaning of Abstract Art," in his* The Dilemma of Being Modern: Essays on Art and Literature, *Routledge & Kegan Paul, 1956, pp. 128-34.*

David Baxandall (essay date 1952)

[In the following excerpt, Baxandall comments on several pieces from Hepworth's 1952 exhibit at the Lefevre Gallery, noting her importance in the field of modern sculpture.]

The current exhibition of recent carvings and drawings by Barbara Hepworth at the Lefevre Gallery, following, as it does, the large retrospective exhibitions of her work at the Venice Biennale of 1950 and in this country last year, gives a welcome opportunity to take stock of her achievement. That this achievement places her among the two or three most important living British sculptors has become increasingly clear in recent years, while her works shown in the permanent collections of the Tate Gallery and the New York Museum of Modern Art are seen to take an honourable place in the field of contemporary sculpture as a whole. (p. 116)

The retrospective exhibitions showed the work of a sculp-

tor (to be more precise, a carver) who for twenty-five years had pursued her aims with a wholly admirable determination and integrity. To summarise these aims is not easy, but it is perhaps not too misleading to say that they concern the carving of chosen materials into shapes that can delight and move us and that embody an idea or intuition. The carvings of Miss Hepworth's earlier years were simplified massive versions of the human figure; explorations of the expressive possibilities of shape and material in a direction perhaps suggested by ancient Mexican and Sumerian sculpture. These early works were not unlike the early works of Miss Hepworth's fellow Yorkshireman Henry Moore, but since that time their development has followed diverging lines. The element in Moore's mature works that Dr. Herbert Read has called expressionist is not found in Miss Hepworth's, which soon showed signs of the pursuit of a more classical perfection.

This was particularly clear during the years when her work was almost wholly non-representational. This does not mean that the carvings were divorced from the contemplation of nature, for they were clearly governed by an understanding of the way nature shapes things, an understanding that could only have come from long contemplation of the natural world. A work called *Wave,* of carved wood and stretched string, illustrates this. It was not a representation in solid material of any wave the artist had seen. Instead of attempting to portray a wave, the artist had fashioned a symbol which seemed to embody an intuitive or imaginative understanding of the natural forces that have shaped all the waves of all the seas that have ever been. By making this symbol a piece of visual music, beautiful in its own right, the artist made us understand also the delight and wonder that accompanied her understanding.

Miss Hepworth's non-representational phase lasted until the war. During the war itself the care of small children and the growing of food left no time for major sculpture, but she was able to produce many drawings. These were nearly all non-representational. Shortly after the war there came a change; she entered a hospital for an operation, was fascinated by the grave ritual of the operating theatre, and returned after her recovery to make many drawings. In these, her feeling that the gowned and masked figures were dedicated ministrants gave the drawings an almost devotional seriousness that was expressed in a solemn music of massive, monumental forms. This reawakened interest in human figures affected her post-war sculpture. Her 1949 exhibition included carvings in the form of a human figure, simplified, but more nearly a representation in stone, and less a symbol, than she had attempted for many years. Other works, although entirely self-sufficient stone or wooden forms, were as clearly related to the theme of the human figure as the earlier non-representational works were related to the contemplation of waves, shells or crystals. Many of the new carvings contain this reference to the human figure—distant, not naturalistic, but nevertheless present and giving the works a slightly different tone from that of the sculptor's non-representational phase.

Consider the carving of Spanish mahogany called *Figure.*

One's first impression is of the main shape, a form lyrical and pure, tense and alive with its own shape-life. In it there is a hollow; this has a fascinating and beautiful shape, but it has a value beyond that, which, to me at least, brings a new experience. In previous carvings by Miss Hepworth and other sculptors in which the main form has been pierced by one or more holes, one has felt the hollow to be a means of penetrating the main form, of passing through it to increase one's consciousness of the other side. The surfaces of the hollow were felt either as part of the main form or as surfaces enclosing space. But the hollow here is different; it implies another form, complete and existing in its own right, but enclosed in the main form and related to it. Never before has one been made to feel so conscious of this other form, which is just sufficiently anthropomorphic to allow the fancy at the back of one's imagination that it must have newly stepped out from the enclosing form, as a dryad might from her enclosing tree.

In this carving one is conscious of three themes: first the main form, its surface completed by the imagination to leave no hollow; then the imaginary enclosed form, implied by the hollow impress it has left; and lastly, and most powerfully, the complex solid form that results when the enclosed form has stepped forth—the work, that is, as it exists in fact. Each of these is satisfying in itself, but the full effect of the work comes from the counterpoint between them. It is in sensing and following out their relationships, so tense and exquisitely poised, so mysterious and yet stated with such perfect clarity, that one experiences the full delight that the work has to give.

The clarity with which complex relationships are felt and stated, which is a characteristic of Miss Hepworth's work, is equally impressive in the stone *Image.* It is comparatively easy to *hint* at a relationship of form, to give an approximation. One can readily get away with this in oil paint; in modelling and even in carving it is possible to disguise an imperfect grasp of relationships by a romantically rough surface treatment. Miss Hepworth has never evaded the issue in this way. Her statement is precise to the last millimetre. Once it has been made, the slightest flattening of a curved surface, the faintest blunting or sharpening of an edge, and the statement is different, distorted, no longer hers.

"Truth to material" is often spoken of as part of the modern carver's creed; a comparison between the two works *Image* and *Figure* shows very clearly what this means. Either might be described as an upright form enclosing a hollow, but one form is clearly of the nature of stone and the other of the nature of wood. *Image* shows a deep understanding of the way that natural forces, such as weather, water, and abrasion, themselves work stone. It is not in any way an imitation of any particular result of the action of such natural forces that the sculptor may have seen; it has been carved with the purely human purpose of embodying an idea or intuition, but the carver has worked in harmony with Nature's way of working this compact and fairly homogeneous stone. Perhaps that is why the work seems to tell one something about the relationship between the human figure and a landscape as old

and stony as that of the Penwith peninsula where the sculptor lives and works.

Figure, on the other hand, is carved from wood, from part of a tree trunk. Wood is not homogeneous; it is made up of bunches of fibres running in the direction of growth of the tree, its lines curving, affected by wind pressure on the growing tree and by the spreading of branches. The forms in *Figure* show an instinctive understanding of this. The vocabulary of forms in which the idea is expressed is taken from a language quite different from that of *Image;* what is important is that both languages are understood and respected.

To a sculptor with this feeling for truth to material, carving becomes something more than making the wood or stone imitate a preconceived form. I do not mean that it becomes an improvisation in which clever use is made of accidents of grain—we have all seen carvings of this sort and found them mere trickery. In Miss Hepworth's work a deeply felt idea is obviously present before carving begins; in some cases there are drawings that show this. But during the long days of carving, a further exploration seems to have been carried out in collaboration with the material; the idea has taken shape, but because it has taken shape in wood or stone of a particular grain and texture and hardness, this shape—the shape most completely expressive of the original idea—may have been discovered to differ from the shape originally conceived.

A common characteristic of the two works that prompted this digression is the enfolding of a hollow within a form. This is carried still further in *Form Enclosed* of Derbyshire alabaster. The very lovely outer form is penetrated by a hollow cave; if one ignores the cave, this form is a variation on an ovoid with one end flattened, the end to the spectator's left in the illustration. Within the cave nestles a smaller form, again a variant of an ovoid with a flattened end, but this time it is the end to the spectator's right; thus one might very loosely say that the small form is related to the large one in a visual equivalent of diminution and inversion in music. One is also conscious of a very satisfying relationship between the smaller form and the inner surface of the cave that pierces the larger one. But this is not all, for the smaller form itself encloses a hollow that pierces it, and this hollow, unlike the cave in the larger form, is one with the same sort of new meaning as that of the hollow in *Figure*—a hollow implying the form that we are persuaded once occupied it and has still its own existence.

The suggestion of a human shape at the centre of this system of forms within forms gives it an emotional overtone different from that of the earlier abstract works. I do not think it is a matter of merely "literary" symbolism. To say that it symbolises a subconscious desire for escape back to pre-natal security, as amateur psychologists undoubtedly will, seems to me a sadly unconvincing, because monstrously incomplete, reason for the work's power to move us. Like all but the very simplest works of art, this operates on several planes at once. The suggestion that the hollow at the centre of the work resembles the impress of a human form seems to be a valid but comparatively small part of this work's appeal. The spectator does not receive

what the work has to give unless he can also ignore this while he follows the music of the abstract shape of stone that surrounds this hollow.

The Senavezza marble *Group* is a new development. In certain of the non-representational works two, or occasionally three, forms were placed in relation to each other. The difference here is in the greater complexity—no less than twelve forms are grouped on the marble base—and in the fact that these forms are a set of variations on the theme, not exactly of the human figure, but of a simplified symbol for it. At first sight one may feel that the power this artist has shown can result from two subtle but simple forms in tense and perfect relation to each other has here been diffused; that it has become a more complex but lower-powered affair. But with further acquaintance one becomes aware of a dominating power operating through the whole work; the life of the work seems to depend not so much on relations between particular forms as on an intrinsic unity.

Visual art tends to be either a re-presentation of something seen or a symbol of something apprehended. The two intentions can co-exist in the same work, but we can say, for example, that in Byzantine art the symbol predominates, while from the High Renaissance to Impressionism representation prevails. Miss Hepworth's work, like that of many of her contemporaries, is largely symbol. No one knows all that happens when a work of art is either created or enjoyed, but it is probably true to say of these carvings that each is a symbol by means of which we can understand the artist's apprehension of some aspect of the harmony or order that underlies the world of which we are part. (pp. 116-18)

David Baxandall, "Some Recent Carvings by Barbara Hepworth," in Apollo, *Vol. LVI, No. 332, October, 1952, pp. 116-18.*

John Berger (essay date 1954)

[*Berger is an English painter, novelist, essayist, and art critic who worked for more than a decade, beginning in 1951, for the* New Statesman. *A proponent of realist painting in the early 1950s, a period in which realism was unfashionable, his exhibit at the Whitechapel Gallery in 1952 under the title "Looking Forward" aroused much indignation from, among others, Herbert Read and Patrick Heron, both prominent art critics at that time.* Permanent Red *(1960), Berger's first book of art criticism, was denounced by many commentators who disapproved of his eschewal of given historical categories of criticism in favor of an existential engagement with the historical moment of the artist and the work of art. In the following excerpt from a review of Hepworth's retrospective exhibition at Whitechapel (1954), Berger asserts that her sculpture is "clinical" in form and devoid of meaningful content.*]

The 200 drawings and carvings in Barbara Hepworth's retrospective (1927-54) exhibition at Whitechapel have been well chosen. One can trace the whole course of her career as an artist from her early Negro-influenced figures through her geometric abstractions to her more recent

works which do not derive from the human form but raise just the suspicion of a human presence. Also, the well-lit spacious gallery with its stone floor and high ceiling shows off the particular quality of Miss Hepworth's sculpture to its best advantage; her carvings there have the finality that, say, aeroplane parts might have in a hangar. Yet as I walked round I was reminded of how, when Miss Hepworth's two monumental figures called **Contrapuntal Forms** arrived at the South Bank for the Festival, the workmen who unloaded them spent a long time searching for an opening or a hinge because they believed that the real figures must be inside. I do not repeat this story now to encourage all those who automatically hate contemporary art for being contemporary: but because it seems to me to point to the basic emptiness of sculpture like Miss Hepworth's—there wasn't anything inside the contrapuntal forms. What are the causes of this emptiness: an emptiness which even all the good intentions, energy, sensibility, skill and single-mindedness that may like behind such works cannot fill?

First, at the heart of Miss Hepworth's and many other contemporary artist's and critic's ideas there is a fundamental confusion about the relationship between form and content. (Here I should emphasise that content is not the same thing as subject matter: it is what the artist discovers *in* his subject.) It is its content that makes any work of art dynamic. It is the content that the artist distils from life and which, through its influence on the spectator as he comprehends it, flows back into life. The function of the form of a work is to concentrate, to hold the pressure of both the artist's and spectator's experience of the content.

Yet that is only half the problem. Many of Miss Hepworth's works are not strictly speaking abstract. They vaguely resemble figures or natural objects and so can be said to have content of a sort. Why do these seem as empty and dead as the others? In any period that lacks a faith which is so intrinsically part of the whole culture that its symbolism can be automatically applied by everybody to every event, the content of a work of art can only derive from definite, specific, particular experience. The artist may achieve some general truth, universality; but he cannot aim at such qualities directly. They will only be achieved by the most faithful insight into what it means to be a particular person in a particular situation. Every great work since the High Renaissance proves the truth of this. Yet Miss Hepworth says that she wants to discover "Some absolute essence in sculptural terms giving the quality of human relationships." The absolute essence of human relationships! Work with such a motive can get no nearer to interpreting a human heart or a human predicament than the Kinsey Report.

Mr. Baxandall in his introduction to the catalogue describes one of the works—roughly a sphere scooped out into a spiral—as follows:

> The total effect of this form on our feelings is, of course, inexplicable, although we are aware of a sense of enhanced vitality as we contemplate it. The sculptor herself has spoken of its connection with the experience of living between the enfolding arms of St. Ives bay, but one feels also that a sense of forces as diverse as those that shape

> the swing of sea waves and the curves of unfolding ferns has entered into the making of this extremely beautiful and expressive form.

This is as vague, generalised and in the end as woolly as Miss Hepworth's own statement. It could refer just as well to an aeroplane propeller.

Yet to go further: what is the cause of this evasion of real content, this retreat into an abstract world, or a world so generalised that all identity and therefore all conflict and therefore all vitality disappears? As an artist Miss Hepworth hasn't the conviction to face up to the real consequences of the crisis in which we live. Describing her childhood in Yorkshire, she says:

> It is a country of quite extraordinary natural beauty and grandeur: and the contrast of this natural order with the unnatural disorder of the towns, the slag heaps, the dirt and ugliness, made my respect and love for men and women all the greater. For the dignity and kindliness of colliers, mill hands, steel workers—all the people who made up that great industrial area gave me a lasting belief in the unity of man with nature—the nature of hills and dales beyond the towns.

She is intelligent and warm-hearted enough to see what is happening. But her solution—the unity of man with the Nature of hills and dales beyond the towns—evades the whole problem; the problem of how men can make their towns worthy of their "dignity and kindliness." This evasion then leads her to this sort of ambivalence:

> When drawing what I see I am usually most conscious of the underlying principle of abstract form in human beings and their relationship one to the other. In making my abstract drawings I am most often aware of those human values which dominate the human structure and meaning of abstract forms.

When she looks at the real she exorcises a sense of crisis by abstracting it: and when she creates abstractions she tries to make-up for this by imposing upon them a vague, "safe" human significance. Her attitude is made even more explicit in the following:

> The artist rebels against the world as he finds it because his sensibility reveals to him the vision of a world that could be possible—a world idealistic, but practical—idealistic: inclusive of all vitality and serenity, harmony and dynamic movement—a concept of a freedom of ideas which is all-inclusive except to that which causes death to ideas. In his rebellion he can take either of two courses—he can give way to despair and wildly try to overthrow all those things which seem to stand between the world as it appears to be and the world as it could be—or he can passionately affirm and reaffirm his faith and demonstrate in his plastic medium his faith that this world of ideas does exist. He can demonstrate constructively, believing that the plastic embodiment of a free idea—a universal truth of spiritual power—can do more, say more and be more vividly potent, because it puts no pressure on anything.

She can only conceive of the desire to change the real world as one based on despair, and so inevitably chooses to deal in ideas which put *no pressure on anything*—which form a vacuum.

From all this come the weaknesses of Miss Hepworth's work considered æsthetically. It is because her energy has been spent on inventing a substitute "ideal" world that she has lacked the passion to investigate *actual* structure. Her straightforward drawings of nudes, when once one has allowed for their tricks of textures, are extraordinarily weak—notice in particular their feet, ankles and hands. It is the ambivalence of her attitude to reality that has led to the emotional split in her work. One moment her tenderness is excessive, the next it is defensively repressed. On the one hand, her drawings such as those of surgeons and nurses in the operating theatre are extremely sentimental—everything depends upon the mascara smudges of their eyes: and on the other hand, her sculpture is monumentally cold, impersonal, clinical. Finally and most important of all, her desire to contribute something perfect, something above the struggle, has lead her to such precision and sheerness of technique for its own sake that many of her carvings look machine made. As a result they deny their own nature as sculpture. Their surfaces are not forced round their corners but slip round with such facility that one's eye takes them for granted and has no compulsion to follow.

John Berger, "Sculptural Vacuum," in The New Statesman & Nation, *Vol. XLVII, No. 1206, April 17, 1954, p. 498.*

Hepworth on her approach to sculpture:

In approaching a commissioned sculpture, I very much like to begin from the position that a new form, a new idea springs into one's mind. If it doesn't, I never really want to carry out the commission. It must be an instant reaction to the light and place. But with the free works which I do for myself, I always imagine the sort of setting I would like to see them in, because I firmly believe that sculpture and forms generally grow in magnitude out in the open with space and distance and hills, so that the natural setting is the most tremendously inspiring one to me. And when I go out in the country here in Cornwall, motoring over the hills, I stop, and more often than not I make drawings, not of what I'm looking at, but what springs into my mind is a form which I would love to make for such a landscape. Therefore, the works I do are a mixture of an ideal situation in shape and spontaneity reacting to landscape and a feeling of evoking how I feel, myself bodily, in relation to this landscape.

From 5 British Sculptors (Work and Talk), *by Warren Forma.*

Herbert Read (essay date 1957)

[*A prominent English novelist, poet, and art historian, Read was best known as an outspoken champion of avant-garde art. His aesthetic stance is characterized by* his belief that art is a seminal force in human development and that a perfect society would be one in which work and art are united. In the following excerpt, he examines various influences on Hepworth's thought and art.*]

In approaching the work of any contemporary artist one has always to dispose of the tiresome question of influences—tiresome because, being a contemporary question, it is bound to involve those not very creditable emotions we generally hide under the French phrase *amour propre.* To the objective student of art these emotions seem unreasonable, for the whole history of art is a close texture of such influences, and those who are most free from them are certainly not the greatest artists. One might even risk the generalization that the great artist emerges precisely at the point where the greatest number of strands meet, to create, not a confusion, but a pattern of universal significance. Michelangelo is such a *nodus,* and in our own time, Picasso.

Barbara Hepworth has mentioned the main influences in her own development, and I shall comment on them presently. But she might have mentioned more, for by quite consciously situating herself in the historical tradition of sculpture, she allowed her roots to strike deep into the past, as well as to spread widely in the present. One might as well begin with the Aphrodite of Knidos, for a *Torso* carved by Barbara Hepworth at the age of twenty-five is conceivably a derivative of the lost masterpiece of Praxiteles. One must mention African tribal sculpture, Mexican sculpture, Egyptian sculpture and certainly the sculpture of the Italian Renaissance, for the secrets of all these styles were absorbed in an apprenticeship that was as profound as it was passionate. But an artist must finally submit to the strongest influence of all, which is the influence of one's age—that insistent and all-pervasive demand for an idiom that will express the dumb consciousness of a generation resolved to find its own answer to the enigmas of existence. In this situation the artists of a period are the language-makers, inventing visual symbols for the hitherto unexpressed intuitions of an evolving humanity—but expressing them in a *common* language, a language with a logical syntax and a flexible articulation.

Barbara Hepworth has been a contemporary, a compatriot and fellow student of Henry Moore. Five years older than her, he was five years nearer to these influences which were to be their common source of inspiration. Until about 1935 they are tacking against the same wind, and their courses though separate are often parallel. Then the wind drops and they move out into the open sea, each to pursue a different direction. The metaphor is commonplace, but capable of elaboration (I am thinking of the common dangers they encountered, of the signals they exchanged). But there was, from the beginning, an innate difference of temperament. This is well illustrated by the statements which they both contributed to *Unit One,* the manifesto of a group of English architects, sculptors and painters published in 1934. Barbara Hepworth evokes a landscape, speaks of "the relationship and the mystery that makes such loveliness", of "projecting her feeling about it into sculpture"; of "building up a new mythology" and of "an impersonal vision *individualized* in the par-

ticular medium". It is a "sense of mystery" that gives her the power to project "some universal or abstract vision of beauty" into her plastic medium. If we turn to Henry Moore's statement we find a similar concern for nature, but no mention of mystery or loveliness, but an explicit disclaimer of beauty ("Beauty, in the later Greek or Renaissance sense, is not the aim of my sculpture.") He goes to nature for a vocabulary of form—"form-knowledge experience", he calls it; and gives as the aim of his art, vitality. "Between beauty of expression and power of expression there is a difference of function. The first aims at pleasing the senses, the second has a spiritual vitality which for me is more moving and goes deeper than the senses."

The two ideals, distinct in their essence and expression, are denoted by the words "beauty" and "power", and these two words express the divergence that was to take place in the development of the two sculptors. It is possible to argue that these qualities, in a work of art, can never be wholly separated; there is power in beauty ("the terrible crystal"), and there is beauty in power (Blake's "tyger burning bright"). But if these qualities are sufficiently differentiated as ideals, it must not then be supposed that the one is sentimental or feminine, the other realistic and masculine. What one might venture to suggest is that they represent those two components of the psyche which Jung has differentiated as the *anima* and the *animus*. According to this hypothesis, we all carry in us an image of the other sex, "the precipitate of all human experience pertaining to the opposite sex", and as we tend to project everything that is latent and undifferentiated in the psyche, man projects his "Eve" and woman her "Adam". But the projection of images from the unconscious is never direct (except in dream or trance); the woman has to disguise her animus in feminine attributes (loveliness), the man his anima in masculine attributes (vitality, virility). In each case the secret power of the projected image comes from this state of tension, this sexual ambiguity or dialectic.

The dialectic which Barbara Hepworth was to develop from 1934-5 onwards was between the antitheses of Geometry and Grace (one is tempted to use Simone Weil's terms Gravity and Grace, especially as she always conceived gravity as a geometrical or mechanical phenomenon). It may be objected that geometry is not necessarily graceless, but this is to confuse grace, which is lively, rhythmical, *mouvmenté,* and essentially labile and organic, with proportion, which is measured, mathematical or algebraic, and essentially non-vital. To infuse the formal perfection of geometry with the vital grace of nature—that might be taken as a description of the ideal which Barbara Hepworth now began to desire and achieve. The basic studies generally taking the form of drawings, are geometric. But when we compare the finished sculptures with such preparatory drawings, we see immediately that a subtle but substantial change has taken place. There is a deviation towards organic form. The form, though still geometric, seems to have a vital function, as though a perfect geometrical spiral has been transformed into an organic shell, a *nautilus pompilius.* As Dr. Johnson observed (it is a quotation used by D'Arcy Thompson at the beginning of *Growth and Form*): "The mathematicians are well ac-

quainted with the difference between pure science, which has to do only with ideas, and the application of its laws to the use of life, in which they are constrained to submit to the imperfections of matter and the influence of accident." The sculptor is not constrained to submit to the imperfections of matter, but rather to its limitations—to its tensile strength, its texture or toughness; and what Johnson calls "the influence of accident" becomes, in the artistic process, the influence of the artist's own organism—the sense of vitality, of change, of growth. One might say that space is transformed by time, but that is too abstract a formula; we should say rather that idea, in becoming material mass, is transformed by the human pulse, by vibrations that spring from the heart and are controlled by the nerves of a living and creative being.

In the formulation and development of this dialectic Barbara Hepworth was aided by two artists who worked in close touch with her for a number of years—Ben Nicholson and Naum Gabo. The closer influence—that of Ben Nicholson—was no doubt the deeper influence. He himself had been influenced—not so much directly, as idealistically—by Piet Mondrian, and the ideal which all these artists share is one which has become known under the confusing name of "abstraction". Abstraction was logical enough as a term for those compositions which were derived, or abstracted, from the natural object—the various stages of cubism were stages in abstraction. The term became ambiguous once the artist began with a non-figurative or geometrical intuition of form, and either clothed this with features reminiscent of the natural object (Juan Gris), or pursued the intuition until all naturalistic reference had been excluded. But after a certain stage in his development Mondrian, and Gabo from the beginning of his Constructivist period, began with a purely formal concept, and what they then create, as an objective work of art, has no reference whatsoever to naturalistic forms—it is a "new reality".

The daring originality of this attempt—daring from both an artistic and a philosophical point of view—has not yet been sufficiently appreciated by the critics of modern art. It is not only assumed by these artists that they can produce, by a subjective mental process, images which have no reference to the natural world but which nevertheless are logically coherent (in the sense that they can be communicated to other people), but even that these images express an essential reality which is beyond, or in some sense superior to, the reality of appearances. It is as if the artist were a demi-god, capable of creating a new satellite, a world dependent on this world but not of it; a new world. It is not a question of creating a pleasing pattern (for which reason all objections to this type of art based on its merely decorative function are beside the point): it is a question of origination, of what Heidegger calls *Stiftung* (establishment). To quote Gabo:

> I am constantly demanding from myself and keep on calling to my friends, not to be satisfied with that gratifying arrangement of elemental shapes, colours and lines for the mere gratification of arrangement; I demand that they shall remain only means of conveying a well-organized and clearly defined image—not just some image,

any image, but a new and constructive image by which I mean that which by its very existence as a plastic vision should provoke in us the forces and the desires to enhance life, assert it and assist its further development.

Abstract art, like realistic art, is always in danger of degenerating into academicism. It fails to renew its forces at the source of all forms, which is not so much nature as the vital impulses which determine the evolution of life itself. For that reason alone it may be suggested that an alternation between abstraction and realism is desirable in any artist. This does not mean that abstract art should be treated merely as a preparatory exercise for realistic art. Abstract art exists in its own rights. But the change-over from one style to another, from realism to abstraction and from abstraction to realism, need not be accompanied by any deep psychological process. It is merely a change of direction, of destination. What is constant is the desire to create a reality, a coherent world of vital images. At one extreme that "will to form" is expressed in the creation of what might be called *free* images, so long as we do not assume that freedom implies any lack of aesthetic discipline; and at the other extreme the will to form is expressed in a selective affirmation of some aspect of the organic world—notably as a heightened awareness of the vitality or grace of the human figure. Some words of Barbara Hepworth's express this antithesis perfectly: "Working realistically replenishes one's *love* for life, humanity and the earth. Working abstractedly seems to release one's personality and sharpen the perceptions, so that in the observation of life it is the wholeness or inner intention which moves one so profoundly: the components fall into place, the detail is significant of unity."

A new and constructive image which provokes in us a desire to enhance life, assert it, and assist its further development—there we have the definition of the kind of work of art which a sculptor like Barbara Hepworth tries to create. Whether the emotions before such a work of art are *sui generis* and distinct from the emotions evoked by a classical work of art—say the Aphrodite of Knidos—must still be discussed. We need not refer to a Roman copy of Praxiteles' work—let us make the adequate comparison of the *Torso* already mentioned and a constructive image such as that presented in **Pelagos.** There is no doubt that both images—the one realistic, the other abstract—convey life-enhancing values. **Pelagos** conveys them directly: the wood is carved into a tense form which suggests the unfolding point of life itself (as in a fern frond, or a spiral shell; or the tense coil of a snake). By duplicating the point of growth in a screw-like torsion an infinitely prolonged rhythm is created, but held in momentary stability by the strings connecting the two terminations. The experience of the spectator is purely emphatic—that is to say, our senses are projected into the form, fill it and partake of its organization. If we live with such a work of art it becomes a *mandala,* an object which in contemplation confers on the troubled spirit a timeless serenity. To object that such a state of passive serenity is not "life-enhancing" is to miss the whole significance of art, which is not a stimulus to biological vitality so much as to that apprehending con-

sciousness or cosmic awareness upon which life itself finally depends.

The directness of such an aesthetic experience may now be compared with the indirectness of the experience conveyed by the **Torso.** One should perhaps first dismiss, as irrelevant, the sexual appeal of this particular work (or of others like it). It is not that its sexual appeal is to be despised; but one does not begin to appreciate a work of art with the aesthetic sensibilities until one has set it apart from actuality. This is what Susanne Langer [in her "Abstraction in Science and Abstraction in Art," *Essays in Honor of Henry M. Sheffer,* 1951] has called "the primary illusion" in art—the form must be closed and must exist in itself and for itself. "The work of art has to be uncoupled from all realistic connections and its appearance made self-sufficient in such a way that one's interest does not tend to go beyond it." It may be that what one might call the *duplicity* of representational art has been a necessary stage in the social evolution of art; and it may be that socially speaking many of us are not ready to dispense with "realistic connections" in a work of art; but at least let us all realize that these values are secondary and unrelated to the perceptual experience of form. This is not to separate art from life, or the artistic experience from the sexual experience of any other kind of sensuous experience; on the contrary, it is merely to distinguish, for unalloyed enjoyment, "the pattern of vitality, sentience, feeling, and emotion". The analogy of music may help the reader at this point.

Having, I hope, made this distinction clear we may return to a consideration of the new plastic image, its origins and functions. . . . [According] to Gabo the image is of intuitive origin. It is a projection from the visualizing consciousness, from the *imagination* (the image-making faculty), and though one must suppose that this function is only possible to a mind that has had normal visual or tactile experience (experience of natural objects), the image, in Gabo's case, is always "mentally constructed".

The process is not so clearly defined in the case of Barbara Hepworth. Obviously she sometimes begins with geometrical constructions (generally in the form of preliminary drawings) and modifies these vitalistically in the process of transforming them to a sculptural mass. But equally obviously she sometimes begins from a life-study, and many of her forms suggest, however indirectly, naturalistic prototypes. In a few instances she gives a naturalistic emphasis to an otherwise abstract form by the addition of a naturalistic detail. This, in my opinion, is an unhappy compromise. I can perfectly well understand a decision not to follow Gabo into a world of mental construction unrelated to immediate visual experiences; but having chosen to remain in the world of organic symbolism, it was surely unnecessary to label the symbol with a representational motive. (pp. 228-36)

Barbara Hepworth's greatest achievement, up to the present, undoubtedly lies in those monumental carvings destined for a civic setting—the **Contrapuntal Forms** commissioned for the Festival of Britain and later erected in the new town of Harlow, and the **Vertical Forms** commissioned for Hatfield Technical College. The significance of

such sculpture is more than aesthetic—it is a social challenge. Modern sculpture (and we might say the same of modern painting) has yet to assume the functions and achieve the status of a public art, and unfortunately that will not depend on any specific efforts of the sculptor. One must first reckon with a disunity of the arts, and however willing the architect and town-planner may be to co-operate with the sculptor, the fact remains that as artists they have different origins, different ideals, and different social functions. A unified plastic vision, embracing all the arts, is a thing of the past. But even more detrimental to any social acceptance of modern sculpture on a monumental scale is the almost complete atrophy of plastic sensibility in the public at large. The bored or busy eyes that contemplate these sculptured monuments will only very rarely penetrate to their secrets, to discover a pattern of vitality. Harwell may be a "new town" but it is not ready for the impact of a "new reality". All the more credit, it should be said, to those in authority who have had the courage to mount those monoliths as advance guards to a new civilization.

I have known Barbara Hepworth throughout most of her active career, and what has been astonishing and of some general significance is the fact that she has remained a completely human person, not sacrificing either her social or her domestic instincts, her feminine graces or sympathies, to some hard notion of a career. This deserves emphasis because it is often suggested (and the suggestion is often accepted) that an artist must lead a monachal existence, denying himself if not all human contacts, at least all human entanglements—what Cézanne called *les grappins*. Any consideration of the lives of typical "great" artists should have shown the absurdity of this idea. Art is a reflection, however indirect, of the basic human experiences, and all these daily tensions and conflicts, these surrenders and obsessions which seem at the time to distract the artist from his work are secretly replenishing the sources of his inspiration. The solitariness of the artist, so necessary for the intermittent flux of this inspiration, he must carry within himself; the artist is a man capable of being solitary in a crowd. The serenity of the artist is not achieved by isolation, but by the cultivation of those powers of attention which make him the spectator *ab extra* of the human scene.

The other factor in Barbara Hepworth's career which seems to me to be of particular significance is her devotion to the technique of carving. Somewhere I have called this a moral, and not an aesthetic prejudice, and I would still maintain that art must be judged by its results, and not by the means used to obtain those results. But the moral factor is not irrelevant in any total estimate of an artist's achievement. The act of carving is not only technically, but one might almost say "mystically" distinct from any other method of creating solid forms in space. Chinese mysticism makes much use of the symbol of the Uncarved Block; it represents the possibilities latent in the universe, to be released by contemplation, by mental "attention". The plastic images latent in that same block can only be released by similar disciplines—there is in art a law of compensation by which the greatest impression of ease is the effect of the highest degree of skill. It is not necessary

to deny skill to the crafts of modelling clay or forging iron; but one does deny these materials the capacity for fully satisfying the full range of aesthetic sensibility. The hierarchy of materials is natural, related to profound aspects of human experience, to that nostalgia which ever seeks, in the flux of life, perenniality in its monuments. (pp. 236-39)

> *Herbert Read, "Barbara Hepworth," in his* The Tenth Muse: Essays in Criticism, *Routledge & Kegan Paul, 1957, pp. 228-39.*

Alastair Gordon (essay date 1966)

[*In the following excerpt, Gordon examines the style and themes of four drawings prominent among Hepworth's studies of hospital operating theaters, finding them representative of her highest artistic achievement.*]

[Hepworth's drawings entitled **The Hands and the Arm, Concentration of Hands No. 1, The Hands,** and **Study in Red Chalk**] were done between 1947 and 1949 when [she] became fascinated by the work of hospitals and operating theatres. In a career that has so far covered some forty years, these two years of studies seem to represent all that her work stands for. As studies they are a climax to a sculptor's career, as drawings I consider them the most beautiful ever executed by a British artist of human activity. These two categorical statements need explanation.

Some artists take time to come to terms with themselves: they have to make inspired improvisations as to what is their natural style of expression. Intelligent ones evolve, perhaps through several styles and technical devices to a final discovery of themselves.

Barbara Hepworth appears never to have doubted firstly that she would be a sculptress, and secondly that her life-work would be to express and symbolise the spirit, grace and beauty of human activity. All her sculpture has humanity for its theme, no matter how far the physical has been abstracted. She is at once concerned with the whole form and mass, and the core, the vital centre that motivates the form. The larger and monumental form, and the smaller vital point are inevitably integrated to symbolise positive organic life. That is why her simplest sculptured form is not simple, why it is moving and not static. The spirit that was in and about the physical—the Greek ideal—is here too. She sees that human demonstration and figuration alters with sensation, that the natural action is more true to reality than the studied or rehearsed action. A perfect marriage of the physical and spiritual can only be on the highest plane, directed towards something positively life-giving. The revelation of this inner life, the finding of the vital epicentre, this is what Barbara Hepworth's work is about.

There could hardly be a better subject for her, therefore, than people whose vocation is healing. Standard academic drawing could record the operating theatre scene, but there would be generalised 'overallness' about the draughtsmanship. In these drawings there is a monumental stillness about the bodies described by the draperies, a dynamism in the hands and eyes as they go about their life-giving work. They induce a recollection of Masaccio's

Tribute Money. They were born of a mind that was no mere recorder, but of one that responded to the scene by entering into the minds and bodies of the people grouped round the inert form, every sinew working smoothly. When the operation is reaching a climax the hands take on more urgency, the bodies incline forward in suspense, the eyes are wide with concern. So wrapt did Barbara Hepworth become with this drama that was all reality, that she was even fascinated by the abstract patterns of red blood smeared and spattered over the green draperies. What really moves her is the gracefulness and rhythm and tautness of efficient physical operation: the lack of strain or ugliness or wasted power. When she draws a nurse relaxed, one is aware of a special type of relaxation by one whose work is by nature all efficient movement. Once one appreciates these ideals of hers the point of her sculpture becomes clear. The opinion that her sculpture is cold and geometric is a fundamental error. Her sense of scale is exact (in this context I do not mean scale as described by length and breadth and depth). She can therefore indicate gravity and space, volume and mass, quite instructively. Once an artist has this gift fully developed, the unerring inner eye will never make the mistake of emphasis in the wrong place or the wrong weight. There will never be understatement nor overstatement. It is this supreme comprehension of scale, therefore, that makes these drawings masterworks: the tensions are of the right density, the relaxations of the right balance: an uncomprehending mathematician would go mad trying to calculate and analyse the design. They could only have been arrived at solely by intuition and emotion.

Hepworth on abstract style:

Working abstractly seems to release one's personality and sharpen the perception so that in the observation of life it is the wholeness, or inner intention, that moves one so profoundly: the components fall into place, the detail is significant of unity.

Sculpture is to me an affirmative statement of our will to live: whether it be small, to rest in the hand; or larger, to be embraced; or larger still, to force us to move around it and establish our rhythm of life. Sculpture is, in the twentieth century, a wide field of experience, with many facets of symbol and material and individual calligraphy. But in all these varied and exciting extensions of our experience we always come back to the fact that we are human beings of such and such a size, biologically the same as primitive man, and that it is through drawing and observing, or observing and drawing, that we equate our bodies with our landscape. A sculptor's landscape is one of ever-changing space and light where forms reveal themselves in new aspects as the sun rises and sets, and the moon comes up. It is a primitive world; but a world of infinite subtle meaning. Nothing we ever touch and feel, or see and love, is ever lost to us. From birth to old age it is retained like the warmth of rocks, the coolness of grass and the everflow of the sea.

From Barbara Hepworth: Drawings from a Sculptor's Landscape.

It seems wholly logical that although most of Barbara Hepworth's drawings are representational, most of her sculptural oeuvre is organic. It would therefore be impossible to simplify down to the inner arresting movement if confined to chiselling a synthesis of human figuration. When art has to be fundamental no distracting detail is possible. There must only be a totality concentrated in Oneness. (pp. 24, 26)

> *Alastair Gordon, "Barbara Hepworth: Four Drawings, Four Masterworks," in* The Connoisseur, *Vol. 163, No. 655, September, 1966, pp. 24, 26.*

Robert Melville (essay date 1968)

[*In the following excerpt, Melville assesses some of the strengths and weaknesses of Hepworth's style.*]

It's curious that artists who have been trained in the representation of the human figure but want to go non-representational feel compelled to devalue the figure before taking the plunge. [In Barbara Hepworth's sculpture] there are some transitional works of this kind, carved in the early Thirties, which are not helped by the presence of a stone-carving of great formal beauty and serenity in which she pays her last respects to woman. The extreme simplification of human forms in the transitional pieces gives them an oddly blurred and soapy look, as if the sculptor might be trying to imagine the appearance of slithy toves. A *Mother and Child* resembles a seal and her pup; the *Sculpture with Profiles* gives the impression of being a human bust hidden under a wet cloth, and the profile of a face scratched on the head-knob is confusingly placed on the opposite side to a protrusion which suggests the presence of a nose; a series of featureless vertical forms in pairs (one always a bit shorter than the other) maintains an incipient and comically penguin-like relationship to married couples.

They are followed by a remarkable series of totally invented works which have given her a high and richly deserved international reputation. The outer forms are simple and not very interesting, but they are primarily vehicles for holes. She is a sculptor of interior spaces and probably the most compulsive tunneller in the history of sculpture. Most of the complexities and refinements of her art occur inside the object. Sometimes she is content simply to make deep concavities and sometimes bores a small, trim, circular hole in them as a sort of climax, but her most exciting work is characterised by an extreme opening-up of the interior. Much of the tunnelling is like the passage of a dumdum bullet, small at the point of entrance, huge and gaping at the point of exit, and when in a wood carving like *Corinthos*—a large, bulky form, gleaming as darkly as a conker on the outside and painted white inside—she attacks from all sides, and the tunnels converge to make a large inner chamber, one's sense of scale collapses and one finds oneself on the verge of an interior landscape of undulating dunes infinitely larger than the form which encloses it.

A number of smaller works are equally fine. An ovate form in polished bronze is hollowed out in a way that

creates a multiplicity of pure ovals; the marvellous *Pelagos* is an almost totally eviscerated ball of wood, with parts of the exterior cut away to leave two thin tongues which appear to be opening out but remain within the curve of the ball. These tongues are joined by seven lengths of coloured string which are seemingly preventing an explosive expansion and their presence creates an astonishing sense of tension. A variation on the same theme called *Wave* is no less beautiful, but one of the tongues of wood dominates the other and its over-arching, incurving form brings to mind the wave in Hokusai's famous woodcut. Another extremely expressive use of coloured string is in the white ovate form from which two large geometrical segments have been removed. The red strings are attached at one end to the outer rim and at the point where they converge, far back in the interior, they form a dramatic spot of red like a blood-clot. In later works the string is used more decoratively, and in a large bronze called *Bryher II,* shaped like a leaf, the strings are arranged very prettily but have every appearance of having been added to lend interest to a rather blank form.

Very few of the works are purely geometrical, most come under the heading of organic abstracts. They arouse very mixed associations, although the sculptor herself and those enthusiasts who feel that her work is not beautiful relatively but absolutely do their best to maintain some sort of verbal control over our responses. They talk, legitimately enough, of the sea and caves in the cliffs and the whole Cornish scene. But there is another side to it. Some of the things with branching tunnels look as if a mole of high intelligence has been at work. The simple outer forms remind one of eggs, pods and chrysalides. The holes in them suggest that they have been ransacked for food by marauding animals. And when the pod-like forms are stood on end they look like eroded phalluses, as if they might be the talismans of an army of Amazons.

Her fame has brought her many large commissions in recent years, but she is not a monumental artist, and her very big works look rather vacant. From time to time she attempts to refer to the human image, but only succeeds in spoiling her abstract forms with a weak and irritating anthropomorphism. Her latest work, a large geometrical *Crucifixion* which pays homage to her old friend Mondrian is likely to make him turn in his grave.

Robert Melville, "Creative Gap," in New Statesman, *Vol. 75, No. 1935, April 12, 1968, p. 494.*

Lawrence Alloway (essay date 1974)

[*Alloway is an English art critic who has written extensively on abstract and popular art. In the following excerpt, he discusses Hepworth's* Single Form *as an example of her public sculpture.*]

If I go to an art gallery . . . and look at the sculpture of Barbara Hepworth, my act is part of a particular context. I know that she is British, of the same generation as Henry Moore, and that like him she is an Abstract artist, though not a strict one. That is to say, their pieces carry references to idealized nature and are not generated on the basis of

an internally consistent structure. . . . Like Moore, [Hepworth] began as primarily a carver and, again like him, expanded her techniques to include modeling. However, their bronzes retain a good deal of the compactness of carving from stone, so that density, rather than weightlessness or arabesque, marks their cast pieces.

What happens, however, when one comes on a sculpture by Hepworth in a public space, such as her memorial to Dag Hammarskjöld in the grounds of the United Nations? Here she cannot count on the sympathetic knowledge which enables one to locate her art in a relevant cultural ambience. In the gallery I can see some of the reasons why her work looks as it does. At the U.N., under the great reflective slab of the building, her sculpture cannot rely on evoking the special knowledge that it is normal to possess in an art gallery. In fact, my own prior knowledge shrinks in usefulness as I witness the confrontation of her monument and the encompassing architectural setting. And to spectators who do not start with the recognition of authorship, what does the sculpture mean? Modern sculpture does not become *public* merely by being set out of doors. To what extent can it be considered a public work, with a capacity to symbolize a public theme, or to what extent is it a regular Hepworth in an unexpected context?

One difficulty that faces modern sculpture out of doors, in the absence of an agreed-on public style, is that of scale. Hepworth's U.N. sculpture is 21 feet high and looks to be about the height of the row of rather straggly trees along the base of the building behind it. In a word, it looks small. The upright rounded planar form has human associations, especially since its head is pierced in the upper zone by a big circle, a device that we have learned to read in the iconography of Arp, Moore and Hepworth as an eye. However, this reading is hard to maintain on the site. Instead of a giant head . . . another image occurs, inconceivable in the privileged space of a gallery. It looks like a pierced ornament, a pendant worn by the primary form of the building: in which case the building becomes the head. The patina of the sculpture, treated by Hepworth so that a brassy display of metal should not conflict with the organicism of her imagery, suggests the texture of age. Against the bright green reflective facade of the building, her sculpture is dull green and scarred; the two greens engage the sculpture in a contest of new and old which confers exaggerated archaism on the sculpture.

This sculpture, called *Single Form,* is, I think, a failure as a public work, which is not the same thing as saying it is a bad Hepworth. On the contrary I think it is a characteristic example of her style, conscientiously conceived, with dignity, and executed scrupulously. However, it is placed equivocally between the street, First Avenue, and the building. It is in a restricted area, off center in a fountain, in front of the building. The delegates' cars have to go round it every time they enter (a form of homage which would soon fade into habit) and from the street the largest profile is visible. It is a site that denies intimacy or impact and though the responsibilities for the siting of public sculpture are often divided among various uncooperative authorities, Hepworth has made an error either of siting

or of scale. The work should have been closer to the flow of people or more grandiose.

The sculpture was unveiled by U Thant ten years ago and that is enough time for the monument to have been accepted or forgotten. What does "accepted" mean in this public context? It means that it will have joined the form of the building itself and the flags that line the street and the ceremonial delays of the entrance as symbols. (The slab of the building signifies the U.N. vividly, as we know from countless media usages.) The sculpture however has not received that kind of currency as a signifier. This sculpture, like an Easter Island head flattened into the rippling flat plane of a sole, has not entered the realm of public symbols. It signifies neither Dag Hammarskjöld nor the U.N. as some kind of union. What the sculpture signifies is the presence of the artist: it is a Barbara Hepworth and that is the end of it.

This is one of the problems of modern public sculpture. It is a cluster of styles that developed no effective way to communicate with people at random. When pieces of modern art were first put into public places, it was taken as evidence of an increasing enlightenment among patrons and public. Most of the sculptors foresaw no difference between working for their usual habituated audience and for a general public unconditioned to admire them. The result is a series of works like Hepworth's *Single Form,* conspicuous modern sculptures that either invoke hostility or become invisible through apathy. The Hepworth sculpture at the U.N. is in the latter class.

The failure of public sculpture is not so much the result of the brute public but of dumb artists. The German philosopher Max Bense has pointed out that "The path of a sign is simultaneously the path of its alteration." Thus, when a work of art is taken from the context of a gallery and shifted, enlarged but not otherwise changed much, as in the case of *Single Form,* its value as a sign changes. Formal statements are highly satisfactory in a social context that is compatible with them (like a gallery), but displaced to the crowded and intricate communication system of the city they are fragile. Hepworth's problem is that of the majority of modern sculptors whose technical training enables them to work at a public scale but whose aesthetic inhibits their capacity to signify public issues in readable visual forms. In a sense, it is a failure of sociability.

> *Lawrence Alloway, in a review of "Single Form," in* The Nation, *New York, Vol. 219, No. 8, September 21, 1974, p. 254.*

A. M. Hammacher (essay date 1987)

[*In the following excerpt, Hammacher presents an overview of Hepworth's bronze sculpture and examines the influence of nature and landscape on her art.*]

In 1936 it must have seemed inconceivable that Barbara Hepworth would ever work in bronze. The revolt against modelling in clay was both an historical revolt and one involving artistic and moral principles; it concerned what followed after the modelling—the casting in bronze. Twenty years later it could be said that the battle had been

won, views had matured and the younger generations had no ambition to revive Rodin—what they wanted to do was to broaden their means of expression by using other techniques. Truth to material, as has been said, was more than a technique, it was part of a way of life.

The generation of Reg Butler, who had been familiar with working in iron from childhood onwards, of Chadwick, Armitage, Paolozzi, Caro, introduced other values. Butler's award-winning *Monument to the Unknown Political Prisoner* riveted attention on iron and bronze, always seen in relation to the psychological and aesthetic areas of experiences which could find a means of expression in such materials and such a technique. Herbert Read does not exactly say so but the names he quotes in his *Concise History of Modern Sculpture* allow one to conclude that the choice of materials in sculpture must be dependent on whether the artist is, or is not, subjected to some degree to the 'shadow' in the unconscious, which term Read derives from Jung. The surrealists, the vitalists, do not, indeed, succeed with Brancusi's and Hepworth's rigorous discipline of material and form nor with that of the constructivists. Yet it can hardly be maintained that this 'shadow' element is lacking in Hepworth's work, though in that work it is held in check.

The development reflected in her work during the 1950-57 period was none other than a coming to terms with the active shadow elements in her personal life. Then, too, there was the process of ageing, of gradual apprehension of the past. The strength of her style has lain in the nobility with which this has been objectified in the construction of the forms, which, in my view rightly, rejects any reference to events in the artist's private life. A distance has been created between the artist and such events, which are nevertheless presented in her work. The building up of form in her work has always amounted to a victory over life's various destructive threats and assaults. The same year which saw the creation of the large sculptures which Greece had inspired, *Delos* and the others, shortly afterwards produced her first experiments with metals, with iron and bronze carved in hard plaster. It would appear today as having been a concession to the methods Butler had introduced. Actually, however, it was, it seems to me, in part a matter of sensitivity to what the younger generation was doing. Although she did not share the views of Butler and his fellow-artists, she pondered the possibilities which iron and bronze had to offer to her. It rescued her from the dangers inherent in accepting the 'truth to material' as the sole determinant of sculpture's significance.

But she would not be the artist she has become if here, too, she had not sought for a technique related to carving, which conferred on the bronze—via the plaster and after the surface had been finished—a character all its own, making it something more than a way of reproducing a model.

Another and more important factor was that these bronzes were produced simultaneously with the wood and stone carvings and at a moment in her life when she was ready for work of this kind.

The drawings of this period confirm the process. Alan

Bowness was right to attempt for the first time to trace the connexion between the drawings and the sculptures. When after the journey to Greece a hitherto unknown freedom and mobility became evident in the drawings, especially in their colour, this seemed at first to be inexplicable. Inexplicable to those who held fast to the stringent recipe used for the carvings. But the artist later supplied the answer herself—in her bronzes, which, as forms, have indeed been enticed out of the material. This does not of course apply to the bronzes which assumed forms that had been conceived earlier on, when she was working in other materials. Although these castings, too, were subjected to a special treatment, they nevertheless fall into a different category.

Working on a large scale where bronzes are concerned poses its own problems and invariably involves a special effort and technique. Hepworth's work had previously exceeded her normal scale in some commissions, for instance the sculpture for the Royal Festival Hall done in 1953, but now she had to grapple with volume and mass. Seen from a distance *Meridian,* done for the State House in London in 1958, is graphic in character, yet at close quarters the effect is three-dimensional. That is to say it has three-dimensional lineation which seems conceivable and capable of execution only in bronze. It was beautifully cast by Susse Frères, in Paris. The originality of this work lay in the fact that the large scale of the open lines was related to the architecture of the building, one which a closed structure of the same dimensions would have lacked, for a closed form would have seemed small or, in any case, not

Meridian *(1959).*

big enough. The open structure, on the other hand, does away with all suggestion of competition between the sculpture and the building itself as to character and size.

Three years later, in 1962, she made *Winged Figure* for a side façade of John Lewis's London store in Oxford Street. Erected above eye-level, it is like a shield strung with harp strings which create a play of shadows in the morning and evening light. Here, too, the original touch lies in the open structure of the aluminium figure, which does not emphasize the extent of the long façade and which also succeeds in preserving its own truth although related to the whole.

The bronzes form three groups. One group comprises the closed, strictly geometrical concept, with polished surface. Another comprises the open interior, taken to great lengths, and from this second group the bronzes intended for architectural commissions stemmed. Thus *Cantate Domino* came about via the *Gloria* of 1958, in the form of a complete opening-out of the related motif, in which the right and left sides incline towards each other at the top, without actually touching. . . . In the maquette of *Meridian* the movement of lines turns back into itself, sealing itself off.

The third group comprises the organic, abstract bronzes, closed or half-open, like shells, and receptive, with the same delicate female elements which can be seen in *Porthmeor.* All these works have a lyrical, sometimes almost tragic or elegiac undertone (see, for instance, *Ulysses* and *Torcello*) which had hitherto naturally been rare in her work.

Thus the years 1958-59 were full of potential, with a wider range of materials and an expansion in the number of themes, partly springing from the past, partly new. After the perfectly controlled beginning with the Greek sculptures, done in African wood in 1957, the introduction of a new rhythm was clearly evident in the following year, a rhythm less perfect at times, on account of the influence dark, human undertones had on the absoluteness of the form. Freer, some have said, when thinking of the geometry and the crystals of the past, the results of abiding by the rules. A different sort of freedom, however, when one considers that rules are also involved in obeying forces of another order, the forces of body and soul.

These bronzes heralded the latest phase in her work—a phase in which international recognition has at last brought her commissions, prizes, distinctions. (pp. 127-41)

.

[Hepworth's] sensitivity, and relation, to nature—ever a positive sensitivity—prevented her from attempting absolute suppression and destruction of form. Just as Wordsworth stood apart from the other poets in his relation to, and vision of, nature, so Hepworth in her art remains—where feeling for landscape is concerned—innocent of any projection of the self on to the landscape. . . . What Hepworth's work does possess is a curious component which is at one and the same time symbolic and abstract; in it, in fact, the natural and the human have become metaphorical.

With this we arrive at the fundamental question which will principally determine her place in the entire repertory of twentieth-century sculpture: to what extent is her work really a re-presentation in our century of the equipoise of classical times . . . ? In the sense of that great continuity which is so dear to England, the idea inherent in her work often comes sufficiently close to the mainstream of romantic ideas to permit us to doubt her classicism; yet, never quite close enough to associate it with romanticism in the broad sense. That her generation should have rebelled against the English romanticism of the late pre-Raphaelite flowering is an entirely different matter. Just as it is necessary to consider Wordsworth distinct from the romantics surrounding him, so Barbara Hepworth, too, should be assessed on her own merits as regards her attitude to nature (man and landscape), and as a twentieth-century abstract artist.

It is a fact that the element of self-control, control of her passions, emotions, feelings, work, is an attempt on Hepworth's part to exclude all *laisser aller*. Her natural inclination was anti-naturalistic, geometric, abstract, which explains her affinity with the world of Mondrian. Yet at the same time this anti-naturalism is contradicted by an exceptional sensitivity to nature and the elements, which could indeed have led her into modern romanticism, if that control, that abstraction, that urge towards clarification and contemplation had not been present and dominant.

Hepworth only discusses the problem as it affects an abstract and figurative drawing. She is aware that 'the whole process'—of abstract drawing—'is opposite to that of drawing from life'. And she goes on: 'With the model before one . . .one chooses those forms which seem to be structurally essential to the abstract equivalent, relevant to the composition and material in which one wishes to convey the idea.' Mondrian would have rejected this last proposition in his theory of neo-plasticism, although before and during his cubist period he himself followed something approaching the method Hepworth has described.

The antithesis between figurative and abstract drawing has, after all, deep roots in her unconscious. I cannot agree with Alan Bowness when he says that the figurative and abstract influence one another in her work. The influence is all from one side—the abstract side. The intimate relationship between the two is not a marriage. It is a symbiosis; the one lives on the other. In the depths of her being there exists this conflict between nature and spirit, between feeling for landscape and abstract emotion. By holding fast to her material she has held fast to nature. She did not resolve the conflict by subjecting form to the abstraction, but she did discover a style which could accommodate nature-material-form. The harmony in her work is not a classical harmony, but a spiritual (not a natural) accord between the abstract and her feeling for nature. In the drawings there is never any true amalgamation of line with colour: instead, the two correspond, are in ratio with one another. It is a case of the comparable behaviour of two elements appearing simultaneously. This comparative method of seeing and experiencing, the measuring of a

unit against its environment and vice versa, or of two or more units, the splitting up of one centre into two—this is the real well-spring of her creative imagination, which is able as a result to arrive at a metaphor. Now and again nature attempts to increase its influence, but this is invariably followed by its suppression, to make room for tensions which occur in the abstract.

Barbara Hepworth has not accepted the consequences, as Mondrian did, of suppressing and overcoming the natural in every form, and this has created new problems. Here, for the dogmatists, lies her apostasy. Yet it is here, too, that the living sequence of her achievement is to be found, her own true value, her positive contribution to twentieth-century sculpture. For out of the profound contradictions and antitheses which keep our age in a state of tension, which keep it alive, she has conjured up works in space which continue the dialogue between space-in-landscape and space-in-sculpture, between natural forms and creative man, in a form whereby its complexity becomes simplicity, its turmoil peace. (pp. 173-89)

A. M. Hammacher, in his Barbara Hepworth, *revised edition, translated by James Brockway, Thames and Hudson, 1987, 216 p.*

FURTHER READING

I. Writings by Hepworth

"Barbara Hepworth." In *5 British Sculptors (Work and Talk),* by Warren Forma, pp. 7-27. New York: Grossman Publishers, 1964.
> Includes Hepworth's description of her approach to sculpting.

Barbara Hepworth: A Pictorial Autobiography. New York: Praeger Publishers, 1970, 128 p.
> Autobiographical text supplements 345 numbered reproductions of photographs, sketches, critical essays, and letters.

II. Biographies

Gardiner, Margaret. *Barbara Hepworth: A Memoir.* Edinburgh: The Salamander Press, 1982, 61 p.
> An account of Gardiner's experiences with Hepworth during the 1930s.

Hammacher, A. M. *Barbara Hepworth.* London: Thames and Hudson, 1987, 216 p.
> Critical biography.

III. Critical Studies and Reviews

Batcheller, Isabel. "Barbara Hepworth, Sculptor." *Canadian Art* XIII, No. 2 (Winter 1956): 225-27.
> Pithy overview of Hepworth's style and method.

"Recent Museum Acquisitions."*Burlington Magazine* CVIII, No. 761 (August 1966): 425-26.
> Brief description of several important Hepworth sculptures acquired by the Tate Gallery in 1964.

Gibson, William. "Art—Barbara Hepworth." *The London Mercury* XXXVII, No. 217 (November 1937): 57-8.

Review of Hepworth's sculpture at the Reid and Lefevre Galleries. Gibson asserts that their "predominant quality [is] plasticity."

Grierson, John. "The New Generation in Sculpture." *Apollo* XII, No. 71 (November 1930): 347-51.

Examines the early works of Hepworth and John Skeaping.

Heron, Patrick. "Barbara Hepworth—Carver." *Arts Magazine* 29, No. 15 (1 May 1955): 8-9, 30.

Considers aspects of Hepworth's artistry that distinguish her works from those of her contemporary Henry Moore.

Hodin, J. P. "Barbara Hepworth: A Classic Artist." *Quadrum* 8 (1960): 75-84.

Examines classical elements in Hepworth's works.

Kirkpatrick, Diane. "Modern British Sculpture at the University of Michigan Museum of Art." *Bulletin: Museums of Art and Archeology—The University of Michigan* III (1980): 64-76.

Discusses the works of several prominent British sculptors, including Hepworth, Moore, and Robert Adams.

Larson, Kay. "Humanism in No-Man's-Land." *New York* 15, No. 34 (30 August 1982): 58-60.

Reviews Hepworth's exhibition at the Storm King Art Center, focusing on her bronze series *The Family of Man* and praising its "primal humanism" and "economical romanticism."

Levy, Mervyn. "Impulse and Rhythm: The Artist at Work." *The Studio* 164, No. 833 (September 1962): 84-91.

Critical commentary and interview occasioned by Levy's visit to Hepworth's workshops and garden. Hep-worth discusses her work habits as well as the method and philosophy of her sculpting.

Newton, Eric. "The Sculptor Returns." In his *In My View,* pp. 201-03. London: Longmans, Green, and Co., 1950.

Compares Hepworth's sculpture with that of Henry Moore. Newton concludes that Moore "progresses further from his starting-point in the direction of humanism than Barbara Hepworth, and comes nearer to the fusion point of geometry with humanity."

Small, Christopher. "Barbara Hepworth." *The Spectator* 192, No. 6564 (16 April 1954): 457.

Positive review occasioned by Hepworth's retrospective exhibition at the Whitechapel Gallery.

IV. Selected Sources of Reproductions

Bowness, Alan, ed. *The Sculpture of Barbara Hepworth, 1960-69.* New York: Praeger Publishers, 1971, 222 p.

Includes an introductory interview with the artist and more than two hundred plates of her works.

Frederick A. Praeger. *Drawings from a Sculptor's Landscape.* New York: Frederick A. Praeger, 1967, unpaged.

Includes an autobiographical introduction by the artist and an introductory overview of the drawings by Alan Bowness.

Percy Lund, Humphries & Co. *Barbara Hepworth: Carvings and Drawings.* London: Percy Lund Humphries & Co, 1952, 15 pp. + 160 plates.

Contains plates representing Hepworth's career through 1952, an introduction by Herbert Read, and commentary by Hepworth.

Edward Hopper

1882-1967

American painter and graphic artist.

Hopper is regarded as one of the greatest twentieth-century American representational artists. While he is renowned for realistic paintings depicting particular aspects of modern American life, his works, in the words of Gail Levin, "aspire to the universal" in their simplification of visual elements to form timeless, evocative portraits of familiar scenes.

Hopper was born in Nyack, New York, where his father ran a dry goods store. He demonstrated an early interest in drawing, and after graduating from high school, decided to become an artist. Convinced by his family of the practicality of a career in commercial art, he enrolled at the Correspondence School of Illustrating in New York City. However, finding that his real love was oil painting, he soon transferred to the New York School of Art. There he studied with some of the most important artists and teachers in early-twentieth-century American art, among them Robert Henri, who was influential in bringing such European painters as Edgar Degas, Edouard Manet, and Rembrandt to the attention of his American students and in promoting representationalism in American art. After six years at the school—during which time he won several prizes and was asked to teach drawing classes—Hopper went abroad to study European painting. While in Paris, he emulated the Impressionists, painting Parisian scenes in bright, mottled colors.

In 1910 Hopper settled in New York, where he was obliged to support himself as an illustrator, an occupation he hated. For the next decade, he attempted to establish himself as an oil painter. Although he participated in numerous exhibitions, his works met with little critical or financial success. It was during this disheartening period in his career that a fellow artist introduced him to etching. In this medium, Hopper experimented with composition, design, and such subjects as architecture and the lone figure as exemplified in the prints *Evening Wind* (1921) and *Night Shadows* (1921). By 1923, his prints had received critical acclaim and were in demand. While spending the summer of this year in Gloucester, Massachusetts, Hopper began to paint in watercolor. The resulting works, with New England subjects including *House with a Bay Window* (1923) and *The Mansard Roof* (1923), were exhibited later that year at the Brooklyn Museum through the auspices of a friend and artist, Josephine Nivison, and were a resounding critical success. A solo exhibition of watercolors at the Rehn Gallery in New York City in 1924 proved crucial to his career; all of the works were sold and Hopper was able to give up illustration and fully devote his time to painting. Hopper married Nivison soon after this, and for the next forty years they divided their time between New York City and Cape Cod, interrupting this routine with occasional trips across the country during pe-

(c) Arnold Newman

riods when Hopper was not painting. These years were increasingly successful both financially and critically, as Hopper painted such memorable oils as *Early Sunday Morning* (1930), depicting a row of brick tenements and shop fronts in morning sunlight; *Nighthawks* (1942), a night view of a city diner and its clientele; and *Rooms by the Sea* (1951), showing an open door and the sea beyond. Hopper died in his studio in 1967.

By 1925, the major features of Hopper's style had emerged, and critics note that he spent the remainder of his life in the process of refining these. *House by the Railroad* (1925) exhibits typical compositional elements: a strong interplay of light and dark; harsh, lifelike, color; the use of angled horizontals; and a strong underlying geometric form. The painting also unites two of Hopper's best-known subjects, New England architecture and the railroad. Other subjects frequently treated in Hopper's paintings are cityscapes; boats and lighthouses; hotel lobbies and motel rooms; and the interiors of offices, theaters, and restaurants. Such visual motifs as the view from inside or outside an open window and the depiction of one or more lonely and noncommunicative figures, suggesting themes of voyeurism and alienation, dominate his compo-

sitions, and it is this evocation of mood, combined with his characteristic simplified realism, that forms the most recognizable features of his work. Although the melancholy quality of Hopper's vision is often viewed as a commentary on modern American life, Hopper denied any specific social content in his work. Rather, he insisted that he strove for an individual interpretation of life based on "the most exact transcription possible" of his "intimate impressions of nature," a process he felt best expressed the unique emotions and inner vision of the artist and constituted the basis for great art.

ARTIST'S STATEMENTS

Edward Hopper (essay date 1933)

[*In the following essay, Hopper defines his artistic purpose and discusses the future trends of American painting.*]

My aim in painting has always been the most exact transcription possible of my most intimate impressions of nature. If this end is unattainable, so, it can be said, is perfection in any other ideal of painting or in any other of man's activities.

The trend in some of the contemporary movements in art, but by no means all, seems to deny this ideal and to me appears to lead to a purely decorative conception of painting. One must perhaps qualify this statement and say that seemingly opposite tendencies each contain some modicum of the other.

I have tried to present my sensations in what is the most congenial and impressive form possible to me. The technical obstacles of painting perhaps dictate this form. It derives also from the limitations of personality. Of such may be the simplifications that I have attempted.

I find, in working, always the disturbing intrusion of elements not a part of my most interested vision, and the inevitable obliteration and replacement of this vision by the work itself as it proceeds. The struggle to prevent this decay is, I think, the common lot of all painters to whom the invention of arbitrary forms has lesser interest.

I believe that the great painters, with their intellect as master, have attempted to force this unwilling medium of paint and canvas into a record of their emotions. I find any digression from this large aim leads me to boredom.

The question of the value of nationality in art is perhaps unsolvable. In general it can be said that a nation's art is greatest when it most reflects the character of its people. French art seems to prove this.

The Romans were not an aesthetically sensitive people, nor did Greece's intellectual domination over them destroy their racial character, but who is to say that they might not have produced a more original and vital art

without this domination. One might draw a not too far-fetched parallel between France and our land. The domination of France in the plastic arts has been almost complete for the last thirty years or more in this country.

If an apprenticeship to a master has been necessary, I think we have served it. Any further relation of such a character can only mean humiliation to us. After all we are not French and never can be and any attempt to be so, is to deny our inheritance and to try to impose upon ourselves a character that can be nothing but a veneer upon the surface.

In its most limited sense, modern art would seem to concern itself only with the technical innovations of the period. In its larger and to me irrevocable sense it is the art of all time; of definite personalities that remain forever modern by the fundamental truth that is in them. It makes Molière at his greatest as new as Ibsen, or Giotto as modern as Cézanne.

Just what technical discoveries can do to assist interpretive power is not clear. It is true that the Impressionists perhaps gave a more faithful representation of nature through their discoveries in out-of-door painting, but that they increased their stature as artists by so doing is controversial. It might here be noted that Thomas Eakins in the nineteenth century used the methods of the seventeenth, and is one of the few painters of the last generation to be accepted by contemporary thought in this country.

If the technical innovations of the Impressionists led merely to a more accurate representation of nature, it was perhaps of not much value in enlarging their powers of expression. There may come or perhaps has come a time when no further progress in truthful representation is possible. There are those who say that such a point has been reached and attempt to substitute a more and more simplified and decorative calligraphy. This direction is sterile and without hope to those who wish to give painting a richer and more human meaning and a wider scope.

No one can correctly forecast the direction that painting will take in the next few years, but to me at least there seems to be a revulsion against the invention of arbitrary and stylized design. There will be, I think, an attempt to grasp again the surprise and accidents of nature, and a more intimate and sympathetic study of its moods, together with a renewed wonder and humility on the part of such as are still capable of these basic reactions. (pp. 17-18)

> *Edward Hopper, "Notes on Painting," in* Edward Hopper: Retrospective Exhibition, *The Museum of Modern Art, 1933, pp. 17-18.*

Edward Hopper with Katharine Kuh (interview date 1960)

[*In the following interview, Hopper discusses his artistic aims and influences.*]

[Kuh]: *At lunch the other day you suggested that a book dealing exclusively with the lives of artists would be valuable.*

[Hopper]: I didn't mean that. I meant with their charac-

ters—whether weak or strong, whether emotional or cold—written by people very close to them. The man's the work. Something doesn't come out of nothing.

You also mentioned that most of your paintings are not transcriptions of known scenes.

Early Sunday Morning was almost a literal translation of Seventh Avenue. Those houses are gone now. But most of my paintings are composites—not taken from any one scene. There was a canvas, though, I did on the Cape called **Cape Cod Afternoon**—just a house and shed done directly from nature. There have been a few others which were direct translations—but earlier.

Do you make sketches first?

Yes, usually pencil or crayon drawings. I never show these. They're more or less diagrams. I make preliminary drawings of different sections of a painting—then combine them. My watercolors are all done from nature—direct— out-of-doors and not made as sketches. I do very few these days; I prefer working in my studio. More of me comes out when I improvise. You see, the watercolors are quite factual. From the oils I eliminate more. It's an advantage to work in a medium that can take corrections and changes as oil paintings can.

Does this mean you prefer to work slowly?

I don't think that's the reason I do fewer watercolors. I think it's because the watercolors are done from nature and I don't work from nature any more. I find I get more of myself by working in the studio.

Which of your works do you prefer?

Perhaps the latest picture I painted last summer—**Second Story Sunlight.** It shows the top stories of two houses with an upper porch and two figures, a young and an older woman. I don't think there was really any idea of symbolism in the two figures. There might have been vaguely; certainly not obsessively so. I was more interested in the sunlight on the buildings and on the figures than in any symbolism. Jo [Mrs. Hopper] posed for both figures; she's always posed for everything.

Two other paintings I also like very much are **Cape Cod Morning** and **Nighthawks.** The latter was suggested by a restaurant on Greenwich Avenue where two streets meet. **Nighthawks** seems to be the way I think of a night street.

Lonely and empty?

I didn't see it as particularly lonely. I simplified the scene a great deal and made the restaurant bigger. Unconsciously, probably, I was painting the loneliness of a large city. I'm fond of **Early Sunday Morning,** too—but it wasn't necessarily Sunday. That word was tacked on later by someone else.

What about **Cape Cod Morning?** *Why did you particularly mention it?*

I think perhaps it comes nearer to what I feel than some of my other paintings. I don't believe it's important to know exactly what that is.

Has living on Cape Cod in the summers affected your work?

I don't think so. I chose to live there because it has a longer summer season. I like Maine very much, but it gets so cold in the fall. There's something soft about Cape Cod that doesn't appeal to me too much. But there's a beautiful light there—very luminous—perhaps because it's so far out to sea; an island almost.

Do you feel your early trips to Europe influenced you?

I really don't know. I did a lot of work there—paintings that will be shown some day, I suppose. They are in a high key, somewhat like impressionism or a modified impressionism. I think I'm still an impressionist.

Why?

Maybe simplification has something to do with it. For me impressionism was the immediate impression. But I am most interested in the third dimension, of course. Some of the impressionists were too, you know. French painting, even when trivial and slight, is three-dimensional. Take Fragonard.

What painters from the past do you admire?

Rembrandt above all, and the etcher Meryon. His sunlight is romantic; there's absolutely the essence of sunlight in that etching of his called *Turret in the Weavers Street.* Rembrandt is tremendous. I also like Degas very much.

What influences are strongest in your work?

I've always turned to myself. I don't know if anyone has influenced me much.

Do you feel your work is essentially American?

I don't know. I don't think I ever tried to paint the American scene; I'm trying to paint myself. I don't see why I must have the American scene pinned on me. Eakins didn't have it pinned on him. Like most Americans I'm an amalgam of many races. Perhaps all of them influenced me—Dutch, French, possibly some Welsh. Hudson River Dutch—not Amsterdam Dutch.

Whenever one reads about your work, it is always said that loneliness and nostalgia are your themes.

If they are, it isn't at all conscious. I probably am a lonely one. As for nostalgia, that isn't conscious either. People find something in your work, put it into words and then it goes on forever. But why shouldn't there be nostalgia in art? I have no conscious themes.

What do you mean by that? For instance, didn't you have a theme for **Second Story Sunlight**?

This picture is an attempt to paint sunlight as white with almost no or no yellow pigment in the white. Any psychological idea will have to be supplied by the viewer. But to paint light was not my initial impulse. I'm a realist and I react to natural phenomena. As a child I felt that the light on the upper part of a house was different than that on the lower part. There is a sort of elation about sunlight on the upper part of a house. You know, there are many thoughts, many impulses, that go into a picture—not just one. Light is an important expressive force for me, but not too consciously so. I think it is a natural expression for me.

I heard about a symposium in Provincetown last summer where a member of the "new academy" said that "it" just comes from the heart through the arms, through the fingertips, onto the canvas. Now some of it does comes from the heart, but it has to be amplified by cerebral invention. It's not as easy as just coming through the fingertips. It's a hard business. It's like everything else in art and life; it's hard.

What made you turn from the figure to landscape and architecture?

In art school you paint the figure because the model is there to work from. Afterward you're free to do what you want. Maybe I include figures sometimes because I feel it's a duty to "do" humanity. Though I studied with Robert Henri I was never a member of the Ash-Can School. You see, it had a sociological trend which didn't interest me.

Is there any social content in your work?

None whatsoever.

What part does color play in your paintings?

I know I'm not a colorist. I mean I'm not very much interested in color harmonies, though I enjoy them in nature. I'm more concerned with light than color.

[Mrs. Hopper]: You should be careful what you say about color.

Why, because I might offend color? I don't think my work is colorless, but my color schemes are pretty simple and almost always the same. I don't think I have a formula. It's just that I use what happens to correspond to my sense of color. I'm sure I couldn't do in monochrome what I do in color.

You said you were a realist.

Yes I am. I guess the popular conception of a realist is one who imitates nature.

What is your definition?

I'm not sure. I feel Rembrandt was a realist but there's a great deal more than factual reporting in him. You know Renoir said the essential element in a painting cannot be explained. I hope I'm not a realist who imitates nature, though I'm very interested in the phenomena of nature. They are so far beyond what man can invent.

What about texture?

I try for certain kinds of texture. Trees have a different texture than houses or human flesh. But I think heavily painted brushstrokes are a by-product as they are with Rembrandt. I feel they are not necessary. Among more superficial painters, heavy impasto is not even involved with their end efforts, while with great artists like Rembrandt it's a logical by-product—not an end in itself.

How do you finally choose the subject for a painting?

Once I talked to Guy Pène du Bois about this. He used the word "inspiration." I said, "That's a terrible word." He said, "That's a fine word." Well, maybe there is such a thing as inspiration. Maybe it's the culmination of a thought process. But it's hard for me to decide what I

want to paint. I go for months without finding it sometimes. It comes slowly, takes form; then invention comes in, unfortunately. I think so many paintings are purely invention—nothing comes from inside. You have to use invention, of course; nothing comes out without it. But there's a difference between invention and what comes from inside a painter.

Has your work changed in the last twenty-five years?

I think so. The paintings are less literal, perhaps.

Do you paint to satisfy yourself or to communicate with others?

I paint only for myself. I would like my work to communicate, but if it doesn't, that's all right too. I never think of the public when I paint—never.

You say you are painting for yourself. Could you amplify?

The whole answer is there on the canvas. I don't know how I could explain it any further. (pp. 131-42)

> *Edward Hopper and Katharine Kuh, in an interview in* The Artist's Voice: Talks with Seventeen Artists, *by Katharine Kuh, Harper & Row, Publishers, 1962, pp. 131-42.*

SURVEY OF CRITICISM

Lloyd Goodrich (essay date 1927)

[*A director of the Whitney Museum of American Art, Goodrich was an important influence in Hopper's career, mounting two Hopper retrospectives at the museum in 1950 and 1964 and serving as one of his most devoted advocates. In the following essay, he provides an enthusiastic appreciation of Hopper's works.*]

In Edward Hopper this country has the unusual phenomenon of a vigorous and eminently native painter, whose style has already reached maturity, but whose paintings were until recently comparatively little known to the general public. His etchings have been familiar to all those who care for prints which are more than mere collector's items, but the recent exhibition of his work at the Rehn galleries in New York was the first time that any considerable group of his paintings and watercolors has been gathered together. The result was to confirm a suspicion that many individuals have had for some time, that Hopper belongs in the front rank of contemporary American painters.

The chief reason why this fact has not become evident until now lies in the unusual nature of the artist's development. Hopper's painting has only reached its full measure of individuality within the last three or four years, whereas many of the painters who were associated with him as students made their reputations ten or fifteen years ago. Hopper was a member of that group which studied under Henri at the New York School of Arts and which included

Bellows, Kent, Du Bois and Gifford Beal. Together with the others he joined in the first "radical" exhibitions of about 1908 and 1909, but whereas the brilliant work of Bellows at once caught the eye of the public. Hopper's less spectacular painting failed to do so. His work of this time, much of which was done during a stay of several years in France, was impressionistic in its high color and its feeling for light and air, but it had a directness of statement and an unromantic candor in the choice of subject matter that was entirely personal.

When he returned to this country, however, it was not to share in the triumphs of the other members of the Henri group. At this time the only place for an artist to show his work, aside from the dealer's galleries, was the Academy; but Hopper soon learned by bitter experience what many other young painters were learning, that the doors of this institution were closed to art which showed any independent tendencies. When the Society of Independents was started, in 1917, he exhibited there; but in the meantime he had turned his hand to etching. Prints could make their way into exhibitions where paintings could not; and it was in etching that he first began to express his peculiarly individual viewpoint and to make a name for himself. From etching it was a natural step to watercolor; and then, within the last three or four years, the same qualities which first appeared in his prints began to take shape in his oils.

This unusual development has been due largely to Hopper's independence, which not only kept him from being recognized by the academic world, but also made his own evolution as a painter slower than that of less individual men. This very slowness, however, seems to me to be a sign of the strength and genuineness of his work. He has always been absolutely himself, going his own way and working out his own problems. Self-expression has not come easy to him; he has no taste for the facile depicting of superficialities, and he seems to be incapable of prettifying or compromising his own vision of the world. The same independence which kept him out of the Academy has also prevented him from riding in on the crest of the wave of fashionable modernism. While others have been painting this country as Cézanne painted the south of France, he has had the courage to keep his eyes fixed on the environment which actually surrounds him, to forget how other artists are painting, and to put down his own version of the America that he sees.

It is hard to think of another painter today who is getting more of the quality of America in his canvases than Edward Hopper. In all his work one feels the transparent brilliancy of our skies, our strong sunlight, the clearness of our atmosphere—natural qualities which find their echo in the stark angularity and hardness of American architecture. The latter is Hopper's favorite theme. The cheap little frame houses that stick up uncompromisingly in the desolate wastes of the outskirts of cities, the pretentious suburban residences of the 'nineties, with their mansard roofs and turrets and jigsaw decorations, the drab monotony of rows of identical red brick tenements, the faded splendors of demodé apartment houses—all these characteristic features of the background of our modern American life appear in his pictures, and are painted with

an intense realism that spares us none of their ugliness. But it is too easy to see in the artist's attitude toward these things nothing but satire, and to miss the deep feeling that underlies it. The environment which he paints is the environment in which he and the rest of us have grown up; we may see its bareness and crudity, but we are still bound to it by strong ties. In more than one of Hopper's works one feels less satire than sympathy for a racial expression which, in spite of its obvious shortcomings, has the courage to be itself. The watercolor of *Talbot's House,* for instance, is not so much a caricature as an appreciation of the triumphant and vigorous individuality of this house, which flouts all the laws of good taste and yet makes the artiness of twentieth century "Tudor" and "Colonial" seem insipid.

It is not only in his choice of subject matter, however, that Hopper's native quality shows. In the most genuinely American art there are two characteristic strains: an inward, romantic, mystical strain, exemplified in such men as Ryder, Fuller, and Blakelock; and a realistic, spare, almost Puritanical strain, which appears in the anonymous American primitives, in some of the makers of popular prints, and in painters like Winslow Homer and Thomas Eakins. It is to the latter tradition that Edward Hopper belongs. His work is akin to theirs in a fundamental quality which can only be described as austerity. We hear a great deal about austerity nowadays, and some of our painters are trying to achieve it by painting like fourteenth century Italians; but Hopper's austerity is a more instinctive affair. It is not the bloodless austerity of the would-be primitive, but the positive austerity of an artist who hates insincerity, false emotion, and superfluous decoration. But while it pervades his whole work, entering into his choice of subject, his style, even his brushwork, it has never become a mannerism. Judging by his latest paintings, there is little danger of his work becoming stylized.

Hopper's painting is not "modern" in the narrow sense in which that word is sometimes used to describe those artists who abjure the representational side of art. The vision expressed in his pictures is very much that of the average man, transformed into something more significant by the vision of the artist. The power which one feels in his work is all below the surface; it does not manifest itself in violent distortions or in riots of color. His sense of form is firm, sharp, spare; his color is not sensuously seductive, but it is always strong, clear, and ringing, and often of an invigorating brilliancy. In the watercolor of *Talbot's House* the blazing whites, the keen blues, and the deep note of the red of the chimney have a tonic, stimulating quality that is at the opposite extreme from the tired browns of the near-Derains. In Hopper's color, as in his drawing, there is an unfatigued, hard vigor that seems to me to be as native to this country as his choice of subject matter or the spareness and austerity of his style.

Technically, Hopper is one of the most accomplished of contemporary American painters, but this accomplishment has never taken the form of fireworks. He dislikes slippery, superficial brushwork as much as he dislikes sentimentality, and while his painting is always capable, always under control, he never indulges in tricks. And yet

one feels that if he wished to he could easily be a highly proficient circus performer with the brush. Particularly in his watercolors it seems to me that he has all the brilliancy of Sargent, but it is a solid brilliancy, with a force of mind rather than of hand behind it. The touch is form, crisp, almost neat, with something in it that reminds one less of Sargent than of Winslow Homer.

Hopper is not a rapid worker; his total output of oils within the last three or four years is not large; but the increased maturity and richness of his last few paintings indicate that he is just on the threshold of his best achievement. Speculations as to an artist's future are always hazardous; but Hopper's sincerity, his dislike of the easiest way, and his interest in so many varied aspects of the world make it certain that this achievement will not be just a repetition of what he has already done, but will be as fresh and unhackneyed as his former work. (pp. 134-38)

> Lloyd Goodrich, "The Paintings of Edward Hopper," in The Arts, *New York, Vol. XI, No. 3, March, 1927, pp. 134-38.*

Helen Appleton Read (essay date 1933)

[*In the following review of a retrospective exhibition of Hopper's paintings held at the Museum of Modern Art in 1933, Read praises Hopper's works, focusing in particular on their American subject matter and point of view.*]

It is so rare and exhilarating an experience for me to come inadvertently upon my critical utterances of a decade ago and discover that I can still agree with them instead of being a trifle embarrassed at an omniscience which I have lived to modify that I use it as the justification for the somewhat unusual procedure of commencing the present appreciation of Edward Hopper's exhibitions at the Modern Museum with a quotation from my first review of his work.

The review which appeared in *The Brooklyn Eagle* under the heading "Brooklyn Museum emphasizes New Talent" was written on the occasion of Edward Hopper's exhibiting four watercolors at the Museum's biennial watercolor exhibition. These were the first of the type now regarded as characteristic of his point of view and style. The review commenced as follows: "The Hopper group is one of the high spots of the exhibition. What vitality, force and directness. Observe what can be done with the homeliest subject, provided one has the seeing eye." The "seeing eye" referred to Mr. Hopper's use of native material which had hitherto escaped the attention of his fellow artists who dedicated their talents to interpreting their native environment. For this was the first exhibition in which the mansard roof type of architecture was shown as subject for art; a theme which not only opened up new sources of native material but was definite impetus to discovering the quality existing in forgotten or discredited periods of American taste.

The seeing eye and the courage to state the vision of life seen, the qualities which stirred me in Edward Hopper's work when I first saw it ten years ago, have been the deter-

mining factors in his work since then and this point of view the Modern Museum has honored to the extent of giving over their galleries to a one-man show of Mr. Hopper's work.

Perhaps Mr. Hopper's appraisement of the work of Charles Burchfield, which appeared in *The Arts* magazine some time ago [see Further Reading, Section I] and which is apropos of the seeing eye, could be quoted as being equally descriptive of his own mental processes, "As is usually the case," he wrote,

> when one meets such intimate interpretations of the common phases of existence and of nature's more commonly encountered moods, one wonders why it has not been done before, since it reveals what many had had at heart and always had seen, but considered unworthy to be dignified by art.

And then to further amplify his idea he quotes the celebrated passage from Emerson,

> In every work of genius we recognize our own rejected thoughts: they come back to us with a certain alienated majesty. Great works of art have no more abiding lesson for us than this. They teach us to abide by our spontaneous impression with good humored inflexibility, and most when the cry of voices is on the other side. Else tomorrow a stranger will say with masterly good sense precisely what we have thought and felt all the time, and we shall be forced to take with shame our opinion from another.

But it is not only that Edward Hopper liberated certain subjects from the "taboos of their time," to quote again from the Burchfield article, but he brought to it a point of view that was so essentially American, a combination of Puritan austerity and nothing excess with Yankee impatience of "side" and "bunk" that his work has become synonymous for racial quality in contemporary American painting. It is doubtless for this reason that the Modern Museum, in continuing its policy of exhibiting the work of artists who express and illustrate some predominating trend or influence, chose Edward Hopper as the most effective exponent and illustration of the national trend which characterizes contemporary American Art.

A member of the Henri radicals back in 1908 and '09, it was inevitable that Hopper should have followed Henri's fundamental admonition to his pupils—"go to life about you for your subject matter"—as it was also inevitable that this advice should have been the *leit motiv* of his painting career just as it was for almost all those who had the privilege of studying with Henri or coming under the influence of his personality.

What differentiates Edward Hopper's career from that of the traditional Henri pupil is the fact that he waited for over a decade before he recognized what aspect of the life about him called forth a personal and genuine emotional reaction—a reaction that when it did come differed fundamentally from Sloan's or Du Bois' satire or from George Bellows' dramatization of everyday themes or Rockwell Kent's romantics.

When the Henri group held their first independent show in a loft on 34th Street, Mr. Hopper was not one of those to draw attention to himself by any striking evidence of personality or theme. The honors went to George Bellows for one of the first of his prize fight subjects, to Rockwell Kent for a romantic winter sunset, to Polly Rice for her socialistic *Bread Line* and to Homer Boss and Randall Davey for their full length portraits of white-faced women with scarlet mouths and staring black eyes. To be radical and American in those days required making considerable noise about it either through dashing technique and unacademic subject matter or through the suggestion of an underlying social message. It is possible, had Hopper's cool objective statements been exhibited in those years, that their essentially native quality might not have been recognized as such.

For ten years after he left the Henri class, Edward Hopper was scarcely heard from in American art circles. He did commercial work and painted Paris street scenes in blond impressionistic tones. While he was in Paris he was in no way influenced by the modern movement which was already commencing to attract the more internationally minded American students. Paris for Edward Hopper was apparently only another place in which to paint. The only indication of his mature style and point of view to be found in the painting of this period is the refusal to be influenced by prevailing fashions in technique and a certain dogged objectiveness.

It was not until the winter of 1923 that Edward Hopper gave any striking indication of his talent. The first watercolors using the type of subject matter which is now inseparable with his name were those shown at the Brooklyn Museum which occasioned my quoted enthusiasm of a decade ago. They were the logical outgrowth of a few etchings of similar subjects which he had exhibited the year before, one of which had won prizes. He had approached this untried medium sacrosanct with tradition with the same quite debunking attitude that characterizes his approach to the other mediums which he later enjoyed and which is an integral part of his philosophy of life. Apropos of all the talk that one hears among print connoisseurs about the etcher's line and humble respect for the medium, Edward Hopper retorted that the etcher's line is no different from any other line and its object is to express the artist's vision of life in humanly understandable terms.

The subject matter of his compositions has developed from the Victorian architecture motive to include almost any aspect of the American scene. To enumerate his subjects is to prove the truth of his much quoted *mot,* "Anything will do for a composition." But in announcing that anything will do for a composition Edward Hopper exercises a selectiveness that removes his work from mere imitative realism. He creates an ordered design from those slices of his environment which he chooses to use for a composition as carefully arranged as that of an avowed abstractionist. Definitely opposed to the school of aesthetics that disavows the importance of visual reality and human emotion as material for art his pictures can nevertheless be reduced to geometric patterns. In fact it is the angular and geometric in nature that he consistently returns to; the

spare angularity of New England architecture, the straight lines and vanishing perspectives of city streets, to mention some of the more recurrent motives. And to further modify his definition of what constitutes material for subject matter it must not be supposed that Edward Hopper's compositions are devoid of human implications. It is an integral part of their interest, this implication of the human lives and emotions that are bound up in his architectural subjects. His implications, as it happens, are more suggestive and effective than those compositions which actually introduce the human figure and human activities. An open window, a half closed door are far more evocative, for example than windows or doors through which the life beyond is actually portrayed. In his architectural themes, notably the houses of the Garfield and McKinley periods, he is able while giving a straightforward presentation of his subject to suggest the vigor and abundant life that created and preferred such types of dwelling houses as well as suggesting the continuity of family life that has been lived behind their shining white walls, ample verandas and flamboyant porticos.

There are some admirers of Hopper's work who like to think of him as a satirist. What other reason could he have for deliberately preferring to paint the stark angularity and bad taste of American architecture, the sordid monotony of run-down apartment houses or the drabness of suburban Main Streets if it were not to point the finger of ridicule at the crudeness of American civilization? The truth of the matter is that Edward Hopper likes his native environment for all its faults and crudities. He likes it because it is native and has the courage to be itself. It is in accord with his own aesthetic creed which is to have the courage to be oneself.

I have spoken of Hopper's native accent as being one reason why he was the Modern Museum's choice for a one man show which should illustrate the trend of time. It is this same racial quality in subject and point of view which accounts for his rapid rise to fame after his reappearance in the art world a decade ago. But a contributing factor to this rise was the growing tide of nationalism which came as a reaction to the overemphasis on French which had prevailed since the radicalism of modern art had superseded the Henri brand. George Bellows for all that he continued to champion American subject matter and the American point of view was too well known a figure, had passed too successfully beyond his pioneering days to act as the prophet of nationalism and his untimely death cut short any further efforts that he might have made in this direction. Guy Pene Du Bois was in Paris commenting on the Gallic *Comedie Humaine* and Rockwell Kent was off adventuring. When the inevitable reaction set in, when young American artists determined to return to native sources of inspiration with an ardor which suggested that it was going to be as much a fashion to be "American" as it had been to be called a "modern," they found in Edward Hopper a painter who was giving mature and exciting evidence of what it meant to be a modern American painter. He was the living embodiment of a definition of racial quality which I think must be attributed to Guy Pene Du Bois—"native quality is the artist's reaction to his native land modified and directed by the fundamental heritage of

race." The American scene in the manner of Hopper has been an outstanding trend in American painting during the last five years. Inevitably much of the material exhibited in the belief that it expresses the unadulterated American spirit is the rankest imitation painted without any genuine reaction to native environment and too often without the leaven of racial inheritance. In contrast to this self-conscious effort to be American Hopper's complete absence of affection and his unswerving honesty are in striking contrast. It is this honesty that makes a virtue out of his deliberate refusal to add interest to a passage by any display of technical accomplishment or emphasis on seductive color or surface. The medium whether it is line, watercolor or oil is there to express his vision of life. It does not exist for itself as an exercise in color and form.

If the wave of nationalism comes as reaction against the over-great influence of France the growing interest in the subject picture comes as a reaction against the theory that painting as representative art is over. In repudiation of this idea which Hopper believes contradicts the fundamental purpose of art, he has said in his "Notes on Painting" [see Artist's Statements dated 1933]: attached to the Modern Museum's catalogue of his work.

> No one can correctly forecast the direction that painting will take in the next few years, but to me at least there seems to be a revulsion against the invention of arbitrary and stylized design. There will be, I think, an attempt to grasp again the surprise and accidents of nature, and a more intimate and sympathetic study of its moods, together with a renewed wonder and humility on the part of such as are capable of these basic reactions.

(pp. 8-10, 30)

Helen Appleton Read, "Edward Hopper," in Parnassus: Poetry in Review, *Vol. 5, No. 6, 1933, pp. 8-10, 30.*

Parker Tyler (essay date 1948)

[In the following review, Tyler analyzes the function of light in Hopper's paintings.]

What is the secret of Vermeer's and Rembrandt's successes with light? Light is that which unites with the universe. The "theatre" of Rembrandt, as attested by his supernatural subjects, is nothing but God's house. And none doubts the all-shining nature of the light finding its gentle, inquisitorial ways into Vermeer's interiors. This universal light is that which *gives* as well as *defines* all relationships. Objects both animate and inanimate, human and divine, are joined together by it, their close interrelations being precisely hinted by its subtle continuities.

Of Edward Hopper's significant use of light in his interiors, one cannot say that, natural or artificial, light has this universal effect, this structure interlocking the most humble object with the empyrean. Hopper obviously belongs to the age of functional architecture, skyscrapers and streamlining, not necessarily because he paints such subjects (most of his buildings are outdated), but because of the paint-feeling, especially with reference to the light.

Tending toward geometrical forms because it falls on furniture, walls, buildings, his light unites (if it does) through monotony rather than variety. One is as much aware of the segregation of the lighted unit as of its repetition, as in the windows that appear in the artist's long views of buildings; with shades up or lowered, curtained or uncurtained, with different densities in the darkness behind, these windows are symbolic of the drama of light and darkness that is ever being shown by Hopper.

In many subjects of Vermeer and Rembrandt, such as the former's *Maidservant Pouring Out Milk* and *Young Woman With a Water Jug,* and the latter's *Portrait of Saskia* and *Man With a Golden Helmet,* the points of light are many, jewel-like; they form an harmonic constellation with an axial center, a climax. As our world's light, coming from the sun, irradiates from a single source, it finds a single objective in the "point of light" effect in painting. Rembrandt's golden haze, lying on man or landscape, articulates the sensuous planes of everything it touches; its progression through space, its interruptions, are dramatic as well as mysterious; the resultant light-form, often seeming like a stage spotlight, is never obvious. In his *Holy Family with Angels,* the light of Heaven falls on the angels at the upper left, floods the Madonna's face in the central part and, as though by refraction, places an aureole about the Christ Child in the lower left, indicating that on earth true heavenly light comes not from without but from within.

A phenomenon such as "inner light" is inconceivable in Hopper's work. It might be said that he illuminates the earthly dark by accenting its resolutely opaque surface; thus light is an apparent means by which an object or person isolates itself both from other objects and persons and even from the universe—that is, from a sense of unity with all other things. Light, especially artificial light, is granted its space by Hopper with logical exactitude; no matter how sharp the angle, the painter articulates its trajectory to the final point as though some grim principle of justice ordained he should show the ultimate destination of its direction. Just the contrary was true of impressionist painting, for in Seurat and Monet we see the world of objects, no less than the air, saturated by natural light. But whatever rigidly limited expression light achieves in Hopper's work, it makes the best of it, negatively, by alienating whatever resists it.

Morning in a City, showing a naked girl just arisen from her bed, may be contrasted and compared with Vermeer's *Young Woman Reading a Letter.* The full relief of both profile figures is cut down the middle, separating the side towards the window from the side towards the room. But Vermeer subtly weds the lighted side of his apparelled young woman to the light on the wall behind her and to the light-modulations of shadowed furniture in the foreground. Hopper's figure, on the contrary, is isolated from both dark background and dark foreground; moreover his colors tend to stay in their patches, and light—passing over them like quicksilver—does nothing to release them by reflection. Even when Vermeer sets a figure in shadow, not only is it formally related in terms of design to shapes that connect it with lighted objects, but the dark figure is

sometimes delicately modulated by reflected light. The light on the body of the girl in Hopper's painting, however, is cut off both from the white of the bed linen and the brilliant light of the exterior visible through the window.

This unmodulated "stratification" of light and dark is a stylistic trait of the artist's. It is very clear in the sunlight falling almost flush with the front of a row of buildings in *Early Sunday Morning* and so precisely marking out features that project from the common façade. His style simplifies shapes and mutes details, as though he blunted everything a little to make rough contrasts of both colors and light/dark. Nowhere is this more literally apparent than in *Hotel Lobby,* where the dark strip of the carpet cuts the blond empty floor space between the reading girl on the right and the couple on the left. This painting reveals particularly the matter-of-fact estrangement of transient hotel life. In fact, the mutual glance seems almost totally lacking in Hopper's work; if his people see each other at all, it is never, seemingly, with direct attention. *Office at Night* shows light as a wedge pressing people back into their own private darkness; under the merciless glare from overhead (seeming symbolic of the constraint of working overtime) the girl clerk's figure is united with the filing cabinet she stands by, while her boss is united with his desk: the blond, blank wall divides them while they are fused with things. The dark welding of desk with filing cabinet at the lower parts of these objects contains a certain erotic insinuation: this little contact after hours may be prelude to an "evening out" for these two workers.

Hopper's darkness may serve the same dividing purpose as his light. In *New York Movie,* the usherette leaning against the side wall is separated in her light zone from the dimmer light supplied by ceiling lamps under the boxes on the opposite side of the perspective and by the light from the movie screen itself. How pathetic is the sharp "theatrical" emphasis given her: only small gleams from a brass rail in the lower center connect her with the light of the world of the imagination. The *closeness* of the light on her reminds us of effects in Rembrandt that spiritually are so different. *Automat* cannot be bettered for showing light at its most forlorn and barren: a lone patron of the restaurant is sitting at a completely empty table and opposite her is an empty chair; no other human being is visible. This theme is especially suited for the aggressive appropriation of space by light that leaves it meagre rather than rich.

Often in Hopper objects are *multiple* and people are *single* or in *pairs.* The "lone individual" and the "pair" appear in *New York Movie, Hotel Lobby* and *Two on the Aisle* and in all three cases, surprisingly enough, have the same relative positions. The multiple objects appear as one set of triple lights in *Automat* and two sets in *New York Movie* and as the three fuel stands in *Filling Station,* which also has the lone individual (the attendant).

It seems significant that when group unity makes a claim in Hopper's work it tends to be (as seen in the above numerical comparisons) through inanimate objects arranged in geometric uniformity. There are also the railroad ties that form such a curiously illusive foundation for the building in *House by the Railroad;* this is unity in quantitative repetition. The ornate windows of the Victorian

dwelling crystallize the style of this architectural object, yet the angle of light helps to differentiate one window from another, indicating their unique situations on the buildings. Here, in a building, is a symbol of the lone individual, isolated no matter how much surface variety the light may transiently, fickly lend him; the railroad ties likewise form a barrier of time, for we see the Victorian object from the standpoint of our contemporary space, giving the innocent sunlight a *temporal* irony.

Hopper's light plays on equal terms with the defiant density of objects (often depending on them as a visible source) but seems to vanquish humanity, reduce it quantitatively. At times there is a conspicuously empty chair; *i.e.,* one occupied only by light. The occupancy of light alone appears in *Compartment C; Car 293,* where a lone woman sits in a Pullman compartment, the place beside her empty but illuminated. If light is designed to illuminate human *presence* in Rembrandt, illusorily proceeding from within, certainly it is designed (coming strictly from outside) to illuminate human *absence* in Hopper. Why is this pleasant-looking young woman alone in her compartment? Is she unaccompanied? The only companion the spectator can be sure she has is light. There are also the many untenanted theatre seats in *Two on the Aisle,* the untenanted chair opposite the seated woman in *Automat* and the gaping chair by the couple in *Hotel Lobby.*

Room in New York and *Nighthawks* seem to offer even wider meanings than the foregoing. As in Rembrandt, light in Hopper does a great deal of the coloring, muting what is local to objects. *Nighthawks* reveals the light/dark drama in a moral scheme parallel to Rembrandt's, for we see plainly where light ends and dark begins: three customers (a couple and a single individual) are seated in a fishbowl-exposed corner lunchroom at an hour when obviously the city is officially "asleep." The visible buildings are completely dark within, being shown only by the gratuitous light from the lunchroom. A sinister eeriness of light emanates from this painting. It is more cleanly painted than some of Hopper's works, and the overhead light source with the metal coffee dispensers and the white-uniformed attendant contain the echo of a hospital; there is something antiseptically clean about everything, carefully measured and disposed. Although the counterman's uniform, overlapping on the bright wall behind him, unites him with his shop, the customers are seen almost wholly against the dark beyond the window-glass; "night hawks," they belong to the dark; light picks out their features only to render them with cold impartiality.

The poverty of detail in Hopper's work corresponds to a spiritual poverty in the subject matter, a lack of attention to details, to a focus on special objects. His world is swept clean of the small, textured things that light may proclaim so intimately and warmly in many painters of all moods in the past. Hopper is a spiritual antithesis of the early American school of fetishistic still life of which Harnett is the leading exemplar. He seems so important as a contemporary American artist just because of a major social statement, which he has obtained by the mathematical definition of light, dividing the world without fuss into clear, uncomplicated areas. That more than a few of his

Edward Hopper, 1882-1967 Room in New York. *Oil on canvas, 29 × 36", 1932.*

important scenes have windows, seen from both interior and exterior viewpoints, emphasizes the sense of the spectator and the spectacle as objectively embodied within the painter's vision. Light cannot go where it pleases; walls and other obstacles segregate it. Selfishly it seems to tell the spectator of a Hopper work: "See all the places I can go—I exclusively! I can't possess everything, no, but what I find I make my own." Perhaps this accounts for a certain pathetic detail found in **Office at Night** and **Night Windows:** a breeze blowing curtain or shade; a breeze may enter an open window at will and join the light within, but the spectator must remain outside.

The lighted top of an empty table appears also in **Room in New York,** showing a man in shirt sleeves seated by it, while across it a young woman has swung around to idle with the keys of a piano. The usual economy of statement is especially pointed here. Light from overhead floods the premises, concentrating on the flatness of the table top and throwing into relief the bored relations between the two people by the very fact that all that breaks the lighted oval of the table is the shadow of the newspaper: symbol of the man's disorientation from his surroundings. A lighted table top also appears in the *Christ at Emmaus* of Rembrandt, but Jesus' hands, as well as various utensils, break

the edges, thus weighting the top with both sanctity and humanity. All that defines the table top in Hopper's picture (besides the shadow of the paper) is a prim centerpiece echoing the shape of the table itself.

The contrast between Hopper and the classical painters I have mentioned must necessarily be a strong one. But if we analyze this artist in relation to his naturalistic contemporaries, we see that no other has achieved the same distinctness of style, the same skill in rendering a unique version of the world. The tendency toward simplified mass and emphatic chiaroscuro in Hopper relates him both to the abstract style and to an impressionist such as Manet, yet he is unquestionably a naturalist and his coloring alone would separate him from Manet. Hopper's Americanism arises, however, not only from the subjects he paints; it also seems to echo some of the native passion for observing in terms of statistical generalizations and "getting the facts straight." This artist paints a *genre* of social relations along with a *genre* of chiaroscuric relations, and his conceptions of density and balance might be praised by a physicist.

In terms of social statement, Hopper's achievement seems to merit the word monumental. And if his version of the

human is laconic, grim, ironical—only obliquely warm and magnetic—we should not be able to ignore the fact that his people, while lacking the charm that Vermeer's, for example, abound in, have an undeniable health and animal tenacity; even an elusive energy, a veiled heat. They proclaim, one might say, a stubborn molecular density opposed to the idea of their sudden, unnatural destruction: the charged atoms in them seem interlocked like steel girders. I think particularly of the eloquent back of the isolated, standing female watcher in *Sheridan Theatre,* swathed, composed, unstylish, at ease, perfectly integral. This purely personal and physical integrity may be, after all, the final triumph of humanity extending before us like infinity itself. (pp. 291-95)

Parker Tyler, "Edward Hopper: Alienation by Light," in Magazine of Art, *Vol. 41, No. 8, December, 1948, pp. 290-95.*

Charles Burchfield (essay date 1950)

[*Burchfield was an influential American painter. His works, primarily in watercolor, reflect three distinct phases: the imaginative fantasy paintings of nature and rural scenery produced during his early years; the more realistic cityscapes of the 1920s and 1930s; and his later paintings, which combine aspects of each of his earlier styles and culminate in a series of vivid expressionist landscapes which many critics consider his best work. Although Burchfield successfully employed varying styles, his works are unified by their consistent expression of what Hopper called "nature's unlimited physical moods and changes." In the following excerpt, Burchfield offers an appreciative overview of Hopper's career, anticipating the popular appeal and critical importance of the artist's work to future generations.*]

With the opening of the retrospective exhibition of the work of Edward Hopper at the Whitney Museum, the public has a chance to review the work of one of America's most original and powerful creators. Here is seen the summation of an artist who has seen his goal almost from the beginning, set his course accordingly, and unerringly steered toward it, veering neither right nor left. And here it will be evident, I feel sure, that the art of Edward Hopper is destined to become a classic, like Homer's and Eakins' whose tradition he has so ably carried on.

Of the very early work I know only through hearsay; there seems to have been some influence from the Impressionists in the pictures done in Paris before 1910. But as he shrugged off this spurious influence very soon, I do not feel the need of concerning myself too much with it. Likewise the story of his early career—his struggles and frustrations, his constant rejection by the Academy, his potboiling illustrations, etc.—has been so ably described already (see especially [text by] Alfred H. Barr, Jr., in *Edward Hopper,* Museum of Modern Art, 1933 [see section IV in Further Reading]) that I will pass this by, too, and go on to the year 1913, the earliest date on any picture of Hopper's which I have seen. This is his *Corner Saloon.* Already in it are evident, however haltingly stated, the qualities which, while they have developed and grown richer through the years, are the main characteristics of his work

today. From that time on there have been no detours or digressions, the march toward his goal has been uncompromisingly true and straight.

The date 1913 immediately calls to mind the Armory Show and its terrific impact on our native art scene. It has become customary to ask an artist: "What did you think of the Armory Show? How did it influence you?" Looking at the work of Hopper from 1913 on, you would never know that there had been an Armory Show at all, and yet, curiously enough, Hopper, along with members of "The Eight" and other independents, was included in it. Through the years, the original purpose of that exhibition has been gradually obscured. Instead of a chance for many independent talents to show their work, it has come to mean specifically the entrance of ultramodernism on the American art stage. If much of what the Armory Show was against has properly sunk into oblivion, so also much of what it was for has become dated. But this is not so with Hopper. In reviewing his work, 1913 has no special significance; he is as much 1950 as 1913. With the passing of time it will be revealed that his work is timeless, set apart from, and uninfluenced by the varying currents of his day, and strongly rooted in our contemporary life.

A clue to the means by which Hopper has achieved this unflinching devotion to his inner vision is found in his own "Notes on Painting" [see Artist's Statements dated 1933]. I wish it were possible to quote all he had to say on his approach to his art, for it is an unusually knowing expression of a personal bias, but the initial sentence may suffice: "My aim in painting has always been the most exacting transcription of my most intimate impressions of nature." A study of the exhibition of his work at the Whitney Museum will show, I feel sure, that few artists have succeeded so signally in realizing their aim as he.

Having written all the foregoing, it occurs to me that writing about Hopper at this time is sort of a gratuitous affair. After all, he is a man at the height of his career; he needs no introduction; it would be pointless to either attack or defend him; his very name has become a part of the language. Under such circumstances, I can simply allow myself the luxury of looking at his work, and as I do so, to tell what it means to me, why I like it, and get such pleasure and stimulation from it.

Hopper is one of those rare artists who has worked successfully in three mediums: oil, watercolor and etching; so successfully indeed that his fame could rest on the work that he has executed in any of the three.

Almost first, in point of time, if we disregard the early oils, which he gave up in discouragement, come the etchings, that remarkable series done over a period of almost a decade. They number about twenty and cover a variety of subjects. Having done them, and said what he wanted to so magnificently, Hopper never returned to the medium. In them he was laying the foundations, in theme and structure, for what later on, when courage returned, he was to express so powerfully in oil.

While Hopper's watercolors are as carefully thought out and executed in just as monumental a manner as the oils, they seem less concerned with human activities as such,

and show more the artist's concern for pure beauty of form and texture. They have a clarity, or better, a chastity of outlook that seems to stem from the New England scene from which so many of them are taken. There is a certain affinity with the watercolors of Winslow Homer, whose work Hopper is said to admire so much (he has his own tropical scenes, that beautiful recent series done in Mexico, but not, however, in conscious emulation of Homer). They reveal the artist's reactions to his material in so individual a manner that they stand apart in the whole field of American watercolors.

For his oils, he seems to reserve subjects dealing with some human episode or drama and yet, the moment I make that statement, so many exceptions spring instantly to mind that I feel it will be better to discuss his work in less general terms.

In studying Hopper's pictures there are so many angles one may consider. There is the modest, unobstrusive—almost impersonal—way of putting on paint; his use of angular or cubical shapes (never invented, but as occurring in nature); his simple, seemingly uncontrived compositions; his avoidance of any dynamic tricks to contain a picture within a rectangle. But I find myself thinking about elements in his work that seem to have little to do with pure painting, but which reveal the spiritual content.

There is, for example, the element of silence that seems to pervade every one of his major works, whatever the medium. This silence, or as someone has so aptly expressed it, "listening quality," is just as evident in the pictures where human beings appear as in those of nothing but buildings. It can vary greatly in its emotional significance; it can be impressive or monumental as in *Seven A.M.,* or expectant, as in the stark *Approaching a City* or *Dawn in Pennsylvania;* it can be almost deadly, as in *Room in New York;* or it can have in it an element of mystery as in the beautiful *Cape Cod Evening*—a picture that, parenthetically, seems to be one of the highlights, not only of Hopper's art, but of the whole field of American painting. It is felt just as strongly in *Barber Shop* where normally one expects all sorts of chatter and activity to go on. Coupled with the element of silence is that of intense loneliness, felt, as in the case of the former, even where there are people introduced.

We all know the stories of how in the ruins of Pompeii were found human beings overtaken by the great disaster, "frozen" in the act of doing certain things—a man making bread, lovers embracing, a woman nursing a baby—having died instantly in those positions. Likewise, Hopper has somehow managed to take a particular moment, a split second almost, to make time stand still, and to give the moment an enduring, universal significance. I feel it strongly in *Tables for Ladies.* The waitress leans over to get a grapefruit; there is no uneasiness felt in the uncompleted action, so much is her position a part of the monumental design. Again in *Hotel Lobby,* a particular moment has been caught—perhaps the elderly gentleman has just said "Well, shall we be going?" It seems like a trivial episode, but Hopper manages to convey in this picture all the hotels of a big city and the life that goes on in them.

One of the most impressive characteristics of Hopper's work is its extreme simplicity verging, in many instances, on starkness. Everything about nature that might have the slightest superficial charm or embellishment has been scrupulously avoided; there remains only the uncompromising classical form, freed of all restricting variations or digressions. Only rarely does this simplification become over-emphasized and run into a certain sterility of interest; in the main it has been successfully and vigorously carried out. Following this line of thought let us look at his well-known *Early Sunday Morning,* one of his supreme achievements in making much out of meager materials. If we wanted to be brutal about it, we could say that it was merely a collection of horizontal lines, opposed to squares and rectangles, inadequately relieved by a barber pole, a fire-plug and a ruffle or two of awning. True, the ten windows of the second story have been carefully varied so that no two are alike, but I am sure that all this has little to do with the picture's compelling fascination, its evocation of a mood, its concentration of all quiet Sunday mornings formed into one. The picture lacks all the ingratiating tricks generally used to make banal material palatable and yet it sustains the observer's interest and seems more fascinating and baffling on each viewing. In the end it must be admitted that the picture's power defies analysis, which, no doubt, is as it should be. In this connection also, I think of *Approaching a City* where the excitement of entering a great city is conveyed by the most barren materials; and the same could be said of *Seven A.M.* or *August in the City.*

Hopper has caught the barrenness of certain phases of our contemporary life to a degree almost unendurable, or shown up a banality about it that could be very disturbing if he did not somehow stamp it with an interest of his own making. In this connection, it seems pertinent to say a word about his titles, which are so provocative in their terseness. Indeed, in their laconic bluntness seems to lurk a sense of irony. *Hotel Lobby,* for example, points up the feeling I get here of all the futility that goes with living in obscure hotel rooms. *Compartment C; Car 293* suggests all the boredom of travel in a railroad car—and Hopper's genius is such that the painting is anything but boring. *Gas,* to a less discerning artist, would have come out as *Gas Station* or *Gas Station Attendant*. The solitary word "gas" seems to express the whole impact of that commodity on American life.

In many instances Hopper seems to need some special moment in human relations to start him off, even though the final result may justify its existence as pure painting. To look again at *Room in New York*—conjectures about the meaning of this picture can be extended indefinitely in both directions in time. What has led up to this moment? What will follow after what seems like an inevitable explosion of some sort? It is almost as if it were a climactic point in a novel, and then suddenly we come to and realize that all this has little to do with the real essence of the painting, with its intensity of light and its masterly distribution of geometric shapes and spaces. This sense of a brooding moment in the life of a human being is encountered again and again. Even those pictures into which the nude is introduced reflect an episode in the life of the sitter, as in *Hotel*

Room, Seven A.M., Morning in a City or in the etching *Evening Wind* with its haunting evocations of a mood.

Posterity will be able to learn more about our life of today through looking at Hopper's work than from all the social schools, political comments or screaming headlines of the present. Look at *Nighthawks* with its suggestion of the vast loneliness of a city at night as it appears to late stragglers; or at *New York Movie* with its brooding usherette; the almost brutally bald *Night Windows; Office at Night;* or *Rooms for Tourists,* which recalls for us all the times we have ever driven up to one of these places, tired from a day of heavy driving. These are comments on our way of life that are disconcertingly penetrating.

Then there are those creations of Hopper's in which the human element has no important role, such as the whole gamut of his watercolors, and those pure landscapes, in both oil and watercolor, that stand apart from the main body of his art. In certain cityscapes, such as *Blackwell's Island* and *Manhattan Bridge Loop,* in the sailboats, Hopper has asserted his individuality just as much as in the works dealing with human existence. There comes to mind the beautiful *Camel's Hump* with its elemental feeling of the ancientness of the earth; the related picture, *Hills of South Truro* and the forbidding *Oregon Coast.* Then there are certain watercolors, such as *House on Pamet River,* where texture plays so important a role, and the one called *Methodist Church,* a study in complex angles formed by gables facing every direction. In tackling a subject of this sort, many artists, looking for an easy way out, would have made a very clever abstraction out of it. Hopper gives you all the intellectual stimulation of an abstraction, but much more besides—the beauty of reality itself.

Certain subjects, certain aspects of nature seem taboo for Hopper. Weather has no interest for him; I have heard of, but not seen, one watercolor which has a grey sky, otherwise skies are clear, or at most relieved by a few cirrus or cirro-stratus clouds. Cumulus clouds would not attract him, perhaps because of their voluptuous, decorative character. I am sure he has never painted snow, although his treatment of white sails, etc., suggests he could do wonders with drifted snow-banks in sunlight. Gulls have appeared in one picture that I have seen, a collie in another, otherwise there are no animals. Not for him are the subway rushes or beaches with their multitudes of writhing people. In a city noted for its skyscrapers his lack of interest in such architectural subjects seems most unusual. I don't know why these omissions should be pointed out, except as one more indication of the complete integrity of the artist; he knows what he likes and wants to do and will not deign to yield to a superficial interest in a subject just to be broad in his taste. And what he chooses to do is enough for us.

With most artists who have become classic, we usually fix upon one characteristic that seems peculiarly their own, but Hopper has put the stamp of his ownership on so many elements. We speak of "Hopper houses," thinking of white houses in clear sunlight, which he has made so inevitably his own; of lighthouse towers almost as though he had invented them instead of being merely their record-

er. How characteristic is his use of horizontals at the base of a picture, or of light falling at a forty-five degree angle? The list of Hopper hallmarks might be extended indefinitely.

Contrary to the case of many famous artists, it is unnecessary, or even impossible to ignore Hopper the man in studying his art. Examples almost without number could be given of artists of whom we say that the work is in direct opposition to the life or character of the man, that they produced great things in spite of, and not because of what they are. But with Hopper the whole fabric of his art seems to be completely interwoven with his personal character and manner of living. The simplicity of his work, its economy of means, its avoidance of ingratiating decoration all seems to stem directly from his almost ascetic makeup. Compared to other luxury-loving Americans, he demands very little of so-called creature comforts; the most modest of living quarters seem sufficient for him; there are no obvious self-indulgences. His is a life devoted to his art. Into the career of every creative artist must come periods of complete sterility. Some learn to accept such times and to await with resignation the return of the impulse to paint. Hopper, however, suffers agony during his dormant periods, so important to him is his need to paint. Once, he told me, he became almost panic-stricken and thought he was through—and of course after that came some of his most important works. There seems something so inevitably consistent about everything connected with Hopper and his work: even his physical make-up, his almost painful modesty about his art, his softspoken manner. Integrity is the word that instantly comes to mind in contemplating the man and his art.

The idea of a rock as a symbol of stubborn individualism has been used so often that I hesitate to add to the business of making it a cliché by using it again. Yet, search as I will, it is virtually impossible to find a better figure of speech to express what I feel about Edward Hopper as artist and man. So a rock it must be: a rock that stands forth boldly, impervious to, and unaffected by the complex currents of change and decay that eat at the structure of our present-day art world. On such a rock might be built one of the noble lighthouses Hopper has made so famous, and, like one of those landmarks gleaming in the sunshine, his work will stand forth bold and uncompromising for not only our own, but for the generations of the future to admire. (pp. 15-17, 62-4)

Charles Burchfield, "Hopper: Career of Silent Poetry," in ARTnews, *Vol. XLIX, No. 1, March, 1950, pp. 15-17, 62-4.*

James Thrall Soby (essay date 1950)

[*Soby was an influential critic, editor, curator, and champion of Modernist art. He is noted in particular for his long association with the Museum of Modern Art in New York City and for his many highly regarded critical studies. In the following review of a Hopper retrospective held at the Whitney Museum of Modern Art in 1950, Soby discusses time, color, light, and composition in Hopper's paintings.*]

The Whitney Museum of American Art in New York is now holding a large retrospective exhibition of the works of Edward Hopper. . . . In the opinion of a number of our critics, Hopper is one of the finest and most individual artists America has produced lately. To many of abstract art's formalist devotees, on the other hand, his painting is a negation of everything for which the modern movements have stood. Hopper is a realist and an illustrator, they will tell you, and as such belongs to a tradition which the progressive currents of our era have made permanently obsolete. Well, the controversy between the two schools of thought about Hopper has been going on for a long time. By now nearly everyone's critical chips are down one way or the other, and in a sense the Whitney show declares a firm *"rien ne va plus."* The stake is the degree of the future's interest in this artist. My own bet is on Hopper, across the board.

Hopper is a realist and an illustrator, of course. But what the Whitney exhibition makes clear, as never before, is the eloquence of his realism and the profundity of his illustrative means. His greatest achievement, it seems to me, has been to create an extremely personal and memorable interpretation of New York City and its environs. It is no easy matter to suggest the fiber of a great city without descending to topographical anonymity of style, and not many living painters have done it anywhere near so successfully as the eighteenth-century Venetians. One thinks at once of moderns like Sickert, Utrillo, Kokoschka (who has been a brilliant painter of travelogue rather than the recorder of a single city), De Chirico, Sloan, Burchfield, and Marin. Of all these painters Hopper is closest in spirit to Sloan and Burchfield, both of whom he admires. Yet the mood of his art is more piercing than theirs: for the gusto of Sloan's local color he substitutes a reticent but quite unforgettable drama of loneliness; to Burchfield's almost "Gothick" commentary on the Victorian architecture of Buffalo he opposes a more arbitrary and structural vision in which the past is less often a spectral entity than a real and sidling presence. Presumably Hopper loves New York as much as John Marin. But while Marin's pictures of the city are motivated by rapture toward its contemporary vitality, Hopper's are by comparison meditative, retroactive, and immeasurably restrained. The latter's paintings often portray those stilled antechambers—a movie theatre, an office at night—wherein people refute for a while the engulfing metropolis that Marin welcomes with open arms.

Hopper's pictures tell the time of day or night accurately, but only in order to bring the clock to an absolute halt. In this regard it is interesting to note that Lloyd Goodrich, in his fine catalogue of the Whitney exhibition, mentions Giorgio de Chirico as, like Hopper, an artist particularly interested in the "poetry of buildings and places." I would go further and say that there is a decided affinity between the two painters as to their conception of the dramatic possibilities of arrested time. Both artists, if very unlike in temperament and style, have created an evocative imagery of temporal pause, an imagery in which an atmosphere of time-gone-by acts as the foil to a hushed present. There is, however, an important difference between the two men's pictures, and it perhaps tells us something about Hopper's

unmistakably American psychology as an artist. Whereas De Chirico's art conveys an impression of ominous, impending event, that of Hopper seldom hints at any such metaphysical allusion. Nevertheless, Hopper's factual bluntness is charged with its own emotional power. We may have seen his basic subjects a hundred times in life itself, but it is his summary which makes them stick to consciousness. Indeed, for me one of the fascinations of the Whitney exhibition was that, though my pictorial memory often goes out from under me like Leon Errol's trick knee, I knew most of the paintings by heart.

To the formalists, of course, Hopper's acceptance of existing reality makes him seem uncreative. I cannot help feeling that they look too casually at his pictures, put off by subject matter's aggressive presence. Hopper's art at its best has virtues which account for its illustrative intensity and at the same time go beyond it. Take, for instance, his color. Even his admirers tend to speak cautiously of him as a colorist, and obviously he cannot be compared to men like Bonnard or Marin in terms of sensuous appeal.

But that is not the point. Hopper's color is the quiet but trained handmaiden of his romantic-realist conviction; it does not claim the autonomous excitement to which the post-impressionists' innovations opened the way for many modern artists. Within its function, however, Hopper's tonal control is changeable and deft, and its solidity compensates for a lack of textural interest. Moreover, his color's "abstract" contribution to mood and to design is more important than generally acknowledged. The picture called *Chop Suey,* for example, portrays four figures seated in a restaurant, which might be of any modest species—except that through the window can be seen an electric sign with the word "Suey" partly visible. The sign is a fire-cracker red, and its hue identifies the scene even more forcefully than its lettering. A traditional Chinese color, of course, but how well suggested and placed in this picture! The red's reflections are arbitrarily cut dead by the surrounding light, and within the restaurant the bland, American colors of the women's clothes predominate. Thus Hopper evolves a subtle interplay between interior and exterior setting, between day-by-day New York reality and sudden, exotic infusion.

Chop Suey was painted in 1929. Since that early date in a career which began late (Hopper was almost forty before he began to work professionally in oils), the artist has gained steadily in assurance, and his paintings of the past ten years are on the whole the most remarkable. Among them *Dawn in Pennsylvania,* with its muted gradations of gray and rust, illustrates superbly his ability to record the slightest shifts in illumination as it falls on varied surfaces. Light for him is the precious substance it was for the seventeenth-century Dutch painters; he weights it carefully, then uses it boldly. His *Approaching a City* of 1946 is primarily a study of the effect of light on masonry and concrete walls, recalling the fact that he once gave as his most fervent ambition "to paint sunlight on the side of a house." His preoccupation with stillness in subject matter is the result of his concern with light, and often the scenario of his pictures consists in a drama between shadows and glare.

It is not only in his handling of color and light that Hopper

has gained authority with the years. His compositional system, almost always vigorously horizontal, was announced by his etchings of 1919-23, but has since been consistently enriched. Its fundamental is a seemingly casual asymmetry that may originally have owed something to Degas' snapshot arrangements of form, but which Hopper has made into a rare documentary instrument. Thirty years ago Hopper and other native painters and photographers may have decided that it was useless and untrue to impose on the American scene the classical balance which, a hundred years before, had made our Hudson River artists fervent disciples of Poussin and Claude. At any rate, Hopper more than anyone has revealed the overwhelmingly lonely lyricism of American streets, where the jostle of epochs obviates over-all plan, where the present is bright, the past dark and subdued.

Nighthawks is an impressive summary of Hopper's esthetic. Within the cafe figures and objects are instantly believable, and only with study do we realize the skill of their selection and grouping. I suppose the pantry window could have been placed elsewhere but I cannot see how; the outside mullion traverses the gleaming coffee urn at the one inevitable place. The figures are noncommittal and undramatic in a human sense but it is they who enliven the thrust of the cafe's rounded prow against the darkened walls of an earlier era, across the street. *Nighthawks* is only one of numerous paintings in the Hopper show in which plastic discipline combines with a strong and tearless romanticism to dignify homely reality. (pp. 42-3)

> *James Thrall Soby, "Arrested Time by Edward Hopper," in* The Saturday Review of Literature, *Vol. XXXIII, No. 9, March 4, 1950, pp. 42-3.*

Hopper on representational art:

Great art is the outward expression of an inner life in the artist, and this inner life will result in his personal vision of the world. No amount of skillful invention can replace the essential element of imagination. One of the weaknesses of much abstract painting is the attempt to substitute the inventions of the intellect for a pristine imaginative conception.

The inner life of a human being is a vast and varied realm and does not concern itself alone with stimulating arrangements of color, form, and design.

The term "life" as used in art is something not to be held in contempt, for it implies all of existence, and the province of art is to react to it and not to shun it.

Painting will have to deal more fully and less obliquely with life and nature's phenomena before it can again become great.

> *From* Edward Hopper, *new concise edition, Harry N. Abrams, Inc., Publishers, 1976.*

Jacob Getlar Smith (essay date 1956)

[*In the following essay, Smith examines theme and technique in Hopper's works.*]

In an age when dynamic influences fling all their might against the delicate armor of the creative artist, it is the rare painter who does not in some degree give way to their sly inducements and adjust his artistic speech accordingly. For years most of the rewards have been falling to the more amenable ones and few to die-hards, so we are prone to look inquiringly, if not curiously, at the isolated few who have elected to follow their own paths, popular or not.

Painting in our country has known many such a stubborn soul, staunch lone wolf holding steadfast to his private visions and throughout his life giving us creations untouched by foreign influence. Subject matter was always the life he knew, meaty, direct, and intimate, in language marked by a pungent idiom unmistakably American. Bingham, Ryder, Blakelock, Eakins, Homer, Bellows, Sloan and Benton are all of the fraternity. But none surpasses Edward Hopper either in devotion to national traits or in sublime indifference to the pull of alien ways.

Hopper is the poet of man's loneliness—of his solitary existence in a world frequently not of his own making and often bewildering. His paintings are heavy with suspense. Nothing moves; all is still; not the halt of motion temporarily arrested gathering strength for another forward push, but the apathy of weary spirits, wondering and perplexed. Life is serious for his performers whether they be in a theater, at a restaurant or in the dismal climate of a cell-like bedroom.

Look at *Two on the Aisle.* An evening at the theater should be the occasion for pleasure, for entertainment anticipated and realized. None of this mood is felt in the painting. The man removes his coat, the woman prepares the seats, both without hint of the quiet excitement that preludes such an event. The very air is passive; even the yet-to-be-filled seats project a disquieting sense of numbness. Hopper is too adroit a painter not to have done this intentionally. We must therefore assume the deliberate courting of such results and wonder why. Only after studying the bulk of his work, oils and watercolors, does the answer shape up.

Hopper is a preacher, in many ways as moralistic as the most rabid "social-conscious" painter of the depression. Critics have mentioned his lack of sentiment, but they are fooled by the unique twist it takes in his work. It is there in heavy doses, but it is sentiment by indirection, the fervency hidden under a thick coat of austerity. No one seems to have noticed the strain of puritanism permeating his every brush stroke; this is the most important key to his place in twentieth-century American painting. Much of the middle class he portrays is drab. His constant retreat from gay color and ostentatious technique emphasizes the sternness of life. Nothing ever moves him to witty statement; his view of the world has the severity of the ascetic.

While we are always aware of the artist's sympathy for his

characters, a sympathy frequently encompassing pity and compassion for the lonely men and women who sit and stare, there is never the pathos frequently found in other social painters. Hopper's respect for man's dignity is too apparent to permit exaggerated emotionalism. *Room in New York* is more than an excuse for delightful pattern— it is a pointed comment on the shallowness of unanchored living. A shirt-sleeved man bends listlessly over his newspaper as the girl toys apathetically with the piano keys. The dull interior, bare table, monotonous door paneling, all bathed in an irritating light, combine to create as depressing a setting as one can find in this era that boasts its special refinements.

Chardin's passionate devotion to the inanimate world would never intrigue Hopper. Nor is there the joviality of Guardi when depicting a city view. Eakins' probing finds little counterpart in him. Hopper's reluctance to look too deeply into personalities might denote a natural respect for privacy—a feeling that even the artist should stop at a given point. It is this seeming refusal to editorialize that, because of its blunt, unvarnished statement, frequently culminates in a biting report on modern life.

Strangely enough, for one who is so concerned with man's ways, the human element is peculiarly missing from paintings that naturally call for its inclusion. *Dawn in Pennsylvania* shows everything pertaining to one of our major links to survival—a railroad. The platform, train and all the odds and ends that never fail to bring a thrill to such a view are there—all except the central character, man. Hopper has seen fit to present the entire cast without his main actor, bringing to the painting the breathlessness of still life rather than the animation of a living force. The pulse of life is missing, producing a disturbing feeling of abandonment and complete despair.

Claude Monet, the great French impressionist, in his painting of a somewhat similar subject, *St. Lazare,* escaped the same trap by the simple expedient of introducing smoke in the railroad engine, placing man in the picture by implication and in this manner achieving an effect of tremendous vitality.

Hopper's periodic forsaking of the human element in paintings that are at no time landscapes in the classic or idyllic sense, like those of Inness or Corot, is puzzling. Were he concerned with the poetry of nature, divorced from man's place in it, we might understand. But these transcriptions of farm houses, rolling hills and sparse foliage are too much like theatrical backdrops to stand alone. Patiently we wait for the leading man to appear and cannot disguise our disappointment when he fails to do so.

This might be overlooked were Hopper enchanted with shapes, patterns, color and all the secondary qualities haunting many of his contemporaries. But he is essentially a humanist; to him, man is the hub of the universe. So enmeshed in the spectacle of life is he that his work overflows with an inexorable curiosity about all its aspects. His is that rarest of virtues in a painter, one that negates all technical considerations—the ability to seize upon the essence in the commonplace and give it universal import. It is his greatest claim to fame and when he deserts it, if only

momentarily, he is lost. We are therefore mystified by the deliberate elimination of people (and everything Hopper does is deliberate) in compositions that fairly plead for them.

Macomb's Dam Bridge is another example of such evasion. This bridge is no isolated structure stuck away in some backwoods glen. It is a bustling thoroughfare in the bosom of New York's crowded upper East Side where it forms a major artery through that jostling, noisy bit of metropolis. Is it that the artist occasionally wearies of mortals? If so, we cannot blame him; man sometimes becomes too much even for himself. But to exclude him from a painting of this bridge invites a mood of desolation contradicting its very spirit. When Hopper disregards his gift for homily and resorts to harmless still life, the sharp sting singling him out from the pack is lost.

Those pictures that do include people rarely have more than two or three, unwieldy and quiescent. Lacking the gusto that gives Sloan and the Ashcan School much of their stimulation, Hopper's paintings possess a power in no way dependent upon paint sorcery for effectiveness. His men and women are saturated in sobriety. Terse, unpretty statement is his trademark and he seems to say, "If you cannot stomach my kind of plain speech, go to the sentimentalists with their cute pinks and blues, maudlin tenderness and decorative pretentiousness."

Hopper is the perfect antidote for those who attempt to reduce the American scene to coquettish fretwork of old railings, orgies of weather-beaten surfaces, miles of multi-colored brick walls, pseudo-primitivism and all the other jargon of worn-out statement. His color is acrid, at times rasping—raw blues, dirty yellows and crude greens; it makes little attempt to beguile. In fact so secondary is the color that his paintings lose little of their force in black and white reproduction. The sensuous pleasure of technique is nonexistent. Paint is laid on trowel-like with scarce regard for subtleties of texture or tactile enjoyment. Little opportunity is offered the cognoscenti who love to indulge in the mystifying hocus-pocus of esthetic terminology—his work is all too unaffected.

Hopper's best card lies in the rugged firmness of his drawing. It dominates every canvas and watercolor, their granite architecture recalling the hardy Cape Cod countryside he knows so well. *House by the Railroad* and *Captain Ed Staples* stand like ancient megaliths; theirs is the temper of a Puritan straightback chair, rugged and imperturbable.

It might be called heavy-handed painting and there are times when the medium seems to get in the way. Even watercolor (he ranks as one of our best) becomes too much now and then, resulting in a dull, overworked picture. Like Van Gogh, with whom an unflinching probity places him in close proximity, there is often evidence of long struggle. Distinctive composition, stalwart form, blunt attack, any of which would serve as notable qualities in a less gifted painter, are never allowed to run away with the painting. Hardly glib, Hopper is no tremendous producer. The doctrinal view implicit in everything he touches must dominate; the idea always comes first. And ideas, as we all know, have a way of slipping out of reach.

Life is not lusty for him as it was for Bellows, nor boisterous as for Luks—and certainly not earthy as it is for Benton nor gimcrack as for Shahn. Exuding from Hopper's pictures is a somberness, a realization that existence is serious and at times desolate—that despite rigid demands, out of every day percolates a radiancy, the haunting spell of life itself. *Early Sunday Morning* has that quality in full measure. Not a soul is abroad (in this case the absence of people is a stroke of genius) and we are stirred with the joy of renewed hope that comes with every morning sun. Far more than a clever portrayal of quiet homes and empty shops it is a deeply moving essay on the beauty of peace coursing swiftly through our spirits like the bodily diffusion of a soothing drug. Here Hopper has achieved a great monument in American art fit to rank with the best of the century, irrefutable testimony to the undying vigor of representational painting.

The watercolors, like the oils, reflect his grave temperament. Technically, no art is so seductive as watercolor; few practitioners go through an extended period without occasionally succumbing to its tricks and wiles. The best sooner or later bog down in bravura and wallow in empty passages of florid painting; but never Hopper. His sledge-hammer approach is the result of a minimum interest in titillating painting. Color is happier, more resonant, undoubtedly due in part to the medium's innate delicacy. He is not so prone to belabor watercolors; a fresh transparency invests these unassuming studies with a fragile tenderness bearing further witness to a sympathy for nature.

His world is real, bedrock, unromanticized and stoic. It offers no panaceas, making neither compromise nor concession. This kind of artist is America's conscience; how sad for us there are so few. To the young who clutch wildly in the choppy seas of conflicting philosophies—to the mature who find themselves saddened by isolation, Edward Hopper remains a heartening example of the virtue of independence. By walking alone he has discovered the sound of his own voice. (pp. 23-7)

> *Jacob Getlar Smith, "Edward Hopper," in* American Artist, *Vol. 20, No. 1, January, 1956, pp. 23-7.*

Lawrence Campbell (essay date 1964)

[*In the following review of a Hopper retrospective held at the Whitney Museum of American Art in 1964, Campbell differentiates Hopper from other American Realists of his era, focusing on his unique interpretation of the American scene.*]

Edward Hopper has had significant things to say through his work since the 1920s; in the past four decades, he has never been out of style or neglected. He is the only living artist to have two retrospective exhibitions at the Whitney Museum. In his long life as America's most widely-respected painter of the American Scene, he has received numerous other tributes, including a retrospective at the Museum of Modern Art in 1933 when the Modern was young and championing painters of the Scene. (pp. 42-3)

Hopper believes that art should be close to "life," a credo which comes directly from the heady 1908 ambiance of Robert Henri and his friends. He studied with Henri and Kenneth Hayes Miller at the New York School of Art (The Chase School). At first Henri was the big influence, and Hopper worked quite freely with his brush. But as his own style matured, it seems that Miller's influence took over, especially in the deliberately meager surface and in the thinking about composition and volume.

There were two interludes of working in Europe, in Paris from 1906 to 1907, in France and Spain from 1909 to 1910. In between, in 1908, he exhibited in New York City with Bellows, du Bois, Friedman and other Henri students, and he sold his first painting. He also sold one of the two works he exhibited in the Armory Show in 1913, but from then until 1923 he sold nothing, and supported himself by working as an illustrator. Soon after 1923—the year he sold a watercolor from an exhibition at the Brooklyn Museum—he found himself being acclaimed as a great American talent. It was not necessary to work as an illustrator after 1924.

Henri's group of independents had an ideal of humanitarian internationalism (at times tinged with socialism) in which American art would find a rightful niche. Henri himself respected, even if he did not always understand, what was taking place in Paris. His group supported the Armory Show, although it regretted afterwards the eclipse of American art by the European avant-garde. But Hopper's generation of realists ignored or turned its back on Europe. The *dernier cri* was to be American. By the 1930s, this Americanism had sprouted wings and become chauvinism in the work of Benton, Curry, Wood and others.

The curious thing about much of the American Scene painting of the 1920s is that it put together all kinds of rickety theories with an approach to American life which was quite often more critical than descriptive. The Ashcan painters were more accurate as objective reporters. Charles Burchfield, with whom Hopper found himself coupled for a time (as painters they have little in common except a mutual admiration and a shared interest in the Scene), was always more of a nostalgic satirist than a realist, and he seems to be dreaming of an idyllic, more rural America when his spiky manses were young and not yet fantastic. But Hopper was never a nostalgic nor a critical painter. Instead he taught his audience to look at America squarely on his own terms. If nowadays his audience reads nostalgia into his paintings of the 1920s, it is because the urban spectacle which Hopper loved is now being mercilessly destroyed by bulldozers and wrecking crews as a whole style of life fast disappears. People can see in a Hopper painting something which reminds them of when they were young and all alone in a hotel with no company but a Gideon Bible.

If not a sentimentalist or a critic of the scene, Hopper is always conscious of being an American before he is an Artist, and the qualities he respects in a colleague are what he considers "American" qualities. He wrote an appreciation of Burchfield in the 1920s titled "Charles Burchfield: American." And Burchfield responded with an appreciation of Hopper in which he said: "Edward Hopper is an American—nowhere but in America could such an art

have come into being . . . it is my conviction that the bridge to international appreciation is the national bias" [see Museum of Modern Art entry in Further Reading, section IV].

Unfortunately for Hopper, his national bias was always so extreme that until the rest of the world takes on the aspect of America, it is hard to see how any foreigner could appreciate his work, let alone penetrate into it. (Such talk about being American, which could hardly be doubted in view of his nationality, reminds one of delegates to national nominating conventions who find it obligatory to refer to each other as "that Great American, a man who . . . ")

Some writers on Hopper have tried to explain the strange quality of his paintings by an alleged love-hate relationship to an uncommonly dismal scene. How otherwise, they argue, could Hopper paint with such icy passion? The fact is, the depressing quality one finds in his paintings is a quality of his mind, and is quite separate from the subjects he has chosen to paint. Coleman painted such streets, Sloan's lively New York paintings are filled with the bustle of everyday life, Myers's New York overflows with children, Prendergast's watercolors are enchanting evocations of recognizable places around New York. But Hopper's streets and buildings have the impact Hoboken has on a European visitor who arrives there instead of in New York City and has his dreams of a new world of steel and glass rudely dispelled. There is always shock, Hopper seems to be saying; there is no beauty in America. Actually what he is doing is to create an idealism of the ordinary and ugly. The memory of his paintings tyrannizes over the sight of the scene itself. One begins to see Hopper's paintings everywhere. Now that the old-fashioned cafeterias, diners, chop-suey restaurants, movie palaces and darkly-porched houses are disappearing, or fallen into the hands of interior decorators, and everywhere motels and housing projects take the place of brownstones or frame houses with heavy cornices, mansard roofs, dormer windows, engaged columns and fancy trimmings, one finds a kind of sublime grandeur in his humble but aggressive scenery. But Hopper saw this in America before others did.

Hopper is a "Thou Shalt Not" painter: "Thou Shalt Not" use texture, "Thou Shalt Not" paint for fun, "Thou Shalt Not" leave anything unfinished or unstated, "Thou Shalt Not" paint from sketches—although he makes very good ones. Typical of an American (or English) "Thou Shalt Not" attitude is an unwearying interest in the opposite sex. This finds an outlet in his paintings in repeated Peeping-Tom situations, like the story of the clergyman in Sherwood Anderson's *Winesburg, Ohio* who knocked out a pane from the stained-glass window in his church in order to spy on a woman lying in a bed in a room across the street. In a Hopper painting, the missing pane of glass is usually a window across the street or a hidden place within a room from which one can safely observe a woman undressing or stripteasing, or a naked woman standing or sitting on a bed looking out of a window, and when there is no woman in view, a mysterious lighted window suggests she may soon appear.

These fantasies occur in an America which Hopper sees as a world of utter loneliness and monotony, inhabited, if at all, by people with anonymous, white, executive faces. He throws a light into his buildings with a beam as unwavering as moonlight. When his people sit facing into the sun it is as though they were looking into an empty grave. Even unspoiled nature seems dehumanized and ominous.

Hopper's people remind one of the stupefying dullness of the characters in *The House of the Seven Gables* who serve mainly as props to give significance to the strange house itself, to its musty rooms and its ticking clock which, in a great scene, picks up the cadence from a dying heartbeat and becomes the heartbeat itself when the man's life has slowly ebbed away. Hawthorne's Yankees seem entirely withdrawn from the life which built the railroads and canals, settled the West and fought some of the bloodiest battles in history. Hopper's people seem similarly withdrawn from the life of the twentieth century—yet one supposes they must be useful cogs in a society devoted to utilitarian interests.

Hopper is a slow worker and rarely turns out more than two paintings a year in his recent period, and seldom more than three a year in his earlier. Lloyd Goodrich speaks of finding him in his studio in Truro on Cape Cod absorbed in the contemplation of a stretcher without canvas. Hopper said he had been looking at this stretcher for the better part of the summer the better "to see" the painting. The anecdote illuminates Hopper's approach. Although he may have on occasion worked outdoors directly from the motif, as a rule his paintings do not relate to specific places, but are the projections of an interior vision. He furnishes his vision with clearly-defined solids, separate and distinct from each other, conceived in local rather than atmospheric color, casting shadows academically bluish rather than the colors of perception, and interrupting light to make a balanced, patterned illusionist composition with the parts fitting together, tongue in groove, as snugly as a piece of Shaker furniture. He is a conceptual painter.

Lloyd Goodrich quotes Hopper as saying that all he wanted to do was paint the sunlight on the side of a house. This makes Hopper sound like an optical Impressionist, and, in fact, he himself once stated that his aim was always the "most exact transcription of my most intimate impressions of nature." But this statement, except for the word "intimate," does not apply to the painter he has been for the last forty or more years. It is impossible to look at a light reflecting on or from a surface, and remain true to one's sensation, without becoming aware of a continuously palpitating change. In fact no particle of any single surface is exactly like any other particle. Hopper, in his paintings, does not paint light as it appears, but represents it by a logical sign. The relation of this sign to actual light is by analogy. In doing this he has resolutely turned his back on the discoveries about direct painting made in the nineteenth century. In his approach to light and solidity, he is closer to Caravaggio and to seventeenth-century metaphysical painting even if, like Miller—who also rejected optical painting—he composes a painting as a slice of life, as though he saw it in the frame of a camera viewer.

When one studies a typical Hopper painting—and all his oils appear more or less typical—one is reminded, despite

the prosaic, everyday nature of his subjects, of Chirico's long, glancing shadows and of his mood of supernatural unreality, like the weather which a Los Angeles forecaster once described as "neurotic." One must also be reminded of that more consistent Surrealist, Magritte, whose dead-pan technique, like old-fashioned commercial illustration, allows the objects in his pictures to speak for themselves.

If one can free oneself from Hopper's spell, one finds that his American Scene belongs to the world of his paintings rather than to the world itself. His is a romantic rather than an objective report. One searches for a particular house or street or perhaps some framehouses floating along Main Street, like those in his paintings, but in vain one seeks for them. For his subjects always appear more real than any real place one ever saw. They do not capture a scene, they create it. (The only pictures which really capture the Scene are by certain Pop Artists. But the Pop Artists cut the Gordian knot of painting by moving the scene or a *trompe-l'oeil* of it into the gallery. They avoid the problems of paintings by declaring them no longer valid to art. This is the great weakness of Pop. It does not impose itself as a Super-Reality.)

The late Guy Pène du Bois once wrote: "It is a great temptation to declare Edward Hopper the most inherently Anglo-Saxon painter of all time" [see Further Reading, section III]. If to be an American Anglo-Saxon is to be Puritan, he could not have been closer to the truth. The Puritans left Europe, not because they wanted to find liberty (there was already sufficient religious liberty in England in the seventeenth century for them to have survived without undergoing the hardships of a long sea voyage), but in order to set up a theocracy free from the contaminating influences of the Renaissance. Listen to Hopper, this latter-day Puritan, writing in 1928: "Good painting (so-called), that degenerate legacy from the late Renaissance, has no place in this writing down of life; the concentration is too intense to allow the hand to flourish playfully about."

For a fact there is nothing playful about Hopper's hand. It leaves behind a starved surface—the strokes long since dwindled to near extinction. He summarily dismisses all pleasurable, moving things—such as the sight of leaves glinting in the sunlight, the delightfulness of grass and flowers, and paints such things as "et ceteras" in dyspeptic color. Still his paintings have the solid force of stage scenery. As Baudelaire wrote: "It is in such scenery that one finds one's dearest dreams artistically expressed and tragically concentrated. These things, because they are false, are infinitely close to the truth, whereas the majority of landscape painters are liars precisely because they have neglected to lie."

Hopper's lies are at all times astounding, and sometimes he utters truths which transcend the pictorial. One recalls them afterwards as endless visions of endlessness. In this respect, if in no other, one can discern a relationship with Abstract-Expressionism which also, though more consciously, tries to go beyond the fixed picture-surface.

Such reflexions would hardly give pleasure to Hopper, who has remained close to the illusions formed in his youth. As a painter he is like some extraordinary monument in a city somewhere in upper New York State, always there, larger than life and maintained in perpetuity by the American Legion. He presents a singular, synthetic, arbitrary, abstracted, composed vision disguised as an optical experience. His American Scene may not exist independently of his paintings, but how can one come to grips with the real thing, with the weight and vigor of its masses, its lights and darks, its strange commonplaceness, without for a time sitting at his feet? (pp. 42-5, 58)

> Lawrence Campbell, "Hopper: Painter of 'Thou Shalt Not'," in ARTnews, Vol. 63, No. 6, October, 1964, pp. 42-5, 58.

William C. Seitz (essay date 1967)

[*An American artist and critic, Seitz was the author of numerous studies of modern art. In the following essay written on the occasion of the 1967 Bienal de São Paulo in which Hopper's works were exhibited, Seitz analyzes Hopper's work and discusses his place in Western art.*]

> The thing that makes me so mad is the American Scene business. I never tried to do the American Scene as Benton and Curry and the midwestern painters did. I think the American Scene painters caricatured America. I always wanted to do myself. The French painters didn't talk about the 'French Scene,' or the English painters about the 'English Scene.' It always gets a rise out of me. The American quality is *in* a painter—he doesn't have to strive for it.
>
> Edward Hopper

No occasion could offer a better setting for a complete (and one hopes final) disengagement of Edward Hopper's painting from the social realism championed by Thomas Craven in the 1930's than the ecumenical scope of the Bienal de São Paulo. The time has come when Hopper must be given the position in world art that he has in his own country, and that his mastery demands. Provincialism has its roots in ignorance and chauvinism, not in a precisely determined choice of theme and style. Hopper's very personal art both predates and postdates the "American Scene" School, and his justified objection to identification with it can be extended by pointing out that Goya, Vermeer, Renoir, Cézanne and Vuillard (to choose names almost at random) were never similarly labeled for painting subjects from the life and environment around them, nor were the Italian Futurists. If Franz Kafka or Vladimir Nabokov had been born in Nyack or Topeka instead of Prague and St. Petersburg, the novel *Amerika* and the memorable descriptions of motel and highway life in *Lolita* might well have been classified as "American Scene" writing.

Hopper chose to reject avant-gardism. But it was not, as Brian O'Doherty has demonstrated, because his thinking is narrow or circumscribed. No painter who quotes Verlaine in French and Goethe in German, and dismisses Sinclair Lewis as "a fathead," can be impaled by any of the terms—"hoosier," "buckeye," "big-towner," "Amurican"—reserved for various species of the hidebound Yankee. Even the more appropriate term "puritan" (which

Edward Hopper, American, 1882-1967, Nighthawks, oil on canvas, 1942, 76.2 × 144 cm, Friends of American Art Collection, 1942.51

has been applied to Hopper because of his austere manner, laconic speech, and perhaps also because he passes his summers in New England) disintegrates in the high existential and even sexual temperature of some of his paintings.

During three extended trips to Europe between 1906 and 1910, had Hopper been a Stanton Macdonald-Wright, a Max Weber or a Morgan Russell, he might have sought out the modernist art that would have propelled him toward abstraction and avant-gardism. But what he saw in Paris was the light. In direct and freely painted scenes of the quays and bridges along the Seine it is apparent how easily he could have mastered the method of the Impressionists, whose painting he admired and whose goals he in part shared. "My aim in painting," he once stated, "has always been the most exact transcription possible of my most intimate impressions of nature" [see Artist's Statements dated 1933]. He has even described himself as an Impressionist. Yet, except for the continuation—but only in watercolors—of direct painting from the motif, he quickly abandoned Impressionism. Engrossed though Hopper has always been by light, natural or artificial, and essential as are qualities of light and time of day or night to his works in all media, they bear no resemblance whatever to the paintings of the Impressionists or Neo-Impressionists. The pure hues of the spectrum, divisionist brushwork and juxtaposition of complementary colors never attracted him. He chooses tones and hues that fit the subjects he paints: brick and gas-pump reds, grass green, the white and blue of clapboards in sunlight and shadow, shingle and mahogany browns, flesh, asphalt, the cold tones of business offices. His light ranges, as Lloyd Good-

rich has emphasized, from pure white to shadows that are almost black. The bulk and solidity of objects is retained, and the delineation of edges (which the Impressionists avoided) is clear and sharp. Except for an occasional patch of sky, grass, foliage or some other imprecise object or necessary effect, the brushstroke—in truly Impressionist painting the irreducible unit of form—is never permitted to break free of the object it depicts. Nor, other than in a few early paintings, does he take advantage of the sensuous impasto of which oil pigment is capable.

What is perhaps the most fundamental divergence of Hopper's art from Impressionism is conceptual rather than technical. Monet took a specific motif, on a particular day or even during a single half-hour, as his point of departure. Hopper's paintings in oil, conceived in his mind before they were executed, are never the record of a single perceptual encounter with a scene or event, even though an existing building or landscape is sometimes re-created with crystal clarity. "Most of my paintings are composites," he told Katharine Kuh in 1962 [see Artist's Statements dated 1960], "not taken from any one scene." His compositions arise from a synthesis of observations, impressions and thoughts, are carefully and intellectually planned, and take form within a preconceived pictorial language.

French art proved to Hopper that "a nation's art is greatest when it most reflects the character of its people." He belongs by choice to the tradition of American Realism. Nonetheless little is gained (excepting a few instances in which his people have a second-cousin resemblance to those painted by his friend Guy Pène du Bois) by thinking of him in the company of Luks, Sloan, Burchfield, Bellows

or the American Scene painters. Now he should be seen against the broad panorama of Western art. In this context, even though his subjects are regional, both style and method of work place him within the classical tradition. Unlike Monet, Mondrian, Kandinsky or other artists whose manner evolved toward some nebulous goal, Hopper's development need not be apprehended as a sequence of alterations in concept, sensibility or style. Although minor changes can be noted, differences in date as wide as that between *Hotel Room* (1931) and *A Woman in the Sun* (1961) are almost irrelevant. The Classicist is concerned with being rather than becoming. Hopper has maintained an enduring attachment to a single ruling concept of form unaffected, fundamentally, by developmental revisions. He is a Classicist also by virtue of an all but Davidian spareness and severity in his placing of objects, the immobility of his figures, and the severe rectilinear and parallel relationships that make up his characteristic compositional structure. His scrupulously disposed backgrounds, figures and objects, swept clean of the clutter of everyday life so dear to the genre painter, are embodiments of ideas as well as representations of nature and human situations. As a result his tableaux of life—suspended, silent and immobile—have a dramatic power truer to inner experience than the painting of any more anecdotal Realist.

No portrayal in art of a nation as vast and diverse as the United States can be anything but fragmentary, even in as embracing a form as the novel. Entirely different impressions, depending on period and locality as well as on individual viewpoint, arise from the works of F. Scott Fitzgerald, Sinclair Lewis, John Steinbeck, William Faulkner, John Dos Passos or Jack Kerouac. Painting cannot begin to handle a comparable variety of images, and for a more encyclopedic multiplication of subjects and aspects one must look to photography, the film, television or the press. Hopper's images ring so true because they reflect personal conviction and feeling rather than a program of social comment. The truth to which one responds is that of art distilled from life, not that of sociology or journalism; yet the sense of objectivity and accuracy is inescapable as one factor contributing to his reputation as the most American of painters.

Hopper's portrayals of the terrain of the United States always convey a topographical convincingness, yet landscapes without buildings are rare among his oils, and one does not think of him as a landscape painter. Nevertheless, such works as *The Camel's Hump*—stark, unseductive and painted with consummate solidity and breadth—cannot be forgotten in considering the power and range of his art. The majestic *House by the Railroad* combines two of his favorite motifs: a mansard-roofed Victorian house and a railroad line. Only the postcard-blue sky and the strong light and shadow belong to nature.

Precise and dramatic illustrations for a study of American architecture during the early years of industrialization could be selected from among Hopper's paintings. They would include fine examples of those Victorian houses that only now, as they begin to disappear, are regaining the dignity that the original owners saw in them, and in which not long ago we could see only ugliness. Lloyd Goodrich

has quoted Hopper concerning the "hideous beauty" of our native architecture, with "its fantastic roofs, pseudo-Gothic, French mansard, Colonial, mongrel or whatnot. . . ." There are blocks of New York walk-ups (as in *Early Sunday Morning,* with its mysterious light coming from far outside the picture, as in Corot's early Italian scenes), severe office-building façades, in *The Circle Theatre* an entire city square, as well as poor, boxlike habitations isolated beside country roads. One can find commanding lighthouses, sharply delineated homes of New England sea captains, clustered farm buildings, and, in such paintings as *East Wind over Weehawken,* entire neighborhoods of the "mongrel" houses that most Americans lived in before the years of far uglier suburbias made up of endlessly multiplied ranch-types and split-levels. Architectural minutiae are eliminated, but nothing is permitted to obscure the basic geometry of Hopper's buildings. They have a clarity and presence one experiences in actuality only during rare moments of heightened perception. Many of the paintings that include architecture (as well as most of the interiors) emphasize windows and doors. One looks into, or out of, buildings. "It's hard," Hopper has said, "to paint outside and inside at the same time."

Some landscapes are dominated by a highway. Its disappearance toward the horizon is accentuated, in *Route 6, Eastham,* by a dividing stripe. The presence of the road can also be suggested by a fence that one knows parallels it, or by a bridge over which the road passes. Highways and railroads have a somewhat similar meaning. An etching of 1920, *American Landscape* (five years before *House by the Railroad*), includes a bare house rising behind a horizontal cut of track over which three cows cross. Mr. and Mrs. Hopper are both rail and automobile travelers, and have therefore observed the United States from the same moving vantage points as have millions of other tourists. Watercolors painted directly on the site during auto trips served to impress specific images on the artist's memory. "To me the most important thing is the sense of going on," Hopper once said [see *Time* magazine entry in Further Reading, section III]. "You know how beautiful things are when you're traveling." He has given repeated attention, as Sidney Tillim has emphasized, to "subjects which were also symbols of transience—railroads, cafeterias, gas stations, motels and hotels, rooming houses, some containing weary wanderers, others uninhabited by anything but the light of a particular hour . . . " [see Further Reading, section III].

Hopper is a master who magnifies the significance of the artifacts he represents: not only buildings, but also sections of buildings (such as the masonry blocks of apartment houses and office façades), railroad cars, telephone and barber poles, gas pumps and hydrants, window frames and moldings, dressers, tables and chairs, cash registers, clocks and framed reproductions hanging on plain walls. As tragic drama is stripped of irrelevant chatter, Hopper's compositions are never contaminated by paraphernalia and litter. The objects he paints are not simply still-life representations or anecdotal props: they have been projected into the realm of ideas, distilled to their essence by a mind that has scrutinized the world of artifacts again and again. One knows that he has meditated on their form

and function as well as on their relation to each other and to the beings to whose use they are dedicated. "He doesn't waste a thing," O'Doherty comments on Hopper, "a gesture, a brushstroke, a word, a thought." He has often said that what he is trying to paint is himself. This thought is expanded in one of his favorite quotations, from Goethe, which defines the goal of literature as "the reproduction of the world that surrounds me by means of the world that is in me, all things being grasped, related, re-created, moulded and reconstructed in a personal form and an original manner." Again: ". . . outside and inside at the same time."

Although Hopper never seems to romanticize, either in choice of themes or their treatment, the sense of need, of unfulfillment, of alienation from human companionship which his paintings can arouse is profound. (The opposite mood, one of embracing warmth and protectiveness, is compassionately expressed in Picasso's family groups of 1904–1905.) The types that make up Hopper's *dramatis personae* are drawn from various professional and social groups.

There are sedate members of the upper class, doing nothing in a hotel lobby or, formally attired, in a theater waiting for the curtain to rise; middle-class and poorer occupants of hotel and motel rooms, railroad compartments and restaurants; office workers, as typical as statistics; an ungainly teen-age couple leaning against the porch railing on a summer night; another couple, older, glued to stools of an all-night lunch room; a waitress, a gas station attendant, an old man in a Pennsylvania coal town raking his lawn; customers in the automat, the cafeteria and the barber shop.

Yet, important as these settings are for Hopper's poetry of the American environment, distinctions of class, occupation or activity are all but irrelevant to what his people seem to experience. Meditating, brooding—striving, it seems, to evolve a philosophy of acceptance—or momentarily diverted by books or magazines that free them from the weight of actuality, they are members of one psychic family, contemplative and melancholic. Almost never, as in *Conference at Night,* do more than two individuals try to communicate, and even in this case, it is evident, the three business associates confer on a coldly impersonal plane. Scenes in public places divide into couples, service personnel and loners. None of these, even man and wife, appear to share with each other the challenges of existence that often seem to burden them: one sleeps while the other ponders; one reads while the other stares dourly through the window holding a flameless cigarette. This solitariness, the imprisonment of the individual within his own body, thoughts and feelings, is specifically emphasized in *Room in New York.* Seen through the window from the outside, as on a stage, a husband reads his newspaper while his wife, separated from him by a circular table, sits at the upright piano and, in a charade of utter boredom, picks out a tune with her index finger. A subject often repeated is that of a solitary woman, unclothed, or almost so, and neither seductive nor ugly. In *Hotel Room* the female occupant sits primly on a neatly made bed in her slip, clothes and luggage beside her, a book that her eyes do not see

held in both hands on her lap. *Girlie Show*—a surprising subject for a "puritan"—presents a flamboyant burlesque stripper who parades naked before an audience of shadowed heads. It could be this same performer, tall, voluptuous, her long hair now blond, who lolls (as Hopper's figures seldom do) in an overstuffed chair at the right of *Hotel Lobby.*

The compelling existential substance of Hopper's figure paintings, it goes without saying, comes about not because of backgrounds, objects, or even figures in isolation, but because of a nuanced complicity among all three, augmented by the abstractly beautiful compositions, the hard fluorescence of the lighting, the merciless description of the human body, the blunt forthrightness of the color, and the frugality of the paint surfaces. Such easily ignored peripheral details as corners and right-angular intersections are of immense importance, and the geometric dividing edges between light and shadow areas are far more significant than they may at first appear. The resulting patterns are as essential to creation of mood in the interior subjects as they are to the crisp definition of architectural detail in the exteriors.

As a result of these combined means, the spectator unconsciously makes a leap to the experience of Hopper's protagonists. Like their surroundings, their meditations (except for those who evade by work or divertisement) must be divested of everything meretricious, frivolous or superfluous. Essential to this implication—but immediately evident once it is noticed—is the absence of the surface ornamentation endemic to the actuality from which Hopper's subjects derive. Planes, volumes and shapes are never softened, confused or camouflaged by the patterned wallpaper, rugs, table and bed covers, lamp shades, dresses and hats that a reportorial Realist would feel compelled to include. (Equally personal, but at the furthest remove from Hopper, is the "intimism" of Vuillard's interiors, brought about by the interlocked patterns, stripes and pointillist brushwork that pad his rooms and embrace his figures, pressing them inward with a womblike contraction.) There is no superficial ornament in Hopper's world. Draperies are plain and hang straight; dresses, suits and hats are of unfigured materials, abstracted to an elemental simplicity of shape. Even in the baroque interior of *New York Movie,* ornament and pattern are barely discernible.

The mechanical impersonality of electric lighting, like his cold sunlight, is especially suitable to Hopper's clear delineation of figures and objects. One marvels, looking at such a work as *Office at Night,* that in 1940 any American painter devoted so much care and skill to the depiction of commercial activity and its utilitarian setting and equipment. The graceless walls, partitions and furnishings of the office are measured by the projection of electric lighting from both inside and out. The desk, the heavy office chairs, the umbrella stand, telephone and lamp, the typewriter and papers are given a psychedelic clarity. Against these artifacts the rounded body of the secretary is strikingly sensuous. By contrast with her strong form and assured stance, her employer is a hollow man, hardly human. Nevertheless an almost painful psychic, even sexual, tension results.

Although the nuances of interaction in Hopper's art cannot profitably be analyzed in detail, its primary elements can at least be stated. First of all he is a Realist, but one concerned with essentials, not incidentals or accidents. His procedure from idea to form could be summarized by quoting the Cubist Juan Gris: "I start with an abstraction in order to arrive at a true fact. Mine is an art of synthesis, of deduction."

Because of this procedure, and also by virtue of his predisposition toward structure and essentialization, Hopper belongs among the Classicists. Yet, not only in figure subjects, but in paintings of interiors—and even in those exteriors seen in early morning or late afternoon light, some surrounded by dark shadows or woods—he is an existential painter as well. Edvard Munch painted extremes of love, anxiety, death and terror. Hopper's themes are never so melodramatic, and are closer to ordinary life. The familiar tension that he presents to us of human aspiration confronted with mortality, monotony and the inability to communicate is not comforting but it meets the test of subjective experience. Whether such responses to existence are characteristically Western, American or contemporary is difficult to determine. (pp. 17-28)

> *William C. Seitz, "Edward Hopper: Realist, Classicist, Existentialist," in* São Paulo 9, United States of America: Edward Hopper and Environment U.S.A., 1957-1967, *The Smithsonian Institution Press, 1967, pp. 17-28.*

Brian O'Doherty (essay date 1973)

[*O'Doherty was an artist (under the pseudonym of Brian Ireland), writer, editor, and the director of visual arts programs for the National Endowment for the Arts. His works include* Museums in Crisis *(1972), and* American Masters: the Voice and the Myth *(1973). In the following excerpt from the latter work, O'Doherty defines the elements of what he describes as Hopper's artistic "voice."*]

The mysteriousness of Hopper's pictures lies in the disparity between cause and effect. Sunlight falling across a floor amounts to an event, an empty street holds attention. How such scenes become important has engendered much critical speculation. "There is a sense of silence and detachment, as if one were looking at the scene through plate glass," wrote Alfred Barr of Hopper's interiors in 1933 [see Museum of Modern Art entry in Further Reading, section IV]. Guy Pène du Bois, one of Hopper's more perceptive critics, wrote in 1931: "There is a definite static quality . . . a stillness that has its counterpart in the calm preceding the storm," and again, "His honesties carry considerable brutality with them." Robert Coates felt that "the source of his extraordinary evocativeness lies in the balance . . . between the rigidity and monumentality of abstraction and the particularity of realism." Alexander Eliot wrote in 1948 that Hopper's work "is familiar vision without any of the dullness familiarity brings." Lloyd Goodrich wrote of Hopper's interiors in 1950 that "there is a sense of remote but observant viewpoint . . . glimpses of private life give a penetrating feeling of the vast impersonality of the city, of the loneliness that can be experi-

enced most intensely among millions." William C. Seitz wrote in 1967 that Hopper's buildings "have a clarity and presence one experiences in actuality only in rare moments of heightened perception," and that his objects "have been projected into the realm of ideas, distilled to their essence by a mind that has scrutinized the world of artifacts again and again" [see excerpt above].

Hopper would have had a simple answer for his transmutation of facts into mysteries. The artist's personality stamps a scene with an intimacy that makes all of it—woods, houses, people, sky—an act of formal and private possession, as if he had passed through each object and space.

And if the artist's personality is as much a mystery to the artist as to the observer, as much an object of speculation and pursuit, the artist would in effect have chased himself out of the picture, leaving the observer to track down his passage. Hopper's scenes not only invite literal comments on the observer and observed, they play a game of hide-and-seek in which the artist's pursuit of his identity is pursued by the audience. The elements of such a game are part of the picture's content—disappearance, silence, stealth, suspense, bafflement, glimpses—but no denouement. As in such a pursuit, objects become dumb, eloquent, blank, mysterious; they assimilate a vocabulary and speak a language. This is the "voice" in Hopper's work and it has a great deal to do with what he called "the fact."

For years Hopper painted from the fact—what he saw. His concentration on a scene was such that his painting lifted it out of its natural continuum, so that one might say that for Hopper a fact was a snapshot of a process. In this way, meaning was made inaccessible but, as in an uncaptioned news photograph, still implied. By denying meaning, his pictures provoke it; they pretend to a familiarity of recognition which they eventually frustrate. His art often has to be defined by negatives until something positive is forced into the open. This is appropriate for the reversals his pictures provoke—switching emptiness into fullness, isolation into spiritual richness, lack of emotion into feeling. His work ties a neat slipknot in time, revealing the transience in permanence, the permanence in transience. This traffic through opposites leads again into their apparent source: the separation and fusion of object and subject, signified further by the frequent traffic between inside and outside in his work, which can be extended to the observer and observed, the artist and his tracker, as described above. Hopper's "voice" has to do with these intimate detachments.

Facts, of course, are subjects. Hopper's art profited from the revolution in subject matter pioneered in American art by the Eight. He came out of Henri's circle, a circle that can perhaps be identified with a particular kind of picture: a landscape or cityscape seen with a bluff unsentimentality, displaying a painterly impetus as if painting were a "coats off, gentlemen" business. (This is perhaps exemplified by much of Rockwell Kent's work. Close to Hopper's sophisticated detachment is an almost forgotten figure, G. L. Chatterton, a few of whose works could be mistaken for Hoppers.) Hopper's attitude toward his subject matter, antiromantic and asentimental, was unmatched in twenti-

eth-century American art until Pop art inserted its ironies between the artist and the banal.

Hopper mostly painted scenes of utter banality in the city, and his recognition of subjects amounted to a vision. He incidentally explained his own attitude to "unimportant" subjects in his essay on Burchfield [see Further Reading, section I]:

> This thing has been said by Emerson with incomparable clarity: "In every work of genius we recognize our own rejected thoughts; they come back to us with a certain alienated majesty." Great works of art have no more affecting lesson for us than this. They teach us to abide by our own spontaneous impression with good-humored inflexibility—most when the cry of voices is on the other side. Else tomorrow a stranger will say with masterly good sense precisely what we have thought and felt all the time, and we shall be forced with shame to take our opinion from another.

Writing further on Burchfield he said:

> From what is to the mediocre artist and unseeing layman the boredom of everyday existence in a provincial community he has extracted a quality that we may call poetic, romantic, lyric, or what you will. By sympathy with the particular he has made it epic and universal. No mood has been so mean as to seem unworthy of interpretation; the look of an asphalt road as it lies in the broiling sun at noon, cars and locomotives lying in God-forsaken railway yards, the steaming summer rain that can fill us with such hopeless boredom, the blank concrete walls and steel constructions of modern industry, midsummer streets with the acid green of closecut lawns, the dusty Fords and gilded movies—all the sweltering tawdry life of the American small town, and behind all, the sad desolation of our suburban landscape. He derives daily stimulus from these that others flee from or pass with indifference.
>
> (pp. 19-20)

[Hopper] made boredom epic, baptized the raw scene with light, and measured it with a grave spatial geometry. His detached viewpoint, which has been compared to a lens, the eye of a voyeur, and the eye of God, hints at a moral bias one would not suspect unless one knew that his pessimism is often highly critical, and that his realism, like Zola's, is a sort of moral force. He despised anything that obscured the truth and it often led to harsh judgments on human nature. Mrs. Hopper reported he had said at Macy's: "Lord. Wouldn't He drive the money changers out of this if He were here." Although Hopper said that Guy Pène du Bois always "treated me as if I were pure Anglo-Saxon, which I'm not at all," du Bois said the last word on Hopper's puritanism thirty years ago: "He has turned the Puritan in him into a purist, turned moral rigors into stylistic precisions."

The life of pictures in the mind is a subject that hasn't received much attention. The way one remembers an artist's work, and the dialogue between the remembered image and the work when actually seen again, involves perceptual revisions of a somewhat obscure nature. When the picture is part of our cultural image-bank, as many of Hopper's pictures are, I find that it is occasionally reversed in memory, its parts unequally emphasized, indeed sometimes adjusted to one's own aesthetic interests. Many things influence the way we remember works of art and so inflect our always tentative possession of them, particularly *where* they are seen. With a change in country, for instance, an artist's work often looks different; the new milieu has subjected it to another set of cultural cues. Sometimes the work refutes this subtle influence, firmly carrying its own idea of place with it.

When one speaks of memory it is often assumed that nostalgia, a corruption of memory, is involved. Nostalgia is the result of a process by which the lazy mind stocks itself with cozy furniture and has nothing to do with the process under discussion. Hopper . . . was greatly concerned with a picture's conceptual formulation *before* he had painted it, and would have been greatly interested in its subsequent history in the observer's mind. Indeed, the way in which Hopper's pictures survive in the mind is an extension of the process whereby the artist is tracked down by the observer, where traces of the artist's passage provide intimations of intention that modify the image of the work during flashes of recall.

Hopper's images have, to my mind, a distinct relationship to another class of images which are less subject than ordinary images to the dynamics of remembering and forgetting. These are images with a strong emotional tone, persisting from some experience, but often without memory of the experience. In retrospect, they seem quite irrelevant to our lives, and why they should be remembered is not clear. A face, seen momentarily years before among hundreds of anonymous faces, can assume an inexplicable importance in memory. There are those moments of déjà vu when we stop a car in a strange place, and move on again, haunted by a troubling sense of familiarity. The unimportant scene becomes important and a banality is transformed into a vision. Such moments, while depending on one's mood and on the psychological context, are deeply affected by atmosphere and light. Hopper's pictures, in their peculiar isolation from identifying contexts (his work by and large is placeless and unlocatable), have something in common with such images. And light, of course, his main preoccupation when painting, is the chief protagonist in his tableaux. He had a distinct preference for waxing and waning lights and for artificial light. His best work was not done in the midday glare.

If isolation is to be spoken of in Hopper's work, the isolation of the individuals from each other, or even from the environment, should not be emphasized. The Nighthawks inhabit a not unfriendly oasis; many of his people are not unaware of each other sexually and, as animals, they seem to be in their proper habitat. A more telling isolation is of two orders. One is the observer's distance from the scene. (Whose eye is watching?) The other is the isolation of the image from any easily accessible context that would make it psychologically available. (There is a massive abstraction to Hopper's realism.) These have hardly begun to be investigated, since Hopper studies have been delayed by

another kind of isolation, the isolation of his oeuvre by "American Scene" misunderstandings and by his myth.

At this point it is necessary to correct another misunderstanding. Hopper himself talked about his devotion to the fact. This should not be taken literally. Though he started painting directly from life he eventually put his pictures together from notes and recollections. When he spoke of the fact he meant a recognizable image from life, as distinct from abstraction. As William C. Seitz wrote: "His compositions arise from a synthesis of observations, impressions and thoughts, are carefully and intellectually planned, and take form within a preconceived pictorial language." The conceptual nature of the later pictures is very evident in their lack of detail. They are made up of a few broad generalized units. "It's hard to define how they come about," Hopper said of his pictures, "but it's a long process of gestation in the mind and a rising emotion." . . . Remembering and forgetting apparently collaborated in purging detail, emphasizing aspects of the unimportant, and depriving scenes of their specificity. By this process the generalized statement is disguised as a particular, and a conceptual rigor taps formal energies usually confined to abstraction. "It is very well to copy what one sees," wrote Degas. "It's much better to draw what one has retained in one's memory. It is a transformation in which imagination collaborates with memory. One reproduces only that which is striking, that is to say, the necessary. Thus one's recollections and invention are liberated from the tyranny which nature exerts."

Hopper's famous statement [see Artist's Statements, dated 1933] is mainly concerned with the process by which the idea of the picture is translated to the canvas: "My aim in painting has always been the most exact transcription possible of my most intimate impressions of nature. . . . I have tried to present my sensations in what is the most congenial and impressive form possible to me. The technical obstacles of painting perhaps dictate this form. It derives also from the limitations of personality. Of such may be the simplifications that I have attempted."

The loaded words in Hopper's aesthetic are used here: "intimate," "sensations," "personality." The next part of the statement deals with his attempt to close the gap between fact and idea, between sensation and experience, between memory and the present: "I find, in working, always the disturbing intrusion of elements not a part of my most interested vision, and the inevitable obliteration and replacement of vision by the work itself as it proceeds. The struggle to prevent this decay is, I think, the common lot of all painters to whom the invention of arbitrary forms has lesser interest."

The idea that the birth of a picture involves a kind of death is not a new one. But why, of all words, had he used "decay"? "You start with the canvas and you have an idea up here," [Hopper said]. "It isn't very clear, but it has definition. As soon as you start putting it on canvas every concrete element is driving it away from the idea. You can't project your mind onto the canvas because there are concrete things that interfere, technical things. It's *decaying* from your original idea. I think a great deal of contemporary painting doesn't have that element in it at all. It's all

cerebral invention. Inventions not conceived by the imagination at all. That's why I think so much contemporary painting is false. It has no intimacy."

Hopper made a distinction between "invention" and "imagination." He associated invention generally with abstract painting, and by implication with the "new." He assumed, incorrectly, that abstract art limited the expression of a personality. Abstract painting could not draw on the powers of the imagination nurtured by the rich matrix of the real world. He felt strongly about this. Franklin Watkins remembers serving on a jury with Hopper when another member commented that a picture under review was "imaginative." Hopper corrected this to "inventive," launching into a discourse about the distinction. Abstract (that is, "inventive") painting for Hopper lacked "intimacy," a quality won, in his canon, by an obstinate rearguard action against the decay of the idea while realizing the picture. Hopper's conception of process was a highly sophisticated one, providing him with a sense of difficulty entirely appropriate to the ethical nature of his vision. The intimacy may have been connected with the reconciliation of the raw landscape with thought, a civilizing process that has troubled American artists from Washington Allston on. The subject was thus as important to him as the means of expression, which purged the subject of the anecdotal. At the same time the subject continued to define the means. ("If what you want to express is literary, then you can come near achieving it. I was never able to paint what I set out to paint. That's a very crude statement in the popular mind.")

In this fusion between subject and means, Hopper made an important contribution to "realist" painting. For such a practice implies a realization (rather than a redefinition) of conventions each time around, and an anxiety that ranks with more glamorously publicized anxieties in modernist practice. And the emotional neutrality which gives Hopper's scenes that potential into which we can read our own scenarios is the result of a process not unlike de Kooning's having to make everything abstract before he can use it. Rothko was traveling in exactly the opposite direction, giving the abstract a content which it apparently precluded. If Rothko could appropriate a literary apparatus through abstraction, Hopper appropriated profound abstract energies through his variety of realism. Thus we cannot look to either, as we can to purer practitioners, for definitions of realism or abstraction. Their ambitions and performance went beyond such limits. I believe Hopper was an artist of comparable intelligence and sophistication to Rothko and de Kooning. He was pleased when someone told him that de Kooning liked his work, and he might well have enjoyed a contact with them that was cut off by his wife, on whom the word "abstraction" had much the same effect as a cross would have on a werewolf.

If through that process of decay, Hopper's personality was realized even as it eluded him, what was left behind after he had eluded himself, as it were, is a cluster of motifs. The conception of the painting descends through modes and habits of seeing that turn up repeatedly in his pictures. Like habits of movement or speech they indicate personality and character. These motifs are intimately connected

with Hopper's "voice," that element in the picture that re-creates a figure distinct from the actual artist or the myth of his work. This fragile locution is difficult to recover from those modes of perception that close off the voice effectively or destroy it through assimilation into the social context. Since the voice is really a form of silence which articulates for us what cannot be expressed, and is thus vulnerable, each generation has the responsibility to reconstruct it, and so give to works of art that life which is always being frozen by coarser public transactions. This complicated dialogue between the voice and the myth is far too easily abandoned to certain kinds of art history or to "smart" avant-garde thinking. The once-revolutionary and now fashionable view of the perishability of art—that its energies and moral force quickly expire—is a modish capitulation that ignores our capacities to engage the forces that vitiate and pervert the work of art. If the critical act is to have any meaning, it is part of its responsibility to resuscitate and recover the voice, stifled by neglect or overacceptance, that gives a work of art its permanent, and permanently elusive, value. In this way not only are art's potentially moral energies made accessible, but culture itself is preserved.

So Hopper's motifs, telescoping formal and psychological elements that in their own way subvert critical orthodoxies as surely as do Rothko's paintings, open a field for study that has hardly been explored. Some of these motifs are: aspects of the figures; the way edges edit his pictures; his magisterial horizontals; certain recurring geometric patterns produced by the dialogue of buildings and light; habits of handling paint; woods; and, of course, windows.

Hopper's figures (influenced slightly, as William Seitz has pointed out, by Guy Pène du Bois) embody a curious dialogue between the general and the particular. Irrespective of age or occupation they have an animal kinship, as if an alien eye had recognized the species but not learned to make fine discriminations. They move slowly, turn their blank faces to the light, relax, or are stilled in some transitory pose that has as part of its content a complete unawareness of being watched. This amounts to a cruelty, somewhat reminiscent in kind if not in pose of Degas, whom Hopper admired. (The only reproduction in either of the Hopper houses was a Degas nude in the bedroom at Truro.) The isolation of his people is perhaps due to the absence of any event or action that could give their presence some motivation. They exist, to adapt Robert Lowell's phrase, in "a wilderness of lost connections." Such neutrality, however, returns to the observer a constant stream of suggestions, much as Rothko's powerful neutrality does. The figures measure not just the degree of our aesthetic perception, but of our wisdom—as if we were confronted by them in real life. For instance, the physiognomy of hands, particularly the women's, often summarizes personality in a flash (for example, the two fingers shot around a cigarette in *A Woman in the Sun*—1961). And the eloquence of many figures is hardly in the face, but in the tone and posture of the body. There is a depth of worldly knowledge camouflaged as simple observation. What Hopper wrote of another artist is more applicable to himself; his paintings are "stated with such simple hon-

esty and effacement of the mechanics of art as to give almost the shock of the reality itself."

On occasion, when figures are absent, they were originally present and their traces remain, often in pentimenti, more often in the atmosphere, which remains inhabited—again perhaps a residue of the artist who has passed through the picture. In 1930 Hopper put a figure in one of the windows of *Early Sunday Morning* and then painted it out. The sketch for *Sun in an Empty Room* also had a figure which he took out.

Hopper's connoisseurship of "our native architecture with its hideous beauty, its fantastic roofs, pseudo-Gothic, French Mansard, Colonial, mongrel or what not . . . " is an unexplored subject. Tracking the fall of sunlight across its angularities is obviously one of his ruling passions. "Such easily ignored peripheral details as corners and right-angular intersections are of immense importance, and the geometric dividing edges between light and shadow areas are far more significant than they may at first appear" (Seitz). The geometry of shapes and shadows make two of his pictures look Cubist (*House on Pamet River* of 1934 and *Skylights* of 1925), but this is coincidence rather than intention. Frequently, long diagonals at the base of the picture (railway tracks, a road, a wall) are tilted in a way that underlines the scene and at the same time urges it to slide away, relieving the fairly consistent frontality. "I hate diagonals," said Rothko, "but I like Hopper's diagonals. They're the only diagonals I like." His framing ("The frame? I consider it very forcibly") crops in ways that stimulate and frustrate attention, sometimes suggesting movement and change while fixing the subject so firmly that his best works appear like freeze-frames from a lifelong movie. Hopper's viewpoint, framing, and lighting frequently appropriate movie and theater conventions.

Hopper's art affords frequent glimpses of distant woods, often through windows. They are nearly always impenetrable and thus mysterious, and have a distinct organic force. By seeing the wood rather than the trees, he makes "the wood" a single idea which ties in with the conceptual mode of assembling his compositions in large units. The wood's silence is formidable, frequently accenting the sensations provoked by the man-made components: the gas stations, the houses, the road itself. This muffling of sound is emphasized by Hopper's method of painting. Though the early Paris pictures are confidently painterly, he later seems to have invented difficulties for himself, in a habit usually described as "American," but which may be primarily related to the increasing conceptualization of his vision. As time went on, the thick impastos gave way to a precisely controlled painterliness which softens the impact of his laconic subjects. This discreet painterliness turns hard in the memory, so that one tends to remember the image as more sharply defined than it really is.

This, indeed, is one of our more profitable dialogues: between the memory of Hopper's work and actually seeing it—undoubtedly, too, a part of that dialogue between the voice in the work and the myth that suppresses it. Hopper's painterliness, however, is a subject that has more than its share of surprises. Elements that demand a sophis-

ticated painterly touch are not handled well. He told du Bois that it was years before he could bring himself to paint a cloud. The mutable always escaped him and numerous unsuccessful attempts to paint sea underline the conceptual nature of his approach. Water wouldn't stay still long enough, and he couldn't find a convincing rapprochement between formula and perception. Yet occasional details, for example, the pastries under glass in *Tables for Ladies* (1930), are handled with a fluent painterliness which inserts into a picture a quota of surprise. Over the years the paint got thinner and more transparent and, like Rothko, he made corrections when painting. Indeed, the frank way Rothko often edges his rectangles is not unlike the way Hopper turns a corner or effects the transition from sunlight to shadow.

The mature art is more summary and selective. The intensification of the image, burning away all trivia, amounted to a quickening, a speeding up of his art, and a closer approximation of the idea whose decay he tried to subvert. After a lifetime in which small adjustments in his families of motifs indicate considerable interior changes, Hopper could express movement and transience more indirectly and yet more powerfully. The *Railroad Train* of 1908 hurtles out of the picture with the aid of dashing strokes and leaning effects. The train in *Dawn in Pennsylvania* (1942) hardly moves, but the eclipsing frame forces a realization of its imminent departure. The *Road with Trees* (1962) contains no moving object at all. But the road rushes past the darkening trees with a speed all the more urgent because the means producing it are more hidden. Thus Hopper engaged those problems of fixity and motion, of impact and recollection which can be identified with the preservation of the image, and its decay through process, which was his central concern.

These and other aspects of Hopper's art are exemplified by his most obvious and enigmatic motif: the window, which signifies most clearly those habits of observation that bring the distinctive "voice" into Hopper's work. The window as lens or eye, of course, monitors traffic between inside and outside. Within a picture, a window is a kind of inner eye through which the subject can flow either way, introducing a dialogue that Hopper frequently replicated by providing numerous vantage points of more distant observation, leading to such questions as: Who is it that sees the picture? Or, who is it that the picture itself "watches"? Hopper's voice is, to my mind, composed of three elements, each of which can be distinctly separated: observer and observed, which can easily be translated into pursuer and pursued, and the further system of observation signified by the witness who watches this. The pursuer, the pursued, and the witness prompt recollections of the phantom traffic within Jasper Johns' paintings through which the artist escapes into silence, leaving only stealthy residues. But Johns' traffic is mediated by ironies Hopper never summons. In Hopper's work the window (as eye, as vacancy, as threshold, as silence, as labyrinth, as escape) is a common denominator to the elusive transactions of the pursuer, pursued, and witness, which, I believe, have hardly begun to be understood. Through them he avoided the Ping-Pong dialectics into which modernist game-playing often falls. Instead, he achieved a neutrality

that made his pictures available to numerous readings, depending on the observer's capacities. Such an achievement leads to comparisons, not with other realists, but with his great colleagues—with Davis in terms of subject, with Rothko in terms of suggestive neutrality, with de Kooning in terms of those gaps between parts of the picture that Hopper, in assembling his conceptual structures, experienced in terms of subject. (pp. 20-5)

[Part] . . . of the task now is to deal with Hopper's art in the wider contexts into which it has been projected since his death in 1967. It is clear that his theme, like so much that has been considered "American," was simply a *subject* in advance of the rest of the world—the commercial landscape has no American patent. And the sophistication of Hopper's thinking, and its relations to French literature, are only beginning to be brought into the oddly postponed critical discourse about his work. It is now time to advance the claim that, like Morandi, he is one of the great realists of the twentieth century, of which there are hardly a handful. We are thus watching Hopper transcend his American status, and so fulfill it in a far more effective way than those of his colleagues who achieved a more limited goal more completely.

Hopper, like Davis—their careers are surprisingly comparable—had larger ambitions. The two of them used certain American myths to create the contexts in which, unsupported by a strong contemporary tradition, their voices could be heard. The myths they engineered were of a different order and magnitude from those their colleagues appropriated—and so they amount to a kind of inspiration. There is no question that the artists of Hopper's and Davis' generation were aware that there were powerful myths to be tapped, myths that would establish a sense of place and a confidence from which to undertake the modernist enterprise in America. Hopper and Davis both coped successfully with the problem of being major artists in America at a time when this was not thought possible. Hopper's voice was nourished by silence, stealth, and a camouflaged sophistication, Davis' by aggressively acclimating Cubism to the American vernacular. But that their myths would eventually come into conflict with their work was inevitable. (p. 43)

> *Brian O'Doherty, "Hopper's Voice," in his* American Masters: The Voice and the Myth, *Random House, 1973, pp. 10-43.*

Peter Schjeldahl (essay date 1988)

[*In the following essay, Schjeldahl explores the impact of Hopper's visual style and assesses his reputation in the 1980s.*]

Edward Hopper had first-rate artistic skills which in his mature work, after 1924 or so, he seemed to regard with familiar contempt. In his best pictures—each one-of-a-kind and started from scratch, as if it were the first painting in the world—he regularly pushed his talents to the breaking point. You can sense their creaks and groans in Hopper's often tortured surfaces and "awkward" figures, at the same time that you feel the force of driven genius that made him the best American artist to emerge after

Sun in an Empty Room *(1963).*

Homer and Eakins and before the Abstract Expressionists: better than Hartley, Marin, and Davis, though not as compelling in pictorial invention, and better than Demuth, Dove, and O'Keeffe, though not nearly as refined. Hopper was better because his ambition for art was larger—too large to permit him a moment of feeling successful—and because he submitted himself to it with a passion rivaled only in Hartley's most eloquent late paintings. His contemporaries pursued the necessary task of getting the United States up to speed with European modernism. Hopper's job was the self-assigned, quite uncalled-for, awesome one of combining formal rudiments of Post-Impressionism with a meager American store of pictorial authenticities—from Eakins and Homer, from unnoticed aesthetics of demotic architecture and popular culture, from folk art and commercial illustration—to tell the truth and, if not the whole truth, nothing but the truth about the human soul in a hard country.

The next time you are in any museum's rooms of American "early modernism," perform this test: run your eyes passively along the walls. When you're jarred, like a car hitting a rock in the road, stop. Nearly always, you will be gazing at a Hopper. The reason won't be the picture's subject matter—if you've done the test fairly, you won't

be aware of subjects—but the way it's put together, and how the construction grips you. A Hopper has no style, properly speaking, unless sheer effort, straining against the limits of technique, can be called a style. Each element feels *ad hoc,* an emergency measure. The emergency is a moment in narrative time, the breathless midpoint of an unknown story. There are oddly angled, vertiginous spaces and dramatic light, and color that sneaks up on you; but time is the key. The length of your contemplation—literally, how long you pay attention—is time spent outside yourself, in the suspended moment of the scene. (How does Hopper do it? We'll get to that.) You rarely feel that something objectively in the world, some actual place or person or event, is being represented. Simply, you are not given the leisure to wonder about the subject, because you are plunged directly into an apprehension of its meaning. Hopper is more a naturalist than a realist, and a symbolist above all.

Hopper's non-realism is clinched by looking at sketches and studies for his paintings. These are the work not of an observer of the visible world but of an imagination-powered *metteur en scène,* a stage or film director blocking in the vision of a final effect to be reached through cunning labor. Each drawing considers one or more of the deci-

sions that will accumulate to dictate the picture. Even the simple selection of format makes meaning. I find something ineffably racy about the rectangle Hopper draws to start a sketch. It is like a blank movie screen when I'm in the mood for a movie: a silver terrain teeming with memory and anticipation, rife with spiritual possibility. Hopper understood the metaphysic of film like no other artist until, perhaps, Andy Warhol, and better than all but the greatest filmmakers. He had an instinct for the definitive, unarguable, mythic construction of great film images, all the more potent when their subjects are humble and "typical." He understood that afternoon or early morning in a successful picture must evoke *every* afternoon or *all* early mornings, just as each featured man must be Man and each woman Woman. You can see it coming together—and being concentrated, edited down to irreducibles—in the drawing: set-making, lighting, casting.

The figure study for **Cape Cod Morning** is a superlative drawing, mightily architectonic and sculptural (it seems to me a waste that Hopper didn't make sculpture). Though covered by a skirt, the woman's legs palpably rise like a solid column to the pelvis, which hinges sharply forward. The torso falls heavily, caught and supported on powerful arms. Note the detail drawings of the hands, subtly distorted to suggest strong pressure. The head and neck strain away from the body, as if to pull free of it. In the painting, the masterful finesse of a draftsmanly conception is literally covered up with paint. (The mature Hopper ruthlessly expunges any "admirable" passage; he forbids us to admire him.) In swift, lovely studies of the bay-windowed house, meanwhile, we see to-be-abolished architectural detail and, on one sheet, a change in the picture's rectangular proportions that reorients it from squarish to horizontal. Brought together on the canvas, raked at a slight forward angle from the right by pale morning sun, the staring woman and the house generate a lateral thrust like that of a ship plowing into swells. "Yearning," the automatic word for the mood suggested, is pathetically inadequate to the frozen violence of the scene, which tells us that whatever we think we know of disconsolateness and desire isn't even the half of it.

Hopper's paintings (portraits, in a real sense) of buildings are his most conventional-seeming, most nearly realist works, making especially instructive their Hopperesque qualities, the narrow margin by which they transcend visual description for psychological symbolism. As always, it is an affair of *decisions,* strange emphases and abnegations, too pronounced for either realist comfort or aesthetic savor. Some of the decisions may be unconscious. A psychoanalyst might adduce a neurotic pattern from the unenterableness of most Hopper buildings: we rarely see a door clearly, and when we do it rarely looks operable, let alone inviting. All the life of the buildings is in their glaring windows. However, such a lot of life is there, such a visionary intensity (an intensity *of* vision, of purely *seeing*), that any glib analysis is confounded. Whatever may have been stymied in Hopper's psyche did not fail or fester, but simply went elsewhere with the ornery vitality of a tree growing sideways to come up around a boulder. Any sense of isolation in Hopper is always defiantly upbeat: not loneliness, solitude. Regard deserted, apparently

forlorn **Gloucester Street.** See how the windows of the banal houses *look* in more ways than one, so many rectangular eyes. The doors of the houses may be impassable, but you just know somebody's home. And note the fiercely red, priapic chimneys: there is heat in the cellars equal to a new Ice Age. Waste no pity on those houses.

Waste no pity, either, on any of Hopper's figures, whose meaning is too often marred by sentimental, patronizing interpretations. They are heroes and heroines of American survival, every one of them unkillably resilient. What they are up against in their lives could make you cry, but only imagine yourself in their places. They are dry-eyed and doing fine. Like Hopper's houses, his people are invariably caught in the act of *seeing.* They look outward, like the Cape Cod woman, or abstractedly gaze inward upon thoughts no less real for being invisible to us. In the latter cases, Hopper always provides ambient clues to the character of the person and to the occasion and nature of his or her thoughts. In my own favorite Hopper painting, **New York Movie,** an orchestration of ferociously sensual effects pivots in the reverie of the tired usherette. (She overwhelms me: sister, daughter, lover, victim, goddess, all in one, caught in the movie palace that is a modern philosophical realization of Plato's Cave.) You attain Hopper's wavelength when you register how the subjectivity of his places and people is subsumed to the whole picture. A Hopper painting is a window turned inside-out. You don't look into it. It looks out at you, a cyclopic glance that rivets and penetrates. To see and to be seen are the terms of the deal Hopper strikes with us. It is a spirit-enhancing bargain in which some gaucherie, some forced quality of form or execution, is about as onerous as a crooked halo on an angel who has appeared to us, offering to share state secrets of Heaven.

Hopper's crooked halo—formal abruptness, technical rawness—is basic to his profound modernity: not as a self-conscious reflection on the medium (modernist) and still less as an expressive mannerism ("modernistic"), but as an objective correlative of what *lived* modern experience is like. Fragmentary, distracted, moment-to-moment, phenomenological, existential, empirical: no useful term for the character of modern life is not also a straightforward characterization of Hopper's paintings. It has taken American art culture, transfixed by superficial distinctions of style, a long time fully to catch up to Hopper's advanced truth, his news that stays news. (Like "Kafkaesque," "Hopperesque" names not a style but a particular face of reality—which we would feel even if Hopper never lived, though more obscurely.) Along with Manet, Munch, and other past masters whose "heroism of modern life" (in Baudelaire's clairvoyant phrase) had been depreciated by blinkered attention to *signs* of the modern (modernist, modernistic), Hopper has gained a freshly honed edge from the sensibility of the 1980s. Hopper's keynote—images of life presented with tough-minded candor about the artificial, theatrical nature of images—is also that of some of our most impressive contemporaries, notably Eric Fischl and Cindy Sherman. Like him, they obtrude technique as a democratic site of complicity with the viewer, of dead-level, intimate communication in

which aesthetic value must play a subordinate (though scarcely negligible) role.

Tellingly, few of us could say of a Hopper painting that it is "beautiful" without feeling that we had said, thereby, both too much and too little. A supreme masterpiece like the Whitney Museum's *Early Sunday Morning,* with its light-transfigured row of dumpy storefronts, may ravish us, but not in a way apt to remind us of Raphael. A poignance of imperfection unites the painting with its subject, producing a naked factuality as lethal to idealism as DDT is to gnats. Nor is a sentimental formula like "beauty in the ordinary" called for. What Hopper does in paintings of the mundane is far more devastating: he annihilates "the ordinary" along with "the beautiful" and every other conceivable category of aesthetic experience. The effect is "striking," keeping in mind that so is being hit by a truck. I think the effect is this: the arousal of more emotion than can be explained or contained by its evident cause. It is a lonely sensation, a congestion of feeling incapable of articulation, like being tongue-tied with love. The parallel is pretty close: the aspect of the buildings in *Early Sunday Morning* is like that of an unremarkable person with whom you are suddenly, hopelessly enamored. You can no more describe the aspect than you can breathe under water. You may feel terror unless the person breaks your isolation by speaking to you, if only with a look—as Hopper does with his plainspoken brushwork, literally showing his hand.

The Hopperesque pertains to a glimpse that burns into memory like a branding iron. Anyone who has done much living knows situations in which mood and moment produce a spark, and some utterly neutral thing is permanently charged. I remember being emotionally distressed once in a restaurant in a country town. A distant window in the shadowy room framed an aspen tree against summer sky. I will never forget it. More to the point, I knew immediately, in that instant, that I would never forget the look of that tree, which seemed to me sacred. (I've since forgotten exactly what I was upset about.) I try, and fail, to fantasize how Hopper might have rendered this experience of mine, and my failure instructs me. To lose one's soul to a vision is just a neurological glitch in terms of giving one anything to communicate: it might make a needle jump on some brain-monitoring device. To reel one's soul back in with the vision attached, preserving both in a formal order, is genius. It is what W. B. Yeats called poetry: "a raid on the inarticulate." It is also hard, complicated, equivocal work with a frequent air of rough, even shocking presumption, as Hopper never took pains to conceal.

What is most equivocal in Hopper's practice—shady and potentially embarrassing, an open secret that critics tend to mention, if at all, evasively—is the kinship of such psychological vision to voyeurism: you can get a quick, cheap equivalent—an automatic "burning glimpse"—by peeping at someone who is oblivious of you. (If properly brought up, you will also feel sick; but that's your business.) Hopper plainly was comfortable with the voyeurist impulse, which informs so much of his art directly and just about all of it indirectly—along a Platonic sliding scale from the grossest to the most transcendent knowledge,

from the intrusive glance of *Night Windows* to the metaphysical mystery of *Sun in an Empty Room.* (No one has ever seen, with their own eyes, the inside of an empty room.) Genius may rely as much on a lack of something normal as on possession of something exceptional: in Hopper's case, a lack of shame. Though distinctly puritan in his detachment, his proud spiritual isolation, he wasn't at all inhibited about his sexual interest, notoriously explicit in his characteristic exaggerations of the female body. Only squeamishness, I think, might make us see those distortions differently than the distortions Hopper visits on trees, lighthouses, gas stations, and everything else he responds to. I submit that a polymorphous sexual alertness—"adhesiveness," in Walt Whitman's wonderful term—informed Hopper's perception of the whole world. In the lowest is the highest. A mystic is a voyeur who peeps at God.

Tension between voyeurism and detachment, an aroused fascination and a reticent distance, is the moral engine of Hopper's mature art, giving rise at times to an almost Buddhistic, compassionate equilibrium. He is excited by the unguarded moment, the exposed innocence, of a person, a building, a place—anything at all, though certain things and situations (generally involving windows) pique him more than others. At the same time, he is devoted to the inviolability of the innocence he avidly surveys. You may feel in his work the tug of sex, and often a tug toward satire, but they are always checked. (That's my ideal of morality, founded not in repression and shame but in respect—the function of self-respect that we call character.) The "coming egghead," as Hopper wryly termed the primly seated, incongruously muscular woman in the late painting *Intermission,* need fear no humiliation from the gazing artist, who claims, however, a corresponding liberty to gaze without qualm. We know such gazes from the work of Hopper's French heroes: the meltingly sensual gaze of Manet, the urbanely cool one of Degas. It is the way civilized eyes behave in the modern city. To have transposed this protocol of gazing from molten Paris to stony America was not the least of Hopper's feats.

If, as I've said, Hopper has won special, heightened appreciation in the 1980s, that does not mean that he has been fully and finally understood. On the contrary, we have become wise precisely to the limitation, the premature closure, of all previous interpretations of his achievement. Our uncertainty was usefully complicated, perhaps, by the rather grueling retrospective that opened in 1980 at the Whitney. That show flooded us with unfamiliar early and otherwise minor pictures, many excellent in their way and valuable for, among other things, showing the virtuosity that Hopper's strongest work suppresses. We learned that Hopper was artistically equipped to develop in any number of ways other than the way he did, which thus took on more dramatic definition as a conscious, even arbitrary quest—an *action* of the spirit with historic and moral resonance. The task now is to winnow from the lovely chaff of Hoppers the obdurate kernel of the Hopperesque, the narrow canon of his works primary to an American intuition of modernity. It is not a task reserved for specialists, though they will play their roles in it. Only individual human hearts can ultimately assess the diagnoses of this

doctor of democracy, who asked if the soul—and art, which is its mirror—could survive an inclement century. His answer: yes, *in a way*. I have given my views about the nature and meaning of that way. . . . I am pleased to believe that, in this matter, there can be no end of views while there are viewers with courage to think and feel. (pp. 5-12)

> *Peter Schjeldahl, in his* Edward Hopper Light Years, *Hirschl & Adler Galleries, Inc., 1988, 59 p.*

FURTHER READING

I. Writings by Hopper

"John Sloan and the Philadelphians." *The Arts* 11, No. 4 (April 1927): 168-78.

> Chronicles the emergence of distinctively American art through a discussion of the careers of John Sloan, Robert Henri, and other American Realists.

"Charles Burchfield: American." *The Arts* 14, No. 1 (July 1928): 5-12.

> In a discussion of Burchfield's originality, Hopper delineates his own attitudes toward realistic representation and artistic expression.

II. Interviews

Morse, John D. "Edward Hopper." *Art in America* 48, No. 1 (Spring 1980): 60-3.

> A discussion of the durability, form, and artistic significance of several of Hopper's paintings.

Rodman, Selden. "Edward Hopper." In his *Conversations with Artists,* pp. 198-200. New York: Devin-Adair Co., 1957.

> Interview in which Hopper discloses his views on abstract painters: "Their painting sometimes pleases me with its bright colors and clever design, but it is essentially decoration to me, and I suspect that's all it really is to anybody. Art for art's sake followed to its ultimate conclusion ends in a feeble, emasculated art. Originality is neither a matter of inventiveness nor method—in particular a fashionable method. It is far deeper than that, and is the essence of a personality."

III. Critical Studies and Reviews

Baigell, Matthew. "The Silent Witness of Edward Hopper." *Arts Magazine* 49, No. 1 (September 1974): 29-33.

> Places Hopper in the artistic, literary, and cultural milieu of post–World War I America. Baigell examines Hopper's treatment of themes of alienation and isolation and asserts that "the essential attitudes revealed in his works are contemporaneous with our own time."

Barker, Virgil. "The Etchings of Edward Hopper." *The Arts* V, No. 6 (June 1924): 322-27.

> Examines Hopper's etching techniques. Barker demonstrates that "in the particular medium of etching Hopper's work is conspicuous for its originality."

Brace, Ernest. "Edward Hopper." *Magazine of Art* 30, No. 5 (May 1937): 274-80.

> Appreciative review of Hopper's works. Brace states: "As a realist [Hopper] employs facts that many of us would romantically ignore if not hide, and yet he is able to create with them fresh and vivid pictures which subtly suggest the strangeness added to beauty which Pater described as the romantic character of art."

Brown, Milton W. "The Early Realism of Hopper and Burchfield." *College Art Journal* VII, No. 1 (Autumn 1947): 3-11.

> Compares and contrasts Hopper's and Charles Burchfield's depictions of America in the 1920s.

Burrey, Suzanne. "Edward Hopper: The Emptying Spaces." *Arts Digest* 29, No. 13 (1 April 1955): 8-10, 33.

> Biographical sketch and critical overview of Hopper's works.

Canaday, John. "The Solo Voyage of Edward Hopper, American Realist." *Smithsonian* 11, No. 6 (September 1980): 126-33.

> Review of the 1980 Hopper retrospective at the Whitney Museum of American Art. Canaday states that "it is becoming possible to see Hopper simply as a great American painter rather than the great exception to the rule that American painters of his generation and the next were important to the extent that they experimented with innovative concepts. We are also beginning to see that Hopper himself was more innovative than he seemed in immediate context with his more obviously adventurous contemporaries."

Du Bois, Guy Pène. "The American Paintings of Edward Hopper." *Creative Art* 8, No. 3 (March 1931): 187-91.

> Praise for Hopper's works by a fellow art student and friend.

———. *Edward Hopper.* New York: Whitney Museum of American Art, 1931, 55 p.

> Introduction to Hopper's works in which Du Bois declares that "[Hopper] is a painter who will make many painters of the past or of the present, European or American, seem trivial."

Forgey, Benjamin. "Hopper's America." *Portfolio* II, No. 4 (September-October 1980): 46-53.

> Traces Hopper's artistic development.

Frank, Elizabeth. "Edward Hopper: Symbolist in a Hardboiled World." *ARTnews* 80, No. 2 (February 1981): 100-03.

> Review of the 1980 Hopper retrospective at the Whitney Museum of American Art. Frank concludes: "Hopper was no more a realist than were Elihu Vedder, Albert Pinkham Ryder or Ralph Blakelock. He was a symbolist whose achievement has the integrity of any closed system that pulls the reality found into correspondence with the reality already imagined, but insists upon a technique that appears to reverse these terms."

Geldzahler, Henry. "Edward Hopper." *The Metropolitan*

Museum of Art Bulletin XXI, No. 3 (November 1962): 113-17.

Survey of Hopper's growth as an artist presented through an examination of works owned by the Metropolitan Museum of Art.

Goodrich, Lloyd. *Edward Hopper.* New York: Whitney Museum of American Art, 1964, 72 p.

Catalog of Hopper's solo exhibition at the Whitney Museum with a critical overview.

Goodrich, Lloyd; Clancy, John; Hayes, Helen; Soyer, Raphael; O'Doherty, Brian; and Flexner, James. "Six Who Knew Edward Hopper." *Art Journal* 41, No. 2 (Summer 1981): 124-35.

Personal reminiscences by Hopper's friends, patrons, and other artists.

Hanson, Anne Coffin. "Edward Hopper, American Meaning and French Craft." *Art Journal* 41, No. 2 (Summer 1981): 142-49.

Examines Hopper's painting techniques in order to demonstrate that after the termination of his studies in France, he "continued to exploit an underlying structure of French facility and craft throughout the remainder of his career."

Heller, Nancy, and Williams, Julia. "Edward Hopper: Alone in America." *American Artist* 40, No. 402 (January 1976): 70-75, 103-06.

Biographical and critical introduction to Hopper's works that concludes: "[What] Hopper accomplished was his unique manner of selecting some of the most inherently dull and uninteresting aspects of American life—buildings we would never glance at twice, figures we would miss entirely—and, by choosing unusual compositions and viewpoints, by introducing evocative titles, and by making an intriguing mystery of the fall of light, he transformed them into something interesting, upsetting, or lyrical."

Hollander, John. "Hopper and the Figure of Room." *Art Journal* 41, No. 2 (Summer 1981): 155-60.

Examination of "the figurative or metaphoric representation of enchambered space that appears in some of Hopper's central paintings, in those scenes of openness and closure, of emptiness and possibility, of minimal occupancy and uncontested possession of place" in order "to celebrate the very way . . . in which these themes, these epistemological and moral subjects that Hopper's paintings of interiority seem to be about, are themselves related to the crucial questions of pictorial space in the general sense to which painting since Cézanne has had to respond, those responses having become in turn the subject matter of much modern art."

Kramer, Hilton. "An American Vision." *The New Leader* 47, No. 21 (12 October 1964): 28-9.

Review of the 1964 Hopper retrospective at the Whitney Museum of American Art in which Kramer states that the exhibit "confirms [Hopper] as an artist of unique, if narrow, vision—a vision which bequeaths little to the esthetics of painting but which nonetheless penetrates American experience with a particularly incisive eye."

Lanes, Jerrold. Review of the Edward Hopper Retrospective at the Art Institute of Chicago. *The Burlington Magazine* CVII, No. 742 (January 1965): 42-6.

Surveys Hopper's artistic development, focusing on one of his later oils, *Sun in an Empty Room,* as "a good measure of the ambitiousness, the purity and the success of Hopper's art at its best, and . . . of the extent to which it transcends the limitations of the American or any other scene."

Levin, Gail. "Hopper's Etchings: Some of the Finest Examples of American Printmaking." *ARTnews* 78, No. 7 (September 1979): 90-3.

Discusses the details of Hopper's career as printmaker.

———. "Edward Hopper's Evening." *The Connoisseur* 205, No. 823 (September 1980): 56-63.

Analyzes the symbolic meaning of evening in several of Hopper's works.

———. "Edward Hopper: The Influence of Theater and Film." *Arts Magazine* 55, No. 2 (October 1980): 123-27.

Demonstrates that Hopper's art was influenced by his love of theater and film.

———. "Edward Hopper's *Nighthawks.*" *Arts Magazine* 55, No. 9 (May 1981): 154-61.

Discussion of Hopper's paintings, his taste in literature and art, and his experiences as an illustrator in an examination of the inspiration behind his well known oil *Nighthawks.*

———. "Symbol and Reality in Edward Hopper's *Room in New York.*" *Arts Magazine* 56, No. 5 (January 1982): 148-53.

Advances a symbolic interpretation of Hopper's pivotal painting *Room in New York.*

———. *Hopper's Places.* New York: Alfred A. Knopf, 1985, 89 p.

Compares small-format reproductions of Hopper's works to photographs of the same subjects in an attempt to "illuminate the artist's motivations and working procedure."

Meyerowitz, Joel; Segal, George; Bailey, William, and Levin, Gail. "Artists' Panel." *Art Journal* 41, No. 2 (Summer 1981): 150-54.

Personal reactions of the photographer Joel Meyerowitz, the sculptor George Segal, and the painter William Bailey to Hopper's art.

Mumford, Lewis. "Two Americans." *The New Yorker* 9 (11 November 1933): 60-1.

Review of exhibitions by Hopper and John Marin. Mumford labels Hopper's artistic vision "limited," concluding: "While I think Hopper a *good* painter and immediately enjoy his dustswept colors and his inverted open-eyed sentiment, I think John Marin a great painter, an artist who has not merely recorded the common experience but added dimensions to it."

Nochlin, Linda. "Edward Hopper and the Imagery of Alienation." *Art Journal* 41, No. 2 (Summer 1981): 136-41.

Examines Hopper's depiction of the theme of alienation in his works.

Silberman, Robert. "Edward Hopper: Becoming Himself." *Art in America* 68, No. 1 (January 1980): 45-7.

Review of the 1979 Hopper exhibition at the Whitney Museum of American Art. Silberman examines the role Hopper's prints and illustrations played in the development of his artistic vision.

————. "Edward Hopper and the Implied Observer." *Art in America* 69, No. 7 (September 1981): 148-54.

> Review of the 1980 Hopper retrospective at the Whitney Museum of American Art. Silberman explores the function of the observer in Hopper's paintings and discusses Hopper's "preoccupation with the relationship between the familiar and the strange."

Stein, Susan Alyson. "Edward Hopper: The Uncrossed Threshold." *Arts Magazine* 54, No. 7 (March 1980): 156-60.

> An analysis of the theme of "defeated pursuit" in Hopper's paintings.

Tillim, Sidney. "Edward Hopper and the Provincial Principle." *Arts Magazine* 39, No. 2 (November 1964): 24-31.

> Asserts that Hopper's best works transcend the limitations of American provincialism.

"The Silent Witness." *Time* LXVIII, No. 26 (24 December 1956): 28, 36-9.

> Overview of Hopper's life and career.

Ward, J. A. "Edward Hopper." In his *American Silences: The Realism of James Agee, Walker Evans, and Edward Hopper,* pp. 168-202. Baton Rouge: Louisiana State University Press, 1985.

> Studies the mood of silence suggested in Hopper's works.

Watson, Forbes. "A Note on Edward Hopper." *Vanity Fair* 31, No. 6 (February 1929): 64, 98, 107.

> Summary of Hopper's career to 1929.

Young, Mahonri Sharp. "Edward Hopper: The Ultimate Realist." *Apollo* CXIII, No. 229 (March 1981): 185-89.

> Negative view of Hopper's art that concludes: "[The] only way [Hopper] got where he is today was by allowing people to pretend he was something he was not."

IV. Selected Sources of Reproductions

Goodrich, Lloyd. *Edward Hopper.* New York: Harry N. Abrams, 1976, 159 p.

> Color and black-and-white reproductions, including six oils, nine watercolors, and thirty-two drawings from Mrs. Hopper's bequest to the Whitney Museum in 1968. Also included are a biographical and critical introduction to Hopper's works by Goodrich and three statements by Hopper, two of which are excerpted above.

Levin, Gail. *Edward Hopper as Illustrator.* New York: W. W. Norton & Co./Museum of American Art, 1979, 506 p.

> Color and black-and-white reproductions with an overview of Hopper's life and works by Levin.

————. *Edward Hopper: The Complete Prints.* New York: W. W. Norton & Co./Whitney Museum of American Art, 1979, 36 p. + 109 plates.

> Reproductions of Hopper's prints. In addition, Levin provides a biographical and critical introduction to Hopper's career as a printmaker.

————. *Edward Hopper: The Art and the Artist.* New York: W. W. Norton & Co./Whitney Museum of American Art, 1980, 304 p.

> Color and black-and-white reproductions of Hopper's works arranged thematically and accompanied by an introductory overview of Hopper's career by Levin.

Museum of Modern Art. *Edward Hopper: Retrospective Exhibition.* New York: Museum of Modern Art, 1933, 83 p.

> Catalog published in conjunction with the 1933 Hopper retrospective at the Museum of Modern Art. Contains a biographical and critical sketch by Alfred H. Barr; an appreciation of Hopper's art by Charles Burchfield; "Notes on Painting" by Hopper, excerpted above; and seventy-two black-and-white plates.

Wassily Kandinsky

1866-1944

Russian painter and graphic artist.

Considered one of the most influential painters of the German Expressionist movement, Kandinsky is best known for his artistic and theoretical contributions to the development of nonrepresentational, or abstract, art. Using brilliant colors in compositions of geometric shapes and lines, Kandinsky sought to communicate experiences and emotions through a purely visual language divested of all symbolic or narrative content. In doing so, he redefined traditional concepts of the picture plane and provided the rationale for much of modern art.

Kandinsky was born to an affluent family in Moscow and educated in Odessa, a port city in the southern Ukraine. In 1886 he enrolled in a postsecondary program of law, economics, and politics at Moscow University, where, after graduating in 1893, he accepted a position on the Faculty of Law. During his years as a student and instructor, Kandinsky became fascinated with art, and after viewing the paintings of the French Impressionists in 1895 he abandoned his teaching position to study painting.

Kandinsky was accepted into the Munich Academy of Art in 1900. There, as a student of Franz von Stuck, he developed an interest in *Art Nouveau* or *Jugendstil,* a movement whose adherents promoted decorative art. By 1901, Kandinsky had become a noteworthy figure in the art community in Munich, founding *Phalanx,* an exhibition association and school for avant-garde artists, and teaching classes in drawing and painting. Over the next six years, he travelled throughout Europe, spending a year in Paris, where he exhibited handicrafts, woodcuts, and paintings. Kandinsky's paintings during this early period were highly stylized and colorful landscapes which reflect the influence of the Fauvists, often containing figures reminiscent of fairy tale and Russian folklore characters, as in his *Couple Riding* of 1905.

Critics generally refer to the years between 1908 and 1914—when Kandinsky first espoused abstractionism—as the period of his greatest achievements. According to an often cited anecdote, Kandinsky's "discovery" of abstract art occurred in 1908 when, struck by the beauty and originality of one of his own paintings, he realized that the work had been turned upside-down; the figures he had found especially pleasing and communicative owed their advantage to their lack of conventional denotation. Thereafter, Kandinsky's paintings became increasingly abstract, consisting of black lines and vividly colored arcs and triangles in compositions predominantly blue, purple, yellow, and red, colors that Kandinsky believed representative of specific psychological states of mind. In addition to painting, Kandinsky documented the artistic principles upon which he based his use of color and form, publishing his theories as *Über das Geistige in der Kunst (Concerning the Spiritual in Art)* in 1911. The main ideas put forth by

Kandinsky in this seminal work are, as paraphrased by Herbert Read, that "art springs from an internal necessity, a need to communicate feeling in an objective form," and that "the work of art is a construction . . . making use of all the potentialities of form and color, not in an obvious way, for the most effective construction may be a hidden one, composed of seemingly fortuitous shapes." In 1912 Kandinsky, along with his colleagues Gabriele Münter, Franz Marc, and August Macke, formed the Blaue Reiter (Blue Rider) group. Blue Rider offered a forum in its publication *Blaue Reiter Almanach* for the diverse viewpoints concerning art, music, and architecture found in the Expressionist movement.

At the onset of World War I, Kandinsky returned to Russia, where he remained for seven years, teaching art at the University of Moscow and serving as a consultant for the country's cultural education program. Due to his administrative duties during this time, Kandinsky's creative activity was limited, and most critics regard this period in his career as an interim. In 1922 Kandinsky accepted a teaching position on the staff of the Bauhaus, Germany's creative center for architecture and design. Directed by architect Walter Gropius, the Bauhaus became an influential

school, promoting compatibility between art and industry through excellence, simplicity, and innovation in craftsmanship.

Kandinsky's theories of aesthetics and his dedication to precise design contributed to the Bauhaus's promotion of a modern style favoring severe lines and geometric shapes. During the "Bauhaus years", Kandinsky's painting came under the influence of his friend and colleague Paul Klee, and many of his works assumed a less serious approach, as illustrated in his 1929 painting entitled *Obstinate,* in which a human figure represented by triangles balances awkwardly on one leg. In 1926, Kandinsky published the critically acclaimed *Punkt und Linie zu Fläche (Point and Line to Plane),* in which he discussed the specific meanings associated with the points, lines, and planes in his paintings, suggesting parallels between the experiences of "reading" literature and art.

Kandinsky remained as an instructor at the Bauhaus until 1933, when the National Socialist Government forced the school to close. He then moved to Paris where he set up a studio and devoted his time to painting until his death in 1944. The later work of the "Paris years" is generally seen as a continuation and refinement of the techniques he had strengthened at the Bauhaus, and most critics note that the geometric and organic shapes in his later works are more precisely defined and more intricate in dimension, creating an impression of energy and movement. Seen as a culmination of his talents, Kandinsky's later works, according to Paul Overy, serve "to express the spiritual in art, to speak of mystery in terms of mystery."

While Kandinsky's delineation of the aims of abstract art is regarded as eloquent and important, many critics contend that his own work often failed to incorporate the principles he advanced. Such critics note in particular that Kandinsky's paintings do not achieve his goal of creating nonrepresentational works that would transcend mere decoration through their power to express ideas and emotions. However, Kandinsky's theories were successfully realized by subsequent artists and art movements, and he is therefore acknowledged as the primary theorist of modern abstractionism.

ARTIST'S STATEMENTS

Wassily Kandinsky (essay date 1911)

[*In the following excerpt from the English translation of his* Über das Geistige in der Kunst (Concerning the Spiritual in Art), *Kandinsky discusses color and form as unifying elements in his formulation of a new aesthetic based on spiritual harmony.*]

From the nature of modern harmony, it results that never has there been a time when it was more difficult than it is today to formulate a complete theory, or to lay down a firm artistic basis. . . . It would, however, be precipitate

to say that there are no basic principles nor firm rules in painting, or that a search for them leads inevitably to academism. Even music has a grammar, which, although modified from time to time, is of continual help and value as a kind of dictionary.

Painting is, however, in a different position. The revolt from dependence on nature is only just beginning. Any realization of the inner working of colour and form is so far unconscious. The subjection of composition to some geometrical form is no new idea (cf. the art of the Persians). Construction on a purely abstract basis is a slow business, and at first seemingly blind and aimless. The artist must train not only his eye but also his soul, so that he can test colours for themselves and not only by external impressions.

If we begin at once to break the bonds which bind us to nature, and devote ourselves purely to combination of pure colour and abstract form, we shall produce works which are mere decoration, which are suited to neckties or carpets. Beauty of Form and Colour is no sufficient aim by itself, despite the assertions of pure aesthetes or even of naturalists, who are obsessed with the idea of "beauty." It is because of the elementary stage reached by our painting that we are so little able to grasp the inner harmony of true colour and form composition. The nerve vibrations are there, certainly, but they get no further than the nerves, because the corresponding vibrations of the spirit which they call forth are too weak. When we remember, however, that spiritual experience is quickening, that positive science, the firmest basis of human thought, is tottering, that dissolution of matter is imminent, we have reason to hope that the hour of pure composition is not far away.

It must not be thought that pure decoration is lifeless. It has its inner being, but one which is either incomprehensible to us, as in the case of old decorative art, or which seems mere illogical confusion, as a world in which full-grown men and embryos play equal *rôles,* in which beings deprived of limbs are on a level with noses and toes which live isolated and of their own vitality. The confusion is like that of a kaleidoscope, which though possessing a life of its own, belongs to another sphere. Nevertheless, decoration has its effect on us; oriental decoration quite differently to Swedish, savage, or ancient Greek. It is not for nothing that there is a general custom of describing samples of decoration as gay, serious, sad, etc., as music is described as Allegro, Serioso, etc., according to the nature of the piece.

Probably conventional decoration had its beginnings in nature. But when we would assert that external nature is the sole source of all art, we must remember that, in patterning, natural objects are used as symbols, almost as though they were mere hieroglyphics. For this reason we cannot gauge their inner harmony. For instance, we can bear a design of Chinese dragons in our dining or bed rooms, and are no more disturbed by it than by a design of daisies.

It is possible that towards the close of our already dying epoch a new decorative art will develop, but it is not likely to be founded on geometrical form. At the present time

any attempt to define this new art would be as useless as pulling a small bud open so as to make a fully blown flower. Nowadays we are still bound to external nature and must find our means of expression in her. But how are we to do it? In other words, how far may we go in altering the forms and colours of this nature?

We may go as far as the artist is able to carry his emotion, and once more we see how immense is the need for true emotion. A few examples will make the meaning of this clearer.

A warm red tone will materially alter in inner value when it is no longer considered as an isolated colour, as something abstract, but is applied as an element of some other object, and combined with natural form. The variety of natural forms will create a variety of spiritual values, all of which will harmonize with that of the original isolated red. Suppose we combine red with sky, flowers, a garment, a face, a horse, a tree.

A red sky suggests to us sunset, or fire, and has a consequent effect upon us—either of splendour or menace. Much depends now on the way in which other objects are treated in connection with this red sky. If the treatment is faithful to nature, but all the same harmonious, the "naturalistic" appeal of the sky is strengthened. If, however, the other objects are treated in a way which is more abstract, they tend to lessen, if not to destroy, the naturalistic appeal of the sky. Much the same applies to the use of red in a human face. In this case red can be employed to emphasize the passionate or other characteristics of the model, with a force that only an extremely abstract treatment of the rest of the picture can subdue.

A red garment is quite a different matter; for it can in reality be of any colour. Red will, however, be found best to supply the needs of pure artistry, for here alone can it be used without any association with material aims. The artist has to consider not only the value of the red cloak by itself, but also its value in connection with the figure wearing it, and further the relation of the figure to the whole picture. Suppose the picture to be a sad one, and the red-cloaked figure to be the central point on which the sadness is concentrated—either from its central position, or features, attitude, colour, or what not. The red will provide an acute discord of feeling, which will emphasize the gloom of the picture. The use of a colour, in itself sad, would weaken the effect of the dramatic whole. This is the principle of antithesis. . . . Red by itself cannot have a sad effect on the spectator, and its inclusion in a sad picture will, if properly handled, provide the dramatic element.

Yet again is the case of a red tree different. The fundamental value of red remains, as in every case. But the association of "autumn" creeps in. The colour combines easily with this association, and there is no dramatic clash as in the case of the red cloak.

Finally, the red horse provides a further variation. The very words put us in another atmosphere. The impossibility of a red horse demands an unreal world. It is possible that this combination of colour and form will appeal as a freak—a purely superficial and non-artistic appeal—or as a hint of a fairy story—once more a non-artistic appeal. To set this red horse in a careful naturalistic landscape would create such a discord as to produce no appeal and no coherence. The need for coherence is the essential of harmony—whether founded on conventional discord or concord. The new harmony demands that the inner value of a picture should remain unified whatever the variations or contrasts of outward form or colour. The elements of the new art to be found, therefore, in the inner and not the outer qualities of nature.

The spectator is too ready to look for a meaning in a picture—*i.e.,* some outward connection between its various parts. Our materialistic age has produced a type of spectator or "connoisseur," who is not content to put himself opposite a picture and let it say its own message. Instead of allowing the inner value of the picture to work, he worries himself in looking for "closeness to nature," or "temperament," or "handling," or "tonality," or "perspective," or what not. His eye does not probe the outer expression to arrive at the inner meaning. In a conversation with an interesting person, we endeavour to get at his fundamental ideas and feelings. We do not bother about the words he uses, nor the spelling of those words, nor the breath necessary for speaking them, nor the movements of his tongue and lips, nor the psychological working on our brain, nor the physical sound in our ear, nor the physiological effect on our nerves. We realize that these things, though interesting and important, are not the main things of the moment, but that the meaning and idea is what concerns us. We should have the same feeling when confronted with a work of art. When this becomes general the artist will be able to dispense with natural form and colour and speak in purely artistic language.

To return to the combination of colour and form, there is another possibility which should be noted. Non-naturalistic objects in a picture may have a "literary" appeal, and the whole picture may have the working of a fable. The spectator is put in an atmosphere which does not disturb him because he accepts it as fabulous, and in which he tries to trace the story and undergoes more or less the various appeals of colour. But the pure inner working of colour is impossible; the outward idea has the mastery still. For the spectator has only exchanged a blind reality for a blind dreamland, where the truth of inner feeling cannot be felt.

We must find, therefore, a form of expression which excludes the fable and yet does not restrict the free working of colour in any way. The forms, movement, and colours which we borrow from nature must produce no outward effect nor be associated with external objects. The more obvious is the separation from nature, the more likely is the inner meaning to be pure and unhampered. (pp. 46-50)

From what has been said of the combination of colour and form, the way to the new art can be traced. This way lies today between two dangers. On the one hand is the totally arbitrary application of colour to geometrical form—pure patterning. On the other hand is the more naturalistic use of colour in bodily form—pure phantasy. Either of these alternatives may in their turn be exaggerated. Everything is at the artist's disposal, and the freedom of today has at

once its dangers and its possibilities. We may be present at the conception of a new great epoch, or we may see the opportunity squandered in aimless extravagance.

That art is above nature is no new discovery. New principles do not fall from heaven, but are logically if indirectly connected with past and future. What is important to us is the momentary position of the principle and how best it can be used. It must not be employed forcibly. But if the artist tunes his soul to this note, the sound will ring in his work of itself. The "emancipation" of today must advance on the lines of the inner need. It is hampered at present by external form, and as that is thrown aside, there arises as the aim of composition—construction. The search for constructive form has produced Cubism, in which natural form is often forcibly subjected to geometrical construction, a process which tends to hamper the abstract by the concrete and spoil the concrete by the abstract.

The harmony of the new art demands a more subtle construction than this, something that appeals less to the eye and more to the soul. This "concealed construction" may arise from an apparently fortuitous selection of forms on the canvas. Their external lack of cohesion is their internal harmony. This haphazard arrangement of forms may be the future of artistic harmony. Their fundamental relationship will finally be able to be expressed in mathematical form, but in terms irregular rather than regular. (pp. 51-2)

> *Wassily Kandinsky, "Theory," in his* Concerning the Spiritual in Art, *translated by M. T. H. Sadler, 1914. Reprint by Dover Publications, Inc., 1977, pp. 46-52.*

Wassily Kandinsky (essay date 1938)

[*In the following excerpt from an essay originally published in 1938 in the French journal* XXe *Siècle, Kandinsky examines the sensory effects that abstract, or "concrete," art may produce in the spectator.*]

All the arts stem from the same and unique root.

Consequently, all the arts are identical.

But the mysterious and precious thing is that the "fruits" produced by the same stem are different.

The difference manifests itself by the means of each single art—by the means of expression.

It is quite simple at first. Music expresses itself by sound, painting by color, etc. Everybody knows that.

But the difference goes further. Music, for example, arranges its means (sounds) in time, while painting arranges its means (colors) on a surface. Time and surface must be "measured" with exactness, and sound and color must be "limited" with exactness—these "limits" are the basis of "balance" and consequently of composition.

The enigmatic but exact laws of composition destroy differences, since they are the same in all the arts.

I would like, by the way, to emphasize the fact that the "organic difference" between time and surface is generally

exaggerated. The composer leads his listener by the hand into his musical work, guides him step by step, and leaves him once the "piece" is over. The exactitude is perfect. It is imperfect in painting. Nevertheless! . . . The painter is not deprived of this "guiding" power—he can, if he wants to, compel the beholder to enter here, to follow a given path into his pictorial work and to "come out" there. These are extremely complicated matters, still not very well known, and above all scarcely resolved.

I would only wish to say that the relationship between music and painting is obvious. But it manifests itself in an even deeper manner. You know of course about "associations" elicited by the means of the different arts? A few scholars (especially physicists), a few artists (especially musicians) have noticed for quite a while that, for example, a musical sound provokes an association with a definite color. (See, for example, the correspondences worked out by Skriabin.) In other words, you "hear" the color and you "see" the sound.

It has been almost thirty years now since I published a little book that also dealt with this problem. YELLOW, for example, has the special capacity for "rising" higher and higher and for reaching heights unbearable to the eye and to the spirit: [it is like] the sound of a trumpet played louder and louder, becoming "shriller and shriller," hurting the ears and the spirit. BLUE, with its totally opposite power of "descending" into unfathomable depths, takes on the sound of the flute (when the BLUE is light), that of the cello by "going further down," that of the double bass, with its deep and magnificent sounds, and in the depths of the organ you "see" blue depths. GREEN, well balanced, corresponds to the extended middle register of the violin. Skillfully applied, RED (vermilion) can give the impression of loud beats on the drum. Etc.

Vibrations of air (sound) and of light (color) surely form the basis of this physical kinship.

But it is not the only basis. There is still another one: the psychological basis. The problem of the "spirit."

Have you ever heard or have you yourself used the expressions, "Oh, what cold music!" or "Oh, what a glacial painting!"? You have the impression of icy air coming in through an open window in winter. And your entire body is displeased.

But an adroit application of "warm tones" and "sounds" gives both the painter and the composer a fine opportunity to create warm works. They burn you directly.

Pardon me, but it is truly painting and music that [can] give you (although not too often) heartburn.

You also know how, when running your finger over various combinations of sounds or colors, you have the impression that your finger is "pricked." As if by thorns. But at times your "finger" runs over a painting or a piece of music, as if over silk or velvet.

Finally, isn't the "fragrance" of VIOLET unlike that of YELLOW, for example? And of ORANGE? Of light BLUE-GREEN?

And as "taste," aren't these colors different? What a tasty

painting! With the beholder or the listener it is the tongue that begins to participate in the work of art.

There they are, the five senses known to man.

Do not make the mistake of thinking that you "receive" painting only through your eyes. No, you receive it without your knowledge through your five senses.

Do you believe it could be otherwise?

In painting what is meant by the world "form" is not color alone. What is called "drawing" is another inevitable part of the means of pictorial expression.

And beginning with the "point," which is the origin of all the other forms, whose number is unlimited, this small point is a living being that exerts many influences on man's spirit. If the artist aptly places it on his canvas, the small point is pleased, and satisfies the beholder. It says "Yes it's me—do you hear my small but necessary sound in the great 'chorus' of the work?"

And how painful it is to see this small point where it does not belong! You have the impression of eating a meringue and of tasting pepper instead. A flower with the odor of rot.

Rot—that's the word! Composition becomes decomposition. It's death.

Have you noticed that while I was talking rather at length about painting and its means of expression, I have not said a word about the "object"? The explanation of this fact is quite simple: I have talked about the essential pictorial means, that is to say, the inevitable ones.

One will never discover ways of painting without using "colors" and "drawing," but painting without an object has existed in our century for over twenty-five years.

As for the object, it can be *introduced* in a painting or not.

Whenever I think about all those disputes around that "not," disputes that started almost thirty years ago and are not completely over today, I see there the tremendous power of "habit," and at the same time the tremendous power of what is called "abstract" or "nonfigurative" painting, which I prefer to call "concrete."

That kind of art is a "problem" which they have too often wanted to "bury," which was said to be definitively solved (in the negative sense of course), and which does not allow itself to be buried.

It is far too alive.

The problem of either Impressionism or Expressionism (the Fauves!) or Cubism no longer exists. All those "isms" are being put away into the different boxes of the history of art. The boxes are numbered and carry labels corresponding to their contents. And in this manner the disputes are ended.

That's the past.

And one cannot as yet anticipate the end of the disputes concerning "concrete" art. Capital! "Concrete" art is in full growth, especially in the free countries, and the num-

ber of young artists who support the "movement" keeps increasing in those countries.

That's the future! (pp. 814-17)

Wassily Kandinsky, "Concrete Art," in his Kandinsky: Complete Writings on Art, Vol. II (1922-1943), *edited by Kenneth C. Lindsay and Peter Vergo, G. K. Hall & Co., 1982, pp. 814-17.*

Wassily Kandinsky (essay date 1939)

[*In the following excerpt from an essay originally published in 1939, Kandinsky suggests some ways in which colors and dimensions inform the principles of abstract art.*]

Put one apple beside another and you will have two apples. By simple addition you get hundreds and thousands of apples, and the increase can continue indefinitely: arithmetical process.

Addition in art is enigmatic. Yellow + yellow = yellow². Geometrical progression.

Yellow + yellow + yellow + yellow + . . . = gray. The eye grows tired of too much yellow: psychological limitation.

Therefore the increase becomes a decrease and arrives at zero.

Beware of pure reason in art, and do not try to "understand" art by following the dangerous path of logic.

Neither reason nor logic can be excluded from any consideration of art, but perpetual corrections are necessary from the angle of the irrational. The feelings must correct the brain.

This assertion applies to art in general, without distinction between representational and concrete art. From this point of view the two kinds are alike.

The two kinds, however, exist:

Representational painting: the artist cannot do without the object (or he imagines he cannot). He uses the object as a "pretext" for pure painting, which is always more essential for him than the object.

The spectator cannot do without the object (or he imagines he cannot) to "understand" the painting.

Concrete painting: the artist frees himself from the object, because it prevents him from expressing himself exclusively through purely pictorial means.

The spectator is deprived of the "bridge" which gives him the possibility of entering into the field of pure painting, and if he is deprived at the same time of the necessary feeling he is disconcerted. He thinks he has no longer any standard by which to appreciate art.

The result of this difference in kind:

Representational painting is based on a more or less "literary" content, since the object (even the most quiet and modest one) "speaks" by the side of the pure painting.

(Here is a parallel, comprehensible and at the same time more or less fundamental: a popular song, composed of a simple narrative clothed in a fairly primitive musical form, when it is deprived of its words becomes monotonous and finally impossible. In the same way representational painting "clothed" in monotonous pictorial forms is only possible as long as the object is constantly varied.)

Concrete painting offers a kind of parallel with symphonic music by possessing a purely artistic content. Purely pictorial means are alone responsible for this content.

From this *exclusive responsibility* arises the necessity for the *perfect accuracy* of the composition from the point of view of balance (values, weights of forms, and of color-masses, etc.) and for the perfect accuracy of every part of the composition, *to the least little detail,* since inaccuracies cannot be concealed.

There arises also the possibility and the necessity for the fancy of the painter, deprived of a "pretext," to develop freely and to make new discoveries constantly. These possibilities are unlimited.

As we have seen that increase in art often turns into decrease; now we find that the opposite is true, and that decrease can become increase.

When the object is suppressed the means of expression are not diminished, but infinitely multiplied. This is artistic mathematics, the opposite of the mathematics of science.

But quantity is not of course quality. This richness in the means of expression of concrete painting must have, I repeat, an *irreproachable accuracy* for basis.

How can this be measured? That is to say, what is the proper method of assessing the *value* of a work?

The most obvious methods of assessing this value would seem to be:

1. through knowledge of the constant rules of painting, compulsory for the artist, and

2. through the degree of application of these rules in his work.

We shall see whether these compulsory rules exist, or used to exist in the past, and whether it is possible, or used to be possible, to discover their application in a work of art.

Here are several examples which I consider striking:

The old Italian recipes ordained, strictly and definitely: "If you want to paint a fish in water, the first coat on the canvas should be such and such, the second such and such . . . " "If you want to paint an old man in the shade, your first coat . . . "

In this way the painter arrived easily, it seems, at producing a work of value, and the connoisseur was perfectly able to affirm it. If the coats of paint are wrong the picture is worthless.

Later, after the discovery of perspective, the theory of coats of paint was discredited. This new formula appeared: if the perspective is false the picture is worthless.

Science entered the realm of art. And since the favorite theme of "high" art was the human body, the study of anatomy became indispensable—the structure of the bones (especially of the skull), of the nose, the nostrils, the forms and functions of the muscles, etc.

Drawing became a science, and the academies prescribed four years to be devoted to the study of drawing, followed by four more years of instruction in painting proper.

A fine system which has done a great deal toward the production of *"pompiers"* ["conventional pictures"].

And it was considered absolutely certain (as it is sometimes even now) that this course of consecutive studies would guarantee the value of a young painter's work. Quite a dramatic point of view for the connoisseur, who did not usually have the faintest idea of anatomy.

Now this gives a puzzling sort of result. Among thousands—we can safely say hundreds of thousands—of canvases irreproachable from the points of view of anatomy and perspective we find in general a negligible quantity of pictures that leave a deep impression on the memory of the spectator. These correct canvases are forgotten as easily as a piece of music composed according to all the rules of the academy, which passes from the memory as soon as the concert-hall is left; or as a book written according to the rules of etymology and syntax which is shut without regret for a single comma.

Why?

Can this mystery be elucidated through an analysis of the *harmony* of the work?—since "painting is beautiful if it is harmonious." This question embraces two elements of painting—the element of color and that of form proper (drawing).

Harmony of color. Leonardo da Vinci, according to an authentic account, invented a system of little spoons of different sizes to measure accurately the quantities of colors to be used on a canvas: an exact proportion of blue, violet, white, etc.

These spoons were filled with dust in the master's studio—he never made use of his invention.

Another more attractive system, which is still sometimes followed, consists in adding a "suspicion" of some particular color to all the colors which go to make up the canvas as it is painted—a little green or red or some other color serves as a "bridge" between all the colors applied and is a sure guarantee of harmony, complete harmony. As you see, this system excludes the use of pure colors, which I will consider next. As for this "bridge" system with its full guarantee of irreproachable harmony, would it not be dangerous to use it on every occasion without exception? Wouldn't the artist run a terrible risk of producing an unlimited number of desperately boring and monotonous works?

To enrich the possibilities, perhaps it would be profitable to admit the opposite of the "bridge" system also, that is to say the system of pure colors. The rainbow is harmonious. The possibilities of variation would be very limited, but harmony would be assured. It would be assured if we could have exactly the same palette as the rainbow. But

the painter receives his colors not from the sky, but from factories—each of these "pure" colors is supplemented by a dash of white and black. So, for example, the vermilions of different factories are never the same. The idea of pure colors is therefore a beautiful Utopian dream.

"Absolute" means do not exist in painting; its means are relative only.

This is a positive and cheering fact, since it is from interrelation that the unlimited means and inexhaustible richness of painting arise.

Harmony is indeed a complicated subject—the brain reels before it. The opposite of harmony is disharmony. And throughout the history of painting the disharmony of yesterday has always become the harmony of today. Art is a complicated phenomenon.

I do not wish to become tedious by going into too much detail; I must however give a few examples which I will briefly mention: the part played by the dimensions of the color-masses, by the neighborhood of other colors, and by the dimensions of their masses, the reciprocal influence of every part of the canvas, etc. A small form may receive so strong an "accent" that it completely changes the size, the intensity, and at the same time the importance of the large forms. It works in the same way as a siren which envelops all the noises of the town, narrowing the streets and diminishing the buildings.

I cannot omit some mention of the importance of the place occupied on the canvas by a form. In one of my books I have attempted to give an analysis of the "tensions" of the empty canvas, that is, of the latent forces inherent in it, and I think I have arrived at several just definitions of the essentially different tensions of the top and the bottom, of the right and the left. A blue circle set at the top left-hand corner of the canvas is not at all the same as one set at the bottom to the right—the weight, the size, the intensity, the expressions are different. This is an example of the immense part played by "details."

The canvas is divided into large and small parts. The dimensions of these parts produce the proportion. The proportion determines the value of the work, the *harmony of forms* of the design.

How is the true proportion to be found? Is it possible to calculate it?

A simple trial: on a piece of paper measuring 20 × 40 cms. two rectangles are placed, one of 2 × 4 cms., the other of 4 × 8. Harmony is attained schematically by true proportion. Not a very cheering composition, but at least of guaranteed value.

But there is another obstacle: colors change dimensions. A very simple example: a black square on a white ground gives the impression of being smaller than a white square on black. Optical proportions destroy mathematical proportions and replace them.

The effect of a painting—unhappily or happily—is of an *optical* nature.

Then what remains of "true proportion"?

(It is true in the sparrow or the ostrich?—the giraffe or the mole?)

What can we say, then?

We know examples of calculated works. It is certain that sometimes this calculation is made by the subconscious, sometimes mathematically. Either it leaps to the eye or it requires measuring to be brought out.

A Russian musician, M. Chenchine, undertook an impressive analysis more than twenty years ago. By counting the notes he measured two parts of Liszt's "Années de Pèlerinage," which had been inspired by the "Pensieroso" of Michael Angelo and by the "Sposalizio" of Raphael respectively. In continuation of his research he measured the two plastic works. The result was surprising: the "Pensieroso" of Michael Angelo showed the same formula as the musical work of Liszt dedicated to this sculpture. (Formula in figures.) The same with the "Sposalizio" of Raphael and of Liszt. I think that in these cases we have the two kinds of calculation. If we can take it that the two plastic works were calculated directly, that is to say by a mathematical method, there is on the other hand no doubt that Liszt divined the two formulas with his subconscious mind. He had translated the plastic works by means of identical formulas without knowing them.

And, after all, it would be pernicious to put all one's faith in calculations. It would perhaps work with the even numbers, 2, 4, 6, 8—(but don't forget the black square and the white square!) Color cannot be measured, and it changes the dimensions of the design. But apart from the color, the design cannot be measured either down to the final details, to the smallest differences which can only be discovered through feeling, that is, through intuition. And there you are—it is exactly the details which make the "music." If you find two people of exactly the same figure, of the same breadth of shoulders, of hips, having identical dimensions of arms, hands, legs, and feet, yet you would never say that the two people are identical. The "general proportion" is never decisive, it is the details which count—the eyelid, the little fingernail of the left hand, etc.—the tiniest details.

It is the same in painting: the most "insignificant" differences, sometimes "invisible" differences, are often more important than the "general proportion" and decide the value of the work. There are no other means of arriving at the "optical proportion."

We cannot but wholeheartedly love the pure faith of Henri Rousseau, who was entirely persuaded that he painted according to the dictates of his dead wife. Artists know well this mysterious voice which guides their brush and measures the design and the color.

Art is subordinate to cosmic laws revealed by the intuition of the artist for his work's sake and for the sake of the spectator who is often delighted through the operation of these laws without knowing it. It is an enigmatic process.

Is it sad to have to do with riddles in art?

I began with a question, and I have put a questionmark at the end of the last sentence—a vicious circle.

All the same, I consider that I have said two important things. I have firmly underlined the decisive part played by *detail*. And I hope I have provoked a certain distrust of art criticism based on exterior indices, such as the criterion of the "technique" of painting, "objective" standards of value, and in short all "scientific" indices generally. All these give negative results.

Now I will attempt to supplement this negative by a positive remedy. It is well enough known that every period in art has a special physiognomy which distinguishes it from the past and the future. The period offers a new spiritual content which it expresses through exact and convincing forms. They are new forms, unexpected, surprising, and for that reason annoying. There is general opposition to these annoying forms, since they express a *new content of spirit*, the spirit of an age hostile to an accustomed and now facile tradition. Humanity is only very slowly adapted to changes in spiritual content.

Any given period with its decided physiognomy is no more than the sum of the complete works of the artists of the period. And it is only natural that every complete work of any artist of the time should reveal on its own account a decided physiognomy.

This physiognomy is an expression of a new world unknown till that time and discovered by the intuition of the artist.

In consequence it is evident that:

1. It is difficult, if not impossible, to judge a single work of any artist without knowing his complete work as much as possible, and that

2. When this knowledge has been obtained, it is necessary to consider whether it reveals a new world unknown before.

The value of the complete work depends on the diversity of the forms of expression (the richness of the content) and on the force (the accuracy) of this expression. At the same time, in spite of this diversity, each of the separate works of an artist of value is so distinct, and is bound up so closely with his complete work, that the origin of this separate work is evident, the artist's "handwriting" is recognized.

To my mind the *key to the value* of a "figurative" or "concrete" work is the force of expression in the diversity of the separate works and then in the complete work, that decided "physiognomy" of an artist who offers to humanity a world unknown before. This is the key which opens the doors of painting with an "object," or without one, alike. And it is this key which shows clearly that the difference between these two kinds of painting has been exaggerated. An unknown world may be revealed with or without an object.

Yet on the other hand there is a decided difference between these two manners of expression or of revelation.

The object! It is common enough for the spectator who sees the object to imagine he sees the painting. He recognizes a horse, a vase, a violin, or a pipe, but may easily let the purely pictorial content escape him. On the other hand, if the object is veiled or made unrecognizable by the painter, the spectator clings to the title of the picture, since it alludes to the object. He is satisfied and thinks he is pleased with the painting itself. Sometimes the object deludes the mind. In such a case it is no longer a "bridge," but a wall between the painting and the spectator. To see the object and the painting together is a capacity which springs from innate feeling and from practice.

The capacity of seeing concrete painting is the same. I have often seen spectators who were very much interested in concrete art, though they "did not understand it" until at an unexpected moment their eyes were opened. It was fine to see the joy of their discovery.

I should like now to say a few words about my personal intention. For long years I have been occupied with concrete painting, and not without considerable effort, since it was necessary to replace the object by a purely pictorial form. I had to wait for the dictates of the "mysterious voice." It was favorable to me, because I loved painting too much to veil it in objects. Art forms are not found "on purpose," by willpower, and nothing is more dangerous in art than to arrive at a "manner of expression" by logical conclusions. My advice, then, is to mistrust logic in art. And perhaps elsewhere too!

Personally, I am happy to know that "scientific standards" of the value of art can never exist. Indeed, these standards would offer a new obstacle to the effort to "understand" art. Reason would replace feeling; and feeling, for the artist, is creative power, and for the spectator it is the necessary guide by which he can enter into a work of art. Reason, overestimated today, would destroy the only "unreasonable" domain left to our poor contemporary humanity.

It is exactly at this time that we can see many examples of "art" forced into becoming reasonable—humiliating examples indeed.

In the past I used often to say to my pupils: think as much as you like and as much as you can, it's an excellent habit—but never think in front of your easel.

I should like to give the same advice to people who vainly seek "standards of value": open your ears to music, your eyes to painting. And don't think! Examine yourselves, if you like, when you have *heard* and *seen*. Ask yourselves, if you like, whether the work of art has made you free of a world unknown to you before.

And if it has, what more do you want? (pp. 820-28)

Wassily Kandinsky, "The Value of a Concrete Work," in his Kandinsky: Complete Writings on Art, Vol. II (1922-1943), *edited by Kenneth C. Lindsay and Peter Vergo, G. K. Hall & Co., 1982, pp. 820-28.*

INTRODUCTORY OVERVIEW

Marian Kester (essay date 1983)

[*In the following excerpt, Kester discusses Kandinsky's art as it reflects his aesthetic theories.*]

Kandinsky was one of the foremost philosophers of the abstract expressionist movement in painting. He was an artist of unsurpassed lucidity who refused to choose for the "analytical" against the "mystical/lyrical," and successfully *materialized* his vision in oils, watercolor, and graphics. At once artist and intellectual, he was the common point of a number of creative vectors, among them Dada, Surrealism, German Expressionism, the Bauhaus, Constructivism, and the many other lively trends in early Soviet art. For example, as a poet, Kandinsky contributed to the Dada review *Cabaret Voltaire* in 1916; he was instrumental in introducing the *Neue Sezession* group of Berlin to the Munich *Neue Kunstlervereinigung* and to the Russian Suprematists and Rayonists: his nephew was Kojeve, the professor of philosophy who introduced Hegel to the Generation of 1905 in Paris; he was a major figure in the Bauhaus and personally recruited a number of participants to that unique experiment. In effect Kandinsky formed an individual center of gravity around which the ideas of revolutionary art revolved in the 1910-1933 period, a living symbol of what those ideas sought to embody.

Kandinsky's background and character were very unlike those of most of the young artists involved in the new movement. He was born into a well-to-do Russian family which at one point had been transported to Siberia for anti-czarist activity. His father, after financing the son's lengthy course of study in political economy and law at the University of Moscow, still proved willing to support Kandinsky's belated decision (at age 30) to study painting in Munich.

In contrast to most of his younger, less disciplined colleagues, Kandinsky's relationship to art was always that of a scholar, experimenter, and publicist—almost a technician. His theoretical writings on the nature of painting and the meaning of abstractionism are among the most comprehensive and striking of any modern artist. Moreover, his work was never conducted in romantic isolation, but always in the full light of journalistic publicity, association, cultivation of a hoped-for mass "audience," and the sort of quasi-political organizing efforts typical among movements of the period (Futurism, Constructivism, Dada, and so on).

The year 1912 was the cutting edge: a new "spiritualism," like the social revolution, was springing to life simultaneously in different fields and cultures, and individuals embarked upon greatly varied projects were to recognize *affinities of spirit* with one another's efforts. In Russia the mass strikes were building like a wave, soon to topple centuries of stonelike social edifice. To Western Europe came the calm before the storm: not even the war proved able to consume the energies about to burst forth in this period.

The most sensitive gave voice to—or "mirrored"—the underlying longings for transcendence, immediate appropriation of technology's potential, the freeing of man from labor and squalor, the transformation of everyday life according to the laws of beauty and the "luxury" of art. This longing for *realization* was, paradoxically, the ideological motive for the turn toward nonobjective, nonrepresentational, abstract art—a turn led by Kandinsky. (pp. 250-51)

It is well known that photography provoked a severe crisis in easel painting. The effect was not instantaneous or total, but slowly, surely, the nature and aims of art had to be rediscovered and reconsidered. (A similar problem was faced by the theater with the advent of cinema). The camera simply caught more, from every angle; every pore and shadow, every cloud and wave could be eternalized. Thus the surface of things, whose reproduction had come to be seen as painting's *raison d'etre,* was looted once and for all by the mechanical competitor.

Notes for what was to become Kandinsky's abstractionist manifesto, *Concerning the Spiritual in Art,* as well as studies for what were to be the first purely nonobjective canvases ever produced, date back to 1901, although neither was to achieve full-fledged expression until 1910. Up to that point, Kandinsky had been obsessed with variations, increasingly free-form, on a horse-and-rider motif, a symbolic working-out of his personal struggle to resolve the reason/unconscious duality: "The horse bears the rider with strength and speed. But the rider guides the horse."

In *Concerning the Spiritual in Art,* Kandinsky argued that abstraction was the necessary next step, the *revolutionizing perspective* which could free art of the false consciousness that had initially led to the crisis over photography's superior ability to represent reality. While recognizing that other artists would continue to fear "excluding the human" from their work, since for them immateriality possessed as yet no "precise significance," Kandinsky considered abstraction to be the "left wing" of the new art movement, an "emergent great realism," a departure more radical than any figurative mode, however "expressive." It is not hard to understand why he thought so: the entire tendency of post-Impressionism had been to abolish the primacy of the material object, the thing, in order to reveal that inner force which was the sole true "subject" of artistic knowing.

> The love visionaries, the hungry of soul, are ridiculed or considered mentally abnormal. . . . In such periods art ministers to lower needs and is used for material ends. . . . Objects remaining the same, their reproduction is thought to be the aim of art.

Relinquishing the object offered the artist undreamed-of new freedom. *Concerning the Spiritual in Art* refers constantly to the image of a world choking on dead matter, on reifications which must be superseded in order to reverse the hardening process and release the dammed and vital flow of creative energies. Pure abstractionism for Kandinsky was primarily an intensification of man's struggle with matter. That this concern was not "escapist" is confirmed repeatedly in his own writings. The four chief works—*Concerning the Spiritual in Art* (*Ueber das Geistige in der Kunst*), "On the Question of Form" ("Ueber

die Formfrage"), "Reminiscences" ("Rückblicke"), and *Point and Line to Plane* (*Punkt und Linie zur Fläche*)—radiate an ecstatic sense of history and a serene (if Manichean) confidence in the victory of "the white, fertilizing ray" of creativity over "the black, fatal hand" of blindness, hatred, fear of freedom, and insensate materialism. What animates these writings is the desire that all evolving "new values" be *materialized,* and then—because "we should never make a god out of form"—that they should give way before still newer values.

It was also important to create an art freed of literary associations, of that oppressive narrative quality that stifled the potential development of visual language by tying it to readymade verbal categories. Painting was no longer to be a branch of conventional literature, telling a "story in pictures," but a world of its own.

Klee put it thus, writing of the tendency of modern art toward abstraction:

> [The artist] is, perhaps unintentionally, a philosopher, and if he does not, with the optimists, hold this world to be the best of all possible worlds, nor to be so bad that it is unfit to serve as a model, yet he says: "In its present shape, it is not the only possible world."

Abstractionism was to enable the artist and audience to experience alternative realities, a different order of things, another possible cosmos. By stepping outside the given and offering an unanticipated perspective, nonobjective painting played its own role in the disintegration of old verities which characterized the death throes of the nineteenth century. (pp. 252-55)

Kandinsky's work went through at least six distinct phases. First came canvases reminiscent of Russian folk and religious art, then impressionistic studies and landscapes, already notable for their fascination with color and disinterest in human subjects. Studying in Munich at this time, he recalled "wandering about with a paintbox, feeling in my heart like a hunter." Natural phenomena, which aroused in him strong emotions, communicated themselves as bright, inchoate, yet distinct visions: visual metaphors.

There followed a rather Fauvist period: brilliant-hued towns, animals, fairy-tale figures on horseback in transfigured night. But the practice of rendering particular objects in themselves began to strike him as absurd and pointless. What he wished to capture was the ontological ground in which these particularities participated and upon which they moved and reveled in their being. The last of Kandinsky's conventional works were done while he was already, with a mixture of patience and impatience, experimenting with creating his own autonomous forms in a series of "improvisations," first in pen and ink and aquarelle, and later in lithographs and oils. The "objects" they depicted, although obviously suggested by a richly *lived* and observant life, seemed increasingly to refer to nothing beyond themselves. From *Point and Line to Plane,* written in 1926 to serve as a Bauhaus educational text, it is clear that Kandinsky studied many varied forms—crystals, star clusters, architectural drawings, construction frameworks

(e.g., the Eiffel Tower), flowers, microorganisms, alphabets. The new forms were meant to suggest the energy state of matter which, though just as real as mass, was rarely *seen* by man as he sleep-walked (or rather, did a forced march) through existence.

By 1910, Kandinsky felt himself "ready at last" to make a complete break with the final vestiges of representation in his work. The horse and its rider, the slant of a village roof, the curve of blue mountain in the distance—these forms freed themselves entirely from verisimilitude and took flight with visible joy. The ability to make this break he ascribed to a *maturation of the spirit of the age* within himself; indeed, that Kandinsky became the first pure abstractionist was a matter of chance, as others like Franz Kupka and even Arthur Dove were following closely upon the same path. Yet Kandinsky's work is especially revealing of this "dematerialization process": one can *see* the objects and their fixed associations twist and turn upon the canvas in convulsive beauty, seeking liberation.

Several works after the "spiritual turning point" of 1910 were entitled *Improvisation* and given a number. But Kandinsky's method remained constant throughout: before each completed composition came numerous preliminary sketches, "Impressions," in which each individual element of the whole was painstakingly arranged and rearranged until the proper harmony was achieved. *Point and Line to Plane* is a veritable encyclopedia of the various types of lines, forms, colors (by themselves or in combination), and other configurations which must be put into resonant relationship with one another on the canvas:

> Only by means of a microscopic analysis can the science of art lead to a comprehensive synthesis, which will extend far beyond the confines of art into the realm of the "oneness" of the "human" and the "divine."

He begins by dissecting the Point, defined with a certain mathematical poetry as "the highest degree of restraint which, nevertheless, speaks, . . . the ultimate and most singular *union of silence and speech.*" Then he proceeds, uncannily like a natural scientist, "to determine wherein the living conforms to law" in painterly composition. Such a highly deliberate method of composition could not be more foreign to the romantic theory of "genius." Yet the finished works of this fourth period have about them a look of spontaneous and natural existence, of internal *necessity,* that makes their actual laboratory-style genesis seem implausible.

The fourth period in particular, longest of the six, saw the emergence of most of the typical and distinctive forms comprising Kandinsky's "language of the eye." The swim or float about some unseen center of gravity: powerful black lines and curves, translucent amoeba-like creatures, jagged rainbows of color, spheres (often deep blue), triangles, swirls reminiscent of gas clouds, targets, orbiting planets, arrows, chessboard grids. More metaphorically, they resemble the tracks of subatomic particles, power lines, cityscapes viewed from above, untranslatable hieroglyphs, engineering blueprints, and in particular the notational systems of certain modern composers.

Kandinsky may not have been aware that he had converged, from the opposite direction, upon the same symbols at which modern music had arrived as it distanced itself from the assumptions of classical tonality. In any event, Kandinsky, the voluptuary of color, was himself a frustrated musician; like Klee, he had first experienced his creativity as a musically-talented child, and ever afterward regretted that his own metier could only *suggest* the total immateriality of which music was capable. He often spoke of painting in musical terms, referring to "the inner sound" of a work:

> Color is the keyboard, the eyes are the hammers, the soul is the piano with many strings. The artist is the hand that plays, touching one key or another purposively, to cause vibrations in the soul.

While at the Bauhaus he experimented with the *Gesamtkunstwerk* ["total work of art"]—for instance, "The Yellow Sound," which was a kind of tone poem enacted within a three-dimensional painting, integrating color, words, music, and drama.

Colors, instead of music, turned out to be Kandinsky's medium as an artist, but he continued to hear as well as see them:

> Blue is the typical heavenly color; the ultimate feeling it creates is one of rest. When it sinks almost to black, it echoes a grief that is hardly human. It becomes an infinite engrossment in solemn moods. As it grows lighter it becomes more indifferent and affects us in a remote and neutral fashion, like a high, cerulean sky. The lighter it grows, the more it loses resonance, until it reaches complete quiescence, in other words, white. In music a light blue is like a flute, a darker blue a cello; a still darker blue the marvelous double bass; and the darkest blue of all, an organ.

The serene blue sphere to be found in most of the *Improvisations* and *Compositions* represents a sort of celestial vantage-point from which the spectator gazes down at these systems of color and energy as upon an "ideal plane." The "subject" of each canvas is the universe itself viewed from a different angle and in a different energy state.

Kandinsky's search for the laws of the soul and senses culminated during the 30's in a cool geometric style, his "Bauhaus period"; the glowing radiation had lessened, like planets slowly crystalizing out of clouds of glittering dust. The compositions no longer appear to have been spontaneously improvised. This is considered by some to be the "reification phase" of Kandinsky's vision. In terms of the social reality to which that vision was hypersensitive, such crystalization mirrored the growing *stasis* of the postwar revolutionary movement, from Weimar Germany to the USSR. The new style further reflected, in its rigidity and almost excessive self-containment, the *implosion* of that movement. This fifth phase is severe, mechanical, inorganic. For his part, Kandinsky felt the "coldness" to be the coldness of *necessity,* a necessity which his undertaking was meant all along to unearth.

But it would be unwise to make of Kandinsky's develop-

ment a mere mirror of general events. His sixth and last period, arising out of Parisian exile, has been called a "great synthesis," and witnessed the reintroduction of motion, warmth, organicism, playfulness, and grace, while retaining the clarity and definition of form attained during the Bauhaus years. Such works as *Relations* and *Sky Blue* resemble delightful microscopic worlds where tiny beings sport in harmony, and this vision can hardly be said to "reflect" society during the Nazi occupation of France. At a certain point Kandinsky's project became transfixed, as it were, and it is at such points that the autonomous development of the individual can be said to overcome external determination. (pp. 255-59)

Kandinsky called the final phase of the abstraction process "monumental," "absolute," or "concrete" art; it would be the point at which all of life was deliberately composed in a single language of beauty, continuously renewing itself at the call of internal necessity. Gropius himself expressed the same rather hazy idea:

> Our ultimate goal, which is still far off, is the unified work of art, the "great work" in which no distinction between monumental and decorative art will remain.

Since Kandinsky's death in 1944, it seems the reverence—indeed, the love—he received while alive has only grown. He is constantly being "rediscovered" in his capacity as visionary, champion of articulate beauty, and creator of vividly beautiful images. Diego Rivera, who can scarcely be accused of harboring mystic impulses, wrote of him in 1931:

> I know of nothing more real than the painting of Kandinsky—nor anything more true and nothing more beautiful. A painting by Kandinsky gives no image of earthly life—it is life itself. . . . He organizes matter as matter was organized, otherwise the universe would not exist. . . . Some day Kandinsky will be the best known and best loved by men.

Yet it is perhaps this beauty for which he is so beloved that poses the greatest problem: it too can get in the way of necessity, as Kandinsky well knew. Beauty is easily "recuperated": it would come as no surprise to see Kandinsky motifs turn up on frocks at the next Paris rag fair. There is no aspect of knowledge about how people perceive the world ("the laws of the soul and senses") that is immune to perversion in the service of the market. How color, line, and form affect the viewer emotionally, how they play in concert upon the piano of the soul—all this passionately interested Kandinsky with regard to his project of creating "a new humanism and a truly popular culture" (Marc). The same knowledge becomes just another technique of advertising and behavioral control in the hands of a society driven to turn every native impulse against itself as a means of self-preservation.

The road to the Absolute has turned out to be the road to the obsolete, after all. Kandinsky himself situated the dilemma as early as 1913: "The danger of ornamentation was clear, yet the dead make-believe of stylized forms could only frighten me away." He rightly turned away from dead make-believe, but could do no more. Abstrac-

tion calls "painting" itself into question: the end of pictorial *representation* points past itself, perforce, toward the real thing: toward a resolution which lies well beyond the canvas and the colorful death agonies of art. Kandinsky either did not or could not realize this:

> The general viewpoint of our day, that it would be dangerous to "dissect" art since such dissection would inevitably lead to art's abolition, originated in an ignorant underevaluation of these [artistic] elements thus laid bare in their primary strength. . . . [The] "injurious" effects are nothing other than the fear which arises from ignorance.

Kandinsky, born in the old world, maintained a delicate, immovable balance on the cutting edge of the new. At the precise moment that art could no longer resist pointing beyond itself, he turned its secrets inside out, revealed all its ruses, and located its demise within that vast sweep of history which was already putting a *practical* end to "representation." "We have before us," he wrote, "an age of *conscious* creation." (pp. 269-71)

"The feeling for the good"; the spirit open fearlessly to all possibilities; the belief in the unfettered creative process and in the divinity of *man,* against all those . . . who would force humanity back into "stale repetitions of a world already too well known"—this vital spirit Kandinsky both expressed and embodied. It is the content of his work: *being,* generosity, transparency. It is what one can learn, or rather relearn, from that body of work. Only a genuine, active commitment to the development of free, purposive human creativity could have expressed itself in an aesthetic achievement of such value, such substance as Kandinsky's farewell to art as we have known it. Only of such achievements can no mistake be made. (p. 271)

> Marian Kester, *"Kandinsky: The Owl of Minerva," in* Passion and Rebellion: The Expressionist Heritage, *edited by Stephen Eric Bronner and Douglas Kellner, 1983. Reprint by Columbia University Press, 1988, pp. 250-75.*

SURVEY OF CRITICISM

Patrick Heron (essay date 1957)

[*In the following excerpt, Heron rejects Kandinsky's paintings as overly intellectual, indefinite, and emotionally unengaging.*]

I have never really liked Kandinsky. Historians of modern art, and all those who can recognize when an artist has at length been canonized, and are not so unrealistic as to raise a lone protest *after* the *fait accompli*—these will call my protest idiosyncratic. I do not care. I do not like Kandinsky! At least, I liked nothing by him until I saw one of his Fauve paintings—an *Arabian Cemetery* painted in 1909. . . . This picture vibrated with a sensuous con-

trol of touch that was to become utterly eclipsed by the far too exclusive intellectuality of all his works thereafter. It proved to me that at least Kandinsky had originally possessed powers of the sort needed to make a painter, not a philosopher. In painting, intellectuality is valid only if transmuted, that is, if it issues *through* an intuitive and *physical* experience. By the time the picture is actually being painted it is too late to *think:* the hand and arm and shoulder and, above all, the eye, are in sole control when work is, literally, in progress. Thought there is all the time; but the thought that goes into the painting is already something that has been done before the act of painting began: it is the *result* of the hours of thinking (while looking, walking or talking: not painting) that flows, only semiconsciously, from the memory into the picture that is under construction. The last long phase of Kandinsky, so mathematically tight and so literally measured, shows a brain making use of a hand and brush; whereas true painting shows the animated hand, nearly autonomous, eliciting meaning and energy from the mind *and* body of the painter.

I know, of course, about the influence of Kandinsky on present-day non-figurative painting. But possibly it is the things in the pictures of the Tachists and the action painters that are wrong that have come from Kandinsky? And from other Northern Expressionist sources: for Expressionism is at the root of the trouble with such quantities of Tachist and action painting now. And Expressionism springs from the overintellectual, as in Kandinsky, just as easily as from the over-emotional, as in Beckmann. Expressionism is therefore not a style, obviously: it is a broad category of artistic failure, and its prime characteristic is *unbalance*—the lack of an equilibrium in which the most intense passion is precisely held in control by intense rationality, or thought. In the greatest painting initial emotions of the utmost depth and violence are caged and sieved by a relentless *formal* faculty or instinct; the steam from the boiler emerges only in the rhythmic and limited release of piston strokes. In the painting of Van Gogh, for instance, each piston stroke was a brush stroke—each is perfect in its rhythmic order, for Van Gogh conquered the Expressionist in himself and forced his passions to translate themselves into impeccable design.

When, earlier this summer, the Arts Council brought an exhibition of paintings from the Guggenheim Museum. New York, to the Tate Gallery, there were no less than five Kandinskys. And so one was able to ponder the riddle of his influence (many of the younger painters in the collection were evidence of it) and wonder whether the formal genius represented in the same room by, preeminently, Bonnard and Picasso would ever reconquer the pictorial scene. Take Kandinsky's *Black Lines, No. 189,* painted in 1913. In color vapid, indefinite in every tone, with no sort of weight or finality in any single color-area or shape or form. A steamy, streaming flow and flux permeating all its ingredients; a lopsided, sideways-slipping scheme made up of a mass of unrelated, glittering touches—all different in tempo, in touch-pressure and in rhythmic character: a total absence of that *underlying* pulse, that as it were subterranean rhythmic unity which gave strength to the apparently shifting, disorganized atmo-

spheric surfaces of the Impressionists or Turner—to name examples that might be thought (wrongly) to exemplify the less formal in painting. Every element in such a painting as this Kandinsky is awkward, at odds with the media, at odds with the flatness and squareness of the canvas itself. It epitomizes *un*wisdom in painting. The sad, twitching, sliding brush lines wander with a perverse movement over the canvas, beginning with a show of impetuosity and then tailing off weakly into nothingness, a feeble twitching and an erratic slashing and stabbing alternating undecidedly. And the corners of the canvas are empty, proving that the type of thought here expressed is essentially nonplastic, non-pictorial: the picture surface is not a cardinal reality to the creator of this work. (p. 12)

> *Patrick Heron, "London," in* Arts, *Vol. 31, No. 10, September, 1957, pp. 12-13, 64, 65.*

Clement Greenberg (essay date 1961)

[*Greenberg is considered one of the most important American art critics of the twentieth century and is renowned in particular for his eloquent arguments in favor of abstract art. In the following excerpt, he offers a brief overview of Kandinsky's career.*]

Picasso's good luck was to have come to French modernism directly, without the intervention of any other kind of modernism. It was perhaps Kandinsky's bad luck to have had to go through German modernism first. Whether or not this is part of the real explanation, his success in anticipating the future remained compromised by his failure ever quite to catch up with the present. He was influenced by Cézanne and he was influenced, crucially, by Cubism, but he was never quite able to grasp the pictorial logic that guided the Cubist-Cézannian analysis of appearances—a logic that Matisse and every subsequent master of modernist painting has had to understand and come to terms with in order to realize himself. What were side issues for Cubism became ends in themselves for Kandinsky, and what were really the main issues he, in effect, skipped. Before a new generation of artists could take the path he opened, they had to retrace his steps and to make good, by going through Cubism, what he had omitted. Still, the largest cost was to his own art.

Starting from German Art Nouveau, Kandinsky entered artistic maturity with a style that was a highly original combination of Impressionism and Fauvism. Under the instigation, at least, of Braque's and Picasso's early Cubism, this turned into the stylistic vehicle of an outright abstract art. His best pictures were painted in the years just before and after this turn, between 1907 and 1914, a period coinciding almost exactly with that of Analytical Cubism. Even after becoming completely abstract in intention, Kandinsky's art continued for a time to evoke landscape and even flower subjects, and its allusions to nature do almost as much as anything else to secure the unity and coherence of the individual picture. Lightly modeled shapes hover, and purely linear motifs circulate, within an illusion of three-dimensional space that, except for its shallowness, is almost pre-Impressionist. There is a Cubist note in the play of "hard" drawing against "soft" brush-

ing, but Analytical Cubism, with its final assertion of a dynamic flatness that conventional modeling or shading could not penetrate, was really more "abstract," more organically nonillusionist than Kandinsky in his freest improvisations. The atmospheric space in which his images threaten to dissolve remains a reproduction of atmospheric space in nature, and the integrity of the picture depends on the integrity of an illusion.

It was after 1920, however, that Kandinsky's lack of Cubist grounding in the nature of pictorial "abstract" space began to reveal itself most unmistakably as a liability. Like many an outsider who sees things more quickly than insiders do, Kandinsky had in 1911 perceived and seized upon those implications of modernist painting which made it possible to envisage a nonrepresentational art that would be pictorial before it would be decorative. Cubism, according to the internal evidence, furnished him with the clearest indication of this possibility; but the nonrepresentational tendency of Cubism was a by-product and not the aim of its reconstruction of the picture surface. Kandinsky's failure to discern this led him to conceive of abstractness as a question down at bottom of *illustration,* and therefore all the more as an end instead of as a means to the realization of an urgent vision—which is all that abstractness as such, like illustration as such, can properly be.

Kandinsky's exceptional contribution was to keep flatness and the nonrepresentational dissociated for a little while longer. Cubist flatness imposed geometrically oriented drawing and design on ambitious painting, but Miró, the Late Cubist, was able to loosen its hold with the help of Kandinsky's "free" contours and his shallow but indeterminate depth; and Gorky and Pollock in America were able to do likewise in their own good time. By 1920, however, Kandinsky himself had accepted what he thought was Cubist flatness, following the lead more or less of Synthetic Cubism, which, at the same time that it returned to more obviously representational silhouettes, resigned itself to a more obvious flatness. And along with this flatness, Kandinsky accepted geometrical drawing, but without understanding the necessity in the relation between the two. For him the picture plane remained something negatively given and inert, not something that acted upon and controlled the drawing, placing, color and size of a shape or line, and whose flatness was re-created by the configurations upon it, or at least (as with the Old Masters) reinvoked. Geometrical regularity, instead of preserving the tension and unity of the surface by echoing the regularity of its enclosing shape, became for Kandinsky a decorative manner that had little to do with pictorial structure. The surface remained, in effect, a mere receptacle, the painting itself an arbitrary agglomeration of shapes, spots and lines lacking even decorative coherence.

There is a great variety of manner, motif, scheme and configuration in Kandinsky's later works, but it is a mechanical variety, ungoverned by style or by the development of style. The works in themselves remain fragments, and fragments of fragments, whose ultimate significance lies mostly in what they allude to: peasant design, East European color, Klee, the world of machinery—and in fact that

they contain almost nothing spurious. Kandinsky may have betrayed his gifts but he did not falsify them, and his honesty, at his own as well as art's expense, is utterly unique. For this reason alone if for no other, we shall have to go on reckoning with him as a large phenomenon if not as a large artist.

A last question that suggests itself is whether he did not make a mistake in terms of his own development by abandoning representational art when he did. Might he not have produced more work of intrinsic value, and of greater intrinsic value, had he continued to exploit his vision of landscape a while longer? Have not more than a few of even the best of his early abstract paintings taken on that characteristically faded look which belongs to premature innovations? Such questions are not idle in the case of this artist and this art, the status and value of which are so hard to determine. (pp. 111-14)

> Clement Greenberg, "Kandinsky," in his Art and Culture: Critical Essays, *Beacon Press, 1961, pp. 111-14.*

Herbert Read on Kandinsky:

Kandinsky's art is not for every taste; but for those who can appreciate the strength and beauty of an art that imposes the clearest intellectual unity on a chaos of Dionysian elements, his achievement will rank among the highest in the history of modern art.

> *From* Kandinsky (1866-1944), *Faber & Faber, 1959.*

Paul Overy (essay date 1964)

[*Overy is an English educator and art critic. In the following excerpt, he examines Kandinsky's use of color.*]

It is significant that, even in his childhood memories, Kandinsky detached colour from the object:

> The first colours which made a strong impression on me were light juicy green, white, crimson red, black and yellow ochre. These memories go back to the third year of my life. I saw these colours on various objects which are not as clear in my mind today as the colours themselves.

These early experiences of natural colours were paralleled by his first contact with the artificial colours used by the artist. Kandinsky records the immense thrill of squeezing his first oil colours out of the tubes, at the age of thirteen or fourteen; they seemed to assume an autonomous life of their own. As he mixed the colours on the palette

> the brush with unbending will tore pieces from this living colour creation, bringing forth musical notes as it tore away the pieces.

Kandinsky was fascinated by the arrangement made by left-over colours on his palette, for this partly reflected the will of the artist and partly the law of accident. He learned

much from these coincidental combinations: their influence can be clearly seen in the works of 1913-4, such as *Large Study,* which give the impression of being elaborate preparations for some vast 'work in progress' (the nature of which could only be inferred from these complex colour *schemata*).

Before Kandinsky came to use colour in this free manner, many inhibitions and conventions had to be overcome. He had to liberate himself not only from the nineteenth-century academic fear of the free use of colour which he encountered in Munich in his early years, but also from the impressionist ideas of employing colour so as to capture the play of light on objects. Although, finally, the influence of Matisse and the Fauves freed him from this, elements in his own background and environment also helped. In 1889, while a research student at Moscow University, Kandinsky had made a sociological expedition to the peasant community of Vologda in Siberia. There he was deeply impressed by the peasants' houses, which were completely covered inside with brightly coloured woodcuts and everything, from ovens to lavatories, ornamented with bold, gay design. He did many sketches of these ornamentations which, he recalled, 'were painted so strongly that the object dissolved within them', though he added, that this impression became clear to him only much later on. The power of colour to 'dissolve' the object was to be of extreme significance in his work of the Blaue Reiter period.

Later encounters with German folk art were equally important, in particular Bavarian glass-painting, from which Kandinsky drew constant artistic sustenance during the years before the Great War. Sir Michael Sadler, who visited Kandinsky and Gabriele Münter in their house at Murnau, in the Bavarian Alps, recalled that it was full of such glass-paintings. Sadler was there only for a brief half-day visit, but Kandinsky insisted on taking him to an old glass-painter's workshop to see further examples.

In Kandinsky's landscape sketches painted before 1908 in the immediate environs of Munich, his colours, although rich, have a low-toned, sticky quality. The thick golden-syrup light of the Isar valley, which inspired them, was hardly conducive to the expression of natural energy through colour. His use of the palette knife to break down light into malleable lumps, instead of trying to catch the fleeting flicker of light on natural surfaces, after the Impressionist manner, was moderately successful, as in works like *Kallmünz Oberpfalz,* 1903, but tended to produce a clotted, static effect.

> With my spatula I cut coloured spots and stripes on the canvas and let them sing as loud as I could. . . . In my eyes was the strong, colourful scale of the Munich light. . . . Later at home always deep disappointment. My colours appeared too weak to me; the entire study an unsuccessful attempt to capture the energy of nature.

Exactly! Kandinsky was still too cautious. Although the quality of the paint was rich, the colours were too weak and too flat to 'sing' very loudly. And his aim was to achieve the equivalent of the rhythmic, melodic and har-

monic energy of a song. In 1908 he finally discovered how this could be done. He began to use saturated rather than 'rich' colours and utilized the optical effects of these saturated colours, placed in close proximity, in order to achieve a strong, pulsating rhythm and to produce powerful harmonies and discords. Melody was still absent, or, at best, rudimentary. Melody in painting is essentially linear and the line plays a relatively unimportant rôle in the works of 1908-9. Perhaps it was the astringent mountain air of the Bavarian Alps, where he began to paint in 1908, that finally gave Kandinsky the necessary physical stimulus to free his work from the sticky harmonies of the earlier Munich works, although his visits to Italy and France (1905-7) had also had their effect. The works he painted abroad, such as **Rapallo,** 1906, were superior to those painted in Munich; colour is used more freely and with a lighter and more vibrant touch.

Colour was for Kandinsky a spiritual experience; and when finally, in 1908, he began to treat pure colour as an expressive force, we feel the synthesis is like a jubilant song of praise. His work suddenly comes alive and, with this explosive liberation, he began to achieve what he had been striving after for many years—the transformation of a landscape into a viable image expressing his innermost thoughts and emotions. Colour and form assume, as it were, an accelerated quality. Landscape takes on the quality of *movement* rather than of space or light. The overworked and slightly contrived effect of the early style vanishes and is replaced by an ease of execution and a fluency of colour which give to these works their extraordinary quality of exhilaration.

In the finest of these paintings, for example, **Landscape with Tower,** 1909, the illusion of depth is eliminated almost completely: the pure, saturated colours pulsate and thrust forward on to the picture plane the forms they denote. Thus the abstract and expressive, rather than the representational, elements are strongly emphasized; and the energy of nature is dynamically expressed through colour, but is still controlled within the structure of the composition. In the later Blaue Reiter works, these energetic forces were to explode violently on the canvas and Kandinsky was forced to devise new means to control them, once the representational framework had been swept away.

Colour alone now began to suggest the form and structure of the composition (in the way that Kandinsky described the influence of his own palette on his work). Areas of colour appear to expand until they are halted by their impingement upon each other. The expressive structure of the painting is built up on the chords created by the collision of these expanding colours, until, in works such as **Large Study** 1914, the process can go no further without artistic disintegration. Some other way had to be found of composing colour, some new and more precise method of controlling it.

Kandinsky brooded over this problem in the artistically inactive years he spent in Russia, from 1914 to 1921, and the few works he then produced reflect this preoccupation. The chance to try out his developing ideas in pictorial form duly came with his arrival at the Bauhaus in 1922.

In the early Bauhaus works, line plays a very prominent rôle. Kandinsky was not a natural draughtsman, in the way that he was a natural colourist, and sometimes, in the early Bauhaus works, we get the feeling that line is a little too consciously imposed on colour: the two elements are not entirely integrated and the result is a slight awkwardness. In the later Bauhaus paintings and in the works he produced in Paris, during the last ten years of his life, Kandinsky had completely overcome this difficulty: line and colour work together to produce some of the most beautiful and profound paintings in twentieth-century art. This resolution is first achieved in the magnificent **Composition VIII** of 1923.

A work of 1925, **Black Triangle,** is particularly interesting, because Kandinsky reproduced a drawing for this in the appendix to *Point and Line to Plane.* The drawing is very exactly done with ruler and compass and the design of the finished picture is virtually unchanged except for a few (but significant) additions—the Ferris wheel shape on the left-hand side, the three small, coloured circles below it, the crescent moon in the top right-hand corner and the three straight blue lines leading down from just below it. However, the finished work is far more than a drawing to which colour has been applied. The colour is bounded within the lines, but it is not always applied uniformly. The orange-pink of the crescent-moon shape is applied thickly and unevenly, giving it a glowing, organic effect. Most of the triangles and circle segments are filled in with fairly flat colour, as befits their more precise nature. The grey-green background is brushed fairly thinly, but is slightly darker round the edges, concentrating the attention on the centre of the picture.

In the early Bauhaus works, Kandinsky left the backgrounds white or painted them pale yellow, making his bright colours sing out sharply against them, but in these works of the mid-twenties the colours burn luminously through sombre grey-blue or grey-green backgrounds with an increased subtlety. The range of colours is extremely wide, but arranged so carefully that the full extent of it grows on one only gradually. Thus there are at least four different blues, four different greens, various shades of yellow and ochre and of red and brown. Where the various planes of colour overlap, subtle new shades are created. The whole work is extremely complex and the relationships between linear forms, the colours delineated by these and the colours created by the overlapping of two or more forms are very carefully worked out. At each inspection the work reveals new combinations and relationships.

Kandinsky wished to produce a kind of painting which would have the same direct effect on the spectator as music has on the listener, by-passing the representational element which seemed to block or dilute the true expression of the artist's thought and emotion. He saw in the use of colour, divorced from all its descriptive connotations, the means of doing this. In *Concerning the Spiritual in Art* (written in 1910), he wrote:

> Colour is the keyboard, the eyes are the hammers, the soul is the piano with many strings. The artist is the hand that plays, touching one

key or another purposely to cause vibrations in the soul.

However, it needed the addition of a highly organized linear structure to introduce the important element of *melody* into his art; and this was his great achievement, when he succeeded in making line and colour work together in the later Bauhaus paintings.

If **Black Triangle** has the hushed and intimate quality of chamber music, a picture like **Green Sound,** 1924, is comparable with a full orchestral work: the vibrant reds, yellows, ochres and violets are like the drums and brass of a large orchestra; but it is the 'green sound' of the title which, on further inspection, predominates, like the sound of the subtler and less brazen woodwind or of strings. *Yellow Circle,* 1926, is extraordinarily simple yet extremely powerful, deep and rich in tone, like an unaccompanied 'cello suite.

As a young man, Kandinsky had stood before the Rembrandts in the Hermitage and noticed that, because of the incredibly subtle gradations between the enormous contrasts of light and dark, these works appeared to 'last long'—to have the quality of *time;* one of the most important characteristics of music and one that painting rarely achieves. Many years later, in the works he produced during the last ten or fifteen years of his life, Kandinsky found his own way of achieving this. The paintings are constructed of several broad areas or forms, filled with strong colours which contrast with each other, producing basic harmonies or discords. Then there are small bands or shapes in which subtler and less obvious colour chords are produced; and, finally, the many tiny forms scattered over the picture surface, often brightly coloured, produce further chords. The whole construction of forms is usually spread over a dark- or neutral-coloured background. The spectator's attention is first arrested by the major colour relationships; then the subtler and less obvious chords make their presence felt, the picture unfolding a sequence of colour harmonies which become increasingly subtle and complex, as each newly perceived relationship modifies the whole structure of the painting as seen by the spectator. The painting has become an incredibly rich and exciting expressive form imbued with constantly changing energies.

Nowhere can this be more clearly seen than in the stupendous works he produced in 1936, **Dominant Curve** and **Composition IX,** the highest point of his artistic career. The colours of these works have an almost indescribable magnificence. The Oriental colour chords, which occur often in these late works, sound here with unusual power and splendour—green, lilac, egg-yellow and brilliant, searing vermillion stand out against duck-egg blues and greens and, as the eye examines the profusion of coloured forms, endless gradations of tone and pitch are revealed. Here, as in the Munich works of 1913-4, Kandinsky displays his great mastery of colour, but composed with far greater clarity, precision and coherence. However loose and various the forms, however daring the colour harmonies, everything is under complete control, nothing is arbitrary. There is none of the suggestion of the imminent chaos of the earlier work, and yet the whole constellation of forms and colours appears so spontaneous that one is hardly conscious that they are *drawn* at all. The effect of a work like **The Good Contact,** painted two years later, is scarcely less powerful, but, in the dark background and slightly hushed harmonies, Kandinsky is now moving towards the more muted, slightly sombre works, full of the calm contemplation and acceptance of death, which characterized the work of his last few years. (pp. 407-13)

> *Paul Overy, "Colour and Sound," in* Apollo, *n.s. Vol. LXXIX, No. 27, May, 1964, pp. 407-13.*

Rose-Carol Washton (essay date 1969)

[*Washton is an American art historian who has written extensively on Kandinsky. In the following excerpt, she discusses the works that Kandinsky produced during the last eleven years of his life, focusing in particular on the means he used to achieve tension.*]

In 1933 [Kandinsky] was forced by the political situation in Germany to move to France. It was difficult for the 66 year old artist to leave the country where he had worked so successfully since 1897, but, despite initial misgivings, he remained in Neuilly-sur-Seine on the outskirts of Paris until his death in December 1944, writing numerous theoretical articles and painting over 350 oils, watercolors and gouaches. While the Paris paintings can be said to be less revolutionary than the earlier canvases, they are at the same time more complex in their resolution of spatial and structural problems. Flowing amoeboid shapes activate the surfaces, providing a distinct contrast to the geometric figures which appear in many of the compositions. Color, primarily of a pastel nature, alternately soothes and jars. Planes shift, projecting and receding at the same time. In these paintings, Kandinsky manipulated color and structure to create spatial ambiguities, believing that the resulting tensions would attract and hold the attention of the viewer. He had always considered the involvement of the spectator as one of the most important aspects of his work.

Although his style changed several times during his 48 year career, his goals remained remarkably constant. A statement written in 1942 declaring art to have a "prophetic power" recalls the mystical flavor of a 1912 description of painting as a "power which must be directed to the development and refinement of the human soul." In the years before World War I, he had been influenced by the Theosophical ideas of Rudolf Steiner, whose theories about a "spiritual revolution" were well known in Germany. Kandinsky had become committed to a messianic view of the artist and he continued to believe that the arts could directly stimulate a change in man's spiritual life. After the move to Paris, he explained in one essay that the study of art would lead to knowledge of a "cosmic" world, which he described as more real and more concrete than man's physical environment. In reaffirmation of this belief, he began during the 1930s to apply the terms "real" and "concrete art" to his paintings.

Abstraction was central to his vision, for he felt it was the style best suited to the communication of a "spiritual" message. Maintaining that colors and forms unconnected

to the delineation of an object could produce the most universal and timeless of paintings with the strongest "spiritual vibrations," he searched for combinations which would penetrate man's consciousness to arouse an emotional reaction. Consequently, his interpretation of abstraction changed over the years. His first experiments before World War I were based upon the simplification of an object to an outline over which skeins of brilliant color were loosely painted further to obscure the image. These "proto" abstract paintings often relied upon Apocalyptic symbols such as trumpets and angels to suggest the rebirth of spirit and resurgence of energy which he believed would emerge after the destruction of materialistic values. A few years later, he replaced the eschatological symbols with geometric shapes, drawn with the aid of a ruler or compass. A prolonged visit to Russia in 1915-21, where he met a number of abstract painters using geometric forms (among them Malevich and Tatlin), was partially responsible for his greater reliance on Euclidian figures. Teaching at the Bauhaus from 1922 to 1933 confirmed his view that geometry contained the purest and most universal forms known to man.

Although he had written of the relation of organic shapes to cells, protoplasm and other elements connected with the beginning of life as early as 1926 in his major theoretical tract, *Point and Line to Plane,* he did not fully explore these possibilities as the basis for an abstract style until after the move to Paris. The shift in favor of organic shapes is clearly evident in a number of paintings of 1934; geometric figures have not completely disappeared but curved leaf-like and amoeboid ones have become dominant. *Green Figure,* 1936, suggests a microscopic vision of protoplasmic matter while *Variegated Black,* 1935, and an untitled gouache of 1941 contain shapes resembling an embryo in its sac. Kandinsky must have been encouraged by the biomorphic abstractions of Miro whose paintings could easily be seen in Paris. Moreover, his interest in the emotional power of zoomorphic and biomorphic figures was reinforced by the Surrealists' experiments with automatism.

Believing that the observer's attention would be attracted by the implicit vitality of life-like organic forms, Kandinsky sought to prolong the spectator's involvement with his work by creating a feeling of tension on the surface of his canvases. In most of the paintings of this period, spatial ambiguities, color transparencies and weight reversals are combined to achieve the desired tensions. *Dominant Violet,* 1934, is one of the first of the large-scale paintings to exploit these intricate devices in the arrangement of its geometric and biomorphic forms. The most striking and certainly the most ambiguous area is the large purple tentacle shape which gives the painting its name. The contrast between its thick texture and its thin color sets up an immediate conflict. Although heavily laden with sand, the purple color appears to be transparent, reflecting other shapes, such as a green rectangle, in its massive ground. The spectator's attention is shifted away from the lower portion of the painting, the traditional center of interest, by the placement of the purple mass in the upper section. The instability resulting from this reversal is further reinforced by the drawing of smaller biomorphs lower on the

picture plane and by the narrowing of pastel rectangles at the bottom rather than at the top. While the sandy texture and the flat, weightless shapes emphasize the picture plane, the reversal of balance, in addition to the absence of a ground or horizon line creates the illusion of a pool in which the organic and geometric forms seem to float.

In *Point and Line to Plane,* Kandinsky explained how tensions between forms and the picture plane could be used to create an "indefinable space." He had written of "dematerializing" the basic picture plane, suggesting that the creation of illusionistic space was equivalent to the creation of cosmic space. At one point, he had related the upper section of the canvas to the heavens and the lower part to the earth. Although he warned that his explanation was not meant to be taken literally, his choice of words may clarify to some degree the complex orientation of his paintings.

A number of Kandinsky's largest oils have the strongest shapes in the upper section of the canvas. *Composition IX* and *X* and *Center with Accompaniment,* to mention only three, reveal this type of structure. Contrasts between small and larger figures add to the spatial ambiguity. However in *Composition IX,* the vivid colors of the striped background counter the illusion of depth created by the size differentials. In *Composition X,* the black background reinforces the two-dimensional nature of the picture plane, but at the same time the multi-colored curving shapes appear to float in a limited space.

In other works, ambiguities as to figure and ground contribute to the tension. In *Two, Etc.,* 1937, the almost symmetrical division between white and black sides creates an illusion of shifting planes. While the white side seems to project in front of the black, the color reversal of the figures (in this case—flags) sets up exchangeable spatial values. This instability is intensified by the curvature of the bluish-white flag which appears convex at one moment and concave the next; the black flag remains relatively flat.

Occasionally, Kandinsky alleviated the results of the tension-producing devices by using them to a whimsical end. The intricate balance in *Yellow Painting,* 1938, is playfully lightened by the suggestion of an anthropomorphic form in the pattern of colors. A figure, balancing on one foot while holding a tray in its hand and a heavy weight on its head, seems to emerge from the checkerboard pattern.

During the last four years of his life, Kandinsky seemed to grow more confident in the ability of the biomorphic and zoömorphic forms to vitalize his canvases. Tension-inducing elements such as the use of color transparencies are reduced. Many of the oils are quite small and are painted on board (a result of the wartime shortage of canvas and paints) causing a variety of textures. To compensate perhaps for the disappearance of geometric forms, Kandinsky frequently arranged the zoomorphs into several clearly defined rectangular areas. In *Division Unity,* one of the most beautiful of Kandinsky's last works, the picture plane is divided into three rectangles which tend to activate the surface through their different spatial properties. Despite the different levels of recession, the similarity

of the various shapes, the repetition of a number of key colors, and the weightlessness of all the forms, allow this oil to live up to its title of "division" and "unity."

In addition to 144 oils, Kandinsky painted over 200 water-colors and gouaches during these last 11 years. Although some are studies for larger works, most can be considered independent of but equal to the paintings on canvas. They have a delicacy of color and texture that is commensurate with their smaller size. Particularly after 1940, these wa-tercolors and gouaches often seem more experimental in their exploitation of the medium than do the oils. In some, stippled or sprayed paint is used to create a textured back-ground while in others, the color of the paper is allowed to show through the layer of paint. Kandinsky frequently contrasted opaque and translucent areas as he did in the larger paintings. In an untitled gouache of 1937, the changing of the color of one shape as it passes over another complicates the relationship between the small zoo-morphs, the vertical and horizontal rectangles and the pic-ture plane. Similar to the structure found in the oils, the composition becomes heavier near the top. Like many of the paintings of the Paris period, the gouache is in pastel colors, but it does not have the sharp, jarring tones found in some of the larger canvases. The closer color harmony contributes to the feeling of lightness which permeates this work.

Kandinsky's last completed painting, **Moderate Momen-tum,** 1944, offers a somber contrast to the airiness of the watercolors and gouaches. The deep, mauve background of the oil has been said to reflect Kandinsky's conviction that purple is the color of sadness. The placement of the forms, particularly the dull green octopus shape in the upper left, contributes to a spatial ambience that is not felt in many of his paintings of the 1940s. One could easily be led by the deeper space and the mournful color romanti-cally to hypothesize that this painting transmits a prophe-cy of Kandinsky's impending death. However, there is lit-tle evidence to suggest that the artist was aware of the seri-ousness of the illness which was to keep him bedridden for several months before he died. **Moderate Momentum,** like most of Kandinsky's works, is best understood as a contin-uation of his earliest principles, annunciated at the very beginning of his experiments with abstraction:

> Painting is a thundering collision of different worlds, intended to create a new world in, and from, the struggle with one another, a new world which is the work of art. Each work originates just as does the cosmos—through catastrophe which out of the chaotic din of instruments ulti-mately create a symphony, the music of the spheres. The creation of works of art is the cre-ation of the world.
>
> (pp. 46-49, 56)

Rose-Carol Washton, "Vasily Kandinsky: A Space Odyssey," in ARTnews, *Vol. 68, No. 6, October, 1969, pp. 46-9, 56.*

Kandinsky on the artist:

One must not forget that art is not a science, where the "cor-rect" theory proclaims the old one false and cancels it out.

The only stand toward art which is creative demands, with all clarity, that one surrender oneself to the personal reso-nance of the artist, that one entrust oneself to him, that one enter so deeply into his work that all which is old and stale is reduced to silence. Then a new world, which he has never known before, opens up for the spectator. He journeys into a new land of the spirit where his life will be enriched.

This country, which the artist is compelled to show his fel-low men and which, despite all and defying all, he must em-body, is created by the will of fate, not for the artist's sake but solely for the spectator's, because the artist is the slave of humanity.

From Artforum, *March, 1973.*

Peg Weiss (essay date 1979)

[An American educator, museum curator, and critic, Weiss is concerned in particular with early influences on Kandinsky's career, particularly that of Germany's dec-orative arts, or Jugendstil, movement. In the following excerpt, she cites Kandinsky's woodcuts as important precursors to his espousal of abstract art.]

For Kandinsky, the woodcut represented a *Klang* [tone], a synthesis of poetic, musical, and artistic elements. In his moving defense of the woodcut medium, Kandinsky had described his woodcuts specifically as "artistic purposes [leading] toward a goal," "stations on the way" to works of art. They already bore a *Klang* of the end goal within them. Woodcuts were at once "decorative" and signifi-cant. They were capable of suggesting profound meaning in much the same way as poetry, by means of a condensed image. . . . [Kandinsky's] first significant work, **Poems without Words,** was a supremely poetic effort. A second portfolio of woodcuts published in 1909 represented an-other such effort. It was called **Xylographies,** an obvious reference to the musical quality Kandinsky felt them to represent. In 1913 Kandinsky published his graphic mas-terpiece, the volume of prose-poems and woodcuts enti-tled *Klänge,* which contained echoes of his work from his earlier to his later Munich period.

It was the woodcut which was to serve as the bridge over which Kandinsky was able to advance from "decorative" art to abstraction. In an essay written for *XX*ᵉ *Siècle* in 1938, Kandinsky in fact stated that in his woodcuts and poems were to be seen the traces of his development from the "figurative to the abstract. . . . "

Whereas Kandinsky's early landscapes, until approxi-mately 1907-08, remained for the most part hesitant and awkward, his more decorative paintings and his woodcuts fairly sang with confidence and skill. While exhibiting a steady progress in clarity of color and ease of paint appli-cation, many of the landscape oil studies can only be as-

sessed as minor works in the total oeuvre. The woodcuts, on the other hand, despite their size, are works of major significance. The *Zylographies,* made in 1906, demonstrate a superb technical finesse quite beyond many paintings of the same period (compare, for example, the 1906 oil study, *Near Paris,* and the woodcut from *Xylographies, The Birds.* The published portfolios do not by any means represent all of his graphic work at this period. Between 1906 and 1908, some thirty-three woodcuts by Kandinsky were published in the French periodical *Tendances nouvelles,* some dating from as early as 1902-04.

One of the technical devices Kandinsky adapted from his earliest *decorative* paintings to the transitional landscapes of the Murnau period (after 1908), was the short, oblong, mosaiclike brush stroke. Already in those early paintings, such as *White Cloud* or *Riding Couple,* the color *Fleck,* or spot, had an independent compositional significance. In the later landscapes, enlarged in size, these color dots were used quite like independent building blocks, as for example in *Street in Murnau* of 1908.

It is also interesting to note that many of the Murnau landscapes bear a characteristic resemblance to woodcuts. *Church in Murnau,* for example, with its strong, flat areas of color and simplified forms has the crispness of a color woodcut. The palette has been reduced to a few saturated colors, which are placed next to one another without transitional tones. The dark and light areas contrast strongly and are handled in much the same way as positive and negative space in a woodcut. If we compare the painting *Landscape near Murnau* of 1909 with a woodcut on a similar theme by Martha Cunz, the resemblance is striking. While the Cunz work is somewhat more "naturalistic," both the smoke and the train are stylized and treated as independent compositional forms as in the Kandinsky painting. The trees and clouds in the painting are even more concentrated than in the print.

The woodcut by Cunz, called *Evening,* had been reproduced in the same 1905 article by Wilhelm Michel on Munich graphic artists that had included reproductions of two Kandinsky woodcuts, as well as a discussion of Kandinsky's work in that medium. In fact, Kandinsky had corresponded with Michel, with whom he seems to have shared ideas on art, for the article began:

> Graphic art is style, graphic art is aperçu, lyric, extremely personal epigram; graphic art is no striving after truth to nature, but rather yearning for subjective language. Graphic art is not world history, but rather, diary. Far off, life, large and incomprehensible, strikes the waves of its colors and lines, but on the modest, plain wood block are found only schematic abbreviations and personal sublimations of all that richness together. Graphic art is therefore romanticism. . . . Graphic art is conscious subjectivism, it is critique of perception and transcendental idealism. . . . Graphic art is aphorism. . . .

A little farther on, Michel added the very Kandinsky-like note: "Everywhere the material is the vehicle of the spiritual" ("Uberall ist die Materie das Vehikel des Geistigen").

It had become clear to Kandinsky that the drastic simplifications required by woodcut resulted in an enhancement of his work. That he placed a high value on his work in this medium can be seen by the fact that he continued to produce woodcuts and to exhibit these works throughout the Munich period. He exhibited his woodcuts in Phalanx exhibitions and in all of the Neue Künstlervereinigung exhibitions in which he participated. They were also included in his retrospective exhibition at Der Sturm in 1913. Kandinsky decorated his book *Über das Geistige* with his own woodcuts and included them in the *Blaue Reiter* almanac, the cover of which bore his woodcut variation on the theme of St. George and the dragon.

The horse-and-rider motif in fact represents a theme that can be traced through Kandinsky's oeuvre almost from beginning to end. Its gradual transformation from a figurative symbol to a symbolic abstract image can be observed in his decorative work, and in the woodcuts, with more consistency than in the paintings. A brief survey of the theme in terms of these works reveals the gradual development of an abstract form-language. . . . (pp. 127-28)

Kandinsky himself provided a fascinating clue to the development of this formal language in observations he made to Paul Plaut in 1929:

> If for example in recent years I have preferred to use the circle so often and passionately, the reason (or cause) for this was not the "geometric" form of the circle, or its geometrical characteristics, but rather my strong feeling of the inner force of the circle in its countless variations; I love the circle today as I previously loved the horse, for example—perhaps more, because I find in the circle more inner possibilities, for which reason it has taken the place of the horse.

Kandinsky further associated the circle itself with his concepts of the romantic and the lyric, in a letter written to his biographer Will Grohmann, in 1925, just a year before completion of the major painting, *Several Circles.* . . . For him, the romantic represented a constant, timeless value: "The sense, the content of art is romantic, and it is our own fault if we take the historical phenomenon for the whole concept." He felt that his painting *Romantic Landscape* (with its three racing horses) expressed the timelessness of the concept. " . . . where are the boundaries between the lyric and the romantic?" he wrote. "The circle, that I have used so much recently, can often be characterized in no other way than as romantic." Thus the "inner power," the "romanticism" once embodied for him in the horse, was now symbolized by the circle with its "inexhaustible" variations and "countless tensions."

The horse-and-rider motif in Kandinsky's early work was associated with the knight-crusader image, the image of St. George, the riders of the Apocalypse, and had perhaps as well associations with the Russian fairy tale, and with fond memories of a favorite jockey game he played as a child and recalled in "Rückblicke." Thus, many myths were concentrated in one image, and later transferred to the circle conceived as a truly "cosmic" symbol as in the 1926 masterpiece *Several Circles.*

Since this is such a powerful motif in Kandinsky's oeuvre, it is important to consider if indeed the horse and rider did actually evolve into a circle, and if so, how this was accomplished. By tracing the evolution of the motif in the woodcuts it may be possible to gain some insight into the method of transformation and into the question of whether or not this transformation was rooted in Kandinsky's decorative graphic art, as he himself suggested.

One of the earliest horse and riders in Kandinsky's oeuvre is to be found in the decorative painting *Dusk,* which was shown at the second Phalanx exhibition in the early spring of 1902. In the catalog, *Dusk* was identified as a "decorative sketch." Due to the broad outline around each of the forms in the design, it can be safely assumed that the work was intended as a design for appliqué. It depicts a knight on horseback charging through a moonlit wood. Both horse and rider are romantically set off with silver paint. The moon, the backing of the flower in the foreground, and the star are also silver. The star itself and the lance are gold, while the petals of the flower, in true romantic fashion, are blue. The horse is also pale blue, while the rider's cape and plume, the reins, saddle blanket, and harness plume are all a brilliant, saturated red. The acid green of the turf contrasts sharply, while the mottled brownish tone of the wood balances the composition. It is a bold painting. The wavy line surrounding the rectangular area of the painting is an integral part of the design, as can be seen by the fact that the work is signed in the lower left corner, well below the border. This wavy line has the effect of softening the rectangular contour of the composition and perhaps suggests a primitive hint of the circular motif to come.

It is on the title page of *Poems without Words* that we find the horse-and-rider motif for the first time surrounded by a circular border. The circle contains four horses and riders in all, one of whom is a mounted trumpeter; a boy in medieval garb with hands pressed together in a prayerful attitude; an incongruous cat, and several Russian buildings, some topped by crosses. Clouds swirling across the sky seem to dissolve into the decorative border. This is indeed a circle with many "inner possibilities."

Some of the woodcuts published in *Les tendances nouvelles* also associated the horse and rider with a circular motif. *The Dragon* depicts a horse and rider leaping or flying over a deep chasm, threatened by the three-headed beast. While this knight is not surrounded by a circle, he carries a perfectly round shield and is enclosed overhead by a sweeping half-circle, perhaps alluding to a rainbow.

Knight on Horseback reverts to the more-or-less rectangular format of *Dusk* with a similar motif, the knight charging from right to left. But here the outline has definitely been softened, not by a wavy line, but by a strong decorative oval.

While *Russian Knight* is not enclosed by a circle, it is on a perfectly square block and the points outlined by the horse's forelock, the tip of the rider's helmet, the top of the building in the background, and the horse's tail and raised foreleg, as well as the lines of the background hill, suggest an invisible circle.

This principle of the invisible compositional circle combined with the horse-and-rider motif can also be observed in the membership card for the Neue Künstlervereinigung of 1909. The theme is based on the earlier color drawing and painting *Riding Couple.* Here the circular movement is initiated by the curving black cliff on the left, carried on by the stepped roofs of the buildings on the higher cliff, then by the inward sweeping branches of the tree on the right. The hind legs of the horse touch the lower circumference of the circle.

Meanwhile the horse and rider began to undergo simplifications such that in a small woodcut for *Tendances nouvelles* in 1908, the horse is suggested by little more than the wood grain. In *Über das Geistige,* the horse appears in a drastically reduced image again enclosed by a circular form. In the vignette preceding the chapter "Die Bewegung," the horse leaping from left to right seems to burst through the plane of the circle. The form that streaks upward above his head suggests an abbreviated lance.

In several of the preliminary sketches for the cover of the *Blaue Reiter* almanac, the horse-and-rider motif appears as the central image, contained within a distinct circular form as, for example, in the watercolor sketch GMS 603. In the woodcut design for the cover of a monograph on Kandinsky (which subsequently was not published), we find the image of the battling stick-figure horses of *Composition IV.* Here once again, the invisible compositional circle is apparent, its upper left circumference marked by the back of the left-hand horse and its lower right circumference by the bending forms of the couple.

In the 1913 publication *Klänge,* there are a number of horse-and-rider motifs in combination with circular or oval forms. [In one woodcut] the central rider is enclosed by a domed cloud form suggesting a circle. [Another] depicts two riders surrounded by an oval. In the vignette for the poem "Fagott" the stick figure riders are framed by an oblong form. And the rider motif accompanying the poem "Blätter" is completely enclosed in a circle. In this case, the circle is actually repeated and reinforced by a series of dots around the outer circumference.

But the real beginning of the dissolution and final transformation of horse and rider to circle is to be seen in [the woodcut in which] horses, reduced to the barest outlines, are partially masked by large floating color motifs in circular shapes. One small horse and rider is visible in the upper central portion of the composition, the other two move toward left and right foreground, seeming to burst out from the center. Again, the whole design has been contained by a circular movement, this time suggested by the rounded corners on the left. The riders have been reduced to hooked or double curved lines, suggesting the head and back only of each rider.

Another work in which the horses and riders are drastically reduced, and also in which the masking spots appear, is the vignette for the poem "Ausgang." The color spots are much more explicit in the watercolor on the same motif known as *With Three Riders.* Here the three riders are clearly distinguished by large egg-shaped forms in yel-

Study for the Blaue Reiter Almanach *(1911).*

low, blue, and red, and have been reduced to the double curved line.

The most famous horse and rider, in the woodcut *Lyrical,* in *Klänge,* does not display an obvious circle. However, once again the corners of the composition have been softened so that the whole contour is more like an oblong than a rectangle. Again the development of the rider to a simple double curve is apparent.

Kandinsky wrote to Grohmann in 1932 that he had "transferred the line from its narrow confinement in graphics over into painting." To determine whether or not these motifs were indeed transferred by Kandinsky to his paintings, we have only to study *Picture with White Edge.* The central motif reveals the double curve associated with the rider motif in the woodcuts already analyzed. But further, he is surrounded by a large circular color spot associated, as has been indicated, with the horse-and-rider motif in several previous works. In fact, a drawing of 1912, closely related to this painting, displays the horse-and-rider motif clearly enclosed within a circle. The painting, dated 1913, may have been begun as early as 1912. However, the woodcut *Lyrical,* in which the double curved rider is apparent, can be dated to 1911. It is also likely that the *Klänge* woodcut with the three riders and the color spots dates from this earlier period.

In 1913 Kandinsky created a drawing related to his paint-

ing of the same year *Small Pleasures,* which was, as Lindsay has said, "like a late bud on a tree . . . prophetic of future growth" ["The Genesis and Meaning of the cover Design for the first *Blaue Reiter* Exhibition Catalogue" in *The Art Bulletin* (March 1953)]. The drawing demonstrates in no uncertain terms the transition of the horse-and-rider motif to the circle. On the left side of *Small Pleasures* three riders gallop up a hillside. They are even more clearly to be seen in the glass painting of the same title in the collection of the Städtische Galerie. In the remarkable drawing (which is signed and dated 1913), irregular circular forms take the place of two of the horsemen, while a perfect circle appears to replace the third. A transitional watercolor study of 1913 reveals the beginning of the angular horse motif (lower left) to which the perfect circle in the drawing is affixed. Slightly above this and to the right, a half-circle begins to encompass the next horse and rider, while near the upper center, an irregular, pale blue color spot envelops the third horse and rider, reduced now to linear schemata. In 1924, Kandinsky took up this theme once again to create the painting called *Backward Glance,* in which all of the horsemen have become circles.

After World War I, the circle appeared repeatedly in Kandinsky's work, often accompanied by a "lance," by the double curved sign for the "rider," or by the serpent-shaped dragon of St. George. All of these signs appear in *Backward Glance.* In a 1938 woodcut for the cover of *Transition* magazine, we find the horse-and-rider circle, the lance, and the serpent in constellation.

Kandinsky himself had suggested that traces of his development from the "figurative" to the "abstract" might be found among the decorative woodcuts. Indeed, the evolution of a favored motif has been traced. Thus did the artist's formal language progress toward abstraction. It may be recalled that one of Kandinsky's most successful and at the same time most Jugendstil decorative designs was composed of circles and wavy lines alone. If he had begun to compose paintings at that time, as early as 1904, with circles alone, he would have violated his own principles. For the artist *"must have something to say."* He could only arrive at a concrete image by imbuing it with experience. The circle eventually contained the crusader, the mounted trumpeter, the leaping horse, the lyric couple, the battle, the contradictions, the "inner force," in short, the sum of the "romantic."

Kandinsky was in later years adamant that the public should not be content merely to observe his use of circles and triangles. He wanted people to see what lay *behind* his paintings, what he called the "inner." The circle, he said later, comes the closest of the three primary forms to the fourth dimension. And the past it contained for him extended back in time to his first horse and rider in *Dusk.* The circle had become for Kandinsky a nexus of experience and memory, a cosmic all-encompassing image through which his past sped ever toward the future. Graphic art had served him well as a bridge over which he passed from Jugendstil toward abstraction. (pp. 128-32)

Peg Weiss, in her Kandinsky in Munich: The

Formative Jugendstil Years, *Princeton University Press, 1979, 268 p.*

Pierre Volboudt (essay date 1986)

[In the following excerpt, Volboudt offers an overview of Kandinsky's work during his years as a student and instructor in the Bauhaus.]

[The] Bauhaus years, first in Weimar (where the Olympian Goethe would have been hard put to it to find common ground with these new disciples of 'pure form'), then in Dessau, and finally in Berlin (where the Utopian venture became a practical, modern reality), were for Kandinsky a time of serene and intense creativity. The atmosphere suited him perfectly. He could paint, and he could also function as a teacher, administrator and writer. Over this period he published *Point and Line to Plane,* and produced numerous lectures and essays: 'The Basic Elements of Form', 'Colour Course and Seminar' and 'Concerning the Value of Theoretical Instruction in Painting'.

At the Bauhaus, the pupils were encouraged to concentrate on the abstract problems of form rather than to indulge in the act of painting. The walls were deliberately left bare. Possibly the blank surfaces that greeted Kandinsky on his arrival gave him an added incentive to retreat from the excesses of colour and turbulent effusions of his pre-war period. In Russia he had already taken the first steps towards clean lines and geometrical exactitude.

Pictorial space now became a pure surface, barely sullied by pigment and shot with hazy washes, or dark and practically opaque. Sometimes a particular plane stood out, like a painting within a painting, the break against the continuity of the ground serving to introduce an element of drama, a sort of relief in pictorial and fictive terms. What was lacking, for the full expression of intensity, was colour, and the drama of line itself.

Kandinsky said he did not choose his forms, they chose themselves through him, obeying a sort of necessity. He began to produce paintings in which the different elements coalesced, graphism predominating in wonderfully complete and satisfying compositions, balanced wholes, in which opposing forms acted as counterweights one to the other. Suppressed tensions energized the core of the picture, opening up gaps and fissures that split it apart and created secondary spaces within the limits of the closed forms. Diagonal rays beamed through the concentrations of abstract figures, glancing against their surfaces or skirting them altogether and leaving them unchanged and indifferent. A series of contradictory rhythms passed through the painting like waves, meeting in a moment of intensity. There was fixity of form, but it was the immobility of frozen movement. And the direction of that movement was predominantly upwards.

The theme of ascent permeates Kandinsky's work. In the final scene of [Kandinsky's play] *The Yellow Sound,* the giant rises up and is lost in darkness. There are numerous pictures with titles such as ***Floating, Graceful Ascent, Joyful Ascent, Now Upwards!, Reaching Upwards, Rising Warmth, Upward.*** For Kandinsky, art expressed aspiration, elevation in both the literal and the mystical sense. The shaman of the Altaic cultures might have recognized himself in the Giant who stands, hands to his sides like a tree-trunk, a triangular bird's wing above his head. The ladder that occurs so often in Kandinsky's work is a pictogram of the same cosmic tree, also represented by the mountain which, after Dessau, becomes a triangle.

There is a shaman song which goes:

> Above the white sky,
> Above the white clouds,
> Above the blue sky,
> Above the blue clouds,
> Rise into the sky, Bird!

The counterpart to this is one of the poems in *Klänge,* in which Kandinsky attempts to express colour as sound:

> Blue, Blue, shot up and up, and fell.
> Pointed, slender, whistled, dived and did not
> pierce.
> All quivered loud.
> Thick brown clung unyielding.

It is true that, in these paintings, nothing 'pierces', on the contrary, everything is suspended in space in a network of communications, discontinuities and convergencies. The forms are weightless; gravity holds them in position amid the geometric constellations of an abstract firmament. Sometimes they are attached by a slender thread to some narrow crescent, or skim the tip of a triangle, itself resting on an unsupported line. An arrow veers off at a tangent, or it points at an impenetrable circular mass that draws it as a magnet.

Each figure is caught in the nexus of tensions. It gravitates towards another formation, or repels it. A dynamic of fixity within instability governs the elements of these systems of forms, that are in fact force-fields. Spidery structures arise out of verticals and diagonals, forming frail linear webs and frameworks, terraces and pylons. Thin 'creatures' stand rigid as trees, resisting the forces that bear down upon them.

Yellow, Red, Blue (1925) illustrates very well this brand of formal invention. A number of superimposed rectangular panels are set above a flimsy armature that consists of a few lines traced on a swirling background; in another section of the canvas the ground is obscured by an upward-moving complex of interlocking planes, which straddle and mask the blue circle that is the dominant feature of the composition; that circle, finally, is pinned down with a thick, black flourish, a figure frequently employed by Kandinsky.

The principle underlying this and other compositions is one of duality, of opposing pairs. 'And' becomes a key word. It is a conjunction that implies both relationship and antithesis. Many of the titles presuppose the concept 'and', even though they do not state it explicitly: ***Division-Unity, Light in Heavy, Hard but Soft, Hard in Slack, Light over Heavy, Pointed and Round, Quiet Assertion, Same and Different.*** Kandinsky saw a profound significance in yoking together disparate images, since the apparent contradiction masked a fundamental principle of unity in which all things were interlinked.

Yellow, Red, Blue *(1923).*

Of all the forms distributed about his pictorial space, the dominant shape is the circle. Kandinsky regarded it as the ideal figure, both the simplest and the most assertive, a single contained tension that exerted a gravitational pull and yet itself remained unchanged and aloof. Depending on the distance from which you chose to look at it, it could be planet or asteroid, atom in space or space itself. The circle is omnipresent. It is the sign of completeness, and yet is capable of enclosing a void. Unvarying in its form, it is nevertheless capable of infinite variations, now a hard, unyielding disc of colour, ringed with concentric bands or fringed with haze, or sometimes diaphanous, or bitten with shadow and variegations, merging into an ethereal background. On its own, above the abbreviated bar of some illusory horizon (**Blue Circle No. 2**), it looks like a bright, shining star. In **In the Black Circle,** its dimensions have increased until it fills the picture, indeed it becomes the picture. In **Accent in Pink** (1926) and **Circles within a Circle** (1923), it spawns constellations that extend into an infinite space. Clustered together, these small clones overlap, sometimes transparent, sometimes imprinted with the hard edge of a partial eclipse. When they are more loosely grouped, they swarm in profusion and fly free, escaping the influence of the parent body; scattered stars, inextinguishable monads, they dwindle into stardust, tiny points of light, microcosms of form that contain within them the seeds of other forms.

Everything starts with the point. The barest dab of the

brush or nib on the bare canvas or the blank page, and the point becomes a line. Line dictates the form, guiding the artist's hand, willing itself into existence. It is action expressed in visible form.

Line makes the imaginary incarnate. A swift series of strokes, precisely applied, straight and curving, that is all it takes to construct the pictogram of an idea. In *Point and Plane to Line,* published in 1926 when he was at the Bauhaus, Kandinsky defined and classified all the elements of line and the properties and values it could acquire in combination. In these prolegomena concerning the 'science of art', he established the basis for a morphology and syntax of the components of his formal language, cataloguing them according to their nature, their innate characteristics and their functions. He further described them in terms of their orientation, the way they could be changed by pressure, or distorted, or grouped together in series, the influence of their positioning within a composition, as central or subsidiary parts, and finally their relationship to colours and the values expressed by colour. The vertical line tended, he believed, towards white, the horizontal towards black, and the diagonal towards grey. He saw angles too as having colours: right-angles were red, acute angles yellow and obtuse angles blue. But drawing needed only two 'colours'—the non-colours that subsume all the rest, black and white.

The austerity of Indiaink, its watery blackness shot with surreptitious lights, and the matt opulence of gouache;

these were for Kandinsky parallel mediums of expression. Graphism, in the spare simplicity and firmness of its line, is infinitely responsive, bounding ahead, slowing, pausing, following the inflexions and impulses of the moment. By virtue of its speed it is best suited to translate the fleeting promptings of the Spirit. (pp. 54-63)

'A circle, a line and nothing else.' This aphorism sums up an essential truth about Kandinsky's work. 'More than painting, it is drawing that creates,' said Leonardo da Vinci. Line is, in effect, rhythm, and we see that rhythm permeating Kandinsky's pictures. It emerges in the brush-stroke or the imprint of pen or pencil, dictating the overall tempo of the composition. For Kandinsky, everything could be seen and expressed in terms of line. Even the bowed strokes of the violin, slicing through the orchestra with their parallels and *sostenutos,* he described as lines. Listening to *Lohengrin* at the Court Theatre in Moscow, he saw them rising in the air in front of him, tangling in the sound-space, pausing, swelling and fleeing into infinity.

The silence of the blank page is the silence of the musical score that is yet to be written. On it will be created a pattern of dynamics, sharps, black and white notes, quavers, *appogiaturas,* downbeats and upbeats, rests and imperious chords. The graphic works are modulated like music, all types of line playing their part in the arrangement: bars, heavy scorings, sensuous undulations, thick and inky, or fine and insubstantial threads. Verticals, diagonals, symbols like forked tree-trunks, barbed with spines and antennae, stiff wheat-ears sprouting from some triangle, these co-exist with curls and arabesques, full elliptical orbs concentrating and dispersing space, sparsely inked trails linking two points, cross-hatchings, and free-floating calligraphic traces.

Out of these Kandinsky created geometric extravaganzas. Sometimes the drawing might be no more than a sketch, an outline scheme, sometimes it was a more or less exact study for a projected canvas. Even when Kandinsky was young he liked to draw pencil sketches of stylized landscapes. He was meticulous over architectural details or the finer points of a medieval scene. When he turned his back on bearded popes and bell-towers, and forms lost their representational value, he gave free rein to the fantasies of abstraction. Line flowed in thick waves, wove a dark tapestry. It narrowed, fragmented, span and swirled in effusions and trickles of ink, while at the heart of the confused mêlée a hard kernel presaged the calm perfection of the circle. As airy delicacy gave way to encroaching darkness and weight of pigment, so line was used to point up its forms. Equilibriums were established, the theme stated, echoed in subplots and diversions, modulated, repeated and inverted in an infinite number of variations.

The *Small Worlds* of Kandinsky's series of prints hardly qualify as forms at all—they are more like fragments, or shards, on the point of coalescing into their final shape. They are loosely encased in a sinuous line that cannot quite contain their pent-up energies and internal tensions. Movement is pinned down in line, and becomes fixed. But the inky crust themselves are unstable, they crumble, they drift, or become dispersed in veils of transparency. Soon

they will be no more than a cloud of dust, a powdering of dark phosphorescences in which hazy outlines can just be glimpsed. The touch lightens. Line becomes more sensitive, expressing tension and balance between the forms. The theme is orchestrated in a lyrical geometry, a subtle interplay of affinities, analogies and antagonisms. Even the most microscopic element—the point—has its function; for the artist it is a crucial presence, acting as both a focus and a counterweight, concentrating and linking the forms.

Strange new species spring to life in these prints, belonging to no single realm of creation. Hybrids of pure invention, the only reality they have is as line. These 'small worlds' are populated with polymorphous beings, ranging from the elemental to the most complex. Some are like cells, grafted together, others are fully formed, and covered in stripes, grids, checks, spots and striations of all kinds. They multiply by division and push out tentacles and new growths. As beams of light play over the black and inky presences—angles and arcs, arrows and winged signs—they seem charged with all the intensity of colour itself.

'Line is colour,' said Gauguin, and that is eminently true of Kandinsky's graphic works. It applies also to his watercolours and gouaches, consummately skilful linear inventions to which colour itself supplies a muted or strident accompaniment. The application of the paint lends a shimmering depth to the flat surface, veils of transparency overlapping in complex layers. The brushwork can be expansive, it can dilate and concentrate, and then immediately compensate by heightening a passage, adding a point of emphasis or a velvety smoothness, always responsive to the wayward caprices of a medium that must be captured in the instant.

By temperament, Kandinsky preferred to leave little to chance. When he used washes, he had to embrace chance as necessity. In wash-painting, speed is of the essence. The paper absorbs the fluid and becomes waterlogged, the colour runs, and there are only seconds for the brush to make its mark on the damp page. There is a sense in which every watercolour is an improvisation—and indeed Kandinsky was in the habit of painting watercolour studies for his definitive *Improvisations* and *Compositions.* The watercolours are so close to the form of the final oil paintings that you could superimpose them almost exactly. The masses, the movements of the lines and axes, the focus of force and intensity, all are the same. But these watercolours have a spontaneity and vigour and brilliance of colour that make them far more than sketches—or even replicas of a work that is anticipated though it does not yet exist. A watercolour by Kandinsky, whether technically a study or not, is a finished work in its own right, a wonderfully radiant fantasy of form and colour.

In *Green Perfume* (1929), the line snakes out from a green mist, shining with spangles, and threads its way through hazy shadows and swirling constellations that emerge from a pale, abstract sky. In *Black and Upwards* (1927), by contrast, the sky is the intense blue of a 'transfigured night', illuminated by the black glow of two discs trapped at the apex of a cluster of tall, thin triangles. The *Last Watercolour* shows a troop of identical forms tumbling this way and that as they frolic in space.

The enchantment and grave wit of so many of the water-colours are found too in the later oil paintings. ***Development in Brown,*** painted just before Kandinsky left Germany in 1933, looks forward to an era where forms will be liberated and undergo fantastic metamorphoses. Two dark panels open like curtains on a stage, to reveal a jumble of brightly lit triangles and crescents. They are like the announcement of a new generation of forms, no longer starkly geometric but straining to transcend their boundaries. Some of these forms will contain within them other figures that are diminutives of themselves. Others will be 'conglomerates'—coloured panels with little insets, the separate parts forming a whole. Other forms will be contained within structures resembling chessboards of thirty squares, the separate symbols commenting on each other as they are reinforced or negated by repetition or contrast within the context of the entire composition.

These late oils have a strong dynamic, thesis and antithesis. The duality may operate within a tightly-knit organization of space or an altogether looser arrangement of the forms, but in either case the canvas itself imposes finite limits. The opposing forces are locked in an impossible confrontation, free neither to retreat or advance. One massive presence dominates a puny adversary. Two others are balanced on a thread, held apart by a ring of multicoloured circles (***Reciprocal Accord,*** 1942). Groups of forms or individual figures are linked always by subtle correspondences; harmonies and discords are established between them. They are as though suspended on a line, like notes on a stave, attached to invisible threads that link a pair of diagonals, or ovals, triangles, squares, little amoebae, crested creatures or spiralling snails. Geometrical figures of all kinds co-exist with imaginary life-forms that flow in an unending stream from Kandinsky's brush and pen—polyps and miniature octopuses trailing long tentacles of colour. The only elements that stand apart from the seething activity are the unbending rectangles and squares, the trapeziums and the calm enclosed space of the circle.

Sometimes these figments of beings take on the look of costumed figures, in striped cassocks and masks, or little tricorns with crests of feathers and trialing ribbons. The giants of old have exchanged their shrouds for the gaudy geometric trappings of a ghostly Commedia dell'Arte. Euclid has assumed the guise of Harlequin.

In Kandinsky's *œuvre* there is utter seriousness combined with flights of light-hearted fantasy, a nonsense that hints at depths of meaning, protean, always, commenting on itself. Novalis talked of 'playful seriousness'—'the Tragical Play of Colours'. Did not Kandinsky once say that his aim in painting was to 'elevate himself to the heights through Tragedy'? Perhaps this profound and irreducible conflict of the forms was the means by which he chose to achieve that end.

The profusion of invented forms, endlessly metamorphosed, seem to arise from the depths of primordial memory, from the unconscious world of dreams. Antique chimeras are reborn in weird and unpredictable manifestations. An entirely abstract mythology is created, of which Kandinsky's *œuvre* is the visible representation. Its em-blem—the emblem of his life—could be a drawing of a white star in the sky above the black bar of the horizon, from which the meteors and clouds of the Spirit rise up ineluctably.

As an old man living in France, Kandinsky could look out from his open window at sunset and see the waters of the Seine glimmering through the foliage of the chestnut trees. One last cruel spectacle was reserved for him. As rockets shot up into the night—creating images like those he had painted all his life—he thought at first he was watching some maladroit firework display. War had created before his eyes a travesty of the arts of peacetime.

Only in his canvases did the fairytale live on. As fires were lit in Europe and the skies were ablaze with points and circles of light, streaked with black diagonals, the trajectory of his own life, which had spanned a continent, drew to a close. An era was ended, a line abruptly terminated. (pp. 66-77)

Pierre Volboudt, in his Kandinsky, *translated by Jane Brenton, Universe Books, 1986, 117 p.*

FURTHER READING

I. Writings by Kandinsky

Complete Writings on Art. 2 vols. Edited by Kenneth C. Lindsay and Peter Vergo. Boston: G. K. Hall, 1982.
> Journal articles, essays, and major texts on aesthetics and technique.

Concerning the Spiritual in Art. Translated by M. T. H. Sadler. New York: Dover Publications, 1977, 57 p.
> Seminal formulation of the principles of abstraction.

Sounds. Translated by Elizabeth R. Napier. New Haven: Yale University Press, 1981, 136 p.
> Volume containing reproductions of Kandinsky's woodcuts with accompanying prose-poems written by the artist.

Point and Line to Plane. Translated by Howard Dearstyne and Hilla Rebay. New York: Dover Publications, 1979, 146 p.
> Theoretical text in which Kandinsky explains the interaction between forms and the picture plane.

II. Catalogs raisonné

Roethel, Hans K. and Benjamin, Jean K. *Kandinsky: Catalogue Raisonné of the Oil-Paintings.* 2 vols. Ithaca: Cornell University Press, 1982.
> Complete catalog of Kandinsky's work in two volumes. Includes a biographical introduction and photographs of the artist.

III. Biographies

Grohmann, Will. *Wassily Kandinsky: Life and Work.* New York: Harry N. Abrams, Inc., 1965, 428 p.

Critical biography including a catalog of works, color reproductions, and photographs of the artist.

IV. Critical Studies and Reviews

Art Journal, Special Issue: Wassily Kandinsky 43, No. 1 (Spring 1983): 9-66.

Includes essays on various aspects of Kandinsky's work by Peg Weiss, Kenneth C. Lindsay, Wolfgang Venzmer, Monica Strauss, Edward J. Kimball, Susan Alyson Stein, and Rose-Carol Washton Long.

Ashmore, Jerome. "Sound in Kandinsky's Painting." *The Journal of Aesthetics and Art Criticism* XXXV, No. 3 (Spring 1977): 329-36.

Analyzes the techniques used by Kandinsky to represent sound in his painting.

Cohen, Ronny. "Kandinsky among the Constructivists." *ARTnews* 83, No. 4 (April 1984): 90-3.

Discussion of Kandinsky's middle period (1915-1933) occasioned by an exhibit entitled "Kandinsky: Russian and Bauhaus years," organized by the Guggenheim Museum in New York.

———. "Kandinsky: The Last Decade." *ARTnews* 84, No. 5 (May 1985): 98-101.

Appreciative review of the later works of Kandinsky occasioned by the exhibit "Kandinsky in Paris," organized by the Guggenheim Museum in New York.

Fineberg, Jonathon David. *Kandinsky in Paris, 1906-1907.* Ann Arbor, Mi.: UMI Research Press, 1984, 148 p.

Discusses Kandinsky's development as an artist during a year spent in Paris early in his career.

———. "Les Tendances Nouvelles, the Union Internationale des Beaux-Arts, des Lettres, des Sciences et de l'Industrie and Kandinsky." *Art History* 2, Vol. 2 (June 1979): 221-46.

Traces Kandinsky's involvement with Les Tendances Nouvelles, an international group of artists dedicated to the promotion of Symbolism in art and Utopian social concerns.

Garte, Edna J. "Kandinsky's Ideas on Changes in Modern Physics and Their Implications for His Development." *Gazette des Beaux-Arts* CX, No. 6 (October 1987): 137-44.

Discusses Kandinsky's theories of art, focusing on his critical inquiry into the role of intuition in formal applications of physics and painting.

Hahl-Koch, Jelena. "Kandinsky's Role in the Russian Avant-Garde." In *The Avant-Garde in Russia: New Perspectives, 1910-1930,* edited by Stephanie Barron and Maurice Tuchman, pp. 84-90. Los Angeles: Los Angeles County Museum of Art, 1980.

Account of Kandinsky's reception in and influence on the artists' community in Russia.

———, ed. *Arnold Schoenberg—Wassily Kandinsky: Letters, Pictures, and Documents.* Translated by John C. Crawford. London: Faber and Faber, 1984, 221 p.

Documents parallels in the theories and works of Kandinsky and avant-garde composer Arnold Schoenberg. Includes critical essays by each artist.

Harms, Ernest. "My Association with Kandinsky." *American Artist* 27, No. 266 (June 1963): 36-41, 90-91.

Recollections of Kandinsky's character and career by a noted psychologist and friend of the artist.

Hayter, Stanley William. "The Language of Kandinsky." *Magazine of Art* 38, No. 2 (May 1945): 176-9.

Offers an analysis of such aspects as dimension, motion, and color in Kandinsky's "language of expression."

Holtzman, Harry. "Liberating Kandinsky." *ARTnews* 51, No. 3 (May 1952): 22 ff.

General discussion of Kandinsky's reputation as an artist and theoretician.

Judd, Donald. "Kandinsky in His Citadel." *Arts Magazine* 37, No. 6 (March 1963): 22-5.

Expresses disappointment with a major Kandinsky retrospective held at the Guggenheim museum, noting: "Kandinsky is not an artist of the first rank. . . . There are several lucid, rigorous, paramount paintings in the exhibition, a preponderance of middling works, neither lucid nor rigorous, and several poor paintings."

Kroll, Jack. "Kandinsky: Last of the Heresiarchs." *ARTnews* 61, No. 10 (February 1963): 38-41, 54-5.

Argues that Kandinsky's aesthetic of abstraction was based on a confrontation with realism and has been rendered ineffective by the wide acceptance of abstractionism in contemporary society.

Kurtz, Stephen A. "In the Beginning Was Kandinsky." *ARTnews* 68, No. 3 (May 1969): 38 ff.

Reviews an exhibit of Kandinsky's abstract watercolors, offering a general characterization of the artist as an idealist.

Lassaigne, Jacques. *Kandinsky.* Translated by H. S. B. Harrison. Geneva: Editions d'Art Albert Skira, 1964, 131 p.

Richly illustrated biographical and critical study of the artist.

Lindsay, Kenneth C. "Kandinsky's Method and Contemporary Criticism." *Magazine of Art* 45, No. 8 (December 1952): 355-61.

Explicates Kandinsky's works in a defense of non-objective art.

Long, Rose-Carol Washton. *Kandinsky: The Development of an Abstract Style.* Oxford: Clarendon Press, 1980, 200 p. + 217 plates.

Chronicles Kandinsky's espousal of abstraction and ensuing struggle to reach a wide audience through his art.

———. "Occultism, Anarchism, and Abstraction: Kandinsky's Art of the Future." *Art Journal* 46, No. 1 (Spring 1987): 38-45.

Suggests that Kandinsky entertained radical political and religious beliefs in his search for "a new way to 'shock' his audience out of lethargy into involvement, to prepare them for the struggle for the great utopia."

Mackie, Alwynne. "Kandinsky and Problems of Abstraction." *Artforum* XVII, No. 3 (November 1978): 58-63.

Argues that "to measure all art at the crossroads of an artistic development against the aims and achievements of what finally developed out of the ferment—as if that were what it already should have been—seems to me misguided. Judged by those standards Kandinsky's works was a failure; judged by its own, it is not."

Overy, Paul. "The Later Painting of Wassily Kandinsky." *Apollo* LXXVIII, No. 18 n.s. (August 1963): 117-23.

Calls for a greater appreciation of Kandinsky's later

work, which the critic characterizes as "more intellectual than that of the Munich period because it attempts to represent abstract thought transferred into terms of paint."

————. *Kandinsky: The Language of the Eye.* New York: Praeger Publishers, 1969, 192 p.

Examines color, form, and symbolism in Kandinsky's later abstract paintings.

Ratcliff, Carter. "Kandinsky's Book of Revelation." *Art in America* 70, No. 11 (December 1982): 105 ff.

Demonstrates the ways in which Kandinsky had "a modernist sensibility stranded in the harsh light of its own yen for an apocalyptic tomorrow."

Ringbom, Sixten. "Kandinsky and 'Der Blaue Reiter'." In *German Art in the 20th Century: Painting and Sculpture, 1905-1985,* edited by Christos M. Joachimides, Norman Rosenthal, and Wieland Schmied, pp. 429-31. Munich: Prestel-Verlag, 1985.

Discusses Kandinsky's literary contribution as a member of 'Der Blaue Reiter,' an informal organization whose periodical Kandinsky founded and edited.

Robbins, Daniel. "Vasily Kandinsky: Abstraction and Image." *The Art Journal* XXII, No. 3 (Spring 1963): 145-47.

Contends that, despite the presence of clearly defined periods, the artist's career is characterized by continuity.

Selz, Peter. "Esthetic Theories of Wassily Kandinsky." In his *German Expressionist Painting,* pp. 223-33. Berkeley and Los Angeles: University of California Press, 1957.

Considers Kandinsky as a leading contributor to the realization of Expressionism's artistic goals.

Tower, Beeke Sell. *Klee and Kandinsky in Munich and at the Bauhaus.* Ann Arbor, Mi.: UMI Research Press, 1978, 330 p.

Examines the artistic backgrounds, friei ɔ and mutual influence of the two painters.

Weiss, Jeffrey. "Late Kandinsky: From Apocalypse to Perpetual Motion." *Art in America* 73, No. 9 (September 1985): 118-25.

Review of the exhibit "Kandinsky in Paris: 1934-1944" praising the works influenced by Surrealist biomorphism.

Weiss, Peg. "Kandinsky: Symbolist Poetics and Theater in Munich." *Pantheon* 35, No. 3 (July-September 1977): 209-18.

Focuses on similarities between the works of Symbolist poet Stefan George and the woodcuts Kandinsky produced in Munich.

————. "Kandinsky and the Symbolist Heritage." *Art Journal* 45, No. 2 (Summer 1985): 137-45.

Suggests an association between the "Blue Rider"—the symbol Kandinsky chose to represent the artistic coterie and periodical he founded in Munich—and St. George, a prominent character in Russian folklore.

Werenskiold, Marit. "Kandinsky's Moscow." *Art in America* 77, No. 3 (March 1989): 97-111.

Suggests that Kandinsky's paintings were spiritually informed by his childhood years in Moscow.

Whitford, Frank. "Some Notes on Kandinsky's Development Towards Non-Figurative Art." *Studio International* 173, No. 885 (January 1967): 12-17.

Emphasizes Kandinsky's Russian heritage as an important factor in his conception and practice of nonfigurative art.

Man Ray
1890-1976

(Born Emmanuel Radensky; last name sometimes given as Rudnitzky) American photographer, painter, film-maker, and multimedia artist.

Man Ray is most popularly renowned for his photographic portraits of prominent figures of avant-garde art and literature residing in Paris during the interwar era. Noting his participation in the Dada and Surrealist movements of that time, however, critics and scholars also commend his nonrepresentational photographs, films, and assembled objects (or assemblages) for expressing intentional irrationality and the provocative anti-art statement. Man Ray's works are especially praised for their wit, sophisticated interplay of images and titles, and eroticism, qualities that have gained him acclaim as one of the first major American contributors to Modernism in the visual arts.

Man Ray was born in Philadelphia, but moved to Brooklyn, New York, with his family in 1897. He painted intermittently throughout his childhood, and in high school concentrated on architectural drawing and engineering. After graduation Man Ray attended evening classes in drawing and painting at the National Academy of Design and the Ferrer Center, while earning a living as a designer, first with an advertising agency and then with a cartographic firm. His earliest paintings of the pre–World War I years are largely representational and attracted little notice. However, the exhibition of European Modernist paintings in the Armory Show of 1913 and his exposure to works exhibited at Alfred Stieglitz's 291 Gallery motivated Man Ray to experiment with the techniques of Cubism, Expressionism, and other contemporary avant-garde movements, developing an eclectic style best represented by such paintings as *Man Ray 1914* and *War—A. D. MCMXIV* (both 1914). His first solo exhibition was held in 1915, and although his work was not critically well-received, it was financially successful and enabled him to rent a studio in New York City.

During this year Man Ray met French artist Marcel Duchamp, who had recently moved to New York, and they began a lifelong relationship as friends and collaborators. Duchamp greatly influenced Man Ray through his use of found everyday objects as works of art—which Duchamp termed "readymades"—as well as through his presentation of elusive puns in the titles of his works and his selection of abstract, often mechanical images. With Duchamp and the painter Francis Picabia, Man Ray founded the New York Dada movement, which stressed a disdain for rationality and the Western tradition in art and championed spontaneous or chance artistic creation, tenets that anticipated the European Dada movement originated by Tristan Tzara in 1916.

Until the end of the decade Man Ray created works that feature untraditional materials, collage techniques, and abstract subject matter, exemplified by his *The Rope*

Dancer Accompanies Herself with Her Shadows (1916). Noted for its visual affinities with Duchamp's *The Bride Stripped Bare by Her Bachelors, Even* (1915-23; also titled *Large Glass*), Man Ray's *Rope Dancer* presents several colored pieces of paper cut out to create the figure of the dancer, forms that Man Ray then enlarged and rearranged around the central figure to suggest pictorial "shadows." Man Ray also produced assemblages and airbrush paintings during the New York Dada period, and at this time he executed his first photographs; he originally employed the medium to make reproductions of his painted works, but gradually realized its aesthetic potential.

Following Duchamp's return to France in 1920, Man Ray moved to Paris, where he focused primarily on photography, engaging until World War II in what critics judge the most successful phase of his career. While he earned his livelihood contributing photographs of fashion models to couture houses and both French and American periodicals, Man Ray became a regular presence in circles of the Dada and subsequent Surrealist movements. As a result of his numerous friendships and contacts within Parisian literary and artistic circles Man Ray created his well-known photographic portraits of major practitioners of

Dada and Surrealism, such as Tristan Tzara, André Breton, and Max Ernst, as well as of unaffiliated figures of the interwar avant garde, including Gertrude Stein, Pablo Picasso, and James Joyce. These works are praised for their straightforward presentation and perceptive expression of the sitters' personalities, although occasionally criticized for overutilization of the conventions of portrait painting. Man Ray also engaged in photographic studies of female nudes during the 1920s and 1930s, the most prominent model being his companion Kiki, who is featured in the famous *Violon d'Ingres* (1924) with two black cutouts superimposed on her back to resemble the sound-holes of a violin. Prolifically experimenting with photographic effects throughout this period, Man Ray is additionally recognized for establishing several techniques within the medium. Most significantly, critics laud his use of the rayograph, which, as recounted in a frequently quoted anecdote, he first produced when photographic paper in his studio was accidentally exposed to light, creating a cameraless negative of the objects lying on the paper. Encouraged by Tzara, Man Ray arranged everyday objects in subsequent rayographs to produce white, dreamlike forms on black backgrounds. Also deemed innovative are his solarizations of the early 1930s, photographs in which he manipulated the development process to achieve pronounced outlines around previously photographed nudes and portrait subjects.

Critics typically place Man Ray's interwar films and paintings within the context of the Surrealist movement. Although Man Ray did not publicly subscribe to the official dogma of Surrealism, commentators generally concur that the irreverent humor and cryptic juxtaposition of images in his works exemplify the movement's aesthetics. Man Ray's first film, *Le retour à la raison,* was rapidly composed in response to a request by Tzara for a film for the multimedia performance and exhibition "Le coeur à barbe" ("The Bearded Heart"). A soundless, brief work that includes filmed versions of rayographs, *Le retour à la raison* broke midway through its showing and was succeeded by an audience riot. Nonetheless, Man Ray achieved local renown as a filmmaker and was commissioned to create three subsequent films during the 1920s: *Emak Bakia* (1926), *Les mystéres du château du dé* (1929), and *L'étoile de mer* (1928), the latter based on a poem by Surrealist Robert Desnos. While commentators observe that Man Ray's cinematographic works chiefly feature camera angles that are frontal and pictorially conventional, he is highly regarded for decontextualizing common objects to produce mysterious images, for his nonobjective sequences created through distorted lenses, and for his visual and verbal paradoxes; Steven Kovács thus deems him "the one who contributed the most to the development of the cinema as a Surrealist medium." Man Ray's paintings and assemblages created before World War II are similarly considered to reflect the Surrealists' emphasis on unconscious association and often disquieting subject matter. *Cadeau* (1921; *Gift*), for example, consists of a flat iron with an unexplained spine of protruding metal tacks glued to its surface, and *Object to Be Destroyed* (1923) presents a cutout photograph of an eye attached to the pendulum of a metronome. Man Ray's Surrealist paintings, the best-known examples of which he created

during the 1930s, characteristically combine disparate images in an evocative, nonrealistic manner, as with the enlarged pair of lips that hover over a landscape and an observatory tower in *A l'heure de l'observatoire—Les amoreux* (1932-34; *Observatory Time—The Lovers*).

Following the German invasion of France, Man Ray returned to the United States in 1941. There he resided in Hollywood and worked as a fashion photographer, while creating photographic artworks and increasingly abstract paintings. He moved back to Paris in 1951, baffling critical expectations of his work with such stylistically atypical paintings as *Rue Férou* (1952), a relatively realistic depiction of a local Parisian street. Man Ray's autobiography, *Self Portrait,* was published in 1963, and three years later his first retrospective was held at the Los Angeles County Museum of Art, a decade prior to his death in Paris in 1976. In recent years, international appreciation of Man Ray's work has grown significantly. While some commentators disparage his oeuvre as careless in technique and representative of a self-indulgent Dada aesthetic, the overall diversity and determined iconoclasm of his work have earned him a reputation as a definitive Modernist.

ARTIST'S STATEMENTS

Man Ray (essay date 1934)

[*What follows is "The Age of Light," Man Ray's preface to his collection* Man Ray: Photographs, 1920-1934 Paris, *in which he discusses the potential for artistic expression in modern society.*]

In this age, like all ages, when the problem of the perpetuation of a race or class and the destruction of its enemies, is the all-absorbing motive of civilized society, it seems irrelevant and wasteful still to create works whose only inspirations are individual human emotion and desire. The attitude seems to be that one may be permitted a return to the idyllic occupations only after meriting this return by solving the more vital problems of existence. Still, we know that the incapacity of race or class to improve itself is as great as its incapacity to learn from previous errors in history. All progress results from an intense individual desire to improve the immediate present, from an all-conscious sense of material insufficiency. In this exalted state, material action imposes itself and takes the form of revolution in one form or another. Race and class, like styles, then become irrelevant, while the emotion of the human individual becomes universal. For what can be more binding amongst beings than the discovery of a common desire? And what can be more inspiring to action than the confidence aroused by a lyric expression of this desire? From the first gesture of a child pointing to an object and simply naming it, but with a world of intended meaning, to the developed mind that creates an image whose strangeness and reality stirs our subconscious to its

inmost depths, the awakening of desire is the first step to participation and experience.

It is in the spirit of an experience and not of experiment that [I present autobiographical images in my photographs]. Seized in moments of visual detachment during periods of emotional contact, these images are oxidized residues, fixed by light and chemical elements, of living organisms. No plastic expression can ever be more than a residue of an experience. The recognition of an image that has tragically survived an experience, recalling the event more or less clearly, like the undisturbed ashes of an object consumed by flames, the recognition of this object so little representative and so fragile, and its simple identification on the part of the spectator with a similar personal experience, precludes all psycho-analytical classification or assimilation into an arbitrary decorative system. Questions of merit and of execution can always be taken care of by those who hold themselves aloof from even the frontiers of such experiences. For, whether a painter, emphasizing the importance of the idea he wishes to convey introduces bits of ready-made chromos alongside his handiwork, or whether another, working directly with light and chemistry, so deforms the subject as almost to hide the identity of the original, and creates a new form, the ensuing violation of the medium employed is the most perfect assurance of the author's convictions. A certain amount of contempt for the material employed to express an idea is indispensable to the purest realization of this idea.

Each one of us, in his timidity, has a limit beyond which he is outraged. It is inevitable that he who by concentrated application has extended this limit for himself, should arouse the resentment of those who have accepted conventions which, since accepted by all, require no initiative of application. And this resentment generally takes the form of meaningless laughter or of criticism, if not of persecution. But this apparent violation is preferable to the monstrous habits condoned by etiquette and estheticism.

An effort impelled by desire must also have an automatic or subconscious energy to aid its realization. The reserves of this energy within us are limitless if we will draw on them without a sense of shame or of propriety. Like the scientist who is merely a prestidigitator manipulating the abundant phenomena of nature and profiting by every so called hazard or law, the creator dealing in human values allows the subconscious forces to filter through him, colored by his own selectivity, which is universal human desire, and exposes to the light motives and instincts long repressed, which should form the basis of a confident fraternity. The intensity of this message can be disturbing only in proportion to the freedom that has been given to automatism or the subconscious self. The removal of inculcated modes of presentation, resulting in apparent artificiality or strangeness, is a confirmation of the free functioning of this automatism and is to be welcomed.

Open confidences are being made every day, and it remains for the eye to train itself to see them without prejudice or restraint.

> Man Ray, *"The Age of Light,"* in his Photographs: 1920-1934 Paris, *James Thrall Soby, 1934.*

Man Ray (essay date 1943)

[*In the following excerpt, Man Ray evaluates photography as an art form.*]

> "I wish I could change my sex as I change my shirt."
>
> André Breton

Ask me, if you like, to choose what I consider the ten best photographs I have produced until now, and here is my reply:

1. An accidental snap-shot of a shadow between two other carefully posed pictures of a girl in a bathing suit.

2. A close-up of an ant colony transported to the laboratory, and illuminated by a flash.

3. A twilight picture of the Empire State building completely emptied of its tenants.

4. A girl in negligee attire, calling for help or merely attracting attention.

5. A black and white print obtained by placing a funnel into the tray of developing liquid, and turning the light onto the submerged paper.

6. A dying leaf, its curled ends desperately clawing the air.

7. Close-up of an eye with the lashes well made up, a glass tear resting on the cheek.

8. Frozen fireworks on the night of a 14th of July in Paris.

9. Photograph of a painting called *The Rope Dancer Accompanies Herself with Her Shadows.* Man Ray 1916.

10. Photograph of a broken chair carried home from Griffith Park, Hollywood, at one of its broken legs the slippers of Anna Pavlova.

Do you doubt my sincerity? Really, if you imagine that I value your opinion enough to waste two minutes of my precious time trying to convince you, you are entirely mistaken.

Let me digress for a moment. Some time ago, in the course of a conversation, Paul Eluard proclaimed very simply, "I detest the horse." And yet the horse in Art . . . from Uccello to Chirico, the horse reappears again and again as a dream motive and as a symbol of woman. Its popularity is universal, from the most vulgar chromo of the racing fan to the painting full of implications by the psychologist. One of the reasons we have to thank abstract art is that it has freed us from this obsession. One would have thought that a single picture of the horse would have been sufficient once and for all to dispose of this preoccupation, and that never again would an Artist have resorted to the same motive. Noble animal! The horse a noble animal? Then are we by comparison nothing but dogs, good or bad, as the case may be. The dog's attachment to man is not the result of any similarity that may exist in physiog-

nomy between him and man, nor even of odor. What attaches the dog is his own capacity for loving. The dog is such a complete lover. The horse, however, like the cat, is content with *being* loved. But *we* are not such good lovers, we humor the horse for his hoofs as we cater to the cat for her guts, and our affection and caresses are calculated to exploit their attributes. And so we kid the dog along for his doggedness. So agree; the dog is the only animal that knows what real love is. With his set expression, but unlike that of his determined master, he has no hope, no ambition, he has only the desire for the regular caress and the bone. Take the following example. It is a one-sided but true story of man's perfidy:

> For fifteen years this woman has been raising dogs. Now she is twenty-four years old, and wishes to retire. She wants to sell her dogs, fifty-seven of them, all pedigreed, sell them so that she may retire and devote the rest of her life to writing poetry. She speaks,

> Yesterday was a cocoon

> Tomorrow will be a butterfly

> Tonight as I sit and gaze at the moon

> I wonder and mutter "WHY?"

.

Speaking of horses, personally, I admit I have never been able to draw a horse, nor for that matter, photograph one. But that is merely a question of habit like so many other of our prized accomplishments. When I was called out to do a portrait of the Maharaja's favorite racing nag, I had considered myself fortunate to be living in an age that put the camera at my disposal. Leonardo and Dürer had raked their brains to produce an optical instrument, if only as an aid to their drawing. It was not their fault (nor very much to their credit) that they were unable to perfect a device that might have freed them entirely from the drudgery of reproducing the proportions and the anatomy of those subjects that served them as a vehicle to their full expression, vehicles that so many of us still admire and emulate. We, some of us, still repeat them, and with them we admire the drudgery that they involve. "What," do you say, "should we do today; draw autos and planes? This involves just as much drudgery, if we do not use the camera, which after all is not a sensitive instrument like the hand." I wish to point out here that the horse has one advantage over modern vehicles, and that advantage has confused the Artist down to the present time. The horse does not have to be built, he already exists. Whereas the automobile or the airplane must be drawn again and again to bring them to the state of perfection attained long ago by the horse. Once that perfection attained, the camera will come into its own, to record the perfected new vehicle. Yes, with all the variations of proportion, distortion, light and shade that have been applied to the interpretation of the horse. The camera waits for the human hand to catch up with it.

But why was I unable to photograph the horse, that already perfected animal? Let me explain. I took him full-face, three-quarters, profile. I caught the white star on his forehead, his liquid eyes, his beautiful glossy skin with its nervous veins, the quivering nostrils, (I'm sorry, the camera was too fast for that, but we know horses' nostrils quiver). However, when I showed the results to the trainer, his face assumed a worried look. "Ah, but you haven't got his soul." I ask you, now, how was I to know the animal had a soul like we humans. I have been told so often in my portraits of men and women that I have caught their soul. I do not wish to apologize, I simply conclude that I have no feeling whatsoever for the horse. I admit it, and from now on I shall loudly proclaim it, before any one else can accuse me of lack of feeling or imagination. In short, I detest the horse, and you shall hear no more about the noble animal!

Dear gentle but ruthless reader, if I seem to cover a great deal of ground in too short a space (of time), remember that I am a product of my times and proud of it. I travel in modern vehicles and avoid circumlocution. I have the choice of the means of locomotion. Nevertheless, I consent to stop again by the wayside for an instant, and introduce you to one of my oldest friends, THE ARTIFICIAL FLORIST. Realizing long ago that the perfect crime does not exist, any more than perfect love can exist, and if these existed, we would not call them either crime or love; realizing a state of things that opens the way to repeated effort, he cast about for an object capable of improvement, or of modification, in that it lacked at least one desirable quality. We all love flowers, that goes without saying, but I wish to state it, although others expect of me so many things without saying so. The flower, in all its perfection, lacks one quality, that of permanence. This has been one of the chief concerns in art for centuries, both material and esthetic. Of course, nature has found a substitute for permanence, in repetition, but that is not an admitted human function. Anyhow, when man turns to imitating the processes of nature, he invariably tries to substitute permanence for repetition, just as he tries to reproduce all the various lever movements in nature with the principle of the wheel, which does not exist in nature. In the same manner, he carries the confusion even into such comparative human activities as painting and photography, to the extent of imagining that he is making a good drawing, when he is simply making a poor photograph, or that he is making a work of art with the camera when he makes a good automatic drawing with it. Here may I ask you, reader, to read this foregoing statement several times to get my meaning. You see I ask you now to slow down your pace, just as you asked me to do previously, except that my trajectory enters into the realm of the permanent while you in the role of reader must practice the art of repetition as this time.

To return to my ARTIFICIAL FLORIST; loving flowers as he did, and being more human than nature-loving, he wished to assure himself of the permanence of certain blooms. The choice of two courses lay open to him, either to paint them, or to make the actual artificial flower, and he made his decision in the following manner: Looking one day at a painting that meant nothing to him he asked me to explain what there was beautiful about it. I replied that I would, after he had explained to me what there was beautiful about a painting of flowers. "One can then still have

them in winter time," he answered. Thus we both skillfully parried the question of beauty. But his mind was made up from then on; he would make actual flowers, instead of painting them, flowers that would not fade, but be permanent, like painted flowers. The question of odor did not enter into the project, since no one had ever demanded of painted flowers that they smell. ARTIFICIAL FLORIST became very expert in the making of permanent flowers, so that at a short distance they were easily mistaken for nature's work. One day I came around with my camera and photographed the permanent flowers. I took them against the sky, I added drops of water to simulate the dew, and I even put a bee in the chalice of one of them. However, when I showed the results to FLORIST, his face fell. "Ah, but you haven't got their souls." Once again I had failed. Now I ask you, how can we ever get together on the question of beauty?

This dilemma, fortunately no longer troubles a self-respecting Artist. In fact, to him the word beauty has become a red rag, and with reason. I am not being sarcastic, but mean it in all sincerity, when I say that the Artist even when copying another, works under the illusion that he is covering ground which he imagines no one has covered before him. He is then necessarily discovering a new beauty which only he can appreciate, to begin with. (In this respect he really returns to nature, because he employs her time-honored mode of repetition, unconsciously. Only the desire to make a permanent work is conscious.) Aside from this, *the success with which the Artist is able to conceal the source of his inspiration, is the measure of his originality.* The final defense is, of course, "I paint what I like," meaning he paints what he likes most, or he paints that which he fears, or which is beyond his attainments, in the hope of mastering it.

Happily, most of the pioneers of the past two generations have freed themselves from these obsessions and the rot of past performances. A few are still walking ahead with their heads completely turned around, looking backwards as they advance, in an impossible anatomical position in spite of their respect for the old masters. Then there are the few pessimists and disillusioned ones, bewildered and discouraged, who say, "What is the use, in medical parlance, whether the stool is easy and abundant or difficult and meagre, the anus is equally soiled." As for the practical ones who are always ready with their wash-rag, soap and water, they can take care of themselves. But it is useless to deny the future, and especially the present. . . .

Have you ever tried looking at a Veronese or a Vermeer through a red glass? They become as modern as a black and white photograph. And how often has a painter, upon seeing a black and white reproduction of his work, had a secret feeling that it was better than the original. The reason is that the image thus becomes an *optical* image. In the last few generations our eyes and brains have become *optically* conscious, not merely plastically conscious. Turner and the impressionists were the first painters to develop this optical nerve in color. It was a mere hazard that photography began with the black and white image, perhaps it was even fortunate for the possibilities of a new art, or that a new art might become possible. The violent attacks by painters on photography were mitigated by its lack of color, of which they still had the monopoly, and they could afford a certain indulgence. Just as in writing, "l'humeur noir" ["black humor"] had been considered the bastard child, a new black and white graphic medium could never be feared as a serious competitor. But, if this humor should assume all the colored facets of a serious form, like the present discourse, or if a photograph should break out into all the colored growths accessible to the painter, then the situation would indeed become serious for the exclusive painter. Then the danger of photography becoming a succeeding art, instead of simply another art would be imminent. Or rather, the danger of photography becoming simply Art instead of remaining AN art. To complete this result, a little research and some determination could prove that whatever was possible in the plastic domain, was equally feasible in the optical domain. The trained human eye, guiding one of glass, could capture as wide a field as had been controlled by a more or less trained hand guided by a half-closed eye.

It is the photographer himself who is to blame for his lack of standing amongst art dealers accredited by their supporters, and self-accredited critics. Until now he has relied too implicitly on the short-sighted scientists who have furnished him the materials of his medium. His concern with *how* the thing is to be done, instead of *what* is to be done, is a repetition of the spirit that held in the early days of painting, when painters went about smelling each other's oils. Of course, painting dates back 10,000 years, while photography is barely a century old, and there is hope for it. The photographer has pulled his little Jack Horner, has pulled the chestnuts out of the fire for the scientists and the manufacturers, and it is time he kick over the bucket and put out the fire. Wet chestnuts are better than singed fingers, a drop in the bucket cannot compete with a plum out of a pie, but even so, the greatest thrill can be obtained only by throwing the whole pie into the face of those who have arrogated to themselves the monopoly of intelligence, perception and knowledge. Proverbs are at their best when they are reversed, as practised by our most revered poets, who also have announced that poetry should be practised by all. I remember one poet, especially, in the course of a talk, accused of irrelevance, and requested to stick to the subject of poetry, replying, "Damn it, this is poetry!" In another instance, the poet spits in the face of those who are charmed with the form of his writing and politely ignore the too inflammatory content. We can no longer be satisfied with the ivory tower of quality, but that does not mean we shall make a point of setting up our artistic headquarters in a steel skyscraper, which would be equally evasive. A cry or a song emanating from a palace or a prison, if they are loud enough, can stop us dead in our tracks. I do not think the architecture has anything to do with the message, with human functioning, any more than a sunset is motivated by esthetic considerations on the part of nature.

We can only see, hear, feel what we have been in the habit of seeing, hearing and feeling, or if it is a new and unfamiliar world, we must be prepared in advance and disposed for its reception. The optimistic subject that comes into my studio with the concentrated idea of having a success-

ful photographic portrait of himself, does not even see the for him weird and abstract canvases on the walls. (pp. 77-8, 97)

[But] in the end, the object or the subject will play the final role and will determine the validity of the result. Therefore, the intentions of the self-appointed chronicler will be of little importance. The inventor is the tragic figure, he who adapts and improves is the lucky guy. The inventors of the present war are doomed, for they have indicated merely the way, to be improved upon and turned against them with a hundred-fold power.

This thing called time, beautiful, automatic dimension that relentlessly measures our steps, neither hastening them nor retarding, however short or long they may be, time will resolve all our problems. It is useless to rack our brains for the solution, we must live as if there were no problems, and as if there were no solution to be obtained. This is the final automatism, demanding no effort but that of living and waiting. To all this you will agree or disagree according to whether you have felt in a similar way, or not felt at all. I said living and waiting, and do not we perform all our necessary physical functions while awaiting the most desired results? Thoughtless wishing, you may say, but see into what blind alleys of action the contrary, wishful thinking, has led us.

And now, patient reader, it is time for me to meditate, to reassemble my memories, put my house in order, without further disturbance of the dust of past experiences, except for this stereotype, or photograph:

"Time Is"
It was not a long walk
From the Place de la Concorde to the
 Champs de Mars
Not any longer than the transition
From white to black from peace to war
From water to blood

Cleopatra's Needle stood nakedly straight
 and white
In the night's projectors of the Concorde
Eiffel's Folly concaved black to a point
In the dimmed regions of Mars
Flashing its own light from minute to
 minute
Visible time inaudible

White shaft black shaft
With the eternal patience of inanimate
 objects
Wait for their transport transformation
And for their destruction
It is all one they have made their point

The supine Pont du Jour has already less
 time to travel
It has reversed the process of erection
Experienced by the obelisk recorded on its
 very base
Indeed there will be records of all transfor-
 mations
A record will never equal the accomplished
 fact of an erection
Can never replace it
Will always be an obituary.

To conclude, nothing is sadder than an old photograph, nothing so full of that nostalgia so prized by many of our best painters, and nothing so capable of inspiring us with that desire for a true Art, as we understand it in painting. When photography will have lost that sourness, and when it will age like Art or alcohol, only then will it become Art and not remain simply AN art as it is today. (p. 97)

Man Ray, "Photography Is Not Art," in View, *Nos. 1 and 3, April and October, 1943, pp. 23, 77-8, 97.*

INTRODUCTORY OVERVIEW

Jules Langsner (essay date 1966)

[*The following excerpt is from Langsner's introduction to the catalog of the Man Ray retrospective organized by the Los Angeles County Museum of Art. Here, he surveys Man Ray's career and describes his aesthetics.*]

Man Ray has been painter, sculptor, maker of collages and objects, architectural draughtsman, designer, printmaker, chess player, writer, photographer, pioneer of avant-garde film, inventor, recluse, wit, bon vivant, and intimate of many notable figures in the arts of our century. Despite the multiplicity of his interests, he has looked upon himself as an artist since the age of seven when he elected that vocation as his calling. The high caliber and astonishing range of works in this exhibition substantiate that early and insightful view of himself.

None of the designations favored by critics, reviewers, art historians, curators, educators, psychoanalysts and other compulsive classifiers of art and the human spirit fit this inventive, seminal and protean artist. "I don't know what is original or modern," he has said, "I just try to be myself." Having an original cast of mind, he became a significant originator. The classifiers are going to classify whether their classifications are meaningful or not. One result of their labors has been to make Man Ray known primarily as one of the founders and leading spirits of Dada and Surrealism, all too often neglecting to mention, however, that he was the only American artist to play a prominent role in the launching of those two far-reaching movements. The New York painter, William Copley, spoke for the Pop and Neo-Dada generation of the Sixties when he called Man Ray, quite accurately and properly, "The Dada of Us All." Such Dada objects as *New York 1920* (an olive jar stuffed with steel balls) and *Cadeau* of 1921 (the famous flat iron with a row of nails, points outward, down the middle of the working surface) might have been conceived at any time within the past half-dozen years. Their impact has not diminished. His contributions to Surrealism are equally distinguished. Such paintings as *Observatory Time—The Lovers* (1932–1937) and *Le beau temps* (1939) are among the masterworks of Surrealism. Other surrealist works by him anticipate certain aspects of Pop Art—for example, *The Fortune* of 1938, in which

a billiard table with three balls scattered over the top stretches into vast space. The picture relates to Pop Art in the meticulous rendering of ordinary things unexpectedly isolated for our contemplation. With this significant difference, however: Man Ray's surrealist pictures are invested with enigma, while Pop Art avoids the poetic and mysterious aspects of the commonplace.

Man Ray's contributions to Dada and Surrealism comprise a very large proportion of works in the exhibition, but there are many other arrows in his quiver. His varied achievements as an artist cannot be encapsulated within a couple of designations. Following the 1913 Armory Show in New York, an enlarging experience for him, as for other budding modernists of his generation, he became one of the pioneers of abstract art in America. Starting from a Cézanne phase, as in *The Village* of 1913, he evolved a highly personal Cubism, as in the tubular figures and horses of *A.D. MCMXIV* painted the next year, and in 1916 he ventured into Abstraction in such works as *The Rope Dancer Accompanies Herself with Her Shadows.* The *Rope Dancer* (along with certain other works between 1916 and 1920) parallel current efforts to interlock flat colorforms on the surface plane. As for the recent interest in giving paintings and painted sculpture a high-gloss, machine-like finish, Man Ray was involved with a similar intention in 1918 and 1919. Such works as the 1919 *Admiration of the Orchestrelle for the Cinematograph,* rendered entirely with airbrush, were conceived with the intention of giving forms a machined appearance.

For several decades Man Ray has followed the impulse of the moment wherever it has led him. He believes that

> Art simply varies in its sources of inspiration and in its modes of execution. It can vary within one man, depending on his curiosity and on his sense of freedom . . . The real experiment is in proportion to the desire to discover and enjoy, and this desire alone can be the only measure of the painter's value to the rest of society.

Following the impulse of the moment, Man Ray may turn from painting to sculpture or collage or the making of an object or a rayograph or to the creation of works that fit no conventional designation. Is the *Lampshade* an object or a mobile? First conceived in 1919 of paper from a lamp, it was twisted into a spiral and suspended from the ceiling, rotating slowly as if imbued with a life of its own. What about *The Orator* of 1935, both painting and object? Or *Talking Picture* of 1954, a work incorporating a loudspeaker that, properly installed, is wired to a radio-phonograph? During recent years Man Ray has fashioned works listed as 'collages' in the catalog. In such string collages of 1965 as *Inquietude* and *The Necklace,* string projects into forward space, adding the advance and negative openings of relief to the pictures. In these, as well as in numerous other works in the show, Man Ray erased boundaries separating one medium from another. Unconcerned with the properties said to be intrinsic to this or that medium, he is among the first boundary-hoppers in twentieth century art.

Not only has Man Ray hopped boundaries separating established media, he has been among the handful of inventors of viable new art forms such as the rayograph (considered later in this introduction) and the 'object,' a new kind of visual entity he originated with his friend Marcel Duchamp. The object as work of art consists of ordinary artifacts which, pried loose from their usual setting and by their placement together, disclose hitherto unseen esthetic and psychological properties. The esthetic attributes of ordinary artifacts, in the sense of good design, had long been appreciated. What had not been perceived were the intrinsically formal properties of artifacts apart from their function and (equally important) the psychological overtones such artifacts might convey if viewed as works of art. The incorporation of ordinary artifacts in collage preceded the object. In collage, however, ordinary things are incorporated as part and parcel of a pictorial conception. In the object, artifacts (usually in their original state) are, themselves, the imagery offered for our perception. The intuitive eye of the artist transforms artifacts (as such) into a mode of imagery. Man Ray's *Smoking Device,* an object of 1959, for example, combines a pipe rack, some marbles, and a piece of rubber tubing. Nothing more, yet the startling strangeness and relationships of this grouping involves the spectator in a form of art experience.

The object owes its beginnings (in part) to the verbal imagery of the poet, Isidore Ducasse, who called himself the Comte de Lautréamont. In *Les chants de Maldoror,* published in 1874, Lautréamont introduced such imagery as " . . . the chance encounter on a dissecting table of a sewing machine and an umbrella." This evocative and unexpected conjunction of everyday objects was to make Lautréamont one of the patron saints of Surrealism. But Man Ray had been an admirer of Lautréamont long before the advent of Surrealism in 1924. His photograph of 1920, *The Enigma of Isidore Ducasse,* presents a haunting image of something that is itself an object, a bulging cloth tied down by ropes. No one but the artist knows what is under that disturbingly bulging cloth. It must forever remain undecipherable. It was Man Ray's tribute to the precocious (now shrouded in mystery) Comte de Lautréamont.

Man Ray never has adhered long to any stylistic direction. Indeed, he frequently has shifted back and forth between various attitudes to the image. Finding the date of one of his efforts may be interesting for one reason or another, but it is not necessarily illuminating information. The critic or art historian bent on tracing Man Ray's development, in the sense of some sort of progression, is bound to be, not only frustrated, but defeated. In this regard, there is the story he is fond of telling of his painting, *Rue Férou,* a 1952 picture of the little street off the Place St. Sulpice in Paris where he lives with his wife. The painting upset a friend who was visiting the studio. "Why did you do a thing like that? It's so realistic," the friend demanded to know. Characteristically, the artist replied, "Because I wasn't supposed to." Moreover, Man Ray always has felt free to restate a work of years before in a manner close in spirit to the original effort, or else resume an idea he may have put aside long ago, an idea that perhaps belongs to some earlier phase of his career.

Man Ray, in his capacity as artist, values to the highest

Cadeau *(1921).*

admiration for any technical excellence usually sought for in works of art. The streets are full of admirable craftsmen, but so few practical dreamers.

For Man Ray, the execution of a work of art is significant in relation to the ideas that work embodies. Emphasis on technique may cloud ideas, or else conceal the artist's impoverishment of ideas. With regard to his own work, germinal ideas must be interesting in some way. By no means must such ideas be weighted with profound implications. They may be interesting if amusing, suggestive, provocative. Moreover, the idea for a work of art has to possess him. On this score he has said, "I never paint because I am a painter. I paint because I have an idea. I let the idea recur and recur; it has to haunt me until I *have* to put it down in concrete form." With all the forethought that may enter into the making of one of his works, Man Ray, true to his Dada and Surrealist inclinations, keeps himself wide open to the unforeseen, to chance, to accident, to the fortuitous.

Man Ray's penchant for giving many of his works witty titles disturbs some purist viewers and critics. Pure painting, painting that exists purely as such, is only of peripheral interest to him. The notion that words (or other "literary values") get in the way of the pure experience of art he considers just another "sacred cow." Highly literate and adept with words, the full flavor of many of his works can only be savored by fusing visual and verbal statements. Words often are an inseparable part of the visual imagery, just as a poem often is integral to Far Eastern painting. Something of value is lost in both instances when the words are severed from the visual entity. Sometimes, in the case of Man Ray, the verbal aspect involves a pun, or a play on words. This may present hazards to the spectator unfamiliar with French when the titles are in that language. Puns and plays on words often do not translate successfully. The object titled **Blue Bread** in English has entirely different connotations when presented with its original designation of **Pain peint.** On the other hand, other titles, such as that for the object, **Mirror to Die Laughing By,** do not lose by translation.

Man Ray is a wit with visual images and with words, and with both simultaneously. Moreover his wit is tinged with irony and, sometimes, with a drop of acid. Many Americans are ill-at-ease with irony, with his kind of playful quickness of intelligence. But Man Ray has lived in France for many years. In that country, ironic play with words, puns, double-entendre are admired and cultivated. That is one of the reasons he finds the intellectual milieu of Paris so congenial. Not surprisingly, the last word on the subject belongs to him—"If some of my works are ironical or joking that's because I am sure of myself." Not trying to be anything other than himself, there is no need for him to prove anything. Viewers uncomfortable with irony, the quip, the jest in works of art are advised to concentrate on other facets of Man Ray's work.

Man Ray the photographer, is no easier to pin down than Man Ray the artist. One suspects that he was bound, sooner or later, to take a crack at photography, considering his interest in all aspects of visual imagery and his disdain of

degree his autonomy, his freedom to pursue his work in whatever way happens to interest him at the time. So far as he is concerned, such attributes as consistency, advance, progress, development, stylistic identity obstruct his total freedom to go his own way, wherever it may lead. Autonomy in the studio is of the utmost importance to him. Not long ago he stated his position with reference to his total freedom as an artist: "I like contradictions. We have never attained the infinite variety and contradictions that exist in nature. Tomorrow I shall contradict myself. That is one way I have of asserting my liberty, the real liberty which one does not find as a member of society." It is a declaration spoken in the essential spirit of Dada, a core aspect of Man Ray. (pp. 9-12)

There is another aspect of Man Ray's works that must be confronted: the seemingly cavalier attitude he sometimes has taken to the technical side of art. Numerous works in the exhibition demonstrate his craftsmanship. But craft, as such, does not interest him. Man Ray's conception of the technical side of art is crucial to full understanding of his approach to art experience. Therefore, it behooves the viewer to learn what he has to say about the matter. Twenty years ago, speaking of his own work, he wrote.

In whatever form it is finally presented, by a drawing, by a painting, by a photograph, or by the object itself in its original materials and dimensions, it is designed to amuse, bewilder, annoy or to inspire reflection, but not to arouse

the conventional division of art into fine and not-so-fine. When I asked him how he happened to get as involved with photography as he did around the close of the First World War, he gave me a different kind of answer altogether. The truth of the matter was, he explained, "I had to get money to paint. If I'd had the nerve, I'd have become a thief or a gangster, but since I didn't, I became a photographer." In this decision he was right. He emerged rapidly as one of the most noted photographers of the Twenties and Thirties, commanding handsome fees for portraits and fashion photography. Commissioned photography in no way diminished the quality or inventiveness of his work, whether for a fee or in an endeavor of his own determination. And as a photographer he was able to pursue his other work in the studio with the total freedom he finds essential to his well-being.

The invention of the rayograph was one of those chance discoveries familiar in science and technology. Without intending to do so, Man Ray left some objects on an unexposed negative. He discovered, to his surprise, when he developed the negative, that the objects left a white impression while the rest of the print remained black. This must have happened innumerable times before, but only someone prepared to take advantage of chance could have foreseen the possibilities for a new kind of photographic imagery produced entirely without the camera. That order of imagery occupies a domain somewhere between the black and white photograph and the black and white abstract print. The rayographs in the show reveal the scope and richness of this medium of expression. (pp. 12-14)

Man Ray's films of the Twenties have exerted a continuing influence on avant-garde and commercial motion pictures. The three films of which prints have survived—***Emak Bakia, L'etoile de mer*** and ***Les mystères du chateau du dé***—extended the medium into previously unexplored kinds of imagery. The films, discussed in depth by Carl Belz—were solely the work of Man Ray. He was cameraman, director, editor and the sound accompaniment was his choice of phonograph records of the day. Nothing less than complete authorship of a work interests him. Collaboration would dilute his freedom as artist. In speaking of his insistence upon sole authorship of his works, he told me, without cracking a trace of a smile, "I never collaborate with more than one person at a time, and then only for pleasure." I also learned that the films were shot without preliminary scripts, evolving as he went along in order to take full advantage of chance and of improvisation. Ironically, when he was in Hollywood during the Forties, the magnates of the motion picture industry failed to employ his remarkable gifts as a film maker. Short of funds at the time, if given the chance and a free hand, he almost certainly would have added luster to the history of film in America.

Man Ray the person is just as elusive, just as much a paradox, as Man Ray the artist. Even though the full story of his life can be found in his autobiography, *Self Portrait*, published in 1963 [see Further Reading, section I], certain aspects of his personality are worth noting here. A Parisian since 1921, Man Ray remains American to the core. Encountering him in Paris, one senses instantly that his American roots are as firm and vigorous as they were forty odd years ago. Paradoxically, when he was in Hollywood during the Second World War and for a few years thereafter, he was as much an expatriate on these shores as his friends Max Ernst and André Breton. Like them, he was forced to take refuge in America at that disruptive juncture in history. There are other enigmas. One—the spirited playfulness in his legendary wit and in much of his work as an artist, yet, on acquaintance, he usually is grave, reserved, saturnine, almost dour. Another—the fraternization, in his work, thought and conversation, of poetic flights of imagination with analytical intelligence. It is as if René Descartes and Hieronymous Bosch were one and the same. Finally—in keeping with his Dada approach to life, he scorns and derides modern civilization, yet he is one of the most civilized men of our time.

The most illuminating clue to Man Ray the artist and Man Ray the person—mirror images of one another—can be found in his Dada attitude to art and life. It has been fifty years since the Dada attitude to art and life first was articulated by a handful of expatriate poets and artists from several corners of Europe at the Cabaret Voltaire in Zurich during the darkest days of the First World War. At that moment, the superstructure of Western Civilization appeared to have collapsed. Sanguine faith in the rule of reason had been undermined by the horrors of technological warfare. The notion that mankind was destined to progress ever onward and upward was seen by the poets and artists at the Cabaret Voltaire as a fraudulent snare and delusion.

The youthful Dadaists who took over the Cabaret Voltaire—among them Hugo Ball, Tristan Tzara, Hans Arp and Marcel Janco—believed it was time for a wholly new beginning in their efforts as artists and in their view of life in the modern world. They were convinced that existing systems of thought had failed in large measure because thought in science and philosophy was systematized. In the arts, they opposed the regulation of creative endeavor by codified rules of any kind. In place of the Rule of Reason, they favored the Whims of Chance. Moreover, they asserted that the artist contaminates the sensibility unique to himself to the extent he adheres to doctrines, credos, conventions, authority.

From that slant, the institutional structure of art was seen as obsolete. Museums, academies, art schools, contending movements, the sanctifications of art history, the pecking order infesting the art world were considered to be vestigial absurdities. It is in this sense that Dada was anti-art. The Dadaists jeered Culture with a capital C, Art with a capital A. They believed that by removing art from the hurly-burly of life and installing it as something sacred, the vital experience of art was transformed into a mandate of what one ought to feel and enjoy. Anti-art in this sense is not the same as the rejection of art per se. After all, the Dadaists went on making works of art, writing poems, staging performances at the Cabaret Voltaire that today would be described as music hall Happenings. They refused, however, to conform to any stylistic procedure, including any approach they themselves might enunciate.

That being the case, there is no such thing as an identifiable Dada style.

The procedures of dividing art into schools, movements, epochs, countries, regions and stylistic tendencies of one sort or another are the stock in trade of critics and art historians. Dada rejected these procedures. Consequently, the Dadaists repudiated the endorsement of critics and art historians. Each work of art, they affirmed, must be contemplated as an entity unto itself. Its connections with other works are incidental, not essential. The Dada artist could, accordingly, conceive his work in any way he wished, including the fashioning of images in some accredited style, if that suited his fancy, or to cross boundaries between styles thought to be distinctive from each other. In short, no holds were barred. Such are the perverse effects of time, Dada now is a respectable designation employed by art critics, and it enjoys an esteemed place in the studies of art historians.

Dada freedom with reference to style appears again and again in the works of Man Ray. One cannot stylistically identify a work as indisputably by him. Nor would he be gratified if one could. He refuses to play the game according to the rules proclaimed by critics and art historians. Even in his Surrealist days, from the middle of the Twenties to the onset of the Second World War, he avoided conformity to doctrines of the movement. He retained a Dada independence throughout the Surealist period, creating works from time to time that do not accord with the principles of that school. For Man Ray, the making of works of art, is not work in the burdensome sense. He has said, "Everything I do is done in the spirit of pleasure. Sometimes my work is physically hard work. Mentally, it's pure pleasure." The equation of work and pleasure is a Dada attitude and it has characterized Man Ray for a half-century or longer.

Another side of Dada provides clues to Man Ray—its delight in the enigma, in the inexplicable, in mystification. On more than one occasion he has remarked to the writer that a work of art which can be taken apart and put together as if it was some kind of machine holds no interest for him. What does engage his interest in a work of art are those facets which defy analysis and are imbued with mystery. This applies to his own efforts as well as to the creations of others. In the preface to a proposed book, titled *One Hundred Objects of My Affection,* he says,

> In assembling *Objects of My Affection,* the author indulged in an activity parallel to his painting and photography, an activity which he hopes will elude criticism and evaluation. These objects are a mystery to himself as much as they might be to others, and he hopes they will always remain so. That is their justification, if any is needed.
>
> We all love a mystery, but must it necessarily be murder?

This kind of mystification applies to Man Ray the person. There is about him something of the conjurer, the prestidigitator enveloped by the strange, the anomalous, the unexpected.

One more aspect of Dada appealing to Man Ray was its glee in the spoof, its spirited hi-jinks, its refusal to be pompous. It is no wonder he found his milieu in Paris in 1921 when he was welcomed with open arms by Tristan Tzara, Max Ernst, Marcel Duchamp and the other Dadaists who had preceded him there. On the occasion of his first Paris exhibition, shortly after his arrival, they presented him to the public as an enigma. The catalog they prepared for his show at Libraire Six was headed *Good News.* It stated, among other things, that it was not known where the artist was born, and that after a career as a coal merchant, several times millionaire, and chairman of the chewing gum trust, he accepted the invitation of the Dadaists to show his recent paintings. It is the kind of introduction Man Ray could have engineered himself.

When Man Ray arrived in Paris he was the acknowledged American prototype of Dada. By 1921 Dada had sprung from Zurich to Cologne, Berlin, Paris and New York. Indeed, about the same time in 1916 when the young poets and artists in Zurich were taking over the Cabaret Voltaire, Marcel Duchamp and Man Ray in New York were taking similar positions with regard to art and life, unaware there was a Zurich group calling itself Dada. They became aware of the Zurich development upon the arrival in New York of the painter Francis Picabia from war-torn Europe. Marcel Duchamp and Man Ray contributed in New York to Picabia's publication, *391,* and subsequently the two edited the sole issue of *New York Dada.* Shortly afterward, Marcel Duchamp, and then Man Ray, departed for Paris.

Through the years, Man Ray has known and been a close friend of many distinguished persons in the arts. Of all these, his most enduring and meaningful friendship has been with Duchamp. They have influenced each other in numerous and subtle ways, and for half-a-century they have retained, without diminuition, their high regard for one another. When they meet, on occasions when Duchamp is in Paris, or Man Ray in New York, or during the Summer at Cadaques on the Costa Brava in Spain, they play chess and resume the conversation of their last encounter. It is a unique and consequential friendship in the annals of modern art.

As for Man Ray's participation in Surrealism, he was inspirited by such ideas of that movement as the significance of the dream, the unconscious, chance, accident, free association, and by the attraction of the surrealists to the mysterious and the disquieting. Such surrealist works by him as the series entitled **Shakespearean Equations** are suffused with the inexplicable. At the same time, he introduced into the **Shakespearean Equations** an ironic Dada element in the juxtaposition of rational mathematical structures (he had seen in three-dimensional form at the Poincaré Institute in Paris) and irrational images sprung from the depths of his unconscious. His closest attachment among the surrealists in Paris was with the poet Paul Éluard. They issued two volumes of verse and illustrations—*Facile* in 1935, with photographs by Man Ray, and *Les mains libres* in 1937, with drawings by the artist. While the surrealist years account for many of the artist's

finest works, those accomplishments are in many ways an extension of his Dada attitudes to art and life.

It is forty-five years since Man Ray, the young Dadaist, came to Paris for the first time. In matters that count, he is as Dada now as then. He persists in being purely and simply himself, going on with his work for the pure pleasure it gives him. (pp. 14-18)

> *Jules Langsner, in an introduction to* Man Ray: An Exhibition, *Los Angeles County Museum of Art, Lytton Gallery, 1966, pp 9-18.*

SURVEY OF CRITICISM

Willard Huntington Wright (essay date 1916)

[*Under the pseudonym S. S. Van Dine, Wright was one of the most popular American detective fiction writers of the late 1920s and 1930s. Prior to 1925, however, Wright was known as an editor and as an art, music, and literary critic for contemporary periodicals. In the following excerpt from a review of "The Forum Exhibition of Modern American Painters" at New York's Anderson Galleries, Wright commends Man Ray's aesthetics.*]

In the latest work of Man Ray the casual observer would see the influence of Picasso's thought, whereas in reality the result arrived at, though it does stem from the great Spaniard, is the result of a totally different mental attitude. Picasso has ever been the slave of objectivity, no matter how broken up or distorted his canvases may appear. Man Ray merely uses certain phases of objects in order to have a convenient and well-known type of form with which to work. Between the two men is a vast gulf. Picasso works toward abstraction from very simple, solid, every-day objects, while Ray's desire to create is inspired less by nature than by thought. He cares little with what forms he erects his ordinances: it is the creation which is all-absorbing to the artist, and it is the result, the complete offspring of his thought, that interests him. Ray has passed many stages along the road of his development. Some of the later French painters of figure composition have influenced him, as well as Picasso in certain works exposed a while ago at [the Daniel Gallery in New York City]. Even a man so slight as [Francis] Picabia has had a hand in Ray's painting. But from out the work of student days he has come to guide his own star. Personal problems he has set himself to solve, believing, like all artists, that salvation lies in such solutions. One of his principal preoccupations is with the diversity and order of piquant texture. Indeed, it is in his accomplishment of this, one of his cardinal qualities, that lies any sense of emotional depth he may give us. Ray believes that painting, being done on a two-dimensional surface, should satisfy itself with this flat restraint; and he has set himself to beautify his canvas even more diligently than if he were a sculptor. That he has penetrated far into the fundamental problems of formal order in two dimensions is undeniable. That he has

achieved much on the way is quite as evident. In all his work there is a sensitivity to greys of the more softly harmonious kind, and a progress toward massive line-forms which give promise of a greater extent in his future work. Let it be noted, however, that his expression thus far is not in advance of his technical ability; and his very approximation toward a complete finish gives his work an appearance of finality. (pp. 467-68)

> *Willard Huntington Wright, "The Forum Exhibition," in* Forum, *Vol. 55, April, 1916, pp. 457-71.*

Tristan Tzara (essay date 1922)

[*A Romanian-born French poet, essayist, and dramatist, Tzara was the most prominent proponent and theoretician of Dadaism. He was a close friend of Man Ray's in Paris during the 1920s, and he collaborated with the artist on several creative projects and exhibitions. In the following essay, which originally appeared as a preface to Man Ray's collection* Les champs délicieux, *Tzara celebrates the rayograph.*]

No longer does an object, by crossing the trajectories of its outer edges within the iris, project a badly inverted image on the surface. The photographer has invented a new method: he presents to space an image that exceeds it, and the air, with its clenched fists and superior intelligence, seizes it and holds it next to its heart.

An ellipse turns around the partridge; is it a cigarette box? The photographer turns the spit of his thoughts to the sputtering of a poorly greased moon.

Light varies according to how stunned the pupil is by the coldness of paper, according to the weight of the light and the shock that it causes. A wisp of delicate tree conjures up metal-bearing beds of earth, or bursting plumes of water. It lights the hallway of the heart with a lace of snow. And what interests us is without reason and without motive, like a cloud dropping its load of rain.

But let's speak of art for a moment. Yes, art. I know a gentleman who makes excellent portraits. This gentleman is a camera. But, you say, there is no color, no trembling of the brush. At first this uncertain quiver was a weakness that justified itself by calling itself sensitivity. Apparently the virtues of human imperfection are to be taken more seriously than the virtues of a machine's precision. And still lifes? I would like to know if hors-d'oeuvres, desserts, and baskets of game are not more attractive to the breath of our appetite. I listen to a snake whirring in a mine of petroleum; a torpedo twisting its mouth; dishes breaking during domestic quarrels. Why don't they make portraits of this? Because what this concerns is a medium that conveys a special commotion to those who approach it, but that uses up neither eyes nor colors.

The painters saw this, they gathered in a circle, they argued for a long time, and they came up with some laws of decomposition. And laws of construction. And of convolution. And laws of intelligence and comprehension, of

Man Ray recounts his creation of the first rayograph:

Again at night I developed the last plates I had exposed; the following night I set to work printing them. Besides the trays and chemical solutions in bottles, a glass graduate and thermometer, a box of photographic paper, my laboratory equipment was nil. Fortunately, I had to make only contact prints from my large plates. I simply laid a glass negative on a sheet of light-sensitive paper on the table, by the light of my little red lantern, turned on the bulb that hung from the ceiling, for a few seconds, and developed the prints. It was while making these prints that I hit on my Rayograph process, or cameraless photographs. One sheet of photo paper got into the developing tray—a sheet unexposed that had been mixed with those already exposed under the negatives—I made my several exposures first, developing them together later—and as I waited in vain a couple of minutes for an image to appear, regretting the waste of paper, I mechanically placed a small glass funnel, the graduate and the thermometer in the tray on the wetted paper. I turned on the light; before my eyes an image began to form, not quite a simple silhouette of the objects as in a straight photograph, but distorted and refracted by the glass more or less in contact with the paper and standing out against a black background, the part directly exposed to the light. I remembered when I was a boy, placing fern leaves in a printing frame with proof paper, exposing it to sunlight, and obtaining a white negative of the leaves. This was the same idea, but with an added three-dimensional quality and tone graduation. I made a few more prints, setting aside the more serious work . . . , using up my precious paper. Taking whatever objects came to hand; my hotel-room key, a handkerchief, some pencils, a brush, a candle, a piece of twine—it wasn't necessary to put them in the liquid but on the dry paper first, exposing it to the light for a few seconds as with the negatives—I made a few more prints, excitedly, enjoying myself immensely. In the morning I examined the results, pinning a couple of the Rayographs—as I decided to call them—on the wall. They looked startlingly new and mysterious. Around noon, Tristan Tzara came in to see if we might lunch together He spotted my prints on the wall at once, becoming very enthusiastic; they were pure Dada creations, he said, and far superior to similar attempts—simple flat textural prints in black and white—made a few years ago by Christian Schad, an early Dadaist.

Tzara came to my room that night; we made some Rayographs together, he disposing matches on the paper, breaking up the match box itself for an object, and burning holes with a cigarette in a piece of paper, while I made cones and triangles and wire spirals, all of which produced astonishing results.

From Self Portrait.

sales, of reproduction, of dignity and preservation in museums. Others came along afterward with cries of enlightenment to say that what the first ones had done was nothing but cheap bird excrement. In its place they proposed their own merchandise, an impressionist diagram reduced to a vulgar though charming symbol. For a moment I believed in their cries, the cries of idiots scoured by fountains of snow, but I very quickly perceived that they were only tormented by a fruitless jealousy. They all ended up confecting English postcards. After having known Nietzsche and sworn on their mistresses, after having extracted the

enamel from their friends' corpses, they declared that beautiful children deserved good paintings in oil, and the best of these was the one that returned the highest price. Paintings with tailcoats and curled hair, in gilded frames. To them this is marble; to us, our chambermaid's urine.

When everything we call art had become thoroughly arthritic, a photographer lit up the thousand candles of his lamp, and the sensitized paper absorbed bit by bit the black outlines of some everyday objects. With a fresh and delicate flash of light, he invented a force that surpassed in importance all the constellations intended for our visual pleasure. The mechanical, exact, unique, and correct distortion is fixed, smooth, and filtered like a mane of hair through a comb of light.

Is it a spiral of water or the tragic gleam of a revolver, an egg, a glistening arc or the floodgate of reason, a keen ear attuned to a mineral hiss, or a turbine of algebraic formulas? As a mirror throws back an image without effort, as an echo throws back a voice without asking why, the beauty of matter belongs to no one: from now on it is a product of physics and chemistry.

After the grand inventions and the tempests, pockets of magic wind sweep away all the little swindles worked by sensitivity, knowledge, and intelligence. The dealer in light values accepts the bet proposed by the stableboys. The measure of oats they give to the horses of modern art each morning and evening will not disrupt the thrilling course of his game of chess with the sun.

Tristan Tzara, "Les champs délicieux: Man Ray, 1922," in Aperture, *No. 85, 1981, p. 63.*

Robert Desnos (essay date 1923)

[*A French poet of the early twentieth century, Desnos was one of the original members of the Surrealist movement and one of the most adept at expressing the Surrealist impulse in poetry. His poems of the Surrealist era adhere to the movement's tenets, attempting to free subconscious thought from the constraints of rationality through such techniques as automatic writing and employing "speaking thought" to generate material for writing while in hypnotic sleep. Desnos became acquainted with Man Ray and his work through their mutual interest in and contact with Dadaist and Surrealist circles in Paris during the 1920s. In the following essay, which originally appeared in* Le journal *of Paris in 1923, Desnos describes the revelatory power in Man Ray's artwork and aesthetics.*]

The universe—we haven't explored it except in the comfort of the tainted sense of prejudice. Our vision of the world reduced to the four elements is the same as that of the most distant anthropopithecus. The blind fish of the ocean depths undoubtedly constructs his mythology among the aromatic algae, in spite of the whole collection of gods there that man makes every effort to cause to rise from the sea. The day when our senses awakened, we declared that chaos had been dispersed, but other confusions surrounded us. We don't have the means to separate them into water, air, earth, and fire. We are lacking in infinity of senses. The conquest of just one would revolutionize the

world more than the invention of a religion or the brutal advent of a new geologic age.

Besides, we don't possess the complete mastery of those five delicate receivers, in spite of an experience of several thousand years. Dreams, for example, which essentially reveal intentions, and what we call optical illusions because the camera does not record them, escape the control that man aspires to exert over what surrounds him. Such control would be, in my opinion, to falsify the universe that is suggested to me by Man Ray, a universe that lingers over the representation of dizziness, because it reveals a tangible, unquestionably material country under the same heading as light, heat, and electricity.

As a painter, Man Ray strives more toward spiritual chess than toward painterly chess. He speculates on a slight displacement of an obelisk or on the throat of Marcel Duchamp. Spirals coil like flexible brains, but no needle obeys their attempts to straighten out their curves to draw a lottery winner or, even more illusory, an hour. He arrives between two jolts of an earthquake; he stops creation at the top of a leap, right before the return to the normal position. He captures faces at the fleeting moment that separates two expressions. Life isn't present in his pictures, but neither is death. There is only a pause, a stop. Man Ray is the painter of syncopes.

As a sculptor, he demands that the most fatal laws take a direction out of the reach of draftsmen. He leaves marble and granite for tombs, he leaves clay under his feet; he needs other plastic materials to realize constructions independent of human forces in space. His mysterious physics makes little distinction between the fragility of paper and the solidity of porphyry. He can endow the former with strength and the latter with the restless mobility of liquids, if he wants. The kind of unwieldiness he seeks will transform a lampshade into a spiral that is more sensitive than a seismograph or a precision weathervane trapped by meteorological caprice under a mute glass bell.

As a photographer, Man Ray is no longer dependent upon a servile reproduction of "nature." Planes and bumps will reveal someone you don't know, whom you have never dared to catch a glimpse of, even in your dreams. A new "you" will arise from the delicate hands of the chemist, in the red gleam of the laboratory. You will blink your eyes when you come into the open air, like a night bird.

No word yet exists to designate Man Ray's invention, those abstract "photographs" in which he makes the solar spectrum participate in adventurous constructions. Like children, we make cutouts of our hands on a piece of paper exposed to the sun. Starting from this naive procedure, he succeeds in creating strange, unearthly landscapes, a chaos more astounding than the Bible could ever describe. A miracle lets itself be recorded, and something else also leaves the distressing mark of its thumb on the revealing paper.

The sentimentality that dishonors almost everything that man touches is forbidden here. . . . An attentive chloroform will communicate to you that metaphysical anguish without which there is no dignity on the earth. If you can abandon earthly conceptions, you will penetrate a world

without latitude or longitude, a scrap of that infinity which, open to some, is the most moving excuse that the modern age can still give for its aptitude to produce.

Like the famous monk who, far from the eucharistic balms, ascertained the presence of thunder in a mixture of sulfur and saltpeter, Man Ray doesn't calculate, doesn't prophesy the result of his manipulations. Following him, we will descend those toboggans of flesh or of light, those pointed slopes, we will search for the key to hidden cellars. A clown, in his paper costume heavier than lead, is making signals from far off. But we hold the marvelous within the sides of this piece of paper like we hold it everywhere we want, a big, imaginary maelstrom that hollows out and offers us its dizzy bouquet. But we don't dare lose ourselves in it, in spite of the repeated appeals of our image in the depths of the water. Tomorrow you will read in the newspapers a detailed account of the crime, with supporting evidence—fingerprints and anthropometric photographs. Be sure, nevertheless, that we won't agree about the meaning of the black or colored characters, the letters and the images.

It is unimportant to me whether Man Ray's conception is superior or inferior to its realization. When I agreed to look at it, I acquired the same rights as he over his work. If my door is locked, those whom I love know how to force it open. Critical exposition irritates creative people. Seeing their work escape, they can't repress the feeling of ownership, master of mediocre souls. If the reasons that a spectator gives to justify a work are superior to those of its author, the spectator becomes the legitimate owner of the work about which he is speaking. But Man Ray's attitude doesn't imply such a situation. It guarantees him supremacy in the regions of his work. Behind his obstinate silence, I like to see the partial bliss of those who have had a revelation. Whatever his initiation was, Man Ray springs from poetry, and it is under that title that I have come today into his domain, which is as open as Eternity.

Robert Desnos, "Man Ray," in Man Ray: The Photographic Image, *edited by Janus, translated by Murtha Baca, Barron's, 1977, p. 215.*

Lewis Mumford (essay date 1934)

[An American sociologist, historian, philosopher, and author, Mumford was particularly interested in the relationship between the modern individual and his or her environment, and contributed several important studies that examine the interrelationship of cities and civilization over the centuries. Mumford's work generally suggests that firm moral values are necessary for the growth of civilization. In the following excerpt, he negatively assesses Man Ray's photographs as presented in Man Ray: Photographs, 1920-1934 Paris.]

Living in Paris, Man Ray has become slightly legendary. Those who wish to preserve the legend should not look into the book of photographs by him, [**Man Ray: Photographs, 1920-1934 Paris**], published by James Thrall Soby at Hartford. If they should get past the terrible color lithograph on the cover, they will find an extremely adroit technician, who has done almost everything with a camera ex-

cept use it to take photographs. Man Ray's repertory is large. There is the usual study of stone texture; a flat shadow-graph of a flower; a pocket cigarette-lighter juxtaposed to a walnut that looks like some opened brains. There is the oval head of a lady, placed horizontally on a table in the manner of Brancusi; there is a schoolboyish imitation of O'Keeffe, with the aid of an apple and a metallic screw—perhaps it is meant to be funny. There is a Renger-Patzsch forest, an Eisenstein statue, a Paul Strand rock formation. Man Ray can make a photograph look like a water color, or a crayon drawing, or a charcoal drawing; he can even produce the brush effects of an oil painting. . . . I cannot think of a single trick anyone has done during the last fifteen years that Man Ray does not show in this book, and for all I know, he may have done the trick first. But, considering Man Ray's capacities, it is a pretty sad performance, for in some of his male portraits, particularly in those of Derain, Schoenberg, Joyce, and Lewis, he shows honest gifts as a photographer, and he need not have smirked and gyrated so often to call attention to his talents. A photographer who can deal intelligently with the human face should not waste his time photographing calla lilies so that they will look like a drawing by a second-rate academician. (pp. 34-5)

> Lewis Mumford, in a review of "Man Ray: Photographs, 1920-1934 Paris," in The New Yorker, *Vol. X, No. 33, September 29, 1934, pp. 34-5.*

Carl Belz (essay date 1964)

[*Belz is an American educator and art historian who has written on modern art. In the following essay, he discusses Man Ray's early paintings as reflections of the development of his Dadaist aesthetics.*]

> In whatever form it is finally presented, by a drawing, by a painting, by a photograph, or by the object itself in its original material and dimensions, it is designed to amuse, bewilder, annoy or to inspire reflection, but not to arouse admiration for any technical excellence usually sought for in works of art. The streets are full of admirable craftsmen, but so few practical dreamers.

This statement by the American-born artist, Man Ray, provides a key to the understanding of a body of material which, to several critics at least, appears uneven and inconsistent with respect to artistic sensibility. Beneath the surface of these remarks lies Man Ray's fundamental Dada orientation, just as, beneath the simple and deceptive surfaces of his paintings, lie many complex enigmas and paradoxes. Such qualities first appear in Ray's work during the 1910's, a period which witnessed his gradual liberation from the academic tradition in which he was trained, and during which he first associated with Marcel Duchamp with whom he has formed a lasting friendship. In addition, Ray's work during this decade provides an illuminating aspect of New York Dada, one of the important, but "unofficial" phases of the sprawling and hectic international movement.

An event of singular importance in Ray's early career was the Armory Show of 1913. Despite the artist's knowledge of Alfred Stieglitz and [his gallery] 291, and, hence, some of the avant-garde trends which appeared in this country before 1913, his work does not exhibit a consistent involvement with the problems of either Cubism or abstraction in general until after this date. One earlier work in particular, however, provides an anticipation of Ray's Dada inclinations: *Tapestry,* 1911. The composition consists of a series of colored, rectangular, cloth blocks which the artist selected from a fabric sample book. As an abstraction the work is one of the earliest dated examples by an American painter. However, despite the purity of abstraction and the precocious 1911 date, it would be incorrect to champion Ray, on the basis of this single composition, as one of the first Americans who worked in this idiom. The object represents a complete break with Ray's work of the period, and its *raison d'être* places it more within a Dada context than as part of a chronology of early abstract expression. Man Ray has remarked that *Tapestry* represented his first gesture of revolt after leaving the academy. When we encounter a motive like revolt, the formal or aesthetic qualities of a work naturally assume secondary importance. Thus Man Ray did not develop an abstract style out of *Tapestry,* nor did his earlier work anticipate its form.

Tapestry is one of a series of pre-Dada adventures—that is, dating before the official naming of the movement in 1916—which erupted in Europe and America. The best-known continental examples are Duchamp's readymades; his *Bicycle Wheel* and *Bottlerack* date from 1913 and 1914 respectively. In addition, *Tapestry* anticipates a larger area of twentieth-century art: the assemblage construction. It thus belongs to a long line of inspirations, many of which emerged from the Zurich atmosphere of 1916-18. The abstract block patterns of Hans and Sophie Taeuber Arp are closest in form to Ray's own work. In content, however, Duchamp's readymades or Schwitters' "Merz" constructions more closely match the spirit of *Tapestry.* All represent gestures against traditional artistic style and technique, and all find their inspiration in the paraphernalia of everyday life: a child's play object, street litter or newspapers, or, in the case of Man Ray, the fabric sample book.

While *Tapestry* indicates Man Ray's ability to translate an assemblage construction into a personal and reactionary message, *Man Ray 1914* exhibits a like phenomenon in painting. Although not actually a landscape, the subject at first glance appears like a desolate rocky promontory or some towering city interior. In reality the composition consists solely of the letters of the artist's name and its date of completion. Like *Tapestry* this painting reveals Man Ray's Dada nature. In style and content it is at once an anti-art and anti-Cubism gesture. Regarding style, Ray employs all of the geometric and planar trappings common to the Cubist vocabulary, but applies them, not to make a statement of mass or space or movement, but simply to glorify his own name. Like Klee, who also used numbers or letters in some of his paintings of Cubist derivation, Man Ray transforms the style into a facade and vehicle for his personal whimsy.

The content of **Man Ray 1914,** however, exhibits an ultimately Dada character. The work is as biting and humorous as Duchamp's readymades and, beneath the veil of a Dada joke, represents as strong an argument for non-objective painting as Kandinsky's *On the Spiritual in Art.* For, by transforming a name into subject matter, Ray not only mocks any work of "serious" or "realistic" content, but also provokes the question of whether any painting need have literal content. The artist permits a name to qualify as subject matter for a painting in the same way that Duchamp's readymades put the mass-produced bottlerack on the level of sculpture. The work is wholly Dada because of its double-edged nature: on one level an amusing joke and a visual slur on Cubism; on another level a sharp criticism of a traditional attitude about painting and a jibe at the public. For, as Marcel Jean neatly observes, "in a picture, is it not above all the signature that counts" [*The History of Surrealist Painting,* 1960].

The year 1915 marks another important event in Ray's career: the beginning of his friendship with Marcel Duchamp. When Duchamp arrived from Paris, in the summer of 1915, Ray was living in Ridgefield, New Jersey. That same year he returned to work in New York City. The change seems to represent a turning point in the artist's career. While painting had been his sole artistic activity before this time, Ray begins, around 1915, to work in new and different media. He first takes up photography and then broadens his scope still further with his work in collage, in constructing objects, and finally with his machine paintings, the airbrush series of 1917 to 1920. This new breadth of interests must have harmonized perfectly with Duchamp's mentality which is possessed of a similar catholicity of taste. Ray's studio soon became filled with photographic equipment and other mechanical gadgets which had accumulated from his involvement with architectural drafting work. These objects fascinated Duchamp and provided an additional point of contact for the two artists. During the years between 1915 and 1921 both men remained in New York, occasionally collaborating on an individual project, but consistently exploring similar artistic and intellectual problems.

Three paintings from 1915, **Still Life, Interior,** and **Cutout,** display an advanced stage of Man Ray's Dada attitude toward technique and content. The works share an important feature: their unfinished appearance. Forms are loosely handled, lines remain incomplete or scribbled, and perspective distortions are permitted to exist next to visually objective areas. However, to consider the paintings as experimental sketches would be incorrect, for Ray maintains that none of the pictures which emerge from his studio is an experiment. Each is, in its way, a final product. A possible explanation for the seemingly careless treatment would involve the artist's attitude about technical excellence. To insure a non-visual appreciation of his work Ray consciously avoids a carefully finished surface and uses a deliberately careless manner. But the involvement with technique does not cease with the loose rendition of forms. Ray seems to toy with different technical problems; at one moment he uses technique to produce an illusionistic *tour de force,* and in the next he completely negates it. In **Still Life,** for instance, nearly all the forms are loosely

painted in an offhand manner with the brushstroke clearly visible. Only the central area of the flat dish on the right side of the composition is smoothly and carefully rendered. Its rim is depicted in correct perspective, but an unexplained shadow lines the upper portion of the circle. The result is a *trompe l'oeil* effect: the dish appears to be cut out and lying over another flat form. The illusion also holds the possibility that a hole has been cut in the canvas.

In **Cutout** this illusion becomes a reality. Here the artist employs the same technical devices which he used in **Still Life.** All the brushwork is apparent except for the areas on the right and left extremities of the painting. In these sections the smooth surface reappears, but in this case the illusion is not the result of a painterly manipulation. It results from the actual cutting away of the picture surface and hanging of the painting before a white cardboard backdrop. By adjusting the light on the picture, Ray darkens half of this backdrop, and in this way destroys the appearance of uniformity which might reveal the visual trick. **Still Life** and **Cutout** thus complement one another; the same visual illusion is achieved using two different methods. Ray first uses the careful technique of a painter, but then negates it by employing a much easier method. **Cutout** becomes tantamount to a Dada question: why bother with laborious techniques when they can so easily be eliminated?

Interior contains similar enigmas. The painting appears to contain a meaningless conglomeration of elements, and the title does not seem to apply to the forms as a whole. Some of the elements are recognizable. The white background form is that of a horse and rider; the group is a detail from **War—**A.D. MCMXIV with the figures reversed. The chains, weight, and pendulum of a clock are also shown, as well as a mysterious number, "1000." Upon examination, at least two of these elements are understandable in terms of the title, **Interior.** The equestrian groups is a detail from the "interior" of another painting, and the chains, weight, and pendulum belong to the "interior" mechanism of a clock. Both the clock and the painting probably comprised part of the "interior" trappings of Ray's studio. The other forms, for example, the hexagonal solid in the lower left corner of the picture, may have been inspired by other objects strewn about the same "interior." Finally, the painting itself has its own "interior:" the dark rectangle which seems to be a cutout pasted in the center of the composition. However, at this moment the progression disintegrates. Just when we seem to have discovered the organization behind **Interior,** its own physical "interior" turns out as an abstract scribbling of black lines. Because of its non-objective form, this area of the painting casts a veil of absurdity upon the possible logic of the rest of the picture. In the same way the number "1000" may not be entirely insignificant. Since we are already presented with parts of a clock, we could suppose that the number refers to a specific hour, exactly 10 o'clock. But here again Ray leaves the viewer in an absurd situation: 10 o'clock, but when? A specific moment is left within the abstract abyss of at least an entire year.

Ray seems to be playing Dada games, directing the viewer along a seemingly logical path, but then interjecting a fac-

tor which leaves him totally confused. The above discussion has attempted to demonstrate the artist's penchant for such reversals of style and content. But these are equally serious intellectual exercises which raise problems of paradox and ambiguity and question the traditional concepts of style, content, and technique. Such concerns reveal a fundamental aspect of Man Ray's art: its underlying intellectual content. Already in the 1910's he was not content to become wholly involved with the aesthetic problems of style. In *Man Ray 1914* the artist stated his criticism of content, but with the paintings of 1915 he reveals a content of a different intellectual order.

These interests bear a remarkable resemblance to those of Ray's new acquaintance of 1915, Marcel Duchamp. Robert Lebel [in *Marcel Duchamp,* 1959] has described the dilemma out of which came Duchamp's decision to abandon painting: "Duchamp soon deduced, from the praise he received and the consideration he began to enjoy, that his works, although laden with meanings, would forever be judged by others only in terms of their aesthetic qualities." Ray also disparages so-called aesthetic analyses of his work, and insists upon their content and personal message. Lebel goes on to state a question which seems to apply equally to either man during this critical period around 1915: "Was he to let himself disappear in the horde of painters pushing toward the threshold of notoriety? Should he, in his turn, under the threat of commercialization, be driven to the emptiness of tireless repetition?" In their respective works both Duchamp and Man Ray rejected the popular course and answered with a negative the above questions. While Duchamp's decision led him to the readymade, the *Large Glass,* and, eventually, a complete denial of painting, Ray's involved him in continuously varied statements in the forms of objects, photographs, machine creations, and paintings like the ones from 1915. Between 1915 and 1921 the paths of Ray and Duchamp cross regularly and provoke comparisons which must be considered as we encounter Ray's different works. The harmony of artistic outlook shared by the two men helps to account for their collaboration during the New York period. In addition, it provides much of the intellectual force of New York Dada.

While negating a conventional understanding of style or technique, Man Ray never abandons completely a concern with these problems. As Georges Ribemont-Dessaignes pointed out in a 1924 monograph on the artist, Ray never hesitates to recreate "plastic" situations in order to have, at a later date, an object of destruction. Such is the case with the ten panels comprising the series of *Revolving Doors* on which the artist worked during 1916 and 1917. Superficially the "doors" seem to involve only formal intentions, the balance and interplay of non-objective units which float in an abstract space. However, a number of other considerations are involved in the conception of the panels, and these serve to make their issue more complex.

The abstractions consist of colored paper cutouts pasted on white backgrounds. This system immediately causes a technical ambiguity: the cutouts appear to be finely controlled watercolors and have none of the rough-edged or littered quality usually associated with the *papier collé* me-

dium. The transparency of the planes adds to this watercolor effect. Ray thus adapts what was for him an entirely new medium and transforms it into a visual system which is a continuation of his painting style during these same years. While the forms of a work such as *The Rope Dancer Accompanies Herself with Her Shadows,* 1916, have an angular, mechanical quality and appear as paper cutouts, the abstracts in the *Revolving Doors,* similar in type to the painting, actually are geometric cutouts. The artists builds an intricate technical system—a composition of many large and small, angular and curvilinear bits of colored paper—and at the same time avoids the manual labors which would be required to gain an identical effect in paint. Similar tendencies may be found in Duchamp's work after 1912 when he began his machine pictures. As Lebel writes, "Duchamp was inclined to 'intellectualize' his works, thereby eliminating more and more what they might still contain of the manual." Although Ray's panels are less abstract and philosophically oriented than, for instance, Duchamp's *Large Glass* [also called] *La mariée mise à nu par ses célibataires même,* the assault on painterly style provides them with a mutual foundation. Similar to Duchamp in the *Large Glass,* Ray's *Revolving Doors* show him as a meticulous technician who is able to avoid traditional technical procedures.

The "doors" also contain color experiments. In each case the artist has started with three planes of primary colors, red, yellow, and blue. Whenever two or three of these overlap or intersect, variations of the complementary colors result. The various complexes of tones are therefore prismatically determined. In addition, each set of forms is specifically titled. In *Encounter,* for example, three abstract planes collide along the central axis of the composition, and the "encounter" results in a multi-colored vertical spiral. In *Jeune fille,* a series of simple, delicate and slender forms are related by title to the image of a young girl. The titles seem to have been inspired by the forms—a system the artist has used on other occasions—and in such a way that Ray engages the viewer in word games and the association of abstract images with the concepts or objects they might suggest.

The ten panels thus exist on a variety of levels, and, as a group, raise various technical, intellectual, and visual problems. They constitute a kind of assemblage of Ray's artistic questions and ideas. This pictorial synthesis of a personal system can also be found in Duchamp's work, namely *Tu m'* which he completed in 1918. While the precise meaning of all the elements in this painting is a matter open to conjecture, writers are agreed that the mural represents a *summa* of Duchamp's ideas on art. As Marcel Jean points out, questions of color, proportions, feeling, matter, *trompe l'oeil,* reality, and movement all arise from the contents of *Tu m'.* Similar to Ray's work, however, only the questions are stated, and, in negativist Dada fashion, the answers remain vague and ambiguous. This quality is characteristic of Ray's and Duchamp's New York Dada activities. In Ray's work alone we have already encountered questions pertaining to the validity of style and abstraction, the limits as well as a new type of content, and the role of the title and technique in a work of art. With both men Dada assumes the role of *advocatus diaboli*

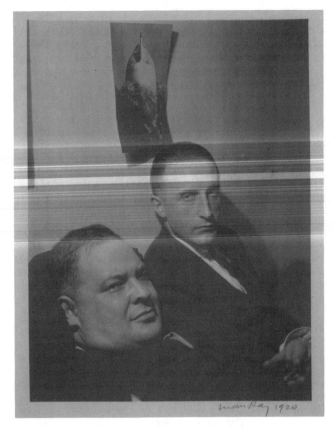

Joseph Stella and Marcel Duchamp *(1920)*.

["devil's advocate"], and no traditional questions are exempt from their intellectual attack.

Ray's *The Rope Dancer Accompanies Herself with Her Shadows,* already mentioned, deserves further consideration in light of the above observations. This work, Ray's largest composition of the New York period, is again comparable to Duchampian efforts during the 1910's. This painting, in size and in its visual qualities, bears comparison to Duchamp's *Large Glass.* Most obvious is the placement of precisely outlined forms against a clear, light background. The figure of the rope dancer, from which emanate the six curves connecting her with her accompanying shadows, is similar in type to the bride's "nine malic moulds" on the lower left of the glass. In each case a series of connecting lines orient the figure, or figures, with other areas of the composition. Further, the complex geometric outlines which define the dancer give the form a transparent quality which is like that of Duchamp's system on the lower half of the glass, especially in the "glider" and the "chocolate grinder."

These comparisons, however, do not establish any cause and effect relationship between the two works. Each represents the continuation of a personal development of artistic ideas. The fact that the two men were working so closely during this period should provide sufficient explanation for the sharing of certain stylistic features. What could have influenced Ray was the *type* of project involved in Duchamp's glass: a compilation of ideas on which the art-

ist worked over a period of years. For Man Ray the *Rope Dancer* assumes a similar role, a further synthesis of his 1915-16 work, in particular the stylistic, intellectual, and technical problems of the *Revolving Doors* on which he worked at the same time as he did the "dancer." In the entirely painted *Rope Dancer,* however, he reasserts the artist's technique rather than simulating such qualities with colored paper and mechanical cutouts.

Like *Still Life* and *Cutout,* the *Revolving Doors* and the *Rope Dancer* establish a complementary set of artistic statements. While the forms of the "doors" consist of shapes cut out of paper, the large areas of the *Rope Dancer* were determined by the shapes of the scraps left over from cutting out the forms of the dancer herself. In other words, Ray designed the dancer as a series of cutouts which he used as stencils over which to draw his figure. The leftover pieces he enlarged and rearranged to achieve the larger areas of the composition. Thus these pictorial "shadows" are actually determined by the shape of the dancer; or, as with shadows in nature, her shape conditioned their shape, and the latter are always as large or larger than the former. Aware of the fluctuations of natural conditions, however, the artist realizes that shadows are not necessarily exact replicas of their objects' outlines. Different light conditions produce different shadow effects. In the *Rope Dancer,* therefore, Ray reproduces what might be called the essence or idea of the dancer's shadows and not their natural appearance under one specific lighting condition.

As with the *Revolving Doors,* we have in the *Rope Dancer* an intellectualized world of paradox and ambiguity. The forms appear to be cutouts, but actually are painted. The large pictorial areas do not appear as shadows, but in reality are determined by a shadow principle. The dancer figure is a transparent abstraction which would seemingly have no shadow. The shadows themselves seem to represent a theory; if so, do the painted counterparts represent reality, or only the illusion, idea, or shadow of reality? The painting seems to reflect a philosophical principle in which Duchamp, according to Katherine Dreier [in *Collection of the Société Anonyme: Museum of Modern Art, 1920*], also believes: that the value of an object lies not in the object itself, but in the mind of him who creates the value. Whatever the ultimate solution to these riddles may be, one conclusion seems certain: Man Ray is dealing not only with technical and stylistic problems, but also with the intellectual problem of picturing the idea of a word. The task is tricky, and the word itself is evasive; but, while answers may not be forthcoming, questions themselves are raised to the level of a challenging content.

Both Duchamp and Man Ray seem to have been involved with the idea of shadows. Shadows is the theme for another of Ray's *Revolving Doors,* and they recur a year later in Duchamp's *Tu m'.* In the mural the shadows of three readymades, the *Bicycle Wheel, Bottle Opener,* and *Hat Rack,* are projected "ghost-like," as Marcel Jean writes, "over the whole image." Jean considers *Tu m'* as Duchamp's recapitulation of pictorial conventions; he quotes the artist as calling it a "dictionary of the principle ideas preceding 1918: readymades, standard stoppages, rent, bottle-brush, cast shadows, perspective." If Jean is correct

about pictorial conventions—and the title, "you bore me," provides strong evidence in his favor—then the shadows of the readymades hold an important meaning in the painting: the existence of any work of art (pictorial conventions) is subject to negation by the idea of the readymade. And their shadows, not the objects themselves of which there might exist countless numbers, hang threateningly behind the traditional pictorial ideas. The painting would thus contain Duchamp's personal interpretation of the intellectual force of the readymade object. If our analyses are correct, we have in *Tu m'* and the **Rope Dancer** two more cases showing how Duchamp and Ray were able to employ the visual aspects of abstract painting without sacrificing their interest in content. This content, however, is not of the traditional variety, but consists, beneath the Dadaist visual jokes and deceits, of ideas and shadows, and an involved intellectual order.

Dada is generally remembered, especially in the European phases of its history, for its satirical humor and the boisterous public demonstrations which it inspired. While events like the Arthur Craven scandal at the Salon of Independents, in 1917, contributed a certain notoriety to New York Dada, the work of Man Ray during the same years, as with that of Duchamp, helps to illuminate the serious, even intellectual side of the moment. The contributions of these men are, like the men themselves, inclined toward contemplative, even philosophical problems. Ray's paintings in particular are interesting in the light of his remarks about technique. In them he seems to disrupt a conventional understanding of style, content, and technique. But while negating such concepts, he invariably replaces them with questions of a challenging nature to the inquiring viewer. Thus—and perhaps this is a peculiarly American quality—he transforms paradox into content, thereby avoiding the complete nihilism of Dada philosophy. (pp. 207-13)

> *Carl Belz, "Man Ray and New York Dada,"*
> *in* Art Journal, *Vol. XXIII, No. 3, Spring,*
> *1964, pp. 207-13.*

Barbara Rose (essay date 1971)

[*Rose is an American art historian and critic who specializes in twentieth-century American painting. In the following excerpt, she examines Man Ray's career as a filmmaker, addressing his cinematic work as an attempt by the artist to create a kinetic solution to the pictorial limitations of painting and sculpture.*]

Conceived during the period between the two world wars of the *détente* from Cubism, the films of Man Ray . . . attempted to formulate an alternative to painting at a time when painting had lost much of its innovational impetus. This period of relaxation after the extraordinary decade of experimentation that closed with World War I called forth doubts regarding not only "progress" in abstract art, but also doubts regarding the function of painting and sculpture within mass industrial societies. In this context artists questioned, as they are questioning today, the social relevance of the traditional arts, as well as their ability to sustain a level of innovation equal to that of modern sci-

ence and industry. Given the problematic status of the traditional arts within such a revolutionary situation, the new art of film appeared to some a possible antidote to demoralization and paralysis. A mass art born of modern technology, free of the deadening burden of tradition, film began to attract artists eager to experiment with a young medium that seemed *by definition* the characteristic art of the industrial age. The camera had no need to ape machine imagery or adopt its mechanical forms because it was, quite literally, a machine. Not only artists eager to break with inherited traditions but the very apologists for those traditions, such as art historians Erwin Panofsky and Arnold Hauser, speculated that film might indeed prove the most significant medium in modern times.

Film fitted perfectly the futuristic prescriptions of the modern movements: a reproductive art of multiple originals, hence a popular social art, film referred to the greater world beyond the narrow confines of the studio, which in a revolutionary climate often seems stifling. Eventually, film came to be seen, for reasons we will examine, as the means of reconciling the avant-garde artist, so long alienated from society, with his fellow men. In the context of the difficulties confronting the progress of abstraction—even Picasso and Matisse returned to more explicitly figural styles during the *détente*—film had a distinct advantage: its images were mechanically, and not manually, recorded. It had the capacity to banish the *hand* of the artist, detested by both Dadaists and Constructivists alike for related reasons. The revulsion against "painterly" painting among artists who carried the banner of vanguardism between the two world wars can be explained by political and geographical factors. The tradition of painterly painting was a Mediterranean tradition. But Dada and Constructivism were creations of provincial artists. Revolting against painterly painting in the name of political protest, their radical manifestos implied that the single feature separating the fine artist from the mass of men was his unique talent, that is, his "hand." Democratization of art hence entailed the obliteration of such inherited distinctions in talent as well as that of wealth. Along with the hand would go that other relic of Renaissance individualism and social stratification, personal style.

Handcraft had already disappeared with folk art in advanced industrial societies. It was now proposed that handwork should equally disappear from art. . . . The sense that the Renaissance world of fixed values was dead and that a new civilization as yet unnamed and unknown was being born, created a mood of imminence and a climate of disorganization nearly as exaggerated as our own. Artists searched for "modern" themes, exalted the urban environment, and envied scientists their greater prominence in the world. The interest in science had already generated an obsession with breaking through the traditional limitations of the space arts among Cubists and Futurists. Influenced by chronophotographs, the Futurists illustrated the passage of time through a literary conceit. The Cubists, more sophisticated conceptually, superimposed views of the same object from differing vantage points, and tried to incorporate the fourth dimension through simultaneity.

Their images picturing time were dramatic, but it soon became obvious only actual movement could combine time with space. Around 1920, a number of painters and sculptors experimented with kinetic art literally involving the dimension of time. Among them were Thomas Wilfred and Ludwig Hirschfeld-Mack who worked with colored light projections and the early kinetic sculptors, the Constructivists Vladimir Tatlin and Naum Gabo and the Dadaist Marcel Duchamp.

Through Duchamp, whom he met in 1915, Man Ray became interested in movement. Duchamp's *Bicycle Wheel* of 1913 was not only the first "ready-made," it was also the first modern kinetic sculpture. In a single revolutionary gesture, Duchamp introduced the new genre in which he made several experiments, including one that almost killed Man Ray. Shortly before the two left New York for Paris, Duchamp was working on a revolving construction made of transparent planes painted with parts of a spiral supposed to fuse optically. Unfortunately, Duchamp's conception was ahead of his engineering. As Man Ray stood before the piece to photograph it, one of the planes of glass came flying off and hit him on the head. Duchamp continued to experiment with "rotoreliefs" as he called his kinetic paintings. Eventually, the optical discs containing spiral motifs were mounted on the bicycle to make *Anemic Cinema,* which Man Ray filmed for Duchamp in 1926. In *Anemic Cinema,* Duchamp accomplished what he had set out to do in the ill-fated *Rotary Glass Plate* of 1920: he created the illusion of a spiral projecting three-dimensionally toward the audience.

It is impossible to disengage Man Ray's career from Duchamp's. His best known painting, **The Rope Dancer Accompanies Herself with Her Shadows** is in a sense, a hard-edged synthetic Cubist female pendant to Duchamp's notorious *Nude Descending the Staircase.* Next, Man Ray proceeded to literalize motion by cutting the "shadows" of such a figure out and pasting them on pieces of cardboard attached to a revolving spindle. In Paris, he followed Duchamp by abandoning painting completely, turning to photographs, Rayographs, and Dada objects. From his interest in photography and motion, it was but a brief step to film, although it was a step it took him a few years to take. Initially, his interest in photography had been inspired by Alfred Stieglitz. In Paris, his assistant, Berenice Abbot, herself a gifted portrait photographer, introduced him to Atget's piquant and nostalgic Paris street scenes, which find echoes later in the scenes of **Emak Bakia.** Man Ray turned to photography as the modern form of representation. "I could not help thinking," he wrote in his autobiography *Self Portrait,* "that since photography had liberated the modern painter from the drudgery of faithful representation, this field would become the exclusive one of the photograph, helping it to become an art in its own right."

His final experiments in painting involved the search for an automatic mechanical technique. In 1919 he executed his first Aerographs, paintings made with the commercial technique of airbrushing, often used in photo-retouching. One of these Aerographs, titled the **Admiration of the Orchestrelle for the Cinematograph,** contained a rectangular grid on the left margin reminiscent of a film strip, marked with numbers indicating a progression in time. He was particularly proud of the nonpainterly quality of the Aerographs, which closely resembled photographs. "It was thrilling to paint a picture, hardly touching the surface—a purely cerebral art, as it were," he said of them.

The following year, apparently by accident, Man Ray stumbled on the process of cameraless photography while developing some negatives. The process had been known since 1839 when Fox-Talbot first created photographic images directly in his photogenic drawings, but Man Ray's use of the technique to create elegant pictorial effects involving space, texture, and abstract composition, were remarkable. (p. 69)

Man Ray was particularly pleased with the visual, nontactile quality of his films as well as with the Rayographs. He described his second film **Emak Bakia** as "purely optical, made to appeal only to the eyes." Freed from adherence to any convention of narrative, he mixed abstract and representational elements in both Rayographs and films. The sense of discovery he felt in so doing is understandable: the freedom to combine previously unrelated material was one of the few new areas of exploration available to experimental artists of the twenties and thirties.

Indeed the period between the two wars saw the principle of *assemblage*—of forms, concepts, materials, and images associated to produce new meanings—gain ascendance in all the arts. In literature, the stream-of-consciousness technique allowed the free merging of material from the newly discovered subconscious. The common denominator of Dada and Constructivism formally was that both were basically arts of *assemblage:* Constructivism assembled planes, shapes, textures, and materials; Dada depended on collage (both flat and three-dimensional) to strike new meanings from the association of familiar objects. Man Ray's 1921 Dada object, **Gift,** one of the first Dada objects he made on arriving in Paris, combines an ordinary iron with a row of spiked nails to create a menacing image of aggression and potential danger. In film, the equivalent of assemblage and collage was, of course, montage. Through montage the film artist could create complex fusions of images charged with poetic and allusive meaning.

Because its very construction depends on this principle of association, film solved many dilemmas for Man Ray. Much as he loved photography, he also hated the literalism of "reality." (He left America, he claimed, because it had no mystery.) In film, he could combine "found" images, that is, images preexisting in the world, in novel and imaginative ways which poetically inverted and subverted reality. Later the Surrealists' desire to create *peinture-poésie* drove Dali, Ernst, Delvaux, and Magritte—and eventually Man Ray—to adopt all the conventions of academic art Cubists had discarded.

But "film poetry" permitted the literary identification of subject matter without requiring such a compromise with academicism. Given this situation, the *cinépoème,* Man Ray's subtitle for **Emak Bakia,** was a natural solution to the dilemma of reconciling representational imagery with modern attitudes. This problem of imagery, a result of the

literary origins of Surrealist imagery, could never be adequately solved in painting that aspired to be poetry. Film, however, offered the possibility of *cinépoésie,* which might even include abstract elements, provided they were subsumed in a context of poetic allusion.

Despite the obvious logic of Man Ray's debut as a film maker (he prophetically signed Picabia's guest book as "Man Ray, Director of Bad Films" on his arrival in Paris), he fell into film work with characteristic insouciance. His initial film experience came in helping Duchamp try to make 3-D movies in New York in 1920, just prior to their departure for Europe. Always one jump ahead of the game, Duchamp used dual cameras attached to a single gear to record the same image simultaneously. Most of the film was ruined because the two experimenters used old garbage can lids which leaked as developing tanks; but a few feet were eventually projected through a standard stereopticon. According to Man Ray, the result was of three-dimensional images fused through binocular vision.

Man Ray made his own first film, characteristically, by chance. The poet Tristan Tzara announced he had placed a film by Man Ray on the program of the last great Dada evening, the "Coeur à barbe," held in 1923. Man Ray complained he had no such film, only a few random shots taken with a movie camera. Tzara suggested he make a lot of quick footage by using the technique of cameraless photography on film. Combining what he had with footage produced by placing objects on undeveloped film and then exposing it, Man Ray had enough for a five-minute film he called *Return to Reason*— the last thing any self-respecting Dadaist planned to do. A fight broke out, so that the film was a success by Dada standards. This persuaded the wealthy patron Monroe Wheeler to give Man Ray enough money to make *Emak Bakia,* a film of sufficient interest and originality to suggest Man Ray might have become a major Surrealist film maker, had he not been, as he readily admits in his autobiography, simply too lazy.

Between the making of *Return to Reason,* which is hardly more than an assemblage of unrelated images, and the far more ambitious *Emak Bakia* in 1927, André Breton had published his Surrealist manifestos, Léger had filmed *Ballet mécanique,* and Man Ray had worked with Duchamp on *Anemic Cinema.* These events obviously contributed considerably to Man Ray's ideas on film. After *Return to Reason,* Man Ray had continued to think of film, experimenting with animating black and white stills. At about this time he was approached by the American film maker Dudley Murphy. Although Man Ray declined to work with Murphy (apparently for financial reasons), Murphy found another artist interested in making a film with him. Before starting *Ballet mécanique* with Léger, however, Murphy introduced Man Ray to the lenses that would deform and multiply images that lend *Ballet mécanique* its distinctly Cubist quality. For this reason, *Emak Bakia,* whose title is most likely a punning reference to both *Ballet mécanique* and *Anemic Cinema,* has certain visual effects, such as splintering images and fragmenting planes for example, that relate to images in Léger's film.

Emak Bakia is a classic of early experimental cinema.

With the help of special lamps, an electric turntable, and an assortment of crystals, Man Ray was able to create a number of stunning visual effects. Abstract passages, as well as the images developed through the Rayograph process incorporated from *Return to Reason,* were interleaved rather than organically related to the realistic action scenes Man Ray shot with a small automatic hand camera. These random shots recorded diverse kinds of movement: the legs of Kiki of Montparnasse dancing the Charleston; Monroe Wheeler's wife driving her Mercedes at 90 m.p.h.; a herd of sheep charging across the screen.

All of Man Ray's strengths as an artist are present in *Emak Bakia.* There is the spirit of adventure and risk, his willingness to use chance as a creative element in the unconventional shots achieved by throwing the camera in the air and catching it. This sequence, which follows that of Mrs. Wheeler in her Mercedes, he thought suggested a collision between the car and the herd of sheep. It reads of course more like a blur, but an exciting blur. Because of the randomness of Man Ray's approach, one cannot really speak of the structure of *Emak Bakia,* which like *Un chien andalou,* is basically a series of disconnected visual gags. Certain images reoccur, however, creating a kind of *leitmotif* that might be considered structural: there are many close-ups of eyes, including a montage of eyes overlaid with car headlights. The final dramatic sequence features Kiki, Man Ray's celebrated mistress, appearing to stare straight at the audience, only to open her eyes, revealing the eyes we have seen as painted on her closed eyelids! This image is pure Man Ray: a witty ironic *double entendre* concerning the process of vision itself—a piece of sly trickery unveiled at the last moment to convince us of the cleverness of the artist and his awareness of his illusionistic means. Together with the image of Man Ray with the movie camera that opens *Emak Bakia,* it frames the film and exposes its optical trickery.

So concerned was Man Ray that he might be taken too seriously that he chose to end with a satire on conventional movie endings. The last sequence of the film, which has been a Dada hodgepodge without rhyme or reason throughout, opens with the words—The Reason for this Extravagance—raising the expectation that we will be given the cause of all this madness. According to Man Ray, he ended with such a satire on the movies "so that the spectator would not think I was being too arty." Actually, the effect is to introduce a false note of realistic narrative to further frustrate the spectator and deny him his right to logical explanations. Set up to expect a conventional flashback treatment of the cause of the events we have witnessed, we are allowed no such catharsis. Here is the essence of Dada, with its disdain for teleology as well as for the feelings of the audience.

The closing scenes of *Emak Bakia* are as topsy-turvy as the rest. A man drops collars to the floor. The collars come to life and jump around, twisting and revolving like kinetic sculptures. If *Emak Bakia* reveals Man Ray's strengths as an experimenter and imaginative artist, it exposes his weaknesses as well, which are not only his own, but those of the Dada esthetic generally. For Dada's main purpose, according to Man Ray was "to try the patience of the au-

dience." Directed to the reaction of the viewer, Dada allowed audience reactions to gain precedence over artistic necessity.

Man Ray's next film, *L'étoile de mer,* was based on the Surrealist poem by Robert Desnos. The poem's imagery was easily translated into a film scenario closely following Desnos' text. Technically, *L'étoile de mer* is notable for the distortions created by use of a treated gelatin filter, which caused images to appear mottled "like a sketchy drawing or painting," according to Man Ray. Undoubtedly Desnos' poem appealed to Man Ray because of its calculated eroticism and romantic fantasy combining nature images with mysterious sinister undercurrents. (The filter apparently had to be designed because the nude scenes would obviously not pass the censors otherwise.) Like *Emak Bakia, L'étoile de mer* had a considerable success in art houses throughout Europe.

Man Ray's last film, *Les mystères du château du dé,* was financed by the Vicomte de Noailles, a well known patron of the avant-garde. Filmed in a cubistic mansion designed by the fashionable architect Mallet-Stevens, it featured as cast the Vicomte's aristocratic friends, lavishly turned out in period drag. It is Man Ray's most preposterous and pretentious film, full of heavy references to Mallarmé's line, "A throw of the dice can never abolish chance." Essentially a sophisticated home movie made for the amusement of the idle rich, the *Château du dé* suggests the malingering ennui of Axel's Castle with its "shall-we-go?," "shall-we-stay?," and "what-difference-does-it-make-anyhow-since-life-is-just-a-game?" dialogue.

Although the Vicomte de Noailles offered to back Man Ray as a film maker, the latter refused, and the money was given to two other rising Surrealist directors, Luis Buñuel and Jean Cocteau, to make the twin touchstones of Surrealist film, *L'âge d'or* and *Blood of a Poet.* From this evidence, one may assume that Man Ray was not really interested in film as an independent art; indeed, he tells us so in his autobiography. It is not surprising then that little is distinctly cinematic even in his best film, *Emak Bakia.* Except for a few sequences such as the one in which Mrs. Wheeler's car hurtles forward directly into the spectator's space and another in which a figure walks back and forth through a series of doorways receding into space articulating a filmic third dimension, Man Ray confined himself mainly to the flat pictorial effects of still photography. The specifically illusionistic scenes of projection and recession within the film ·space were probably inspired by Duchamp's preoccupation with spatial effects in *Anemic Cinema.*

Man Ray renounced painting like a good Dadaist, but he continued to think as a pictorial artist when he made films. In the scenario of the *Mystères du château du dé,* the last scene is described as follows: "The pose becomes fixed like a photograph, against the sky as a background. The view gradually changes into a negative, white bathing suits against a black sky, like a piece of sculpture." It is true that Man Ray occasionally uses unusual camera angles, such as the shot from directly overhead in *Emak Bakia;* however, the movement of his camera is not the fluid continuous movement of film, but the series of disconnected

shots of the same object from different points of view familiar from Cubist paintings. Even his most radical shot—the full 180-degree inversion of sky and sea—is not explored in depth, but remains a frontal, surface statement, a pictorial image that owes more to Surrealist conventions of inverting normal relationships than to any concern with articulating film space as such. Similarly, when a sculptural object, such as the dancing collars or the Dada object reminiscent of a violin handle known also as *Emak Bakia* is shown, the camera does not move in space to explore the object, rather the object revolves in front of a static camera. From this we may conclude that despite the use of *trompe l'oeil* effects created by defracting crystals, reflecting mirrors, and distorting lenses to deform and multiply images, Man Ray seldom if ever conceived films as anything other than animated painting and sculpture, kinetic solutions to pictorial problems regarding time, motion, and representation. (pp. 70-1)

For Man Ray, the camera was an instrument of poetic transformation; yet his images continued to adhere closely to the frontal images of painting. In a film like *L'étoile de mer,* for example, the starfish of the title which reappears as a connective motif throughout the film, is photographed as part of a conventional still-life arrangement which some other artist might paint. The geometric solids which resemble pieces from a chess set designed earlier by Man Ray arranged in changing patterns in *Emak Bakia* find equal analogies in Cubist still life. . . . [His] films thus constitute a special and limited category tied not to cinematic values, but to the problems of animating painting and sculpture. (p. 73)

Barbara Rose, "Kinetic Solutions to Pictorial Problems: The Films of Man Ray and Moholy-Nagy," in Artforum, *Vol. X, No. 1, September, 1971, pp. 68-73.*

Roger Shattuck (essay date 1988)

[*An American critic, editor, writer of fiction, and translator, Shattuck is acknowledged as an authority on French literature of the late nineteenth and early twentieth centuries. His most noted works of literary criticism include* The Banquet Years *(1958), a study that traces the development of French literature from the death of Victor Hugo to the end of World War I, and* Proust's Binoculars *(1963), an investigation of Proust's use of optical metaphor in* A la recherche de temps perdu *(Remembrance of Things Past).* The following excerpt is from the exhibition catalog of the 1988-1989 retrospective, *Perpetual Motif: The Art of Man Ray, organized by the National Museum of American Art of the Smithsonian Institution. Here, Shattuck elaborates on Man Ray's relation to the cultural milieu of Paris in the 1920s and 1930s, and focuses on elements of mystery, humor, and the erotic in his work.*]

Man Ray had connections. He moved as easily from one social group to another as from one country to another. He seemed to be always on familiar ground. When this short, determined American arrived in Paris in 1921 at the age of thirty, he brought with him an old theatrical trunk full of works of art. He also had with him a few hundred

Man Ray on the Dada movement:

Who made Dada? Nobody and everybody. I made Dada when I was a baby and I was roundly spanked by my mother. Now everyone claims to be the author of Dada. For the past thirty years. In Zurich, in Cologne, in Paris, in London, in Tokyo, in San Francisco, in New York. I might claim to be the author of Dada in New York. In 1912 before Dada. In 1919, with the permission and with the approval of other Dadaists I legalized Dada in New York. Just once. That was enough. The times did not deserve more. That was a Dada-date. The one issue of New York Dada did not even bear the names of the authors. How unusual for Dada. Of course, there were a certain number of collaborators. Both willing and unwilling. Both trusting and suspicious. What did it matter? Only one issue. Forgotten—not even seen by most Dadaists or anti-Dadaists. Now we are trying to revive Dada. Why? Who cares? Who does not care? Dada is dead. Or is Dada still alive?

We cannot revive something that is alive just as we cannot revive anything that is dead.

Is Dadadead? Is Dadalive? Dada is. Dadaism.

From Self Portrait.

borrowed dollars, no knowledge of the language, and hopes that a French friend he had known for five years in New York would meet the boat train. The friend, Marcel Duchamp, was waiting on the platform at the Gare Saint-Lazare and took him that afternoon to the café Certà in a dusky glassed-in *galerie* near L'Otéra. The dada group of moonlighting medical students and writers met there every afternoon dressed like Man Ray himself in suit, tie, and fedora. It was 22 July, a date he later changed to Bastille Day. At the Certà, André Breton, Louis Aragon, Philippe Soupault, Paul and Gala Eluard, Jacques Rigaut, and Theodore Fraenkel welcomed Duchamp's friend more with gestures than with words. Age meant a great deal to this exuberant band. Breton, the oldest at twenty-five, was ten years younger than Duchamp and five years younger than Man Ray. The dadaists were eager to add to their number an experienced American who had found his way in New York to an artistic dissidence and extremism close to their own. Always independent, more protected than hindered by being an outsider, Man Ray stayed with the French group through the next twenty years of unruliness and adventure. (p. 311)

By the autumn that followed Man Ray's arrival, the raucous, yet fragile, dada movement had fallen apart into three clusters around Tzara, Breton, and Francis Picabia. Breton was himself virtually put on trial for proposing a plan as serious as a huge international congress to consider the state of European culture. It took three years to construct out of the ruins of dada a new enterprise that would be called surrealism.

During the interval, which was both slack and tense for the dadaist-surrealist group, Man Ray simply followed the connections he found within his reach. Before he had un-

packed the works in his trunk, his new friends proposed that he provide the first exhibit at the Soupaults' Librairie Six gallery. Through Picabia's first wife, Man Ray met the fashion designer Paul Poiret and began taking commercial photographs for him. By the time of his December opening, Man Ray had started the portrait photography that brought him growing celebrity and a stream of famous sitters—French, American, English, and Irish. He had also begun learning French from Kiki, the popular artists' model and Montparnasse figure who became his mistress for nine years.

In the catalogue of the Librairie Six show, the dadaists rivaled one another in their fabulous descriptions of Man Ray as a chewing-gum millionaire turned artist and come to Paris to bring a new poetic springtime. Among the densely packed balloons at the opening, Man Ray met the fifty-five-year-old composer Erik Satie. They went out to warm up with a grog in a café. Coming back, Satie helped Man Ray buy a flatiron and tacks for the self-defeating *Cadeau* he constructed on the spot and added to the items on exhibit. Also at that opening, Man Ray's guest Matthew Josephson met Louis Aragon and through him the rest of the dadaists. Because he could speak reasonably fluent French, Josephson became the only American who participated in the group's discussions and celebrations. Also at this time, Tzara became enthusiastic about Man Ray's cameraless rayographs. The Romanian contributed the influential preface to the album in which the first rayographs were published, *Les champs délicieux* [see excerpt dated 1922]. (Two years earlier, Breton and Soupault had called their automatic writings *Les champs magnétiques*.) When Breton gave a talk in November 1922 at the Atheneum in Barcelona on the state of the arts in France, he devoted as much time to Man Ray as to Duchamp and Picasso. Within a short while, living what he called a double life between commercial photography and art, Man Ray had arrived. His sense of humor and his genius inspired André Thirion to write the most succinct of all biographies: "Man Ray had an important position in Montparnasse because of his inexhaustible inventiveness, his friendliness, and the new use he made of the camera. He dazzled us all with his cars. And the girls he went out with were beautiful."

Neither wealth nor social standing gave Man Ray the connections that opened his way to success in Paris. He had earned them during twelve hard years as a fledgling artist in New York. While he was steadily employed as a draftsman for a map publisher, his own work recapitulated the stages of Western art up to the 1913 Armory Show. That huge display of the latest European work seemed made to order for this young American who had chosen art as his calling. At twenty-two, already a habitué of Stieglitz's Gallery 291 of photography and painting, he left his Jewish family and moved to a house in rural New Jersey. He took a new name, married a young Belgian woman with a child by a previous husband, and found a set of new friends among writers, artists, and anarchists.

Everything pointed to Man Ray's independence and resolute purpose. Through Stieglitz, through his well-read wife, Adon, and through his new friend Marcel Duchamp,

Man Ray educated himself spottily in literature, art history, and philosophy. In *Self Portrait,* he states that in 1913 or 1914 Adon produced out of a crate of books works by Baudelaire, Mallarmé, Rimbaud, Lautréamont, and Apollinaire and translated them for him. His chronology may waver a bit, but there is no denying that he picked up an impressive French background without the language. The three single-issue avant-garde reviews he published, the *Ridgefield Gazook* (1915), *TNT* (1919), and *New York Dada* (1921, with Duchamp), display his own spirited originality and anarchist humor more than they reveal the influence of reviews from Zurich and Paris. Appropriately, Duchamp took the ferry from Manhattan to look up Man Ray in New Jersey, not vice versa. By the time Man Ray finished **The Revolving Doors** in 1917, he had assimilated the formal innovations of cubism and futurism, of machine art, abstraction, and collage. He was working on his own. "I couldn't go back; I was finding myself."

Displayed with all their provoking titles as the centerpiece of his third one-man show at the Daniel Gallery in 1919, **Revolving Doors** remained renderings on paper and were never translated into the series of paintings he had once planned. But they represented Man Ray's state of mind at that time better than the large-scale painting **Rope Dancer.** The colored cutouts of **Revolving Doors** developed a brand of geometric-anthropomorphic fantasy that we can associate either with nineteenth-century caricaturists like John Tenniel and Grandville or with modern makers of the whimsical grotesque like Paul Klee and Max Ernst. Aerographs and photographs, which he conceived of not as mere records but as independent works, would soon give him further opportunities to distance himself from traditional easel painting.

Two photographs of 1920 have particular significance. One shows a large lumpy object covered with a rug or heavy matting and firmly tied with rope. Its title, **The Enigma of Isidore Ducasse,** underlines the uncertain identity of the shape, which could be vaguely human, or animal, or mechanical. The famous simile from Lautréamont's *Les chants de Maldoror,* "lovely as the fortuitous encounter on a dissecting table of a sewing machine and an umbrella" (*chant sixième*), has led many observers to see in the round projections the form of a sewing machine. In any case, Man Ray assembled the amorphous object in his New York studio, photographed it, disassembled it, and kept only the print for exhibition. The cropping and title of another photograph, **Dust Raising,** exploit ambiguity in a different fashion. En route to identifying the dust-covered shape as Duchamp's *Large Glass (The Bride Stripped Bare by Her Bachelors, Even)*, we respond to various cues that suggest both landscape (oblique perspective, straight lines like roads) and cloudscape (clumps of dust in the foreground). The photograph masks its subject more than it displays it. In both cases, since the original assemblage or object has ceded its existence to the photographic image, we adopt an aesthetic attitude toward the photograph. These are not identification pictures but works of art in themselves.

Because of the presence of these two photographs in his luggage, along with several paintings, Man Ray arrived in Paris as an involuntary smuggler. He relates in some detail the misleading explanations he gave the customs inspector about the strange objects in his trunk. The works, however, cleared the severe inspection of not only the French customs service, but also Breton and the dadaists. They had strict regulations, based in part on the attitudes of Rimbaud and Lautréamont and more recently Jacques Vaché, who "kicked any work of art away from him with his foot." The dadaists excluded from their universe art for art's sake. According to Breton, dada works had to "lead somewhere"—to a revision of moral and aesthetic values, to a new spark of lucidity, even to a nihilistic "nothing." Max Ernst's collages passed inspection as anti-painting, and in the catalogue preface to Ernst's first Paris show in 1921, Breton referred in his first sentence to the moral blow administered to painting and literature respectively by photography and automatic writing. Man Ray's collection passed dada muster for similar reasons. Objects and photographs figured prominently among his works; few were easel paintings. He often chose enigmatic and humorous titles. These factors prompted the dadaists to accept Man Ray as a fellow anti-artist who had liberated himself from traditional art.

Despite appearances, Man Ray introduced into the dada movement works that obliquely or covertly incorporated principles of design and form, color and line long associated with Western art. The sackcloth texture, diagonal trussing, and looming relation between figure and ground in **The Enigma of Isidore Ducasse** are carefully arranged within a conventional frame to suggest, precisely, the fetishism of an undivulged work of art. **Dust Raising** does not mock the category of "art"; rather it suggests the build-up on Duchamp's work-in-progress of a special kind of reverse patina or aura, not a rich layer of color but a sedimentation that evokes burial and archaeological rediscovery. Furthermore, Man Ray's prints seem to have convinced the dada group almost overnight that the unpredictable results he obtained from a partially mechanical process were particularly appropriate to their anti-art stance in *Littérature* and later in *La révolution surréaliste.*

Late in life Man Ray made a statement that applies to his whole career: "Everything is art. I don't discuss these things anymore. All this anti-art business is nonsense. They're all doing it. If we must have a word for it, let's call it Art."

The quiet, contraband artist who supplied dada and surrealism with art in the form of photography and displaced objects like **Cadeau** had three interchangeable garments in his wardrobe: the garments of mystery, humor, and the erotic. He sometimes wore all three at once. "Mystery—this was the key word close to my heart and mind," he said. His objects were "designed to amuse, bewilder, annoy." Many of his self-portraits served a similar function of mocking provocation. One of them shows the artist, with only a bathrobe to cover his nakedness, standing next to a bed and close to a nude photograph (could it be a mirror?) of Lee Miller the beautiful on the door beside him. Sensuous floral wallpaper fills the rest of the composition. In another self-portrait, he lounges in double-breasted suit and tie, smoking a cigarette, in what is obvi-

ously a lighting setup for dress models. He called it **Fashion Photograph.**

This tendency toward spoof declared itself very early in Man Ray's free-wheeling use of language. The one irrepressible number of the *Ridgefield Gazook* in 1915 reveled in puerile puns and portmanteau formations. "How to make tender buttons itch." "Soshall science." "Art Motes." This low level of wordplay became somewhat more subtle after he met Picabia and especially Duchamp, whose style of sophisticated verbal invention increasingly displaced the plastic components of his anti-art objects. Man Ray's titles, however, do not reliably endow his works with undertones of mystery, as Magritte's and De Chirico's titles do, or with innuendos of eroticism and humor, as Duchamp's do. Only *Violon d'Ingres* sets off an inexhaustible series of associations that combines mystery, humor, and the erotic. I cannot help wondering which (presumably French) collaborator helped him find the multiple visual-aural pun that rhymes violin shape with woman's torso, with the French expression for hobby, with a famous composition by Ingres—and more. Does the title of this photograph that apes a painted nude tell us that photography was only Man Ray's hobby? In any case, Man Ray never gave up on words. At the end of *Self Portrait,* he twice refers to reversing the Chinese proverb to produce the notion that one word is worth a thousand images. "In a life devoted to the graphic arts, I have felt more and more a desire to supplement my work with words." He wrote those words in the book that represented that very supplement.

Man Ray's wardrobe was not his only resource. Another reason why he won a place for himself as an artist in several media is that he was handy—handy not so much with brushes and words as with things and devices. As a young boy he built a soapbox cart that looked like a locomotive and devised a sheet-brass lampshade with decorative perforations made on his mother's sewing machine. He excelled more in mechanical than in artistic drawing. Throughout his life he never stopped selecting objects from his environment and displaying them with titles intended to generate a steady cultural-aesthetic current of the unexpected. One of his first creations in Paris was *L'hôtel meublé.* The small wooden assemblage (a combination bookshelf/floor plan/cabinet) crosses the seamy connotations of life in furnished rooms with a neat structure suggesting the niches and categories of the mind. One of his last objects, *Etoile de verre,* is a fragment of glass glued onto painted sandpaper (*papier de verre*) to make a dim pun and a striking facsimile of a seascape. This handyman worked steadily at his chosen tasks and achieved the rewards he deeply desired. The most ingenuous and unpretentious sentence he ever uttered describes his carving out a new life for himself in Hollywood during World War II: "Well, now I had everything again, a woman, a studio, a car"—a down-to-earth version of "A loaf of bread, a jug of wine, and Thou," without the sentimentality.

By the time Man Ray walked into the café Certà in Paris, he had also found his pace. Here more than anywhere he revealed himself as a cultural and artistic crossbreed. His formative years in and around New York City gave him many of the characteristics of a young man in a hurry. Most of the early incidents in *Self Portrait* illustrate the rapidity with which Man Ray wanted to work through the stages of art-school training and reach the contemporary scene. By the end of his life, he perceived that swiftness arose out of long years of discipline, as in the case of the Chinese artist who spoke of the lifetime of practice required to draw one adequate dragon. "In painting, with skill and new techniques," he said, "I sought to keep up with the rapidity of thought, but the execution still lags behind the mind as it does behind perception." To a large extent, Man Ray learned such patience and wisdom from his French friend in New York, the artist who retired from active painting before he was thirty. Duchamp's coolness and detachment left a deep mark on Man Ray. The word *leisure* keeps recurring in *Self Portrait* in an unselfconscious fashion. One of the few significant reasons he gives us for not devoting himself more to film had to do with the tension generated by its limited period of screening: "I prefer the permanent immobility of a static work which allows me to make my deductions at my leisure, without being distracted by attending circumstances." Not unexpectedly, he projected this pace, this sense of being a spectator of life and art, even a certain laziness, onto the ethos of Paris:

> I'd go into hiding [during World War II], I thought, until I could return to my accustomed haunts: to the easy, leisurely life of Paris, where one could accomplish just as much and of a more satisfying nature—where individuality was still appreciated and work of a permanent quality gave the creator increasing prestige.

He preferred to take his time. But he could also respond swiftly to commissions like Tzara's urgent request in July 1923 for a film to be used during "Soirée du coeur à barbe," or to unexpected situations like forgetting the lens when he went to photograph Matisse in the painter's studio. (He substituted a pair of eyeglasses.)

Man Ray worked at a steady, leisurely, almost lazy pace of invention that arose both from a certain detachment from his surroundings—always the American in a foreign culture—and from confidence in his materials—always the handyman and jack-of-all-trades.

Man Ray chose to live peacefully with two anomalies. He was an American living and pursuing a prominent career in a foreign country, and he was an artist who practiced two creative careers that were widely considered incompatible. (pp. 312-20)

Man Ray loved Paris deeply but kept his feet firmly planted on the ground of his career as an artist and photographer, serving no cause more limited or limiting than individual freedom. He was admitted directly into high-party councils of dada and surrealism. . . . But Man Ray refused to be an ideologue and maintained a special status in which he was not subject to party discipline and politics. Partly through his own temperament and his experience in New York, benefiting from the example of Duchamp as independent senior partner to everyone, Man Ray succeeded . . . in remaining patiently himself, an un-

Observation Time-The Lovers *(1934)*.

insistent American. He sustained the role through two of the most turbulent decades of artistic activity in the history of Paris. The fact that he was neither an intellectual nor middle class probably protected him against the temptations of ideology and snobbery.

Near the end of his life, in a series of interviews with Pierre Bourgeade, Man Ray pointed out in passing: "In my first film, *Etoile de mer* (**Star Fish**, 1928) there are no doors. Doors have disappeared. People disappear without going through doors because there aren't any." Man Ray's memory failed him about the film, two scenes of which prominently feature a door. Yet the motif of a universe without boundaries, without compartments, remains significant. Duchamp, by building a mock-up of a two-way door in a tight corner of his Paris studio, proved that a door can be simultaneously open and shut. In his early writings especially, Breton speaks of leaving doors open so that people can come freely in and out of his life. Through out-of-focus shots and unfettered editing, Man Ray went a long way in **Etoile de mer** toward eliminating barriers. Nonalignment functioned from the beginning as a principle of his artistic conduct. He moved unrestrained among nationalities, social classes, artistic genres, and rival schools.

One aspect of this openness was his willingness to collaborate. A lot could be said about his prolonged collaboration with Duchamp, and about the works he produced with Tzara and Eluard. Reversing the usual order of events surrounding the French *livre d'art,* poets set down words to "illustrate" images that Man Ray had already created. Breton relied on him as house photographer for *La révolution surréaliste* and used him to illustrate his most important literary works, principally his novel *L'amour fou* (1937). Man Ray's relations with Kiki, Lee Miller, Adrienne, and Juliet add colorful chapters to the history of the manifold form of collaboration known as "the artist and his model."

Yet his principal collaborations may have been with artists he never met in the flesh. In 1925 Breton had the aging poet Saint-Pol-Roux "Le Magnifique" visit Man Ray's studio for a portrait photograph. Some twenty-five years before, the poet, in his flamboyant early days, had been photographed in the Nadar studio. Man Ray cannot have lived very long as a photographer in Paris without coming up against the figure of Félix Tournachon. Under the name of Nadar, he drew caricatures, wrote journalistic pieces, developed the photographic portrait into a stunningly successful and subtle art form, and constructed his own balloon for aerial photography and publicity. Man Ray and his biographers never mention Nadar, but it is hard to believe that his blend of art, technology, and self-promotion did not play a role in Man Ray's career decision six months after he arrived in Paris: "I now turned all my attention to getting myself organized as a professional photographer." His portrait photographs of famous persons, particularly in the twenties and thirties, practiced a combination of straightforwardness and sensitivity to the sitter's personality and vocation that lies close to Nadar's work. The miniature shots of the surrealists pasted up as a chessboard refer obliquely to Nadar's Rogues' Gallery displays of painters and fashion models. The blurred nude photograph (probably of Kiki) that appears in the second issue of *La révolution surréaliste* (1925) occupies an artistic space close to that of one of Nadar's rare nudes. Nadar's model is traditionally identified as Christine Roux, the inspiration for Musette in Henri Murger's *Scènes de la vie de bohéme* (1851). In both photographs, the model holds her arms over her head and reveals her shapely body in a pose reminiscent of Ingres's *La source.*

Much more has been made of Man Ray's collaboration with Lautréamont. On several occasions, Man Ray stated that his first wife, Adon Lacroix, introduced him to *Les chants de Maldoror* in 1914. Unless she had among her books a very rare early edition, it seems more likely that he encountered the tortured imagination of Lautréamont

in 1919 in the pages of *Littérature* or in the following year in the edition published by La Siréne. In fact, 1920 is the date assigned to the unidentified wrapped object now known as *The Enigma of Isidore Ducasse;* Man Ray was still in New York.

Man Ray's claims to have been marked by Lautréamont several years before the dadaist-surrealist group discovered him ring less true than his statements about the importance of his discovery of the Marquis de Sade. In his conversations with Bourgeade, Man Ray told how one of his neighbors in the Montparnasse building where he had his first studio, barely a year after his arrival in Paris, was the devoted Sade editor and expert Maurice Heine. Heine asked Man Ray to photograph the fragile fifty-foot roll of paper on both sides of which Sade had written *The One Hundred Twenty Days of Sodom* in prison. Intrigued, Man Ray investigated Sade's career more thoroughly than he had that of any other historical person. And he went on to read all of Sade's novels:

> above all *Aline and Valcour* which is in my opinion the most important because all political questions are treated in it with very little pornography. It's a bit boring to read, that's true, but I read it from beginning to end. In this book Sade talks already of a United States of Europe! He solved all the problems!

In 1940 Man Ray "waxed fervid and eloquent" about "his hero" to Henry Miller in Hollywood: "Sade represented complete and absolute liberty."

Man Ray's respectful opinion of Sade's imaginary African country of Butua makes one wonder if he understood the language of *Aline and Valcour.* Butua's "incredible liberty" consists of the total, institutionalized subjugation of women to men's pleasure (female orgasm, considered dereliction of duty in servicing a man, merits the death penalty), absolute tyranny of the sultan, human sacrifice, and cannibalism. "Sade showed what you could do if you had power."

Man Ray's blind enthusiasm when he talked about Sade disappears in the images he devoted to the writer-philosopher. Their subtlety points to a whole different circuit through which he could channel human fantasies about power and pleasure. The series of photographs and paintings, executed over a twenty-five-year period, turns on three primal scenes. In the earliest scene, later restated in the oil painting *Aline et Valcour,* an artist's articulated manikin reclines in the foreground between a cone and a sphere. Out of the background looms a lovely (severed?) head of a blindfolded woman, her chin resting on a green book, the whole encased under a gleaming glass bell that stands on a bureau. From Sade's novel of systematic repression of everything except male pleasure, Man Ray distills a cryptic, almost lyric dream image. Only the faint decapitation motif suggests the carnage and algolagnia of Sade's narrative. The painting conveys the impression of a code, a rebus. The book is closed, as is the drawer. The woman's eyes cannot see. The wooden manikin is only a replica of a human being. All communication seems blocked.

One assembles the cues of *Monument à D. A. F. de Sade* with greater reward. The folds of naked flesh are framed by the cutout of an inverted cross. It takes a moment to recognize that the soft folds belong to the buttocks of a person seen close-up from behind, with his or her left leg raised as if on tiptoe. The superimposition of a rigidly ruled cross over delicate asymmetrical shadings from a particularly private part of the human body shouts with connotations: beauty, excrement, vulnerability, asininity, intimacy, sodomy, black magic, incongruity, blasphemy, and more. Here the simplicity and familiarity of the elements combined suggest that Man Ray was spoofing the myth of Sade as an author who attracts by corrupting and whose perversion some would equate with innocence. *Monument* remains one of Man Ray's most successful and witty compositions.

In 1938 he painted another striking work that identifies the marquis as its inspiration: *Imaginary Portrait of D. A. F. de Sade.* A massive masonry head (with red lips and one blue eye) bursts out of the semblance of a masonry body in the foreground and looks toward the Bastille, in flames in the background. In the middle ground, small figures lit by the fire enact scenes of struggle and defiance— or perhaps celebration. The great stone face missing one eye and labeled below in large capitals "S A D E" conveys a menacing authority as it contemplates the holocaust. The composition—a humanoid figure on the left imagining or witnessing a possibly frightful and enigmatic scene in the right background—recurs in *Aline et Valcour.* Paradoxically, the seemingly indestructible figure of stone decrees in the subscription painted on the canvas below that the "traces of my tomb shall disappear from off the face of the earth, as I hope my memory shall be wiped out in the minds of men—the last sentence of Sade's will. Those words deeply impressed Man Ray, who seems to be implying the opposite result. As the stones of the Bastille were looted and reused in hundreds of other structures, Sade's teachings will "disappear" into the subconscious musings of mankind. Man Ray's response to Sade is troubling and more ambiguous in his images than in his words.

Man Ray described Maurice Heine, who devoted most of his life to rescuing and publishing Sade's work, as a sweet and gentle man. I read this description as an involuntary anti-Sadean self-portrait, another of his major genres. For Man Ray's favorite collaborator was himself. Among his self-portraits, there is a brief series worth lingering over. In 1937 Man Ray experimented with a variation on the rayograph, this time using a camera with the shutter open in the semidark. Sitting in front of it with a small flashlight, Man Ray "drew" in the air and thus onto the film. The white arabesques of movement between blobs of rest have a physical scale that corresponds to the reach of the arm of the blurred, yet recognizable, artist whose body fills the frame. We discern in the background works by Man Ray and other artists. In *Space Writings,* the photographer has recorded himself as an easel artist painting in framed space, a proper tribute of the photographer to the painter. It is almost a spectral portrait.

The rapid ten-year evolution of Man Ray's art in New York records his discovery of flatness, of the picture plane

as reaffirmed by at least a half-century of European painting culminating in cubism. What happens in *Space Writings* replicates a tendency visible in many of his early works like *Dance, Rope Dancer,* and *Revolving Doors.* By inscribing movement through an overlay of images, as suggested by cubism, futurism, and Duchamp's famous *Nude* in particular, Man Ray began to flatten out not only space but time as well. The long exposure time that remains undeclared and unfelt in *Dust Raising* cannot be overlooked in *Space Writings.* A major segment of Man Ray's best work, encompassing both machine motifs and the human figure, studies movement or narrative crossed with a static freeze-frame image. He apparently never reproduced Etienne Marey's and Eadweard Muybridge's experiments with multiple cameras and motion study. But in works like *Revolving Doors* and *Space Writings* he expressed a desire to test Lessing's law: the image describes; the word narrates. The format of *Revolving Doors*— images hinged to a vertical stand, permitting the viewer to flip through the plates easily and rapidly—suggests a narrative sequence. At the same time, each separate colored plate in the group forms a free-standing multiple overlay of elements that projects the tracery of their possible permutations. A single well-chosen image encroaches on narrative time. As a photographer, Man Ray never lost a powerful sense of the *instantané,* or snapshot that both arrests and affirms motion. Some of this quality was evident early on in the plates of *Revolving Doors.* The precisely drawn spiral that forms the vertical armature of *The Meeting* lays out around itself the space and time for the two caricatured male and female cutouts to turn and maneuver as on a carousel. Thirty years later, Man Ray followed similar principles in painting his other important series, *Shakespearean Equations.* Photographs taken in the Poincaré Institute of artificial objects constructed to illustrate mathematical formulas provided him with templates, which he varied and combined freely. By letting the "abstraction" reside in the mathematically generated models, Man Ray could first photograph and then paint their convenient concreteness. A mixture of playfulness and formalism propels *Shakespearean Equations* and— more successfully—*Revolving Doors.* Those images iron time flat and present it as a laminated series of stencils.

Man Ray remained a studio artist. Except for a few commissions (it was Tzara who dragged him to photograph Proust on his deathbed), he did not work as a journalistic or candid photographer. His late statement about his hybrid vocation rings true: "I paint what I cannot photograph, something from the imagination, or a dream, or a subconscious impulse. I photograph the things that I don't want to paint, things that are already in existence." He never confined himself to bed like Proust with his manuscripts banked around him. But his life and work centered in the restricted city spaces he designed for himself in New York, Paris, and Los Angeles. After two years in rural New Jersey, he never again aspired to work *en plein air.* His location of choice was a personal downtown quarterdeck or headquarters where his handiness, his freedom, and his penchant for collaborations could find their mutual compatibility. Apparently, he never developed studio fever; his photography, his painting, and his three-dimensional constructions fed and foiled one another in

ways that kept Man Ray constantly on the move artistically. He may have been right in considering himself lazy. But his laziness was shot through with an insatiable restlessness. "Man Ray has one fault. He never does the same thing twice." [Bourgeade, *Bonsoir, Man Ray*]. No, Bourgeade was wrong. That's a description of Duchamp, the cat that walked alone. Man Ray repeated himself often, always with enough variation in medium and approach to produce a new work. For instance, the self-portrait he offered as a frontispiece to his autobiography is a modified and reversed replica of *Monument à D. A. F. de Sade.* Instead of a backside seen through an inverted cross, he presented his own full face with cross hairs running through his pupils and aimed to catch him precisely between the eyes. I am, the image says, a camera-rifle-captive-model-eye-target-prey-witness-hunter-artist come out of America to explore the no-man's land between art and photography. Nothing could be more candid than my self-portrait. Nothing could be more perverse than some of my works. (pp. 322-32)

Roger Shattuck, "Candor and Perversion in No-Man's Land," in Perpetual Motif: The Art of Man Ray, *by Merry Foresta and others, Abbeville Press Publishers, 1988, pp. 311-33.*

Deborah Solomon (essay date 1989)

[*Solomon is an American journalist, art critic, and the author of* Jackson Pollock: A Biography *(1987). In the following excerpt, she reviews the retrospective organized by the Smithsonian's National Museum of American Art, deeming Man Ray's oeuvre of minor significance to modern art.*]

Man Ray was the ultimate networker. From the time he was twenty-three years old, when he asked Alfred Stieglitz to sit for a painted portrait, he had an uncanny knack for befriending important people. Through Stieglitz he met the collector Walter Arensberg, who introduced him to Marcel Duchamp, who was waiting at the Gare Saint-Lazare when Man Ray first arrived in Paris and who promptly ushered him to the Certà café, where he met the whole Dada crowd. Man Ray got along with everyone. As the years passed, he became known as the one member of the Dada-Surrealist group who never struck up an argument or abruptly broke off a friendship, the only person to win the approval of rivaling ringleaders André Breton and Tristan Tzara. As a member of the movement that specialized in the artful insult, Man Ray was the one who insulted no one.

Man Ray's relation to the tradition of art was every bit as cordial and deferential as his relation to his peers. While he originally started out as a painter, he realized soon after arriving in Paris that he had no chance of competing successfully with the leading talents of the day. And so he graciously stepped out of the ring. Laying down his brushes, at least for a while, he began experimenting with less conventional media—assemblage, photography, filmmaking, polemics, and so on. His various endeavors were all united not by a vision so much as a strategy, one which exploited the psychological and sexual obsessions of Sur-

realism for surfacey ends. Long-lashed eyes crying tears of glass, disembodied lips hovering absurdly in Paris skies, two pieces of silverware posing as *Mr. Knife and Miss Fork*—these images and objects embrace the spirit of Surrealist revolt while remaining undeniably cheerful.

Central to the Surrealist movement was the notion of the artist as public provocateur, and Man Ray had no trouble fulfilling this role. He could always be counted on to say something shocking, or to show up at a party in an outrageous costume with his latest beautiful girlfriend in tow. Eventually, he came to be regarded as one of the more glamorous figures on the Paris art scene in the fabled years between the two world wars; it's revealing, I think, that he recently became the first artist in living memory to have a Manhattan restaurant named after him.

Man Ray's reputation has never been stronger than it is right now, and it isn't only restaurateurs who would have us see him as the epitome of avant-garde chic. The first biography of him has just been published [see Baldwin entry in Further Reading, section III], and *Self Portrait,* his own autobiography, has been re-issued in a new, illustrated edition. "Perpetual Motif: The Art of Man Ray" is the name of a large retrospective travelling around the country this year as well as the six-pound catalogue accompanying the show [see National Museum of American Art entry in Further Reading, section V]. These various events have been celebrated in the media with a level of hype exceeding even the usual excess; writers are claiming that Man Ray is not only "the greatest artist America ever produced" (as a critic for *7 Days* put it) but a prophetic figure whose work fully captures the Zeitgeist of the Eighties. This latter claim is true, and it's hard to know whom it reflects worse on—Man Ray or us. (pp. 22-3)

The Man Ray retrospective, which originated at the National Museum of American Art in Washington, D. C., starts out with a drum roll. No one would ever argue that Man Ray was a great painter, but his early paintings, which were done in the years following the Armory Show, do hold our interest. They consist mostly of figurative images composed of studiously splintered planes and colors that owe everything to the Fauves. Man Ray was never much of a draughtsman—his lines are stiff and mechanical—but he did have a gift for pattern and design. There's a crude vividness to his *A.D. MCMXIV* of 1914, in which an army of faceless, blocklike figures marches in rhythmic unison, as if following orders from the generals of Cubism. Man Ray's early paintings are essentially inspired pastiches, the work of a young man star-struck by the art of Paris.

Before long the show branches out to include assemblages, some of which are quite winning. *Obstruction,* which consists of a cluster of wooden coat hangers suspended from the ceiling, is surprisingly intricate and lovely. An unfurled lampshade (*Lampshade*) looks like a form plucked from an Arp as it gently winds its way to the floor. A household iron studded with a row of fourteen nails (the famous *Cadeau*) makes one think of Degas's weary laundresses and how they might have relished the chance to avenge their employers with this wicked object. Man Ray's assemblages come out of the same rakish humor as

Duchamp's "readymades," but they don't try to proclaim the futility of making art. Man Ray is Duchamp minus the nihilism.

Man Ray's playfulness carried over into his photographs. He holds the patent on the cameraless "rayograph," in which combs, pipes, and other common objects are placed against photosensitive paper and exposed to light to simulate glowing silhouettes. These works have gone down in the annals of photography as daring new additions to the medium, but their thrill has eroded over time. To be sure, Man Ray brought the techniques of Surrealism into the darkroom, but the images that resulted have more in common with the illustrational Surrealism of Salvador Dali than with the lyrical Surrealism of Arp or Miró. The "rayographs" all feature juxtaposed objects—hotel keys, revolvers, blindfolds, the kind of objects one might find in the home of the Marquis de Sade. They exploit the sadist preoccupations so basic to Surrealism while politely avoiding any hint of menace. Clearly it amused Man Ray to push S&M party props around in dark space. László Moholy-Nagy, by comparison, used similar cameraless techniques to push form to radical extremes.

It is, of course, as a portrait photographer that Man Ray is best known, and the exhibition in Washington dutifully rounds up the usual subjects. The ardent, young face of Ernest Hemingway gazes serenely into the distance, a dreaming folk hero posed in front of a banjo. Brancusi with his flowing gray beard looks as wise and ancient as Moses. Duchamp is dressed up as Rrose Sélavy. Breton appears in profile, stoically displaying his high, noble forehead and classical features. Picasso, as usual, glares defiantly. There are many pictures of glamorous ladies—Lee Miller retreating into rich shadow; Peggy Guggenheim modeling a new Jazz Age dress, one hand on her waist, the other waving what must be the longest cigarette holder in history. And then there's Kiki, who's sitting on a table coyly displaying her white nakedness, her painted lips parted suggestively, her contours as rounded and seemingly boneless as one of Ingres's sylphic nudes. As a whole, Man Ray's portraits are fairly straightforward, but they lean more toward the soft pictorialism of the past than the stark, street-wise candor of his contemporary Brassaï or other modern photographers.

There's a certain temptation to see Man Ray as a prototype of Andy Warhol. They shared a fascination with the American dream of fame, and their best-known work consists in large part of celebrity portraits. They both made plotless movies starring their friends. (Warhol, by the way, made a silkscreened portrait of Man Ray in 1975.) Neither artist knew how to draw, except to produce a mechanical line, yet both were tremendously ambitious men who were able to get around their artistic deficiencies on the basis of technical innovation. Whereas Warhol applied the techniques of photography to painting, Man Ray applied the techniques of painting to photography. But the irony is that Man Ray's best photographs take their inspiration not from the painting of his own time, but from the conventions of nineteenth-century academic painting. This is particularly the case with his solarized prints, which often show gleaming female nudes entrapped in

dark outlines, their flesh compressed into pure form; these works come straight out of Ingres.

The Man Ray show in Washington didn't end so much as it abruptly collapsed about two thirds of the way through. There was a gallery devoted to the artist's paintings from the Thirties, when he was working in a Surrealist style, and it was in this room that we were forced to relinquish any hope we may have had of seeing Man Ray evolve into a mature artist. He never did. *Easel Painting,* of 1938, shows a painting within a painting—a large yellow canvas of a female nude resting on an easel. It's intended as a high-minded joke, but it comes across as a crude cartoon. Whatever feel Man Ray had for paint when he first started out in New York was eventually stifled by his instinct for design; his late paintings never rise above the level of commercial art. His flair as an assemblagist deteriorated, too. The last galleries of the show, which followed Man Ray up until his death in 1976, mercilessly subjected us to one bad joke after another, such as *It's Springtime,* in which a figure made out of heavy metal springs (get it?), flings its arms wide open in corny celebration of the new season.

A key problem with the Man Ray exhibition—and with the artist's career as well—is that it lacks any sense of inner momentum. It doesn't build toward a climax or make you feel you're in the presence of a man with a vision. Instead of depth, we get variety.

The catalogue accompanying the show [*Perpetual Motif: The Art of Man Ray*] tries to make the case that variety is enough. It includes essays by seven scholars, each of whom has been assigned to write on a different chapter of the artist's life—his New York years, his Paris years, etc. The strange part is that these various essays end up sounding virtually the same, for they all revolve around the assumption that "Man Ray was dazzling in the multiplicity of his talents," as curator Merry Foresta gushingly puts it. Yes, it's true, Man Ray worked in many media, but does that alone make him dazzling? What did he achieve in these various media? Weren't his paintings totally derivative? Weren't his assemblages just a PG version of Duchamp's X-rated urinals? Weren't his portraits distinguished by little else than the fame of their subjects? Throughout his life, Man Ray embraced the spirit of adventure we tend to associate with high modernism while failing to enact the miracles of form inscribed in the work of so many of his contemporaries. He didn't shape the art of his time so much as it shaped him, and to ignore this fundamental distinction, as the catalogue does, is to fail to come to terms with his achievements.

No exhibition this season has generated more publicity than the Man Ray retrospective. Condé Nast, which for years provided Man Ray with a paycheck, has given him a triple salute—full-length features in *Vanity Fair, Vogue,* and *HG.* There have also been articles in *Harper's Bazaar, Interview, Art & Antiques, Smithsonian,* and *Fame*—to mention the few I recently came across in an admittedly haphazard survey of friends' coffee tables. All of these articles appeared before the exhibition even opened, and all, in their own way, seemed oddly eager to proclaim Man Ray as a man for our time. As one writer put it, "when all is said and done, Man Ray . . . may well emerge as the patron saint of the postmodern."

Man Ray's apotheosis as a hero of the Eighties isn't taking place only in the pages of glossy magazines. A one-day symposium held last December at the National Museum in Washington was devoted to the subject of Man Ray's (presumably large) influence on contemporary artists. Who, exactly, has he influenced? William Wegman, for one, who came down to Washington to show several short films starring his labrador Man Ray. (The artist told the audience that he originally intended to name his dog Bauhaus—or would that be Bow-haus?—but then changed his mind.) Roberta Smith, an art critic for *The New York Times,* put on a slide show featuring the work of fashionable SoHo artists and linked them one by one to Surrealism. David Salle, she explained, juxtaposes incongruous images. (pp. 25-8)

To be sure, one can find parallels between Salle and Surrealism, but one can also find parallels between a lemon and a golf club; one can find parallels anywhere one wants to. That doesn't mean they're not strained or contrived. The spirit of Surrealism died long ago, even before the Surrealists did, and to exhume its exquisite corpse in the name of Eighties-style revisionism is not much more honest than grave robbery. But perhaps I'm being a little too quick to utter one more requiem for the old avant-garde; how easy it is to lament the absence of adventure or daring in these pinstriped times. The current revival of Man Ray does indeed speak to something embedded in the collective unconscious of the art world, but my own sense is that it doesn't have anything to do with art.

Man Ray's career was eternally divided between art on the one hand and fashion on the other, and at a time when the line between these two worlds is thinner than ever, it's only logical that he should be looked to as a hero. He taught us that you don't have to suffer to make art. You can make money, too. You can go to parties. You can have famous friends. Most important, Man Ray taught us that it's okay to be just minor. He knew he didn't have a chance of achieving much in an age that was far greater than he was, an age so great that artists today are still living in the shadow of its legacy. How can one ever hope to compete with the amazing achievements of modernism? Like so many contemporary artists, Man Ray got around that problem by forsaking any interest in genuine innovation for the slight but sure rewards of cleverness. This represents a triumph of sorts, but a triumph of attitude rather than of imagination, and one wishes his admirers would stop confusing the two. (p. 28)

Deborah Solomon, "The Resurrection of Man Ray," in The New Criterion, *Vol. VII, No. 7, March, 1989, pp. 22-8.*

FURTHER READING

I. Writings by Man Ray

Self Portrait. Boston: Atlantic/Little, Brown, 1963, 398 p.
Provides valuable insight into Man Ray's aesthetics, techniques, personal philosophy, relationships with women, and friendships with major artists and authors of the early and middle twentieth century.

II. Interviews

Amaya, Mario. "My Man Ray: An Interview with Lee Miller Penrose." *Art in America* 63, No. 3 (May-June 1975): 54-61.
Conversation with the former photographic assistant and companion of Man Ray's, who recalls his photographic techniques as well as the cultural milieu of Paris during the early 1930s.

Hill, Paul, and Cooper, Tom. "*Camera*-Interview: Man Ray." *Camera* 54, No. 2 (February 1975): 37-40.
Features discussion by Man Ray of his life, contemporaries in the arts, and aesthetics as a photographer.

Schwarz, Arturo. "An Interview with Man Ray: 'This Is Not for America'." *Arts Magazine* 51, No. 9 (May 1977): 116-21.
Transcript of the final interview with Man Ray. The artist comments on his early career in America, his relationship to the Dada movement, and his contact with artists in New York City.

III. Biographies

Baldwin, Neil. *Man Ray: American Artist.* New York: Clarkson N. Potter, 1988, 449 p.
Elaborates on the "historical basis for Man Ray's life and times," viewing him as "the quintessential modernist personality."

IV. Critical Studies and Reviews

Artforum X, No. 7 (March 1972): 6-7, 9.
Features two letters: in the first, Steven Kovács objects to the terminology and critical conclusions of Barbara Rose in her essay on Man Ray's films (see excerpt dated 1971); in the second, Rose responds to Kovács and clarifies her stance. Kovács's two-part essay on Man Ray's filmmaking career is cited below.

"Man Ray." *The Connoisseur* 189, No. 760 (June 1975): 176-77.
Judges Man Ray and the Dada movement "a failure not of aims and intentions, but of theory, strategy and tactics."

Fillin-Yeh, Susan. "*Three Heads* and Other Mysteries: Man Ray's Photographs of Marcel Duchamp and Joseph Stella." *Arts Magazine* 62, No. 8 (April 1988): 96-103.
Focuses on Man Ray's photograph *Three Heads* and others of Duchamp and Stella as the works offer "a vision of the tactics and personalities of what we now call New York Dada in the 1910s."

Fuller, John. "Atget and Man Ray in the Context of Surrealism." *Art Journal* 36, No. 2 (Winter 1976-1977): 130-38.
Compares and contrasts the photographic techniques and subject matter of works by Man Ray and French photographer Eugène Atget.

Hedges, Inez. "Constellated Visions: Robert Desnos's and

Man Ray's *L'étoile de mer.*" *Dada/Surrealism,* No. 15 (1986): 99-109.
Analyzes Man Ray's film *L'étoile de mer,* discussing how the the poem by Desnos, on which it is based, informs the alchemical symbolism and iconography of the cinematic work.

Hochswender, Woody. "Man Ray as Fashion Photographer." *The New York Times* (14 September 1990): B1, B5.
Favorably reviews the New York exhibition "Man Ray/*Bazaar* Years: A Fashion Retrospective," examining his career as a commercial fashion photographer in light of contemporary trends in the medium.

Kovács, Steven. "Man Ray as Film Maker: Parts I and II." *Artforum* XI, Nos. 3, 4 (November 1972; December 1972): 77-82, 62-6.
Offers two essays: the first outlines Man Ray's filmmaking technique in *Le retour à la raison* and *Emak Bakia,* asserting that he was instrumental in developing cinema as a Surrealist medium; the second analyzes technical and literary aspects of *L'étoile de mer* and *Les mystères du château du dé.*

Kuenzli, Rudolf E. "Reprint of *TNT*." *Dada/Surrealism,* No. 14 (1985): 146-63.
Reproduces the single issue of the journal published by Man Ray and anarchist Adolf Wolff. Kuenzli provides brief commentary.

Martin, Henry. "Man Ray: Spirals and Indications." *Art International* XV, No. 5 (20 May 1971): 60-5.
Describes Man Ray's career as a continual attempt "not so much to unmask reality as rather to look at the mask itself, as an indication of something behind it."

Martin, Jean-Hubert. *Man Ray: Photographs.* Translated by Carolyn Breakspear. New York: Thames and Hudson, 1982, 255 p.
Features an introduction by Martin, essays by Philippe Sers, Herbert Molderings, and Janus, and reprints Man Ray's "Photography Is Not Art" (excerpted above) and "Photography Can Be Art." Also included are a reprint of a 1975 interview of Man Ray and numerous reproductions of his works.

Melville, Robert. "Man Ray in London." *Arts* 33, No. 9 (June 1959): 45-7.
Reviews the retrospective at the Institute of Contemporary Arts, focusing on Man Ray's paintings.

National Museum of American Art, Smithsonian Institution. *Perpetual Motif: The Art of Man Ray.* New York: Abbeville Press, 1988, 348 p.
Catalog of the retrospective exhibition featuring an introduction by Merry Foresta and essays by Foresta, Francis Naumann, and several others, that individually address a period or medium of Man Ray's career. Roger Shattuck's essay, "Candor and Perversion in No-Man's Land," is excerpted above.

Naumann, Francis [M]. "Man Ray: Early Paintings, 1913-1916—Theory and Practice in the Art of Two Dimensions." *Artforum* XX, No. 9 (May 1982): 37-46.
Argues that Man Ray's paintings of the period significantly depart from his earlier formalist theories of painting and prefigure his conceptual, Dada-oriented approach.

————. "Man Ray and the Ferrer Center: Art and Anarchy in the Pre-Dada Period." *Dada/Surrealism,* No. 14 (1985): 10-30.

> Elaborates on the significance of Man Ray's contact with cultural and political radicals associated with the Ferrer Center in New York City and suggests that his exposure to anarchist thought before World War I "served to prepare him for the acceptance of Dada's more radical, nihilistic, and unconventional qualities."

Padgett, Ron. "Artist Accompanies Himself with His Rays." *ARTnews* 65, No. 7 (November 1966): 51-3, 79-81.

> Discusses Man Ray's career in a review of his 1966 retrospective at the Los Angeles County Museum of Art. The essay is based on an interview with the artist in Paris.

Penrose, Roland. *Man Ray.* Boston: New York Graphic Society, 1975, 208 p.

> Biographical and critical study. The book also contains selected reproductions and a bibliography.

Rabbito, Karin Anhold. "Man Ray in Quest of Modernism." *The Rutgers Art Review* II (January 1981): 59-69.

> Surveys major paintings created by Man Ray from 1913 to 1920, noting significant artistic influences that shaped the development of his career during his New York period.

Rabinovitz, Lauren. "Independent Journeyman: Man Ray, Dada and Surrealist Film-Maker." *Southwest Review* 64, No. 4 (Autumn 1979): 355-76.

> Outlines Man Ray's career prior to 1923 and elaborates on his significance as an American avant-garde filmmaker, briefly analyzing each of his films of the 1920s.

Schwarz, Arturo. *Man Ray: The Rigour of Imagination.* New York: Rizzoli, 1977, 384 p.

> Extensive study of Man Ray's work and career, with thematic discussion reflecting the author's concern with Jungian archetypes and alchemical symbolism. The book also offers numerous black-and-white reproductions and color plates of Man Ray's artwork, a reprint of Henry Miller's "Recollections of Man Ray in Hollywood," and a comprehensive bibliography.

Tashjian, Dickran. "Marcel Duchamp and Man Ray." In his *Skyscraper Primitives: Dada and the American Avant-Garde, 1910-1925,* pp. 49-70. Middletown, Conn.: Wesleyan University Press, 1975.

> Compares and contrasts the aesthetics of Man Ray and Duchamp through an examination of Man Ray's paintings, mixed media objects, and rayographs.

Walker, Ian. "Man Ray and the Rayograph." *Art & Artists* 10, No. 1 (April 1975): 40-2.

> Outlines the precursors, significance, and technical procedures of the rayograph.

Wescher, Paul. "Man Ray as Painter." *Magazine of Art* 46, No. 1 (January 1953): 31-7.

> Focuses on Man Ray's paintings and his aesthetics of painting through the early 1950s.

Wieder, Laurance. "Sex and Death and Man Ray." *Aperture,* No. 103 (Summer 1986): 9-12.

> Focuses on central themes of Man Ray's work as expressed by two photographs exhibited at New York's Light Gallery, *Spider Lady* and *Moulage de Man Ray.*

V. Selected Sources of Reproductions

Aperture. *Man Ray.* Millerton, N.Y.: Aperture, 1979, 95 p.

> Provides numerous reproductions of representative photographs by Man Ray.

"*Les champs délicieux:* Man Ray, 1922." *Aperture,* No. 85 (1981): 62-75.

> Offers large-format reproductions of the 1922 series of rayographs and a preface by Tristan Tzara that is reprinted above.

Aperture. *Man Ray.* New York: Aperture Foundation, 1988, 95 p.

> Contains reproductions of Man Ray's photographs and an introductory essay by Jed Perl.

Esten, John. *Man Ray: "Bazaar" Years.* New York: Rizzoli, 1988, 111 p.

> Includes reproductions of Man Ray's fashion photographs executed for *Harper's Bazaar* in the 1930s and early 1940s in conjunction with the exhibition organized by the International Center of Photography in New York. An introduction by Willis Hartshorn discusses the mixture of commercial and aesthetic motivations behind the works.

Janus, ed. *Man Ray: The Photographic Image.* Translated by Murtha Baca. Woodbury, N.Y.: Barron's, 1980, 227 p.

> Contains large-format reproductions of Man Ray's photographic work originally published in conjunction with a 1976 exhibition in Venice. The collection also reprints statements by Man Ray, Tristan Tzara, Francis Picabia, and several early French critics. Janus's introduction and conclusion note Man Ray's subversion of traditional concepts of imagery and language in his photography.

Los Angeles County Museum of Art. *Man Ray.* Los Angeles: Los Angeles County Museum of Art, Lytton Gallery, 1966, 148 p.

> Catalog of the 1966 retrospective that also contains numerous statements by Man Ray and his contemporaries in the Parisian avant garde, as well as Carl Belz's essay "The Film Poetry of Man Ray." The survey of Man Ray's career by Jules Langsner is excerpted above.

Man Ray. New York: Pantheon Books, 1989.

> Provides reproductions of Man Ray's photographic works, including representative rayographs, solarizations, nudes, and portraits in a collection originally published by the Centre National de la Photographie in Paris.

Man Ray: Photographs, 1920-1934 Paris. Hartford, Conn.: James Thrall Soby, 1934, 104 p.

> Contains numerous large-format reproductions. The bilingual English and French text features commentary by André Breton, Marcel Duchamp (as Rrose Sélavy), Tristan Tzara, and a poem on Man Ray by Paul Eluard. Man Ray's preface, "The Age of Light," is reprinted above.

Diego Rivera

1886-1957

Mexican painter and muralist.

One of Mexico's most important painters, Rivera is best known for the politically controversial murals he created in his native country and in several North American cities. In these frescoes, Rivera proclaimed a sympathy for the oppressed and a vision of society that grew out of his association with the Communist party. Rivera's refusal to adhere to Communist doctrine, however, alienated him from its ranks, and over the course of his career he also antagonized patrons, the media, and the general public. In the words of Bertram D. Wolfe, Rivera "took the issues and the aspirations of art from the studio to the street, made them a subject of newspaper headlines, parlor conversations, music-hall satire."

Born in Guanajuato, Rivera showed talent at an early age and began studying at the National School of Fine Arts in Mexico City at the age of ten. Living in Europe from 1907 to 1921, Rivera absorbed the styles of such Post-Impressionists as Paul Cézanne and Georges Seurat, and such Cubists as Juan Gris and Pablo Picasso, demonstrating his considerable skills as an imitator, but not yet distinguishing himself as an artist. In 1921 Rivera returned to Mexico, distancing himself from his European influences and formulating his own style. As Alfred Werner wrote, "Rivera . . . needed Mexico as much as Mexico needed him. He might not have discovered and developed his vigor of originality had he not come back to his native land." Rivera's first mural commission, *Creation* (1922)—featuring allegorical representations of Knowledge, Faith, and Tradition alongside representations of Mexico's native population—decorated the Bolívar Auditorium of the National Preparatory School in Mexico City. He created murals for the Ministry of Education Building in Mexico City from 1923 to 1926 and the National School of Agriculture in Chapingo in 1927. Depicting various aspects of Mexican history, Rivera's murals were designed to instill a sense of revolution and patriotism in the people of Mexico. Critics have disputed the effectiveness of Rivera's conception of public art as an instrument of propaganda, but most concur that his compositional sense and boldness of color revitalized the fresco genre which had been dormant for centuries, inspiring the two other leading Mexican muralists, José Clemente Orozco and David Alfaro Siqueiros.

Rivera and his wife, the surrealist painter Frida Kahlo, toured the United States from 1930 to 1934, and during these years he painted two of his most controversial murals: one inside the main hall of the Detroit Institute of Arts and another in the RCA building at Rockefeller Center in New York. *Detroit Industry* (1932), commissioned by auto magnate Edsel Ford, captures Rivera's impressions of an automobile manufacturing plant featuring robotic laborers and gigantic turbines, along with menacing characterizations of the weapons and pharmaceutical in-

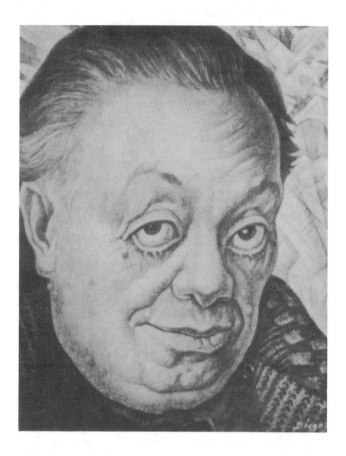

dustries. The work provoked immediate hostility from many directions. Church groups objected to what they perceived as a perversion of the nativity scene in the pharmaceutical panel; the *Detroit News* called the fresco "un-American" and lobbied for its destruction; and the Communist party, which had already officially expelled Rivera for pro-capitalist activities three years earlier, censured him for accepting commissions from wealthy industrialists. Ford himself defended the work, thereby ensuring its survival. On the other hand, the Rockefeller Center mural, *Man at the Crossroads* (1933), was destroyed at the direction of patron Nelson Rockefeller because Rivera refused to remove the portrait of Vladimir Ilyich Lenin incorporated into its design.

Returning to Mexico in 1934, Rivera concentrated on several large-scale murals. During this period, he also established himself as an original and perceptive portraitist and worked on a series of highly regarded paintings depicting flower vendors in a style inspired by his own vast collection of pre-Columbian art. He courted controversy yet again in 1948 with the mural *Dream of a Sunday Afternoon in the Central Alameda* by inscribing it with the message "Dios no existe" ("God does not exist"). In 1954, the

368

Communist party readmitted Rivera; three years later the artist died of cancer. While commentators during his lifetime focused primarily on his controversial ideology, recent critics more often stress his role in popularizing pre-Columbian iconography in his frescoes and paintings.

ARTIST'S STATEMENTS

Diego Rivera (essay date 1924)

[In the following excerpt, Rivera describes how "a syndicate of painters and sculptors" created murals in Mexico City.]

When I returned to my native Mexico almost three years ago, after fourteen years in Europe, I found the atmosphere of art fairly stagnant—almost inert. Many artists of merit, and a true genius or two, were working, but they were so separate in their aims that they were making no headway against the enormous indifference of the so-called cultured classes, who support only the kind of art they like, naturally—and needless to say they did not like anything that was being done around them by such painters as Adolfo Best-Maugard, Xavier Guerrero, or Clemente Orozco.

Conditions were therefore not altogether promising. The Post-Impressionist bloc held together very well, animated by hatred of all that came after their period. Various art schools enlisted the loyalty of earnest-minded students, bent on problems of style, mathematical proportion and sleek brushwork. Two or three painters of the old schools, unable to communicate their essential qualities to their pupils, were now painting mere reminiscences of themselves.

Adolfo Best-Maugard, having devoted ten years to the study of ancient Mexican design, had founded an entire system of painting and teaching upon it, and was beginning the work of organizing the art departments of the public schools throughout the Republic. Xavier Guerrero, without ever leaving his native state in the north of Mexico, was already painting Indian designs in his native tradition.

But there was a prodigious quantity of life, of talent and energy going to waste among the younger painters. All, or nearly all of them were revolutionists, members of various radical groups; all understood thoroughly the communistic principle as applied to government, to life, to economics. But they were still thrall to the idea that the artist is an entity distinct from the human world about him, mysteriously set apart from the community; I think they still regarded painting as a sort of priestly function.

This is an old superstition, and though the artist did not invent it, he became, ultimately, its victim. True creativeness is a force inexplicable, and therefore hostile, to those who do not possess it. Now and again there occurs a great

epoch when this vitality, this force of life, will rise to such high levels that a whole nation will evince the most astounding fullness of genius. These are the times when the guild, the community, the syndicate, if you will, of artists and craftsmen flourish. Almost every race experiences at least one such epoch of lofty intellectual and spiritual development. This does not occur by miracle, but is a culmination of centuries of preparation, centuries wherein the race grows gradually in the love and understanding of art, and with this love and understanding comes the power of projection, of rich accomplishment.

When art becomes a cult of individual eccentricity, a meager precious and neurasthenic body struggling for breath; when it becomes modish and exclusive, the aristocratic pleasure of the few, it is a dead thing, and the nation which produces it is ready to perish. This is part of a tragic cycle, inescapable, a natural circumstance of decay. I believe that art has recently passed through this period of death, and is now preparing for a resurrection in the world. In Mexico, this resurrection is most heroic, most radiant, in the arts of painting and sculpture.

It is to me a most virile sign that artists and craftsmen everywhere are returning to the guild, to the community of labor. (The Indian artists have never departed from it, but then, the Indians are wise "by heart" as one of them explained to me!) The artist is coming again to the conclusion that he must be first a man, a worker who creates beautiful things with his brain and his hands, satisfying to the needs of his spirit, as a carpenter makes a chair adapted to the needs of his body. If he fails in this, his work is not a true work of art, because it will lack the all-important human essence. However faithful a reflection it may be of an honest point of view, it remains a fragment, not soundly related to the physical and spiritual proportion of man.

The guild is the fine flower of human comradeship and unity in art. The artist breathes most freely in an atmosphere of revolution, of intelligent and merciless criticism, of creative liberty. These things are such old truths it may seem absurd to say them again. But we are constantly in danger of forgetting the old truths. And what is revolution but a restatement of man's eternal will to be free, written out in his own blood? And what is art but a perpetual struggle to express again, in newer, fresher terms, the old ideals of beauty? A century of violence, of experimentation, is not given in vain if at the end it flowers in a single achievement of victorious creation.

Now I believed that the time had come in revolutionary Mexico for the foundation of a syndicate of painters and sculptors. If these young artists of Mexico were to an identifiable part of the new esthetic pattern of their country, they must first humanize themselves. It was necessary to direct their robust, inclusive, apostolic energy towards a definite end. They must work together to create an atmosphere in which the idea of art could grow. When the time comes, the supreme geniuses which I believe will follow us may rise on the supporting body of this community, free to complete their destinies without expending half their early strength in combatting alien and blighting influences.

To this end we joined forces. I had begun work on my encaustic mural, *Creation,* in the amphitheater of the Preparatory School of the National University. There joined me in this work the young painters, (whom I wish to name here as a matter of record) Alva, Charlot, Caero, Leal, and Reveueltas; these labored together in the true fraternal spirit, each man adapting his talents to the severe constructive discipline imposed by such a project. A little later, there came Siqueiros and de la Cueva, full of ardor, with fresh spirit and enthusiasm. Their painting was of no time nor mode nor epoch, they were as original as the early Italians, as modern as Picasso. Guerrero, already a developed personality, well understanding the office of painter, also came, with Merida and Amero.

These were the pioneers. The guild existed, but it had not taken final form. With the cooperation of José Vasconcelos, Minister of Education, we went under contract as a labor union to decorate the walls of the Preparatory School and the Ministry of Education building. We are laborers, but not mercenary ones. We work from ten to sixteen hours a day, with the privilege of working on Sundays if we like! for a wage that comes to about four pesos the square *metro.* When we are absent, except on sketching trips, we do not receive our pay. If I receive a little more than the others, it is because I paint more than the others, and also pay a helper who mixes my plaster and prepares the walls.

On these terms and under these conditions, this syndicate is painting on the walls of these buildings a history of the Mexican people. Beginning with the mural, *Creation,* in which I sought to portray in a figure which has been called symbolic (there is no abstraction in Mexican art, however!) all the essential ingredients of this race; from thence we have simply followed very faithfully all phases of Mexican life, through the conquest, to the present day, in their wars, their religions, their work, their festivals and their sufferings. We are at present painting the story of the ten years revolution just past.

Each artist is at liberty to paint on his own particular wall in his own way, obeying the general plan, but in no wise hampered as to style or technique other than the physical requirements of fresco painting. He is bound only in this: he must not interfere with the freedom of his brother artists, and he must remember that he is a laborer subject to the rules of his syndicate. All are, then, free, but free as morally responsible members of a community.

The artist needs simple food, clothing enough to protect him from the elements, a roof to cover him when he sleeps. I strongly doubt if he needs more. I strongly doubt if any human being needs more. For the rest, the satisfactions of his life must come from the sense of work well done. The materials for his work should be provided by the community, and in turn he must give all that he can of beauty to the common store. . . . This was the revolutionary ideal which we hoped to accomplish, and the results were very strange.

A legend took immediate form about our syndicate. It was said we were paid stupendous sums for our painting, that we were growing wealthy at the expense of the public school funds. Newspapers, notoriously uninterested in anything but the fabulous and the sensational, devoted long columns to our mercenary spirit, mingled with sneers at our ambition to restore painting to its rightful place—to the walls of public edifices, where the great masses of the people might come in contact with its living being, where it might become a part of their daily life, instead of confining it to the walls of the wealthy, or closed galleries of museums.

Academic painters and professors of art were enraged at what they termed our cult ugliness. This because we neglected to paint beautiful young ladies with white useless hands, or to compose pretty studies of water reflecting trees and castles. They said that our pictures of deep breasted Indian women suckling their children were vulgar; that our pictures of revolution and labor were ugly and horrible. In a word, it seemed that all things natural, undecorated and innocent were ugly and horrible.

We were attacked on political grounds. In newspapers, by poster, and in public speeches we were called Bolsheviki, revolutionists, communists, socialists and anarchists, by men who had no conception of what these things meant, but intended them as terms of insult. In the meantime, the members of the syndicate of painters and sculptors sat on their scaffolds and painted.

The loud voiced quarrelling of our critics had this effect: the public began to hear of our work, and painting became a current issue for the first time in several centuries. Every day the number of visitors to the Ministry and the Preparatory School was increased. They came, the bourgeoisie to scoff and laugh as always, the very sophisticated and prepared minds to enjoy; and the simple honest Indian, finding there something recognizable and human, came to love the paintings. The Mexicans were getting aroused to the fact that something was going on of the utmost importance to the nation—an art that went hand in hand with revolution, more powerful than war and more lasting than religion.

Today, all the painters are working, some as members of the syndicate, others as individuals. Clausel and Atl, two members of an older generation, have renewed their labors. The children in the schools are studying by the system devised and perfected by Best. New personalities have emerged who give brilliant promise, such as Abrahan Angel, Rodriquez Lozano, and Clemente Orozco. We find ourselves in the beginning of an enlightened period, comparable to the eras of poetry in China, or to one of the grand Italian epochs of painting.

We will grow as the spirit of liberty grows in Mexico and in the world. I cannot say that we, the artists of Mexico, have yet regained that unanimity of purpose which constructed the pyramids of Teotihuacan, or the Maya temples; we are still hampered by personal ambitions, and the peevish habit of breaking up into infinitesmal dissenting groups on minor points of doctrine. Naturally, that is to say, humanly, all wish to be first in the house of beauty. We have yet to learn that the dream is greater than the man.

But these things pass, and the work remains. We have a

lucid, tremendous idea, and a powerful force is its ally. This force is, I believe, the profound, vehement desire of the Mexican people for a richer and more eloquent life, freedom to flower from within; for a life in which every man shall be both artist and worker, and above all a liberated human being. (pp. 174-78)

Diego Rivera, "The Guild Spirit in Mexican Art," in an interview with Katherine Anne Porter, in Survey, *Vol. LII, No. 3, May 1, 1924, pp. 174-78.*

Diego Rivera (essay date 1934)

[*In the following excerpt from his introduction to* Portrait of America, *a collection of reproductions of his North American murals, Rivera chronicles his experiences in San Francisco, Detroit, and New York.*]

The social development of our time is a continuous, accelerated march towards collectivization, and for this reason the necessity for mural painting, the character of which is essentially collective, becomes ever more urgent. In reality, the advanced, modern architecture of today has provided fresco painting as never before with its *raison d'être.* The unequalled trinity of modern construction, steel, glass, and concrete, would in itself be the best reason for the birth of fresco in our day, if fresco were not already as ancient as the first buildings in which man employed mortars on a base of lime or cement for his architectural efforts. Fresco is the only form of painting which finds its true place as readily in the light, soaring constructions of steel, concrete, and glass which we erect today as on the gigantic heavy walls of earlier architecture.

Tomorrow, architecture, the mother of all the plastic arts, will be rationalized, will slough off the leprous scales of its traditional ornamentation and vomit the useless trumperies and horrible gingerbread adornments from its walls, in order to substitute for these a rationalized dwelling whose bright walls are splendidly illuminated by great spaces of glass and light—a dwelling suitable to the cerebral functioning of civilized man who has conquered himself by means of the machines he has built and has thrown off the diseases of mystic ideologies. Only so can true mural painting grow in splendor and importance and play its part in helping mankind to traverse the road that leads to the classless society of the future.

But today as well, mural painting must help in man's struggle to become a human being, and for that purpose it must live wherever it can; no place is bad for it, so long as it is there permitted to fulfill its primary functions of nutrition and enlightenment.

It was with these ideas already partially formulated that I returned from France to Mexico in 1921 in search of walls to paint. I had never painted in fresco up to this time, and I learned the technique of my craft from masons and housepainters, for these journeymen painters of Mexico have kept alive the art of fresco painting since those remote times when the entire surface and the sculptures of ancient Indian architecture were covered, in fresco, with beautiful colors.

In Mexico, I was forced to use what walls I could find, almost invariably old and covered with the ravages of nitrate, and enclosed in a lamentable architecture; or else in newly constructed buildings of atrocious style and taste, built, which is worse, with materials salvaged from the demolition of older structures already contaminated with the leprosy of saltpetre, as in the Secretariat of Public Education.

Between the nitrate and the "decent" people of Mexico, my frescoes were often damaged and partially destroyed, to the great satisfaction of the bourgeoisie and especially the Spanish sections thereof, religious bigots and enslavers of men, as well as to the dissimulated hypocritical rejoicing of the thieving and corrupt counter-revolutionary official bureaucracy, social elements who were also enraged by the form and, above all, by the content of my Mexican frescoes.

On the other hand, the peasants and workers of Mexico liked and enjoyed my frescoes, an experience which authorizes me to declare that for them my work was of value— and that is all that interests me.

Mexico is much more an agricultural than an industrial country, and one, moreover, whose agriculture, based on a poor, primitive, and defective soil, must still struggle painfully, under the yoke of foreign imperialism and of the brutal repression of the national capitalism which daily assassinates peasants throughout the entire country, to emerge from semi-feudalism and colonial slavery. Consequently, the painting I did in Mexico had to conform to these circumstances and was necessarily of a predominantly peasant character.

Thus, the larger experiment in mural painting, of which all my work since 1921 has been a part, could not be completely realized in Mexico. Its early stages had produced very satisfactory results, but it was urgently necessary for me to continue it in a highly industrialized country, under conditions impossible to find in Mexico. Only by testing the action and reaction between my painting and great masses of industrial workers could I take the next step towards my central objective—that of learning to produce painting for the working masses of the city and country.

Now, Mexican economy depends on the North-American bourgeoisie, and the United States, a country of the same soil as Mexico, part of the same continent, is the land in which industrialization has reached a maximum degree of development, along with that great concentration of capital which culminates in imperialism. It was thus the most propitious place in which to continue my work. For years I had been waiting for the first opportunity offered me to enter the United States with my work and there make the attempt to complete the experiment which occupied my whole attention.

When Mr. Ralph Stackpoole, of San Francisco, a sculptor whom I had known well in Paris, came to Mexico, I spoke to him of my plans. Mr. Stackpoole very generously interested himself in my work and did his utmost, after his return to San Francisco, to interest others there, with such success that Mr. William Lewis Gerstle, President of the Society of Fine Arts of San Francisco, donated the sum

of $1,500 for a fresco to be painted by me if I should ever go there.

I was unable immediately to avail myself of this offer because I had been invited by the Soviet Commissariat of Education to attend the tenth anniversary celebration of the October Revolution in Moscow. Not until 1930, some time after my return to Mexico from Russia, was I at last free to go to San Francisco. Ralph Stackpoole had not stopped his efforts on my behalf, and during the time that had elapsed he had succeeded in interesting others of his friends in a second proposal. The architect, Timothy Pflueger, who had just finished constructing the new building of the San Francisco Stock Exchange, suggested that I paint a mural in the interior staircase of the building's Luncheon Club, where Stackpoole, Clifford Wight, and other artists had worked together on the decorative scheme.

California was for me the ideal intermediate step between Mexico and the United States. Although it is also more agricultural than industrial, its agriculture is highly advanced and mechanized; its mining districts are very like the part of Mexico where I was born, even though the primitive mining technique of my boyhood days bore little enough relation to the methods in use here; and the state as a whole is a rich land intimately bound up with the remains of its earlier Mexican character, forming a transition stage between the industrial East and primitive, backward Mexico; a region whose mountains and deserts are the connecting link between the strong, bitter, rugged landscape of Mexico and the flat plains and lake-dotted rolling hills of the Middle West, North, and East, the cradle of America's industrialization.

My fresco in the Stock Exchange Luncheon Club objectifies the productive resources of California and typifies its workers—the agriculturist and horticulturist, expressed by the figure of Luther Burbank; the ranchers, the miners and gold prospectors, represented by Marshall, the discoverer who gave the signal for the Gold Rush; the mechanic, man of the mines and tractors and steamships and oil-wells. In the midst of these, I placed the young worker-student, holding in his hand the model of an airplane. California itself is symbolized by a large female figure—a woman of tanned skin and opulent curves modeled after the rolling hills of the landscape, with one hand opening the sub-soil to the labor of the miners, and with the other offering the ripe fruits of the earth.

The painter's intention, of course, must not lie outside the function of the place in which his painting has its being, else his work will be lacking in both objective and subjective correctness and truth. In this mural in a luncheon club, I painted the fruits of the earth which enrich and nourish because of the productive labor of workers and farmers. I painted no mortgage-holding bankers, or industrial overlords, or parasitic exploiters—only the modern workers and discoverers, as well as the pioneers and those brave adventurous guides of the prairie schooners which brought the bloodthirsty hordes across the lands defended by the free Indians, there to become despoiling adventurers, persecutors of Mexicans, populators of the land of gold; all those barbarous settlers and entrepreneurs who

were as necessary as the fatal crimes they committed in the process of transforming this new land by industrialization into something that would, as Marx foretold in a brilliant prophecy, convert the Atlantic Ocean into an inland sea and make the Pacific the new ocean of world commerce.

I was reproached by many people for not having included a portrait of Tom Mooney in the Luncheon Club mural, and there might be some justification for their criticism if one did not also take into account the place in which I was painting. But I believe implicitly that a work of art is true only if its function is realized in harmony with the building or room for which it has been created, and I cannot bring myself to believe that the place for an image of Tom Mooney, victim of a bourgeois frame-up and martyr in the social war, is an exclusive restaurant dedicated to the sole use of its stockbroker members. What I painted for them there was designed to show them that what they eat and what enriches them are the products of the toil of workers and not of financial speculation—the natural beauty of California, fertilized by the vigor of workers, farmers, and scientists.

Later, when at Rockefeller Center in New York I painted the naked and objective truth about the essential factors of social strife, and included a portrait of Lenin, I did so because Rockefeller Center is a group of public buildings open to all the inhabitants of the city and containing theaters, lecture halls, offices, radio and television studios, laboratories, and even a subway station! There I could only paint that which corresponded to and was significant for the entire mass of producing citizens; for the buildings which today have been erected out of the capitalist drive for profits, will tomorrow, because of their public functional utility, be delivered over into the hands of the workers. Tomorrow there will be no stock exchanges or brokers or frescoes in their luncheon clubs, and if, by some chance, the victorious working class should preserve my Stock Exchange fresco, it will be only for whatever historical value it may possess; while the Rockefeller Center mural would have been just as relevant after the establishment of the new social order as it was when I painted it, for then, as now, radio stations, television, theaters, great buildings, and subways will be just as necessary to the collectivity of man.

The fresco I painted in the San Francisco School of Fine Arts seems to me to express exactly the objective situation which produced it and to contain, technically, all the possibilities of mural painting; and, since it was executed in a technical school of the plastic arts, these, naturally, had to be its first functions.

The wall is subdivided into cells by the scaffold, which is the necessary pre-construction for all buildings. The scaffold is not only visible, it constitutes the very frame of the work and indicates the structural simplicity and plastic honesty of the composition. The various cells which it establishes contain all the elements of architectural construction; in the center and base, are the machine, the engineer, the architect, and the donor; on either side, the raw materials, and the trained workers who construct and operate the machine and those who calculate and trace the plans of construction; above these draftsmen are the metal

workers who are raising the steel skeleton of the building, and opposite them, above the mechanics and iron forgers, the sculptors are giving living form to the stone with chisels driven by the power of air compressed by the machine; above the sculptors, the ventilators, those beautiful functional sculptures created by industrial necessity, renew the air of the factory; in the center, on the planks of the scaffold, are the painters and masons working on a fresco which shows the gigantic figure of a worker grasping the power control of the machine with his right hand and with his left the lever which regulates its speed. His head completes the composition at its highest point, and his gaze is fixed firmly forward. . . .

These two frescoes completed my work in California, and, as I have suggested, served me as a sort of transition from Mexico and as an introduction to the United States. From there I looked forward, to undertake the following year the beginning of my "portrait" of America.

While I was still in California, I was presented to Dr. William Valentiner, Director of the Detroit Museum of Art. I confided to him my project of interpretation of the industrial life of the United States and the possibilities I saw in the development of a series of murals based on a given industry, making plastic the beautiful, continually ascending rhythm moving from the extraction of the raw material, product of nature, to the final elaboration of the finished article, the product and expression of human intelligence, will, and action; and, surrounding and interpreting this rhythm, the expression in plastic values of the social implications of the life of the producers.

Dr. Valentiner was greatly interested in my plans, and several months later, before I had left California, I received a concrete proposal from him to paint a series of murals in the Detroit Museum on the industrial life of the city. The cost of the work was to be borne by the President of the Detroit Commission of Art, Mr. Edsel B. Ford.

The industries of Detroit—metallurgy, industrial and biological chemistry, and the mechanics of the automobile—were precisely those which most suited my taste as subjects for painting, and I accepted the proposal with the greatest enthusiasm. Unfortunately, I was unable to go at once, as I had to return to Mexico where I was being called to continue work on the frescoes I had already begun on the central staircase of the National Palace. While I was there, another prospective commitment became definite. Some time before, the Directors of the Museum of Modern Art in New York, Messrs. Jere Abbott and Alfred Barr, whom I had met in Moscow in 1928, had asked me to give a retrospective one-man show of my work in New York. I now accepted this invitation as well, and came to New York in the Fall of 1931.

Together with my drawings and oils, the Modern Museum wished to exhibit several examples of my murals, and in spite of the fact that I had never considered mural painting to be anything but a painting executed in a determined architectural place and space, I was nevertheless interested by this idea as an opportunity to show the New York public several movable panels painted in fresco—merely, of course, as a sample, to show technical methods of work.

The themes I chose were several free replicas of some of my Mexican frescoes, and three whose subjects were the result of observations in New York; a composition built around the work in an electric power plant; a group of workers with pneumatic drills; and a cross-section of the city, which the newspapers baptized *Frozen Assets.*

From New York I went to Detroit, and in that city I found waiting for me and ready to hand marvelous plastic material which years and years of work could not exhaust. I should have liked to remain there eight or ten years at least, to manipulate, digest, understand, and express the material in a planned and carefully thought out scheme of work. Unluckily, I had but one year in Detroit, and during that year I did as much as I could and lived what was perhaps the best and most fruitful period of my life. I painted twenty-seven panels of various sizes on the walls of the covered central courtyard of the Detroit Museum, and at the same time, stored up within myself sufficient material for many years of future work. The full direct contact, which I was experiencing at last, with the massed industrial proletariat and with its methods of production, and the intensive study of the workers from the plastic point of view, made that single year worth at least ten in my development as an artist and in the clarification of my social outlook and mentality.

I have always maintained that art in America, if some day it can be said to have come into being, will be the product of a fusion between the marvelous indigenous art which derives from the immemorial depths of time in the center and south of the continent (Mexico, Central America, Bolivia, and Peru), and that of the industrial worker of the north. The dynamic productive sculptures which are the mechanical masterpieces of the factories, are active works of art, the result of the genius of the industrial country developed in the historico-social period which canalized the plastic genius of the superior and gifted individual within the broad stream of the workers for the creation of industrial mechanical art. Bridges, dams, factories, locomotives, ships, industrial machinery, scientific instruments, automobiles, and airplanes are all examples, and merely a few of them chosen at random, of this new collective art.

A machine is an assemblage of indispensable materials, and its forms and essential proportions are planned in immediate and direct relation to its function; that is to say, a machine that lives, and performs the functions for which it was intended, must have been constructed under inevitably harmonic conditions. Do not painting, sculpture, and architecture require the same harmony and functional utility to be considered as really living, dynamic, and socially enlightening?

When my Detroit frescoes were completed, I obtained indirect proof of their value and of the efficiency of the experiment I had carried out and the correctness of the line I had followed. If my work has a purpose, it may be summed up as being to make the greatest contribution of which I am capable to the esthetic nourishment of the working class, in the form of clarifying expression of the things that class must understand in its struggle for a classless society. All the social elements of Detroit which represent the forces of resistance against that purpose re-

acted violently, almost hysterically, against my frescoes. Elegant clubwomen and preachers employed every available means, from society gossip and slander to the anathema of Heaven, to undo the work I had accomplished, and even raised a cry for the whitewashing of my paintings on the ground of their "un-Americanism," the un-Americanism of the Detroit factories and workers! Is this not a marvelous example of the esthetic-nationalistic logic of the bourgeoisie?

These same sectors of the bourgeoisie, and in particular all the representatives of the various religious orders and faiths, charged that my worked showed me to be an atheist, a materialist, and a bolshevik, and that I had painted absolutely nothing "spiritual." As a matter of fact, my Detroit frescoes, which are nothing but a simple plastic expression of the subjective and objective truth of the time and place in which I was working, contain not the slightest tinge of demagogy, nor are they paintings of agitation. But the opinion of the "nice" people of Detroit was not unexpected, and I could hardly ask the class enemies of the proletariat for a better confirmation of the essential rightness of my work.

But the direct uncontestable proof of the validity of my experiment was furnished by the thousands of industrial workers, who formed a united front to defend my murals in whatever fashion it might be necessary. The factory workers, the youth, the school boys, came day after day by the hundreds to see the frescoes; their enthusiasm was for me the clearest demonstration of the worth of the decade of experimentation in art for the masses which I was just completing.

In the last few months of my work in Detroit, I received a definite offer to paint three panels in the lobby of the RCA Building in Rockefeller Center. Matisse and Picasso, I was informed, were to be offered the two lateral corridors in which each was to paint five panels. I was very doubtful that these two painters would accept, and said so to the architect of the building who was negotiating with me; nevertheless, the possible company of these painters (which was certainly good company), and above all the large, well-proportioned, and well-lighted wall that was offered me, decided me to accept. Even the theme was not bad, although it had been worded in very pretentious terms by the general staff of the management: *Man at the Crossroads Looking with Uncertainty but with Hope and High Vision to the Choosing of a Course Leading to a New and Better Future.*

From the very beginning, I explained to the architects, as well as to the owners and management of the building, my interpretation of the theme—for a man of my opinions, the only possible interpretation. The crossed roads were the individualist, capitalist order, on the one hand, and the collectivist, socialist order, on the other; and Man, the Producer, in his triple personality of worker, farmer, and soldier, stood at their intersection. Thus, my composition would synthesize, contrasting them by means of their most typical realities, the two opposed concepts; and Man would be represented, naturally, as the skilled worker, the worker who is also man of science, the classless man, controlling by means of the machine which is the child of sci-

entific knowledge, the vital productive energy in order to canalize it from its various natural functions into the broad stream of fundamental human necessity: that is to say, production in the hands of the producer and not of the exploiter.

I had also to take into account the fact that the wall offered me was well situated in an open and public site and that it was of the utmost importance to utilize it well; for, no matter what the outcome of the events that the painting must surely have produced, they would in any case constitute a most valuable test, as the mural would indubitably, if correctly done, focus international interest on its social significance.

As I had expected, the painters first proposed refused the commission. Matisse objected that neither the building nor the size of the wall was suited to his intimate style; while Picasso would not even receive Raymond Hood, the architect, nor Mr. Todd, of the contractors, to discuss the project with them. Since they were unable to secure the work of these two good painters, the management thereupon engaged José María Sert and Frank Brangwyn.

But this put another face on the matter for me, and my first reaction, as a painter, was naturally to refuse the commission. Moreover, Mr. Todd was insisting at all cost that the painting must be a canvas mural of the usual "expensive wallpaper" type, and with good reason, for such murals avoid difficulties, distract no one from the weighty affairs of business, and are so "distinguished" that no one sees them; thus bourgeois digestions are not upset, nor is the risk run of arousing the unrest of exploited employes.

Two members of the owners' family, however, were interested—or so they assured me—in having at least one true mural in the building, and they insisted that I accept the commission. They supported my opinion that the painting be done in fresco and in colors, so as to "center" the series of murals, as well as to emphasize the point of the axis of the group of buildings, something which was obviously necessary and finally admitted even by the architects. Only Mr. Todd still held out for black and white, and on the day that the final meeting was held to authorize the use of fresco and of color, he preferred to go rabbit-hunting rather than take part in a decision which he considered a violation of all those principles of esthetics, ethics, religion, and capitalist politics which he held sacred.

The Rockefeller Center architects had always wanted to use black and white in the decorations. One of them, perhaps the most modern of them all, and, as far as painting was concerned, with the most cultivated taste, had mentioned to me that his personal preference was for canvas murals which would be "something like Chinese painting." I have no idea why he conceived the notion of going to painters who have a definite personality and a style of their own to produce anything of that sort. As for the other architects of the project, the one among them who enjoyed the greatest authority and renown told me frankly, on a number of occasions, that he understood nothing of painting, something which seemed to me undeniable. Moreover, subsequent events have demonstrated that, like the majority of their American colleagues turned out by

the Paris École de Beaux Arts, they can only tolerate as mural painting those nauseating productions of the infra-academic painters deriving from the same school, or of the stepsons of that famous establishment.

A small amount of reflection will, I think, enable anyone to realize that the only things these architects really like to paste on the walls of their buildings are canvas enlargements of the vulgarest kind of illustration from the popular magazines, done in oils, and as slick, smooth, and shiny as the patent leather pumps which they wear to their evening parties. (Historical note: Mr. Todd, in the contracts drawn up under his orders, insisted on inserting the express condition that the murals done in oils must be given at least five coats of varnish!)

Needless to say, the problem, for me, was totally different. It was the problem of painting a fresco that would be useful to the working people of New York, since the producers have enriched the financiers who "own" the building; and, in all justice, it is to the working people of the city and of the world that Rockefeller Center really belongs. Thus, I considered that the only correct painting to be made in the building must be an exact and concrete expression of the situation of society under capitalism at the present time, and an indication of the road that man must follow in order to liquidate hunger, oppression, disorder, and war. Such a painting would continue to have esthetic and social value—and still greater historical value—when the building eventually passed from the hands of its temporary capitalist owners into those of the free commonwealth of all society.

The owners of the building were perfectly familiar with my personality as artist and man and with my ideas and revolutionary history. There was absolutely nothing that might have led them to expect from me anything but my honest opinions honestly expressed. Certainly I gave them no reason to expect a capitulation. Moreover, I carried my care in dealing with them to the point of submitting a written outline (after having prepared the sketch which contained all the elements of the final composition) in detailed explanation of the esthetic and ideological intentions that the painting would express. There was not in advance, nor could there have been, the slightest doubt as to what I proposed to paint and how I proposed to paint it.

In the actual work, which I tried to carry out to the best of my ability and to make superior to anything I had done before, I was assisted with the generous collaboration of distinguished scientists, engineers, biologists, inventors, and discoverers, one of them an important research worker in a well-known scientific institution supported by the owners of Rockefeller Center. Doctor and biologist of international reputation, he carried his generosity to the extent not only of lending me his biological skill and knowledge to be made plastic on the wall, but of working at my side night after night, sometimes until three o'clock in the morning, so that the material he supplied me might possess its correct social and esthetic function in the finished painting. Talented young artists, some of them at the beginning of a brilliant career, sacrificed their time and gifts in order to become my assistants. And the workmen engaged in the construction of the still unfinished building

took such an interest in the progress of the fresco that they would arrive an hour before their day's work began in order to watch us, much to the annoyance of the foremen and private guards of the owners, whose job it was to police them.

Large numbers of the outside public, as well as many qualified specialists, took a lively interest in the work. I think it may be said that all the positive social forces were for it, and, naturally, only the negative forces against it. There was nothing grandiloquent or demagogic in the painting, nothing that did not correspond accurately to the reality of the existing social situation. It was a work of art made to function in society, and it is no self-flattery to believe that its purpose would have been fulfilled. Had its functioning been less efficient, its interpretation of the given theme less penetrating and accurate, the bourgeoisie would not have proceeded against it with all the force and power at their command and, finally, destroyed it.

The attack was at first veiled, and couched in the courteous language of diplomacy. But when the painter failed to give ground before the conciliatory offers of these patrons of the arts; when, before the power of the richest people in the country, the colors of the painting did not pale or a single form disappear; then these all-powerful lords sent their trusted employes, the executors of their peremptory orders, to deal drastically with the situation.

I preserve a beautiful memory of this "Battle of Rockefeller Center." A mysterious warlike atmosphere made itself felt from the very morning of the day that hostilities broke out. The private police patrolling the Center had already been reinforced during the preceding week, and on that day their number was again doubled. Towards eleven o'clock in the morning, the commander-in-chief of the building and his subordinate generals of personnel issued orders to the uniformed porters and detectives on duty to deploy their men and to begin occupying the important strategic positions on the front line and flanks and even behind the little working shack erected on the mezzanine floor which was the headquarters of the defending cohorts. The siege was laid in strict accordance with the best military practice. The lieutenants ordered their forces not to allow their line to be flanked nor to permit entrance to the beleaguered fort to anyone besides the painter and his assistants (five men and two women!) who constituted the total strength of the army to be subdued and driven from its positions. And all this to prevent the imminent collapse of the existing social order! I wish I could have been equally optimistic!

Several days before, orders had been given out not to allow camera men to enter. They were now made even more stringent, and there was no doubt that the owners would under any circumstances try to prevent the publication of any reproduction of the fresco. Fortunately, Miss Lucienne Bloch, one of my assistants, was adroit enough to take a series of ten details, as well as one complete view, with a tiny Leica camera under the very noses of the enemy's spies, who were so efficient that they failed to notice it!

Throughout the day our movements were closely

watched. At dinner time, when our forces were reduced to a minimum—only I, my Japanese assistant, Hideo Noda, my Bulgarian assistant, Stephen Dimitroff, and the Swiss-American, Lucienne Bloch, were on duty—the assault took place. Before opening fire, and simultaneously with the final maneuvers which occupied the strategic posts and reinforced those already occupied, there presented himself, in all the splendor of his power and glory, and in keeping with the best gentlemanly traditions of His Majesty's Army, the great capitalist plenipotentiary, Field-Marshal of the contractors, Mr. Robertson, of Todd, Robertson and Todd, surrounded by his staff. Protected by a triple line of men in uniform and civilian clothes, Mr. Robertson invited me down from the scaffold to parley discreetly in the interior of the working shack and to deliver the ultimatum along with the final check. I was ordered to stop work.

In the meantime, a platoon of sappers, who had been hidden in ambush, charged upon the scaffold, replaced it expertly with smaller ones previously prepared and held ready, and then began to raise into position the large frames of stretched canvas with which they covered the wall. The entrance to the building was closed off with a thick heavy curtain (was it also bullet-proof?), while the streets surrounding the Center were patrolled by mounted policemen and the upper air was filled with the roar of airplanes flying round the skyscraper menaced by the portrait of Lenin. . . .

Before I left the building an hour later, the carpenters had already covered the mural, as though they feared that the entire city, with its banks and stock exchanges, its great buildings and millionaire residences, would be destroyed utterly by the mere presence of an image of Vladimir Ilyitch. . . .

The proletariat reacted rapidly. Half an hour after we had evacuated the fort, a demonstration composed of the most belligerent section of the city's workers arrived before the scene of battle. At once the mounted police made a show of their heroic and incomparable prowess, charging upon the demonstrators and injuring the back of a seven-year-old girl with a brutal blow of a club. Thus was won the glorious victory of Capital against the portrait of Lenin in the Battle of Rockefeller Center. . . .

But it was not yet over. If it is true that it is highly improbable that many of the seven million inhabitants of New York City would have seen the dangerous painting, on the other hand, thanks to the valiant attack of Capitalism against the mural, the press, the radio, the movies, all of the modern mediums of publicity, reported the event in the greatest detail over the entire territory of a country peopled by 125,000,000 people and even in the smallest villages of the United States. Tens of millions of people were informed that the nation's richest man had ordered the veiling of the portrait of an individual named Vladimir Ilyitch Lenin, because a painter had represented him in a fresco as the Leader, guiding the exploited masses towards a new social order based on the suppression of classes, organization, love and peace among human beings, in contrast to the war, unemployment, starvation, and degeneration of capitalist disorder. . . .

Even now, a year later, I continue to receive publications from Europe, from South Africa, from the Far East, China and Japan, from India and Australia and South America, carrying the same message to all the exploited workers in all parts of the world. Can Mr. Todd and Mr. Robertson ever calculate the number of exploited and oppressed proletarians who, thanks to their good offices, have been taught that in the opinion of the very overlords of America there is only one solution to the problems of hunger, unemployment, war, and all the cruel stages of capitalist crisis, and that this solution bears the name of Lenin?

The attack on the portrait of Lenin was merely a pretext to destroy the entire Rockefeller Center fresco. In reality, the whole mural was displeasing to the bourgeoisie. Chemical warfare, typified by hordes of masked soldiers in the uniforms of Hitlerized Germany; unemployment, the result of the crisis; the degeneration and persistent pleasures of the rich in the midst of the atrocious sufferings of the exploited toilers—all these symbolized the capitalist world on one of the crossed roads. On the other road, the organized Soviet masses, with their youth in the vanguard, are marching towards the development of a new social order, trusting in the light of History, in the clear, rational, omnipotent method of dialectical materialism, strong in their productive collectivization and in their efforts for the abolition of social classes by means of the necessary and logical proletarian dictatorship, result of the social revolution. This was expressed without demagogy or fantasy, with a simple objective painting of one of those marvelous mass demonstrations in the Red Square, under the shadow of the Kremlin and the Tomb of Lenin, which year after year give to the entire world an unequalled spectacle which makes visible and tangible the revolutionary march of the 160,000,000 inhabitants of the Soviet Union towards a better world. That road, too, is painful, hard, and filled with difficulties, but it leads ever forward, despite all the political vicissitudes inevitable in any revolutionary movement to a more logical, juster, and more efficient human society, towards that time in which the period of "prehistory" will come to its end and, with the beginning of Communism, true human history will begin.

In the painting, Lenin, the Leader, unites in a gesture of permanent peace the hands of the soldier, the Negro farmer, and the white worker, while in the background the mass of workers with their fists held high affirm the will to sustain this fact; in the foreground, a pair of young lovers and a mother nursing her newborn child see in the realization of Lenin's vision the sole possibility of living, growing, and reproducing in love and peace. In the center, Man, the intelligent and producing skilled worker, controls vital energy and captures it for his own uses through the machine and by means of his knowledge of the life of the vast inter-stellar spaces and of the immensity of microbiologic space; while the mechanized hand, symbol of human power in action, grasps within its fingers the vital sphere—atoms and the cell, which are the essential reality of all life.

Two enormous lenses placed at the sides magnify these central elements of the composition for the eyes of the stu-

dents and workers ranged in seated groups on each side of the main panel; these groups are made up of international types—Anglo-Saxons, Germans, Latins, Scandinavians, Indians, Jews, and Negroes—thus expressing the reality of the population of this continent, a continent peopled by numerous delegations of all the races of humanity, to realize in the future the synthetic human compound divested of racial hates, jealousies, and antagonisms, the synthesis that will give birth to intelligent and producing Man, master, at last, of the earth, and enjoying it in the high knowledge of creative energy and without the exploitation of his fellows. (pp. 11-29)

With the Rockefeller money (that is to say, with the money extorted from the workers by the Rockefeller exploiters), I painted a series of twenty-one panels in fresco in the New Workers' School of New York. The Rockefellers thought to prevent my talking to the people by destroying the fresco in their Center. In reality, they succeeded only in clarifying, intensifying, and multiplying my expression.

I shall not speak at length here of that series of panels, which is the first affirmative outline of the Portrait of America which I have begun to paint. . . . I painted them for the workers of New York, and for the first time in my life, I worked among "my own"; for the first time, I painted on a wall which belonged to the workers, not because they own the building in which their school has its quarters, but because the frescoes are built on movable panels which can be transported with them to any place where their school and headquarters may be called to move. They all helped in the work, and there, in the modest premises of an old and dirty building in 14th Street, at the top of a steel staircase as steep as those of the pyramids of Uxmal or Teotihuacán, I found myself in what was, for me, the best place in the city. The work lasted six months. I did all that I could to make something that would be useful to the workers, and I have the technical and analytical certainty that those frescoes are the best that I have painted, the best constructed, the most correct in historical dialectic, the richest in materialistic synthesis, and, moreover, informed with the greatest enthusiasm and love that I am capable of feeling.

For these reasons, I offered them to the workers of New York and asked the comrades of the New Workers' School to be their depositories. They, and many thousand others, were happy in the arrangement, and they notified me that, in the name of the producing masses of the United States, they were naming me the first "People's Artist" of America. In other words, they socialized me, as is done in Russia with those intellectuals who are considered useful to the community at large. And so America, the true, producing America, paid me in advance this splendid price for the portrait which I am just beginning.

I hope that this portrait may be in some small degree useful to a few hundreds, or thousands, or as many as possible, of the millions of workers who, in the near future, will carry out the formidable task of transforming, by means of revolutionary struggle and proletarian dictatorship, the marvelous industry of the super-capitalist country into the basic machinery for the splendid functioning of the Union of Socialistic Soviet Republics of the American Continent. (pp. 31-2)

Diego Rivera, in his Portrait of America, *Covici, Friede, Publishers, 1934, 231 p.*

INTRODUCTORY OVERVIEW

Bertram D. Wolfe (essay date 1963)

[*Wolfe was an American historian and biographer and one of the founding members of the Communist party in the United States. Although he wrote extensively on Spanish and Mexican history and culture, he is better known for his numerous studies of Marxism, soviet history, and soviet political figures. Foremost among these is* Three Who Made a Revolution *(1948), a collective biography of V. I. Lenin, Joseph Stalin, and Leon Trotsky. Wolfe wrote two biographies of Rivera over the course of their long association,* Diego Rivera: His Life and Times *(1939, see Further Reading) and* The Fabulous Life of Diego Rivera *(1963). In the following excerpt from the latter work, Wolfe provides a comprehensive portrait of Rivera.*]

The Revolution which took possession of Diego Rivera and made him its painter, was the Mexican Revolution not the Russian. The upheavals in Mexico that began in 1910 and continued for more than a decade, preceded the Russian Revolution, developed independently, had causes which sprang from Mexico's own condition. Its aims, however, vague, were entirely its own. Its agrarian revolution produced not a new state-controlled serfdom as in Russia but an independent peasantry.

When the Tsar was overthrown by spontaneous rebellion in the Spring of 1917 and the new Russian democracy was in turn overthrown by Lenin in the Fall of that same year, the Mexican Revolution had already been going on for seven years.

In 1917, for a moment a few of Mexico's ideologues turned their gaze uncertainly towards Moscow, then again looked inward, rejecting as alien Russia's influence, her dogmas, and the arrogant commands and instructions of her new rulers.

The Mexican Revolution was above all an attempt at self-discovery. A poor, unhappy land, which for the first century of its independent existence had been colonial and imitative in its culture, sought to find its roots in its own past, to assert thereby the worth and dignity of its own folk. If in several decades the Mexican Revolution has not accomplished much else, this much it has accomplished: the reversal of some of the social consequences of the Spanish Conquest and the rise of the Indian to full citizenship in his country. And this, it seems to me, leads us to the essence of Rivera's painting in Mexico, not in his murals alone but in most of his easel paintings and drawings, as well.

To be sure, this suggests that Diego Rivera was a populist rather than a Communist. And that indeed is what his painting says concerning him.

The first sketch Diego did on his return to Mexico in 1921, a sketch for an intended painting, with color notations still written in French, was entitled *Zapatistas.*

Once before, some six years earlier, when there was as yet no Russian Revolution, in mid-1915 Diego ceased for a moment his endless succession of Paris cubist scenes, Paris studio objects, and Paris cubist portraits, to do a unique canvas, bright with colors almost never used in somber cubist painting. Its background was a geometrically stylized Mexican mountain landscape with nothing cubist about it. Its foreground, on a flat surface of the deepest Mexican blue, was a cubist construct, made up of bits and pieces, colors and shapes, abstracted from the equipment and costume of a Mexican agrarian revolutionary. The core of the construct is a small bore rifle such as the *agrarista* carried into battle. The gun is surrounded by elements derived from a sombrero, a bright *sarape* of Saltillo, a mule's head, saddle bags, a water canteen, white patches suggesting peasant raiment, fragments of rock, grained wood, deep green foliage with bits of its own shade. All this forms a single cubist object, resting on a deep blue ground behind which rises the Mexican sierra. Its granite craters and cones, the highest topped with perpetual snow, rise into a remote, clear, light-filled, pale green-blue Mexican sky. The painting was entitled *Paisaje Zapatista.* The colors, the mixture of poetic elements, cubist and noncubist, and, above all, the subject itself, tell more of the nostalgic landscape of Diego's spirit at the moment than they do of Paris painting or the Mexican Revolution. It is a fall from cosmopolitan-Parisian grace, a ballad in cubist language to the Mexican agrarian revolution, a cry of longing for home and country. Its title foreshadows the protagonist of some of the most poetic passages in Diego's future murals: Emiliano Zapata. Its fragments of folk garb, revolutionary folklore and folk uprising, against the background of Mexican soil and sky, constitute an inventory of elements in so many of Diego's future frescoes. The little rectangle of paper, nailed with a painted nail near the lower right-hand corner of the blue foreground, is worth noting, too. When such scrolls appeared later, they were taken to be a conventional expression of Communist leaflets and posters, but here we have such a placard done before Lenin seized power in Russia or founded his Communist International. Actually it was taken not from Communism but is a common feature of Mexican primitive painting and of the Mexican *retablo.* The painters of primitive portraits generally put the name of painter and subject in such a placard or scroll, while the *retablo* painter used the same device to recount the miracle which called forth the votive offering.

In 1917 when the two revolutions occurred in Russia, Rivera went on doing much what he had done before. Only in 1921, when he set foot once more on his native soil, or rather in late 1922, after a journey through the strife-torn land, when he got his second wall (in the Secretariat of Education), did the Paris studio painter become the Mexican painter we know. Only then did he find his characteristic style and subject matter. And, as panel after panel proclaims, at last he had found his epic subject: the Mexican folk.

Diego was then thirty-six. He had left Mexico, already an accomplished landscape painter, at the age of twenty-one. Abroad he had worked hard and wrestled to wring their secrets from all the great pictures and schools of European painting, modern and classic. Despite his awesome productivity, his marvelous draughtsmanship, his chameleon-like ability to take on a hundred styles without altogether losing himself, he had not found himself. His work remained the derivative-original work of a talented "provincial" or "colonial" who had spent fifteen years in Europe, more than a decade in Paris, yet was still a stranger in the *Quartier Latin.*

Only when he renewed contact with his native earth was his strength renewed for the great labors he was henceforward to undertake. One cannot help but feel that if he had remained for the rest of his life in Paris, as so many painters do, though he would have done many excellent paintings, the final verdict would likely have been little different from that which was pronounced on him when he first made the Autumn Salon in 1914 and Guillaume Appollinaire wrote: *"Rivera n'est pas du tout négligeable"* ["Rivera is not at all unimportant"].

Thus Diego's return to Mexico and his contact with the Mexican Revolution was for him what the Revolution itself was for his country—an experience in self-discovery—an enhancement of his appreciation of his native roots and autochthonous plastic sensibility.

That he at times confused the Mexican Revolution with the excitements of anarchist and socialist ideological fragments picked up in café conversations in Madrid and Paris is not surprising. Diego was not the only painter in Paris, nor in St. Petersburg either, to confound the studio-and-café revolutions aimed at upsetting, astonishing, defying the "bourgeois" with Lenin's hatred of the bourgeoisie or determination to liquidate whole classes of men. By "bourgeois" the artist meant little more than someone insensitive to modern art, possessing bad taste, subservient to habit and routine, neglectful of living art and the living artist. But Lenin . . . was ready to include under the category "bourgeois" the entire intelligentsia of Russia and of Europe, and to regard as "petit-bourgeois" those workers who concerned themselves with economic and political reform in order to improve their lot in "bourgeois society." And, for good measure, Lenin added the real hero of Rivera's painting, the agrarian peasant revolutionary, to the category of the bourgeoisie, to be distrusted and eventually eliminated.

None of the painters ever took the trouble to study the writings of the Marx and Lenin whose names on occasion they invoked. Even Modigliani, whose brother was an outstanding leader of the Italian Socialists, knew nothing of the literature of Marxism. Mastering political and economic treatises was not their *métier.* All that Diego ever knew of Marx's writings or of Lenin's, as I had ample occasion to verify, was a little handful of commonplace slogans which had attained wide currency. Even if Diego and

his fellow artists had wanted to study Lenin's works, they would not have found the more horrendous and dogmatic part of his doctrine available in Spanish, or French, or English, nor would they have understood its meaning without considerable effort. Indeed, specialists in political theory have learned to understand its meaning only with the benefit of hindsight.

Up to 1914, the doctrines of this ardent pedant of totally centralized, totally organized power, and total terror were rejected by every serious socialist leader, insofar as they themselves understood what Lenin was driving at. After 1907, the influence of Lenin's sect in Russia itself dwindled rapidly.

But in August, 1914, began four terrible years during which the crisis in European civilization manifested itself in total war without definite aims or visible limits. During those years, statesmen and generals treated their own people as human matériel to be expended in pursuit of undefined and unattainable objectives. Universal war so brutalized civilized man that it became possible to beguile him into fresh brutalities by the fury of his resentment against brutality. This it was which made Lenin's fantastic prescriptions for the waging of the class war ("kerosene rags to start fires; tacks for horses' hoofs; children and old people to pour acid and boiling water from roof tops") seem less fantastic. Men no longer shuddered at his proposal to continue the endless world war by prolonging it into universal civil war. With whole nations under arms, his plans for the military discipline of his party and of society seemed less strange, too.

Before there could come what Churchill was to describe as the reign of "the bloody minded professors of the Kremlin," there first had to be the bloody mess of Flanders Field, of which no less a one than England's wartime leader, Lloyd George, would write: "Nothing could stop Haig's compulsion to send thousands and thousands to their death in the bovine and brutal game of attrition."

In Paris, Diego was a close witness of the secular crisis in European civilization, of which this century's first total war was striking evidence, and Communism and Nazi Fascism two characteristic by-products. Born in the trench psychology of the First World War, these twin isms with their paramilitary organizations turned the streets of every great European city into battlefields, destroyed the young democracies of Germany and Russia, then joined hands in the Stalin-Hitler Pact which engendered the Second World War. How could Diego and his fellow painters understand this when neither historians nor statesmen nor philosophers understood it?

All that painters and poets heard of Lenin's words and meanings was the echo of their own longing in their ears. "Since it was a time of horrors," they told themselves, "at least let violence have peace as its objective, and as its enemy the civilization that had made the sterile carnage possible." That Lenin meant to prolong the carnage into an all-inclusive and universal civil war was a fine point which escaped them. That he expected the time of violence to endure for an entire epoch until man had been remade

in accordance with his blueprint and for that blueprint he had won the world, escaped them, too.

Above all, how could a Picasso or a Rivera imagine that the Lenin to whom they attributed their dreams of freedom was actually possessed by the dream of subjecting all forms of human activity, including those of the spirit, to the total control of state and party and dictator?

Only because Communist Parties did not conquer the lands in which they lived and painted, were Rivera and Picasso able to paint in such un-Communist fashion and continue to call themselves Communist painters. Because they remained outside the walls, each could paint according to his vision, which is the moral imperative of the artist. Rivera was expelled once, resigned once, was hectored and harassed, but since he lived in a country where the Communist Party did not possess a monopoly of power, neither expulsion nor condemnation was fatal.

In 1927, before the mold constricting the arts in Russia had hardened, the relatively liberal Lunacharsky invited Diego to Moscow to do a mural. After the party bosses (Lunacharsky was not one of them) had seen Rivera's sketches and heard his views, the opportunity to paint on a public wall in Moscow was denied him.

Two years later, it was completely impossible for anyone with the esthetic sophistication of a Rivera or a Picasso, with their mastery of the officially condemned impressionist, cubist techniques, to paint in Russia at all. The Russian artists whom Diego had known in Paris, returning to their homeland to serve their people and the Revolution and enjoy its new freedoms, either fled again to the West, or were denied the right to be true to their own vision and esthetic conscience. Some ceased to paint; others were forced to debase their art to vulgarity and flattery; many ended in concentration camps.

Rivera and Picasso loved freedom and took the freedom to follow their own vision for granted. They never dreamt that in the modern world direct censorship of painting was possible. But under the Communist dispensation in Russia, to censorship by the powerful has been added total ownership and total control of all museums, all galleries, all institutions that might commission, purchase, or display one's painting. To censorship and total ownership has been added positive dictation to the painter of both theme and method of treatment. The writer's situation under totalitarianism was no better, for here, too, along with censorship and dictation of style and theme, the party controlled a monopoly of all journals, printing presses, and publishing houses, all bookstores and libraries, all reviews, and all reviewers. One can hide an occasional manuscript "for posterity," but where can one hide a stack of paintings or find a wall?

Unlike Picasso, Diego cherished the additional dream of painting for the people. In the Soviet Union, to be "accessible to the masses" meant painting to suit the tastes of a Stalin or a Khrushchev, and of their culture overseers, for the Party bosses claim to speak for the masses in the arts as in all other respects.

To Diego's credit be it said that he openly rejected the no-

General Porkbarrel Dancing with Miss Mexico *(1936); from the Hotel Reforma.*

tion that the unformed taste of the esthetically illiterate masses should determine what and how a painter should paint. Though he did not emphasize the fact that he was opposing the Soviet dictators, his answer to them was direct and forthright:

> The workman, ever burdened with his daily labor, could cultivate his taste only in contact with the worst and vilest part of bourgeois art which reached him in cheap chromos and the illustrated papers. This bad taste in turn stamps all of the industrial products which his salary commands. . . .

> Popular art produced by the people for the people has been almost wiped out by [an] industrial product of the worst esthetic quality. . . .

> Only the work of art itself can raise the standard of taste . . .

This is clear enough, but when Diego said it in the Soviet Union it was not printed. When he got back to Mexico he made the same statement for an American art journal.

On another occasion, when he was in the United States and had gone to a gallery which prided itself on always following the *dernier cri,* Diego delivered himself of some judgments on spontaneous action painting, on painting which welled up from the "subconscious" without guidance from the conscious, and on painters who scorned to

master their technique or to study the great inherited tradition of the past.

> Do we have to discard all our modern technical means and deny the classic tradition of our *métier?* Just the contrary—it is the duty of the revolutionary artist to master and use his ultramodern technique. He must try to raise the level of taste of the masses, not debase himself to the level of unformed and impoverished taste. He must allow his classic training to affect him subconsciously while he sees with his trained eye and thinks with his trained hand. Only thus can he form of the masses an audience worthy of the best work of which he is capable. Only thus can he make their life more beautiful and joyous, nourish their sensibility, help great art to come out of the masses.

When I asked him what he thought of nonobjective art, he expressed admiration for such painters as Klee and Kandinsky, and, as always, for the restless experimentation of Picasso. But then he added:

> The painter can and must abstract from many details in creating his painting. Every good composition is above all a work of abstraction. All good painters know this. But the painter cannot dispense with subject altogether without his work suffering impoverishment. The subject is to the painter what rails are to a locomotive. He cannot do without it. Only when the artist has selected a congenial subject appropriate to his purposes and attractive to him, is he free to create from it a thoroughly plastic form. A subject properly selected frees the painter for abstraction from it, yet guides him. When he refuses to seek a proper subject for his plastic experiments, don't think he is without a subject altogether. His own plastic methods and his own esthetic theories become his subject. He becomes nothing but an illustrator of his own state of mind, which is likely to be a smallish matter for painting. That is the secret of all the boredom which one feels from so many of the expositions of modern art.

If Diego managed to get back into the Communist Party in his old age, three years before his death, it was not because the Communists considered that he would be easy to manage. After so many wayward deeds and heretical pronouncements, they knew he would continue to be unmanageable. But they decided that "on balance" he was "useful." As with Picasso, many things have to be forgiven to "useful" artists working in the "bourgeois world" which would not be permitted to workers in the arts in the Soviet Union.

When a friend went to Picasso after one of the latter's pro-Communist gestures, to remind him of the fate of painters such as he in the Soviet Union, Picasso lost his temper. Then he grew silent and thoughtful and at last he said:

> If they threw me into jail, I would sever an artery in my arm, and on the floor of my cell with my last drop of blood, I would paint one more Picasso.

A magnificent gesture! But some scrubwoman or warden would take care of the "last Picasso."

What then induces a Picasso or a Rivera—or, for that matter, a Siqueiros—to serve the Party which, if it takes power in his country, will make some Thorez or Fajon the arbiter of their painting? What makes such freedom-loving painters help a movement which, in power, would destroy the one freedom which matters most to an artist? To this question Karl Marx has no answer. Nor has Lenin, nor Stalin, nor Khrushchev. Perhaps Freud does though: he called it the death wish.

Near the end of his life, Diego said one day to Gladys March:

> Looking back on my work today, I think the best I have done grew out of things deeply felt, the worst from a pride in mere talent.

A wise judgment. To "mere talent" I would add "mere cleverness."

If we look at Rivera's portraits of Marx and Engels, we see lifeless faces, clichés not men. Had Diego looked at his Marx portrait critically he would have used against it one of his favorite Paris epithets for hollow rhetoric in art: *pompier* [conventional]. Nor are the various portraits he did of Lenin any more alive. Paradoxically, the benevolent, smiling Stalin Diego did in the *Peace Mural* is less endowed with vitality than the jovial face of John Foster Dulles in the Guatemala poster, whom he meant to lampoon. But the malevolent Stalin of the portrait which the painter called "the executioner of the Revolution" is completely alive, for in it the artist's intensest feelings were enlisted.

On the ground floor of the Secretariat of Education Diego painted the labors and the festivals of his people. Despite a few lines of propaganda verse from Gutierrez Cruz and an occasional symbolic gesture, labor is not an object of exploitation or a subject of class struggle, but a rhythmic dance. There is great beauty in the *Trapiche* (Sugar Mill) with the graceful rhythm of bodies bending in the foreground to pour the juice of the cane, the veritable dance movement of the men in the center stirring the molasses with great poles, and the contrasting severe geometric perspective of ground and beams and pillars. What commands the eye in the *Entrance to the Mine* is the curve of vaulted arches and the curve of bent backs carrying straight beams. In *Waiting for the Harvest,* Indian women are grouped in tenderly treated little pyramids, as is an Indian man completey wraped in his *sarape* and tilted sombrero, the human forms echoed by the conical mountain peaks in the background against the Mexican sky. If, as Lenin wrote, "Class hatred is the prime mover of revolution," then clearly the man who painted these scenes informed with love of the common folk and love of the spectacle of their labor and the landscape in which it takes place is no Leninist.

Indeed, as we go through the vast body of painting by Rivera, it is hard to think of any passages of real anger and hatred. One finds neither the bombastic rhetoric so frequent in Siqueiros's social painting, nor the prophetic denunciation which at times moves Orozco. When Rivera strove hardest for such effects, what he achieved was sardonic laughter or mocking caricature. Only rarely, when he lost his remarkable control of his medium or tried to shout too loud, was he likely to degenerate into melodrama, as in the excessive number of what are intended to be piteous red wounds in the children strewn around the foreground of his Guatemala poster. Or the ludicrous, over-literary imprecation in his "scientific" portrait of the knock-kneed, chicken-breasted Cortés in his later painting. Rivera was not born to be a Savonarola in paint as Orozco was, nor a strident soap-box orator like Siqueiros.

On the stairway of the National Palace Diego painted a striking history of his country, and a pageant of *Mexico Yesterday, Today, and Tomorrow.* Tomorrow, it must be said, fares badly. It is presided over by an oversized, pompous, stiff-bearded Karl Marx, holding a scroll with some of his apothegms in one hand while with the other he points out to a bemused and far from bright-looking trio of Mexicans, a worker, peasant, and soldier, the Mexico of the future. The landscape he points to lacks the beauty possessed by so many of the landscapes in the upper reaches of Diego's frescoes; it is cluttered with a dam, a mine shaft, some smokestacks, a grove of fruit trees, and an observatory. It is more intellectual cliché than hope or dream. But when Diego got to Detroit, in the America not of tomorrow but of today, he fell in love with the beauty of the machines he saw, finding in them a design to delight the eye, even, as in his *Turbines,* something of the voluptuous beauty generally associated with other painter's nudes.

In contrast to the drab Mexico of Tomorrow, the Mexico of Yesterday on the left wall of the Palace stairway, the Mexico of authochthonous Indian civilization before the Spaniard came, is lyrical in organization and in the treatment of its nameless figures, in the poetry of the arts and crafts of that vanished Golden Age, the graceful flowery wars, the idyllic landscape overhung by a personified and animated sun, presided over by three legendary incarnations of Quetzalcoatl. He rises out of a volcano as the feathered serpent in tongues of flame; he rides the sky in a serpentine boat; he presides, as Marx fails to on the opposite wall, over a group that forms a graceful circle around him, while with majesty, benevolence, and wisdom, he expounds the arts and crafts and imparts learning to men.

The landscape of the *Future,* does not loom large enough in Rivera's scheme to fill the right wall, the lower part being occupied by a spill-over from the *Mexico of Today,* a caricature of millionaires worshipfully watching a ticker tape, which feeds some of its profits to a trio of the Mexican military man, the politician, and the priest. But the Golden Age of Mexico's past cannot be completely contained on its single left wall. It spills over onto the lower part of the central wall to provide a magnificent spectacle of knights in armor battling Aztec warriors dressed in the barbaric-poetic dress of knights of the eagle and the tiger, opposing to the cold steel of the Spaniards wooden lances and swords tipped with obsidian.

This Golden Age may never have existed, or may have been rude and barbarous and cruel, but no matter. Its tem-

ples and codices, its sculpture and remnants of poetry and artifacts, testify to the fact that it was a profoundly esthetic culture, more cruel and passionate and mythopoetic than logical and rational. It stirred the artist in Diego. He believed in it, idealized it, was moved by its real and imagined splendors. Wherever he has painted it, in Cuernavaca, on the stairway and later on a wall of the corridor of the National Palace, in the Hospital of the Race, his painting moves the beholder. Rivera's true Prometheus is not Marx but Quetzalcoatl. His golden age is not in the mine shafts, smokestacks, and observatory of the *Future* (in the real future the smokestacks will disappear), but in the morning splendors of the Golden Age that has vanished, insofar as it ever was, this painter of his country's epic has found his utopia.

From infancy, Diego drew and painted, early becoming one of those virtuosos of pencil and brush who could do what his eye and hand and mind and heart wanted to do. His draughtsmanship was superb; his artistic sensibility great; his capacity for work, almost until the very end, that of a tireless giant. Indeed, he was a monster of nature, a prodigy of fecundity, rapidity, and prodigality of creation. Such sheer fecundity occurs but rarely in the history of man. He is for painting and drawing what a Lope de Vega is for literature. Such men, by the ease and volume of their work, and by the excellence of so much of it, enlarge one's faith in the capacity of man.

If Diego had not been thus fruitful and overflowing, he would not be the painter we know, but another. His work might have gained in rigor and self-discipline; he might to the end of his days have set himself fresh plastic problems; but his work would have lost in opulence, in abounding vigor, in the insatiable appetite to embrace, to create, a world—on paper, on canvas, on walls.

If he was at times too complaisant with himself, if it was too fatally easy for him to paint well, and to repeat himself, yet he turned out more really good works in a year than many another painter, who has limited himself to a handful of paintings, in a lifetime. With unflagging energy and never idle pencil and brush he covered miles of canvas and paper and wall.

Though much of his work is less than his best, there is little indeed which is lacking in skill. There are literally hundreds of paintings and drawings, along with a half-dozen or so of his great walls, which will take their place among the notable fruits of artistic creation.

When time has finished the task of selection which that amazing "biological urge" to create did not permit him to attempt, the "complete works" will reveal him as one of the most fecund of men of plastic talent, while his "selected works," I am convinced, will show him to have been at his best one of the most fruitful and sizable of geniuses.

He has had large aims and achieved them on a large scale. His total work from his thirty-sixth year on is undoubtedly the most ample, complete, and wide-ranging plastic portrait of Mexico. Indeed, I doubt if any other land has had so much of its life set down on wall and canvas by another painter.

Not alone, but surely in the forefront with a handful of others, Diego's work broke ground for the Mexican renaissance in painting and the contemporary revival of the art of fresco on the walls of public buildings. He took the issues and the aspirations of art from the studio to the street, made them a subject of newspaper headlines, parlor conversation, music-hall satire. Issues of esthetics became public issues.

What lives on his walls and in his sketches and paintings is the Mexico of his dream as seen by the gifted eyes of a painter of sharper vision than the normal. His eye and hand taught outsiders and Mexicans alike to see a Mexico which until then had escaped their vision. Who can any longer lift his eyes to the mountains, behold the villages and the folk, without seeing everywhere "Riveras"? As long as his walls and paintings will endure, men will go back to them to delight the eye, to learn how this world was and how this painter saw it. The propaganda in his painting is already stale, as is the propaganda in Bertolt Brecht's *A Man Is a Man,* but Brecht's work will continue to be living theater as Rivera's will continue to be alive plastically, living a life that is rich and abundant. Then as now, no one could look at his work without having his vision sharpened, his sensibility intensified, his joy in the forms of the visible world increased, and his understanding of those forms deepened.

Neither the "decent folk," nor the "masses" whom he hoped to "nourish" esthetically, liked his frescoes. At first only artists, critics, a handful of Mexican intellectuals, and Communists hailed his work, the latter generally for reasons which had nothing to do with art.

"As a social person," Samuel Ramos once wrote, "Diego is democratic, but as an artist he possesses a distinction and a refined taste which separate him from the multitude." Yet even if their taste has not been "formed and nourished" as he had hoped, by the refinements in his art, the multitudes have become more aware of their world as seen through his eyes than before. The Mexican nation has come to regard him with pride, as they do the "ugly" plumed serpents and Aztec gods. At the very least, he has become a "national monument" like the pyramids and temples. But thereby, half unconsciously, the Mexican people has become more aware of itself and its heritage, and the rest of the continent more aware of Mexico.

Diego's composition began with dogmatic theories about geometrical structure, the "golden section" and "dynamic symmetry." As he painted tirelessly, thinking with his hand and the sophistication acquired by his search of the secrets of all the great works of Europe, of ancient Mexico, and of the cosmopolitan world of modern plastic sensibility, his construction of a painting became increasingly instinctive, freer, easier, with more play of delight in the wonders he saw everywhere. The geometric design remained a scaffolding, but flowing curves, echoing, repeating, and modifying themselves, gave his works more graceful and more abundant life. The baroque sensibility which is part of Mexico's precious heritage prevailed over severer theories of composition, baroque curve and opulent detail straining at the painting's structure, yet, as a rule, firmly contained by it.

It has been a fashion to deplore the folkloric, the decorative, the lovely, and the opulent in recent Mexican painting. Beauty is a word for the moment out of fashion. "I say we have had enough of pretty pictures of grinning peons in traditional Tehuana dress," Siqueiros rudely told the press in his last attack on Rivera less than two years before Diego's death. "I say, to hell with ox carts—let's see more tractors and bulldozers. Mexican art is suffering from primitivism and archaeologism" [*New York Times*, 11 December 1955].

But the weakest passages in Rivera's painting are precisely his tractors and bulldozers, or their equivalent. Nor have tractors and bulldozers yielded any plastic beauty in the work of Siqueiros, not to speak of Orozco or Tamayo. The unfinished painting on the walls of the Chapultepec Palace, which, even unfinished as it is, seems to me the best of Siqueiros, is concerned not with tractors and bulldozers but with the epic of the Mexican agrarian revolution and masses of primitive peons on the march.

As for Rivera, the tenderest and most lyrical sections of his work are precisely those inspired by the love of his people, by the beauty of the Mexican landscape and the life of the Mexican folk, a life which, for all its misery and poverty, is the expression of a civilization more passionate and esthetic than rational in its quality. In his weavers and fishermen, in invaders climbing the branches of trees to cross a canyon, is neither the cruelty and brutality of war nor of exploitation, but the harmonious arabesque of a plastic dance. In the awkward grace of his Mexican children and the simple, elegant, abstracted curve of the back of one of his burden-bearers, it is not poverty we see but the tenderness of the vision of a painter who loved his country and his people.

The world he finally idealized, as we have noted, was not the grim world of Communism, but the poetic world of pre-Columbian civilization as seen by his fantasy. The colors of that world are brighter, the forms more solid, the air flooded with a brighter light. Here is joy and beauty in labor, preternatural skill in primitive surgery and science, plastic splendor in the ceremonies of human sacrifice. The terrifyingly beautiful and monstrous gods and temples are free from the feeling of terror and somehow full of splendor. What can bulldozer and tractor offer to compete with this vision? Or with the beauty which Rivera sees in the disinherited, impoverished descendants of this splendid people, the simple Indians and Indian children of modern Mexico whom Rivera portrays with such tenderness and affection, and in whose name he claims their lost inheritance?

The last words in these notes should be given to Frida Kahlo, who knew Diego Rivera best, and knowing his weaknesses and experiencing his cruelties, yet gave him unstinting love as a person, and admiration as the great artist she saw in him.

> No words can describe the immense tenderness of Diego for the things which had beauty. . . . He especially loves the Indians . . . for their elegance, their beauty, and because they are the living flower of the cultural tradition of America. He loves children, all animals, especially the Mexican hairless dogs, and birds, plants and stones. His diversion is his work; he hates social gatherings and finds wonder in truly popular fiestas. . . . His capacity for energy breaks clocks and calendars. . . . In the midst of the torment which for him are watch and calendar, he tries to do and have done what he considers just in life: to work and create. . . .

Let these words be the painter's epitaph. (pp. 415-32)

> *Bertram D. Wolfe, in his* The Fabulous Life of Diego Rivera, *1963. Reprint by Scarborough House, Publishers, 1990, 457 p.*

SURVEY OF CRITICISM

Edmund Wilson (essay date 1933)

[*Wilson, considered America's foremost man of letters in the twentieth century, wrote widely on cultural, historical, and literary matters. Although he was not a moralist, his criticism displays a deep concern with moral values. In the following excerpt, Wilson interprets the meaning and impact of the frescoes in the Detroit Institute of Art.*]

In February, 1932, the Communist literary magazine, the *New Masses,* published a scathing exposé of the career of Diego Rivera, the Mexican artist, then visiting this country. Here it was shown that, though once a member of the Central Committee of the Communist party of Mexico and head of the Workers' and Peasants' Bloc, Rivera had betrayed his cause by assuming under a bourgeois government the post of Minister of Fine Arts; that his point of view, as expressed in his art, had then unmistakably changed from Communist to bourgeois-chauvinistic—as evidenced by his substitution, in the arms of a gigantic Mexico in one of his murals, of specimens of the national fruit for the figures of a worker and a peasant which had originally been contemplated; and that he had finally been expelled from the party for political opportunism and for accepting without party permission a government appointment to the directorship of the National School of Fine Arts. When he appeared before the New York John Reed Club, he was howled out with hideous jeers. The paper of the expelled Communist faction led by Jay Lovestone was afterwards able to show, by publishing a photograph of the mural in Mexico City, that, instead of a woman with mangoes and grapes, it had for its summit and climax a worker pointing the way to a Communist future. (pp. 230-31)

The same year, Edsel Ford gave money to the Institute of Arts in Detroit for a set of mural paintings depicting Detroit industries; and the director engaged Rivera, who addressed himself to covering the walls of the "Italianate garden" of the Institute with gigantic Communist cartoons. Ford workers as pinched and pallid worms are seen enmeshed in the metallic entrails of conveyors; between

ranks of pale sexless virgins excising the glands of animals, a bone-spectacled drug-manufacturer studies the pharmacopœia, with one hand on a system of push-buttons and the other on an adding-machine which surmounts a church-windowed radio. Creatures like infernal pigs with jointed mosquito proboscides brew poison-gas and manufacture projectiles; a Holy Family consisting of a medical Joseph, a white-halo-capped nurse-Virgin and

Rivera on revolutionary art:

Only the work of art itself can raise the standard of taste. Art has always been employed by the different social classes who hold the balance of power as one instrument of domination—hence, as a political instrument. One can analyze epoch after epoch—from the stone age to our own day—and see that there is no form of art which does not also play an essential political role. For that reason, whenever a people have revolted in search of their fundamental rights, they have always produced revolutionary artists: Giotto and his pupils, Gruenewald, Bosch, Breughel the elder, Michelangelo, Rembrandt, Tintoretto, Callot, Chardin, Goya, Courbet, Daumier, the Mexican engraver Posadas, and numerous other masters. What is it then that we really need? An art extremely pure, precise, profoundly human, and clarified as to its purpose.

An art with revolution as its subject: because the principal interest in the worker's life has to be touched first. It is necessary that he find aesthetic satisfaction and the highest pleasure appareled in the essential interest of his life.

I have therefore arrived at the clearest and firmest conviction that it is necessary to create that kind of art. Is it necessary therefore to discard all our ultra-modern technical means, necessary to deny the classic tradition of our métier? Not at all. It would have been as foolish to believe that in order to construct a grain elevator, a bridge, or to install a communal co-operative, one should not use the materials and methods of construction achieved by the industrial technique of the bourgeoisie. It is on the contrary the duty of the revolutionary artist to employ his ultra-modern technique and to allow his classic education (if he had one) to affect him subconsciously. And there is absolutely no reason to be frightened because the subject is so essential. On the contrary, precisely because the subject is admitted as a prime necessity, the artist is absolutely free to create a thoroughly plastic form of art. The subject is to the painter what the rails are to a locomotive. He cannot do without it. In fact, when he refuses to seek or accept a subject, his own plastic methods and his own aesthetic theories become his subject instead. And even if he escapes them, he himself becomes the subject of his work. He becomes nothing but an illustrator of his own state of mind, and in trying to liberate himself he falls into the worst form of slavery. That is the cause of all the boredom which emanates from so many of the large expositions of modern art, a fact testified to again and again by the most different temperaments. That is the deception practiced under the name of "Pure Art," two new resounding words which attest to nothing more in the work of talented men.

From Artists on Art, *edited by Robert Goldwater and Marco Treves, 1945.*

a dough-faced Infant Jesus whom Joseph is vaccinating, rise above the manger animals, the horse, the cow and the sheep, which have piously supplied the serum, while, above, a dead-eyed biologist is vivisecting a dog. From a higher level the room is dominated by four reclining female Titans, black, red, white and yellow, who represent the four chief raw materials: coal, iron-ore, limestone and sand; in the background, the hands of hidden masses—grasping fingers and menacing fists—reach up, huger still, from behind a wall. Edsel Ford, with popping eyes, looks on scared.

When the frescoes were nearing completion, the conviction began to sting the Detroiters that something was being put over on them. The clergymen became indignant over the clinical Holy Family and they mistrusted the ecclesiastical radio. The *Detroit News* denounced the motor panel as "a slander to Detroit workingmen" and suggested wiping the whole thing out. A united front of 12,000 workers notified the mayor of Detroit that if an attempt was made to destroy it, they would defend it. When young Ford had to go with his Arts Commission budget before the Detroit City Council, one of its members characterized the murals as a "travesty on the spirit of Detroit . . . and Mr. Ford's factories. . . . There is not a man there with a pleasant look or a smile. . . . The anatomical exhibition," he added, "can't be sent through the mails." Edsel Ford did not try to reply; but, when interviewed afterwards by the newspapers, he came to Rivera's defense. "I admire Mr. Rivera's spirit," he said. "I really believe he was trying to express his idea of the spirit of Detroit."

So both from above and from below the disintegrating rays of Marxist thought prick the numb and flabby tissue of Detroit. Rivera, rejected by the Communist party, remains one of the most powerful prophets of Communism; he moves across America like a dark amorphous cloud from which an accurate hand emerges and brushes terror-striking pictures onto the walls of public buildings. Rivera leaves his message for the imagination; from the ground, other hands deal body-blows. (p. 231)

Edmund Wilson, "Detroit Paradoxes," in The New Republic, *Vol. LXXV, No. 971, July 12, 1933, pp. 230-33.*

Walter Pach (essay date 1933)

[*Pach was an American painter and critic best known for his work* The Art Museum in America *(1948). In the following excerpt, he laments the censorship and potential destruction of Rivera's mural in Rockefeller Center.*]

An old fight is on again; this time it has broken out in Radio City, New York. To read the newspapers one might think it was between Rockefeller and Lenin, but it goes much deeper than that. It is between art and the counterfeit of art. The conflict between the two affects the lives of all of us more than do the economic or political systems attached to the names of the great capitalist and the great Communist.

The present discussion turns upon a fresco by Diego Rivera in Rockefeller Center. When the Mexican painter began

to accept commissions from rich Americans protests went up from the Communists, which confirms me in doubts as to their intelligence. The artist had already expressed in his distinguished paintings, as no other in recent times has done, the life and aspirations of the workers, manual and intellectual; but on a suspicion that he had "sold out" to capitalistic patrons the Communists repudiated him. Now that they are confronted by a thing so blatantly within their philosophy as a picture of Lenin on the walls of a capitalist's building, they begin to see Rivera as more useful to their cause—less purely "aesthetic" than they thought. What neither the critics of the fresco nor its Communistic defenders realize is that the significance of this vast work does not hinge on a particular detail. It resides in the artist's whole attitude toward life, life's purposes, and the means of fulfilling them.

And from this standpoint it may well turn out that Rockefeller and Lenin stand much closer together than people think. Both believe in eliminating waste through the concentration of effort. Both look toward a future in which mankind will benefit by unity of purpose instead of suffering the discord and confusion inevitable in the long past when races, countries, and even neighboring cities stood apart in mutual hostility, and spent incalculable time and strength on activities that were futile if not actually destructive. Rockefeller and Lenin are culminations, perhaps even definitive ones, of man's collective purpose to base his life on more reasonable conditions. Which system is to be in control of these conditions? I am sure I do not know. With diversity of opinion on every hand, I think it extremely probable that we have still got to go through a lot of experimenting, that we must arrive at modifications of both schemes before even the wisest of us can discern the controls for the unimaginable machine of the future world.

But while professing ignorance about the system to evolve for the America of the future and for the rest of the world, I do not see how the fiercest opponent of Lenin can deny that his ideas have their place in a great mural painting when the artist undertakes to depict **Man, at the Crossroads, Looks toward his Future.**

Rivera, the Mexican who has done so much in renewing the ancient art of fresco, was charged with this impressive work. He made of it a splendid and dynamic exposition of the forces, scientific, mechanistic, and social, at work in American life to-day. It could not to his mind fail to include a statement about Communism. The need grew more specific as his picture developed, and instead of the abstract figure of a leader which he had sketched at an earlier stage of his planning he introduced a portrait of Lenin. It is unmistakable and important, but remains a small detail in the vast scheme, by no means a dominant one. Mr. Nelson A. Rockefeller wrote, asking the substitution of some other feature, one which should not offend the feelings of the people (they would unquestionably be a great number) who would resent the portrait of the Russian in the great building. It is on American soil, not that of Mexico or of Russia, and everyone will agree that it is *our* ideas that should be told of there. But at once the question

arises—who knows those ideas in their fullness and their depth? (pp. 476-77)

We base the right of American art on its unbroken tradition of success covering thousands of years. The coming of the white man marked a great chapter in that history, but it is only a chapter. Long ago the soil of this continent brought forth architecture, sculpture, and painting that must be rated with the most important art produced in the Old World. And that art of the Mayas and the Aztecs stretches in space across the whole of America, with magnificent examples of it in the United States. It continues in time, also, as our present-day Indians of the Southwest go on with painting, ceramics, weaving, no whit inferior to those of their ancestors.

But the main line of continuance between pre-Columbian America and that of our time is found in Mexico. It was Aztec workmen who built the splendid colonial churches in the land to the south of us, and their art is clearly seen also in the decorations. While Spain was naturally the country to which the earlier Mexicans turned for instruction as a rule, certain frescoes indicate beyond dispute that the walls of Italy were also consulted; and the fact may be partially explained by the use of a similar process of painting in the buildings of the time before Cortez. In a thousand ways the present art of the Mexican republic carries on the ancient traditions, and notable instances are the great murals executed by Rivera, Orozco, and others in public buildings of the capital, at Cuernavaca, Orizaba, and elsewhere.

These murals have been admired by thousands of visitors from our side of the Rio Grande, and now that our architecture has reached a point where we can think of other problems than those of pure construction, it was natural that we should address ourselves to a Mexican for a fresco. He is a master of the medium, and he is American in the broader sense of the word that denotes all the people and lands west of the Atlantic. Such was the genesis of the decorations painted by Rivera in San Francisco, the admirable ones he did in Detroit, and the fresco at Rockefeller Center.

Work on this last is halted, at present writing. No one knows what its fate will be. The request from the authorities of the building for the suppression of the Lenin head was met by a refusal on the part of the artist; he was handed a check for the sum agreed on for the whole work and dismissed. A committee of American artists, writers, and scientists (the last named as representatives of a field which has benefited from the funds created for research by the Rockefellers) has protested against the action at Radio City, and discussions are engaged in as to what can be done.

The committee is in the position of sympathizing with both sides. Appreciating the public-spirited work of the Rockefellers at the Metropolitan Museum, the Modern Museum, and many other places, they realize the difficulties of the present undertaking and are eager for its success. But they also sympathize with the artist, whose rights they believe to have been transgressed. No man of interest in any field works solely for his hire, and in art es-

pecially the chief reward is always the satisfaction of work well done. This is denied to Rivera by the interruption of his painting, and if it be argued that he forfeited his right to complete the fresco by introducing into it features not clearly agreed on by his employers, then a judgment of that claim must be sought. No conception of such vast scope as Rivera's can be anticipated in its every detail; it grows as it develops—more even than does the group of buildings called Radio City. Had the contract been for a given number of square yards of housepainting, it would have fallen into one category of transactions—with a corresponding rate of payment. But a work of art was asked for, at a price based on creative ability and not merely physical effort, and that demands another point of view.

Rivera's fresco has to be considered as a whole, as a book has to be judged as a whole. To take certain passages out of the Bible, Shakespeare, or other classics is to convict them of obscenity. To publish a single detail of the present work, the portrait of Lenin, was to give the idea that the painter is no more than a propagandist for Communism. Accordingly the first result of the newspaper notoriety, as stated by the General Motors Corporation, was the cancelling of its order for a decoration at the Century of Progress Exposition in Chicago.

But Rivera's work has an interest far transcending its possible role as propaganda (the Communists, by the way, object to his advertising of capitalistic enterprises in his frescoes). Its prime interest is as art, and that justifies an intervention not only by other workers along intellectual lines, not only by educators concerned about their own freedom of expression, but by representatives of the public as a whole; for it is the ultimate beneficiary from the development of American art and thought. Therefore, the fate of this fresco is a matter affecting the ideas and so, to some extent, the future of every one of us. Two courses alone seem possible: either to have the artist complete the work or else to destroy it. (pp. 478-80)

I am confident that Rockefeller Center can survive such incitements to Communism and other dangers as are contained in Rivera's fresco if that work is shown to the public. Or, to stick to practical matters like real estate, I believe that the prestige the buildings will gain through the possession of a great work of art will more than compensate for the loss of prospective tenants who could not bear to be under the roof with a portrait of Lenin.

I am less confident about the effect on American art and American thinking if this fresco is suppressed. Miss Suzanne La Follette, in the editorial pages of the *New Republic,* called attention to a serious consequence which seems practically certain to result if the decision goes against Rivera's work. American mural painting until now, as Miss La Follette says, and has reason to know from the studies which led to her admirable book on our art, has been chiefly bathos—the insipidities of a time that had not yet come to understand the importance of a serious statement on walls that are to be viewed by all men. The easel picture, destined for a more intimate circle, may permit free and personal handling, lightness and spontaneity of touch. But the enduring and grave material of fresco, and the fact

that it is addressing itself to masses of people, have given it a tradition of strong and weighty ideas.

If we now set the example of effacing or even concealing work because we do not quite agree (or even because we quite disagree) with what the artist has to say, we throw American painters back to the mumbled triteness that offends nobody and inspires nobody. As Miss La Follette continues, that is not what the Rockefellers have led us to think of as their ideal for American art, anymore—one might add—than we had thought of them as people willing to rest content with their legal right to obliterate the great fresco. There is no law against destroying works of art, not even the works of the masters, when you legally own them, nor—what may be more important than Old Masters—the work of the men who count today.

The essential question before us is not one of law any more than of politics. It is one of art or the counterfeit of art, as I said at the outset. A group of men in Rivera's profession has attacked his work, another such group has defended it. Art must be defined in terms of thought quite as much as in terms of line and color. The idea indeed has always been seen as the thing which determines the nature of the form. When Rivera was asked to alter his work he replied that rather than sacrifice its integrity he preferred to see it destroyed. That is the spirit in which we must hope to see American artists work.

The counterfeit of art is production lacking in that sense of the integrity of the work which makes a Rivera reject compromise with his idea, whatever the cost of his refusal. The weak emptiness of Ezra Winter's mural in Radio City tells of its failure to find a valid relation with life and with art. The pompous platitudes of Sert, in the same great group of buildings, have been published and can be judged; assuring us that all is for the best in the best of worlds, they continue the unworthy tradition running from Kenyon Cox and the men before him to the latest producers of commercial art. Whether they do courthouse stuff (figures of Justice, Wisdom, etc.), he-man stuff (Far North trappers and Far East pirate-fighters), or whether their specialty is that maid-of-all-work, the bathing girl, with her invitation to buy deodorants, candy, or what not, they inculcate an ideal of life as false as it is cheap, like the "happy ending" of the froth people consume at most of the movies.

There is no cheap art as there is no cheap truth. And the artist tells the truth. He is willing to pay a price to tell it, and I believe we are willing to pay a price to know it. It may be thought arrogant for me to assume that I know where truth lies in the present case. But I do not try to be the arbiter. I give certain reasons why I think Rivera should be asked to finish his work and the public to see it. If his art is not true the fact will transpire, and so we need not fear to look at the picture. What we should fear is the mentality described by Milton in the ever-young pages of the *Areopagitica:* that of the "gallant man" who thought to make the crows stay within the park by shutting its gates. (pp. 482-83)

Walter Pach, "Rockefeller, Rivera, and Art," in Harper's Monthly Magazine, Vol. 167, September, 1933, pp. 476-83.

Alfred Werner (essay date 1960)

[*Werner was an Austrian-born American critic, poet, and biographer. In the following excerpt, he argues that Rivera's conception of the social function of public art was unrealistic; however, he also emphasizes Rivera's powers as an artist.*]

"Wer den Dichter will verstehen, Muss in Dichters Lande gehen," wrote Goethe, to advise those who wished to understand a poet to become acquainted with the poet's native land. If this is sound advice, it is even more applicable to the realm of art. For the artist is, by necessity, an *"Augenmensch"* (this, too, from Goethe), a creative human being depending more than anyone else on sensations received by the eye. Not before setting foot in Mexico last summer did I feel that I had arrived at a real understanding of Diego Rivera's work, not before experiencing the country's semi-tropical colors, seeing the palm, cactus, and agave that so often surround his figures, and, of course, not before watching the natives at work and play. To appreciate the sources of Rivera's art, one must not only have seen the plump Indian women stoically flattening the maize dough for the tortillas, the silent farmers toiling in the fields, the fiestas in the small towns and villages, but also the treasures of pre-Columbian art nowhere as abundant and magnificently displayed as in Mexico City's Museo Nacional de Antropológia. (p. 88)

Most articles devoted to Rivera stress his indebtedness to [Pablo Picasso], and Rivera has, indeed, been quoted as saying that, while he never believed in God, he did believe in Picasso. The similarities between these two men, in background and character, are striking enough: both came from intellectual middle-class families, achieved wealth through their art, yet became enthusiastic sponsors of Communism. Both made headlines a hundred times more frequently than such equally important, but much less eccentric and extroverted, contemporaries as Braque or—in Mexico—Orozco. Both have challenged the old established values in art: Picasso by introducing Cubism, Rivera by his large compositions simplified in form and color that have ushered in a truly Mexican art and supplanted the sentimental imitation of French academic art and Zuloaga and Sorolla.

But there is a marked difference in their attitudes regarding the function of art. Picasso, who was sixty-three when he officially joined the Communist Party, never cared whether or not his work might be understood by the masses, and in his famous interview with Christian Zervos even poked fun at people overly eager to "understand" art. Rivera, however, along with Siqueiros and, to a lesser degree, perhaps, Orozco, deliberately went out to "socialize artistic expression." He, who was a Communist—though not always a follower of Moscow's party-line—for the last half of his life, insisted upon the role of art as a social instrument.

He once explained why he loved such abstract painters as Kandinsky and Klee, yet himself produced nothing that, in his opinion, might be beyond the ken of the average man. Connoisseurs, he explained, love *canard faisandé*—duck that has been hung until it has become "high"—but the ordinary French worker would throw it out. Just as

the cuisine of the sophisticated bourgeois makes the proletarian queasy, so will he react violently against bourgeois painting. He, Rivera, was fortunate enough to have an "educated nose," but he, himself part Indian, could never forget or ignore the simpler tastes of the millions, never paint anything that was not clear, firm, and plainly to be understood by everyone.

Both Picasso and Rivera arrived in Paris in a period when the arts were in ferment and the idols of Renaissance tradition broken or discarded forever. But Picasso was never to leave France, except for brief journeys, and developed an art that is as tortuous to the uninitiated ones as *canard faisandé* is unappetizing to the non-gourmet. By contrast, Rivera returned to a Mexico whose population consisted mainly of poor, uneducated péons, and which had produced no genuine, indigenous art since the fall of Montezuma. Picasso no longer had any use for Spain; Rivera, on the other hand, needed Mexico as much as Mexico needed him. He might not have discovered and developed his vigor of originality had he not come back to his native land. One is reminded of the story of Antaeus, the giant of Greek mythology who proved invincible as a wrestler, for, whenever his strength began to wane, he derived fresh strength from renewed contacts with his mother earth. Hercules, however, discovered the source of his strength and, lifting him away from the earth, was able to crush him to death.

Artistically, Rivera might have been "crushed to death" by his friend Picasso, for Rivera's early cubist paintings are utterly derivative; the still lifes, musicians, and card players painted by Picasso around 1914 were imitated by this "Mexican cowboy" (as the Parisians called him) with little conviction, and less success. Thus, it was his good fortune to have known the source of his own strength and to have returned to Mexico in 1921. His biographer, Bertram Wolfe, relates [in *Diego Rivera: His Life and Times;* see Further Reading, section III] that Rivera had become homesick "as an artist even more than as man," and adds:

> The merest hints of Mexico, a softness in the air, or a solitary plant, was sufficient to set his nostalgic mood to work. . . . For thirteen years now he had struggled to be a European and had not succeeded. . . . On his innumerable works . . . there were legible the traces of a desperate conflict: the struggle between disoriented imitativeness striving to learn and acquiring great skill and virtuosity in the process, and a personality seeking to express itself in terms of its own heritage and views, which were other than the heritage and view of his masters.

In the Mexico of the Twenties, Rivera became a Communist, not because he had read *Das Kapital* or Lenin's theoretical writings and found himself to be in agreement with them, but because the Communists in this backward, demoralized, and impoverished country appeared to him to be the only ones anxious and able to fulfill the vast promises made by the national revolution of 1910. Even in 1959, any American crossing the Rio Grande quickly notices that he has entered another world, picturesque, no doubt, but also sadly lacking in the material comforts offered even by the less prosperous parts of the United

States. Nearly four decades ago, Rivera, returning from France to a country where illiteracy was high and where a dozen rabble-rousers had filled their pockets and those of their lieutenants at the expense of the unorganized, politically naive masses, must have felt that the machinery of democratic reform that he had seen at work in Western Europe was much too slow for his country. He feared that it might not work at all, and that the only means with which to combat reactionary force was counter-force.

Picasso is more of an Anarchist than a Communist, and, world-famous and independent, he has repeatedly defied the Party in matters of aesthetic principles. Rivera became a Communist as early as 1922 and within a year was elected to the party's Executive Committee, but his comrades were justified in suspecting him of being a Zapatist rather than a true Leninist or Stalinist. (Emiliano Zapata was the primitive leader whose major aim was an agrarian revolution that would oust estate owners, land sharks, venal judges, and other oppressors of landless peasants.)

It is difficult to say whether his politics influenced his art or whether his aesthetic principles made it easier for him to join a party claiming to be of and for the masses. One ought to remember that in the nineteenth century the artist became the isolated and economically insecure figure that he has remained to this day. To combat this state of affairs, artists wanted to become a "mass," they banded together in a variety of groups. Camille Pissarro even wanted the Impressionists to be a co-operative modeled on a professional bakers' association whose set-up he had studied. He dreamed of ways of making art accessible to the masses through inexpensive reproductions and was active in a *Club de L'Art Social* which had among its objectives the encouragement of popular art and the establishing of contacts between literary, artistic, and political groups.

These and similar efforts were premature and therefore in vain, or European artists were too unruly to join anything resembling a trade union (*vide* Modigliani, or Picasso!). But Diego Rivera and his colleagues, in the Twenties, succeeded in organizing the "Revolutionary Union of Technical Workers, Painters, Sculptors, and Allied Trades." Believing in "Mexicanidad," they were determined to create an art that would be national (based on the traditions of pre-Columbian architecture and sculpture) and social (clear, simple, direct, so that everyone would understand it)—an art that would take its motifs from historic events close to the hearts of the common people.

These aims were, perhaps, admirable—but they were too self-conscious, too rigid, to permit the free flow of creative imagination. Rivera, well versed in the history of art, ought to have realized that strict programs and regulations are a hindrance rather than a help in the realm of art and that creativity thrives on freedom. The art of Byzantium was limited by the dictatorial regime the Eastern Church exerted upon all its members, including craftsmen and architects. Art developed in the Renaissance period to the height we admire in Da Vinci, Michelangelo, and Raphael mainly because the Patron Church permitted its artists liberties that no medieval pope or bishop would have allowed. Art suffered in the seventeenth century

when the French Academy demanded that its practitioners should treat only important and noble subjects, preferably from classical antiquity, and there was again a decline when Jacques Louis David, as the art dictator of the French Revolution, ushered in an era of grandiosity, with many a frigid, pretentious, and declamatory composition.

Rivera was far too clever a man to think that his fellow-Mexicans, especially those who were not even able to read or write, were the most reliable arbiters of good taste, himself having observed that "the workman, ever burdened with his daily labor, could cultivate his taste only in contact with the worst and vilest portions of bourgeois art which reached him in cheap chromos and the illustrated papers." But he was sufficiently optimistic to believe that he and his friends might be able to uplift the "man in the street" by giving him the proper food for his eyes: wholesome, yet also well cooked, of a good quality, while also easy to digest.

The triumvirate of Mexican muralists—Rivera, Orozco, and Siqueiros—concentrated on the importance of public buildings: the ordinary worker, they argued, never enters a museum but often finds his way into government offices—hence, their wall space must be utilized. At the same time, knowing that people who hurriedly walk through such buildings on their everyday errands will not stop for a careful inspection, they planned and executed the picture so that it could be taken in even by a passing glance. Finally, the subject matter was chosen to be of the most immediate interest to the man, woman, or child casually looking at the work.

With all these interesting ideas and ideals, Rivera and his friends soon ran into trouble. They were content to tell anecdotes, they drew their inspiration from Aztec folklore, they spread naked political propaganda, yet, being intrinsically and basically artists, they used artistic means. But did the Indio, looking at the huge superhuman nude figures spread out, tapestry-like, in rhythmic organization, really recognize himself and his fellow-Mexicans? Were not the emotion-fraught colors rather different from those which the peon noticed upon and around himself? Even at the height of their political enthusiasm, these artists were not able to forget completely the maxim that had been formulated by the French painter, Maurice Denis: "Remember that a picture—before being a battle horse, a nude woman, or some anecdote—is essentially a plane surface covered with colors assembled in a certain order."

This, then, was their dilemma: if they remained artists above anything else, they were liable to produce murals emulating (though perhaps not achieving) the grand scale of a Michelangelo, provided they would neglect the limitations of the "patron's" perceptive faculty. On the other hand, if they stooped to lower their artistic standards sufficiently to make themselves understood by everyone, they were squandering their tremendous technical skills on propaganda sheets blown up to huge dimensions.

As for Rivera, too often did he cram too many figures and episodes into a panel with an exaggerated realism that leaves no room for flights of imagination and in flat, shrill color devoid of all sophistication. Where is the joy that we

derive from the subtle chromatic combinations in Klee's paintings? Where is the equilibrium of Mondrian's design? Where the unceasing inner flame that moves Picasso to proceed from one experiment to another?

Had Mr. Rockefeller permitted Rivera's mural to stay (in the New York center that bear's the financier's name) rather than to insist upon its destruction (Rockefeller was annoyed by Lenin's portrait within the picture), Rivera would not have derived the satisfaction of being saluted as a martyr to capitalist oppression. Today, few people would have paid much attention to them, except for tourists to whom certain details might have been pointed out for their worth as sheer curiosities. I was struck by his work's artistic inadequacy after seeing, last summer, a very slightly altered version in Mexico City's Palacio de Bellas Artes. (There Trotzky and Marx are added to Lenin, and a portrait of John D. Rockefeller, Jr. is included in the night-club scene, in an understandable stroke of vengeance.)

But he could do much better—for instance, the frescoes he made for the Detroit Museum of Fine Arts. I believe they are superior because, coming to Detroit, he for the first time came into contact with factories, machine shops, and laboratories of a kind he had never seen in Europe, and certainly not in a country as undeveloped as Mexico. The poet in him was awakened by what he saw, and the naive joy of fresh discovery proved to be stronger, at that point, than the abhorrence of the indubitably ugly aspects existing in the laborers' life and work. All that he had learned about the inevitability of a classless society, to be achieved through the dictatorship of the proletariat, sank into oblivion for the moment while he was fascinated by the city's "marvellous plastic material which years and years of work could not exhaust," by "bridges, dams, factories, locomotives, ships, industrial machinery, scientific instruments, automobiles, and airplanes." Since these were relatively new to him—at least as they presented themselves to him within the framework of the world's most advanced center of engineering, manufacturing, and building—his usual overstating of familiar facts was not possible. With an architect's keen eye for solid construction, he divided the entire available wall space of the inner court into twenty-seven panels to show through them how an abundant life might be created through the fusion of the earth's mighty resources with the superior intelligence of man.

In lieu of the crude naturalism that we find so annoyingly boring in some of Rivera's propaganda pieces, the artist had to resort to symbolism, aided by geometric patterns provided by moving conveyor-belts and other machinery in motion. "As basic plan for the mural decoration," Rivera wrote, "I chose the plastic expression of the wave-like movement which one finds in water currents, electric waves, stratifications of different layers under the surface of the earth, and, in a general way, throughout the continuous development of life."

The Detroit murals were produced in 1932-33. About six years earlier Rivera painted what is considered his best work: the murals in the Escuela Nacional de Agricultura of Chapingo, some miles east of the capital city. In a bar-

rel-vaulted rectangular room that had once served as a chapel, he made man's social development and the fertilization of the earth his double theme. Being Rivera, he could not help introducing here, too, the class struggle, with satirical exposés of capitalist, militarist, and churchman. But these scenes, fortunately, do not dominate. Still lingering in my fond memory of the recent excursion to Chapingo are the pictures of earthy female nudes, symbolizing fructification, fecundity, and germination, and of men and women at work in the fields. In these scenes he is gentle and lyrical, fascinated by the sinuous curves of the female body and by the quiet grandeur of simple people who have the same dignity that Gauguin immortalized in the Tahitians. Luckily for the artist, space limitations ruled out the painting of mass scenes, so that, instead, he had to make do with single figures or small groups and could devote to them his inherent poetry, embodied in the convincing simplicity of sure yet tender drawing, in pure yet restrained color, and in an unlabored play of movement.

Though the man Rivera, the lover and dreamer, reveals himself as nakedly as nowhere else, and though aesthetic considerations gain control over outspoken anti-capitalistic and anti-clerical propaganda, the hall became something like a "Sainte-Chapelle of the Mexican Revolution." Even those Mexicans who are not admirers of Rivera, and even rejoice that this art dictator has gone, concede that the Chapingo frescoes constituted the peak of the painter's work, never matched during the thirty years of activity that were to follow. Foreigners take the trouble to make the one-hour trip to Chapingo just to visit the chapel. One of them, a French critic, has summed up these murals enthusiastically:

> The emotion overflows, an irresistible seduction sweeps criticism off its feet; on that drawing, which overwhelms you, an admirable rainbow of colors, a play of all violets, oranges, tender greens, rose of fire, unfolds its cargo of delights, all the voluptuous gamut of the light of Mexico.

Ironically, the same Mexicans who take the art-loving tourist to Chapingo, or to what is now the *Museo Frida Kahlo* (a two-house establishment, connected by a bridge, the "little house" having been for Frida, the "big house" for her husband), are likely to tell you (unless they are unreconstructed Communists) that Rivera's death removed, not only an important artist, but also a ruthless egotist who considered every available wall space to be destined for his use. They will also tell you, with relief, that Siqueiros, the only survivor of the trio, while vociferous and eager to play the role of dictator, is not powerful enough to turn the clock back. (pp. 91-8)

Nevertheless, quite a few people in Mexico (and, for that matter, in the United States as well) insist that Rivera's attitude to art and to people was right. They argue that, although the masses now enjoy greater liberty than they did in the era of dictator Porfirio Diaz, and though the literacy rate is much higher today than it was when the new Mexican art arose, there are still many millions who are ill-fed, ill-clothed, ill-housed, ill-informed, and who, could they be made to look at pictures, would get something out of

Rivera's frescoes but would be only baffled by abstractions.

But the harsh truth is that these people do *not* bother to look at Rivera's work. For the serape vendor who, after a day's work, is unable to fill his belly or his family's with any but the cheapest, least nourishing, food; for the Indio woman who, after bearing a dozen children, is depleted and aged at thirty; for the ragged boy who supports three younger brothers and a sick mother by shining shoes—Rivera does not exist.

The gigantic mural Rivera did for the lobby of the strikingly modern Hospital de la Raza, *The People's Demand for Better Health,* shows, in numerous brightly hued episodes, the development of medicine in Mexico from the pre-Columbian period to the present day. It is one of his very last works, yet it recaptures the classic flavor and the rhythmic vitality that characterize his earlier, better work, and, unlike other works of his old age, it shows no trace of improvisation or hurry. Unfortunately, not one of the hundreds of passers-by (including serape vendors, Indian mothers, shoe-shine boys) seems to notice this luminous, dynamic fresco—nobody, that is, except for some *gringos* who may have read about it in *Artes de Mexico.*

But the *gringos,* having grown up in a climate of Abstraction and Abstract-Expressionism, are likely to be prejudiced against "Social Realism" even in its most valid manifestations. Time is working against Rivera, even in the sense that chemical changes are ruining his frescoes, some of which have aged more rapidly than Da Vinci's *Last Supper,* due to careless application of pigment on poorly prepared surfaces. I can foresee a time when of these big murals little will be left that was made by the hand, or, at least, under the supervision of, Rivera, for some of these works have been allowed to deteriorate to such a degree in the past twenty to forty years that even if restoration were to begin right now, one-third to four-fifths of the pigmented space would have to be repainted completely.

But even if the generation to come should be deprived of much of Rivera's basic work, the surviving murals would give some idea of the man and his soul—for excellent passages can be found, here and there, even amidst some altogether unsatisfactory work. And future art lovers may also discover what I wish to call the "unknown" Rivera, the maker of numerous small pieces, such as sensitive pencil drawings of women, oil portraits of friends, watercolor sketches of landscapes, works that have been neglected—unfairly we hasten to add—over certain big anecdotal murals that created controversies and made good newspaper copy. These small, unambitious works provide good insight into the man Rivera. They indicate that, despite all the bragging and self-advertising and shouting, he must have been a rather lovable monster, this Gargantua who was able to retain the love of many a woman, the friendship of such gentle individuals as Modigliani, Lipchitz, and Elie Faure, and the respect of critics, including some who, while not sharing his political ideas, could not help admiring the zest and versatility of his genius. (pp. 99-100)

> Alfred Werner, "Diego Rivera and His Mexico," in The Antioch Review, *Vol. XX, No. 1, Spring, 1960, pp. 88-100.*

James B. Lynch (essay date 1972)

[*In the following excerpt, Lynch discusses Rivera's association with the Cubists in Paris between 1909 and 1920.*]

Diego Rivera is best known as a pioneer of the Mexican Renaissance. His name usually summons visions of acres of historical anecdotes brushed indefatigably but conventionally upon walls in Mexico and the United States from the early twenties until his death in 1957. Knowing his paintings of that period only, one might justifiably conclude that Rivera was a conservative, relatively untouched by the experiments of the *avant-garde.*

It is a fact, however little known, that in earlier years Rivera played a modest but not insignificant part in the development of Cubism. (p. 30)

Rivera lived in Paris from 1909 to 1920. He established himself there at a wonderfully propitious moment. As Edward Fry reminds us in his book on Cubism, the decade just before World War I proved to be seminal as well as brilliant. Fundamental new ideas and methods infiltrated the arts and sciences. Those ten years produced Picasso, Braque, Matisse, Gris, Léger, Delaunay, Brancusi, Archipenko, Kandinski, Lipchitz, all of whom—except Kandinski—were in the French capital during much of Rivera's stay. (pp. 33-4)

Through the Chilean painter Ortiz de Zarate, Rivera met Picasso, whom he immediately came to idolize. Thanks to Picasso and Cézanne the Mexican began to drift into the orbit of the *avant-garde.* Soon he was exhibiting at the Salon d'Automne and the Salon des Indépendants. At this time, incidentally, he was living at #7 Rue de Bagneux, Montparnasse. Lipchitz, Brancusi, and Modigliani were neighbors who, in the evening, often met at Rivera's. Picasso came too.

By 1911, the date of his return from a trip home, Rivera had abandoned the quasi-Impressionist manner of [Eduardo] Chicharro in favor of a neo-Impressionist style. Now and then he returned to Cézanne for inspiration. This predilection for Cézanne, which was born long before his arrival in France, must have been further nourished through his friendship with Picasso. As for the influence of neo-Impressionism, it can be traced to his contact at this time with the optical theories of Chevreul, Blanc, and Rood.

Specifically, neo-Impressionism discloses itself in Rivera's *Catalonian Landscape,* a painting of 1911 executed in the Pointillist technique of Seurat. On the other hand, *The Bridge* of 1913 . . . represents homage to Cézanne. Such was his interest in color at this time, by the way, that our artist worked with a palette of seven colors to achieve an effect almost like Aztec feather mosaics.

In this same year of *The Bridge,* 1913, Rivera plunged directly into Cubism. That, as everyone knows, was a movement launched originally by Pablo Picasso and Georges Braque about 1907. Between 1911 and 1914 it spread beyond the circle of the founders, thanks largely to publicists like Apollinaire. From 1914 until perhaps 1925 a great many artists were painting "Cubist" pictures. Thus Rivera entered the ranks of Cubism at the moment when it was

Detail from Clash of Civilizations.

changing from a parochial to an international group. He became committed to Cubism, however, on essentially negative rather than positive grounds. He joined the movement not so much for what it affirmed as for what it rejected. Cubism seemed to him, of all trends, the most violent reaction to academic painting.

From its inception until Rivera became a member in 1913, Cubism had progressed fitfully. During 1911, for example, Picasso and Braque began to fear that Cubism—or Analytical Cubism, as that stage is now designated—was somewhat vague, even metaphysical, in its plastic language. In order to root their compositions more firmly in the world of visual experience they started rendering the textures of things, first by conventional brushwork, then—in the case of Braque—by a housepainter's comb, and finally (as in Picasso's *Chair Caning* of May, 1912) through the introduction of non-traditional substances. Gris, following this quirk, used pages from books and pieces of mirror in his pictures; he also thickened the paint with sand or ashes. Moreover, by 1912 Gris had broken away from monochrome and found his personal solution of the color problem that had burdened Analytical Cubism since its founding.

According to Rivera, "Picasso is my teacher. My working manner is close to Juan Gris." Much evidence, written and pictorial, supports this declaration. [Ilya] Ehrenburg, for instance, recalls that Picasso

> never tried to persuade Rivera about anything but only showed him his work. Picasso did a still life containing a bottle of Spanish aniseed liqueur. Soon I saw a similar bottle in one of Diego's paintings. Rivera did not realize of course that he was imitating Picasso. And when he did realize it, many years later, he began to revile the Rotonde: he was settling accounts with the past.
>
> *[People and Life 1891-1921]*

As for the influence of Juan Gris, it is to be seen by and large in Rivera's arrangement of supplementary views—double and triple exposures as it were—of given objects so as to create a composite imagery of pictorial and psychological variations. These secondary views are often, as in Gris, presented at angles to the primary representation. Also, like Gris, Rivera often added gritty substances to his pigments for textural and tactile effects.

What the Mexican contributed of his own was an ethnic and personal quality rather distinct from the Picasso-

Braque-Gris brand of Cubism. Not completely at home in France, which was a tame, flat country compared to Mexico, the "wild cowboy"—as he was often known—frequently introduced souvenirs of home into his Cubist paintings. *Zapata Landscape,* for example, contains such exotica as serapes, sombrero, rifle, or Mt. Popocatepetl, while the blue waters beneath the mountain recall the old Valley of Mexico before Cortez. The rich, often intense colors in this and other of Rivera's Cubist pictures are reminiscent of Mexican landscapes and textiles.

Maternity, painted in 1916, . . . is endowed with deeply personal emotive data seldom associated with orthodox Cubism; it is Cubism "with a human face." Angelina Beloff is here depicted nursing Diego's son, who was soon to die of malnutrition caused by deprivations endured in wartime Paris. Large unmodulated planes, alternately hot and cool, produce on the surface of this canvas broad undulating waves of energy in contrast to the flickers of movement in comparable pictures by Picasso and Braque. Axial tilting here of course derives from Gris.

It is, then, an intrinsic Romanticism, subjective and exotic, that distinguishes Rivera's Cubism from the garden variety. Moreover, although Picasso and Braque shifted to what is called "synthetic" Cubism in 1914, their Mexican colleague continued to pursue the relative naturalism of the Analytical phase until 1915; from then, until he quit Cubism two years later, the two types—Analytical and Synthetic—often coexisted in his art.

But why did he defect? The motivation behind his apostasy is both complex and ambiguous. First, it is necessary to recall that his conversion to Cubism was less than wholehearted. For Diego as for the *avant-garde,* Cubism was more or less the focal point of rebellion in painting, a means of subverting academic art.

More significant is the fact that socio-political and economic factors, some of them enhanced by the war, tended increasingly in the years 1913-1917 to shape his concepts of art. The following excerpt, attributed to Rivera, from a conversation linking him, Léger, Ehrenburg, and Modigliani is enlightening. Rivera speaks now with Rousseauesque enthusiasm of the messianic role to be played by the cultures of backward and undeveloped areas:

> No one in Paris needs art. Paris is dying. Art is dying. Zapata's peasants never saw a machine in their peasants lives, but they are a hundred times more modern than Poincaré. I am sure that if we were to show them our art, they would understand it. Who built the Gothic cathedrals and the Aztec temples? Everybody. And for everybody. Ilya, you're a pessimist because you're too civilized. Art needs to swallow a mouthful of barbarity. Negro sculpture saved Picasso. Soon you'll all go to the Congo or to Peru. A school of savagery is what is needed.

On hearing news of the Russian Revolution, Rivera proclaimed: "Art must respond to the new order of things." He spoke of an art belonging to the people. The logical place for this, he said, was on the walls of public buildings. Conversations with his compatriot David Alfaro Siquei-

ros, who came to France in 1919, and with the writer Élie Faure, strengthened these views.

One more factor needs to be adduced. About the time that World War I ended, Diego's association with the Section d'Or commenced. Although most members of this organization were practicing Cubists, nevertheless they charged Picasso and Braque with indifference to theory. To this extent the Section d'Or was separatist. Among themselves they shared the conviction that intellectual speculation, aesthetic theories, and social concerns were vital to art. And so again Rivera was drawn away from the formalism of orthodox Cubism toward artistic humanism. In turn this change of direction caused a growing estrangement of Rivera from the ranks of the *avant-garde.*

His break with the progressive forces of European art, however, was neither sudden nor unexpected. Typical of the transitional nature of his work about this time is *The Mathematician* of 1918, with its more conventional naturalism. Two years later, during a sketching trip of some seventeen months, the majesty of Italian wall paintings of the Middle Ages and the Renaissance reaffirmed his conviction that art must serve the people, that it must communicate simple truths through simple aesthetic means.

The years 1909-1920, the Paris years, were for Diego Rivera an era of—forgive us the cliché—identity crisis. According to Ortega y Gasset, the great purpose of life is to become what we are; if so, in the Paris years Rivera became what he was. (pp. 35-6)

> *James B. Lynch, "Rivera in Paris," in* Américas (A bimonthly magazine published by the General Secretariat of the Organization of American States in English & Spanish), *Vol. 24, Nos. 11-12, November-December, 1972, pp. 30-6.*

Max Kozloff (essay date 1973)

[*Kozloff is a highly esteemed art critic and author and the winner of the Pulitzer Prize for his art criticism published in the* Nation *magazine. His book-length studies include, among others,* Photography and Fascination *(1979) and* The Privileged Eye *(1987). In the following excerpt, Kozloff describes in detail the frescoes at the Detroit Institute of Art and recounts the circumstances surrounding their creation.*]

They look as complex and involved as machines themselves. But if the ensemble is hard to remember, the large masses of these paintings are immediately felt. The eye notes a thousand independent shapes entered into a pattern that has yielded to them without interrupting its flow. The more simplified "technological" styles of Western Europe—in Holland, France, Germany, and Russia—are *not* more monumental. Rivera's pictorial economy takes into itself the insatiable need to show how things work and his frescoes, loaded with an almost bewildering amount of information, are more descriptive than any other works with a comparable subject. Instead of a utopian mystique of mechanical control, incarnated by a "supreme" abstract order, he is interested in how machinery came to be. The origins of modern industry are summoned up before us as part of current experience. Though expressively as power-

At its most synthetic, the large panel displays an asymmetric tripart breakdown, established by the main verticals of the off-center, portal-like presses. These are reinforced by right-angle girder patterns throughout (as if, somehow, the environment is being constructed before our eyes). Of course, these girders buttress and compartmentalize the action at the same time as they compose it with an informal grid (which no Renaissance master could have quite envisaged because it is Cubist in origin). The artist challenges himself with a great design problem: how would the eye navigate this composite, multiepisodic space, that oscillates so drastically between near and far, with its miles of depth, disparate eye levels, scales, and vantages, closed and open environments, and casts of thousands—how could the viewer accept this as one totality rather than as an arbitrary patchwork of separate narratives?

Rivera, remembering that the snake was a symbol of life to the ancient Mexicans, finds the answer in his concept of wavelike or serpentine form. He gives us vast conveyor belts circuiting through the archaic, static masses. They comprise a slow, lateral entanglement, sensuous in its curves, convincing as realistically observed detail from the assembly line, and, above all, as an infusion of continuous energy that rhymes with the allegorical "chapter headings" above. Further, he populates this environment with the angular figures of workers who invariably counterpoint each other—bent elbows thrust up or forearms bearing down—the push of any work in the foreground answered by comparable pulls. Rivera shows those close-up as dense, rounded, solid forms, intent and concerted in their postures. Surely this is how Piero's figures would

Vaccination; *a panel from* Detroit Industry *(1933).*

ful as the ultramodern Italian Futurists, he parts ways with them because his technology has an ancient history. It is a collaboration of all cultures and lives. What we achieve today, no matter how advanced, does not represent a break with the past, but its fruition in the millennial efforts of man, the artificer. Rivera's fatal determinism will not truck either with evanescent phenomena—though his every image is activated—nor a rigid, impersonal geometry—though his will is incredibly authoritative.

The main fresco of the north wall in the Detroit Institute of Arts' garden court represents the manufacture of the internal combustion engine at the Ford River Rouge plant in 1932. In the upper left, molds are made, and the conveyor belts feed parts and move the motors past furnaces, drills, and presses to a final polishing on the left. Above this panel, from top down, one sees giant reclining figures, archetypes of the Asiatic and black races, flanking a volcano whose slopes sprout enormous clenched, metal-holding fists. Beneath this, a subterranean world of mineral crystals and organic materials wells open at center with a great gush. Directly below the latter, the artist locates a blast furnace. But now the work loses its central axis as well as its fabled space. The scheme recalls a traditional Italian Renaissance device which separated the symbolic from the earthly actors, the divine from the material worlds. Rivera has even followed through with "predella" panels, inserted at bottom level, and a "donor portrait," of Edsel Ford, on the south wall.

move if they had a job. One can no longer tell if the exact placement of the workers' volumes results from their assigned stations or the almost mathematical acuteness of the artist. The "further" the eye penetrates, the more contraction is signified by background clustering of these men, while the widening of graded intervals in the foreground frieze, with the strongest decorative contrasts, individuates the play of human forces.

Though his hard edges and firm lines are everywhere appropriate to this metallic forest (and viewing from a distance), Rivera varies, not the focus, but the transparency of his subjects, keeping them always under optical control. (Another reason he can compress so much incident on the wall emerges from the almost telephoto packing of left and right areas.)

But what really dramatizes and orchestrates these tableaux is color. From on high, where the deep azures, warm siennas, and umbers sink in with a saturation uncommon in fresco, the eye descends to airier terrains, signaled by the whites of the massive machines upon which play almost dainty blue and orange reflections. Skylights and blast furnaces both diffuse the light of day and tear open the shadows of night. The healthy freshness of Rivera's paint, every gentle stroke guiding a form, is not even compromised by the nacreous greens of the foundry sequences, as if the artist were in realistic accord, here at least, with old Henry Ford's mania for cleanliness in the factory. But one is impressed by the high-powered metaphors of this palette, as well. For, in producing the internal combustion motor, man is shown harvesting and releasing, by his ingenuity, the raw energies of underground minerals, and Rivera's color symbolism, by its echoes, works to clarify his argument about the union of man, earth, and machine.

His program is condensed overall by covert montage, although particulars are distributed as if in one long tracking shot, left to right. If not in technique, in concept, this work presents affinities with 19th-century historical or allegorical panoramas, like Ford Maddox Brown's "Work." Still, neither in our century nor the last, had an artist introduced into such a mode references to "the Nahautl cosmogony of earliest prehistoric America, that historical substratum in which plunge the roots of our continental culture" [see "Dynamic Detroit—An Interpretation," by Diego Rivera, in Further Reading].

On the south wall of the garden court (body presses and assembly of chassis), no less than in the many subsidiary panels, this genetic, cross-racial and temporal program is inescapable. At Detroit, Rivera produced one of his few major works not reminiscent of popular Mexican painting nor engaged with the revolutions of his homeland. Rather than articulating a native consciousness, he brought it to the picturing of what was, for him, an entirely new society. This citizen of an underdeveloped, agrarian economy, obsessed by the working of all phenomena, had one of the most sophisticated pictorial intelligences of his time. In the United States he encountered a spectacle of collective effort within an overwhelmingly mechanized world whose example might harmonize all national energies. The art that resulted was as rich and unique as the circumstances that brought it about. As an insight into the conditions of

the modern working class, as an analysis of mass product assembly, with its support systems, planning, and processing, as a public and political document of the possibilities of technology, the epic Detroit frescoes have no peer in Western art. (pp. 58-60)

For anyone familiar with his native works, the Detroit frescoes of Rivera startle because there is nothing lonely about them. At Cuernavaca, despite the hordes of figures and the chill in the colors, the subjects are frozen in an exotic jungle ballet, that permits a ritual violence and a fierce criticism of the Spanish, but no observed individualities, no sense of the present as defined by men interacting positively with each other and in control of nature. Zapata is locked in a fairy-tale dream of the ancient land and holds by the bit the famous white lily of his Uccello horse. In Detroit, by contrast, the man-made "landscape" entirely reflects all that the men within it are doing. As for the workers themselves, a film commissioned by Ford shows Rivera drawing many of "their" portraits on the spot, from posing museum guards and assistants. This is not a world where typecast heroes and villains make cameo appearances amid a dense, plumed grouping of anonymous pawns. The variety of racial types (a special program at Ford made efforts to employ minorities, even handicapped), and their divided, identifying skills, imparts to these workers a realistically collective psychology, without traces of that haunted isolation that stills Rivera's Mexican throngs. Neither oppressed nor privileged, these men of the American industrial masses are shown as the main producers of society. Their labor is in itself essentially innocent and their lives are unproblematical. Nowhere in these frescoes, moreover, does one find that will to give blue-collar existence a superhuman mold that will strike so false a note in countless WPA followers of Rivera in the '30s.

Yet, however vital, the particulars seized by his eye, through months of detailed sketches in the factories, are not promoted as a form of industrial genre. The artist had a "scientific" rationale for his concept. "I chose," he wrote,

> the plastic expression of the undulating movement which one finds in water currents, electric waves, stratifications of the different layers under the surface of the earth. . . . The central reason for . . . this theme was the objective fact that the different manifestations of matter are, in the last analysis, only differences of speed in the electronic systems of which matter is formed; the principal manifestation of this fact which gives to the city of Detroit its special and unique character is the automotive industry . . . the industry of speed, together with the chemical and pharmaceutical industry, which effects its results by means of changes in speed caused by the structure of the materials which it synthesizes, analyzes and transforms.
> [quoted in Bertram Wolfe, *The Fabulous Life of Diego Rivera*].

Such an elemental scheme has a double commencement in the rendering of unmined minerals and fossils, on one hand, and of germ cells and a human embryo (first seen on the east wall as one enters), on the other. To the left

of the volcano and blast furnace on the west wall, cargo ships transport ore through a network of waterways to the factory. This was no chamber-of-commerce allegory of American enterprise. Tourists to the River Rouge plant were correctly informed that the company owned its own iron mines, steel yards, transport vessels, refineries, and railroads. Henry Ford's loathing of subcontracting evolved into a pluralistic, drawn-in and self-contained manufacturing empire, focused on the production of the car. For entirely different reasons, this system stimulated in Rivera a poetic analogy between the primordial movement of matter and modern technology. He asserted that the American economic system, even if capitalist, does not separate man from his human nature, however he may be deprived of the means to own the instruments of production or the knowledge of its various phases. The artist unrolls a spectacle that combines the genius from the depths of space in the North, as he put it, with the genius from the depths of time in the South. And all this is ruled by a cyclical view of human destiny in which birth, death, and re-creation distend yet measure the act of human labor through redemptive change.

Doubtless, Edsel Ford had not bargained, at the original $10,000, for such a grandiose vision. Coordinated in 27 panels, it rose as far above capitalist propaganda as the Ford Plant views of Charles Sheeler, another company-commissioned artist, fell beneath it. But by no means can we look upon the Detroit frescoes as unqualified affirmation of the industrial order.

There still remains Rivera's symmetrical posing of the alternative uses to which this monstrous technology might be put by its managers. Formally speaking, everything is poised between constructive and destructive potentials. If he shows the wonders of science in a vaccination panel, he must balance this with the making of poison gas; if fleet, modern Ford trimotor planes are eulogized, he gives us a lethal biplane fighter with masked pilots. Beneath the latter, a diminutive Henry Ford presides under gigantic turbines in the electricity segment, while flanking him across the entrance, a sturdy worker, with a red-starred glove, signifies steam. Completing this pat symbolism are a dove and a hawk, which occupy left and right positions respectively, as one faces the west wall.

In its setting, this western ensemble is framed by the museum's portal inscription, *Vita Brevis Longa Ars,* and, of course, the marble Neo-Baroque pilasters, scrolls, and satyr heads of the court decoration. Their contrast with his vision is marvelously ironic, and one can see Rivera footnoting the whole series with sometimes gentle, sometimes biting sarcasm. Of the pharmaceutical panel, for instance, *Fortune* magazine [February 1933] noted that its dour scientist, surrounded by telephone, microphone, televisor, bottles, and the exposed calves of female workers, counts on an adding machine that surmounts an ecclesiastical radio and is "obviously a satire upon the marriage of medicine and big business. Mr. Rivera, though no longer a member of the Communist party, retains his somewhat ironic view of capitalist civilization and the college of machine virgins which perform its rites" [see Further Reading].

There are other touches throughout.

On the north wall, a row of workers assembling the cylinder block has a frightening day-glow green complexion. On the south wall, a reptilian manager in a Panama hat oversees body polishing, while underneath in a "predella" panel, a cantankerous Henry Ford lectures employees on the famous motor that has been turned into a fat bulldog with a gearstick tail. And what were the burghers of Detroit to think of themselves in the role of priggish, cross-dangling tourists, unimpressed by the laying down of the chassis? And how would automotive executives react to that drollery which makes of their completed product, the finished car—the result of a mammoth career of smelting and refining, fabricated from thousands of units according to thousands of plans—a tiny, unnoticed red speck in the distance?

Beyond these nettlesome details, the Detroit frescoes broach a more thoughtful and possibly frightening critique of modern industry. As Rivera sees it, the scene is a triumph of means over ends, of a pitiless efficiency that is the concrete embodiment of abstract ideas. A part of him, endowed with an extraordinary eye, responds to the panoply of technique for its own sake. Detroit workers, apparently seeing little else, were to compliment him on the superb accuracy of his observation. Yet, one divines another part of him that senses in the factory a kind of gorgeous inferno, unnoticed by all within it. Everything that occurs there is subject, and possibly sacrificed, to an unknown, inexorable will. Lording over the toiling masses are giant multiple drill presses that could almost invoke the ancient warriors at Tula. On one level, Rivera, the medical historian, unfolds an interpretation of the assembly line as a vast circulation system, analogous to a living organism as sophisticated as the human body. But the archeologist within him detects the kinship of this present civilization with the terroristic and now ruined military technocracies of ancient Meso-America. As for present day Mexico, it is a culture where, as Octavio Paz jibes, "If we do not mass produce products, we vie with one another in the difficult, exquisite, and useless art of dressing fleas." [*The Labyrinth of Solitude*].

Upon their opening to Art Commission membership in 1933, the Detroit frescoes were immediately resented by shocked corporation wives who did not find in their temple of art a reflection of the Grosse Pointe leisure that was, in fact, built upon the clangorous input of the Dearborn factories Rivera so vividly showed them. In *The New York Times* [22 March 1933] he said, "Some society ladies have told me that they found the murals cold and hard. I answer that their subject is steel, and steel is cold and hard" [see Further Reading]. But there turned out to be greater inducements to uproar when all the Catholic and many of the Protestant groups in the city saw in the thematically peripheral vaccination panel a quote from traditional Nativity scenes. In a country where the Scopes Monkey Trial was a recent charade, where Father Coughlin was listened to on the radio by untold millions, this rather benign parody was judged the utmost affront to religious faith. Ignoring the more amusing Temptation of St. Anthony theme in the pharmaceutical panel, gathering outrage, that

moved even into the city council, called for the destruction of the paintings. The *Detroit News* called them un-American, incongruous, unsympathetic. Yet, at approximately the same time that Dr. George Derry, president of Marygrove College, conceived that Rivera had "perpetrated a heartless hoax on his capitalist employer . . . a communist manifesto," the artist's compatriot and fellow artist, David Alfaro Siqueiros, railed against him as a "mental tourist," "trade union opportunist" (it's difficult to know what that meant), the "esthete of Imperialism" [quoted in Bertram Wolfe, "Diego Rivera on Trial"; see Further Reading]. Rivera himself [in "Dynamic Detroit—An Interpretation"; see Further Reading] was quick to sally against the parochialism of his Detroit critics:

> And now we have the curious spectacle of the local prelates of two religious organizations of European origin—one of which openly avows allegiance to a foreign potentate, while the other has its roots deep in alien soil—stirring up the people in patriotic defence of an exotic Renaissance patio against what they decry as an "un-American" invasion, namely, the pictorial representation of the basis of their city's existence and the source of its wealth, painted by a direct descendant of aboriginal American stock!

Large bodies of vigilantes, no doubt of left-wing sympathies, thought it necessary to guard the frescoes after they had been opened to the public. In the end, the works were probably saved only by the bewildered Edsel Ford, who said: "I admire Mr. Rivera's spirit: I really believe he was trying to express his idea of the spirit of Detroit."

What can be said about that "spirit" in 1932, one of the worst moments in the city's and nation's history? Ridden by Mafia gangsterism, racial hatreds, and virulent anticommunism, Detroit was also the setting of the first serious sit-down strikes in labor tradition. Employment reached its lowest ebb. Ford was doing only one-fifth its production of 1929. And the municipal government came so close to bankruptcy that Edsel Ford had to pay for the running of the Institute of Arts for a whole month out of his own pocket. Without social security or unemployment insurance, out-of-work masses lived on dwindling savings quickly exhausted in this, the nadir of the Depression. President Hoover's secretary of the treasury, Andrew Mellon, a great art benefactor, thought the solution was to "liquidate labor, liquidate stocks, liquidate the farmer, liquidate real estate" [quoted in Samuel Eliot Morrison, *The Oxford History of the American People*]. Bread lines and soup kitchens dotted the city, as elsewhere. As for the "genetics" of speed, huge Pullman trains would make cross-country trips practically devoid of passengers. In factories, there was a terrible management fear of outside agitation. Detroit was the most refractory city for union organizers. All the large companies opposed any steps for collective bargaining. Old Henry Ford despised unions because he saw in them the seeds of class warfare. He thought the United States was fortunate in having no fixed classes, except that major division between the men who will work and those who will not. "People are never so likely to be wrong as when they are organized" [quoted

in Alan Nevins and Frank Ernest Hill, *Ford, Expansion and Challenge, 1915-1933*].

Obviously this stricture did not include the "organization" the bosses imposed upon the workers. "As soon as you went through the door and punched your card, you was nothing more or less than a robot" [Bob Stinson, a Ford worker, quoted in *Hard Times,* by Studs Terkel]. Rotating two-week shifts that constantly disoriented workers, factory rules that prohibited talking or sitting, and that allowed only 15 minutes for lunch, that fired workers if they were late, and that set spies and spotters among them everywhere: these were normal conditions at River Rouge during Rivera's stint in the city.

He limned a world in which such practices were entirely imaginable, though he himself discreetly overlooked them. More important, at what seemed a crisis point for laissez-faire capitalism, the moment when its earlier confidence and inevitable workings became fatally open to question, he rendered it prophetically as a fount of terrifying and beautiful creativity. In this respect, he does not depict the historical moment of 1932 at all, but one five years before or ten years after it. And this was necessary, not only to avoid offending Ford, but because he wanted to portray the might of those above the worker masses that had not yet rebelled. In Mexico, that rebellion had already subsided, a fact which makes his works there more emphatic glorifications of brotherhood and even more remote in their temporal specifics. While behind the scenes he financed the trip back home of a number of Mexicans unemployed and stranded in the American city, he gave his last parting shot to his fractious audience:

> If my Detroit frescoes are destroyed, I shall be profoundly distressed, as I put into them a year of my life and the best of my talent; but tomorrow I shall be busy making others, for I am not merely an "artist," but a man performing his biological function of producing paintings, just as a tree produces flowers and fruit, nor mourns their loss each year, knowing that the next season it shall blossom and bear fruit again
> ["Dynamic Detroit—An Interpretation"]

(pp. 62-3)

Max Kozloff, "The Rivera Frescoes of Modern Industry at the Detroit Institute of Arts: Proletarian Art Under Capitalist Patronage," in Artforum, *Vol. XII, No. 3, November, 1973, pp. 58-63.*

John Milner (essay date 1988)

[In the following excerpt, Milner favorably reviews an exhibition of Rivera's easel paintings at the Hayward Gallery in London.]

Up to Rivera's return to Mexico from Europe in 1921 his painting was largely a conversation with European art. He learnt voraciously. This process began in his early youth in Mexico at the San Carlos Academy. *Head of a Woman* of 1898 is a thoroughly European academic study, conforming closely to the conventions and techniques of art-school teaching, which would not be out of place in Paris

or Madrid. But an early major oil of 1904, *La era,* reveals his own identity. An elaborately constructed landscape, it has a characteristic appearance of simplicity. The mountain Popocatapetl dominates and closes an extensive Mexican landscape, in which a farm-worker prepares to leave the bare-walled farm with two horses and the Mexican worker makes his first appearance. The composition is original and sparse. The dichotomy between studying European art and yet revealing his Mexican identity was to preoccupy Rivera intensively for the next seventeen years.

In 1906 Rivera won a scholarship to Europe. In 1907 he was studying Goya in the Prado, and by 1909 he was in Paris, insatiably learning new techniques. After a brief return to Mexico at the time of the Revolution in 1910, he settled in Paris, pursuing over the next eleven years an extraordinary and intensive study of cubism whilst periodically continuing to explore Spanish art in Spain. In 1912 he was in Toledo studying El Greco whose impact upon cubists remains to be explored, but also responding to more recent Spanish art including that of Zuloaga. Recollections of both are evident in *The Old Ones* of 1912. Rivera was clearly at ease with large figure compositions by 1912, but this is nonetheless a derivative painting, containing a wealth of precisely observed detail that is redolent of the posed studio piece. Sitters appear against the backdrop of a rising pink hill: no effective middle distance is established to relieve this evident but dramatic artificiality.

In Paris Rivera's eclecticism was rampant, the example of Cézanne proving difficult to shake off. It was as evident in the concern with the brush-work and *réalisation* of form in a *Still Life with Fruit* of 1908 as it was a decade later in the structure of *Woman with Geese* which is so close to Cézanne in composition (even in the buildings' shift from the vertical) that it comprises a homage to Cézanne. In Paris Rivera adapted one visual language after another, learning them thoroughly and painting vigorously, but much of what emerged was necessarily second-hand invention, some of which is of real art-historical interest. Who but Rivera responded to Mondrian's cubism in Paris in 1913? And who within two years could quite so ably and adroitly paraphrase Metzinger, Gleizes, Delaunay, Gris, Picasso and Jacques Villon? Of Braque and Léger there is little sign, but an otherwise so explicit record of cubist development can scarcely have been encompassed in a single artist's work. Yet these derivative paintings are robust and impressively resolved. There is nothing tentative about Rivera's enthusiasm, his composition or his colour. He was rarely wholly original at this time but when his own distinct achievements did emerge they did so in isolated works of great force. Two examples of this in the exhibition assert a shift away from the multifarious conventions which Parisian cubism was evolving. Their inconsistency of style marks them out from more simply derivative works, yet they are both so well resolved that the inconsistencies are scarcely noticed. The *Portrait of Adolfo Best Margaud* of 1913 is the first of these. A slender, well-dressed man is posed full-length against a view of industrialised Paris. He stands on a red iron bridge. A steam train that recalls Severini's hurtles past through a cityscape from Delaunay, dominated by the immense ferris

wheel erected for the 1900 Exposition Universelle. Only the twisting *contrapposto* of the urbane Maugard reconciles the cubo-futurist backdrop of Paris with the completely unfaceted, unstylised figure that dominates the foreground, a compositional link driven home by the precise placing of the gloved hand before the centre of the big wheel and the head at its rim. The straight cane presents a compositional axis worthy of cubism without the least departure from *trompe l'œil* realism. This remarkable synthesis is unique to Rivera. With different means it is achieved two years later in the magnificent *Zapatista Landscape—the Guerilla,* perhaps the most emphatic painting in the exhibition. The flat planes of a cubist still life reveal Mexican motifs of sombrero and decorated blanket. Woodgraining further asserts the lessons of cubist Paris but shocks are to follow. The dominant off-vertical axis is marked by a rifle pressed hard against the picture plane and impossible to mistake or ignore. As its base there is an illusionistic strap and at bottom right a piece of *trompe l'œil* folded paper is pinned against the flat blue that surrounds the central cluster of forms. Behind all this rise the mountains of Mexico. The inconsistency of styles is overcome by compositional means as sombrero and mountain coincide. The theme is clear: it is Mexican, political and—despite its eclecticism—distinctly Rivera.

Rivera's very numerous contacts in Paris included Modigliani (met in 1911), whose *facture* is perhaps evident in the *Mathematician* of 1918, from which overt references to cubism are expunged. Yet in this brown, sombre and significantly melancholic portrait a geometric diagram on a background screen depicts a simple means of determining the Golden Section, recalling not only the cubist group of that name but the interest aroused by Henri Poincaré's mathematical works. An unfinished *Still Life with Ricer* of 1918 . . . reveals a preparatory grid in which the Golden Section is employed.

With *Zapatista Landscape,* the sole distinctly Mexican cubist work exhibited here, Rivera begins to re-approach his Mexican identity. This process leads ultimately to the murals, by way of a seventeen-month visit to Italy in 1920-21 filled with drawings after Italian masters from Giotto to Tintoretto. Here was a public, decorative and communicative art designed to be legible to a mass of viewers. When he left for Italy, Rivera already had Mexican mural commissions in mind, prompted by José Vasconcelos, rector of the University of Mexico. The opportunity this presented and the experience of Italian painting were decisive for the rest of his career. As the *Mathematician* showed, Rivera had already put the intellectual language of cubism behind him. He was to use what he had learnt in Paris to develop a unique and deceptively simple picture space, but he never returned to the relative obscurity of cubist language once the first mural commissions were received. Indeed he was closer in some ways to Gauguin and Puvis de Chavannes.

In Mexico in 1921 Rivera began to produce decorative paintings that were public, politicised and monumental. A charcoal and red chalk drawing of *David Alfaro Siqueiros* permits a glimpse of his new means. Recognisably of Siqueiros in the curl of lip, set of eye and shape of ear, the

drawing appears specific in its description and simple to understand. On closer inspection the nose appears slightly flattened against the picture plane; the ear presents more of a side view than the angle of the brow would suggest possible in a single view, and the jacket is in profile at left but flattened into front view at right. Parisian lessons are discreetly at work, yet it is an immediately intelligible and recognisable portrait.

The political origins of the mural commissions enabled Rivera to embody his own political sympathies on the most grandiose scale, but if this was propaganda, it was achieved by means of sophisticated and deceptive simplicity. Drawings for the murals, numerous and well displayed here, show Rivera characteristically editing down a mass of information to definitive outlines flat on the paper even in foreshortened poses. Where this flatness necessitates distortion, Rivera does not hesitate to use it. Once defined, figures are assembled and overlapped up the plane of the mural. They rarely if ever engage in rapid movement. There is little narrative as Rivera's subjects engage in actions only to indicate their occupations or rôles. Moreover the figures became generalised and often anonymous. Occasionally, and less successfully, he approached caricature, as in his depiction of the enemies of the Revolution. Sometimes his heroic figures appear like icons caught within an irreligious and communist framework. But he is most subtle and convincing in his depiction of the Mexican peasant, anonymous, slow-moving and dedicated to simple tasks, as in *The Grinder* of 1924.

Rivera's politics were problematic. A member of the Mexican Communist Party from 1922, he was later expelled, and refused membership on subsequent applications. He had close contacts with Soviet art, signing a contract with Lunacharsky in Moscow in 1927, supporting the *October* group in 1928 and sketching the May Day parades. Yet almost immediately after this Soviet visit he was in the United States (1930-31), receiving the accolade of the MOMA exhibition, and his May Day sketchbook was purchased by Abby Aldrich Rockefeller. Fifty-seven thousand people visited the New York exhibition and mural commissions followed for the Detroit Institute of Arts. He painted Edsel B. Ford in 1932 and was in turn criticised by the Communist Party of the U.S.A. His RCA murals featured a large head of Lenin which Rivera refused to remove, leading to the rejection of the murals and their eventual destruction. Rivera returned to Mexico in 1934 and was instrumental in providing the exiled Trotsky not only with political asylum but with accommodation in his own house (1937-39). With the arrival of André Breton in 1938, the three men became close, and surrealist aspects become evident in Rivera's painting (see *The Hands of Dr. Moore* of 1940). After the assassination of Trotsky in 1940, Rivera was anxious enough to post armed guards at his mural scaffolding. In later life Rivera returned to the Soviet Union, partly in an attempt to cure his cancer (1955-56), returning to Mexico via Prague, Poland and East Germany; yet his last years witnessed the completion not only of immense mural projects but also of spectacular society portraits, of which the exhibition contains remarkable examples, such as *Señorita Matilda Palou* (1951) in a magnificently nationalistic dress. In 1942 Rivera began

an enormous building project, Anahuacalli, which houses his collection of over 60,000 pieces of pre-Columbian art. It would have been an appropriate assertion of his identification with Mexico to present a few examples in the exhibition.

The exhibition cannot, of course, convey the importance of the murals as the major achievement of Rivera's life. Neither the life-size reproductions nor the film can do more than point to their achievement. Only a visit to Mexico to see the murals functioning *in situ* can adequately permit their success to be assessed, for despite their broadly human appeal they responded to their political as much as their physical context. It is that which cannot be packaged or exported. (pp. 47-9)

> *John Milner, "Diego Rivera at the Hayward," in* The Burlington Magazine, *Vol. CXXX, No. 1018, January, 1988, pp. 47-9.*

FURTHER READING

I. Writings by Rivera

"Dynamic Detroit—An Interpretation." *Creative Art* 12, No. 4 (April 1933): 289-95.
> Detailed explanation of the scenes and figures in the Detroit Institute of Arts murals.

My Art, My Life (with Gladys March). New York: Citadel Press, 1960, 318 p.
> Reminiscences about his involvement with the Communist party, his friendship with Pablo Picasso, and other episodes comprising his personal and professional history.

II. Interviews

Laidler, Harry W. "Rivera, Socialist Painter of Mexico." *The Mentor* 14, No. 3 (April 1926): 15-18.
> Conversation in which Rivera declares, "The soul of the Indian is essentially democratic, essentially communal. In that ideal . . . lies the hope of my country."

"Detroit in Furor over Rivera Art." *The New York Times* (22 March 1933): 15.
> Reports on the controversy over the Detroit murals and quotes Rivera's response to his critics.

Tully, Jim. "Diego Rivera." In his *A Dozen and One*, pp. 77-95. Hollywood: Murray & Gee, 1943.
> Recounts the discussions of art and politics that took place during several meetings between Tully and Rivera.

III. Biographies

Wolfe, Bertram D. *Diego Rivera: His Life and Times.* New York: Alfred A. Knopf, 1939, 420 p.
> Wolfe's first biography of Rivera, focusing on his development as an artist and his political struggles.

IV. Critical Studies and Reviews

"Misconceptions." *The American Museum of Art* XXVI, No. 5 (May 1933): 221.
> Claims that the controversy surrounding the murals in the Detroit Institute of Arts testifies to their vitality.

Bloch, Lucienne. "On Location with Diego Rivera." *Art in America* 74, No. 2 (February 1986): 102-21, 123.
> Reminisces about the creation and destruction of the Rockefeller Center fresco.

Bongartz, Roy. "Who Was This Man—and Why Did He Paint Such Terrible Things About Us?" *American Heritage* 29, No. 1 (December 1977): 14-29.
> Biographical sketch focusing on Rivera's years in America.

Brenner, Anita. "Diego Rivera." In her *Idols Behind Altars,* pp. 277-87. New York: Payson and Clarke, 1929.
> Portrays Rivera as a socially conscious artist whose work elicits a strong response from viewers.

Burr, James. "Artist as Revolutionary." *Apollo* CXXVII, No. 311 n. s. (January 1988): 64-5.
> Characterizes Rivera as "a giant among painters and a tireless champion of liberal humanism."

Catlin, Stanton. "Political Iconography in the Diego Rivera Frescoes at Cuernavaca, Mexico." In *Art and Architecture in the Service of Politics,* edited by Henry A. Millon and Linda Nochlin, pp. 194-215.
> Detailed study of the frescoes with numerous illustrations of pictorial antecedents to Rivera's work.

Charlot, Jean. *An Artist on Art: The Collected Essays of Jean Charlot,* Vol. II. Honolulu: University Press of Hawaii, 1972, 397 p.
> Selection of writings on Mexican art, including five essays devoted to Rivera.

"Diego Rivera: The Raphael of Communism." *Creative Art* VII, No. 1 (July 1930): 27-32.
> Praises Rivera's political and moral outlook.

Danto, Arthur C. "Diego Rivera: A Retrospective." *The Nation* 243, No. 2 (19-26 July, 1986): 56-9.
> Considers the difficulty of evaluating Rivera's contributions to public art.

Elitzik, Paul. "Discovery in Detroit: The Lost Rivera Drawings." *Américas* 32, No. 9 (September 1980): 22-7.
> Discussion of the *Detroit Industry* murals prompted by the discovery of Rivera's preliminary drawings for the project.

Evans, Ernestine. "If I Should Go Back to Mexico." *The Century Magazine* 111 (February 1926): 455-61.
> Enthusiastic description of the experience of witnessing Rivera's murals.

"Industrial Detroit." *Fortune* VII, No. 2 (February 1933): 48-53.
> Preview of the Detroit murals with photographs and commentary on some of its panels.

Frankfurter, Alfred M. Editorial in *The Fine Arts* XX, No. 2 (June 1933): 5-6.
> Argues that the inclusion of Lenin's portrait in the Rockefeller Center mural demonstrates Rivera's bad taste.

Furst, Herbert. "Diego Rivera and Our Times." *Apollo* XXXII, No. 189 (September 1940): 71-2.
> Contends that Rivera's work "is significant because it is seemingly powerful art and certainly bold propaganda."

Getlein, Frank. "Diego Rivera and Monumental Painting." *The New Republic* 137 (16 December 1957): 21.
> Obituary tribute evaluating Rivera's achievements as a painter in the "monumental" style.

Helm, McKinley. "Diego Rivera." In his *Modern Mexican Painters,* pp. 37-61. New York: Dover Publications, 1941.
> Anecdotal character study.

Januszczak, Waldemar. "The Life and Art of Diego Rivera, 1886-1957." *Artscribe International,* No. 58 (June-July 1986): 58-9.
> Presents a vivid appraisal of Rivera and his legacy on the occasion of the centenary of the artist's birth.

Johnson, William Weber. "The Tumultuous Life and Times of the Painter Diego Rivera." *Smithsonian* 16, No. 11 (February 1986): 36-51.
> Biographical sketch of Rivera, including E. B. White's acerbic poem about the Rockefeller Center mural controversy, "I Paint What I See."

Kramer, Hilton. "Art and Revolution." *The Nation* 198, No. 1 (4 January 1964): 18-19.
> Review of Bertram D. Wolfe's *The Fabulous Life of Diego Rivera.* Kramer writes: "The tide of history has left Rivera's art isolated in his native Mexico, a local rather than an international concern."

Leighton, Frederic. "Diego Rivera." *The Freeman* VII, No. 181 (29 August 1923): 586-88.
> Enthusiastic description of *Creation.*

Lewisohn, Sam A. "Mexican Murals and Diego Rivera." *Parnassus* VII, No. 7 (December 1935): 11-12.
> Praises the narrative element in Rivera's painting.

"Rivera—Greatest Mexican Painter." *The Literary Digest* 112, No. 4 (23 January 1932): 13-14.
> Surveys opinions of Rivera that appeared in various periodicals during the painter's lifetime.

Mishnun, Virginia. "God in the Hotel Del Prado." *The Nation* 166, No. 26 (26 June 1948): 713-15.
> Documents the controversy that arose from Rivera's inscribing "Dios no existe" ("God does not exist") on his mural *Dream of a Sunday Afternoon in the Central Alameda* at the Hotel del Prado in Mexico.

"Diego Rivera at Work." *The Nation* 137, No. 3557 (6 September 1933): 257-58.
> Reports on Rivera's progress in creating a mural inside the New Workers' School in New York.

Pincus, Arthur. "Fellow Travelers: Leon Trotsky, Art Critic, Meets Diego Rivera, Revolutionary." *Art & Antiques* (October 1984): 49-52.
> Details the origins of the friendship between Trotsky and Rivera and offers high praise for Rivera's Cubist works.

Putzel, Howard. "Rivera." *The American Magazine of Art* XIX, No. 7 (July 1928): 384-87.
> Praises the emotional and intellectual depth of Rivera's frescoes and easel paintings.

Richardson, E. P. "Diego Rivera." *Bulletin of the Detroit Institute of Arts* XII, No. 6 (March 1931): 74-6.
> Introduces works featured in a Rivera exhibition.

Rosenfeld, Paul. "The Rivera Exhibition." *The New Republic* LXIX, No. 892 (6 January 1932): 215-16.
> Admires the skill and range of Rivera's art.

Sykes, Maltby. "Diego Rivera and the Hotel Reforma Murals." *Archives of American Art Journal* 25, Nos. 1 & 2 (1985): 29-40.
> Reminisces about the creation of the Hotel Reforma murals.

Wolfe, Bertram D. "Diego Rivera on Trial." *Modern Monthly* VIII, No. 6 (July 1934): 337-41.
> Strident defense of Rivera's art and politics. Wolfe accuses Rivera's detractors of hypocrisy, myopia, and jealousy.

—————. "Diego Rivera—People's Artist." *The Antioch Review* VII, No. (March 1947): 99-108.
> Follows Rivera's career from his early stylistic experiments to his status as Mexico's preeminent painter.

V. Selected Sources of Reproductions

Arquin, Florence. *Diego Rivera: The Shaping of an Artist, 1889-1921.* Norman: University of Oklahoma Press, 1971, 150 p.
> Reproduces and discusses works from the first half of Rivera's career.

Favela, Ramón. *Diego Rivera: The Cubist Years.* Phoenix: The Phoenix Art Museum, 1984, 175 p.
> Reprints Rivera's Cubist works and describes his participation in the European art world.

McMeekin, Dorothy. *Diego Rivera: Science and Creativity in the Detroit Murals.* East Lansing: The Michigan State University Press, 1985, 71 p.
> Reproductions of each panel of the Detroit murals with commentary in Spanish and English.

Rochfort, Desmond. *The Murals of Diego Rivera.* London: Journeyman, 1987, 103 p.
> Reproductions of Rivera's murals with an essay by Rochfort and a political chronology of Mexico by Julia Engelhardt.

Eero Saarinen

1910-1961

American architect and designer.

Acknowledged as one of the most innovative architects of the twentieth century, Saarinen rejected the precepts of prevailing architectural styles and schools of design, instead approaching each project as a problem to be solved and seeking "the style for the job." He continually explored ways that technology could liberate architecture by freeing the architect to create new forms able to reflect the uses and requirements of each structure. David G. De Long has written that Saarinen's incorporation of diverse materials, textures, and shapes resulted in "a more personal, more flexible approach" to modern architecture than ever before.

Saarinen was born in Kirkkonummi, Finland, to the architect Eliel Saarinen and the artist Louise Gesellius Saarinen. The family's combined home and studio was a gathering place for architects, artists, authors, and composers, and early artistic endeavors on the part of the Saarinen children were encouraged and guided by some of Europe's most renowned creative minds. When Saarinen was twelve the family moved to the United States and settled in Michigan, where the elder Saarinen was appointed to the University of Michigan College of Architecture. His work there brought him to the attention of entrepreneur George Gough Booth, who engaged him to design a complex of schools and oversee the educational program for an art academy at Cranbrook, Booth's 175-acre estate. The project enlisted the talents of the entire family: Saarinen's mother and sister created rugs, draperies, tapestries, and upholstery, and Saarinen himself designed furniture.

Saarinen initially intended to become an artist, and in 1930 he entered the Académie de la Grande Chaumière in Paris to study sculpture. Although he abandoned this pursuit after a year, commentators often attribute the sculptural quality of several of his buildings to his formal training in the discipline. On his return to the United States he entered Yale University, receiving a degree in architecture in 1934. A traveling fellowship enabled him to spend two years in Europe, after which he returned to Cranbrook as an instructor and joined his father's architectural firm. During the Second World War Saarinen worked in Washington, D.C., for the Office of Special Services and designed wartime housing. After the war the Saarinens were commissioned by General Motors to prepare preliminary studies for a Technical Center; in 1948, the project was ceded primarily to the younger Saarinen. On its completion in 1956 the General Motors Technical Center was hailed as a model of resourceful engineering and construction techniques brought to bear on contemporary design requirements. While most commentators agree that the design is reminiscent of Mies van der Rohe's Illinois Institute of Technology, they consider it unique for the innovations accompanying its construction, in-

cluding new methods of enameled wall panel and glass construction and the development of neoprene gasket weather seals. Also in 1948 Eliel and Eero Saarinen separately entered the design competition for the St. Louis National Expansion Memorial; after a misunderstanding in which the congratulatory telegram was sent to the elder Saarinen, they learned that Eero had in fact won. He refined his design over the next decade for what is now known as the St. Louis Arch as considerations of site were addressed. The massive arch, completed in 1965, is generally agreed to be one of the most beautiful monuments in the world.

Following the death of his father in 1950, Saarinen became head of the firm, and in the ensuing eleven years before his own death designed and built many of the structures that won him international renown. His search for the appropriate shape to reflect the function of each building is exemplified in such structures as the Kresge Auditorium and Chapel (1956), the David S. Ingalls Hockey Rink (1959), and the Trans World Airlines Flight Center (1962). According to De Long, with these buildings Saarinen "departed consciously from designs restricted primarily to rectangular shapes," creating sculptural forms. Saarinen

fitted the interior of the Kresge auditorium to visual and acoustical requirements and topped the structure with a dome, a more graceful shape than the rectangular forms of post-and-beam construction used for the rest of the building. For the chapel, Saarinen designed a windowless brick cylinder, mounted on irregularly spaced arches rising from a moat. A 1953 review in *Architectural Forum* suggests that its unique design renders it "one of the most extraordinary religious buildings of our time," and Saarinen considered the enclosed circular space symbolic of the inner security afforded by faith.

Saarinen believed that the hockey rink and airline terminals were best served by equally dramatic shapes. Reinforced concrete and ceilings supported by suspension cables enabled him to enclose large, open spaces. The design of the Ingalls rink is widely acclaimed. Commentators have suggested that the gracefully sloped wooden ceiling, which resembles the overturned prow of a ship with crossmembers radiating from a center spine, evokes the speed and movement of the sport of hockey. The TWA terminal is Saarinen's most purely sculptural building, its sweeping curves resembling the image of a bird in flight. Dulles International Airport (1962) is widely regarded as Saarinen's greatest achievement. It is considered one of the most visually striking and well-designed airports in the world: a strong, hovering form that Saarinen perceived as a platform between the sky and the plain on which it is situated. Saarinen addressed the problem of conveying passengers to waiting planes with the invention of the mobile lounge, an innovation that allows the terminal building to exist as a single monumental form free of protruding passenger walkways. Of the mobile lounges Peter Papademetriou said: "Saarinen cut off a piece of the building and put it on wheels, giving away part of his territory, but thereby being able to claim more. He was saying that the architect can design a larger environment of which the building is just a piece," an observation in harmony with Saarinen's definition of architecture as "the total of man's man-made physical surroundings." Saarinen maintained near the end of his life that the Dulles airport was "the best thing I have done. . . . Maybe it will even explain what I believe about architecture."

Saarinen's furniture designs, many of them done in conjunction with Charles Eames and Florence Knoll at Cranbrook and under the auspices of Knoll design studios in the 1940s and 50s, have been credited with helping to establish the dominant American "look" for interior decor in the mid-twentieth century. Saarinen created comfortable, sleek chairs and couches of molded plywood or plastic shells supported by tubular metal legs, best exemplified by his widely recognized and copied "womb chair" (1948), so called because of the fetal posture it encourages. His Pedestal group of chairs and tables (1958), with a single graceful column in place of legs, has become an American design classic.

Saarinen's iconoclastic approach to architecture has been the focus of some negative commentary. Vincent Scully wrote in 1969 that Saarinen's work embodies "a good deal that was wrong with American architecture in the mid-fifties: exhibitionism, structural pretension, self-defeating

urbanistic arrogance." Most critics, however, commend the resourcefulness with which Saarinen met each new design challenge, and describe his career as one of continuous growth and development, marked by several unqualified successes.

ARTIST'S STATEMENTS

Eero Saarinen (essay date 1952)

[In the following excerpt, Saarinen delineates the primary concerns of modern architecture.]

Today [architects] are concerned with the integration of architecture with the different kinds of engineering and construction. This awareness comes from the two preceding major influences we have had—the awareness of fabrication which has led us into modular systems, and the awareness of structure for which we thank Mies [van der Rohe]. It is natural that we now should be concerned with how these can be integrated with all the new technical advances in air conditioning, lighting, flexibility and so forth. We should apply our minds now to this problem as well as we can, but we must think of it as a problem along the road, because ahead of us we have many more before we shall have grown to maturity. We can only speculate about them—but let us do just that.

There are three areas of development and awareness which I feel are now coming into view. They are:

1. The problem of our environment.

2. An integration among all the design professions.

3. A greater spiritual meaning of architecture to our civilization.

First, the problem of our environment: It seems to me that our profession has been concerned with and created many beautiful buildings but has taken little responsibility towards our total environment. By total environment, I mean the picture we see if we turn in any direction and look in our cities or on our highways. All we see is signs and hamburger stands and gas stations. We really are a very ugly civilization compared to the old New England village or the medieval town of Europe. It is true that our civilization has gone through a fantastic change, but all cannot be blamed on that. It is about time that we put our best thought and energy into what can be done to improve this situation. What can be done to make city planning more effective? What should be done to unify our commercial streets? What can be done to save our roadsides? These, it seems to me, are all problems where we as a profession should lead. But how can we achieve such leadership? I think, by each and every one of us taking an active interest in city planning and related problems.

The next problem I mentioned was the integration of all

the design professions. At the time of the Renaissance, there was a fine relationship among the arts. The architect, the sculptor, and the painter worked hand in hand and actually produced the total of man's physical environment, all with a common philosophy. Today there is a whole constellation of different design professions, quite separated from each other but performing roughly the same functions. Industrial design, advertising design, interior decorating, and many others have grown up. There is no integration and common philosophy among all these, and some of them seem to be derived from shallower ideologies. Should not architecture take a lead in trying to get some unity among what now seems to be a chaos? A more widespread interest in the integration of commercial furnishings for interiors would do much to improve the situation. Through the leading position the architectural schools have in relation to the other fields of design, much can be done also. But it is the architect's responsibility to expand the teaching in the schools to include these other professions.

The third challenge which I would like to mention is the greater spiritual meaning of architecture to our civilization. When maturity gradually comes to our civilization as a whole, the architect may be called upon to play a different and more important role. Civilizations of the past seem to have placed a greater, almost spiritual value on architecture. They did not always try to build as small and economically as possible; the enclosure of space with the least effort was not always the demand placed on the profession. Is it not possible that architecture may some day again play this higher role in society?

These are three fields of new awareness and new activity that I can imagine. What actually might happen may be entirely different—we can only guess. (pp. 245-47)

> Eero Saarinen, "Our Epoch of Architecture," in AIA Journal, *Vol. XVIII, No. 6, December, 1952, pp. 243-47.*

Eero Saarinen (essay date 1968)

[*In the following excerpt from a compilation of his statements regarding architecture, furniture, and interior design, Saarinen defines the scope and purpose of architecture and comments on some of his most notable structures.*]

I think of architecture as the total of man's man-made physical surroundings. The only thing I leave out is nature. You might say it is man-made nature. It is the total of everything we have around us, starting from the largest city plan, including the streets we drive on and its telephone poles and signs, down to the building and house we work and live in and does not end until we consider the chair we sit in and the ash tray we dump our pipe in. It is true that the architect practices on only a narrow segment of this wide keyboard, but that is just a matter of historical accident. The total scope is much wider than what he has staked his claim on. So, to the question, what is the scope of architecture? I would answer: It is man's total physical surroundings, outdoors and indoors.

Now, what is the purpose of architecture? Here again I would stake out the most ambitious claim. I think architecture is much more than its utilitarian meaning—to provide shelter for man's activities on earth. It is certainly that, but I believe it has a much more fundamental role to play for man, almost a religious one. Man is on earth for a very short time and he is not quite sure what his purpose is. Religion gives him his primary purpose. The permanence and beauty and meaningfulness of his surroundings give him confidence and a sense of continuity. So, to the question, what is the purpose of architecture, I would answer: To shelter and enhance man's life on earth and to fulfill his belief in the nobility of his existence. (p. 5)

．．．．．

In 1948, we won the national competition for a new national park in St. Louis, symbolizing and commemorating the westward expansion of America. The major concern here was to create a monument which would have lasting significance and would be a landmark of our time. An absolutely simple shape—such as the Egyptian pyramids or obelisks—seemed to be the basis of the great memorials that have kept their significance and dignity across time. Neither an obelisk nor a rectangular box nor a dome seemed right on this site or for this purpose. But here, at the edge of the Mississippi River, a great arch *did* seem right.

But what kind of an arch? We believed that to stand the test of time the arch had to be the purest expression of the forces within. This arch is not a true parabola, as is often stated. Instead it is a catenary curve—the curve of a hanging chain—a curve in which the forces of thrust are continuously kept within the center of the legs of the arch. The mathematical precision seemed to enhance the timelessness of the form, but at the same time its dynamic quality seemed to link it to our own time. The arch, as redesigned, is 630 feet high with a span of 630 feet. Fifty-six feet at the triangular bases, it tapers to eighteen feet at the apex. It seems now really to be an upward-thrusting form, not an earthbound one.

Having arrived at a shape that seemed to have permanence and to belong to our time, what material would also fulfill these two qualities? Stainless steel seemed the inevitable answer—and so we decided on stainless steel with a concrete core.

All these things seemed to come together to make a right monument for this place and for our time. The arch could be a triumphal arch for our age as the triumphal arches of classical antiquity were for theirs. Lofty, dynamic, of permanent significance, the arch could be a proper visual center and focus for the park and, as 'The Gateway to the West,' it could symbolize the spirit of the whole Memorial.

We believed that what downtown St. Louis most needed was a tree-covered park. We wanted to have the most nature possible toward the city.

The arch was placed near the Mississippi River, where it would have most significance. Here it could make a strong axial relation with the handsome, historic Old Courthouse which it frames. Here, from its summit, the public could

confront the magnificent river. The arch would draw people to the superb view and picturesque activity at the river's edge. The museum, the restaurant, the historic riverboats were all projected on the levee. The river would be drawn into the total composition.

The arch will be on a raised plaza of about twenty-five feet. This base not only gives the arch more dominance over the tall buildings of the city, but it seemed essential as an approach to a vertical monument. On the levee side, this becomes a broad, monumental stairway (a symbolic stairway as well as an actual one, for it symbolizes the movement of peoples through St. Louis, the gateway). The stairs of which we built a part in full-size mock-up, have treads of decreasing depth toward the top to dramatize the upward sweep of the approach to the arch.

The formal elements of the plaza and the axial, tree-lined mall leading to the Old Courthouse are contrasted with the romantic areas on each side of the axis—areas with pools, rock outcroppings, and winding paths. All the lines of the site plan, including the paths and the roads, and even the railroad tunnels, have been brought into the same family of curves to which the great arch itself belongs. More and more I believe that all parts of an architectural composition must be parts of the same form-world. (p. 22)

.

Our intention [for the **General Motors Technical Center**] was threefold: to provide the best possible facilities for industrial research; to create a unified, beautiful, and human environment; and to find an appropriate architectural expression.

General Motors is a metal-working industry; it is a precision industry; it is a mass-production industry. All these things should, in a sense, be expressed in the architecture of its Technical Center.

Thus, the design is based on steel—the metal of the automobile. Like the automobile itself, the buildings are essentially put together, as on an assembly line, out of mass-produced units. And, down to the smallest detail, we tried to give the architecture the precise, well-made look which is a proud characteristic of industrial America. The architecture attempts to find its eloquence out of a consistent and logical development of its industrial character. It has been said that in these buildings I was very much influenced by Mies. But this architecture really carries forward the tradition of American factory buildings which had its roots in the Middle West in the early automobile factories of Albert Kahn.

Maximum flexibility was a prime requirement of the complicated program. It was achieved by applying the five-foot module not only to steel construction but also to laboratory, heating, ventilating, and fire-protection facilities as well as to laboratory furniture, storage units, wall partitions, and so on, all of which are keyed to it.

Now, as to the environment. The site occupies the central 320 acres of an approximately 900-acre area. The Center consists of five separate staff organizations—Research, Process Development, Engineering, Styling, and a Service Center as well as a central restaurant (in addition to cafe-

terias in the building groups). Each staff organization has its own constellation of buildings. There are twenty-five of these, including laboratory, office and shop buildings, and special use ones, like the two Dynamometer buildings.

Some sort of campus plan seemed right, but we were concerned with the problem of achieving an architectural unity with these horizontal buildings. The earlier scheme we made in 1945 had its great terrace and covered walk which unified the buildings into one great enterprise, but these had proved expensive and impractical. In the new scheme, developed when General Motors came back in 1948, we depended on simpler visual devices.

One of these is the twenty-two-acre pool. Not only does this form one dominant open space, but it also helps unity by providing a strong, hard architectural line and by strengthening all vertical dimensions of the buildings through their reflection.

Another unifying device is the surrounding forest, the green belt that should in time give the buildings the effect of being placed on the edge of a large glen. We gave very careful study to the placing and heights of the various buildings so they would form a controlled rhythm of high and low buildings, of glass walls and brick walls, of buildings seen between trees and buildings open to the square. Our basic design allowed variety within unity. The standardization of module throughout the project was arrived at for practical reasons, but we also hoped the constant use of this one dimension would have a unifying effect.

The use of color in an overall sense was devised, not only for its pleasing aspects, but also to help bind the project together. By an overall sense, I mean that color is not used in small ways on the exterior. The brilliant blues, reds, yellow, orange, black are on the great big end walls of buildings. Some of these are about forty feet high and each is of one color, so they are rather like cards of color in space. Then all the glass and metal walls have certain standardized neutral colors.

In the earlier scheme, there was a tall administration building which gave the project a strong, vertical focal point. When that building was dropped from the program, we sought vertical focal points in other ways. Where the administration building would have been, we put the great fountain, a 115-foot-wide, fifty-foot-high wall of moving water. Then, instead of hiding the water tower, we designed it to be a proud 132-foot-high, stainless-steel-clad spherical shape and set it in the pool as a vertical accent in the whole composition. The water ballet with its playing jets, by Alexander Calder, is another visual accent near the Research building.

The Center was, of course, designed at automobile scale and the changing vistas were conceived to be seen as one drove around the project. However, opposite the water wall fountain, in front of the central restaurant, we deliberately created a little pedestrian-scale court.

Each of the staff organizations prides itself on its own individuality and its range of activities. Each wanted its own 'personality.' We tried to answer this desire architecturally in the main lobby of each of the five groups. In four of

these, the visual climax to the lobby is the main staircase. These staircases are deliberately made into ornamental elements, like large-scale technological sculptures.

The public usually does not see the shop areas of the Center. We tried to keep the architectural character of the whole. They are generally wonderfully big open areas with long-span construction. We organized all the mechanical facilities with the structure so that we could avoid the usual slum-like appearance of factory buildings. We used color on the machines to make the areas visually agreeable and to unify them in the total environment. In the Dynamometer buildings, the free-standing exhaust pipes were designed to be strong elements in the composition.

One of the things we are proudest of is that, working together with General Motors, we developed many 'firsts' in the building industry. I think that this is part of the architect's responsibility.

We had previously used a baked enamel-finished panel on the Pharmacy Building at Drake University, which may well have been the very first instance of the now so familiar metal curtain wall. But General Motors represents the first significant installation of laminated panels and the first use anywhere of a uniquely thin porcelain-faced sandwich panel which is a complete prefabricated wall for both exterior and interior. For this project, we also developed the brilliantly colored glazed brick. The ceilings in the drafting rooms are the first developed completely luminous ceilings using special modular plastic pans. Perhaps the greatest gift to the building industry is the development of the neoprene gasket weather seal, which holds fixed glass and porcelain enamel metal panels to their aluminum frames. It is truly windproof and waterproof and is capable of allowing the glass or panels to be 'zipped out' whenever a building's use changes. All of these developments have become part of the building industry and a common part of the language of modern architecture. (pp. 30-2)

.

I believe the **David S. Ingalls Hockey Rink** is one of the best buildings we have done and I am very proud of it.

The concept of the building was arrived at as a completely logical consequence of the problem. There was the site—an open location, somewhat remote from the compact campus. It seemed a place where one could express the special nature of this absolutely independent building and could express its structure freely. The site indicated that the building should be placed in such a way that its entrance was at the end closest to the campus.

There was the functional requirement: a hockey rink of standard size (eighty-five by 200 feet) with seating for 2,800 (and the possibility for 5,000 when the rink would be used for other purposes). These requirements indicated a stadium-like plan, roughly oval in shape, with access corridors or ramps around the seating area.

The question was how best to span this area. With the structural engineer, Fred Severud, we worked out a system of a central arch spanning the length of the rink and a hanging roof coming down from this arch.

The great spine-like concrete arch is the dominant theme. We wanted it to be both structurally effective and beautiful. We decided to counteract the normally downward aspect of the arch form by making the ends sweep up in cantilevered extensions. This soaring form was further emphasized by the lighting fixture at the entrance end, which we commissioned from a sculptor, Oliver Andrews, so it would have expressive as well as functional meaning.

The cables, which were suspended in catenary curves from the central arch, stretch down to their anchorage in the exterior walls on each side. These curved walls are counterparts to the arch: they are in plan as the shape of the center arch is in section. These walls, which surround the scooped-out stadium, were also made to slope, both in order to increase structural efficiency and to enhance the visual expression of the stress flows. Vaulted or domed shapes often have a heaviness or bulginess. On this exterior, the contrast of the concave and the convex seem to me to have achieved the kind of sweep and lightness which we wanted.

The interior is absolutely simple. The wood deck of the roof really looks like boat construction. The structural members are visible—the sweeping arch and the longitudinal cables under the roof. The concrete, the wood, the ice, and the fluorescent lights all seem in character with each other. They seem to me to give a luminosity and lightness to the interior space which make one almost feel as if one were floating.

It is a building which, as Severud has said, expresses in its various forms and in the ways its materials are used the tug-of-war between pull and resistance. It is a building in which the form-world created by the basic ingredients of the structure is carried out in all the component parts. And it is a building in which we have not hesitated to dramatize and emphasize. Thus, in summary, I would say that I think the building succeeded because of the clarity and strength of its statement and because of the consistency and relatedness of all its parts. (p. 60)

.

The challenge of the **Trans World Airlines Terminal** was twofold. One, to create, within the complex of terminals that makes up Idlewild, a building for TWA which would be distinctive and memorable. Its particular site—directly opposite Idlewild's main entrance road and at the apex of the curve in the far end of the terminal complex—gave us the opportunity of designing a building which could relate to the surrounding buildings in mass, but still assert itself as a dramatic accent.

Two, to design a building in which the architecture itself would express the drama and specialness and excitement of travel. Thus, we wanted the architecture to reveal the terminal, not as a static, enclosed place, but as a place of movement and of transition.

Therefore, we arrived at this structure, which consists essentially of four interacting barrel vaults of slightly different shapes, supported on four Y-shaped columns. Together, these vaults make a vast concrete shell, fifty feet high and 315 feet long, which makes a huge umbrella over all

the passenger areas. The shapes of these vaults were deliberately chosen in order to emphasize an upward-soaring quality of line, rather than the downward gravitational one common to many domed structures. We wanted to counteract the earthbound feeling and the heaviness that prevails too much in the M.I.T. auditorium. We wanted an uplift. For the same reason, the structural shapes of the columns were dramatized to stress their upward-curving sweep. The bands of skylights, which separate and articulate the four vaults, increase the sense of airiness and lightness.

In studying the problem in model after model, both exterior and interior, we realized that having determined on this basic form for the vaulting, we had committed ourselves to a family of forms and must carry the same integral character throughout the entire building. All the curvatures, all the spaces and elements, down to the shapes of signs, information boards, railings, and counters, would have to have one consistent character. As the passenger walked through the sequence of the building, we wanted him to be in a total environment where each part was the consequence of another and all belonged to the same form-world. It is our strong belief that only through such a consistency and such a consequential development can a building make its fullest impact and expression. (p. 68)

.

The architectural character [of the **Deere & Company World Headquarters**] was determined largely by the site and the character of the company. The 600-acre site consists both of high table land and low river land, its edges broken by wooded ravines. One of the broad ravines seemed the finest, most pleasant and most human site for the building complex. In such a tree-studded site, where it would be intimately connected with nature, a strong, dark building seemed appropriate.

Deere & Co. is a secure, well-established, successful farm machinery company, proud of its Midwestern farm-belt location. Farm machinery is not slick, shiny metal but forged iron and steel in big, forceful, functional shapes. The proper character for its headquarters' architecture should likewise not be a slick, precise, glittering glass and spindly metal building, but a building which is bold and direct, using metal in a strong, basic way.

Having decided to use steel, we wanted to make a steel building that was *really* a steel building (most so-called steel buildings seem to me to be more glass buildings than steel buildings, really not one thing or the other). We sought for an appropriate material—economical, maintenance free, bold in character, dark in color. We located a certain high tensile steel, which has a peculiar characteristic: if this steel is left unpainted, a rust coating forms which becomes a protective skin over the steel. This rust coating—which does not develop beyond a certain point—is a cinnamon-brown color which makes a beautiful dark surface on the steel. We built a full-size mock-up section of the façade on the site to make sure the steel would act as we had anticipated. It has. I predict other architects will use it widely.

The plan was determined both by the client's needs and

the site. The eight-storey administration building is placed crosswise on the floor of the valley. At its fourth floor level, glass-enclosed flying bridges stretch out to the laboratory and the exhibition buildings on the high slopes of the ravine. The complex is approached from the valley below. We planned the roads carefully, keeping in mind how the building would be seen as one drove along the man-made lake up to the parking lot behind the building and to the entrance.

Having selected a site because of the beauty of nature, we were especially anxious to take full advantage of views from the offices. To avoid curtains or Venetian blinds, which would obscure the views, we worked out a system of sun-shading with metal louvers and specified reflective glass to prevent glare. These louvers will cut out direct sun about ninety per cent of the time. We were not trying to ignore the fact that a sun problem will exist for some nice, sunny days in winter. I know the problem is there and one must face it. But we felt it was more important to retain the open quality of the design, which could be enjoyed *without* sun problems for ninety per cent of the year, than to sacrifice it for a small amount of time. We will solve the sun problem that will exist occasionally for some of the offices in winter in some positive but modest way.

Besides functioning as an efficient sun-shading device, the steel louvers dramatize the character of the building, which is one where we have tried to use steel to express strength. (p. 82)

.

As an airport, the Washington [**Dulles**] international airport is unique in many ways. It is unique in one way because it is the first commercial airport really to be planned from the start for the jet airplane.

No one asked us to grapple with the problem of a jet-age terminal beyond the question of pure architecture. But I believe the architect has to assume that kind of responsibility. Therefore, together with the team of Ammann & Whitney, engineers, Charles Landrum, airport consultant, and Burns & McDonnell, mechanical engineers, we decided to make a fundamental analysis of the whole problem of a large terminal for jet airplanes. It was a hard-boiled problem and we wanted to solve it in a hard-boiled way.

We sent out teams with counters and stop-watches to see what people really do at airports, how far they walk, their interchange problems. We analyzed special problems of jets, examined schedules, peak loads, effect of weather. We studied baggage handling, economics, methods of operations; and so on. We reduced this vast data to a series of about forty charts.

We found there were three very critical areas. One was the time and inconvenience of getting passengers to and from planes. We discovered the already tremendous distances passengers walk through terminals and the 'fingers' extending from them would become as nothing compared to the distances they would have to walk in jet terminals. Another critical area was the heavy cost of taxiing jet planes. A third consideration was the increasing need for greater possible flexibility in operations and servicing of aircraft.

We became convinced that some new method of passenger handling had to be found. The soundest system seemed to be one which brought the passenger to the plane rather than the plane to the passenger. We discarded the European bus system because it has inconveniences, and we did not want to take a negative step. Gradually, we arrived at the concept of the mobile lounge: a departure lounge on stilts and wheels, a part of the terminal which detaches itself from the building and travels out to wherever the plane is conveniently parked or serviced.

As we investigated further, we became convinced the mobile lounge was a logical solution to the critical problems. We were aware that, like any prototype vehicle, it would be expensive and might have 'bugs.' But we believed it a sound system. We think we have made a real contribution. The mobile lounge can have large application. It can be used in new terminals and it has obvious advantages for the economic, efficient expansion of existing ones.

After the Federal Aviation Agency accepted the idea, we had the formidable job of explaining or 'selling' it to many people within twelve air lines. We worked with Charles Eames, who did a marvelous job, to reduce our data and thinking to a short movie. Clear and exact communication with the client is always important.

This airport is unique in other ways, too. It is unique in being the national and international gateway to the nation's capital. It is unique in its ownership—the Federal Government. It is unique in being a part of the whole complex of buildings that create the image of our nation's capital. We felt the terminal should express all that in its architectural design.

The tradition of Federal architecture is static, but a jet-age airport should be essentially non-static, expressing the movement and the excitement of travel. We thought that if we could bring these two things together into a unified design we would have a very interesting building.

There was also the problem of the site—a beautiful flat plain. In a way, architecture is really placing something between earth and sky. We came to the conclusion that a strong form that seemed both to rise from the plain and to hover over it would look best. The horizontal element, or roof, would be the highest element. It should be tilted forward so the building would be seen. The terminal should also have a monumental scale in this landscape and in the vastness of this huge airfield.

The acceptance of the mobile lounge concept allowed us to make the terminal a single, compact building. We started with abstract ideal shapes for the site and went through many forms—things like a reverse staircase, pyramidal forms—and then many forms that would also work functionally. We wanted a high front covering arriving passengers, because many measly marquees 'rat up' a building. Gradually, we arrived at the idea of a curved roof, high in the front, lower in the middle, slightly higher at the back. It occurred to us that this could be a suspended roof. One had worried that a hanging roof might look heavy from underneath, but the **Ingalls Rink,** with its sweeping lightness, gave us courage to go to the hanging roof here.

This roof is supported by a row of columns forty feet apart on each side of the concourse, sixty-five feet high on the approach side, forty feet high on the field side. It is like a huge, continuous hammock suspended between concrete trees. It is made of light suspension-bridge cables between which concrete panels of the roof deck fit. The concrete piers are sloped outward to counteract the pull of the cables. But we exaggerated and dramatized this outward slope as well as the wide compressive flange at the rear of the columns to give the colonnade a dynamic and soaring look as well as a stately and dignified one.

But how should this strong, hovering form be placed on the site? How should it be seen from the plain? How should it look as one approached and arrived? The closer you come to some buildings, the less you see. On a functional basis, we had carefully worked out approach ramps on three levels. Esthetically, we realized we could make these ramps into a base for the terminal. Seen from the distance, as one drove down the access road and around the sunken parking lot, the building would seem to rise from this base and assert itself as a hovering form between earth and sky. Approaching closer and arriving, one would see the large colonnade. The control tower (whose form was arrived at after much study) was finally placed at the back of the terminal where it could be seen in changing and good relationships to the terminal from the access and approach roads.

We saw many other problems here as part of the architect's responsibility. There was the problem of the interiors. We felt these should convey the same special and distinctive character we tried to give the architecture itself. Instead of the honky-tonk, Klondike-like chaos of commercial space in most airports, all the interiors and commercial space should be thoughtfully organized to be dignified and attractive. Inside and outside should be all one thing. There was the problem of long-term landscaping, which was worked out with Dan Kiley. There was the crucial problem of disciplined, long-term, and imaginative zoning. Of special importance was the problem of some kind of continuing control in the terminal and its surroundings. We made proposals about these things which I hope will be carried out.

I don't think the terminal should be evaluated just as a work of art. I think we faced this job as an architect's problem in total relation to the present world. We tried to give a completely logical, imaginative, and responsible answer to that problem. I hope as such that we have done a good job.

I think this airport is the best thing I have done. I think it is going to be really good. Maybe it will even explain what I believe about architecture. (pp. 102-04)

Eero Saarinen, in Eero Saarinen on His Work, *edited by Aline B. Saarinen, revised edition, Yale University Press, 1968, 117 p.*



1937 Paris Exposition, but it is perhaps his "Forum" drawing that shows this most clearly. Done in competition for a commercial complex in downtown Helsinki, its taut transparency and curvilinear form recall Asplund's Paradise Restaurant at the 1930 Stockholm Exhibition. Both look back to work by Eric Mendelsohn (1887-1953) and suggest a kind of "Northern modernism," in which the underlying philosophy of European modernism was accepted, but its architectural expression modified by the incorporation of more diverse materials, textures, and shapes than were the norm for the major monuments of the International Style. It is a more personal, more flexible approach. This attitude is nowhere more apparent than in the work of Alvar Aalto (1894-1976), who had led Finland toward modernism in the late 1920s and who had begun to modify it by 1935.

Eero Saarinen returned to Cranbrook during the summer of 1936 and entered into practice with his father. During the next three years they produced a series of designs that . . . served as a point of departure for Eero's independent work. Those in the office at the time recall Eero's increasingly important role in the years prior to World War II, a role suggested by new elements in the designs produced.

The Institute of Science at Cranbrook, constructed from 1936 to 1937, indicates the direction of these designs. Its awkwardness as well as early date suggest that it was one of the very first such designs by the firm. The blocky, sharply articulated parts with flat roofs and simply cut openings resemble Eero's design for a police station that had won a mention at Yale in June 1932, a few months after Eliel had become involved in preliminary planning for the Institute. Also similar to the Institute and leading toward the . . . work of the later 1930s are the Community House in Fenton, Michigan (1937-38); the Civic Center project, Flint, Michigan (1937 ff.); and early designs for the music shed and related buildings of the Berkshire Music Center, Tanglewood, Massachusetts, begun in 1937. With its curved auditorium openly expressed as a major design element, the latter leads directly to the Kleinhans Music Hall.

In October 1938, Eliel and Eero Saarinen were commissioned to design the Kleinhans Music Hall in association with the Buffalo firm of F. J. and W. A. Kidd. Construction was underway by fall 1939, and the building was officially opened on October 12, 1940. The major elements of the building are clearly expressed on the exterior, with the curved shapes of the large auditorium and small chamber music hall joined to a two-story lobby between them. The massive exterior of the steel-framed structure is clad in a warm tan brick, lightened visually by thin concrete canopies that cantilever over the entrances and varied by the panels of buff Mankato stone that enclose the chamber hall. A reflecting pool, now filled in, originally surrounded this hall and enriched the composition by completing the curve of the auditorium at ground level. Inside, the strong, ship-like curves of the lobby and grand, simple sweep of the auditorium impart a sense of great calm. (pp. 62-5)

Concurrently with Kleinhans the Saarinens were working on the Crow Island School, Winnetka, Illinois. Again it was a collaborative effort, for they were associated with the Chicago firm of Perkins, Wheeler and Will, an office then recently established that received the commission on the condition that they entrust its design to a more experienced architect. Eliel Saarinen, a friend of Perkins' father, was the young firm's choice. Work began on the design early in 1938, construction in 1939, and the building was completed in 1940.

Even more than Kleinhans, the Crow Island design is conceived as a series of distinctly articulated parts, similar to such obvious parallels as the Bauhaus, Dessau (1925-26). It seems again to reflect Eero's presence, for it is quite unlike Eliel Saarinen's earlier, more visually cohesive designs and seems instead a direct reflection of attitudes expressed by Eero in Finland. The visual separateness of classroom units emphasizes their independent function, reinforcing educational philosophies advocated by Winnetka's Superintendant of Schools at the time, Carleton Washburne. Richard J. Neutra (1892-1970) had earlier pioneered in the design of such schools in America. Yet the low, spreading wings and grouped windows of Crow Island evoke a Wrightian feeling not unlike Kingswood. An early study in Eero's hand, with hipped roofs and overtly Wrightian details, confirms this link. Again, the tie was tenuous: discontinuous windows, blocky proportions, and an abbreviated overhang (reportedly cut to reduce costs) obscure the similarity. The tall pylon marking the entrance—in function a chimney—partly reestablishes the parallel. Its picturesque quality was criticized by [a leading exponent of the International school, Joseph] Hudnut.

The Tabernacle Church of Christ (now the First Christian Church) in Columbus, Indiana, commissioned while designs for Kleinhans and Crow Island were reaching completion, shows greater assurance. Eliel Saarinen was first contacted by members of the building committee in February 1939 after more conventional proposals by other architects had been rejected. He and Eero were given the commission in April of that year; construction began in the summer of 1940, and the church was dedicated on May 31, 1942. Its major components—sanctuary, offices, and educational wing—are placed in three clearly defined rectangular wings, the two along each side being connected by a third that is raised on columns and bridges across a sunken garden. The larger of the two side wings contains the sanctuary, its entrance emphasized by a tall, freestanding bell tower rising from the sunken court that originally contained a large reflecting pool. Earlier designs for a stepped tower, flared like the Kingswood columns, were revised to express a simpler statement of form. The treatment of the building masses with flat roofs and sharply cut openings, as well as the combination of warm tan brick with buff stone panels and trim, reinforce themes of Crow Island and Kleinhans. Cryptic geometric ornament on column and wall surfaces imparts an immediacy to the planar surfaces. While Eliel Saarinen avoided obvious iconography in much of his ornament, the angular shapes leading to the cross above the entrance seem meant to suggest its worldly setting, contrasting with the image within which the cross appears suspended in light, symbolic of resurrection. The asymmetrical composition of the sanc-

tuary reflects the elder Saarinen's urge toward the particu-
larization of space.

While the Columbus church seemed to lack immediate
precedents in America, it did follow an approach clearly
established by slightly earlier designs by Finnish architects
including Aalto and Erik Bryggmann (1891-1955), among
others. It seems certain that Eero was familiar with at least
some of these, for they had been published in Finnish peri-
odicals, and in a letter written from Finland he includes
sketches for a church that links Columbus with its Finnish
prototypes. Further, interior details including railings,
light fixtures, and wood screens closely resemble similar
designs by Aalto. Yet it is not simply a matter of direct
translation. Other details, including built-in seating and
fireplaces, recall work by Wright, and thus partly nation-
alize the design. Moreover, masonry textures and detailing
reflect the elder Saarinen's stablizing hand and establish
continuity with his earlier practice in America. (pp. 66-8)

Two designs produced at the same time as the Columbus
church—each for an art gallery—suggest emerging differ-
ences in the approaches of Eliel and Eero Saarinen. The
first, for the Smithsonian Gallery of Art, seems to have
been largely Eero's, while the second, for the Cranbrook
Academy of Art Museum and Library, seems more attrib-
utable to the elder Saarinen. In July 1939, the Saarinens'
Smithsonian design was declared winner of the first prize
in a national competition that had been initiated in Janu-
ary. Two earlier designs in which Eero's dominant role is
clearer are strikingly similar: the 1938 project for the
Wheaton College Art Center competition, submitted by
Eero alone, and the project for a theater at the College of
William and Mary, on which he collaborated with Ralph
Rapson and Frederic James. The latter, also submitted in
competition, won first prize in April 1939, and according
to Rapson its final form was due largely to Eero. Rapson's
first sketches, done independently, confirm the change
Eero brought to the design. Rapson also concurs that
Eero, not Eliel, was largely responsible for the Smithsoni-
an design.

The major components of the Smithsonian project were al-
most diagrammatically separated, as they had been in the
Columbus church, but with a changed attitude toward the
expression of mass. The main entrance led from the mall
through an open pavilion and foyer to the grand gallery
beyond, a one-story, loft-like space. A long passage also
led from one side of the vestibule to a theater at the south
end. Above the main block, an L-shaped element con-
tained offices and a library, with a long segment left open
to create a double-height space in the gallery below. A
large pool set within the wings was planned to contain a
sculpture by Carl Milles. The building, designed with
cladding of marble and glass slabs set in thin metal frames,
drew closer in appearance to the International Style than
had any earlier design by the Saarinen firm, for textural
effects were minimized and forms expressed as simply as
possible. The Saarinens now earned the approval of Hud-
nut, who served as professional advisor to the jury. Their
design was also praised by jury member Walter Gropius,
then teaching at Harvard and considered an even more
persuasive advocate of the International Style than Hud-

nut. This support signaled a recognition of modernism
that ultimately proved its undoing. The Saarinens' design
was criticized for its lack of cohesive unity, and for being
"too stylish." The controversy surrounding what would
have been the first clearly modern building on the mall led
to delays, and eventually the project was cancelled.

This level of criticism had not plagued the Saarinen office
in other commissions, nor had their work invited it. The
easier acceptance of their more traditional work again pre-
vailed in the Cranbrook Museum and Library. In its clas-
sical balance and solid monumentality, with reliance on
textured materials and surface ornament, it seems clearly,
at this date, to have been more Eliel's than Eero's. The
Cranbrook trustees had, in fact, asked Eliel Saarinen to
begin drafting the program for its design in 1937, though
actual planning does not seem to have begun before 1938,
and work continued through most of 1939. Construction
started in May 1940, and the building was essentially com-
pleted by late 1942. While it followed the general dictates
of his earlier master plan and continued to reflect his sensi-
tive integration of such related elements as pools and
sculpture, its manner contrasts with earlier Cranbrook
buildings and confirms Eliel Saarinen's acceptance of a
modern vocabulary. Yet it was still a compromise with
modernism that relied on the vocabulary much popular-
ized by the 1937 international exposition in Paris. Saari-
nen had visited that exposition and his design seems partly
inspired by the Musées d'Art Moderne, erected there as
a permanent monument. The grandly ceremonial propy-
laeum connecting the Museum and Library in Saarinen's
design also recalls Asplund's Woodland Crematorium,
Stockholm (1935-40), as well as still earlier work by Hoff-
mann.

During these years, from the fall of 1939 through Decem-
ber 1941, Eero taught at Cranbrook, appointed officially
as assistant to his father. Even before that time he had
taught informally, acting as design critic in the Cranbrook
studio. Eliel Saarinen's hope that his son would eventually
succeed him at Cranbrook was ended when [Cranbrook
founder and patron George G.] Booth terminated Eero's
appointment and asked the Saarinens to move their office
from Cranbrook premises. To Cranbrook students that in-
cluded Ralph Rapson and Harry Weese, Eero's presence
was important, partly because he seemed closer to recent
developments in the field. (pp. 68-70)

Eero Saarinen spent the war years working for the Office
of Strategic Services in Washington. He returned to
Bloomfield Hills in 1945 to rejoin his father, drawn by the
promise of a commission for the design of the **General
Motors Technical Center.** Different attitudes toward de-
sign within the firm continued to be apparent. In later
work that Eliel Saarinen directed in the office, he refined
the manner of designs dating from the late 1930s. (p. 71)

Eero's approach, as demonstrated by the Smithsonian
project, and even earlier by his 1938 entry for the Wheaton
Center, developed gradually into something quite differ-
ent. In his design for the **General Motors Technical Cen-
ter,** elements that had been connected in the Smithsonian
project disengage and spread across the landscape, creat-
ing a campus of independent parts unified by the vast pool

at the center. This project was underway by 1946 after a more ambitious scheme that he and his father worked on in the previous year had been set aside. Postwar material shortages delayed construction on the later scheme until 1949; the first buildings were completed by 1951, and the complex was essentially completed by 1956. It is Eero's most complete essay in modernism and obviously derives from the Illinois Institute of Technology, Chicago (1939-41 ff.) by Mies van der Rohe (1888-1969). Yet that vocabulary is modified by brightly glazed panels of brick and by an exaggerated emphasis on industrial materials. Pioneering developments in enameled panel and glass construction, structurally dramatic stairs designed in partnership with his office associates, and the very prominence of the domed auditorium and water tower suggest a fascination with traditional forms transformed by new building techniques. Eero's pursuit of new technologies as a means of architectural expression eventually led away from the more conservative forms advocated by his father, yet in his respect for structure and materials a sense of continuity is retained. There is also a sense of continuity in his belief that the integration of commissioned works of art was essential to modern design, signaled at **General Motors** by examples including Alexander Calder's fountain, Harry Bertoia's screen, and Antoine Pevsner's sculpture, *Bird in Flight.*

As work on **General Motors** was beginning, Eero collaborated with Charles Eames on two designs that were commissioned as part of the influential Case Study House series sponsored by *Arts and Architecture* magazine. This series was intended to elicit prototypical solutions for postwar houses, and those by Eames and Saarinen were among the first group announced in 1945: Number 8 for Charles and Ray Eames, and Number 9 for John Entenza, editor of *Arts and Architecture* and the guiding force behind the ambitious program. Both were conceived as open pavilions with geometrically clear boundaries. They relate not only to earlier designs by Mies van der Rohe, but also to California work by Rudolph M. Schindler (1887-1953) and Neutra. More immediately, both recall designs of the early 1940s by Eero Saarinen: the raised wing of his 1941 Bell house project anticipates the Eames house, as the open plan of his 1943 design for a prototypical house does the Entenza house. Curvilinear elements in Saarinen's 1943 design as well as radiating segments in the Entenza house also recall Rapson's and Runnells' 1939 Cave House project, and suggest a degree of interaction among the many talented designers who were together at Cranbrook in the late 1930s and early 1940s. (pp. 72-3)

Eero Saarinen and his associates realized aspects of [Charles and Ray Eames's] Wilder project in the **Miller house,** Columbus, Indiana (1953-57). It further extended the image of the Case Study houses and was intended, like houses by Eames, to provide a universal enclosure that would allow change within. The ease with which Alexander Girard's interior arrangements fit testifies to its success, and in its luxury of finish and quality of detail it is surely unsurpassed for its time. Eero had first proposed a raised pavilion located on a lower portion of the site, and next a house built partly underground. His final scheme—a simple pavilion supported on a regular grid of

steel columns—is placed within a landscaped setting that expands its architectural boundaries. Linear skylights delineate the column grid and relieve the ceiling plane of visible weight. They also transform the walls of thin marble or slate panels into translucent planes that seem themselves a source of light. Enclosed suites, located at each of the four corners in a pinwheel arrangement, reinforce the logic of the enclosure. In one important aspect it departs from comparable work by Eames, for the attention given to details is part of a passionate search for form that distinguishes Eero's later career. He sought associative meanings appropriate to a modern architecture, yet avoided specific historic references. For him such meanings must have seemed possible in the handling of such recognizable and essential elements as columns, which could be given rich yet timely meaning if transformed by new uses of materials and advanced building techniques. The welded steel column capitals of the **Miller house,** carefully detailed in a manner he approved, illustrate one instance of this.

Eero Saarinen's winning entry in the **Jefferson National Expansion Memorial** competition had earlier demonstrated his determination to find new meaning in the redefinition of traditional forms. . . . Many of the schemes included monumental arches. But the bold scale of Eero's stood apart, as did the ease with which it relegated to a minor position the museums and amphitheaters encouraged by the program. (pp. 77-9)

Although in certain ways problematic, the **M.I.T. Chapel** and **Auditorium** are even more prophetic of Eero's later career than his **Jefferson Arch.** They were commissioned in October 1950; construction on the **Auditorium** began in May 1953, and on the **Chapel** in May 1954; both were dedicated in May 1955. Saarinen conceived the **Auditorium** as a segment of a sphere, its concrete shell roof supported at three points and its walls largely glazed. By contrast the chapel is a windowless brick cylinder set within a moat, lit within by a single skylight and by light reflecting up through a glazed band at the perimeter of the undulating interior wall. The immediate precursor of the **Chapel** is Eliel Saarinen's 1947 project for a similar chapel at Stephens College, still being designed by the elder Saarinen at the time of his death in 1950. Both of these centralized chapels relate ultimately to Early Christian prototypes, and the connection may have been a conscious one. The varied shapes of the supporting arches in the **M.I.T. Chapel** also correspond in feeling to those in the entrance gate and elsewhere in the first buildings at Cranbrook, affirming continuity between father and son, as did the inclusion of sculpture. The screen by Harry Bertoia, animated by light, provides extraordinary interior focus. Theodore Roszak's spire, also integral to Saarinen's concept, seems less effective, perhaps diminished by the sculptural qualities of the building itself. Eero persisted in his quest for sculpture that might extend and strengthen architectural form, yet his own, larger creations remained dominant.

In the M.I.T. buildings Eero departed consciously from designs restricted primarily to rectangular shapes. Significantly he did not regard this as reacting against the work of such established modernists as Mies van der Rohe, but rather as being sympathetic to it for the choice of form

honored functional need and structure was honestly expressed. In seeking appropriate expression of function, he examined needs with the intent of selecting specific, observable shapes. He argued that a triangular shape offered the most appropriate plan for an auditorium, while a circle epitomized a timeless, non-denominational quality ideal for the **Chapel.** Its textured walls of brick related to existing M.I.T. buildings, expressing a sensitivity to setting that Eero also believed essential. In accordance with precepts of modern architecture as he interpreted them, he also felt obliged to examine forms made possible by new building techniques; his M.I.T. dome was one of the first examples in the United States to exploit the possibilities inherent in thin shell construction. Preliminary sketches for the **Auditorium** recall buildings in the first proposals made for General Motors in 1945 and anticipate such later designs as **Dulles International Airport.** In seeking variations of a fundamental sort, Saarinen was almost certainly aware of similar departures being made in that same period by such leading figures as Le Corbusier (1887-1965). A more immediate example was Aalto's Baker House dormitory (1946-49), adjacent to Eero's M.I.T. buildings. By joining an international shift toward a more varied modern architecture, Eero Saarinen embarked upon a demanding course that encouraged the invention of a new architectural vocabulary for each commission.

During the brief decade of his fully independent practice, Eero Saarinen's office received an extraordinary number of major commissions. Several of the resulting designs utilized relatively conventional framing and were developed for situations without the contextual restraints of an urban setting. In these designs, form was determined primarily by use, and Saarinen continued to explore various geometries. Among the best is the **Thomas J. Watson Research Center** for IBM, Yorktown, New York (1957-61). Its curved plan yielded advantages in office arrangement and provided visual relief within the 1000-foot-long corridor. The elegantly detailed, dark-tinted curtain wall is anchored to fieldstone elements at each end and along the inner face of the curve, providing a sense of fixed location. This and other complexes for major corporations—such as the **Bell Telephone Laboratories** at Holmdel, New Jersey (1957-62)—offered persuasive, influential models for suburban office complexes.

In situations restricted by a more constrained site, where architectural form was determined partly by the need to relate to adjoining buildings, Eero appeared less at ease. His allusions to architectural motifs of a more eclectic age seemed almost apologetic, as in the **Emma Hartman Noyes House,** Vassar College (1954-58), or the **Law School** at the University of Chicago (1956-60). Large numbers of design studies for the similarly restricted **U.S. Embassy** in London (1955-60) reflect an approach that Eero usually followed, with all possible alternates being reviewed as a means to a more perfect solution. Yet the focus of these studies on facade variations rather than volumetric concerns implies a certain degree of frustration. In other, later instances he achieved better results, as in the **Samuel F. B. Morse** and **Ezra Stiles Colleges,** Yale University (1958-62). There through texture and irregular form generated by a revived technique of poured stone

construction, Eero produced a picturesque and effective evocation of another age. The cohesiveness of related parts, and the care with which exterior areas were shaped, recall the spirit of Cranbrook itself.

In designs where form was determined largely by structure, Eero realized his greatest successes. In these he gave careful consideration to problems of use and setting as they affected design, but one senses an underlying stimulation that came from an expanded opportunity to sculpt space. Study models that he routinely used to record ideas were much employed in the development of these designs. Following the **M.I.T. Auditorium,** his next two major works exploring new structural systems were the **David S. Ingalls Hockey Rink** at Yale University (1956-58), and the **Trans World Airlines Terminal** at Idlewild (now J. F. Kennedy) Airport, New York (1956-62). In both, Eero believed the particular nature of the major function to be housed was best served by the visibly dramatic form he chose.

The **Ingalls Rink** was the first to be designed. Eero began with a concrete arch that could span the length of the rink without intermediate supports, honoring the oval shape of the rink itself. The suspended roof enriches the sense of curved form, its outer edge anchored to walls that are themselves curved in plan. Preliminary sketches show one of several variations, tried before the arch itself was lifted up at each end, its actual support partially concealed by entrance doors.

In the **TWA Terminal,** Eero sought an expression of flight itself. Comparisons are often made with expressionistic sketches done by Mendelsohn in the late teens and early 1920s that Eero may have seen as a valid statement of twentieth-century architecture, and one too long ignored. Any interpretation of Mendelsohn was surely encouraged by Joern Utzon's Sydney Opera House (completed 1973), a design strongly defended by Eero as a member of the jury for that competition. In America, the most immediate parallel was the more conventionally shaped Lambert Airport Terminal Building, St. Louis (1953-56), by the firm of Yamasaki, Leinweber, and Associates. Eero's terminal is far more personal and more complexly shaped, composed essentially of four sculpturally formed barrel vaults, each supported at two points and so balanced that the entire structure rests on only four Y-shaped columns. The sensuously formed interior generates a feeling of continuous motion that was without exact parallel, and the lack of scale-giving elements enhances the sculptural effect of the building, emphasizing a futuristic, machine-like quality that was no doubt intentional. It was a significant attempt at revised spatial definition, partly based, as were many of Eero's designs, on a subjective interpretation of structural technology.

Eero Saarinen's tragic death cut short his evolution as an architect. That he was moving toward a brilliant resolution of divergent forces is demonstrated by three late works: the **Deere & Company Administrative Center,** Moline, Illinois (1957-64); the **Dulles International Airport** near Washington, D.C. (1958-63); and the **Columbia Broadcasting System Headquarters,** New York City (1960-65). Each reflects a creative interpretation of func-

tion, place, material, and structure that is balanced by intelligent logic.

The **Deere Center** celebrated steel as no other building ever had. At first, Eero proposed an inverted pyramid, but next conceived the building as a bridge connecting two gentle hills. Interpreting an essential quality of the farm implement company the building was to serve, he developed an architecture of metal parts that was meant to honor machinery. These parts were shaped and connected with a sensitivity suggestive of Japanese wood detailing. Glazed walls were protected by exposed structure and by shading devices of the same material; these enhanced a permeable appearance. Characteristically seeking underutilized technologies, he specified steel that would protect itself by a layer of corrosion: its color and texture added extraordinary finish.

In **Dulles** more convincingly than in the **TWA Terminal,** Eero gave universally appreciable form to an airport, achieving for that new building type what Sullivan had managed for the skyscraper. Its success depended as much upon Eero's analysis of function as upon his intuitive grasp of structure, for his concept of a mobile lounge allowed the weakening complications of airport walkways to be eliminated, and thus justified a single form deserving monumental expression. It is a terminal as place, as essentially one building that is the anchor of movement rather than its imitator. Surpassing the more personal shapes of **TWA,** there is a visible logic to **Dulles'** regular structure. The smooth integration of its suspended canopy with lower terraces, and the dramatic accent of the control tower, recall aspects of Eliel Saarinen's Helsinki Railway Station: both architects grasped a potential inherent in buildings specific to their time. And with **Dulles,** as much as with any of his later designs, Eero Saarinen returned to an architectural concept of cohesively connected parts.

The **CBS Building** also balances the achievements of father and son, for the vertical rise of its expressive masonry supports realizes a potential inherent in the Tribune project of 1922. Eero's first schemes called for a sculptural frame that was to rise from a terrace located on a level below the street. He moved gradually toward his final scheme, a single, unbroken shaft that to him epitomized simplicity. It was not the simplicity of blank planes, but rather of a surface enriched through a logical manipulation of structure and services. Such pleated treatment can be found in German skyscrapers of the early 1920s, and has its roots in Expressionist towers. For Eero there were other justifications. It was New York's first major skyscraper to be built of reinforced concrete, and he celebrated its structural weight through the repeating pattern of partly hollow triangular piers. These imparted depth to the building's outer walls and the hollow upper portions provided spaces for mechanical services. The doubling of these piers at the corner sustained the logic of the alternating pattern, yet left unresolved the definition of the walls themselves. There is a certain nobility in the very lack of compromise.

Essentially, Eero Saarinen's approach was intelligently pragmatic rather than consciously intellectual. The symbolism of his buildings related to their immediate function

and was largely self-contained. He did not actively seek connections with broader intellectual currents in his work—such issues began to be reintroduced in America only in the late 1950s, beginning especially with the work of Louis I. Kahn (1901-74) and others in his circle. A major stimulus in the intellectualization of American architecture, the first section of Kahn's Alfred Newton Richards Medical Research Building at the University of Pennsylvania (1957-61) was only completed in the year of Eero's death. Yet before that time, Eero was an acknowledged leader among American architects seeking new architectural expressions appropriate to the 1950s. His office, its productive force guided by such valued associates as Kevin Roche, John Dinkeloo, and Joseph N. Lacy, attracted people of unusual talent. There they assisted Eero in his passionate search for form and witnessed his determined, often brilliant invention of new vocabularies for major commissions. That he sought new answers within the established framework of modern architecture, through exploitation of various materials and structural systems, is understandable. For in accepting the immediate past by problem solving rather than seeking to explore abstract concepts, he reinforced a belief in cultural continuity that is essential to an understanding of Cranbrook students' basic tie to a crafts tradition. That his invention of vocabularies within this framework could not be sustained at the level Eero demanded, nor its results appreciated without an extended period of development, was soon recognized. Robert Venturi, who worked in Saarinen's office from 1951 to 1953, and who later taught with Kahn at the University of Pennsylvania, was perhaps most articulate in calling for an architecture that established meaning through the manipulation and refinement of certain architectural details rather than whole building forms. Changing fashions led to critical evaluations of Saarinen's work that often overlooked his sincere efforts to arrive at just such details (as in the **Miller house**), but according to his own terms, and in an essentially modern rather than historic guise. (pp. 79-87)

David G. De Long, "Eliel Saarinen and the Cranbrook Tradition in Architecture and Urban Design," in Design in America: The Cranbrook Vision, 1925-1950 *by Joan Marter and others, Harry N. Abrams, Incorporated, 1983, pp. 47-89.*

SURVEY OF CRITICISM

Architectural Forum (essay date 1953)

[*In the following excerpt, the critic examines ways that Saarinen challenged conventional thinking about building shape and structure with his design of the Kresge Auditorium and Chapel at the Massachusetts Institute of Technology.*]

1. Is the conventional column-and-beam structure still the

most economical and practical way of enclosing a big space like an auditorium—as it has been to date in terms of the American building economy? Has the time come when a shell concrete dome will be just as cheap, more efficient and less wasteful of material and space—as it would be in Europe and South America?

2. Does a modern auditorium have to have the angular, wedge-shaped plan now considered "modern"? Is there a better way of bringing audience and speaker into more intimate contact?

3. Is there any reason why "polite" contemporary architecture should not throw off the straight jacket of T square and triangle and employ the daring forms of some modern industrial construction?

4. Does a chapel have to be oblong? Might not a cylindrical chapel give you a greater feeling of enclosure and, thus, a sense of security through religion?

5. Is there any reason why a chapel need have windows? Could it not be illuminated by light reflected through water as in the beautiful grottoes of Capri?

6. Is there really a fixed relationship between Form and Function—as Louis Sullivan declared? Have our building functions become so complex and our available building forms so numerous that any number of forms combined with any number of functions can produce an efficient building?

Saarinen's answers to these and other questions are incorporated in the [**Kresge Auditorium** and **Chapel**]. Like the answers MIT's scientists get from their laboratory experiments, Saarinen's buildings for MIT need to withstand a great many tests before they will be generally accepted. But regardless of whether or not each of his experiments is an unqualified success, American architecture and building are not likely to be quite the same after MIT's new center is finished.

The questions listed [above] make it very clear that Eero Saarinen and his associates have given MIT something more than a very handsome auditorium and a strange, haunting chapel, both set on a patterned platform. They have challenged current thinking and started some basic rethinking about architecture and building.

The auditorium is a wide departure from the more conventional shapes that the Saarinens had made familiar earlier in the Buffalo Kleinhans auditorium or in the Berkshire Music Sheds. It is a shell concrete dome, ⅛ of a sphere, supported at three points on heavy abutments, the dome cut away between these points for segmental window walls. A highly competent and recognized firm of engineers, Ammann & Whitney, is making the computations and is convinced that this auditorium will be at least competitive to the conventional "modern" auditorium shape in cost. MIT's own famed acoustical experts, Bolt, Beranek & Newman, are convinced that the acoustics can be solved not only adequately but with considerable grace. But there are deeper reasons why the dome became a dome. . . .

In the brick cylinder chapel Saarinen and his associates

have out-traditionalized today's traditionalists just as conclusively as they out-modernized today's modernists in using a dome instead of the familiar wedge shape for the auditorium. More specifically, the chapel is as timeless as the dome is timely. The architects used the cylindrical form and the masonry arch support for an emotional content associated with religion as far back as the temples of Vesta and beyond. The fact that the chapel depends on a moat of glittering water under the arches to bring in light instead of using windows, and the way it depends on light from above for a climax at the altar make it one of the most extraordinary religious buildings of our time.

Before getting into such details most readers will want to know how Saarinen came to these remarkable solutions. Was this simply an effort to be original or was there something deeper behind it?

To answer this, one would have to remark that Saarinen, a careful designer, has been weighing the MIT problem for a number of years, and that behind the originality lies some rather profound thinking about architectural fundamentals. Specifically, the two buildings on their platform represent an overhaul of Louis Sullivan's credo (which Sullivan phrased much more simply than he practiced) that "form follows function." To speak of the auditorium first, what we know as "modern" auditoriums had their structure derived as directly as possible out of the best knowledge of the twenties concerning sight lines and acoustics. The enclosure was designed as nearly as possible to fit these requirements like a glove, and "form following function" produced the unique "auditorium" shape with ordinary post-and-beam construction.

Saarinen's dome, however, is obviously not a special auditorium shape derived directly out of supposed auditorium functions. His dome is, on the contrary, a generalized kind of structural shape—the universal kind of shape which would span that kind of space with greatest economy of material regardless of whether the space were an auditorium, an exhibition building, or even a supermarket.

Obviously what Saarinen has done is to act as a matchmaker—matching a set of auditorium functions to a structural form chosen as a structural form. And in all marriages, the success depends upon two things: first, how well the partners were suited to one another, and second, how well they can adapt themselves to one another. In this case, on both scores the rating is high—especially since this particular auditorium requires no stagehouse.

But beyond its significance as a mating of function and form, this auditorium does something others have not attempted: it brings the graceful and fluid technology of airplane hangars and shopping centers into "polite" architecture—recently so dominated by the rigid rectangular forms of post-and-beam construction.

In the chapel the functional problem was more difficult.

Because religious architecture has not produced many original answers in the recent past, Saarinen had to find his own. They were: Here is a campus full of activity, excitement, bustle, noise. The chapel, surely, should be a retreat—a complete enclosure, quiet, dim, remote. How to

make it so? A solid wall around it, or even a moat? And the light should create a magic aura—not stained glass, but something out of Nature in an age of science.

The result—a solid brick cylinder resting on irregularly spaced arches that in turn stand in a moat filled with water! The light is reflected from the moat through the arches and into the chapel.

What could be a better symbol of an inner security attainable through religion? What could be better than this structure without time or place—and therefore of all times and places? What could be a better foil for the dome across the plaza?

The plaza is the third architectural element. It is not just what is left over after the rest has been built—it is a big, gregarious outdoor space, free from automobile traffic (there is a huge parking garage under the paved area). It is a big outdoor living room like the Piazza San Marco in Venice, the heart of the community.

For some years Eero Saarinen has wanted to break away from the rectangle (in the conviction that architecture should be more fluid).

His reasons, of course, were not only esthetic. After all, the shell is just about the strongest form you can get with the least amount of material. Higher erection cost somewhat offsets the material saving; but even in the US, with its high labor costs, the engineers think Saarinen's dome will be easily competitive in terms of cost with more conventional auditorium construction. (pp. 126-28)

The three-pronged dome does something else for the auditorium which the ordinary column-and-girder structure cannot do: After the latter is up, you still have to build side walls and put up a roof. In the MIT dome, there will be virtually no exterior walls left to build (except for the glass areas) once the shell is up. Say the engineers: "The more we work on this, the more sense it makes."

The dome (exactly ⅛ of a sphere) makes particular sense at MIT, for on this campus the dome shape is a repeated *motif* that helps pull together some of the otherwise unrelated buildings. It is particularly well suited to the *kind* of auditorium Saarinen wanted—a 1,200-seat hall in which there must be an intimate relationship between audience and performers or speakers.

That space is, in effect, created by a second bowl, this one containing the seats and platform. The result is a building that is like two cupped hands placed palm to palm. This graceful composition will be apparent from the outside of the building, for its exterior walls are all glass, leaving only the dome and the seating bowl as opaque forms resting on the circular, paved pedestal.

Says Saarinen: "There are two opposite poles of thinking on auditoriums. You have the concept developed by Le Corbusier in his League of Nations project. Here the auditorium was shaped according to the best knowledge of acoustics at the time. The structure followed the lines of this knowledge. In other words, all water was squeezed out of the mass. Now, actually, one ideal acoustical shape might be some kind of cone where the listener sits in the

pointed end of the cone. *But the ideal seating shapes for an auditorium tend to be the exact opposite.* There is an inherent conflict, no matter what you do. Actually, I don't think of it as a conflict because I think of acoustics more as a servant than a dictator. There is no ideal acoustical shape. There are millions of combinations of shapes that might add up to perfect acoustics—and one of them is the best answer to one particular problem."

Saarinen took advantage of the fact that today's acoustical treatment need not stick to the building shell—it could be hung.

"We found, however, that there was no need to put a hung ceiling under the *whole* dome to get the best reverberation and distribution of sound. Instead we only had to break up the ceiling partially with our 'floating clouds.' They are very useful in connection with the lighting and air conditioning as well, and they look nice, especially as you see them against the dome above."

Saarinen's "floating clouds" will be painted white to contrast with the grayish-blue dome above them—the dome forming a kind of night sky whose horizon you are aware of but cannot see. (pp. 128-29)

[Discussing the MIT chapel] Saarinen says that "religion today does not have the expanding optimism of the past and is sustained during this nonreligious period by the force of its traditions. In such a soil," he thinks, "new forms don't grow. Therefore, religious architecture as we find it today depends either on traditional forms—or else, on forms developed in residential and other architecture."

This meant that Saarinen and his collaborator, Bruce Adams, felt their problem to be twofold: first, the building had to be timeless—not of 1953, not of 1253, not of 53 A.D., but of no particular time and of no particular place (and consequently of all times and places). Second, they felt that the building had to be as unlike the rest of MIT as they could make it. The chapel had to be a quiet retreat, a place into which one could withdraw and in which one could contemplate and release the tensions of jet-propelled life in an Institute of Technology. So Saarinen and Adams went ahead and committed the greatest sin modernists could possibly commit: they designed something that had no relation at all to anything else done in this century and no relation at all to any inventions to be made in the next. They designed a brick tower, a cylinder which rests (in the Age of the Module) on arches irregularly spaced and irregularly shaped. These, in turn, stand in a circular moat. The light of the sun will be reflected from the rippling surface of the water, will bounce up from the water's surface and through the masonry arches, and wash across the wavy interior walls of the chapel in a mysterious and dim play of brightness and shade.

There is no way of describing the effect in graphic form. Those who have seen the grottoes on the Island of Capri may get some idea of the strangely fascinating glimmer of light which will permeate this chapel. To balance this mysterious light from below, the designers placed a circular skylight in the roof of the chapel to direct a shaft of dim light onto the altar. This light from above will have a very different character from the other: it will be strong-

er and sharply defined. For the designers stretched stainless steel wires from the periphery of the circular skylight to the periphery of the larger circular altar below. The wires will glisten in the light from above, will surround the altar with a semicircle of silvery rays. (p. 130)

The dome and the cylinder in Saarinen's design not only represent two extreme opposites in contemporary architecture; they also pose a pretty tough problem of architectural relationships.

It is relatively easy to relate a rounded form to an angular form (viz. Trilon and Perisphere); it is relatively easy to relate *three* freestanding forms (especially if the third is a tall tower, or something like it); finally, it is relatively easy to relate two forms of very different size but of similar shape.

Saarinen tried all of these ways. In his early sketches . . . there were times when (a) the chapel was rectangular and the auditorium the only rounded shape; when (b) there was a freestanding and very tall campanile off to the northeast of the auditorium entrance; and, finally, when (c) the chapel was made as a kind of "baby dome"—closely related to the "mother dome" of the auditorium, but very much smaller. All these were rejected.

The present scheme is about as difficult to solve as any that Saarinen could have picked for himself. He has *two* rounded forms; they are not very different in height; and the chapel (being round and massive) may, from some angles, look almost as big as the auditorium (which is almost triangular and light).

Here is how Saarinen overcame these problems: first, he used a low-slung, flat-roofed element as a link that almost connects the two buildings, contains some administrative offices and sheltered passages; second, he used scattered trees both to give the chapel a sheltered feeling, and to screen it slightly against the auditorium; and, finally and most importantly, he saw the plaza in relation to the surrounding campus buildings.

These buildings are quite tall. In future years, new and even taller buildings will be added to those existing today—including a long, eight-story building along the north side of the Saarinen plaza. This means, of course, that any vertical element in the plaza would have to be a little Eiffel Tower to count for anything at all on the campus as a whole—and, by that time, it would look ridiculous within the framework of the plaza.

So Saarinen developed his two buildings in a close and even intimate coherence, awaiting the arrival of the eight-story slab to the north to provide him with a plain backdrop on that side of his plaza. To the south, his long, flat-roofed element will define that boundary, while a screen of trees will stand between the plaza and the principal MIT buildings to the east.

MIT—the "laboratory college" whose fine reputation for foresight and vision was never more strikingly demonstrated—will need the plaza as a focus in a college community that has no real center to date. It is no accident that Saarinen solved this problem in a manner which many critics feel is his best effort to date, for this is to him the

most interesting architectural problem of our time. As he said recently: "Civilizations of the past seem to have placed a greater, almost spiritual value on architecture . . . is it not possible that architecture may, some day, play this higher role again?" (pp. 132-33)

"Saarinen Challenges the Rectangle," in Architectural Forum, *Vol. 98, No. 1, January, 1953, pp. 126-33.*

Saarinen outlines his four basic principles of modern architecture:

The basic principles of modern architecture that seem the most important and essential to me are these:

1. Each age must create its own architecture out of its own technology, and one which is expressive of its own Zeitgeist—the spirit of the time.

2. Functional integrity. In the Twenties there was an overemphasis on the principle of functionalism, that is, the belief that form could be found by strict adherence to function. This is seldom true, and we soon learned that functionalism was not and could not be the whole story. But the principle of functional integrity seems to be one of the keystone principles of modern architecture.

3. The structural principle. From as far back as I can remember in modern architecture, structural integrity and structural clarity were basic principles.

4. Recognition of the importance of space as a primary architectural element; a new sense of space becomes more important than mass.

These principles are not, of course, in themselves architecture. They are the moral code behind architecture—and a very good moral code at that. They allow an infinite number of expressions and out of them we can create beauty. They also suggest an infinite number of expansions: they can sustain a rich and growing vocabulary.

From Architectural Record, *August, 1954.*

Lawrence Lessing (essay date 1960)

[*In the following excerpt, Lessing examines Saarinen's working methods and approach to architectural design.*]

Among the younger architects who have risen with great speed and lift in the [1950s], Eero Saarinen is unquestionably of the first rank, the most controversial and hardest to place. As one spectacular building after another has emerged from his office, no two looking alike, criticism has mounted that Saarinen is "reaching" for effects, has "no fixed style," is "irresponsibly" adding to the riot of U. S. forms.

From the great rectilinear exercise of his **General Motors Technical Center** (1948-1956), probably the most influential industrial architecture of this era, Saarinen went on to mold the curvilinear, domed **M.I.T. Auditorium** (1955),

the first sophisticated use of shell construction in the U.S., and the swooping, cable-hung Yale hockey rink (1958), a great whale of a building set down in New Haven's genteel purlieus. Currently, the intricate concrete formwork of his "flying bird" **TWA [Terminal]** is startling transients at New York's Idlewild Airport, while his sedate new **U.S. Embassy** in London, elegantly fitted into a Georgian-style square, awaits dedication. Meanwhile, moving through Saarinen's busy office are four major projects, even more diverse in character.

At the center of this diversity is a stocky, calm, blue-eyed man, son of the late, noted Finnish Architect and Town Planner Eliel Saarinen, who at 50 has gone beyond his father in works accomplished. Easy mannered, lively, without "side," the younger Saarinen combines a puckish sense of humor with a driving competitive force, ambidextrous virtuosity with an intense seriousness about architecture. Below the diversity lies a cool rationale for an advancing architecture. To carry out this rationale, Saarinen has been building an organization for the practice of what he calls "responsible" architecture, unique in two ways. It is more oriented toward research than any architectural office of its kind, carrying on research from the original analysis of a client's problem through the testing of design solutions and materials—even to the development of new materials or components—down to the final execution. And this research in turn is used to engage the client in advancing architecture, by showing him how it more closely fits his needs.

"To the question, what is the scope of architecture," said Saarinen in accepting the Dickinson College Arts Award last spring, "I would answer, it is man's total physical surroundings, outdoors and indoors." He believes that the architect, by historical accident, is practicing in only a narrow segment of his full range, but that he may soon be called upon to widen his role and purpose, which ideally is to shelter and enhance man's life on earth.

In the same revealing speech, Saarinen analized the sources of his own diversity. Modern architecture was raised on three great pillars: functional integrity, honest expression of structure, and awareness of the times, especially the new potentials of science and industry. And these principles were raised to great heights by three diverse masters: Wright, LeCorbusier, and Mies van der Rohe. Their hegemony differed in different parts of the world, Corbu being strongest in the Latin countries and in concrete, while Mies's "marvelous discipline" in metal and glass came to dominate the heavily industrial U.S. In the exciting technological and emotional release following World War II, some younger architects refused to stop there. They refused to believe that all modern architecture—an airport, a skyscraper, a girl's dormitory—could be contained in the same rectilinear metal-and-glass jacket or "universal style" that Miesian purists were advocating, but that the future must remain open to the exploration of new forms and principles. Three additional pillars were raised: that a building must make an expressive statement, that it must be concerned with site and environment, and that it must express itself throughout as a unity.

Saarinen was aligned with this new generation from the

start, for he had imbibed from his eclectic father a strong resistance to being trapped by a style. "I believe," he said at Dickinson College,

> that all six principles have to be included to create real architecture and so I try to practice what I preach. The inclusion of the last three inevitably creates a diversity of solutions, and thereby the external form of my work varies greatly. But inside the solution of every problem there are six threads that hold it together, and these six threads—or was it pillars I was calling them—join each building I have done to every other one.

The problem of style, oscillating between petrifaction and undisciplined chaos, is eternal. But the greater danger today, in an age of transition and of continuing dynamic development in science and technology, is that modern architecture may be prematurely frozen before realizing its full potentials. One of the most obvious potentials to Saarinen is concrete, only the surface of which has been scratched so far in research, prefabrication, and "a whole new form world" for architecture. Many architectural firms maintain at best only an uneasy, arm's length truce with technology. But in Saarinen's office, technology is wrestled with on the bare floor to seek understanding and use of its great potentials. (p. 95)

Few younger architects have initiated and developed more new materials and ideas than Eero Saarinen and Associates. This deep concern with industrial materials and processes was once a vital part of the modern movement, weakened today by advocacy of a single set of materials and overdependency on stock catalogues. Yet the building industry cannot be depended on for original developments. Many of the developments . . . were secured outside the building industry, often after having been turned down by its largest units. Generally, Saarinen finds, the larger the company, the less it will risk on a new idea. He does not claim any of these ideas as wholly original, and has never tried to patent or exploit them, but many have become flourishing businesses for others. (p. 102)

The introduction of new materials and concepts, Saarinen believes, imposes on the architect the major responsibility of making sure that they work. Hence his obsession with research and exhaustive testing of each new idea, form, or material in models, mock-ups, or controlled experiments. . . .

Mistakes sometimes occur in this difficult forward area—to the cawing delight of critics who like to confuse science with omniscience—but every technological problem contains, in the hard-working methods of science, its own ultimate solution or correction. For instance, the **M.I.T. Auditorium** roof began to leak under a new, acrylic plastic coating, lacking in weathering experience, but this was solved on the Yale hockey rink roof by developing a superior neoprene rubber sheet roofing, while new polyvinyl compounds are coming along which will be used on the TWA terminal shells, where a transparent sealant is required to show the concrete.

The ultimate test is whether a building works. And in this respect Saarinen's buildings rank high, the Yale hockey

rink being pronounced by players and spectators alike a superb sports arena, the **M.I.T. Auditorium** being much sought after by performers for high-fidelity recording sessions because of its acoustic quality.

Esthetic judgments are harder to arrive at. "I believe," says Kevin Roche, with some bias, "that this firm in 30 years will have done the most significant work in the country in expressing the finest relationship between architecture and society. We have the secret of growth. Whereas those who come up against the stone wall of a single form are stuck with it, our approach has unlimited possibilities." That, at least, expresses the Saarinen pride in and philosophy of architecture as a continuing development.

Certainly the more intense critics of this position have little basis for their odd theory that somehow something went wrong with Saarinen after the **G.M. Technical Center,** since much of his work is still outstandingly in that idiom. Moreover, some of the extreme criticism has that high irrational pitch that invariably greets innovation and new forms, while other tones reveal a plain desire to rest on the plateau of a tried form, endlessly refining it, rather than to make the strenuous effort that is required to develop or understand new ones.

On the other hand, diversity in architecture has the ever present danger of excess, while experimentalism daily courts disaster. Saarinen would be the last to deny that some of his bold excursions have been less successful than others. Moreover, there is a strain of now-native American exhibitionism in him, presaged in his 1949 design for a river-front national park memorial in St. Louis, to be completed in 1964, which has as its centerpiece a giant, Paul Bunyanesque arch, 630 feet high in stainless steel, symbolizing the Gateway to the West. (For this arch, Saarinen is carefully exploring mathematical formulae to get the most perfect catenary curve possible, and a new type of elevator to get people to the top of it.) And running through his later works, particularly the new **TWA Terminal,** the Yale [**Ezra Stiles** and **Samuel F. B. Morse**] colleges, and the **John Deere** project, is a new strain of exaggeration, off-beat rhythms, bold underlining of elements and materials, which seems to be in that line of avant-garde development called, for want of a better term, the new brutalism, yet with a lyric and internal harmony that is Saarinen's stamp. This new strain in architecture is still too much in flux for cool judgment, and it is probably a correct assessment that it will take the better part of another decade to see Saarinen's work in perspective in all its relationships between architecture and society.

Meanwhile, it is salutary to have a man of large talents and integrity striving to enlarge the vocabulary of architecture to meet the multiple, fast-changing problems of the age. (p. 103)

> Lawrence Lessing, "The Diversity of Eero Saarinen," in Architectural Forum, *Vol. 113, No. 1, July, 1960, pp. 94-103.*

Charles Eames (essay date 1971)

[*Eames was an American architect and furniture and interior designer best known for the series of chairs he designed over a period of thirty years, beginning with chairs and couches of molded plywood and plastic created in conjunction with Saarinen in 1940. In the following essay, Eames discusses Saarinen's problem-solving approach to architectural design.*]

Twenty-five years ago, the electronic computer was just emerging as the tool we know today; the systematic problem-solving strategies developed in World War II were being reapplied in peacetime science and production; and—for these and other reasons—large-scale industry was beginning to shed its brute-force, Industrial Revolution image in favor of a more sophisticated and responsive one.

A major industrial company, for the first time, was setting out to build a campus-type complex of technical buildings whose high architectural quality was to express a promise about the company's role in the future.

Alfred P. Sloane was Chairman of the Board, Charles Kettering was Director Emeritus of Research, and Harley Earle was Director of Styling, when General Motors commissioned Eliel Saarinen as architect of its **Technical Center.** Eliel, in association with his son Eero, did design a first version; but the second version—three years later—and its subsequent development were the work of Eero, with the critical support and stringent conscience of his father.

In the course of the General Motors job, Eero learned to smoke cigars, but he learned a great deal more besides. He had already a practical instinct for problem-solving methods of a kind which in a formal version would be called operations research. He had an intuitive grasp of the branching structure of alternative strategies; if instinct or evidence suggested, he wouldn't hesitate to go back down the tree and start along another route—keeping the effort invested up to that point only as background and experience.

Much of this can be traced back to the fact that he was perhaps the most natural architectural *competitor* that ever lived; he spent his childhood in an atmosphere of disciplined architectural competition, he was educated in competitions. He formalized his competition-winning methods to the point of inventing his own matrix schema, based on exhaustive lists of variables, which he would apply to decisions in all departments of life; the desire to carry off the prize was giving way to a passion for finding the best of all possible solutions.

In this intense optimizing mode, Eero's interaction with a generous mix of systems-oriented engineers produced a remarkable architectural result, and had a lasting effect on the work of the Saarinen office.

Industrial research vocabulary and procedures accorded in many ways with Eero's fondness for testing by models, both abstract and concrete; innovative building elements were tested at full scale, in real conditions, over time. Energy and experience from each stage of construction were fed back to the successive ones, to upgrade the details and materials. Surface finishes were changed and changed again; aluminum glazing strips gave way to precisely de-

tailed neoprene gaskets, as the same new techniques were incorporated in GM's assembly lines. From the beginning, the 5' grid governed not only the plan and structure but the mechanical services, lighting and movable fittings as well; the modular principle, so often taken only as an esthetic guideline, was applied with unprecedented operational thoroughness.

By the time the center was completed, Eero had become a master of the feedback principle; he had found confirmation of his natural commitment to systems, but he didn't narrow it to technical applications. He retained from then on the capacity to sit down and really communicate with engineers and businessmen.

In the work that followed, Eero intensified his pursuit of the concept and the structure peculiarly appropriate to each particular problem. It is this consistent attitude that gives continuity to Eero's architecture; each building is in effect a model of the particular problem it seeks to answer. Both Kevin Roche and John Dinkeloo joined the Saarinen office just at the time that the first of the GM buildings was going into construction. They have succeeded in carrying on this continuity—perhaps because it is a legacy of concept and procedure, rather than of form.

If you consider the buildings together—

GM Technical Center	**Bell Telephone**
Kresge Auditorium at	**Laboratories**
M.I.T.	**C.B.S. Building**
St. Louis Gateway Arch	**Oakland Museum**
TWA Terminal	**Ford Foundation**
Dulles Airport	**Knights of Columbus**
John Deere & Co.	**New Haven**
Center	**Coliseum**

—what they have in common becomes apparent. Each building is a model of its special problem; and Eero's "shortcut" to the model was simply that he put more energy and time into clarifying the unique nature of each problem than anyone else had even thought of doing. And the process was remarkably free from preconceptions; he was always open to new concepts, yet constantly on guard to protect existing concepts from erosion.

It isn't an approach that makes the practice of architecture any easier; but in a time when the latitude of choice threatens to overwhelm us, it seems to be our best bet for improving the state of things. (pp. 23-7)

> *Charles Eames, "General Motors Revisited,"*
> in Architectural Forum, *Vol. 134, No. 5, June,*
> *1971, pp. 21-7.*

George McCue (essay date 1978)

[*McCue, an American writer and historian who has written extensively on American architecture and city planning, is the author of several studies of St. Louis architecture. In the following excerpt, he provides a history and appreciation of the Jefferson National Expansion Memorial and the Gateway Arch.*]

The tall blond graduate student in economics from Amsterdam tilted her head far back to focus her Japanese camera on the towering, shimmering symbol of the American West done by a Finnish architect. She moved to another position to catch an almost blinding highlight that flashed from near the stainless steel summit. Then she took a picture of two companions, with the base of the monument as background. Then she walked close to the mirror-like surface, and looked at it intently. Then she gave it a light pat, and stroked it with her open hand.

If there were a choreography for something like "Afternoon at the Gateway Arch," these would be its opening passages. Of the 3.5 million persons from most parts of the world who visit Eero Saarinen's monument at St. Louis every year, few seem able to walk past its gleaming triangular bases without administering what the arch's custodians call The Touch.

"I like to try to see how structures are put together, and I looked at the Eiffel Tower for a long time. But I'll have to ask somebody about the gateway arch, because it's all under that beautiful skin." This was a building contractor from San Diego. He took the pictures; he patted the beautiful skin and stroked the finely crafted welded seams, and finally he rapped it with a knuckle. He was rapping a quarter inch of stainless steel plate, enclosing three feet of concrete lined with three-eighths inch of structural steel plate, all tied together with a thick lattice of rods and bolts. Men almost always test the arch with their knuckles, and they always seem pleased, even surprised, at its solidity.

The Touch may be partly a ritual gesture of respect (and, after long association, of affection), but it seems that this contact sometimes may be made to confirm that the arch is really there, a substantial, dependable vision that Saarinen confidently asserted could endure for a thousand years, and not like a rainbow that can be verified by the eyes but never by the fingertips.

The **Gateway Arch** has its moments of ephemerality, despite all that structural thickness, and despite its being 630 feet tall and 630 feet between the points where the legs spring from the ground and soar skyward to be joined high above the city. In the river mist of early morning the arch appears to have become partly dissolved overnight, and its upper structure fades in and out of the gray atmosphere. With an overcast there is no shiny finish. The polished steel takes on the character of the ambient light, so a dull day makes the arch as impassive as a piece of neglected pewter, although its form can make a forceful dark silhouette when the ceiling lifts. On a bright day there is another condition that gives cause for wonder whether the arch is really permanent. On the side hit by the sun, the surface becomes crinkly, like reused kitchen foil. The thick, hard stainless steel ripples under the stresses of expansion and contraction as one huge surface warms up, while the two shaded sides remain cool. It was this pushing and pulling of the structure by solar action that made it necessary, during construction, to make the transit measurements at night.

The vision had a long, difficult gestation. It has been 43 years since the riverfront blocks of the original village of St. Louis were designated a national historic site by President Franklin D. Roosevelt. In its entirety, this is the **Jef-**

ferson National Expansion Memorial, and from the outset the intention was to have a monumental image as its dominant feature.

In the somewhat monumental language of its inception, the project was conceived to provide "an appropriate national memorial to those persons who made possible the territorial expansion of the United States, including President Thomas Jefferson and his aides, Livingston and Monroe, who negotiated the Louisiana Purchase, the great explorers, Lewis and Clark, and the hardy hunters, trappers, frontiersmen, pioneers and others who contributed to such expansion."

The two-stage design competition, with 172 first-stage entries and five finalists, was concluded 30 years ago, on Feb. 17, 1948, with the award to Saarinen by unanimous vote on the first ballot. The jury's evaluation of the design was that "it tends to have the inevitable quality of a right solution. . . . The memorial structure is of that high order which will rank it among the nation's greatest monuments."

Thirteen years remained to Saarinen, in which to refine his scheme. In those years he did all the other 27 commissions that constitute the major body of his work. Ten of these were yet to be completed when he died on Sept. 1, 1961, at the age of 51. At that time excavation for the gateway

Jefferson National Expansion Memorial (1965).

arch foundations was still in progress. The arch, said Aline Saarinen at topping-out ceremonies in 1965, "was the climax of my husband's career—the thing that meant most to him."

Saarinen was 37 when he won the St. Louis competition. Most of his previous work had been in collaboration with his noted father, Eliel Saarinen, and his own record of independent architecture consisted of the Music Tent at Aspen, Colo., and two experimental projects—a community center and an "unfolding" house—developed as models. But he was seasoned in large conceptions, and fully equal to the challenges that the St. Louis project presented in the scale of the area to be designed, and the magnitude of its exceedingly troublesome physical obstacles, chief of which was an elevated double railroad track from the 1880s on a scaley structure 25 feet high along Wharf Street, just inside the east line of the memorial area. A single track lay, and still does, in the middle of Wharf Street, city property.

The contestants were conducted to the quicksands with the bleached bones of 25 or more riverfront design proposals put forth since the 1890s. St. Louis has a historic urge to prove that it has not really turned its back on the river that gave it life. After Eads Bridge was completed in 1874, making the city a railroad center and accelerating the steamboat's demise, the business core began moving away from the levee. The buildings were continued in service as warehouses for furs, feathers and wool, with a scattering of goulash restaurants, bars and other picturesque low-pressure enterprises. All these buildings dated from about the same period, the years soon after the great fire of 1849 burned out everything in the old town area except the 1834 Old Cathedral and the Manuel Lisa Warehouse, a two-story stone building of 1818, last survivor of the early village. Much of the rebuilding availed itself of the new technology of iron-front construction.

As this area declined, plans proliferated for endowing it with profitable new life. There were projects calling for business and residential towers, and for sports arenas, railroad terminals, airplane landing strips, continuous warehousing for the length of the area with rooftop parking all the way, and for vast neoclassic and Beaux-Arts promenade compositions of fountains, museums, statuary and river overlooks. All these attempted to combine revenue-producing function and civic art. The white-city evocations inspired by the world fairs of 1893 and 1904 wistfully ignored the harsh reality of the coal smoke that poured from switch engines, industrial plants and house chimneys, often darkening the city until midmorning, encrusting the noblest buildings with grime and sending residents to the suburbs. With all their variety of forms and uses, they had one thing in common—the stumble over the elevated tracks. The pervasive treatment was to wall in the tracks with arcaded masonry up to a promenade deck at the same level as Third Street, with ramps to the levee.

Some of these efforts and their frustrations were still in the public memory at the time of the competition, and any misgivings about the possibilities of still another go at the riverfront were reasonable. But this time the circumstances were much more productive. (pp. 57-60)

Saarinen's first-stage perspective showed a four-sided arch close to the levee, with sculptures and murals in an arcade running parallel with the arch and extending beyond the bases. On the East St. Louis side of the river, today still a wasteland of railroad tracks, highway ramps and vacant ground, he drew a landscaped area with stadium, playing fields and boat basins. (p. 60)

In his second-stage design, Saarinen made the arch an equilateral triangle in section, with an exquisitely refined taper as it rose in an inverted catenary form. He kept it near the levee, within a few feet of the strip from which the elevated tracks were to be removed. The arch's north leg was placed north of the Lisa Warehouse, which was to serve as entrance to an underground loading platform for the arch elevator. A river overlook housing a railroad museum was at the northeast corner of the site, and a second overlook with river museum at the southeast corner, both with restaurants. A museum for the architectural relics was at the southwest corner, and near the wooded north end were a frontier village reconstruction, a tea pavilion and a campfire theater—the latter standard in national parks. [Landscape architect Dan] Kiley's landscaping covered most of the area with trees, and provided a gentle upward slope from the levee, to extend beneath the arch, past the sculpture arcade and to the future expressway at Third Street.

The track relocation became a stone-wall controversy involving the railroads, the city and government agencies, and it almost killed the project. It was resolved in 1957, after the St. Louis Chapter/AIA, then headed by Eugene Mackey, prepared a questionnaire and survey directed at bringing the issues into focus. This was turned over to Mayor Raymond R. Tucker, an engineer, who achieved, with editorial pressure by the *Post-Dispatch* and *Globe-Democrat*—a compromise solution: The tracks were moved inland a few feet, to pass through cuts and tunnels concealed in a hillside. The slope to the river was destroyed, and the topography reversed to place the arch on an embankment to be built high above the levee, with the slope now gently downward toward Third Street and precipitous at the levee. The new track route crossed the rear of the Lisa Warehouse, which had been painstakingly restored, so it was torn down. The few rocks identifiable as original to its walls were marked and piled in the Old Courthouse basement, for the day when the warehouse might be reconstructed somewhere—a fractional residue for a remote possibility. The new bridge and its highway approaches at Poplar Street, the site's south boundary, took from the memorial 15 acres that had included the architecture and river museums, the south overlook and the larger of two parking lots.

With some of the crucial "givens" of the program a shambles, Saarinen reworked his entire concept. The arch was moved west to about the site of the sculpture arcade but high above it on the new embankment, for which he designed monumental steps. Instead of a small underground space for elevator loading, he carved out a subterranean visitor center for the entire distance between the legs, to include a pair of small theaters, with entrance by inward-sloping ramps.

Only the two river overlooks remained from the competition scheme's surface features. The sculpture arcade, museums, restaurants, village, tea garden and campfire theater: all abandoned. But the new position made the arch more prominent, and reinforced its axial relationship with the Old Courthouse and a mall to be extended westward on the same axis. . . . The strengthened association with downtown was at the sacrifice of association with the river—the old turned back again—which now cannot be seen from the base of the arch or from anywhere in the memorial site but the edge of the embankment. (pp. 60-1)

The arch rose steadily during three years and four months, with spectacular precision. Like Eads Bridge, it was a unique structural invention. MacDonald Construction Co. was the prime contractor for the entire development, including track relocation. The steel was prefabricated in sections 12 feet high and erected by Pittsburgh-Des Moines Steel Co.

With Saarinen partner John Dinkeloo in charge of engineering, the great structure was rooted in bedrock, and the form that looks so slender from a distance is 54 feet from corner to corner of its three sides. For the first 300 feet of rise, the legs were weighted with concrete, poured between the outer stainless steel and the structural steel lining, three feet thick at the base and tapering to one foot. It is post-tensioned with 252 bars, 1 and a quarter inches in diameter, loaded to 71 tons by hydraulic jacks. Some 170 bars extend to the top of the concrete mass, and the others were terminated and stressed at intervals during the pour. Additional compression on the concrete is provided by thousands of lateral bolts, tightened by hand. For the rest of its height, the structure is stiffened by crossbracing within the steel walls, which taper to 7 and a half inches thickness at the top. In each leg, there is a service stairway and a train of eight capsules, each capsule seating five visitors knee-to-knee in a semicircle. At the summit, they walk up a short distance to rows of slit windows. There is one more step in altitude, for access to the red aircraft warning light, serviced by climbing out through a hatch and standing on top of the world's most awesome man-made slippery slide.

The entrance ramps, open to the sky, are efficient catch basins for rain. Five drain channels cross each ramp, but one cloudburst overloaded the drains, with some water build-up outside the glass entrance doors. The drains were enlarged by Ted Rennison, who came to the project in 1961 as a Saarinen engineer, and remained with park service.

Saarinen's concept had not included a facility for interpretation of the history of the westward expansion. In 1960, when construction was about to begin, George B. Hartzog Jr., then the National Park Service superintendent at St. Louis, arranged for Saarinen to add space for a museum in the underground area. This roughed-in cavern, 290 × 150 feet, 20 feet from dirt floor to concrete ceiling supported by a grid of 40 columns on 30-foot centers, was closed for 10 years.

Then Hartzog, having advanced to director of the National Park Service, selected Aram Mardirosian and his Potomac Group to design and finish the museum, in collabora-

tion with contract manager Frank Phillips, an NPS veteran who directed construction, installation of exhibits and quality control. The museum, ranked by the park service as its biggest and best, was opened in 1976.

A few pieces of sculpture related to the expansion theme are in the museum, and it is hard to see the loss of the surface arcade as anything but a benefit, like absence of the tea house and campfire theater. As Aline Saarinen said at the topping out, "You can't use sculpture in the ordinary sense because of the vast scale. My husband loved the Old Courthouse, a building of great authority and beauty and conceived it as part of his design. The Old Courthouse *is* sculpture in relation to the arch." (pp. 61-2)

There is abundant evidence that the **Gateway Arch** has grown in the national consciousness as a pre-eminent symbol and memorable image, for which the sacrifices were well spent. For those of the St. Louis region it stands as a resplendent vision, visible for more than 30 miles from Illinois hilltops and highways. On the Missouri side, more hilly terrain limits the viewing distance to 15 miles or so on clear days, when it is revealed by a sudden flashing of the sun from the summit curve. Within the city, the experience of discovering and rediscovering the arch is varied considerably by one's location. It dominates the skyline from several expressway approaches, but drops from view at closer range when tall buildings intervene. Then, across the roof of a warehouse, or at the end of a row of alleys, or high above industrial chimneys, suddenly there it is. The unexpectedness of these far-and-near glimpses is the most exciting part of the viewing experience for those who live with the arch, and who can savor its endless variety from day to day. There was a time when floodlighting was considered. Thankfully, this idea was left swinging slowly in the wind. The response of the gleaming finish to the light that bathes it is one of the special delights at night, when stray colors from downtown sources race along its crisp edges or tint parts of its surface. Sometimes a towboat searchlight will strike a blaze near its base. And under a full moon it glows with an unearthly luminosity that is worth the trip from anywhere to see. The towering form reads distinctly from a passing plane, and its gateway symbolism becomes even more far-reaching from such a height.

The **Arch** contributed to a renewed sense of civic identity that seemed dissipated after removal of the wondrously visionary Louisiana Purchase Exposition, produced with prodigious effort in Forest Park so long ago. Its economic effects are more measureable, in the revival of downtown investment and a new stir of street life, especially along the levee and in Laclede's Landing, the nine-block remnant of the city's first street pattern, cobblestones and all, immediately north of the memorial. Its sturdy warehouses, similar to those demolished, are found to be readily adaptible to restaurants, offices, studios, galleries and apartments.

"The impact of the **Gateway Arch** has been enormous," said Edward A. Ruesing, executive director of Downtown St. Louis, Inc. "One has to recall that in the '50s the project had many detractors who thought parking was the highest and best use of the cleared blocks. What was seen by some as a nonutilitarian monument is the main reason

for millions of dollars in downtown improvements, and for St. Louis's need for the 2,000 new hotel rooms it has gained since 1975. This would not have come about without the **Arch** momentum, which has made tourism a growth industry here." (p. 62)

> *George McCue, "The Arch: An Appreciation,"*
> *in* AIA Journal, *Vol. 67, No. 13, November,*
> *1978, pp. 57-63.*

Saarinen on the design principles of his pedestal furniture:

I've been wanting to clear up the slum of legs in our rooms for many years, and to create a restful atmosphere. I tried to think what would look best in a room instead of the ugly clutter of cages and legs going in different directions. The single pedestal seemed the answer.

I wanted to make the chair *all one thing again.* All the great furniture of the past, from Tutankhamen's chair to Thomas Chippendale's have always been a structural total. They belong to the post-and-lintel furniture of the wood era.

Legs became a sort of metal plumbing. Modern chairs with shell shapes and cages of "little sticks" below mix different kinds of structures. The pedestal chair tries to bring unity of line.

From Arts & Architecture, *July, 1957.*

Andrea O. Dean (essay date 1981)

[*In the following essay, Dean offers a retrospective assessment of Saarinen's work and the scope of his influence, including commentary from his associates and contemporaries.*]

During his lifetime, Eero Saarinen absorbed more punishment from critics than any other prominent architect of his generation. At a time when consistency of style and stylistic development were expected, Saarinen's unpredictability and bold diversity annoyed, even angered, many of his contemporaries. His **General Motors Technical Center** in Detroit (1956) was a vast Miesian ensemble dubbed "the industrial Versailles" by *Architectural Forum,* while **Concordia Senior College,** Fort Wayne, Ind., (1958) was, in contrast, a modest, almost vernacular-looking complex. **Kresge Auditorium** at MIT (1955), a domed, concrete structure, was very sculptural, as was the adjacent chapel, a brick cylinder with arches of varying sizes; the **U.S. Chancellery Building,** London (1959), would today be called contextual. The **Ingalls Hockey Rink** at Yale (1959), the **TWA [Terminal]** at JFK airport (1962) and **Dulles** (1962) were highly expressive, exuberant buildings, while the **CBS [Headquarters]** in New York City (1964) was a dark and brooding minimalist statement. Saarinen's work, wrote Vincent Scully in 1969, "embodied a good deal that was wrong with American architecture in the mid-'50s: exhibitionism, structural pretension, self-defeating urbanistic arrogance."

It is 20 years now since Saarinen died of a brain tumor at the age of 51, "struck down just as he reached the staircase," as Walter McQuade wrote in memoriam [see Further Reading, Section III]. Since Saarinen's death, there has been an odd silence on the subject of his life, work and influence. It seems time, then, to record some opinions of critics, historians and architects who knew Saarinen well.

No other architect in memory has had as distinguished and varied a succession as Saarinen. As heirs to the office, the firm of Kevin Roche, John Dinkeloo & Associates has faithfully added to the legacy it inherited by designing some of the nation's most innovative and spectacular buildings. In addition, an astonishing number of today's most prominent and influential architects spent time under Saarinen's tutelage and later developed in highly individual ways. Among them are Cesar Pelli, Charles Bassett, Gunnar Birkerts, Paul Kennon, Robert Burley, Warren Platner, Anthony Lumsden, Robert Venturi. How account for what has been called "the Saarinen spawn?"

Though a relentless achiever, Saarinen was, perhaps, better able than other famous architects to tolerate and even encourage a succession because he himself was a successor, on the one hand to his famous architect father, Eliel Saarinen, on the other, to the first generation of modern architecture's pioneers. Historian David De Long . . . points out that in the 1950s "when young architects looked around for innovative designers to work for they saw Mies and Wright, who were very old, rather fixed in their ways and dealing with vocabularies that didn't seem to point toward a new future. Eero Saarinen's seemed the most exciting office." Louis Kahn hadn't yet surfaced as a charismatic innovator, the large architectural firms were just beginning to emerge and, like Skidmore, most stood for a specific approach. The Saarinen office with its large, exciting commissions was, therefore, most appealing to young architects. As Gunnar Birkerts recalls, "As soon as I saw the work—**Drake College,** the **Tech Center**—I came under the spell."

Saarinen was clearly blessed with an exceptionally sensitive nose for people. And as Irwin Miller, his client for the **Irwin Union Trust Co.** in Columbus, Ind. (1955), says, "Saarinen appreciated brilliance in others whether or not it followed his own ways." For one thing, he was supremely self confident. As McQuade has observed, "Most famous architects act a lofty role, but Eero Saarinen was too direct for that. All his pride—and there was plenty of it—went into his buildings." His total commitment to his profession explains, in part, the strong impression he left on people who worked for him. Roche remembers that "He talked of nothing but architecture; it was his whole life." And there "was much more to Saarinen than met the eye," in the opinion of architect and critic Peter Blake. "Eero's strength of character," according to Philip Johnson, "was simply beyond belief."

Architect and historian Robert A. M. Stern ventures that Saarinen's followers "each exemplified an aspect of Saarinen's very eclectic personality and outlook. Roche developed the notion of the architectural organization, the big scale project, the experiment with new materials, the possibilities of the technological age. Then you have Pelli and

Birkerts, who pushed the expression of technology in a kind of pictorial way, glittering, even glitsy, but done with great panache and adapting the ideas of technology to the marketplace with integrity. And there is Venturi, who represents the symbolically expressive, metaphorical side of Saarinen. The wonderful thing about Saarinen was his ability to combine all these things and move them from building to building with a responsive attitude."

Most characteristic and unique, especially during the very doctrinaire postwar period of architectural history, was Eero Saarinen's continuous search for new solutions. This attitude became known as using "the style for the job." As Johnson puts it, "Eero was the leader of the movement toward more individual architecture and away from the stamped out International Style of his time. With him, it took the guise of making the style for the job. He believed very much in starting over again in each job, every day, practically. This led him into paths as far apart as the expressionist bird **(TWA)** and the Holmdel mirror building **(Bell Laboratories,** 1962), which is just a box for a factory. He was an extreme pragmatist. He wasn't a guru like Kahn, who stumbled along using long words or asking, 'What does an arch want to be?'"

Irwin Miller compares Saarinen to Christopher Wren, "a problem solver who never bothered with styles or schools." The contemporary architect most like Saarinen, thinks Miller, is Kevin Roche, "because by his own nature he's also a problem solver and not a person who works in a style. While the outward appearances are different, the fundamental approach is very, very similar." Like Saarinen, Roche treats each project as a unique case, never repeats a solution or approaches a building as a container in which objects must be fitted.

According to Roche, Saarinen searched for "the style for the job" in the spirit of industrial designers Norman Bel Geddes and Henry Dreyfuss, who looked to the machine for design solutions. "Paul Rudolph, Yama, Ed Stone and others," says Roche, "who were searching for new forms of expression, arrived at largely decorative solutions. Eero was using the device of function to produce form, which was really a reversion to the very earliest manifestoes of modern architecture. But it produced a certain kind of sculptural exuberance, because of Eero's interest in sculpture."

How form literally followed function for Saarinen is best illustrated at **Dulles Airport,** which, it is agreed, was also his greatest. The conciseness of the terminal emerged from the system of mobile lounges invented by Saarinen to minimize taxiing for planes and walking for people. Critic Peter Papademetriou . . . found that "when Eero Saarinen was fairly young, his father's firm did a proposal for a restaurant called 'Serving Suzie.' It had a mobile lounge concept. The customers sat down, and this Joe Colombo thing made its way to their tables." Papademetriou regards **Dulles** as "an all inclusive environmental gesture, a great gateway for arrival and departure." With the lounges, he says, "Saarinen cut off a piece of the building and put it on wheels, giving away part of his territory, but thereby being able to claim more. He was saying that the architect can design a larger environment of which the

building is just a piece. I think that's a tremendous contribution."

Saarinen, himself, defined architecture very broadly, "as the total of man's man-made physical surroundings." Roche believes that "if you were to call anybody an architect in the complete sense of the word, which includes being an artist, an intellectual, a socially conscious person, an inventor, a sculptor, a planner, a visionary who is nevertheless totally responsible to his clients, it would be Eero. Sure he had failings. He took chances, and making mistakes was not anything that bothered him; he regarded that as part of the price to be paid for taking the chance. He made errors because he did things for which there was no precedent." Blake feels that another reason for Saarinen's mistakes was "that Eero often showed really bad taste. If you look at **TWA,** as a piece of sculpture, it is about as sophisticated as a certain kind of modernistic Danish modern stainless steel flatware."

On a more positive note, Blake believes that "most impressive was Eero's interest in and use of new technologies—and of technologies in other fields." Harry Weese remembers that Saarinen "was very influenced by the designers that surrounded the auto industry, their techniques, how they mocked up things, the nuts and bolts and all that." Saarinen's chief for production, the late John Dinkeloo, was responsible for the first use in buildings of Cor-Ten steel, neoprene gaskets and reflective glass. Says De Long, "I think Saarinen believed that for an architect to ignore the technological achievements of his own time was tantamount to turning his back on the most dramatic art of the future. Giedion's whole theory of the evolution of modern architecture, of course, depended on new materials, and most architects took that very seriously." Miller adds that "while his father was a craftsman, Eero was fascinated by the possibilities of new techniques and materials and the possibility they had for liberating the architect."

Saarinen's successful attempt to free architecture from the dogmas and constraints of his time made him a transitional figure, possibly a revolutionary one. Pelli notes that "to free oneself from the canons of the International Style today seems quite easy and natural; at the time it seemed inconceivable. And Eero concerned himself with issues that were not being addressed by the International Style, such as the need for architecture to communicate, express things other than its own structure." Roche believes Saarinen had "broken the mold long before Bob Venturi by freeing architect's minds from the rigid patterns."

Both his upbringing and training would have predisposed Saarinen against accepting the strictures of the International Style. The effect of his Finnish origin—Saarinen was 12 when his family moved to America—is, as De Long says, "hard to pin down, except that the Finns tended to reject standard sorts of images and had a fascination for materials, especially natural materials." Also, the younger Saarinen grew up at Cranbrook, which as Papademetriou says, "was a situation outside the dogmas of the modern movement, in many ways. (Eero, of course, also chose Yale with its Beaux-Arts education for his architectural training.) Eliel Saarinen's Cranbrook had a Beaux-Arts plan, and my feeling is that Eliel gave form

there to his urban theories, which combine Beaux-Arts and medieval schemes. At Cranbrook you get these great axes organizing public space in an intricate, picturesque composition of small spaces. If you look at Eero's site plans, you see modern buildings laid out according to Beaux-Arts compositional principles." Saarinen's personal history and predilections came together, says Papademetriou, "to create a feeling on Eero's part that the language of architecture was very complex and not the package that the International Style represented. As he said himself, he wanted to enlarge the alphabet beyond A and B."

The very diversity of Saarinen's architectural vocabulary and the fact that each of his buildings looks different "appears very relevant today," says Venturi. "In those days, that was not the acknowledged way to behave if you were to be a great architect; you could distinguish a great architect by his originality and consistency of vocabulary. Today, diversity is in the air in all fields."

Was Saarinen, then, a precursor of postmodernism? There are sharp differences of opinion, especially since postmodernism has different meanings for different people. Roche dismisses Saarinen's relation to postmodernism as "just nonsense, because while Eero was very aware of the history of architecture, he would not have used historical forms—at least not at that time. He was, I think, very fundamentally a modern architect, a part of the postwar brave new world drive, which was going to produce an all new environment based on technology." At least in principle, Pelli agrees: "I think Eero would have been totally uninterested in the issues of postmodernism. But, then, I think postmodernism has already blown away. It doesn't mean anything. It talks about history and context, but so did many others, including, of course, Eero. Look at Corbu's books; they are full of historical references, and someone like Aalto, who is a great hero of the modern movement, doesn't fit any of the supposed dogmas of the modern movement. Eero borrowed things from history, but always absorbed and transformed them, while for most today the borrowings remain undigested. Lutheran College in Concordia is reminiscent of a Nordic village, but there is nothing literal about it. The same is true of the colleges at Yale. What I believe and Eero believed is that issues such as decoration, which was abundant in Frank Lloyd Wright's work, were not separate from the mainstream of modern development, though they were separate from the most dogmatic core of the CIAM and Bauhaus disciples."

In Scully's opinion, Saarinen's tendency to reinvent the wheel with every new project, his emphasis on new structural techniques and abstraction placed him squarely in the modernist camp. He sees **Concordia** and the Yale [**Ezra Stiles** and **Samuel F. B. Morse**] colleges as contextual, not vernacular. "If Saarinen had been still more contextual," says Scully, "the buildings would have worked a lot better." Even Venturi denies Saarinen's connection with postmodernism, because "postmodernism is based on an attitude that admits symbolism in a very explicit way. I don't think Eero was so much involved in symbolism as expressionism. **Dulles** and **TWA** weren't reminding you of

anything specific; they weren't looking like something else."

Robert Stern, on the other hand, believes: "Saarinen's way was to make a building devoted to flight look something like a bird. He also tried to reinvent the classical mood through technology, as at Dulles. He tried to make tall buildings seem more abstract and more like monuments, like graveyard stelae almost, as at CBS. You could say that he was a precursor of postmodernism. He had a broad view of context as both physical and symbolic—what the culture would expect a building to look like."

Johnson, with usual levity, sums up the topic, saying, "Eero was a proto-postmodernist as was I, though we had entirely different approaches. But don't forget, postmodernism doesn't exist. It broke the mold of the modern strictures, but what happened afterwards can be called by anybody's name."

When he died, Saarinen was about the age of the architects Johnson still calls "the kids." And had he lived, Saarinen would today be younger than Johnson. It is, of course, impossible to know what path his career might have followed or how his work might have matured. But it's an intriguing question.

Gunnar Birkerts ventures that "for a while Eero would probably have gone just about where Kevin went, because they were very close and Kevin was influencing Eero toward the end. But later, maybe he would have worked more like Cesar or myself. He would certainly be trying new things." Papademetriou's guess is that "because Saarinen was a man of the 20th century, a modern architect, I don't think you'd find him doing shingle style vignettes. He would still be an important architect. His work would always be changing. He'd be more at home with Emilio Ambasz than Bob Stern. He'd still have a faith in technology. He'd probably be wearing a throwaway Seiko watch with a calculator on it, just so he could run figures by real fast. And I think he would be doing buildings in a direction not unlike Kevin's."

Kevin Roche? He says, "I think his career would have continued much the same way it had been going, which is to say that he would have produced fairly remarkable buildings. He was just getting into stride when he died. He died before all his major buildings except General Motors were finished. I don't see that he would have readily fallen into any of the current movements. He probably would have spawned several movements himself. I don't see him as a hardline traditionalist or a late-coming postmodernist, though he might have dabbled in new things. He had a broad acceptance of other people and what they were doing and was all for anything that would broaden the vision of architects."

In De Long's opinion, Saarinen's last building showed a cohesive clarity, and he was beginning to really "understand materials and expression in a way that he'd been working for. He was moving from a fascination with particularization to an interest in universal sources of expression and prototypes. He was gaining extreme confidence." According to Scully, meanwhile, very few of the people who were inventive in that late modern phase "have come

through. I think maybe the premise was all wrong. Precisely because they were still involved in the mythology of modern architecture, which hated most of what existed in the world, for that reason they were damned. I don't know how Saarinen would have gotten around that. He was an eclectic, in terms of the style for the job. Maybe that would have enriched itself."

In Blake's view, "Saarinen, like Philip Johnson, was always very aware of what is going to be happening next, what people would be exploring next. And he was very anxious to be there first. When people were talking about shell concrete structures, he was trying to get there first with the **Kresge Auditorium.** When people were talking about contextual architecture, he was doing the Yale colleges, and he got there first. He was very much aware of what was in the wind. He was enormously competitive, enormously competitive. But what he actually would be doing is totally unpredictable."

Gordon Bunshaft, who worked with Saarinen at Lincoln Center, believes "CBS was an indication that Saarinen was going to be a more disciplined architect and get away from the plastic period, which to me wasn't very great except for Dulles. I think he would have developed into a very important architect." Harry Weese says, to the contrary, that Saarinen belonged with Corbusier and Aalto "who were able to free-hand things and weren't caught with a grid. I think Eero would have gotten more and more into the free line. I think he would have been an antidote to Philip Johnson. I can't tell you what he would be doing, but it would be very gutsy, structural and sculptural. It's only a pity he couldn't have hung around a lot longer. I think he would be telling Philip a thing or two."

Catch, Mr. Johnson. "Eero was altogether unpredictable," he says. "He would have influenced everybody, all of us."

And Scully, who was not among Eero Saarinen's admirers during the architect's lifetime, concludes, "A man's life should be seen in its shape. His shape was to die at that time. In a way, it's really wonderful to have 10 years of activity like that, absolutely pure, like a kind of Achilles and then you're gone so clean. But, I wish he was still around so I could apologize." (pp. 39-51)

Andrea O. Dean, "Eero Saarinen In Perspective," in AIA Journal, *Vol. 70, No. 30, November, 1981, pp. 36-51.*

R. Craig Miller (essay date 1983)

[*In the following excerpt, Miller assesses Saarinen's furniture designs, interior designs, and stylistic elements of some of his important buildings.*]

By the late thirties, a [young] generation of students and faculty gathered at Cranbrook that was to exert a profound influence on American design after World War II: Charles Eames, Florence Knoll, Benjamin Baldwin, and Eero Saarinen. The important friendships that began among this circle were to affect profoundly their personal and professional lives over the succeeding decades. The last years before World War II were a germinal time for

modern design in America, and it is these years that have often been called the "golden moment" at Cranbrook. (p. 108)

In 1939 Eames and Eero Saarinen designed an exhibition of the resident faculty's work, which was installed at Cranbrook Pavilion. It was an architectonic installation with wood structures used to define areas and act as display surfaces. The exhibit seems to be the first collaborative design by Saarinen and Eames to have been executed and was a harbinger of the highly influential exhibition installations that Charles and Ray Eames were to do in the 1940s and fifties.

Saarinen's and Eames' most famous collaborative efforts were, of course, their entries for the "Organic Design in Home Furnishings Competition" held at The Museum of Modern Art in 1940-41, for which they won two first prizes for a series of chairs, modular storage units, sectional sofa, and tables. That competition may now be seen as the presage of the important developments in American furniture design in the third quarter of the twentieth century, and it clearly established Saarinen and Eames as leaders in the modern design movement.

The significance of Saarinen's and Eames' Organic Design entries can be properly understood only if one views them in relation to the developments in furniture design in the previous fifteen years. The year 1925 was a critical point in time. . . . The [Paris Exposition] was an impressive showcase for the work of the more conservative Art Deco designers such as Jacques-Emile Ruhlmann, but it also featured examples of the International Style, most notably Le Corbusier's Pavillion de L'Esprit Nouveau. It was also in 1925 that Marcel Breuer (1902-1981) designed his first tubular steel chair at the Bauhaus. This was followed in the late twenties by a series of remarkable designs by Breuer and Mies van der Rohe that formulated a new conception of the chair with tubular steel cantilevered frames and minimal upholstery. By the mid-thirties, Breuer and Aalto had extended this aesthetic of minimal mass and a clear articulation of frame and seating area to include two-dimensionally laminated wood forms. Saarinen's and Eames' achievement in 1940 was in bending laminated wood in a third dimension and in creating a new aesthetic featuring a lightweight molded shell on an attenuated base. As Eero Saarinen himself later noted, "New materials and techniques have given us great opportunities with structural shells of plywood, plastic and metal. . . . The problem then becomes a sculptural one, not the cubist, constructivist one . . . " (of the De Stijl and Bauhaus designers in the early decades of the century). Saarinen's and Eames' work over the next fifteen years may be seen as a development of these initial technological innovations and sculptural forms.

The most important entries for the Organic Design competition by Saarinen and Eames were for a side chair and several versions of an armchair and lounge chair. All had three-dimensional plywood shells and were available with foam rubber padding and fabric upholstery. There were several modifications between the designs submitted and the prototypal pieces executed. The drawings show chairs with aluminum legs attached by a rubber-weld joint,

whereas wood legs were finally used. Likewise, the chairs were designed to have their wood veneer backs exposed but because of surface imperfections had to be fully upholstered. The one exception was the side chair, which had its Honduras mahogany veneer exposed on the back, though even here the drawing showing a bare wood shell could not be achieved.

Modular case units were certainly not a new idea, but the Saarinen/Eames design of Honduras mahogany veneer was a handsome, straight-forward solution for flexible storage. The series was based on an 18-inch module. Cabinets and raised bases came in a variety of sizes; the former were to be made with interchangeable shelves, drawers, or doors. The Saarinen/Eames design was thus not only adaptable, but the modular construction facilitated packaging and shipping. Knockdown furniture was an idea that Eames addressed directly in several later designs.

Likewise, sectional sofas were not a novelty but Saarinen and Eames envisioned a sofa that would be physically and visually light instead of typically heavy and upholstered. Their design employed a molded plywood shell for a base and flat—rather than helical—springs with foam rubber padding for the seating surface. An interesting detail was a zipper along the edge to join the units together. (pp. 109-11)

Of the younger generation at Cranbrook, Eero Saarinen was certainly the most universal designer. As he said in a 1960 speech in Munich, "My father, Eliel Saarinen, saw architecture as everything from city planning to

Sketches for the pedestal chair.

the ash tray on a living room table. This is what I also believe . . . " Eero Saarinen's approach to the design of interiors and furniture was characteristic of a significant segment of American design in the late 1940s and fifties. First, Saarinen conceived of an interior and its furnishings in terms of the overall architectural conception of a building. Everything down to the smallest detail had to be a part of this "organic unity," a concept which Saarinen acknowledged he had learned from Frank Lloyd Wright. "A room is like a piece of art—it is just one idea." Secondly, contemporary design should be expressive of a twentieth-century *Weltanschauung,* particularly avant-garde painting and sculpture. Moreover, the Industrial Revolution had necessitated fundamental changes in our society; to meet the demands of the modern age, furniture had to be mass-produced, and interiors must assume a certain anonymity. "The . . . mass-produced walls and spaces and the mass-produced furniture must never lose their impersonal character. These mass-produced elements are to the interior as structure is to architecture." One's identity could be expressed by "ornamental or non-structural elements": flowers, paintings, books, handcrafted objects. Eero Saarinen brought an additional richness to his buildings—particularly in the case of sculpture and color treatments—through a continuation of the Cranbrook tradition of a collaboration with other artists, although he did not note this point in his Munich speech.

Saarinen's design approach, moreover, is indicative of rather fundamental changes which occurred in the postwar design movement in America. First of all, the emphasis was clearly on mass-produced furniture, not custom designs. The majority of the commissions for modern interiors and furniture were for contract—i.e., commercial—not residential use. This shift toward large-scale projects and industrial production implies a staff or studio effort; for a design to go from conception to production requires many contributions. In the case of the Saarinen office, a generation of talented designers was involved.

The majority of the postwar domestic designs by Eero Saarinen belong to the 1940s. The **A. C. Wermuth house** in Fort Wayne, Indiana (1940-41), and a project for the Sam Bell house (c. 1941) repeat many motifs used by Marcel Breuer and Walter Gropius (1883-1969) in a series of houses built on the East Coast from the thirties onward: raised sections on pilotti, the use of fieldstone and wood siding for exteriors and for the curved or askew interior walls. Considerably more original was a project (1943) done by Eero Saarinen and Oliver Lundquist for a competition sponsored by *Arts and Architecture.* Important features were the preassembled components which were delivered from the factory with everything built in. Of particular interest is the multiple-use and multilevel living space which was a prototype for the later Entenza residence. A perspective with a cut-out revealing the interiors showed prototypal sketches for the "womb" settee and chair (c. 1946-48).

The two most important domestic commissions jointly designed by Saarinen and Eames from the forties were the Entenza and Eames residences, a pair of houses built in a meadow overlooking the Pacific Ocean in Pacific Palisades, California. The Entenza house (1945-50), with its open plan and generous terraces, took advantage of the California climate. In contrast to the primary colors on the exterior, the interior was rather neutral; the living room had a wood ceiling, beige carpeting, a fireplace accented in orange-red, and a large built-in sofa covered in Belgian linen.

In many ways, the **Irwin Miller residence** (1953-57) in Columbus, Indiana, was an outgrowth from the Entenza house in plan and in the use of metal structure. The **Miller house,** however, was much more formal in its arrangement of family spaces in a modified Greek cross plan with private areas in each corner. The steel frame was decidedly Miesian in its fine detailing and pristine white finish, recalling Mies' elegant pavilion for Dr. Farnsworth, Plano, Illinois (1950). Saarinen personally supervised the design of this sumptuous villa for the Millers with the assistance of Alexander Girard for the interiors. The principal spaces have a travertine floor, white marble walls of book-matched panels, and an exposed steel structure with skylights illuminating alternating interior walls. Color is provided by the upholstery, art collection, and plants. Special features of interest are the sunken conversation pit, the pedestal dining room table, and a storage wall designed by Girard. The **Miller residence** was Saarinen's finest domestic commission, and with the possible exception of the Farnsworth residence, it was perhaps the most beautiful modern house built in America during the 1950s.

The acclaim awarded the Tabernacle Church of Christ brought other ecclesiastical commissions to the Saarinen office. While some of these jobs came into the office in the late forties, the majority were executed after Eliel Saarinen's death in 1950. The younger Saarinen was increasingly concerned with how architecture could convey "emotionally the purpose and meaning of the building . . . Conveying significant meaning is part of the inspirational purpose of architecture and, therefore, for me, it is a fundamental principal of our art." For these ecclesiastical commissions, Eero Saarinen employed three building types, which while different, nevertheless share certain characteristics. The circular chapel was perhaps the most original spatially, and its most fully realized example was the Chapel at the Massachusetts Institute of Technology, Cambridge (1950-55). For the Lutheran **Concordia Senior College,** Fort Wayne, Indiana (1953-58), Saarinen designed an A-frame structure whose pronounced verticality he felt recalled the tradition of Northern European churches. In contrast, the last churches designed before his death in 1961—such as the North Christian Church, Columbus, Indiana (1959-63)—are partially sunken buildings which rise out of the earth, in a Wrightian sense, to a central belfry. All of these sanctuaries were envisioned as spaces that would have a powerful emotional effect on the worshiper. They were unadorned interiors finished in exterior materials. Most importantly, their beauty was largely derived from dramatic lighting effects, whether from oculi or indirect sources.

The majority of the commissions for office complexes that came into the Saarinen office during the forties and fifties were for suburban or rural sites. The landscape was thus

of the greatest importance. The grounds in many cases were conceived on the scale of the gardens of André Le Nôtre (1613-1700) with their *allées,* lakes, and fountains; interior views were very carefully planned to coincide with these beautiful vistas. Most importantly, as Eero Saarinen reached his maturity in the late forties, he developed an individual design approach. Charles Eames noted:

> Eero intensified his pursuit of the concept and the structure peculiarly appropriate to each particular problem . . . each building is in effect a model of the particular problem it seeks to answer . . . [Saarinen's] legacy [is thus one] of concept and procedure, rather than of form.

The office buildings of the fifties most readily reflect this design approach.

The **General Motors Technical Center,** Warren, Michigan (1945-56), was the first large postwar commission executed by the Saarinen office, and it further marked the transition from father to son there. A prodigious complex of twenty-five buildings, the entire center was laid out with a Miesian rigor on a five-foot module which completely determined the planning of the interiors. The interiors, though, are considerably richer in color and texture than the German master would have allowed. The public reception areas received particularly dramatic treatments. The lobby of the Research Administration building has walls of glazed brick and floor to ceiling glass. A dramatic contrast is achieved in the juxtaposition of embossed wood ceiling panels with the exposed steel columns. Visually striking are the somewhat theatrical stairways in the lobbies; the floating spiral stair of granite suspended on stainless steel rods in the Research Administration lobby is certainly the most virtuoso example. Senior executive offices in the Styling Administration building approach sumptuousness with their wall-to-wall carpeting and silk-paneled ceilings. Of particular interest are the undulating walls of extruded metal and the extravagant continuous built-in sofa and desk of laminated wood. One of the important innovations in the GM interiors was the ceiling treatment. With the development of curtain wall buildings in the fifties, lighting levels and air conditioning systems grew increasingly complex, and a major goal of interior designers was to clean up this clutter. The five-foot-square luminous ceiling panels have all of the mechanical systems integrated into the structure, which is also integral to the movable wall system.

In outfitting the interiors of a complex of this scale, Saarinen relied largely on general furnishings produced by Knoll. It was at GM that the **No. 71** and **No. 72 chairs**—known the world over as the chair with the hole in the back—were first used. Eero Saarinen also produced a custom design for a lounge chair and sofa used in several of the lobbies. Obviously inspired by Le Corbusier's Grand Confort (1929), Saarinen's design differs in that it is a solid upholstered unit suspended in its aluminum frame, rather than loose cushions inside a steel frame. Further decorative treatments were provided by the custom rugs designed by Marianne Strengell for the library and other major interiors. A pacesetter for American corporate architecture, the GM Technical Center was one of the largest building projects to be undertaken in the United States during the postwar period and required more than a decade for completion. It established Eero Saarinen as one of the major American corporate architects.

In the headquarters for **Deere & Company,** Moline, Illinois (1957-64), the relationship between the interior and exterior is as subtle and complex as with a Japanese house and its gardens. One stands in a highly articulated structure of cor-ten steel and gold-tinted glass with the landscape always present. This feeling of transparency is further enhanced in the innovative layout of the offices: secretarial areas are open spaces on the exterior, and the interior private offices have glass partitions. Since the interiors were largely completed after Eero Saarinen's death, the furnishings are mainly the work of Warren Platner, a senior designer in the office, although Alexander Girard did lend assistance.

The **Thomas J. Watson Research Center** for IBM in Yorktown, New York (1957-61), also featured a remarkably innovative plan. All the laboratories and offices were designed as interior spaces, and the peripheral window areas are used as the main corridors. The laboratories and offices are laid out back to back, so that each section shares a utility core. Perhaps the most interesting space in the crescent-shaped building is the long, glazed peripheral corridor behind the front facade; there is a certain anomaly here in the use of glass exterior walls and fieldstone interior walls. The two-story entrance lobby, however, is enlivened spatially by the use of a rather baroque double stair with balcony, although it is not quite the tour de force of the GM examples. The plan of the mammoth Bell Laboratories in Holmdel, New Jersey (1957-62), is a further development from the IBM building, but the principal innovation is the introduction of an interior court which is Piranesian in scale.

Eero Saarinen explored the idea of interior courts in several public buildings during the fifties. The **American Embassy** in London (1955-60) has a modest pool in the lobby area, but the **Oslo Chancellery** (1955-59) has a multistory, diamond-shaped courtyard of impressive proportions. Perhaps the most significant space is the multi-level court in the **Women's Dormitories** at the University of Pennsylvania (1957-60); the planting, fountains, and shuttered balconies add texture and life to this space. These interior courtyards were antecedent to the extremely popular atrium hotels built in America during the 1960s and seventies.

Concurrent with this concern for innovative plans and interior courts, Eero Saarinen's preoccupation with strong sculptural forms enclosing large interior spaces was increasingly explored in a series of postwar buildings. The use of the wedge- or horseshoe-shaped auditorium in the late thirties, as in the Kleinhans Music Hall, has been noted [elsewhere]; this was followed by a fascination with domed structures for large interior spaces in the late 1940s. At the **GM Technical Center,** the dome was expressed on the exterior and interior, while at the **MIT Auditorium** (1950-55) the concrete shell simply served as a means of spanning the space. By the early fifties, the younger Saarinen had begun to employ bold structural sys-

tems—reinforced concrete and suspension cables—which allowed him to design some of the most visually exciting and original spaces produced at mid-century. The important transitional work in this series was the **Ingalls Rink** at Yale University (1956-58). As Saarinen noted shortly before his death:

> . . . I would agree the **Hockey Rink** marks an important moment in my work. You could say it strengthened my convictions about making everything part of the same "form-world" and gave us confidence about handling vaults and suspended roofs which have interested me since some projects of the 'Fifties and the **Aspen Tent** [1949]. It influenced both **TWA** and the Washington [**Dulles**] airport [see excerpt dated 1968].

This search for strong sculptural forms enclosing large interior spaces culminated in these three buildings: the **Ingalls Rink, TWA Terminal,** and **Dulles Airport.** With its massive concrete spine and wood deck supported by longitudinal cables, the **Ingalls Rink** is not unlike an inverted boat's hull. The vaulting space with its sense of movement and energy embodies the speed and action of the game on the ice. This desire for expressive interiors reached its culmination in the soaring vaults of the terminal for Trans World Airlines, at Kennedy Airport, New York (1956-62). Here Saarinen wanted to create an interior that would express the "excitement of travel." The bilateral terminal consists of four enormous vaults divided by bands of skylights. A central soaring bridge separates the two main areas for ticketing and waiting. Stairs, counters, and seating are all integral to the sculptural whole; the red seating area provides an accent of color to the off-white and light grey surfaces. **TWA** and **Dulles,** outside Washington (1958-63), personify the sensation of flying as no other twentieth-century buildings do. **Dulles** is a serene pavilion which seems to be suspended above the Virginia plains. From the exterior, it is certainly one of Saarinen's most arresting forms; the interior, however, seems less successful than **TWA.** The space is too low for such a long building, and the counters, shops, and service areas interrupt the unity of the dramatic space. Such temple-like structures cannot easily accommodate numerous functional demands.

Eero Saarinen's furniture was an integral part of his work as a designer. While the office certainly continued to produce custom designs for a client's specific needs, his major interest from the 1940s onward was in mass-produced furniture. It is a measure of his commitment to his work that he was able to pursue in essence two careers (as an architect and furniture designer) at the same time.

The first evidence of Saarinen's maturity as a furniture designer was his entries with Charles Eames for the Organic Home Furnishings competition (1940-41) noted earlier. The outbreak of the Second World War prevented their manufacture. After Florence Knoll joined Knoll Associates (c. 1943), one of the primary achievements of the company was enlisting a generation of young designers. Eero Saarinen joined Knoll around 1943. His first design, still working with wartime limitations, was the **No. 61 lounge chair and ottoman** (c. 1946). The profile of the laminated wood base with multiple bends was contrasted

against a sculptural seating panel. The chair was quite comfortable and was available upholstered or with webbing. The design was not especially innovative, though, since the frame was an amalgamation of the detailing of Aalto and Mathsson.

The material that was to have the greatest impact on furniture design at mid-century was plastic. A new material for the furniture industry, its potential was realized during the 1940s by a number of designers working on innovative chairs. Eero Saarinen and Ralph Rapson published sketches in the March 1946 issue of *Interiors* showing several prototypes for molded shell chairs, but perhaps the most noteworthy design of the forties was Mies' conchoidal chairs. Saarinen began his designs for his **No. 70 lounge chair** (popularly called the womb chair) as early as 1946, but it was not manufactured until 1948 by Knoll, making it the first fiberglass chair to be mass-produced in America. The chair has a molded, reinforced plastic shell with foam rubber padding and fabric cover; a seat and back cushion were added for additional comfort. The base was of metal rod with a chrome or painted finish. Prototypes of the chair show Saarinen's struggle to find a base for the powerful shell that would work structurally and aesthetically; the junction of the plastic or plywood shell with its base was, in fact, one of the major problems facing furniture designers at mid-century. The introduction of a successful design to the Knoll line invariably resulted in spin-offs: in this case the **No. 74 ottoman** (c. 1950) and the **No. 73 settee,** Saarinen's only mass-produced sofa.

A follow-up to the **No. 70 lounge chair,** the **No. 71 armchair** was first introduced at the **GM Technical Center** (c. 1950) and has become one of the most widely used office chairs of the twentieth century. Saarinen's experiments with plastic are continued in the fiberglass back, but the seat is a standard wood panel with foam rubber upholstery. The design is derived directly from the Organic Design entries. The soft sculptural forms, though, belie their simplicity: a close examination of the detailing of the base, shell, and upholstery reveals a masterful design.

Eero Saarinen's last furniture design for Knoll was the so-called "pedestal" series (1955-57). Saarinen felt that he had resolved the problem of "the slum of legs" in a room, and he achieved perhaps the most successful resolution—at least visually—of a plastic shell to its base, though not his goal of a sculptural shell in one piece and of one material. The chairs rise out of the floor on a single stem to a shell of soft folds, almost flower-like. In reality, the shell is made of molded plastic but a stable base could only be achieved in cast aluminum with a matching fused plastic finish. While the chairs have been justly praised, it is perhaps the line of tables which is most pleasing. The large tables, in particular, with their composition of a floating plane on a single thin pedestal, have an elegance—if not an ethereal quality—that makes them one of the assured classics of the twentieth century. (pp. 112-21)

R. Craig Miller, "Interior Design and Furniture," in Design in America: The Cranbrook Vision, 1925-1950 *by Joan Marter and others, Harry N. Abrams, Incorporated, 1983, pp. 91-143.*

FURTHER READING

I. Writings by Saarinen

"A Few Thoughts about the Hidden Talent Competition." *Architectural Record* 105, No. 3 (March 1949): 88.

Commentary on an architectural competition project mentioning "certain aspects of architecture that should be emphasized—simplicity, the need for an over-all concept in a building, a clear structural system, and, in some cases, the need for a certain formality," and stressing that architectural design should have its roots "in life itself—the way the building is used and a love for the people who use it."

II. Bibliographies

Kuhner, Robert A. *Eero Saarinen: His Life and Work.* Monticello, Ill.: Council of Planning Librarians, 1975, 73 p.

Lists books and articles on Saarinen's life and works.

III. Critical Studies and Reviews

"First Honor: Eero Saarinen & Associates." *AIA Journal* XLVI, No. 1 (July 1966): 34-7.

Includes the jury's comments regarding Saarinen's winning design for the Dulles International Airport terminal competition and Saarinens' statements about airport design.

Andrews, Wayne. "Eliel and Eero Saarinen's Michigan." In his *Architecture in Michigan,* rev. ed., pp. 111-15. Detroit: Wayne State University Press, 1982.

Brief history of the Saarinens' careers focusing on Eliel Saarinen, with mention of Eero Saarinen's outstanding achievements.

"TWA's Graceful New Terminal." *Architectural Forum* 108, No. 1 (January 1958): 78-85.

Reports on Saarinen's method of evolving his design for the Trans World Airlines Terminal using primarily models rather than drawings.

"Saarinen Places Furniture on a Pedestal." *Architectural Record* 122, No. 1 (July 1957): 284.

Describes Saarinen's pedestal furniture and discusses the principles underlying its design.

"Saarinen's New Vocabulary." *Architectural Record* 126, No. 6 (December 1959): 9.

Reports on Saarinen's design for the Ezra Stiles College and Samuel F. B. Morse College at Yale University, finding that he addressed challenges presented by the building site with a new phase of architecture: "polygonal masonry architecture," which allows for the diversity, variety, and individuality he wanted for the project.

Banham, Reyner. "The Fear of Eero's Mana." *Arts Magazine* 36, No. 5 (February 1962): 70-3.

Suggests that though Saarinen was often criticized for the stylistic variability of his buildings, this is what "set him apart from the rest of the top of his profession, just as his sheer professional expertise set him apart from the non-top architects" of his time.

Dorr, Maude. "Portraits in Architecture." *Industrial Design* 10, No. 5 (May 1963): 62-71.

Brief essay characterizing Saarinen's attitude toward architecture as "experimental," followed by photographs and discussion of several Saarinen projects.

Freeman, Allen. "The World's Most Beautiful Airport?" *AIA Journal* 69, No. 13 (November 1980): 46-51.

Discusses the beauty and functionality of Dulles International Airport and charges that the facility is underutilized.

Gandy, Charles D., and Zimmerman-Stidham, Susan. "Eero Saarinen." In their *Contemporary Classics: Furniture of the Masters,* pp. 149-57. New York: McGraw-Hill Book Co., 1981.

Discusses Saarinen's innovations in furniture design. The article is illustrated with schematic drawings and photographs.

Haskell, Douglas. "Eero Saarinen, 1910-1961." *Architectural Forum* 115, No. 4 (October 1961): 96-7.

Obituary tribute commending Saarinen's individuality.

Hewitt, William. "The Genesis of a Great Building—And of an Unusual Friendship." *AIA Journal* 66, No. 9 (August 1977): 36-7, 56.

Reminiscences by Deere & Company's president about his association with Saarinen during the planning and building of the company's administrative center.

"Eero Saarinen, 1910-1961." *Interiors* CXXI, No. 4 (November 1961): 128-31.

Obituary tribute focusing on Saarinen's contributions to furniture design.

Larrabee, Eric, and Vignelli, Massimo. *Knoll Design,* pp. 15ff. New York: Harry N. Abrams, 1981.

History of Knoll Associates design studio that includes discussion of Saarinen and his furniture designs.

Marder, Tod A. "The Cranbrook Vision, 1925-1950: A Reconsideration." *Arts Magazine* 59, No. 8 (April 1985): 72-7.

Account of the Cranbrook Institute that includes commentary on Saarinen's contributions.

McQuade, Walter. "Eero Saarinen: A Complete Architect." *Architectural Forum* 116 (April 1962): 103-19.

Anecdotal reminiscences about Saarinen's life and discussion of his major works.

Moholy-Nagy, Sibyl. "The Future of the Past." *Perspecta,* No. 7 (1961): 65-90, 166-67.

Includes a brief favorable assessment of Saarinen's approach to architecture.

Schmiedeke, Denis C., and Mercer, Max G. "Tributes to Eero Saarinen." *Progressive Architecture* 42 (December 1961): 162.

Letters written in obituary tribute to Saarinen commending his contributions to architecture.

Smithson, Peter. "Controversial Building in London." *Architectural Forum* 114, No. 3 (March 1961): 80-5.

Discusses Saarinen's planned design of the U.S. Embassy in London. Includes excerpts of assessments by R. Furneaux Jordan and Reyner Banham.

Sparke, Penny. "America: Technique and Innovation." In her *Furniture,* pp. 54-9. London: Bell & Hyman, 1986.

Brief consideration of Saarinen's furniture designs. Sparke states that "the furniture pieces with moulded plywood shell seats and backs designed by Charles Eames and Eero Saarinen in 1940 were a prime example of the use of advanced manufacturing techniques applied to furniture design and production."

Temko, Allan. *Eero Saarinen.* New York: George Braziller, 1962, 127 p.

Biographical and critical study that offers extensive discussion of Saarinen's principal structures. The volume is profusely illustrated with photographs of buildings, furniture, models, and blueprints.

"Recent Work of Eero Saarinen with Some Statements by Eero Saarinen." *Zodiac,* No. 4 (1959): 30-67.

Offers a brief assessment of recent projects by Saarinen, numerous photographs and drawings, and commentary by Saarinen.

IV. Selected Sources of Reproductions

Meyerowitz, Joel. *St. Louis & The Arch.* Boston: New York Graphic Society, 1980, 112 p.

Fifty-nine color plates from a project begun by Meyerowitz in 1977: a series of photographs exploring the omnipresence and impact of the Gateway Arch on the St. Louis cityscape. An introduction by James N. Wood describes the project and provides technical information about Meyerowitz's equipment.

Saarinen, Aline, ed. *Eero Saarinen on His Work.* Rev. ed. New Haven, Conn.: Yale University Press, 1968, 117 p.

Photographs of Saarinen's projects selected by his wife "to convey the sense of his intent and the spirit of his buildings." The volume includes a biographical outline, a list of honors and awards won by Saarinen, and a chronological list of his architectural projects. Portions of the accompanying text by Saarinen are excerpted in the entry above.

Spade, Rupert, ed. *Eero Saarinen.* New York: Simon and Schuster, 1971, 128 p.

Includes one hundred plates, several in color, from photographs by Yukio Futagawa, an introduction by the editor, a chronological list of Saarinen's projects, and a bibliography of work by and about Saarinen.

Minor White

1908-1976

American photographer.

Among the most influential photographers of the post-World War II era, White was also a respected educator, editor, and curator. A fervent student of such Eastern religions and philosophies as Zen and Confucianism, White believed that photography could transcend its realistic origins to communicate the spiritual and the sacred. He therefore experimented with Alfred Stieglitz's Theory of Equivalents and promoted "camerawork" as a state of mind requiring the extensive "reading" of a subject to ascertain its underlying meaning. In his black-and-white prints, White elicited specific emotional responses by focusing on natural images that resemble human forms and actions. Although some critics objected to his esoteric approach to the medium, most regard White as an important innovator whose photographs unite the ordinary and transcendent.

Born in Minneapolis, Minnesota, White was introduced to the medium by his grandfather, an amateur photographer who possessed a vast collection of hand-tinted slides. As a youth, White experimented with a Brownie camera given to him at the age of eight and later studied botany at the University of Minnesota, where he expanded upon his technical knowledge of photography by making photomicrographs of algae and other plant life. He also became deeply interested in writing, and, for five years after graduating, devoted himself to composing poetry. In 1937, he renewed his interest in photography and traveled to Portland, Oregon, where he taught and exhibited his photographs at the YMCA while sporadically working as a hotel clerk, houseboy, and department store Santa Claus. White later secured a job as a photographer for the Works Progress Administration (WPA) and captured Portland's iron-front buildings and other historic structures on film before their demolition. In 1940, he became director of the WPA's La Grande Art Center in Seattle, but was drafted two years later and sent to Hawaii as a member of the Army Intelligence Corps. During his three years in the service, White maintained an unofficial portrait studio for the 24th Regiment, the results of which he later exhibited as the sequence *Amputations.*

Following his discharge, White traveled to New York City to work at the Museum of Modern Art for Beaumont and Nancy Newhall, famed curators who introduced him to Ansel Adams, Edward Weston, and other renowned photographers. At this time White also met Alfred Stieglitz, whose Theory of Equivalents profoundly influenced White's approach to photography. As delineated in his series of cloud-formation images, Stieglitz's theory posits that the finished print should represent the emotional state of the photographer, making photography an expressive medium akin to the other fine arts. Accordingly, White largely abandoned portraiture and began producing im-

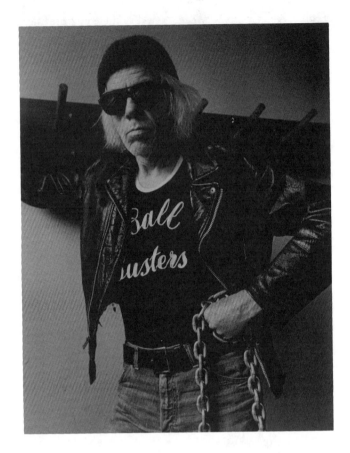

ages of such natural phenomena as rock formations, swirling water, and drying mud to metaphorically convey psychological complexities. White also began arranging his images in non-temporal sequences to enhance their emotional impact. In 1947, he left New York to join Ansel Adams at the California School of Fine Arts in San Francisco. There, White exhibited *Song without Words,* a series of photographs in which images of the California coastline are used to communicate sexual desire and fulfillment. Critics generally regard this as White's most successful sequence.

In 1952, White became editor of *Aperture,* a photographic periodical he founded with Ansel Adams, Dorothea Lange, and others. Described by White as his own "private journal," *Aperture* effectively set the tenor of creative photography during the 1950s. During his years with the magazine, White left the west coast to become a curator at the George Eastman House in Rochester, New York, and began exploring Zen and other belief systems. He then applied elements of these disciplines to his photography; for example, he used meditation and extensive self-analysis to ascertain the latent essence of an image or subject. White eventually left the Eastman House and, after

teaching at various other colleges, accepted a post at the Massachusetts Institute of Technology. His unconventional seminars at MIT often featured hypnosis, meditation, and dance. In 1968, he published *Mirrors, Messages, and Manifestations,* his first comprehensive monograph, which features his best-known sequences, including *Amputations, Song without Words, Sequence 13/Return to the Bud,* and *Rural Cathedrals.* During the late 1960s and early 1970s, White suffered three heart attacks, and although he continued to teach, his health steadily declined until his death in 1976. Three years later *Aperture* published *Minor White: Rites and Passages,* which reproduces White's most important images as well as excerpts from letters and diaries he composed during the 1950s. In 1989, the exhibition "Minor White: The Eye That Shapes" opened at the Museum of Modern Art. Featuring homoerotic images deliberately suppressed by White during his lifetime, the exhibition further demonstrated the expression of human emotion in his work.

Evaluation of White's career has focused less upon his photographs than upon his near-mythical status in the artistic community. His work as an editor and educator drew widespread admiration, and although his ideas are considered remote from current artistic concerns, he remains a pivotal figure in the evolution of photography from its unsophisticated beginnings to its present status as a highly respected artistic medium capable of expressing the metaphysical. John Szarkowski has observed: "Of those photographers who reached their creative maturity after the Second World War, none has been more influential than Minor White. Only three or four others of this generation have had a comparable impact on our sense of photography's potential. . . . White's influence has depended not only on his own work as a photographer but on his service as teacher, critic, publisher, theoretician, proselytizer, and house mother for a large portion of the community of serious photographers. Indeed, White's omnipresence in the photographic world has made it easy to forget at times that he has remained first of all an artist: a photographer who has made some of the medium's most memorable pictures."

ARTIST'S STATEMENTS

Minor White (essay date 1952)

[*In the essay excerpted below, White describes the creative state of "sensitized sympathy," an integral component of his approach to photography.*]

If we had no words perhaps we could understand one another better. The burden is ours, however. So in using the word "creative" to refer to a state of mind in photographers, I expect to be fully misunderstood.

It is no longer news that a cameraman is faced with a very different situation from that of a painter starting a new canvas. The latter has a bare surface to support an invented image, or a blank space in which to spin invented volumes or, as probably some artists feel, a free space in which to live, dance, think—leaving marks where a thought passed or a tactile muscle felt a color. And as he is inventive, he is creative—or so it is popularly thought.

The photographer starts from an image already whole. Superficially it looks as whole as a finished painting, although it is rarely completed. The photographer completes the whole or total image by analyzing a variety of whole images. So the photographer invents nothing; everything is there and visible from the start. Here I should, I suppose, be worried to find that I have written that a photographer invents nothing, since in the recurrent discussions over the creative possibilities of the camera medium, the fact that the photographer invents little if anything is a point the cons labor and the pros fumble trying to circumvent. (Not that it is necessary, of course; the photographs of Stieglitz and Weston provide all the evidence needed.) However, still other evidence has accumulated—the work of the great documentary photographers, for instance—which shows very well that our continual linking of the word "inventive" with "creativeness" has kept us from remembering that creativeness is expressed in many ways. It is time that we in esthetic fields remembered that analysis in scientific fields is often as inspired or creative as a work of art. We should also remember that the camera is a definite link between science and art, or, if not a link, that it partakes of both. It is time we recalled that "man seen" or "man found" is just as expressive as creativeness as "man made." It is time to remember (the period of discovery is long past) that the camera lures, then compels, a man to create through seeing. It demands that he learn to make the realm of his responses to the world the raw material of his creative activity. Creative understanding is more camera-like than invention.

A young man looking at a photograph of mine—in the midst of experiencing and before he could weigh his words, said, "This is like a painting." Since this did not sound very much like what he had in mind he tried again. "It is obviously a photograph. But the placement—looks—as if a man—as if a man had invented them—things are where a man would put—them—it looks manmade—not like nature—not found."

Yet it had been found, "seen," and merely recorded by the camera. (Because a man trains himself to see like a camera, it is only more appropriate that he uses a camera to record his seeing.) That this picture causes a reaction in a young painter that he can talk about only in terms of painting does not mean that an "esthetic reaction" is taking place. Perhaps it began with little more than an impact of recognition of something *like* a painting. We must remember, however, that recognition is frequently the start of the "esthetic" chain reaction.

If he was only surprised at the likeness, consider where he found the likeness: in the perceptive realm of man, not in the camera's imitation of some aspect of painting surfaces. His reaction is important because it shows that we are so conditioned to painting as the criterion of the visual esthetic experience that the possibility of a photograph's

being another path to esthetic experience, like a piece of sculpture or a poem, has been overlooked or not realized—if not actually denied or pushed out of the realm of possibilities.

Yet to "see," to "find," is a human activity linked to human creativeness. The fact that this particular young man related a "found" picture to his experience of the "made" objects and could enjoy it as if it were a "made" object is a simple demonstration of how human the "seeing" of photographers is. And, if one would stretch the demonstration slightly, of how inventive "seeing camerawise" is.

The state of mind of the photographer while creating is a blank. I might add that this condition exists only at special times, namely when looking for pictures. (Something keeps him from falling off curbs, down open manholes or into the bumpers of skidding trucks while he is in this condition but goes off duty at all other times.) For those who would equate "blank" with a kind of static emptiness, I must explain that this is a special kind of blank. It is a very active state of mind really, a very receptive state of mind, ready at an instant to grasp an image, yet with no image pre-formed in it at any time. We should note that the lack of a pre-formed pattern or preconceived idea of how anything ought to look is essential to this blank condition. Such a state of mind is not unlike a sheet of film itself—seemingly inert, yet so sensitive that a fraction of a second's exposure conceives a life in it. (Not just life, but *a* life.)

In a way the blank state of mind is a little like the blank canvas of the painter—that is, if we must have an analogy and insist that art must have a point of departure from nothing. (If a blank sheet of paper can be called nothing.) Poets buy a ream of paper and wonder what obscurity will darken the sheets or what revelation will illuminate the mind reading his black marks. But the paper's blankness has little to do with his creative action. Or to the sculptor feeling somehow the form lying in a block of stone, the stone is not a blank so much as a wrapping that only he can unwind.

The photographer is probably more akin to the sculptor in wood or stone than to painters, as far as his mental creative state goes. The whole visual world, the whole world of events are wraps and coverings he feels and believes to be underneath. Often he passes a corner, saying to himself, "There is a picture here"; and if he cannot find it, considers himself the insensitive one. He can look day after day—and one day the picture is visible! Nothing has changed except himself; although, to be fair, sometimes he had to wait till the light performed the magic.

A mind specially blank—how can we describe it to one who has not experienced it? "Sensitive" is one word. "Sensitized" is better, because there is not only a sensitive mind at work but there is effort on the part of the photographer to reach such a condition. "Sympathetic" is fair, if we mean by it an openness of mind which in turn leads to comprehending, understanding everything seen. The photographer projects himself into everything he sees, identifying himself with everything in order to know it and feel it better. To reach such a blank state of mind requires effort, perhaps discipline. Out of such a state of mind he loves much, hates much and is aware of the areas of his indifference. He photographs what he loves because he loves it, what he hates out of protest; the indifferent he can pass over or photograph with whatever craftsmanship of technique and composition he commands.

If he were to walk a block in a state of sensitized sympathy to everything to be seen, he would be exhausted before the block was up and out of film long before that.

Perhaps the blank state of mind can be likened to a pot of water almost at the boiling point. A little more heat—an image seen—and the surface breaks into turbulence.

Possibly the creative work of the photographer consists in part of putting himself into this state of mind. Reaching it, at any rate, is not automatic. It can be aided by always using one's camera for serious work so that the association of the camera in one's hands always leads to taking pictures. But certainly once the mood is reached, that which happens can get out of control, as it seems it should. We have heard of inspired singing, of inspired poetry, of inspired painting—of production during moments of intensity or lucidity when one feels as if one is an instrument of transmission like a narrow channel between two oceans. (Do telephones feel this way?) The feeling is akin to the mystic and to ecstasy; why deny it? And in this condition the question of whether photography is or is not art is laughable. One feels, one sees on the ground glass into a world beyond surfaces. The square of glass becomes like the words of a prayer or a poem, like fingers or rockets into two infinities—one into the subconscious and the other into the visual-tactile universe.

Afterwards one can look at the photographs and try to find in them something by which to explain what happened. In the illustration titled *51-248*, I can point out that light seems to come from inside the photograph, which is certainly not at all like the condition which my reason tells me prevailed at the time, though exactly like what I saw in a moment of highly charged vision. I can also say this symbolizes the emotion felt while making it, and know only how little of this vision the picture must cause in others. Feeling and photographing what causes feeling is no assurance that others will feel. But after once discovering what one wants to arouse in other people, the knowledge that one may frequently fumble in trying is only a challenge.

The picture mentioned above climaxed an afternoon's work in which I started out by saying to myself, "What shall I be given today?" It progressed by stages of a growing awareness of absorption into the place. Exposure after exposure were sketches leading—in no very conscious way—towards this final one. The same shapes, forms, designs recurred with a growing tension. When this was seen on the ground glass, anything separating man and place had been dissolved.

This is no isolated experience, occurring only with nature; I can parallel it with many experiences in photographing people. The duration of a session is one of growing *rapport*, of a deepening friendship. The camera is hardly more than

51-248 Moment of Revelation *(1951).*

a recording device for an experience between two people. They create in one another—only the photographer is conditioned to see like a camera, so the end result is a photograph.

This is not so much a scholarly discussion of the photographer's creative state of mind as it is a first-hand report. The scientist using the camera as an instrument will probably not have much idea of what I am talking about; however, photographers using the camera as a deeply expressive medium or those using it to document human situations will have experienced the sensation of the camera dissolving in an accord between subject and photographer. And what impresses me now is that I no longer care to prove that some photographs can do the same thing for people that paintings do. (They call it "art.") I merely want to cause in others some degree of experience: shall we call it spirituality? identification? by using photographs as the excitant. The photographs, may I add, *not* the objects photographed? While the photographer cannot eliminate the object (nor does he want to destroy the experience of the visual world transforming into an unconscious world, the very source of his excitement), he still wants the photograph to be the main source of the spectator's feeling. While he cannot erase from the viewer's mind the im-

plications of the subject, he prefers to depend for his effect on the visual relations that are present in the print itself.

"Blank" as the creative photographer's state of mind is, uncritical as it is while photographing, as sensitized, as prepared for anything to happen, afterwards with the prints safely in hand he needs to practice the most conscious criticism. Is what he saw present in the photograph? If not, does the photograph open his eyes to something he could not see by himself? If so, will he take the responsibility for the accident and show it as his own, or will he consider it as a sketch for his subconscious to digest? He needs to study further the reactions of the viewers: do they match his own? come close? or depart in amazing directions? In a sense, this is the activity that brings the creative state of mind near the boiling point: conscious criticism of new prints, digestion of what the prints do, as compared to what he wanted them to do. Without this siege of analytical work, the state of sympathetic sensitivity, the "blank" state of mind will not recur. (pp. 16-19)

Minor White, "The Camera Mind and Eye," in Magazine of Art, *Vol. 45, No. 1, January, 1952, pp. 16-19.*

Minor White with Paul Hill and Tom Cooper
(interview date 1977)

[*In the following interview, which was originally published as a three-part series in* Camera *magazine, White discusses the various factors that influenced his career and outlines his artistic vision based upon Eastern philosophies.*]

[Hill and Cooper]: *Did you get involved in photography as a child?*

[White]: My maternal grandfather was an amateur photographer. He used to hand-tint glass slides. I can remember my grandmother spending evenings binding the two pieces of glass together with black tape. And I learned to do that—I was 6 or 7 at the time. I was given a box Brownie probably at about 9 or 10. When I started going to college I was making snapshots and having them drug-store-finished. I never learned to process.

Do you remember what you photographed then?

The ones I recall are of my buddy and my grandmother in my grandmother's garden. Later on I was photographing little waterways and a creek near my house. I was living with my parents in Minneapolis at the edge of town, so the creek and the countryside were very close.

Were there any photographic images that you took at that time that mean anything to you?

I remember one very especially—the bend of the creek. There were some willows hanging out over it. I'm sure that photograph's been lost—but that's the one that stays in my head.

You were how old at this time?

Oh, 16 or 17. I started college when I was 18 and I can recall that I had to stop photographing—I must have been doing more than I should—in order to give more time to college.

Why did you study botany at college?

The influence of a teacher I happened to like very much and who took a liking to me. And Grandmother's garden was a very important part of my life. (p. 36)

Why didn't you study an art subject at college?

I think my interest in botany started in high school and continued in college. The 'art' influence was there however. My grandfather was a house contractor and he had his offices in a very well-known art gallery in Minneapolis. So weekend after weekend I would go there and wander around the gallery. I saw all kinds of art until I was about twelve. Thereafter I didn't get associated with art very much except through music. I was given piano lessons and was very interested in classical music—I still am.

Did you do much photography while you were at the University of Minnesota?

I learned the processes in developing film, making prints, and all that. My work was with photo-micrographs of algae and various other plant forms. It was all done on glass plates.

Did your interest in English emerge at this time?

The actual writing aspect of it got started in Grade School, but I didn't do very much. In college there were courses in English. There wasn't very much creative writing being done there.

Did you find it easier to express yourself through words at that time rather than visual imagery?

While I was in College it was all scientific photography. There was no attempt at self-expression. When I got out of college—it was right in the middle of the Depression—I almost immediately turned to writing verse.

Why?

With not having a job, and not knowing what to do with myself, that was the only free thing I could do as I had no money for photography. So for the next four or five years I did no photography at all and I spent all my free-time writing. (pp. 36-7)

How old were you at this time?

Mentally about two! I was a typical teenage kid of the 1930s.

Did you get a job?

I got a job as a house-boy in a private club and I graduated to being a bartender, a waiter, and a cook. That went on for 5 years, making almost no money. I managed to save up to about 125 dollars and I bought an Argus camera, a couple of rolls of film, and I got on a bus and went to Portland, Oregon, and settled there—again with no money. It was a very tight squeak there for a long period.

Why Portland, Oregon?

Oh just a fluke. I had a letter of introduction for Seattle and I stopped at Portland. Then I heard something about the Rose Parade which was in about 3 weeks and I thought I'd stick it out for that. I was staying at the YMCA and photographed the parade. By that time I was so short of money I had to get a job, so I stayed in Portland.

Would it be at this time that you were involved in composing your **Sonnet Sequence***? Did you think at that time there might be a relationship between sequencing visual imagery as well as words?*

No, I had no such comprehension at all.

What was it that you found so interesting about lyric poetry?

I did it because I wanted to. I have no other recollection.

Had you come into contact with any of the 19th century American Transcendentalist literature?

I read it before I went up to college. It didn't make too much sense to me—a little over my head.

Did you get involved with photography as a means of earning a living in Portland?

When I left Minneapolis I decided to be a photographer. I'd tried poetry for 5 years and that didn't get me any-

where, so I tried photography. I realized that I could shift over to photography although it would probably take me five years to do it; I felt that there was an essence of something that I knew I would do in photography, but I didn't know how. While I was writing a verse I'd get a hold of the feeling of poetry. It was a very strange—even spiritual. I'd done a lot of reading on what poetry was all about, and I thought that all I had to do then was just change the medium. I knew what I wanted to say.

I was photographing a lot and I borrowed a camera and photographed still more and moved around the city and made a lot of photographs. Then I got on to the WPA—Works Progress Administration—as a creative photographer. Also I was constantly having shows and I was working with the Oregon Camera Club. Once I was working for the WPA I had enough time and enough materials to undertake photographing the iron-front buildings. That was the first project I did for them, and the second project was just the water-front. It was the iron-front buildings that really mattered. Out of that grew the opportunity to do a teaching tour of the art centres and there were three of them around Oregon teaching photography. I got over to Le Grande Art Centre who were having trouble with the director. By some fluke or other I took the job of director; so I was teaching the photography course and also running the whole thing. This included art, painting, basket-making, weaving, and children's clay modelling—that sort of thing.

Did you see any photographic work at that time that meant something to you?

While I was at the Oregon Camera Club they subscribed to every publication in the world I should think. There was a constant influx. *Camera Craft* was published in San Francisco at that time. That's when I ran into Edward Weston's first book. That bowled me right over—that was about the best stuff I'd ever seen in my whole life. I was really the high peak, and at the same time I was seeing everything that was available.

Did this response that you had to Weston's work equal the feeling that you said you had right from the beginning: that you could do something with the camera?

I don't know whether it did or it didn't. I can't recall. (pp. 37-8)

When you made the transition from poetry to photography you felt that you were able to say or could do a thing with the camera. Could you say what that thing was?

I felt that I had learned what poetry was. This was an experience I can't get into words—it was an experience within myself. I think in an earlier period I had a similar experience with music. I realized that I would never have been much of a pianist, I couldn't do it. But I learned, one afternoon, how to bridge. I knew just how to do it so the bridge would work. Then I stopped playing, and I stopped reading music. That same point happened when I was working with poetry. I came to the point where I could say: 'Now I know what "X" is, I'll learn how to do it in photography.'

So there was this peculiar assurance which I didn't recognize at the time. I went ahead into photography in a blind way. It was the same kind of decision when I went into college and I decided to drop photography in order to learn whatever one has to learn in college. . . .

Why did the job at the centre finish?

The draft came along and I had to leave, but I did spend some time in Portland where I got a job as a department store Santa Claus. I was dressed up in these robes, with a stuffed pillow—I was as scrawny as a bean-pole at that point—and sat there talking to the kiddies.

I also had an exhibition at the Portland Art Museum. It went out just before I had to join the army. Also at that time I photographed two houses. That was the last job I did although I was working with the Portland Civic Theatre during that period. I was doing theatre photography a good deal just before I left. (p. 38)

What did you do during World War II?

I was in intelligence at regimental and corps level. I was close to front lines but I never actually got into combat. I didn't have to shoot somebody or get shot at.

What sort of photography were you involved with at that time?

I had a very sympathetic captain and he saw to it that I had the opportunity to photograph: portraits of officers and soldiers. I ran a little studio down in one of the towns in Hawaii. I processed there and I was practically out of the war for some time doing that.

Did being in the Army have any emotional effect on you in terms of your work?

It did, but I don't know how to explain it.

Did it shape you in any way?

I think it shook me more than shaped me, but having the opportunity to photograph for several months right out of basic training was very helpful. But there was no evidence of it affecting my work very much.

One of your first sequences was titled **Amputations** *wasn't it?*

Yes. There had been an earlier one done around a YMCA camp up in the mountains in the middle of the winter. Everything had been given to the YMCA, the negatives—its all lost now. But that was the first one.

Amputations *pertains to work that you did directly while in the service then?*

All the portraits do.

The style was extremely confessional.

It always has been. That sequence came together in about 1947 or 46. There was something like 50 poems and 50 pictures.

Did you see the pictures as being co-equal with the words?

I could see them as being equal with each other. The sequence was much more linear and all the poems were much longer.

During the war you were converted to Catholicism, was it your experience during the war that lead to this?

No. This came from a girl friend I had when I was living in Oregon. She was a Catholic and we used to talk about it once a while. When both of us found ourselves heading for the army we had a long weekend discussion in which she very powerfully and sincerely urged my taking up the Church. She had all sorts of fine arguments as to why I should. When I got in the army I became acquainted with our chaplain. I talked with him a little while and he thought it would be a fine idea too—obviously! I looked at it from the stand-point: 'Well, I ain't got anything else to do in this damned army, so let's get into this business of religion; and since the Catholic religion is the most complicated and the most authentic from my viewpoint, let's try that one.' So I did. I was baptized and all sorts of things went on. I used it very faithfully while I was in the Army, but when I got out of the army I drifted right out. (p. 38-9)

After the war, what did you do?

I realized that I just about had time to get started in school someplace. I came back to Washington and almost immediately got on a train as fast as possible to New York City and Columbia University, where I enrolled for some extention courses. For one year I studied under Meyer Schapiro in Art History. He was my advisor for a paper on art history in relation to Edward Weston. I also worked with [Beaumont and Nancy Newhall] at the Museum of Modern Art. I was copying a lot of cartoons and slides. I did a lot of copying photography for them on a regular basis. It was a way to make some money. I really caught up on art history.

How did you know the Newhalls?

I was already recognized as a photographer with my travelling shows at the WPA. The Newhalls had taken two photographs of mine from Oregon for a little book. So I was a name for them before I arrived, and when I landed, they took me under their wing immediately and we got along really well from the start. There were no problems about getting along with the Newhalls. Beaumont was just back from the war when I arrived. That was an extremely exciting rebuilding for me. I met Stieglitz, Strand, Ansel Adams, Callahan, Smith, Barbara Morgan, Georgia O'Keeffe, and anybody who was there in New York at the time. I was also elected to the Photo League. I went up to see Stieglitz in his little gallery and I had three or four conversations with him. Within a five minute period Stieglitz had got me back moving again. I had always had this sensation that while in the Army something had died or at least gone underground. Stieglitz came along and reactivated something.

Was there a crucial phrase, sentence, or a word even, that really rekindled that fire again for you?

I asked if I could be a photographer, and Stieglitz said: 'Well, have you ever been in love?' and I said: 'Yes', and he said: 'Then you can be a photographer.'

Why did you do a paper on Weston?

The reason for picking Weston was because there was his retrospective show that year. It was a big show and there was plenty of stuff I could work with.

Did you work with Nancy Newhall on the show?

Not really. I just stood around watching her move one photograph here, and one there. I certainly learned that when she moved one thing to go with another it was magic. All of a sudden it would come together.

Did you feel that you were appreciating the formal combination of two images, or was it a more emotional response to their positioning?

Emotional response. She was working with highly formal images. I could just see by how she put them together what a whizz she was at it. She was superb. I had already been hanging exhibitions back in Oregon, with artists, and I'd learned a good deal about it from them. You don't put two green paintings beside each other and that kind of thing. I worked with Nancy from time to time for many years. When I was in Rochester I had lots of shows to do—twelve major shows a year and some little ones. I had lots of practice.

Did Weston see your paper?

Much later; I wrote it twice. Weston did see it, but didn't particularly approve of it. He said: 'You've made some silly mistakes.' Of course, I thought it was the greatest paper that had ever been written and wondered why somebody wouldn't publish it. It never has been published—which is just as well!

Were you working on certain photographic ideas at that time?

When I came to New York I said—I'm not going to photograph New York—but I did a little. I photographed the interior of my own small room that I had when I was in Columbia, and 53rd Street which I photographed in the snow. The things that attracted me most were the lights in the windows of the tall buildings at dusk. I did quite a number of portraits, including Meyer Schapiro. Photography wasn't dominant though. It never dominates my life, it just has to be done along with a load of other things.

Had you seen any of Stieglitz's New York pictures?

Oh yes, the Museum had some and I did manage to see a few things at the gallery.

Did the idea of the equivalent mean anything to you then?

Yes. I had read *America and Alfred Stieglitz* when I was in Oregon and the idea of equivalent really hit me very hard; and one other phrase of his—'You can imitate everything in art except spirit.' Those two ideas were what I took from him.

Why did you move from the East Coast to the West Coast at that time?

I had the promise of a job at the Museum in Portland, but during the year in New York that job dissolved. Then Ansel Adams was starting his photography programme in California. I met Ansel and he accepted me. I immediately

went to San Francisco, and on my birthday I started teaching there.

That's the California School of Fine Arts, now the San Francisco Art Institute?

Right.

Was it that time that your close relationship with the West Coast tradition, exemplified obviously by Ansel Adams and Edward Weston, really cemented itself?

Yes. In New York I had seen Edward's show and I really studied it. I haven't studied a show that well since. I arrived in San Francisco in July and in December four students and myself went down to see Edward. We had a marvellous afternoon out on Point Lobos. From then on I saw a great deal more of his work. I used to take classes down to him at least once a year but he was pretty frail. We went down there three weeks in a row and talked and looked at his photography. That was also the time I started photographing Point Lobos. I was fascinated by it. That one year was a very crucial one. It soldified the idea of the equivalent for me. I became very much closer to the Newhalls and that is when my curatorial career began to get underway. Strand, Stieglitz, Weston and Ansel all gave me exactly what I needed at that time. I took one thing from each: technique from Ansel, the love of nature from Weston, and from Stieglitz the affirmation that I was alive and I could photograph. Those three things were very intense. And I also got an interest in the psychology of art from Meyer Schapiro.

Did you find all of these understandings culminating in anything?

They culminated in the sequence **The Song without Words.** The pictures were taken mainly around the San Francisco area. As soon as that was done there was a recognition, psychologically anyway, and everybody recognized that this was quite something.

Who recognized it?

The Newhalls did, and photographers, students and friends realized it too. I realized that I had come home to something.

The teaching of a course in photography at that time was fairly unusual as far as American education was concerned was it not?

Yes, Ansel had started a few months before I arrived and for a while we were teaching together. I can remember the first morning I heard the Zone System explained and I thought why didn't I think of that—its so easy! And so that afternoon I started explaining the Zone System to people. (p. 39-40)

What sort of assignments did you set the students?

They were architectural assignments—but the equivalent was always right there. They had to find the essence. Ansel would go up to a building and insist on orientation shots so you knew what the building was. I always insisted on moving in to get the details and if you could get any equivalents out of them, so much better. So between the two of us, it worked out pretty well.

Then they would be sent out into various parts of San Francisco to do a week or two documenting an area. I would do critiques of every person each assignment, as well as the general critique for the whole group. The critiques would run from nine in the morning until five in the afternoon. I didn't leave a photograph unscathed! (Finally I learned to stop that a little bit.) So while they were out photographing I was always talking to two or three of them. I never got out on these trips, but I got to see San Francisco because they photographed it for me.

Did you develop the theory of the sequence alongside the equivalent?

There was never much theory of the sequence—they just did it. I just did it. I don't recall students doing much with sequence when I was out there.

Single image work then?

Mainly. We did groups of things. Assignments such as 5 to 50 photographs out of area A, or something like that. Or take one object, photograph it for what it is and photograph it for what else it is, and then photograph an equivalent of it. Then make a fourth photograph which is an equivalent of the equivalent. That really threw them!

Did they present them on a wall in exhibition style?

As I recall I never looked at unmounted photographs. We put them upon a little ledge with the lights on them, and we discussed them. Sequencing was done of a sort. I suppose I moved things around—I don't particularly recall that. Mostly I talked about individual photographs. About how this one got along with that one.

But not in terms of the whole?

I didn't as a rule. The Spring exhibition was always a whopping big thing. There would be a large hall and photography had one wall and our own studio. It was a big studio—two storeys high and lots of light. It was at that time that I began to really practice what I had learned in New York in terms of putting photographs together. And under those conditions many students worked on putting their own shows together.

So then maybe what you learned from Nancy Newhall was grouping photographs rather than sequencing them?

Yes, because she was working with single images. They were not sequenced. Edward Weston never made a sequence in his life. I used to ask him about sequencing, and he'd say: 'Oh yes, I made a sequence'. And he'd bring out three photographs of the same person in three different positions. That was his idea of a sequence.

Did any particular motif draw you more than any others—the landscape or the city?

I would generally photograph nature. I didn't photograph the city a lot. My preference would always be to go down to Point Lobos to photograph. But after three years I started not wanting to go to Lobos. There's lots of places up and down the coast where I photographed. Then I'd get hungry for the city and I'd photograph the city too. In numbers I suppose there's as many of one as there is of the other. There's a lot of little corners around San

Francisco I just loved to take pictures of. In that little corner over there there's a photograph I would think, and someday I'll find it. Well, sometimes I did and other times I didn't. I'd go look at it every now and then to see whether it had arrived yet. (p. 41)

.

In terms of what we were just talking about you mentioned that you sometimes feel like going into urban and rural situations to find a photograph. Are you looking for still-lifes?

I work with a view camera all the time so I would say yes.

Not the spontaneous human document?

No. I didn't do that until I started working with the smaller camera, about '48, I guess.

At this time you had been exhibiting fairly frequently. . . .

I don't recall when I first had an exhibition in San Francisco. **Amputations** was to be shown at the Legion of Honour Museum but at the last minute they said: 'Can we show it without the verse?' I said: 'No'. So it wasn't shown.

What was the objection to the verse?

The verse was too controversial. It was all about war—too controversial.

Was there a pacifist overtone to it that might have offended at that period of time?

I didn't ask questions, they just said they weren't going to show it with the words; and I said: 'You are going to show it with or you aren't going to show it at all.'

Did the concept of an exhibition mean anything specific to you? What did you want from them, and what did you get out of them?

I had done a lot with the Oregon Camera Club. We had yearly exhibitions and I always took part in them, and in the YMCA Camera Club small exhibitions. All I understood by an exhibition was that it was a way of getting in front of the public. I liked the stuff I did in Eastern Oregon. It was stuff that was meaningful to me—expressive—and it was a means of getting it shown. I had no fancy ideas about what I was supposed to do with it other than to get it on the wall so people could see it.

Was there anything you wanted them to do?

Be seen. Sure I had read about equivalents and all those sorts of things but they were photographs that were primarily expressive. I thought: let's get them out. I didn't have any specific idea about what they were supposed to do to anybody except express aesthetic pleasure, if you can call it that.

Did you exhibit within the concept of the equivalent to evoke some sense of equivalency from an audience response?

I may have had such a notion. They were more about essence rather than equivalence at that point.

And what exactly was this essence?

I'll show you a picture that will tell you what essence is.

I usually missed of course and if I tried deliberately to get the essence of something I'd always miss it.

It did not necessarily have to do with the materialistic fact of things being in front of the camera?

Let's look at Edward Weston's photographs. How would you define those facts? I was in love with all the stuff I saw. I was interested in communicating what I was looking at—a nice tree, a nice building, and all that. It was pretty straight photography.

No implication of it being more than 'the thing itself'?

I would say that in the photography done while I was up in Oregon there was no attempt at equivalence. I knew about it but I was more concerned with Weston's approach, or Ansel Adams' approach, to the straight photograph. It wasn't until I got back from the war that I began to use the equivalent. I didn't know much about it—I postponed using it—I had no interest in it yet. But there were many things in the war that I had not been able to photograph and so then I began to use equivalents. There were a few photographs I made of clouds when I first got back to San Francisco. They looked something like Stieglitz's.

The sequence that you did in San Francisco 'Song without Words' did you publish it? Was it exhibited?

It was exhibited, but it was never published until **Mirrors, Messages and Manifestations.** Here was a set of photographs that came out rapidly. I looked at them and sequenced them, and showed them more as Weston showed his photographs—'here it is!' Even though I began to know about sequencing and equivalents I wasn't trying to impose equivalents on people. In the classroom you talk about equivalents—is it one or isn't it? But to get it up on a wall in an exhibition you can't go round and ask the people is it an equivalent for you, or isn't it?

But you did set it up as a sequence when you put it up on the wall?

That's true. It was a sequence.

Would it have been the first conscious public exhibition of a sequence by you?

No. My first one was done when I was in Oregon. That was intended as a picture story.

About this time in the early fifties the publication Aperture *appeared. How did the idea of such a publication emerge?*

That came out of the one and only photography conference held at Aspen, Colorado, by the Container Corporation. One afternoon there was a discussion of a publication with the Pictorial Society of America or the Pictorial Photographers of America—something like that. They had a publication, and there was a large round-table discussion about a different sort of publication. No one seemed to want to go ahead and do anything. Someone said: 'Let's just sabotage them and work from within!' But that idea got dropped. A few months or weeks later, Nancy Newhall, Ansel, and I were in Ansel's house and the idea of a publication emerged once more. They'd thought it through two or three years prior to that with a magazine

they were going to call 'Light'. I remember them pulling the first little pieces of it out. We then got busy and called Barbara Morgan on the phone, and Dorothea Lange came over, and one of the wealthy women who lived over in Ansel's area came over—she got a lawyer in, and a designer, and a couple of other people, and some students. There were seven or eight people. We sat down, talked it out, and decided to do it. Ansel said he would write 25 letters asking for 25 dollars each, and that's how it got started. And at this point the question of who's going to edit it came up. Strangely enough everyone was much too busy, but apparently I had less to lose since I was practically broke and the money I was making at school didn't help much. So, by default, I ended up being the editor. They all promised that they would come and help me when we got the material together.

Was there a guiding concept?

Yes. It was an angel with pink wings and a long tail with a point on it! We talked about what we thought *Aperture* ought to be. Excellent reproductions of the finest photographs, superb articles, and a journal for discussion.

It sounds something like Alfred Stieglitz tried to do with Camerawork. *Did you have that in mind?*

Of course, everyone was aware of what Stieglitz had done. It would be the obvious thing for that group of people to want to do. But it became, very quickly, just a one-man operation. It was not a forum for discussion, it became Minor White's private journal.

What did Minor White do with it?

He just made it his own private property. It was my growth. People who took photographs I wanted to show landed in it. My own stuff landed in it, from time to time, and everything I was doing with photography I was putting into it. It was a beautiful teaching device for a while.

It seems that in the middle sixties you began to promote, very powerfully, an idea that you summed up in the term 'reading photographs'. Could you talk about what that means?

It came about very easily. Studying with Meyer Schapiro and the Newhalls I was dealing with photography on a curatorial level—exhibitions which we had to write the contents for. You try to view a photograph and experience it, and then you try and communicate that experience to somebody else, not in photographs, but in words. It's a thing that the critic and the art historian have to do all the time. (p. 36-7)

Is that important to you that an exhibition can, in fact, attract a lot of people who are not the aesthetes of photography?

Yes, of course, I think it is extremely important. Steichen was very conscious of that, and he tried a way of making an exhibition which would perhaps take us away from further wars and show people what they are. It did show that vast numbers of people could be very excited by a photographic exhibition—it was at their level. Not the aesthetic stuff but very straight forward semi photo-journalistic documentation. Some of it, though, was really magnificent

aesthetically. The design was a very active one and you didn't have to stop and look at the pictures very long.

About this time you got interested in Eastern philosophy and religion. How did this come about?

Barbara Morgan gave a large branch of what's sometimes called Burning Bush. She gave it to Nancy Newhall and somehow within a few days she gave it to me. It was late fall and we had some magnificent frost and the branch was covered in it—I made a picture of it called **Ritual Branch.** That coincided with a gift from Nancy Newhall of a book called *Mysticism.* Then someone showed up on my doorstep with two books, *The Doors to Perception* by Huxley, and *Zen and the Art of Archery.* John Upton was living at the house that year and he was studying mythology over at the University of Rochester. I picked up Underhill's *Mysticism* and read it with great interest. *Doors of Perception* was of less interest. I got interested in Zen and mysticism in general. Zen seemed to be something I could kind of get my fingers into. And then within two years Walter Chappell showed up from the West Coast and he told me about an experience he had had with a Gurdjieff group in New York. He was talking along fine and all of a sudden I couldn't understand what he was talking about. I said: 'Why don't you back up and start over again.' He started all over again and at the same point I blanked out on him again. I couldn't make out what he was talking about. We ended up very angry that afternoon! That was my introduction to it but I couldn't grasp what he was saying. He came back several years later to Rochester and I talked to him a little more about it and this time it made a little more sense.

Then we got a reading group going and someone came up from New York to help out on that and I became acquainted with a Mrs Louise March. I attended these first few meetings and then evaporated from the scene except that I kept in contact with Mrs March. That was my real introduction to Gurdjieff and that constituted a very profound change in a lot of the things I did. Finally I came to a decision to connect myself with something. If there had been one in Rochester I would have gone to a Zen group. But since there wasn't and the Gurdjieff group interested me I started working with them, and have ever since.

Was it at about this time that the idea of 'camera consciousness' began to be a thing that concerned you?

I think the idea of 'camera consciousness' began to emerge around '65, '66 at about the time I began to move to MIT.

There was something that you mentioned recently that seemed to impress you in a book on mysticism. It was a statement. . . .

The statement was—I can't quote it exactly—'the mystic could understand the artist, but the artist couldn't understand the mystic'. When I read that I said: 'Well, I don't believe it.' It wasn't until I began to have inner growth—I won't call it spiritual experience—that I began to realize that a mystical quality wasn't showing up in photographs.

What do you mean by this?

Where I was in my 'inner landscape'; the sequences weren't doing it. Take the 1968 sequence (the last in my book), which certainly reflects a given state of mind, but it's a long way from what's going on inside.

Was the experience akin to anything that you had discovered in music that made you stop studying music, and in poetry that made you stop poetry, and then in photography that seemed to culminate in a meeting with Stieglitz?

There was a moment one morning when I was aware of something inside moving into place and filling up a gap. It was completely powerful. It was akin to what Stieglitz had done. He filled a hole there somehow. It was the same kind of thing, but it had nothing to do with photography. It just simply happened inside and there was no exterior anything at that moment. I asked Mrs March about it later, and she was quite emphatic, and she said: 'There is a throne and whoever is supposed to sit on it finally came and sat on it.' She explained it that way. That was a very profound moment but it had no relationship with photography. But it did have a relationship to the work I was doing with this woman. It came through the disciplines we had been working on. I no longer remember the date, but I remember it was prior to my moving to Boston, maybe '62 or '63.

Why did you resign from George Eastman House?

The major reason for resigning was that I just couldn't stand the Director—who was not Beaumont Newhall, but a general. I just couldn't take that man anymore. I worked at Eastman House over three years, and I was in Rochester eleven. All of these growth things were done whilst I was teaching.

There seems to be an incredible sense of urgency about this time. You seem to be looking at things like the I Ching, *investigating Zen, investigating Gurdjieff and also hypnosis. Why were you investigating so many things?*

I think it is just a natural eclectic tendency. I tried everything. I tried them on photography to see whether it fitted or whether it wouldn't.

Did you use these things as teaching aids as well?

Very often it would become part of that.

Did you find that any of them were successful?

They were all very useful—I still use most of them.

How was hypnosis useful?

It's a means of concentration. One goes into some kind of a state—not exactly a trance state. I'd been trying earlier to establish a way of reading, or viewing, photographs, and arriving and interpreting an experience. It's the experiential attitude I was always trying to get at. I looked at hypnosis from the outside and I thought: 'This is just a fast way of doing it.' For years I would have people gather around a photograph in a classroom or in a house and look at it for an amount of time and then try and talk about it. When we got the hypnosis technique going we reacted pretty passively. It was a technique where we could relax all energies. You learn to be very passive with the image until the things talk to you—and sooner or later they do.

But the intent always was: how to get involved with images as an experience.

Do you feel a little strange trying to confront people with images when they were in a state of hypnosis?

I played with this for several years. On one of the workshops out in Oregon around 1960, I met a Dr Ruston, who is a professional hypnotist. He uses it for his medical operations. He sat in on one of my lectures and grabbed me by the scruff of the neck and explained to me a lot about hypnosis! It helped a lot and he was most useful because he realized that I was up to something that I wasn't too sure about; so he helped me get sure about it. In 1963 or 64 there was a national convention of hypnotists and he said would I mind showing this technique to a group of them. I demonstrated this thing for about three hours. Different methods, with and without music, single images, sequences, and the whole thing. When we started out Ruston said: 'Professor White here has a means we would like you to look at. It seems to be hypnotic and we would like to know whether it is or whether it isn't.' The conclusion was that what I was doing was hypnoidal, but not hypnotic. They recognized that instead of putting people under a state of heaviness and under the control of the hypnotist, we were doing the opposite; we were going towards lightness and turning the student over to the influence of the image, not the hypnotist.

Do you ever see a relationship between this and the way Stieglitz was said to have some sort of hypnotic effect on people?

Probably not, but he may have had a hypnotic effect on people. I realized after a while that all I have to do is just talk for a little while and I've got everybody hypnotized. I think Stieglitz probably did the same without even intending to. I suddenly woke up to the fact that I'd been doing it for years and didn't even know it!

At this time you got very involved with the workshop system. Do you feel that this is a better way of teaching photography than in a more institutionalized way?

It's an alternative, neither better or worse. The first workshops occurred in San Francisco. Then from time to time people have lived with me. I've never been married so there's always been room for someone around. In 1959 was the first time we held a living-in workshop (for 5 people).

There's always a workshop going on. It served two things—companionship and being able to teach people more directly and more intimately than I could do in an academic situation. I couldn't go as far in an institution—I couldn't use hypnosis as much, and I couldn't do this and I couldn't do that. I wanted to take things further. Paul Caponigro was working with me for two summers which was just right. A person being with you for a year, or a year and a half, was always too much—I used to dominate.

What did you teach in the workshops?

Experience of the subject while photographing it and while looking at the images—and anything else that came

to mind. We'd probably talk about graphics, about design, about history, whatever was on top of my mind. There was never any fixed course. If I was working with *Aperture* they would hear about it, and sometimes they would help.

Was it during the workshops that you began to develop the theory of taking and viewing photographs in a state of 'hightened awareness'?

The 1959 workshop made it a pretty conscious affair. Up until that time we had been doing something like it, but in a very passive way. I have a feeling that a person looking for a good photographic education should have workshops with various people plus an academic training during the same period of time, say, three or four years. Most people don't make workshops quite as intensive as I do. You just simply live, sleep, eat photography for 5, 10 or 15 days. You do nothing else. The work we can accomplish is just unbelievable. The 'hypnosis' just starts on the first evening and it goes on until the last. For example, we may photograph water as your partner and photograph your partner like water. Anything I think up. But it's the intensity of it. We used to feel so high on the last night— and without pot or alcohol or anything like that. I discovered that that was a great mistake, however, so I started making the high peak about two days, or even three days, before the end. I would literally coast them down, so when they left they didn't drive off a cliff or things of that sort! (pp. 38-40)

.

Was it during your time at RIT, that you started to introduce rhythm and movement into your classes?

That was not done at RIT. It was done in the various private workshops.

What was the reason for that?

In 1961 or '62 I gave a workshop outside Los Angeles, in the mountains. It was a family camp kind of thing, and they taught all sorts of things, largely on a family basis. They had a dance group up for a week, and this group put on a performance in which the director stood on a podium and lectured while his dancers illustrated everything he was talking about. It struck me as just fine and I got well acquainted with him. Sometime prior to that, up in Portland, I had been having people try in interpret an image with music, and I was having people dance improvisations of a slide or a photograph. Well, this particular chap I talked to caught on very well, and he took time off one morning to work with us. We made some sketches of things—heightened awareness, etc., and then we brought the sketches to where he was. First thing you know, all of us where dancing to the sketches. It was an incredible morning because you could see the equivalents from one to another. It was just so obvious. That's what we were driving at, an equivalent in dance to something visual. (pp. 34-5)

How do students at MIT find it?

They love it! They think it's great. (p. 35)

Within four years it had grown into a Creative Audience class Jonathan Green took over the Evaluating Photogra-

phy class which has primarily gone over towards history and evaluation.

In the Creative Audience class the photographer induces heightened awareness in himself in order to have an experience of the thing he is going to photograph. And a person who is just going to look at photographs can do exactly the same thing. I figure it is creative to be able to induce that state, because it puts one in touch with deeper places in oneself. One can get in touch with the Creator within oneself. I always use a dancer, who understands what I'm doing and who understands what they're trying to do. We're really teaching movement, not dance. I'm teaching seeing, not photography.

The whole emphasis is on the expansions of the seeing process, and learning to bring in what is going on in the body, to become aware of it, and to reach a consciousness of it. Conscious photography then is being aware of one's body while making, or looking at photographs.

Does that make a person more able to respond, though not necessarily to understand?

Oh yes, absolutely. We don't necessarily get an understanding, but it leads to it. Now Gurdjieff ideas are involved in this quite deliberately. And one of the ideals of Gurdjieff is to function as a whole or total human being, which for the sake of convenience is broken up into three parts: the intellect, the emotions, and the sensations— head, heart, and body. There's a lot more to it than that, but that's enough to start with.

By getting people to look at images and to become aware of their body reactions, they are being asked to add their body to their sensations and their intellectual activity to that. The idea is to be able to respond on all three of these levels simultaneously. Nothing comes first. Except in our education, the head comes first then, by accident. We teach our body through our heads. So we're trying to introduce a connection between all these centres. You start either from the body or from the head, and get them both going, and very often the emotions come in on their own accord after that.

As in an intuitive response—the emotions bursting forth as intuition?

No. We don't have much control over our emotions, they come and go, and we go along with them. We do, however, have some control over our thinking, and we can become conscious of our bodies. By getting head and body conscious and functioning the emotions sometimes arise of their own accord. But that isn't intuition. The emotions are something else. Because I know something about it and my body has a sensation of it, very often I begin to get emotional.

Sensory and intellectual responses are catalysts for the emotions?

No. They're just parts of the recipe. You put so much butter and so many eggs, and something else emerges—you have an idiot, you have a cake, you have an experience, or you have something which is full. I mean it can be a total experience. We're leading to a total response, and we

Two Waves and Pitted Rock*(1952).*

have to start with people who are using their heads a lot. The intellectual knowledge they know very well—it's amazing how much. We try an experiment: we look at a photograph or a slide and then we talk about it. A good deal of information comes off it. They've been looking at photographs all their lives, they respond to them, and analyse them. We do the same thing in a state of heightened awareness.

How does the state of heightened awareness come about? You induce it?

It's definitely induced. I use a very definite relaxation-rebound technique. We look at a different image, and people will always say: 'I get more out of it under this condition than any other.' Their intellect sees more at that point. Mostly they're talking out of their heads. Now through dance and movement practice, which takes just a few weeks, people begin to realize that the image is reaching their body and they begin to find out how. They move or take positions that relate to their experience of what they're looking at. This doesn't cut out the intellectual aspect of it at all, it adds to it. We begin to realize that the emotions emerge when you're doing the other two things. They emerge of their own accord sometimes, but

not always. There seems to be no direct way of getting that emotional side. You can't just command them and say emote that image! If you do that nothing happens.

Wynn Bullock uses the word apperception with regard to his own philosophical approach to photography and space/time. Do you use this approach in your Creative Audience classes?

I never use it myself but maybe I could find a way of using it. As an aside: I try to read what Wynn says but I usually end up getting only the dimmest glimmer of what he's driving at. Maybe when he reads what I wrote, he has the same problem!

The comparison has been made, with your own approach to photography and Bullock's. He seems to think that you part company when it comes to a comprehension of existence. He felt at variance with the spiritual and religious side of your philosophy. What do you feel about this?

It sort of makes me wish I'd never used the word spirit. Because I don't think we do part company on that at all. Spiritual is a word that people always misunderstand. They imply things to it which should not be implied. I've used such words as creative and spiritual rather freely be-

444

cause it's useful—but they always need to be defined very carefully. In the past few years I tend to stay away from spirits and spiritual. People who have not gone into disciplined esoteric work generally have the weirdest idea of what spirit is. I have been defining creative ever since I came to MIT: as anything which brings us into contact with our Creator, either inwardly or outwardly. That's an unusual definition of the word creative, because creative sometimes means putting things together that haven't been together before.

I think this definition very clearly states what I'm driving at in teaching, in my photography, in the criticism, and in the picture editing I've done. I try to find this Creator in everything I do. This is the way that you can move through photography, or anything else that you're doing, towards locating that aspect which is ever-present and ever-hidden from us. My philosophy of photography since I came to MIT is tied up in that definition. That's what Iam driving at. All the activities that I do take me in that direction. (pp. 35-6)

Do you feel that this might seem subversive, using photography as a vehicle for your religious beliefs without actually coming out and saying so?

Well, one has to keep that very quiet! That's why I want to get away from the word spiritual because people mix it up with religion. I don't like the word religion, but I don't mind using the word sacred.

Do you equate that with what you call camerawork?

Camerawork is like equivalent, it works at many levels. Equivalents can be on a graphic level or they can be on a sacred level. Camerawork is primarily interested in fine, beautiful, aesthetic and somewhat sacred photography. Camerawork does not, however, automatically mean sacred photography.

What do you mean by sacred photography?

Sacred photography tries to lead the photographer towards a recognition that there is a hierarchy of forces. There are lower levels which are not sacred, higher levels which are sacred, and still higher levels that we don't know anything about. There's an ordinary level of life and there's an extraordinary level of life. When you start talking about sacred photography, you are talking about religion. I think that any art medium is 'a step on the way', and to many artists this is their ultimate expression—a sacred one, in some form or another. A lot of the highly expressive painters who are only after ego-expression, or seeming to be, very often touch on the sacred without really intending to. (p. 37)

Is it necessary to hold religious views to really appreciate a sacred photograph? Or can you appreciate it if you do not believe in any higher being?

I think if a person does not believe in any higher being then he can't see it. He can't imagine such a thing exists, or won't admit it. Therefore he never can see it.

Is it essential for him to see it whilst viewing a photograph?

No. The photograph may not have it either. As one looks at photographs and one looks at things to take photographs of, you begin to recognize that this is an ordinary situation, this one is a little extraordinary, and this very extraordinary. You begin to realize that there may be this same force behind absolutely everything. We keep saying this one has it, this one doesn't. I use the word presence, which simply means the same thing. This has presence, and this one does not. And what is that presence? That presence is something sacred, it's our Creator, or it's another force, it's grace. Through the centuries there's been many names for it. If you give a person a word for it, he doesn't see it, or he says he sees it, but he really doesn't. You have to work for it.

Are you saying, therefore, that like beauty, presence is in the eye of the beholder?

No. If the eye of the beholder does not have that capacity, then a person can never see it.

Do you feel though that the less informational subject matter that there is in an image, the more successful it is as an equivalent?

It's simplified. It does not make it more of anything. I always feel that it's pretty hard to predict what a photograph is going to do what to whom.

Mirrors, Messages and Manifestations *was probably the first body of your own work to be seen.*

Correct.

Was it deliberate that you waited so long before you published?

I could not find anybody to publish it before that. I'd have been perfectly willing to publish twenty years earlier than that! It's just as well I waited, I think.

The book has a title that's reminiscent of Jung's posthumous autobiography, Memories, Dreams, Reflections. *Did this influence you?*

I have read Jung. I was conscious, of course, of his book.

Do you see your book as autobiographical?

What else?

Is there an essential overall theme that you see revealed?

You've read it?

Indeed.

Then you know more about it than I do!

You've said that personal photography continues to be a statement of position. Could you say what your position is now?

I don't think I will ever manage to get my position appearing in photography or in my photographs. I am attempting to be in contact with my Creator, asking and allowing that to tell me what to do. I'm trying to be in contact with something that is ultimately wise, and follow it's directions, instead of trying to be self-expressive so much. I've gone through all that. I need now to work with 'this something'. To make things go differently. Or maybe not differently, I don't know what it'll do.

How would you like to see photography develop?

It makes absolutely no difference what I want it to do. It's going to do what it's going to do. All I can do is to stand back and observe it do it.

What don't you want it to do?

That doesn't make any difference either. It'll do that whether I want it to or not!

Surely, you've got to have some feelings?

In one sense I don't care what photography does at all. I can just watch it do it. I can control my photography, I can do what I want to with it—a little. If I can get into contact with something much wiser than myself, and it says get out of photography, maybe I would. I hesitate to say this, because I know it's going to be misunderstood. I'll put it this way—I'm trying to be in contact with my Creator when I photograph. I know perfectly well it's not possible to do it all the time, but there can be moments.

Do you see anything in contemporary photography that distresses you?

Whatever they do is fine.

Is there any work that you are particularly interested in?

Whatever my students are doing.

There seems to be a passing on of certain sets of ideas and understandings. Do you feel yourself to be an inheritor of a set of ideas or ideals?

Naturally. After all I have two parents, so I inherited something. I've had many spiritual fathers. The photographers who I have been influenced by, for example. There have been many other external influences. Students have had an influence. In a sense that's an inheritance. After a while we work with material that comes to us and it becomes ours, we digest it. It becomes energy and food for us, it's ours. And then in turn I can pass it on to somebody else with a sense of responsibility and validity. I am quoting it in my words, it has become mine, and that person will take it from me, just as I have taken from people who have influenced me. Take what you can use, digest it, make it yours, and then transmit it to your children or your students.

It's a cycle?

No, it's a continuous line. Not a cycle at all. . . . (pp. 37-8)

> *Minor White with Paul Hill and Tom Cooper, in an interview in* Camera, *Vol. 56, Nos. 1, 2 and 3, January, February and March, 1977, pp. 36-41; 36-40; 34-8.*

SURVEY OF CRITICISM

Janet E. Buerger (essay date 1976)

[*In the following excerpt, Buerger analyzes the formal qualities of White's photographs.*]

Although there is a tacit admiration of the pictures of Minor White among photographers and photo-historians, much of his enormous prestige derives instead from his activity as an artist-teacher. Emphasis is given to his teaching because he was a prolific writer and, in the course of this, a self-critic. The formal aspects of his photographs, on the other hand, while they've been intuitively appreciated, have never been actually explained, thus escaping their correct position in the history of photography. He suffers the same fate as Josef Albers and other great artist-teachers of this century in that his work, although a milestone in its medium, totally lacks proper critical assessment.

In a short essay, particularly one which purports to be in his memory, it is difficult to claim that any one consideration is the most important to be chosen about his *oeuvre*. He was known for accomplishments in many areas: his Zennist approach to photography; his identification with Ansel Adams' zone system; his Portland and San Francisco cityscapes—a theme to which he would return later; his infrared photographs; his nature compositions; his portraits; his negative prints; his superimposed images; his demand for a "creative audience;" his sequencing and poetry; his role as editor. Fortunately, Peter Bunnell's excellent bibliography and chronology of him, which is published in White's autobiographical book, **Mirrors, Messages, Manifestations** [see Further Reading, section IV], would make a sketch of this sort redundant here.

Instead, the following discussion will concentrate on the formal quality of the nature "abstracts" that are normally considered his most characteristic work and will suggest, particularly to those who lose him when prajña is mentioned, that this alone secures his position as one of the most significant artists in the medium. If his students approach this quality, it is termed plagiarism, and none has surpassed him in his own direction. An examination of White's oriental philosophy, of course, would deepen an appreciation of his work, but the intention of this article is to indicate that even without this his photographs represent an important advance in the art.

White claimed that he was indebted mainly to three photographers: Stieglitz, Weston and Ansel Adams. The last was important mainly for technique and so will not be discussed here. Technique is crucial in White's method, as will be shown below, but the zone system on which it's based is well understood today and needs no elaboration. Stieglitz and Weston must be mentioned briefly, however, because White's achievement rests on qualities in their work that are rarely analyzed. This is particularly true of Stieglitz. White's images are normally considered a continuation of Stieglitz's "equivalency" concept and usually White referred to the *Equivalents* when speaking of the earlier artist. It is generally recognized that with his *Equivalents,* which were pictures of clouds done from the

early '20s to the '30s meant to represent his life's experience, Stieglitz introduced the idea that a photograph could have multiple meanings, and initially White was impressed with this. Stieglitz himself, however, preferred *The Steerage* (1907) to any of his other photographs and ultimately White's advance departs from this, rather than from the *Equivalents*. Though the *Equivalents* were important in pointing out the extreme ability of photography in the direction of allusion, and though White perpetuated the theory, the idea they presented was not generally new: it was basically related to a variation of an aesthetically oriented symbolism that had appeared in different guises in previous non-photographic art, i.e. where the given image stands for or alludes to an idea that is not depicted. The viewer gains this idea through his intellect, or making associations. The formal quality of the picture has little to do with this intellectual activity. To this extent, then, Stieglitz's *Equivalents* did not represent an advance over what had been accomplished already in other areas of the arts.

Returning to *The Steerage,* one finds a totally different situation. If the value of *The Steerage* is understood, White's accomplishment will be clearer. Considering the state of art in 1907, Stieglitz's picture holds up well. The viewer's eye is caught by the drawbridge and, although the picture is "realistic," the eye constantly returns to this central bright spot, not to the more typical subject matter of the people. Yet the crowd sets up a tension that pulls the eye away from the bridge because it takes up a larger area of the surface and because the viewer is compelled by tradition to seek out the figural areas. The image becomes important for itself instead of for the subject matter or something it represents. The content of the image lies in the photograph rather than in what is depicted or in an ambiv-

alent reference to anything that is not depicted. The formal achievement of reducing the image to what is seen edge to edge on the photograph while defying any complete interpretation through subject matter was something even Picasso, who admired the picture, could not boast of in his own work in 1907.

Although White encouraged his audience to read into his pictures ideas that were not literally depicted, and this activity was an important part of his work, a more significant aspect of his creativity develops directly from his manipulation of what was already in his given materials. He intentionally maintains the integrity of the photograph as a complete statement in itself, independent of the subject matter, and in this way the result derives from what was achieved in *The Steerage*. The allusionistic experience attached to his nature compositions is based on the manner in which he advances formally from Stieglitz's picture: he adds another dimension that serves the dual function of virtual physical depth (of the image, not only the depicted object) and, from the way in which he achieves this illuded depth, consequent psychological depth. In other words, one allusion involved in White's pictures is dependent at all times on the formal quality of his image. In this case, the two serve interdependently, not separately as in the case of symbolism or equivalency.

Psychological depth, of course, existed already in Weston's photographs but was still tied formally to the depicted object and to an intellectual jump into this metaphysical depth. He spoke of his pictures in expressions that were similar to White's: that they were abstract images, completely outside of the subject matter, images that take the observer beyond the world of the conscious mind to an inner reality. He called this "significant presentation." The similarities in their writing tend to obscure the differences in their prints. The intended end is apparently similar but the means are different.

White's success in instilling his extra dimension was already assured in 1947 with his shot ***Sun in Rock***. He began to expound the theories behind his work in the early '50s. Although the following passage presents a somewhat simple explanation, it clearly indicates that White aimed at a four level interpretation. The fourth level is the important one for the purposes of the following argument because, while one might suggest that the first three represent the method in which White often worked, the fourth might be considered as his ultimate aim. An appreciation of the formal qualities of his pictures would be enhanced by separating this fourth idea from the concept of, or the word equivalency. The image that accompanied the passage is not as important as White's discussion of it itself; later he cropped the picture, excluding one of the holes in the sand. The discussion explains various depths of "equivalency" in photography.

> The subject matter can be seen as a rock formation, but this is evidently only a framework for the meaning. The two curious holes become the subject of the photograph only momentarily. Transparency takes place. A visual pun appears because the holes suggest eyes or ears. Then a still deeper layer of meaning becomes visible, the philosophical pun on the words either-or. We

Nude, San Francisco *(1947).*

are either this or that, good or evil, alive or dead. Finally, still a deeper layer reveals we are looking at the conflict in the heart of a man [*American Photography* (November 1951)].

Some of these layers are valid in strictly formal terms, indeed. He intends "realism" and gives it to the viewer for a moment. Like Weston, White believed that if photographic realism, or objective naturalism, were not employed, one would be ignoring the facileness or ability of photography to render nature objectively. In addition, he was equally aware that if he held on to this objective naturalism, he risked losing another quality he felt important to the medium: allusion to something beyond the depicted object. But, as was suggested already, when White introduces his allusion it is not necessarily independent of the original realism or of the print itself. He sustains all three at the same time in the nature "abstracts" under discussion. His allusion might in other cases go to simple association, then to symbolism (Steiglitz's "equivalency") and so depart from the original realism, but the strength and complexity of the formal quality of his nature pictures is often such as to exclude allusion in these senses. This is where the fourth layer comes in.

White goes directly to his "conflict in the heart of a man" through his print quality. This is accomplished by presenting a tension in the formal elements, specifically between the realism and his created illusion of depth. By the tension, he joins these together into one bond and by joining them he prevents the viewer from understanding the photograph or relating it to a meaning because they are no longer intelligible as a logical state of affairs. He forces the viewer's intuition (or heart, or soul) to complete the picture because his intellect cannot. As a result, the picture and the person are also bound together with the formal quality of the print. In fact, the print tension becomes part of the viewer's non-intellect. This unity of the print, its tension (between objective naturalism and artist-created illusion) and the viewer's non-intellectual component is closer to being at the "conflict in the heart of a man" than any concept of equivalency, or any extension of that concept. The very word "equivalent" implies that there are two things involved, one equal to the other; formally and experientially, White's photographs only involve one. In essence they are the contradiction, therefore, of "equivalency." Again, the appreciation of what happens in this group of photographs would be greatly increased by an understanding of White's eastern philosophy but a more purely formal analysis is the purpose of this paper.

An understanding of the nature of White's formal means is critical to a full understanding of his accomplishment because it is through a sharp ability to control not only tonal values but compositional and illusory components in his prints that he succeeds in going beyond his colleagues to this fourth layer. His ability to reach this layer through formal means without eliminating the original realism or the integrity of the print, to allude without eliminating the means through which he alludes, was a significant advance in photography.

An untitled photograph from *Sequence 8* is an example of White's manipulation of formal elements to transform his depicted information. The photographed object is some kind of rock formation again, apparently a dark rock covered with snow. He has taken an area where the rock, projecting toward the viewer at the left, recedes away from the picture plane and turns parallel to it in the large dark shape in the center. Already, the surface of the rock is, so to speak, twisted. It should be noted that White played on the ability of the glossy surface of a photograph to lead the viewer right past it into the illuded space beyond, the through-the-window illusory potential of all two-dimensional art. He called this a "glass-surface" approach. The rock surface, then, is the first surface the viewer perceives. White has composed the scene to work toward his previsualized final image.

But his composition of the given rock surface is only one of the means toward his end: he has also created an independent design by manipulating the tonal values by means of the zone system. In the upper left corner he has allowed the viewer to see the snow as it was, intact upon the rock, while in the dark central area he has emphasized the lower value of the dark rock and thrown it into depth by expanding the snow's tones (already lowered in value through exposure) to lighter values, which results, in certain areas, in its exaggerated projection out toward the viewer. This is particularly obvious in the lower center and right portions of the picture and in the irregular specks to the left, now suspended in the midst of a vast space that contradicts the natural volume of the rock. In other words, White artificially creates a sense of depth and projection independent of the rock's natural state but yet derived from it by photographic means. This potential play with the illusion of depth or projection was to be a key element in abstract imagist and color-field painting, too. The photograph presents a complex medium for such a play because of the inherent reality to which White's purely artist-created illusion is added.

Like the technique that enables it to appear, design acts as a determining tool. It not only allows artificial illusion of depth but frees the image from the reality of the depicted object by destroying its complete credibility: it gives you White's creation (the image, or the print). The photographic medium was particularly appropriate for White because he wanted to transcend the normal qualities that pin the artist and viewer to the world of ordinary human knowledge—the physicality of the materials of other media would have been a hindrance to him. His realistic, glass-surface photography was a mediumless medium, as it were: the surface (of the photograph) disappears and the straight photographic style is close enough to the appearance of reality to suggest the absence of a medium. This sense of non-medium, or rather non-apperception of medium, is enforced by the viewer's instinct to wonder what is depicted.

When White remakes the object in his image by manipulating the tonal values, the viewer is left between the absence of medium and the absence of reality and is forced to enter into an undefinable space dependent on what White preferred to call his "state of heightened awareness." Paradoxically, the participant is neither in a totally virtual real space nor a totally artist-created space but is

definitely beyond the picture plane. The space has transcended ordinary human knowledge; it exists only in the mind of the viewer, who easily intuits it but is hard put to explain it. The same situation can be found in **Sun in Rock,** and the Rochester photograph from **Sequence 13.** White worked along these lines for twenty years. . . . (pp. 20-4)

White's method relies on the definition of a space and to the extent, of course, that photographic space usually depends on what is invariably termed realism, it relates to the Renaissance conception of a perspectival, three-dimensional world of art. To some degree this has caused photography to appear pinned into a "style" that has been obsolete for most of this century. It is a tribute to White that he succeeded in achieving a formal advance based on purely contemporary concepts while retaining the medium's classic essence of naturalistic rendition. He took the best of both worlds, not only dealing with a figure-ground problem but completely destroying the figure-in-landscape situation, which appears momentarily even in modern painting, by the contradiction of the very aspects that define such a situation: tonal implication of planes in space and the perspectival quality that pins these planes into an intellectually comprehensible area of that space.

To reassure those who are suspicious of White as a mystic, however, it can also be suggested that his transcendent space relies heavily on the psychological possibilities that were a result of the introduction of the perspectival space of the Renaissance period. These possibilities were recognized by Alberti when, in the first half of the fifteenth century, he suggested that the greatness of a painted *istoria* was not to be in its size and that the formal qualities of a painting were only to be a means to its end. This *istoria,* which is an untranslatable term that Alberti used to refer to the subject matter, composition, perspective, and so on in a work of art, was a concept that included a metaphysical dimension toward which all this method and accuracy of technique was to aim, i.e. communication of the soul. It was incomplete and, in fact, nonexistent without this dimension. White's combination of form and content in his nature compositions is an amazing contemporary revival of this concept.

This dimension, in both Alberti's theory and in White's photographs, is experienced instantaneously, whether understood or not, quite unlike the "equivalent." Alberti said that a perfect *istoria* is a painting "so agreeably and pleasantly attractive that it will capture the eye of whatever learned or unlearned person is looking at it" [*On Painting* (1973)]. In both Alberti and White the greatness of the work depends on the inclusion of this non-intellect of the viewer.

It is curious that when French history painting and all that it involved, failed to be acceptable to the modern world of the nineteenth century it was partly because the psychological depth of Alberti's *istoria* had been reduced to a moral, i.e. shallower sense of implied significance. Although displeased, however, the nineteenth century Frenchman was not in a position to understand that the concept of Alberti's "history painting" had been long lost over the centuries. The French artist, rejecting the French

version of the tradition as unviable, turned to something totally different, something more formally oriented, on which the formal aspects of most later western art depends. This change coincided with the invention of photography; in other words the Albertian concept, or its remains, had been rejected before photography was developed. From the middle of the nineteenth century, the new painting directed itself more and more toward an art for art's sake that was increasingly dependent on the physical terms of the work, i.e. the canvas, paint, or whatever, with brief periods of experimentation in symbolism. This was basically a return to an aesthetically oriented art that excluded the non-aesthetic content they felt history painting involved. Implications for the artist's personal sensitivity, starting with the "pure painting" of Manet, developed through the Impressionists and Cézanne to Cubism, where, as in Stieglitz's *The Steerage,* the abstract formalism that was later to culminate in the '60s began. With White's photographs, his transcendent transparency, or allusion to something beyond the depicted object in the Albertian sense, was reintroduced into this formal abstract art as dependent on its formal qualities, i.e. in the way that Alberti originally introduced the concept. When White insisted on technical expertise as an *a priori* ability on the part of his students, he was insisting not on a technical excellence in the manner of Ansel Adams, so much as on the capacity to use this "scientific" knowledge to create an aesthetic ambience into which the artist could draw the viewer's soul (as Alberti would have called it).

White's style is, as was suggested above, completely contemporary. It should be assumed that he was fully aware of the power of design in the other visual arts. He began teaching at the California School of Fine Arts in 1946, the same year that Clyfford Still did, and it was then one of the most progressive art schools in the country. By this time, he had already studied some art history at Columbia University with Meyer Schapiro, for whom he wrote a paper analyzing Weston's photographs according to Wölfflin's principles. Like Stieglitz, he wasn't limited to photography for his vision.

To put White into proper perspective he must be seen as having anticipated in his photographs the formal achievement that would appear in the early '50s in the abstract expressionism, or abstract imagism, of Hans Hofmann, Rothko and Newman, and even the color-field canvases of Morris Louis and Jules Olitski in the '60s. Albers, Motherwell and Still were working along similar lines, of course, but it would take a longer essay to fully discuss this period. The fact that White's production in the later '60s was more in the teaching and editing line, and that specifically he stopped producing the type of nature "abstracts" discussed above, coinciding with the decline of color-field painting, should indicate how significant this type of work was to him and how it must be seen in the context of the period.

White has done what the modern painters did formally without the least deviation from inherent photographic factors. He begins with the same thing he ends with: a created image at once derived from and independent of a depicted object. (pp. 24-5)

Of course there is no "meaning" to White's transcendent space, otherwise it would not be transcendent. There is a tendency on the part of the intellect to want to explain everything or, conversely, to want to understand everything. In essence, White's photographs defy either attitude. An accurate appraisal of twentieth century photography and art cannot be presented by explaining White's work as a continuation of Stieglitz's *Equivalents* or Weston's "significant presentation," or even as the manifestation of a technically skilled mystic. His anticipation of the formal qualities of the art of the '50s and '60s should be recognized, and the addition of a psychological dimension directly dependent on these formal advances should be noted.

Max Kozloff, who has published some of the most valuable critical discussion of the photographic medium, points out that:

> Exactly because the level of recognizability in photography is so high, their random accidental lapses from that level form a very keen-edged exploration into the unknown [*Renderings, Critical Essays on a Century of Modern Art* (1968)].

White spent his whole life trying to create a responsive audience. Now, after his death, and now with the history of photography at last claimed as a legitimate field of study, perhaps it is time to require comprehension as well as response. White's "lapse" was no accident and this fact makes him a pivotal figure in the history of art. (pp. 25-6)

> *Janet E. Buerger, "Minor White (1908-1976): The Significance of Formal Quality in His Photographs," in* Image, *Vol. 19, No. 3, September, 1976, pp. 20-32.*

> **White on photographic sequences:**
>
> Sequences originate for me from some hidden place. Though I habitually play photographs against each other, or words against images in pairs, triplets, or rows of four with expectations of magic, sequences originate from within. And I prefer to let them. In fact I cannot seriously do otherwise than photograph on impulse and let whatever words will, flow spontaneously. Now and again a fragment of poetry will breathe out as I am making the exposure.
>
> *From* Mirrors, Messages, Manifestations.

FURTHER READING

I. Writings by White

"On the Strength of a Miracle." *Art in America* 46, No. 1 (Spring 1958): 52-5.

> Examines how photographers such as Alfred Stieglitz and Edward Steichen transcended the "mirror-nature"

of photography to achieve the creative force of other artistic mediums.

II. Interviews

Lee, Nicholas. "Minor White." *The British Journal of Photography* 123, No. 6056 (20 August 1976): 712-16.

> Focuses upon White's career as a professor of photography.

III. Critical Studies and Reviews

Aperture. *Minor White: A Living Remembrance.* New York: Aperture, 1984, 78 p.

> Anthology of reminiscences and essays concerning White which features photographs by White and others.

De Lory, Andrew. "Mirrors, Messages and Minor White." *The British Journal of Photography* 122, No. 46 (14 November 1975): 1026-27.

> Personal recollection by de Lory concerning his visit to White's home in Boston, Massachusetts.

Larson, Kay. "Seeing and Believing." *New York* 22, No. 21 (22 May 1989): 62-3.

> Review of "Minor White: The Eye that Shapes," an exhibition of White's photographs at New York's Museum of Modern Art. Larson praises White's endeavor to unite the ordinary and the transcendent

Lord, Catherine. "Minor White: The Making of the Myth." *Afterimage* 7, Nos. 1 and 2 (Summer 1979): 4-5.

> Review of *Minor White: Rites and Passages* in which Lord, while praising the book as an informative representation of White's achievements, contends that James Baker Hall's biographical essay would have benefited from "a more questioning approach" to White's legendary career.

Pultz, John. "Equivalence, Symbolism, and Minor White's Way into the Language of Photography." *Record of the Art Museum, Princeton University* 39, Nos. 1 & 2 (1980): 28-39.

> Examines White's interpretation of Stieglitz's theory of equivalency.

Sischy, Ingrid. "White and Black." *The New Yorker* LXV, No. 39 (13 November 1989): 124; 129-46.

> Discusses how White's unacknowledged homosexuality shaped his career.

IV. Selected Sources of Reproductions

White, Minor. *Mirrors, Messages, Manifestations: Photographs and Writings 1938-1968.* New York: Aperture, 1969, 248 p.

> An extensive collection of prints with commentary provided by such critics as Beaumont Newhall, Meyer Shapiro, and Peter Bunnell.

————. *Minor White: Rites and Passages.* New York: Aperture, 1978, 141 p.

> Portfolio of photographs that are considered to be White's most important images. Also includes letters and diary excerpts written by White throughout his life.

————. *Minor White: The Eye That Shapes.* Princeton, N.J.: The Art Museum, Princeton University, 1989, 289 p.

> Contains previously unpublished photographs first ex-

hibited at New York City's Museum of Modern Art in
1989.

MODERN ARTS CRITICISM

Cumulative Indexes

Cumulative Artist Index

Abbott, Berenice **2**
Adams, Ansel **1**
Albright, Ivan **2**
Alechinsky, Pierre **1**
Arbus, Diane **1**

Arp, Jean (Hans) **1**
Barlach, Ernst **1**
Bearden, Romare **1**
Botero, Fernando **1**
Brassaï **1**
Burchfield, Charles **2**

Calder, Alexander **2**
Cartier-Bresson, Henri **2**
Chagall, Marc **2**

Chirico, Giorgio de **2**
Cornell, Jospeh **2**
Dalí, Salvador **1**
Dix, Otto **2**
Friedlander, Lee **2**

Gabo, Naum **2**
Giacometti, Alberto **1**
Gogh, Vincent van **1**

Goings, Ralph **1**
Hepworth, Barbara **2**
Hopper, Edward **2**

Kandinsky, Wassily **2**
Katz, Alex **1**
Kiefer, Anselm **1**

Kokoschka, Oskar **1**
Lange, Dorothea **1**
Magritte, René **1**
Man Ray **2**
Matta **1**
Modersohn-Becker, Paula **1**
Moore, Henry **1**
Moses, Ed **1**
O'Keeffe, Georgia **1**
Rauschenberg, Robert **1**
Rivera, Diego **2**
Saarinen, Eero **2**
White, Minor **2**
Winogrand, Garry **1**
Wright, Frank Lloyd **1**

Medium Index

ARCHITECTURE
Saarinen, Eero **2**
Wright, Frank Lloyd **1**

ASSEMBLAGE
Cornell, Joseph **2**
Rauschenberg, Robert **1**

COLLAGE
Bearden, Romare **1**

PAINTING
Albright, Ivan **2**
Alechinsky, Pierre **1**
Botero, Fernando **1**
Burchfield, Charles **2**
Chagall, Marc **2**

Chirico, Giorgio de **2**
Dalí, Salvador **1**
Dix, Otto **2**
Gogh, Vincent van **1**
Goings, Ralph **1**
Hopper, Edward **2**
Kandinsky, Wassily **2**
Katz, Alex **1**
Keifer, Anselm **1**
Kokoschka, Oskar **1**
Magritte, René **1**
Matta **1**
Modersohn-Becker, Paula **1**
Moses, Edward **1**
O'Keeffe, Georgia **1**
Rivera, Diego **2**

PHOTOGRAPHY
Abbott, Berenice **2**

Adams, Ansel **1**
Arbus, Diane **1**
Brassaï **1**
Cartier-Bresson, Henri **2**
Friedlander, Lee **2**
Lange, Dorothea **1**
Man Ray **2**
White, Minor **2**
Winogrand, Garry **1**

SCULPTURE
Arp, Jean **1**
Barlach, Ernst **1**
Calder, Alexander **2**
Gabo, Naum **2**
Giacometti, Alberto **1**
Hepworth, Barbara **2**
Moore, Henry **1**

Title Index

A-1 (Moses) **1**:465
A-2 (Moses) **1**:465
A-3 (Moses) **1**:465
A. C. Wermuth house (Saarinen) **2**:427
A.D. MCMXIV (Man Ray)
 See *War--A.D. MCMXIV*
A l'heure de l'observatoire--Les amoureux
 (*Observatory Time--The Lovers; A l'heure de
 l'observatoire--Les amoureux*) (Man Ray)
 2:342
Above Clouds Again (O'Keeffe) **1**:491
Above the Clouds (O'Keeffe) **1**:490
Above Vitebsk (Chagall)
 See *Over Vitebsk*
Abraham's Sacrifice (Chagall) **2**:120
Abschied von Hamburg (Dix) **2**:192
Absolute Unity (Matta) **1**:389
Abstract Composition (Arp) **1**:86
Abstract Configuration (Arp) **1**:84
Accent in Pink (Kandinsky) **2**:332
Accomodations of Desire (Dalí) **1**:168-69, 179-
 80
Ada Ada (Katz) **1**:282, 285
Ada and Vincent in the Car (Katz) **1**:284
Ada in Bathing Cap (Katz) **1**:283, 288
Ada in Black Sweater (Katz) **1**:281
Ada in Blue Housecoat (Katz) **1**:280
Ada in White Dress (Katz) **1**:271, 281, 284,
 288
Ada with Superb Lily (Katz) **1**:281
*Admiration of the Orchestrelle for the
 Cinematograph* (Man Ray) **2**:343, 355
After Softball (Katz) **1**:281
After Us (Alechinsky) **1**:29
L'âge d'or (Dalí) **1**:157-58, 161, 171, 173
Agoraphobia Square (Alechinsky) **1**:29
The Air and the Song (Magritte) **1**:366
Airstream Trailer (Goings) **1**:264
Alex (Katz) **1**:288

Alfred Flechtheim (Dix) **2**:204
Alice Grandit (Alechinsky) **1**:35
Aline et Valcour (Man Ray) **2**:362
Allegory (Rauschenberg) **1**:518, 525-26
Alma I (Dix) **2**:193
Almost a Triangle (Calder) **2**:69
Almost Horizontal Red (Calder) **2**:69
The Alphabet of Revelations (Magritte) **1**:373
Alpine Landscape, Mürren (Kokoschka) **1**:316
Altar Für Cavaliere (Dix) **2**:193-96
Alter Mann (Dix) **2**:196
Altes Liebespaar (Dix) **2**:195
Alto Composite (Bearden) **1**:119
Am Spiegel (Dix) **2**:193
American Landscape (Hopper) **2**:297
Among Those Left (*The Blacksmith*) (Albright)
 2:21, 26
Amputations (White) **2**:437, 440
*And God Created Man in His Own Image
 (Room 203)* (Albright) **2**:18, 20-3, 25-6, 28
Angélus architectonique de Millet (Dalí) **1**:179
Animal Head (1956) (Moore) **1**:456
The Animals (Winogrand) **1**:532, 538, 540,
 543, 549
Annette Seated (Giacometti) **1**:199
The Anniversary (Magritte) **1**:377
Anno Domini MCMXVI Post Christum Natum
 (Barlach) **1**:95
Anti-Protonic Assumption (Dalí) **1**:184
Anxiety in Trompe l'Oeil (Matta) **1**:390
The Anxious Journey (Chirico) **2**:163
Apparatus and Hand (Dalí) **1**:168-69
Apple Monster (Calder) **2**:79
Approaching a City (Hopper) **2**:288, 290
The Approaching Storm (Bearden) **1**:111
An April Mood (Burchfield) **2**:45, 51
Aquasapphire (Matta) **1**:389
Arabian Cemetery (Kandinsky) **2**:321
Arc III (Calder) **2**:74

Arch (Gabo) **2**:243
The Arch (Moore) **1**:455
The Arch (Saarinen)
 See *Jefferson National Expansion Memorial*
The Archeologues (Chirico) **2**:163
The Archer (Moore) **1**:457
The Argumouth (Matta) **1**:390
L'arlésienne: Madame Ginoux (*The Woman of
 Arles*) (Gogh) **1**:231-33, 245, 247
Arranged According to the Laws of Chance
 (Arp) **1**:72
Arrow Cloud (Arp) **1**:75
Arrows (Calder) **2**:69
The Art of Conversation (Magritte) **1**:360
The Art of Living (Magritte) **1**:378
Artisten (Dix) **2**:193
The Artist's Mother (Giacometti) **1**:202
The Artist's Parents II (Dix) **2**:206
The Artist's Studio (Kiefer) **1**:303
Aspen Tent (Saarinen)
 See *Music Tent*
Aspens, Northern New Mexico (Adams) **1**:16
Astre et désastre (*Star and Disaster*)
 (Alechinsky) **1**:31, 35-6, 41
At Connie's Inn (Bearden) **1**:117, 119
At Eternity's Gate (Gogh) **1**:229
At the Edge of Les Alpines (Gogh) **1**:232
Atmospheric Skull Sodomizing a Grand Piano
 (*Sodomy of a Skull with a Grand Piano*)
 (Dalí) **1**:162, 181
August in the City (Hopper) **2**:288
August North (Burchfield) **2**:40, 44-5
Autobiography (Rauschenberg) **1**:526-27
Automat (Hopper) **2**:285
Autumnal Meditation (Chirico) **2**:164
Avenger (Barlach) **1**:97
*The Average Atmospherocephalic Bureaucrat in
 the Act of Milking a Cranial Harp* (Dalí)
 1:167

459

Awakening (Arp) **1**:85
B-2 (Moses) **1**:465
The Bachelors Twenty Years Later (Matta)
 1:386, 390, 400
Backward Glance (Kandinsky) **2**:330
Bad Trouble over the Weekend (Lange) **1**:340
Baghdad Opera House garage (Wright) **1**:574
Balders Träume (*Baldur's Dreams*) (Kiefer)
 1:293
Baldur's Dreams (Kiefer)
 See *Balders Träume*
Baltimore, 1968 (Friedlander) **2**:216
The Baptism (Bearden) **1**:110
Barclay Street Elevated Station: 1932 (Abbott)
 2:9
Barclay Street Ferry: 1933 (Abbott) **2**:9
Barge (Rauschenberg) **1**:510, 514
Die Barrikade (Dix) **2**:192, 196-97
The Basket of Bread (Dalí) **1**:168, 185
Bather (Katz) **1**:282
Bathers (Botero) **1**:130
Bathing Boys by Canal (Modersohn-Becker)
 1:422-25
The Battle of Argonne (Magritte) **1**:363, 380
Battle on a Bridge (Chirico) **2**:163
Le beau temps (Man Ray) **2**:342
The Beautiful Captive (Magritte)
 See *La belle captive*
The Beautiful Relations (Magritte) **1**:377
Beauty Contest in a Nudist Camp--
 Pennsylvania, 1963 (Arbus) **1**:47
Bebe (Cornell) **2**:175
The Bed (Botero) **1**:130
The Bed (Rauschenberg) **1**:504, 512, 528
Beech Trees (Burchfield) **2**:41
The Beggar (Barlach) **1**:94, 96
Being with (Matta) **1**:390, 398
Bell and Navels (Arp) **1**:72, 81, 85
Bell Telephone Laboratories (Saarinen) **2**:412,
 419, 423
Bella with a White Collar (Chagall) **2**:138
La belle captive (*The Beautiful Captive*)
 (Magritte) **1**:356, 358
Bem unbekannten Maler (*To the Unknown*
 Painter) (Kiefer) **1**:295-96
La berceuse (Gogh) **1**:243
Berlin, 13 August 1966 (Kokoschka) **1**:320
Berryessa Valley, Napa County, California
 (Lange) **1**:340
The Betrayal of the Images (Magritte)
 See *La trahison des images*
Between Lily and Tusk (Arp)
 See *Entre lys et défense*
Bijenkorf Structure (Gabo) **2**:236, 245
Biocentric Form (Hepworth) **2**:263
Biolith (Hepworth) **2**:263
Bird and Necktie (Arp) **1**:72
Bird Basket (Moore) **1**:434
Bird-Like Cloud (Arp) **1**:85
Bird Mask (Arp) **1**:82, 84, 89
The Birds (Kandinsky) **2**:328
Birds in an Aquarium (Arp) **1**:72
The Birthday (Chagall) **2**:133, 138
Der Bischof (Barlach) **1**:104
Black and Upwards (Kandinsky) **2**:333
Black and White (O'Keeffe) **1**:489
Black Ball, White Ball (*Une Boule Noire, une*
 Boule Blanche) (Calder) **2**:77, 80
Black Beast (Calder) **2**:64, 70
Black Cliffs, Schoodic Point, Maine (Albright)
 2:25
Black Cross (O'Keeffe) **1**:485

The Black Dress (Katz) **1**:275, 281, 285-86
Black Hollyhocks and Blue Larkspur
 (O'Keeffe) **1**:489
Black Houses (Burchfield) **2**:34
The Black Jacket (Katz) **1**:273-75
Black Lines, No. 189 (Kandinsky) **2**:321
Black Market (Rauschenberg) **1**:519, 526
Black Mother and Child (Bearden) **1**:118
Black Patio Door (O'Keeffe) **1**:489
The Black Place (O'Keeffe) **1**:485
Black Triangle (Kandinsky) **2**:324-25
The Blacksmith (Albright)
 See *Among Those Left*
Blackwell's Island (Hopper) **2**:289
Blinderbettler (Dix) **2**:196
Blond-Haired Girl in White Shirt (Modersohn-
 Becker) **1**:422
Blonde Girl with Shiny Lipstick, N.Y.C., 1967
 (Arbus) **1**:59
Blood is Sweeter Than Honey (Dalí) **1**:168
Blossoming Pear Tree (Gogh) **1**:243
Blue Bread (Man Ray)
 See *Pain peint*
Blue Circle, No. 2 (Kandinsky) **2**:332
Blue Diner with Figures (Goings) **1**:262
The Blue Jeep (Goings) **1**:263
Blue Lines X (O'Keeffe) **1**:493
Blue No. III (O'Keeffe) **1**:493
Blue Poles (Katz) **1**:281
Blue Umbrella #2 (Katz) **1**:281, 284
The Book (Kiefer) **1**:301, 309
Une Boule Noire, une Boule Blanche (Calder)
 See *Black Ball, White Ball*
Boy with a Cat (Modersohn-Becker) **1**:415
Boy with a Straw Hat (Arbus) **1**:60
Boy with Open Mouth (Katz) **1**:277
Bradley house (Wright) **1**:568
The Bride of the Wind (Kokoschka) **1**:327
The Bridge (Rivera) **2**:390
Broadacre City (Wright) **1**:559, 563, 584-88
Broadcast (Rauschenberg) **1**:511
Bryher II (Hepworth) **2**:272
The Bud Sucker (Matta) **1**:393
Bust of Gnome (Arp) **1**:91
Cadeau (*Gift*) (Man Ray) **2**:342, 355, 358-59,
 364
The Cage (Giacometti) **1**:197, 204-05
Calvary (Chagall) **2**:134
Cambridge, Massachussetts, 1980 (Friedlander)
 2:217
Camel's Hump (Hopper) **2**:289, 297
Cantate Domino (Hepworth) **2**:274
Canton, Ohio, 1980 (Friedlander) **2**:216
Canyon (Rauschenberg) **1**:511, 517, 527
Cape Cod Afternoon (Hopper) **2**:279
Cape Cod Evening (Hopper) **2**:288
Cape Cod Morning (Hopper) **2**:279, 305
Captain Ed Staples (Hopper) **2**:292
Captain Joseph Medill Patterson (Albright)
 2:25
Cardboards (Rauschenberg) **1**:527-28
Cardinal, Cardinal (Dalí) **1**:179-80
Carolina Shout (Bearden) **1**:119
Carving (1934, stone) (Moore) **1**:439
Cassiopeia No. 3 (Cornell) **2**:172
A Castle in Disneyland, Cal., 1962 (Arbus)
 1:53
Cat (Giacometti) **1**:209
"Cat Meets Dog" (Winogrand) **1**:540
Cat-Tails (Burchfield) **2**:41
Catalonian Landscape (Rivera) **2**:390
The Cattle Dealer (Chagall) **2**:113, 137

The Cello Player (Chagall) **2**:115
Center with Accompaniment (Kandinsky)
 2:326
Central Park (Alechinsky) **1**:29, 35, 40
Cézanne's Apples (Matta) **1**:390
The Chagrins of Victory (Chirico) **2**:150
The Chair (Dalí) **1**:186
Chambole-les-amoureuses (Matta) **1**:390
Champion of the Spirit (Barlach)
 See *Geist Kaempfer*
Les champs délicieux (Man Ray) **3**:358
Changing New York (Abbott) **2**:5, 12-13
Chanin Building: 1931 (Abbott) **2**:10
Charging Infantrymen (Dix) **2**:201
Chariot (Giacometti)
 See *Woman with a Chariot*
Chariot for Apollo (Rauschenberg) **1**:527
Charlene (Rauschenberg) **1**:510, 518, 526
Charnley house (Wright) **1**:581
Cherry Street: 1931 (Abbott) **2**:10
Le cheval (Dalí) **1**:161
Chien (Giacometti) **1**:201
Un chien andalou (Dalí) **1**:157, 161, 163, 168-
 69, 171, 175, 177
A Child Crying, N.J., 1967 (Arbus) **1**:60
Child with a Toy Hand Grenade in Central
 Park, N.Y.C., 1962 (Arbus) **1**:47, 65
Childhood's Garden (Burchfield) **2**:33
The Child's Brain (Chirico) **2**:150
Chimerical Font (Arp) **1**:73
Chippewa Falls, Wisconsin, 1986 (Friedlander)
 2:216
Chocolat Menier (Cornell) **2**:171
Chop Suey (Hopper) **2**:290
Christ of St. John of the Cross (Dalí) **1**:185
Chromatic Buoy (Alechinsky) **1**:31-2
Chrysanthemums in Flower Market, Paris
 (Friedlander) **2**:226
Church Bells Ringing--Rainy Winter Night
 (Burchfield) **2**:40-1
Church in Murnau (Kandinsky) **2**:328
The Church is Full, Near Inagh, County Clare
 (Lange) **1**:340
Cicada (Burchfield) **2**:36
Cigar Store, Third Avenue: 1929 (Abbott)
 2:10
The Circle Theatre (Hopper) **2**:297
Circles within a Circle (Kandinsky) **2**:332
Circular Relief (Gabo) **2**:246
Circulation (Calder) **2**:74
Circus (Calder) **2**:58-9, 73
The City (Calder) **2**:60
City Square (Giacometti) **1**:191, 206
Civic Improvement (Burchfield) **2**:39
La Clé des songes (*The Key to Dreams*)
 (Magritte) **1**:356, 366, 369
Clearing Winter Storm (Adams) **1**:22
Cléo de Mérode (Cornell)
 See *L'Egypte de Mlle. Cléo de Mérode: Cours*
 Elémentaire d'Histoire Naturelle
Clock (Arp) **1**:84
Clowns at Night (Chagall) **2**:129
The Coast at Dover (Kokoschka) **1**:317
Cobra-Centaur (Arp) **1**:73
Cockchafer Fly (Kiefer)
 See *Maikafer Flieg*
The Cocktail Party (Katz) **1**:281, 285
Coentie's Slip: 1933 (Abbott) **2**:9
Coexistence (Rauschenberg) **1**:510
The Collective Invention (Magritte) **1**:364, 378
Collins Diner (Goings) **1**:262
The Color of Time (Alechinsky) **1**:38

Color Tear (Arp) **1**:72

Columbia Broadcasting System headquarters (Saarinen) **2**:412-13, 419

Column (Gabo) **2**:244-45, 247

The Coming of Spring (Burchfield) **2**:35

Compartment C--Car 293 (Hopper) **2**:285, 288

Composition (Hepworth) **2**:261

Composition (1931, Cumberland alabaster) (Moore) **1**:437

Composition (Moore) **1**:437

Composition IV (Kandinsky) **2**:329

Composition VIII (Kandinsky) **2**:324

Composition IX (Kandinsky) **2**:325-26

Composition X (Kandinsky) **2**:326

Composition with Seven Figures and a Head (The Forest) *(The Forest)* (Giacometti) **1**:205, 212

Concentration of Hands No. 1 (Hepworth) **2**:270

The Concert (Chagall) **2**:132-33

The Concert (Kokoschka) **1**:328

Concordia Senior College (Saarinen) **2**:422, 424, 427

The Conference (Burchfield) **2**:40

Conference at Night (Hopper) **2**:298

Configuration in Serpentine Movements (Arp) **1**:73

Conjur Woman (Bearden) **1**:112

Conjur Woman as an Angel (Bearden) **1**:111

Connecticut, 1973 (Friedlander) **2**:220, 224

Conoid, Sphere and Hollow (Hepworth) **2**:259

The Conqueror (Magritte) **1**:355

Constellation (Arp) **1**:84

Constellation of Leaves (Arp) **1**:83

Constellation of Neutral Forms (Arp) **1**:84-5

Constructed Head No. 1 (Gabo) **2**:238-42

Constructed Head No. 2 (Gabo) **2**:239-41, 243

Constructed Head No. 3, Head in a Corner Niche (Gabo) **2**:239-41, 243

Construction for a Stairwell (Gabo) **2**:245

Construction in Space: Crystal (Gabo) **2**:243, 250

Construction in Space: Soaring (Gabo) **2**:250

Construction in Space with Balance on Two Points (Gabo) **2**:240-41, 243, 249

Construction in Space with Crystalline Center (Gabo) **2**:247

Construction on a Line (Gabo) **2**:243

Contrapuntal Forms (Hepworth) **2**:266, 269

The Convict of Light (Matta) **1**:390

Convolute (Hepworth) **2**:259

Coonley house (Wright) **1**:569-72, 579, 581

Corinthos (Hepworth) **2**:271

Corner Saloon (Hopper) **2**:287

Cornfield and Cypress (Gogh) **1**:230

Cornfield with Rooks (Gogh)
 See *Crows over the Wheatfield*

Corpus Hypercubicus (Dalí) **1**:184-85

Corpuscular Madonna (Dalí) **1**:185

The Cosdon Head (Hepworth) **2**:260, 263

Côte d'Azur (Brassai) **1**:144

Cottage and Cypresses (Gogh) **1**:229

Country Blacksmith Shop (Burchfield) **2**:39

Couple on a Red Background (Chagall) **2**:133

Cow (Calder) **2**:62

Cow's Skull with Calico Roses (O'Keeffe) **1**:485, 493-94

Coyote (Moses) **1**:464

The Crau (Gogh) **1**:232-33

Creation (Rivera) **2**:370

Creation of Man (Chagall) **2**:119-20

The Crouching Man (Dix) **2**:201

Crown of Buds (Arp) **1**:85

Crown of Gregor's Head (Lange) **1**:339

Crows over the Wheatfield (Cornfield with Rooks) (Gogh) **1**:223-26, 228

Crucifixhim (Matta) **1**:401

Crucifixion (Hepworth) **2**:272

The Crystal Cage: Portrait of Berenice (Cornell) **2**:170

The Crystal Palace (Cornell) **2**:174, 178

The Cube (Giacometti) **1**:211

Cubist Drawing B2 (Moses) **1**:471

Cubist Drawing G2 (Moses) **1**:471

Cubist Drawing G4 (Moses) **1**:471

Cubist Drawings (Moses) **1**:471

Cubist Head (Giacometti) **1**:190, 211

Culver Tract A Sec. 2 (Moses) **1**:468

Curfew (Rauschenberg) **1**:510

Currents (Rauschenberg) **1**:525-26

Cutout (Man Ray) **2**:351

Cypress Trees (Gogh) **1**:229, 41

Damaged Child, Shacktown, Elm Grove, Oklahoma (Lange) **1**:339

Dance (Man Ray) **2**:363

Dancer (Arp) **1**:85

Dancer (Dix) **2**:202

The Dancers (Katz) **1**:270

Dandelion Seed Balls and Trees (Burchfield) **2**:43

Dandelion Seed Heads and the Moon (Burchfield) **2**:35, 51

Dangerous Relationships (Magritte) **1**:377

Dante Drawings (Rauschenberg) **1**:525

Daphne (Arp) **1**:80

Dark Mesa and Pink Sky (O'Keeffe) **1**:489

Dartington Memorial Figure (Moore) **1**:436, 440-43

David Alfaro Siqueiros (Rivera) **2**:397

David and John (Katz) **1**:279

David in His Old Age (Kokoschka) **1**:329

David in Profile (Chagall) **2**:138

David Playing before Saul (Chagall) **2**:118

David S. Ingalls Hockey Rink (Saarinen) **2**:405, 412, 422, 429

The Dawn Donor (Matta) **1**:393

Dawn in Pennsylvania (Hopper) **2**:288, 290, 292, 303

Dax (Moses) **1**:468

The Day-Dreams of the Solitary Stroller (Magritte) **1**:361

Dead Cottonwood Tree (O'Keeffe) **1**:485

The Dead Man (Chagall) **2**:112

Death (Barlach) **1**:96

Death and Resurrection (Dix) **2**:201

Death and the Young Girl (Alechinsky) **1**:42

Decalcomania (Magritte) **1**:379

December (Katz) **1**:281, 283, 287

The Decisive Moment (Cartier-Bresson) **2**:95

Decoder (Rauschenberg) **1**:525

Dedicated to My Fiancée (Chagall) **2**:124-25, 127-28

Deere and Company Administration Center (Saarinen) **2**:406, 412-13, 418-19, 428

La Défense (Calder) **2**:73

Delos (Hepworth) **2**:273

Delusion of Grandeur (Magritte) **1**:357

Demeter (Arp) **1**:89, 91-2

Densité V (Calder) **2**:74

Les Dents du Midi (Kokoschka) **1**:317

Departure (Chirico) **2**:153

The Departure of the Knight (Chirico) **2**:160

Deserted Perch (Cornell) **2**:171, 176

Detroit Industry (Rivera) **2**:383-84, 392-96

Das deutsche Volksgericht (Kohle für 2000 Jahre) (Kiefer) **1**:299

Deutschlands Geisteshelden (Heroes of the German Spirit) (Kiefer) **1**:293

Development in Brown (Kandinsky) **2**:334

Diego (Giacometti) **1**:198-99, 213

Diego au blouson (Giacometti) **1**:212

Diego au chandail (Giacometti) **1**:212

Diner with Pink Tile (Goings) **1**:262

Direct Hit (Dix) **2**:201

Dirt (Rauschenberg) **1**:515

Disabled Man Playing Cards (Dix) **2**:202

Disagreeable Object (Giacometti) **1**:211

The Disasters of Mysticism (Matta) **1**:388, 396

Discovery (Magritte) **1**:379

The Dismal Sport (Dalí)
 See *Le jeu lugubre*

The Disquieting Muse (Chirico) **2**:163

Division Unity (Kandinsky) **2**:326, 331

Doctor Mayer-Hermann (Dix) **2**:207

Dog at the End of Pier (Katz) **1**:288

Dogwood (Calder) **2**:59

Dominant Curve (Kandinsky) **2**:325

Dominant Violet (Kandinsky) **2**:326

Dompteuse (Dix) **2**:193

The Door (Albright)
 See *That Which I Should Have Done I Did Not Do*

Dorian Gray (Albright)
 See *The Picture of Dorian Gray*

Double Portrait (Kokoschka) **1**:323

Double Portrait of Robert Rauschenberg (Katz) **1**:282, 285

Double Trac (Moses) **1**:465

The Dove (Bearden) **1**:110, 113

The Dove Cote (Cornell) **2**:172, 177

The Dragon (Kandinsky) **2**:329

Drake College (Saarinen) **2**:423

Draped Seated Woman (Moore) **1**:458

The Drawbridge (Gogh) **1**:231

Drawing No. 10 (O'Keeffe) **1**:492

"Drawings from Life" (Moore) **1**:433

The Dream (Dalí) **1**:169

The Dream of Christopher Columbus (Dalí) **1**:184-85

Dream of Jacob (Jacob's Dream) (Chagall) **2**:129, 134-35

The Dreamborne (Kokoschka) **1**:322

The Dreaming Youths (Kokoschka) **1**:312, 314, 321, 323

Drei Dirnen auf der Strasse (Three Prostitutes) (Dix) **2**:191, 193-94

Dresden, The Elbe Bridges (with Figure from Behind) (Kokoschka) **1**:317

The Drunkard (Chagall) **2**:124

The Drunken Soldier (Chagall)
 See *The Soldier Drinks*

Dulles International Airport (Saarinen) **2**:406, 412-13, 419, 422-24, 429

The Duo (Chirico) **2**:160

La duré poignardée (Time Transfixed) (Magritte) **1**:352-53, 363, 377

Dusk (Kandinsky) **2**:329-30

Dust Raising (Man Ray) **2**:359

Dyad (Hepworth) **2**:263

Dying Soldier (Dying Warrior) (Dix) **2**:200

Dying Warrior (Dix)
 See *Dying Soldier*

Dylaby (Rauschenberg) **1**:519

Early Sunday Morning (Hopper) **2**:279, 285, 288, 293, 297, 302, 306

Earth Day, April 22 (Rauschenberg) **1**:525
The Earth Is a Man (Matta) **1**:389, 396, 399, 401-02
Easel Painting (Man Ray) **2**:365
East (Katz) **1**:289
East Wind and Winter Sun (Burchfield) **2**:35
East Wing over Weehawken (Hopper) **2**:297
The Echo (Chirico) **2**:160
Ecran de la memoire (Matta) **1**:408
Eddie Morris (Friedlander) **2**:217
The Eggboard (Arp) **1**:70, 84
Egypt-Trac (Moses) **1**:465
L'Egypte de Mlle. Cléo de Mérode: Cours Elémentaire d'Histoire Naturelle (*Cléo de Mérode*) (Cornell) **2**:168-69, 176
The Eight O'Clock Fish (Calder) **2**:69
Elderly Couple on a Park Bench, N.Y.C., 1969 (Arbus) **1**:59, 63
Elective Affinities (Magritte) **1**:362
Elephant Chair with Lamp (Calder) **2**:61
Eleuthera (Katz) **1**:281, 286, 289
Eli (Katz) **1**:282-83
Elle Hegramme to the Surprise of Everyone (Matta) **1**:406
Emak Bakia (Man Ray) **2**:344, 355-57
Emanation (Kiefer) **1**:301
Emma Hartman Noyes house (Saarinen) **2**:412
Empire I (Rauschenberg) **1**:513
The Empire of Lights (Magritte) **1**:358-59, 361, 363, 376
The Enchanted Domain (Magritte) **1**:371
Enclosed Field with Peasant (Gogh) **1**:249
Encounter (Man Ray) **2**:352
End of Shift, Richmond California (Lange) **1**:339
Engelreigen (Barlach) **1**:102
The Enigma of an Autumn Afternoon (Chirico) **2**:143, 164
The Enigma of Isidore Ducasse (Man Ray) **2**:343, 359, 362
The Enigma of the Hour (Chirico) **2**:164
The Enigma of the Oracle (Chirico) **2**:164
The Enigma of William Tell (Dalí) **1**:172-73
Enlevons les cartes (Matta) **1**:401
Ennis house (Wright) **1**:578
Entrance to a Quarry (Gogh) **1**:243
Entrance to the Mine (Rivera) **2**:381
Entre lys et défense (*Between Lily and Tusk*) (Arp) **1**:89, 91-2
Eocene (Hepworth) **2**:260
La era (Rivera) **2**:397
Et la terre tremble encore (Kiefer) **1**:294
L'etoile de mer (*Starfish*) (Man Ray) **2**:344, 357
Etoile de verre (Man Ray) **2**:360
Euclidean Walks (Magritte)
See *The Promenades of Euclid*
The Europeans (Cartier-Bresson) **2**:95-6
Evans house (Wright) **1**:580
Evening (Katz) **1**:273-74
Evening, 9:10, 461 Lenox Avenue (Bearden) **1**:112
Evening Wind (Hopper) **2**:289
The Exiles (Kokoschka) **1**:316, 323
Exodus (Chagall) **2**:134
The Explanation (Magritte) **1**:356, 358, 364
Exploding Raphaelesque Head (Dalí) **1**:184-85
Extreme Overhang III (Calder) **2**:69
Eye and Navel Dress (Arp) **1**:76, 83
Ezra Stiles College (Saarinen) **2**:412, 418, 424

Façade (Brassai) **1**:144
The Face of the Poet (Katz) **1**:273-74, 276
Factory Valleys (Friedlander) **2**:216, 227
Factum I (Rauschenberg) **1**:499, 513
Factum II (Rauschenberg) **1**:499
The Fall of Icarus (Chagall) **2**:135
Fallen Tree (Burchfield) **2**:40
Falling Ranks (Dix) **2**:201
Falling Warrior (1957, bronze) (Moore) **1**:452, 455
Falling Water (Wright)
See *Kaufmann house*
The False Front (Burchfield) **2**:37
The False Mirror (Magritte) **1**:359, 361, 372
Family (Botero) **1**:126
Family Dinner (Bearden) **1**:118
Family Group (Moore) **1**:442, 446-49
A Family on Their Lawn One Sunday in Westchester, N.Y., 1968 (Arbus) **1**:59
The Family; or, Maternity (Chagall) **2**:113, 134
The Farmer's Kitchen (Albright) **2**:25
Father Hirsch (Kokoschka) **1**:315
Faust, tanzend mit den Jungen (Barlach) **1**:101
La Favorite (Cornell) **2**:170
February Thaw (Burchfield) **2**:34, 43
Felix Albrecht Harta (Kokoschka) **1**:330
59th Street Studio (O'Keeffe) **1**:489
51-248 (White) **2**:434
Figure (Hepworth) **2**:264-65
Figure (1936, elm) (Moore) **1**:439, 442
Figure (1933, Corsehill stone) (Moore) **1**:437-38
Figure (1933, Travertine marble) (Moore) **1**:437
Figure (1930, Armenian marble) (Moore) **1**:437
Figure (1930, Cumberland alabaster) (Moore) **1**:437
Figure between Two Houses (Giacometti) **1**:205
Figure Composition (Modersohn-Becker) **1**:419
Figure in Concrete (1929) (Moore) **1**:436
Figure with Clasped Hands (1929, Travertine marble) (Moore) **1**:436
Figures, One Large and Two Small (Arp) **1**:85
Filling Station (Hopper) **2**:285
Finding of the Infant Moses (Chagall) **2**:118
Fire (Matta) **1**:390
First Hepaticas (Burchfield) **2**:40-1
The First Lady (Botero) **1**:125
First Landing Jump (Rauschenberg) **1**:510, 526
First Steps (Gogh) **1**:252
The Flag Pole (O'Keeffe) **1**:487
Flamingo (Calder) **2**:73
Flandern (Dix) **2**:197, 200, 205
The Flavour of Tears (Magritte) **1**:364
Der Fleischerladen (Dix) **2**:195
Flesh (Albright) **2**:20-1, 25-6
Fliehender Verwundeter (Dix) **2**:197
Flight of Birds (Arp) **1**:83-4
Floating (Kandinsky) **2**:331
Der Flötenbläser (Barlach) **1**:102
The Flowering Tree (Gogh) **1**:231
The Flying Carriage (Chagall) **2**:134
Flying Colors (Calder) **2**:73
The Folk Musicians (Bearden) **1**:111
Follow Me (Albright)

See *I Walk To and Fro through Civilization and I Talk as I Walk*
The Folly of Horses (Chirico) **2**:153
The Font (Dalí) **1**:166, 169
For Vava (Chagall) **2**:129
Ford Foundation (Saarinen) **2**:419
Forest (Arp) **1**:72, 80, 82, 84, 89
The Forest (Giacometti)
See *Composition with Seven Figures and a Head* (*The Forest*)
Forgotten Game (Cornell) **2**:171
Forks and Navel (Arp) **1**:84
Form Enclosed (Hepworth) **2**:265
Former Shop for Nautical Instruments: 1930 (Abbott) **2**:10
The Fortune (Man Ray) **2**:342
Four Children (Katz) **1**:288
Four Figures on a Pedestal (*Four Women on a Base*) (Giacometti) **1**:196, 212
Four Grey Sleepers (Moore) **1**:430-31
Four People at a Gallery Opening, N.Y.C., 1968 (Arbus) **1**:53-4
Four Women on a Base (Giacometti)
See *Four Figures on a Pedestal*
Francesca de Rimini (Cornell) **2**:168
Freezing Girl (Barlach) **1**:95
Freight Cars (Burchfield) **2**:34
Freight Cars under a Bridge (Burchfield) **2**:35, 42-3
The Friends (Kokoschka) **1**:316, 323
The Friend's Departure (Chirico) **2**:163
Fries der Lauschenden (Barlach) **1**:102
From Summer Until Fall of 1969 I Occupied Switzerland, France, and Italy (*Occupations*) (Kiefer) **1**:293, 308
Frozen Assets (Rivera) **2**:373
Full Moon (Chagall) **2**:125-26
Full Moon Sunset (Katz) **1**:289
Funeral Cortege, End of an Era in a Small Valley Town, California (Lange) **1**:341
Furniture in a Valley (Chirico) **2**:160-61, 163
Future (Rivera) **2**:381-82
The Future of Property (Alechinsky) **1**:44
Gala and the Angelus of Millet Immediately Preceding the Arrival of the Conic Anamorphoses (Dalí) **1**:170
Gala with Two Lamb Chops Balanced on Her Shoulder (Dalí) **1**:185
Garden of Memories (Burchfield) **2**:40-1
Garland of Buds (Arp) **1**:79
The Gateway Arch (Saarinen)
See *Jefferson National Expansion Memorial*
Geist Kaempfer (*Champion of the Spirit*) (Barlach) **1**:99
Die Gemeinschaft der Heiligen (Barlach) **1**:102
Gémissement Oblique (Calder) **2**:74
General Motors Technical Center (Saarinen) **2**:404, 410-11, 416, 418-19, 422-23, 428, 429
Giant Seed (Arp) **1**:85
Gibraltar (Calder) **2**:63
Gift (Man Ray)
See *Cadeau*
Gift for Apollo (Rauschenberg) **1**:518, 526
Girl (Moore) **1**:437
Girl before a Mirror (Dix) **2**:202-03
Girl in a Coat Lying on Her Bed, N.Y.C., 1969 (Arbus) **1**:59
Girl in Landscape (Modersohn-Becker) **1**:422
Girl Sewing (Dalí) **1**:168
Girl Sitting on Her Bed with Her Shirt Off (Arbus) **1**:49

Girl with a Cat (Modersohn-Becker)　**1**:415
Girl with Doll (Kokoschka)　**1**:318
Girl with Yellow Wreath and Daisy
　(Modersohn-Becker)　**1**:423
Girlie Show (Hopper)　**2**:298
The Glade (Giacometti)　**1**:212
Gladiators (Chirico)　**2**:163
The Glazier (Matta)
　See *Le vitreur*
Gloria (Hepworth)　**2**:274
Gloria (Rauschenberg)　**1**:516-17
Gloucester Street (Hopper)　**2**:305
Going over the Top (Dix)　**2**:200
Golconda (Magritte)　**1**:354
The Golden Legend (Magritte)　**1**:377
The Good Contact (Kandinsky)　**2**:325
Good Samaritan (Modersohn-Becker)　**1**:415
Gothic Construction from Scraps (Calder)　**2**:80
Graceful Ascent (Kandinsky)　**2**:331
Gräfin Else (Dix)　**2**:193-94, 198
La Grande Vitesse (Calder)　**2**:72-3, 81
Les grands transparents (Alechinsky)　**1**:38
Les grands transparents (*The Great Transparent
　Ones*) (Matta)　**1**:400
Grave, Dead Soldier (Dix)　**2**:200
Grave Situation (Matta)　**1**:390, 398
The Great Masturbator (Dalí)　**1**:162, 180
The Great Tower (Chirico)　**2**:155
The Great Transparent Ones (Matta)
　See *Les grands transparents*
The Great Voyages (Magritte)　**1**:356
Green Figure (Kandinsky)　**2**:326
The Green Horse (Chagall)　**2**:129
The Green Jew (Chagall)　**2**:114
Green Patio Door (O'Keeffe)　**1**:489
Green Perfume (Kandinsky)　**2**:333
Green Sound (Kandinsky)　**2**:325
Greetings from a Distant Friend (Chirico)
　2:159
Gretchen (Barlach)　**1**:105
Gretel (Dix)　**2**:202
The Grinder (Rivera)　**2**:398
Großstadt (Dix)　**2**:199
Group (Hepworth)　**2**:265
Growth (Arp)　**1**:85
Guggenheim Museum (*Museum of Non-
　Objective Paintings*) (Wright)　**1**:560, 567-68,
　573-77, 579
Le Guichet (Calder)　**2**:72, 81
Gush (Rauschenberg)　**1**:528
A Half-Hour Later, Hardman County, Texas
　(Lange)　**1**:339
Half-Past Three (*The Poet*) (Chagall)
　See *The Poet; or, Half-Past Three*
*Hallucination partielle: Six Images de Lenine
　sur un piano* (*Partial Hallucination: Six
　Images of Lenin on a Piano*) (Dalí)　**1**:172,
　179
The Hand (Giacometti)　**1**:202
Hand Caught by a Finger (Giacometti)
　See *Main prise*
Hand Fruit (Arp)　**1**:72, 85
Hand, Indonesian Dancer, Java (Lange)　**1**:339
Hand-to-Hand Fighting (Dix)　**2**:200
The Hands (Hepworth)　**2**:270
The Hands and the Arm (Hepworth)　**2**:270
The Hands of Dr Moore (Rivera)　**2**:398
Hanging Construction (Gabo)　**2**:239
Hans Tietze and Erica Tietze-Conrat
　(Kokoschka)　**1**:330
Hard but Soft (Kandinsky)　**2**:331
Hard in Slack (Kandinsky)　**2**:331

Hardy House (Wright)　**1**:572
Harness Shop, East 24th Street: 1931 (Abbott)
　2:10
The Harvest (Gogh)　**1**:219
Les hautes herbes (Alechinsky)　**1**:34
Hazard (Rauschenberg)　**1**:525
Head (Giacometti)
　See *Tête qui regarde*
Head (Hepworth)　**2**:262
Head and Leaf (Arp)　**1**:85
Head of a Man on a Rod (Giacometti)　**1**:205,
　211
Head of a Woman (Rivera)　**2**:396
Head with Annoying Objects (Arp)　**1**:85, 90
Head with Claws (Arp)　**1**:73
Heads or Tails (Brassaï)　**1**:144
The Healer (Magritte)
　See *The Therapeutist*
The Heart of Autumn (Bearden)　**1**:118
The Heart Players (Matta)　**1**:398, 405
*Heavy the Oar to Him Who Is Tired, Heavy the
　Boat, Heavy the Sea* (Albright)　**2**:26
Hector and Andromache (Chirico)　**2**:163
Hegel's Holiday (Magritte)　**1**:357, 363
Helicoids in Sphere (Hepworth)　**2**:259
Heliogabal (Kiefer)　**1**:295
Hello, Dalí! (Dalí)　**1**:177
Helmet (1940, lead) (Moore)　**1**:440, 442-43
Here Sir Fire, Eat (Matta)　**1**:396, 402
*Hermaphrodite with a Dog in a Carnival
　Trailer* (Arbus)　**1**:49, 59, 65
Herodotus (Kokoschka)　**1**:320
Heroes of the German Spirit (Kiefer)
　See *Deutschlands Geisteshelden*
Herwarth Walden (Kokoschka)　**1**:315
Hexenritt (Barlach)　**1**:104
Hickox house (Wright)　**1**:568, 580
Hills of South Truro (Hopper)　**2**:289
His Behind the Back Pass (Katz)　**1**:289
Hoarfrost (Rauschenberg)　**1**:528
Holos! Holos! Velázquez! Gabor! (Dalí)　**1**:186
The Holy Carter (Chagall)　**2**:125, 127
Homage to Rodin (Arp)　**1**:72
Homages to the Romantic Ballet (Cornell)
　2:183-84
Hommage à Apollonaire (Chagall)　**2**:125-27,
　137
L'homme invisible (Dalí)　**1**:158
Homme traversant une place (Giacometti)
　1:212
Hopi Indian, New Mexico (Lange)　**1**:339
Horner house (Wright)　**1**:580
Horse Fountain, Lincoln Square: 1929 (Abbott)
　2:10
Horses by the Seaside (Chirico)　**2**:163
Horses Pierced with Arrows (Chirico)　**2**:150
Hot Morning Sunlight (Burchfield)　**2**:40
Hotel Lobby (Hopper)　**2**:285, 288, 298
L'hôtel meublé (Man Ray)　**2**:360
Hotel Room (Hopper)　**2**:288, 297-98
Hôtels (Cornell)　**2**:176
Hound (Tracks) (Rauschenberg)　**1**:525
House by a Railroad (Burchfield)　**2**:39
House by the Railroad (Hopper)　**2**:285, 292,
　297
House on Pamet River (Hopper)　**2**:289, 302
House on the Hill (Arbus)　**1**:65
House on the Mesa (Wright)　**1**:566, 568, 586-
　88
Houston, 1977 (Friedlander)　**2**:217
Human Concretion (Arp)　**1**:72, 81, 85
Human Concretion on Oval Board (Arp)　**1**:72

The Human Condition I (Magritte)　**1**:356,
　359, 361-62, 371-73
Human Heads (Kokoschka)
　See *Menschenköpfe*
Human Lunar Spectral (Arp)　**1**:86
Hymnal (Rauschenberg)　**1**:510, 516
I Am Free, Yells the Glow-Worm (Alechinsky)
　1:41
I and the Village (Chagall)
　See *Moi et le village*
*I Found Myself in the Bottom of the Sea, an
　Ancient, a Dry Sea* (Albright)　**2**:25
I Slept with the Starlight in My Face
　(*Rosicrucian*) (Albright)　**2**:25
*I Walk To and Fro through Civilization and I
　Talk as I Walk* (*Follow Me*) (Albright)
　2:26
Ice Glare (Burchfield)　**2**:35
Ida (Albright)
　See *Into the World There Came a Soul
　Called Ida*
The Idea (Magritte)　**1**:378
Identical Twins, Roselle, N.J., 1967 (Arbus)
　1:46, 63
If Life Were Life--There Would Be No Death
　(*The Vermonter*) (Albright)　**2**:20, 28
Ikarus (Kiefer)　**1**:293
Illumined Pleasures (Dalí)
　See *Les plaisirs illuminaes*
Illusionists at 4 P.M. (Bearden)　**1**:111
Image (Hepworth)　**2**:264-65
Images 1923-1974 (Adams)　**1**:14
Images à la sauvette (Cartier-Bresson)　**2**:101-
　02
Imaginary Portrait of D. A. F. de Sade (Man
　Ray)　**2**:362
Impala (Katz)　**1**:284-85
Imperial Hotel (Wright)　**1**:562, 564, 574
In Front of the Picture (Chagall)　**2**:134
In Memory of the American Chestnut Tree
　(Burchfield)　**2**:48
In Praise of Dialectic (Magritte)　**1**:361
In the Black Circle (Kandinsky)　**2**:332
Infant Nursing (Modersohn-Becker)　**1**:413
Inferno XXXIII (Rauschenberg)　**1**:526
Les infeuillables (Alechinsky)　**1**:37
Infinite Amphora (Arp)　**1**:83-4
Inlet (Rauschenberg)　**1**:517
Inquietude (Man Ray)　**2**:343
Inscape (Matta)　**1**:395, 399, 404
The Insect Chorus (Burchfield)　**2**:41
Inter-Atomic Equilibrium of a Swan's Feather
　(Dalí)　**1**:184
Interior (Chagall)　**2**:113
Interior (Man Ray)　**2**:351
Intermission (Hopper)　**2**:306
Interplanetary Navigation (Cornell)　**2**:177
The Interrogation (Matta)　**1**:401
Interview (Rauschenberg)　**1**:504, 517
Into the World There Came a Soul Called Ida
　(*Ida*) (Albright)　**2**:19, 21-3, 25-6
Invisible Object (Hands Holding the Void)
　(Giacometti)　**1**:211
Iris (Gogh)　**1**:232
Irving and Lucy (Katz)　**1**:282, 288
Irwin Union Trust Company (Saarinen)　**2**:423
It's Springtime (Man Ray)　**2**:365
Ives Field #1 (Katz)　**1**:271
Ives Field #2 (Katz)　**1**:271
*J. R. Butler, President of the Southern Tenant
　Farmers' Union, Memphis, Tennessee*
　(Lange)　**1**:339

Jacob's Dream (Chagall)
See *Dream of Jacob*
Jammer (Rauschenberg) 1:526, 528
Japonaiserie: The Actor (Gogh) 1:243
Japonaiserie: The Bridge (Gogh) 1:243
Japonaiserie: The Tree (Gogh) 1:243
Jazz (Bearden) 1:118
Jazz Rhapsody (Bearden) 1:119
Je m'arche (Matta) 1:404
Je m'honte (Matta) 1:404
Jefferson National Expansion Memorial (*The Gateway Arch*; *The Arch*) (Saarinen) 2:411, 419-20, 422
Jerusalem (Kiefer) 1:301, 303-04
Jester house (Wright) 1:575
Le jeu lugubre (*The Dismal Sport*; *The Lugubrious Game*) (Dalí) 1:162, 168-70, 172, 177, 180
Jeune chaosmos (Matta) 1:408
Jeune fille (Man Ray) 2:352
The Jew at Prayer (Chagall) 2:114
The Jewish Angel (Chirico) 2:159
A Jewish Couple Dancing, N.Y.C., 1963 (Arbus) 1:59
A Jewish Giant at Home with His Parents in the Bronx, N.Y., 1970 (Arbus) 1:46, 65
Joe James (Friedlander) 2:217
John Penn (Dix) 2:192
Johnson Wax Company Administration Building (Wright) 1:567, 582-84
Joshua as a Warrior (Chagall) 2:120
Joyful Ascent (Kandinsky) 2:331
Junction of the Divie and Findhorn Rivers (Kokoschka) 1:317
The Junior Interstate Ballroom Dance Champions, Yonkers, N.Y., 1962 (Arbus) 1:53
Kallmünz Oberpfalz (Kandinsky) 2:323
Karalyn (Katz) 1:269
Karl Kraus (Kokoschka) 1:315
Kaufmann house (*Falling Water*) (Wright) 1:564, 566-68, 579
Kentucky Fried Chicken (Goings) 1:258, 261
The Key to Dreams (Magritte)
See *La Clé des songes*
Kidnapping (Botero) 1:128
Kinetic Construction (Gabo) 2:244
Kinetic Stone Carving (Gabo) 2:244
King and Queen (Moore) 1:452, 456-58
The Kissproof World (Matta) 1:393
Kite (Rauschenberg) 1:514
Klänge (Kandinsky) 2:330
Knife-Edge: Two Piece (Moore) 1:458
Knight, Death and the Devil (Kokoschka) 1:323
Knight Errant (Kokoschka) 1:316, 323, 327
Knight on Horseback (Kandinsky) 2:329
Knights of Columbus (Saarinen) 2:419
Knoxville, Tennessee, 1971 (Friedlander) 2:219, 224
Korean Child (Lange) 1:339
Kranke kunst (*Sick Art*) (Kiefer) 1:296
Kresge Auditorium (*MIT Auditorium*) (Saarinen) 2:412, 414, 416-19, 422, 425, 428
Kresge Chapel (*MIT Chapel*) (Saarinen) 2:411, 414
Der Krieg (*War*) (Dix) 2:196-97
Die Kriegskrüppel (Dix) 2:196
Kupperlin (Dix) 2:193
Der Kuss (Dix) 2:193
Ladder to the Moon (O'Keeffe) 1:476

Lady at a Masked Ball with Two Roses on Her Dress, N.Y.C., 1967 (Arbus) 1:60
Lampshade (Man Ray) 2:343, 364
Landmark (Arp) 1:85
Landscape Nature Forms (O'Keeffe) 1:491
Landscape near Murnau (Kandinsky) 2:328
Landscape with Tower (Kandinsky) 2:324
The Language of the Child (Chirico) 2:157
The Large Circus (Chagall) 2:132
The Large Family (Magritte) 1:379
Large Figure (Giacometti) 1:205
Large Study (Kandinsky) 2:323-24
Larkin Building (Wright) 1:572, 574, 582-83
Last Supper (Bearden) 1:117
Last Watercolour (Kandinsky) 2:333
Leafless Garden (Bearden) 1:118
Leda (Dix) 2:192
Leda Atomica (Dalí) 1:183
The Leg (Giacometti) 1:212
A l'heure de l'observatoire--Les amoureux (Man Ray)
See *A l'heure de l'observatoire--Les amoureux*
The Liberator (Magritte) 1:371-74, 378
Light Coming on the Plains No. 2 (O'Keeffe) 1:489, 493
Light Coming on the Plains No. 3 (O'Keeffe) 1:488
Light in Heavy (Kandinsky) 2:331
Light over Heavy (Kandinsky) 2:331
Lili, die Königin der Luft (Dix) 2:193
Linear Construction in Space No. 2 (Gabo) 2:246, 250
Linear Construction in Space No. 4 (Gabo) 2:241, 243
Linear Construction No. 1 (Gabo) 2:241, 243
Linear Construction No. 2 (Gabo) 2:241, 244
Lineman (Albright) 2:25-6
Linoleum (Rauschenberg) 1:502
Listen to Life (Matta) 1:389
Listeners Frieze (Barlach) 1:94-5
The Listening Room (Magritte) 1:361, 377, 380
Little Blue under Red (Calder) 2:60
A Little of the Bandits' Soul (Magritte) 1:362
Little Universe (Calder) 2:74-5, 78
A Lobby in a Building, N.Y.C., 1966 (Arbus) 1:53
Lobster Ballet (Cornell)
See *Pantry Ballet for Jacques Offenbach*
Locking Piece (1963-64) (Moore) 1:453, 455
London, Tower Bridge (Kokoschka) 1:317
Los Angeles, 1965 (Friedlander) 2:220
The Lost Jockey (Magritte) 1:356
The Lost Steps (Magritte) 1:364
Lot and his Daughters (Dix) 2:191, 199
Louis XVI and His Family in Prison (Botero) 1:126
The Lovers (Chagall) 2:133
The Lovers (Magritte) 1:378
Lovers on Graves (Dix) 2:200
Lovers under Lilies (Chagall) 2:133
Lovers with Cat (Kokoschka) 1:316
The Lugubrious Game (Dalí)
See *Le jeu lugubre*
Lulov und Essrog (Chagall) 2:114
Lustmörder (*Sex Murderer*) (Dix) 2:195, 201
Lyrical (Kandinsky) 2:330
Macomb's Dam Bridge (Hopper) 2:292
Madame Torso with Wavy Hat (Arp) 1:82, 84
Madonna (Botero) 1:125
Madonna and Child (Bearden) 1:117

Madonna and Child (Northampton) (Moore) 1:433-35, 440-43, 448
Madonna of Port Lligat (Dalí) 1:184
The Madonna of the Birds (Dalí) 1:167
Madonna of the Village (Chagall) 2:133
Madrid, 1933 (Cartier-Bresson) 2:105-06
Maikafer Flieg (*Cockchafer Fly*) (Kiefer) 1:295, 299, 308
La main (*le remords de conscience*) (Dalí) 1:161
Main prise (*Hand Caught by a Finger*) (Giacometti) 1:202, 211
Malen Verbrennen (*Painting Burning*) (Kiefer) 1:293, 297
Malerei der verbrannten Erde (*Paintings of the Burnt Earth*) (Kiefer) 1:295
Man (Calder) 2:71
Man (Apollo) (Giacometti) 1:211
Man and a Boy on a Beach in Central Park, N.Y.C., 1962 (Arbus) 1:59
Man at a Parade on Fifth Avenue, N.Y.C., 1969 (Arbus) 1:53
Man at the Crossroads Looking with Uncertainty but with Hope and High Vision to the Choosing of a Course Leading to a New and Better Future (Rivera) 2:374, 385
Man Dancing with a Large Woman, N.Y.C., 1967 (Arbus) 1:59
Man-Eater (Calder) 2:64
Man in an Indian Headdress (Arbus) 1:60
Man in the Wood (Kiefer)
See *Mann im Wald*
Man Pointing (Giacometti) 1:191
Man Ray 1914 (Man Ray) 2:350-52
Man Ray: Photographs, 1920-1934 Paris (Man Ray) 2:349
Man Smoking (Botero) 1:130
Man Stepping from Curb (Lange) 1:339
Man Trembling (Matta) 1:390
Man Walking toward the Horizon (Magritte) 1:367
Manhattan Bridge Loop (Hopper) 2:289
Manifestation (Albright) 2:23
The Manifestations of God (Barlach)
See *Die Wanlungen Gottes*
Mann im Wald (*Man in the Wood*) (Kiefer) 1:295
Mannequin Rotting in a Taxicab (Dalí) 1:163, 165
Many (Calder) 2:75
Map Room Two (Rauschenberg) 1:500, 502, 525-26
Maple at Lake George (O'Keeffe) 1:485
March (Burchfield) 2:38
March Heath (Kiefer)
See *Märkische Heide*
Margarete (Kiefer) 1:309
Marital Sculpture (Arp) 1:85
Märkische Heide (*March Heath*) (Kiefer) 1:299, 308
Marseille, 1932 (Cartier-Bresson) 2:105
Martin house (Wright) 1:581-82
Mary Supporting Christ (Bearden) 1:117
Mask (Arp) 1:84
Mask (1924) (Moore) 1:434
The Mastersingers (Kiefer)
See *Die Meistersinger*
Match Vendor (Dix) 2:201
Maternity (Rivera) 2:392
The Mathematician (Rivera) 2:392, 397
Matrose Fritz Müller aus Pieschen (Dix) 2:192
Matrose mit Negerin (Dix) 2:192

Matrose und Mädchen mit Zigarette (Dix) 2:192-93
Matrosen Liebste (Dix) 2:192
Maud Arizona (Dix) 2:193
McCormick house project (Wright) 1:569, 572
Mädchem und Tod (Dix) 2:195
Medici Slot Machine (Cornell) 2:169-70, 173, 175-77
Meditation upon the Harp (Dalí) 1:170
Mediterranean Sculpture I (Orphic Dream) (Arp) 1:86
Die Meistersinger (The Mastersingers) (Kiefer) 1:293, 301, 309
The Melancholic Transvestite (Botero) 1:126
The Melancholy of Departure (Chirico) 2:157
Memoires Inédits de Mme. la Comtesse de G. (Cornell) 2:168
Memory (Magritte) 1:355, 357
A Memory from Childhood (Burchfield) 2:41
Menschenköpfe (Human Heads) (Kokoschka) 1:328
Mercury Fountain (Calder) 2:78
Meridian (Hepworth) 2:274
Mesa and Road to the East (O'Keeffe) 1:490
Metamorphosis (Shell-Swan-Swing) (Arp) 1:85
Metaphysical Interior I (Chirico) 2:159
The Metaphysical Interior with Head of Mercury (Chirico) 2:163
Methodist Church (Hopper) 2:289
Mexican Dwarf (Arbus) 1:63
Mexico, 1934 (Cartier-Bresson) 2:105
Mexico of Today (Rivera) 2:381
Mexico Yesterday, Today, and Tomorrow (Rivera) 2:381
Micky (Alechinsky) 1:39
Midgard (Kiefer) 1:301
The Midnight Marriage (Magritte) 1:361
Midsummer Caprice (Burchfield) 2:35
Midtown Night View (Abbott) 2:10
Midway Gardens (Wright) 1:574, 582
Migrant Mother, Nipoma, California (Lange) 1:334-35, 339, 341, 344, 346-48
Migratory Cotton Picker, Eloy, Arizona (Lange) 1:339, 341
Millard house (Wright) 1:578
Miller house (Saarinen) 2:411, 427
Miners (Moore) 1:435
Mirror to Die Laughing By (Man Ray) 2:344
Mirrors, Messages, and Manifestations (White) 2:440, 445-46
Mr. Knife and Mrs. Fork (Man Ray) 2:364
Mrs. Rosennast (Dix) 2:205
Mrs. Rubens (Botero) 1:126, 128
MIT Auditorium (Saarinen)
 See *Kresge Auditorium*
MIT Chapel (Saarinen)
 See *Kresge Chapel*
Mlle. Télé (Giacometti) 1:212
Model of a Monument for an Observatory (Gabo) 2:245
Moderate Momentum (Kandinsky) 2:327
A Modern Inferno (Rauschenberg) 1:525
Moi et le village (I and the Village; The Village and I) (Chagall) 2:110-13, 125, 127-28, 137
Mollusk (Scale) (Rauschenberg) 1:526
Mona Lisa, Age 12 (Botero) 1:124
Monogram (Rauschenberg) 1:499, 517, 525-27
Monolith-Empyrean (Hepworth) 2:263
Monolith, The Face of Half-Dome (Adams) 1:10, 16, 22
Monsieur Phot (Cornell) 2:184

Montagne regardant (Alechinsky) 1:34
Monument (Rauschenberg) 1:507
Monument à D. A. F. de Sade (Man Ray) 2:362-63
Monument for an Airport (Gabo) 2:240, 244
Monument for an Observatory (Gabo) 2:236
Moon and Half-Dome (Adams) 1:21
Moonflowers at Dusk (Burchfield) 2:45
Moonrise, Hernandez New Mexico (Adams) 1:16, 22, 24
Moose Horn State Park (Katz) 1:284, 289
Der Morgen (Dix) 2:193-94
Morning Beckon (Matta) 1:393
Morning in a City (Hopper) 2:284, 289
Morning Star (Calder) 2:63
Morning Work Train (Bearden) 1:117
The Morphology of Desire (Matta) 1:395, 404
Morris shop building (Wright) 1:575
Mother and Child (Hepworth) 2:262, 271
Mother and Child (Kokoschka) 1:317
Mother and Child (Modersohn-Becker) 1:415
Mother and Child (1931, Verde di Prato) (Moore) 1:451
Mother and Child (1967, red Soroya marble) (Moore) 1:453
Mother and Child (1931, Cumberland alabaster) (Moore) 1:437
Mother and Child (1928, Styrian jade) (Moore) 1:451
Mother and Child (1929, Verde di Prato) (Moore) 1:451
Mother and Child (Moore) 1:440, 443, 455
Mother Superior (Botero) 1:131
The Motorized Mobile That Duchamp Liked (Calder) 2:62
Mount Galen Clark (Adams) 1:10
Mount Williamson, Sierra Nevada (Adams) 1:16
The Mountain (Gogh) 1:243
Mountain, Table, Anchors, Navel (Arp) 1:70, 84
Multiple Cubes (Cornell) 2:167, 170-71, 175, 178
Museum of Non-Objective Paintings (Wright)
 See *Guggenheim Museum*
Music (Chagall) 2:133
Music Tent (Aspen Tent) (Saarinen) 2:420, 429
Musical Box (Rauschenberg) 1:515
The Musician (Chagall) 2:133
Mutilé et apatride (Arp) 1:87
Les mystères du château du dé (Man Ray) 2:345, 357
Mysteries (Bearden) 1:112
Mysterious Baths (Chirico) 2:163
The Mysterious Bird (Burchfield) 2:43
Mysterious Spectacle (Chirico) 2:163
The Mystery and Melancholy of a Street (Chirico) 2:155
The Mystic Trip (Botero) 1:128
The Myth of Orpheus (Chagall) 2:135
Mythical Composition (Arp) 1:84
The Mythology (Chirico) 2:163
Myxomatosis (Calder) 2:64
Nabil's Loft (Katz) 1:278-79
A Naked Man Being a Woman (Arbus) 1:49
Napoleon's Mask (Magritte) 1:379
National Holiday (Botero) 1:134-35
The Natural Graces (Magritte) 1:364
Near Paris (Kandinsky) 2:328
Near Westley, California (Lange) 1:340
Nebula (Cornell) 2:185

The Necklace (Man Ray) 2:343
Neo-Cubist Academy, Figures on the Sand (Dalí) 1:168
Nero Paints (Kiefer) 1:304
Network (Alechinsky) 1:38, 40
New Born Nun (Botero) 1:131
"*The New California*" (Lange) 1:338
New Haven Coliseum (Saarinen) 2:419
New Orleans, 1968 (Friedlander) 2:216
New York (Kokoschka) 1:320
New York 1920 (Man Ray) 2:342
New York Movie (Hopper) 2:285, 289, 298, 305
News Building: 1930 (Abbott) 2:10
Nibelungen Leid (Suffering of the Nibelung) (Kiefer) 1:296
Night (Katz) 1:281, 286
Night I (Katz) 1:289
Night Café (Gogh) 1:221, 236, 244
Night of the Equinox (Burchfield) 2:45
Night Song (Bearden) 1:117
The Night Wind (Burchfield) 2:33, 40-1
Night Windows (Hopper) 2:286, 289, 306
Nighthawks (Hopper) 2:279, 285, 289, 291
Nile Valley (Lange) 1:340
No More Play (Giacometti) 1:211
Noonday Heat (Burchfield) 2:34, 37
North Wind (Moore) 1:433-34, 436
The Nose (Giacometti) 1:202
Nostalgic Echo (Dalí) 1:171
A Not Altogether Horizontal Mobile (Calder) 2:69
Nouveaux Contes de Fées (Cornell) 2:171, 175
November Dawn (Burchfield) 2:38
November Evening (Burchfield) 2:37
Now Upwards! (Kandinsky) 2:331
Nude (Dix) 2:202
Nude (Giacometti) 1:211
Nude Child with Gold Fish Bowl (Modersohn-Becker) 1:415
Number 9 (Bearden) 1:118
Number 12 (Bearden) 1:118
Number 61 lounge chair and ottoman (Saarinen) 2:429
Number 70 lounge chair (Saarinen) 2:429
Number 71 chair (Saarinen) 2:428
Number 72 chair (Saarinen) 2:428
Number 73 settee (Saarinen) 2:429
Number 74 ottoman (Saarinen) 2:429
Nürnberg (Kiefer) 1:293, 301
Nursing Mother (Modersohn-Becker) 1:422-23
NY. Trac. (Moses) 1:468
O Ewigkeit, du Donnerwort (Kokoschka) 1:323, 327
O Ewigkeit--du Donnerwort (Bach Cantata) (Kokoschka) 1:327
Oakland Museum (Saarinen) 2:419
Object with Red Discs (Calder) 2:77
Objects Arranged as Writing (Arp)
 See *Objets placés comme écriture*
Objets placés comme écriture (Objects Arranged as Writing) (Arp) 1:77
Observatory Time--The Lovers (Man Ray)
 See *A l'heure de l'observatoire--Les amoureux*
Obstruction (Man Ray) 2:364
Occupations (Kiefer)
 See *From Summer Until Fall of 1969 I Occupied Switzerland, France, and Italy*
October #2 (Katz) 1:281, 285-86
October Moonset (Burchfield) 2:38
L'octrui (Matta) 1:401, 405
Odalisk (Rauschenberg) 1:510, 516-17

Of the Blues (Bearden) **1**:118-19

Office at Night (Hopper) **2**:285-86, 289, 298

Old Age, Adolescence, Infancy (Dalí) **1**:171

Old Almshouse Woman (Modersohn-Becker) **1**:414

The Old Couple (Bearden) **1**:111

Old Drug Store, Market Street: 1931 (Abbott) **2**:10

Old Inn at Gardenville (Burchfield) **2**:39

The Old Ones (Rivera) **2**:397

The Old Peasant (Gogh) **1**:221

Old Peasant Woman (Modersohn-Becker) **1**:413-14

The Old Worker (Dix) **2**:205

The Olive Grove (Gogh) **1**:232-33

Omega of a Lost World (Matta) **1**:389

On the Heights (Adams) **1**:10

Oncoming Spring (Burchfield) **2**:36

One Flight Up (Katz) **1**:284, 287

One Nation Indivisible, San Francisco (Lange) **1**:339

The Onyx of Electra (Matta) **1**:397, 403

Open Bible (Gogh) **1**:239

Operation Barbarossa (Kiefer) **1**:304

Operation Sea Lion (Kiefer)
 See *Unternehmen Seelöwe*

L'or du rien (Alechinsky) **1**:41

Oracle (Rauschenberg) **1**:498, 502

Oranges (Botero) **1**:130

The Orator (Man Ray) **2**:343

The Order of the Angels (Kiefer) **1**:301, 303

Oregon Coast (Hopper) **2**:289

Orpheus (Chagall) **2**:135

Oru (Arp) **1**:73

Oslo Chancellery (Saarinen)
 See *United States Embassy Chancellery, Oslo*

The Ottobrata (Chirico) **2**:160

Our Lady of New York (Botero) **1**:128

Oval Sculpture (Hepworth) **2**:260

Over Vitebsk (Above Vitebsk) (Chagall) **2**:114, 135

Owl's Dream (Arp) **1**:71

The Pail of Ganymede (Rauschenberg) **1**:517-18

Pain peint (Blue Bread) (Man Ray) **2**:344

A Painter (Botero) **1**:131

Painting with the Red Letter S (Rauschenberg) **1**:516

PaintingBurning (Kiefer)
 See *MalenVerbrennen*

Paintings of the Burnt Earth (Kiefer)
 See *Malerei der verbrannten Erde*

Pair of Boots (Gogh) **1**:223-240

Paisaje Zapatista (Zapatista Landscape--The Guerrilla) (Rivera) **2**:378, 387

The Palace at 4 A.M. (Giacometti) **1**:190, 206, 211

Palette (Kiefer) **1**:295

Pantomime (Rauschenberg) **1**:500, 510-11

Pantry Ballet for Jacques Offenbach (Lobster Ballet) (Cornell) **2**:170, 178

The Parade (Burchfield) **2**:43

Paranoiac Astral Image (Dalí) **1**:159

Paris, 1978 (Friedlander) **2**:214

Paris de nuit (Brassaï) **1**:139, 144-45, 147, 149-51

Paris par le fenfre (Paris through the Window) (Chagall) **2**:110

Paris through the Window (Chagall)
 See *Paris par le fenfre*

Parmelian Prints of the High Sierras (Adams) **1**:12

A Parrot for Juan Gris (Cornell) **2**:175

Partial Hallucination: Six Images of Lenin on a Piano (Dalí)
 See *Hallucination partielle: Six Images de Lenine sur un piano*

Pas de deux (Katz) **1**:287

Passage clouté (Brassaï) **1**:144

Passing (Katz) **1**:282, 288

Passion (Kokoschka) **1**:323

Passion of Christ (Bearden) **1**:117

Pastorale (Hepworth) **2**:263

Paths IV (Kiefer)
 See *Wege IV*

Patio Door (O'Keeffe) **1**:489-90

Patio with Red Door (O'Keeffe) **1**:490-91

Patriotic Young Man with a Flag, N.Y.C., 1967 (Arbus) **1**:59-60

Paul Scheerbart (Kokoschka) **1**:315

Paul Taylor (Katz) **1**:282-83, 288

Paul's Hands (Lange) **1**:340

Pawky Cascade (Rauschenberg) **1**:528

Pawtucket Pier, South Street: 1931 (Abbott) **2**:9

Pax Vobiscum (Dalí) **1**:173

Peasant with a Sickle (Gogh) **1**:229

Peasant Woman in Profile, Facing Right (Modersohn-Becker) **1**:421

Peasant Woman Praying (Modersohn-Becker) **1**:417

Pee Wee's Diner (Goings) **1**:261

Pelagos (Hepworth) **2**:263, 269, 272

Pelican (Rauschenberg) **1**:500, 526

Pelvis IV (Oval with Moon) (O'Keeffe) **1**:489

Pelvis with Shadows and the Moon (O'Keeffe) **1**:485

Pelvis with the Moon (O'Keeffe) **1**:489

Pendour (Hepworth) **2**:262

Pennsylvania Station: 1931 (Abbott) **2**:9

Penny Arcade Portrait of Lauren Bacall (Cornell) **2**:169

The People's Demand for Better Health (Rivera) **2**:390

Le persistance de la memoire (The Persistence of Memory) (Dalí) **1**:158, 171-72, 175, 185

The Persistence of Memory (Dalí)
 See *Le persistance de la memoire*

Personal Values (Magritte) **1**:356, 361, 380

Peter Altenberg (Kokoschka) **1**:330

The Phantom Cart (Dalí) **1**:171

The Phantom Landscape (Magritte) **1**:367

Pharmacy (Cornell) **2**:175

The Philosopher's Conquest (Chirico) **2**:158

Phoenix (Rauschenberg) **1**:527

Photographs (Abbott) **2**:11

Piazza d'Italia (Chirico) **2**:163-64

The Picture of Dorian Gray (Dorian Gray) (Albright) **2**:23

Picture with White Edge (Kandinsky) **2**:330

Pierced Hemisphere (Hepworth) **2**:259

Pilgrim (Rauschenberg) **1**:510, 518

The Pilgrim of Doubt (Matta) **1**:405-06

Pink Palace (Cornell) **2**:175

Pipes and Gauges, West Virginia (Adams) **1**:21

Pistil (Arp) **1**:89-92

Pittsburgh, 1979 (Friedlander) **2**:216

Pittsburgh Memory (Bearden) **1**:112

Place (Katz) **1**:281

La Place de l'Europe in the Rain (Cartier-Bresson) **2**:96

Plagiarism (Magritte) **1**:363

Plague of Darkness (Chagall) **2**:118

Les plaisirs illuminaaes (Illumined Pleasures) (Dalí) **1**:160, 168-69, 179

Plant Hammer (Arp) **1**:72, 82, 84, 89

Plate, Fork, and Navel (Arp) **1**:72

Players (Chagall) **2**:131

Plumbing Heating Truck (Goings) **1**:260

Poems without Words (Kandinsky) **2**:327, 329

The Poet (Gogh) **1**:220-21

A Poet (Matta) **1**:390, 397

The Poet; or, Half-Past Three (Half-Past Three (The Poet)) (Chagall) **2**:113, 125, 137

Pointe a l'oeil (Giacometti) **1**:202

Pointed and Round (Kandinsky) **2**:331

Poland Is Not Yet Lost (Kiefer) **1**:304

Pond in the Woods (O'Keeffe) **1**:488

Pont d'anglais (Gogh) **1**:219

Poor Room--There Is No Time, No End, No Today, No Yesterday, No Tomorrow, Only the Forever, and Forever and Forever without End (The Window) (Albright) **2**:18-9, 26-8

The Portfolios of Ansel Adams (Adams) **1**:20

Porthmeor (Hepworth) **2**:274

Portrait of a Degenerate Artist (Kokoschka) **1**:318-19

Portrait of a Woman (Kokoschka) **1**:323

Portrait of Adolfo Best Margaud (Rivera) **2**:397

Portrait of Annette (Giacometti) **1**:213

Portrait of Dr. F. (Dix) **2**:190

Portrait of Dr. Gachet (Gogh) **1**:233

Portrait of Johanna Ey (Dix) **2**:191

Portrait of Josef May (Dix) **2**:207-08

Portrait of Karl Krall (Dix) **2**:191

Portrait of My Aunt Emily (Burchfield) **2**:42-3

Portrait of My Dead Brother (Dalí) **1**:185

Portrait of Patience Escalier (Gogh) **1**:247

Portrait of the Artist's Mother (Kokoschka) **1**:316

Portrait of the Artist's Parents I (Dix) **2**:205-06

Portrait of the Lloyd Family (Katz) **1**:273

Portrait of the Photographer and Art Dealer Hugo Erfurth (Dix) **2**:192, 207

Portrait of Tzara (Arp) **1**:72, 80, 84, 89

Portrait of Yanaihara (Giacometti) **1**:213

Portraits (Cartier-Bresson) **2**:101

Porträt Eines Blinden Bettlers (Dix) **2**:196

The Postcard (Magritte) **1**:378

The Potato Eaters (Gogh) **1**:229, 233-34, 242, 247, 250

The Power of Music (Kokoschka) **1**:316-17, 323

Prager Strasse (Prague Street) (Dix) **2**:194, 196, 202

Prague Street (Dix)
 See *Prager Strasse*

Prescience (Matta) **1**:396, 404

Prevalence of Ritual, Tidings (Bearden) **1**:112

Private Domain (Katz) **1**:274

Procession Bearing Food to the Dead, Upper Egypt (Lange) **1**:340

The Prodigious Adventures of the Lace-Maker and the Rhinoceros (Dalí) **1**:175-77, 185

The Profanation of the Host (Dalí) **1**:169

Project for a Radio Station (Gabo) **2**:236

Project for the Palace of the Soviets (Gabo) **2**:236

Projections (Bearden) **1**:110, 112, 118

Der Proktophantasmist und anderes Gelichter (Barlach) **1**:105

Promenade (Burchfield) **2**:34, 39

The Promenade (Chagall) **2**:114

The Promenades of Euclid (Euclidean Walks)
(Magritte) **1**:360, 363
The Prometheus Saga (Kokoschka) **1**:320, 324
The Propheteer (Matta) **1**:393
*Prostitute and War Invalid (Two Victims of
Capitalism)* (Dix) **2**:190, 201
Provisional Cactus (Calder) **2**:69
Psychological Morphology of Expectation
(Matta) **1**:399
Psychology of Morphology (Matta) **1**:399
Ptolemy (Arp) **1**:73, 79, 81, 86
Public Relations (Winogrand) **1**:532, 536,
538, 549
Puerto Rican Woman with a Beauty Mark
(Arbus) **1**:65
Le puits (Dalí) **1**:161
Pussy Willows (Burchfield) **2**:35
Quaternity (Kiefer) **1**:296
Quiet Assertion (Kandinsky) **2**:331
Quilting Time (Bearden) **1**:117-18
Railroad Bridge (Gogh) **1**:247-48
Railroad Gauntry (Burchfield) **2**:38
Railroad Train (Hopper) **2**:303
Rain (Chagall) **2**:124
Rain-Wedge (Moses) **1**:467-68
Rainer Maria Rilke (1904) (Modersohn-
Becker) **1**:415
Rainy Night (Burchfield) **2**:35, 46
Ralph's Diner (Goings) **1**:259
Ram's Head, White Hollyhock, Hills
(O'Keeffe) **1**:484
Rapallo (Kandinsky) **2**:324
Rape (Magritte) **1**:363
Rape and Murder (Dix) **2**:201
Rape 2 (Dix) **2**:191
The Ravine (Gogh) **1**:222, 224, 232-33
Reaching Upwards (Kandinsky) **2**:331
The Ready-Made Bouquet (Magritte) **1**:361,
372
The Reaper (Gogh) **1**:248
Rebus (Rauschenberg) **1**:504, 510, 519, 525
Reciprocal Accord (Kandinsky) **2**:334
Reclining Figure (1947, brown Hornton stone)
(Moore) **1**:443
Reclining Figure (1946, bronze) (Moore)
1:443
Reclining Figure (1963-65: Lincoln Center)
(Moore) **1**:449, 458
Reclining Figure (1945, terra-cotta) (Moore)
1:443
Reclining Figure (1950: Festival of Britain)
(Moore) **1**:447, 449
Reclining Figure (1940, lead) (Moore) **1**:437
Reclining Figure (1946, terra-cotta) (Moore)
1:443
Reclining Figure (1939, elm) (Moore) **1**:439-
40
Reclining Figure (1945-46, elm) (Moore)
1:436, 442-43
Reclining Figure (1938, green Hornton stone)
(Moore) **1**:439
Reclining Figure (1945, bronze) (Moore)
1:443
Reclining Figure (1936, elm) (Moore) **1**:435,
439, 442
Reclining Figure (1939, lead) (Moore) **1**:437,
439, 442
Reclining Figure (1931, lead) (Moore) **1**:437,
439
Reclining Figure (1938, lead) (Moore) **1**:437-
38, 442

Reclining Figure (1930, Ancaster stone)
(Moore) **1**:437
Reclining Figure (1937, Hopton-Wood stone)
(Moore) **1**:438
Reclining Figure (1929, alabaster) (Moore)
1:433, 436
*Reclining Figure (1933, carved reinforced
concrete)* (Moore) **1**:437, 439, 450
Reclining Figure (Moore) **1**:440, 443-44
Reclining Figure (1930, Corsehill stone)
(Moore) **1**:437
Reclining Figure (1929, brown Hornton stone)
(Moore) **1**:436, 442, 450
Reclining Woman (1930, green Hornton stone)
(Moore) **1**:437
*Reclining Woman (1930, carved reinforced
concrete)* (Moore) **1**:437
Reclining Woman Who Dreams (Giacometti)
1:211
*Rectangles Arranged According to the Laws of
Chance* (Arp) **1**:72
Recumbent Figure (1938, green Hornton stone)
(Moore) **1**:433, 438-40
Red and Black World (Chagall) **2**:133
Red Coat (Katz) **1**:283
The Red Egg (Kokoschka) **1**:319-20
Red Hills and Sky (O'Keeffe) **1**:489
The Red Model (Magritte) **1**:356, 358, 361,
364
Red Past View (O'Keeffe) **1**:491
Red Patio (O'Keeffe) **1**:491
Red Poppy (O'Keeffe) **1**:494
The Red Smile (Katz) **1**:282-83, 285-86, 288
Red Sun (Calder) **2**:71
Red to Black (O'Keeffe) **1**:487
The Redness of Lead (Matta) **1**:386
Reitender Urian (Barlach) **1**:101
Relations (Kandinsky) **2**:320
Remembrance of a Journey (Magritte) **1**:364
Reservoir (Rauschenberg) **1**:526
Resumptio (Kiefer) **1**:295
Resurrection of Christ (Dix) **2**:205
Resurrexit (Kiefer) **1**:296
*Retired Man and His Wife in a Nudist Camp
One Morning* (Arbus) **1**:65
Return to Reason (Man Ray) **2**:356
The Revolt of the Opposites (Matta) **1**:400
The Revolution (Chagall) **2**:115, 132, 138
Revolvers (Rauschenberg) **1**:526-27
Revolving Doors (Man Ray) **2**:352-53, 359,
363
Rhythmic Form (Hepworth) **2**:260, 263
Riding Couple (Kandinsky) **2**:328-29
Rising Warmth (Kandinsky) **2**:331
Ritual Branch (White) **2**:441
River Forest Golf Club (Wright) **1**:566
River Mist (Bearden) **1**:118
Road with Cypresses and Evening Star (Gogh)
1:240
Road with Trees (Hopper) **2**:303
Roberts house (Wright) **1**:580-81
Robie house (Wright) **1**:560-69, 571-72, 581-
82, 587
Rocks in a Wood (Gogh) **1**:224
Rogues' Gallery (Burchfield) **2**:40, 43
Romantic Landscape (Kandinsky) **2**:328
Romeo and Juliet windmill (Wright) **1**:562
Roof Garden (Katz) **1**:281
Room in New York (Hopper) **2**:285-86, 288,
292, 298
Room 203 (Albright)

See *And God Created Man in His Own
Image*
Rooms for Tourists (Hopper) **2**:289
The Rooster (Chagall) **2**:133
*The Rope Dancer Accompanies Herself with
Shadows* (Man Ray) **2**:349, 343, 352-55,
359, 363
Rose Hobart (Cornell) **2**:184-85
Les rosembelles (Matta) **1**:401
Rosicrucian (Albright)
See *I Slept with the Starlight in My Face*
Ross house (Wright) **1**:580
Roulin the Letter Carrier (Gogh) **1**:231
Round Hill (Katz) **1**:279, 289
Route 6, Eastham (Hopper) **2**:297
Rudy and Edwin (Katz) **1**:288
Rudy and Yvonne (Katz) **1**:277
Rue Férou (Man Ray) **2**:343
Russian Beggarwoman (Barlach) **1**:98
Russian Knight (Kandinsky) **2**:329
Russian Village, from the Moon (Chagall)
2:125. 127
Sabbath (Chagall) **2**:113
Sacrament of the Last Supper (Dalí) **1**:181
Sacrifice of Manoah (Chagall) **2**:118
The Sadness of Springtime (Chirico) **2**:154
Safway Jeep (Goings) **1**:260
St. George and the Dragon (Botero) **1**:128
St. George Killing the Dragon (Chirico) **2**:153
St. Mark's Tower (Wright) **1**:588
Der Salon (Dix) **2**:193-94
Same and Different (Kandinsky) **2**:331
Samuel F. B. Morse College (Saarinen) **2**:412,
418, 424
Sand Fountain (Cornell) **2**:178
Sandy's Butterfly (Calder) **2**:63-4
Der Sänger (Barlach)
See *Singender Klosterschüler*
Santa Barbara, California, 1984 (Friedlander)
2:214
Santiago el Grande (Dalí) **1**:185-86
Satellite (Rauschenberg) **1**:504
Saul and David (Kokoschka) **1**:329
Sauterelles (Cornell) **2**:169
Schematic Composition (Arp) **1**:84
Schneckenhexe (Barlach) **1**:104
Die Schöne Mally (Dix) **2**:193
Der Schützengraben (Dix) **2**:197-98
Schwangeres Weib (Dix) **2**:192
Las scillibas de Scylla (Matta) **1**:408
Scotland, Dulsie Bridge (Kokoschka) **1**:317
Scotland, Plodda Falls (Kokoschka) **1**:317
Sculpture (1937, bird's eye marble) (Moore)
1:438, 443
Sculpture (1937, Hopton-Wood stone) (Moore)
1:438
Sculpture with Profiles (Hepworth) **2**:271
Seated (Arp) **1**:73
Seated Girl (Modersohn-Becker) **1**:415
A Seated Man in a Bra and Stockings (Arbus)
1:54
Seated Shepherds (Barlach) **1**:94
Seated Warrior (Moore) **1**:458
Second Liners (Friedlander) **2**:217
2nd P (Moses) **1**:467
Second Story Sunlight (Hopper) **2**:279
Secret Heat (Matta) **1**:393
The Secret Paris of the 30's (Brassai) **1**:141,
144-45, 147
The Seducer (Magritte) **1**:363
Self-Portrait (Chirico) **2**:154
Self-Portrait (Katz) **1**:272

Title Index

Self-Portrait (Cigarette) (Katz) **1**:281
Self-Portrait (1907) (Modersohn-Becker)
 1:413
Self-Portrait (1906) (Modersohn-Becker)
 1:413
Self-Portrait as a Prisoner of War (Dix) **2**:204
Self-Portrait as a Soldier (Dix) **2**:200
Self-Portrait as Mars (Dix) **2**:200-01
Self-Portrait in Front of Paris Buildings
 (Modersohn-Becker) **1**:422
Self-Portrait with Camellia Branch
 (Modersohn-Becker) **1**:419
Self-Portrait with Cap (Kokoschka) **1**:318
Self-Portrait with Carnation (Dix) **2**:198
Self-Portrait with Lemon (Modersohn-Becker)
 1:422
Self-Portrait with Necklace (Modersohn-
 Becker) **1**:422, 424
Self-Portrait with Sunglasses (Katz) **1**:277,
 288
Señorita Matilda Palou (Rivera) **2**:398
Sequence 8 (White) **2**:448
Sequence 13 (White) **2**:449
The Servant of the Disciples of Emmaus (Dalí)
 1:185
Seven A.M. (Hopper) **2**:288-89
The Seven Deadly Sins (Dix) **2**:199
Seven Whites (Rauschenberg) **1**:515
The Seventh Day (Barlach) **1**:95
Several Circles (Kandinsky) **2**:328
Séville en fête (Brassaï) **1**:144
Sex Murderer (Dix)
 See *Lustmörder*
Shades of Night Descending (Dalí) **1**:166
Shakespearean Equations (Man Ray) **2**:346,
 363
Sheherazade (Magritte) **1**:372
Shell (Arp) **1**:85
Shell Crystal (Arp) **1**:72, 85
Shell Profiles (Arp) **1**:85
Shellhole with Flowers (Dix) **2**:200-01
Shelterers (Moore) **1**:435
The Shelton (O'Keeffe) **1**:482
Shelton with Sun Spots (O'Keeffe) **1**:489-90
Shepherd of Clouds (Arp) **1**:79
Sheridan Theatre (Hopper) **2**:287
The Ship (Dalí) **1**:167
Shirt and Tie (Arp) **1**:72, 84
Shirt Front and Fork (Arp) **1**:72, 83-4
Shore Sentinels (Albright) **2**:25
The Showcase Doll That Was Never Painted
 (Albright) **2**:19, 23, 25
Shulamite (Kiefer) **1**:304
Sick Art (Kiefer)
 See *Kranke kunst*
Sidney, 1977 (Friedlander) **2**:215
Der singende Mann (Barlach) **1**:102
Singender Klosterschüler (*Der Sänger*)
 (Barlach) **1**:102
Single Form (Hepworth) **2**:272-73
Sister Toni by a Window (Dix) **2**:205
Sistine Madonna (Dalí) **1**:185
Six O'Clock (Burchfield) **2**:35, 48
*Six Tenant Farmers without Farms, Hardman
 County, Texas* (Lange) **1**:339
Die Skatspieler (Dix) **2**:196
Sketsch (Dix) **2**:193
Skull (Dix) **2**:202-03
*Skull and Its Lyric Appendage Leaning on a
 Commode Which Should Have the
 Temperature of a Cardinal's Nest* (Dalí)
 1:157

Sky Above Clouds II (O'Keeffe) **1**:491
Sky Above Clouds IV (O'Keeffe) **1**:479
Sky Above White Clouds I (O'Keeffe) **1**:491
Sky Blue (Kandinsky) **2**:320
Skylights (Hopper) **2**:302
The Slave Girl (Kokoschka) **1**:317
Sleeping Bishops (Botero) **1**:126
Sleeping Woman (Dix) **2**:202
Slow Drag Pavageau (Friedlander) **2**:217
Small Pleasures (Kandinsky) **2**:330
Small Rebus (Rauschenberg) **1**:519
Smoking Device (Man Ray) **2**:343
Snake Bread (Arp) **1**:73, 79
Snake Movement II (Arp) **1**:71
Snow (Katz) **1**:289
Soap Bubble Set (Cornell) **2**:167, 170, 172
Sodomy of a Skull with a Grand Piano (Dalí)
 See *Atmospheric Skull Sodomizing a Grand
 Piano*
A Soft Self-Portrait of Salvador Dalí (Dalí)
 1:177
Soft Self-Portrait with Fried Bacon (Dalí)
 1:181
Soldat (Dix) **2**:197
The Soldier Drinks (*The Drunken Soldier*)
 (Chagall) **2**:113, 137
Solitude (Burchfield) **2**:35
Solitude (Chagall) **2**:122, 133
Solstice (Rauschenberg) **1**:527
Song of the Katydids (Burchfield) **2**:40-1
The Song of the Peterbird (Burchfield) **2**:35
The Song of the Storm (Magritte) **1**:363
Song of the Telegraph (Burchfield) **2**:45
Song without Words (White) **2**:439-40
Sonnet Sequence (White) **2**:436
Soundings (Rauschenberg) **1**:526
South Street: 1931 (Abbott) **2**:9
Sow (Calder) **2**:61
The Sower (Gogh) **1**:220-21, 230
Space Writings (Man Ray) **2**:362-63
Spain (Dalí) **1**:171
Sparrowhawk Weather (Burchfield) **2**:48
The Spectre of Sex Appeal (Dalí) **1**:157
Spheric Theme (Gabo) **2**:241
The Spherical Roof around Our Tribe (Matta)
 1:398
Sphérique I (Calder) **2**:74
Spielleutte (Barlach) **1**:104
The Spinster (Botero) **1**:130
Spiral Theme (Gabo) **2**:244, 246
The Splitting of the Ergo (Matta) **1**:390, 398,
 404
Spontaneous Generation (Magritte) **1**:373
Spoon Woman (Giacometti) **1**:210
Spring in Berkeley (Lange) **1**:339
Square Form (1936, green Hornton stone)
 (Moore) **1**:438
Square Forms (1936) (Moore) **1**:438
Squibbs Building: 1930 (Abbott) **2**:9
Stag (Arp) **1**:84, 89
Standardized Village Service Station (Wright)
 1:588
Standing Figure: Knife Edge (Moore) **1**:457-
 58
Star (Arp) **1**:79
Star and Disaster (Alechinsky)
 See *Astre et désastre*
Starfish (Man Ray)
 See *L'etoile de mer*
Starfish and Hemisphere (Calder) **2**:80
Starlight Night (O'Keeffe) **1**:492
Starry Night (Gogh) **1**:227-28, 233, 241, 243

Starving Woman (Matta) **1**:405
State of Grace (Magritte) **1**:362
Statuary Shop, Water Street: 1930 (Abbott)
 2:10
Steel Fish (Calder) **2**:78
Still-Life (Botero) **1**:131
Still Life (Chirico) **2**:153
Still Life (Man Ray) **2**:351, 353
Still-Life with Boiling Water (Botero) **1**:128
Still Life with Fruit (Rivera) **2**:397
Still Life with Head of Apollo (Chirico) **2**:164
Still-Life with Pineapple (Kokoschka) **1**:315
Still-Life with Pitcher, Peonies and Orange
 (Modersohn-Becker) **1**:421
Still Life with Putto and Rabbit (Kokoschka)
 1:316
Still Life with Ricer (Rivera) **2**:397
Still-Life with the Dead Sheep (Kokoschka)
 1:323
Still Life with Violin (Chirico) **2**:159
Still-Life with Yellow Bowl (Modersohn-
 Becker) **1**:421
Stilleben im Atelier (Dix) **2**:195
Stock Photographs (Winogrand) **1**:536, 550-53
Stone Formed by the Human Hand (Arp)
 1:72, 82, 85
Stoned Moon (Rauschenberg) **1**:525
Story without a Name: For Max Ernst (Cornell)
 2:178
Strassenkampf (Dix) **2**:196
The Street (Bearden) **1**:110
Street in Murnau (Kandinsky) **2**:328
Street in Saintes-Maries-de-la-Mer (Gogh)
 1:247
Street Pepper (Alechinsky) **1**:31
Der Streichholzhändler I (Dix) **2**:196
Striding Man (Moore) **1**:447-49
Studio Painting (Rauschenberg) **1**:514
Study for a Constructed Head (Gabo) **2**:249
Study for Block II (Bearden) **1**:118
Study in Red Chalk (Hepworth) **2**:270
Success to the Glazier (Matta) **1**:406
Suckling Child (1930, alabaster) (Moore)
 1:451
Suffering of the Nibelung (Kiefer)
 See *Nibelungen Leid*
Suite de la Longitude (Cornell) **2**:178
Suleika, das Tätowierte Wunder (Dix) **2**:192-
 93
Summer Game (Katz) **1**:277
Summer Metope (Arp) **1**:84
Summer Rain (Burchfield) **2**:40
Summer Rental (Rauschenberg) **1**:526
Summer Solstice (Burchfield) **2**:48
Summer's Steps (Magritte) **1**:361
Sun and Rocks (Burchfield) **2**:35, 45
Sun Box (Cornell) **2**:178
Sun in an Empty Room (Hopper) **2**:302, 306
Sun in Rock (White) **2**:447, 449
Sunday Morning (Burchfield) **2**:41
Sunflowers (Gogh) **1**:223, 231-33, 238, 241
Sunny (Katz) **1**:274
*Sunrise, Death Valley National Monument,
 1948* (Adams) **1**:21
*The Sun's Anxiety after the Passage of Two
 Personages* (Matta) **1**:399
Suntop houses (Wright) **1**:580
The Supper (Botero) **1**:125
Supper (Katz) **1**:277
Die Süsse Kleine Elly (Dix) **2**:193
Swamp Maple, 4:30 (Katz) **1**:281, 285-87

A Swan Lake for Tamara Toumanova (Cornell)
 2:168, 170, 175, 178
Swimmer #3 (Katz) **1:**270, 281, 283
Swizzle Sticks (Calder) **2:**63
Tables for Ladies (Hopper) **2:**288, 302
Taglioni's Jewel Casket (Cornell) **2:**167-68,
 172, 183
Talbot's House (Hopper) **2:**281
Taliesin East (Wright) **1:**579, 581, 584
Taliesin West (Wright) **1:**562, 568, 579, 587
Talisman (Rauschenberg) **1:**508
Talking Picture (Man Ray) **2:**343
Tant qu'il y aura des bêtes (Brassai) **1:**150
Tanzende Alte (Barlach) **1:**101
Taos Pueblo (Adams) **1:**10, 12
Tapestry (Man Ray) **2:**350
Tarascon diligence (Gogh) **1:**246-47
Tattooed Man at a Carnival, Md., 1970
 (Arbus) **1:**59
Technisches Personal (Dix) **2:**193
*Teenage Couple on Hudson Street, N.Y.C.,
 1963* (Arbus) **1:**46, 59
The Tempest (Kokoschka) **1:**323
The Tender Loin (Matta) **1:**393
Tenor Spot (Bearden) **1:**119
Teodelapio (Calder) **2:**65, 72
La terrasse (Dalí) **1:**161
Tête de Diego (Giacometti) **1:**212
Tête qui regarde (Head) (Giacometti) **1:**210
Tête-stabile (Arp) **1:**89
The Thanks Giver (Matta) **1:**393
*That Which I Should Have Done I Did Not Do
 (The Door)* (Albright) **2:**18-20, 22-3, 26-8
Le théâtre aux armées (Alechinsky) **1:**35
The Therapeutist (The Healer) (Magritte)
 1:373-74, 378
Thermopylae (Kokoschka) **1:**320, 324
Theseus and Antiope (Kokoschka) **1:**320
Third Time Painting (Rauschenberg) **1:**510
This Ichnolite of Mine (Albright) **2:**25
This Is How I Looked as a Soldier (Dix)
 2:201
This Is Not an Apple (Magritte) **1:**366
Thomas J. Watson Research Center (Saarinen)
 2:412, 428
III.166 Hegemann (Moses) **1:**467
Three Love Birds (Albright) **2:**23, 25
Three-Piece Reclining Figure (1961-62)
 (Moore) **1:**452
*Three-Piece Reclining Figure No. 2: Bridge
 Prop* (Moore) **1:**452
Three-Piece Sculpture No. 7: Pipe (Moore)
 1:453
Three Prostitutes (Dix)
 See *Drei Dirnen auf der Strasse*
Three-Quarter Figure (Moore) **1:**458
Three Rings (1966-67) (Moore) **1:**453
Three Standing Figures (Moore) **1:**438, 441-
 44
Three Walking Men (Giacometti) **1:**208
Three-Way Piece: Points (Moore) **1:**453
Thursday Night #2 (Katz) **1:**281
Tiled Lunch Counter (Goings) **1:**265
Time Transfixed (Magritte)
 See *La duré poignardée*
To Be Lost in the Woods (Arp) **1:**72, 85
To Cover the Earth with a New Dew (Matta)
 1:393, 399, 401
To Escape the Absolute (Matta) **1:**397, 403
To Russia, Asses, and Others (Chagall) **2:**125,
 128
To the Unknown Painter (Kiefer)

See *Bem unbekannten Maler*
Tod und Auferstehung (Dix) **2:**195
Tomb of Rachel (Chagall) **2:**118
The Tomb of the Wrestlers (Magritte) **1:**377
Topless Dancer in Her Dressing Room (Arbus)
 1:62, 65
Torcello (Hepworth) **2:**274
Torsion (Gabo) **2:**245
Torso (Hepworth) **2:**262, 267, 269
Torso, 1920 (Arp) **1:**84
Torso, 1931 (Arp) **1:**85
Totentanz (Barlach) **1:**101
Tournament (Arp) **1:**85
Toward the Future (Alechinsky) **1:**38
Tower (Rauschenberg) **1:**526
Tower, Model for a Fountain (Gabo) **2:**245
Track Jacket (Katz) **1:**281, 288
Traffic Yellow & Green (Rauschenberg) **1:**516
*La trahison des images (The Use of Language;
 Treachery of Images; The Betrayal of the
 Images)* (Magritte) **1:**364-66, 369, 373
Trance Player (Kokoschka) **1:**322
Trans World Airlines Flight Center (Saarinen)
 2:405, 412-13, 417-19, 422-24, 429
Translucent Version on Spheric Theme (Gabo)
 2:241, 247
*Transvestite at Her Birthday Party, N.Y.C.,
 1969* (Arbus) **1:**53
Trapiche (Rivera) **2:**381
Traveller (Magritte) **1:**361
Treachery of Images (Magritte)
 See *La trahison des images*
A Tree in Winter (Katz) **1:**289
The Trench (Dix) **2:**190, 198
Trench with Flowers (Dix) **2:**200
Trinity Church and Churchyard: 1933 (Abbott)
 2:9
Trinquetaille Bridge (Gogh) **1:**247-48
Triplets in Their Bedroom, N.J., 1963 (Arbus)
 1:53
Triumph des Todes (Dix) **2:**195
Trödelhexe (Barlach) **1:**105
Trophy I (Rauschenberg) **1:**510
Trophy III (Katz) **1:**277
Trophy for Merce Cunningham (Rauschenberg)
 1:517
Trophy for Tiny and Marcel Duchamp
 (Rauschenberg) **1:**518
Troubadour (Chirico) **2:**163
Trudl with Head of Athena (Kokoschka)
 1:318
Tunny-Fishing (Dalí) **1:**186
Turbines (Rivera) **2:**381
25th Street and Second Avenue (Alechinsky)
 1:42
Twilight (Katz) **1:**281, 285
Twin Springs Diner (Goings) **1:**261
2 Browns (Dix) **2:**191
Two, Etc. (Kandinsky) **2:**326
Two Figures (Katz) **1:**281
Two Forms (Hepworth) **2:**262
Two Forms (1936) (Moore) **1:**438
Two Friends at Home (Arbus) **1:**49
*Two Girls in Identical Raincoats, Central Park,
 N.Y.C., 1969* (Arbus) **1:**60
Two Heads (Arp) **1:**72
Two Little Girls in Front of Tree Trunks
 (Modersohn-Becker) **1:**422
The Two Mysteries (Magritte) **1:**366
Two Nudes (Kokoschka) **1:**316
Two on the Aisle (Hopper) **2:**285, 291
Two on the Aisle (Man Ray) **2:**285

Two-Piece Reclining Figure (Moore) I:457
Two Victims of Capitalism (Dix)
 See *Prostitute and War Invalid*
Two Women in a Courtyard (Bearden) **1:**111
U.S. Highway No. 40, California (Lange)
 1:339
Ullapool (Kokoschka) **1:**319
Ulysses (Hepworth) **2:**274
Ulysses' Return (Chirico) **2:**163
The Unexpected Answer (Magritte) **1:**362
Ungleiches Liebespaar (Dix) **2:**195
Union Square: 1932 (Abbott) **2:**10
United States Embassy Chancellery, London
 (Saarinen) **2:**412, 417, 422, 428
*United States Embassy Chancellery, Oslo (Oslo
 Chancellery)* (Saarinen) **2:**428
Unity Temple (Wright) **1:**572
A Universe (Calder) **2:**62, 76
University of Chicago Law School (Saarinen)
 2:412
Unternehmen Seelöwe (Operation Sea Lion)
 (Kiefer) **1:**293, 299, 303
Upright Motive (Moore) **1:**452, 455
Upright Motive No. 1: Glenkiln Cross (Moore)
 1:452, 457
Upside-Down Ada (Katz) **1:**283, 285, 288
Upward (Kandinsky) **2:**331
Uranium and Atomica Melancholica Idyll
 (Dalí) **1:**172
The Use of Language (Magritte)
 See *La trahison des images*
Van Gogh's Bedroom at Arles (Gogh) **1:**231-
 32, 239, 245
Vanitas (Dix) **2:**195
Variegated Black (Kandinsky) **2:**326
Vase of Flowers (Giacometti) **1:**202
Vegetation (Arp) **1:**89
*Velázquez Painting the Infanta Margarita with
 the Lights and Shadows of His Own Glory*
 (Dalí) **1:**185
Venus des kapitalistischen Zeitalters (Dix)
 2:191, 193-94, 197-98
Venus with Black Gloves (Dix) **2:**191
Die Verächter des Todes (Dix) **2:**193
The Vermonter (Albright)
 See *If Life Were Life--There Would Be No
 Death*
Vertebrae (1968) (Moore) **1:**453
Vertical Construction No. 2 (Gabo) **2:**244
Vertical Forms (Hepworth) **2:**269
Vertige d'Eros (The Vertigo of Eros) (Matta)
 1:385, 390, 396-98, 400, 402
The Vertigo of Eros (Matta)
 See *Vertige d'Eros*
La vertue noire (Matta) **1:**386
Verzweifelter Abtanz (Barlach) **1:**101
Vienna, View from the Wilhelminenberg
 (Kokoschka) **1:**318
View (Katz) **1:**289
View from the Commodore Hotel (Abbott)
 2:13
The Village (Man Ray) **2:**343
The Village and I (Chagall)
 See *Moi et le village*
Village Fair (Chagall) **2:**132
Ville d'Arles (Alechinsky) **1:**42
Vincent and Sunny (Katz) **1:**277
Vincent and Tony (Katz) **1:**288
Vincent with Radio (Katz) **1:**281
Vincent's House at Arles (Gogh)
 See *Yellow House at Arles*
Violon d'Ingres (Man Ray) **2:**360

Le vitreur (*The Glazier*) (Matta) **1**:400-01, 406

Vohse und Louis (Dix) **2**:194

Volcano in Red and Black (Calder) **2**:80

Voyage to Upper Mongolia (Dalí) **1**:177

Waft (Moses) **1**:467

Wager (Rauschenberg) **1**:517-18

Waiting for the Harvest (Rivera) **2**:381

Walk (Katz) **1**:285

Walking Man II (Giacometti) **1**:212

Walkway (Alechinsky) **1**:33

Die Wanlungen Gottes (*The Manifestations of God*) (Barlach) **1**:95, 98, 101

War (Chagall) **2**:135

War (Dix)
See *Der Krieg*

War--A.D. MCMXIV (*A.D. MCMXIV*) (Man Ray) **2**:343, 351, 364

War Cripples (Dix) **2**:201-03

War Memorial at Magdeburg (Barlach) **1**:96

War Triptych (Dix) **2**:201, 204

Ward house (Wright) **1**:580

Washpaints (Alechinsky) **1**:38

Water Street and Maiden Lane: 1930 (Abbott) **2**:9

Watering Time (Burchfield) **2**:37

The Wave (Hepworth) **2**:260, 264, 272

The Wave (O'Keeffe) **1**:482

Ways of World Wisdom (Kiefer)
See *Wege der Weltweisheit*

The Weaning of Furniture-Nutrition (Dalí) **1**:157

The Wedding (Chagall) **2**:113, 115, 124-25

Weeping Woman (Barlach) **1**:95

Wege der Weltweisheit (*Ways of World Wisdom*) (Kiefer) **1**:301, 304, 308

Wege der Weltweisheit--die Hermannsschlacht (Kiefer) **1**:293, 298-99

Wege IV (*Paths IV*) (Kiefer) **1**:293

West Broadway: 1932 (Abbott) **2**:9

West Street: 1932 (Abbott) **2**:9

Wet Evening (Katz) **1**:289

Whale (Calder) **2**:64

What We Are Fighting For (Kokoschka) **1**:319

Wheat Field with Tower (Burchfield) **2**:41

Wherefore, Now Ariseth the Illusion of the Third Dimension (Albright) **2**:21, 26

White Angel Breadline, San Francisco (Lange) **1**:340, 348

White Cloud (Kandinsky) **2**:328

White Crucifixion (Chagall) **2**:115, 134-35, 138

White Frame (Calder) **2**:77

White Paintings (Rauschenberg) **1**:526

White Patio with Red Door (O'Keeffe) **1**:489

White Roses (Gogh) **1**:232

White Shell with Red (O'Keeffe) **1**:494

The White Street (Botero) **1**:131

White Violets and Coal Mine (Burchfield) **2**:36

"*Whitey the Goat and Her Kids*" (Winogrand) **1**:540

Who's Who (Matta) **1**:405

Wife of the Phantom (Magritte) **1**:356

Willey house (Wright) **1**:568

William Christenberry, Tuscaloosa, Alabama, 1983 (Friedlander) **2**:216

Willitts house (Wright) **1**:568, 580

The Wind and the Song (Magritte) **1**:356, 360

The Window (Albright)
See *Poor Room--There Is No Time, No End, No Today, No Yesterday, No Tomorrow, Only the Forever, and Forever and Forever without End*

Windward (Rauschenberg) **1**:511

Winged Figure (Hepworth) **2**:274

Winslow house (Wright) **1**:571-72

Winter Cottonwoods Soft (O'Keeffe) **1**:490

Winter, East Liverpool, Ohio (Burchfield) **2**:43

Winter Night Skies (Cornell) **2**:171-72

Winter Pool (Rauschenberg) **1**:510, 518

Winter Scene (Katz) **1**:281, 288

Winter Solstice (Burchfield) **2**:37

Winter Sunrise, Sierra Nevada (Adams) **1**:16, 21

With Eyes Closed (Alechinsky) **1**:41

With Three Riders (Kandinsky) **2**:329

Woman (Albright) **2**:21, 26

Woman (Giacometti) **1**:210

Woman in a Bird Mask (Arbus) **1**:65

The Woman in Blue (Kokoschka) **1**:327

Woman in Her Negligee, N.Y.C., 1966 (Arbus) **1**:60

A Woman in the Sun (Hopper) **2**:297, 302

The Woman of Arles (Gogh)
See *L'arlésienne: Madame Ginoux*

Woman of the High Texas Panhandle (Lange) **1**:340

Woman of Venice II (Giacometti) **1**:205

Woman on a Park Bench on a Sunny Day, New York City (Arbus) **1**:46

Woman with a Chariot (*Chariot*) (Giacometti) **1**:191, 211

Woman with a Fur Collar on the Street, N.Y.C., 1968 (Arbus) **1**:60

Woman with a Parrot (Kokoschka) **1**:318

Woman with Geese (Rivera) **2**:397

Woman with Her Throat Cut (Giacometti) **1**:190, 210-11

A Woman with Pearl Necklace and Earrings, N.Y.C., 1967 (Arbus) **1**:59

Woman with Veil on Fifth Avenue, N.Y.C., 1968 (Arbus) **1**:49, 55, 60

Women Are Beautiful (Winogrand) **1**:544-45, 547, 549

Women of Venice (Giacometti) **1**:212

Women's dormitories, University of Pennsylvania (Saarinen) **2**:428

Wooden Joe Nicholas, New Orleans, 1957 (Friedlander) **2**:215, 217

Wound Interrogation (Matta) **1**:407

Wrapping It Up at the Lafayette (Bearden) **1**:119

The Wrath of the Gods (Magritte) **1**:363

Xmas Tree in a Living Room in Levittown, L.I., 1963 (Arbus) **1**:53, 63

Xylographies (Kandinsky) **2**:327-28

Years of Fear (Matta) **1**:390

Yellow Circle (Kandinsky) **2**:325

Yellow House at Arles (*Vincent's House at Arles*) (Gogh) **1**:224, 231

Yellow Painting (Kandinsky) **2**:326

Yellow, Red, Blue (Kandinsky) **2**:331

The Yellow Room (Chagall) **2**:124

Yellow Wheat and Cypresses (Gogh) **1**:232

Young Blond Nude (Dix) **2**:191

Young Boy in a Pro-War Parade (Arbus) **1**:48

A Young Brooklyn Family Going for a Sunday Outing, N.Y.C., 1966 (Arbus) **1**:59

Zapatista Landscape--The Guerrilla (Rivera)
See *Paisaje Zapatista*

Zapatistas (Rivera) **2**:378, 392

Zirkus (Dix) **2**:193

The Zouave (Gogh) **1**:223